MEXICO
Splendors of Thirty Centuries

MEXICO

Splendors of Thirty Centuries

INTRODUCTION BY OCTAVIO PAZ

THE METROPOLITAN MUSEUM OF ART
New York

The exhibition is made possible by the Friends of the Arts of Mexico.

This publication is issued in conjunction with the exhibition *Mexico: Splendors of Thirty Centuries*, held at The Metropolitan Museum of Art (October 10, 1990–January 13, 1991), the San Antonio Museum of Art (April 6–August 4, 1991), and the Los Angeles County Museum of Art (October 6–December 29, 1991).

An indemnity has been granted by the Federal Council on the Arts and the Humanities. Additional support has been provided by the National Endowment for the Humanities, The Rockefeller Foundation, The Tinker Foundation, Inc., The William and Flora Hewlett Foundation, and the Mex-Am Cultural Foundation, Inc.

John P. O'Neill, Editor in Chief
Kathleen Howard, Editor
Bruce Campbell, Designer
Gwen Roginsky, Production Manager

Set in Trump Medieval and Optima by U.S. Lithograph, typographers, New York
Printed on Gardamatte Brilliante, 135 gsm
Separations made by Arnoldo Mondadori Editore, S.p.A., Verona, Italy
Printed and bound by Arnoldo Mondadori Editore, S.p.A., Verona, Italy

Photographers in Mexico commissioned by the Metropolitan Museum: Salvador Lutteroth/ Juan José Medina, Jesús Sánchez Uribe; Encuadre: Gerardo Suter–Lourdés Almeida; Enrique Franco Torrijos; and Michel Zabé

Translations by Edith Grossman, Samuel K. Heath, Margaret Sayers Peden, Donna Pierce, and John Upton

Maps and drawings by Wilhelmina Reyinga-Amrhein, with the exception of those on pp. 52, 63, 138, and 158 (Irmgard Lochner) and on p. 178 (Debra Nagao)

Jacket/Cover Illustration
Flanged cylinder (cat. no. 65, detail)

LIBRARY OF CONGRESS CATALOGING-IN-PUBLICATION DATA

Mexico: splendors of thirty centuries/The Metropolitan Museum
 of Art.
p. cm.
"A Bulfinch Press book."
Includes bibliographical references and index.
ISBN 0–87099–595–2 (hc). ISBN 0–87099–596–0 (pbk.).
ISBN 0–8212–1797–6 (Bulfinch Press—distributor)
1. Art, Mexican—Exhibitions. 2. Indians of Mexico—Art—
Exhibitions. I. Metropolitan Museum of Art (New York, N.Y.)
N6550.M48 1990
709'.72'0747471—dc20 90–38083

Published by The Metropolitan Museum of Art and Bulfinch Press

Bulfinch Press is an imprint and trademark of Little, Brown and Company (Inc.).

Published simultaneously in Canada by Little, Brown & Company (Canada) Limited

Contents

Director's Foreword

It gives me joy and pleasure to introduce *Mexico: Splendors of Thirty Centuries*, an exhibition that does justice to the great breadth and continuity of Mexican art. Few societies can boast such an unbroken cultural life marked by such a high level of creativity and achievement.

In terms of complexity—some four hundred pieces drawn largely from Mexican but also from European and United States lenders—*Mexico: Splendors of Thirty Centuries* has been a daunting undertaking, one that has challenged a broad spectrum of the Metropolitan Museum's staff while calling upon all its abundant resources. The exhibition was conceived in early 1987, when Mr. and Mrs. Emilio Azcárraga, the noted patrons, suggested that the Metropolitan Museum mount a comprehensive exhibition conveying the diversity of Mexican art from the earliest times through the twentieth century. The Museum set about shaping the exhibition with the counsel of two of Mexico's most distinguished thinkers: the poet Octavio Paz and the architect Pedro Ramírez Vázquez. Their suggestions inspired the efforts of dozens of advisers throughout the United States and Mexico. The extraordinary complexity and richness of Mexican history and culture have called forth a wide range of responses from scholars and historians; the multiplicity of views expressed in this publication reflects the protean spirit of the Mexican nation.

With the inauguration of President Salinas de Gortari in Mexico in 1988, the project acquired one of its most enthusiastic supporters. Since so many of the exhibited works were drawn from Mexican public collections—indeed the very patrimony of Mexico—it was clear we needed an advocate in Mexico to help us contact appropriate government ministries, ecclesiastical authorities, and state governors. President Salinas therefore directed us to work with the Consejo Nacional para la Cultura y las Artes, which he had founded. Víctor Flores Olea, President of the Consejo, and Luis Felipe del Valle Prieto, Horácio Flores-Sánchez, and Miriam Kaiser, the Consejo's directors for cultural exchanges, have facilitated our communications at all levels.

Essential financial support for the exhibition was provided—again with the help of the Azcárragas—through the Fundación de Investigaciones Sociales, through which a group of Mexican corporations fund broadly cultural activities. The Fundacíon is the main support of the Friends of the Arts of Mexico, whose president is Dr. Miguel Angel Corzo. Dr. Corzo's knowledge of Mexican affairs and his imagination and dedication have repeatedly cut through problems that would have otherwise resisted solution. Additional financial support has come from an indemnity supplied by the Federal Council on the Arts and the Humanities, and grants from The Rockefeller Foundation, The Tinker Foundation, Inc., The William and Flora Hewlett Foundation, and the Mex-Am Cultural Foundation, Inc.

The curators at the Metropolitan responsible for selecting the works on view are Julie Jones of the Department of Primitive Art (Precolumbian art); Johanna Hecht of the Department of European Sculpture and Decora-

tive Arts (viceregal art); John McDonald (nineteenth-century paintings); David Kiehl of the Department of Prints and Photographs (nineteenth-century prints by Posada and his contemporaries); and William S. Lieberman of the Department of Twentieth-Century Art assisted by Kay Bearman (twentieth-century art). Their gratitude to colleagues in Mexico and the United States is expressed in the Acknowledgments.

This exhibition has required the constant attention of dozens of individuals. In the initial stages Wilder Green, formerly of the American Federation of Arts, and later John McDonald, Rochelle Cohen, and Jane Tai, working with Mahrukh Tarapor, the Museum's Assistant Director, provided critical support for all phases of the exhibition. John Buchanan, Chief Registrar, had the formidable task of organizing the crating, packing, and shipping of all works—many extremely heavy and cumbersome. The exhibition catalogue—for which some forty authors contributed texts, many in Spanish, and for which more than five hundred photographs were commissioned—was guided by John P. O'Neill, Editor in Chief. Many elements had to be brought together to make this immense publication; the credit for this wizardry belongs to Kathleen Howard, Senior Editor. Gwen Roginsky, Production Manager, oversaw its production with devoted expertise.

A special acknowledgment is due the Museum's Design Department headed by Jeffrey Daly. To deal with so much and such disparate material, the services and talents of three designers were required: Jeffrey Daly, Daniel Kershaw, and Michael Batista. The complex graphic presentation was designed by Barbara Weiss, also of the Design Department. The assembly and movement of many large and fragile pieces within the building was supervised by Linda Sylling, Assistant Manager for Operations, and Franz Schmidt, Buildings Manager.

In Mexico City we took the unprecedented step of setting up an office to assist in managing this project. For two years essential functions were carried out there by Kären Anderson and Debra Nagao; their care and energy were indispensable. Space for the office was graciously donated by the Centro Cultural/Arte Contemporáneo, whose Director, Robert Littman, further helped us by providing temporary storage for a number of the objects in the exhibition.

Finally, it has been our intention to present the arts of Mexico in a clear and representative fashion—as little distorted by cliché as possible. One Mexican scholar was exceptional for his ability to frame such exhibitions, and these he did by the score over many years. I refer, of course, to the late Professor Fernando Gamboa who died in a tragic automobile accident last spring. At critical junctures he spoke eloquently to his compatriots on behalf of this exhibition. We once again express our great debt to him and our heartfelt thanks, with the hope that he would approve our efforts.

PHILIPPE DE MONTEBELLO
Director
The Metropolitan Museum of Art

Sponsor's Statement

Friends of the Arts of Mexico was founded with the help of Mexican corporations and American friends. Now based in Los Angeles, the foundation is dedicated to promoting the awareness and appreciation of Mexican art, cultural life, and history throughout the world. The bulk of its support comes from the Fundación de Investigaciones Sociales and its supporters: Bacardi y Compañía, Casa Pedro Domecq, Compañía Vinícola Del Vergel, Grupo Cuervo, Grupo Televisa, Tequila Sauza, and The Seagram Company.

The exhibition *Mexico: Splendors of Thirty Centuries* is the largest project sponsored by Friends of the Arts of Mexico to date. The foundation has, however, also initiated the effort to protect and conserve *América Tropical*, the Los Angeles work that is the only remaining public mural in the United States by David Alfaro Siqueiros. It is also involved in preserving the rock art of Baja California, one of the world's largest and most dramatic sites. In addition, numerous other events highlighting contemporary Mexico—such as the exhibition *Seventeen Contemporary Mexican Artists* and the symposium *Contemporary Mexican Architects*, both held recently in Los Angeles—are supported by the Friends of the Arts of Mexico.

This exhibition, which will be shown in New York, San Antonio, and Los Angeles, comes at a time of renewed awareness of the importance of Mexico's cultural heritage. Friends of the Arts of Mexico is especially proud to share some of Mexico's greatest art treasures with the American public.

EMILIO AZCÁRRAGA
Chairman
Friends of the Arts of Mexico

Foreword

The exhibition *Mexico: Splendors of Thirty Centuries* is the fruit of an enormous joint effort by the cultural institutions of the Mexican government, The Metropolitan Museum of Art, and the Friends of the Arts of Mexico. These organizations, aided by the strong interest and support of President Carlos Salinas de Gortari of Mexico, have assembled one of the most complete overviews of Mexican art ever presented. Three thousand years of culture—the creations of those peoples who inhabited the territory of Mexico long before the arrival of Europeans, the works of the new civilization that arose from the cultural shock of the Conquest, and the art of the independent nation that was born in the past century—have been brought together in an ambitious synthesis at the Metropolitan Museum.

The task has not been easy. A number of institutions and people joined forces to arrange for the transportation of the monumental pieces representing the extraordinary Precolumbian civilizations and the colonial world of the sixteenth through the eighteenth centuries. In addition to the logistic difficulties of moving these large-scale objects, we had to consider the sentiments of the communities that are the legitimate heirs of these treasures and that regard much of this art as an organic part of their environment and daily life. Before travel permits were issued for the works in the exhibition, careful studies evaluated their physical condition; in a number of cases restoration was undertaken, and intricate technical adjustments were made. All these exacting tasks were efficiently carried out by the participating museums and institutions and were coordinated by the Consejo Nacional para la Cultura y las Artes.

In Mexico crucial help was provided by the Instituto Nacional de Antropología e Historia and by its regional affiliates and subsidiary museums, such as the Museo Nacional de Antropología, the Museo Nacional de Historia, the Museo Nacional del Virreinato, and the Museo del Templo Mayor. The Instituto Nacional de Bellas Artes, together with the Museo Nacional de Arte, the Museo de Arte Moderno, the Museo de Arte Alvar y Carmen T. de Carrillo Gil, and the Pinacoteca Virreinal de San Diego, also provided essential support for the project. We are grateful to the Ministries of Foreign Affairs, of Public Education, and of Urban Development and Ecology, all of which share the responsibility of protecting the national patrimony.

Additional assistance was given by scholars and experts throughout Mexico and by state and city governments. Especially helpful have been the governments, cultural and academic institutions of the states of Aguascalientes, Chiapas, Coahuila, Guanajuato, México, Morelos, Oaxaca, Puebla, Querétaro, Tabasco, Tlaxcala, Veracruz, Yucatán, and Zacatecas. All of these states made significant loans to the exhibition.

This unprecedented cultural collaboration between institutions in Mexico, the United States, and seven other countries has brought together

some four hundred pieces—all of exceptional importance—from archaeological sites, museums, churches, and private collections.

The task of selection was difficult, requiring a thorough analysis of the importance of each piece in Mexico's artistic and cultural development. Only the most representative works were considered; therefore each painting and sculpture, each work in precious metal or ceramics, each textile, each piece of jewelry, and each architectural element provide a unique insight into the complex cultures that are among the oldest and richest of the American continent. It is our hope that this exhibit will not only give a fuller understanding of this hemisphere's strength and dynamism but will also reveal the deep sources from which the historic personality and cultural identity of Mexico spring.

The works from the Precolumbian era allow us to demonstrate the splendor of Mexico's indigenous past: the bedrock of the powerful national culture that was enriched by contributions from Europe, Africa, and Asia. The Hispano-Mexican art of the sixteenth to eighteenth centuries, a time of encounter between two cultures equally rich in symbols and aesthetic codes, shows the intricate and fascinating fusion of Gothic, Moorish, and Renaissance art, which culminated in the breathtaking Mexican Baroque. The selections from the nineteenth and twentieth centuries reveal a new creative impulse in Mexican art. With roots in classical and academic art and in popular tradition, these works set an entirely new course. The great creators of this century, marked by the grandeur and vigor so evident in our past, reach toward a new and universal language.

VÍCTOR FLORES OLEA
President
Consejo Nacional para la Cultura y las Artes

Lenders to the Exhibition

Foreign (excluding Mexico)

Canada
George R. Gardiner Museum of Ceramic Art, Toronto

France
Bibliothèque Nationale, Paris
Musée des Jacobins, Auch

Netherlands
Stedelijk Museum, Amsterdam

Spain
Monastery of San Lorenzo de El Escorial, Spain
Museo de América, Madrid
Museo Nacional de Etnología, Madrid
Placido Arango Collection, Madrid

United Kingdom
Government Art Collection of the United Kingdom,
 Great Britain
Collection at Parham Park, West Sussex, England
Trustees of the Victoria and Albert Museum, London

U.S.S.R.
Hermitage Museum, Leningrad

Vatican City
Museo Missionario Etnologico, Musei Vaticani, Vatican City

Mexico

*Consejo Nacional para la Cultura y las Artes–Instituto
 Nacional de Antropología e Historia*
Ex-convento Franciscano, Tecali
Gobierno del Estado de Guanajuato, Museo Regional de
 Guanajuato, Alhóndiga de Granaditas, Guanajuato
Museo del Ex-convento Franciscano, Huejotzingo
Museo del Templo Mayor, Mexico City
Museo de Sitio de Chichén Itzá, Chichén Itzá
Museo de Sitio de El Tajín, El Tajín
Museo Nacional de Antropología, Mexico City
Museo Nacional de Historia, Mexico City
Museo Nacional del Virreinato, Tepotzotlán
Museo Regional de Antropología de Yucatán, Mérida
Museo Regional de Chiapas, Tuxtla Gutiérrez
Museo Regional de Guadalupe, Zacatecas
Museo Regional de Oaxaca, Oaxaca
Museo Regional de Puebla, Puebla
Zona Arqueológica de Teotihuacán, Teotihuacán

*Consejo Nacional para la Cultura y las Artes–Instituto
 Nacional de Bellas Artes*
Casa de la Cultura, San Luis Potosí
Gobierno del Estado de Guanajuato, Museo Casa Diego
 Rivera, Guanajuato
Gobierno del Estado de Zacatecas, Museo Francisco Goitia,
 Zacatecas
Instituto Cultural de Aguascalientes, Museo de
 Aguascalientes, Aguascalientes
Instituto Nacional de Bellas Artes, Mexico City
Museo de Arte Alvar y Carmen T. de Carrillo Gil, Mexico
 City
Museo de Arte Moderno, Mexico City
Museo Nacional de Arte, Mexico City
Pinacoteca Virreinal de San Diego, Mexico City

Secretaría de Desarrollo Urbano y Ecología
Basílica de Guadalupe, Mexico City
Catedral de Cuernavaca
Catedral de Puebla
Catedral de Saltillo
Catedral Metropolitana, Mexico City
Museo de la Basílica de Guadalupe, Mexico City
Santuario de Nuestra Señora de Ocotlán, Tlaxcala
Santa Rosa de Viterbo, Querétaro
Templo de la Compañia de Jesús, Guanajuato
Templo de San Cayetano de la Valenciana, Guanajuato
Templo de San Francisco, Tlaxcala

Public Lenders
Collection Banco Nacional de México, Mexico City
Dirección General del Patrimonio–Universidad Nacional
 Autónoma de México, Mexico City
Gobierno del Estado de México, Instituto Mexiquense de
 Cultura, Museo de Antropología e Historia, Toluca
Gobierno del Estado de México, Secretaría de Educación,
 Cultura y Bien Estar Social, Instituto Mexiquense de
 Cultura, Museo de Bellas Artes de Toluca, Toluca
Gobierno del Estado de Tlaxcala, Instituto Tlaxcalteca de
 Cultura, Tlaxcala
Gobierno del Estado de Veracruz, Xalapa
Instituto de Cultura de Tabasco, Dirección de Patrimonio
 Cultural, Museo de Historia de Tabasco, Villahermosa
Instituto de Cultura de Tabasco, Dirección de Patrimonio
 Cultural, Museo Regional de Antropología "Carlos Pellicer
 Cámara," Villahermosa
Instituto de Cultura de Tabasco, Dirección de Patrimonio
 Cultural, Parque Museo de la Venta, Villahermosa

Museo de Antropología de la Universidad Veracruzana, Xalapa
Museo Franz Mayer, Mexico City
Museo Frissell de Arte Zapoteca de la Universidad de las Américas, A.C., Mitla
Patronato del Hospital de Jesús, Mexico City
Secretaría de Hacienda y Crédito Público, Mexico City

Private Lenders
Agustín Acosta Lagunes, Mexico City
Collection Isaac Backal, Mexico City
Collection Jorge Alberto Borbolla Villamil and Angela Malo de Borbolla, Cuernavaca
Luis Felipe del Valle Prieto, Mexico City
Alejandra R. de Yturbe and Mariana Pérez Amor, Galería de Arte Mexicano, Mexico City
Collection Franz Feuchtwanger, Cuernavaca
Fundación Dolores Olmedo Patiño, A.C., Mexico
Adriana Garduño Vda. de García Flores, Mexico City
Fernando Leal Audirac, Mexico City
César Montemayor Zambrano, Monterrey
Montiel Romero Family Collection, Mexico City
Dr. José L. Pérez de Salazar, Mexico City
Felipe and Andrés Siegel, Mexico City
Private collection, Mexico/Courtesy of CDS Gallery, New York
Private collections (8)

United States

Public Lenders
American Museum of Natural History, New York
The Art Institute of Chicago, Chicago
The Brooklyn Museum, Brooklyn
Collection of IBM Corporation, Armonk, New York
Collections of the International Folk Art Foundation at the Museum of International Folk Art, Museum of New Mexico, Santa Fe
The Davenport Museum of Art, Davenport, Iowa
Hirshhorn Museum and Sculpture Garden, Smithsonian Institution, Washington, D.C.

Latin American Library, Tulane University, New Orleans
Los Angeles County Museum of Art, Los Angeles
Meadows Museum, Southern Methodist University, Dallas
The Metropolitan Museum of Art, New York
The Minneapolis Institute of Arts, Minneapolis
Museum of Art and Archaeology, University of Missouri–Columbia, Columbia, Missouri
The Museum of Modern Art, New York
Natural History Museum of Los Angeles County, Los Angeles
Netti Lee Benson Latin American Collection, The University of Texas at Austin, Austin
Peabody Museum of Archaeology and Ethnology, Harvard University, Cambridge, Massachusetts
Philadelphia Museum of Art, Philadelphia
The Phillips Collection, Washington, D.C.
The Saint Louis Art Museum, Saint Louis
San Diego Museum of Man, San Diego
San Francisco Museum of Modern Art, San Francisco
Santa Barbara Museum of Art, Santa Barbara
Smith College Museum of Art, Northampton, Massachusetts
University of California at San Francisco, School of Medicine, San Francisco
Washington University Gallery of Art, Saint Louis

Private Lenders
Mr. and Mrs. Fenton M. Davison, Flint, Michigan
Collection of Mrs. Carolyn Farb, Houston
Samuel Goldwyn, Jr., Beverly Hills
The Guennol Collection, New York
Collection of Mr. and Mrs. Stanley Marcus, Dallas
Mrs. William H. Moore III, New York
Mr. and Mrs. Roy R. Neuberger, New York
Dr. Rushton E. Patterson, Jr., Memphis
Private collections (3)
Private collection, New York, Courtesy of Mary-Anne Martin/Fine Art, New York
Private collection, Switzerland, Courtesy of Mary-Anne Martin/Fine Art, New York

Contributors to the Catalogue

OCTAVIO PAZ
Mexico City

DRA. BEATRIZ DE LA FUENTE
Profesora, Instituto de Investigaciones Estéticas,
Universidad Nacional Autónoma de México,
Mexico City

JORGE ALBERTO MANRIQUE
Investigator, Instituto de Investigaciones Estéticas,
Universidad Nacional Autónoma de México,
Mexico City

FAUSTO RAMÍREZ
Investigator, Instituto de Investigaciones Estéticas,
Universidad Nacional Autónoma de México,
Mexico City

DORE ASHTON
New York City

VAA VIRGINIA ARMELLA DE ASPE
Pinacoteca Virreinal de San Diego, Mexico City

CB CLARA BARGELLINI
Investigator, Instituto de Investigaciones Estéticas,
Universidad Nacional Autónoma de México,
Mexico City

EHB DR. ELIZABETH HILL BOONE
Director, Pre-Columbian Studies, Dumbarton
Oaks Research Library and Collections, Wash-
ington, D.C.

MB DR. MARCUS BURKE
Visiting Professor in Religion and the Arts, Yale
University

RCC ARQLGO. RUBÉN CABRERA CASTRO
Arqueólogo, Instituto Nacional de Antropología
e Historia, Mexico City

RAD DR. RICHARD A. DIEHL
Professor and Chairman, Department of Anthro-
pology, University of Alabama, Tuscaloosa

CEM DRA. CRISTINA ESTERAS MARTÍN
Profesora Titular de Historia del Arte de la
Universidad Complutense de Madrid

RF RAMÓN FAVELA
Assistant Professor, Department of Art History,
University of California, Santa Barbara

RGM ARQLGO. ROBERTO GARCÍA MOLL
Director General, Instituto Nacional de
Antropología e Historia, Mexico City

MCGS MARÍA CONCEPCIÓN GARCÍA SÁIZ
Conservadora Jefe Sección Colonial, Museo de
América, Madrid

EIEG ELENA ISABEL E. DE GERLERO
Universidad Nacional Autónoma de México, Mex-
ico City

JGH JUANA GUTIÉRREZ HACES
Investigator, Instituto de Investigaciones Estéticas,
Universidad Nacional Autónoma de México,
Mexico City

JH JOHANNA HECHT
Associate Curator, Department of European
Sculpture and Decorative Arts, The Metropoli-
tan Museum of Art

HH HAYDEN HERRERA
New York City

EQK DR. ELOISE QUIÑONES KEBER
Associate Professor of Art History, Baruch Col-
lege, City University of New York

DWK DAVID W. KIEHL
Associate Curator, Department of Prints and
Photographs, The Metropolitan Museum of Art

CLC CLARE LE CORBEILLER
Associate Curator, Department of European
Sculpture and Decorative Arts, The Metropoli-
tan Museum of Art

GWL GARETH W. LOWE
Research Associate, New World Archaeological
Foundation, Brigham Young University, San
Cristóbal de las Casas

EM ARQLGO. EDUARDO MATOS MOCTEZUMA
Director, Museo del Templo Mayor, Mexico City

LMM LISA M. MESSINGER
Assistant Curator, Department of Twentieth-
Century Art, The Metropolitan Museum of Art

XM XAVIER MOYSSÉN
Investigator, Instituto de Investigaciones Estéticas,
Universidad Nacional Autónoma de México,
Mexico City

JOL JAIME LUIS ORTÍZ LAJOUS
 Arquitecto; Miembro de la Comísión Nacional
 de Preservación del Patrimonio Cultural de
 México; Vicepresidente del Consejo Internacional
 de Monumentos y Sitios–ICOMOS, Mexico City

DP DR. DONNA PIERCE
 Research Associate, Palace of the Governors,
 Museum of New Mexico, Santa Fe

BP BEATRIZ SÁNCHEZ NAVARRO DE PINTADO
 Presidente, Asociación de Amigos del Museo
 Nacional del Virreinato, Mexico City

JQ DR. JACINTO QUIRARTE
 Director, Research Center for Visual Arts,
 University of Texas, San Antonio

MMRR MARÍTA MARTÍNEZ DEL RÍO DE REDO
 Mexico City

SR SABINE REWALD
 Associate Curator, Department of Twentieth-
 Century Art, The Metropolitan Museum of Art

RRG ROGELIO RUÍZ GOMAR
 Investigator, Instituto de Investigaciones Estéticas,
 Universidad Nacional Autónoma de México,
 Mexico City

PJS DR. PETER J. SCHMIDT
 Director, Museo Regional de Antropología de
 Yucatán, Instituto Nacional de Antropología e
 Historia, Mérida

LSS LOWERY S. SIMS
 Associate Curator, Department of Twentieth-
 Century Art, The Metropolitan Museum of Art

SV SUZANNE VALENSTEIN
 Research Curator, Department of Asian Art, The
 Metropolitan Museum of Art

EVL ELISA VARGAS LUGO
 Instituto de Investigaciones Estéticas, Universidad
 Nacional Autónoma de México, Mexico City

SJKW DR. S. JEFFREY K. WILKERSON
 Director, Institute for Cultural Ecology of the
 Tropics, Gutiérrez Zamora

MW DR. MARCUS WINTER
 Archaeologist, Centro Regional de Oaxaca,
 Instituto Nacional de Antropología e Historia,
 Oaxaca

Note to the Reader

The following abbreviations are used in the catalogue:

CNCA Consejo Nacional para la Cultura y las Artes

INAH Instituto Nacional de Antropología e Historia

INBA Instituto Nacional de Bellas Artes

SEDUE Secretaría de Desarrolla Urbano y Ecología

MEXICO
Splendors of Thirty Centuries

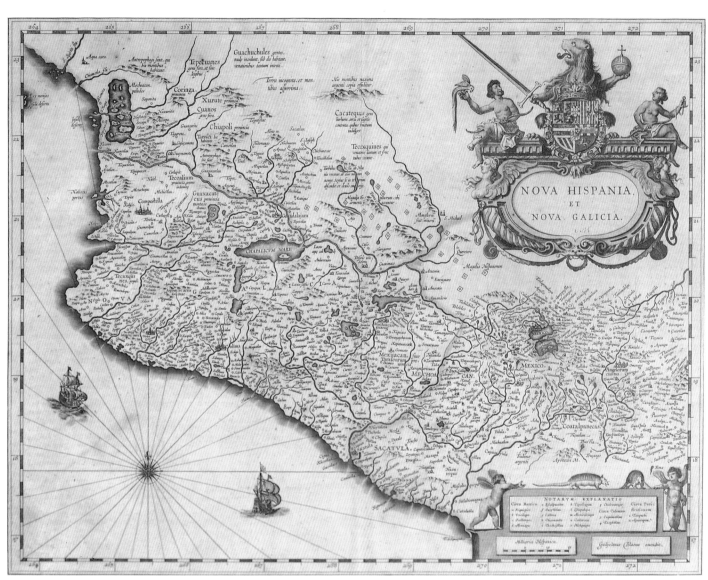

Willem Blaeu. *Nova Hispania et Nova Galicia*
[Mexico, about 1635]. Courtesy New York Public
Library, Map Division

Will for Form

OCTAVIO PAZ

The geography of Mexico is abrupt. Two powerful parallel cordilleras, the Sierra Madre Occidental and the Sierra Madre Oriental, run the length of its territory. To the north these mountains penetrate the western United States, while to the south they join together to form a knot of mountains on the Isthmus of Tehuantepec. The two ranges divide the country into lowlands and highlands arranged in successive terraces that end on a vast plateau. It is impossible not to think of a truncated pyramid, the emblematic form of the Mesoamerican civilization. This complicated geography is responsible for the multiplicity of extensive valleys—each enclosed within mountains, like a fortress—and for the variety of Mexico's climates and landscapes. To ascend to Mexico City from the burning sandy beaches of Veracruz is to travel through every landscape, from the suffocating vegetation of the tropics to the temperate lands of the meseta. In the lowlands the air is warm and humid; on the high tableland it is dry and, by night, quite cool. From impressionist mist and violent color to the sobriety of a composition governed by the geometry of drawing. Contrasts and oppositions, but also sudden combinations and unusual conjunctions. Every day the tropical sun shines down on the naked peaks and perpetual snows of the volcanoes surrounding the Valley of Mexico.

On the maps, Mexico has the form of a cornucopia. This image, visually exact, does not take historical reality into account. Mexico has been, and is, a boundary between peoples and civilizations. In the Precolumbian period, between the civilization of Mesoamerica and the nomad tribes who roamed through what today is the southern part of the United States and the north of Mexico; in the modern age, between the two versions of the European civilization that were implanted and developed on our continent: Anglo-American and Latin-American. Boundaries, however, are not only disjunctive obstacles, they are also bridges. One of Mexico's historical functions has been that of bridge between the English- and the Spanish- and Portuguese-speaking worlds. I scarcely need add that *Mexico: Splendors of Thirty Centuries*, sponsored by the Metropolitan Museum of Art in New York and later to be seen in San Antonio and Los Angeles, is a positive example of such mediation.

The history of Mexico is no less intricate than its geography. Two civilizations have lived and fought not only across its territory but in the soul of every Mexican. One is native to these lands; the other originated outside but is now so deeply rooted that it is a part of the Mexican people's very being. Two civilizations and, within each of them, distinct societies frequently divided by differences of culture and concerns. Internal sunderings, external confrontations, ruptures, and revolutions. Violent leaps from one historical period to another, from polytheism to Christianity, from absolute monarchy to republic, from traditional to modern society. Prolonged lethargy and sudden insurrection. Nevertheless, through all these

upheavals one can perceive a will that tends, again and again, toward synthesis. Again the figure of the pyramid appears: a convergence of different cultures and societies, the superposition of centuries and eras. The pyramid conciliates oppositions but does not annul them. The process (rupture-reintegration-rupture-reintegration) can be taken as a leitmotif of the history of Mexico. The true name of this process is the will for life. Or, to be more precise, the will for survival whether faced with discord and defeat or mere uncertainty with the dawn of each new day. A will sometimes blind, sometimes lucid, but always secretly astir, even when it adopts the passive form of traditionalism.

Will for life is will for form. Death, in its most visible and immediate expression, is the disintegration of form. Childhood and youth are the promise of form. Old age is the ruin of physical form; death, the fall into formlessness. That is why one of the most ancient and simple manifestations of the will for life is art. The first thing man did upon discovering that he was mortal was to erect a tomb. Art began with the consciousness of death. The mausoleum, since ancient times, has been both an homage to the dead and a defiance of death: the body decays, turns to dust, but the monument remains. Form remains. We are threatened not only by death but by time itself, which makes, then unmakes, us. Every sculpture, every painting, every poem, every song is a form animated by the will to survive time and its erosions. The *now* wants to be saved, to be converted into stone or drawing, into color, sound, or word. This, to me, is the theme this exhibition of Mexican art unfolds before our eyes: the persistence of a single will through an incredible variety of forms, manners, and styles. There is no apparent commonality among the stylized jaguars of the Olmecs, the gilded angels of the seventeenth century, and the richly colored violence of a Tamayo oil—nothing, save the will to survive through and in form. I shall venture, furthermore, something that is not easily proved, although easily sensed. An attentive and loving eye will perceive, in this diversity of works and epochs, a certain continuity. Not the continuity of a style or an idea, but something more profound and less definable: a sensibility.

Mesoamerica

A Strange Civilization

Each civilization provokes a different response, one in which taste and concept, sensation and idea, are indistinguishable. The creations of the ancient cultures of Mexico invariably elicit an impression of strangeness. This word designates, first of all, the surprise we feel when we see something unexpected, unique, or singular. Surprise when confronting what is alien, what comes from outside; also what is rare or extraordinary. The emotion that paralyzed the conquistadores when, from the heights, they looked down for the first time upon the valley, the lake, and the pyramids of Mexico City corresponds exactly to this definition of strangeness. Bernal Díaz del Castillo, who was not given to hyperbole, reports this unforgettable moment in simple terms: "Before us we saw many cities and towns—on

the water and on terra firma. . . . We were wonderstruck, and we said that what lay before us was like the enchantments related in the legend of Amadis. . . . Some of our soldiers said even that what they were seeing was a thing of dreams . . . it is, then, not surprising that I should write of it in this manner, because there is much to ponder in it that I know not how to tell: witnessing things never heard, nor seen, nor even dreamed, such as we were seeing." The sensations the chronicler describes in those few phrases from his *Discovery and Conquest of Mexico* have since been experienced and lived by uncounted travelers, historians, writers, and merely curious observers. Enigmas attract and vex man. The enigmatic civilization of ancient Mexico has intrigued many generations and continues to fascinate us to this day.

Strangeness begins with surprise and ends with questioning. As we consider the strange object, we ask ourselves: What is it? Where does it come from? What does it mean? These questions express our curiosity but also suggest an undefined uneasiness, a malaise that in certain cases is transformed into anxiety, even horror. It is an ambiguous emotion composed of attraction and repulsion; the strange is simultaneously marvelous and horrible. The marvelous component attracts us. It is unique, magical or fantastic, wondrous, and, of its kind, perfect. Horror, in contrast, is fear and repulsion, but it is also respect and veneration for the unknown or the sublime. Horror is not terror, it is fascination, bewitchment. Racine speaks of "sacred horror," and Baudelaire expresses in two admirable lines the ambiguous seduction of this emotion:

> J'ai peur du sommeil comme on a peur d'un grand trou,
> Tout plein de vague horreur, menant on ne sait ou . . . [1]

The sculptures and monuments of the ancient Mexicans are works that are at once marvelous and horrible. By that I mean works that are impregnated with the vague and sublime sense of the sacred. A sense that wells from beliefs and images issuing from very ancient and radically *other* psychic depths. In spite of their strangeness, in an obscure and almost never rational way, we recognize ourselves in them. Or, more exactly, we glimpse through their complicated forms a buried part of our own being. In such strange objects—sculptures, paintings, reliefs, sanctuaries—we contemplate the unfathomable depths of the cosmos, and we peer into our own abyss.

From the beginning, as always is the case, there was an attempt to minimize the strangeness of the Mesoamerican civilization and its arts. It seemed inexplicable that American Indians, on their own and with no external contact, should have created such complex societies, societies that in many respects rivaled those of Europe. Thus the question of the origins of the American Indians came to be associated with the subject of the originality of their cultures. A double mystery: on the one hand, the radical strangeness of that civilization, so different from the European; on the other, the suspect similarity of some of its rites—confession, baptism, communion, sacrifice—to those of Christianity. Fray Bernardino de Sahagún, in his *Historia general de las cosas de Nueva España* (General History of New Spain), exalts the moral and intellectual virtues

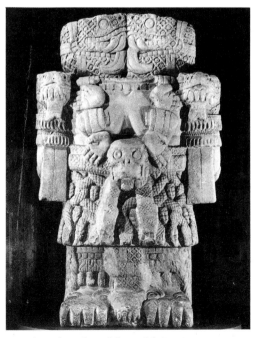

Coatlicue (mother of the gods). Stone. Aztec. From the Sacred Precinct, Tenochtitlan. CNCA–INAH, Museo Nacional de Antropologia, Mexico City

of the Indians, "[who were] skilled in all the mechanical and liberal arts, as well as in Sacred theology. . . . In matters of policy they are several steps ahead of many other nations that presume to greatness in the political arena. . . . [They are] perfect philosophers and astrologers." Nevertheless, when he comes to the subject of their beliefs and rites, he does not hesitate to say that these practices were inspired by the devil and that they are an abominable caricature of the Christian mysteries.

The collaboration of the devil in the religious and political institutions of the Indians is a topic that is repeated throughout the sixteenth and seventeenth centuries. Some authors preferred fantasy-based interpretations of history over the theory of supernatural intervention. For some, the Indians were one of the lost tribes of Israel; for others, they were Phoenicians or Carthaginians or Egyptians. This latter attribution was very popular in learned circles during the seventeenth century and was argued vigorously and brilliantly by the famous Athanasius Kircher. At the end of that same century several Jesuits proposed that the god Quetzalcoatl (Plumed Serpent) was none other than St. Thomas the Apostle. In that same period the scholar Carlos Sigüenza y Góngora wrote that the Mexican Indians had been led to these lands by Neptune, a great commander and navigator who was later deified by his pagan followers. It is, then, no exaggeration to say that the Discovery (*dis*coverage) was followed by a long period of *cover*age. It was not until the end of the eighteenth century that the slow *re*-discovery of American civilizations began—a process that is still incomplete.

It was, and it is, difficult to accept that the two great American civilizations —the Andean and the Mesoamerican—are in fact original. The current opinion of historians and anthropologists, however, is that they are autochthonous. That the Indians migrated from Asia is undisputed. Also inarguable is the fact that they brought with them to our continent certain beliefs and basic notions. Upon this base, through many centuries, they erected their complex religious concepts and their magnificent structures and arts. To cite but one example, the quadripartite vision of the universe inspired in the four cardinal points, the foundation of their cosmology and pyramidal architecture, is also peculiar to ancient China. But this and other similarities do not affect the essential and fundamental originality of the two American civilizations. Both developed their own organisms; both were autonomous creations. Communication between Andeans and Mesoamericans was sporadic and intermittent. They lived in isolation, each enclosed in their own worlds. Their mental horizon opened not toward geographical distance but upon the supernatural beyond. The two civilizations emerged, expanded, and developed almost unaware of one another; both their histories are slow processes of repetitions and variations that in no way alter their essential characteristics.

In the Old World, history was the continuous clash of civilizations and peoples, religions and philosophies. In America there was nothing similar to the influence of Babylonian astronomy or the Phoenician alphabet in the Mediterranean, to the adoption of Greco-Roman sculpture by Indian Buddhism, or to the influence of that religion in southwest Asia or in Tibet, China, and Japan. The Greeks do battle and have cultural inter-

change with the Persians and Egyptians; the Japanese appropriate Chinese script and Confucian political philosophy; the Chinese translate the great Buddhist texts of India; the Mediterranean peoples leap from polytheism to Christian monotheism; the Slavs adopt the Cyrillic alphabet; the wave of Islam covers half the known world, reaching as far as Spain; medieval philosophers rediscover Aristotle through Averroës, and on and on. The extraordinary richness, variety, and inventiveness of the civilization of the Old World are, incontestably, indebted to a plurality of peoples and cultures in continuous interrelationship: conflicts, immigrations, fusions, imitation—innumerable collective re-creations. None of the great European and Asiatic civilizations, not even the most self-contained—India and China—were entirely original. America was a continent removed from world history for thousands of years, and this tremendous isolation explains the uniqueness of its creations. It is also its most obvious and fatal limitation: the first outside contact annihilated those societies. Lacking biological defenses, the indigenous populations of Mesoamerica fell easy victim to European and Asiatic viruses. The same defenselessness, in the spiritual and psychological realms, explains their vulnerability to European civilization.

Epochs, Peoples, Cultures

The word Mesoamerican, employed now for half a century by historians and anthropologists, designates a group of peoples that occupied what in our time is the central area of Mexico south to the Yucatán, Chiapas, Belize, Guatemala, and Honduras. The history of Mesoamerica has been divided into three periods: the Formative (1500 B.C.–A.D. 300), the Classic (A.D. 300–900), and the Post-Classic (900–1500). These terms can lead to confusion; there is nothing classic—in the sense of the antithesis of romantic—in the art of Teotihuacán or Uxmal. Classic here refers to the apogee of Mesoamerican culture. The dates are relative. True civilization begins about 1000 B.C. with the Olmecs. The Classic period begins in Teotihuacán a century earlier than in the zone of the Maya and also ends earlier, at the beginning of the eighth century. During these twenty-five hundred years, remarkable cultures, in several regions, emerged, flourished, and collapsed. The oldest, the root of the others, was the work of the mysterious Olmecs from the warm, fertile coast of the Gulf of Mexico. We do not know what the true name of the Olmecs was or what language they spoke. At the beginning of the following period (Early Classic), two great centers appeared: one on the highlands, Teotihuacán (again, we do not know what language was spoken there); the other in Oaxaca, the Monte Albán of the Zapotecs. Teotihuacán was a true cosmopolitan metropolis distinguished by concentrations of foreigners such as those we know in large twentieth-century cities. Teotihuacán exerted an enormous influence over all the peoples of Mesoamerica and was particularly visible in the Formative period of the Maya (Kaminaljuyú and Izapa).

The great epoch of the Maya, initially indebted to the Olmecs, begins around the fourth century. Two of their great cities, Tikal and Palenque, deserve to be compared with Teotihuacán. In Teotihuacán, a rigorous geometry of pyramids, vastness of plazas, and openness of spaces; among

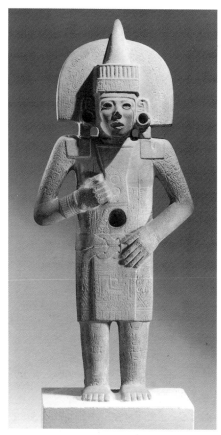

Life-Death figure (front). Stone. Huastec. Brooklyn Museum, Henry L. Batterman and Frank S. Benson Funds

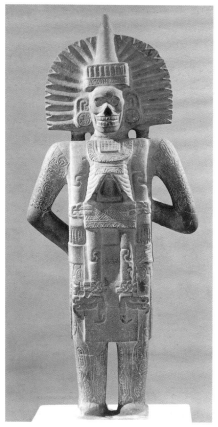

Life-Death figure (back)

the Maya, a proliferation of symbols, predominance of curve and spiral, and enormous stone masses converted into a foliage of fantastic forms. In Teotihuacán and Monte Albán the architecture is an imposing mass dominated by strict line and sharp angles aligned before an open space. In Maya territory architecture becomes sculpture, and sculpture is transformed into masks that conceal the edifice. Symbols often choke Mesoamerican art, like the erudite quotes and allusions of Pound's poetry. The Maya are not entirely exempt from the tyranny of symbols, but their greater imaginative freedom led them, both in sculpture and painting, to an art of graceful lines that at times approaches Western naturalism. A second great culture, probably the direct descendant of the Olmecs, flourished on the Gulf Coast; it left at El Tajín some splendid buildings, among them the perfect Pyramid of the Niches. The causes for the collapse of these great centers during the ninth and tenth centuries continue to intrigue historians. Such declines are enigmatic: do we truly know the causes for the fall of Rome?

The Post-Classic period is one of reconstitution. It had moments equally as brilliant as those of the Classic period: I am thinking of Chichén Itzá and Tenochtitlan. On the highlands, Maya influence was felt at the beginnings of this period (Cacaxtla, Xochicalco). In Oaxaca, another extraordinary achievement of the Zapotecs: Mitla.[2] The walls of its buildings are covered with geometric mosaics that shimmer in the light of the sun or the moon as if alive. Two marginal cultures, but ones that produced striking works, are those of the Huastecs, a discrete branch of the Maya tree, sculptors of solid, weighty forms, and the Mixtecs, who excelled in goldsmithing and the painting of codices. Sometime during the tenth and eleventh centuries the Nahua peoples appear in central Mexico. One branch, the Toltecs, founds Tula, a military and religious capital. Their memory is associated with the legend of Quetzalcoatl (Plumed Serpent) and his battle with Tezcatlipoca, a rival god who tricks him into committing a sin that leads to his downfall. A myth? Yes, but also a historical event. Quetzalcoatl reappears on the Yucatán as the founding chieftain among the Maya, but with the name of Kukulcán (Plumed Serpent in Maya).[3] This Maya-Toltec synthesis was a felicitous one. It resulted in Chichén Itzá, one of the notable architectural complexes of Mesoamerica, a combination of the geometry of the highlands and of Maya exuberance.

The fate of the Toltecs, and of the Maya-Toltecs, was the same as that of their predecessors: destruction. In the fourteenth century a new power emerges; another Nahua nation, the Mexica, better known as the Aztecs, founds Tenochtitlan. A doubled city, a city made of stone, water, and reflections, Tenochtitlan amazed and enchanted the Spanish. The story of its siege recalls the fate of Troy. The memory of it still disturbs our sleep. When we leaf through a volume of old engravings depicting its lakes, volcanoes, and temples, our thoughts evanesce,

> en una claridad en forma de laguna
> se desvanecen. Crece en sus orillas
> una vegetación de transparencias
> Rima feliz de montes y edificios
> se desdobla el paisaje en el abstracto
> espejo de la arquitectura....

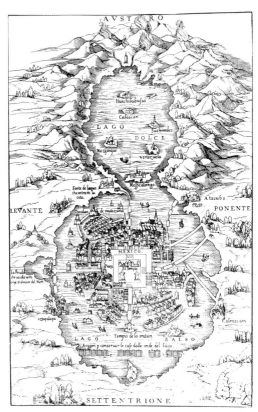

Plan of Mexico City, from Ramusio, *Conquistador anonimo* (1556)

Las olas hablan nahua. . . .
(estampas: los volcanes, los cúes y, tendido,
monto de plumas sobre el agua,
Tenochtitlán todo empapado en sangre).[5]

A Warring Constellation

Considering the variety of nations, tongues, cultures, and artistic styles, the unity of these peoples comes as a surprise. They all share certain ideas and beliefs. Thus it is not inaccurate to call this group of nations and cultures a Mesoamerican civilization. Unity in space and continuity in time; from the first millennium before Christ to the sixteenth century, these distinct Mesoamerican peoples evolve, reelaborate, and re-create a nucleus of basic concepts as well as social and political techniques and institutions. There were changes and variations, the violent collapse of cities and nations, the rise of others, periods of anarchy followed by periods of individual dominance, but never was the continuity broken.

The relative uniformity of the Mesoamerican world is visible, first of all, in the domain of its material and technical culture. The great economic revolution came with the domestication of maize, which transformed nomads into sedentary peoples. It is not surprising that they deified the grain. Another characteristic is the absence of draft animals, and, subsequently, of the wheel or cart (except, curiously, as toys). In sum, a rather primitive technology that did not develop beyond the Stone Age, except in certain limited areas such as goldsmithing, in which their skill was exquisite. Yet they also excelled in carving and polishing obsidian, jade, and other stones as well as in painting, producing codices, feather-working, and other arts. They were master architects and sculptors. In contrast, they never learned navigational skills. An eminent historian, Michael D. Coe, has said that in order to find true cultural contemporaries of the Mesoamericans, we would have to go back to the Bronze Age in Europe. This is only partially true. I say partially, because when we consider other Mesoamerican achievements—positional notation, the discovery of the concept of zero, astronomy, architecture, the arts, poetry—differences with the peoples of the Bronze Age are enormous. A civilization is not measured solely by its technology. Its thought, its art, its political institutions, and its moral achievements must also be weighed.

We can think of Mesoamerica as a constellation of nations. Different languages and conflicting concerns, but similar political institutions, analogous social organization, and related cosmogonies. A world that recalls the Greek polis or the republics of the Italian Renaissance. As with them, two elements define Mesoamerican societies: cultural homogeneity and intense, ferocious rivalries. On the highlands, an impressive succession of city-states (Teotihuacán, Tula, Tenochtitlan) attempted total domination over other peoples, without ever completely succeeding. The other great city-states (Monte Albán, El Tajín, Tikal, Copán, Palenque) waged war ceaselessly but were not expansionist, at least not to the degree of the peoples of the highlands. A parenthesis: modern historians are loath to call these great architectural concentrations *cities*, except in the case of Teotihuacán and Tenochtitlán. They prefer to use a different term, "ceremonial centers." An unfortunate expression. It is difficult to believe that

the magnificent buildings on those sites served only as theaters for religious rites and public functions. Almost surely they were also political and administrative centers, residences for royalty, the military aristocracy, the priesthood, and high bureaucrats, as evidenced in Palenque. Be that as it may, a plurality of city-states (or "ceremonial centers") was the hallmark of Mesoamerican history. Along with the twofold consequence of that reality, war and commerce.

Commerce was international in scope. A vast trade network united even the most remote regions. There were centers of international commerce not unlike our free ports, and parties of merchants, reminiscent of the caravans of the East, traveled well-established routes. From time to time there were more warriors than merchants; at times they acted as spies. Tactics as ancient and universal as politics and war. Thus the Teotihuacán peoples reached the zone of the Maya and established outposts in Central America. For their part, the Maya penetrated the highlands and, after the fall of Teotihuacán, left the mark of their presence (and of their artistic genius) in Cacaxtla and Xochicalco. Aztec merchants were one of the arms of Tenochtitlan foreign policy.

The highest class of Aztecs was composed of the hereditary nobility (*pilli*) and of professional warriors (*tecuhtli*). This was a traditional division and common to other peoples. The priesthood shared the apex of the social pyramid with noble warriors. For many years historians referred to the splendor of Mesoamerican civilization as the "theocratic period," and some believed that this was an era of peace, especially among the Maya. In the light of advances in Maya epigraphy, this hypothesis has been dismissed. The importance of the priestly class has been minimized, and the dynastic nature of Mesoamerican societies emphasized. Nevertheless, we should not go to the other extreme: that civilization was profoundly and fervently religious, as Cortés, Bernal Díaz del Castillo, and the first missionaries were quick to observe. The basis for the royal order was religion, and when we say religion, we mean priesthood. Even in Europe, royalty and feudal nobility would not have been possible without the papacy. Royal rule by divine right was a universal institution in Mesoamerica, to judge by Olmec indications—the monumental heads are perhaps effigies of deified rulers—and by Maya, Zapotec, Toltec, and Aztec monuments. After partially deciphering Maya inscriptions, we know today the names of many kings and the dates of their battles, victories, ascents to the throne, and other details of their reigns. The supreme leaders were of divine blood and, at their death, were almost always deified. This is the source of the king's sacerdotal duties. The boundary between the political and the religious was very tenuous. There was intricate overlapping among royal, military, and priestly powers.

The predominantly religious character of Mesoamerican art is well known. At the same time, almost all its representations allude to war or to the rites narrowly associated with war, such as the sacrifice of prisoners, or to the emblems, attributes, and symbols related to the two military orders, the Eagles and the Jaguars. Mesoamerican war has twofold meaning. It is political and it is religious; it is the search for material gain and it is ritual. In the former aspect war is the other face of commerce; that is, it

JAMES DICK,
AU

Dear Concertgoer!
We should be most gra
time to complete this
used only to assist u
ning and presentation
form at the box offic

HOW DID YOU KNOW ABOU
(Please circle and/or
Mailing List.
Friends.
The Press. What newsp

The Radio. What stat
Television. What Chan
Passing by.

DO YOU FEEL THE TICKE
(Please circle)
Inexpensive Rea

ARE YOU RESIDENT IN T
(Please circle) Yes
If yes, what city____

WHAT ATTRACTED YOU TO
(Please circle) The O
The Soloist The P

IS THIS YOUR FIRST VI
FESTIVAL HILL? (Ple

AGE GROUP (Please cir
18 - 25 26 -
46 - 55 56 -

THANK YOU!

is one of the consequences of the plurality of city-states and of their opposed interests. Wars did not have conquest as their primary goal, neither did they—except in most unusual cases—seek the enemy's annihilation. Their aim was to subject that enemy and force him to pay tribute. The idea of empire, in the sense of a plurinational society in which one state governs and dominates all others, never appeared at any time in Mesoamerica—not even in the expansionist periods of Tula and Tenochtitlan. The notion of empire was foreign to the Mesoamerican tradition, since it was in open contradiction to the basic principle that inspired and justified warlike activity: obtaining prisoners for sacrifice. I shall develop this point later; for now it is sufficient to say that war was endemic in Mesoamerica. One can also say it was consubstantial, because it corresponded both to the ideology and to the very nature of that world.

Another salient characteristic is what I have referred to elsewhere as the circular nature of Mesoamerican history. My statement may seem too categorical; it is not, however, inexact. Not only does Mesoamerican civilization appear millennia later than the cultures of the Old World, its history is a constant beginning again, a rising up, falling, rising only to begin again. This repetitiveness is undoubtedly responsible for the primitive or archaic nature of so much of its technology, as well as of certain customs and institutions, among them human sacrifice. This staggering forward, or around in circles, can be explained, as I have noted, by the fact that—unlike the cultures of Europe and Asia—the only external influence on Mesoamerican cultures were those of the marauding barbarians who wandered the plains and deserts of the north. Those nomadic tribes were not a military threat during the apogee of the great city-states of the highlands, but the moment those states were destabilized, whether through internal convulsions or because of other circumstances, the nomads appeared, sacked the cities, and even settled in the ruins. With time, the descendants of the invaders remade in their own manner the cultures of the cities they had devastated. Occasionally the new versions were superior to the old, at times they were nothing more than gross copies. From the Olmecs to the Aztecs, Mesoamerican civilization is a history of variations on a single model; sometimes sublime, as in Teotihuacán, sometimes imaginative and brilliant, as in Palenque and Tikal. There were beginnings and rebeginnings, perfectings and declines, but never change. In the Old World the continuous exchange of goods and technology, gods and ideas, languages and styles, produced enormous transformations. In Mesoamerica immigrations brought fresh blood, not new ideas. Tula repeats Teotihuacán, and Tenochtitlan repeats Tula.

Sacrifice and Transfiguration

The Mexican myth of the creation of the world tells that the gods met together in Teotihuacán to create the world for the fifth time. After rituals of penance, two of them threw themselves into the flames and became the sun and the moon. But these heavenly bodies failed to move; they were fixed in the sky. Confronted with a universe in stasis and in danger of perishing, the remaining gods decided to sacrifice themselves. This is how the sun and the moon—the entire universe—were set in motion. At

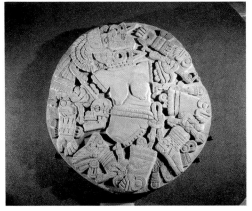

Coyolxauhqui. Stone. Aztec. From Templo Mayor, Sacred Precinct, Tenochtitlan. CNCA–INAH, Museo Templo Mayor, Mexico City. Photo: Michel Zabé

a different moment of the same myth, the sun grows weak; it must be nourished with the blood of the stars before it can continue its orbit. Opposition between night and day, the nocturnal and diurnal skies: the war of the heavens. The stars are conquered and sacrificed, the sun drinks their blood, and day begins. Cyclic victory: the combat is renewed every day, and every day the sun must again vanquish night. In the first tale, the self-sacrifice of the gods creates the world; in the second, the divine war and the blood of the conquered stars vitalizes the sun and keeps the universe alive. Here is an aspect of that sacrifice that has scarcely been noted: the universe is movement, and movement is unceasing transformation, continuous metamorphosis. As it sets the universe in motion, sacrifice initiates the chain of transformations among the gods. Thus begins the prodigious ballet of the gods and goddesses, all masked and endlessly being transformed into their opposites—which are also their twins. The sacrifice has a threefold function: it creates the world, it sustains it, and as it sustains it, transforms it. The Mesoamerican peoples were obsessed by the responsibility for keeping the cosmos in movement. They believed that the universe is in eternal danger of stopping, and thus perishing. To avoid this catastrophe man must nourish the sun with his blood.

With minor variations that do not alter its essential meaning, this myth appears among the Maya and other Mesoamerican peoples. It is a basic concept of their cosmogony. It is, furthermore, the core of their spiritual life. Sacrifice, in its duality—the gift of one's own blood and the offering of the blood of the prisoner captured in battle—is a vision of the world and of man's place in the cosmos. It is the fundament of the ethic of Mesoamerican man: through sacrifice man collaborates with the gods and becomes godlike. For all Mesoamericans life here below is a reflection of the cosmic drama. We humans imitate or reproduce the acts of the gods. In this sense, life is nothing more than a rite. The world is the theater of the gods, and the actions of man are ceremonies that reproduce the first acts of creation, self-sacrifice and celestial warfare. A polemical vision of the cosmos: war in the heavens, war of the elements, and war among men. Although all living beings, from gods to ants, play a part in this drama, man's responsibility increases in accord with his ascendant position on the social pyramid. The prince, the warrior, and the priest are closest to the gods, and thus their obligations are greater in the daily task of re-creating the world and assuring its uninterrupted movement.

The Maya reliefs of Yaxchilan depict royal personages mortifying their flesh and spilling their blood. These ceremonies were sometimes public, held in broad daylight before the throngs on the steps of the pyramid; some were secret, performed by torchlight in subterranean chambers. The loss of blood and ingestion of hallucinogens caused visions in which a divine ancestor might appear in the maw of a fantastic serpent. Priests, warriors, nobility, and then common people repeated with decreasing rigor the penitential rites of their monarchs. Similarly proportional were the responsibilities, rewards, and risks in the activity complementary to self-sacrifice, war. The fate of the captured noble warrior was the sacrificial stone (the "divine stone"), while slavery was the lot of plebeian prisoners.

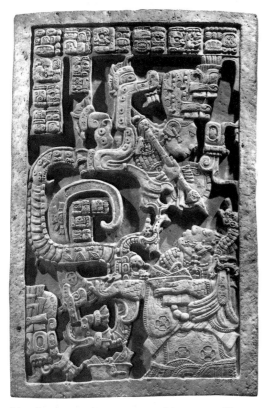

Lintel 25: accession ceremony. Limestone. Maya. Yaxchilan, Chiapas. British Museum. Photo: Justin Kerr

INSTITUTE AT

TOP

UND TOP, TEXAS 78954

RTIST-DIRECTOR
RVEY

you would spare the
he information will be
ture concert plan-
leave the completed

NCERT?
)

or magazine?

———————————————

:

 Expensive

———————————————

ICULAR CONCERT?
 The Conductor
 The Venue

ONCERT AT
) Yes No

36 - 45
66 and over

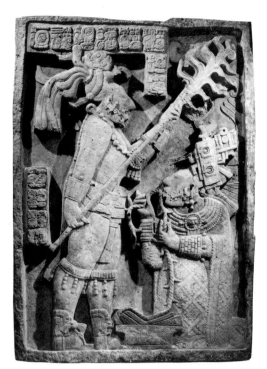

Lintel 24: blood-letting ceremony. Limestone.
Maya, Yaxchilan, Chiapas. British Museum.
Photo: Justin Kerr

He who fell in combat was turned into a bird or butterfly; he accompanied the sun in his perilous daily journey through the sky and the underworld. Women who died in childbirth were also deified. Finally, in addition to material gain and public honors, the conqueror became a part of the cosmic process and was in close communion with the divine. The magic bridge to this status was the blood of the sacrificed prisoner. This is the meaning of the ritual that scandalized the Spanish because of its similarity to the Christian sacrament of the Eucharist, namely, that the conqueror ate a small section of the sacrificed prisoner's thigh.

We cannot close our eyes to the central role of human sacrifice in Mesoamerica. Its frequency, the number of victims, and the cruelty of many of those ceremonies have evoked widespread censure. This attitude is comprehensible but does not contribute to understanding. It is as if we were condemning an earthquake or flogging a river that overflows its banks. I do not suggest we withhold moral judgments from the historical process; I believe that before judging we must understand. The Spanish conquistadores could not contain their perplexity when they compared the moderation and gentleness of the Aztecs' customs with the cruelty of their rituals. A psychoanalyst might attribute the severity of aggressive and self-punishing tendencies to the rigid puritanism of those societies. But, in that case, how shall we explain the Roman circus in an age of sexual license? Others blame religious delirium, or the terrible tyranny of military and priestly aristocracies, or the absolutist nature of the predominant ideology, or state terror, or the merciless struggles among the city-states. None of these explanations is entirely satisfactory. They are not false; they are incomplete. Perhaps all explanations of history are imperfect. Among the causes of any historical event, there is one element that is ever-changing and unfathomable: man.

We can approach this subject from a different perspective. Whatever our views on human sacrifice, we cannot deny that the notion of sacrifice is basic to all religions and most ethical systems. It seems equally undeniable that the rigor and asceticism of those men and women, their courage in the face of adversity, and their serenity before death are examples of fortitude, and, in the original sense of the word, of virtue (from the Latin *virtus*, strength, manliness). Two qualities define their morality: oneness with the cosmos, and individual stoicism. Nothing could be more remote from our own attitudes toward nature and ourselves. For centuries, with consequences we are facing today, our ideal has been to tame and exploit the natural world while, with equally unfortunate results, "liberating" our passions. We are incomparably more tolerant and indulgent than past societies, but have we not lived in times of totalitarian regimes, concentration camps, and mass slaughters? The Mesoamerican vision of the world and of man is shocking. It is a tragic vision that both stimulates and numbs me. It does not seduce me, but it is impossible not to admire it. Sahagún quotes a phrase the priest spoke as the prince ascended the throne: "Remember, Lord, that kings eat the bread of sorrow." Heroic morality at once senseless and sublime. Its pessimism neither bows nor dissolves will, it sharpens and tempers it. It teaches us to look destiny in the face.

Two, Four, and Five

A myth of the creation of the world tells that when Nanahuatzin and Tecuciztecatl threw themselves into the flames to become the sun and the moon, "an eagle flew into the fire and was also burned, and that is why it has coarse, blackened feathers. After a while the jaguar also entered the fire; it was not burned but was singed, leaving it with black and white spots. This is why men skilled in war are called eagles and jaguars." This version of the myth is Aztec, but the eagle-jaguar dichotomy is older than that society and is shared among all the peoples of the highlands and the Mexican Gulf Coast. This is the origin of the two warrior orders, Eagles and Jaguars. Both were, like the medieval Knights Templars, military and religious bodies. They were prominent in Tula and Tenochtitlan; they were not, however, exclusive to the Nahua world but belong to all Mesoamerican peoples. We find emblems of the two orders in Teotihuacán, and the rivalry between the two is the subject of the celebrated frescoes at Cacaxtla, of Maya workmanship. The principal fresco illustrates a battle between richly attired warriors. Their garments of skins and feathers (Jaguars and Eagles) are symbolic, but the combat is real: luxury and blood. The rhythm animating the composition, the whistling lances and glimmering shields, recalls the tourneys of the Flamboyant Gothic or certain paintings by Uccello. The two orders represent the two aspects of reality; the night/day dichotomy, the origin of the celestial war that animates the universe, is symbolized by these two sacred animals. The mythology of Mesoamerica is a prodigious dance of transformations. If the eagle is the sun, the jaguar is "the sun of the night." This vision of the jaguar as a flaming sun in the dark nocturnal jungle would have delighted William Blake, who believed in the universality of the poetic imagination: "Tyger! Tyger! burning bright/in the forests of the night."

The surprising metaphor of the jaguar as a nocturnal sun is a further expression of the dualism that lies at the base of Mesoamerican thought and is the root both of its cosmology and of its philosophical and moral ideas. From the beginning this dualism is almost obsessively visible in the small clay figures of Tlatilco (about 1200 B.C.). Some display two heads. In some, half the head is a skull and the other half a laughing face. Still others are given two noses and two mouths, an unexpected prefiguration of paintings by Picasso. The Aztecs had one god, a supreme god, who was named Ometeotl, the Lord of Duality. More than a god, he was a concept. Sources mention two forms of this god: Ometecuhtli, the male, and Omecíhuatl, the female. This dual divinity was the origin of all beings and things, but was not worshiped. Literally, it was *beyond*. "In the Aztec philosophy," says Michael Coe, "this was the one reality, and all the rest was illusion." The Lord of Duality had an infernal counterpart, the Lord-and-Mistress of Death. Each god had his animal double in addition to his female, also double, counterpart. For example, Xochiquetzal (Flower Feather), a young goddess, is mentioned in the myth of the creation of the world; she appears as two goddesses with the same name but different attributes: "she of the green skirt" and "she of the red skirt." Another example is Xolotl (the Twin), patron of twinned forms of nature, such as the amphibian *axolotl*. In the Borgia Codex, Mictlantecuhtli, god of death,

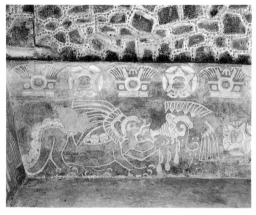

Jaguar with conch-shell trumpet. Detail of wall painting, Palace of the Jaguars, Teotihuacán. Photo: Enrique Franco Torrijos

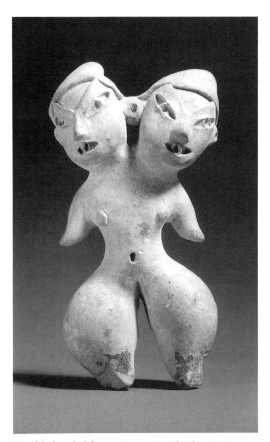

Double-headed figure. Ceramic. Tlatilco. Princeton Museum, Gillett G. Griffin Collection. Photo: John Bigelow Taylor

and Quetzalcoatl, god of life, can be seen joined back to back like Siamese twins. This representation—and it is not unique—reveals a profoundly intellectual art in which form functions as concept. Art, in the strictest sense of the word, that is also philosophy.

Two is doubled and becomes four, the number that is the archetype of Mesoamerica. The Lord of Duality engenders four Tezcatlipocas, each a different color, corresponding to each of the four cardinal points. The Maya gods have four aspects, four forms, four functions. Each of them, in turn, has a consort that quadruples into four manifestations. Like the Aztecs, the Maya believed in the four creations, or ages, of the world, followed by a fifth, the present. Again, this belief in the four ages corresponds to the division of space into four regions, conforming to the four cardinal points, with a center zone. For the Maya, the center was green; for the Aztecs, the center was the sun of movement, the sun that animates our era but that one day will destroy it. The Maya sky was upheld by four Bacabs; in the center grew a wondrous tree, the perennially green ceiba. The priest responsible for sacrifices had four acolytes, each called Chac, like the god of rain. Examples proliferate ad nauseam. The number four ruled Mesoamerica as the triad ruled European peoples.

The rectangular, stair-stepped pyramid is the canonical form of Mesoamerican religious architecture. It is a projection of the quadrangle formed by the four cardinal points. Pyramids were sanctuaries and tombs. The sanctuary was high on the platform atop the structure; the tomb, as in Egypt, was in a subterranean chamber. The model for the pyramidal form was the mountain. The world is a mountain and the archetype of the mountain is the pyramid, an analogy that appears as well in Egypt, Mesopotamia, and India. The pyramid has an equivalent in the sphere of religious representations: the heavens, composed of thirteen layered zones, and the underworld, composed of nine. But the pyramid is more than the symbolic representation of the mountain composing the world and the underworld; the movement that thrusts the quadrangle upward (or downward), transforms it into time. The pyramid is space become time; in turn, in the pyramid, time becomes space, petrified time. Sunrise and sunset, the movements of the constellations, the appearance and disappearance of the moon, Venus, and other planets, determined the orientation of the pyramids and their relation to other structures. In Uaxactún, says Mary Ellen Miller, the placement of the pyramids served to mark the passage of time and movements of the stars.[5] In Chichén Itzá, at the autumnal equinox, seven luminous segments can be seen moving across the steps of the pyramid called the Castle; they are seven segments of the serpent that ascends toward earth from the depths of the underworld.

The pyramids were tombs and thus representations of the underworld and its nine zones. At Palenque, in the Temple of Inscriptions, the sepulcher of King Pacal, the pyramid has nine levels. Inside, in the center of the lowest level, is the magnificent mortuary chamber. There is more. Thirteen cornices rise from the tomb to the highest level. Nine and thirteen: the stages of the underworld and of the heavens. At Tikal, Pyramid I, also the tomb of a king, has nine levels. At Copán there is another notable example of a funeral pyramid with nine terraces; it may perhaps have

been the tomb of the king Smoke Jaguar. In contrast, the pyramid of Tenayuca, near Mexico City, is adorned with fifty-two serpents' heads, reflecting the fifty-two years of the Aztec century. The pyramid of Kukulcán in Chichén Itzá has nine double terraces, symbolizing the eighteen months of the year. There are 364 steps, plus the step of the platform, equaling the 365 days of the solar calendar. In Teotihuacán the two stairways of the Pyramid of the Sun each have 182 steps: 364, plus that of the platform. The temple of Quetzalcoatl has 364 serpents' maws. At El Tajín the principal pyramid has 364 niches, plus one that is hidden. Marriage of space and time, the representation of movement in petrified geometry.

The pyramid is not the only example of the transfiguration of space into time. The vertical movement that lifts the quadrangle can also be horizontal. Metamorphosis repeats itself, space unfolds and becomes time, *now* becomes a calendar. The form it assumes is twofold: the lunar calendar of 260 days and the solar calendar of 360 days, plus five ill-fated and unnamed days. They were the empty days. The Aztecs, ever poetic, represented them masked in the leaves of the maguey cactus. The lunar calendar served for divination and had religious and magic connotations. In the West one is born under a star sign; in Mesoamerica one was born under a sign from the lunar calendar. The signs were ambiguous, consisting of a cluster of predispositions that might, according to the circumstances, occur in order or be perverted, either through conjuring or, as Sahagún records, "through the diligence or negligence and weakness" of the individual. We need not dwell on the subtle and intricate details of the two calendars, but it is useful to observe that the complete rotation of the two calendars formed a cycle of 18,980 days, at the end of which a determined day would occupy its original position. Each cycle took fifty-two years: the Mesoamerican century, divided into four quarters of thirteen years each. The Maya perfected the calendar by introducing the so-called Long Count. Like us, they conceived an ideal date for beginning the count. Ours is the birth of Christ; for them, a date of divine action (the zero point of creation) that corresponds in our calendar to the year 3114 B.C. The calendar: time made stone, stone revolving.

As the original quadrangle—the four cardinal points—unfolds horizontally, it tends to turn back upon itself and be transformed into a circle with one point in the center, motionless but nonetheless active. Although the cyclical concept of time was common to many peoples—we need go no further than the Greeks and the Romans—nowhere except in India did it reach the complexity and refinement achieved in Mesoamerica. The Mesoamerican calendar is not only time become space, and space in movement, it contains an implicit philosophy of history based on these cycles. The famous basaltic disk called the Sunstone expresses this concept with mute yet sculptural energy. In the center is the image of the sun god and the sign of our era (4 Motion); around that, the symbols of the four eras or suns that have preceded the current era; next, another ring with the signs of the twenty days. All of this is encircled by two Fire Serpents. The sign 4 Motion denotes not only the beginning of the world, but also its end by cataclysm. The sun of motion is the energy that moves the universe and causes stars, signs, and seasons to rotate. Terrible energy, a sun ever thirst-

ing for blood. This is why it is portrayed, with chilling realism, with a fiery tongue. Motion, which is rhythmic revolution, the dance of time, will one day become discordant. In the musical sense, discord is dissonance; in the moral and historical sense it signifies dissension. Discord is the rupture of the cosmic rhythm and of the social order. In the Sunstone the Aztecs read their beginning, their high noon, and their end.

The Mirror of Duality

Historians underscore the sophistication of Mesoamerican, especially Maya, astronomy and the precision of their calculations. Let us be clear: their astronomy was both astrology and mythology. The movements of the sky were viewed as a divine account of the conflicts, unions, and transformations of the star gods; in turn, these mythological stories were a translation of the rotation of the stars and the planets. The famous and ubiquitous "ball game" is a ritual translation of these ideas. The origins of the game are mingled with the beginnings of Mesoamerican civilization, as evidenced by the small figures of the Neolithic culture of Tlatilco, among which there are several ball players. In San Lorenzo, the most ancient Olmec site, there are unequivocal signs of the "ball game," such as a splendid sculpture of a player (decapitated and buried during the violent destruction the site underwent). From that time until the arrival of the Spaniards, the peoples of Mesoamerica participated passionately in this game. In all their sanctuaries and "ceremonial centers" there are rectangular courts bounded by walls sometimes decorated with reliefs alluding to the games. The probable focal point was El Tajín, on the Gulf Coast. Eleven playing fields have been found on that site, some with memorable reliefs adorning their walls. It is likely that the inhabitants of El Tajín, heirs to the Olmec culture, specialized in the production of the elastic *hule* balls.[6] Also found in that zone are stone objects called *yugos* (yokes), *palmas* (palms), and *hachas* (axes). The first two are almost surely stone representations of the rubber guards the players wore for protection, much like the helmets and pads American football players wear today. The *hachas* may have served as markers for scoring. These objects are true sculptures, often of great beauty. Some are remarkable for their economy and energy of form, others for expressiveness, and still others for sinuosity and elegance of line. Some of the playing fields are magnificent, such as the one at Chichén Itzá; others, such as those at Copán and Monte Albán, amaze us with their symmetry and harmony with the surrounding landscape. One of the great triumphs of Mesoamerica was the creation of an architecture that replicated the natural world. At Teotihuacán and Monte Albán, for example, one can experience the dialogue between the mountains and the towering geometric masses of the pyramids; at Tikal and Palenque, the riotous vegetation complements the Baroque fantasy of temples and palaces.

This ancient ritual ball game was apparently played for two purposes: as sport and as rite.[7] This latter mode, undoubtedly the older, is the subject of reliefs at El Tajín, Chichén Itzá, Cotzumalhuapan, and other places. As in the case of the Eagle and Jaguar warriors, at the heart of this ritual lies the celestial combat between the sun and the stars, and of day against night,

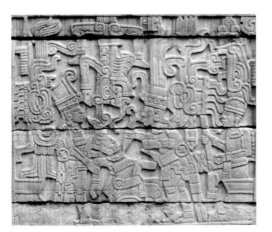

Relief from South Ball Court, El Tajín. Photo: Enrique Franco Torrijos

the polemical duality that moves the world. The battle in the Cacaxtla fresco represents a ritual in which the Eagle and Jaguar warriors are performing (for stakes of life and death) the cosmic drama. The ball game was a similar rite, with parallel outcome: a relief at El Tajín depicts the captain of the conquered team at the moment of being sacrificed. Another relief shows a decapitated player with seven serpents sprouting from his mutilated trunk. This terrible image is repeated at Chichén Itzá. Serpents signify fertility; sacrifice is life.

The mathematics of Mesoamerica was no less remarkable than its astronomy. Two prime discoveries in the history of human ingenuity are positional notation and the zero, or sign of naught. Both were conceived by the Olmecs and later perfected by the Maya. Writing also began with the Olmecs and was then perfected by other peoples, particularly the Zapotecs of Monte Albán. There is similar writing—hieroglyphs with some phonetic elements in the form of logographs—in Teotihuacán, El Tajín, and other sites. We have not yet deciphered these writings, except for toponymic glyphs and calendar dates. Mixtec and, later, Aztec writing combined the pictograph with phonetics. The analysis of one Aztec example concludes: "Thus, the town 'Atlan' was written by combining pictographs of water (a-) and teeth (tlan-)."[8] True rebus puzzle-writing.

The most complete—and most complex—system was conceived by the Maya; it combines ideograph and phonetics with absolute subtlety. The Maya must have had an extensive literature, to judge by the *Chilam Balam* and *Popol Vuh*. Although both of those works were written after the Conquest, they record many religious and cosmogonic traditions, rites, and prophecies of priests. The great majority of the Maya codices were destroyed. Only four remain; the most important among them, conserved in Dresden, is devoted solely to astrology and ritual. We also have numerous inscriptions on temples and stelae. These inscriptions accompanied the figures worked in relief or sculpted on the stelae. Their function was not unlike that of the captions and headings beneath illustrations or photographs in our newspapers and books: to give information about an event and its participants. The extraordinary recent advances in deciphering Maya script have changed many of our ideas about the history of that people. Nevertheless, we are still far from totally comprehending their writing.[9] If the day comes when we succeed in completely deciphering those inscriptions, I fear we shall be disillusioned: they probably consist of strings of names, dates, palace records, and feats of war. The true literature—poems, legends, songs, and stories—must have been oral, as among the Aztecs, the only people who have left us an important corpus of poetry.

It was not only basic principles and myths that were the same for all Mesoamerican peoples: they also shared a pantheon. Under different names, and in different tongues, they worshiped the same gods using similar rituals. Gods of the sky and gods of vegetation, warrior gods and gods of fertility, civilizing gods and gods of pleasure. Gods and goddesses. The god of rain: Tlaloc on the highlands and Chac in the Yucatán. The goddess of water: Chalchiuhtlicue, she of the skirt of jade. The sun god and moon goddess. Coatlicue: she of the skirt of serpents, from whose decapitated

trunk Huitzilopochtli sprang fully armed, like Minerva from the brow of Jupiter. The aged god of fire. The youthful god of maize, Xipe the Flayed, and the goddess Tlazalcótl, Obsidian Butterfly, the archer, goddess of confession and the steam bath, the goddess who swept away filth from the house of the soul. The Plumed Serpent: Quetzalcoatl on the highlands and Kukulcán in the Yucatán, the god who emerged from the Gulf and who blows a conch shell and is named Night and Wind (Yohualli Ehecatl), god of vital breath and the destroyer god of the second era of the world, Evening and Morning Star, god 1 Reed, who disappeared in the place where "the water of the sky joins the water of the sea" (the horizon) and who will return in the same place and on that same day to reclaim his inheritance —Quetzalcoatl, the sinner and penitent god, the painter of words and sculptor of discourse. Mixcoatl, Cloud Serpent, the Milky Way, the blue-and-black god studded with starry points, the night sky....

The theater of Mesoamerican gods is a theater of wondrous metamorphoses that never knew an Ovid. Like the heavenly bodies, plants, and animals, the gods are constantly changed and transformed. Tlaloc, god of rain, appears among the Maya of Yaxchilán as the warrior god. Xochipilli (1 Flower), god of dance and song, is transformed into Cintéotl, young corn. Xochiquetzal is the wife of the youth Piltzintecutli, who is no other than Xochipilli, even though at another moment of the myth the same goddess becomes the consort of Tezcatlipoca. Which Tezcatlipoca? Well, there are four. The black Tezcatlipoca, Smoking Mirror, is the jaguar god who in his mirror sees into the depths of men; he is converted into his opposite and double, the young Huitzilopochtli, the hummingbird, who is the blue Tezcatlipoca. At another point in space appears the white Tezcatlipoca, who is Quetzalcoatl. And at the fourth point, between the green maize and ocher earth, appears the red Tezcatlipoca, who is Xipe Totec. The gods appear and disappear like stars in the mouth of night, like the sun in the west, like the bird between two clouds, like the coyote among the folds of dusk. The gods are time, but not time petrified. Time in perpetual movement, the dance of metamorphoses, the dance that is the "Flower War," a cruel and illusory game, a dance of reflections thrown by four facing, antagonist mirrors. They blend together and become flames, they die low and again spark to life. Who lights them, and who extinguishes them? The Lord of Duality.

MEXICO

The Sword, the Cross, and the Quill

The fall of Mesoamerican civilization was inevitable. More powerful societies with greater defensive capacities—the Chinese, Arabs, Turks, Hindustanis—were similarly incapable of withstanding the onslaught of the great European wave. Nevertheless, the explosive swiftness of its fall and the rapidity with which the Spanish succeeded in creating a new society are facts that deserve a more thorough interpretation. Historians highlight a cluster of circumstances: technical and military inferiority exemplified by the absence of firearms, armor, and cavalry; vulnerability to European viruses and epidemics (smallpox accounted for more Aztec lives than the Spanish harquebus); internal dissension and widespread resentment of Aztec domination (without the aid of Indian armies the Spanish could never have conquered the Aztec state in such a brief period of time). One of the distinctive characteristics of Mesoamerica was its circular concept of history, and the most notorious consequence of that concept was the Indians' inability to resolve the perpetual state of war among their various nations through the establishment of a supernational state. This was precisely the signal achievement of the Spanish and what made it possible for them to reign in peace for three hundred years.

Another equally decisive circumstance was the dismay, bordering on stupor, the Indians experienced at the arrival of the Spanish. In their mental universe there were only two categories for classifying human beings, barbarians and civilized.[10] The Spanish were neither. The Mesoamericans were ignorant of a reality entirely familiar to peoples of Asia and Europe: the existence of other civilizations. They could not *consider* the Spanish; they did not fit their mental categories. To deal with the unknown, they had but one special category, the sacred. Their vision of "beyond here" was not historical but supernatural. Not another civilization, but other gods. Or ancient gods returning, as Moctezuma believed was the case. The attitude of the Indians when they faced Spanish cavalry is an impressive example. At first they believed horseman and mount were one supernatural creature able to divide then rejoin itself. Once disabused of this misconception, they persisted in viewing the horses as supernatural creatures, and for this reason sacrificed them as they did prisoners of war. *Otherness* is a constituent dimension of historical consciousness. He who is without it is defenseless before the new and the strange.

Reality was no less complex from the Spanish side. The discovery and conquest of what is today Latin America were two episodes in the history of European expansion begun at the end of the fifteenth century and not ended until well into the nineteenth. But the temperament of the two peoples who carried out this extraordinary undertaking, the Spanish and the Portuguese, was very different from that of other Europeans. The struggle to end Moorish domination in Spain concluded just as the great American adventure began. Thus this adventure can be seen as a continuation, not only chronological but psychological and historical, of the for-

Hernán Cortés and his coat of arms; wood engraving from Vega, *Cortés valeroso* (1588)

mer. The spirit of the war against the Moors, that is, of the Crusade, was vivid in the minds of Cortés and his soldiers. The first thing they thought of when they saw the temples of the Indians were Muslim mosques. And the thirst for gold? And the pillage? Greed and ambition were not strangers to the spirit of the Crusades. But Cortés was not a medieval warrior. Faith, hunger for wealth, and thirst for fame were joined in his spirit with uncommon political practicality and outstanding historical vision. He was a conqueror, but he was also a founder. Had they but known him, he would have won the admiration of figures as different as Machiavelli and Julius Caesar. A similar blend of impulses and inclinations can be found in his soldiers; they remind us of both medieval Crusaders and Renaissance condottieri. Theirs was a small army, but one rich in unique personalities. How can we overlook the fact that two of those soldiers were accomplished writers, Hernán Cortés and Bernal Díaz del Castillo?

Present with the adventurer and the captain were the lawyer and the court clerk. The Conquest was a public *and* a private enterprise. Its protagonists were volunteers who waged war in the name of the king and the Church but who also fought for personal gain. As soon as the Conquest was completed, the conquerors established a duplicate of the European feudal system, one aggravated by the encomienda system. The conquistadores and their sons became encomenderos, lords of vast estates composed of entire villages of Indians who were in fact servants and tributaries. It became a principal concern of the Crown to limit the encomenderos' power. The struggle between absolute monarchy and feudal aristocracy was repeated in New Spain, and, as in Europe, ended with the victory of centralized power. In that struggle, the viceroys of New Spain—during this early period there were worthy men among them, such as Antonio de Mendoza and Luis de Velasco—found a powerful ally in the religious orders that followed close on the heels of the conquistadores. The first twelve Franciscans debarked in 1524, the Dominicans and Augustines shortly thereafter. This was the Catholic answer to Protestant schism. Sahagún says in the preface to his book, "It seems that in these our times and in these lands and with these peoples Our Lord God has seen fit to restore to the Church what the devil stole from it in England, Germany, and France." Alfonso Reyes defined the missionaries with concise precision: "Lambs with the hearts of lions." Although most were Spanish, there were also priests from the south of France, Flanders, and northern Europe. Many were influenced by Erasmian doctrines, such as Bishop Vasco de Quiroga, who drew ideas from Sir Thomas More. These priests defended the Indians against the evils of the encomenderos, taught them new arts and skills, won their hearts, recorded their stories and traditions, baptized them, and, finally, effected a true revolution—if such a well-worn word will serve for the Indians' conversion to Christianity. Like all conversions, that of the Mexican Indians entailed not only a change of their beliefs but the transformation of the beliefs they adopted. The phenomenon was similar to the change from Mediterranean polytheism to Christian monotheism that had taken place a thousand years earlier. That is, there was a conversion *to* Christianity and a conversion *of* Christianity, the supreme expression of which was, and is, the Virgin of Guadalupe,

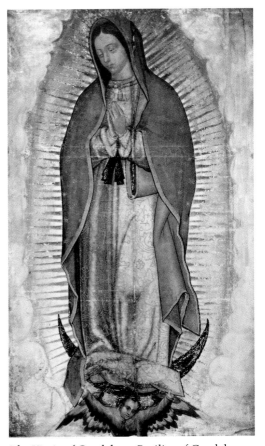

The Virgin of Guadalupe, Basilica of Guadalupe, Mexico City

in whom the attributes of the ancient goddesses are fused with those of Christian virgins. It is natural that Indians should still call the Virgin by one of the names of the earth goddess: Tonantzin, Our Mother.

Evangelization created a need for temples, convents, and schools. It became necessary to found towns, since dispersed populations made the work of the Church difficult, as it previously had in Europe in the early centuries. The construction accomplished by the friars has few parallels in history. In less than half a century the landscape was changed; monasteries, sanctuaries, open chapels, and new urban communities arose. In this titanic task the first viceroys provided indispensable economic assistance and made the additional contribution of prudent judicial and even aesthetic decisions. This undertaking, however, would have been impossible without the collaboration of the native populations. Thousands and thousands of Indian workers and artisans labored to erect temples, convents, aqueducts, and other structures. The Indians' participation cannot—at least not exclusively—be explained by social coercion. It is obvious that the voluntary cooperation of the majority was decisive. And it is not too difficult to understand the reasons for that goodwill. First of all, however difficult the labor they had to perform, it could not be compared to what had been demanded of them under harsh Aztec rule nor to the cruel demands of the encomenderos. George Kubler has also pointed out that in Mesoamerica there was no precise dividing line between ritual and labor; many of the tasks carried out by the Indians were considered duties or ritual functions (among them I would add war itself). Thus it is not surprising that they collaborated in erecting the sanctuaries of their new religion. New? This question deserves separate consideration.

Above all else, it is imperative that we understand the reasons—clearly instinctive, but imbued with profound logic—for the Indians' conversion to Christianity. Again coercion cannot explain the phenomenon, nor can it account for a religious faith as sincere and fervent as that the Mexican people have demonstrated from the sixteenth century to the present day. We can begin to comprehend the psychological and existential mood of the Indians on the day after the Conquest once we accept the fact that to them this terrible event was a spiritual as well as a military and political defeat. The real defeat was that suffered by their ancestral divinities, all of them martial and all impotent before the invaders. One can only imagine the despair of the Aztecs when, near the end of the siege of Tenochtitlan, their chieftains and priests decided to send against the invaders, as a last desperate measure, a fire serpent capable of consuming the world in flames. This enormous paper "magical" serpent, the "divine weapon" of Huitzilopochtli, the tutelar numen, was immediately demolished by the two-handed swords of the Spanish. This fiasco, it appears, precipitated the fall of the city. The defeat of their gods left the Indians in a spiritual orphanhood that we moderns can scarcely imagine. This is the source of the truly visceral nature of the cult of the Virgin of Guadalupe. The new religion, then—and this I consider decisive—offered a mysterious bridge connecting the new with the ancient faith. The basis of Mesoamerican religion, its founding myth and the core of its cosmogonies and ethics, was sacrifice. The gods sacrifice themselves to save the world, and men

The merging of European and Indian styles; atrial cross, Augustinian convent, Acolman. Photo: Michel Zabé

Open chapel, Franciscan convent, Tlalmanalco.
Photo: E. Logan Wagner

Open chapel, Augustinian convent, Zacuapan de
Amilpas, Morelos. Photo: E. Logan Wagner

pay for that divine sacrifice with their lives. The central mystery of Christianity is similarly sacrifice. Christ descends, becomes flesh among us, and dies for our salvation. Christian theologians had seen glimmerings and prefigurings of the Christian mysteries in the pagan rites. In turn, the Indians saw in the Eucharist the supreme mystery of Christianity, a miraculous if sublimated confirmation of their own beliefs. In truth, it was something more than a substitution or sublimation: it was a consecration.

The aesthetic models of the missionaries were those of their time. They were not professional artists, and they conveyed forms and styles prompted not by an aesthetic philosophy but by reasons of a spiritual order and practical considerations. Three styles coexisted in the religious edifices of the period: residues of the Gothic, the Spanish-Arab Mudejar, and the Plateresque, which was the first Spanish version of Renaissance architecture. Ornamentation was fundamental to all three styles. In the Mudejar geometric decoration is dominant, while in the Plateresque facades are richly sculpted. At first the missionaries and their Indian artisans used books of European engravings as models. Later, by midcentury, painters and artisans began to arrive from Spain and other countries. Indian influence is visible not so much in motifs and forms—although notable examples exist—as in the manner of handling materials. Sensibility, more than form. This is particularly evident in sculpture and, to a lesser degree, in painting. The great change, however, was what George Kubler has perceptively called the transformation of the syntax of European styles. As these styles were adapted to new material and spiritual conditions, to the physical landscape, and to the psychological needs of the new believers, their system of internal and external relationships (their syntax) was substantially modified. The vocabulary also changed. European motifs were transformed as they were interpreted by Indian artisans, and the same happened to pre-Hispanic motifs as they were introduced in the new context.

The greatest changes were visible in the major architectural innovation of that century, the open-air chapels. These were the unenclosed sanctuaries that permitted the celebration of divine services before a multitude of the faithful. From the time of the catacombs the Christian faith had been celebrated in enclosed, roofed areas: churches, basilicas, chapels. Worship in Mesoamerica was held under the unobstructed sky and in open space. Crowds gathered in a great rectangular plaza, and the priests stood above them on the platform that crowned the pyramid. These open-air chapels were a compromise between the Christian and Mesoamerican traditions. A compromise, but also—and especially—an important aesthetic creation. Additional relationships can be discerned. In the same way that scenes of Indian myths were represented in the reliefs of their sanctuaries, the walls of the Christian chapels were almost always adorned with reliefs of biblical or evangelical episodes. In Mesoamerica rites and ceremonies were fundamental in the practice of religion; it was only natural that in their new religion Indians should seek an echo or transposition of the pomp and ceremony of their ancient faith. Roman Catholicism fully satisfied this psychological need, not least in the magnificent retablos inside the temples. The markedly sculptural Plateresque style lent itself admirably to the splendor of this form. The retablo, whether painted or

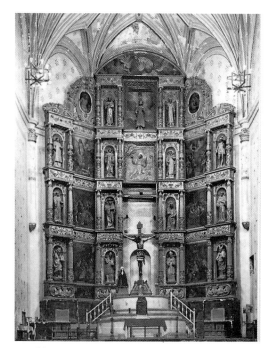

Retablo, 1584–86, Franciscan convent, Huejotzingo, Puebla.

carved, not only permits but demands the collaboration of fantasy. A world of contrasts, gold and shadow, filled with sparkling figures and resplendent images. Superb examples of this art from both the sixteenth century and the Baroque period were left by the artists of New Spain—some European, some Indian.

The sixteenth-century religious art of New Spain was the first non-Indian art of America. It was born of the confluence of two sensibilities and two spiritual movements: those of the missionaries and those of the Indians. This was not merely art exported from Europe, nor was it a continuation of Mesoamerican tradition. It was a new and lively art, profoundly original, with its own unmistakable characteristics. With it began something that continues to the present. From that first moment on, whether in Latin America or in the United States and Canada, the history of American art has been the history of the continuous transformations and metamorphoses undergone by European forms as they have been transplanted and taken root on our continent. The first examples of this process is the art of sixteenth-century New Spain. A sublime example.

The arrangement of the new towns was also of European inspiration. Kubler points out that models were not contemporary cities, all of which had grown in haphazard fashion, but the theories and speculations of the great Italian architects of the Renaissance, permeated with Neoplatonism. Guillermo Tovar de Teresa has demonstrated that the viceroy Antonio de Mendoza was influenced by Leon Battista Alberti's *De re aedificatoria* when he drew up the plan for Mexico City. Although the chessboard-like grid was basically adhered to, this Italian model was modified in several ways. One, in the dimensions of the plazas. The plaza in Mexico City is enormous and is more reminiscent of the great plaza of Tenochtitlan than its homologue in Madrid, the Plaza Mayor. Two, in the facing presence in that same plaza of the seats of both religious and temporal power, the cathedral and the palace of the viceroy or other municipal authority. The sixteenth century left notable examples of civil architecture, public and private, but the moments of greatness belong to a later period. This is also true of the painting not intended for public spaces. In the second half of the sixteenth century the construction of the great cathedrals was begun. Some, like their European counterparts, took several centuries to be completed. The mark of Juan de Herrera is visible in the cathedrals of Mexico City and Puebla, although other styles were superimposed, increasingly more Baroque as that style—rather, plurality of manners—progressed. The art of Herrera, as seen in his masterwork, El Escorial, is the Spanish version of High Renaissance. It is a severe art retaining some morbid traces of Mannerism, such as the figure of the meditative monarch, the melancholy Philip II, enamored of hermetic philosophy and the paintings of Hieronymus Bosch. In New Spain, the transition from Mannerism to Baroque was swift and imperceptible.

Flames and Filigree

Baroque is a word whose origins and meaning is incessantly and eternally debated. Its semantic and etymological imprecision—what does it really mean and where does it come from?—lends itself perfectly to defining the

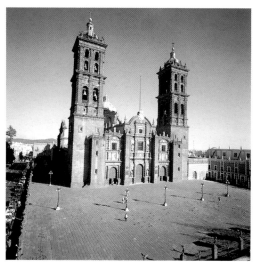

Cathedral of Puebla. Photo: Michel Zabé

style by which it is known. A definition always in the process of being defined, a name that is a mask, an adjective that as it nears classification, eludes it. The Baroque is solid and complete; at the same time, it is fluid and fleeting. It congeals into a form that an instant later dissolves into a cloud. It is a sculpture that is a pyre, a pyre that is a heap of ashes. Epitaph of the flame, cradle of the phoenix. No less varied than the theories that attempt to define it are its manifestations: it appears in Prague and Querétaro, in Rome and Goa, in Seville and Ouro Prêto. In each of these presences it is different and nonetheless the same. Without attempting to define it, we may, perhaps, venture this timid conjecture: the Baroque is a transgression. Of what? Of the style that gave it being, Renaissance classicism. But this transgression is not a negation; the elements are the same. What changes is the combination of the parts, the rhythm that unites and separates them, compresses or distends them, the tempo that moves them and carries them to paralysis or dance, from dance to flight, from flight to fall. The Baroque is a shudder, a trembling—and stasis. A stalactite: congealed fall. A cloud: impalpable sculpture.

Spain quickly adopted the new style and lent it exceptional brilliance in all the arts, from poetry to painting to architecture. New Spain followed and soon was competing—at times triumphantly—with her mother country, especially in the area of poetry and architecture. The last great Baroque poet of our language was born in Mexico. Doubly extraordinary in the history of a style noted for the extraordinary, she was a woman and she was a nun: Juana Inés de la Cruz. The Baroque of New Spain began as a branch of the Spanish tree. As it took root and grew in our soil, it was transformed into a different tree. To understand the amazing aesthetic fortunes of this graft, we must pause for a moment to review the historical and social conditions of the period. The sixteenth century was the political and military apogee of the Spanish monarchy. It was also, at the end of the reign of Philip II, a period of reversals that set the stage for the disasters that would occur during the following century under the rule of his descendants. In New Spain this great Spanish century was the century of beginnings: conquest, evangelization, and the founding of a new society. In the seventeenth century the political, military, economic, and scientific decline of Spain was precipitous, although accompanied by major names and enduring works in the sphere of arts and letters. Twilight is a beautiful moment. While Spain decayed, New Spain was maturing and enjoying a prosperity that, with fluctuations, would continue to the end of the eighteenth century. The historian Enrique Florescano has shown that the crises and failures of the Spanish economy—for example, the decline of its colonial trade—paradoxically favored New Spain, which strengthened its internal markets. The dissolution of the encomiendas, the free labor market for agricultural workers, and the construction of dams and irrigation projects transformed agriculture. One last decisive factor was the boom in mining. Such riches were the result of peace. Spain was bleeding in her European wars, but a peaceful New Spain was expanding and advancing. At the beginning of the eighteenth century, Madrid looked like a poor relative compared to the opulence of Mexico City.

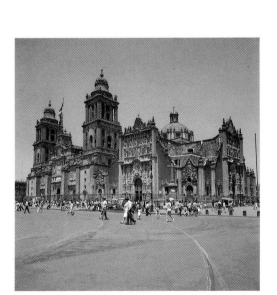

Zócalo and Cathedral, Mexico City. Photo: Michel Zabé

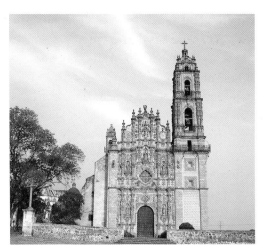
Jesuit seminary, Tepotzotlán. Photo: Michel Zabé

Prosperity coincided with the rise of a new social group, the criollos. They were descendants of the Spanish colonists. Many were major agriculturists; others were miners, businessmen, physicians, lawyers, university professors, clerics, and military officers. These criollos were wealthy and influential, even though they were prohibited from holding some high governmental posts. Invariably the viceroys came from Spain and were from the highest nobility. It was equally difficult for a criollo to become archbishop of Mexico, although the Church was more open. To the Spanish hereditary nobility, the criollos were an aristocracy of storekeepers, pharmacists, and petty lawyers. It is not, therefore, surprising that this group should have begun to experience a kind of formless patriotism that a century later would put them at the forefront of the movement for independence. They felt they were unjustly treated and their relationship with their mother country was unstable and ambiguous: Spain was, and was not, their homeland. They felt the same ambiguity in regard to their native land. It was difficult to consider themselves compatriots of the Indians and impossible to share their pre-Hispanic past. Even so, the best among them, if rather hazily, admired that past, even idealized it. It seemed to them that the ghost of the Roman empire had at times been embodied in the Aztec empire. The criollo dream was the creation of a Mexican empire, and its archetypes were Rome and Tenochtitlán. The criollos were aware of the bizarre nature of their situation but, as happens in such cases, they were unable to transcend it—they were enmeshed in nets of their own weaving. Their situation was cause for pride and for scorn, for celebration and humiliation. The criollos adored and abhorred themselves. They were sensitive and boastful, vain and imaginative, ostentatious, jealous of their privileges yet generous to the point of prodigality, enamored of the secular world but nostalgic for the convent cell, libertines and ascetics. They saw themselves as extraordinary, unique beings and were unsure whether to rejoice or weep before that self-image. They were bewitched by their own uniqueness.

The rise of the criollos coincided with other changes. In the sixteenth century the mendicant orders, principally with funds from the Crown, had carried out the great undertaking of building temples and convents. In the seventeenth century the secular Church displaced the religious orders and took over the administration of the parishes. At the same time the Crown was spending less on constructing convents and temples. The generous new patrons were the criollos, immensely wealthy and deeply devout. The Jesuits, the teachers and the moral and aesthetic conscience of the aristocracy of New Spain, skillful collectors of funds and great builders (not without reason has the term "Jesuit style" been applied to the Baroque), were the intelligent and efficient beneficiaries of criollo largess. The coming together of the native aristocracy and the Society of Jesus was the origin of the second great moment in New Spain's art. (Donations from criollo magnates—for schools, hospitals, convents, temples, altars—have more than one similarity to the modern North American foundations devoted to supporting the arts and humanities.) Artistic activity was not limited to religious art. Palaces and schools were also erected during this period; many survive, and almost all are to be admired.

The Baroque was an eclectic style. Dynamic, not passive. Although it tolerated all forms and did not disdain exceptions or individuality—to the contrary, it sought and celebrated them—it transfigured all these disparate elements with a decided and not infrequently violent unifying will. The Baroque work is a world of contrasts, but is *one* world. This love for the particular, and the will to place it within a larger whole, could not but impress and attract criollos. In a certain way, the Baroque was an answer to their existential anxieties: how could they fail to recognize themselves in the literally catholic appetites of that style? Its love for the singular, the unique, and the peripheral included themselves and their historical and psychological uniqueness. In the previous century there had been an affinity between Indian religious intensity and missionary zeal; there was now a profound psychological and spiritual correspondence between criollo sensibility and the Baroque. It was a style they needed, the only one that could express their contradictory nature, the conjunction of extremes—frenzy and stillness, flight and fall, gold and shadow.

In New Spain the Baroque produced works that stand among the best of the style produced anywhere. I am speaking of poetry, architecture, and the exquisite art of the retablo, which joined volume to color and light to shadow. The painting, on the other hand, is merely respectable. Painters followed Peninsular models, especially Zurbarán, without ever surpassing them. Despite its theatrical contrasts and provocative forms, the Baroque more than once falls into cold affectation. Its very exuberance exhausts us. I am thinking of a representative work from the zenith of that style, one justly considered to be a gem, the Capilla del Rosario in Puebla. It is in fact a jewel, but are we *moved* by a precious gem? It is impossible not to admire the luxuriant and gilded vegetal forms, the Solomonic columns, Corinthian pediments, false arches, leaves, fruit, flowers, stars, virgins, angels like clouds, and clouds like angels. It is dazzling, but that knowing refulgence and calculated splendor fatigue us. The answer to that syrupy beauty is found a few kilometers away in the tiny village church of Santa María Tonantzintla. It is the popular Indian version of Baroque ostentation. The execution is less polished, the materials less elegant. It is, nevertheless, absolutely alive. Forms dance and fly, colors explode, the black hair of the angels floats among the reddish columns and glistening foliage, leaves shine, fruit exudes thick drops of dark honey. The strange relationship—affinity and contradiction—between the Capilla del Rosario and Santa María Tonantzintla is an example of the constant dialogue between the spontaneous and the calculated, the popular and the cultivated traditions, that has been one of the charms of Mexican art from its origins to the present day.

Historians divide this period into two moments: the Baroque proper and the Churrigueresque, after the Spanish architect José Benito de Churriguera (1665–1725). The latter has been called an exaggeration of the Baroque. It was more than that: it was its logical conclusion. The distinctive element of the Churrigueresque is the replacement of the column by the *estípite*, that is, by a pilaster in the form of a truncated pyramid, with the smaller base at the bottom. An inverted pyramid. The *estípite* is a very ancient architectural and sculptural feature (it was pres-

Church of Santa María Tonantzintla. Photo: Michel Zabé

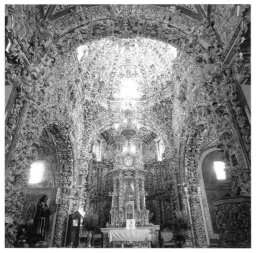
Church of Santa María Tonantzintla. Photo: Michel Zabé

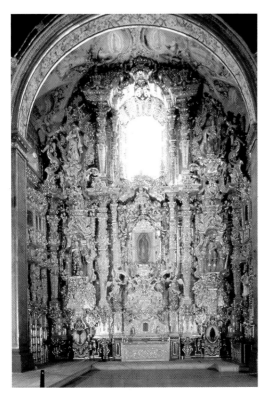

Altar retablo, Jesuit seminary, Tepotzotlán.
Photo: Michel Zabé

ent in early Crete), but it performed a basic aesthetic function in the radical Hispanic version of the Baroque that we call Churrigueresque. The *estípite* divided facades and retablos into rectangular surfaces that were then covered with flowers, caryatids, telamones, garlands, and other ornamental forms. Geometric spaces filled with riotous vegetation. Although the Churrigueresque was born in Spain, its country of choice was Mexico.

The nearly obsessive use of the pyramidal form in the land of truncated pyramids is remarkable. It would be excessive to attribute an esoteric meaning to this coincidence. Yet it is unsettling that one of the most perfect examples of the use of the *estípite* is the Sagrario of the Cathedral of Mexico City, the work of Lorenzo Rodríguez. The structure of this edifice is pyramidal, and its rhythm, like that of the pyramids, is ascendant; at the same time, the rhythm of the facades, dominated by the truncated pyramids, is descendant. Dual movement that is an illustration in stone of the paradox of Heraclitus: the road that rises is the road that descends. Another example of such hallucinatory—there is no other adjective—architecture, but in wood, is that of the retablos in the former Jesuit seminary in Tepoztlán. As we walk from daylight into ecclesiastical penumbra, we suddenly find ourselves in a kind of golden alveolus. Are we in the center of an enormous drop of solidified light? The sensation of *dépaysement*: we are here, but here is *there*.

This disarrangement of spaces goes beyond aesthetics to the spiritual. It corresponds to Góngora's poetic metaphors, which, through violent syntactical inversions, transpositions, and word play, overturn reality and make it *other*, something heretofore unseen. A charming secular example of this Baroque tendency is the palatial house built by an eighteenth-century widow, the condesa del Valle de Orizaba. On a whim she ordered the entire house to be sheathed in tiles. The result is pleasing; more than pleasing, appealing, if somewhat disconcerting. Tiles also adorned the kitchens and, especially, baths. A Baroque metaphor and symbolic striptease: interior converted into exterior. A sly architectural wink. Baroque art tends to dematerialize objects: not the palpable tree but its watery reflection; not the tower but its shadow. Stone becomes foliage, curtain, cloud; a play of reflections that fades as we try to grasp it. This is yet another example of the inveterate tendency of the human mind to make of *this*, stone or metal, something that seems to be *that*, greenery or lace. It is a tendency that appears with regularity throughout the history of the arts: the Flamboyant Gothic, the Baroque, Art Nouveau . . . We are astonished by the variety of objects and beings that compose the world, but we despair at our incapacity to apprehend them in a single intuitive act. What is left? What is left is the metaphor that reconciles conflicting realities: the conceit of the metaphysical poet, the philosopher's "harmony of opposites." What is left is the Baroque.

The Academy and the Workshop

Mexico has experienced two major historical changes, the Conquest and Independence. These changes were births. New Spain was a society radically different from the indigenous societies that preceded it, and Mexico, although in lesser degree, is an entity separate and distinct from

New Spain. The great mutation was the Conquest, since it entailed a change of civilization, whereas Independence was a change of political regime. The Conquest broke the millenary isolation of Mesoamérica; however, as our relationship with the outside world came first through Spain, our vision of universal culture was one seen through Spanish eyes. Independence opened doors to the broader world, and suddenly, with very little preparation, we found ourselves thrust upon the great stage of international history, with all its disputes (witness our wars with the United States and France).

The process of aperture had actually begun fifty years before Independence. Under the beneficent rule of Charles III, an "enlightened" monarch, ideas of emerging modernity had begun to seep into Mexico. Shortly after, given the examples of the French and American revolutions, these ideas would be the yeast of the movement for Independence. It was an era of great reforms in Spain and in Spain's American domains. Neoclassicism, especially in its French and Italian versions, displaced the Baroque tradition. These tendencies spread to Mexico, and in 1781 the Academy of San Carlos, the center of the Neoclassic movement, was founded.

The Academy had a brilliant beginning. Among the teaching faculty of this initial period was a first-rate artist named Manuel Tolsá, a sculptor and architect. He was born in Valencia, Spain, but his life and works belong to Mexico. Like all Neoclassic artists, he always started from a model (he venerated the precept "imitate the ancients"). Tolsá was, however, a synthetic, not an eclectic, talent; he proceeded not by accumulation or superimposition, but by elimination. The result, especially at his best, was frequently a work of great strength and economy, concentration and balance. Two of his works are outstanding and deserve to be considered as part of the artistic patrimony of America: the equestrian statue of Charles IV and the Palacio de Minería. It has been said of the former that Tolsá was overly indebted to François Girardon's equestrian statue of Louis XIV. That is difficult to judge, since Girardon's work was destroyed during the French Revolution. In any case, Tolsá's sculpture is superb. The Palacio de Minería is majestic, not grandiose. It has the tranquil beauty of reason. It is solid without being heavy, convincing without being emphatic. It does not excite us, it persuades us. Manuel Toussaint regards it as cold. I would say that it has the slightly melancholy circumspection of all that is noble in this base world.

The Academy suffered many vicissitudes. For over half a century Mexico underwent a period of civil and foreign wars, an enormous drain of wealth, and the disintegration of all that had been built up during three hundred years of peace. Through all these upheavals the Academy survived and maintained the continuity of the culture; moreover, it was Mexico's only line of communication with universal art. The Academy produced a number of worthwhile artists. The most distinguished was Juan Cordero. He painted murals and a few portraits that I find impressive for their clever craftsmanship and skill with volumes. There was a more popular and spontaneous tradition composed of painters working in the provinces, not in reaction to the Academy but on the fringes, and ignored by it. They have been called popular, or, alternately, regional artists. Both

Palacio de Minería, Mexico City; designed by Manuel Tolsá. Photo: E. Logan Wagner

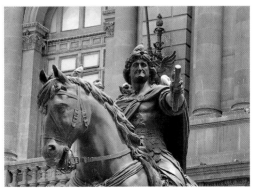
Manuel Tolsá. Equestrian statue of Charles IV. Mexico City. Photo: E. Logan Wagner

terms, although they do not define them, are useful. The isolation and traditionalism of these artists do not imply that they were entirely lacking in aesthetic training. For one thing, works of art could be viewed in the Mexican provinces, as well as books of prints and engravings. In addition, in every city of any importance there was a small academy or, at the least, a studio where a maestro offered lessons in drawing, painting, and sculpture. This was a tradition inherited from the workshops of the preceding centuries.

These painters took their subjects from everyday life and often painted commissioned works: portraits of a father or a sweetheart, a betrothed couple or a young girl, regional scenes, private and public parties, bodegones. Like their contemporaries in other countries, they are not known by name. Although no one would deny the charm of this sort of painting, its grace cannot atone for a certain monotony. These were undoubtedly artists, but artists captive to a manner—the source of our interest in them, as well as their limitation. The true artist escapes the style of his epoch, he goes beyond manner-become-formula to create a personal language. The greatest artists, moreover, give us a world vision. In this tradition we find three painters who transcended the common language and achieved a more authentic and personal expression: José María Estrada (active 1830–1860); Agustín Arrieta (1802–1874); and Hermenegildo Bustos (1832–1907). Each of the three attended a painting school or for a brief time studied with a maestro. Each worked in isolation and without a clear awareness that he was part of a tradition that was slowly dying out. The most cultivated was Arrieta; the most traditional, Estrada; the most profound and personal, Bustos.

We remember Estrada for his portraits, notable for their perception of volumes and for what might be called the *weight* of his forms. Solemn, earthy painting, bound to the soil. Estrada does not offer us a true psychology but a human prototype, a document. A limitation? Yes, but also veracity. Those portraits say to us: *this is how I was.* Arrieta is less static, more vivacious. He painted regional scenes with popular types that make us smile. His weakness is his picturesqueness. His forte, the splendid bodegones in which his sense of composition triumphs; his precise line; his clear, vivid colors; his sensuality. The case of Bustos is something of a miracle. Isolated in a forgotten town in Guanajuato, buried in a rustic traditional society, tied to labors of the field and the pleasures and devotions of that life (the Devil and the Church), he succeeded independently in re-creating the great art of the portrait. His canvases are small but that smallness contains a psychological, if not physical, immensity. Each painting stands as a question that can also be a revelation. His subjects are local folk, simple people living simple lives, but Bustos has penetrated their innermost being, revealing something we knew but had forgotten: all human beings are exceptional. And they are exceptional because they have *souls.*

The last decades of the turbulent nineteenth century were peaceful and prosperous although politically and socially stagnant. A new and well-to-do class emerged during the thirty years of Porfirio Díaz's regime. As in the era of the Baroque, although more briefly and with less splendor, a

segment of society again served as patrons of the arts. In the paternalistic tradition of the Spanish patrimonial state, the government, too, sponsored artistic endeavors. The two most important painters of our nineteenth century come from this period: Hermenegildo Bustos, mentioned earlier, and José María Velasco (1840–1912). Just the opposite Bustos, Velasco made a natural and expected appearance on the scene. He was the final and fully achieved product of the Academy, whereas Bustos was the last expression of a peripheral tradition. The differences between the two men include their lives as well as their works: Bustos was a painter of the human face, the personal; Velasco was a painter of landscapes, the impersonal.

The Academy began with an uncommon talent, the sculptor Manuel Tolsá. It ended almost a century later with another great talent, the painter José María Velasco. With Tolsá began a tradition that, like the academy, ended with Velasco. I am referring to the aesthetic based on confidence in a vision of perceptible reality gained through reason, the senses, and the prolongation of those senses, scientific instruments. As Tolsá believed in reason and geometry, Velasco believed in the modern science of his time. In order to perfect himself in his craft, he studied mathematics, botany, zoology, anatomy, and geology. He was a photographer and a member of the Natural History Society. In those years Mexican intellectuals swore by Comte and Spencer, as earlier they had been disciples of St. Thomas Aquinas and later would be of Marx. Like Constable, Velasco believed that painting was a science and that landscape painting could be considered a branch of natural science. The history of modern painting is the history of the freedoms painters have taken with so-called objective reality, which they have converted successively into sensation, idea, structure, sign, and imago. In this sense, an aesthetic ends with Velasco. But his painting endures. It is not idea, but visible reality.

Like the painters of the Hudson River school, Velasco perceived the grandeur of American nature. Unlike them, he was not inspired by a Romantic sense of the sublime but rather by the contemplation of the order and harmony governing vast spaces. There is nothing picturesque in his paintings. He sees the world as the enormous theater of the accidents and phenomena of nature—changing light, the ocher whirlwind of dust in the distance, the sun shimmering at three in the afternoon on the polished stones of a dry stream bed, the green rain of the *piru* tree falling upon the motionless pond. His greatest compositions are almost always divided by an invisible line, the boundary between two zones of reality, earth and air. A landscape without people and without drama. Nothing moves and nothing happens, except light. Velasco's painting is nothing if not the chronicle of light and its epiphanies. The Valley of Mexico he painted no longer exists; it has been consumed by urban leprosy. But his paintings remain unchanged. He believed in what he painted, although the reality he painted has vanished. Did he lie? The contemporary English poet Charles Tomlinson has written, "The artist lies for the improvement of truth. Believe him."

The engraver José Guadalupe Posada (1852–1913) was a contemporary of Bustos's and Velasco's, but he did not know them, nor they him. He lived the capital, like Velasco, but among newspapermen and artisans, not well-

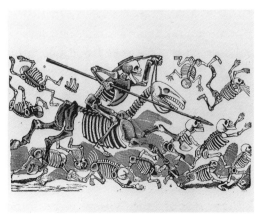

José Guadalupe Posada. *Calavera Don Quijote.* Woodcut, modern restrike from relief zinc block. Art Institute of Chicago, William McCallin McKee Fund

known artists and famous professors. His theme was not the spectacle of nature, like Velasco, nor the mystery of the human face, like Bustos; his subject was the great theater of the world of man, at once drama and farce. He was the engraver and chronicler of the daily scene. His work is vast and diverse, not diffuse. Even with the quantity and variety of his work, he maintained stylistic unity. Naturally, there is much that can be discarded, something that is true of all artists who have written or painted hastily and in great volume, from Lope de Vega to Picasso. Posada's art has humble origins among the caricaturists who illustrated nineteenth-century Mexican newspapers and who were in turn influenced by European caricaturists, especially the French. Posada soon created his own style, endlessly enriched with surprising variations. How to define his technique? A minimum of lines and maximum of expression. By birthright Posada belongs to a manner that has left its stamp on the twentieth century: Expressionism. Unlike the majority of Expressionist artists, however, Posada never took himself too seriously.

When André Breton saw Posada's engravings for the first time, he commented that he had discovered one of the originators of black humor in the visual arts. I do not know whether Posada's humor is black, green, or violet; probably it is every color. I do know that his humor is imbued with sympathy for the weakness and folly of man. It is not a judgment but a wink that is simultaneously one of mockery and complicity. Velasco sought the constancy of nature even in storms; Posada was fascinated by the incredible variety in human nature. He was a true moralist. By that I mean a moralist who did not set out to be one, nor to teach us a great lesson. An involuntary moralist; he shows without instructing. Does the nineteenth century end with Velasco and Posada? Yes and no. Velasco was Diego Rivera's teacher, and Posada had great influence on the art of Orozco.

Eagles and Jaguars

The first artistic movement of the American continent was Mexican muralism, begun in 1921. It is usually considered to be a consequence of the Mexican Revolution, which had started some ten years earlier. This is true, but it is not the whole truth. The artists who participated in the movement had been trained in the art schools and academies of the previous regime. They belonged to the same generation, they had lived through similar experiences, and they had similar objectives and ambitions. They all had talent and the will to create. Thus they would have produced a body of work in any case. Yet we cannot deny that their lives and their art would have been very different had it not been for the Revolution. In the first place, the revolutionary government offered them the walls of its public buildings; second, the Revolution was a convulsive period in our history that revealed many previously unknown aspects of our country. The Revolution not only set itself the goal of creating or inventing a new society, it also proposed to rescue, even disinter, the Mexican past. One of its distinctive characteristics, therefore, was traditionalism. Utopian fervor, although significant, was not the determining factor. Here the great

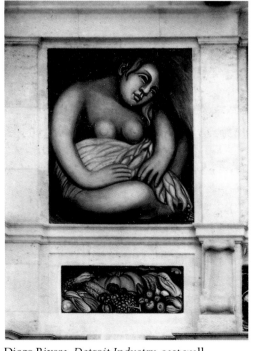

Diego Rivera. *Detroit Industry*, east wall, detail, 1932–33. Fresco. Detroit Institute of Arts, Founders Society Purchase, Edsel B. Ford Fund

revolutionary innovation was the rediscovery of the motherland, along with its popular arts and traditions. The word *revolution* became synonymous with a word vibrant with religious resonances, *resurrection*.

Mexican muralism was also the result of a different revolution, European not national, aesthetic not political: the modern-art movement. Although Mexican artists were trained in the Academy, each of them early on had become acquainted with the tendencies that since the first decade of the century had begun irreversibly to modify the face of art. Diego Rivera studied on a fellowship from the government of Porfirio Díaz and worked in Europe from 1907 to 1921, first in Madrid and later in Paris. In those days Paris was the mind and heart of the modern movement. Rivera participated in the adventures of the avant-garde and for some years embraced Cubism. David Alfaro Siqueiros was also in Europe for a short time; he was interested in the art of the Futurists and in the "metaphysical" painting of De Chirico and Carrà. Nor was José Clemente Orozco indifferent to modern trends. In his first works we see traces of the Expressionists, even of the Fauves. The influence of modern art is visible in more than form, theory, and technique; modern art literally opened these painters' eyes and allowed them to view the ancient art of Mexico in new ways. Cubism showed Rivera the way to comprehend Mesoamerican sculpture, and other artists, such as Gauguin, revealed the magic of a nature and a way of life foreign to modern urban civilization. The road to the Mexican past wound through Paris and the cosmopolitan twentieth-century avant-garde.

The tradition of mural painting is an ancient one in Mexico. Its history is mingled with our history. All Mesoamerican cultures left examples of mural painting, and it is a tradition also present in New Spain and the nineteenth century. In 1920 a remarkable man, the writer José Vasconcelos, minister of education and fine arts for the revolutionary government, decided to commission painters to decorate the walls of major public buildings. The idea grew out of the Mexican tradition and, especially, the examples of Byzantium and the Italian quattrocento. He dreamed of a public art for the Mexico that was being born (or reborn) in those days. At this point we need to stop for a moment to undo a long and deplorable misconception.

In its earliest stages, which was the period of its discoveries and the period that gave it its physiognomy, Mexican mural painting did not have the Marxist—more accurately, communist—coloration for which it later became famous. It was a social but not ideological painting, nationalistic with tendencies that might either be called populist or humanist. These were also the forces of the Mexican Revolution, which never had the doctrinal and dogmatic characteristics of other revolutions of this century. Thus it is more pertinent to speak of inclinations and tendencies than of ideas and doctrines. Between 1921 and 1924 these artists painted scenes of everyday life, "the life and times" of Mexicans, revolutionary exploits with their heroes and martyrs, symbolic landscapes, patriotic annals, and religious celebrations. There are an impressive number of murals on religious themes. There were also theosophical allegories, very

much to the taste of the minister of education, José Vasconcelos, such as Rivera's first mural in the Colegio de San Idelfonso. The phenomenon is not as strange as it appears at first view. The Mexican Revolution had rediscovered popular traditions, and in this first epoch it could not ignore the central role of Catholicism in Mexican customs and beliefs.[11]

Everything changes between 1924 and 1925. Vasconcelos resigns from the Ministry of Education, a new government begins a more extremist and violently anti-Catholic policy, and a number of artists join the communist movement, among them Rivera and Siqueiros. Their conversion is a further example of the great wave of hope that rose up throughout the world in the wake of the October Revolution, particularly in the intellectual community. But the case of Mexico is unique. The government was not communist, so there was a commonality of political interests, not a coincidence of ideas, between government and painters. It was an advantageous arrangement for both parties and lasted many years, unbroken either by swings in governmental policy—at some moments hostile to communists—or by the revolutionary activities of the painters. The history of the second period of the movement is a long one and has been told many times. All was not lost; there were great moments in that second period, and outstanding works were painted. But aesthetic and political dogmas became more and more rigid until the movement stalled in repetition and self-imitation. Muralism died of an ideological infection. It began as a search and ended as a catechism. It was born free and ended by exalting the liberating virtues of chains. There were exceptions. The greatest was that of the greatest among them, José Clemente Orozco.

Can we see the works of Rivera and Siqueiros except through the distorting glass of ideology? This is a difficult question to answer for a contemporary of Hitler's and Stalin's.[12] My answer is an unequivocal *yes!* For we see their painting, not their moral and political aberrations. Without their work, twentieth-century art would be lacking a universal dimension. In the visual arts the Mexican muralist movement was the first American answer to the long monologue of European art. There had been, it is true, other experiments, but they were isolated and episodic. The true precedent is to be found not in painting or sculpture but in literature, in Melville's novels and Whitman's poems. In 1921, for the first time in the history of the art of our continent, a group of artists absorbed the European legacy, especially that of modern art, and, without disavowing it, responded with a distinct art that expressed distinct realities. Until then America had received European forms and reinterpreted them—often with great originality. Muralism was the first conscious and deliberate answer to European art. It began the great dialogue between Europe and America that, using a different aesthetic language, North American Abstract Expressionism would continue. It must be remembered, of course, that at an early stage some Abstract Expressionists worked with the Mexican artists and that many others were early influenced by the Mexicans.

Diego Rivera was not an innovator but a great eclectic talent capable of assimilating a wide variety of lessons, from the quattrocento to Cézanne,

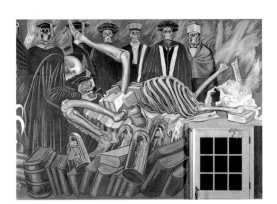

José Clemente Orozco. *Gods of the Modern World*, panel 17 of *The Epic of American Civilization*, 1932–34. Fresco. Hood Museum of Art, Courtesy of the Trustees of Dartmouth College

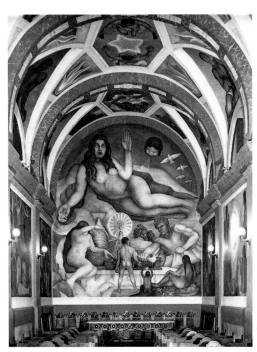

Diego Rivera. *The Liberated Earth*. Fresco. Chapingo, Mexico. Photo: Enrique Franco Torrijos

from Gauguin to Picasso, from popular Mexican art to the Ensor of *The Entry of Christ into Brussels*. Great artists are distinguished by great appetites, and Rivera's were enormous. An artist of consummate ability and an indefatigable worker, he covered kilometers of walls with scenes of the history of Mexico and the world, with revolutionary allegories and political satires. History was cruel. It has given the lie to his prophecies and ridiculed his anathemas. But a compassionate nature filled his cup to overflowing. He did not paint nature in its tempestuous moods but in those serene hours that are like islands of bliss in the river of time: children in a fruit tree, women bathing in a river, flowers on a table, a child with round and questioning eyes. Not the great revolutionary battles but what lies beyond history. Rivera's true myth was not the Revolution but the fruitfulness of nature, incarnate in woman. On the walls of Chapingo, woman is earth, water, and seed. Rivera never tired of painting the daily mystery represented by the female body lying beneath the large green leaves of the Beginning.

David Alfaro Siqueiros. *The New Democracy.* Fresco. Museo del Palacio de Bellas Artes, Mexico City

Siqueiros, or movement. Convulsive movement, struggling against itself. A painter of contrasts, a descendant of Caravaggio and also of Géricault. A contradictory man: adventurer and actor, inquisitor and rebel, libertarian and Stalinist police agent, daring theoretician of painting and coffeehouse polemicist. A religious and fanatic temperament that took pseudo-Marxist simplistic ideas as articles of faith. He was an innovator who explored many territories: unusual points of view, photography, new materials and instruments. His experiments with "drip painting" were direct antecedents of Pollock, who was for some time his disciple. The inverse of Rivera, he was not extensive but intensive. At times his passion became gesture, and gesture degenerated into gesticulation. Other times his painting was a celebration, both somber and luminous, a nocturnal tempest, that reveals an incandescent matter creating forms never before seen. Lava, the volcanic psyche.

All his life Orozco defended the independence of the artist and, with the same passion, the mission of art. For him that mission was not political but spiritual, perhaps even religious—as long as it was outside all orthodoxies and churches. From the beginning he was attuned to Expressionism, and it is not difficult to find in his work echoes and resonances with such artists as Munch, Beckmann, and Rouault. Also El Greco and Goya, to say nothing of Posada. Orozco is one of this century's great Expressionists, and it is scandalous that he be forgotten or hidden now that there is a world Neo-Expressionist vogue. Orozco's vision was profoundly Christian, although his Christianity was esoteric. The subject of his early watercolors was the world of prostitutes and pimps, fallen woman. Later, *campesinos* and soldiers fallen in the fratricidal battles of the Revolution, and then, successively, corrupt leaders, soulless bankers, bloodthirsty ideologues—in other words, fallen man. Like the other muralists, he too was borne on the wild waves of history, but he did not believe that the tide led to an earthly paradise. He did not commit the modern sin of deifying history. His painting is not the chronicle of our march toward the future. For him, history was not a path but a purgatory, a process of testing and

purification. History tempers souls and is the crucible of heroes and saints. This tragic vision does not console us, but it reconciles us with the strange destiny of man. Orozco: sculptor of flames.

Muralism never entirely escaped being a rhetoric in paint. It is therefore not surprising that even before it degenerated into formula independent personalities and work should have appeared here and there, a silent rebellion of a few solitary individuals seeking a way toward universal art and toward themselves. The first signs appeared about 1930, and twenty years later the strain was dominant. No doctrine united these artists, and each of them developed independently. Although Rufino Tamayo was the central figure, there were others who, with less brilliance and energy but not without talent, contributed to the change. Carlos Mérida achieved a personal synthesis between Maya art and abstractionism. Julio Castellanos left a work in which volumes are supported by precise and elegant drawing. One of the most original painters of this time was Antonio M. Ruíz. In his small compositions lyricism is allied to a humor that does not hesitate to resort to the pun. The painting of Ruíz does not speak, it smiles. Two extraordinary women: María Izquierdo and Frida Kahlo. Izquierdo's paintings at times recall the regionalist painting of the past century, although transformed by oneiricism. Reality becomes ghostly, and ghosts, during nights of disturbing dreams, are incarnated in horses of powerful and melancholy sexuality. Two traditions are joined in Frida Kahlo, the academic and the Surrealist, as happens in many painters of the latter tendency (Ernst, Magritte, Dalí, Delvaux). Technical mastery at the service of the "madwoman of the house," fantasy. The painting of a visual poet, precise, precious, and piercing. Cruel humor; wound and flower. Kahlo and Izquierdo are very different, even antithetical, but in some way they complete each other. They are our Janus.

Rufino Tamayo is one of the great painters of the second half of this century. He comes immediately after the Surrealists and slightly before the Abstract Expressionists. In Latin America his companions are two other solitary artists, Matta and Wilfredo Lam. From the beginning Tamayo's painting has been distinguished by severe rigor and violent lyricism. Rigor prevented his falling into the ideological facility and pathos of his predecessors. Again and again he has said that painting is a world of plastic relationships: "Anything else is photography, journalism, literature, or whatever you may wish to call it—demagogy, for example." Rigor does not choke out lyricism, it constrains it to surrender to the dictates of line so it may burst out with even greater impetus. Geometry and passion. Tamayo is a great colorist. His palette is alternately iridescent and explosive, barbaric and refined: the folding fan of night, solar butterfly, green crushed by a savage hoof, tattooed wall, rose-red scar, mother-of-pearl. In few contemporary works, not excluding those of the greatest artists, does the ancient world appear with the explosive fatalism of Tamayo's painting. In his best canvases the Mesoamerican tradition is revived, transfigured. Tamayo's modernity is millenary. A few years ago I wrote, "If one could say in a single word what it is that distinguishes

Tamayo from other painters of our time, I would say, without hesitation: *sun*. It is in all his paintings, visible and invisible. Night itself, for him, is nothing other than the sun seared black."[13]

After Tamayo, the horizon cleared. The following generation appears about 1950. As everywhere else in the world, the characteristic of this period, which continues to the present, has been the multiplicity and coexistence of different trends and personalities. We are living in the twilight of a "modernity" that in the sphere of literature and art began almost two centuries ago with the first Romantics. It was an aesthetic based in the concept of rupture with immediate tradition, a reaction to classicism and its Mannerist and Baroque variants that cultivated "imitation of the ancients." This movement, in successive and always more violent waves, culminated in the avant-garde movements of the first half of this century. The second postwar period saw the rise of various tendencies that were in fact brilliant "revivals" of those of the preceding period. There were also important artists, especially in the United States, where they formed a true constellation. Since then, movements and pseudo-movements, personalities and pseudo-personalities have proliferated at an alarming rate. Avant-gardes grown old but rouged and beautified by two rejuvenating prefixes: *neo* and *trans*. The crisis of the various avant-gardes, however, is not the crisis of art. Our own period—called, inappropriately, Post-Modern—is probably no less rich in works than what went before us, although it is more confusing. Mexico has participated in both the confusion and the vitality of these years. Mexican art during the last thirty years has been intense and varied. For reasons of space and chronology the decision has been made not to include artists in this exhibition who were born after 1905—which is to say, contemporary art. The works of those artists will, however, be on view in New York galleries during the present exhibition at the Metropolitan Museum.

I have written these pages on Mexican art under the auspices of three emblems: the eagle, the jaguar, and the Virgin. The first two were representations of cosmic duality: day and night, earth and sky. Their disputes create the world, engender space and time, determine the rotation of the days and changes of nature. These two slopes of reality are manifest in many ways throughout our history. For example, Indians and Spanish, symbolized by west and east; North Americans and Mexicans, by north and south. This play of complementary oppositions is also seen in religion, ethics, and aesthetics in ways that are not our concern here. In sum, the history of Mexico can be seen as the clashes and reconciliations between two principles, aerial and terrestrial, represented by the eagle and the jaguar. Since ancient times, however, there have been mediators. The Indians conceived Quetzalcoatl, serpent and bird, a being in whom the earthly and celestial principles are joined. In the sixteenth century, religious imagination revealed another mediating figure, the Virgin of Guadalupe. She is even more mysterious, more profound and complete. On the one hand, she is mediation between the Old and New Worlds, between

José Clemente Orozco. *The Table of Brotherhood.* Fresco. New School for Social Research, New York

Christianity and the ancient religions. In addition, she is a bridge between the here and the beyond. She is a virgin, yet she is the mother of the Savior. She reconciles not only two aspects of reality, but the two poles of life: female and male. What better than these three figures, two of creative opposition and one of transcendent mediation, as advocates/intercessors for an exhibition of Mexican art?

Mexico City, August 19, 1989

NOTES

1. "I balk at sleep as if it were a hole/filled up with horrors, leading God knows where . . ." From "Le Gouffre" ("The Abyss") in *Charles Baudelaire, "Les Fleurs du Mal,"* translated by Richard Howard (Boston, 1982) p. 16.

2. Some historians believe that Mitla was the creation of the Mixtecs. In this case, as in others (El Tajín, Tula, even Teotihuacán), the debate continues.

3. Certain historians maintain that the influence occurred in reverse order; that is, that there was Maya influence in Tula. Although relations between the highlands and the Maya zone were unbroken from the end of the Formative period, this is a difficult hypothesis to accept: all the evidence of the Yucatán argues against it. But again, the debate continues.

4. "dissolve into a clarity in the form of a lake./A foliage of transparency/grows on its shore. Fortunate/rhyme of peaks and pyramids,/the landscape unfolds/in the abstract mirror of the architecture. . . ./The waves speak Nahuatl. . . ./(engravings: volcanoes, temples,/and the feathered cloak stretched over the water: Tenochtitlan soaked in blood)." From "Pasado en claro" ("A Draft of Shadows") in *The Collected Poems of Octavio Paz, 1957–1987*, edited and translated by Eliot Weinberger (New York, 1987) pp. 434–37.

5. Mary Ellen Miller, *The Art of Mesoamerica from Olmec to Aztec* (New York, 1986) pp. 104–5.

6. *Hule* (rubber): from the Nahua *ulli*. The designation *olmeca* refers to the "peoples of the *hule* country." Among the Nahuas, the game was called *ulama*.

7. The game—between two teams using a rubber ball—was first played in Mesoamerica; modern football and basketball are offspring of this ancient ritual game. (A kind of football was played by the Egyptians and the Romans; a sort of football was also popular in medieval England. But in all these cases the ball was stuffed and therefore did not bounce or rebound. The two important elements of the game—two teams and a rubber ball—appear for the first time in Mesoamerica about the first millennium B.C.)

8. Michael D. Coe, *Mexico*, 3d ed. (New York, 1984) p. 163.

9. Note especially the work of Yuri V. Knorosov, Heinrich Berlin, and Tatiana Prouskouriakoff. See Michael D. Coe, *The Maya*, 4th ed. (New York, 1987), Linda Schele and Mary Ellen Miller, *The Blood of Kings: Dynasty and Ritual in Maya Art*, exh. cat., Kimbell Art Museum (Fort Worth, 1986), S. D. Houston, *Maya Gliphs* (Los Angeles and London, 1989), and Linda Schele and David Freidel, *A Forest of Kings* (New York, 1990).

10. On the highlands, called, respectively, Chichimecs and Toltecs.

11. On the religious tendencies of the first period of the muralists, the testimony of Orozco and Siqueiros is revelatory. See also Jean Charlot, *Mexican Art*, vol. 2 of *An Artist on Art: Collected Essays of Jean Charlot* (Honolulu, 1972); Laurence E. Schmeckebier, *Modern Mexican Art* (Minneapolis, 1939), and Octavio Paz, *Los privilegios de la vista: arte de México*, vol. 3 of *México en la obra de Octavio Paz* (Mexico, 1987).

12. This terrible question extends to many great artists: Pound, Brecht, Céline, and Neruda, among others.

13. Octavio Paz, "Transfiguraciones," in *El signo y el garabato* (Mexico, 1973). Reprinted in *Los privilegios de la vista*, p. 369.

Precolumbian Art

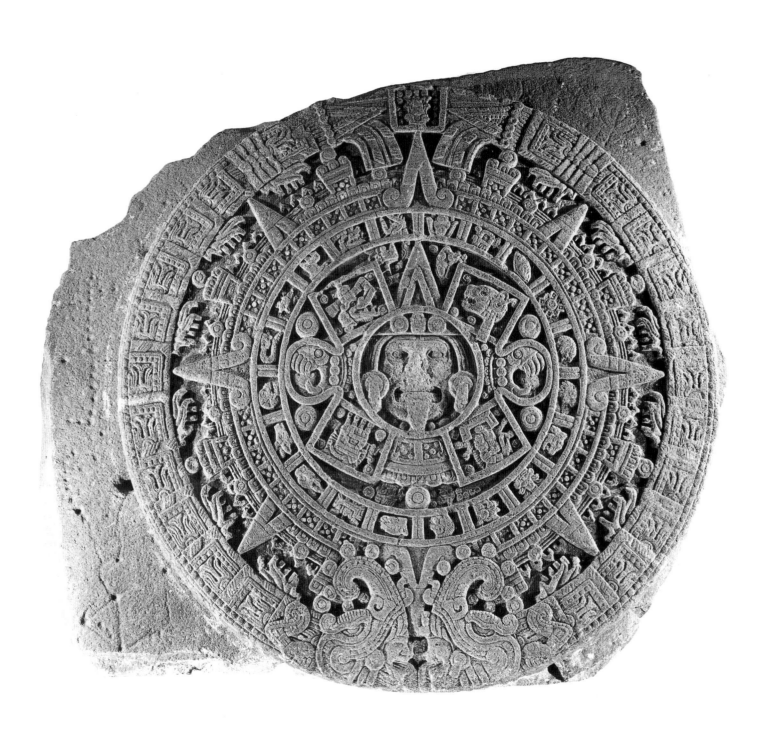

Piedra del Sol. Stone. Aztec. From the Sacred Precinct, Tenochtitlan. CNCA–INAH, Museo Nacional de Antropología, Mexico City. Photo: INAH

▼▼▼

Ancient Mexican Art: Diversity in Unity

BEATRIZ DE LA FUENTE

The art of ancient Mexico has today assumed its rightful place in the history of world art. This recognition began at the end of the nineteenth century as a result of the convergence of three fundamental factors: the accounts of travelers to Mexico informing the world of its archaeological riches; the late resonances of Romanticism which extolled the "purity" and "exoticism" of "primitive" peoples; and the influence that the art of those peoples had on European artists, beginning with the Impressionists. Due to aesthetic eclecticism, art shaped by canons different from those of Western tastes was definitively accepted on equal terms with the art of classical antiquity and the Renaissance.

The arts of ancient Mexico present a mosaic of styles in which each piece manifests a specific artistic volition. They are determined to a certain degree by geography and climate. The art and architecture of the high temperate zones of central Mexico are more rigid, severe, and geometric in form than the exuberant, organic, and sensual art of the tropical lands of the coastal regions.

Olmec is the name by which the first great art of Mesoamerica is known. This style appeared during the centuries around the turn of the first millennium B.C. (1200–600 B.C.) almost simultaneously in various sites along the coast of the Gulf of Mexico: San Lorenzo, La Venta, Laguna de los Cerros, and Tres Zapotes. It is characterized by well-defined architecture and planning, spectacular basalt sculptures, and small masterworks in jade.

At La Venta the plan of the ceremonial area is determined by a central axis laid out from south to north, with a slight deviation toward the east; the principal structures (largely of clay construction) maintain a bilateral symmetry in relation to the axis. It was here that the ruling principles of Mesoamerican architecture were established: the negative space of the plazas balanced by the volume of the mounds and pyramids that limit and order such spaces.

The formal and thematic language of the approximately three hundred colossal Olmec sculptures known today is unmistakable. It was defined at San Lorenzo and from there traveled to La Venta, where it was consolidated. Its dominant qualities are a clear preference for volume, ponderous masses, geometric structures, a preponderance of rounded surfaces, and, above all, just and harmonious proportion. Visually three groups capture our attention: first, the most common, human figures; second, composite figures constituted of human bodies with animal (or fantastic-creature) faces and extremities; and, third and least common, animal figures.

The first group includes impersonal seated figures like those from San Martín Pajapan, Cruz del Milagro, and Cuauhtotolapan, and the sixteen colossal heads—nine in San Lorenzo, four in La Venta, and three in Tres Zapotes. The heads, which compose a group unique in art, are portraits of

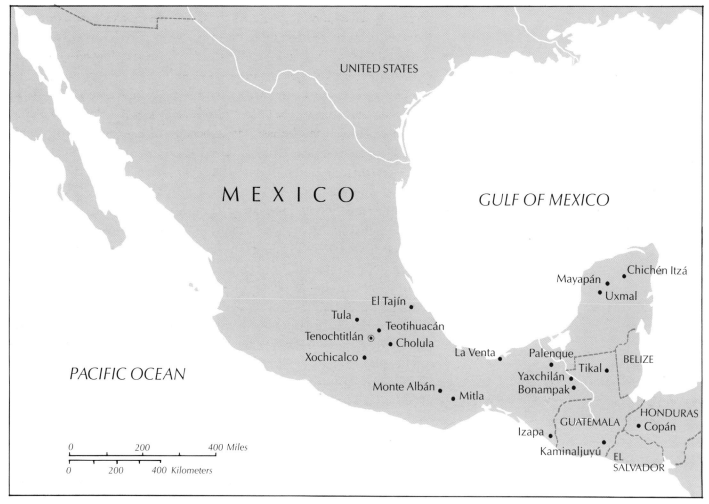

Major archaeological sites

rulers in which the image of the man coincides perfectly with the Olmec concept of cosmic order.

Other sculptures have mythic significance, like the "thrones" or "altars" that depict a myth of origin: man emerging from the cave or earthly womb. Aspects of sacrificial ritual are present in the human figures holding children with elongated heads and fantastic facial features. Such heads, which are found on other colossal sculptures and many small jade figures, were once thought to represent deities in the guise of monstrous jaguars. Today they are recognized as images that incorporate characteristics of other animals—serpents, eagles, monkeys—but in such a way that their identity is still uncertain. They may be either gods or mythological beings.

The Olmecs were the first to make masterful carvings from translucent blue-green jade and other varieties of jadeite. Human figures and portraits of rulers display distinctive Olmec features: corpulent body; short, thick neck; deformed, pear-shaped head; heavy-lidded eyes; and thick lips downturned at the corners. The Olmecs carved masks of singular beauty, as well as other ritual objects such as the *hachas* (axes) with large fantastic heads and stylized human bodies; celts; plaques; perforators; and canoe-shaped objects.

After the decline of Olmec art (300 B.C.–A.D. 250), the Izapa style manifested itself on remarkable stone stelae and altars. The style is found

across a broad region that includes the Gulf Coast, Oaxaca, and central Mexico. At Izapa the artistic language of the Olmecs changes dramatically, and three-dimensional sculpture is replaced by a low relief that favors scenic narrative. Single images become elaborate mythological discourses ranging from imitations of natural forms to abstractions of them. The Izapa style bridges late Olmec iconography and the oldest Maya images. It is at Izapa that the association between the stelae (historical and mythological commemorative monuments in the form of vertical slabs) and the altars (low monuments with zoomorphic elements) that represent the earth monster is first noted.

Supernatural images dominate the mythological scenes: large masks appear at the extremes of flowing water, at the base of mythic fruit trees, or at the tail of two-headed serpents; winged anthropomorphic figures are seen in a descendant attitude; trees whose roots sink into the earth through the heads of caimans; serpents whose bodies arch into a U; skeletal figures sailing on rafts suspended in space. Men with impersonal semblances are secondary figures: they act as officiating priests, they guard censers holding fire, they complete the mythic narrative, and they take the role of sacrificers and sacrificed.

Primordial myths based on the life cycle of man and nature are the principal themes. They are described in three sections on the stelae: the subterranean, or underworld, on the lowest part of the stone; mythic stories, the strongest visually, on the middle segment; and, on the upper portion, the heavens.

To express such concepts, the Izapan sculptors utilized certain formulas of perspective: larger figures indicate the foreground, smaller figures, the far distance. They also created natural and fantastic forms that undergo a metamorphosis within a single image, and endowed the different figures with dynamic attitudes that breathe life into the scenes. It is believed that the consistent recurring patterns on the reliefs—upper and lower bands with diagonal stripes centered by a U, occasionally with wide volutes— symbolize the jaguar and are the specific emblem of Izapa. Earth, shown by serpents, jaguars, and plants; water, represented by undulating designs patterned with plump fish; and fire, seen as volutes rising from censers, are other symbols that appear frequently in these unparalleled Izapan reliefs.

From A.D. 250 to 900, the art of Mesoamerica reveals, in its opulence and diversity, the cultural energy of a number of cities: Teotihuacán on the central highland, Monte Albán in Oaxaca, El Tajín in Veracruz, and Tikal, Copán, Palenque, Yaxchilán, and Piedras Negras, to name the most important, in the central part of the Maya zone.

Teotihuacán, the largest city, imposed a severe geometry upon its urban design, constructions, and sculpture and to a lesser degree on its ceramics and paintings on walls and vessels. At this site, space is ordered into vast square or rectangular plazas bounded by pyramids and platforms that mimic the geometric forms of the plazas. Two great intersecting axes extending from north to south—the Street of the Dead—and from east to west along one side of the Ciudadela, anchor the structures of Teotihuacán. These axes form the urban grid within which the pyramids, temples, palaces, and enormous residential complexes are situated.

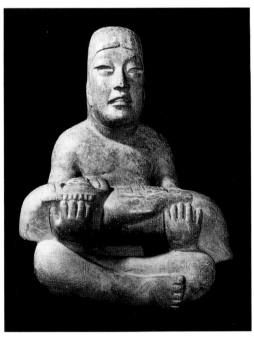

Priest with supernatural "infant." Greenstone. Olmec. From Las Limas, Veracruz. Museo de Antropología de la Universidad Veracruzana, Xalapa. Photo: INAH

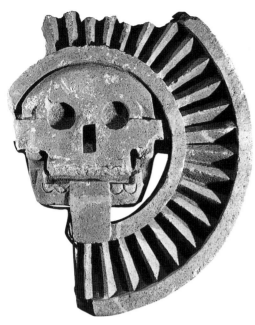

Disk with skull. Stone. Teotihuacán. From Plaza of the Pyramid of the Sun. CNCA–INAH, Museo Nacional de Antropología, Mexico City. Photo: INAH

With the simple forms of the sloping-wall foundations the great Pyramids of the Sun and the Moon express the apparent dichotomy of Teotihuacán architectural language: the ascendant thrust of pyramidal volume, intercut by the horizontal span of superimposed platforms. These forms are accentuated by the *talud* (talus, or sloping wall) and the *tablero* (vertical panel or inset) whose molding frames an inset frieze. In early periods friezes were painted with flat colors; at the height of the city's splendor they were ornamented with sculptural reliefs, as on the Temple of Quetzalcoatl where heads of plumed serpents and geometric masks of the rain god Tlaloc alternate in perfect and uninterrupted rhythm.

Stone sculptures echo the forms of buildings in such a way that the gigantic figure of Chalchiuhtlicue, goddess of water, and the effigies of the Huehueteotls, the gods of fire, appear as massive prism shapes. The many stone masks—granite, serpentine, onyx—are severe, uniform faces that similarly reiterate the rigorous Teotihuacán canon.

The cosmopolitanism of Teotihuacán is evidenced in the eclectic character of its ceramics and mural paintings. These are abundant, varied, and excellently crafted. During its centuries of greatness the city must have been alive with color: flat color painted on exteriors and polychrome scenes on the interiors. In the early periods the palette was broad: brilliant reds, vivid blues and greens, ochers, and blacks. With time, the palette was reduced and images were repeated so faithfully that they might have been made with a stencil.

Space in these scenes is two-dimensional, perhaps because of the imposition of an official pattern that deliberately suppressed planes indicating depth. The murals present large images of gods or priests with rich vestments and masked faces participating in rites and ceremonies. They are often depicted with water flowing from their hands; these streams are filled with animals and jade-colored objects symbolizing rain. Other animals are also seen: the mythic plumed serpent; jaguars, nose to nose or single file; and birds with brilliant plumage. Images of flowering trees with glyphs at their base indicate the existence of an ideographic system of writing. The most important scenes have been found in the palaces: Tepantitla, with its famous paradise of Tlaloc, Tetitla, Yayahuala, Zacuala, Techinantitla, Tlacuilapaxco, and others that have brought artistic renown to that great city.

By the third century A.D. in Monte Albán, Zapotec style has already been prefigured by earlier works. It will be fully developed during the following five centuries when it incorporates formal schemes that originated in Teotihuacán.

A religious and funerary city, Monte Albán, built on a mountaintop in the center of the Valley of Oaxaca, expresses Zapotec architectural language with pristine clarity. It is constructed with enclosed spaces, plazas, and the flattened volumes of pyramidal foundations. Each platform is composed of a *talud* and a *tablero* which is open at the bottom where an inverted U is formed by two moldings (the *doble escapulario*) producing a pleasing effect of chiaroscuro.

The north-south orientation governs the position of the structures, and

although the plan is reminiscent of Teotihuacán, it does not imitate it. Thus the profile of the Main Plaza rising from the summit of the mountain reveals structures aligned to east and west; all are of different elevations and the visual effect replicates the natural forms of the mountains in the background. The Plaza is enclosed at the north and south by architectural complexes consisting of other plazas and buildings. Set before the larger pyramid and to the west are the only twin constructions—Systems M and IV—each with a low pyramid and an enclosed plaza indicating their intimate and sacred nature.

Painted scenes are restricted to funerary precincts. Walls with images of deities seem to lead in opposite directions. One directional perspective orients the viewer toward the principal image. Sharply outlined silhouetted figures painted in flat colors stylize natural movement and symbolically enact religious and mortuary rituals in unreal space.

The custom of erecting stelae to illustrious men may have come to the Zapotecs from lands to the south. The formal Zapotec scheme is simple: a standing ruler or warrior is superimposed on the emblem for a hill accompanied by a hieroglyph for place. Individuals and symbols are worked in very flat relief with linear characteristics that recall the funerary paintings.

The Zapotecs show their superior skills as sculptors in their unique clay urns. The common characteristic is a voluminous modeled image affixed to a hollow cylinder. In early times they represent gods and goddesses with human countenances; in later times ornamental forms proliferate: the headdress is exaggerated, the face is covered by a mask with fantastic features. The human figure is without expression; the seated posture is unalterable, with the hands resting on knees or feet. These clay urns demonstrate the official art imposed by the ruling elite.

The people who inhabited the central Gulf Coast from the seventh to the tenth century A.D. also display particular features in their works of art. El Tajín offers the best example of architecture, while stone and clay sculpture was abundant in several lesser sites of what is today the central portion of the state of Veracruz.

The buildings of El Tajín reveal a freer spirit than those of either Teotihuacán or Monte Albán. They adapt to the topography by means of groupings of structures clustered around plazas. The forms vary in height and ornamentation, producing an elegant and dynamic visual effect; the impression is further enhanced by contrasts of light and shadow created by the niches and jutting cornices embellishing the tiers of the pyramids. The Pyramid of the Niches is an outstanding example: the niches on the six superimposed levels are placed at regular intervals. They total 365, as in the Pyramid of Tlaloc and Quetzalcoatl in Teotihuacán, and that number verifies their use for calendrical and ritual purposes.

Thirteen courts for the ritual ball game are found in the central section of Tajín, indicating the game's importance at that site. The vertical walls of the South Ball Court exhibit reliefs with scenes of the ceremonial game in the double-outline linear style, which includes interwoven scrolls and bands.

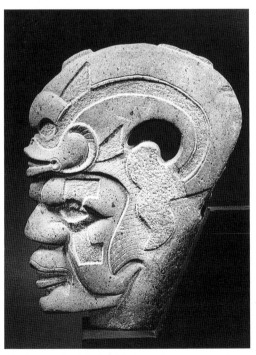

Hacha, head with dolphin headdress. Stone. From Los Tuxtlas region, Veracruz. CNCA–INAH, Museo Nacional de Antropología, Mexico City. Photo: INAH

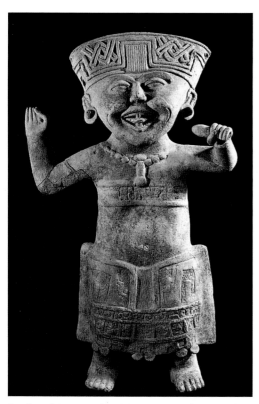

Smiling figure. Ceramic. From central Veracruz. Museo de Antropología de la Universidad Veracruzana, Xalapa. Photo: Enrique Franco Torrijos

Three types of stone sculpture appear to have originated in this region, and all are associated with the ball game: the *yugos*, the *hachas*, and the *palmas* wrought with such astounding mastery and sensitivity. The horseshoe shape of the *yugos* (yokes) symbolically reproduces the players' belts. Most commonly represented on them is the toad, surrounded with typical interlacing. The *palmas*, which resemble oars, have a notched front that fits the *yugo*, as portrayed in the ball-court reliefs. Ordinarily, the *palmas* are beautifully carved with human or animal figures centered in the middle of interlaced bands or borders. The *hachas* may have been used for scoring the game: they are composed of two faces in profile that are joined at the forehead and separate outward, splitting the image into two planes.

In contrast to the esoteric stone carvings, the three-dimensional ceramic images lend a notably human dimension to the art of central Veracruz. They demonstrate a clear intent to model gentle curved forms, and naturalness is underscored in the treatment of faces. A universe rich in symbolism joins two tendencies in its plastic expression: the enigmatic ritual of the ball game and the pleasing softness of the human figure.

Maya art is remarkable not only for its reliefs, mural paintings, painted vases, and small ceramics but also for its hieroglyphic writing. The former narrate real events in human dimensions; the second records knowledge of astronomy and calendar time, as well as acts of rulers and important men and women. Art and writing are combined in stelae, altars, lintels, stone tablets, decorated vessels, and fresco paintings.

If Mesoamerica is like an enormous mosaic composed of a multitude of discrete parts, the Maya zone is like a broken mirror whose fragments reveal strong regional and local styles, similarities and dissimilarities. It is impossible to describe the diversity of Maya art in a few lines. The items seen here come from two important cities: Palenque, which reached its apogee from the seventh to the tenth century and Chichén Itzá, whose high point was from the tenth to the thirteenth century.

Palenque is defined, in its artistic expressions, by a style that extended from the banks of the Usumacinta River to include Bonampak, Yaxchilán, and Piedras Negras. The unifying style of these cities centers on the human figure represented in sculpted relief. Each site, nevertheless, has its own particular identity.

So central are humans to the art of Palenque that its buildings seem to have been designed to enhance humankind. For example, the Palace, a group of buildings with long rooms roofed by the typical Maya vault and arranged around four patios of unequal dimensions, has representations of men and women in stucco relief on its walls. The Temple of the Inscriptions, famous for the magnificent tomb guarding the remains of an illustrious ruler, also portrays (on its pillars) important figures of ruling dynasties.

As a whole, Palenque structures are of different elevations and sizes; the plazas are never enclosed at the corners, so that space flows to create harmonic movement and an equilibrium with the volumes of the pyramids. This is true of the group including the two Temples of the Cross and the Temple of the Sun. The seeming lightness of the pyramids is the result of walls broken up by pillars and alternating open spaces. The graceful pierced roofcombs reinforce the sensation of movement and

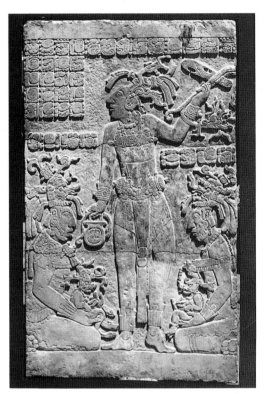

Relief of Palenque ruler. Limestone. Maya. Probably from Palenque, Chiapas. Dumbarton Oaks, Trustees for Harvard University, Washington, D.C. Photo: Dumbarton Oaks

lightness. No two constructions are the same. Although patterns—such as the porticoes with five pillars and three openings, the vaulted sanctuary in the middle of three chambers, the volute cornice at the beginning of the frieze, and the roofcomb inserted in the upper center of the vault—are repeated, the individuality of each building prevails. Some, like the Palace Tower and the Temple of the Inscriptions, are extraordinary examples of Maya architecture.

Stelae were not a feature of Palenque. All sculptural creativity was concentrated in the stuccoed facades: the walls, friezes, and roofcombs of pyramids, palaces, and temples. Interior areas were adorned with splendid reliefs and stone tablets with animated human shapes. The form and content of the Palenque reliefs reveal a definite human orientation, in which the concept of the universe and historical awareness are marvelously harmonized. This is apparent on the lid of the sarcophagus in the Temple of the Inscriptions and on the relief panels in the Temples of the Sun, the Cross, and the Foliated Cross.

The relief was the principal medium of representation for the Maya, and in these both variety of technique and rich inventiveness in stylizing the human figure are found. In Palenque high reliefs were worked in the ductile stucco, and flat relief on the ivory-toned stone of the region. Both materials produced some of the most lifelike portraits in Maya art.

Toward the end of the eighth century, as activity in architecture and sculpture was dying out in Palenque, in Chichén Itzá, the great Maya-Toltec city on the Yucatán peninsula, numerous structures were being erected in the Puuc style of Uxmal. But unlike the precise carving on dry masonry and the mosaic stone designs that ornament the friezes in Uxmal, the structures in "old" Chichén, as well as those of the Temple of the Three Lintels, the Red House, the Monjas, and the Iglesia, show crude stonework and carelessness of proportion in frets and masks.

The astronomical and calendrical intent of many structures of Chichén Itzá from ancient times is evident in the group of buildings called the Caracol (snail), which breaks with Maya architectural tradition. Thus, the openings in the walls of the Caracol served for observing the movements of Venus, and the imposing radial pyramid called the Castillo is oriented in accord with the movements of the vault of the heavens. Its steps total 365, indicating its adaptation to the solar year, and on days of the equinox, the shadow on the nine stepped tiers of the pyramid produces an effect similar to nine segments of a serpent.

The Toltec presence is concentrated in the north part of the city. Serpent columns adorn the entrances to the temples, the head resting on the ground, the upright body forming the fust, and the rattles sustaining the lintel. Spaciousness is suggested by pillars and piers, as in the Temple of the Warriors, the Court of the Thousand Columns, and the Market. The use of the pier also signals a radical change in the concept of space: the narrow Maya vault evolves toward the amplitude of the colonnaded corridor. In Tula and Chichén Itzá interior space is created for the first time in Mesoamerica.

The theme of the Toltec architectural relief is also apparent in the warriors sculpted on pillars, in the friezes with stalking jaguars, in the

Profile head of musician. Detail of wall painting at Bonampak, Chiapas. Maya. Photo: Enrique Franco Torrijos

plumed serpents that alternate with eagles, in the rows of skulls, and in the image of a man held in the maw of a fantastic bird-serpent creature.

Toltecs were also the sculptors of standard-bearers, atlantean figures, and the famous chacmools which contemporary sculptors consider masterpieces of world art. These images indicate substantive changes in the language of sculpture, a return to the three-dimensional figure that had been relegated to the background during the earlier Maya period.

The Toltec presence imbues the sculpture of Chichén Itzá with a singular character: the harmonic fusion of two styles, Maya and Toltec. It is important to point out that the works of Chichén Itzá are extremely fine; the century-old Maya sculpture tradition assured superior artisanry.

Another novel aspect, in form and monumentality, is the Ball Court, bounded by high vertical walls that angle upward from the *talud* bearing scenes in relief depicting the ceremony of the game. The subject matter recalls the representations in El Tajín; the clothing of the players is similar to that of Toltec warriors; and the precisely edged line is found in Maya tradition.

The originality of Chichén Itzá is that it joins artistic antecedents from different times and places in Mesoamerica.

As we approach the art of the Mexica, the last peoples to inhabit central Mexico, the builders of magnificent Tenochtitlan, we are awed by the versatility of their forms of expression. Their architecture, their plastic arts, and their literature reveal a young and vigorous people, profoundly religious and heirs to a thousand-year-old culture that they translated into their own complex cosmic vision. In the span of about two hundred years, from the beginning of the fourteenth century to 1519, the arrival of Hernán Cortés, the Mexica converted the island at the west end of the great lake of Texcoco into a great imperial capital, the *axis mundi* of Mesoamerica.

During the period of Mexica power, Tenochtitlan reclaimed land from the waters and rose on a square grid formed by canals and streets. Three large causeways—Tlacopan, Tepeyac, and one that bifurcated toward Coyohuacan and Iztapalapa—radiated from the center of the city, anchoring the island to terra firma. Four quadrants framed the ceremonial center, which was enclosed by a wall; beside it, but outside the enclosed area, were the palaces of the rulers. The Franciscan friar Bernardino de Sahagún, in the first volume of his memoirs, describes the twin pyramids of Tlaloc and Huitzilopochtli in the center of the city—a grouping known as the Templo Mayor—the circular temple dedicated to Quetzalcoatl; the *tzompantli*, or altar of skulls; the Ball Court; and the wall that enclosed that space. The location of the ceremonial buildings was based on the movement of the sun: according to the time of year, the sun rises either from behind the Temple of Tlaloc, god of rain and agriculture, or from behind the Temple of Huitzilopochtli, god of war and fire. On mornings of the equinox the sun directly faces the temple of Quetzalcoatl.

Many of the monumental stone sculptures are superb, incorporating forms and subject matter from earlier cultures—with new solutions. For example, the Mexica sculptors borrow the colossal magnitude of the remote Olmec tradition, but they overlay the pieces with designs in low

Pendant in the form of a shield. Gold and turquoise. Mixtec. From Yanhuitlan, Oaxaca. CNCA–INAH, Museo Nacional de Antropología, Mexico City. Photo: INAH

relief. The classic Veracruz style returns in the magnificent large-scale clay sculptures found in the Templo Mayor: effigies of young eagle warriors, perhaps anthropomorphic images of the sun god at the moment of beginning his flight through the skies—an eclecticism that hovers between realism and abstraction, according to the tradition of the artists who were summoned from different areas of the empire to work in the capital.

What distinguishes Mexica sculpture from other Mesoamerican works is, in essence, the impeccable structure that underlies the diverse regional modes it incorporated into its strong aesthetic expression—integrated forms, preferably in rounded volumes, within a balanced composition. This sense of structure is found both in works of apparent simplicity (the difficult simplicity of great art)—like the grasshopper in red carnelian, the obsidian monkey, the eagles of the Templo Mayor, serpent heads—and in those that combine a plurality of images and complex symbolism—the goddess Coatlicue, the Coyolxauhquis, the Sun Stone, and the Tlaloc/Chacmool.

The cosmopolitanism of Tenochtitlan is also evident in lesser arts: polychrome vessels, feather objects (crests, mantles, fans), goldwork. Certainly the variety of Mexica art is testimony to its imperial domination, but the great sculpture, what George Kubler has called the "metropolitan" style, carries in its forms a powerful hidden energy that is an outstanding quality of Mesoamerica.

Through two brief centuries, the Mexica artists mastered different modes of artistic creation, but it was in sculpture that they achieved their masterworks, their wisdom in expressing with "what is well crafted" (*toltecayotl*) their concept of humankind and the universe.

When the Spaniards reached the renowned city of Tenochtitlan, they could find no words to express their astonishment at the beauty, orderliness, and serenity they saw before them in that metropolis surrounded by lakes. They were also astonished—in a very different way—by the extraordinary sculpted images; these they pulled down and destroyed, as objects of idolatry. They marveled at the painted books, the codices, the mosaic work in colored stone, and the ornaments made of rare and beautiful feathers. Today we can read their accounts of that experience. The Mexica, or the Aztecs as they are more popularly called, a religious people of extraordinary vigor, created in the course of two centuries astounding and fascinating works of art. Their architecture was essentially traditional; but their sculpture is unequaled in its versatility of form and expression and content. In our time, centuries later, it is world-famous.

The prodigious variety of Precolumbian art is solidly founded upon a common fund of cultural concepts; from this it derives its unity. Civilization in Mesoamerica was whole and continuous, but styles varied at different times and in different places. Those special expressions, like all true art, have taken their place among the world's masterpieces.

The Olmec at La Venta

RICHARD A. DIEHL

La Venta was one of several centers of Olmec civilization, the earliest complex society in the Americas. The ancient community covered a slightly elevated ridge east of the Tonalá River a few kilometers from the Gulf of Mexico in what today is the state of Tabasco. Although the area, and perhaps even the ridge itself, was occupied by 1750 B.C., Olmec La Venta emerged as a major center of Mesoamerican civilization in the four centuries after 1000 B.C. Today the site occupies an "island" in a vast swamp, hardly a propitious setting for a capital of Mesoamerica's oldest civilization. However, the environment has changed over the millennia; Olmec La Venta was surrounded by tropical forests, navigable sluggish streams, fertile river levees where maize and other crops grew in abundance, and estuaries rich in fish and other aquatic life. In Olmec times this productive countryside was inhabited by farmers living in small villages and hamlets who owed their devotion to La Venta's gods and their allegiance and labor to its rulers.

Although La Venta was discovered in 1925, the true size and nature of the ancient settlement became apparent only a few years ago. Until recently archaeological wisdom held La Venta to be a virtually empty "ceremonial center" occupied by a small group of priests and their retainers. However the recent site map prepared by Mexican archaeologist

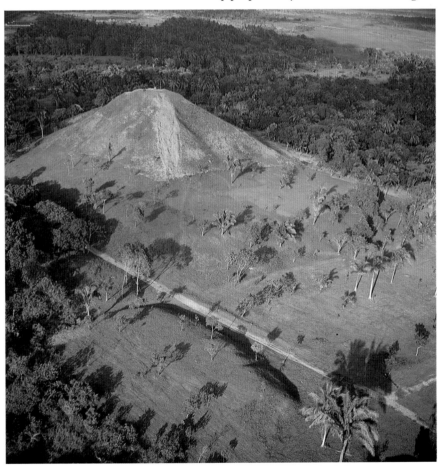

La Venta: view of Great Pyramid (Mound C–1), looking north

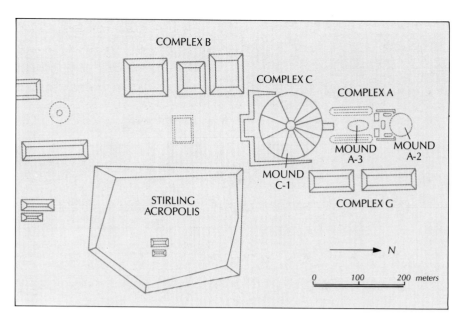

COMPLEX B

COMPLEX C

COMPLEX A

MOUND A-3 MOUND A-2

MOUND C-1

STIRLING ACROPOLIS

COMPLEX G

N

0 100 200 meters

La Venta: site plan

Rebecca González Lauck[1] and her colleagues, the first such map which shows the entire ancient community, makes it clear that La Venta was much larger than previously realized, and recent excavations have uncovered evidence of a substantial population.

La Venta's earth mounds served as bases for temples and houses constructed of perishable materials such as poles and thatch. These mounds are consistently aligned eight degrees west of true or magnetic north. Archaeologists do not know why the Olmecs chose this specific orientation for their constructions, but they suspect that it related to some phenomenon visible in the tropical night sky of the times.

Mound C–1, known as the Great Pyramid, and the Stirling Acropolis were two of the largest structures in the Americas of their time but neither has been excavated. Today C–1 is thirty meters (one hundred feet) high and has a conical shape with ridges and valleys on its surface. Some archaeologists believe that the Olmecs created this form in imitation of the prominent volcanoes found in the Tuxtla Mountains northwest of La Venta. Others hold that the original mound was square or rectangular and that postabandonment erosion accounts for its present condition. Recent excavations at the base of the mound support the latter view but the excavator cautions that a larger area must be exposed before the issue can be settled.

The Stirling Acropolis is a gigantic broad, flat platform containing over half a million cubic meters (650,000 cubic yards) of earth fill, five times the amount in the taller Mound C–1. Although the Stirling Acropolis has never been explored in detail, numerous stone monuments and a drain system constructed of basalt troughs have been located on its surface. The drain, like those uncovered at the neighboring Olmec center of San Lorenzo, seems to have served ceremonial functions in water-deity rituals rather than any utilitarian purpose.

La Venta is justly famous for the stone monuments that dotted its landscape. Colossal human heads are the best known of these, but large rectangular "altars," seated humans sculpted in the round, relief-carved "stelae" portraying humans and supernaturals, and a bewildering array

of part-human, part-animal were-creatures account for just some of the seventy-seven monuments discovered so far at La Venta. Equally impressive as the monuments themselves is the fact that the Olmecs transported the multi-ton basalt rocks from distant quarries in the Tuxtla Mountains to La Venta by raft.

Unfortunately very few La Venta monuments are in pristine condition, and none have been found in their original positions because the Olmecs almost always battered, mutilated, and then buried monuments that had outlived their usefulness. Thus we have no way of knowing which specific monuments, or how many, were visible at one time. This also makes it impossible to place La Venta's monuments in a time sequence relative to one another.

The soil beneath La Venta contains much more than discarded monuments; new constructions often covered older structures, and the Olmecs frequently buried offerings and caches far below the surface. As one might expect in an area where heavy rains cause constant erosion, the mound and courtyard surfaces required almost constant repair. Furthermore major renovations were undertaken from time to time, perhaps when a new ruler assumed the throne. Since the normal procedure was to cover the existing structures and surfaces with the new constructions, La Venta gradually rose in height over the centuries. For example, Complex A, a relatively small but well-studied mound-plaza complex north of Mound C–1, experienced four major and many minor reconstruction episodes which raised it almost three meters (ten feet) in four hundred years. The earth "architecture" in Complex A included adobe-block cores in mound interiors; brightly colored sand floors and clay mound surfaces; and hundreds of long basalt columns placed vertically in the ground to form plaza walls which remind one of giant picket fences. Columns of this type were one of the unusual aspects of Complex A architecture and were also used to construct the spectacular Columnar Tomb (Tomb A), which contained many of the objects seen here.

The soils used at La Venta are primarily a wide color spectrum of clays and sands: the clays include red, yellow, white, blue, olive, brown, pink, purple, and tan shades; the sands are brown, white, old rose, gray, pink, yellow, orange, cinnamon, and red. Clay was used primarily for fill and mound surfaces, while sand was used for fill and plaza floors.

The Olmecs were the first people in Mesoamerica to deliberately bury ceremonial offerings in the ground. Many such offerings and caches were uncovered in Complex A. Some contained only a few precious greenstone celts and figurines, but others are truly impressive in their size and complexity. The latter include four Massive Offerings, deep pits packed with thousands of serpentine blocks placed in clay and covered by carefully trimmed blocks forming highly stylized were-animal faces.

Beyond La Venta's territory lay other equally large Olmec centers, including San Lorenzo, Laguna de los Cerros, and Tres Zapotes. Although much remains to be learned about La Venta's precise historical and chronological relationships with these centers, the cultural and artistic impact La Venta had on other societies in southern Mexico and northern Central America is clear. It is particularly visible in the Olmec-style

sculptures, ceramics, and other objects found in Pacific coastal Chiapas, Guatemala, and Central America but is equally clear in portable jade objects from Guerrero, stone sculpture at Chalcatzingo in Morelos, and other remains in Mexico's central and southern highlands.

Many enigmas surround La Venta, but no circumstance is as puzzling as its demise. It was abandoned by 400 B.C. But why was it deserted after so many centuries of success? Did Olmec culture die out or did remnant groups survive elsewhere? Only future research can answer these questions, but regardless of what happened, the Olmec legacy is apparent in later Mexican Indian art, religion, and life, even in the twentieth century.

1. Rebecca Gonzalez Lauck, "Proyecto arqueológico La Venta," *Arqueología* 4 (1988) pp. 121–65.

1 ◀ Seated Figure

◀ North of Great Pyramid, La Venta,
◀ 10th–6th century B.C.
◀ Basalt; height 104 cm. (41 in.)
◀ Instituto de Cultura de Tabasco, Dirección de
◀ Patrimonio Cultural, Parque Museo de La Venta,
◀ Villahermosa

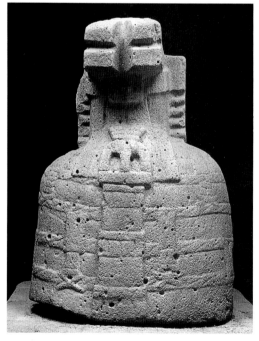

Rear view of cat. no. 1

In addition to being a truly outstanding example of Olmec sculpture, this figure is one of the best preserved ever found. Seated or kneeling life-size figures carved in the round occur commonly at Olmec sites. A great number of examples have been found without their heads, but the numerous bodies and many of the unattached heads portray real people who were probably alive when the sculpture was carved. Their poses and actions vary: some sit cross-legged, others kneel; a few show dynamic movement but most assume a relaxed position; many hold babies, often with were-jaguar facial features; some grasp bars, "knuckle-dusters," and other curious, unidentifiable objects. It is not uncommon for individuals from different Olmec communities to wear strikingly similar headdresses and clothing, suggesting perhaps that elite groups living at different centers used similar insignia of rank. It is also possible, indeed likely, that master sculptors received commissions from different communities, as happened in medieval and Renaissance Europe.

This stocky man sits cross-legged with his hands resting on his knees. His body proportions are as correct as they ever get in Olmec art but, even so, his legs appear larger than in real life. As is generally the case in Olmec art, the sculptor made little attempt to accurately delineate his subject's limbs and muscles. The face is a realistic adult portrayal despite the downturned mouth so common on Olmec faces. Puffy cheeks, a slight tilt of the head, and a hint of a double chin produce the effect of a face that radiates calm determination, if one can project such evaluations across the wide cultural and temporal gaps that separate him from us.

In ancient Mesoamerica clothes announced a person's social status and position. By the time of the Spanish Conquest, the Aztec, the Maya, and other Mesoamerican cultures had strict laws reserving the use of special items of clothing and particular designs to members of the elite. It seems safe to assume that similar distinctions held for the Olmecs who were, after all, the earliest Mesoamerican culture to exhibit the basic features of a social hierarchy. In the case of this monument, special items of dress and adornment abound, even though most of the man's body appears uncovered. His helmet, cape, pectoral, elaborate loincloth, and wrist- and armbands all tell us something about his high rank even though we cannot understand their message.

The helmet originally contained five elements—a front piece (now missing), a swept-back cap terminating in four rectangles, an encircling headband,

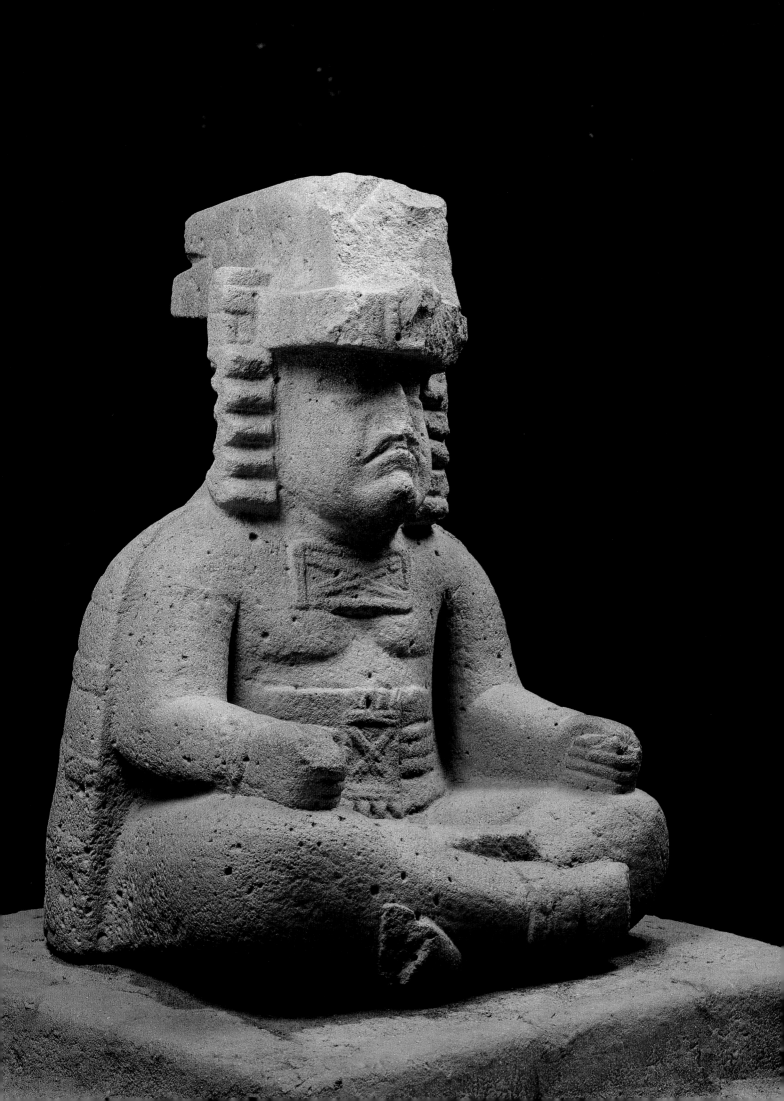

wavy streamers dangling down over the ears, and a tail hanging down to the waist—symbols indicative of the owner's high status and power.

Similar headdresses on other carvings suggest that a mask portraying a supernatural being, variously called a were-jaguar or were-cayman, occupied the damaged area. The swept-back cap appears to be a cluster of feathers held in place by pieces of jaguar pelt (indicated by circles) on each side. Feathers were viewed as precious items in Mesoamerica, and since the jaguar was a sacred animal for the Olmecs, the use of its pelts probably was an elite prerogative. Two V-shaped clefts can be seen at the back of the cap. Such clefts are common in Olmec depictions but their meaning is unclear. Some scholars interpret the cleft as a jaguar symbol, others argue that it reflects reptilian imagery, specifically the area between the eyes of a cayman or crocodile. The wavy streamers over the ears are considered symbolic of an Olmec water deity; the man may be dressed to participate in a rain or water ceremony.

An unusual cape constructed of tied twine or rope covers the man's shoulders and back; it would hang to his waist if he were standing. Capes or mantles were the most important single item of status apparel among the Aztecs, but the meaning of this Olmec example eludes us. His other basic garment is a wide sash or belt which covers his abdomen and holds his loincloth in place. The sash displays a device decorated with the crossed-band (St. Andrew's cross) motif placed within a crenellated rectangle. This design combination occurs in other Olmec sashes but its significance is not known. The crossed-band motif is also present in the rectangular pectoral suspended from his neck.

RAD

DISCOVERY
Uncertain, but possibly uncovered north of Mound C–1

REFERENCES
Beatriz de la Fuente. *Los hombres de piedra. Escultura Olmeca.* Mexico, 1977, pp. 230–33, pls. 59, 60. **Lorenzo Ochoa and Marcía Castro-Leal.** *Archaeological Guide of the Park Museum of La Venta.* Villahermosa, 1986, pp. 47–48, no. 9.

2 ◀ Relief

La Venta, 10th–6th century B.C.
Basalt; height 98 cm. (38⅝ in.)
CNCA-INAH, Museo Nacional de Antropología,
Mexico City 13–599

Most Olmec sculptures were designed to be seen in the round but this handsome carving is an exception. The unfinished, irregular sides and back suggest that the boulder was buried with only the carved surface visible. The scene, cut into the stone in moderate relief, shows a seated man superimposed in front of an undulating rattlesnake. The sculptor demonstrated great skill in adapting the composition to the form of the original block, shaping only the side serving as the foundation for the scene.

The man faces the viewer's left with his legs extended; his right hand holds out a container, perhaps a bag. His awkward position is almost impossible for humans to assume. His simple but elegant dress is very similar to that shown on other La Venta sculptures; a cape or mantle drapes over his shoulders and chest, along with a suggestion of a chest ornament or pendant, and an apron-like breechclout worn with a wide sash or belt covers his waist. His elaborate helmet depicts a jaguar or a creature of mixed jaguar-serpent lineage; the beast's jaw serves as the chin strap and the man's face emerges from the creature's mouth. A large earspool similar to cat. no. 8 appears behind the helmet. The rectangular object surmounted by two crossed-band motifs connected to feathers or tassels in front of the helmet has a cartouche-

56 PRECOLUMBIAN ART

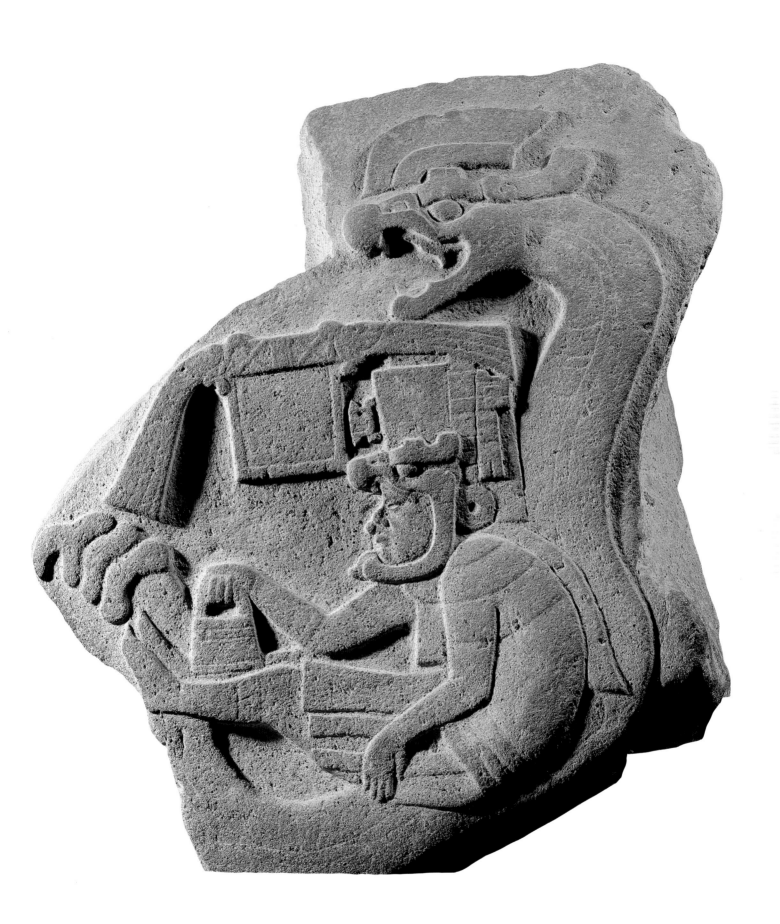

like appearance, which has led some to suggest that it originally contained a painted glyph.

The thick-bodied serpent is considerably larger than its human companion, and it is an excellent example of the Olmec penchant for mixing naturalistic and fantastic elements in the same depiction. The mouth, fangs, belly scutes, scales, and rattles are shown very realistically, but the eyebrows and the crest over the head would never occur in the world of nature. Some scholars interpret the crest as feathers and believe that this sculpture is an early example of the later Mesoamerican feathered-serpent deity known as Quetzalcoatl or Kukulcán, but this identification is not universally accepted.

Many questions of interpretation remain to be answered. The reptile may be protecting, symbolically or otherwise, his human charge. The bag the man holds, a common accoutrement of priests in later Mesoamerican cultures, may indicate that he is a priest. If the serpent is feathered it may be an ancestral form of later feathered-serpent deities.

RAD

DISCOVERY
Possibly by bulldozer on the La Venta airstrip, in 1955

REFERENCE
Philip Drucker, Robert F. Heizer, and Robert J. Squier. *Excavations at La Venta, Tabasco, 1955.* Bureau of American Ethnology, Bulletin 170. Washington, D.C., 1959, pp. 197–200, fig. 55.

3 ◀ Head

Provenance unknown, probably La Venta,
10th–6th century B.C.
Stone; height 61 cm. (24 in.)
Instituto de Cultura de Tabasco, Dirección de
Patrimonio Cultural, Museo Regional de
Antropología "Carlos Pellicer Cámara,"
Villahermosa A–0668

Olmec sculptors portrayed both naturalistic figures modeled on the real world and grotesqueries found only in the human mind. This life-size head is an excellent example of the latter category. It was originally attached to a torso, perhaps that of a seated figure like that in cat. no. 1. Although the artist began with the human head as his conceptual model, the end result was a perversion of reality and perhaps came from a priest or shaman's vision. Although the elements the artist chose occur in other Olmec sculptures, none exhibit such a skilled melding of disparate ideas into a single, coherent unity. Olmec viewers may not have experienced the sense of foreboding and the constrained ferocity that we feel from this head, but they must have felt the power of its expression. Whatever the message this sculpture sent to its intended viewers, it could not have been a subtle one.

The snarling jaguar mouth, exposed canine teeth, and monkey-like snout found here are not common on large Olmec statuary. The creature's eyes are the L-shaped grooves below the prominent square panels that dominate the face. These panels are a puzzle. The motifs within them occur frequently in Olmec art, but like the panels themselves, their meanings are unclear. The common Olmec V-shaped cleft divides the head from front to back and elongated ears projecting from the side of the head remind us of the ears on many Olmec greenstone masks.

Clearly any attempt to interpret the meaning behind this head is risky. Some would consider it a prime example of the Olmec were-animal phenomenon. According to these scholars, the Olmecs believed they were descended from a race of were-jaguars—the offspring of a male jaguar and a human female—and faces such as this depict these mythical ancestors. Others maintain that it reflects a belief that priests and shamans could enter trance states and, with the help of hallucinogens, mystically transform themselves into jaguars. These people would interpret the head as that of a priest, a ruler, or

some other important person who has undergone the transformation. However, many Olmec motifs and symbols are so extraordinarily difficult to identify that even the presence of jaguars in Olmec art has been questioned as a misidentification of a cayman or crocodile. The fact that reasonable arguments can be made in support of diametrically opposed interpretations is one indication of how difficult is the task of understanding the Olmecs' belief-system and their art.

RAD

DISCOVERY
Unknown

4 ◀ Funerary Figure (Figurine 1)

Mound A–2, Columnar Tomb, La Venta,
8th–6th century B.C.
Jade; height 8 cm. (3⅛ in.)
CNCA-INAH, Museo Nacional de Antropología,
Mexico City 13–417

Of the many archaeological surprises La Venta has yielded, none surpasses the tomb or mausoleum uncovered in Mound A–2. The mound—a low, inconspicuous clay structure north of the Great Pyramid—was built expressly to cover the tomb, a unique structure that resembles a wooden shed turned to stone. The tomb walls were built of unmodified basalt shafts or columns, from which the name Columnar Tomb comes. These shafts were placed upright with their smooth sides facing inward and other columns were laid horizontally to form the roof. The interior of the structure was filled with clay identical to that used to build the mound over it, and all the evidence suggests that the tomb was never left open to view as an independent building.

Waterworn limestone slabs laid in pavement fashion formed the floor, which was covered with dark clay stained with red cinnabar. On this layer archaeologists found two concentrations or bundles of very poorly preserved human bones and associated offerings. The skeletons, tentatively identified as those of two young boys, were in a very advanced state of decay.

This unusual seated female figurine, known as La Venta Figurine 1, carved from mottled whitish-blue/gray jadeite has been justifiably described as one of the outstanding masterpieces of native American art and possibly the most exquisite example of jade carving known from ancient America. The figure was among the offerings in the Columnar Tomb. Her relaxed pose, engaging smile, and realistic hair treatment and the striking portrait quality of the entire head certainly place it in a category apart from most Precolumbian representations of the human figure. Depictions of females are rare in Olmec art, and most of those which occur are found on ceramic figurines.

The hematite mirror on the chest is a unique feature of this piece. Other figurines and sculptures are shown wearing this device, but in this case a miniature made of the actual material was used (cat. no. 7 is a functional example of such a mirror). The female coiffure is another distinctive feature; hair is not normally shown in Olmec art (the male figures that predominate almost always wear headgear that hides it).

RAD

DISCOVERY
Excavated by Matthew Stirling and Philip Drucker in 1942

REFERENCES
Matthew W. Stirling and Marion Stirling. "Finding Jewels of Jade in a Mexican Swamp." *National Geographic Magazine* 82 (1942), pp. 640–41, pl. 1, center top. **Philip Drucker.** *La Venta, Tabasco: A Study of Olmec Ceramics and Art.* Bureau of American Ethnology, Bulletin 153. Washington, D.C., 1952, pp. 23–26, 154–55, pls. 46 left, 47 top left.

5 ◀ Funerary Figure (Figurine 2)

◀ Mound A–2, Columnar Tomb, La Venta,
◀ 8th–6th century B.C.
◀ Jade; height 7.5 cm. (3 in.)
◀ CNCA-INAH, Museo Nacional de Antropología,
◀ Mexico City 13–610

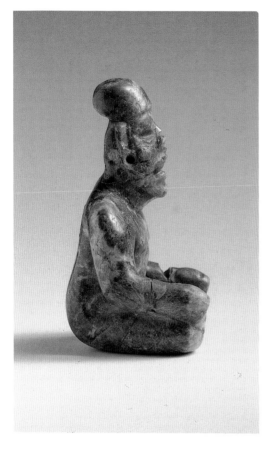

In the Columnar Tomb thirty-five items were placed in two discrete "bundles" on the cinnabar-stained soil covering the flagstone floor. They included some of the finest examples then known of Olmec lapidary work in jadeite —four figurines, a set of earflares, a clamshell pendant, beads, a variety of small pieces probably designed to be attached to perishable wood or cloth backings, stingray spines (both real and jadeite imitations), and a magnetite mirror. Each bundle contained one seated and one standing human figurine carved of jadeite: Figurines numbered 1 (cat. no. 4) and 4 (cat. no. 6) were found in one bundle while Figurines 2 (here) and 3 (cat. no. 6) were found in the other.

This male analogue to Figurine 1 is carved of distinctive mottled white-and-green jadeite. His hands rest on his knees and his body has a more nearly correct proportion relative to his head than does Figurine 1. The surface of Figurine 2, which was broken when discovered, had been polished to a high luster and was coated with red cinnabar upon burial. Remnants of the red pigment are left in the crevices and serve to highlight the features. Red may have held a sacred meaning for the Olmecs, perhaps indicative of blood and life, and they mixed cinnabar in the soil matrix surrounding the Mound A–2 burials and many other offerings at La Venta.

The head of the figure has a truncated conical shape. This is an excellent example of Olmec cranial deformation, a common Mesoamerican practice in which the shapes of children's heads were molded by strapping them to a cradle board or similar device during infancy. Although normal cranial deformation did not impair the mental facilities of the person, this case seems so extreme that one wonders whether such a person could have reached adulthood.

It is also possible that the deformation resulted from an illness, which may have been leprosy or possibly a rare parasitic disease thought to be indigenous to the Americas (also evident in the hunchback, cat. no. 13).

RAD

DISCOVERY
Excavated by Matthew Stirling and Philip Drucker in 1942

REFERENCES
Matthew W. Stirling and Marion Stirling. "Finding Jewels of Jade in a Mexican Swamp." *National Geographic Magazine* 82 (1942), pp. 640–43, pl. 1 center top. **Philip Drucker.** *La Venta, Tabasco: A Study of Olmec Ceramics and Art.* Bureau of American Ethnology, Bulletin 153. Washington, D.C., 1952, pp. 23–26, 155, pls. 46 right, 47 top right.

6 ◀ Two Funerary Figures
◀ (Figurines 3 and 4)

◀ Mound A–2, Columnar Tomb, La Venta,
◀ 8th–6th century B.C.
◀ Jade; height 12.5 and 12 cm. (5 and 4¾ in.)
◀ CNCA-INAH, Museo Nacional de Antropología,
◀ Mexico City 13–418, 13–487

Figurines 3 and 4 were found in the offerings on the floor of the Columnar Tomb. Both represent standing males who wear abbreviated loincloths, the basic item of dress for Olmec men. La Venta has yielded many such small jadeite male effigies. Although they are virtually identical in size, Figurine 4 differs from 3 (and most other known examples) in that it is extremely thin and has holes placed at about elbow level, perhaps for suspension on a string or necklace. Although individual figurines vary in detail, they all share certain basic traits and they always occur in buried offerings. The most spectacular of these, La Venta Offering 4, contained sixteen figurines and six jadeite celts arranged in what is probably a ritual or court scene.

The standard pose for these figurines is a straight-legged stance with arms hanging down. The extreme cranial deformation and the very unnaturalistic faces make it unlikely that they represent living people; in fact, the overall

impression they create is that of an androgynous humanoid. It has been suggested that they represent supernatural beings, perhaps the were-jaguar offspring of a male jaguar–female human primal couple. They also may be ancestral versions of the *chaneques*, the unpredictable and often malevolent dwarf spirits that later Gulf Coast peoples believed inhabited the forests and streams of the area.

<div align="right">RAD</div>

DISCOVERY
Excavated by Matthew Stirling and Philip Drucker in 1942

REFERENCES
Matthew W. Stirling and Marion Stirling. "Finding Jewels of Jade in a Mexican Swamp." *National Geographic Magazine* 82 (1942), pp. 640–43, pl. 1 center top. **Philip Drucker.** *La Venta, Tabasco: A Study of Olmec Ceramics and Art.* Bureau of American Ethnology, Bulletin 153. Washington, D.C., 1952, pp. 23–26, 155–56, pls. 47 bottom, 48.

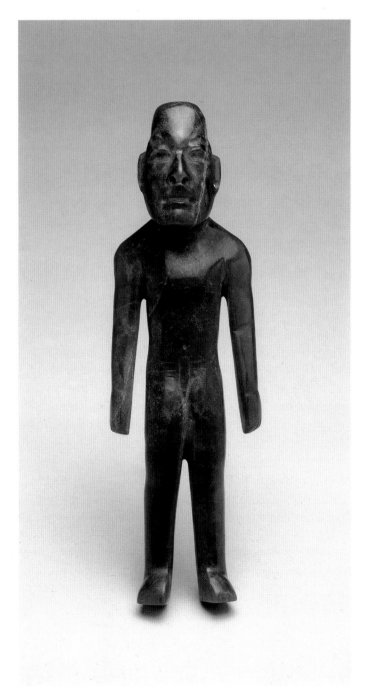

Figurine 3

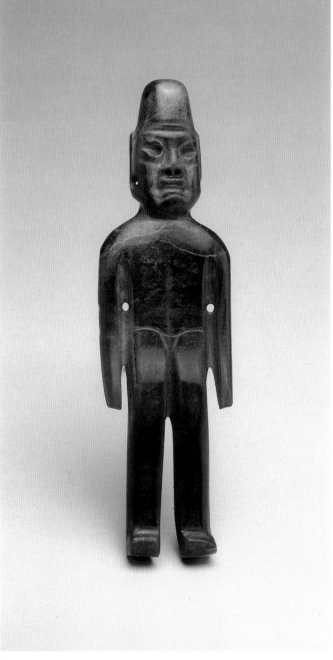

Figurine 4

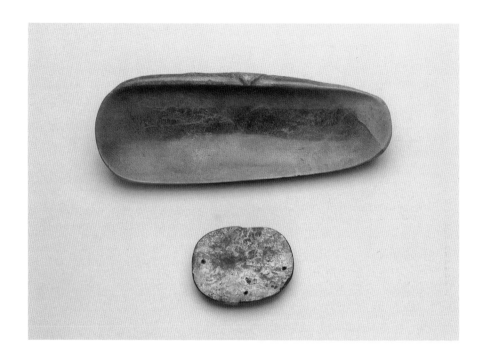

7 ◀ Clamshell Pendant and Mirror

Mound A–2, Columnar Tomb, La Venta,
8th–6th century B.C.
Pendant: jade; height 6.5 cm. (2½ in.)
Mirror: magnetite; height 18.5 cm. (7¼ in.)
CNCA-INAH, Museo Nacional de Antropología,
Mexico City 13–590, 13–202

On occasion the abilities of Olmec lapidaries are evident in even the simplest objects. This outstanding chest ornament in the form of an elongated clamshell is a perfect example. It could not be more restrained or streamlined, yet its slightly but continuously curved interior, together with the surface luster and the visual play of light on its blue-gray color, makes it a most arresting object. Surely it was one of its owner's most prized possessions. The realistically depicted hinge of the half shell on the top of the pectoral has two holes for suspension from the wearer's neck.

None of La Venta's many treasures have created more wonder and puzzlement than the seven mirrors archaeologists found in various caches and offerings. These intriguing artifacts were manufactured from iron-oxide ores, specifically magnetite, ilmenite, and hematite. Their highly polished, usually concave surfaces are almost always paraboloidal or spherical. Most of the known pieces have holes for suspension drilled through their edges, and numerous sculptures and figurines, including the remarkable seated female figurine (cat. no. 4), depict people wearing them as chest ornaments.

Their possible functions have intrigued scholars ever since the first ones were found in 1942. Their polished surfaces magnify images and some can be made to reflect sunlight. A few have optical qualities that would have made it possible for them to be used to ignite fires, and many others could at least have been made to generate smoke from dry tinder. These qualities led astronomer John Carlson to suggest that they were the basis for a cult of a smoking-mirror deity known to the Aztecs as Tezcatlipoca—the Aztec patron deity of royal lineage and descent who was shown with a smoking mirror in place of his left foot.

The example here is an elliptical mirror found in the Bundle 1 offering in the Columnar Tomb. It is rather small, thin, and flat compared to other La Venta mirrors and has never received as much attention as the larger and more spectacular examples, despite the fact that flat mirrors are much more difficult to manufacture than those with concave surfaces. Two holes near the lateral edges probably served as the points of suspension, and a third may have held a pendant or other object that dangled below the mirror.

RAD

DISCOVERY
Excavated by Matthew Stirling and Philip Drucker in 1942

REFERENCES
Matthew W. Stirling and Marion Stirling. "Finding Jewels of Jade in a Mexican Swamp." *National Geographic Magazine* 82 (1942), pp. 640–43, pl. 1 center and right top. **Philip Drucker.** *La Venta, Tabasco: A Study of Olmec Ceramics and Art.* Bureau of American Ethnology, Bulletin 153. Washington, D.C., 1952, pp. 23–26, 163, pl. 53 left (pendant only).

8 ◄ Pair of Earflares

Mound A–2, Columnar Tomb, La Venta,
8th–6th century B.C.
Jade; width 6.5 cm. (2½ in.)
CNCA-INAH, Museo Nacional de Antropología,
Mexico City 13–633

The Olmecs were the first Mesoamericans to place a high value on jadeite, serpentine, and other rare greenstones. They were also the first people to rework older objects into new shapes. It may be that suitable new raw materials were not available when a specific kind of object was needed, or perhaps the mere act of reworking these precious stones had a ritual or symbolic significance. Whatever the case, reused and reworked pieces like these ear ornaments are not uncommon.

This matched pair of rectangular objects served as flares on ear ornaments of the type commonly shown in depictions of Olmec men. They were made from the ends of an older jadeite "canoe," a miniature boat actually shaped like a punt rather than a canoe. The material from the central section of the boat is missing and presumably was reworked into other small objects. The bow and stern were rather crudely trimmed, holes were drilled in the center, the surface was polished, and identical designs were lightly incised around two sides of the holes. Both flares have suffered damage which makes it difficult to understand their identical designs, but according to Drucker, they show "a monstrous Eagle-jaguar with branched eyebrows and angular split fangs and a long down-turned beak." The holes served as eyes for the birds and places to attach the flare to the rest of the ear ornament assembly.

RAD

DISCOVERY
Excavated by Matthew Stirling and Philip Drucker in 1942

REFERENCES
Matthew W. Stirling and Marion Stirling. "Finding Jewels of Jade in a Mexican Swamp." *National Geographic Magazine* 82 (1942), pp. 640–43, pl 1 right top. **Philip Drucker.** *La Venta, Tabasco: A Study of Olmec Ceramics and Art.* Bureau of American Ethnology, Bulletin 153. Washington, D.C., 1952, pp. 168–69, pl. 54a.

Drawing of cat. no. 8

9 ◀ Belt (?)

Mound A–3, Tomb C, La Venta,
8th–6th century B.C.
Jade; width of largest bead 1.9 cm. (¾ in.)
CNCA-INAH, Museo Nacional de Antropología,
Mexico City

The elite of every Mesoamerican culture from the Olmecs until the time of the Spanish Conquest adorned themselves with necklaces, bracelets, and other items made by stringing together greenstone beads. The sixty-odd beads (thirty appear here) and two turtle-shell–shaped end pieces were found in Tomb C, a boxlike structure built of sandstone slabs in Mound A–3 between the Great Pyramid and Mound A–2. Tomb C's interior was almost empty when the structure was buried within Mound A–3, but clay from the mound fill slumped into the empty space after the roof slabs broke. The cist floor was covered with a thick deposit of red cinnabar containing many jade earspools and other ornaments and objects arranged as they would have been on a human body, although no actual human remains were found.

The beads were discovered in a horizontal line across what would have been the person's midriff. However, they do not appear to have functioned as a "belt" because they do not completely encircle the person as a belt would. If someone wore this strand of beads in real life, as surely must have happened, it probably was sewn or attached to a skirtlike garment.

The beads were manufactured from yellowish-green jadeite or serpentine. Many have distinctive grooving or gadrooning dividing them into four, six, or eight segments along their circumference. A square piece of jadeite carved to resemble a turtle-shell platelet was placed at each end of the strand.

RAD

DISCOVERY
Excavated by Matthew Stirling and Waldo Wedel in 1943

REFERENCES
Matthew W. Stirling. "La Venta's Green Stone Tigers." *National Geographic Magazine* 84 (1943), pp. 322–23. **Waldo R. Wedel.** "Structural Investigations in 1943." In *La Venta, Tabasco: A Study of Olmec Ceramics and Art*, by Philip Drucker. Bureau of American Ethnology, Bulletin 153. Washington, D.C., 1952, pp. 67–71, 166–86, pl. 52.

10 ⊰ Anthropomorphic Celt

Mound A–2, Tomb E, La Venta,
8th–6th century B.C.
Jade; height 12 cm. (4¾ in.)
CNCA-INAH, Museo Nacional de Antropología,
Mexico City 13–435

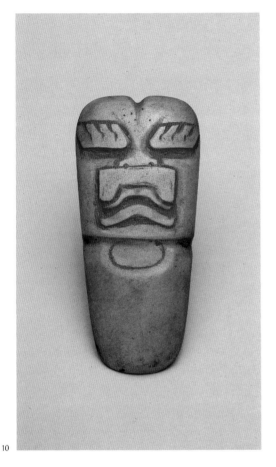

10

This unusual ax, or celt, was part of an offering or cache containing over one hundred greenstone celts, beads, and other objects found in Mound A–2 just a few meters south of Monument 7, the Columnar Tomb. As is common at La Venta, the offering was embedded in a red cinnabar layer covered with soil. Several basalt columns served as a cover for the entire deposit. Despite the complete absence of bones or teeth, the archaeologists who discovered the offering labeled it Tomb E because it contained earspools and other personal ornaments placed in the appropriate positions for a human interment.

The craftsman who made the celt began by working a block of light green stone into a trapezoid-shaped blank. Then he divided it into two segments: a larger upper section for the head, and a smaller body area beneath it. On other Olmec celts of this general shape and design, rudimentary limbs and bodies are indicated with lightly incised lines, but in this case the artist showed only a pendant or necklace on the lower segment.

The face is an archetypal Olmec production with downturned lips, toothless gums, flat nose, flame eyebrows, and a V-shaped cleft at the top of the head. These features occur time and time again, either singly or in combination, in Olmec nonrealistic depictions of humanoids and animals. Numerous explanations have been advanced for each of them, but none are accepted by all scholars. Nevertheless, the presence of even one such element is sufficient to define an object as Olmec. The cinnabar or hematite rubbed into the incisions provides a striking contrast to the pale green stone and probably signified blood as a precious substance.

The original uses of anthropomorphic celts like this one are not known. Their size and shape suggest they may have been designed to be held in the hand.

RAD

DISCOVERY
Excavated by Matthew Stirling and Waldo Wedel in 1943

REFERENCES
Matthew W. Stirling. "La Venta's Green Stone Tigers." *National Geographic Magazine* 84 (1943), p. 332, pl 4 center bottom. **Waldo R. Wedel.** "Structural Investigations in 1943." In *La Venta, Tabasco: A Study of Olmec Ceramics and Art*, by Philip Drucker. Bureau of American Ethnology, Bulletin 153. Washington, D.C., 1952, p. 64, 164–66, pl. 56 left.

11 ⊰ Two Incised Celts

Mound A-2, La Venta, 8th–6th century B.C.
Jade; height 15 cm. (5⅞ in.)
CNCA–INAH, Museo Nacional de Antropología,
Mexico City 13–426, 13–629

Greenstone axes, or celts, are common items at La Venta; archaeologists have found at least 250 of them in buried offerings and caches, and it is safe to assume that looters have removed at least as many. They generally occur in groups which on occasion form vaguely cruciform patterns. Hard jadeite was the preferred material but soft, pale green serpentine was also used extensively. Since none of the celts show any signs of use, they probably were made to be placed in offerings rather than to be used as tools. While the vast majority are undecorated, a few have lightly incised designs on one surface.

The two celts shown here are made of a whitish-green stone. They were found in a cruciform offering of thirty-seven celts buried deep inside Mound A–2. One has a very stylized face with typical Olmec almond-shaped eyes, a headband, and vestigial hands holding an identical pair of double-ended objects (that archaeologists call knuckle-dusters). The design on the second celt suggests an anthropomorphized plant shown in cross-section.

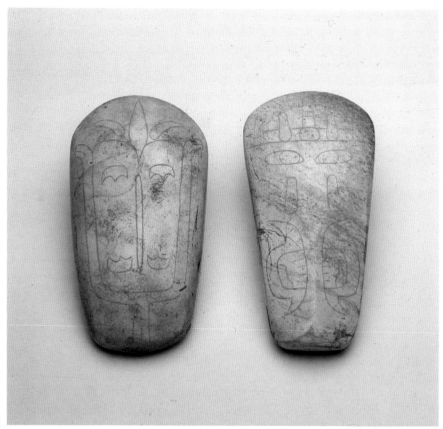

11

Both designs exemplify a distinctive style of light incision found on a few La Venta celts. The style and its execution are so different from mainstream canonical Olmec art that it seems unlikely to be the work of the carvers of jadeite figurines or other Olmec masterpieces. In fact, there is good reason to believe that the fine jades were created by master craftsmen living near the still-undiscovered sources of jadeite and serpentine, while these designs are graffiti added by someone at La Venta to finished pieces.

RAD

DISCOVERY
Excavated by Matthew Stirling and Philip Drucker in 1942

REFERENCE
Philip Drucker. *La Venta, Tabasco: A Study of Olmec Ceramics and Art.* Bureau of American Ethnology, Bulletin 153. Washington, D.C., 1952, pp. 27, 165–66, figs. 10b, 47a, b.

12 ◄ Pectoral

◄ La Encrucijada, 8th–6th century B.C.
◄ Jade; height 8.5 cm. (3¼ in.)
◄ Instituto de Cultura de Tabasco, Dirección de
◄ Patrimonio Cultural, Museo de Historia de Tabasco,
◄ Villahermosa

Olmec artists frequently portrayed humans wearing chest ornaments or pectorals. Two types occur most commonly, rectangular plaques filled with the crossed-band motif and squarish "mirrors" made of obsidian or polished iron ores (see cat. no. 7). Interestingly enough, real examples of the first type have never been found, suggesting that they were made of perishable materials, and objects like the one shown here never appear in the art.

This particularly beautiful example of the real thing came to light during road construction at La Encrucijada, a smallish Olmec mound site located forty kilometers (about twenty-five miles) east of La Venta. La Venta and the other major Olmec centers exercised social and perhaps political control over

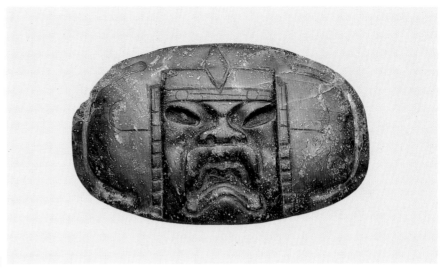

12

smaller satellite communities in their hinterlands, but archaeologists have never examined any of these subordinate centers in detail.

The sequence of steps the craftsman went through to produce this masterpiece has been reconstructed by Gómez Rueda and Courtes. First he worked the raw material, a mottled whitish-green metamorphic rock generically called jadeite, into an elliptical shape. Next he carved the design on the front surface using drills, abraders, strings, and fine abrasive. The final step consisted of polishing the piece with red ocher or hematite, an indigenous equivalent of jewelers' rouge; remnants of this red material were left in the incisions where they serve to highlight the design against the green background.

The pectoral portrays a typical Olmec were-jaguar baby face with slanted almond-shaped eyes; a toothless mouth framed by a flaring upper lip, exposing the gum beneath it, and downturned corners; a wide, flat nose with drilled openings; a headband; and a V-shaped cleft in the head. The lozenge-shaped element in the cleft may represent the ear of a maize plant. Wavy ear ornaments similar to those on La Venta Monument 77 (cat. no. 1) are shown frontally. Many of the iconographic elements have served to identify the face as that of the anthropomorphic dwarf or infant thought by some to be the Olmec rain deity.

RAD

DISCOVERY
Unearthed during the leveling of an ancient mound in order to build a new road in 1987

REFERENCE
Hernando Gómez Rueda and Valérie Courtes. "Un pectoral olmeca de La Encrucijada, Tabasco: observaciones sobre piezas menores olmecas." *Arqueología* I (1987), pp. 73–88.

13 ◀ Lidded Vessel (Hunchback)

Provenance unknown, possibly La Venta,
10th–6th century B.C.
Ceramic; height 36 cm. (14⅛ in.)
Instituto de Cultura de Tabasco, Dirección de
Patrimonio Cultural, Museo Regional de
Antropología "Carlos Pellicer Cámara,"
Villahermosa A–0483

The Olmecs were accomplished potters but archaeologists have recovered surprisingly few complete vessels from La Venta and other Olmec centers. In addition to a wide variety of domestic pots used in cooking and other daily activities, Olmec potters occasionally produced vessels with presumed ceremonial or ritual functions like this striking urn.

Although depictions of illnesses and pathologies are not common in Mesoamerican art, they do occur in virtually every culture and time period. Hunchbacks, deformed limbs, facial paralysis, ulcers, and smiles indicating mental impairment are among the more common conditions shown on sculp-

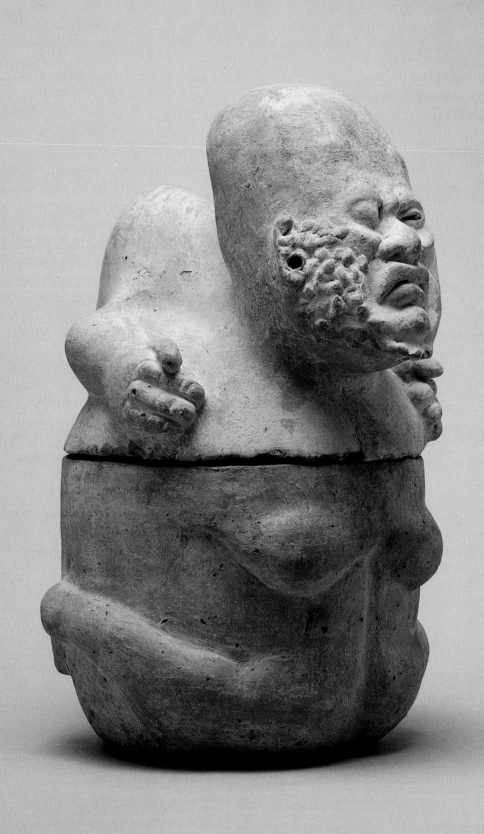

tures and pottery vessels. Depictions of hunchbacks are particularly widespread in time and space, suggesting that people with spinal deformities were considered special in some way and perhaps even revered. The reasons for these depictions are not known; the Mesoamerican peoples may have believed that the sufferer had a special relationship with the supernatural, or like members of most human societies, they may have had a macabre interest in the unusual and the grotesque. Whatever the explanation, these striking pieces afford us a fleeting glimpse into a real world of sick, deformed individuals whose suffering is all too evident.

The find spot of this ceramic urn is not recorded, but the face indicates that it is Olmec. It is possible that the man portrayed on it suffered from a number of illnesses and pathologies including culturally induced cranial deformation and disseminated cutaneous leishmaniasis (DCL), a rare parasitic disease, which may also be seen on Figurine 2 from the Columnar Tomb (cat. no. 5). (If this diagnosis is correct, these objects are the oldest evidence for this rare disease.)

RAD

DISCOVERY
Unknown

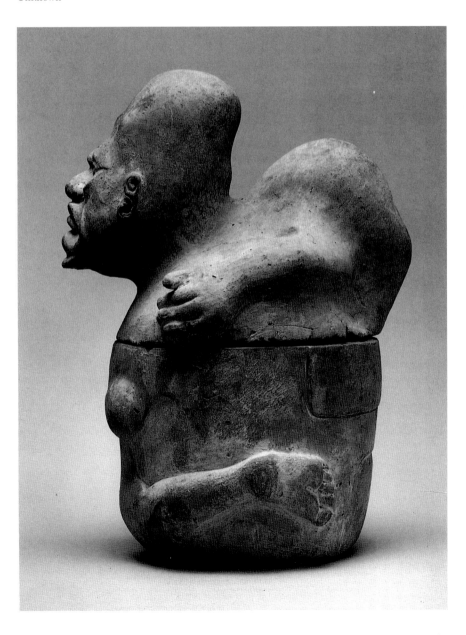

13 Side view of cat. no. 13

14 ◀ Colossal Head

San Lorenzo, 12th–10th century B.C.
Basalt; height 167 cm. (65¾ in.)
CNCA-INAH, Museo Nacional de Antropología,
Mexico City 13–788

San Lorenzo is an Olmec site at least partially contemporaneous with La Venta, and much of its fame is due to the nine colossal heads which have been found there. Colossal human heads carved on large stone boulders are a hallmark of Olmec civilization, and the discovery of one such head at Tres Zapotes in 1862 gave the world its first glimpse of ancient Mexico's oldest civilization. These hauntingly realistic and exquisitely carved portraits evoke as much wonder and puzzlement now as they did in the nineteenth century; today, as then, scholars attempt to document the history and development of Olmec culture while others, perhaps more romantically inclined and less patient with mundane explanations of the ancient world, invoke transoceanic voyagers and even space travelers as an explanation of the Olmec phenomenon.

The sixteen colossal human heads reported from the Olmec heartland all appear to portray adult males wearing headgear vaguely reminiscent of 1920s-style football helmets. Although facial features vary from sculpture to sculpture, the subjects are fully human and, except for two aberrant pieces from Laguna de los Cerros, never show the blending of human and animal characteristics so common in other Olmec art forms. Some scholars believe the heads are portraits of real people, perhaps rulers or warriors, while others regard them as idealized representations of such historic personages.

The colossal head is in excellent condition. The expression has been described as pugnacious although it might also be called a calm but vigilant frown. The sculptor reworked the original boulder so deftly that he imposed his wishes on the material rather than allowing the stone's shape to influence the design. The man's profile is one commonly seen among the Indian descendants of the Olmec who live in the Mexican southeast today, especially the fleshy lips, full cheeks, and flat nose. The treatment of the mouth, particularly the raised border around the lips, is unusually sophisticated. The pitted dimples on the face and helmet may not be part of the original design; similar indentations occur frequently on colossal heads and may represent deliberate mutilation of the sculpture when the monument was discarded and buried. The back was flattened but left undecorated, suggesting that originally this head was displayed against a building wall or some other vertical surface.

The headgear in this example includes crossed bands, perhaps of cloth, and what appears to be a network of strings threaded through open disks. Yale University archaeologists excavating in the ground around the head in 1967 encountered a concentration of perforated iron-ore beads similar to the disks. The chin straps in front of the ears also serve as attachments for large flared ornaments that cover the lower portions of each ear but are not inserted through holes in the earlobes.

RAD

DISCOVERY
First reported by Luis Aveleyra Arroyo de Anda in 1965

REFERENCE
Luis Aveleyra Arroyo de Anda. "Una nueva cabeza colosal Olmeca." *Boletín del Instituto Nacional de Antropología e Historia*, no. 20 (1965), pp. 12–14, figs. 18, 19.

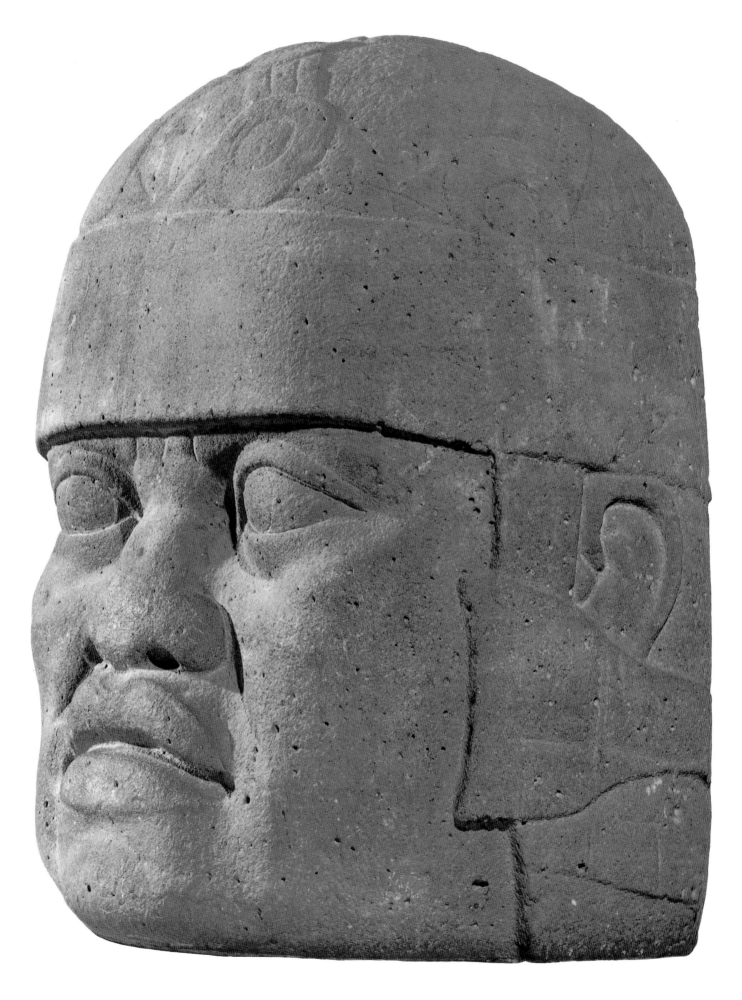

Izapa: Between Olmec and Maya

GARETH W. LOWE

By the fourth to the first century B.C., numerous large centralized communities or "regional centers" with well-developed architecture and stone sculpture were scattered all across the formerly Olmec and early Maya regions of eastern Mesoamerica. Among these early cities, Izapa stands out as particularly significant for several reasons. By the second or first century B.C. the Izapans (or Izapeños) had organized and constructed a formal community with a dozen ceremonial plazas surrounded by large platforms and buildings. Carefully distributed around most of these plazas was the largest assemblage of carved stone monuments known anywhere in Mesoamerica. More remarkable still, as far as we can determine, most of these monuments still stand (or stood, when discovered) in their original placements. Of all the contemporary centers known in Mexico and Central America, only Izapa has survived relatively intact. Central Izapa appears to have been immune to an almost universal custom, or period, of monument destruction that everywhere laid low, broke up, covered over, or reused the sculpture of this early Maya era. Izapa's record of unequaled pristine sculptural development and its unmatched in situ survival indicate that it played some very special sociopolitical role in Mesoamerican history.

The eroded mounds of central Izapa today are more impressive for the luxuriant tree crops and other tropical vegetation that they support than for evidence of architectural grandeur. The topographic map, however, readily demonstrates the well-organized character of the community. Within approximately one square kilometer (⅝ square mile), over one hundred separate platforms are distributed about their plazas, all in general alignment with the winter solstice sunrise on the eastern horizon and the Tacaná volcano on the north (Tacaná is the second highest peak in Central America). The north-south orientation of Izapa is about twenty degrees east of north. Izapa was laid out in the wooded foothills at the base of the high Sierra Madre de Chiapas. This is the best cacao or chocolate growing region in the New World. Rainfall is heavy but not excessive, the soils are volcanic, temperatures high; clear running streams and springs are abundant, and the general drainage is good, the whole zone sloping gently to the south. This is a tropical paradise.

The Izapa architectural platforms range in size from low elite residential or temple substructures up to truly massive pyramids and terraces. The tallest pyramid, Mound 60, is 22 meters (72 feet) high and 120 meters (400 feet) on a side. The largest platforms are over 150 meters (500 feet) wide and about 4 meters (13 feet) high, supporting other platforms and pyramids. (Ordinary dwelling remains of the first millennium B.C. are not visible on today's surface.) Excavations show that platform fill is detritus and clay with original surfaces mainly of river-worn boulders, with some cut stone blocks on stairs and corners. There was use of clay and thin lime stucco. At least one reservoir, 3 meters (10 feet) deep with stone-lined inlet and

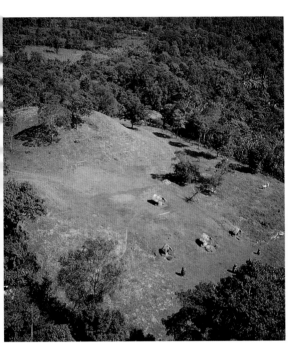

Izapa: view of Mound 30, looking north

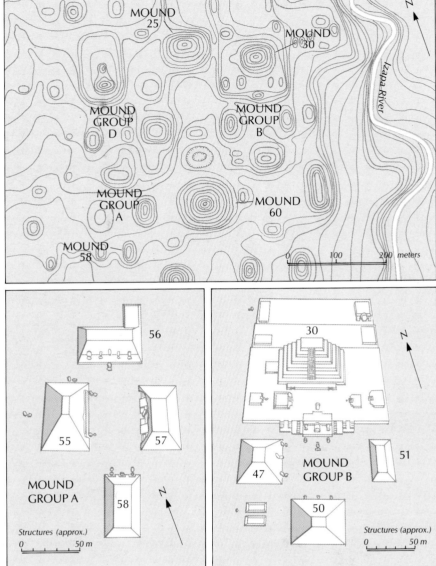

Izapa: site plan and Mound Groups A and B

outlet drains to maintain it was located next to the tall Mound 60 pyramid (it was subsequently filled in and is no longer visible on the surface).

Distributed about the edges of several of the central Izapa plazas, at the bases of platforms, were eighty-nine upright stone stelae, with ninety roundish flat stone "altars" and three carved-legged thrones at their bases, and more than seventy miscellaneous monuments of varying sizes. Some forty of the stelae and eleven of the altars bear carved designs, and all of the miscellaneous sculptures are carved in one way or another.

The Izapa monument groups appear to represent ritual circuits. Related ceremonies would be calendrical in that they are dedicated to seasonal feasts, anticipating the well-known Mexican and Maya practice of dividing the agricultural or solar year into eighteen months (of twenty days each) characterized by fiestas and fasts of varying length and significance, with a remaining five days of usually unfavorable portent. Many of the monuments thus would incorporate fertility myths, commemorate legendary events, and possibly represent dominant lineage patrons. Certainly it is possible to see many Mesoamerican "gods" and, in particular,

to recognize characters from the Maya myths of the *Popol Vuh*[1] and various central Mexican accounts of the creation(s) and successive events.

Many eroded or missing portions of the Izapa sculptures make it difficult or impossible to understand the ceremonial function of Izapa. The dominant position of art and religion manifest in the sculpture indicates a strong ruling class supported by the production of cacao and commerce in this and other tropical goods. Early collapse of the ceremonial center, with its near abandonment but preservation of monuments, suggests a politico-economic overthrow only, with retention of the home populace. Following this shift in control, all new construction, now without sculpture, passed from the ceremonial center to Group A, on the north.

Ancestors of the population responsible for the sculpture at Izapa were important participants in the earliest known advanced Mesoamerican societies, going back to 1500 or 2000 B.C., and in later Olmec developments. A close Olmec relationship is indicated by both ceramics and linguistics, with numerous stylistic parallels appearing between late Olmec and Izapa sculpture. At the Spanish Conquest, Pacific Coast Soconusco natives of southern Chiapas spoke a dialect of Mixe, and all of western Chiapas was Zoquean. The Mixe-Zoque language family also then occupied (and still does) parts of eastern Oaxaca, southeastern Veracruz, and western Tabasco, precisely the regions of major Olmec development. The wide separation of Izapa from the Olmec heartland, of course, explains its distinctive characteristics. The common modern tendency to assign most or all of Mesoamerican sculpture from 400 B.C. to A.D. 400 to an "Izapan" style may not always be technically correct, but it is a fitting tribute to the unique importance of this great ancient city that was frozen in time.

1. *Popol Vuh: The Mayan Book of the Dawn of Life,* trans. by Dennis Tedlock, New York, 1985.

15 ⟨ Stela 1 and Altar 1

⟨ Mound 58, Izapa, 3rd–mid-1st century B.C.
⟨ Andesite; height 168 and 73 cm. (66⅛ and 28¾ in.)
⟨ CNCA–INAH, Museo Nacional de Antropología,
⟨ Mexico City 5–2921, 5–2920

Often viewed as a simple depiction of a "god of fishing," Izapa Stela 1 is, in fact, a very complex presentation of all the forces related to water. These are, from top to bottom: a cloud snake and master, an inverted new moon (thus permitting rainwater to escape), clouds and lightning, fire, rainfall, water storage and flooding or movement, perhaps corn-sprout scrolls, fish, fishing, sacred water carried in the jar for ritual purposes, and a wind flare extending from the main personage's mouth-mask. This main profile figure holding fish in a net represents Tohil, god of storms. Overall, Stela 1 is a depiction of the ninth calendrical day, Water, a day that played an important role in revolving New Year's rites each four years, in thirteen and fifty two-year cycles.

In its original setting before Mound 58 at Izapa, Stela 1 was next to Stela 2, illustrating the gourd tree representing the day Rabbit, virgin birth, and

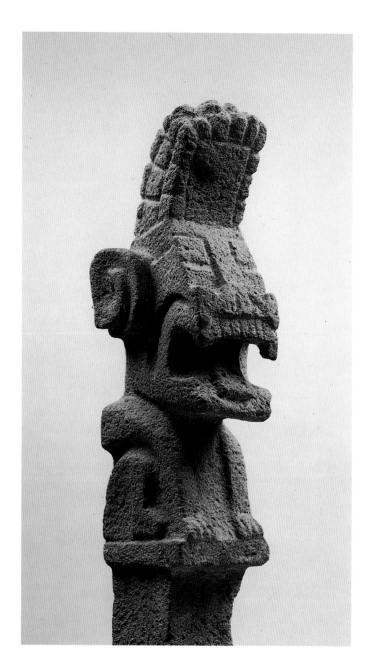
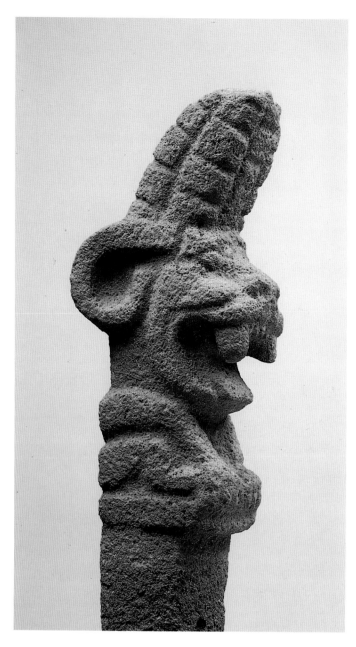

16 ◆ Two Jaguar Pedestal Sculptures

Soconusco or Pacific coastal region of Chiapas,
1st–3rd century
Basalt; height 83 and 104 cm. (32⅝ and 41 in.)
CNCA–INAH, Museo Regional de Chiapas, Tuxtla
Gutiérrez CMRCH–000653, CMRCH–000654

Tall stone pedestals surmounted by carved seated animals or humans are found sporadically across the Pacific coast and highlands of Guatemala. None of the pedestal sculptures, however, have been found in good archaeological context and correct dating is uncertain. Eroded fragments of pedestal and nonpedestal stone jaguars have been found at Izapa, but always in secondary contexts. The two examples here from southern Chiapas belong to a small class apparently restricted to the Pacific slopes: "a jaguar with stylized features, high loaf-shaped headdress, and attenuated hindquarters sits on a square shaft up to 2 m in height. . . . Squared fangs, an exaggerated nose, and stylized ears . . . relate these figures."[1] The shafts of the exhibited examples have been broken off and consequently do not reach the full height.

These jaguar pedestal sculptures appear to represent corn "deities" or protectors. The open mouths surely indicate that the beasts are roaring to keep away intruders and any natural (or supernatural) threats to the crops. Jaguars are creatures of the night and the underworld, and presumably that is when

these sculptures were effective. The figures might also be lineage deities or protectors of village or temple compounds and perhaps one was placed at each cardinal direction or entrance. The elongated pedestal facilitated cyclical rotation of the sculptures.

Pedestal sculptures are typically square in cross-section and are thought to have been carved from natural basalt columns, sources of which are known to exist in southwestern Guatemala.

GWL

1. Miles 1965, p. 248

DISCOVERY
Unknown

REFERENCES
S. W. Miles. "Sculpture of the Guatemala-Chiapas Highlands and Pacific Slopes, and Associated Hieroglyphs." In *Handbook of Middle American Indians*, vol. 2: *Archaeology of Southern Mesoamerica*, edited by Gordon R. Willey. Austin, 1965, pp. 237–75, fig. 11d. **V. Garth Norman**. *Izapa Sculpture.* Papers of the New World Archaeological Foundation, no. 30, pt. 2: text. Provo, Utah, 1976, p. 277, fig. 5.66b.

17 ⦚ Vessel with Wind God Effigy

Mound 30d, Urn Burial F–12, Izapa,
mid-1st century B.C.–1st century A.D.
Ceramic, remnants of stucco;
height 29 cm. (11⅜ in.)
CNCA-INAH, Museo Nacional de Antropología,
Mexico City 5–1117

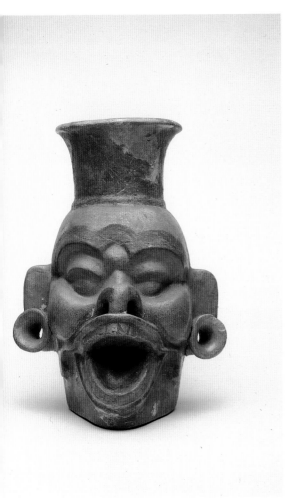

This vessel effigy shows with unusual clarity the wearing of a buccal, or mouth, mask, which fits on the forepart of the nose and extends back to the ears. The head and eyes showing above the mask and the human characteristics of the teeth in the much enlarged mouth indicate that the mask lends a particular power or force to a person who otherwise retains his human and individual character. Presumably the force is that of the wind or some aspect of Ehecatl/Quetzalcoatl, where the gift of speech and wisdom would be an alternative endowment. A particular rank or class might also be indicated. The individual portrayed on the jar may be the person interred in the elaborate Urn Burial F–12, as the jade pieces (cat. no. 18) would suggest; the F–12 earflares are identical to those of the jar, and a necklace pendant the jar contained also is of the wind god.

The Izapa effigy vessel is an import from Guatemala or El Salvador, as are many other vessels in the same offering. It had been given a secondary decoration locally, of pink and white stucco paint over red hematite, but this design is now lost (the vessel was found smashed). Another much larger stucco-painted vessel with this urn burial had an elaborate depiction of a truly stylized wind god, with a tremendous upper jaw and apparently no lower jaw, but it was impossible to consolidate.

Some of the attributes of Ehecatl/Quetzalcoatl are linked to rain, water, and warfare. The find location of Urn Burial F–12, close to Stelae 24, 8, 9, and 10 and Throne 1, seems to be related to the calendar days Motion, Flint, Rain, and Flower/Sun/Ahau, and thus the cyclical patrons of the thirteen-day week Ce Ehecatl or 1 Wind, among others. Durán, explaining the celebration of the Aztec "Great Feast of the Lords," states that: "The god Ehecatl was commemorated on this same feast. He is also the one known as Quetzalcoatl, ... Ehecatl means wind. A man was sacrificed on this day, and this sacrifice was performed in the name of the wind and in honor of this deity."[1]

Quetzalcoatl was, however, also a god of artisans and merchants, again because of his calendrical position: "A feast to the Air was also celebrated under the name of Ehecatl. The Air and its virtues were attributed to the divinity of the people of Cholula: Quetzalcoatl, God of the Merchants and the Jewelers, the most highly reputed and saintly in all Cholula. Great virtues

are attributed to him, heroic deeds regarding merchandise and marketing, the cutting of gems and stones. This Ehecatl was given huge offerings and sacrifices, especially on one day of the week, which was called Ehecatl, meaning wind. When this fell on the number one—just as today we say Monday—and . . . since [these people] had weeks of thirteen days, when they reached thirteen, they began to count again, associating the day with the sign which fell on number one. This was solemnized with great magnificence in special offerings and sacrifices, aside from ordinary ones."[2]

Both Izapa Stela 1 and Urn Burial F–12 provide ample evidence that the wind god was already of great importance there by the fourth–first-century B.C. A pair of carved plumed serpents from Chiapa de Corzo (cat. no. 21) indicates, furthermore, that the Quetzalcoatl theme was present in Chiapas at least as early as 850–300 B.C. The Quetzalcoatl serpent made its first appearance at Olmec La Venta (cat. no. 2) at the same time.

GWL

1. Durán 1971, p. 437
2. Ibid., p. 262

Urn Burial F–12 excavated by Brigham Young University–New World Archaeological Foundation Izapa project in 1962

REFERENCES
Fray Diego Durán. *Book of the Gods and Rites and the Ancient Calendar.* Translated and edited by Fernando Horcasitas and Doris Heyden. Norman, Oklahoma, 1971. **Gareth W. Lowe, Thomas A. Lee, Jr., and Eduardo Martínez Espinosa.** *Izapa: An Introduction to the Ruins and Monuments.* Papers of the New World Archaeological Foundation, no. 31. Provo, Utah, 1982, pp. 191–94, figs. 7.14 f, 9.13.

18 ◀ Personal Ornaments

Mound 30d, Urn Burial F–12, Izapa, mid-1st century B.C.–1st century A.D.
Jade; pendant: height 6 cm. (2⅜ in.); earflares: diameter 5 cm. (2 in.); necklaces: length 40 and 43 cm. (15¾ and 16⅞ in.)
CNCA-INAH, Museo Nacional de Antropología, Mexico City pendant: 5–3658b; earflares: 5–3660; necklaces: 5–3658a, 5–3659

Even more than the associated effigy vessel (cat. no. 17), the jade pendant found in the F–12 urn burial represents a human individual with the simplest of wind-god attributes: he is merely blowing or perhaps speaking forcefully, but in either case he demonstrates the power bestowed upon him by Ehecatl/Quetzalcoatl (this is but one of three separate wind-god portraits in a single offering). The jade pendant has double interconnected perforations on the forehead, chin, and cheeks, undoubtedly to receive tassels or green feathers, which were themselves symbols of Quetzalcoatl.

The jade beads making up these necklaces were found massed at the bottom of the collapsed burial urn, and the assembly of the beads in any particular sequence is problematical. Found associated with them in the bottom of the urn were a narrow hematite mirror, 6 cm. (2⅜ in.) long, and two flat incised ring-tail jade fish (stolen soon after discovery and not recovered). The doubled fish perhaps are significant because Quetzalcoatl was also the god of twins.

The pair of jade earflares seen here (one of two sets found in the burial) closely approximates that worn by the wind-god mask effigy vessel (cat. no. 17). They are simple flares and tubes, somewhat larger than average but not particularly well matched, designed to slip through the enlarged earlobe. The wearing of earplugs and flares by males was a common Mesoamerican custom, and eighteen of the Izapa monuments show individuals wearing earflares, some of them very large. The largest is on Stela 1 (cat. no. 15), precisely on the head or mask of the wind, water, and fishing god. No specific importance is

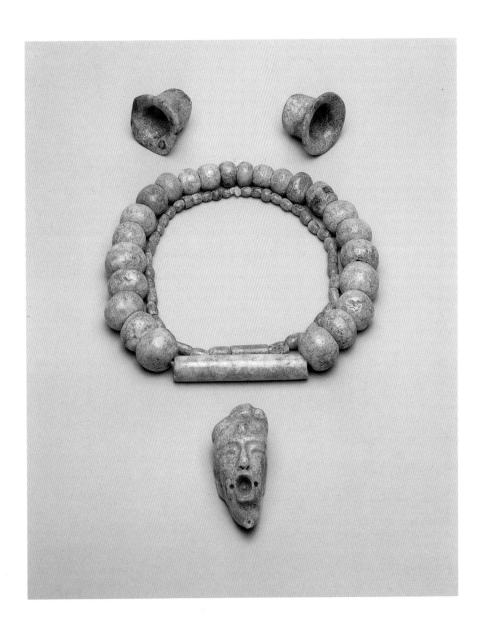

known to have been attached to wearing earflares, contrary to the ritual significance of nose and lip plugs in later times.

Jade was the most precious substance in pre-Hispanic Mesoamerica, and there can be no doubt that the wearing of jade reflected high status (witness the jade on luxuriantly dressed rulers in Maya tombs and sculpture). Simple jade bead necklaces are shown on only a few Izapa monuments (Stelae 5, 18, 21, 24). Larger jade circles indicate "preciousness" or quetzal feathers on four of the Izapa carved bird figures, those of Stelae 9, 18, 21, and 50, with 18 and 50 being in headdresses.

The relatively humble Urn Burial F–12 is one of a half-dozen richest known in southern Chiapas; for its time and place it is the closest thing to a "royal burial" that we have, but it pales by comparison to two known royal tombs of approximately the same date discovered at Kaminaljuyú on the outskirts of Guatemala City. Central Izapa went into decline just as Kaminaljuyú entered its period of maximum development, and it can be argued that the Izapa urn burials, within a final construction stage, represent an immigrant society more than they do old-line Izapa elite. Apparently Izapeños normally disposed of their dead under different circumstances, for almost no other burials

Jade fish (now lost) from Urn Burial F–12

have been found. Bones are not preserved at Izapa, even within urns. Some-
times a few jade beads are the only evidence of once-elegant burials.

GWL

DISCOVERY
Urn Burial F–12 excavated by Brigham Young University–New World Archaeological Foundation
Izapa Project in 1962

REFERENCE
Gareth W. Lowe, Thomas A. Lee, Jr., and Eduardo Martínez Espinosa. *Izapa: An Introduction to
the Ruins and Monuments.* Papers of the New World Archaeological Foundation, no. 31. Provo,
Utah, 1982, pp. 191–94, fig. 9.12.

19 ◀ Fish Ornament

Provenance unknown, possibly southern Chiapas,
1st–3rd century
Jade; height 3.7 cm. (1½ in.)
The Guennol Collection, New York

This fish effigy is quite different from those in cat. no. 20. It has no ring
around its tail and no lower jaw. The three very visible serrated teeth are
definitely sharklike. The open shark mouth and barbel (scrolled fang) at the
back of the mouth closely relate this effigy to the "fire shark" attached to
the back-packed *olla* on Stela 1 (cat. no. 15), as well as to the eroded mask worn
by the Chac bearer himself. This jade fish also may be a *Xoc* or count symbol,
perhaps useful in a cycle ceremony or commemoration. The perforations
around the head and fins may have been for mounting or hanging as a pendant
or may have simply served to attach tassels or feathers.

GWL

DISCOVERY
Unknown

REFERENCE
Metropolitan Museum of Art. *The Guennol Collection.* New York, 1982, pp. 127.

20 ◀ Five Fish Ornaments

Provenance unknown, probably southern Chiapas,
3rd century B.C.–3rd century A.D.
Shell; height 1.5 cm. (½ in.)
Collection Mrs. William H. Moore III, New York

These five small shell effigies are very similar to ring-tail fish that appear in
pairs on Izapa Stelae 5, 22, and 67 and to an isolated example on Stela 3 at
Kaminaljuyú. The two jade ring-tail fish found with Izapa's Urn Burial F–12
(cat. no. 18) are also generally similar. The recovery of several of these small
fish effigies together is extraordinary and indicates a specific offering. Re-
markably, Girard describes rather recent Chorti Maya rituals at the beginning
of the rainy season as follows: "From the spring they carry, in addition [to
'virgin' water] a pair of frogs and five small fishes which will be placed by the
priest in the central basin, full of water, which is beneath the temple altar. All
of these elements work together to magically guarantee a good season and
abundant harvests."[1]

Girard also believes that the fish is a representation of the young god of
corn. The *Popol Vuh*, the sixteenth-century account of Maya myths, pro-

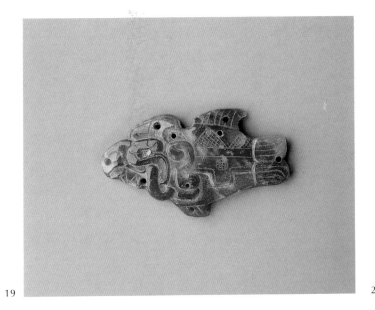

19

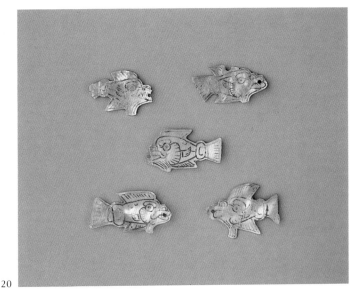

20

vides a story of the twins Hunahpu and Xbalanque who are transformed into fish-men (or men with fish bodies) five days after their bones were ground up and thrown into a river of the underworld. These twins eventually rose to heaven and became the sun and moon. The two fish carved in the basal water panels of Izapa Stelae 1, 22, and 67 must in some way be related to this myth.

What is certain is that fish were commonly offered as sacrifices and that small fish effigies were commonly offered to bodies of water.

GWL

1. Girard 1966, p. 77 (translated by Lowe)

DISCOVERY
Unknown

REFERENCES
Rafael Girard. *Los Mayas: su civilización, su historia, sus vinculaciones continentales.* Mexico, 1966. **Metropolitan Museum of Art.** *The Guennol Collection.* New York, 1982, pp. 125–26.

21 ◀ Pair of Ear Pendants

Mound 1, Burial 74, Chiapa de Corzo,
mid-5th–mid-3rd century B.C.
Shell; height 9 cm. (3½ in.)
CNCA-INAH, Museo Regional de Chiapas,
Tuxtla Gutiérrez CMRCH–000192

Chiapa de Corzo was a Mixe-Zoquean and Olmec-era capital city contemporaneous with Izapa and, like it, had a long developmental history. Large stone-walled platforms were being constructed about 850–300 B.C., and at the southern or rear side of one of them, Mound 1, was interred Burial 74. Burial 74 itself was a simple extended interment without surviving crypt and was accompanied by an offering of but four black-brown vessels, one of them originally stucco-surfaced. The individual wore an elegant pair of worked shell ear ornaments.

These shell serpent effigies are the lower or pendant portions of a matched set of compound earplugs. The plugs themselves, of an organic substance, perhaps hardwood or resin, were not recovered. Facing or capping the plugs were thin round perforated disks of shell, badly fractured, about 4 cm. (1⅝ in.) in diameter (now lost). The shell serpents were suspended from the plugs by a perforation in their tail coils, presumably with each head and tail facing the front (they are mirror images). The serpents appear to be bearded and plumed and thus may be one of the oldest known examples of the Quetzalcoatl theme.

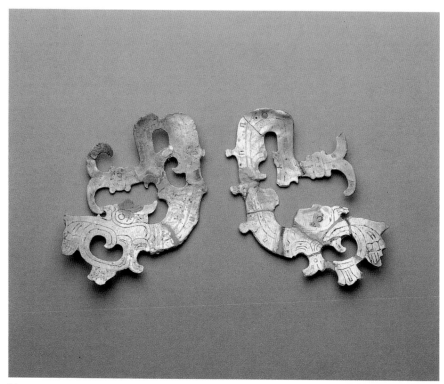

21

Fine-line cross-hatching on the right serpent suggests that this one may have had a darker color. Some think that these effigies are fish of the well-known ring-tailed/bifid-tail class carved, often in pairs, on early monuments or individually as offerings (see cat. nos. 18 and 20). However, the length and contortions of the Chiapa effigies, and the lack of obvious dorsal fins, make this identification unlikely.

Elaborate compound earplugs are commonly shown on sculpture throughout Mesoamerica, but effigy pendants do not appear in the Izapa carvings. Snake appendages in later iconography have been viewed as identity badges for the personage wearing them. The evidence suggests that the Chiapa de Corzo Burial 74 individual had been an important ancillary, perhaps a wind-god priest, but not a ruler since no jade was included in his grave.

GWL

DISCOVERY
Burial 74 excavated from the south side of Mound 1 by the Brigham Young University–New World Archaeological Foundation in 1958

REFERENCE
Pierre Agrinier. *The Archaeological Burials at Chiapa de Corzo and Their Furniture.* Papers of the New World Archaeological Foundation, no. 16. Provo, Utah, 1964, pp. 18–19, fig. 23.1.

22 Spouted Tetrapod Vessel

Mound 1, Tomb 1, Chiapa de Corzo,
mid-1st century B.C.–1st century A.D.
Ceramic; height 22 cm. (8⅝ in.)
CNCA-INAH, Museo Nacional de Antropología,
Mexico City 5-3570

Shown here is a spouted tetrapod jar that was one of three imported vessels found within the collapsed Tomb 1 at Chiapa de Corzo. The multiple-brush Usulutan negative, or resist, decoration of wavy parallel lines indicates a highland Guatemalan or Salvadoran origin. The jar had a secondary covering of thin stucco in several colors (as did all Usulutan vessels imported into Chiapas), but this has flaked away. The four hollow feet, slightly bulbous spout, and inner-grooved lip are traits completely within the traditions of Central America in the first century A.D. Usulutan ware is predominant at several major sites in the Valley of Guatemala, El Salvador, and western Honduras but practically absent in Mexico except as rare trade items. This pattern of ceramic distribution is one of the best evidences for a sharp cultural or ethnic split between Chiapas and Central America, going back well into the first millennium B.C.

GWL

DISCOVERY
Tomb 1 excavated by Pierre Agrinier of the Brigham Young University–New World Archaeological Foundation in 1957

REFERENCE
Gareth W. Lowe and Pierre Agrinier. *Mound 1, Chiapa de Corzo, Chiapas, Mexico*. Papers of the New World Archaeological Foundation, no. 8. Provo, Utah, 1960, pp. 39–42, fig. 37a, pl. 18c.

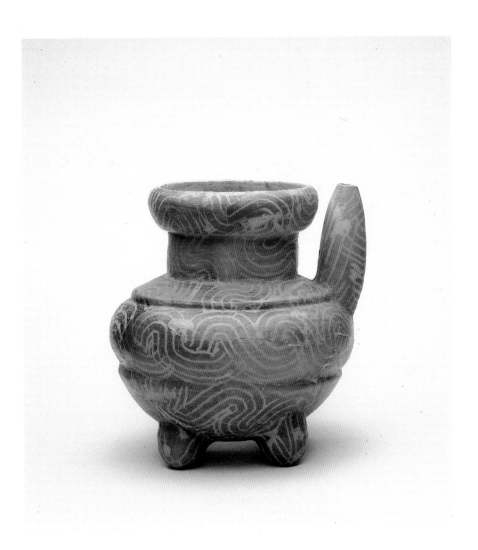

23 ◀ Baton or Handle (one of a pair)

◀ Mound I, Tomb I, Chiapa de Corzo,
◀ mid-1st century B.C.–1st century A.D.
◀ Bone; height 23.5 cm. (9¼ in.)
◀ CNCA–INAH, Museo Regional de Chiapas,
◀ Tuxtla Gutiérrez CMRCH–000193

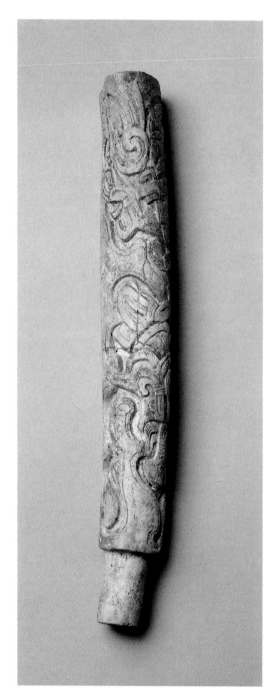

Four worked human leg bones were found aligned together against the west adobe-brick wall of Tomb 1. These were two left and two right femurs that appear to have been royal signa or talismans. The great lance interred with the deceased (cat. no. 25) suggests that the latter was a ruler or warrior and not a medicine priest. No jade was found, but the tomb had been looted in ancient times.

The bones in Tomb 1 formed two pairs differing slightly in shape but with each pair having one carved and one plain bone. Bones 1 (here) and 3 (cat. no. 24) were completely covered with masterfully executed carved designs. On Bone 1 the dragon figure at the bottom appears to be an original Cipactli, or Day 1, glyph of the Mexican calendar. The Cipactli dragon monster figures importantly in the mythology of creation, either as the watery primordial earth or as the Milky Way. At the top appears a bearded figure possibly representing Day 20, Flower/Sun or Hunahpu/Ahau/Sun. This personage with an elongated corn-god head also may represent mature maize, as opposed to the birth of corn seen on Bone 3. The message of Bone 1 thus may be that of a completed cycle (perhaps a combination involving the ritual almanac of 260 days), viewed as an interaction between elements on the earth and in the heavens.

GWL

DISCOVERY
Excavated by Pierre Agrinier of the Brigham Young University–New World Archaeological Foundation in 1957

REFERENCES
Keith A. Dixon. "Two Carved Human Bones from Chiapas." *Archaeology* 12, no. 2, New York 1959, pp. 106–110, figs. 2 left, 3. **Pierre Agrinier.** *The Carved Human Femurs from Tomb 1, Chiapa de Corzo, Chiapas, Mexico.* Papers of the New World Archaeological Foundation, no. 6. Orinda, Calif., 1960. **Gareth W. Lowe and Pierre Agrinier.** *Mound 1, Chiapa de Corzo, Chiapas, Mexico.* Papers of the New World Archaeological Foundation, no. 8. Provo, Utah, 1960, pp. 39–42.

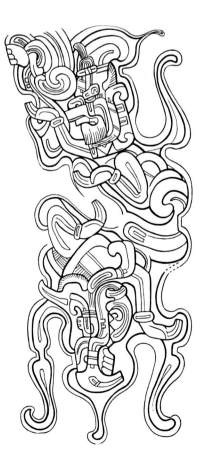

Rollout drawing of cat. no. 23, from Pierre Agrinier (1960), fig. 1

24 ◀ Baton or Handle (one of a pair)

Mound 1, Tomb 1, Chiapa de Corzo,
mid-1st century B.C.–1st century A.D.
Bone; height 26.5 cm. (10¼ in.)
CNCA–INAH, Museo Regional de Chiapas,
Tuxtla Gutiérrez CMRCH–000194

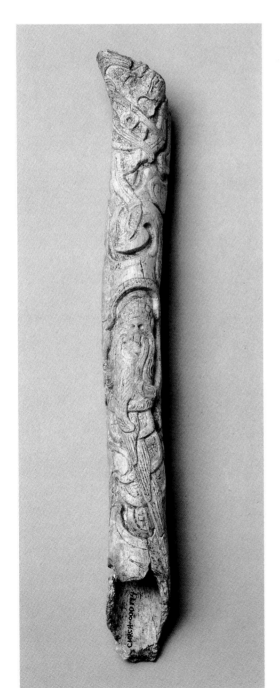

On Bone 3 of the Tomb 1 group, there appears at lower right the same Cipactli dragon as on Bone 1 (cat. no. 23), but seen from above and with insectlike wings and Ik, or wind, signs. Apparently represented are either the earth and underworld, or water and wind, or, more probably, cyclical forces. Emerging at the top left of the design is the "old mother" or ancestor goddess, sometimes also seen as the goddess of death. At the left center a young corn deity is seen sprouting from the cloud or water swirls. A quite similar account of the birth and maturation of maize is depicted on Izapa Stela 5, the "Tree of Life" stone, but there it is diffused within a much more complex creation scene.

There is a clear parallel in skill of execution and somewhat in style between the Chiapa de Corzo carved bone designs and the famed Stela 10 ("black altar") of Kaminaljuyú that bears the earliest known long hieroglyphic inscription in the Maya area. The iconography of the Chiapa bones nevertheless appears to be closer to that of the Epi-Olmec inscriptions found in the Isthmian Gulf Coast region; this fact is suggestive of late Olmec-Mixe-Zoquean origins. Furthermore, these bone designs afford clear evidence for the great age of some Mexican religious beliefs and customs as recorded at the time of the Conquest.

GWL

DISCOVERY
Excavated by Pierre Agrinier of the Brigham Young University–New World Archaeological Foundation in 1957

REFERENCES
Keith A. Dixon. "Two Carved Human Bones from Chiapas." *Archaeology* 12, no. 2, New York 1959, pp. 106–110, figs. 2 right, 4. **Pierre Agrinier.** *The Carved Human Femurs from Tomb 1, Chiapa de Corzo, Chiapas, Mexico.* Papers of the New World Archaeological Foundation, no. 6. Orinda, Calif., 1960. **Gareth W. Lowe and Pierre Agrinier.** *Mound 1, Chiapa de Corzo, Chiapas, Mexico.* Papers of the New World Archaeological Foundation, no. 8. Provo, Utah, 1960, pp. 39–42.

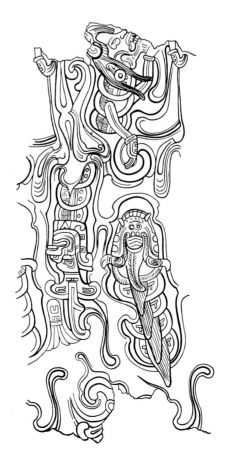

Rollout drawing of cat. no. 24, from Pierre Agrinier (1960), fig. 9

25 ❭ Spear Point

❭ Mound I, Tomb I, Chiapa de Corzo,
❭ mid-Ist century B.C.–Ist century A.D.
❭ Obsidian; height 31.8 cm. (12⅝ in.)
❭ CNCA–INAH, Museo Regional de Chiapas,
❭ Tuxtla Gutiérrez CMRCH–000189

The Chiapa de Corzo spear point was found together with its carbonized shaft lying on the right side of the deceased personage in Tomb I. There was a cruciform massing of fifty-six white shark teeth at the shank of the shaft, some of them with double perforations. These teeth must have been held in position by slotting and binding with the use of gums or resins for additional strength. One can imagine an impressive weapon, whether for battle or ceremony, incorporating this tremendous obsidian blade and its shark-tooth foreshaft.

The obsidian point was formed by a single blow or pressure application to a huge preformed macrocore. The resultant blade has a trapezoidal cross-section and was not retouched—the keenness of the blade edges is formidable. The base of the point was first chipped and then ground down to receive the shaft. Obsidian points of this size and perfection are extremely rare, and there appear to be no other known examples of similarly ground obsidian spear point tangs. The Chiapa de Corzo spear point is one of many evidences of the active exchange in elite goods between central Chiapas and other regions between the first millennium B.C. and early centuries A.D.

GWL

DISCOVERY
Excavated by Pierre Agrinier of the Brigham Young University–New World Archaeological Foundation in 1957

REFERENCES
Gareth W. Lowe and Pierre Agrinier. *Mound 1, Chiapa de Corzo, Chiapas, Mexico*. Papers of the New World Archaeological Foundation, no. 8. Provo, Utah, 1960, pp. 39–42. **Thomas A. Lee, Jr.** *The Artifacts of Chiapa de Corzo, Chiapas, Mexico*. Papers of the New World Archaeological Foundation, no. 26. Provo, Utah, 1969, pp. 154–56.

26 ❭ Fragment of a Stela

❭ Mound 5d, Chiapa de Corzo,
❭ mid-Ist century B.C.–Ist century A.D.
❭ Limestone; height 19.4 cm. (7⅝ in.)
❭ CNCA–INAH, Museo Regional de Chiapas,
❭ Tuxtla Gutiérrez CMRCH–000195

Chiapa de Corzo Stela 2 originally was a thin-slab stela or tablet of unknown dimensions. Its thinness, however, does not suggest a great size. Only the present fragment was recovered in spite of very extensive excavations. The carved stone had been deliberately broken up at an unknown date. This fragment was finally incorporated into an elite house or temple platform, Mound 5d.

A reconstruction of the long count date, the series of bars and dots arranged horizontally that, although it is incomplete, is read as 7.16.3.2.13 6 Acatl (16 Toxcatl), is accepted as correct. When correlated to the Christian calendar, this date reaches 36 B.C. Thus, Chiapa de Corzo Stela 2 bears the oldest recorded date yet known in the New World.

GWL

DISCOVERY
Excavated from the low platform numbered Mound 5d by the Brigham Young University–New World Archaeological Foundation in 1961

REFERENCES
Gareth W. Lowe. "Algunos resultados de la temporada 1961 en Chiapa de Corzo, Chiapas." *Estudios de Cultura Maya* 2 (1962), pp. 192–95. **Thomas A. Lee, Jr.** *The Artifacts of Chiapa de Corzo, Chiapas, Mexico.* Papers of the New World Archaeological Foundation, no. 26. Provo, Utah, 1969, p. 105, fig. 60.

▼▼

The Metropolis of Teotihuacán

RUBÉN CABRERA CASTRO

In the Valley of Teotihuacán, some fifty kilometers (thirty miles) northeast of Mexico City, the most important culture of ancient central Mexico had its origins in the second century B.C. Its influence and territory extended as far as Sinaloa in western Mexico and Guatemala to the southeast, but the capital and the history of Teotihuacán are centered in this valley. It was the site of the largest archaeological city ever to exist on the American continents.

During the period of its greatest flowering, Teotihuacán (the name means the City of the Gods) covered an area of more than twenty-five square kilometers (nine square miles), and its population reached some two hundred thousand inhabitants. This may seem small by comparison to modern cities, but Teotihuacán was larger than cities of the same period in the Old World, and it became the most highly urbanized center in the New World. The religious, political, and economic heart of an immense territory, it controlled the activities of hundreds of thousands of people, and at its height it witnessed a flowering of the arts and sciences, including mathematics, astronomy, time-reckoning, architecture, sculpture, ceramics, and mural painting.

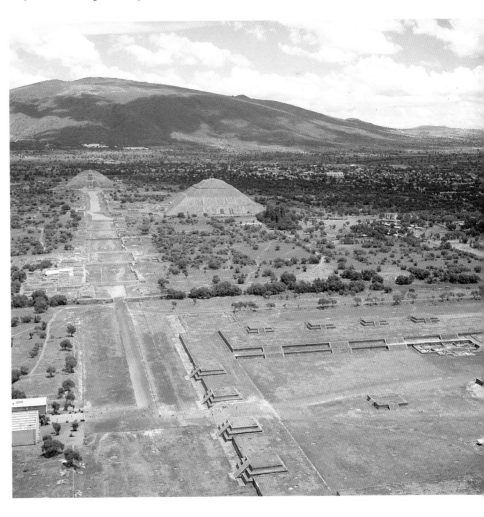

Teotihuacán: Street of the Dead, looking north toward Cerro Gordo

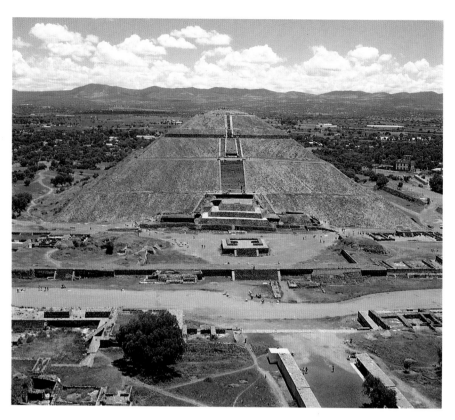

Teotihuacán: Pyramid of the Sun

The history of Teotihuacán began in the Valley and in the Basin of Mexico between 700 and 600 B.C. when small groups of people developed simple, unplanned farming settlements. These groups may have inherited traditions from other localities, but they were in fact Teotihuacanos shaping their own culture. The true origin of Teotihuacán began when several of these settlements joined and formed the first urban center, roughly during the first two centuries B.C., when the population, occupying a very large area, may have reached fifty thousand inhabitants. During this period, construction was begun on the Pyramids of the Sun and of the Moon, the two largest structures in Teotihuacán, and on a group of other temples and architectural complexes. The population increased to one hundred thousand by A.D. 350, by which time the people of Teotihuacán had become religious imperialists who initiated a series of conquests or commercial incursions that would take them to places as distant as Kaminaljuyú in Guatemala.

During this time the city grew to twenty square kilometers (eight square miles) and was, for the most part, totally planned. This was the period when Teotihuacán undertook construction of the major complex that includes the Ciudadela and the Temple of Quetzalcoatl and, possibly, of the great market as well; the Street of the Dead and the Pyramid of the Moon with its extraordinary plaza were completed; the large residential palaces, with their numerous mural paintings, were also constructed at this time. Separate districts existed for the artisans: those who produced ceramics or objects of shell and slate, the specialists who fabricated cutting instruments of obsidian, the architects, masons, stucco-plasterers, and so forth; there were also areas, such as the Oaxaca and Maya districts, that were inhabited by foreigners, indicating that Teotihuacán was an international city where peoples from other localities came to live.

From A.D. 350 to 650, the city reached its greatest splendor. Its past achievements were consolidated and expanded and its population reached two hundred thousand. This was the last great period of construction, when most of the monuments seen today were built. Teotihuacán became an outstanding center for painters; more than two hundred frescoes have been recovered. A good many new techniques and decorations were devised for the adornment of palaces and temples as well as pottery, and the production of huge numbers of figurines brought about new techniques, such as the use of molds that permitted ease and rapidity of manufacture. This period was also characterized by the cutting of fine stones and the importation of marine objects from both the Gulf of Mexico and the Pacific Ocean, which were used for luxury items such as adornments, appliqués, and musical instruments.

Teotihuacán: Pyramid and Plaza of the Moon; Quetzalpapalotl Palace in foreground

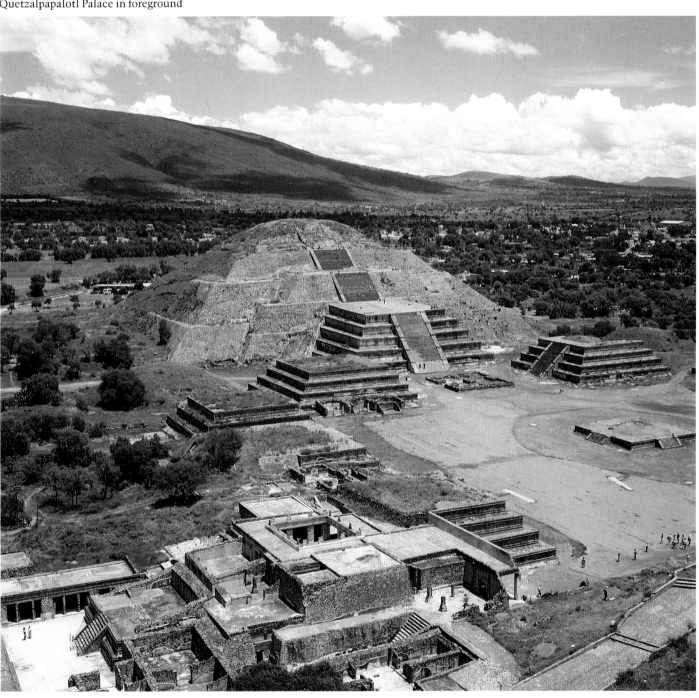

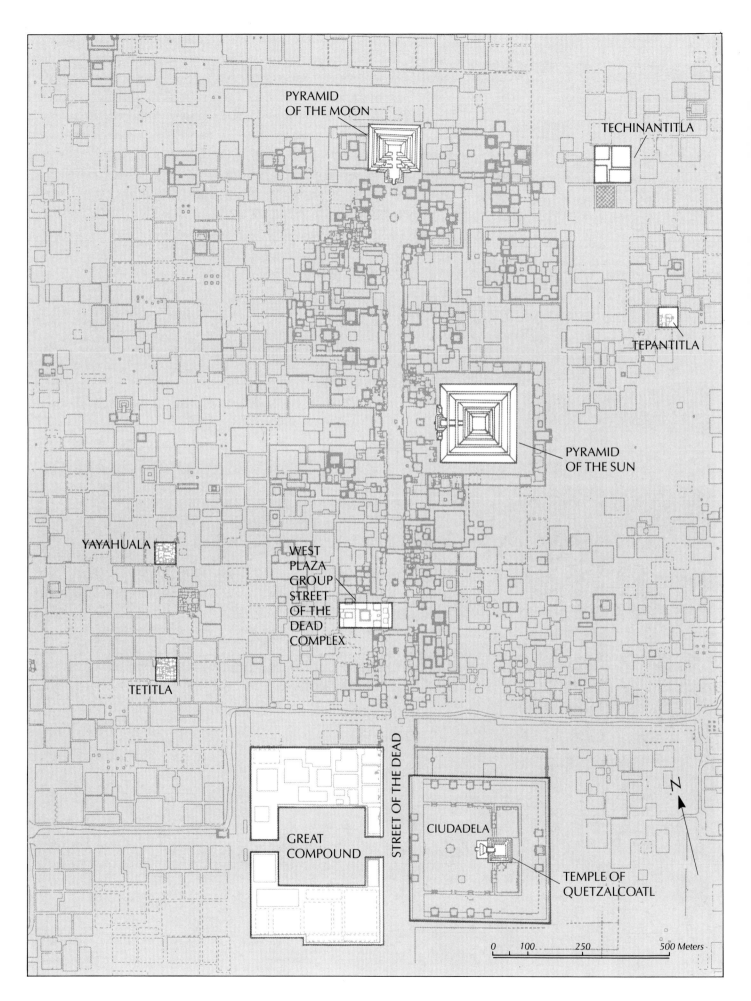

PYRAMID
OF THE MOON

TECHINANTITLA

TEPANTITLA

PYRAMID
OF THE SUN

YAYAHUALA

WEST
PLAZA
GROUP
STREET
OF THE
DEAD
COMPLEX

TETITLA

STREET OF THE DEAD

N

GREAT
COMPOUND

CIUDADELA

TEMPLE OF
QUETZALCOATL

0 100 250 500 Meters

Teotihuacán: facade of the Temple of Quetzalcoatl

The city's final phase ended about A.D. 650–750. During this period Teotihuacán declined, but the final dissolution apparently occurred after the eighth century. The collapse of many buildings located in the center of the city indicates that they were burned and were not rebuilt, which has given rise to many questions about the destruction of Teotihuacán. Was it sacked and burned by invaders? If its center was destroyed accidentally in a great fire, why was it not rebuilt? And if the city fell to invaders, why were the people of Teotihuacán incapable of resisting them? As for its population, what happened to it after the catastrophe? Farmers could move to other fields, but where did the craftspeople go? The presence of objects in the Teotihuacán style in other parts of Mesoamerica indicates that the artisans emigrated to these locales.

This necessarily short and general overview of the more than nine centuries of Teotihuacán history, is followed by a very brief description of the archaeological zone, an area visited by thousands of people every year who come to study and research its history or to contemplate and admire its many monuments, the legacy of a great ancient Mexican civilization.

In the city of Teotihuacán there is a broad avenue, now named the Street of the Dead. It is more than 40 meters (43 yards) wide and 2 kilometers (1¼ miles) long in its explored portion. Walking from south to north, the direction taken by pilgrims visiting the sacred city, the avenue passes in front of the Ciudadela, where the terrain is almost flat and the avenue is 90 meters (98 yards) wide. Crossing the San Juan River, where a wide bridge must have stood, the avenue, now 40 meters wide, follows the natural rise of the terrain until it reaches the Pyramid of the Sun. In this section the avenue forms a series of horizontal patios joined by transverse stairways that compensate for the incline of the terrain. The extreme north end of the avenue opens into an enormous esplanade known as the Plaza of the Moon.

The great Pyramid of the Sun, an ambitious monument of exceptional importance, was built on a squared base, each side 215 meters (235 yards) wide. It is 65 meters (71 yards) high and consists of four stepped, sloped tiers. A stepped platform and stairway is on its western side. Smaller pyramids and temples are symmetrically placed around it, endowing the complex with extraordinary grandeur. The orientation of the Pyramid of the Sun is based on astronomical considerations, and like the Street of the Dead and all the structures in the city, it deviates only slightly from astronomical north.

At the northern end of the Street of the Dead lies the great Plaza of the Moon, surrounded by smaller buildings decorated with polychromed frescoes. The Pyramid of the Moon, not quite as large as the Pyramid of the Sun, stands out magnificently in this complex of harmonious and symmetrically placed structures, its light tones silhouetted against the great, dark blue mass of Cerro Gordo. The temple pyramid, the most frequently used public architectural element, evolved from the simple base platform of an individual temple into the great pyramids which were the principal compositional focus of large architectural ensembles.

The Ciudadela is one of the largest urban complexes in Teotihuacán. An enormous quadrangle measuring 400 meters (437 yards) on each side,

Teotihuacán: site plan of north-central section

it is composed of an enclosing platform at whose summit are fifteen smaller pyramids symmetrically arranged along a main axis. In the foreground of the quadrangle is an immense open space capable of holding sixty thousand people, and at the rear of this space, beyond a central temple on a squared base, stands one of the city's most important monuments, the Temple of Quetzalcoatl.

The Temple of Quetzalcoatl is composed of structures from two different periods. The later construction stage—a plain, stepped structure—was built directly in front of the earlier temple, which was highly ornate. The earlier temple is an impressive monument composed of seven stepped sections. Constructed of large blocks of stone that form the *taluds* and *tableros*, it is decorated with gigantic sculptures of plumed serpents alternating with enormous symbolic heads related to the rain god. These sculptures are developed on a background of marine elements that include bivalves and conch shells and that show traces of blue, yellow, red, and green paint.

To the north and south of the Temple of Quetzalcoatl are two extensive areas of buildings, each occupying approximately 8,200 square meters (9,800 square yards). Each area is made up of five groups of rooms and porticoed spaces, arranged on the four cardinal points around an inner patio. Outstanding are the symmetry of the composition, the equilibrium of its large spaces, both roofed and open, and the privacy maintained within some of the groups by their communications through hallways and rear patios.

These building groups are reached from the esplanade of the Ciudadela by broad flights of steps that lead to a porticoed space. The central portico must have been the point of access to the complexes. Because of the high walls and strictly controlled access to these areas, they are believed to have served an administrative function. The Ciudadela was the center of ideological, political, and administrative control of Teotihuacán society.

Palaces played an important part in the life of the great metropolis. Only some of the palaces have been partially explored, yet they have provided information regarding the private lives of people in high social positions. Located near the center of monumental constructions, they occupy large rectangular compounds and are surrounded by high walls that create narrow streets between them. A single door serves as entrance, and in the interior the rooms are distributed symmetrically, forming numerous patios that provided light and ventilation. All the walls of the rooms and porches were decorated with fresco paintings. There are many architectural complexes of smaller dimensions distributed throughout the city, which display a marked monumental character.

Outside the band of monumental and residential constructions (the latter occupied by the upper classes) lies the ring of craft districts for artisans and merchants, the zones for foreigners, and the dwellings of the laborers and peasants. Obviously these outlying settlements are less luxurious, but their inhabitants played a very important role in the development of Teotihuacán and in the dynamics of its society, economy, and culture.

Mayahuel, the goddess of drink. Next to Stela 2 is Stela 3, depicting the serpent-legged god Tezcatlipoca in his hunter manifestation as the day Deer bearing a throwing stick, or *h'ul-che*. In front of Stela 3 is a huge stone toad, Altar 2, symbolic of the Maya twenty-day month. Stelae 1, 2, and 3 all have new moons carved in their sky panels, suggesting an original lunar month role for each. At any rate, the survival of this row of three stelae still upright and largely exposed and undamaged after two thousand years is mute testimony to their unusual original and lasting importance.

GWL

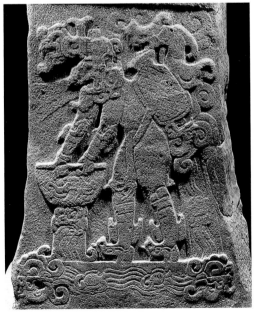

Detail of Stela 1 (cat. no. 15)

DISCOVERY
Partially exposed at the northern base of Mound 58, Group A, excavated by Matthew W. Stirling in 1941

REFERENCES
Matthew W. Stirling. *Stone Monuments of Southern Mexico*. Bureau of American Ethnology, Bulletin 138. Washington, D.C., 1943, p. 62, pls. 49a, 59b. **V. Garth Norman**. *Izapa Sculpture*. Papers of the New World Archaeological Foundation, no. 30, pt. 2: text. Provo, Utah, 1976, pp. 86–92, fig. 3.1.

27 ◄ Two Female Figures

Provenance unknown, probably Teotihuacán,
mid-2nd–4th century
Ceramic, pigment; height 8.2 and 11 cm.
(3 ¼ and 4 ⅜ in.)
Collection Franz Feuchtwanger, Cuernavaca

Countless ceramic anthropomorphic figurines dating from the time of the
founding of Teotihuacán have been discovered. Their style, form of adorn-
ment, and ceramic material allow us to follow the line of development of
Teotihuacán culture. Here two small polychromed feminine figurines show
the skill of the ancient ceramists. The style of the pieces—their adornments
and their facial features (slanted eyes, straight nose, and prognathic mouth) as
well as the technique of their elaboration—indicates their date.

Each of the two figurines wears a long skirt with decoration painted in red,
white, and yellow. The *quechquemitl*, or small cape, covers half the body
from the shoulders to slightly below the waist, and consequently the arms are
not visible. The headdresses on both figures are the same in form although
they differ in their decoration. They consist of a rather wide, uniform band
painted white, red, and yellow and placed horizontally on the head. Each
figurine wears a necklace divided into three parts. The smaller wears two
earflares presented in concentric circles painted green on red, while the larger
figure displays only locks of hair that are visible beneath the headdress and
hang down to the shoulders.

There is not sufficient data to determine whether these figures represent
deities or high-status individuals. Their headdresses may indicate identification
with some special group within the hierarchy of Teotihuacán society, but
there are many types of headdresses on such figurines whose significance is
unknown. All that can be said with certainty is that headdresses, like hair,
must have been subject to laws and norms that formed part of a rigorous
system of signs with hierarchical meaning within the society of Teotihuacán.

RCC

DISCOVERY
Unknown

28 ⟨ Three Male Figures

Provenance unknown, probably Teotihuacán,
1st–3rd century
Ceramic, pigment; height 6.5, 6.8, and 7 cm.
(2½, 2⅝, and 2¾ in.)
Collection Franz Feuchtwanger, Cuernavaca

These three small anthropomorphic clay figurines come from a period when the artisans of Teotihuacán had the freedom to represent the human figure in a variety of attitudes. All three have characteristics typical of figurines from the earliest periods in Teotihuacán. They are hand-modeled, with traces of yellow and white pigment applied over the coffee-colored ceramic. The adornment consists solely of a loincloth that hangs down to the ground in the back, allowing each figure to stand upright in an animated position. The bodies are roughly modeled but have a dynamic attitude. The delicately modeled faces have a realistic appearance: the figures on the left and right seem to represent two aged males; both have a protuberance on the shoulder as if they are carrying a bundle or are hunchbacked; and both have one arm raised. As adornments they wear earflares and a medallion on their sashes; the one on the right displays a tuft of hair on his head. The charming figure in the center seems to represent an adolescent who does not wear earflares or display a medallion on his sash. Two spherical objects adorn the head, and a tuft of hair falls to the shoulders. The figure is lifting a shell trumpet, held in both hands, to his mouth.

RCC

DISCOVERY
Unknown

28

29

29 ⟨ Huehueteotl

Provenance unknown, probably Teotihuacán,
2nd–4th century
Ceramic, pigment; height 5.3 cm. (2⅛ in.)
Collection Franz Feuchtwanger, Cuernavaca

This small object in hand-modeled ceramic represents the old god of fire, whose Nahuatl name is Huehueteotl. He was considered the father and ruler of gods and men by the pre-Hispanic peoples of Mexico and dwelled at the navel of the earth. In Teotihuacán he is generally represented in volcanic stone; thus, the fact that this small piece is elaborated in clay is significant. Unlike those made of stone, this figure has its hands resting on its legs, wears earflares, and is decorated with yellow and white pigments.

The principal characteristics of Huehueteotl are the sitting position, an extraordinary plastic expression in the entire figure, and a balanced arrange-

ment of the other component elements. The ancient god, his face lowered and furrowed with wrinkles, always carries on his head a wide circular vessel with flat base and straight walls. The stone figures were usually used as braziers or incense burners, but this piece is a miniature representation.

<div align="right">RCC</div>

DISCOVERY
Unknown

30 ◀ Seaded Figure

Provenance unknown, probably Teotihuacán,
3rd–5th century
Ceramic, pigment; height 8.5 cm. (3¼ in.)
Collection Franz Feuchtwanger, Cuernavaca

This human figure is shown in a seated position. The legs are semiflexed, and the crossed arms rest on the raised knees. The hands and feet are modeled with no indication of fingers or toes; the eyes and mouth are represented by the small gashes characteristic of the early phases of Teotihuacán.

The personage is attired in an elaborate headdress that consists of a band that encircles the head and two circular motifs applied to it. From the band two elongated adornments extend toward the back and to both sides. The one on the figure's left ends in a spherical element of porous texture that is painted white, as if representing a tassel. The one on the right also has the same kind of tassel, but this adornment extends farther back. The figure wears two circular earflares painted white, from which hang two large hoops or rings, and a necklace formed in two bands with traces of white and yellow paint. Below the knees the figure wears an ornament on each leg, and on the feet are two circular objects painted yellow, simulating a medallion or possibly a bead.

The manner in which the figurine is seated indicates that it is a young male. In Mesoamerican cultures seated adults display greater decorum in their posture, and seated female figures are generally represented either squatting or with their legs to the left or right.

The form of the figurine is exceptional and displays singular beauty. No similar pieces are known, and consequently elements of comparison, which

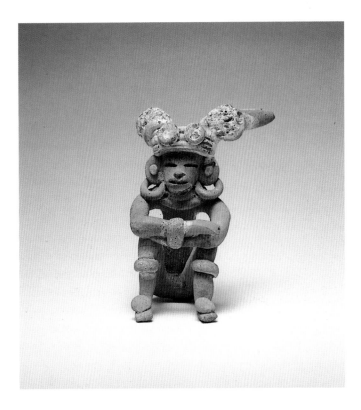

would provide information regarding the personage it represents, are lacking. Nevertheless, the dynamism and freedom of the composition, despite the fact that the figure is seated, may indicate that it is a dancer or a person whose occupation required great speed and agility.

RCC

DISCOVERY
Unknown

31 ◀ Animal Vessel

◀ Provenance unknown, probably Teotihuacán,
◀ 3rd–8th century
◀ Orangeware ceramic; height 23.5 cm. (9¼ in.)
◀ Los Angeles County Museum of Art, Los Angeles,
◀ Gift of Constance McCormick Fearing
◀ M.85.233.7

This is a singular vessel manufactured of orangeware ceramic. This type of ceramic, called "thin orange" ware, indicates that the piece comes from Teotihuacán, and since the ceramic was produced in Teotihuacán throughout its entire existence, the exact chronology of the piece is undetermined.

The body of the vessel comprises the body of the animal; consequently portions of its walls are bulkier to suggest the front and hind legs of the zoomorphic figure. The mouth of the vessel, formed by a short neck of slightly divergent walls, is located on the shoulders of the animal. The vessel is adorned with vertical incised lines that almost parallel each other, as if to suggest a carapace.

Nearly the entire body of the seated animal is covered by a succession of small diagonal grooves that run in alternating lines, as if gouged in zigzag, which may represent the fur or scales of the animal. The head is also covered by gouges and lines. The eyes protrude and are indicated by an incised line; the eyebrows are represented in the form of fern leaves; a slender band with appliquéd, round decorations encircles the head, and above this are wide, rounded ears, indicating that the piece cannot represent a rabbit, as has been suggested. The large mouth is open, the lips are delineated by a slender band, and a long line of teeth is visible, ending toward the frontal portion with large, exaggerated incisors.

The toes on the hind legs, barely visible beneath the body of the animal, are placed at the same level as the base of the vessel. The right arm holds a *sonaja* (rattle) with a cylindrical handle that passes beneath the animal's snout, while the left holds another cylindrical, hollow object with a mouthpiece and grip at one end. It can be interpreted as a flute since the figure is bringing it to its mouth. As adornments it wears a necklace as well as bracelets that are represented by a series of small rounded beads at the ankles of all four paws.

This figure is an extraordinary piece that displays realistic detail and also reveals the artist's creative imagination. The resemblance to models taken from nature indicates the strong desire of the ancient Teotihuacanos to reproduce the natural life of the animals and suggests their profound knowledge of the animals' habits, movements, and postures. However, although the piece is an essentially realistic creation, it is not easy to determine what animal it represents, for the figure also displays extraneous characteristics—the elements employed by the artist as a necessary and essential highlighting of the symbolic meaning he attempted to portray.

RCC

DISCOVERY
Unknown

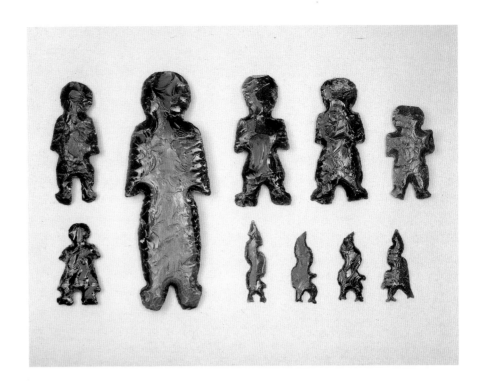

32 ◀ Funerary Offerings

Said to be from Cuauhtitlan, Basin of Mexico,
3rd–7th century
Obsidian; height 2 to 15.5 cm. (¾ to 6 in.)
Saint Louis Art Museum, Saint Louis, Missouri,
Gift of Morton D. May 135:1980

Obsidian, a volcanic glass, was of great economic and industrial importance to the Teotihuacanos, driving them to extend their commerce throughout the Mesoamerican territory. The use of this raw material, which can be worked to extremely sharp edges, can be seen in the elaboration of cutting tools, such as razors, knives, and projectile points, and the manufacture of luxury and symbolic objects such as these small, anthropomorphic figures worked in greenish-black obsidian.

The pieces here are part of an extraordinary group of flaked miniatures originating in central Mexico. Apparently they were found together with forty-eight other pieces of the same material in association with a grave. While the circumstances of the find as well as their dating are uncertain, very similar materials have in fact been excavated from the Pyramid of the Sun in Teotihuacán. Six pieces represent human forms of different sizes; they display bifacial flaking and are of an asexual character. The area that corresponds to the upper body gives the appearance of arms crossed toward the front, and only the elbows and shoulders are represented. In most cases the lower extremities are very short in comparison to the rest of the body.

Included, too, are four sharply pointed abstract serpentine forms that were also flaked with bifacial finishing. At the opposite end from the point, two appendages invariably appear which may represent the lower extremities of a human body or perhaps the open jaws of a serpent.

The complex of elements found in these pieces has led them to be called "eccentrics." Worked in flint or obsidian, and more ostentatious in form, they are common in the Maya area. Whether worked in flint or in obsidian, they are excellent examples of the skill of Mesoamerican stoneworkers.

RCC

DISCOVERY
Unknown

REFERENCE
Lee A. Parsons. *Pre-Columbian Art: The Morton D. May and The Saint Louis Art Museum Collections.* New York, 1980, p. 109, no. 155.

33 ⁞ Huehueteotl

Provenance unknown, probably Teotihuacán,
4th–7th century
Volcanic stone; height 43.5 cm. (17 in.)
Saint Louis Art Museum, Saint Louis, Missouri,
Gift of Morton D. May 206:1979

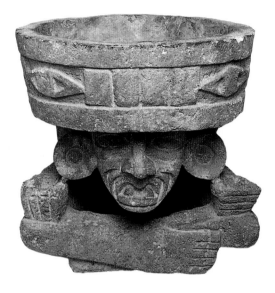

This striking sculpture in volcanic stone of a seated old man with a large vessel on his head represents the god of fire, one of the most ancient divinities of central Mexico. Known as Huehueteotl he was considered the father and ruler of gods and men. It is a common image at Teotihuacán where the form is often found opposite stairways or at entrances.

The personage is shown sitting with crossed legs and arms stretching forward, the hands resting on the knees with one palm turned upward and the other with fingers horizontal. There is a cavity in each hand, as if they had once held objects (perhaps the implements used to light the sacred fire in the most important ceremonies). The face is covered with wrinkles expressed by lines around the open mouth, where only two teeth are visible. Symmetrically opposed, on either side of the face, are two circular earflares turned forward.

As in most cases, this cross-legged deity bears on his head a large vessel that served as the divine brazier, used as an incense burner in ceremonies to other gods. The base is flat, the walls are straight, and a broad exterior band decorates it with repeated representations of the "rhomboidal eye" or "sign of fire," constituting what has been called "the band of fire eyes."

The piece is carved from coarse, porous volcanic stone, and its composition displays extraordinary balance. The geometrical lines of the arms and legs, combined with the curved torso of the ancient personage, form an empty space in the center of the composition suggesting real sculptural negative space. The face of the personage is at the exact sculptural center while the tip of the nose is at the very center of the piece—a magnificent concept by the ancient sculptors of Teotihuacán.

RCC

DISCOVERY
Unknown

REFERENCE
Lee A. Parsons. *Pre-Columbian Art: The Morton D. May and The Saint Louis Art Museum Collections.* New York, 1980, p. 108, no. 152.

34 ⁞ Funerary Bundle Figure

North Side of the Ciudadela, Teotihuacán,
mid-5th–mid-7th century
Ceramic, pigment; height 55 cm. (21⅝ in.)
CNCA–INAH, Zona Arqueológica de Teotihuacán,
Teotihuacán PAT 10276

This is a ceramic figure made in two pieces that were then joined. The stocky body is in a shape similar to a mannequin or dressmaker's dummy, with a flat base, no arms, and a projection representing the head. The rectangular opening in the front was probably meant to hold some complementary object. A removable ceramic mask was attached to the projection with a claylike cement. The mask, typical of those found at Teotihuacán, is modeled in the same style as those found on the double-cone braziers; it bears a headband, and the face is painted yellow. There are holes at the sides and top, perhaps for tying it in place.

This piece was part of an offering found in a tomb on the north side of the Ciudadela, together with remains of double-cone incense burners and a specialized potter's workshop. It has been identified as a funerary bundle figure, presented as an offering at a child's burial.

At Teotihuacán it was the custom in some cases to bury the body wrapped in cloth; in other cases the funerary bundle was cremated. There is considerable evidence of the cremation of mortuary bundles, but until now no ceramic representation of such a bundle had been found. Masks, however, are

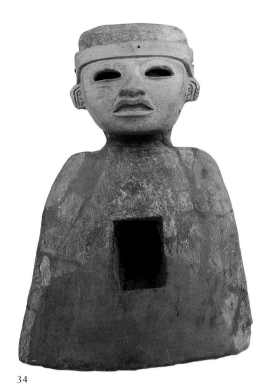

34

commonly associated with funeral furnishings in Mesoamerica, and at Teotihuacán they are closely connected with the worship of the dead.

In murals there are also depictions of the cremation of mortuary bundles; in the Temple of Agriculture, for example, there were two of these bundles giving off scrolls of fire. They were placed on altarlike bases, and at one side a row of personages was presenting offerings in ritualistic attitudes.

RCC

DISCOVERY
Excavated by the Proyecto Arqueológico Teotihuacán 1980–82 in 1982

35

35 ◀ Small Stela

Residential area of the Ciudadela, Teotihuacán,
mid-5th–mid-7th century
Sandstone; height 40.5 cm. (16 in.)
CNCA–INAH, Zona Arqueológica de Teotihuacán,
Teotihuacán ENT 16029

This sandstone work, in the shape of a rectangular prism, is carved in deep, broad lines on four sides, with traces of stucco in several places. The motifs on the two larger sides are similar, with two circular elements and two knot symbols, framed by a thin, plain band and another wider one outside it made up of wavy lines resembling feathers. The top and bottom bear designs in broken lines.

It has been suggested that this piece may represent a warrior's shield (*chimalli*). It is similar in design to other shields framed with feathers. There are various depictions of Teotihuacán warriors' shields, isolated or associated with other figures. A human figure in a mural in the palace at Zacuala carries a similar rectangular shield; he is known as the "Caballero Tigre" (Tiger Warrior). Circular shields also appear in mural paintings; examples may be seen in a room of the West Plaza Group of the Street of the Dead Complex, which has recently been explored.

Because of its shape, it seems more likely, however, that this piece represents a stela, as originally believed, than a shield. With its flat bottom, it could have been stood on end, although it would have needed support to hold it in the ground.

RCC

DISCOVERY
Excavated by the Proyecto Arqueológico Teotihuacán 1980–82 in 1982

REFERENCE
Ana María Jarquín Pacheco and Enrique Martínez Vargas. "Las excavaciones en el Conjunto 1D."
In *Memoria del Proyecto Arqueológico Teotihuacán 80–82*, edited by Rubén Cabrera Castro,
Ignacio Rodríguez García and Noel Morelos García. Colección Científica: Arqueología 132.
Instituto Nacional de Antropología e Historia. Mexico, 1982, p. 111, pl. 8.

36 ◀ Two Serpent Rattles

Rancho La Mora, Toluca, mid-5th–mid-7th
century
Dolomitic limestone; height 80 and 68 cm.
(31½ and 26¾ in.)
Gobierno del Estado de México, Instituto
Mexiquense de Cultura, Museo de Antropología e
Historia, Toluca

Seen here are two pieces of delicately veined pink dolomitic limestone, representing stylized serpent rattles. They are quadrilateral prisms with rounded corners, carved in low relief on four sides.

Each piece has a central vertical axis to which the stylized rattles are oriented. The rattles end in hooks or scrolls at the sides of the sculpture, just as in similar works at Teotihuacán. The taller piece has three sections, the other only two. Both are broken off at the bottom; complete works of this type often depict four rattles.

Although these rattles were not found in connection with any building, they could have served as stelae or markers set upright in the ground or as balusters at the sides of a stairway, as can be seen in some buildings in the archaeological zone of Teotihuacán.

RCC

DISCOVERY
Excavated in a salvage project by Beatriz Zuñiga and Carmen Carbajal in 1985

37 ⟨ Architectural Relief

West Plaza Group of the Street of the Dead
Complex, Teotihuacán, mid-5th–8th century
Stone; height 102 cm. (40⅛ in.)
CNCA–INAH, Zona Arqueológica de Teotihuacán,
Teotihuacán

This sculpture is made up of several blocks, carved in high and low relief; they were found away from their original site, scattered near the southeast corner of the plaza in the West Plaza Group of the Street of the Dead Complex, located in the central part of the archaeological zone of Teotihuacán.

When the stones were assembled, it was possible to join eleven of them to form an incomplete picture of a human face representing an agricultural deity. On the largest piece at the center appears the face of a personage and part of his headdress, with elements characteristic of Tlaloc, the god of water: mustache, necklace, and ear ornaments. The headdress is a kind of panel with birds at either end. Below these are two serpent heads; the serpent's body between them is made up of three contiguous flowers. The presence of elements shared with Tlaloc, in addition to the sprouting plants and water droplets depicted in the relief, makes it likely that an agricultural deity is represented.

On the other blocks making up this sculpture, the elaborate headdress is completed by a large crest of feathers, possibly of the quetzal (a bird of the tropical regions of Mexico and Guatemala). The stone pieces representing the arms and hands are not complete, but we can tell that the hands were placed symmetrically, that they bore bracelets with bells, and that each held a staff from which sprang plants or drops of water, coupled with the Teotihuacán year-sign. At the ends of the staffs are carved symbols representing smoke.

The continuity of the design leads one to suppose that the frieze was much larger and displayed more elements related to the main figure. When some of the other blocks were joined, other images could be seen; one of these is the foreleg and claw of a feline—perhaps a jaguar, an animal often depicted in

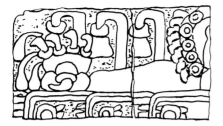

Teotihuacán: drawings of fragments of cat. no. 37
(original drawings by Noel Morelos García)

Teotihuacán: plan of the West Plaza Group of the
Street of the Dead Complex (original drawing by
Noel Morelos García)

Teotihuacán. It bears a crest of precious feathers and jade jewels; from its leg spring three plant motifs, and three drops of water or blood drip from the claw. The entire figure rests upon a series of spirals suggesting moving water. It was possible to match some of the other blocks to make up a row of hearts or seeds, from which sprout vegetable designs. Other pieces show isolated elements.

Apparently this frieze (the agricultural deity and the jaguar) had much the same plan as the Teotihuacán mural paintings; perhaps the secondary motifs, such as the row of seeds, surrounded or framed the central images.

Given the importance of these figures, it is to be supposed that this frieze (or several friezes) was placed near the top of the principal structure of this Street of the Dead architectural complex and that, because of the repetition of several of the motifs, the image of the god was repeated at least three times. It is also possible that the god and the jaguar were combined in a single frieze, or they may have been independent entities.

RCC

DISCOVERY
Excavated by the Proyecto Arqueológico Teotihuacán 1980–82

REFERENCE
Noel Morelos García. "Exploraciones en el área central de la Calzada de los Muertos al Norte del río San Juan, dentro del llamado Complejo Calle de los Muertos." In *Memoria del Proyecto Arqueológico Teotihuacán 80–82*, edited by Rubén Cabrera Castro, Ignacio Rodríguez García and Noel Morelos García. Colección Científica: Arqueología 132. Instituto Nacional de Antropología e Historia. Mexico, 1982, pp. 311–14.

38 ◀ Mask

Complex Northwest of Río San Juan, Teotihuacán,
mid-5th–mid-7th century
Greenstone, shell; height 25 cm. (9⅞ in.)
CNCA–INAH, Zona Arqueológica de Teotihuacán,
Teotihuacán ENT 12208

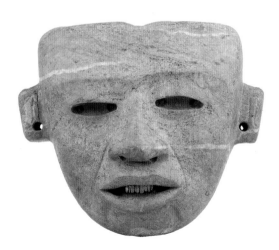

Some of the most subtle creations of Teotihuacán sculpture are ritual masks elaborated from diverse materials. The present work is sculpted from a greenish stone with thin horizontal veins, and it is complemented by small pieces of shell that form the teeth.

The high quality of the piece, which was complete when found, gives an unexpectedly sensitive expression to a typical Teotihuacán face. Its form is rounded and slightly oval, and the elongated oval eyes, which are incised into the piece, are perforated at the outer corners, most certainly because they contained inlays of some other material. The ears are rectangular, with two incised lines and perforations in the lower portions. The broad, somewhat flattened nose and the perfectly carved lips that form the partially opened mouth, are the means by which the sculptor created the mask's surprising expression.

Since this is a mask, one would expect openings on the inside, where there are still gouge marks. The piece, however, has no perforations that would allow the wearer to see, and therefore the mask was not intended to be worn but to be used for ritual and ceremonial purposes.

Despite the frequent finds of masks within the context of Teotihuacán archaeology, their specific use is still not certain. It is believed they may have served as funerary masks that were placed on the mortuary bundles of important persons, but to date none of these masks has been found directly associated with human graves. The newest evidence in this regard is a small funerary sculpture (cat. no. 34), an offering found in a recently explored grave, which is modeled in clay in the form of a mortuary bundle wearing a mask made of the same material.

RCC

DISCOVERY
Excavated by the Proyecto Arqueológico Teotihuacán 1980–82

REFERENCE
Jesús E. Sánchez Sánchez. "El Conjunto NW del río San Juan." In *Memoria del Proyecto Arqueológico Teotihuacán 80–82*, edited by Rubén Cabrera Castro, Ignacio Rodríguez García and Noel Morelos García. Colección Científica: Arqueología 132. Instituto Nacional de Antropología e Historia. Mexico, 1982, pp. 227–46, fig. 8.

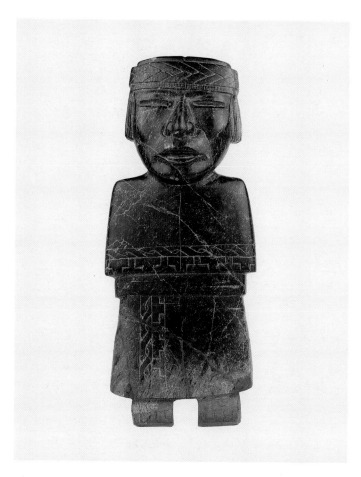

39 ◄ Female Figure

◄ West Plaza Group of the Street of the Dead Com-
◄ plex, Teotihuacán, mid-5th–mid-7th century
◄ Serpentine; height 45 cm. (17¾ in.)
◄ CNCA–INAH, Zona Arqueológica de Teotihuacán,
◄ Teotihuacán 10–213190

This is an extraordinary sculpture representing a female personage with typical angular Teotihuacán features that evince a vast tranquillity seldom seen in such figures, making it truly unique. She is dressed in a straight skirt with a vertical band decorated with fretted and braided designs. A second article, a kind of blouse without decoration, covers her to the hips. The upper half of her body is wrapped in a *quechquemitl*, a garment that is usually triangular but here is rectangular; it serves as a kind of circular cape, with the decoration on its border similar to that of the skirt. A slender headband with a different braided design encircles her head. Only her feet and head are showing. The piece has been worked in serpentine by a process of carving, smoothing, and polishing that has given it a glossy finish.

This is undoubtedly the effigy of a domestic or household goddess, for it was found near a small altar in a dwelling south of the main entrance to the West Plaza Group, next to a similar figure of the same size. The latter piece, although it is nude and asexual, must represent a masculine personage, like most of the Teotihuacán sculptures of this type.

RCC

DISCOVERY
Excavated by the Proyecto Arqueológico Teotihuacán 1980–82

REFERENCE
Noel Morelos García. "Exploraciones en el área central de la Calzada de los Muertos al Norte del río San Juan, dentro del llamado Complejo Calle de los Muertos." In *Memoria del Proyecto Arqueológico Teotihuacán 80–82*, edited by Rubén Cabrera Castro, Ignacio Rodríguez García and Noel Morelos García. Colección Científica: Arqueología 132. Instituto Nacional de Antropología e Historia. Mexico, 1982, pp. 311–14, fig. 9.

40 ⫷ Standing Figure

Provenance unknown, probably Teotihuacán,
5th–8th century
Greenstone; height 16 cm. (6¼ in.)
CNCA–INAH, Museo Nacional de Antropología,
Mexico City 9–1749

This is a small, anthropomorphic sculpture carved in dark greenstone of compact texture, with a shiny, carefully polished surface. It represents a standing human figure; the facial expression, the treatment of the body, and the kind of headdress it is wearing suggest that it may be male. The design is conceived along a symmetrical vertical axis: the limbs and other elements are arranged in equal proportion on both sides. The piece has broad, squared shoulders with arms that hang vertically and rest, on both sides, on the hips, leaving two elliptically shaped spaces between them and the figure's slender trunk. The rounded face, the geometric cuts of the large eyes, the triangular nose, the extremely large mouth, and the quadrangular ears carry the stamp of representations known from Teotihuacán masks, except for the cap or headdress that in this case is formed by two horizontal bands, the smaller over the larger.

Because of the somewhat schematic and not very realistic facial and bodily features achieved by geometric cuts, this figure can be included in the group of sculptures that preserve the Teotihuacán geometrical patterning, with reminiscences of the Mezcala style apparent in Teotihuacán stone figurines from earliest times to the period of its apogee. For this reason, and because stratigraphic and contextual data are lacking, this figure cannot be dated precisely.

The figure's size indicates a possible reference to a household deity whose cult is currently unknown, for the figure has no symbolic element that would identify it.

RCC

DISCOVERY
Unknown

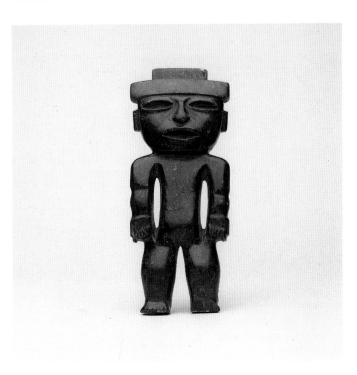

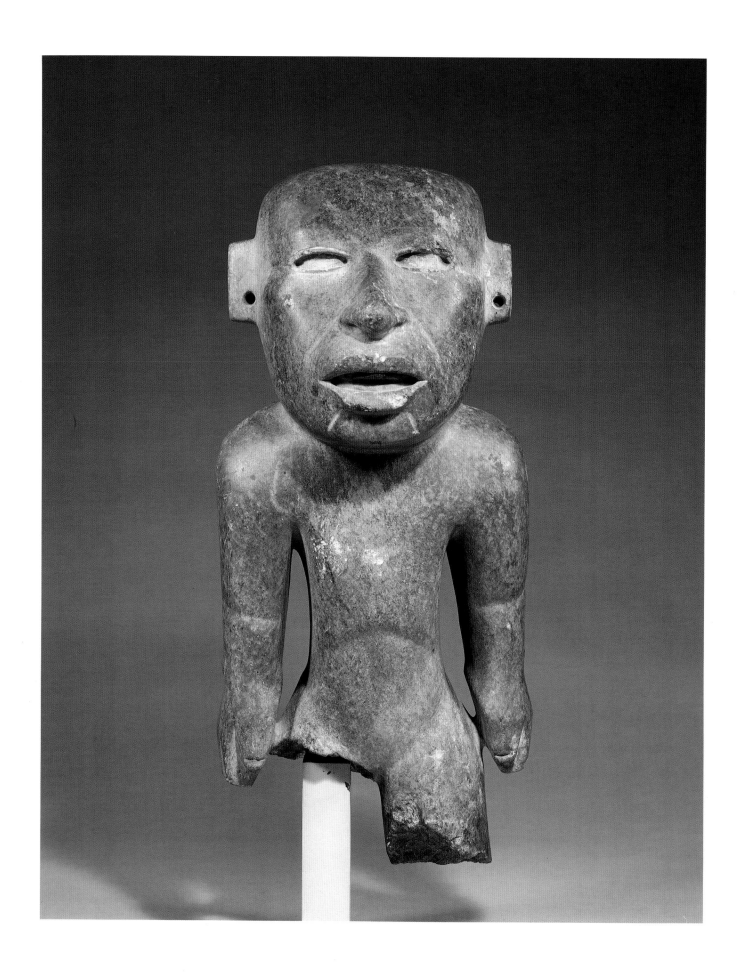

41 ◀ Standing Figure

Provenance unknown, probably Teotihuacán,
7th–mid-8th century
Greenstone; height 40.9 cm. (16⅛ in.)
The Metropolitan Museum of Art, The
Michael C. Rockefeller Memorial Collection,
Bequest of Nelson A. Rockefeller, 1979
1979.206.585

This is an anthropomorphic sculpture, carved in stone of compact texture, possibly serpentine, as are many other pieces in this style; because of the beauty of the stone's natural coloring, the figures do not need to be colored artificially. The notable balance of its component parts, the skillful cutting of the curved surfaces, and its fine polishing make this piece an excellent specimen, although it is, unfortunately, missing its lower extremities. Only a part of the left thigh is preserved, but with the elements that do remain one can note the regularity of its proportions and the composition based on a symmetrical vertical axis; the hips, body, and arms are distributed equidistantly on both sides, as are the ears and the perforations found on them. The eyes, inset farther, have perforations at the outside corners which were undoubtedly intended for inlaying some complementary material, possibly jadeite or shell; the triangular nose, the large, partially opened mouth, and the chin demarcated by two grooves, contribute to the unusual expression achieved by the sculptor.

This is an asexual figure, but the facial features seem to represent a male. The most interesting aspect of this figure is the hieratic face, indicating that it may represent a domestic deity who possibly wore garments of paper, fabric, or feathers. The form and disposition of the features relate it to typical Teotihuacán masks.

RCC

DISCOVERY
Unknown

REFERENCE
Museum of Primitive Art. *Stone Sculpture from Mexico.* New York, 1959, p. 21

42 ◀ Cylindrical Tripod Vessel

San Francisco Mazapa, Teotihuacán,
mid-6th–8th century
Orangeware ceramic; height 18 cm. (7⅛ in.)
CNCA–INAH, Zona Arqueológica de Teotihuacán,
Teotihuacán 10–213195

This is an extraordinary cylindrical vessel with three supports and plano-relief decoration in orangeware ceramic. It was found associated with a human skeleton in the village of San Francisco Mazapa, an elite residential area of Teotihuacán in ancient times.

The bottom of the vessel has a horizontal plane with extremely thin, slightly flaring walls. The decoration, appearing only on the external walls, consists of diagonal bands, one of which represents two stylized serpents formed by volutes drawn with extremely vigorous lines. The heads of the serpents face toward the center and the tails face the edges. In the plano-relief decoration the deeper incisions were covered with red cinnabar highlighting the represented motifs.

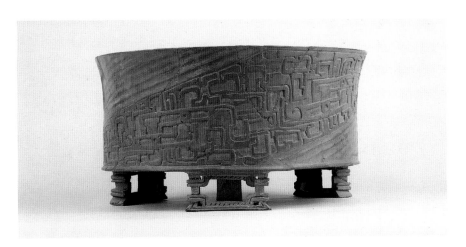

The three supports of the vessel are rectangular on a flat base. They are hollowed and grooved with representations of geometrical figures that resemble the *talud* and *tablero* of Teotihuacán architectural profiles.

The vigorous design is very similar to those of El Tajín on the Gulf Coast, indicating the close relationship between these two centers. Nevertheless, because of the composition of its ceramic material, as well as its proportions and form, it is very likely that this vessel is of local manufacture.

RCC

DISCOVERY
Excavated during a salvage project by Luis Alfonso González in 1982

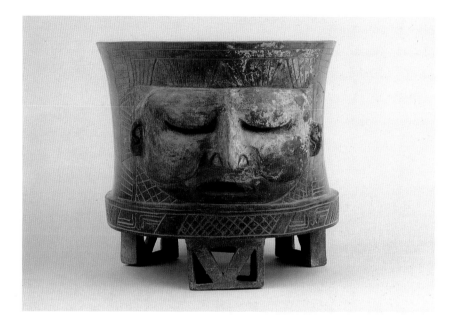

43 ◀ Cylindrical Tripod Vessel with Face

◀ San Francisco Mazapa, Teotihuacán,
◀ mid-6th–mid-8th century
◀ Brownware ceramic; height 25 cm. (9⅞ in.)
◀ CNCA–INAH, Zona Arqueológica de Teotihuacán,
◀ Teotihuacán USACREM 1406

This cylindrical ceramic container with three supports displays a modeled human face on the body. The piece is complete and in an excellent state of preservation. Made of well-polished coffee-colored ceramic, it has elegant and balanced proportions. The walls are slightly flared and the bottom is flat. It has open, hollow quadrangular supports with triangles cut out of them. Toward the base of the body there is a molding with incised decorations and geometrical motifs delineated by thin lines. A projecting mass on the main body of the vessel shows a human face with drooping eyelids and prominent, rounded cheekbones.

This vessel contained the skeletal remains of an infant, and for this reason it has been suggested that it served as a funerary urn, with the face decorating its body being the representation of a dead individual. The funerary practices of the ancient Teotihuacanos were quite varied, and burial in urns and vessels was frequent, especially in the case of infants or newborns whose remains may have been used as offerings.

It is also possible that the effigy on the body of this vessel refers to the fat god or fat-cheeked god of the Teotihuacanos, a deity who appears frequently in relief on the lower molding of cylindrical vessels.

RCC

DISCOVERY
Excavated by Patricia Cruz during salvage operations in 1984

44 ⫷ Feathered Serpent and Flowering Trees

Techinantitla, Teotihuacán
7th–mid-8th century
Painted lime plaster

a. 24 x 376 cm. (9½ x 148 in.)
CNCA–INAH, Zona Arqueológica de Teotihuacán,
Teotihuacán 10–2291950/4

b. 34 x 64 cm. (13⅜ x 25¼ in.)
CNCA–INAH, Zona Arqueológica de Teotihuacán,
Teotihuacán 10–229217

c. 32.3 x 99.6 cm. (12⅝ x 39¼ in.)
CNCA–INAH, Zona Arqueológica de Teotihuacán,
Teotihuacán 10–229218

d. 31.5 x 54 cm. (12⅜ x 21¼ in.)
CNCA–INAH, Zona Arqueológica de Teotihuacán,
Teotihuacán 10–229228

e. 33 x 55 cm. (13 x 21⅝ in.)
Museum of Art and Archaeology, University of
Missouri–Columbia, Gift of Mr. and Mrs. Cedric
H. Marks 71.136

During the period between A.D. 600 and 750, Teotihuacán had a population estimated at between 150,000 and 200,000 inhabitants and covered an area of approximately 23.5 square kilometers (9 square miles). Techinantitla, a large apartment-compound in a district located to the east of the Pyramid of the Moon, was undoubtedly in one of the most prestigious sections of the city, since excellent paintings come from this area. Luxurious palaces and temples were built here, and their walls were painted in a fresco technique, as demonstrated in these mural fragments. Such paintings probably began to be removed from their place of origin in the early 1960s.

a. This mural fragment, depicting a large serpent, is part of a group showing several similar serpents adorned with feathers. They were placed above a row of small flowering trees that incorporate various glyphs. The original mural was painted on the walls of a chamber that must have been part of one of the most sumptuous palace rooms in the Techinantitla compound. The architectural context of the paintings is uncertain, since they were removed from the site surreptitiously.

The length and height of the serpent fragments, some of which still show the borders that framed them, indicate that they were painted on a long *tablero*. The segment shows Serpent number 2, which consists of four large fragments. The colors are still vivid: blue, green, and yellow on a red background. The serpent's body extends horizontally, with drops of water beneath it. The head is at the left, and the tail at the opposite end turns up at a right angle. The head, in profile, is covered with finely delineated feathers, delicately outlined in pale red. Its open jaws reveal dark red fangs separated by traces of lighter red. A red volute begins at the eye and extends upward to the height of the ear. This feature may be seen in other serpent depictions in Teotihuacán such as on ceramic figures and in painted and sculpted architectural details. The forked tongue extends from the reptile's jaws accompanied by a wide band of a flowered cascade of water. This precious liquid is marked by drops of green color and includes elements in the form of eyes. At the lower end of the band are four red flowers, also exuding drops of water.

The serpent body is covered on the top with feathers and drops of water alternating in blue and green, separated by thin yellow stripes. The upright tail ends in three rings of a stylized rattle which are marked with dots; these are topped by feathers and small circles.

The plumed serpent is a common figure in the art and iconography of Teotihuacán. It is found in mural painting, sculpture, and ceramics. The most magnificent and best-known examples are on the Temple of Quetzalcoatl, where huge serpent heads alternate with those of another deity. Some of them seem to emerge from corollas of feathers, and enormous plumed serpent bodies lie along the sloping sides of the facade.

The Teotihuacán feathered serpent is usually associated with deities of water and fertility. It also appears in other contexts—as part of the headdresses of other gods or of important personages. The serpent appeared from the founding of Teotihuacán until its end. At first it was a central theme in art but in later periods it is found primarily as an accompanying figure. This is the case of the present example, where it is probable that the feathered serpents only accompanied the central theme of the mural, which would have risen above them on the wall.

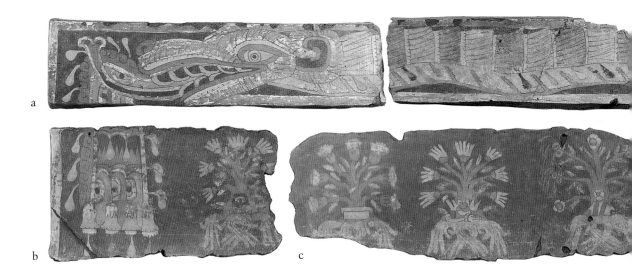

a

b

c

b. The fragments of mural painting seen here (b, c, and d) have been associated
with Serpent 2. From the way in which the pieces were cut, and from the
remnants of the borders, it can be deduced that they came from a typical
Teotihuacán wall—a straight, vertical *tablero* above a sloping lower *talud*.
The serpents were placed horizontally at the bottom edge of the *tablero*,
while the fragments here were from the sloping area beneath them.

This fragment is from the extreme left of the serpent. A current or cascade
of water is made up of drops of different colors, eyes, and flowers in
outline; a scroll band also appears at the left. The design represents moving
water, which when coupled with the eye symbol becomes a sign of terrestrial
water. Since the cascade issues from the jaws of a feathered serpent, the rep-
tile also represents moving water—the fluid that runs over the surface of the
earth and is associated with abundance and fertility.

On the right is a tree with the glyph "mask-step" at its root. The root is
painted green, and the tree consists of seven branches ending in pink flowers.

c. This fragment depicts three blossoming trees with different glyphs. That on
the left bears blue, green, and yellow flowers, which are now faded to white.
At its base is the glyph "yellow platform." The center tree's blossoms are
yellow and blue, and its glyph is "hand-shell-yellow petals." The tree on the
right displays two types of blossoms: three with four yellow petals around a
blue center, and four made up of bouquets of three small flowers with long
petals or drops of water in red. The glyph of this tree is "yellow flower–yellow
and red striped bundle."

d. The next fragment shows two trees with their respective glyphs. That on
the left bears pink blossoms, and from it issues a tassel or scroll of the same
color; its glyph is "pink flower-scroll." The tree on the right has blossoms
with pink petals and the glyph "mask-step."

e. This fragment, which is not as surely associated with Serpent 2 as the
previous examples, represents two flowering trees displaying great dynamism
in their execution; they are painted in green, with very similar roots, and both

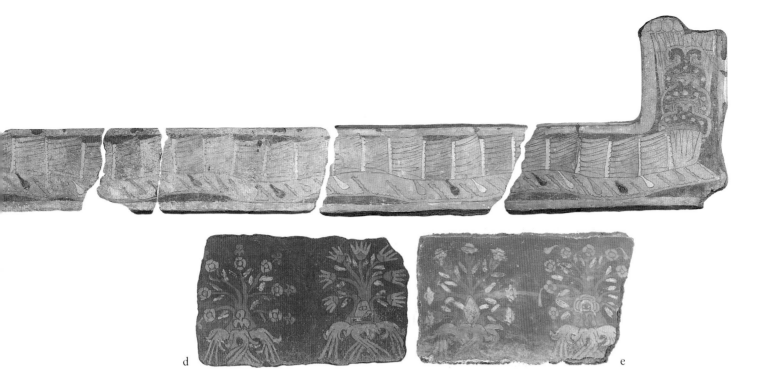

d

e

trees have seven branches, but their flowers are different, and between each
root and trunk is an identifying glyph.

The flowers of the tree on the left are drawn in profile and colored in blue,
green, and yellow; the glyph for this tree identifies it as "blue-green net-
medallion." The tree on the right shows nine branches ending in flowers with
four petals; drops, possibly water, fall from some of these blossoms; the glyph
for this tree displays the "eye-water drops."

At present it is difficult to determine the symbolic meaning of these flowering
trees with glyphs, since they are relatively new data and there are no other
elements of comparison that would allow their significance to be deciphered.
It has been suggested that the flowering trees signify a generic name for specific
groups of plants, especially plants of a symbolic medicinal and religious na-
ture, and that the combination of these trees with the glyphs found at their
base, along with the form and color of their flowers, may designate specific
names of certain species of plants.

It has also been suggested that these plants or small flowering trees may
signify generic place names, or genealogies or lineages, but the firm bases or
elements are lacking that would permit accurate discussion either of their
significance, or of the message that the creators of these murals—and the
Teotihuacanos in general—wished to convey.

The existence of these representations, however, confirms that Teotihuacán
had a complex system of writing that at present is not fully understood. This
system of writing is, of course, comparable to the hieroglyphic or ideographic
system of the Aztecs, who flourished six centuries later in the same geograph-
ical area inhabited by the Teotihuacanos.

RCC

DISCOVERY
Unknown; original location identified by René Millon in 1983–84

REFERENCES
Esther Pasztory. "Feathered Serpents and Flowering Trees with Glyphs." In *Feathered Serpents and
Flowering Trees: Reconstructing the Murals of Teotihuacán*, edited by Kathleen Berrin. The Fine
Arts Museums of San Francisco, San Francisco and Seattle, 1988, pp. 136–61, pls. 2A–D, 3B, C, 4,
fig. VI.7. **René Millon.** "Where Do They All Come From?" In *Feathered Serpents and Flowering
Trees: Reconstructing the Murals of Teotihuacán*, edited by Kathleen Berrin. The Fine Arts
Museums of San Francisco, San Francisco and Seattle, 1988, pp. 78–113.

45 ◀ Bird

◀ Techinantitla, Teotihuacán, 7th–mid-8th century
◀ Painted lime plaster; 26 x 30.5 cm. (10¼ x 12 in.)
◀ CNCA–INAH, Zona Arqueológica de Teotihuacán,
◀ Teotihuacán 10–224408

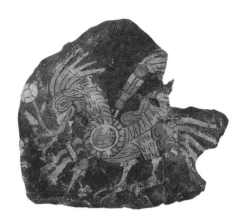

This small fragment of a mural painting showing a multicolored bird on a dark red stucco background is badly damaged along the edges where cracks and scaling occurred when it was detached from the wall. However, the polychrome figure is in an excellent state of preservation. Details in the fragment suggest a date of A.D. 200–400, but its Techinantitla provenance indicates the later date of 600–750.

The piece depicts a small bird in profile with a shield and a lance as well as other symbolic elements. The body is green, with feathers and other details delicately drawn in red; the exception is a blue area under the wing. The bird's open beak is yellow, outlined in red, and the feet are yellow with blue claws. The branch in the bird's beak is red with green leaves and a yellow flower, and two blue streamers joined by a red band appear at the level of the right shoulder.

The shield or disk on its breast is trimmed with green feathers, and through it a hand can be seen holding a yellow lance adorned with blue tassels and green feathers. At the end is a spearhead with barbs like those on the obsidian projectile points often found at Teotihuacán.

At the far left edge of this fragment can be seen the tips of some green tail feathers belonging to another bird. This indicates that the mural was made up of several birds or figures in a line, as though in a procession. Similar processions of other kinds of figures can be seen in the palaces and temples at Teotihuacán. This collection contains other fragments in which the same motifs are repeated: birds bearing shields and lances. In some cases, however, instead of flowers there may be speech scrolls issuing from the beaks, or cascades of water representing fertility.

The shields and lances are military signs suggesting that the birds are warriors. There are numerous military symbols among Teotihuacán materials, indicating the existence of warrior or military groups within Teotihuacán society.

RCC

DISCOVERY
Unknown; original location identified by René Millon in 1984

REFERENCES
Esther Pasztory. "Small Birds with Shields and Spears and Other Fragments." In *Feathered Serpents and Flowering Trees: Reconstructing the Murals of Teotihuacán*, edited by Kathleen Berrin. The Fine Arts Museums of San Francisco, San Francisco and Seattle, 1988, pp. 168–79, pl. 17. **René Millon**. "Where Do They All Come From?" In *Feathered Serpents and Flowering Trees: Reconstructing the Murals of Teotihuacán*, edited by Kathleen Berrin. The Fine Arts Museums of San Francisco, San Francisco and Seattle, 1988, pp. 78–113.

46 ◀ Processional Figure with
◀ Tassel Headdress

◀ Techinantitla, Teotihuacán, 7th–mid-8th century
◀ Painted lime plaster; height 110 cm. (43¼ in.)
◀ Collection Rushton E. Patterson, Jr., Memphis

This fragment, one of a series, shows a profile figure walking to the right; the rich vestments contain several symbolic elements, the most outstanding of which is the "tassel headdress," an adornment used by those of high social standing in Teotihuacán. It is composed of symbolic elements assembled in four levels or bands: uppermost are feathers; below that are four tassels, each placed on a vertical element; next are three concentric circles or precious stones; and finally five projectile points are represented on the bottom band. From the back of the headdress is a streamer with a triple-lobed drop that signifies blood when it is painted red, as it is here.

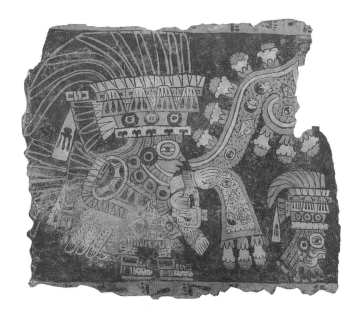

The figure has "goggle eyes" and wears earflares, and a collar or necklace made of circles from which is suspended a bird pectoral with elements associated with death and military activity. On its shoulders is displayed a section of cut shell adorned with feathers; it represents a military device. The figure wears a cape decorated with feathers and coyote tails.

The right hand holds a pouch with seeds that is adorned with drawings of a snake's rattle and strips of coyote fur. From the left hand a band emerges, scattering conch shells, bivalves, beautiful figurines, and other objects resembling eyes. A flowered sound scroll, partially unrolled, issues from the mouth. This is flowery discourse and alludes to the above-mentioned symbols—the snails, shells, and eyes.

A head, also in profile, shown in front of this personage, is the insignia of the god of storms. It wears an elaborate headdress, round earflares, and has "goggle eyes" and a thick labial band with teeth flanked by curved fangs. Four drops of blood hang from the mouth, denoting the practice of human sacrifice.

RCC

DISCOVERY
Unknown; original location suggested by René Millon based on excavation done in 1983–84

REFERENCES
Clara Millon. "Painting, Writing, and Polity in Teotihuacán, Mexico." *American Antiquity* 38 (1972), no. 3, pp. 294–314, fig. 2. **Clara Millon.** "A Reexamination of the Teotihuacán Tassel Headdress Insignia." In *Feathered Serpents and Flowering Trees: Reconstructing the Murals of Teotihuacán*, edited by Kathleen Berrin. The Fine Arts Museums of San Francisco, San Francisco and Seattle, 1988, pp. 114–34. **René Millon**. "Where Do They All Come From?" In *Feathered Serpents and Flowering Trees: Reconstructing the Murals of Teotihuacán*, edited by Kathleen Berrin. The Fine Arts Museums of San Francisco, San Francisco and Seattle, 1988, pp. 78–113.

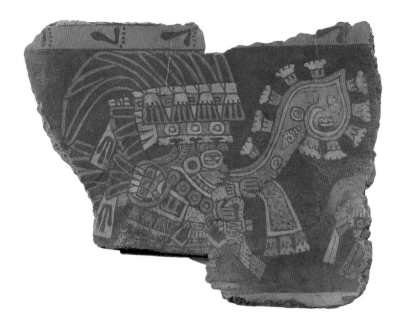

47 ◀ Processional Figure with
◀ Tassel Headdress

◀ Techinantitla, Teotihuacán, 7th–mid-8th century
◀ Painted lime plaster; height 73 cm. (28¾ in.)
◀ Saint Louis Art Museum, Saint Louis, Missouri,
◀ Gift of Morton D. May 237:1978

The figure, painted in three tones of red in a fresco technique, is shown in profile walking to the right, where another smaller head is seen as an insignia. The rich vestments—sandals, tunic, cape adorned with several symbolic elements, and principally an elaborate headdress—indicate that this personage belongs to the highest class in Teotihuacán society. The "tassel headdress" is similar to that of the preceding figure (cat. no. 46) except that it has three projectile points on the bottom tier instead of five. The figure has "goggle eyes" and wears round earflares. A band of facial paint crosses the cheek and a necklace of round ornaments with a suspended medallion is worn. The cape that covers the back ends in coyote tails and on the shoulder is a military device from which a streamer with a triple-drop pattern emerges.

A pouch that ends in the rattle of a snake is in the right hand and from the left issues a band that ends in flowers. A flowery sound scroll unrolls from the mouth of this personage; it is invocatory flowery speech.

The irregular edge of this fragment does not permit a view of the complete head preceding the personage, but based on data from the previous example, it may represent the bust of the god of storms.

This painting is thought to be part of the same suite of paintings as the preceding example. While they are not believed to have been on the same wall in the Techinantitla compound, the processions of figures of which they are part are believed to have been in some relationship one to the other.

RCC

DISCOVERY
Unknown; original location suggested by René Millon based on excavation done in 1983–84

REFERENCES
Clara Millon. "A Reexamination of the Teotihuacán Tassel Headdress Insignia." In *Feathered Serpents and Flowering Trees: Reconstructing the Murals of Teotihuacán*, edited by Kathleen Berrin. The Fine Arts Museums of San Francisco, San Francisco and Seattle, 1988, pp. 114–34, fig. V. 6. **René Millon**. "Where Do They All Come From?" In *Feathered Serpents and Flowering Trees: Reconstructing the Murals of Teotihuacán*, edited by Kathleen Berrin. The Fine Arts Museums of San Francisco, San Francisco and Seattle, 1988, pp. 78–113.

Monte Albán: Hilltop Capital in Oaxaca

MARCUS WINTER

The ancient Zapotec city of Monte Albán is built on an island of hills in the center of the Valley of Oaxaca in the southern Mexican highlands. It was founded about 500 B.C. by villagers from the valley, and during the period A.D. 350–800, Monte Albán grew to its maximum size with an estimated twenty-five thousand inhabitants and covered roughly 6.5 square kilometers (2.5 square miles).

Zapotec is the name of the ethnic group that built and lived at Monte Albán. Their language is also called Zapotec. Zapotec Indians, descendants of the builders of Monte Albán, live today in many towns in the Valley of Oaxaca, the surrounding mountains, and the Isthmus of Tehuantepec. There are more than three hundred thousand Zapotec speakers in Oaxaca. The Zapotecs are one of more than fifty Indian groups in Mexico.

Monte Albán is Oaxaca's biggest and most spectacular archaeological site. It was by far the largest urban center in ancient Oaxaca and the only one that has been extensively excavated, although 95 percent of the site still remains to be uncovered. Several features—the naturally defensible hilltop setting, the central location with respect to outlying communities, and the wide expanse of rich agricultural land on the valley floor several hundred meters below the site, where much of the city's food was grown—allowed Monte Albán to reach prominence.

The Main Plaza, an artificially leveled rectangular area about 300 by 200 meters (325 by 220 yards) oriented north-south, formed the heart of the city and probably functioned as a marketplace and meeting area. Temples, palaces, an I-shaped ball court, and other structures delimit both sides of the plaza, and four temple platforms are built over bedrock outcrops in the center. The huge North and South Platforms, with wide stairways leading up to additional buildings, mark the ends of the plaza.

Stone was the preferred construction material, and naturally occurring limestone and sandstone blocks were readily available at Monte Albán. Major structures here are relatively low, earthquake-resistant stone plat-forms. They have earth and rock-rubble cores and are faced with smooth outer stone walls that were plastered with white stucco, so the stone walls visible today would have appeared smooth and white while the city was functioning. The platforms were the bases for buildings with stone-wall foundations, adobe walls (also white-stuccoed), and roofs of wood beams and thatch.

Most residences at Monte Albán occur on the slopes and terraces outside the Main Plaza and below it. Residences have a square layout with a patio surrounded by rooms, in contrast to the rectangular format of temples. Three sizes of residences are known, reflecting a three-tiered social hierarchy, perhaps consisting of an elite leadership class, a second-level administrative group, and a large stratum of commoners responsible for food production and other labor. All three residence sizes have a standard format, with rooms arranged around a closed central patio with

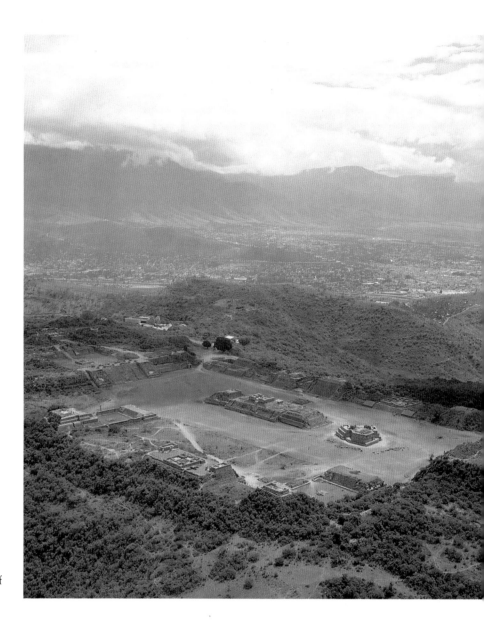

Monte Albán: site view overlooking the Valley of Oaxaca

burials and tombs below a room or the patio floor. The simplest, smallest houses had thin walls, possibly of cane or brush; family members were buried in slab-lined graves beneath room floors. Intermediate-size houses had thick adobe walls and a tomb beneath the patio as well as simple, slab-lined graves. Large houses or palaces had thick stone-wall foundations, steps leading from the patio up to the rooms, and subpatio tombs which were sometimes painted with murals.

Despite Monte Albán's unique size and central location, rival polities arose within the Valley of Oaxaca during the fourth through the eighth centuries and may have challenged, if not superseded, Monte Albán's dominance. One such polity, in the northwest half of the Etla Valley, included the hilltop site of Cerro de la Campana which has yielded numerous carved stones made of soft pink and white tufa quarried there.

Macuilxochitl and Lambityeco, along with smaller concentrations at Yagul and Dainzú, may have constituted another rival group in the Tlacolula Valley. Lambityeco produced salt, and excavations there have revealed stuccoed sculptures depicting personages of a high-ranking lineage as well as masks of Cocijo, the Zapotec rain god.

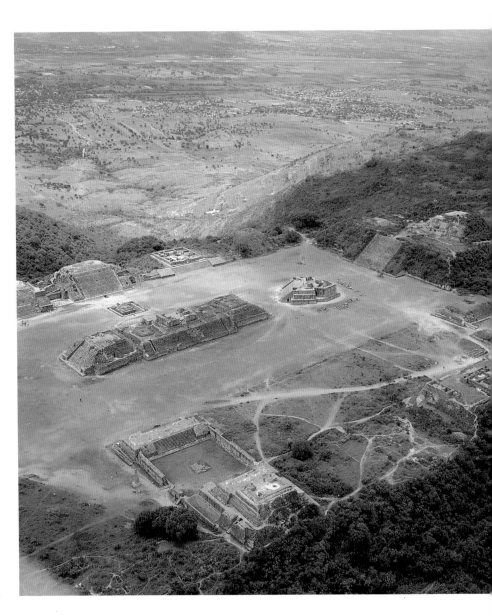

Monte Albán: Main Plaza

A third polity may have been centered in the Zimatlan-Ocotlan area to the south at such sites as Jalieza, Rancho Texas, and Yatzechi. Ceramic tile friezes covered with stucco are probably from sites in this region.

These outlying communities, all within a day's walk of Monte Albán, were occupied by Zapotec speakers and had elements of Classic Zapotec culture, such as the temple-patio-altar (TPA) compound, grayware urns with deities and personages, a writing and glyphic system expressed in various media, and mortuary rites involving reuse of tombs. Several TPAs—architectural units that functioned as ritual-ceremonial precincts, as churches do today—are found at Monte Albán. Urns are cylindrical ceramic vessels with human and other effigy representations, often with elaborate costumes and headdresses modeled on one side.

The Zapotecs expanded from the Valley of Oaxaca, colonizing some mountainous areas two or more days' walk from Monte Albán. Differences in archaeological remains show boundaries with neighboring ethnic and linguistic groups.

Between A.D. 350 and 800, Zapotec art was appropriated by the elite and used mainly in private residential contexts, especially associated with

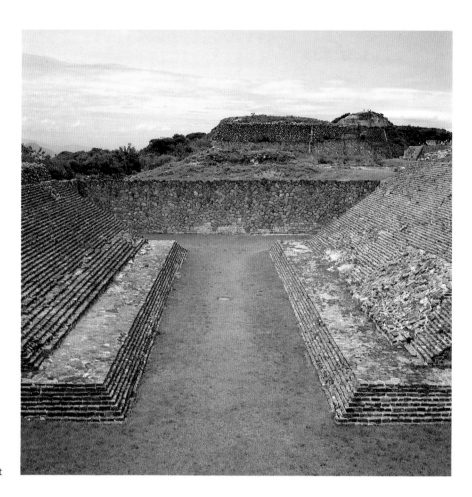

Monte Albán: Ball Court

their elaborate mortuary practices, which included reburial and painting of bones and placement of various offerings within the same tomb. Many of the finest examples of mural paintings, stucco sculptures, carved bones, urns, and carved stone slabs occur in tombs. Much of the art deals with historical and religious themes, particularly the portrayal of elite personages, often in partial guise of a deity. The jaguar was the supreme symbol and embodiment of power among the Zapotecs: rulers are often shown wearing jaguar costumes; jaguar feet, claws, teeth, and skin sometimes function as symbols of the whole jaguar.

Astute observers of astronomical phenomena, the Zapotecs evidently noted cyclical movements of the sun, stars, and planets and devised a 365-day solar calendar and a 260-day ritual calendar. They developed a writing system of glyphs or signs to record dates as well as historical events and people's names. The Zapotec calendar, in contrast to the Maya calendar, lacks a beginning date, and thus it has not been possible to place recorded events in absolute time. The ritual calendar employs twenty day-signs in combination with thirteen numerals. Numerals were expressed as combinations of bars (representing 5) and dots (representing 1). Year bearers taken from the ritual calendar name the solar year. A few day-signs are literal representations—flower, monkey, water, human skull —while some are of unknown derivation and yet others represent deities. Many glyphs appear in both calendric and noncalendric contexts. Since the Zapotec names and meanings are unknown, Alfonso Caso's system of designating the glyphs A, B, C, D, and so forth is usually employed.

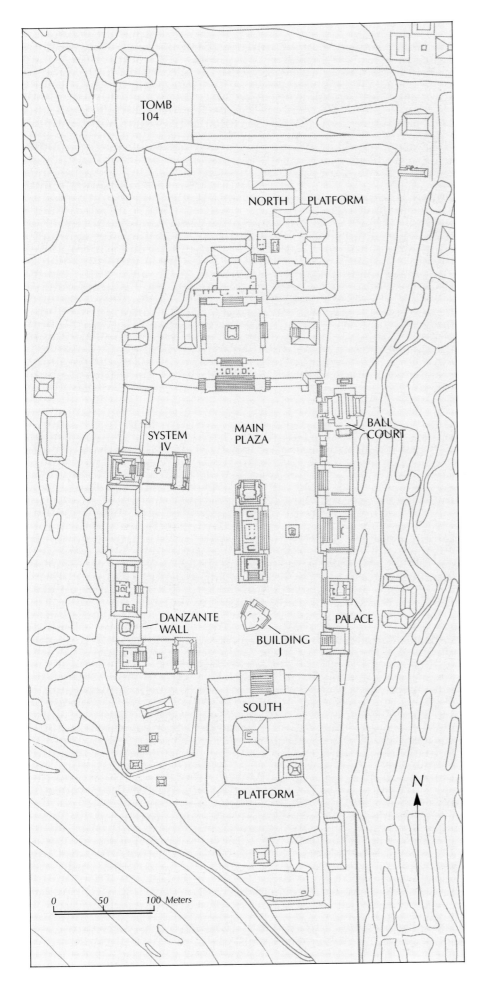

TOMB
104

NORTH PLATFORM

MAIN
PLAZA

SYSTEM
IV

BALL
COURT

DANZANTE
WALL

BUILDING
J

PALACE

SOUTH

PLATFORM

N

0 50 100 Meters

Monte Albán: site plan

Many Zapotec glyphs remain undeciphered, such as verbs, toponyms or names of places, and personal names which often appear to be combination glyphs including one deity designation. Of those, four deities are frequently represented: Cocijo (glyph M); a deity with a wide bird beak (glyph U), possibly derived from a parrot; a deity with a curved nose perhaps known as *xicani* among the Zapotec and as *yahui* among the Mixtec; and a deity which appears to combine attributes of jaguar and crocodile with scrolled eyebrows (glyph V).

Around A.D. 800 Monte Albán and other urban centers in the Valley of Oaxaca and nearby regions were abandoned and population declined. This phenomenon has yet to be explained, although its widespread manifestation suggests that more than local politics was involved. One hypothesis is that several years of drought paralyzed agricultural production in central and southern highland Mexico, which in turn led to site abandonment and population decline over a wide area from Teotihuacán in the Basin of Mexico to Monte Albán in the south.

48 ◀ Funerary Urn with Goddess 13 Serpent

Tomb 109, Monte Albán, 3rd–mid-4th century
Grayware ceramic; height 25 cm. (9⅞ in.)
CNCA–INAH, Museo Nacional de Antropología,
Mexico City 6–4846

Zapotec ceramic urns were often deposited as funerary offerings or used in other ritual contexts. They may be one of the best reflections of religion in the archaeological record. They are typically composed of a cylindrical vessel decorated on one side with a human or part-human, part-animal figure, with attached face, arms, torso, hands, legs, and feet modeled in clay and added onto the cylinder.

The present urn, along with two female "companion" urns (*acompañantes*) and one other urn, was found in Tomb 109, dating to the third–fourth century, beneath an intermediate-size residence of the fourth–seventh century at Monte Albán.

In the Zapotec pantheon female deities are often represented with their hands on their chest. In this example, the figure wears a *huipil*, beaded bracelets, and bead necklace which is tied on her chest with a knot and ends with two ribbons. A braided crownlike headpiece, perhaps woven from vines in life, forms her headdress. Attached to the front is a representation of Cocijo, the Zapotec rain god; at the back is a flat plaque with trilobed lateral decorations. The shell inlay eyes are unusual. Red pigment was frequently used in funerary rituals and may have been applied to the urn during one of the interment ceremonies carried out in relation to the tomb.

Figures on these urns often display elaborate headdresses, masks and distinctive clothing, symbols, or glyphs. Even though this urn lacks calendrical glyphs, Caso and Bernal considered it to represent goddess 13 Serpent who wears a similar woven headpiece in works of the period from A.D. 350 to 500.

MW

DISCOVERY
Tomb 109, excavated in 1937 during the sixth season of Alfonso Caso's Monte Albán project

REFERENCES
Alfonso Caso. *Exploraciones en Oaxaca: Quinta y sexta temporadas, 1936–37.* Instituto Panamericano de Geografía e Historia, Publicación no. 34. Mexico, 1938, pp. 92–95, fig. 105.
Alfonso Caso and Ignacio Bernal. *Urnas de Oaxaca.* Memorias del Instituto Nacional de Antropología e Historia 2. Mexico, 1952, pp. 122, 283, 286, figs. 193, 434.

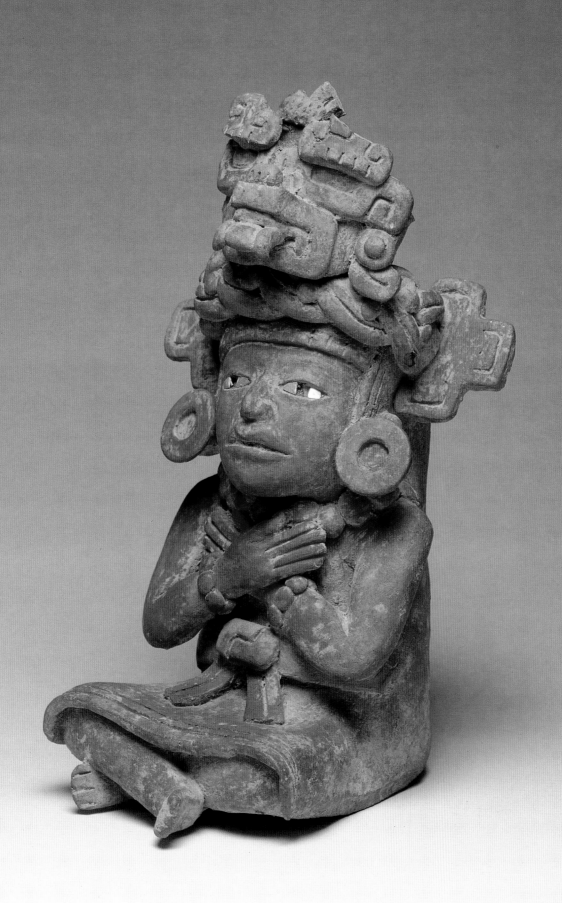

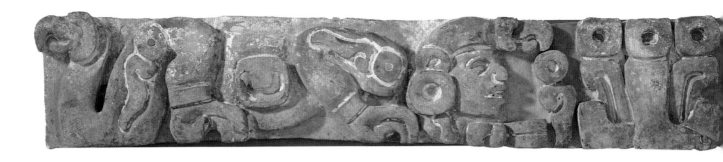

49 ◀ Two Wall Reliefs

Valley of Oaxaca, 4th–mid-8th century
Ceramic, remains of stucco; height 21.5 cm. (8½ in.)
Natural History Museum of Los Angeles County,
Los Angeles F.A. 1272.72.1,2

These mirror-image panels evidently faced a central element in a frieze. Each plaque depicts in profile a man in a jaguar costume; a human head, hand, and foot are visible in each panel. The body is in a jaguarlike crouch with the tail curving up and ending with a claw. The head, shown wearing an earspool, is inside a helmet that ends with a claw at the front and a knot below the chin.

A large square with a U-shaped element on the animal's body identifies the creature by the calendrical name 1 Jaguar. Presumably this is the same 1 Jaguar widely commemorated from the fourth to the mid-eighth century, sometimes together with 2 J who may have been his wife (see cat. no. 51).

A symbol consisting of a wavy object with a curved base hanging from a circle appears three times on each panel at the creature's shoulder, hip, and in front of its face. This glyph evidently implies power and sometimes occurs as the point on a staff of office or spear (see cat. no. 57).

In front of the creature's face on each panel is an undeciphered composite glyph formed by three elements—glyph C, a human calf and foot shown in profile, and at the top three circles. In Zapotec writing, historical personages are often shown with a calendrical and a personal name, hence this glyph may be the personal name of 1 Jaguar. If so, perhaps a person named 1 Jaguar actually existed and was not just a mythical being.

MW

DISCOVERY
Unknown

50 ◀ Two Wall Reliefs

Valley of Oaxaca, 4th–mid-8th century
Ceramic, remains of painted stucco;
height 24.5 cm. (9¾ in.)
Howard Leigh Collection, Museo Frissell de Arte
Zapoteca de la Universidad de las Américas, A.C.,
Mitla 12566, 12567

These two fired-clay panels probably formed part of the same symmetrical frieze, now lacking the central element. Each panel depicts a creature with a jaguar's body partially framed by a stepped platform. On the left panel the spiny dorsal crest and long bifurcated tongue indicate an iguana or lizardlike being, evidently a representation of the Zapotec glyph V (Lizard or Crocodilian). The numeral 8 is shown by a five bar beneath the creature's left foot and three dots along the base of the panel. The animal on the right panel sits on a place sign and has a jaguar head with a long protruding tongue to which symbols are

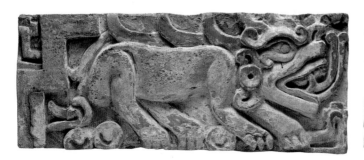

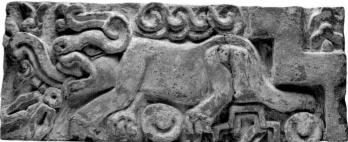

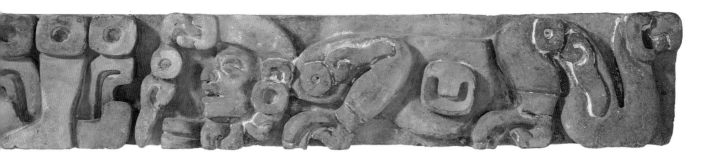

attached. Decorative curls appear above its back. Dots with central U-shaped elements indicate the numerical coefficient 2. Thus each panel symbolically portrays a powerful individual, probably a ruler, and gives his or her calendrical name, on the left 8 V (Lizard or Crocodilian) and on the right 2 M (Jaguar).

A fine layer of white stucco and some red paint that once covered the surface have been partly scraped off. These tiles are made of fired clay, as are those in the Natural History Museum of Los Angeles County (cat. no. 49) and others in the Saint Louis Art Museum;[1] all of these pieces may come from the same archaeological site or area. A likely location would be a site near the alluvium between Zimatlan and Ocotlan in the southern portion of the Valley of Oaxaca, where, in the absence of stone, ceramic tiles were evidently substituted.

Similar frieze panels occur on the patio of a high-status residence at Lambityeco and along the base of a platform on either side of a stairway at Cerro de la Campana. The Lambityeco panels, of stone and stucco, show ancestors while the Cerro de la Campana friezes, carved in soft white stone, depict stylized serpents.

MW

1. Boos and Shaplin 1969, pp. 36–43.

DISCOVERY
Unknown

REFERENCE
Frank H. Boos and Philippa D. Shaplin. "A Classic Zapotec Tile Frieze in St. Louis." *Archaeology* 22 (1969).

51 ◀ Pair of Vessels with Glyphs

Valley of Oaxaca, 4th–mid-8th century
Whiteware ceramic; height 12 cm. (4¾ in.)
Museo Frissell de Arte Zapoteca de la Universidad
de las Américas, A.C., Mitla 8007, 8008

A panel on the upper portion of each cup is carved and incised with a glyph and numeral. These notations are examples of the sophisticated and complex partly phonetic and partly ideographic symbols developed by the Zapotecs —among the earliest systems of writing in Mesoamerica. History and power are predominant themes in Zapotec writing and allowed people to express their identities and locate themselves in time and space. Many glyphs reckon time, name people and places, or express power. Here one glyph and numeral represent 1 Jaguar and the other 2 J. Only the jaguar's face is shown—eyes, nostrils, and upper lip with teeth including the canines. A basal frame bar is interrupted at the center by the numeral 1 indicated by a U element in a square.

The glyph J has a similar basal frame but the numerals are placed in the upper corners of the overall design. It is not certain what glyph J represents, although possibly an ear of corn in vertical position crossed by diagonal lines. Trilobed elements adorn the two sides and top of the glyph.

Pairs of cups with these glyphs have been found at Monte Albán and other sites, sometimes with the two cups joined as one piece. The jaguar was a symbol of supreme power for the Zapotecs, and 1 Jaguar may be the name of a

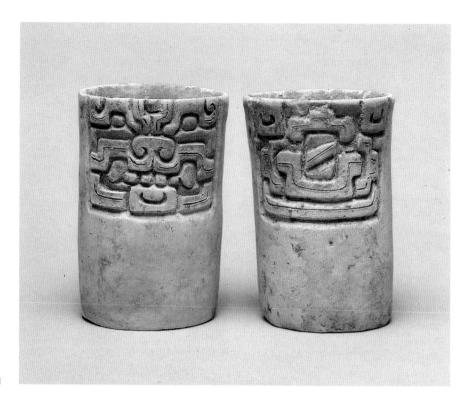

51

powerful ruler (see cat. nos. 49, 52, and 55). It is not certain whether 1 Jaguar and 2J existed or whether they were mythical—as Adam and Eve. The names were clearly important and may have been assumed by people to reinforce their power. According to Caso and Bernal, 2 J is one of the female Zapotec deities and may actually have been 1 Jaguar's wife. Another possibility is that they represent unusual combinations of propitious days in the 260-day ritual calendar. Perhaps the cups were used for drinking in celebration of important personages and dates.

The whitish pottery used for this pair is not common to the Valley of Oaxaca. A pair nearly identical in paste and incising is reportedly from Sola de Vega.

MW

DISCOVERY
Unknown

REFERENCE
Frank H. Boos. *The Ceramic Sculptures of Ancient Oaxaca.* New York, 1966, p. 311, fig. 286.

52 Six Vessels with Glyphs

Shrine 2, Atzompa, 4th–5th century
Grayware ceramic; height 12–13 cm. (4¾–5⅛ in.)
CNCA–INAH, Museo Nacional de Antropología,
Mexico City 6–18, 6–23, 6–24, 6–25, 6–4847,
6–4848

These cups were found in association with an *adoratorio* in a patio at Cerro Atzompa, a hill just northwest of Monte Albán. Although sometimes considered part of greater Monte Albán, Atzompa may have functioned as a separate political entity from the sixth to the mid-eighth century and includes palaces, two ball courts, several temple-patio-altar complexes, and other monumental construction.

The relatively thick sides of the cups permitted the artisan to carve away clay and decorate them in relief. Each cup has a glyph and numeral, which together represent a day in the 260-day ritual calendar. In standard Mesoamerican fashion, the system of counting (necessary for reckoning time) was

expressed with a dot representing the number one and a bar representing five. In the ritual calendar, which evolved in the centuries around the start of the Common Era and was used in addition to the solar calendar, time is expressed by a combination of thirteen numerals and twenty symbols (20 × 13 = 260). Common Zapotec glyphs are probably day-signs, and a person was sometimes referred to by his birthdate in the ritual calendar, for example, as 8 Deer or 5 Serpent. It is thought that powerful people understood and perhaps manipulated calendrical cycles. The days on these cups—13 O, 2 J, 2 L, 5 V, 1 B, and 5 F (or X)—may be special calendrical dates, names of important people, or both. Two of the dates, 1 B (Jaguar) and 2 J, are names that recur in other contexts (see cat. nos. 49 and 51).

MW

DISCOVERY
Excavated in the 1940s by Jorge R. Acosta during Alfonso Caso's Monte Albán project

REFERENCE
Alfonso Caso and Ignacio Bernal. *Urnas de Oaxaca.* Memorias del Instituto Nacional de Antropología e Historia 2. Mexico, 1952, pp. 62–64, fig. 100 bis; p. 187, fig. 316.

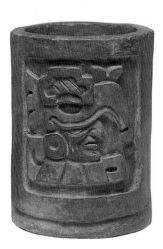

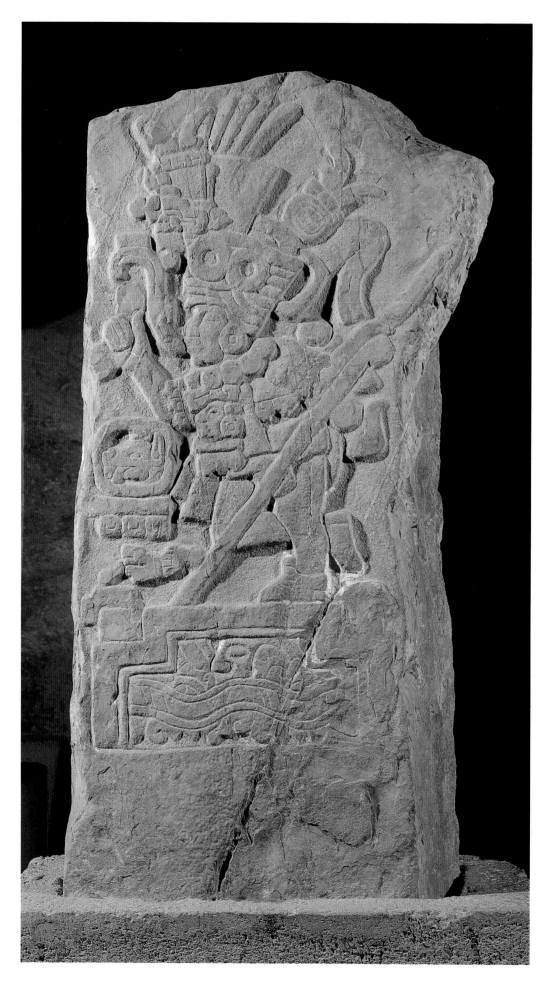

53 ◄ Stela 4

South Platform, Monte Albán,
mid-4th–mid-5th century
Basalt; height 186 cm. (73¼ in.), including
uncarved basal section
CNCA–INAH, Museo Nacional de Antropología,
Mexico City 6–5056

The main face of Stela 4 depicts a man standing on his left foot with his right leg bent at the knee and lifted behind the straight leg. In his left hand he holds a staff, and his weight is forward as if he were thrusting a lance into the ground. His right hand is uplifted and holds an object. Below his hand is glyph G (Deer) and the numeral 8 indicating his calendrical name, and farther below are other glyphs that probably express his personal name. The latter is composed of two symbols—a mouth with protruding tongue and a footprint; it is undeciphered but is clearly not the tiger claw of the famous Mixtec ruler 8 Deer.

The man stands on a place glyph represented by a stepped platform. Within the platform frame is an undeciphered combination of glyphs, possibly a place name, indicated by part of a human head and reptilian jaws (glyph V).

A speech scroll comes from the man's mouth. He wears earspools, a bead necklace, and a jaguar-head pendant on his chest. He is clothed in a cape and a loincloth, and he wears sandals. His conical headdress has unusually elaborate decoration including a Cocijo mask attached to the front.

Like many large stones at Monte Albán, Stela 4 had seen other uses. It was originally used in the period between 500–1 B.C. as shown by the *danzante* carved on the flat narrow side. Between the mid-fourth and fifth centuries it formed part of a set of stones, probably also including Stelae 2 and 6 and perhaps others, set in some kind of scene, possibly at the corner of a building. Later it was moved and reused along with other stelae as one of the large cornerstones in the South Platform. Presumably in this context the stones were plastered over and the carvings were not visible; they functioned as retaining walls for the corner of the platform, resisting the weight of the massive structure. The long uncarved basal section served to anchor the stone in the ground.

MW

DISCOVERY
Found near the northeast corner of the South Platform by Leopoldo Batres in 1902

REFERENCES
Leopoldo Batres. *Exploraciones de Monte Albán.* Mexico, 1902, fig. 3. **Alfonso Caso.** *Las estelas zapotecas.* Monografías del Museo Nacional de Arqueología, Historia y Etnografía 3. Mexico, 1928, p. 83, figs. 33, 34. **Javier Urcid.** "Writing Systems of Southeastern Mesoamerica." Ph.D. diss., Yale University, 1990.

54 ◄ Funerary Urn and Four Companion Urns

Tomb 104, Monte Albán,
mid-5th–early 6th century
Grayware ceramic; height 42 cm. (16½ in.) and
21–23 cm. (8¼–9 in.)
CNCA–INAH, Museo Nacional de Antropología,
Mexico City 6–6086, 6–6087, 6–6088, 6–6089,
6–6090

Tomb 104, beneath the west room of a large residence, is one of the most elaborate tombs at Monte Albán. It has five niches, polychrome murals on the walls, and a large carved door slab. It contained a skeleton in extended position lying on its back, which was accompanied by ceramic vessels, jade and greenstone ornaments, and, just inside the doorway, this elaborate urn flanked on each side by two "companion" urns, all facing the entrance.

The urn shows a person sitting cross-legged in a characteristic pose with hands on knees wearing a cape and a short skirt or kilt. He also wears a feathered headdress, a buccal mask, and a necklace consisting of a cord with a mask and below it a rectangular knot and three tinklers that appear to represent cut olive shells. This kind of necklace with a face or mask, a knot, and olive shells is common on sixth- and seventh-century urns (see cat. no. 56), but masks like this are rare or absent in archaeological context in the Valley of Oaxaca, and it is by no means clear what is represented.

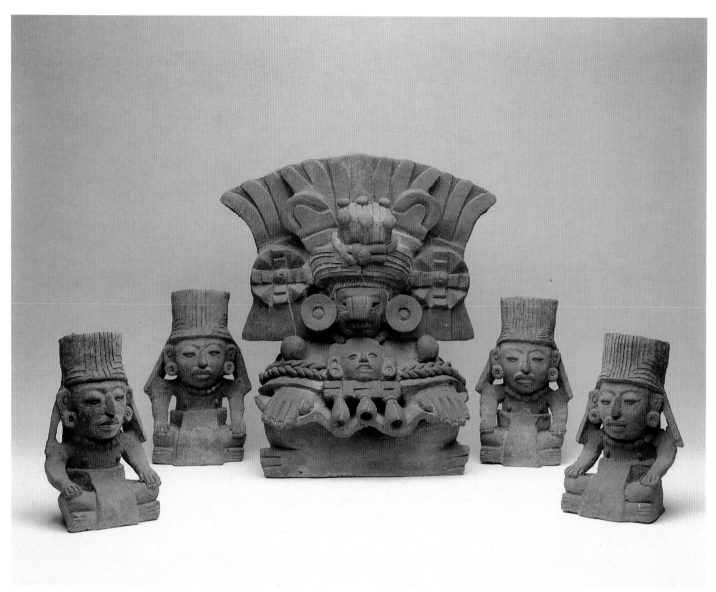

54

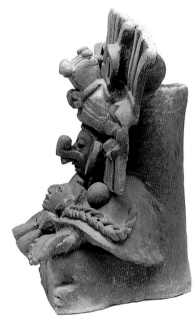

Side view of funerary urn

Caso and Bernal identified this personage as Pitao Cozobi, one manifestation of the maize god. A distinctive characteristic is the knotted bulge at the front of the headdress, which is the defining criterion of glyph Ñ. The same personage (or personified glyph) appears carved on the door slab of the tomb and painted on the wall.

Simple urns are sometimes found in high-status Zapotec tombs as "companions" placed next to larger elaborate urns, as seen here. These represent men wearing loincloths and sitting cross-legged with their hands on their knees. Their tall conical hats with neck covers are scored with incised lines possibly indicating hair. Glyphs and symbols are lacking.

MW

DISCOVERY
Tomb 104 discovered by Martin Bazán in 1937 and excavated by him and María Lombardo de Caso during Alfonso Caso's Monte Albán project in 1937

REFERENCES
Alfonso Caso. *Exploraciones en Oaxaca: Quinta y sexta temporadas, 1936–37.* Instituto Panamericano de Geografía e Historia, Publicación no. 34. Mexico, 1938, pp. 76–85, figs. 101, 102.
Alfonso Caso and Ignacio Bernal. *Urnas de Oaxaca.* Memorias del Instituto Nacional de Antropología e Historia 2. Mexico, 1952, pp. 101, 104, figs. 168, 168 bis.

55 ◀ Tomb Guardian (?): Jaguar Effigy Vessel

◀ Cerro de la Campana, Etla Valley,
◀ mid-5th–early 6th century
◀ Grayware ceramic; height 43 cm. (16⅞ in.)
◀ CNCA–INAH, Museo Nacional de Antropología,
◀ Mexico City 6–68

This effigy vessel portrays a feline sitting on its haunches. A thick-walled bowl forms the animal's body to which separately sculpted limbs and head are attached. A plaque behind the animal's head ends in the trilobed form common from the mid-fifth to early sixth century.

A pectoral dangling from a cord around the animal's neck has a trefoil shape associated with blood. At the base of the pectoral is a numeral 1 with a U-shaped incision, indicating that the entire sculpture represents 1 Jaguar (see cat. no. 51). The jaguar was one of the most powerful Zapotec symbols, and here, as in other feline representations of this period, special emphasis is given to the animal's claws and teeth.

Caso and Bernal say that this piece was found "guarding the entrance" to a tomb at Cerro de la Campana. No additional details on tomb location or other offerings seem to be available. The archaeological site of Cerro de la Campana has also been known as Suchilquitongo, one of the municipalities in which it is located. As a result of the discovery of an important tomb there in 1985, it has further acquired the name of Huijazoo.

MW

DISCOVERY
Reported by Alfonso Caso and Ignacio Bernal in 1952

REFERENCE
Alfonso Caso and Ignacio Bernal. *Urnas de Oaxaca.* Memorias del Instituto Nacional de Antropología e Historia 2. Mexico, 1952, pp. 62–63, fig. 98.

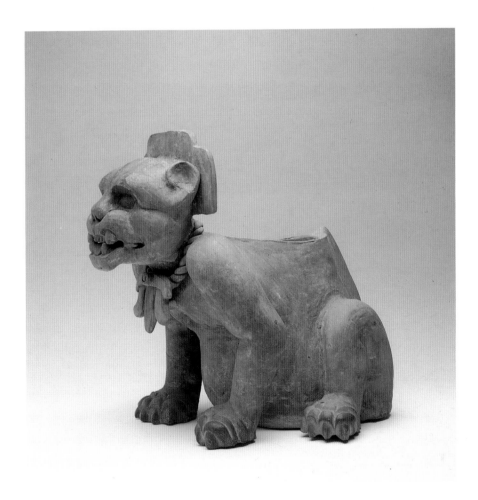

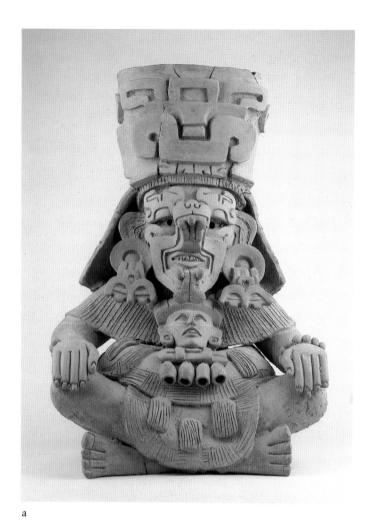

a

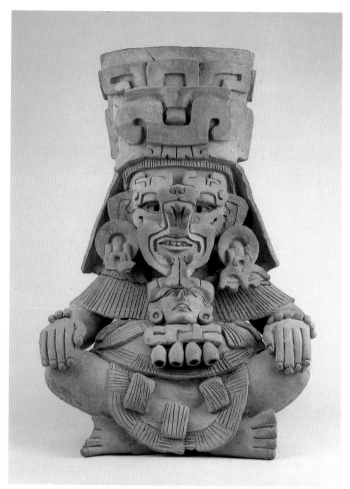

b

56 ◀ Three Funerary Urns

Provenance unknown, probably Cerro de la
Campana, 6th–mid-8th century
Grayware ceramic; height 76.2–78 cm. (30–30¾ in.)

a. Museo Frissell de Arte Zapoteca de la Universidad
de las Américas, A.C., Mitla 927

b. Howard Leigh Collection, Museo Frissell de
Arte Zapoteca de la Universidad de las Américas,
A.C., Mitla 1225

c. On loan to the George Gardiner Museum of
Ceramic Art, Toronto G83.1.179

Cerro de la Campana, the site at which these unusually large urns were
probably found, was a major center of Zapotec art and symbolism, especially
in the sixth, seventh, and mid-eighth centuries. The site itself in the Etla
Valley was strung out along several adjoining ridges with large structures
clustered on ridgetops and residential terraces on the slopes below.

Each of these urns depicts the same personage sitting cross-legged with
hands on knees. The urns probably formed part of a tomb offering along with a
fourth specimen in fragmentary and unrestored condition in the Museo Frissell.

Their repetitive character and the conical hats with neck covers suggest
they may have functioned as *acompañantes* to an even larger and more
elaborate urn or offering. A precedent for elaborate "companion" urns was
reported by Saville early in the twentieth century at Xoxocotlan where he
found three large Cocijo urns together in a row with a fourth large urn.[1] The
Cocijos had not only the pectoral with mask and tinklers but also clothes and
ornamented earspools similar to those seen on these Cerro de la Campana
examples.

The buccal mask with elongated snout and supraorbital plaques with
scrolls are defining attributes of glyph V, one of the glyphs that functions as a
deity as well as a day sign, identifying this personage as Zapotec deity V
which has crocodilian and feline attributes. The deity also wears large circu-
lar earspools to which are attached glyphic elements of unknown meaning.
Glyph C is depicted on the front of the cap, and teeth decorated by filing are
represented at the base of the glyph.

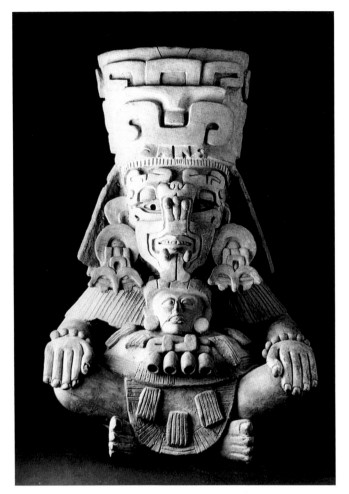

c

The deity's clothes, decorated with incised parallel lines, consist of a shoulder-length cape, a loincloth rounded at the front end, and a short skirt or kilt. A mask is suspended on the chest like a pendant with a stylized knot below it. Four olive-shell tinklers like those on the Tomb 104 urn (cat. no. 54) hang below the knot.

The four toes on each foot are probably the artisan's solution to restricted space rather than realistic representations of unusual feet.

MW

1. Boos, 1966, p. 35, fig. 9

DISCOVERY
Unknown

REFERENCE
Frank H. Boos. *The Ceramic Sculptures of Ancient Oaxaca.* New York, 1966.

57 ◀ Pair of Tomb Doorjambs

Reyes Etla, Etla Valley, 6th–mid-8th century
Volcanic tufa, pigment; height 110 and 116 cm.
(43¼ and 45⅝ in.)
CNCA–INAH, Museo Regional de Oaxaca, Oaxaca
564, 565

These jambs were extracted from a tomb at the Reyes Etla or Las Peñitas site in the northwest end of the Etla Valley where they were placed with the carvings facing the outside of the tomb. Carved in low relief, the jambs are almost mirror images of one another. Each has a sky-jaws glyph at the top and shows a man dressed as a jaguar standing on a place glyph.

The inset panel on each jamb shows a numeral and glyph, 5 D on the left jamb indicated by glyph D (Flower) and a bar below it, and 8 D on the right jamb. The bars are rectangles with two diagonal lines, and the dots are squares

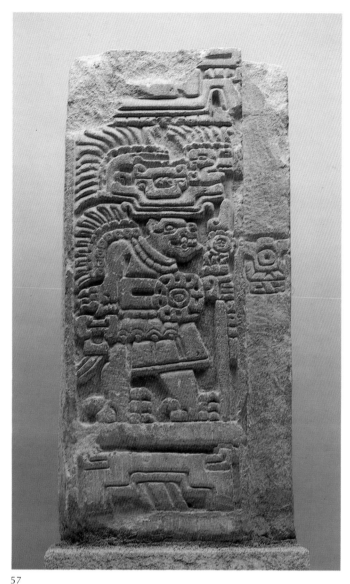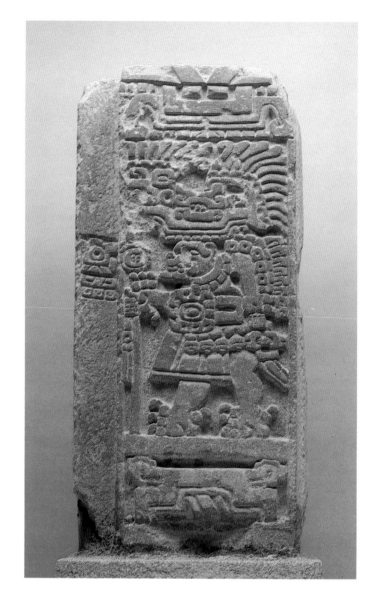

57

with a U incised in the center. 5 D and 8 D are days in the 260-day ritual calendar and evidently name the personages carved on the jambs.

Each personage is shown in profile as if stepping toward the entrance of the tomb. The jaguar face covers the human face, and the jaguar feet with exaggerated claws, three to the front and one to the back, cover the human feet. Human hands emerge from the jaguar suit with the claws dangling near the wrists. One hand holds a staff in front of the figure, and the other is shown near the rear carrying a bag that curves toward the back edge of the stone. These bags are thought to have contained copal, a tree resin burned in ceremonies. Each figure also wears a kind of kilt or apron with a decorated border (horizontal line) fastened at the waist by a broad belt with a large rosette.

The staff of office is a vertical straight stick with a circular decorative element and ribbon or tassel hanging from it. Each staff is tipped with a long point having a curved base. Evidently a symbol of authority and power, this same kind of point appears, for example, on Stela 1 at Monte Albán and on cat. no. 49.

Each man also wears an elaborate headdress which looks like a stylized bird with feathered crest and tail. The bird head is actually a representation of Cocijo's head in profile with characteristic split-eye frame. In the center of the headdress (the bird's body) is glyph V, another Zapotec deity shown here in abbreviated form as the eye with volutes. Toward the back is a curved element with protruding feathers.

The sky-jaws motif consists of the representation of another Zapotec deity —glyph U, a being that wears the mask of a wide-billed bird—shown split and opened out. The rectangles are the eyes, the curved elements at the ends are the beaks or masks. Below is a row of eight teeth shown from the front. The central teeth exhibit a diagonal line filed on each one, indicating decorative dental mutilation.

Red paint on the face and inside wall of each jamb may have been applied after they were set in place in the tomb entrance. Red pigment is often associated with tombs and was sometimes used to paint the bones of the ancestors.

These jambs are of pinkish volcanic tufa of the kind quarried and carved near Cerro de la Campana at Suchilquitongo from ancient times to the present. They are so similar—in raw material, size, technique of carving, personages represented and their clothing—to the jambs in Tomb 5 at Cerro de la Campana that they must have been produced by the same school if not the same master craftsman.

The elaborate Tomb 5 at Cerro de la Campana has ten jambs, with a total of twelve vertical standing figures. All are richly attired although only the two closest to the doorway of the main chamber wear jaguar suits. Jaguar-suited individuals had special status and function perhaps as guardians of the tomb and the ancestors.

MW

DISCOVERY
In the 1940s

REFERENCES
Enrique Méndez Martínez. "Tumba 5 de Huijazoo." *Arqueología* 2, Instituto Nacional de Antropología e Historia, Mexico, 1988, pp. 7–16. **Javier Urcid.** "La tumba 5 del Cerro de la Campana, Suchilquitongo, Oaxaca." Unpublished ms., 1989.

58 ⦚ Commemorative Relief

Valley of Oaxaca, 6th–mid-8th century
Volcanic tufa; height 60 cm. (23 ⅝ in.)
CNCA–INAH, Museo Nacional de Antropología,
Mexico City 6–6059

Two panels on this slab are carved in low relief and separated by a horizontal line. Glyphs appear outside the panels on the right half of the frame. Both upper and lower panels present a pair of figures, a man on the right and a woman on the left. The men sit cross-legged; the women sit back in a kneeling position. The women wear *quechquemitls* over *huipils*, and their hair is piled on their heads in two coils. The men wear short skirts or kilts with decorated borders, tied at the waist and with a piece of the cloth draping over the belt to the back. They also wear conical hats with a piece protruding to the front and two feathers emerging from the top.

The individuals in the lower register are on place glyphs. The woman in the upper register appears to be seated on the ground and the man on a woven mat indicated by crosshatched lines. A sky-jaws motif is at the top of the upper frame and a figure descends from it holding out what appears to be a beaded necklace. A plant grows between the figures in the upper register. In the lower register the woman holds out a bowl; the man sits with crossed arms. In the upper register both individuals hold vessels, perhaps as offerings to each other.

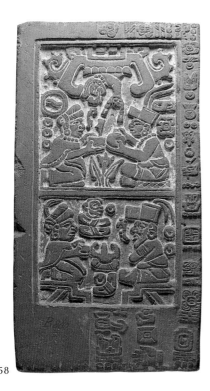

58

Each individual is identified by calendrical name consisting of a numeral and glyph: in the lower panel are Lady 11 O and Lord 6 (8?) N; in the upper panel are Lady 3 Z and Lord 6 L. The individuals in the lower panel are older than those in the upper panel. Lady 11 O has a downturned mouth indicating loss of teeth, and Lord 6 (8?) N has a beard and a line on his cheek indicating age.

The text around the frame reads from bottom to top, thus correlating with the appearance of the older individuals in the lower register. The text begins with a year sign and the year indicator 8 N below it. The next column of three undeciphered glyphs includes glyph I in the center (shaped like a Maltese cross) and below it an open hand. Glyph I and the hand with extended fingers occur on other Zapotec texts and may denote additional calendrical information. Next comes a sequence of thirteen day names: 13 A, 10 L, 5 B, 4 E, 4 C, 4 G, 1 F, 2 Z, 1 N, 6 L, and around the corner 3 M, 13 J, and finally 10 Y. As Caso pointed out in 1928, these may represent "names of gods or of kings." It would be interesting to know why there are thirteen of them. A similar text appears on the lintel of Tomb 5 at Cerro de la Campana.

What is the significance of the two panels? Finely carved rectangular slabs, usually no larger than 1 meter tall by 50 centimeters wide, are assumed to represent relations and events among the people depicted. Some are divided into two or three separate panels relating a sequence of scenes. Rites of passage such as births, presentations of newborns, and marriages are common themes. In this example, the activity in the upper register may indicate union, perhaps a marriage between the two people. The beaded necklace, suspended by a figure emerging from the sky jaws, seems to be uniting the two individuals symbolically; the plant between them may represent fertility and growth. The lower register may portray parents of one or both of the younger individuals. These carved slabs are like books showing important events in the family, and although most are from unknown context, small size and fine detail of the carvings indicate that they were kept and viewed privately in a tomb or residence.

The only slab of this type reported from context is the one from Tomb 5 at Cerro de la Campana which has an uncarved basal portion for setting in the ground. The present example lacks this characteristic and may instead have been moved around or placed in a niche rather than set in a floor.

This stone is known as Lápida 1 of the Museo Nacional de Antropología; its provenance is unknown even though it has been attributed both to Monte Albán and to Zaachila. It is made of light brownish-pink fine-grained volcanic tufa of the kind quarried at Suchilquitongo in the northwest Etla Valley. Since this kind of stone does not occur naturally at Monte Albán or Zaachila, it may have been commissioned and imported. Another possibility is that it was actually found at or near Suchilquitongo.

MW

DISCOVERY
Unknown

REFERENCES
Constantino J. Rickards. "Apuntes generales sobre Lápidas y Petroglifos del Estado de Oaxaca, México." *Boletín de la Sociedad de Geografía y Estadística de la República Mexicana* 5ta. época, 8 (1918), pp. 17–24. **Alfonso Caso.** *Las estelas zapotecas.* Monografías del Museo Nacional de Arqueología, Historia y Etnografía 3. Mexico, 1928, pp. 109–111, fig. 81. **Javier Urcid.** "La tumba 5 del Cerro de la Campana, Suchilquitongo, Oaxaca." Unpublished ms., 1989.

The Maya of Lowland Palenque

ROBERTO GARCÍA MOLL

I t can be said, without fear of contradiction, that the Maya culture was one of the most sophisticated in the New World. Maya knowledge of mathematics and astronomy was striking; they devised a scheme of writing; and they created a refined architectural system combined with a sculptural and artistic concept nearly unequaled in the Western Hemisphere. The highest point of Maya development was reached during the fourth to the tenth centuries, in what is known archaeologically as the Classic Period, although Maya presence begins to be visible even before the Common Era.

Maya culture during those centuries was localized principally in lowlands covered by lush tropical jungle rich in flora and fauna. The most important settlements of Maya culture were in southeast Mexico and adjacent parts of Central America. We also find—in lesser measure—important manifestations on the coasts of the Gulf of Mexico, the Caribbean Sea, and the highlands of Chiapas and Guatemala.

The Maya world has drawn the attention of hundreds of scholars from diverse fields. Thus, thanks to countless studies, we are well informed about the characteristics of the architecture, ceramics, sculpture, and hieroglyphics that, along with other manifestations, constitute the

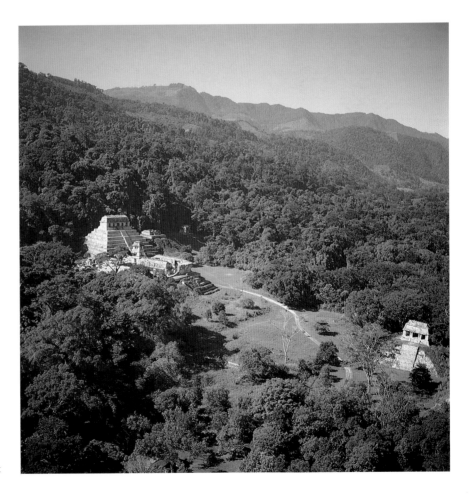

Palenque: site view, looking west

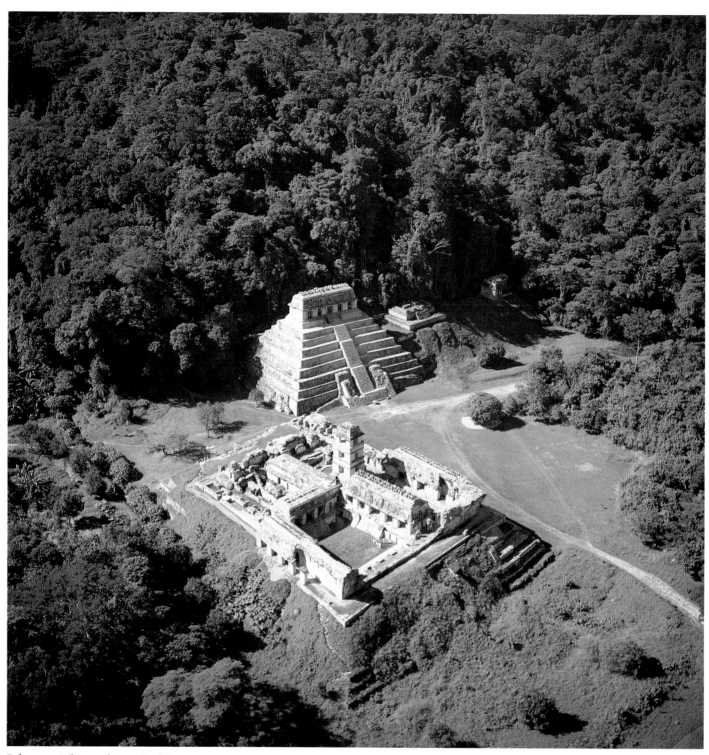

Palenque: Palace and Temple of the Inscriptions

amazing Maya world of this period. Unfortunately, we know less of the origin of these peoples and still less when we speculate about the reasons for their collapse and rapid disappearance.

Near the borders of what are today the states of Tabasco and Chiapas, where the first spurs of the sierra rise from the alluvial plains of the Gulf of Mexico, is the archaeological site of Palenque, in what until several decades ago was the most luxuriant vegetation in the southeast part of the Republic of Mexico.

Palenque is a stellar city in the Maya world. It developed during the first millennium A.D. in an area rich in water, soil, fauna, and flora, all

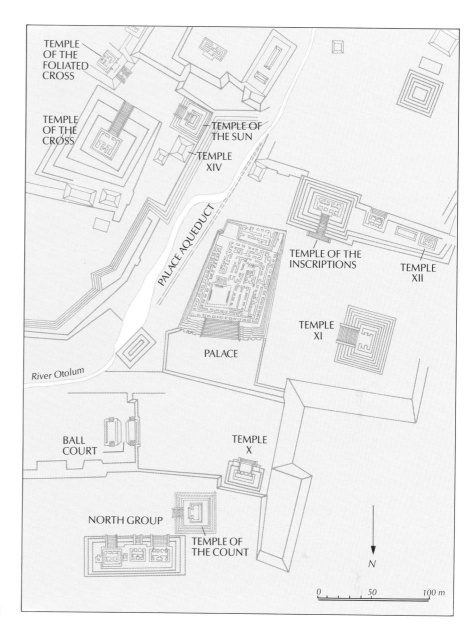

TEMPLE OF THE FOLIATED CROSS

TEMPLE OF THE CROSS

TEMPLE OF THE SUN

TEMPLE XIV

PALACE AQUEDUCT

TEMPLE OF THE INSCRIPTIONS

TEMPLE XII

TEMPLE XI

PALACE

River Otolum

BALL COURT

TEMPLE X

NORTH GROUP

TEMPLE OF THE COUNT

N

0 50 100 m

Palenque: site plan

found in front of the fill containing clay dishes, shells full of red pigment, jade earplugs, and beads and a pearl. When the fill was removed a small wall appeared at the end of the passage: together with the walls of the gallery it formed a compartment in which the remains of five or six young people, in very poor condition, were found. A triangular slab, carefully cut so as to assure perfect adjustment, was found embedded in the slope of the vault. It was removed on June 15, 1952, and an impressive crypt came to view.[2]

Numerous investigators have participated in interpreting the archaeological and aesthetic data, and through their work, we know that the site was first occupied around A.D. 100, although the information sustaining this position is not conclusive. From the fourth century on, Palenque evolved from a small agricultural village to one of the most important cities in the pre-Hispanic Maya world. In Palenque we have access to two complementary sources of knowledge for studying a Maya site: archaeology and epigraphy, both indispensable for reaching an integral understanding of that culture.

Palenque presents characteristics common to other Maya sites, especially those of the Usumacinta and El Petén regions. Among elements

This leads me to believe that excavation will reveal old buildings inside the main Palace mound. We know that it was the custom of the Maya builders to fill up old buildings and place new ones on top of them. Why should this not be the case here?[1]

In 1949 a professional archaeologist whose name would long be identified with the site, Alberto Ruz Lhuillier, initiated the most ambitious research and conservation project at Palenque; it was to continue until 1958. The discovery of the tomb in the Temple of the Inscriptions, in 1952, was his greatest contribution:

> The temple rests on a high socle which places its floor some 75 ft. above the level of the plaza: well cut steps flanked by decorated slabs lead from the platform which crowns the substructure to the building itself. This is divided into two aisles: the first constitutes a portico with five entrances framed by pillars decorated with human figures in stucco: they represent men and women carrying small children. . . . The second aisle consists of a central chamber. . . and two lateral cells.
> Against the back walls of the portico and of the central chamber there are great stone panels covered with hieroglyphic inscriptions: it is to these that the building owes its name. . . .
> As in all other temples of Palenque, there are on the roofs, vestiges of a roofcomb which was ornamented with stucco motives, the same as the frieze.
> The floor of the Temple of the Inscriptions differs from those of the other buildings because it consists of large stone slabs, beautifully cut and fitted together: some are quite huge. . . . Excavation [under the floor] led to the discovery of a vault and later of a stairway which had been entirely filled with rubble. It took four field seasons lasting two months and a half or three months each to reach the bottom of the stairs. . . .
> When the exploration reached the foot of the stairs, we discovered a passage which was sealed with a solid masonry fill: a cist for offerings was

Palenque: East Court of the Palace in 1890–91; photograph by Alfred P. Maudslay (British Museum, London)

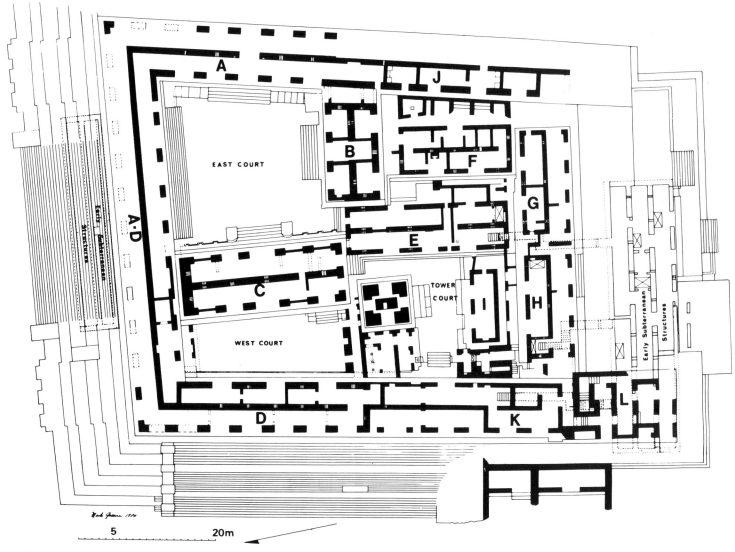

Palenque: plan of the Palace, by Merle Greene
Robertson, *The Sculpture of Palenque*, vol. 2 (1985),
fig. 9

done for the Mexican government, he comments on the Palace, one of the
major structures at Palenque:

> The Palace cannot be called one building. In reality it is a multitude of
> buildings erected around courts on one huge common terrace. To the north
> this terrace is broader than to the south, and on the northern side is a series
> of retaining walls rising in steps. The building standing along the northern
> edge fell towards the north.... The debris... now covers the greater part
> of the side of the terrace.... Here two large stucco masks were found, one
> over the other, modeled on buttresses on the wall. A stairway may have led
> up to the Palace from this side.... It is certain, though, that series of huge
> human faces once adorned the ends of the terrace, and as the two exposed
> faces still show traces of red paint, one can imagine what an imposing sight
> the front of the Palace must once have been....
>
> House E is undoubtedly the oldest of the buildings on the Palace mound.
> Its walls are heavy, its doors narrow, and... it is without roof-comb. Inside
> this house are various stucco ornaments, and an oval tablet carved with two
> figures. Over this tablet is a row of hieroglyphs painted on the wall....
>
> From one of the rooms in this house, one descends a stairway into what
> has been styled the Subterranean Galleries of the Palace. These galleries
> are not below the level of the main temple square, but are built on a low
> terrace. The buildings of the Palace proper are raised on a high foundation,
> so that their floor level lies over the roof of the "subterranean" chambers.

important factors in the growth of one of the most spectacular centers of the ancient world.

The Western world's first knowledge of the existence of extraordinary vestiges—"stone houses"—of the indigenous past came from the small community of Santo Domingo de Palenque, at the end of the eighteenth century. These reports were investigated in the mid-1780s, and in 1787 Captain Antonio del Río transmitted a detailed "Description of the Ruins of an Ancient City, discovered near Palenque . . ." to the Presidente de la Audiencia de Guatemala, then the administrator of the territory. Del Río was also the first to collect archaeological objects from the ruins, which today form part of the collection of Museo de América in Madrid.

The early expeditions were followed by others throughout the nineteenth century. As a result of the writings of these travelers, antiquarians, and early archaeologists, Palenque, in the twentieth century, gained a place in our universal consciousness, and its particular attractions gave rise to an extraordinary quantity of studies.

With the outbreak of the Mexican Revolution at the end of the first decade of the twentieth century, interest in the site declined, and it was visited only sporadically. It was not until 1923 that Franz Blom, on assignment from the Dirección de Antropología under the direction of Manuel Gamio, undertook an expedition that generated a technical report evaluating the importance of the site. In Blom's description of this work

Palenque: Palace

found at Palenque are tiered pyramidal base foundations and stairways bordered with *alfardas*. Another important feature is the interior design of the temple buildings. There are two parallel corridors, or narrow hall-like rooms, each with a vaulted ceiling rising above it. There are also two facades, one interior and one exterior, that are joined with wood beams. Roof combs that rise above the center of the roof are supported by the interior walls that divide the double-corridor buildings. Sanctuaries in the central part of the second corridor and, especially, the excellent quality of the architecture, are also specific characteristics of Palenque.

Typical of Palenque is the profusion of modeled stucco ornamentation on the pilasters, friezes, and roof combs. These include various scenes of historical, religious, or ritual nature. Similar treatment is given the magnificent *tableros*, carved limestone panels set in the interior walls of some of the buildings. Unlike other sites, there are no stelae in Palenque, nor stone lintels with sculptural motifs; it is nevertheless possible that the wood lintels were carved.

The general plan of the city is adapted to the landscape. On a high mesa rising some sixty meters (sixty-five yards) above the plain, the Maya modified the terrain and accommodated the architecture to topographical irregularities; in some cases they utilized physical features to make the monuments stand out even more prominently. Streams flowing from the south mountain range offered a vital source of water, and the inhabitants constructed an aqueduct to carry the waters of the Otolum stream to Palenque, dissecting the ancient city. Bridges were erected to facilitate movement from one part of the city to another.

The site is laid out in several architectural groupings, each responding to a specific space. Among the most important are five temples that make up the North Group, the adjacent Temple of the Count, and Temple X, which bound the site to the north. The Palace and Temple XI are located

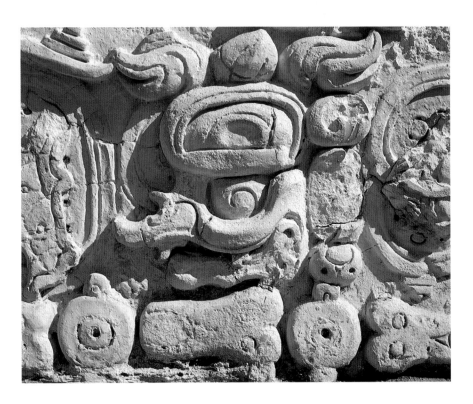

Palenque: detail of stucco relief from House D, Pier F of the Palace

in the center. To the south, constructed on limestone hills, are the Temple of the Inscriptions and Temples XII and XIII, while in the extreme southeast we find the group formed by the Temple of the Sun, the Temple of the Cross, the Temple of the Foliated Cross, and Temple XIV. Uneven ground lay between the different groups, an impediment remedied with landfill, creating a series of several platforms which are still visible.

The above groups are located in the central section of the city and have been explored for a long period of time; an important number of buildings still lie buried beneath jungle growth.

Franz Blom, again on his 1923 assignment, further noted about Palenque structures that:

> to the east rise the Pyramids and Temples of the Sun, the Cross, and the Foliated Cross, and behind these a mountain overlooks the wide plains....
>
> [These] three main temples which are [the] best preserved have so often been described and their general construction is so similar, that I will describe only one of them, the Temple of the Sun.
>
> The facade of this temple is divided into three doorways by two pillars. These pillars had stucco reliefs on their exterior. Over the doorways were wooden lintels which have now disappeared through decay.
>
> The roof slope was decorated with an elaborate ornament consisting of human figures and serpents modeled in stucco low relief. On the saddle of the roof stands the roof-comb, a lattice work of stone which once was entirely covered with a very elaborate decoration, also in stucco. On every part of this facade, coloring is still to be seen in places protected against the weather. The Maya temples, like the Greek, were painted in many colors, among which a deep red was predominant.
>
> The temple contains two parallel halls, the eastern one of which is reached through the main doorways. Three doors lead into the interior hall which is divided into three rooms. In the central room is the sanctuary, a separate house built inside the temple room, with a carved tablet on its back wall. This tablet is of limestone, and is composed of three slabs upon which human figures and hieroglyphs are carved in low relief.[3]

The most frequent representations at Palenque are historical in nature. Glyphic and epigraphic research has revealed the existence of dynastic lineages of rulers, as well as the profoundly religious concept of the Maya with respect to nature, the cosmos, and royal kingship.

A noteworthy feature of Palenque is the complex funerary system which, although sharing many elements with other Maya sites, exhibits in the Temple of the Inscriptions an extraordinary example of architectural and conceptual magnitude and complexity.

NOTES

1. Franz Blom and Oliver La Farge, "Palenque Ruins: Extract of the Report ...," in *Tribes and Temples, A Record of the Expeditions ...*, Vol. I, 1926, The Tulane University of Louisiana, New Orleans, La., pp. 170–72
2. Albert Ruz (Alberto Ruz Lhuillier), *Official Guide from Palenque*, 1978, pp. 32, 34
3. Franz Blom, op. cit., pp. 172–74

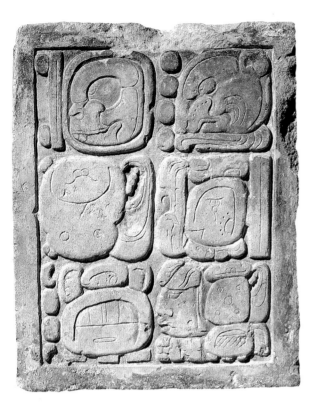

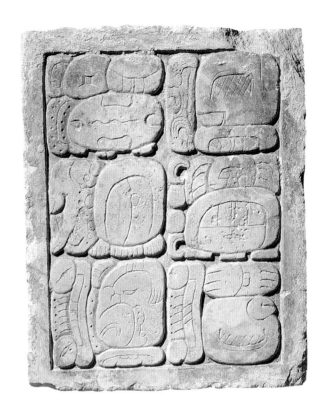

59 ◀ Two Relief Panels with Glyphs

◀ Subterranean Galleries of the Palace, Palenque,
◀ about 652
◀ Limestone; height 41 and 41.5 cm. (16⅛ and 16¼ in.)
◀ Museo de América, Madrid 2597, 2598

These two relief panels are among the archaeological materials collected by Captain Antonio del Río in 1787. They are part of a group of six related *tableritos* (as they have been named) that come from the Subterranean Galleries of the Palace, which are the remains of early structures built on the Palace terrace. The galleries were then filled in to form the support for later buildings.

Emblem glyphs function as place names for the ancient Maya centers. Of the five emblem glyphs for Palenque, one is found on a panel here.

RGM

DISCOVERY
Removed from the site by Captain Antonio del Río in 1787 on an official inspection for Spain

REFERENCES
Antonio Del Río. *Description of the Ruins of an Ancient City, Discovered Near Palenque, in the Kingdom of Guatemala, in Spanish America.* Translated by Paul Félix Cabrera. London, 1822. **Heinrich Berlin.** "Miscelánea palencana." *Journal de la Société des Américanistes* 59 (1970), pp. 122–26. **Linda Schele and Peter Mathews.** *The "Bodega" of Palenque, Chiapas, Mexico.* Dumbarton Oaks, Washington, D.C., 1979, no. 36. **Paz Cabello Carro.** *Escultura Mexicana Precolombina en el Museo de América.* Madrid, 1980, p. 117.

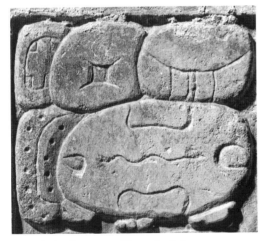

Detail of Palenque emblem glyph from cat. no. 59

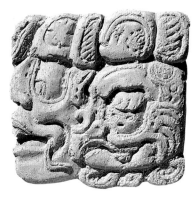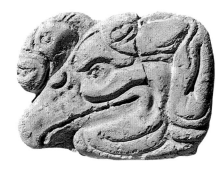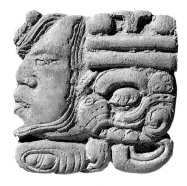

60 ◀ Three Modeled Glyphs

Palenque, mid-7th–8th century
Stucco, remnants of paint; height 15.5–20.8 cm.
(6–8⅛ in.)
Museo de América, Madrid 2602, 2604, 2605

At Palenque, stucco was widely used as a finishing and modeling material, not only as a veneer on architectural structures but also as a medium for profuse decoration: roof combs, foundations, the interior and exterior of temples, and, on occasion, the complement to reliefs carved in stone.

The people of Palenque expressed their concept of the cosmos and of the great events in their history, their gods, names of their rulers, signs, symbols, and dates—all these elements were integrated into an extremely sophisticated system of writing and recording events. They used both stone and stucco, with stucco being used most often. Normally, glyph elements of the type seen here formed part of larger texts composed of groups of stucco elements.

RGM

DISCOVERY
Probably collected by Captain Antonio del Río in 1787

REFERENCE
Paz Cabello Carro. *Escultura Mexicana Precolombina en el Museo de América.* Madrid, 1980, pp. 118–19.

61 ◀ Head

Tomb of the Temple of the Inscriptions, Palenque,
mid–late 7th century
Stucco; height 29 cm. (11⅜ in.)
CNCA–INAH, Museo Nacional de Antropología,
Mexico City 5–78

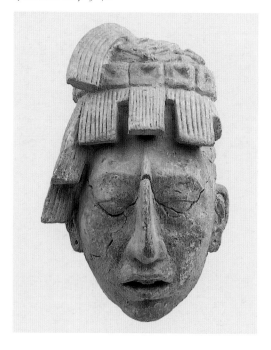

The Temple of the Inscriptions in Palenque represents the most sophisticated architectural and sculptural grouping associated with the Mesoamerican funerary system. No other known structure in Mesoamerica expresses with such magnitude the power of an individual and his people to give continuity to life in death.

Like the succeeding representation (cat. no. 62), this male head was part of Offering 3 in the Tomb of the Temple of the Inscriptions. The heads reveal not only the complex symbolism and ritual of the Maya peoples, but also physical characteristics and aesthetic practices, such as accentuated cranial deformation, the cut of the hair, and adornments like bands of cotton thread, flowers, or diadems of jade plaques. On each head from Palenque the artist has endeavored to depict the features of the individual portrayed. The color of the stucco is badly faded, and the head should be visualized with the rich polychrome finish it once had.

RGM

DISCOVERY
Excavated by Alberto Ruz Lhuillier in 1952

REFERENCES
Alberto Ruz Lhuillier. "Exploraciones en Palenque: 1952." *Anales del Instituto Nacional de Antropología e Historia 1952* 6, no. 34 (1954), pp. 90–91, pl. 21. **Amalia Cardós de Méndez.** *Estudio de la colección de escultura maya del Museo Nacional de Antropología.* Instituto Nacional de Antropología e Historia. Mexico, 1987, pp. 101–2.

62 ◀ Head

Tomb of the Temple of the Inscriptions, Palenque,
mid–late 7th century
Stucco; height 43 cm. (16⅞ in.)
CNCA–INAH, Museo Nacional de Antropología,
Mexico City 5–1031

From its beginnings, in plan and construction, the Temple of the Inscriptions was conceived in every detail as a tomb for a powerful ruler. The stucco reliefs of the facade, the *alfardas*, and the interior reliefs (*tableros*) of the temple and funerary crypt present the history and associated symbolism of a royal personage known in glyphs as Shield II (or Pacal II, his name in Chol Maya) as well as the Maya concept of the world and the universe.

Found under the sarcophagus as part of an offering in the funerary chamber of the Temple of the Inscriptions were two modeled stucco heads. It is possible that they were part of the decoration on one of the roof combs, since remnants of this type of representation are still conserved on other temples at Palenque. These are examples of sculpture in the round and not of the traditional high-relief stucco sculpture on walls and pilasters which, although realized with great dynamism, were not truly three-dimensional.

For a long time it was believed that the heads represented deities, but with recent interpretation of glyphs, they are now recognized as portraits of individuals who actually lived and died in Palenque. In this case, it is supposed that the head represents the person interred in the sarcophagus or a close relation of his. The heads may have been removed from the decoration on the edifice and placed as an offering, since the head here has been identified as the ruler known as Shield II when he was young.

RGM

DISCOVERY
Excavated by Alberto Ruz Lhuillier in 1952

REFERENCES
Alberto Ruz Lhuillier. "Exploraciones en Palenque: 1952." *Anales del Instituto Nacional de Antropología e Historia 1952* 6, no. 34 (1954), p. 90, pl. 20. **Amalia Cardós de Méndez.** *Estudio de la colección de escultura maya del Museo Nacional de Antropología.* Instituto Nacional de Antropología e Historia. Mexico, 1987, pp. 100–101.

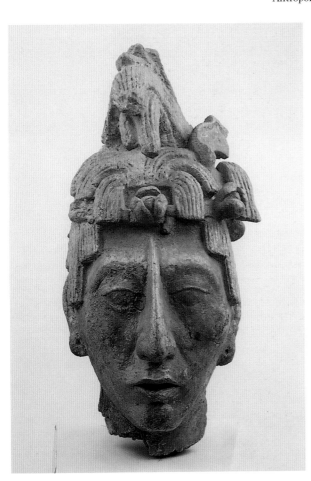 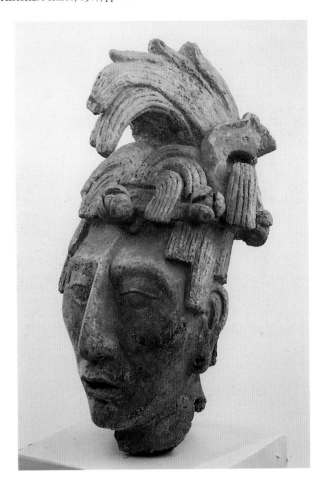

63 ◀ Rubbings of Sarcophagus Reliefs

Tomb of the Temple of the Inscriptions, Palenque
Ink on paper by Merle Greene Robertson, 1960s
from limestone original, about A.D. 683; height:
cover, 372 cm. (146½ in.); edges of cover, 25.5 cm.
(10 in.); sides of sarcophagus, 91.3 cm. (36 in.)
Latin American Library, Tulane University of
Louisiana, New Orleans

The funerary chamber of the Temple of the Inscriptions "lies more or less on the cross axis of the temple, under the stairway of the pyramid, and its floor is some 80 ft. below the floor of the temple above.... The greater part of the crypt was occupied by... a sepulchre, unequalled in all America. It consists of a monolithic sarcophagus almost 10 ft. long [that is] covered with a slab 12½ ft. long, over 7 ft. wide and 10 inches thick. With the exception of the two central supports all [of it is] decorated with carvings."[1]

A skyband with portraits of royal ancestors is carved at the edge of the upper face of the large sarcophagus cover; they serve as witnesses to the death of the Lord of Palenque (Shield II). A superbly conceived and executed earth monster, with his fleshless jawbone, appears in the central scene; a recumbent male anthropomorphic figure lies above him on a cushion bearing signs of the four elements associated with the sacrificial rite: shell, stingray spine, celestial cross, and shoots of young plants—all symbols of power. A tree with the profile of God C, crowned by a fantastic bird, sprouts from the male figure. Gods of royal lineage emerge from the two-headed, skeletal serpent: God K and the jester god. The fantastic bird is composed of several signs: wings with eyes, mask, headdress, and adornments.

On the exterior sides of the monumental rectangular sarcophagus are ten personages, three on each of the longer sides and two on each of the shorter. They are represented from the waist up, as if emerging from the earth. All are carved in limestone and all are adorned with large headdresses featuring fantastic creatures, feathers, and plant signs.

Between the two figures on the north and south ends are two cartouches, each with two glyphs, which correspond to the names and emblems of the personages. These are thought to be the parents of the Lord of Palenque, Shield II: Lady White Quetzal (Zak-Kuk) and Lord Yellow Jaguar-Parrot (Kan-Bahlum-Mo), associated with the Palenque emblem glyph.

On the lateral sides, the figures represent the ancestors of Lord Shield II, with their respective cartouches of two glyphs naming the personages.

It is believed from interpretations of these signs that royal power in Palenque could be transmitted through the maternal, as well as the paternal, line, a thesis reinforced in texts found at other Maya sites in which the woman plays a central role.

RGM

1. Albert Ruz (Alberto Ruz Lhuillier), *Official Guide from Palenque*, 1978, pp. 34–36

DISCOVERY
Tomb excavated by Alberto Ruz Lhuillier in 1952

REFERENCES
Alberto Ruz Lhuillier. "Exploraciones en Palenque: 1952." *Anales del Instituto Nacional de Antropología e Historia 1952* 6, no. 34 (1954), pp. 82–110. **Alberto Ruz Lhuillier.** "Exploraciones arqueológicas en Palenque: 1953." *Anales del Instituto Nacional de Antropología e Historia 1956* 10, no. 39 (1958), pp. 97–112. **Alberto Ruz Lhuillier.** *El templo de las inscripciones, Palenque.* Colección Científica: Arqueología 7. Instituto Nacional de Antropología e Historia. Mexico, 1973. **Merle Greene Robertson.** *The Sculpture of Palenque.* Vol. 1: *The Temple of the Inscriptions.* Princeton, N.J., 1983.

Sarcophagus cover with edges opened out
(cat. no. 63)

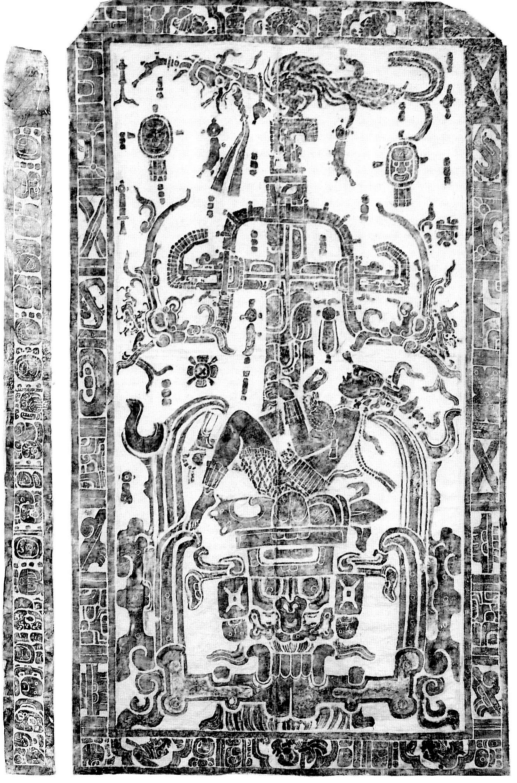

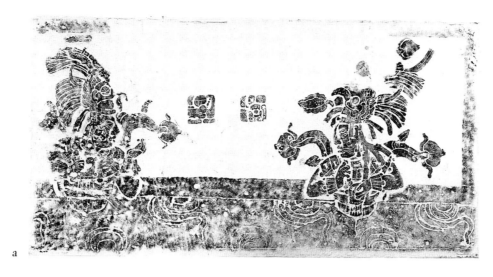

a

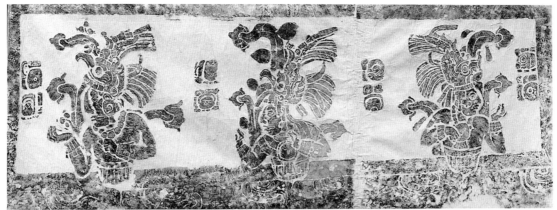

b

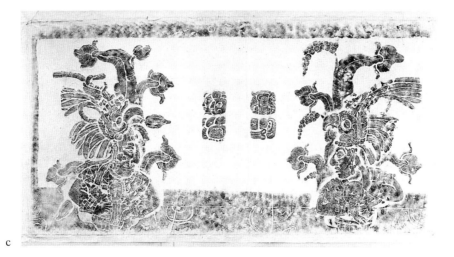

c

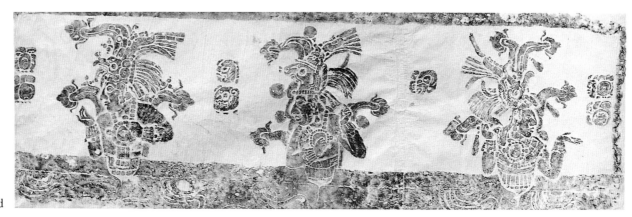

d

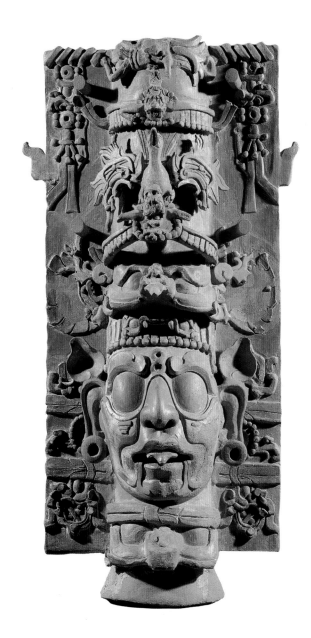

64 ◀ Flanged Cylinder

◀ Temple of the Foliated Cross, Palenque,
◀ about 690
◀ Ceramic; height 115 cm. (45 ¼ in.)
◀ CNCA–INAH, Museo Nacional de Antropología,
◀ Mexico City

Fired clay cylinders with wide side flanges and symbolic decoration are typical of Palenque. These are monumental ceramic works to which profuse decoration has been applied. The central representation is the sun god with all his attributes, especially the feline aspects. The whole was painted in bright colors, traces of which survive.

Some authors have called these objects censers, others censer supports, but judging by their structure and features this does not seem to have been their function. It is more probable that they were important architectural decorations, since they were found embedded on the stepped tiers of the Temple of the Foliated Cross.

RGM

DISCOVERY
Excavated by César Sáenz under Alberto Ruz Lhuillier in 1954

REFERENCE
Alberto Ruz Lhuillier. "Exploraciones arqueológicas en Palenque: 1954." *Anales del Instituto Nacional de Antropología e Historia 1956* 10, no. 39 (1958), pp. 140–46, pl. 33.

Sarcophagus sides: a. south; b. west; c. north;
d. east (cat. no. 63)

65 ◀ Flanged Cylinder

◀ Temple of the Foliated Cross, Palenque,
◀ about 690
◀ Ceramic; height 71 cm. (28 in.)
◀ Instituto de Cultura de Tabasco, Dirección de
◀ Patrimonio Cultural, Museo Regional de
◀ Antropología ''Carlos Pellicer Cámara,''
◀ Villahermosa A–0205

Several fantastic faces—among them a prominent sun—are arranged on the cylinder. The earth monster appears below the faces; above the sun, in manner of a headdress, are two pairs of eyes, a bird, and, completing the ensemble, a small fantastic mammal.

Two wide flanges parallel to the cylinder complement the scene; they bear symbols and signs associated with the sun, like the symmetrically arranged celestial crosses.

There are iconographic similarities among the various cylinders recovered from the foundation of the Temple of the Foliated Cross.

RGM

DISCOVERY
Excavated by César Sáenz under Alberto Ruz Lhuillier in 1954

REFERENCE
Alberto Ruz Lhuillier. ''Exploraciones arqueológicas en Palenque: 1954.'' *Anales del Instituto Nacional de Antropología e Historia 1956* 10, no. 39 (1958), pp. 140–46, fig. 12, pl. 29.

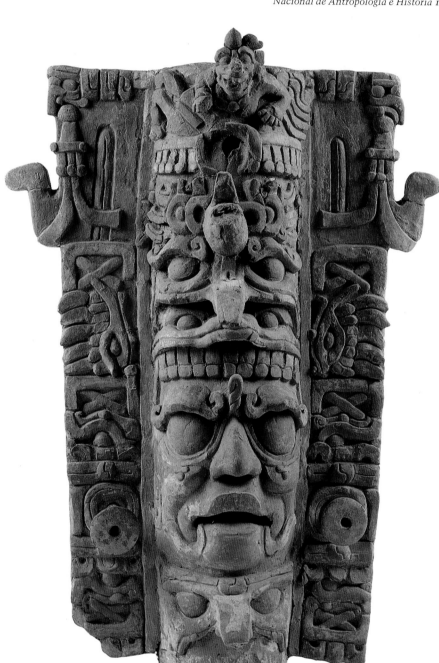

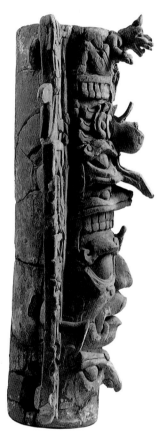

Profile view of cat. no. 65

Detail of cat. no. 65

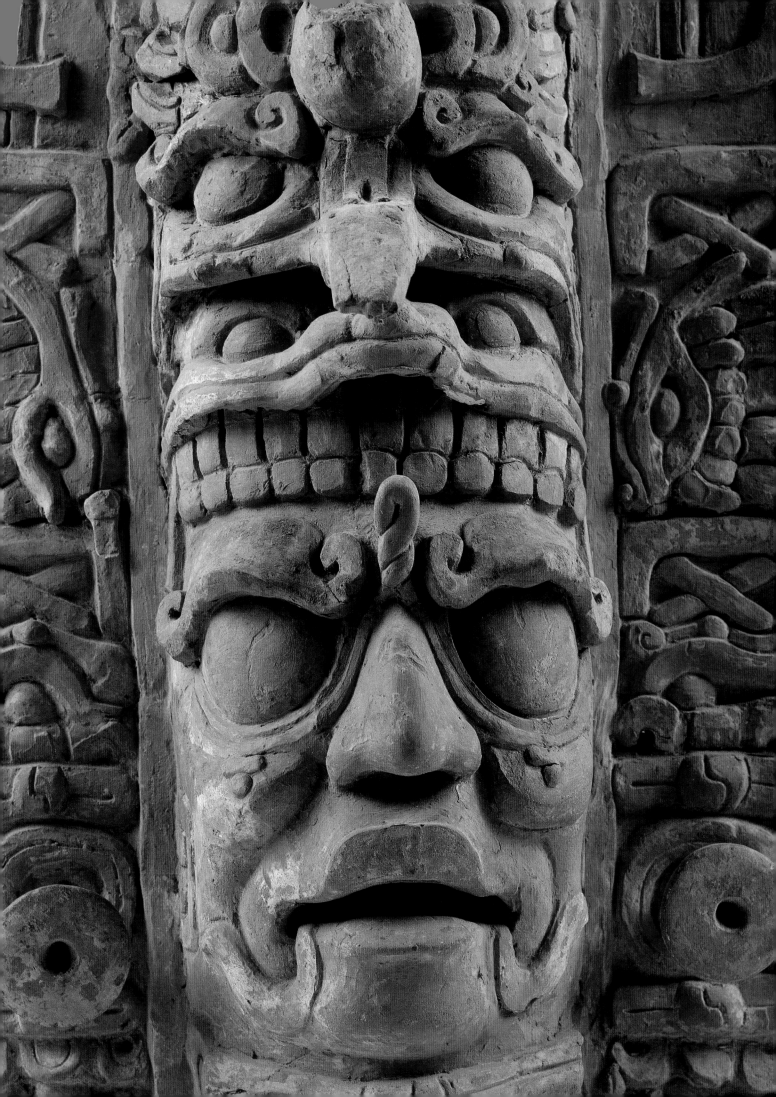

66 ◀ Throne Support, known as the Madrid Stela

◀ House E of the Palace, Palenque,
◀ about 705
◀ Limestone; height 46.5 cm. (18¼ in.)
◀ Museo de América, Madrid 2608

During Captain Antonio del Río's 1787 visit to Palenque, he reported a throne in House E of the Palace; in addition to the throne (now known as the Del Río throne), the group included the Oval Tablet embedded above it in the wall, as well as a rich and complex modeled stucco decoration. Since that report, these pieces have been badly damaged; the several parts of the throne were dispersed, and the stuccos that surrounded the Oval Tablet were destroyed.

The long rectangular stone that formed the throne seat also suffered damage; it is fragmented and its hieroglyphic inscriptions are incomplete. It and the left support are in the site museum at Palenque, whereas the right support, the "Madrid Stela" seen here, is conserved in the Museo de América. The Madrid Stela represents a person who is seated upon an earth monster and whose left hand is raised and holding a water lily. An inscription of six glyphs is found on the left lateral face.

The group undoubtedly marked a very important event, such as the ascent to power of one of the principal governors of Palenque, Shield II.

RGM

DISCOVERY
Removed from the site by Captain Antonio del Río in 1787 on an official inspection for Spain

REFERENCES
Manuel Ballesteros Gaibrois. *Nuevas noticias sobre Palenque en un manuscrito del siglo XVIII.* Cuadernos del Instituto de Historia. Serie Antropológica, no. 11. Universidad Nacional Autónoma de México. Mexico, 1960. **Heinrich Berlin.** "Neue Funde zu alten Zeichnungen." *Ethnos* (Stockholm) 30 (1965), pp. 136–43, fig. 1. **Linda Schele and Peter Mathews.** *The "Bodega" of Palenque, Chiapas, Mexico.* Dumbarton Oaks, Washington, D.C., 1979, no. 140. **Paz Cabello Carro.** *Escultura Mexicana Precolombina en el Museo de América.* Madrid, 1980, pp. 114–16. **Merle Greene Robertson.** *The Sculpture of Palenque.* Vol. 2: *The Early Buildings of the Palace and the Wall Paintings.* Princeton, N.J., 1985, pls. 92, 96, 97.

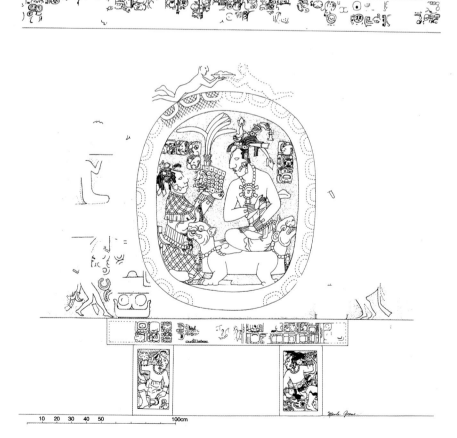

Reconstruction drawing of the Oval Tablet and Del Río Throne, House E of the Palace, by Merle Greene Robertson, *The Sculpture of Palenque,* vol. 2 (1985), fig. 92

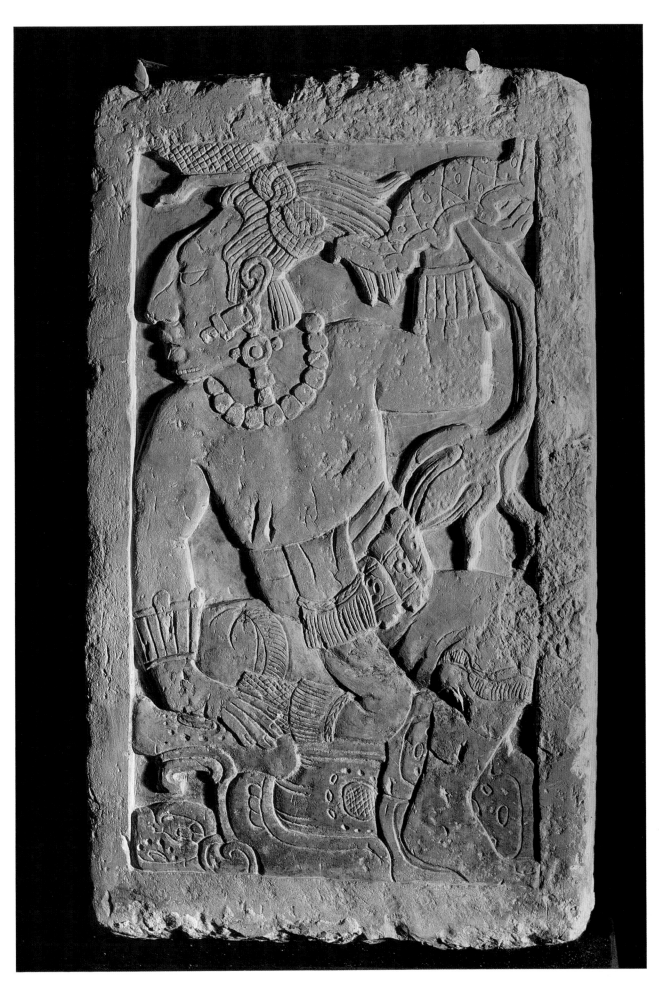

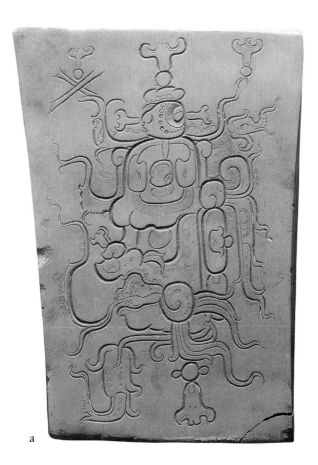

a

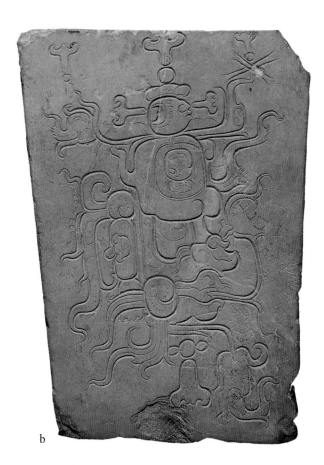

b

67 ◀ Two Throne Supports (?)

◀ Southwest Court of the Palace, Palenque,
◀ mid-8th century

◀ a. Limestone; height 27.4 cm. (10¾ in.)
◀ CNCA–INAH, Museo Nacional de Antropología,
◀ Mexico City 5–1039

◀ b. Limestone; height 26.5 cm. (10½ in.)
◀ San Diego Museum of Man, in memory of
◀ Jeanne P. Haber 1978–70–1

Thrones or benches are represented on ceramics and in paintings and sculptural reliefs. As symbols of power and hierarchy associated with governmental functions and religious rites, they were placed in architectural spaces where such rituals were performed. This is true of the Palace at Palenque, where several thrones were found in interior galleries. These thrones consist basically of supports and a large rectangular limestone slab; carved decoration is frequent on the face of these pieces, as in the works seen here which were found in explorations of the Southwest Court of the Palace. Trapezoidal in form, one of the faces bears the incised semblance of a deity; the incisions still retain traces of red paint. Because of the reference to "water lily" and the symbol *Cauac* (storm), the design is associated with the earth monster.

RGM

DISCOVERY
Excavated by Alberto Ruz Lhuillier in 1951

REFERENCES
Alberto Ruz Lhuillier. "Exploraciones en Palenque: 1951." *Anales del Instituto Nacional de Antropología e Historia 1951* 5 no. 33 (1952), pp. 50–51, 58–59, fig. 5, pl. 27. **Karl Herbert Mayer.** *Maya Monuments: Sculptures of Unknown Provenance in Middle America.* Berlin, 1984, p. 29, no. 9, pl. 39. **Amalia Cardós de Méndez.** *Estudio de la colección de escultura maya del Museo Nacional de Antropología.* Instituto Nacional de Antropología e Historia. Mexico, 1987, p. 83.

El Tajín: Great Center of the Northeast

S. JEFFREY K. WILKERSON

In 1785 a Spanish colonial official set out from the Totonac Indian town of Papantla into the dense rain forest of the Mexican Gulf Coast. At a stopping point along the trail known as El Tajín, he was shown a great pyramidal building concealed by the jungle. Diego Ruíz was astounded by its imposing size and fine stonework "cut with a ruler or square." He was also angered by the fact that the Totonacs had previously "never revealed it to a single Spaniard." Ruíz had inadvertently come upon the Temple of the Niches, one of the most extraordinary and elegant buildings of ancient Mesoamerica.

This building, covered with hundreds of stone niches, immediately caught the attention of many erudite travelers and scholars. In 1804 the Jesuit Pietro Márquez used it as the basis for one of the first comparisons between Mesoamerican temples and Egyptian pyramids. The artist Carlos Nebel later traversed the tangled forest and in 1836 published one of the most striking, and romantic, depictions of any ancient building in the Americas. For a century thereafter others followed with brushes, pens,

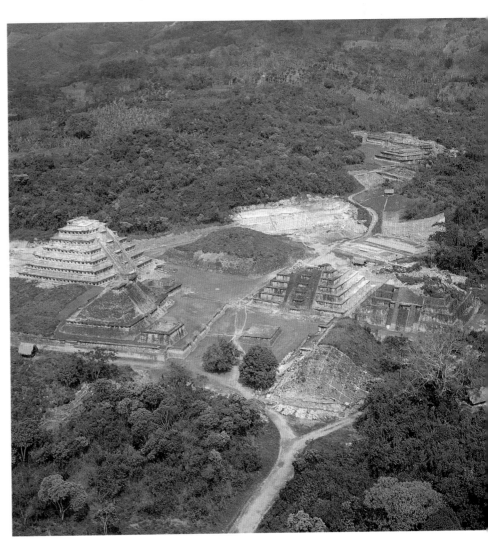

El Tajín: site view, looking north

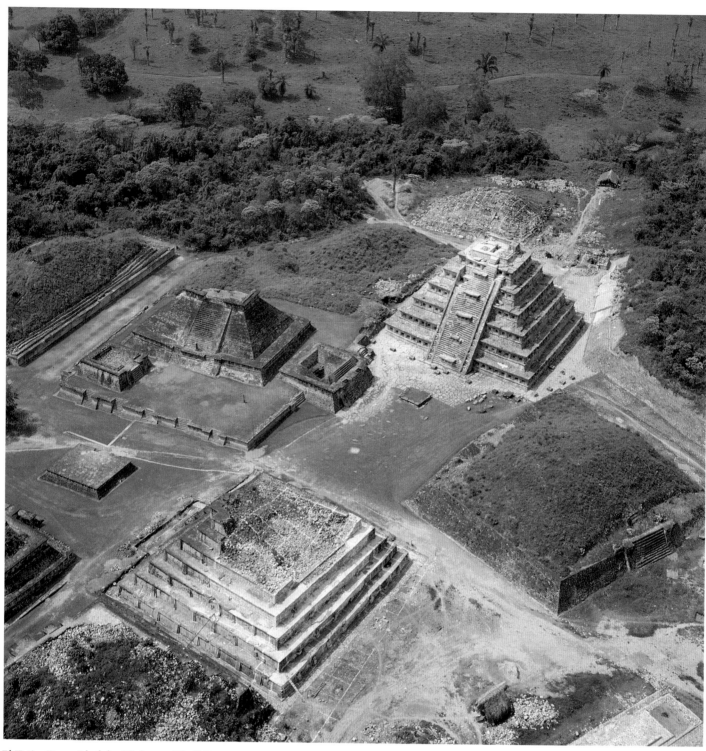

El Tajín: Pyramid of the Niches and Buildings 3,
4, and 5

and cameras until modern excavations began in 1938 under the careful
direction of José García Payón of Mexico's Instituto Nacional de
Antropología e Historia.

As a result of these explorations we now know that Ruíz's ornate stone
structure stands at the heart of the largest and most important ancient
city in northeastern Mexico. El Tajín flourished between A.D. 600 and
1100 as the metropolitan center of a dynamic major lowland culture with
a prominent role in Mesoamerican civilization. In the political dimension,
the city of at least twenty-six hundred acres very probably was the

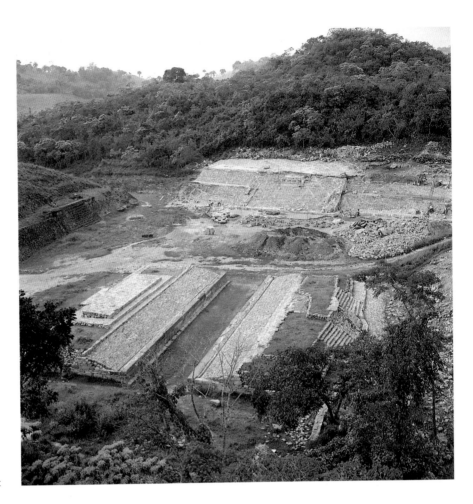

El Tajín: North Ball Court

capital of a centralized tribute state. At its apogee it controlled a very broad area, including much of present-day north central Veracruz and adjoining portions of the state of Puebla. Additionally it was clearly a religious, artistic, architectural, and engineering center of the first magnitude in ancient Mexico. Its florescence had a broad impact on surrounding coastal and highland regions and, in terms of ball-game ritualism and probably trade, even well beyond the northern frontiers of Mesoamerica.

The city itself fills a steep-sided valley near the headwaters of the Tlahuanapa stream, a tributary of the eastward-flowing Tecolutla River which enters the Gulf of Mexico some thirty kilometers (twenty miles) away. As in many Mesoamerican cities that grew during the fourth to the tenth century A.D., most of the buildings are aligned slightly east of north. However, any rigorous symmetry is more apparent than real. The majority of the buildings at El Tajín were intended to be individual visual units, although they often shared functional or ceremonial purposes with other structures about a plaza or within a contiguous complex.

Within the site there are four major groupings of structures that tend to share orientations and characteristics:

1. Tajín proper covers the valley floor and is the location for most of the major temples. Here too are the majority of the carved and plain ball courts as well as ceremonial and market plazas. This older area was the religious and commercial center of the city and the location for much of the sculpture.

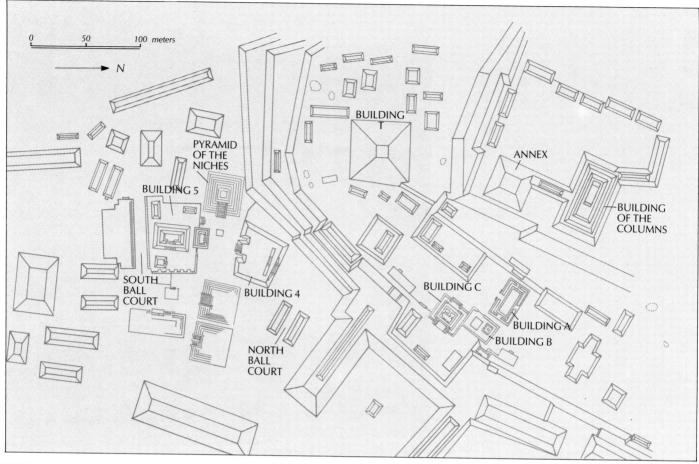

El Tajín: site plan

2. "Tajín Chico" is a huge terraced acropolis dominated by elaborate multistoried palace and administrative structures for the city's elite. Interspersed are temples, access tunnels, and colonnaded buildings. Stucco designs and elaborate murals were common decorative elements. On the upper reaches of this vast, part natural, part man-made height are the largest buildings erected at El Tajín. The Building of the Columns along with its accompanying Annex and broad plaza is the greatest architectural complex in the city. It can be associated with the energetic ruler 13 Rabbit, who governed at the city's zenith. Building T, a massive, still-unexcavated major temple, is probably associated with an immediate predecessor.

3. The West Ridge is mostly an artificially tiered natural hill. Its various levels appear to support elite residences, modest temples, and, perhaps, small ball courts.

4. The East Ridge, with a moderate-sized ball court, is very similar in configuration except for sparser construction.

Architecture at El Tajín was highly distinctive. While the city shared the basic Mesoamerican format of *talud* and *tablero,* the latter was frequently punctuated by hallmark niches and capped with a unique extended or "flying" cornice. Some of the earlier structures, such as the Temple of the Niches, utilized large stone blocks carefully crafted to fit together in the manner of fine carpentry. All major buildings were stuccoed and then monochromed or polychromed depending upon function and time period. The growing use of cement during the city's florescence

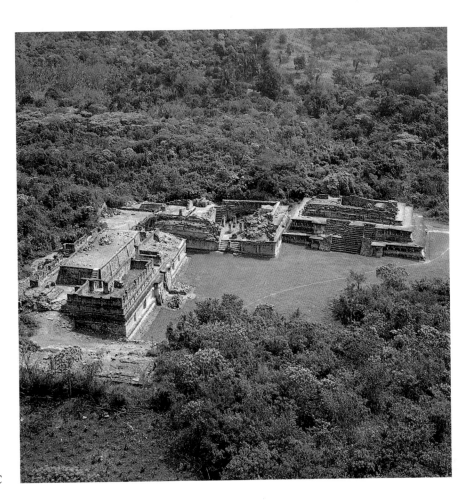

Tajín Chico: Buildings A, B, and C

was innovative and extraordinarily portentive of modern engineering skills. Not only were some surfaces made impermeable by the use of asphalt, but cement shells, providing an archlike ceiling, appear to have been utilized in some of the later buildings in Tajín Chico. Roofs were generally flat and were constructed of poured concrete with pumice stone and ceramic fragments used as bonding aggregates. Such roofs, lacking internal reinforcement, had to be very thick to span the often ample rooms. Building B, for instance, a midsize building, was covered by a single slab 99 centimeters (39 inches) thick, requiring a staggering 350 cubic meters (460 cubic yards) of concrete.

El Tajín has one of the largest sculptural corpora of any site in Mexico and future explorations are certain to increase it. The primary context for practically all of this art is architectural. Shallow relief depictions were located on the limestone walls of ball courts, within temple sanctuaries, and on columns. The Tajín style is distinctive, employing scrolls, often in double outline, and convoluted grotesques about elaborate ritual scenes and symbols. Much of the ritualism and iconography portrayed in such contexts relate to the ball-game ritual. This is not surprising in light of the fact that, while many contemporary Mesoamerican sites have only one court, there were at least eleven courts at El Tajín. Merged with this all-important rite were attributes of the cult of pulque, the major intoxicating drink of central Mexico. Associated too with these rituals were portable ball-game sculptures, known as yokes, *hachas*, and *palmas*, which are found abundantly on the central Gulf Coast.

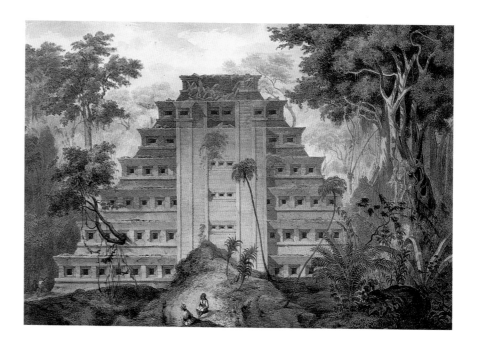

El Tajín: Pyramid of the Niches, from Carlos Nebel, *Viaje pintoresco y arqueológico sobre la parte más interesante de la República Mejicana*... (1839)

The eight thousand-year cultural chronology of the El Tajín area, based largely on the regional stratigraphic explorations of this writer and the architectural sequence of García Payón, indicates that the city came into being in the initial centuries of the first millennium A.D. From about A.D. 300 to 600, it was of modest size and perhaps within the orbit of Teotihuacán, but from about A.D. 600 to 900 it expanded rapidly up the valley slopes as rulers built and celebrated themselves and their gods in sculpture. Almost without a pause this florescence entered a climactic phase from about A.D. 900 to 1100 when the largest buildings of the city were constructed, and then suddenly destroyed. Although the archaeological evidence strongly suggests that a particularly expressive branch of the Huastecs inhabited the region from antiquity, we cannot yet be fully certain who built this great city, or who brought about its abrupt demise. El Tajín today is in the keeping of the Totonacs, who revere it and jealously protect its many secrets, just as the startled Diego Ruíz noted some two centuries ago.

68 ⦃ Cacao Tree Tablet

Pyramid of the Niches, El Tajín, 7th century
Limestone; height 135 cm. (53⅛ in.)
Museo de Antropología de la Universidad Veracruzana, Xalapa 10936

Although worn from exposure, this solid limestone tablet carved in the Tajín style is one of the most striking depictions from the summit sanctuary of the Temple of the Niches. Originally there may have been as many as twenty similarly sized panels within the highly ornate temple. To date, over 28 square meters (300 square feet) of the sculpture that adorned the sanctuary, or stood about the stairway, have been recovered. The present panel was actually found some distance away from the temple near a trail which led northward through the jungle by the Building of the Columns. The slab had been chiseled neatly down the middle with the intention of breaking it into halves. Regardless of how it reached that point, via ancient monument movement, not uncommon at El Tajín, or from unsuccessful looting, its provenance, based upon style, content, and size is definite.

The Temple, erected in approximately A.D. 600, has the unusual distinction of having continuously functioned as a major ceremonial focus throughout much of the city's florescence. The unusual prominence and embellishment of this structure may be due to its early association with an ancestral ruler. Such quasi-mythical personages were important to the Mesoamerican elite in charting their right to govern. The building, polychromed red, black, and blue, and uniquely flanked by bases for large poles for ceremonial banners or ritual paraphernalia, may have been erected by this ruler to glorify himself but may also commemorate his death and be his tomb. In fact, during recent efforts at reconstruction, a vertical passageway, clogged with stone fill, and with a nonfunctional stairway in relief on the partially stuccoed wall, was encountered leading down into its interior like a psychoduct to a tomb.

The tablets from the sanctuary portray a single protagonist performing a series of distinctive rituals. Some appear to depict confrontations with monsters in the mythological underworld after death. The ruler-hero in these scenes either is in the guise of the gods, and particularly variants of the rain god, or is shown as a god himself in the afterlife.

On the present tablet a fruiting cacao grove is indicated by the tree, drawn in the characteristic double-outline style of El Tajín, which dominates the central background. This representation functions as a locative rather than the object of adoration as in the Tree of Life or World Tree depictions common in the codices. The action focus of the scene is a temple platform in the foreground. Ascending the steps is the protagonist, who wears a loincloth with a fan ornament, sometimes associated with commerce, tied at the back

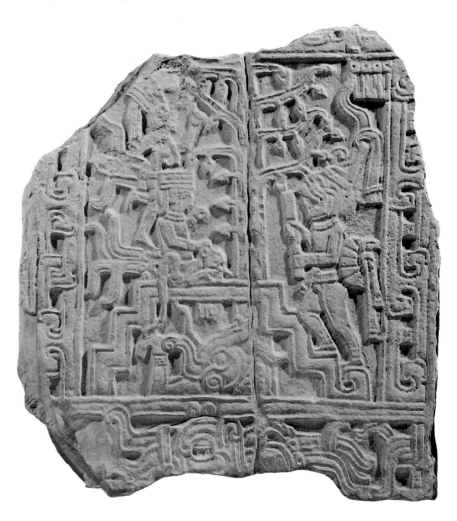

of his waist, while his face protrudes from a headdress in the form of a death's-head. Fastened to the skull helmet is a staff that ends in stylized feathers and a sash. In later Tajín times a very similar adornment symbolizes rulership. Above the figure is a name or day glyph in the form of four dots over four pendantlike features. Held nearly vertically in the hands of the protagonist is a torch bundle.

Seated on the opposite side of the platform is an elaborate figure with a macabre headdress. Bound to his headband is a youthful skeleton with hands upraised toward the cacao tree and legs positioned in a common Tajín ritual posture directly parallel to the Volador and Guagua dances still performed in the region. One hand of the personage is upraised as if to receive the torch. The other caresses the head of a reposing animal, probably feline, whose tail hangs languorously over the side of the structure. Both the cat and the skeleton have a nearly identical form of plumed grotesques attached to them, perhaps as a symbol of sacrifice. Within the temple a dragonlike monster with a jutting tongue and upraised arms opens its fanged jaws as if to swallow the reclining felid. Flanking the scene are linked scrolls, to separate it from adjacent tablets placed in the sanctuary wall, and above and below are now-mutilated grotesques that are frequently shown hovering about many Tajín ritual scenes.

It is a setting highly charged with the iconography of death and sacrifice. The personage carrying the skeleton also occurs on a vertically sculptured jamb in the Temple of the Niches. There he transports the child skeleton on his back. This figure may well be the Tajín version of the Maya God M and the Aztec Yacatecuhtli. This deity, whose attributes include a tumpline, was the patron of merchants and war, and was also known as the "black god of cacao." Sometimes, as in the Madrid Codex, he is shown holding a torch. Overall the tablet scene is remarkably consistent with a Maya ceremony that was held in the cacao plantations during *Muan*, the fifteenth month of the year, to propitiate the gods of rain and commerce. This ritual also involved animal sacrifice.

Chocolate was a significant Pan-Mesoamerican ceremonial drink. Here the ancestral ruler performs an important annual ritual that assures the success of the cacao crop by sacrificial propitiation of the appropriate gods directly in the plantations. The trade, or tribute, in such luxury produce was extremely important in ancient Mexico and held a very prominent place in the lowland economy. In a previous commentary on this tablet, this writer emphasized that there was considerable evidence at nearby Santa Luisa, and elsewhere in north-central Veracruz, for massive, well-engineered field systems under the control of the Tajín state for such crops. The rulers of El Tajín were energetic sculptors of the landscape as well as of stone.

SJKW

DISCOVERY
Reported at El Tajín, displaced at some distance from the Pyramid of the Niches, in about 1930

REFERENCES
Enrique J. Palacios and Enrique E. Meyer. *La ciudad arqueológica del Tajín: Sus revelaciones.* Biblioteca de Estudios Históricos y Arqueológicos Mexicanos, vol. 1. Mexico, 1932, pp. 29–30, photo 10, dwg. 12. **Ellen S. Spinden.** "The Place of Tajín in Totonac Archaeology." *American Anthropologist* n.s. 35 (1933), p. 262–63, pl. 18c. **José García Payón.** "La pirámide del Tajín: Estudio analítico." *Cuadernos Americanos* 60, no. 6 (1951), pp. 153–77. **Michael E. Kampen.** *The Sculptures of El Tajín, Veracruz, Mexico.* Gainesville, Florida, 1972, fig. 5a.

Pyramid of the Niches, El Tajín, 7th century
Limestone; height 46 cm. (18⅛ in.)
CNCA–INAH, Museo de Sitio de El Tajín, El Tajín
225 B.1

Carved along two faces of a large stone block, this composite-image sculpture is one of a nearly matched pair found in the nineteenth century in the plaza of the Pyramid of the Niches. Although at times attributed to the South Ball Court, iconographically and structurally both belong to the group of sculptures from the destroyed sanctuary atop the Pyramid of the Niches. These sculptures were almost certainly meant to cap panels similar to the cacao tablet (cat. no. 68). The blocks may have been placed opposite one another, and perhaps above some extant vertically oriented grotesques at interior corners of the sanctuary.

The depiction is really a series of overlapping images executed in a manner similar to those on many of the portable ball-game sculptures called yokes. It demonstrates a continuity of design, carried over from the rounded surfaces of such sculptures to the flat, intersecting planes formed by El Tajín's massive stone walls. It connotes also a rigorous and multiplex conceptualization of certain earth or underworld deities regardless of medium. Here three distinct, yet merging, figures may be seen.

The most elaborate image is found in the plane along the long side of the block. The baseline for this depiction is at a right angle to the floor. Portrayed is a standing figure with feet apart atop a plumed grotesque in profile with a narrow eye and protruding teeth. The figure wears the highbacked sandals of the elite, a banded anklet on his left leg, and a composite stone anklet on his right. About his knees are the protectors worn in the ritual ball game, shown here as symbols of prerogative and rank. On the chest is a shield with interlocking war lances in a composition that also occurs at Chichén Itzá and was called *tezcacuitlapilli* in Aztec times. There are also two examples in the grotesque band of the North Ball Court. The crossed lances of this insignia form the *ollin* sign, common in the ball-game–oriented iconography of El Tajín and, in some contexts, possibly the emblem glyph of the site. One arm, with curled hand, extends under the face. Above a multistringed necklace, the head is turned abruptly upward from the body. A caplike headdress, now partially destroyed, stretches along the back of the figure.

On the shorter adjacent side of the block is a near mirror image of the standing figure. Although it is now damaged, we can surmise on the basis of the better-preserved companion sculpture, that the portion of the body below the shield device was foreshortened, prone, and had one leg bent upward in a dancelike posture common in Tajín sculpture.

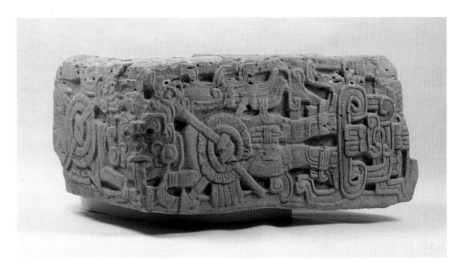

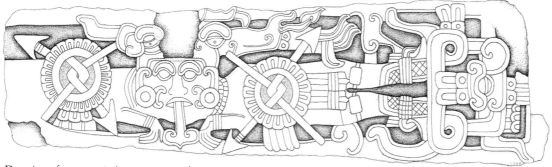

Drawing of cat. no. 69 (courtesy INAH)

The third image is directly at the intersecting planes of the sculpture above the symmetrically placed hands. Here the two heads form one and have a series of masklike elements. These include supraorbital eye plaques, curved cheek patches extending from under the ear ornaments, and a protruding, bifurcate tongue. The composite image is a form of the Tajín pulque god. Thought to reside in the underworld, this deity is at times depicted with a double body and is found prominently in the sculptures of both carved ball courts at El Tajín. Symbolically and physically the contorted countenance dominates the two lateral images.

Pulque, the intoxicating ritual drink par excellence, was extraordinarily important in the ceremonial life of El Tajín and with time came to be intimately associated with the ball-game ritual. While the face, or more likely the mask, is certainly that of the pulque god, the headdress, the accoutrements, and the grotesque at the base of the standing figure are all associated in other sanctuary sculptures with the ruler-protagonist. In this portrayal, as frequently elsewhere in that ornate temple, we are viewing the ancestral ruler in the underworld attired in the multiple ritual guises of one of the principal gods of El Tajín.

SJKW

DISCOVERY
In the plaza of the Pyramid of the Niches in the 19th century

REFERENCES
Ellen S. Spinden. "The Place of Tajín in Totonac Archaeology." *American Anthropologist* n.s. 35 (1933), p. 243, pl. 12a. **José García Payón**. "La pirámide del Tajín: Estudio analítico." *Cuadernos Americanos* 60, no. 6 (1951), pp. 153–77, photo 7. **Michael E. Kampen**. *The Sculptures of El Tajín, Veracruz, Mexico.* Gainesville, Fla., 1972, fig. 27b.

70 ⟨ Carved Yoke

Provenance unknown, 7th–10th century
Stone; length 41 cm. (16⅛ in.)
American Museum of Natural History, New York
30.2/3408

There is no art form more associated with the Veracruz Gulf Coast than the portable ball-game sculptures known as yokes. This example, in the rich Classic Veracruz style, embodies some of the more important compositional characteristics of these unique sculptures. Stone yokes, an inexact name derived from their superficial resemblance to ox yokes, are most abundant in central Veracruz but have been found as far away as central Mexico and El Salvador. They first appear in south-central Veracruz, perhaps as early as 900–300 B.C., and continue to be carved at least until approximately A.D. 900. The more elaborate examples are contemporaneous with El Tajín's florescence.

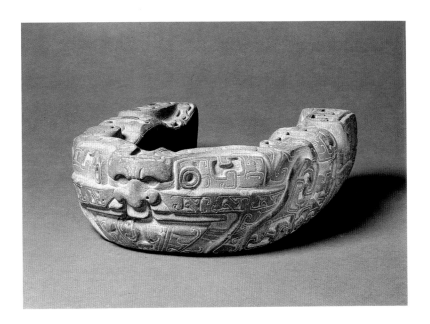

Resembling the waist protectors utilized in the ball game itself, the earliest yokes were plain, more ovoid in form, and sometimes closed on the end. The U-shaped format begins during the period from 300 B.C. to A.D. 300 and was often carved with the "monster of the earth" motif. The entrance to the underworld, thought accessible via the ritual ball game, was believed to be through the jaws of this female, toadlike creature with some feline attributes. The wearing of the yoke—not while playing the game but in associated rituals—was a highly symbolic prerogative of the elite. At El Tajín various ceremonies, including human sacrifice, are shown in the South Ball Court (northwest and northeast panels) and the Building of the Columns with the participants wearing yokelike objects. Although very few have been discovered by archaeologists, yokes are found primarily as mortuary offerings. Most were carved of relatively hard stone and polished. The only example known from an archaeological context in the region of El Tajín had been placed with an elite burial excavated in 1970 by the writer at the nearby site of Santa Luisa.

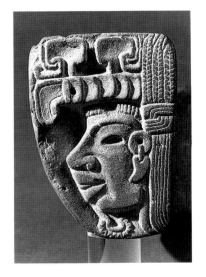 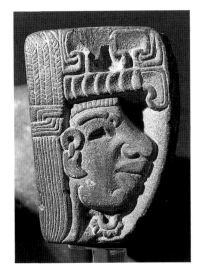

Details of yoke ends (cat. no. 70)

The present yoke comes from the first great collection of ball-game sculptures assembled at the close of the last century by Governor Teodoro Dehesa of Veracruz. This is a recarved yoke; that is, it appears to have first been sculpted in the earlier monster form and subsequently, perhaps centuries later, its final decoration was added. The squatting monster shape with its gaping mouth on the rounded end of the yoke is clearly visible beneath the mantle of ornate scrolls.

While most of the interlocking interlaces are continuous, almost as if they were feline spots, three areas have specific motifs. The most important is at the anterior end of the yoke where, off-center to conform with the original contours of the monster form, a face peers out of the scrolls. The heavyset, almost frowning countenance, has earplugs, an ornament beneath its pug nose, and a large bifurcate tongue shown by incision. This is the pulque god so common at El Tajín. Projecting away from the face on the yoke top are two rattlesnakes with a double-fanged head and scroll eye. On the yoke ends are human heads that symbolize sacrifice in the ball game. They are ornately adorned in a scroll headdress with feathers at the back, a cut shell necklace, and a curved ear pendant that was common in north-central Veracruz. Long hair hangs at the back, and the swollen tongue projects in death. Significantly this magnificent sculpture presents some of the early as well as some of the later motifs in the long yoke tradition.

SJKW

DISCOVERY
Unknown. Ex coll. Teodoro Dehesa, Veracruz

REFERENCES
Jesse Walter Fewkes. *Certain Antiquities of Eastern Mexico.* Twenty-Fifth Annual Report of the Bureau of American Ethnology. Washington, D.C., 1907, p. 255, pl. 112. **Enrique J. Palacios.** *Los yugos y su simbolismo: estudio analítico.* Universidad Autónoma de México. Mexico, 1943, p. 24. **Tatiana Proskouriakoff.** "Varieties of Classic Central Veracruz Sculpture." *Contributions to American Anthropology and History* 58. Carnegie Institution of Washington, Publication 606. Washington, D.C., 1954, p. 74, fig. 1, yoke 9.

71 ◄ Carved Yoke

◄ Provenance unknown, 7th–10th century
◄ Stone; length 41.5 cm. (16¼ in.)
◄ Minneapolis Institute of Arts, Minneapolis,
◄ The Ethel Morrison Van Derlip Fund 41.72

Drawing of yoke excavated at Santa Luisa, from *Boletín* (INAH), no. 41 (1970), fig. 45a

The particular composition of this yoke with upraised hands in the ornate Veracruz substyle probably indicates that it is from the greater El Tajín region since this format is most common in north-central Veracruz. In fact, a yoke of quite similar presentation is known from Martínez de la Torre.[1]

At the anterior end of this yoke a human face with an aquiline nose stares from beneath a feline helmet headdress. Feathers protrude from behind the cat ears, and a bejeweled double-strand sash curls from the headdress to the hands of the figure depicted in split-image form along both sides of the yoke. About the squatting ball player's midriff is a multistrip protective pad secured with a ritual knot, known in glyph form as an *ollin* sign that is one of the

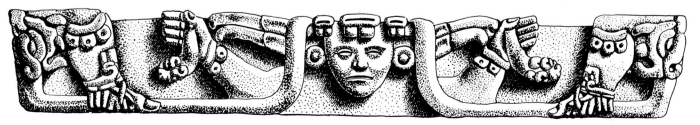

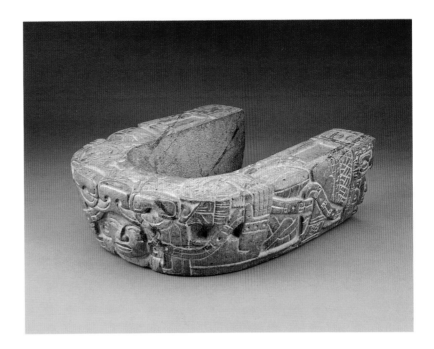

most ancient symbols of the ball-game ritual. The sash continues around the leg with the high-backed sandal and the thigh-length loincloth. The corners of the yoke, about where the figure's waist would be, are adorned by two puffy-faced heads with long hair and zoomorphic, probably feline, headgear that appear to swallow the faces.

The ball game, as shown vividly at El Tajín, had many related ritual events. This highly adorned yoke represents a game participant in a ritual posture associated with the earth deities, holding a ceremonial sash, and accompanied by the severed heads of sacrificed players. It was carved near the end of the yoke tradition.

SJKW

1. Krickeberg 1918–22, p. 43, ill. 18.

DISCOVERY
Unknown

REFERENCES
Walter Krickeberg. "Die Totonaken: Ein Beitrag zur historischen Ethnographie Mittelamerikas." *Baessler-Archiv* 7. Berlin 1918–22, p. 43. **S. Jeffrey K. Wilkerson.** "Un yugo 'in situ' de la región del Tajín." *Boletín* (INAH) 41 (1970), pp. 41–45.

72 ◀ Plaque (possibly a mirror back)

◀ Provenance unknown, 7th–10th century
◀ Slate; diameter 15.3 cm. (6 in.)
◀ The Metropolitan Museum of Art, New York,
◀ Museum Purchase 00.5.991

This plaque, carved in the Classic Veracruz style, comes from a small group of enigmatic sculptures that have been customarily considered backing for pyrite or hematite mirrors. They may well have also served other functions, however, including ceremonial clothing ornamentation, death bundle adornment, or ritual symbol of rank. Most are without provenance, but some are from locations distant from coastal Veracruz. One was excavated in a sixth-century tomb at Kaminaljuyú in Guatemala, and another was found in Queretaro in central Mexico, and one has even been attributed to Colima. Although few have been positively identified as being from Veracruz, the style is unmistakably from the region.

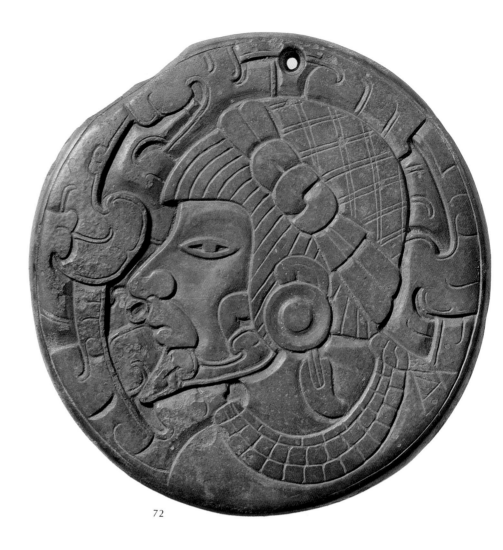

72

Mirrors are shown in the El Tajín sculptures, but with one possible exception, not on men. Rather they are placed on bands diagonally positioned across the chest of the rain god or an anthropomorphized bird deity with sacrificial connotations. They are also all shown as ovoid in shape. One intriguing object of the appropriate size and shape is depicted on a short staff. It comes from an early panel, originally half of a confronting scene, found near Building 5, which shows a figure dressed with full ball-game accoutrements. Covered in scrolls, the plaque is being held as a symbol of rank, or deity association, in a ball-game rite. This may be the primary ritual function of the Classic Veracruz plaques.

Arguably the finest example known is the present plaque with its carefully delineated, portrait-quality depiction of a young bearded figure surrounded by abstract scrolls. Interlaces of this form also occur on the more elaborate yokes of late date. The figure is ornately dressed with a ritual scroll beard, composite earplug, and curved ear pendant of a form common in north-central Veracruz and on Venus presentations. The hair is trimmed around the face and is topped by a netlike cap held with a knotted sash. Similar caps are shown on a deity impersonator in two of the panels of the South Ball Court at El Tajín. The line about the mouth may represent a buccal mask. Beneath the nose is a jade bead, needed for the trip to the underworld, and a possible speech scroll fronts the lips. The inclined torso wears a composite necklace.

The composition differs from most of the other known Classic Veracruz

plaques since it is very closely related to certain head and upper-torso depictions normally found on yoke ends (see cat. no. 70). These figures, unlike the more frequently portrayed severed heads, are generally shown in a more dynamic fashion, with upper torso, refined features, and a grotesque or abstract scroll headdress that approximates a monster jaw. The present plaque, like some of the yoke ends, represents a specific individual in the bearded guise of the Venus god entering the underworld. This plaque has been variously dated from the third to the tenth century A.D. I believe the preponderance of present data clearly indicates placement at the end of the Veracruz plaque tradition.

SJKW

DISCOVERY
Unknown. Ex coll. Louis Petich, New York

REFERENCES
Museum of Modern Art, New York. *American Sources of Modern Art*. Exh. cat., 1933, no. 5.
Tatiana Proskouriakoff. "Varieties of Classic Central Veracruz Sculpture."
Contributions to American Anthropology and History 58. Carnegie Institution of Washington, Publication 606. Washington, D.C., 1954, p. 74, fig. 3, plaque 3.

73 ◀ Head *Hacha*

Napatecuhtlan, 7th–10th century
Basalt; height 38 cm. (15 in.)
Museo de Antropología de la Universidad
Veracruzana, Xalapa

This *hacha* depicting a nearly life-size severed head with a plumed headdress was found, ritually broken and covered with cinnabar, in the interior of a small building. It had been placed there as an offering beneath a ceramic vessel containing the partially burnt bones of an interment. The large site of Napatecuhtlan is at nearly 2,600 meters (8,500 feet) elevation in a highland pulque-producing region that was strongly influenced, if not controlled, by lowland El Tajín.

Hachas, like most ball-game sculptures, are misnamed. Thought at first to be votive axes, they are for the most part stone trophy heads which appear to have been attached to yokelike waist items used in ball-game ritualism. They have been found in burials with plain yokes, but not with *palmas*, and are shown clearly in the sculptures of El Tajín. Their form of attachment, presumably to a wood base, is currently unknown, but with their characteristic sharp basal notch it would have been distinct from that of the concave-bottomed *palmas*. They are an older tradition than *palmas* and, although encountered in several parts of southern Mesoamerica, are most prevalent in central Veracruz. Related forms with a distinct basal projection, the tenoned head, or with no projection or notch at all, can be found extending southward from this core area to southern Guatemala.

The Napatecuhtlan *hacha* portrays a puffy-faced head with earplugs and pendants. The eyes are closed in death and a bifurcate tongue is extended, or perhaps purposely extracted and shaped, in the manner of the pulque deities. The headdress of three long plumes, followed by short feathers trimmed to an L shape, rises from an abstract grotesque base with a snout. The basal scroll elements employed here occur frequently on yokes and the sculptures at El Tajín. Significantly, similar headgear is worn by an important ball player in a sacrifice scene at El Tajín, associated with the South Ball Court. Along the back of the head and plumes runs a commonly depicted border which may be a representation of a frame upon which heads were actually set in the ball-

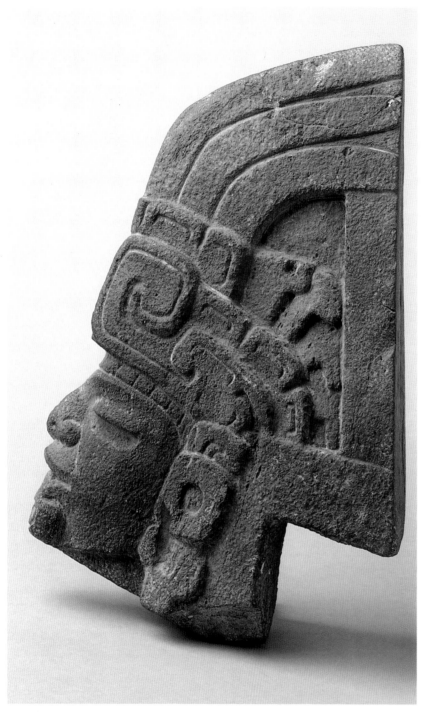

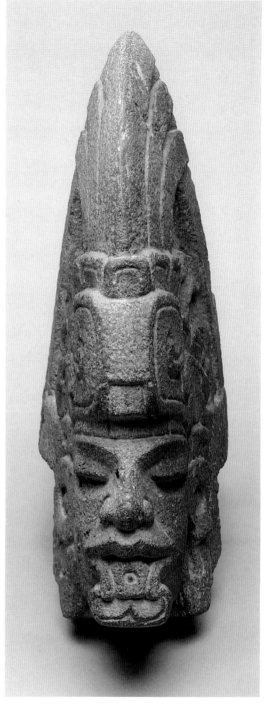

Profile view of cat. no. 73

73

game rituals. The proportions and features of this example also appear in other *hachas*, although generally not as elegantly executed, and suggest a certain standardization for some motifs. This *hacha* portrays the head of a ball player decapitated in a ritual that may well have been associated with the pulque cult so prominent in the narrative panels of the South Ball Court.

SJKW

DISCOVERY
Excavated by Alfonso Medellín Zenil in 1954

REFERENCE
Alfonso Medellín Zenil. *Cerámicas del Totonacapan, Jalapa.* Universidad Veracruzana, Jalapa, 1960, pp. 108, 112–13, pls. 65, 66.

74 ◀ Bird *Palma*

◀ North Zone, Mound A, Santa Luisa,
◀ 10th–12th century
◀ Basalt, obsidian, bone; height 44 cm. (17⅛ in.)
◀ Museo de Antropología de la Universidad
◀ Veracruzana, Xalapa

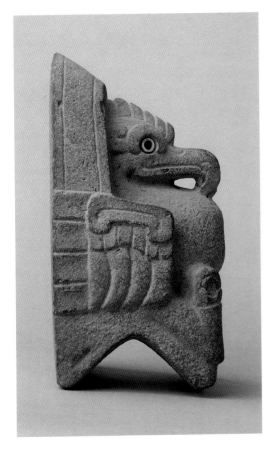

All but a handful of the hundreds of yokes, *palmas*, and *hachas* in collections throughout the world are without provenance. Even fewer of these portable ball-game sculptures have been encountered in formal archaeological excavations. This well-preserved bird *palma* with its delicate encrusted eyes was discovered by the writer at Santa Luisa, a major coastal site dependent upon El Tajín. It had been placed as an offering with a burial beneath a temple floor that was in use during the final centuries of El Tajín. The *palma* was found adjacent to the seated skeleton and inclined downward, as if its concave base had been placed upon a now-vanished object, such as a wood yoke. Just a few feet away the writer excavated a slightly earlier burial with the skeleton seated upon a carved yoke and accompanied by a sacrificial attendant.

Palmas, so named because some of those first found seemed to resemble palm fronds, are closely associated with yokes and *hachas* in depictions from the time of El Tajín. These sculptures, or perhaps facsimiles of wood paraphernalia actually utilized in the ball game, are shown as being worn, as are *hachas*, above a yokelike form at the waist in many depictions from the immediate El Tajín area. They can be found in the South Ball Court, the Building of the Columns, and Building 5, as well as on explicit tablets from the ball court at Aparicio. While *hachas* tend, for the most part, to represent severed heads, *palmas*, although perhaps derived from them, are thematically far more diverse. Even though the palmate, or paddle-shaped, form is slightly more numerous in some areas, *palmas* tend to take many different, even esoteric, shapes. They can vary greatly in size and be highly ornate or totally plain, but all have a curved basal indentation which presumably was for lashing the sculpture to some supporting object. Most tend to portray specific moments, real or mythical, in the ball-game rituals or sacred beings and symbols from such ceremonies. Those that have scrollwork in their designs tend to conform to a particular substyle of the Classic Veracruz style that shares many attributes with the El Tajín sculptures. In the general area of the metropolitan center at its apogee *palmas* appear to replace *hachas*, or at least to be far more abundant.

Palmas in the form of carnivorous birds were particularly popular in the immediate El Tajín region, and they often represent a bird that was prominent in ritual preparations for the ball game and in subsequent human sacrifice. In some instances the bird is shown devouring the flesh of the sacrificed. The Santa Luisa *palma*, with its gorged belly, is a particularly striking example of this group. Its crest suggests a harpy eagle but the scroll over the eye and above the wing is a standard stylization. The bird, with raised talons, projects outward from a flat boardlike headdress which may have originally been painted with designs. The eyes are green obsidian set in bone. The stern visage implies the severity of ball-game ritualism and its often mythical participants.

SJKW

DISCOVERY
Excavated by S. Jeffrey K. Wilkerson in 1974

REFERENCES
S. Jeffrey K. Wilkerson. "Man's Eighty Centuries in Veracruz." *National Geographic Magazine* 158 (1980), pp. 216–19. **S. Jeffrey K. Wilkerson.** "In Search of the Mountain of Foam: Human Sacrifice in Eastern Mesoamerica." In *Ritual Human Sacrifice in Mesoamerica*, edited by Elizabeth H. Boone. Dumbarton Oaks, Washington, D.C., 1984, pp. 117–18, figs. 8, 9.

75 ◀ Two *Palmas*

◀ Rancho El Paraíso, Banderilla, 10th–12th century
◀ Basalt; height 44 and 47 cm. (17⅜ and 18½ in.)
◀ Museo de Antropología de la Universidad
◀ Veracruzana, Xalapa

These ornate sculptures are the most recent discoveries from a small region around Xalapa where, starting late in the nineteenth century, a considerable number of extraordinary *palmas* have come to light. These two examples were found in 1980 during construction at Rancho El Paraíso near Banderilla. A brief salvage exploration in the highly disturbed archaeological context revealed that the sculptures, purposely broken in ancient times, came from a burnt offering which included obsidian projectile points and small clay figurines. No associated burial was found. The *palmas* are in two of the most characteristic formats: the fanlike palmate shape and the often taller, laterally flattened variety. The scrollwork of both is executed in what Proskouriakoff defined as the Tajín style. These pieces may have been carved as a ritual pair with complementary information being conveyed in their designs.

At the front of the palmate example is a nearly nude man on a platform adorned with the niches typical of El Tajín architecture. The image emerges from a background of continuous interlocking scrolls. The building, with its plain balustrades ending in niches and stepped design in the lateral *tablero*, is chronologically late at El Tajín. The stooped, or hunchbacked, man straddling

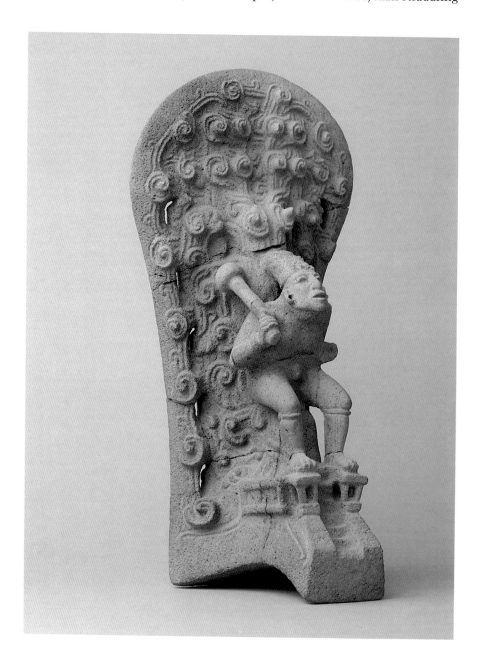

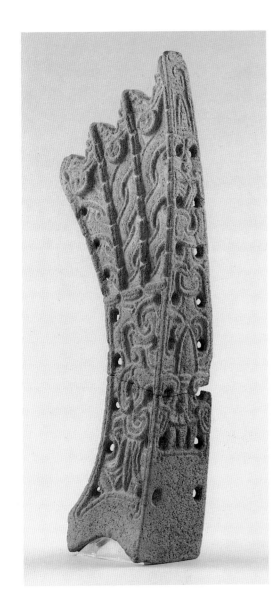

the top of the stairs has the kneebands of a ball player and a flattened forehead with long hair held back by a decorated wrap. In the one surviving hand is a massive macelike implement, uncommon in Gulf Coast depictions. There is a clearly conveyed dynamism in the intense, even strained, gaze of the face and the tensed, nearly contorted body. A specific moment of ritual exertion, almost certainly sacrifice, is being anticipated here. The encompassing scroll backdrop, often symbolizing blood, reinforces the sacrificial setting. Such rituals were probably held on low, easily visible platforms near where the game was played, as on those adjacent to the South Ball Court at El Tajín.

The laterally flattened *palma* also has definite sacrificial connotations. In form it is virtually identical to the *palma* shown on the decapitated and disemboweled ball players in the tablets from the major ball court at Aparicio. The flattened sides have a plumed grotesque with scroll eye in the basal portion, and a scroll guilloche design above that represents spurting blood and evisceration. Each of the two narrow ends terminates in a similar god face, shown with protruding tongues at the top and fangs below. This may be a dualistic portrayal of the rain deity, as a patron of pulque above and in the more standard rain connotation below. A closely related depiction of the rain god, including the plumed element of the *palma* grotesque, symbolizing sacrifice, comes from the sanctuary of the Pyramid of the Niches at El Tajín. This ornate *palma* is charged with the iconography of ball-game sacrifice and its patron gods. It may well symbolize the culminating sacrifice itself, while its companion sculpture denotes a given moment in the grim ritual that led up to it.

SJKW

DISCOVERY
Excavated by Ramón Arellanos Melgarejo and Lourdes Beauregard García in 1980

REFERENCES
Ramón Arellanos Melgarejo and Lourdes Beauregard García. "Dos palmas Totonacas: Reciente hallazgo en Banderilla, Veracruz." *La Palabra y el Hombre* [Jalapa] 38–39 (April–September, 1981), pp. 144–60. **Ramón Arellanos Melgarejo and Lourdes Beauregard García**. "Elementos arquitectónicos en una palma Totonaca." *Cuadernos de Arquitectura Mesoamericana* 8 (1986), pp. 58–62.

76 ◀ *Palma* with Cloaked Figure

◀ Coatepec, 10th–12th century
◀ Basalt; height 45 cm. (17¾ in.)
◀ Instituto de Cultura de Tabasco, Dirección de
◀ Patrimonio Cultural, Museo Regional de
◀ Antropología "Carlos Pellicer Cámara,"
◀ Villahermosa A–0279

This richly decorated *palma* comes from the greater Xalapa area where so many such sculptures have been found. It presents two distinct scenic depictions employing simplified scroll designs that have been tentatively designated the marginal *palma* style. The front of the sculpture portrays a ritual scene with a solemn individual standing atop a platform or litter. Below him are the entwined sashes of the ball-game glyph establishing the ceremonial setting. The stocky figure wears a loincloth, a ropelike shoulder cape, large earplugs, and a lavish conical cap. The face, now damaged, may have originally had a nose ornament or, even more probable, a buccal mask. Held at waist level is a heavy baton similar to the examples possessed by figures in the panels of the South Ball Court. Behind the personage, and presented in the split-image format common to yokes and El Tajín sculptures, is a superb representation of an anthropomorphized butterfly. This should be the Tajín equivalent of the later Aztec deity Itzapapolotl (Obsidian Butterfly). Associ-

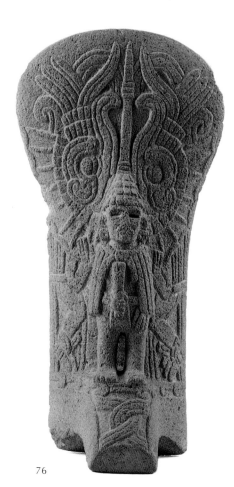
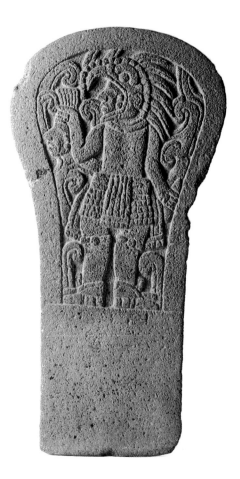

76

ated with death and the Venus cult, this god had many attributes that are thought to come from central Veracruz.

The principal scene focuses upon a particular moment in a ball-game–related ritual. Capes are shown only occasionally in Tajín art and then to connote rulership or divine status. The conical headgear, or "Huastec hat," is often an attribute of the wind god and Venus. The depiction is that of a ball player dressed as a deity about to enter the underworld. On the back of the *palma* is an explicit scene, in shallow relief, of sacrifice by decapitation. A figure adorned in high-backed sandals, the kneebands of a ball player, elaborate loincloth, and a feathered bird helmet fills the frame. Notably, this attire is similar to contemporaneous northern Maya depictions. In the right hand is an unhafted sacrificial knife and in the left is the head of the victim, held by its long hair. The outward pointing position of the sacrificer's feet is a sign of prominence in later Tajín art. The same person, or ruler, may be represented on both sides, impersonating the wind-Venus deity on the front and exercising the prerogative of sacrifice on the back. *Palmas* depict, as do the sculptures of El Tajín, the involvement of both gods and men in the paramount ball-game rituals.

SJKW

DISCOVERY
Unknown. Ex coll. Heredia.

REFERENCES
Walter Krickeberg. "Die Totonaken: Ein Beitrag zur historischen Ethnographie Mittelamerikas." *Baessler-Archiv* 7. Berlin, 1918–22, p. 38, ill. 5. **Tatiana Proskouriakoff.** "Varieties of Classic Central Veracruz Sculpture." *Contributions to American Anthropology and History* 58. Carnegie Institution of Washington, Publication 606. Washington, D.C., 1954, p. 83, fig. 6, *palma* 5.

◀ *Palma* **with Sacrificial Scenes**

◀ Provenance uncertain, probably Texolo, 10th–12th
◀ century
◀ Basalt; height 82.5 cm. (32½ in.)
◀ American Museum of Natural History, New York
◀ 30.2/3407

At the turn of the century this elegantly proportioned *palma* was in the pioneering collection of Teodoro Dehesa, governor of Veracruz. It probably came from Texolo, near Xico and not far from Xalapa, as did a number of similarly ornate *palmas* in that same collection. Carved in the *palma* substyle of Classic Veracruz, it is one of the taller examples of this variety of sculpture. Both front and back present sacrificial scenes executed in low relief, but the major, and most detailed, depiction is across the gradual curves of the frontal surface. It portrays the sacrifice of a figure whose limbs, spread along the margins of the composition, appear to be devoured by serpents.

At the center of this cluttered presentation are entwined double-headed snakes. Paired serpents are important iconographic elements in the sculptures of the Pyramid of the Niches, North Ball Court, and the Building 4 altar at El Tajín, as well as on Huastec shell gorgets. Directly between the open mouths of the snake is the head of the protagonist with his face tilted upward. His long hair is bundled in a way seen only on the last El Tajín depictions, and a speech scroll emerges from his lips. About his neck is a pendant in the form of the *ehecatlcoxcatl*, the "wind jewel" symbol. This is associated in Aztec times with the major deity Quetzalcoatl, who by then had assumed the attributes of the older gods of wind, Ehecatl, and of the planet Venus, Tlahuizcalpantecutli. The Venus cult is of great antiquity on the Gulf Coast and was particularly significant in ball-game ritualism at El Tajín.

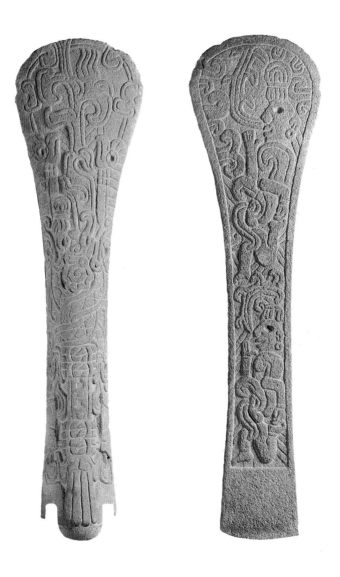

The figure's arms, dressed in feathers and ending in bird heads, extend upward from the fangless snakes. His legs, with the kneebands of a ball player, hang limp, as if suspended beyond the lower snake heads. He is seated upon, or perhaps bound to, the knotted cylindrical object that begins with four long feathers at the base of the sculpture. Behind the human head, and extending to the top of the depiction, is a vegetative scroll like a cornstalk. Disembowelment may be inferred here by the snakes, and the cornstalk is suggestive of a regeneration rite. Evisceration on a cornstalk frame in the context of ball-court ritualism is shown dramatically in 13 Rabbit's carved columns at El Tajín. It apparently was one of the major rites at the height of Tajín culture. The death context of the *palma* ceremony is also manifest in the multiple sacrifice presented on the inverse. Here two sprawled individuals are shown with blood scrolls emerging from their pierced abdomens and from beneath their severed heads. Out of their mouths extend vegetative speech scrolls.

The principal scene depicts the ritual sacrifice, following the ball game, of an impersonator of the Tajín equivalent of Tlahuizcalpantecutli. The planet Venus, when it disappeared from the sky as the evening or the morning star, was thought to be swallowed by serpents and to enter the underworld. Throughout its 584-day celestial cycle Venus was considered to interact with a number of other important deities, including the god of maize. The rites of the ball game in the El Tajín region were many and varied but were unified by the belief that sacrifice led to contact with the gods of the underworld and was ultimately beneficial to humans and their most important crop.

SJKW

DISCOVERY
Unknown. Ex coll. Teodoro Dehesa, Veracruz

REFERENCES
Jesse Walter Fewkes. *Certain Antiquities of Eastern Mexico.* Twenty-Fifth Annual Report of the Bureau of American Ethnology. Washington, D.C., 1907, pls. 116a, 118b. **Tatiana Proskouriakoff.** "Varieties of Classic Central Veracruz Sculpture." *Contributions to American Anthropology and History* 58. Carnegie Institution of Washington. Publication 606. Washington, D.C., 1954, p. 83, fig. 7, *palmas* 15, 16.

78 ◀ Mural Fragment

◀ Building A, Tajín Chico, 10th century
◀ Painted plaster lime; height 17 cm. (6¾ in.)
◀ CNCA-INAH, Museo de Sitio del El Tajín,
◀ El Tajín 003

This significant mural fragment comes from one of the more ornate palace structures on the Tajín Chico acropolis. Building A rose three stories from the level of the Tajín Chico plaza and had a number of interior walls adorned with polychromed stucco decoration and murals.

This example is from a formal portrayal of the El Tajín rain deity. The green face of the god is set against a solid expanse of flat red. Above the white teeth is the deity's characteristic extended upper lip. The white eye, capped by a scroll ridge, is covered by a red lid and bordered by a series of yellow teardrop-like ornamentations. The headdress, ending in a tied bunch of feathers, extends horizontally above with its elements in light blue, green, and dark red. In front of the mouth is a convoluted green band, probably a speech scroll. Near the edge is a twisted blue ornament on a green staff with hatching. This is almost certainly the "rain snake" or "lightning staff" frequently depicted in the god's hand.

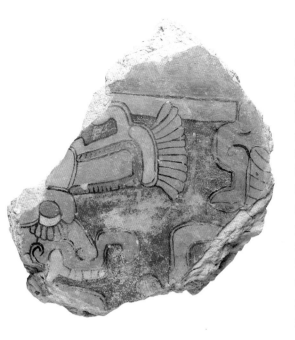

While the headdress, proportions, and red background are vaguely reminiscent of earlier Teotihuacán murals, this depiction is executed in the same double-outline styling found on both El Tajín stone sculpture and some portable ball-game sculptures. In fact, a recently recovered rain-deity head from one of the smashed tablets of the sanctuary of the Pyramid of the Niches is remarkably similar. The mural composition, however, appears more closely related to that of the central panels of the South Ball Court where the rain god is shown officiating at a temple structure. Often the red background tends to be an indicator of interior settings, the yellow bar above the deity may be a building profile, and the blue above, the sky. The rain deity is also shown in such compositions in the Codex Laud and the Codex Fejérváry-Mayer, both of possible Gulf Coast origin. It is conceivable that this mural may represent a ruler impersonating a god, a composition so frequently found at El Tajín. However, not enough remains to be certain. This intriguing fragment provides us with a glimpse of the elaborate murals that once existed throughout this great metropolitan center and suggests the colors that may have been used for polychroming the numerous stone sculptures.

SJKW

DISCOVERY
By José García Payón in 1949

REFERENCES
José García Payón. "Arqueológia del Tajín: II. Un palacio Totonaca." *Uni-Ver* 1, no. 11 (1949), pp. 581–95, fig. 12 upper right. **José García Payón.** *El Tajín. Official Guide.* Instituto Nacional de Antropología e Historia. Mexico, 1957, pp. 14–18. **S. Jeffrey K. Wilkerson.** *El Tajín: A Guide for Visitors.* Mexico, 1987, pp. 48–50.

79 ◄ Two Mural Fragments

Reportedly from Building A, Tajín Chico, 10th century
Painted lime plaster; height 8 and 6 cm. (3⅛ and 2⅜ in.)
CNCA–INAH, Museo de Sitio de El Tajín, El Tajín 001

Two smaller fragments (see also cat. no. 78), reportedly also from Building A, are quite distinct. Both depict processional scenes, but not necessarily the same one, and were painted alfresco on the prepared white stucco background. They appear to have been executed freehand without a cartoon or outline. While similar in some respects to the surviving processional murals at the small provincial site of Las Higueras, they are far more carefully executed. The larger piece shows two individuals offering oblong objects from which project upward two thin rods. The red painted figure also has a green crocodilian headdress often found modeled on clay figurines of warriors along the

Gulf Coast. The smaller fragment has individuals holding staffs, perhaps spears, and a red shield. The sloping foreheads of both individuals suggest the cranial deformation popular in ancient, and particularly lowland, Mesoamerica. These tantalizing little fragments, with their ample range of colors and delicate images, hint at the important role of processions in the ritualism of El Tajín. Nevertheless, just as on the later columns of 13 Rabbit, they are likely portraying specific ceremonies focusing on specific individuals.

SJKW

DISCOVERY
By José García Payón, 1949–69

REFERENCE
S. Jeffrey K. Wilkerson. *El Tajín: A Guide for Visitors.* Mexico, 1987, pp. 48–51.

80 ◀ Column of the Ruler 13 Rabbit

Building of the Columns, Tajín Chico,
11th century
Limestone; height 200.7 cm. (79 in.)
CNCA–INAH, Museo de Sitio de El Tajín, El Tajín
023 A.1

Carved with narrative scenes in the Tajín style, this massive column segment celebrates the rule of one of El Tajín's last and greatest rulers. It comes from the principal portico of one of the most extraordinary structures in ancient Mexico—the Building of the Columns—which was part of a huge, citadel-like complex constructed at the city's zenith by the ruler 13 Rabbit. Situated on the uppermost levels of the Tajín Chico acropolis, the building visually, and symbolically, dominated the city in all directions. The main stairway led up the southeast side of the pyramidal base. At its top, recessed from the edge, stood the portico that provided access to the building. García Payón's preliminary explorations indicated that the rectangular structure, ornamented with stucco designs in relief, was narrow with an unusual sunken courtyard at its

Rollout drawing of middle and top registers of cat. no. 80 (original drawing courtesy INAH)

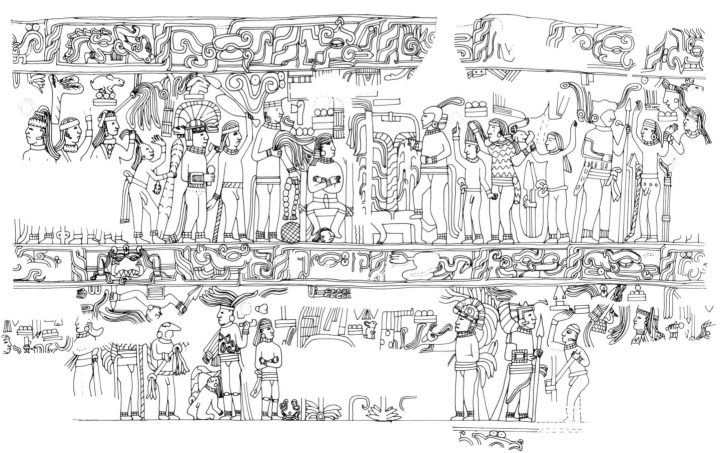

Chichén Itzá and Prosperity in Yucatán

PETER J. SCHMIDT

During the troubled times between the ninth and thirteenth centuries, Chichén Itzá was the most brilliant political and cultural center on the northern Yucatán plains, if not in all of Mexico. Situated about ninety kilometers (fifty-five miles) from the important salt beds of Yucatán's north coast, the ancient city occupied an area rich in natural wells (cenotes) and caves that had access to subsurface water. Such water sources were a necessity of life on the riverless limestone shelf of Yucatán. Chichén Itzá's very name—"At the Mouth of the Well of the Itzá"—refers to one of these life-giving features. It also identifies its location as the seat of the mighty Itzá, a people prominent in the history of the region.

Constructed on the site of an earlier village, Chichén Itzá expanded considerably throughout the centuries of its existence, and if pictorial evidence and obscurely phrased chronicles are to be believed, it ruled by military might and political alliance over vast expanses of Yucatán and beyond. The city was left to decay at the end of the thirteenth century, with only a small town preserving its name. The town's inhabitants attended to services at the Sacred Cenote, which remained a center of pilgrimage and sacrifice until the Spanish Conquest.

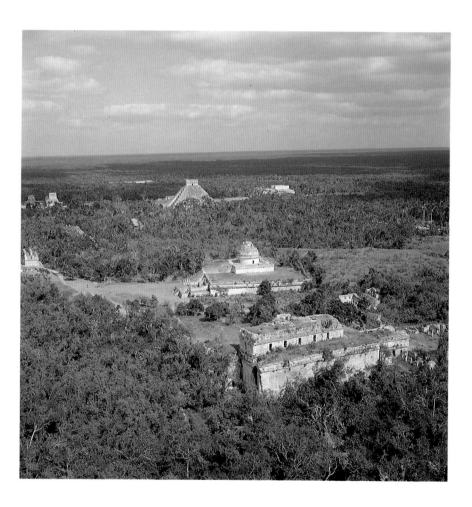

Chichén Itzá: site view, looking north

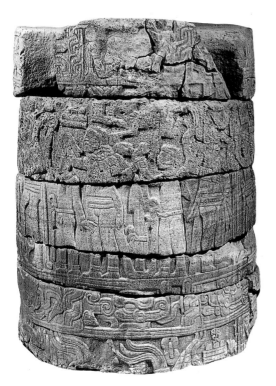

Reverse of column (cat. no. 80)

shoulder is a plumed bird headdress, similar to insignia worn in the Tlaxcala area in later times. Around his waist is a cord, which, although the section is now absent, probably passed into the hand of 13 Rabbit who, behind him, is also participating in what may be another temple ritual. This last scene is far too fragmentary for positive interpretation but once more appears to have 13 Rabbit, or his title, represented on the temple interior as well. On either side the standing participants shake rattles in musical accompaniment.

With the completion of the preparatory rituals the major sacrificial ceremony unfolds in the upper register. It may be taking place in a ball court as evidenced by the sash and large rubber ball prominently displayed adjacent to 13 Rabbit, who is seated on the lashed beam seat at the center. The ruler has his arms crossed and his feet upon a severed head. He overlooks the decapitation and disembowelment of a supine prisoner whose intestines have been placed over a frame decorated with cornstalks. On either side 13 Rabbit and others are shown leading mostly nude prisoners to the place of sacrifice. The fact that all appear to have originally had name glyphs suggests strongly that this is a specific celebration of 13 Rabbit's conquests. Important captives, prominent enough to be named, are being sacrificed by the victorious ruler of El Tajín in a ball court following preliminary rituals near a temple devoted to the ritual drink pulque. Just as in the middle register, 13 Rabbit is depicted at regular intervals throughout the scene, which intentionally makes his image visible to the viewer from any angle.

While there is some thematic continuity from the earlier sculptures of the Pyramid of the Niches in the form of the ball-game symbolism, the pulque cult, and the accompanying grotesque bands, there are also some notable modifications. The column sculptures show conquest, rituals of multiple sacrifice, numerous participants, and the repetitive presence of the ruler in contiguous settings. 13 Rabbit is portrayed in the scenes not solely as a powerful ruler but also as the protagonist of rituals and perhaps in certain instances as a god himself. These sculptures represent the culmination of Tajín art and, most probably, the Tajín state. But if the great Building of the Columns saw the city's apogee, it also soon suffered its downfall. Major temples were frequently the symbolic, and literal, places of last defense in the storming of a Mesoamerican city. Not only was there much evidence of ancient destruction about the building, but considerable effort was expended in breaking, even pulverizing, the column sculptures. 13 Rabbit's celebrated conquests and architectural grandeur were not to endure.

SJKW

DISCOVERY
Unknown. The first mention of the column fragment is in a general regional description by José M. Bausa in 1845. The first to excavate, collect, and order the fragments was José García Payón between 1939 and 1969.

REFERENCES
H. David Tuggle. "The Columns of El Tajín, Veracruz, Mexico." *Ethnos* 33 (1969), pp. 40–70, fig. 1. **Michael E. Kampen.** *The Sculptures of El Tajín, Veracruz, Mexico.* Gainesville, Florida, 1972, fig. 34a. **S. Jeffrey K. Wilkerson.** "Man's Eighty Centuries in Veracruz." *National Geographic Magazine* 158 (1980), pp. 202–31. **S. Jeffrey K. Wilkerson.** "In Search of a Mountain of Foam: Human Sacrifice in Eastern Mesoamerica." In *Ritual Human Sacrifice in Mesoamerica.* Edited by Elizabeth H. Boone. Dumbarton Oaks, Washington, D.C., 1984, pp. 110–14, figs. 6, 7.

center. The roof, thick and flat, was of poured concrete. Distinctively, however, the underside of the span covering the area behind the 110–115-centimeter- (43–45-inch-)wide columns appears to have been intentionally curved, giving it the appearance of an arch. This device, to lighten the roof and distribute its enormous weight, was highly innovative and perhaps unique in Mesoamerican architecture. Recent finds of much smaller-diameter column drums in the vicinity of the west side of the building suggest still another ceremonial entranceway in the complex.

Originally the main east portico had at least five, and possibly six, columns with a height of 3 meters (10 feet) or more. Each was composed of limestone blocks accurately cut to a circle, stacked, and carved in situ. Over 55 square meters (600 square feet) of surface were originally sculpted in low relief. Unfortunately, only a little more than half, and that highly shattered, has been recovered. Differences of proportions and treatment in the depictions suggest several artists. In general the compositions are more plastic, if more crowded, than those of earlier El Tajín sculptures. Practically all of the surviving scenes portray collective rituals, many involving human sacrifice, prominently presided over by 13 Rabbit. As with parallel depictions on Maya mortuary pottery, some scenes may be taking place in the mythical underworld. It is tempting to interpret these sculptures as a complete sequence, beginning with mortal actions and ending with direct interaction with the gods of the underworld, as in the magnificent depictions of the South Ball Court, but with the present partial corpus we can be certain of sequence in only this one column segment.

Preserved on this column are two of the three principal registers and two of the three bands of grotesques. The order of events appears to flow from bottom to top. The lowest register, not present here, almost certainly depicts a ball game or a related ritual held in the proximity of a ball court. The middle register is incomplete but illustrates a series of interconnected events or, more probably, phases of a single ritual, with 13 Rabbit as the protagonist of each. The primary focus is a now-fragmentary structure decorated with maguey plants, perhaps symbolizing the Mountain of Foam, the mythical origin point for the ritual pulque drink. 13 Rabbit's name, derived from the ritual 260-day calendar, is shown there by a glyph in the form of a naturalistic rabbit accompanied by two bars and three dots. Adjacent to the temple's left side is the ruler with an elaborate feathered headdress and an arch of speech scrolls, perhaps invocations, directed toward the temple's interior. On the right side is a long-haired man with a headband, a loincloth, and ball-game knee protectors; his arms are crossed in a sign of reverence.

Flanking this temple scene are two secondary, perhaps earlier ceremonial activities. On the right is a standing warrior holding a raised *atlatl*, or spear-thrower, and gesturing toward a collapsing individual with extracted intestines symbolizing sacrifice. Above is a descending deity holding a knife and spear. Facing this is a nearly nude prisoner with a zoomorphic helmet who holds a decorated spear of a variety used in gladiatorial sacrifice. Around his waist is a long, thick cord which loops up over the arm of 13 Rabbit who is holding the captive's hair in the Mesoamerican symbol of conquest. He is dressed in a *xicolli*, a ritual jacket often associated with sacrifice. On the opposite side are two individuals. One is ornately dressed and holding an upright spear. Facing him is another prisoner pointing upward to the number six, part of his name glyph. Attached to the upper end of the staff over his

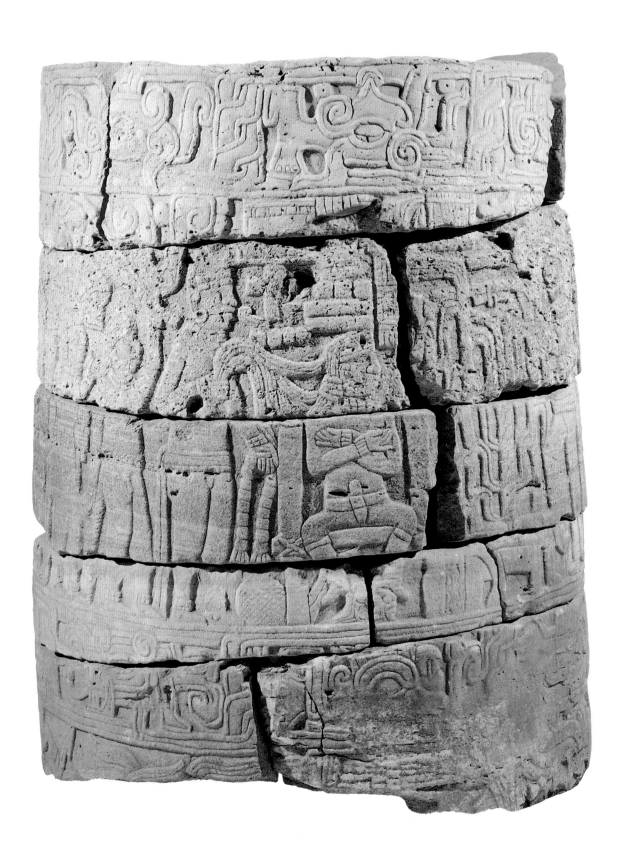

Top register of cat. no. 80

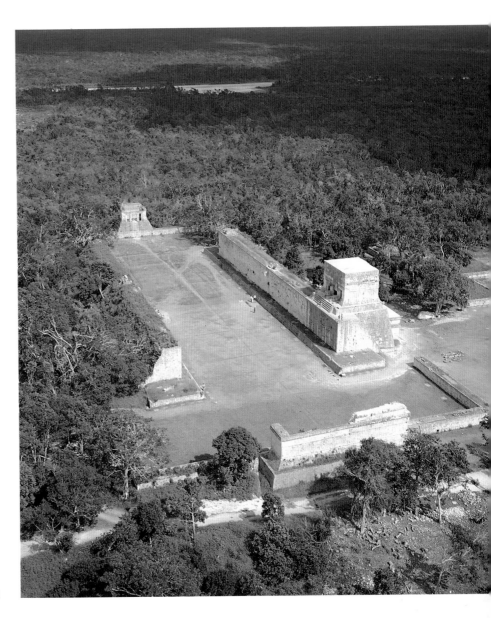

Chichén Itzá: Great Ball Court

The site of Chichén Itzá has been known for its massive architecture and well-preserved buildings since that time. It was placed firmly on the archaeological map by John Lloyd Stephens's and Frederick Catherwood's masterly description and illustration of 1842. Beginning with Augustus Le Plongeon's early excavation in 1875, Chichén Itzá has been the object of numerous archaeological studies, the most comprehensive of which was a research program done under the auspices of the Carnegie Institution of Washington between 1923 and 1936. Restoration work undertaken by the Mexican government is ongoing.

Chichén Itzá is a widely spread-out site, apparently more the result of spontaneous growth than organized planning. Known settlement covers at least fifteen square kilometers (six square miles), but most of the monumental structures are distributed over a system of large terraces and level plazas in the central zone. One enormous plaza includes the three-story Monjas Complex and the Caracol tower of supposed astronomical orientation. Its eastern and northwestern boundaries are delimited by the Akabdzib and Casa Colorada Group. To the north, there is a minor platform with the High Priest's Grave. Another huge terrace with

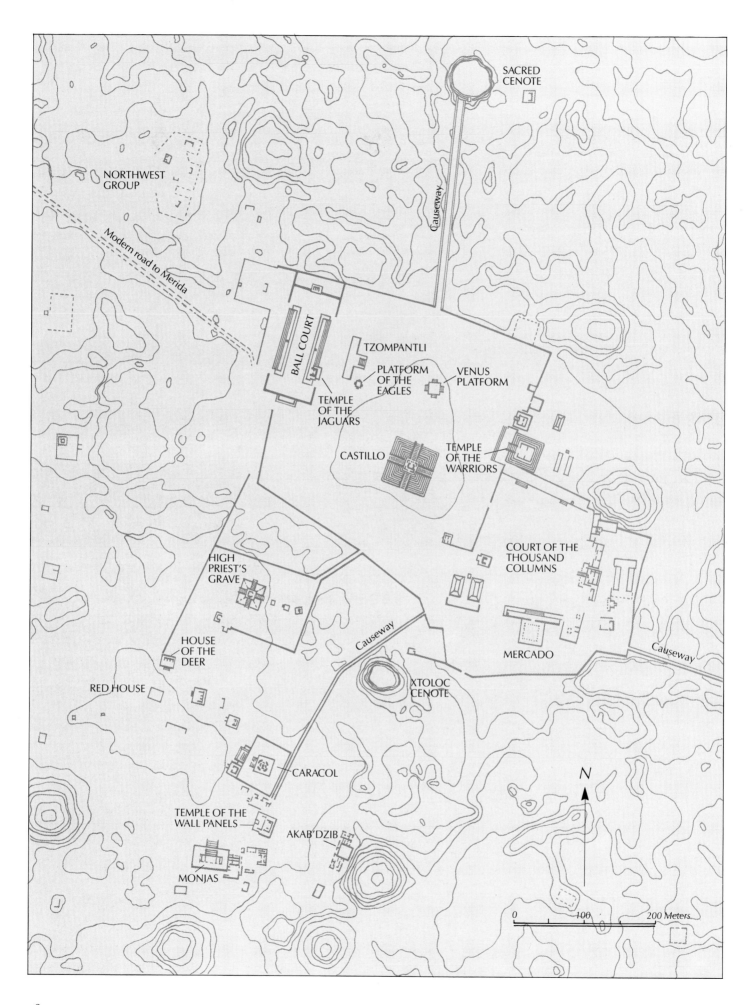

SACRED
CENOTE

NORTHWEST
GROUP

Causeway

Modern road to Merida

BALL COURT

TZOMPANTLI

PLATFORM
OF THE
EAGLES

VENUS
PLATFORM

TEMPLE
OF THE
JAGUARS

CASTILLO

TEMPLE
OF THE
WARRIORS

HIGH
PRIEST'S
GRAVE

COURT OF THE
THOUSAND
COLUMNS

HOUSE
OF THE
DEER

Causeway

Causeway

MERCADO

RED HOUSE

XTOLOC
CENOTE

CARACOL

N

TEMPLE OF THE
WALL PANELS

AKAB'DZIB

MONJAS

0 100 200 Meters

surrounding wall, farther to the northeast, features the Castillo, the Great Ball Court, the Tzompantli and Dance Platforms, and finally the Temple of the Warriors Group and the Court of the Thousand Columns.

Formal architectural clusters of smaller size are interspersed at distances of 200 to 700 meters (220 to 765 yards) in the surrounding settlement area, with a marked concentration toward the south end of the site center. The clusters are often connected by causeways (sacbe-ob), the most prominent of which leads from the great northeastern terrace to the Sacred Cenote. Spaces in between clusters seem to have been taken up by residential structures, kitchen gardens, and agricultural fields. Most houses were of pole-and-thatch construction on low stone foundations, not unlike the traditional Maya dwelling of today. Monumental architecture, on the other hand, relies on solid substructures and thick walls with a compact core of irregular rocks and lime mortar. These were faced with a veneer of well-cut rectangular stones. Roofing followed the principle of the Maya vault, or "false arch."

Chichén Itzá's lengthy prosperity resulted in a city where monuments of different age and style functioned side by side. Multiple rebuilding and reutilization of stones are evidence of vigorous construction activity. Differences of ground plan, building types, facade design, and ornamentation make it possible to distinguish at least two styles of public architecture. The first is a local variant of the type that developed during the seventh and eighth centuries in southern Yucatán and northern Campeche, a style known as Puuc. The other architectural style is partly derived from the same roots but is vastly enriched by elements and concepts from other parts of Mesoamerica, notably the Gulf Coast, Oaxaca, and central Mexico.

Buildings of pure Puuc style are often raised on high basal platforms with simple stairways and are mostly limited to structures of palace- or range-type floor plan. Decoration is concentrated on the upper half of the facade and carried even higher by openwork roofcombs and "flying facades" or false fronts. Principal motifs are stone masks (usually Chac masks, after the Yucatecan rain gods) in different degrees of abstraction and geometric designs that are probably also derived from life forms. Lintels are usually monolithic, frequently carved on the front and underside with hieroglyphic inscriptions.

Constructions in the second style predominate at Chichén Itzá. Substructures, sometimes in the form of stepped pyramids, have walls with a pronounced upward slope and panels of different design on the upper part of each level. Buildings have wide rooms, or series of rooms, with porticoes. Half-open galleries are covered by huge vaults, sustained on columns and pilasters. Other characteristic building types are gallery-patio compounds, open platforms with stairs on all four sides, round structures, sweat baths, and ball courts with narrow side benches.

Most striking and individual, however, is the naturalistic and symbolic decoration in polychrome relief. Paint originally covered substructure panels, balustrades, facades, doorjambs and lintels, columns and pillars, and often interior rooms as well. Feathered and other serpents, striding or crouching jaguars, coyotes, eagles, mythical combinations of jaguar-bird-

Chichén Itzá: site plan

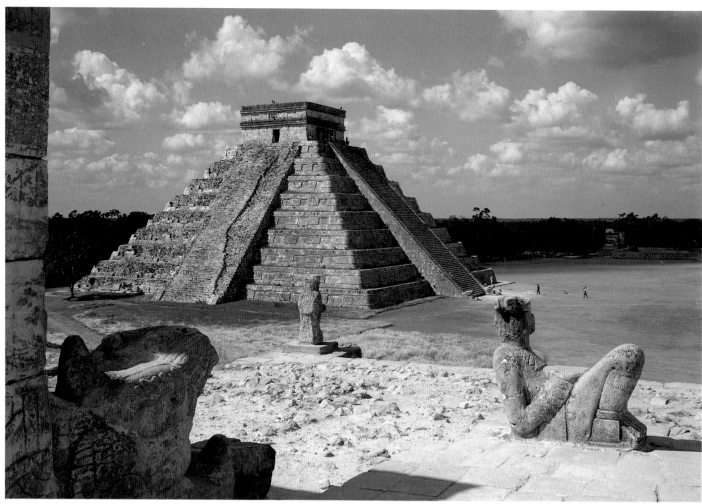

Chichén Itzá: Castillo

serpent-man, sky-bearers and trees full of animals, lively scenes, and endless rows of warriors and other dignitaries in rich attire are some of the more frequent subjects. Huge narrative scenes were represented in wall paintings, with an unmistakable emphasis on depictions of warfare. Even the lintels, usually of wood, bear figural relief carvings.

Fully integrated into architectural space and design was a large series of distinctive, colorful sculptures: half-reclining chacmool figures at temple entrances, atlantean figures both short and tall used to support altar benches and roof beams, jaguar seats or thrones in the center or entrance of important rooms, standard-bearers and stone braziers at the head of stairways and platform edges, sacrificial stones in front of altars, human figures superimposed on facades, and giant serpents converted into balustrades, projecting friezes, or columns supporting wide entranceways. Chichén Itzá at the time of its greatest splendor must have presented a truly brilliant, many-hued aspect in no way comparable to the sober image of green, gray, and white it offers today.

Efforts to correlate distinctive architectural styles with various historical interpretations led some early investigators to propose elaborate building sequences and ethnic identifications for the city's peoples. These proposals have often been taken for established fact. Puuc-like traits were considered "Maya," and everything reflecting central Mexican similarities was declared to be the work of "Toltec" invaders, thought to have been actual

conquerors of Chichén Itzá. The city's history was neatly separated into an early Maya and a late Toltec period, each two hundred years long.

At present, ethnic identifications are regarded with more caution; a hypothesized overlap of both styles is more consistent with chronological, iconographic, and epigraphic evidence. Construction began in the city using local Puuc canons, but Chichén Itzá builders adopted rather quickly the highly eclectic and experimental style that was to characterize the city's florescence. There are indeed surprisingly exact correspondences with the central Mexican city of Tula in Hidalgo, capital of the historic Toltec peoples: much of the figural art of Chichén Itzá and Tula and the belief-system it expresses are greatly similar, as are details of architectural planning and organization. On the other hand, the "Toltec complex" at Chichén Itzá is part of an incomparably richer cultural fabric than that found at Tula itself. Continuity in construction techniques, residential systems, and other features of daily life, such as ceramic vessel types, argue for the continued Maya character of Chichén Itzá. The presence, and influence, of central Mexicans in Chichén Itzá may have anticipated a pattern known later at Mayapán, where central Mexican Nahua mercenaries played an important part in politics and became founders of ruling lineages.

Military prowess, combined with a strong hold on long-distance trade and salt exploitation, was probably the basis of Chichén Itzá's power and that of its ruling lineage, the Itzá. Most early historical sources denounce the Itzá as tyrannical. Unfortunately the sources are fragmentary, obscure, and often contradictory. Even Bishop Diego de Landa, the foremost sixteenth-century authority on Yucatán, confessed his bewilderment. He reports that three brothers were credited with setting up the government at Chichén Itzá but that some time later Kukulcán, identified with the central Mexican namesake Quetzalcoatl, restored order among them and founded the new city of Mayapán. Ongoing epigraphic research may contribute more solid historical information. For instance, a ruler named Kakupacal is already emerging as a major figure in Chichén Itzá history, provisional dynastic name lists are being proposed, and glyphic data confirm links with the important Puuc city of Uxmal around the end of the ninth century.

a b

81 ◀ Two Feathered Serpent Heads

Venus Platform, Chichén Itzá, 9th–13th century
Limestone, remnants of painted stucco

a. Height 64 cm. (25 ¼ in.)
CNCA–INAH, Museo Regional de Antropología de
Yucatán, Mérida
MM 1986–18:20

b. Height 69 cm. (27 ⅛ in.)
CNCA–INAH, Museo de Sitio de Chichén Itzá,
Chichén Itzá
MM 1987–141:26

The two serpent heads seen here belong to a group of twelve that was excavated from underneath the small building known as the Venus Platform (so named for the prominent reliefs depicting the symbol for Venus—the morning and the evening star—that appear on all four of its sides). The heads were discovered with a group of 182 large cone-shaped stones, all of similar size, arranged above and around a stone urn with circular lid that contained an offertory cache. With them was the unique figure of a standard-bearer (cat. no. 82). The serpent heads belong to an earlier structure, or structures, that may have stood close to the present Venus Platform. Some of them have long tenons, while others have undecorated parts that must have been hidden from view in their original position. The missing body parts and tails have still not been found.

Both serpents have necks and heads raised above their bodies, one head looks straight forward, the other curves to the side. An attitude of fixed attention makes them appear ready to strike. Double rows of teeth and curved fangs are visible in open mouths, with an S-shaped element emerging from the innermost corners. When originally found by Le Plongeon in 1883, the heads were considerably better preserved than they are today. Separately carved tongues were attached to the lower jaws, and composite, widely projecting nose plugs and flamelike crests were on top of the heads. Now only stumps and holes indicate their former presence. Green, ocher, red, and white paint, only faintly visible today, distinguish the different features of the serpent body—feathers, eyes, mouth, and the like—and painted stucco layers are preserved in protected areas. The details of the head and body are extremely well finished with feathers and scales intricately worked. An impression of ferocity, as befits these huge serpents, is achieved despite the addition of much symbolic detail.

The feathered serpent—Kukulcán in Maya or Quetzalcoatl in Nahua—is the most important and frequently used symbol at Chichén Itzá. It appears in architectural and relief sculpture and in mural painting as a main figure, as an accompanying element, or simply as an auxiliary symbol, where it distinguishes and identifies the principal human or divine characters in figural representation. Feathered serpents occur very occasionally in earlier Maya art, but their most immediate antecedents are from central Mexico. A surprising

similarity, for example, exists between Chichén Itzá serpents and a painted representation found at Cacaxtla, a hilltop site in Tlaxcala that apparently flourished in the eighth and ninth centuries and where Maya and central Mexican traits reached an astonishing synthesis.

In the sixteenth century Diego de Landa mentions Kukulcán as a highly respected historical leader of Chichén Itzá and Mayapán, one even considered to be a god. Here, as in central Mexico, however, different concepts of disparate historical or mythological origin may be hidden under a single name and image. It would be surprising, for example, if all plumed serpents represented the major god Kukulcán, as some appear in such lesser positions as parts of friezes or balustrades. Feathered serpents usually did not occur as isolated cult images but rather were grouped in great numbers on a given building.

PJS

DISCOVERY
Unearthed by Augustus Le Plongeon in 1883

REFERENCES
Alice Le Plongeon. "Dr. Le Plongeon's Latest and Most Important Discoveries among the Ruined Cities of Yucatan." *Scientific American* 18, Supplement 448 (August 2, 1884), pp. 7143–47, figs. 9, 10. **Eduard Seler.** "Die Ruinen von Chich'en Itzá in Yucatán." In *Gesammelte Abhandlungen zur Amerikanischen Sprach- und Altertumskunde*, vol. 5. Berlin, 1915, pp. 369–77, pls. XLII(2), XLIII(1). **Lawrence G. Desmond and Phyllis M. Messenger.** *A Dream of Maya: Augustus and Alice Le Plongeon in Nineteenth-Century Yucatan.* Albuquerque, 1988, pp. 90–98.

82 ◄ **Standard-Bearer**

Venus Platform, Chichén Itzá, 9th–13th century
Limestone, remnants of paint; height 95 cm.
(37⅜ in.)
CNCA–INAH, Museo Regional de Antropología de Yucatán, Mérida
MM 1986–18:19

Found in the same excavation as the two serpent heads (cat. no. 81), this remarkable freestanding sculpture was lost from view for many years. Augustus Le Plongeon, embittered by the criticism of his eccentric interpretations, had it unceremoniously reburied. Only during the final reconstruction of the Venus Platform was it recovered.

Here the human figure is portrayed with greater individualism than other works of its kind, and it resembles the portrait of a living being. The sculpture is even more remarkable for portraying a person obviously suffering from severe deformity. The neck is stretched forward, the lower body is exaggerated in size, one arm and one leg are shorter than the other, and the right foot is bent inward at nearly a ninety-degree angle. Partial paralysis of the right side of the body seems to be represented, and the rather unnatural stare on the sharp-featured face may be another indication of a pathological condition.

The figure here does not have the rigid posture customary for standard-bearers: it sits with knees drawn up and elbows resting on the upper legs, the face turned slightly to the left. The hands are well separated, and each has a vertical hole between the closed thumb and fingers forming the opening that may have held a staff or pole—the main reason for interpreting the sculpture as a standard-bearer. No companion piece is known, although standard-bearers usually occur in pairs to be placed on each side of the top of an important stairway.

The figure wears a close-fitting skullcap (possibly hair), half "mittens," loincloth, anklets, and elaborate sandals with high ankle-guards. Double perforations at the back of the head and the holes through the earlobes may

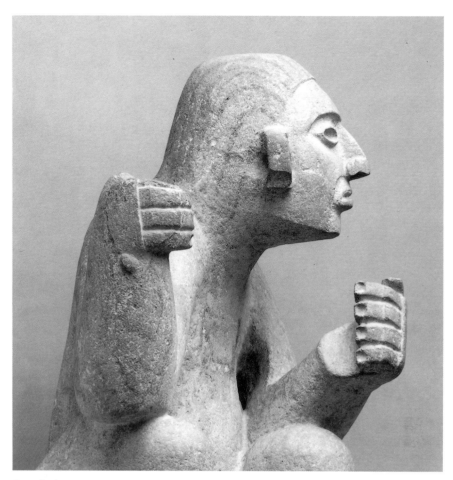

Detail of cat. no. 82

have served to attach ornaments of perishable materials, perhaps of feathers or cloth. The striations of the cap (or hair), and a necklace with face-pendant, are painted in dark red and green colors directly onto the stone. Original paint is also preserved on the sandals and sandal-ties. Eyes, fingernails and toenails, and possibly even the mouth were originally inlaid with pieces of shell and obsidian; some of these elements were recovered by Le Plongeon who also reported additional traces of color.

Individual characterization in the art of Chichén Itzá occurs with more frequency in relief representations than in freestanding sculpture. In reliefs on columns, doorjambs, and wall panels, for example, no two images are exactly alike, even among the great numbers portrayed on the Northern Colonnade or the Temple of the Warriors. In many cases the figures are distinguished from one another by, among other details, glyphic name signs derived from both central Mexican and Maya writing systems.

PJS

DISCOVERY
Unearthed by Augustus Le Plongeon in 1883

REFERENCES
Alice Le Plongeon. "Dr. Le Plongeon's Latest and Most Important Discoveries among the Ruined Cities of Yucatan." *Scientific American* 18, Supplement 448, (August 2, 1884), pp. 7145–46, figs 7, 8.
Eduard Seler. "Die Ruinen von Chich'en Itzá in Yucatán." In *Gesammelte Abhandlungen zur Amerikanischen Sprach- und Altertumskunde,* vol. 5. Berlin, 1915, pp. 369–76, pl. xliii(2).
Lawrence G. Desmond and Phyllis M. Messenger. *A Dream of Maya: Augustus and Alice Le Plongeon in Nineteenth-Century Yucatan.* Albuquerque, 1988, p. 91.

82

83 ◀ Chacmool

Tzompantli, Chichén Itzá, 9th–13th century
Limestone; height 94 cm. (37 in.)
CNCA–INAH, Museo Regional de Antropología de
Yucatán, Mérida
MM 1986–18:13

One of the most characteristic types of sculpture at Chichén Itzá is the "chacmool"—an uncomfortably positioned human being, half sitting, half lying on his back with his face turned sharply away from the line of his body. Feet, lower back, and elbows rest on the ground, knees and upper torso are stiffly raised, and both hands hold a disk or plate in horizontal position on his stomach.

The prototypical example of these figures was discovered in 1875 by Augustus Le Plongeon underneath the Platform of Eagles and Jaguars. Le Plongeon gave the figure the fanciful name "chacmool," meaning something akin to "Red Claw" in Yucatecan Maya, but which he wanted to be read as "Tiger King." Rebus translations of name signs into Yucatecan Maya provided the picturesque explorer with a ready-made list of Maya royalty, whose supposed life histories soon became the subject of the most astonishing interpretations. Independently, however, "chacmool" has survived as a generic name for the class of figures in this particular position. At least fourteen of them have been located at Chichén Itzá, others are known in central Mexico, and lesser numbers in different parts of Mesoamerica.

The example here was found inside the Tzompantli in 1940, undoubtedly having come from an earlier building in the same general area. It is well preserved, although the original inlays in the eyes, fingernails, and toenails and the surface layer of polychrome paint are missing, losses probably due to the figure's rather shallow interment. These additional elements are present on a closely related sculpture preserved in the outer room of an earlier building under the Castillo. The two figures must come from the same workshop, although details in the headdress, ear ornaments, and the like differ. These differences are good indication that chacmools were adorned specifically for the place in which they were destined to serve.

In the present example, the boxlike headdress is decorated with an outer row of perforated disks, probably meant to represent jade, and a central rosette

with two feathers projecting on the back. The composite ear ornaments are of the bar-and-disk type; nose buttons are worn on both sides of the nose. A double-strand necklace with a pectoral in the shape of a human face, probably made of jade, covers the breast and shoulders. The bracelets seem to be of a flexible, fibrous material, and the kneebands, fixed with a complicated knot, have appendages that may represent copper bells, such as those extracted in enormous quantities from the Sacred Cenote. The sandals are distinguished by high ankle-guards with a design that could represent the spots of a jaguar skin. The circular plate held in the hands is flat with a slightly sunken central area.

The great diversity of secondary attributes among the chacmool figures at Chichén Itzá in particular and in Mesoamerica in general, has occasioned interminable speculation and discussion about the specific deity represented. The argument now seems irrelevant. Given the thoroughly subservient role chacmool figures played, placed at the front entrance of temple buildings within a well-defined architectural context, they should be considered as any other architectural sculpture, like standard-bearers or atlantean figures, as part of the ritual paraphernalia of certain temples. Chacmools were not independent deity images, but were most probably, as has been suggested, the recipients of sacrificial offerings.

PJS

DISCOVERY
Unearthed by Manuel Cirero Sansores in 1940

84 ◀ Two *Atlantes*

Temple of the Jaguars, Chichén Itzá, 9th–13th century
Limestone, remnants of paint

a. Height 86.5 cm. (34 in.)
CNCA–INAH, Museo Nacional de Antropología, Mexico City 5–3007

b. Height 86 cm. (33⅞ in.)
Instituto de Cultura de Tabasco, Dirección de Patrimonio Cultural, Museo Regional de Antropología, "Carlos Pellicer Cámara," Villahermosa A–0039

Short, massive atlantean figures served as supports for low tables or benches in some of the major buildings at Chichén Itzá such as the Temple of the Warriors and the Temples of the Little and Big Tables. Customarily, these tables—or daises or altars, as they have also been called—were placed against the back wall of a two-room building facing the entrance. The atlantean figures are usually dressed in warrior-costumes but, as a rule, do not carry weapons since both arms are upraised at the sides of the head to support the table above them. Specific details of dress may characterize various local political, professional, or ethnic groups as well as foreign tributaries. The figures are usually shown in a stiff frontal posture, and although not visible when in situ, the backs are also generally elaborately finished.

These two atlantean figures belong to the best-preserved group of the type, found in 1875 by Augustus and Alice Le Plongeon in the interior of the Upper Temple of the Jaguars, part of the Great Ball Court complex in the northern section of Chichén Itzá. A total of fifteen *atlantes* arranged in five rows of three each supported a relief-decorated table. Le Plongeon's report and photographs indicate that atypically the table stood in the center of the front room just behind the entrance, which was divided by two enormous serpent columns. This irregularity, and the incomplete state of the table in 1875, leave doubts about the originality of this arrangement. Unfortunately, all of the figures were removed to museums long ago and the temple was thoroughly remodeled when restored.

The back of each figure is covered with a long feathered cloak. One was originally painted white (possibly representing heron feathers) and the other

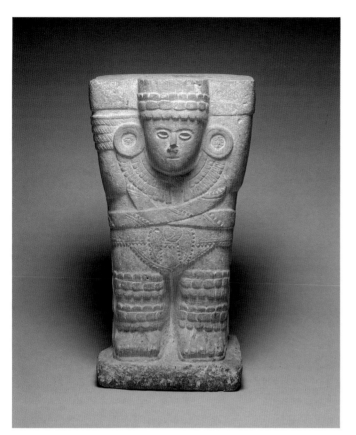

84 a

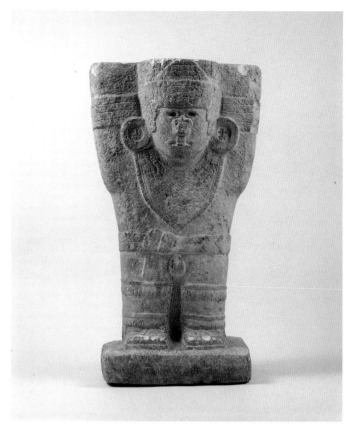

84 b

Back of cat. no. 84a

was green with yellow points (possibly parrot feathers). Both figures have diademlike headbands, one combined with a short feather crown, the other with a triangular element similar in form to the *xiuhuitzolli* worn by Aztec kings. Huge circular earflares with frontal human faces in their center fields are worn by both. Nose buttons and a rectangular plaque suspended from the septum complete the facial adornments of the *xiuhuitzolli* bearer. Also on this figure, both the crown and biblike collar are covered with irregular elements originally painted green, probably signifying turquoise, an exotic import found in some quantity at Chichén Itzá. The neck ornament of the other figure was of yellow feathers. Both *atlantes* wear kneebands and sandals, as well as elaborately tied loincloths. Multistrand wristlets are there but, in a remarkable departure from symmetry, the feather-collared atlantean has none on his left arm.

Atlantean figures, together with other classes of architectural sculpture, represent one of the closest links of Chichén Itzá with central Mexico, where they occur with surprising similarity in the Toltec-Aztec continuum.

PJS

DISCOVERY
By Augustus and Alice Le Plongeon in 1875

REFERENCES
Alice Le Plongeon. "Dr. Le Plongeon's Latest and Most Important Discoveries among the Ruined Cities of Yucatan." *Scientific American* 18, Supplement 448, (August 2, 1884), pp. 7143–44. **Eduard Seler.** "Die Ruinen von Chich'en Itzá in Yucatán." In *Gesammelte Abhandlungen zur Amerikanischen Sprach- und Altertumskunde*, vol. 5. Berlin, 1915, pp. 269–75, pls XVI–XX. **Amalia Cardós de Méndez.** *Estudio de la colección de escultura maya del Museo Nacional de Antropología.* Instituto Nacional de Antropología e Historia. Mexico, 1987, p. 181. **Lawrence G. Desmond and Phyllis M. Messenger.** *A Dream of Maya: Augustus and Alice Le Plongeon in Nineteenth-Century Yucatan.* Albuquerque, 1988, pp. 30–32.

85 ◄ Circular Monument (Altar)

◄ Caracol, Chichén Itzá, 9th–13th century
◄ Limestone; diameter 73 cm. (28¾ in.)
◄ CNCA–INAH, Museo Regional de Antropología de
◄ Yucatán, Mérida
◄ MM 1986–18:7

Chichén Itzá lacks the upright rectangular stone stelae that customarily carry the carved inscriptions and representations of important individuals and/or scenes of political and religious significance. However, some of this information is recorded on lintels, wall panels, doorjambs, and pillars in various architectural contexts.

In fact, one monument discovered in the central niche of the upper stairway of the Caracol is close to the upright stelae in concept. It is a rectangular slab carved on four sides with a long horizontal inscription. It was found together with the disk-shaped monument with a tenon for attachment that is exhibited here. This disk has a figural representation on one of its circular faces and an inscription of twenty-four glyph columns around its circumference. Since the inscription is read most clearly with the monument sideways, it was probably originally set horizontally in the back wall above the niche where it was found. It would have served a similar function as an altar, although the figural representation would have been visible only from the top to persons standing on the platform behind.

A horizontal double line separates the carved surface into two semicircular registers. In the top register six richly attired individuals in groups of three face each other. They are not armed, and the two personages farthest to the left have their arms crossed in the gesture indicating submission or reverence. The two figures at the extreme right carry various items. One is a dish with either food or copal offerings, and the other is unidentified but might be an animal ready for sacrifice. The two largest figures stand on each side of a central brazier from which flames and smoke rise. The person to the right is putting an offering into the fire, which is probably copal incense from the elaborately decorated bag carried in his other hand. The man on the left is masked and holds a small human form over the flames and clouds of incense.

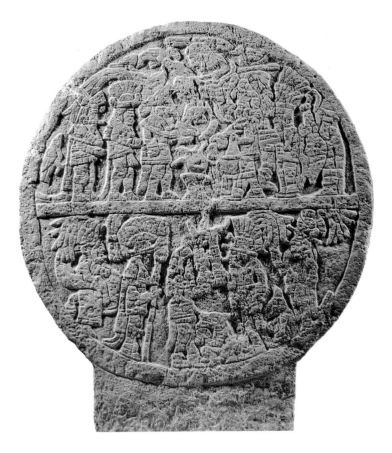

This is either a child or a sacred image represented in a sitting pose. Above and behind the figures there are birds in the sky, and behind the copal-burning lord a serpent lifts its body. A deity armed with dart and spear-thrower emerges from the wide-open mouth of the serpent. Various elements of dress in this relief have been considered as both Maya and Toltec by earlier investigators. The most consistently "Toltec" group includes the officiating lord and what may be his guardian spirit and the subordinate offering bearers to the right behind him.

The lower register scene depicts only five individuals facing toward the center, three to the left and two on the right. All are richly attired; three of them wear huge animal-head headdresses mounted together with feathers on broad-brimmed hats. The two men in the center apparently hold a flaming torch and an offering of burning copal balls. The doglike animals at their feet may be a coyote and a poorly rendered jaguar eating human hearts. These animals are known from other reliefs at Chichén Itzá, but it is also possible that they simply mark the lower world, as the birds were sky symbols in the upper register. One of the persons standing to the left wears a long cloak and holds a spear with feather decoration. The other is dressed in a woman's skirt and carries around his or her body a huge rattlesnake, whose open mouth serves as the headdress or helmet. The last figure on the right raises a hand and possibly holds a leaf-shaped sacrificial knife.

The scenes are difficult to interpret but probably depict long-lost ceremonies, or two parts of the same ceremony or historical event, and they may have a connection to the building in which the altar was found. If the small presentation figure in the upper scene is alive and human, an event in the early life of a ruler may be illustrated; if it is only a humanlike representation, a ceremony involving images, or "idols," as Bishop Landa called them, may be the subject. Unfortunately, part of the relief is greatly eroded and the polychromy that would have allowed identification of many details is lost. The present interpretation is based on a new drawing using the original stone, various photographs, and a rubbing by Merle Greene Robertson.

The long glyphic text around the border, undeciphered as yet, could refer to the events represented. The text contains at least eight examples of the glyph *ahau*, mostly with an added *ahpo*, lordly titles in Yucatecan Maya which may distinguish some of the individuals shown. The long text on the accompanying stelalike monument contains dates corresponding to the years A.D. 886 and 906. It would be of great interest if the text makes reference to the presumed astronomical function of the Caracol building, as the repeated occurrence of the glyph for the planet Venus suggests.

PJS

DISCOVERY
Excavated by Sylvanus G. Morley and José Erosa Penich in 1923

REFERENCES
Karl Ruppert. *The Caracol at Chichén Itzá, Yucatán, Mexico.* Carnegie Institution of Washington, Publication no. 454. Washington, D.C., 1935, pp. 135–40, figs. 164–65, 168–69, 171. **Sylvanus G. Morley.** "Inscriptions at the Caracol." Appendix to *The Caracol at Chichén Itzá, Yucatán, Mexico,* by Karl Ruppert. Carnegie Institution of Washington, Publication no. 454. Washington, D.C., 1935, pp. 282–83.

86 ◄ Lintel or Doorjamb Relief

Structure 4B3, Chichén Itzá, 9th–13th century
Limestone; height 126 cm. (49⅝ in.)
CNCA–INAH, Museo de Sitio de Chichén Itzá,
Chichén Itzá MM 1987–141:25

This enigmatic relief sculpture was discovered among the debris of an isolated minor building during reconnaissance work for the Carnegie Institution's map and catalogue of architecture. It was interpreted as a lintel, which originally spanned the inner doorway. The design consists of three units: a nearly square field on the main surface and two narrow side panels, all of which cover the front and sides of two stone slabs carefully fitted together.

The main field shows a striding human figure or deity facing left, pushing or pointing forward with a diagonally held thick staff crowned by a skull. He grasps the staff with both hands, as if to transfix something in front of him. This figure has a curiously oversize head and wears an elaborate turbanlike headdress or hairdo consisting of various strands tied together with a central knot. He is adorned with a long, bar-shaped, composite nose ornament and a rectangular earplug with bead appendage. From the headdress topknot, long feathers fall to the back, which is covered by a cloak looking like a fish or reptile with long spikes that seems to end in a pointed tail. Only remnants of breechcloth and anklets are preserved, whereas the elaborately tied sandals can be easily recognized. At his feet, facing in the same direction,

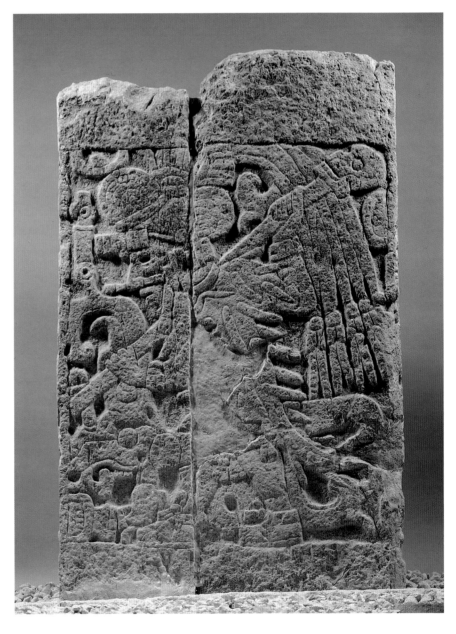

Detail of left panel, cat. no. 86

is a serpent- or dragonlike monster with wide-open mouth showing teeth and fangs, and a high, projecting forehead ending in scrolls. At the lower left there is possibly the monster's claw. A nose plug sticks out of its upper jaw and another jade (?) ornament is possibly represented at the end of one of the forehead scrolls.

On the left panel, a standing warrior facing right is depicted; in his right hand he carries a bundle of short darts, in his left a circular shield. The feathers on his headdress stand up and look as if they were swirling around, contributing to his ferocious appearance which is emphasized even more by a face mask with huge circular eyes and bared teeth as in a skull. The warrior's earplugs are circular disks. A short tunic covers his body; leg and footwear seems to be the same as on the figure on the main field.

The third panel is very much eroded. In the upper part, a crested bird appears to perch on a tree or a vine. Below, only the head and body of a human figure, with his arms bent at the elbows, are preserved. He faces left and is set apart by the apparent lack of a headdress. It may be that he was shown crouching or bundled up on a seat.

Unfortunately, we do not know the meaning of these representations. Since there are narrow framing lines on both sides of the main panel, it is even doubtful that all three should be considered together as a single scene. Serpents and serpentlike monsters occur in various battle scenes and in other representations of military and, presumably, political leaders of Chichén Itzá and may represent guardian spirits or magical ancestors from another world. Warriors with skull masks appear occasionally, but we do not know whether the masks represent a special rank, a regional or family association, or simply a personal distinction acquired by individuals of the real or the spirit world.

The turbanlike headdress of the main personage is a similar case. This type of headdress, as on reliefs of the Great Ball Court and on a gold disk from the Sacred Cenote (cat. no. 95), is represented infrequently and always on persons of rank, without distinction of what traditionally would have been called "Maya" or "Toltec" figures.

A point to reconsider is the identification of the relief as a lintel. It clearly belongs to the second style of architecture and sculpture at Chichén Itzá and would be a unique piece in this context. On the other hand, the position of the figures and the existence of three sculpted sides make its original use as a doorjamb much more probable, although the relief would not cover the full height. It is also possible that if it was salvaged from some earlier structure, as frequently occurs at Chichén Itzá, it may have been reused as a lintel, without much attention having been given to the design.

PJS

DISCOVERY
First published by Karl Ruppert in 1952

REFERENCE
Karl Ruppert. *Chichén Itzá: Architectural Notes and Plans*. Carnegie Institution of Washington, Publication no. 595. Washington, D.C., 1952, p. 89, fig. 139a.

87 ◀ Pendant Picture Plaque

Sacred Cenote, Chichén Itzá, 9th–13th century
Jade; height 9.3 cm. (3¾ in.)
Peabody Museum of Archaeology and Ethnology,
Harvard University, Cambridge, Mass.
10–71–20/C6666

The richest and most variable collection of small finds from Chichén Itzá is from the Sacred Cenote. Dredging and diving operations by E. H. Thompson at the beginning of the twentieth century, and renewed diving projects in the 1960s, have amply confirmed Bishop Landa's sixteenth-century statement: "Into this well they have had, and then had, the custom of throwing men alive as a sacrifice to the gods, in times of drought, and they believed that they did not die though they never saw them again. They also threw into it a great many other things, like precious stones and things which they prized. And so if this country had possessed gold, it would be this well that would have the greater part of it."[1] Human and animal bones as well as amazing quantities of ceramic, lithic, wooden, metal, shell, bone, copal, and even textile offerings have been recovered, preserved in the oxygen-poor conditions at the bottom of the great sinkhole.

Like nearly all of these finds, most of the jade or greenstone retrieved was thoroughly broken and often burned, apparently during the actual offering ceremony. The rare complete pieces were perhaps worn by sacrificial victims —not necessarily only the "virgins" of romantic tales—or even by the volunteers who threw themselves into the Cenote to confer with the gods, as did the famous warrior Hunac Ceel, future ruler of Mayapán, sometime around the twelfth century. The pieces in this exhibition have been restored with the intention of making possible an appreciation of the work as it would have been in its entirety.

The near-rectangular warrior plaque seen here is of brilliant green jade with some darker spots and heavy traces of burning. Three full perforations at the top, a vertical bore crossing the full width of the piece, and seventeen minor

perforations around the edges must have served to suspend it from strings or a strand of beads, to fasten it to a base of cloth, or to integrate it into a more elaborate composite ornament.

The plaque is executed in a particular grooving technique, with one edge of the grooves "shaved off" where background is to be indicated. It depicts a warrior with his darts and spear-thrower, ready to shoot at an unseen enemy off to his right. He is sitting cross-legged on a huge serpent covered with precious greenstone disks that continues from an upraised head in front of the warrior (not unlike cat. no. 81) all along the bottom of the plaque and then turns its feathered tail up and inward behind him. The warrior himself wears a turbanlike headdress with a knotted element in front and a three-feathered piece emerging from its top. Medium-sized bar-shaped earplug, capelike collar, bracelets, anklets, and a star-shaped kilt in front complete his outfit.

A similar star-shaped kilt, possibly related to the sun or the planet Venus, can be observed on murals and reliefs at Chichén Itzá and also in distant Tula. In addition, the serpent of this plaque reminds one of the "serpent raft" used by Quetzalcoatl during his mythical flight to the eastern lands, and it has also been related to warriors in "serpent boats" shown in the Temple of the Jaguars. Serpent borders of a similar kind occur in murals at Cacaxtla, associated with an outer band replete with maritime motifs.

Apart from these mythological associations, the plaque provides a good illustration of the aggressive character that pervades much of Chichén Itzá art. Obviously, military virtues and combative spirit were among the most highly prized attitudes among the ruling elite of the site.

PJS

1. Tozzer 1941, pp. 179–82

DISCOVERY
Recovered by Edward H. Thompson in 1904–1909

REFERENCES
Alfred M. Tozzer, ed. *Landa's Relación de las cosas de Yucatán: A Translation.* Papers of the Peabody Museum of American Archaeology and Ethnology, 18. Cambridge, Mass. 1941. **Tatiana Proskouriakoff.** *Jades from the Cenote of Sacrifice, Chichén Itzá, Yucatán.* Memoirs of the Peabody Museum of Archaeology and Ethnology, 10, no. 1. Cambridge, Mass., 1974, p. 192, color pl. 11a, pl. 78a. **Clemency Chase Coggins and Orrin C. Shane III, eds.** *Cenote of Sacrifice: Maya Treasures from the Sacred Well at Chichén Itzá.* Exh. cat., Science Museum of Minnesota. Austin, 1984, p. 52, no. 28.

88 ◀ Pendant Picture Plaque

Sacred Cenote, Chichén Itzá, 9th–13th century
(possibly carved earlier)
Jade; height 12 cm. (4¾ in.)
Peabody Museum of Archaeology and Ethnology,
Harvard University, Cambridge, Mass.
10–71–20/C6667

Several plaques recovered at Chichén Itzá, from the Cenote as well as from other offering caches, show motifs derived from monumental representations of seated rulers, body in front view, head in profile looking to one side, and accompanied by some symbol of rulership. Most of these are executed in the well-known Nebaj style, named after a Maya site in northern Guatemala where it was first seen in excavation.

This irregular rounded plaque, however, shows a quite different stylistic concept, generally recognized to be much closer to Palenque art. In the wide center field of a cartouchelike frame, a ruler is seated cross-legged, his body slightly inclined forward, the left hand resting on his knee, and the outstretched right hand holding an oval object that seems to be a glyph (largely restored). In front of the strongly deformed head with prominent nose there is a scroll element with abstract, vaguely serpentine forms. The ruler's hair is divided into a section falling forward over the forehead and a longer coil

88

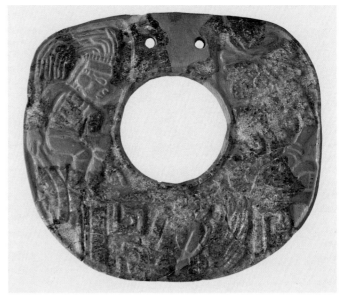

89

falling to the back, decorated with an S-shaped ornament, probably made up of jade beads and tinklers tied to a cloth. Circular earplug and pendant, an elaborate jade pectoral, bracelets, anklets, and a highly decorated loincloth, with long tassels showing to the side of the knee, complete his dress.

The outer border of the plaque contains simple scrolls in each of the four corners. Rows of drilled circlets with a central point occupy the areas in between, similar to the *chalchihuitl* symbol of the ancient Mexicans. The holes repeat the body markings of the serpent on the warrior plaque (cat. no. 87), but the incisions are much more rounded and not so crisp in execution.

This plaque is very thin, and about ten small diagonal bores are distributed around the border, probably for attachment or support. Two more holes are drilled to repair an ancient crack. The jade is lustrous green and white, with some fire blackening at the edges.

As for the plaque's provenance and antiquity, although similarities to the stylistic conventions of Palenque are definitely strong, it should be kept in mind that there is always a possibility of archaizing use of earlier styles, especially in official art where historical claims are meant to be established or supported. The serpentine sign in front of the ruler and the design of the border may be hints that the plaque was executed much later than the date suggested by the principal design.

PJS

DISCOVERY
Recovered by Edward H. Thompson in 1904–1909

REFERENCES
Tatiana Proskouriakoff. *Jades from the Cenote of Sacrifice, Chichén Itzá, Yucatán.* Memoirs of the Peabody Museum of Archaeology and Ethnology, 10, no. 1. Cambridge, Mass., 1974, p. 176, pl. 75a.
Clemency Chase Coggins and Orrin C. Shane III, eds. *Cenote of Sacrifice: Maya Treasures from the Sacred Well at Chichén Itzá.* Exh. cat., Science Museum of Minnesota. Austin, 1984, p. 66, no. 51.

89 ◀ Pendant Picture Plaque

◀ Sacred Cenote, Chichén Itzá, 9th–13th century
◀ Jade; height 10.5 cm. (4 in.)
◀ Peabody Museum of Archaeology and Ethnology,
◀ Harvard University, Cambridge, Mass.
◀ 10–71–20/C6677

Some of the warriors represented on reliefs and murals at Chichén Itzá wear circular breastplates or ring-shaped pectorals. This annular jade plaque, as well as two others that may belong to this class, was reconstructed from numerous fragments in the Cenote collection.

All three plaques are made of a dark green jade with a great variety of

conspicuous crystalline inclusions. They are all decorated on one side only with similar compositions: two armed warriors are sitting or kneeling on either side facing the center hole so that their placement is adapted to the curved field of the plaque. A third person is shown lying on his back or sitting at the bottom, underneath or in front of a high bench (?) that serves as baseline for the warriors. Two perforations in the undecorated top center portion may have served for suspension. The plaques are carved in a sharply outlined low-relief style that coincides remarkably with larger-scale reliefs at Chichén Itzá.

The best preserved of these plaques is exhibited here. On it, two warriors with different types of feather headdresses are pointing toward the smaller individual at the bottom. This man, sitting cross-legged and leaning back in a rather uncomfortable pose, without headdress and unarmed, may be a prisoner. If so, he must be a man of importance, since he is still shown with a necklace, anklets, and a feather-crest on his back.

One of the warriors on top is distinguished by a huge breastplate in the shape of a bird or butterfly with widespread wings—a type frequently worn at Chichén Itzá and also one of the outstanding attributes of relief figures and atlantean columns at Tula.

Both warriors carry curved elements in one hand, probably the wooden instrument that usually complements the spears and spear-thrower and has been called a "fending stick." In fact, Landa commented in his own day on the ability of performers of a particular Maya dance to catch or deflect forcefully hurled reeds with the exclusive help of a fending stick that must have been a direct descendant of the present examples.

PJS

DISCOVERY
Recovered by Edward H. Thompson in 1904–1909

REFERENCES
Tatiana Proskouriakoff. *Jades from the Cenote of Sacrifice, Chichén Itzá, Yucatán.* Memoirs of the Peabody Museum of Archaeology and Ethnology, 10, no. 1. Cambridge, Mass., 1974, pp. 88–89, color pl. 11b, pl. 48a. **Clemency Chase Coggins and Orrin C. Shane III, eds.** *Cenote of Sacrifice: Maya Treasures from the Sacred Well at Chichén Itzá.* Exh. cat., Science Museum of Minnesota. Austin, 1984, p. 53, no. 29.

90 ◀ Pendant Plaque with Figures

Sacred Cenote, Chichén Itzá, 9th–13th century
Jade; height 8 cm. (3⅛ in.)
CNCA–INAH, Museo Regional de Antropología de
Yucatán, Mérida MM 1988–1:126

Rectangular pectorals, presumably of jade, are frequently recognizable as pendants at the center of necklace arrangements. This plaque of grayish green jade with large areas of opaque white material is perforated transversely at the top, presumably for this use. On the front of the plaque are three anthropomorphic figures, the central one sitting cross-legged and full face, the other two standing and in profile. The size of the face and the shape of the eyes of the central figure indicate that it is either a deity or his image, or that the personage is wearing an elaborate deity mask with animal headdress and huge earplugs. A collar with pendant, a bracelet, and loincloth complete his apparel. The accompanying figures, obviously auxiliary and subservient, are dressed in simple loincloth, necklace, earplug, and headband.

On the basis of comparisons with some sculptures from northwestern Yucatán, Proskouriakoff has assigned this plaque to a "Northern Provincial"

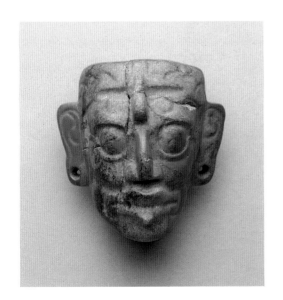

school of jade carving. Distorted proportions of the human body, simplification of features, and poor definition of outline seem to be typical.

Stylistic variation in Cenote jades makes it evident that parts of the collection were produced at widely different times and places, and that the majority probably reached Chichén Itzá as finished pieces. None of the minerals included under the name of "jade" is native to the Yucatán peninsula. This does not exclude, of course, that some raw materials may have been imported to receive their artistic form and final shape at Chichén Itzá or that other pieces were locally reworked or given a second pictorial surface. Special explanation is needed for some pieces that seem to date from far earlier time periods than the Cenote ritual that brought them to their final resting place. Recovery and reutilization of once-buried grave goods as well as a lengthy tradition of handing down heirlooms have been proposed. Approximately contemporaneous pieces from other cultural areas, on the other hand, may have reached the Cenote either as a result of long-distance pilgrimages or as a consequence of trade relations, warfare, and tribute that brought them into the hands of the local elite, directly or through one or more intermediate steps.

PJS

DISCOVERY
Recovered by Edward H. Thompson in 1904–1909

REFERENCE
Tatiana Proskouriakoff. *Jades from the Cenote of Sacrifice, Chichén Itzá, Yucatán.* Memoirs of the Peabody Museum of Archaeology and Ethnology, 10, no. 1. Cambridge, Mass., 1974, pp. 175–77, pl. 76b, frontispiece.

91 ◀ Pendant Mask

Sacred Cenote, Chichén Itzá, 9th–13th century
Jade; height 6 cm. (2⅜ in.)
CNCA–INAH, Museo Regional de Antropología de
Yucatán, Mérida MM 1988–1:147

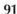

This jade mask or head is an excellent example of how a full reconstruction was possible even though only slightly more than half of the original fragments were available by relying on the symmetry that characterizes most comparable representations.

The mask is of grayish green jade with dark streaks and is worked in very high relief, or nearly in the round. It is carved with a wide vertical perforation and a windowlike opening in the back, probably so it could be mounted on a staff or connected to a body of perishable material.

It depicts a face that is definitely not human, but shows exaggerated features characteristic of certain Maya gods: huge bulging eyes containing scrolls, a projecting forehead or forehead ornament, fillets under the eyes, prominent cheekbones, and a grotesquely enlarged mouth. It is uncertain whether upper incisors filed in the shape of a "T" or a serpent rattle tongue was present. Earlobes and chin are perforated at the bottom, probably to add some perishable ornaments which may have served to better identify the mythological being involved. Unfortunately, no clear-cut identification with a particular deity is possible, although the combination of attributes approaches the traditional form of the sun god, Kinich Ahau.

Present-day Maya folk religion invokes numerous mythological beings, most of them multiplied by four according to the world quarter that each one controls, and colonial manuscripts enumerate an immense list of gods and minor spirits whose functions and attributes are completely unknown or

only vaguely defined. This little mask may represent one of this huge group of supernaturals, somehow related to a special aspect of the sun.

<div align="right">PJS</div>

DISCOVERY
Recovered by Edward H. Thompson in 1904–1909

REFERENCE
Tatiana Proskouriakoff. *Jades from the Cenote of Sacrifice, Chichén Itzá, Yucatán.* Memoirs of the Peabody Museum of Archaeology and Ethnology, 10, no. 1. Cambridge, Mass., 1974, pp. 152–53, pl. 59c, row 3 left.

92 ◀ Pendant Mask

Sacred Cenote, Chichén Itzá, 9th–13th century
Wood; height 8 cm. (3⅛ in.)
CNCA–INAH, Museo Regional de Antropología de
Yucatán, Mérida MM 1986–16:802

Wooden artifacts and fragments are probably the most numerous class of objects in the Cenote collections. Unfortunately, most of the pieces are broken, incomplete, and charred, but enough fragments and even complete carvings remain to allow an appreciation of this ancient art and technique, which in most other sites have been lost from the archaeological record.

The wooden mask on exhibition, perfectly oval in shape, has a projecting face and a roughly hollowed-out back. Facial features indicated are closely spaced almond-shaped open eyes, prominent nose, and a wide-open mouth. Ears are not recognizable, but a slight notch at the height where ears and earplugs should be possibly marks the former presence of some attached element. A small hollow in the center of the forehead and two larger ones symmetrically placed a little higher up must have contained inlays or served as bases for projecting features. A lateral perforation (not repeated in the restored section) may have been a suspension hole or a means to tie the piece to a background of different material.

The mask itself is made of an undetermined dark wood with pronounced fibrous structure. Unfortunately, nothing of the original surface finish is preserved, making an iconographic interpretation nearly impossible. All that can be said is that the mask in its present state looks more like the representation of a human being than the image of a deity or a supernatural.

A series of roughly shaped wooden dolls, of more or less the same scale as the mask and obviously intended to be finished with finer details by application of resin, rubber, and other plastic material and to be dressed before being thrown into the water, are a prominent part of the Cenote materials. They may have functioned as substitutes for real human sacrificial victims. It is possible that the small human masks of much better workmanship served a similar function, forming part of human images constructed of wood, cloth, copal, rubber, or some other material.

Another possibility is that these miniature masks of wood substituted for jade maskettes in belts, collars, or headdresses—all parts of the ordinary accoutrements of a Maya ruler, according to classic Maya standards. This type of mask in jade is widely represented in Chichén Itzá sculpture and painting, and actual examples are frequent in the Cenote collection. If this substitution were the case, the wooden mask would have been stuccoed and painted green before being used.

<div align="right">PJS</div>

DISCOVERY
Recovered by Román Piña Chan in 1960–61 or 1967–68

95 ◀ Disk L

◀ Sacred Cenote, Chichén Itzá, 9th–13th century
◀ Gold (with traces of silver); diameter
◀ 16.9 cm. (6½ in.) Peabody Museum of Archaeology
◀ and Ethnology, Harvard University,
◀ Cambridge, Mass. 10–71–20/25611

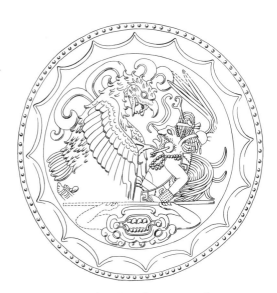

Reconstruction drawing of cat. no. 95, from
Samuel Kirkland Lothrop (1952), fig. 41

Among the most intriguing objects from the Sacred Cenote is a set of at least seventeen gold disks bearing embossed decoration of elaborate scenes, usually referring to battle, conquest, and sacrifice. Most of them are incomplete, because they were crumpled and torn before being cast as offerings into the Cenote. Usually they have a slightly bulging center field and a flat annular border.

Disk L presents a two-figure scene in the center field, surrounded by a border pattern of connected arcs and an outer line of closely spaced embossed points. In a lower register, at the bottom of the central scene, an upside-down reptilian earth monster is represented in front view, holding up the baseline on which the action develops.

The subject of the main scene is a huge eagle with a human face peering from his jaws, attacking a richly dressed man who has been thrown onto the ground and who is desperately trying to support his body with one arm. No weapons are visible. The victim wears an intricately tied turbanlike headdress, not unlike the one worn by the protagonist on the relief from Structure 4B3 (cat. no. 86). A bird claw rises from the headdress, and long sweeping plumes decorate its top. A long nosebar and a disk-and-bar earplug, probably of jade, adorn the victim's face. Characterized by a mustache and pronounced head deformation, the personage may also bear ornamental scarification on the cheek. A necklace of spherical beads hangs over his shoulder and chest. On his back, he wears a backshield or crest of large feathers mounted on a curved base with interlocking fret designs. A studded bracelet, loincloth tied in front, and sandals fixed with a frontal knot are the remaining pieces of attire; the section depicting his hips and legs is missing.

The attacking eagle, with a large scroll design behind, stands or hovers directly in front of his victim. Unfortunately, the missing section of the disk depicts his lower portion and feet; thus it is impossible to determine whether he was a standing warrior with an almost complete eagle costume or a warrior totally transformed into an eagle and attacking in full flight. War leaders with magical capacity to change themselves into raptorial birds

Yucatán is devoid of metal sources; therefore pilgrims' offerings, trade relations, and tribute exactions of Chichén Itzá must have brought these objects to the site, in the same way as jade objects. Even pieces that show decidedly local style and motifs must have been acquired as raw material or half-finished products somewhere else.

Metal finds from the Cenote include gold, *tumbaga* (alloy of gold and copper), and copper pieces from as far south as northwestern Colombia and as far northwest as western Mexico. Almost certainly, most of these widely traveled pieces were handed down through long lines of exchange, where people at one end never had direct contact with those at the other.

Some evidence of a secondary metal industry at Chichén Itzá itself exists; for example, there are cast copper bells still containing their nucleus of carbon, a lack of finish hardly to be expected in an item of trade. Ornaments and designs in purely local style, illustrating local themes, are hammered, embossed, and cut out of sheet metal or added on to simply polished gold disks. According to metallurgical analysis, the sheet metal and disks themselves were probably imported from western Panama.

The most spectacular metal object in Thompson's Cenote collection belongs to this class: a set of three openwork pieces that together constitute a face or mask ornament, hammered and cut out of sheet gold. Traces of resin and of red pigment on the back of the eyepieces may be evidence of the original mounting on a base of perishable material or be a consequence of the final and destructive offering ceremony. Two huge circles surround the eyes, and a near oval shape covers or represents the mouth. The eye rings are surmounted by inward-facing, swirling rattlesnakes with huge feather-tufts on body, nose, and tail, projecting tongue, and wide-open jaws, exposing realistic rows of teeth and extended fangs ready to strike. In the lower corners of the mouth element, more abstractly conceived serpent heads, lacking lower jaws, are surrounded by cloud or smokelike scroll designs.

Ring-shaped eye ornaments are not infrequently depicted on rulers or warriors in reliefs, murals, and sculpture at Chichén Itzá, sometimes combined with similar devices circling the mouth. In a few cases, the circles are formed by serpent bodies, with head and rattle-tail projecting.

More important, however, are representations in the Upper and Lower Temples of the Jaguars of the Great Ball Court of the specific type of ornament we are dealing with, yellow in color to show it was made of gold. In both cases, the face ornament is worn by one of the principal figures, together with a golden disk on his chest and two more huge disks on his forehead. Both times, this protagonist is accompanied and identified by a serpent of green quetzal feathers, leaving little doubt that he is one of a line of Kukulcán rulers, if not this culture hero himself.

PJS

DISCOVERY
Recovered by Edward H. Thompson in 1904–1909

REFERENCES
Samuel Kirkland Lothrop. *Metals from the Cenote of Sacrifice, Chichén Itzá, Yucatán.* Memoirs of the Peabody Museum of Archaeology and Ethnology 10, no. 2. Cambridge, Mass., 1952, pp. 67–72, figs. 54–55. **Clemency Chase Coggins and Orrin C. Shane III, eds.** *Cenote of Sacrifice: Maya Treasures from the Sacred Well at Chichén Itzá.* Exh. cat., Science Museum of Minnesota. Austin, 1984, p. 55, no. 32.

eye (originally inlaid?), and gripping foot make interpretation as a bird of prey more likely. If a king vulture was meant to be represented, the excrescence above the beak should be much shorter.

The original use of the piece was probably more ornamental than practical, not unlike the claw element observed in the victim's coiffure on gold Disk L (cat. no. 95).

PJS

DISCOVERY
Recovered by Román Piña Chan in 1968

REFERENCE
Donald Ediger. *The Well of Sacrifice: An Account of the Expedition to Recover the Lost Mayan Treasures of Chichén Itzá.* Austin, 1971, color pl. following p. 192.

94 ◀ Face or Mask Ornaments

◀ Sacred Cenote, Chichén Itzá, 9th–13th century
◀ Gold (with about 3% silver);
◀ eyes: height 16 cm. (6¼ in.),
◀ mouth: height 7.7 cm. (3 in.)
◀ Peabody Museum of Archaeology and Ethnology,
◀ Harvard University, Cambridge, Mass. 10–71–20/
◀ c7678, 7679

The general scarcity of precious metal in the Yucatán peninsula was one of the early disappointments of the Spanish conquerors. Bishop Landa predicted, in the sixteenth century, that the Sacred Cenote might contain some of the desperately looked-for material, but when it was finally explored, more than three hundred years later, even then the total weight of pure gold recovered did not exceed the rather modest quantity of about twelve pounds, nothing in comparison with the immense amount of treasure recorded from Central and South America and even central Mexico.

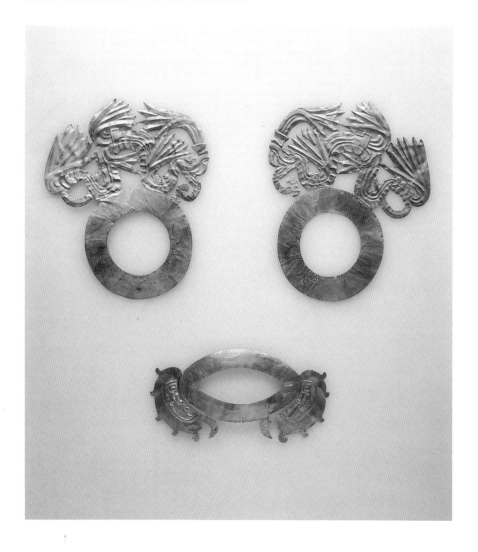

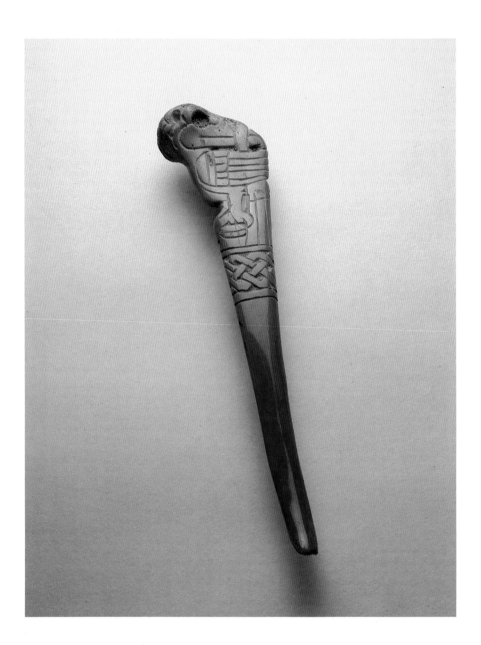

93 } Bird Spatula

Sacred Cenote, Chichén Itzá, 9th–13th century
Bone; length 24.1 cm. (9½ in.)
CNCA–INAH, Museo Regional de Antropología de
Yucatán, Mérida MM 1986–16:686

Bones from the Sacred Cenote are usually well preserved. Most of them are unmodified human skeletal remains, probably vestiges of actual sacrificial victims, mostly young children. On the other hand, both E. H. Thompson's dredging at the beginning of the twentieth century and the renewed diving and excavation projects in the 1960s produced a number of elaborately fashioned bone artifacts, still with their original high polish. Other bone items may have perished or been destroyed during the offering ceremonies.

The spatula on exhibition was carved from a long bone, probably human, that was split and polished, cutting through one of the epiphyses. The working end is slightly curved and terminates in a rounded cutting (?) edge. The natural extension of the bone, near the epiphysis, is used as a convenient handle; lateral notches integrated into the design improve the grip. Decoration and polish are on the front side only.

Combining broad-line incision, gouging, and intelligent use of the bone's outline, the handle is decorated with an upright bird in profile, above a wide band of guilloche, or interlace. Head turned backward, tail straight down, the bird is perching on an oval, glyphlike object. A flap hanging down from the forehead seems to identify the subject as a turkey, but the curved beak, huge

and other ferocious animals and to attack the enemy while in this guise were a well-known concept in fourteenth- to sixteenth-century Mesoamerica. The related complex of eagle and jaguar warrior "orders" was shared by many groups, as their occurrence among the peoples of Cacaxtla and the Toltecs and Aztecs demonstrates.

The eagle with his wide-open beak, spread wings, and claw thrust toward the victim is rather naturalistically shown, suggesting similar subjects in Chichén Itzá architectural relief. The same may be said in general about all the gold disks from the Cenote. People and deities represented are those already known from stone monuments and must have been the protagonists of Chichén Itzá history and mythology. At the same time, the iconography and style of the border elements and earth and sky symbols on the disks are often very close to eighth- to ninth-century Maya style from the Usumacinta-Pasión zone far to the southwest.

According to metal analysis, the disks were probably hammered, cut, and possibly even decorated with the outer embossed lines in southern Central America, most likely western Panama. Only after reaching Chichén Itzá were they covered with their final design, integrated into ceremonial dress, and offered in sacrifice. Earlier interpretations of these disks as related to Maya-Toltec warfare are now being reconsidered, along with the general reappraisal of Chichén Itzá history.

PJS

DISCOVERY
Recovered by Edward H. Thompson in 1904–1909

REFERENCES
Samuel Kirkland Lothrop. *Metals from the Cenote of Sacrifice, Chichén Itzá, Yucatán.* Memoirs of the Peabody Museum of Archaeology and Ethnology 10, no. 2. Cambridge, Mass., 1952, pp. 60–61, figs. 10k, 41. **Clemency Chase Coggins and Orrin C. Shane III, eds.** *Cenote of Sacrifice: Maya Treasures from the Sacred Well at Chichén Itzá.* Exh. cat., Science Museum of Minnesota. Austin, 1984, p. 95, no. 98.

96 ◀ Mask

Sacred Cenote, Chichén Itzá, 9th–13th century
Gold (with 0.2% silver); height 13.5 cm. (5¼ in.)
Peabody Museum of Archaeology and Ethnology,
Harvard University, Cambridge, Mass.
10–71–20/C7689A

Whereas most figural art in Cenote gold has been clearly established as having Central American origins and styles, the source of a small group of gold masks with common attributes has not been definitely identified. They are embossed and cut out of sheet gold that parallels Panamanian metal in chemical composition; their final elaboration may well have been of local workmanship at Chichén Itzá.

The most complex of these masks shows a face with a long and pointed, but well-modeled, nose. Prominent eyebrows, fillets, and tearlike appendages below the eyes, and a row of teeth within the open mouth are indicated by narrow bands of parallel vertical lines. The huge eyes themselves have cross-shaped interlace designs in their centers, which correspond to the central Mexican glyphic symbol for "gold." Raised lumps on the bridge of the nose and in two arches on the cheeks could represent ornamental scarification, not uncommon in Maya art of the Puuc region. The ears are barely outlined by embossed lines, which are difficult to recognize because the mask was crumpled and slightly torn before being thrown into the Cenote. The shape of the eyes indicates that no ordinary human being is represented. On the other

Drawing of cat. no. 96, from Samuel Kirkland Lothrop (1952), fig. 46a

hand, the combination of attributes is not definite enough to identify any well-known supernatural.

Four holes in the forehead and two in the earlobes may have served for attachment to a perishable base or even a wooden figure, but they could also have served to adorn the mask itself with further distinguishing elements.

PJS

DISCOVERY
Recovered by Edward H. Thompson in 1904–1909

REFERENCES
Samuel Kirkland Lothrop. *Metals from the Cenote of Sacrifice, Chichén Itzá, Yucatán.* Memoirs of the Peabody Museum of Archaeology and Ethnology 10, no. 2. Cambridge, Mass., 1952, pp. 64–66, fig. 46a. **Clemency Chase Coggins and Orrin C. Shane III, eds.** *Cenote of Sacrifice: Maya Treasures from the Sacred Well at Chichén Itzá.* Exh. cat., Science Museum of Minnesota. Austin, 1984, p. 96, no. 99.

97 ◀ **Eight Miniature Masks**

Sacred Cenote, Chichén Itzá, 9th–13th century
Gold; height (max.) 2.4 cm. (⅞ in.)
Peabody Museum of Archaeology and Ethnology,
Harvard University, Cambridge, Mass.
10–71–20/C7691A–H

Closely related to the larger masks (cat. no. 96) in raw material, technique, and style is a group of fifteen miniature masks, eight of which are exhibited here. Open mouth, prominent straight nose with flaring nostrils, and schematically indicated ears with perforated earlobes are common to all. The eyebrows are strongly marked, although the eyes themselves, in most cases, are half closed. According to their size, they may have covered the faces of wooden "idols" or doll-like figures, recovered in great quantity from the Cenote. A similar mask was found still attached to the face of a human figurine crowning a wooden scepter. Lack of distortion and supernatural attributes gives them a human aspect, although this matter is difficult to judge, since all but one of them were apparently removed from their original context, crumpled, and folded during offering ceremonies.

As to their provenance, similarity to faces represented in frontal view on some architectural sculpture at Chichén Itzá, notably atlanteans, standard-bearers, chacmools, and braziers, seems to be a powerful argument in favor of local production, using sheet gold imported from the south.

PJS

DISCOVERY
Recovered by Edward H. Thompson in 1904–1909

REFERENCES
Samuel Kirkland Lothrop. *Metals from the Cenote of Sacrifice, Chichén Itzá, Yucatán.* Memoirs of the Peabody Museum of Archaeology and Ethnology 10, no. 2. Cambridge, Mass., 1952, p. 66, fig. 50. **Clemency Chase Coggins and Orrin C. Shane III, eds.** *Cenote of Sacrifice: Maya Treasures from the Sacred Well at Chichén Itzá.* Exh. cat., Science Museum of Minnesota. Austin, 1984, p. 97, no. 101.

Imperial Tenochtitlan

EDUARDO MATOS MOCTEZUMA

The city of Tenochtitlan was the governing center of the vast Aztec empire. Founded, according to tradition, in 1325, the city flourished for nearly two centuries until it was destroyed at the time of the Spanish Conquest in 1521.

Both history and myth indicate that the Aztecs left their homeland about A.D. 1000 and wandered south toward the Basin of Mexico. It was a long pilgrimage, recounted in a number of recorded versions, with the Aztecs following the directions of Huitzilopochtli, their patron deity and war god. Signs promised them by Huitzilopochtli would indicate the place where they should settle: "Wandering from one part to another . . . they beheld the cactus and the eagle perched upon it. . . . And in its talons it held a handsome bird with precious and resplendent feathers. When they saw [the eagle] they humbled themselves before it. . . . The eagle greeted them humbly also, bowing his head low. . . . When they saw the reverence shown by the eagle, and knowing they had found what they desired, the men began to weep, . . . saying: '. . . Now we have obtained what we searched for, now we have found our city, our home. We give thanks to the Lord of Creation and to our god Huitzilopochtli.' "[1] Once having located their sacred site, the Aztecs erected a temple in honor of Huitzilopochtli. The god further instructed them to divide the city into four quadrants with the temple at its center. Sacred and profane spaces were thus deliberately divided and the Sacred Precinct of Tenochtitlan came into being with the Templo Mayor at its heart.

The city was built on an island in the middle of Lake Texcoco. The island was a swampy one, and building began with reeds and straw on a swamp grass foundation. Eventually construction was of stone, and the island was joined to the mainland by three great causeways: that to the north to Tepeyac; that to the west to Tacuba; and that to the south to Itzapalapa. These broad avenues were oriented toward the cardinal points and radiated from the Sacred Precinct. The precinct was, at its height, an enormous walled enclosure approximately five hundred meters (five hundred and fifty yards) on a side. Within it stood at least seventy-eight religious structures. This number is reported by Fray Bernardino de Sahagún in his *Historia general de las cosas de la Nueva España*, a multivolume work of the mid-sixteenth century.

When the Spaniards saw Tenochtitlan for the first time, they were astonished. Lying in the center of the great lake, the city had 250,000 inhabitants and was remarkable for its well-constructed buildings and causeways and canals busy with canoe traffic. One account reads: "When we saw such astounding things, we did not know what to say, or whether what appeared before us was real, for there were great cities along the shore and many others in the lake, all filled with canoes, and at intervals along the causeways there were many bridges, and before us lay the great city of Mexico."[2]

Mexico City: view of area of Tenochtitlan Sacred Precinct.
Templo Mayor at lower left; Cathedral and Zócalo at center

The Spaniards were also deeply impressed by Tlatelolco, the neighboring trading center whose marketplace they visited: "After having carefully examined and thought about what we had seen, we turned to look at the great square and the multitude of people in it, some buying, others selling; the noise and hum of voices could be heard more than a league away. Some of the soldiers with us had been in many parts of the world, in Constantinople and all over Italy and Rome, and they said they had never seen a public square so perfectly laid out, so large, so orderly, and so full of people."[3]

In the city of Tenochtitlan with its Templo Mayor, many artistic elements combined to form a harmonious whole. Architecture, sculpture, and painting expressed the symbolic concepts of a deeply religious people dependent upon the will of the gods for their own survival. The Templo Mayor, the most sacred temple of the land, was made up of four superimposed pyramidal structures placed upon a broad platform. Two stairways on the west side led to the top where there were two shrines, one dedicated to the god of water and the other to the god of war.

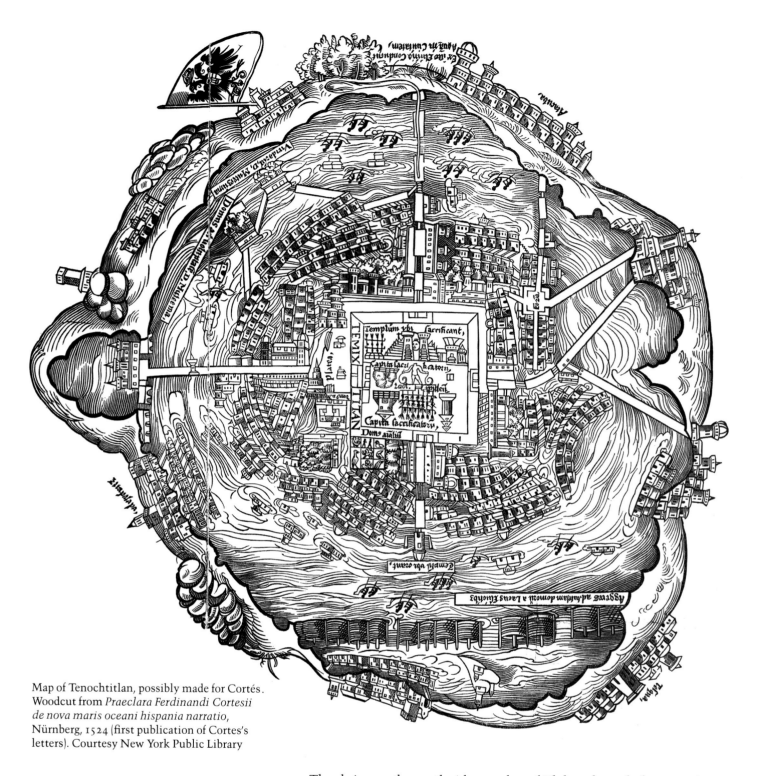

Map of Tenochtitlan, possibly made for Cortés.
Woodcut from *Praeclara Ferdinandi Cortesii
de nova maris oceani hispania narratio*,
Nürnberg, 1524 (first publication of Cortes's
letters). Courtesy New York Public Library

The shrine on the north side was that of Tlaloc, the god of water, rain,
and fertility—in short, of everything related to life. The shrine on the
south was dedicated to Huitzilopochtli, solar god and the deity of war and
conquest, associated with battle and thus with sacrifice and death. Life-
nourishing water was the realm of Tlaloc, and warfare and military
conquest—by which the Aztec empire was maintained and expanded—
fell to Huitzilopochtli. Agriculture and tribute, as the underpinnings of
Aztec life, were reflected in the architecture and sculpture of the Templo
Mayor, as they were in the many offerings proffered to it.

On the principal platform of the Templo Mayor there are at least seven
serpents—two represented completely, the others only as heads. Remains

of the colors with which they were originally painted are visible: red, yellow, blue, and so on. These serpents and serpent heads are an integral part of the architecture. Four of the heads are paired, flanking two stairways, but the serpents on the Huitzilopochtli side relate to the myth in which the god conquered his half sister, the lunar goddess Coyolxauhqui, on the sacred hill of Coatepec, the "Hill of the Serpent." One of the principal Aztec myths is thus represented in the Templo Mayor by the serpents and by the enormous sculpture of Coyolxauhqui. The goddess appears decapitated and dismembered after her defeat by her half brother, the god of war. The great sculpture, which measures 3.5 meters (138 inches) in diameter, lies at the foot of the stairs in front of the Huitzilopochtli shrine. The myth is thus given substance, expressed in form and color.

The Templo Mayor constituted the navel of the Aztec cosmic vision; it offered access to the celestial realms or descent to the underworld. The Sacred Precinct was the supreme sacral place, and indeed the entire precinct was the greatest economic, political, social, and religious center in Mexico at the time.

There are two fundamental categories in the art of this people, the terrifying and the sublime. To understand these aesthetic categories, their symbolism must be comprehended. Perhaps the grandeur that was Tenochtitlan can best be understood from poetry. As a fifteenth-century canticle, originally written in Nahuatl, expresses it, while singing of war, the city was the foundation of the sky:

> Orgullosa de si misma
> se levanta la ciudad de México-Tenochtitlan.
> Aquí nadie teme la muerte en la guerra.
> Esta es nuestra gloria.
> Este es tu mandato.
> ¡O, dador de la vida!
> tenedlo presente, O principes.
> No lo olvideis
> ¿Quién podría sitiar a Tenochtitlan?
> ¿Quién podría conmover los cimientos del cielo?
> Con nuestras flechas.
> Con nuestros escudos.
> Está existiendo la ciudad.
> ¡México-Tenochtitlan subsiste![4]

NOTES

1. Fray Diego Durán, *Historia de las Indias de Nueva España e islas de la tierra firme*, edited by Angel María Garibay (Mexico, 1967) vol. 2, p. 48.
2. Bernal Díaz del Castillo, *Historia verdadera de la conquista de la Nueva España* (Madrid, 1632) edited by Miguel León-Portilla, (Madrid, 1984) vol. A, p. 312 (Ch. LXXXVIII).
3. Díaz del Castillo, *Historia verdadera*, vol. A, pp. 333–34 (Ch. XCII).
4. "In dignity and pride rises the city of México-Tenochtitlan. Here no one fears death in battle. This is our glory. This is your commandment, O giver of life! Keep it in memory, O princes. Do not forget it. Who could besiege Tenochtitlan? Who could shift the foundations of the sky? By our arrows, by our shields, the city abides. México-Tenochtitlan endures!"

Front of cat. no. 98

Back of cat. no. 98

98 ⟨ Lidded Cache Vessel

Templo Mayor, Tenochtitlan, about 1470
Polychrome ceramic; height 45 cm. (17¾ in.)
CNCA–INAH, Museo del Templo Mayor,
Mexico City 219777

During the recent excavations of the Templo Mayor dozens of offerings were found in three different contexts: in small stone-walled chambers lined with stucco; in covered stone boxes; or in deposits placed directly into the earth that covered earlier constructions. Most of the offerings were concentrated below the great front platform of the Templo in areas immediately adjacent to the twin shrines of Tlaloc and Huitzilopochtli. This cache vessel was found in offering Chamber 3 on the Tlaloc side of the structure.

The polychrome urn is decorated all over. On one side, the face and attributes of Chicomecoatl, the corn goddess, are prominently displayed. Her modeled face is red and she wears an enormous headdress that frames it. On her chest, as in her headdress, is a rectangular device with eyes. In her right hand she holds ears of corn and in her left a rattle staff. The skirt shows diagonal lines of red, orange, and white. Below it her feet project from the body of the urn.

On the opposite side of the urn is a representation of Tlaloc, with all his attributes. On the lid is another Tlaloc depicted pouring water from a vessel onto the earth, reminiscent of some Tlaloc images known from the few remaining books, or codices. On the edge of the lid are small projections that made it possible to tie it to the urn. Inside the urn, under the lid, hundreds of greenstone beads were found, covered by a Mezcala-style mask.

This urn was discovered together with a second polychrome vessel, jaguar bones, figures of copal, ceramic flutes, flint knives, shells, masks, and figurines from the Mezcala area of the present state of Guerrero, a region once under the military control of the Aztecs.

EMM

DISCOVERY
Excavated by the Proyecto Templo Mayor in 1980

REFERENCES
Eduardo Matos Moctezuma. *The Great Temple of the Aztecs: Treasures of Tenochtitlan*. Translated by Doris Heyden. New York and London, 1988, pp. 90–91, pl. XI. **Eduardo Matos Moctezuma**. "The Templo Mayor of Tenochtitlan: History and Interpretation." In Johanna Broda, Davíd Carrasco and Eduardo Matos Moctezuma, *The Great Temple of Tenochtitlan: Center and Periphery in the Aztec World*. Berkeley, Los Angeles, and London, 1988, p. 42, pl. 14.

99 ◀ **Lidded Funerary Vessel with Serpent Ornament**

Templo Mayor, Tenochtitlan, about 1470
Orangeware ceramic; height 33.2 cm. (13⅛ in.)
CNCA–INAH, Museo del Templo Mayor,
Mexico City 253292

Of the more than seven thousand items that have been discovered in the offering caches associated with the Templo Mayor, objects of non-Aztec manufacture make up the bulk, with the vast majority of those coming from southern Mexico. The presence of these "foreign" artifacts in Tenochtitlan was primarily the result of the extensive tribute system, but these could be evidence of trade or ceremonial exchange between rulers.

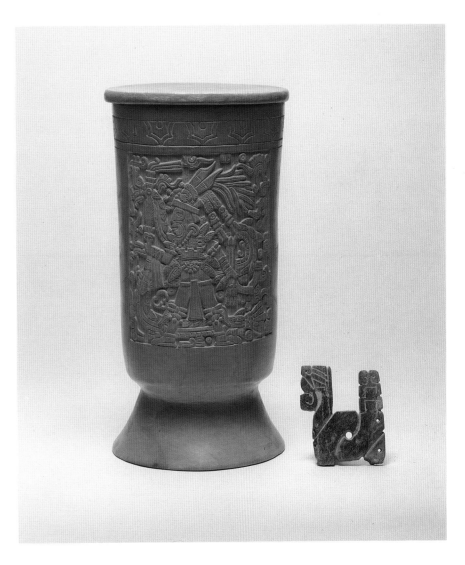

Two magnificently incised ceramic funerary urns (originally from the Gulf Coast), containing cremation burials, are among these non-Aztec objects uncovered in Templo Mayor caches; one of them is presented here. The greenstone serpent ornament was found inside the vessel together with the cremation remains. The vessel is cylindrical with the image of a god in relief on one side. The bearded figure stands, face in profile, wearing a large headdress and multielement necklace. The right hand holds a spear-thrower; the left grasps spears. A giant serpent serves as a background for the entire figure; its open jaws are just above the figure's head. Several stylized shells embellish the relief, and others are incised in a row at the top of the urn.

The identity of the figure is uncertain, as attributes of different deities are present. The stepped pectoral ornament prominently displayed on the chest identifies Xiuhtecuhtli, the fire deity; the shell motif along the border is associated with Quetzalcoatl; and the two feathers set into the ball of down in the headdress indicate Mixcoatl. Perhaps the figure is a composite of all three.

This urn, together with the other similar one, came to light in the immediate vicinity of the monumental relief of Coyolxauhqui on the main platform of the Templo Mayor. This position, on the Huitzilopochtli side of the structure, and its date of about 1470 give rise to the possibility that it held the cremated remains of an Aztec captain killed in the wars against the Purepechas of Michoacán; it is known that one of the most resounding defeats suffered by the Aztecs was at the hands of these people during the reign of Axayacatl from 1469 to 1481.

EMM

DISCOVERY
Excavated by the Proyecto Templo Mayor in 1978

REFERENCES
Diana Wagner. "Reporte de las ofrendas excavadas en 1978." In *El Templo Mayor: excavaciones y estudios*, edited by Eduardo Matos Moctezuma. Instituto Nacional de Antropología e Historia, Mexico, 1982, pp. 119–42. **Vida Mercado**. "Restauración de dos urnas funerarias." In *El Templo Mayor: excavaciones y estudios*, edited by Eduardo Matos Moctezuma. Instituto Nacional de Antropología e Historia, Mexico, 1982, pp. 349–56, pls. 5, 6. **Eduardo Matos Moctezuma**. "Notas sobre algunas urnas funerarias del Templo Mayor." *Jahrbuch für Geschichte von Staat, Wirtschaft und Gesellschaft Lateinamerikas* 20 (1983), pp. 18–19, pls. 8–10. **Henry B. Nicholson, with Eloise Quiñones Keber**. *Art of Aztec Mexico: Treasures of Tenochtitlan*, exh. cat., National Gallery of Art, Washington, D.C., 1983, no. 29, pp. 94–95. **Eduardo Matos Moctezuma**. "The Templo Mayor of Tenochtitlan: Economics and Ideology." In *Ritual Human Sacrifice in Mesoamerica*, edited by Elizabeth H. Boone. Dumbarton Oaks Research Library and Collection, Washington, D.C., 1984, pp. 133–64.

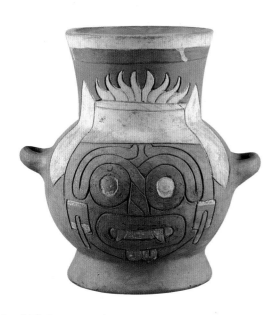

100 ⫷ Tlaloc Vessel

Templo Mayor, Tenochtitlan, about 1470
Ceramic; height 30.5 cm. (12 in.)
CNCA–INAH, Museo del Templo Mayor,
Mexico City 168829

The great majority of artifacts from the Templo Mayor are associated with Tlaloc, god of rain and the earth's fertility. Many works, such as vessels, masks, and figures, depict the deity himself, and the aquatic connotations of the abundant marine fauna—fish, shells, crocodiles, coral, and turtles, for example—found among the offerings are perhaps also symbolic of this important god. The vessels bearing representations of Tlaloc are symbolic containers for the life-giving water that will be poured onto the earth.

DISCOVERY
Known before 1845 in Mexico City

REFERENCES
José Fernando Ramírez. "Descripción de cuatro lápidas monumentales conservadas en el Museo Nacional de México, seguida de un ensayo sobre su interpretación." In William H. Prescott, *Historia de la conquista de México*, translated by Joaquín Navarro. Mexico, 1844–1846, vol. 2, 2d pagination, pp. 106–24. **Manuel Orozco y Berra**. "Dedicación del Templo Mayor de México." *Anales del Museo Nacional de México* (primera época) 1 (1877), pp. 60–74. **Henry B. Nicholson, with Eloise Quiñones Keber**. *Art of Aztec Mexico: Treasures of Tenochtitlan*, exh. cat., National Gallery of Art, Washington, D.C., 1983, no. 11, pp. 52–55.

104 ◀ Shell

Templo Mayor, Tenochtitlan, 1486–1502
Basalt; diameter 49 cm. (19¼ in.)
CNCA–INAH, Museo del Templo Mayor,
Mexico City 208251

One of a group of three similar sculptures excavated at the rear of the Templo Mayor, this giant conch shell is notable for its realistic detail and for the visible remains of stucco. It was found next to a small altar on which it may have originally been placed.

Shells were an important Mesoamerican symbol, and in Aztec times they were directly associated with Tlaloc, god of water and rain. Shells also connote fertility and were significant because they contained life while in water.

EMM

DISCOVERY
Excavated by the Proyecto Templo Mayor in 1979

REFERENCE
Guillermo Ahuja Ormaechea and Mónica Ros Torres. "Conchiglia." In Beatríz de la Fuente et al., *L'arte del Messico prima de Colombo*, exh. cat., Palazzo Ducale. Venice, 1988, p. 66, no. 35.

105 ◀ Upright Drum

Provenance unknown, probably Malinalco,
about 1500
Wood; height 98 cm. (38⅝ in.)
Gobierno del Estado de México, Instituto
Mexiquense de Cultura, Museo de Antropología e
Historia, Toluca

This wooden drum, or *huehuetl*, is one of the best examples of the consummate artistry attained in woodcarving by the Aztecs. It is richly carved with figures associated with warfare. The design field is divided into two parts by a central section of undulating bands that are interspersed at regular intervals with circular shields. The shields are decorated with round devices that represent balls of feather down, and the whole may be one of the emblems of

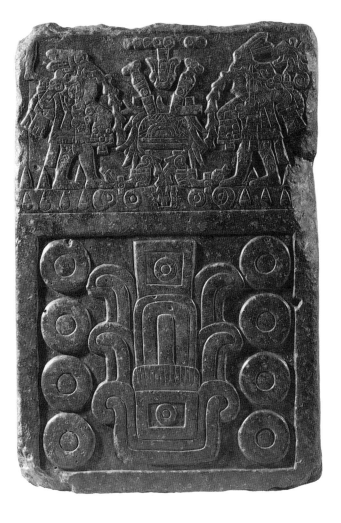

103 ◀ Dedication Stone

◀ Templo Mayor, Tenochtitlan, 1487
◀ Serpentine, height 88 cm. (34⅝ in.)
◀ CNCA–INAH, Museo Nacional de Antropología,
◀ Mexico City 11–3203

The relief on this stone is divided into two areas: in the lower section is the date "8 Reed," which corresponds to 1487 in the Christian calendar; in the upper part are two personages representing Aztec rulers. The ruler on the left is Tizoc, who was in power between 1481 and 1486, and on the right is his brother Ahuizotl, who succeeded him and ruled from 1486 to 1502. Both men appear in profile and are barefoot, standing on the symbol for the earth; they may be identified by their name glyphs in the upper corners behind their heads. They are shown letting blood from their ears with thorns, while streams of their blood flow into the gaping sacrificial jaws of the earth below. At the feet of each ruler is a censer with a serpent's head at one end and a receptacle from which incense rises at the other. The central element is the grass ball, or *zacatapayolli*, with two long thorns of self-sacrifice stuck into it. Above the figures is another numeral, "7 Reed," whose meaning is not clear.

These two rulers are appropriate here, for historical sources recount that Tizoc began an enlargement of the Templo Mayor in 1483 but died before he could complete it. His brother Ahuizotl finished the project. In the Codex Telleriano-Remensis, Tizoc is shown as a mortuary bundle and appears together with his successor in front of the Templo Mayor, which bears the numeral "8 Reed," the date of the dedication ceremonies for the enlargement of the temple.

The relief undoubtedly was part of the Templo Mayor, as several similar stones have been found at the rear of the temple on the Huitzilopochtli side. Perhaps this work, so skillfully carved, came from that area.

EMM

mask was found with a human skull accompanied by a pair of green-stone earflares.

The discovery of ancient objects in Aztec caches raises the issue of how they got to Tenochtitlan. Although Teotihuacán was a visible and sacred place for the Aztecs—indeed it was the "place where the gods were created" — how or why such objects were unearthed at the earlier site is conjectural. Perhaps the Aztecs were amateur archaeologists, searching into the past and revering and copying its treasures.

EMM

DISCOVERY
Excavated by the Proyecto Templo Mayor

REFERENCES
Eduardo Matos Moctezuma. *Obras maestras del Templo Mayor*. Mexico, 1988, pp. 62–63, pl. XVIII.
Eduardo Matos Moctezuma. *Templo Mayor: guía oficial*. Instituto Nacional de Antropología e Historia. Mexico, 1989, p. 92.

102 ◀ Double-Sided Pendant

Templo Mayor, Tenochtitlan, about 1470
Greenstone; height 13.5 cm. (5¼ in.)
CNCA–INAH, Museo del Templo Mayor,
Mexico City 250368

Chamber 1 was an offertory cache of the stone-walled type that was found behind the bottom of the great stairway on the Huitzilopochtli side of the Templo Mayor. The chamber contained a very large (height 140 cm. [55⅛ in.]) greenstone figure of a goddess, possibly Mayahuel, goddess of the maguey cactus and pulque, the fermented beverage made from the juice of this cactus. Many other small sculptures of similar greenstone were in Chamber 1: figures, axes, disks, pectorals, pendants, beads, earflares, and the like. This double-sided pendant was among them.

One side of the pendant, worked in Aztec-style relief, depicts a bedecked deity, who carries four spears in his right hand and a spear-thrower in his left. His arrow-shaped nose ornament suggests that he may be associated with the god Tezcatlipoca, a deity of complex character and the patron of rulers. The reverse, worked in a Mezcala style, shows a simple profile face wearing a circular earflare.

EMM

DISCOVERY
Excavated by INAH in 1978

REFERENCE
Angel García Cook and Raúl M. Arana A. *Rescate arqueológico del monolito Coyolxauhqui: informe preliminar*. Instituto Nacional de Antropología e Historia. Mexico, 1978, p. 63, fig. 55.

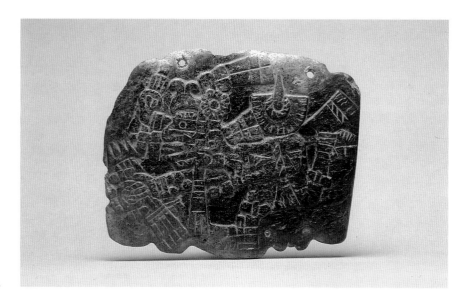

Back of cat. no. 102

Front of cat. no. 102

Sixteenth-century documents report that Tlaloc's attendants, known as *tlaloques*, broke the jars with clubs to release the water.

This vessel is incised with the face of Tlaloc, identified by his traditional features: "goggle eyes," twisted serpent nose, and fanged mouth. Square ear ornaments with long pendants and a headdress are also indicated. Vivid blue and white pigments are still plentiful on the surface.

Found in Offering 31 in the main platform of the Templo Mayor on the side dedicated to Tlaloc, this vessel lay among seashells, sawfish blades, and pieces of coral; inside were Mezcala-style stone figurines.

EMM

DISCOVERY
Excavated by the Proyecto Templo Mayor in 1979

REFERENCES
Eduardo Matos Moctezuma. *Obras maestras del Templo Mayor*. Mexico, 1988, pp. 148–49. **Eduardo Matos Moctezuma**. *Templo Mayor: guía oficial*. Instituto Nacional de Antropología e Historia. Mexico, 1989, p. 124.

101 ◄ Mask

Templo Mayor, Tenochtitlan, about 1470
Alabaster, shell, pyrite; height 16 cm. (6¼ in.)
CNCA–INAH, Museo del Templo Mayor,
Mexico City 220298

The Aztecs worked various types of stone for different purposes. Alabaster, sometimes known as Mexican onyx, was used for medium- and small-sized objects, and a number of miniatures, such as deer heads and rattle staffs are known. Today alabaster is mined in the state of Puebla, an area that came under Aztec economic control during the mid-fifteenth century. Works made from the material appear in Templo Mayor caches, and this alabaster mask was discovered in Offering 82, located in the southeastern corner of the Templo. It has shell inlays in its eyes and one remaining pyrite pupil; a single tooth of shell remains in the mouth. The offering also contained an earlier, or "heirloom," Teotihuacán mask, an indication that the Aztecs were aware of and valued the accomplishments of their predecessors. The Teotihuacán-style

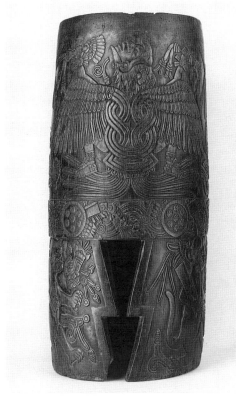

Side view of cat. no. 105

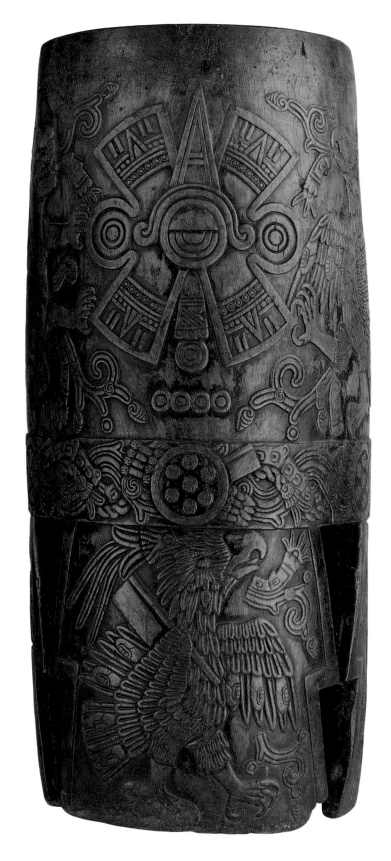

Tenochtitlan. The emblem is found on the platform floor in front of the Coyolxauhqui relief at the Templo Mayor, and it also appears on the first page of the Codex Mendoza, an illustrated manuscript of the early viceregal period that deals with the founding of Tenochtitlan.

The upper register of the drum bears profoundly symbolic imagery. Prominently displayed on one side is the interlaced *ollin* (movement or earthquake)

sign with four circles for the numeral 4 beneath it. This is the symbol for the cosmic era in which the Aztecs lived, an era that they believed would come to an end on 4 Ollin. A jaguar and an eagle, each with long feathers on its head and a flag under an arm, support the *ollin* sign. From their mouths come *atl-tlachinolli* signs, the symbol of sacred warfare; these same signs appear under their feet. Opposite the *ollin* sign on the other side of the drum is an eagle warrior with great wings and tail and outspread arms and legs. The eagle is repeated once and the jaguar twice on the lower section of the drum.

<div align="right">EMM</div>

DISCOVERY
Published in 1887 as being in the town of Malinalco in the Toluca Basin

REFERENCES
Alfredo Chavero. *Historia antigua y de la conquista*. Vol. 1 of *México a través de los siglos*, edited by Vicente Riva Palacio. Mexico, 1887, vol. 1, pp. 596–97. **Eduard Seler**. "Die holzgeschnitzte Pauke von Malinalco und das Zeichen *atl-tlachinolli*." In *Gesammelte Abhandlungen zur amerikanischen Sprach- und Altertumskunde*. Berlin, 1908. Reprint, Graz, 1960, vol. 3, pp. 274–80, fig. 67. **José García Payón**. "Los monumentos arqueológicos de Malinalco, Estado de México." *Revista mexicana de estudios antropológicos* 8 (1946), pp. 5–65. **Henry B. Nicholson, with Eloise Quiñones Keber**. *Art of Aztec Mexico: Treasures of Tenochtitlan*, exh. cat., National Gallery of Art, Washington, D.C., 1983, no. 61, pp. 145–47.

106 ◀ Chacmool

◀ Tenochtitlan, about 1500
◀ Andesite; height 73 cm. (28¾ in.)
◀ CNCA–INAH, Museo Nacional de Antropología,
◀ Mexico City 11–3013

This sculpture is an example of the incorporation of forms from the sculpture of earlier peoples into the Aztec canon. The chacmool type of figure has been found at various sites in Mesoamerica, particularly at Chichén Itzá in the Maya area (see cat. no. 83) and at Tula, the Toltec capital in central Mexico. The Aztecs must have taken the form from Tula, since Aztec versions reproduce Toltec features, which include the reclining posture and a receptacle on the stomach where offerings must have been placed. The chacmool is thought to have been an intermediary between the supplicant and the god of the temple. In the 1978–82 excavations of the Templo Mayor a similar sculpture of earlier date was found in its original position in front of the Temple of Tlaloc.

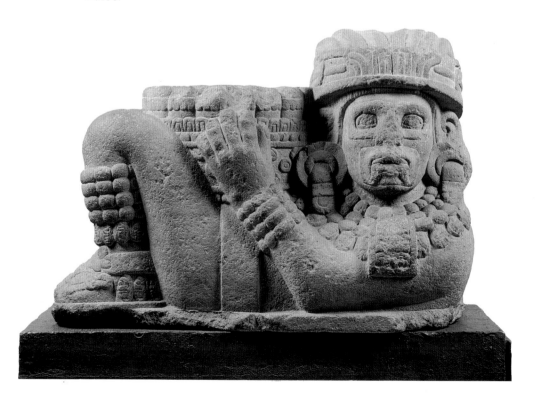

The association of the present sculpture with this god is evident in the face of Tlaloc on top of the receptacle it holds and in another image of the deity carved on the underside of the chacmool. The latter shows Tlaloc in the position of Tlaltecuhtli, the earth monster, together with shells and symbols of running water.

EMM

DISCOVERY
Unearthed at the corner of Venustiano Carranza and Pino Suárez streets in 1943

REFERENCES
César Lizardi Ramos. "El Chacmool mexicano." *Cuadernos Americanos* 14, no. 2 (1944), pp. 137–48. **Salvador Mateos Higuera**. "Herencia arqueológica de México-Tenochtitlan." In *Trabajos arqueológicos en el centro de la ciudad de México*, edited by Eduardo Matos Moctezuma. Instituto Nacional de Antropología e Historia. Mexico, 1979, p. 233, no. 41. **Henry B. Nicholson, with Eloise Quiñones Keber**. *Art of Aztec Mexico: Treasures of Tenochtitlan*, exh. cat., National Gallery of Art, Washington, D.C., 1983, no. 1, pp. 32–33.

107 ◄ Huehueteotl

Near the Red Temple in the Sacred Precinct, Tenochtitlan, about 1500
Stone; height 77 cm. (30¼ in.)
CNCA–INAH, Museo del Templo Mayor, Mexico City 212978

Huehueteotl, the old god of fire, is one of the most ancient deities in the Mesoamerican pantheon, and representations of this deity in the same form and attitude are present in central Mexico from 500 B.C. onward. A small ceramic figure of this god was found at Cuicuilco, one of the first urban centers in the Basin of Mexico, which flourished between 600 and 200 B.C. Later, at Teotihuacán (A.D. 100–750), the image was often carved in stone (see cat. nos. 29 and 33). The features of this god are always the same: seated,

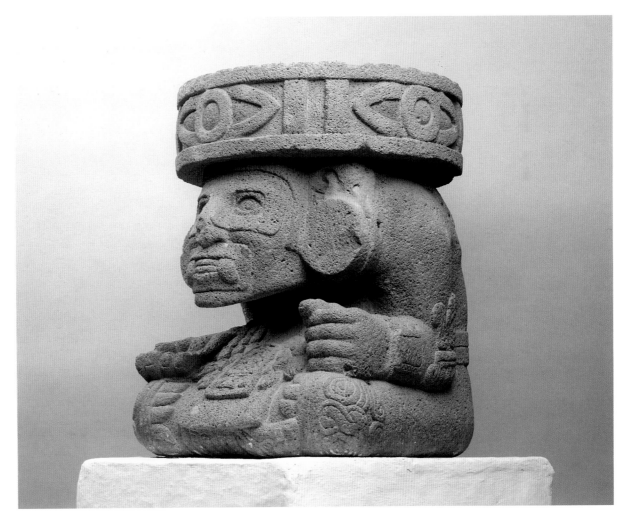

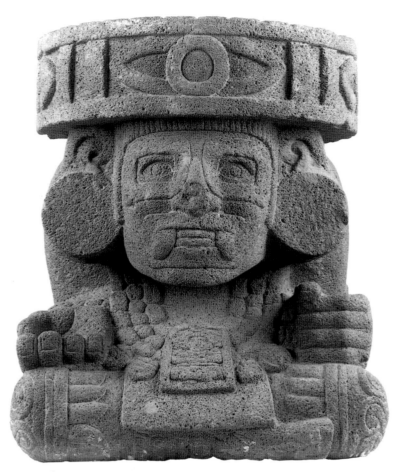

Front of cat. no. 107

hands on knees with the right hand cupped open and the left hand a closed fist. On the head is a large brazier in which fire was kindled for the deity's role as god of fire. The back is bent from the weight of the brazier, and the face is that of a wrinkled, toothless old man.

In the present sculpture the Aztec Huehueteotl retains the ancestral central Mexican features, but there are new elements. The face is almost hidden by a mask that rings the eyes and a mouth mask with fangs; it is framed by large earflares and a great bead necklace with a central pendant that adorns the chest. On the pendant is a representation of a personage. The glyph "11 Reed" is on the figure's back. On the top of the "brazier" (there is no container) two shells are carved in relief surrounded by symbols for running water and whirl-pools. This sculpture indicates the association of the gods of fire and water in Aztec times.

In copying the general form of the god from Teotihuacán and adding their own elements, the Aztecs engaged in conscious archaizing, a tendency found in various ancient societies. In some cases archaizing was only imitation with no understanding of meaning. In others both form and significance were adopted, and further innovations were added, such as in this sculpture of Huehueteotl. In depicting the old god of fire, it represents the deity that ruled the center of the universe, maintaining the equilibrium of the cosmos. In this aspect the sculpture relates to the context in which it was discovered north of the Templo Mayor, very near the Red Temple. The Red Temple also has Teotihuacán features, and the sculpture undoubtedly belonged to it.

Back of cat. no. 107

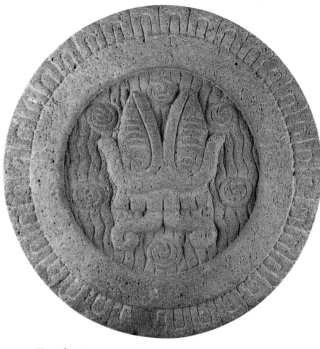

Top of cat. no. 107

The proximity of the Red Temple to the Templo Mayor is important, since that great Templo Mayor complex was believed to be the navel of the world, the center of the Aztec universe. Tlaloc and Huitzilopochtli were present in the Templo Mayor; the first was associated with fertility and rain, the second with battle, sacrifice, and death. Thus, the three deities complemented each other in the principal temple complex of the Aztecs.

EMM

DISCOVERY
Excavated by the Proyecto Templo Mayor in 1980

REFERENCES
Henry B. Nicholson, with Eloise Quiñones Keber. *Art of Aztec Mexico: Treasures of Tenochtitlan*, exh. cat., National Gallery of Art, Washington, D.C., 1983, no. 2, pp. 34–35. **Alfredo López Austin**. "The Masked God of Fire." In *The Aztec Templo Mayor*, edited by Elizabeth Hill Boone. Dumbarton Oaks Research Library and Collection, Washington, D.C., 1987, pp. 257–92.

108 ❧ Lidded Box with Deity Figure

Tizapán, about 1500
a. Box: painted stucco on stone; height 20 cm. (7⅞ in.)

b. Figure: greenstone; height 8 cm. (3¼ in.)
CNCA–INAH, Museo Nacional de Antropología, Mexico City 11–3848

This covered box is particularly interesting because of the extensive remains of stucco surfacing on it. Painted images, in still very vibrant colors, appear on the inside, on the underside of the lid, and on the bottom of the box. The lid bears four images of the water deity Tlaloc, one on each side corresponding to one of the four cardinal points of the universe. These world directions —east, south, west, and north—were very important in Mesoamerican thought.

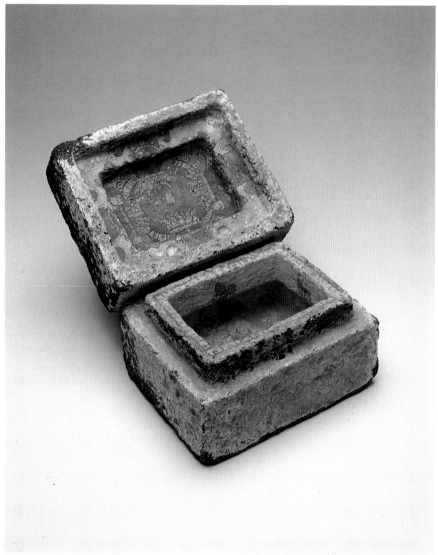

108 a

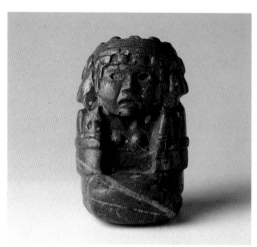

108 b

Each was characterized by a different color: red (east), blue (south), white (west), and black (north).

The four Tlalocs on the lid support a large disk, which is the symbol for precious greenstone, or *chalchihuitl*. Another such symbol appears on the bottom of the box surrounded by depictions of corn plants. When discovered, the box contained a greenstone figure representing Xilonen, who was the goddess of the young maize plant. The maize deity was always female and, although multifaceted, was usually called Chicomecoatl in the Basin of Mexico (see cat. no. 98). A special role was assigned to her, however, when she was protector of the young corn plant at which time she was called Xilonen. Corn was the most important edible plant of Mexico, and in Aztec times it was symbolically used to stand for all food plants. The significant relationship of maize and water is abundantly clear in the imagery of this box.

EMM

DISCOVERY
Unknown

REFERENCE
Esther Pasztory. *Aztec Art*. New York, 1983, pp. 247, 245, pls. 250–51, 270.

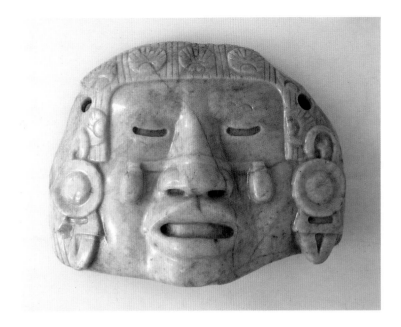

109 ◀ Coyolxauhqui Mask

Provenance unknown, possibly Tenochtitlan,
about 1500
Jade; height 11.5 cm. (4½ in.)
Peabody Museum of Archaeology and Ethnology,
Harvard University, Cambridge, Mass.
20–40–20/C10108

This mask represents Coyolxauhqui, the lunar deity and half sister to Huitzilopochtli, Aztec patron deity and war god. The goddess is identified by the bells on her cheeks, her ear ornaments, the balls of down in her hair, and her half-closed eyes. There are two other well-known representations of Coyolxauhqui. One is a large greenstone head that was discovered in Mexico City in 1830 and is now in the Museo Nacional de Antropología; the other is the great relief sculpture that was found at the Templo Mayor in 1978.

Coyolxauhqui was an adversary of her powerful half brother and fought with him in hand-to-hand combat. Huitzilopochtli defeated her and dismembered her body, and it is in death that the Templo Mayor relief shows her. In one major reading of this myth Huitzilopochtli was identified with the sun and Coyolxauhqui with the moon, and the defeat of Coyolxauhqui represented the sun's triumph over the deities of the night.

Holes above the ears indicate that this mask may have been worn as a pectoral.

EMM

DISCOVERY
Unknown

REFERENCE
Henry B. Nicholson, with Eloise Quiñones Keber. *Art of Aztec Mexico: Treasures of Tenochtitlan*, exh. cat., National Gallery of Art, Washington, D.C., 1983, no. 10, p. 51.

110 ◀ Pendant Bell with Eagle Warrior

Provenance unknown, about 1500
Gold; height 9 cm. (3½ in.)
Hermitage Museum, Leningrad DM–321

An eagle warrior is depicted in this gold bell. The warrior's face, with features quite distinctly rendered, emerges from the bird's large, open beak. He wears round earflares and a biblike breast ornament patterned with undulating lines. His arms appear to be feathered, like those of the ceramic eagle-warrior sculptures found in the Templo Mayor. The right hand, held upright, carries a weapon, while the left hand grasps three darts; on the left arm is a small shield decorated with feathers. Behind the warrior's face and chest is a square framework made of symbols for running water. The body of the warrior is a bell, a globular element from which eagle talons project. The bell is unusual in that it represents one of Huitzilopochtli's warriors of the sun (the eagle was a solar symbol). The bell's rattle is a copper bead.

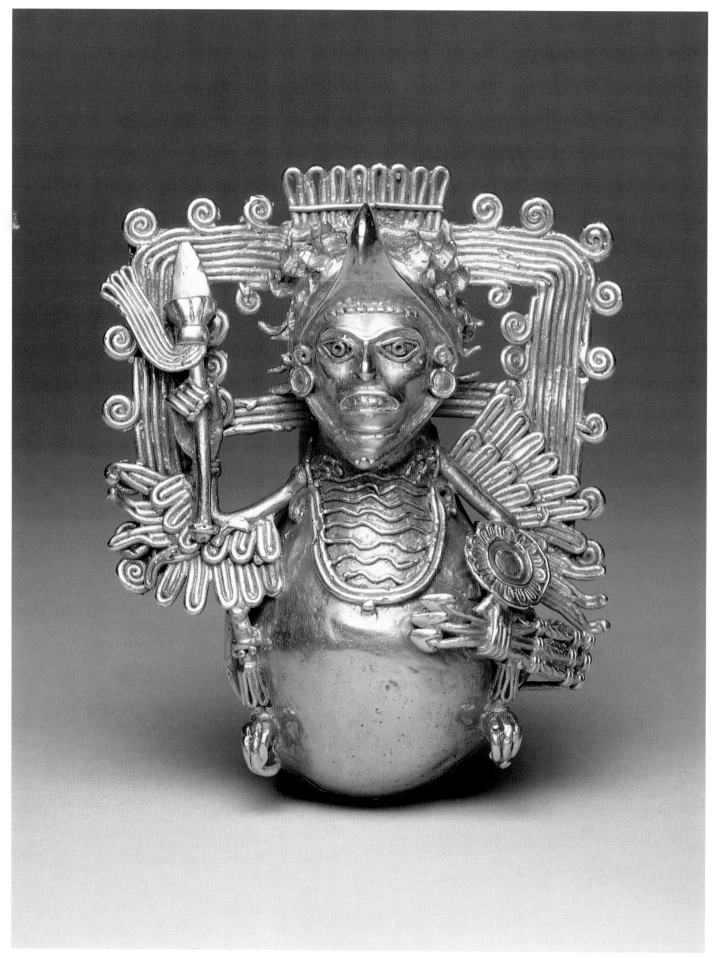

This artifact was made by the lost-wax process, a common metalworking technique in pre-Hispanic Mexico. It is an exceptional example of Mexican craftsmanship.

The bell is believed to have been acquired in Paris in 1886 by a member of the Russian Stroganov family. It entered the Hermitage with other holdings from the Stroganov Palace in 1926.

EMM

DISCOVERY
Unknown

REFERENCES
R. V. Kinzhalov. "Atstekskoe zolotoe nagrudnoe ukrashenie" [Aztec Gold Breast Ornaments]. *Sbornik Muzeia Antropologii i Etnografii* [Academy of Sciences of the U.S.S.R., Moscow and Leningrad] 19 (1960), p. 209, fig. 1. **Jacques Soustelle**. *Mexico*. Translated by James Hoghart. Cleveland and New York, 1967, fig. 136.

111 ◀ Feathered Serpent

◀ Provenance unknown, possibly Tenochtitlan,
◀ about 1500
◀ Stone; height 51 cm. (20⅛ in.)
◀ Museo Missionario Etnologico, Musei Vaticani,
◀ Vatican City AM3296

Images of feathered serpents—large and small, tightly coiled or undulating—appear again and again in Aztec art. This piece is exceptional in the way the sculptor has used the reptile's body to imply a rising motion; the feathers covering the body contribute to the striking fluidity of the work. The magnificently carved head displays teeth and fangs in the half-open mouth, from which a forked tongue extends downward.

In general this type of image is associated with Quetzalcoatl, perhaps the most meaningful of all deities. Of apparent ancient origin, Quetzalcoatl was conceptually complex by Aztec times and was regarded as a powerful benefactor of humankind.

EMM

DISCOVERY
Unknown

REFERENCES
Kunsthaus, Zurich. *Kunst der Mexikaner*, exh. cat., Zurich, 1959, p. 82, pl. 105. **Jozef Penkowski**. "Quetzalcoatl ("The Plumed Serpent")." In *The Vatican Collections: The Papacy and Art*, exh. cat., The Metropolitan Museum of Art. New York, 1982, no. 152, p. 235, pl. p. 234.

112 ◀ Eagle Vessel

Sacred Precinct, Tenochtitlan, 1500–1521
Stone; height 72 cm. (28⅜ in.)
CNCA–INAH, Museo del Templo Mayor,
Mexico City 252747

This sculpture presents the entire figure of a bird, undoubtedly an eagle. It is remarkable for the magnificent way in which the artist captured the tiniest of details even in the treatment of the different types of feathers. The eagle's eye is encircled by long delicate feathers; the short feathers on the top of the head gradually give way to the longer ones that extend down along the body and wings. The tail is made up of yet longer feathers falling vertically, and the talons turn upward at the back. A circular receptacle in its back indicates that the eagle is a *cuauhxicalli*, or offering vessel. Traces of painted stucco remain in the receptacle.

The receptacle is particularly meaningful since it bears on the eagle's relationship to sculptures found in the same location under the Palacio del Marqués de Apartado, just across a city street from the Templo Mayor. Two other interesting sculptures were discovered there: the enormous jaguar cuauhxicalli, which now stands at the entrance to the Mexica (Aztec) Room of the Museo Nacional de Antropología, Mexico City, and a serpent's head, which is now in the Museo del Templo Mayor. Both the eagle and jaguar sculptures are offering vessels.

The eagle was a symbol of the sun and was associated with Huitzilopochtli, the Aztec god of war. The bird was responsible for supplying the sun with the hearts of sacrificial victims, the nourishment it needed to make its journey across the sky. Here, as elsewhere in Aztec thought, life and death were inextricably joined. Death occurred so that life could go on; victims were sacrificed to ensure that the sun, and thus the universe, would not come to a halt.

EMM

DISCOVERY
Excavated by Elsa Hernández Pons in 1985 at the corner of Argentina and Donceles streets

REFERENCES
Elsa Hernández Pons. "Una escultura azteca encontrada en el centro de la ciudad de México." *Antropología* (INAH) (1987). **Eduardo Matos Moctezuma**. *Obras maestras del Templo Mayor*. Mexico, 1988, pp. 51–53. **Eduardo Matos Moctezuma**. *Templo Mayor: guía oficial*. Instituto Nacional de Antropología e Historia. Mexico, 1989, pp. 69–71.

113 ◀ Tlaltecuhtli

Tenochtitlan, about 1500
Stone; diameter 130 cm. (51 in.)
CNCA–INAH, Museo Nacional de Antropología,
Mexico City 11–5354

This stone relief, one of the most recent finds made in Mexico City, portrays the god Tlaltecuhtli, lord of the earth and devourer of the dead. The flat, circular shape of the sculpture is not original, as the work was recut in colonial times into a millstone. Even in its incomplete state, the relief is one of the largest known images of Tlaltecuhtli.

All of Tlaltecuhtli's traits are in evidence: the characteristic headdress and large earflares frame the face; a single raised element both outlines the eyes and forms the nose; four fangs protrude from the mustached mouth. The deity's arms are in the conventional position. Although the hands were largely destroyed when the stone was cut into a circle, remnants of what is probably a human skull can be made out in the left hand. In other depictions of Tlaltecuhtli he holds, and is adorned with, skulls. The huge pectoral is still visible, although the lower section has been destroyed.

The lord of the earth was a most important god. His awesome role as devourer of the dead was commemorated in a hymn: "The god of earth opens his mouth, eager to drink the blood of all those who will die in this battle. . . . It seems that the sun and the god of earth called Tlaltecuhtli wish to rejoice;

they wish to give food and drink to the gods of heaven and hell, making a banquet for them with the blood and flesh of the men who are to perish in this battle."[1]

EMM

1. Fray Bernardino de Sahagún. *Historia de las cosas de la Nueva España*, edited by Angel María Garibay. Mexico, 1956.

DISCOVERY
Unearthed in 1988 on Reforma near the Museo Nacional de Antropología

REFERENCE
Felipe Solís O. and Ernesto González L.. "Tlaltecuhtli, el Señor de la Tierra." *Antropología* (INAH) no. 25 (1989).

114 Colossal Head of a Feathered Serpent

Sacred Precinct, Tenochtitlan, about 1500
Stone; height 94 cm. (37 in.)
CNCA–INAH, Museo Nacional de Antropología, Mexico City 11–3195

Great serpents were an architectural feature of Tenochtitlan's Sacred Precinct. These representations—of the entire serpent or of just its head—were used along temple platforms, paired at the base of wide stairways, and placed in other locations. Some of these depictions were of feathered serpents, such as this example whose entire head is covered with feathers. The expression on the face of this serpent is ferocious, and its impressive fangs are bared. Other such huge heads can be found today in Mexico City, some incorporated into later buildings.

The serpent had many meanings in pre-Hispanic Mexico. It was associated both with the earth and with several celestial deities. The creature was of deep and ancient significance, profoundly important to Mesoamerican thought. It was one of the three most symbolic animals—the eagle, the jaguar, and the serpent.

EMM

DISCOVERY
Unearthed in the atrium of the Mexico City Cathedral in 1881

REFERENCES
Jesús Galindo y Villa. *Catálogo del departamento de arqueología del Museo Nacional.* Part 1, *Galería de monolitos.* Mexico, 1897, fig. 23a. **Salvador Mateos Higuera**. "Herencia arqueológica de México-Tenochtitlan." In *Trabajos arqueológicos en el centro de la ciudad de México,* edited by Eduardo Matos Moctezuma. Instituto Nacional de Antropología e Historia. Mexico, 1979, no. 26 (24–73), p. 223. **Elizabeth Hill Boone**. "Templo Mayor Research, 1521–1978." In *The Aztec Templo Mayor,* edited by Elizabeth Hill Boone. Dumbarton Oaks Research Library and Collection, Washington, D.C., 1987, pp. 31, 33, 35, fig. 21.

Viceregal Art

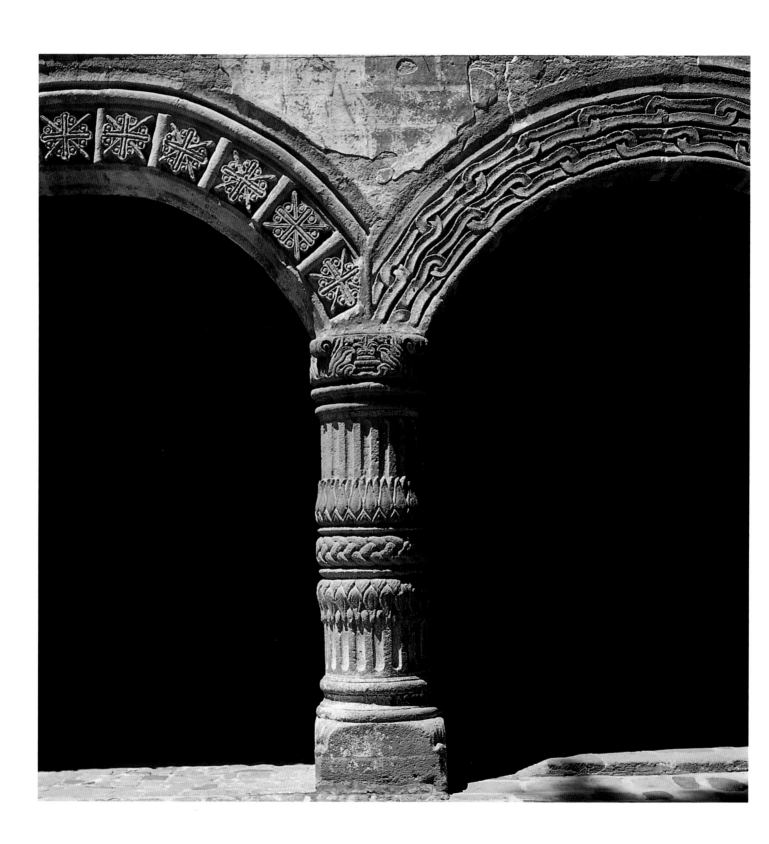

The Progress of Art in New Spain

Jorge Alberto Manrique

Beginning in the sixteenth century, the art produced in America, and especially that in New Spain, constituted the first great extension of the European tradition outside its geographic bounds. This heritage—the accumulation of two thousand years, with lapses, interruptions, impositions of local forms, and rich contributions from Asia and North Africa—is central to an understanding of the art of New Spain. It accompanied the Europeans on their trans-Atlantic voyage to America and was carried through the vast new territories subject to the Spanish crown. Introduced to new lands populated by people having their own rich culture and artistic patrimony, the European tradition changed in form and meaning. This process of transformation gave rise to the art of New Spain.

The Mesoamerican cultures, over thousands of years, had created their own aesthetic history, fashioning many objects which are today regarded as masterpieces. After the Conquest, however, that vast world no longer produced its own models but relied on models from a tradition that was at first alien to it.

Since evangelization was the theoretical justification for the Spanish presence in Mexico and for the subjugation of its people, the Conquest and colonization brought the implicit need for conversion to Christianity. Converting the Indians was a heroic, epic, and at the same time brutal and traumatic enterprise. A religion is not simply an isolated belief and ritual; it is deeply interwoven with social behavior, with community structures, and with the places and objects required by religious practices. The indigenous American world became a world of Christian neophytes—this involved not only a change of religion but also a profound alteration of social structures and behavior. For example, the Christian religion mandated monogamy; in certain social strata of pre-Hispanic communities, however, polygamy and several established forms of concubinage were common. Adopting the new religion meant renouncing polygamy and the delicate structures and customs surrounding it, with an attendant loss of prestige for the indigenous ruling classes.

Neither the forms of representation of the Mesoamerican cultures, nor their extraordinary architecture, nor their objects of worship could be utilized in the practices of the Christian religion—they had to be discarded. The Catholic world required churches and images—that is, a kind of space and a kind of representation that were unknown in the Mesoamerican tradition. Thus the models had to come from outside, from the tradition of Europe. In addition to religious matters, the Spaniards who found themselves in America wanted to reproduce the forms of daily life they had known at home; they were comfortable with neither the spaces nor the objects within the local tradition.

Of course, in this transition to new forms, some pre-Hispanic techniques persisted in ceramics, textiles, and lacquerwork and, most impor-

5-1.
Portería, arches, and baluster column, showing free interpretations of European forms, Franciscan convent, Huejotzingo, Puebla. Photo: Michel Zabé

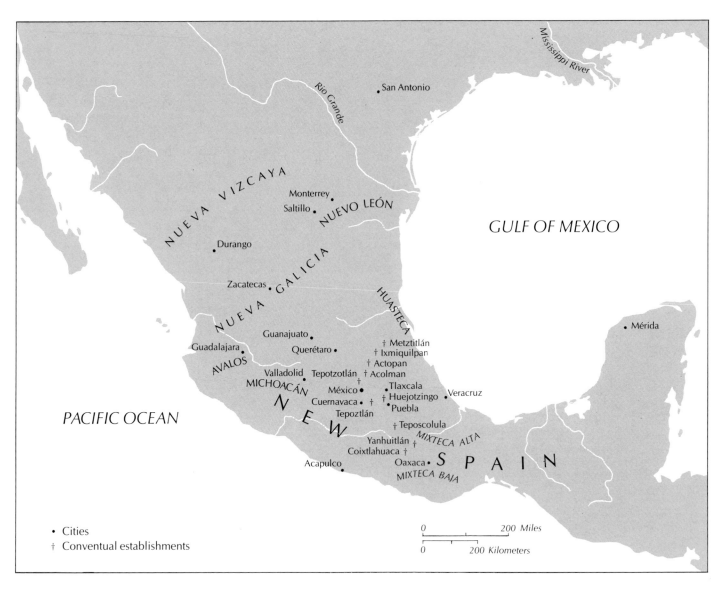

Viceregal Mexico

tantly, in featherwork (feather mosaic) and corn-pith sculpture. But these techniques came to be used for objects whose forms were alien to the native tradition. Featherwork appeared on bishops' miters, on altar silver, and in images copied from oil paintings, while corn pith was used to make lifelike figures of Christ and the saints.

As important as the momentous rupture of tradition and the importation of new models were the ways in which those models were introduced, accepted, and integrated into this world of neophytes. It is this process that generated the art of New Spain, giving it its individuality and personality.

A formal model is not an isolated entity—even though its creator may be a talented artist who seems highly original. Rather it is a term in a long tradition and forms part of a centuries-old sequence of cultural accumulation. It takes on meaning for the artists who are inspired by it because, consciously or unconsciously, they accept that sequence. European models presented the Mesoamerican peoples with immense problems of interpretation, or "reading." In the same way that one who does not know a language cannot repeat its sounds without effort and long training, because he cannot hear them, one who is totally unfamiliar with a

cultural tradition has serious problems in reading its forms, as well as understanding their function and meaning.

Fray Toribio de Motolinía, the sixteenth-century friar and historian, tells of the Indians' astonishment when the first arch was built in the chapel of San José de los Naturales at the convent of San Francisco in Mexico City. When the scaffolding was taken away, they would not walk under the arch, for they were sure it would come down. This was an ancient form in Europe, but it was unknown in the building practices of Mesoamericans and thus was incomprehensible to them. More important to my discussion is the San José Chapel itself, where the first art school in New Spain was established under the direction of the lay brother Pedro de Gante. In the first years after the Conquest there were very few capable art teachers in New Spain, and Fray Pedro himself was not a consummate artist. But at San José he certainly taught his pupils to understand the new forms. That is, he made it possible for the Indians to comprehend a formal world that was alien to them: the meaning, in traditional European art, of line, of foreshortening, of volumes, of color, of costume, of symbols, and so on. Only by making that formal world their own would they be able to reproduce it—that is, make those images and objects that were indispensable for the new religious and social order. In large part they did succeed, but not without difficulties and mistakes in interpretation. It is this distance between the European models and the Indian understanding of them that characterizes the art of the decades following the Conquest—the art called *tequitqui*. It has often been said that *tequitqui* art shows influences of pre-Hispanic forms. In fact, even though there are forms that are clearly pre-Conquest, they are found in connection with definite Christian iconographic programs; a careful study can document no Precolumbian artistic influences. The undeniable differences between the original European models and the Mexican works can only be attributed to "mistakes in reading." We often hear that the friars employed Indian artists who had been trained before the Conquest, but this has not been documented. On the other hand, we read in the chronicles that boys, preferably sons of Indian lords, were taken into their convents and schools to be instructed in the new formal world. Well known among these was Juan Gerson, *cacique* (chief) and painter from Tecamachalco in Puebla.

In succeeding generations the problems of understanding European models diminished, until they seemed to disappear in the more homogeneous world of New Spain during the seventeenth and eighteenth centuries. But even then some uncertainties persisted in the comprehension of the full meaning of imported forms; this hesitation extended into the Neoclassical period and remained one of the characteristics of Mexican art.

I have said that the European models were the only ones used after the Conquest. There was, however, a great shortage of these indispensable models. Pictures and sculptures were imported—but these works were of no great importance and arrived in small numbers. Engravings were the major and most constant source. In the first decades after 1521 there were the modest engravings from books brought over by the religious orders in considerable quantities; these wood engravings were usually simple

illustrations with typographical elements: title pages, grotesque borders, chapter headings, vignettes, and so forth. On the basis of these limited models the people of New Spain mounted an incredible constructive and decorative effort. Typographical borders were made into carved or painted friezes; religious pictures were turned into many thousands of square meters of fresco paintings and sculpted images over doorways; title pages became the monumental facades of churches. A world in the process of acculturation and evangelization experimented with architectural forms that, although derived from European structures, responded to the local situation. For example, the Mexican convent of the sixteenth century was a diversified complex, some of whose elements—the open chapel among them—were absolutely original.

The erection of these structures owed something to the ancient forms of organization among the indigenous peoples; the *tequio*, or system of community service, made it possible in many cases to build monuments of astonishing size. There was also the labor force controlled by the encomienda, the sixteenth-century form of organized production that subjected the Indian communities to Spaniards for tribute labor. The religious orders, which soon attained great power and prestige, were a dominant factor in the organization of large works. Along with the shortage of models, a major problem was that of the lack of specialized workers. The few capable journeymen who crossed the ocean in the early sixteenth century taught small groups of Indians, who then covered the territory in traveling teams. On each project they instructed the local populace and supervised the work. This explains the recurrence of similar solutions in widely separated places, as well as the application of methods that required little specialization, such as the cylindrical columns of the cloisters, all with the same bases and capitals. It was a kind of assembly-line construction that answered the need for speed.

In the last three decades of the sixteenth century there were major crises in New Spain. The most serious was the drop in the native population, which led to a shortage of labor. The encomienda system was coming to an end, and new forms of organized production were being introduced—the repartimiento and the hacienda. The secular clergy led by the bishops began to impose their power on the weakened monastic orders. The cities were growing and taking over the leadership of the country, which had previously been predominantly rural. Artistic production also changed in striking ways. Although the *tequio* was still in evidence, works were no longer produced by the community but depended upon the existence of patrons, rich men who financed buildings, churches, convents, altarpieces, and paintings. The viceregal authorities, the church and civil councils, and private patrons began to impose their individual tastes on public works.

It was under these circumstances that the first coherent group of artists, in the modern sense of the word, appeared in New Spain. They arrived in the entourages of the viceroys or archbishops, or they were brought by some Maecenas. There were Mannerist painters and sculptors trained in Flanders, Italy, or Seville and architects who explained their Mannerist creed in writings circulated in Mexico during the last years of

Wood engravings of the border of the title page of Juan de Zumárraga, *Dotrina breve muy p[ro]vechosa delas cosas q[ue] p[er]tenecen ala fe catolica y a n[uest]ra cristiandad* (Mexico, 1544). Courtesy of the John Carter Library at Brown University

the sixteenth century. Artists in the service of a cultivated class of highly placed churchmen, bureaucrats, or Creoles educated at the University of Mexico (founded in 1553) formed a kind of inner circle devoted to the ideas of the Renaissance. They brought to New Spain what we might call a "modern" concept of the role of the artist.

Each artist came with an ample repertoire of models. Painters and sculptors had portfolios of engravings of famous works; architects carried treatises by Alberti, Serlio, Vignola, and Sagredo. Unlike the earlier builders of the convents, they took pride in their status as artists. The Mannerism of those final decades of the sixteenth century was by far the most faithful expression of contemporary European models to appear in America.

The Mannerist artists opposed their "modern" concept of the artistic object to what may be called the "traditional" one. According to the "traditional" view, an object (what today we call a "work of art") is valid only insofar as it fulfills its function; it is just another object, although one may recognize in it a certain excellence in execution or materials. According to the "modern" view, the artistic object has special qualities that differentiate it from other fabricated objects. After the appearance of Mannerism in New Spain both viewpoints coexisted. The great number of anonymous works, as well as the freedom to alter a sculpture or painting out of necessity or taste, reveals the persistence of the "traditional" concept. On the other hand, the pride with which some painters signed their work and the great prestige they came to attain show us that the "modern" idea was also present. It is this ambiguity we must keep in mind if we are to understand the art of New Spain.

The advent of the Mannerist artists and the establishment of large and prosperous studios capable of handling most of the local needs (and even of providing works for export) very nearly cut off the influx of European works and put a halt to the immigration of European artists. This phenomenon was of capital importance to the subsequent development of art. Having crossed the ocean, the Mannerist artists were separated from the environment in which they had been educated; in their studios they, in turn, trained pupils who had no knowledge of that background. Thus, by the beginning of the seventeenth century Mexican artists were for the most part isolated from the European world. Their information was reduced to what they could learn from engravings, which were not in great supply.

Every artistic form is modified by time; and in this state of isolation the thriving studios of New Spain, which responded to the taste of local society, began an evolution of their own, based on European models but moving in a different direction.

Thus it was this very dynamic of local Mannerism that led to the appearance of a Baroque movement in New Spain, which was not simply an imitation of Baroque forms modified in America. However, Europe did continue to be the source of models, which in one way or another reached the New World. From time to time accomplished European artists crossed the Atlantic, bringing with them the innovations of the moment. These new ideas had their impact on the local scene, but the artists who intro-

duced them modified their own styles to suit an established environment and taste. We must understand the complexity of the relationships between the internal dynamic and the effect of external models (which still suffered from "wrong" readings, although not to the same extent as in the sixteenth century) if we are to follow the tangled expansion of the Baroque movement in New Spain during the seventeenth and eighteenth centuries.

Toward the end of the eighteenth century there was a new departure: Neoclassicism. Local Baroque art had been held in very high esteem (it was often referred to as "the eighth wonder of the world"), but when the artists of New Spain faced the ideas of the Enlightenment, they felt painfully distant from Europe. They had a great desire to overcome their own isolation—which they blamed, and rightly so, on the colonial regime—and to become modern. To do this, they had to establish relations with other nations of the world, which in terms of art, meant embracing Neoclassicism. The founding of the Academy of San Carlos of New Spain (1781) was a response to this desire. But Mexican Neoclassicism, too, had its own course of development, which set it apart from its most immediate European models. For Mexican artists, the price of being modern meant abandoning their own traditions, stepping down from the position they had so proudly held. This censure of isolation and eagerness to join the modern world were announcing, in a way, the coming Independence.

Any attempt to understand the rich and ample world of the art of New Spain must take into account the specific factors that determined its development over three centuries. Among these are: the social conditions under which it was produced; the ambiguous status of the work of art, which shared both traditional and modern concepts; the need for European models and at the same time the scarcity of them; the forms of communal production and wealthy patronage; the isolation from European developments in art and the resultant difficulties of knowing and assimilating them; the shaping of enduring traditions and individual tastes in an out-of-the-way part of the world; and the impact of the great innovations (Mannerism, Neoclassicism) that never, however, quite supplanted local traditions. Thus the art of New Spain appears not as a second-rate derivative of that of the European capitals but as one with its own values and development and with an enormous creative and inventive power. It is the magnificent result of modifying and transporting European culture into another space, into what Baltazar Gracián called, in his Baroque metaphor, "a portable Europe."

The Mission: Evangelical Utopianism in the New World (1523–1600)

Donna Pierce

Posa chapel, about 1550, Franciscan convent, Huejotzingo, Puebla. Photo: Michel Zabé

Since the discovery of the New World occurred in the same year as the Reconquest of Spain from the Moors, it was viewed by Spaniards as a reward from God for centuries of struggle against infidel rule. The awesome gift brought with it an equally daunting responsibility—that of converting hundreds of thousands of American Indians to Christianity. After the discovery of the New World, Pope Alexander VI divided the non-European world between Portugal and Spain granting them the right to exploit the resources of the new lands on the condition that they convert the people of those areas.

Throughout the colonial period, this right to exploit the resources, human and otherwise, and the obligation to spread Christianity often seemed diametrically opposed. Bernal Díaz del Castillo, one of the original conquistadors, expressed the prevailing attitude when he explained that they came "to serve God and His Majesty, to give light to those living in darkness, and also to gain riches."[1] The situation frequently pitted Spaniard against Spaniard, usually civilians against ecclesiastics, in a battle over which goal had priority. The conflicts precipitated a series of theological and philosophical debates that began shortly after the discovery of America and persisted throughout the sixteenth century. The first of the great colonizing nations of western Europe, Spain engaged in probably the one and only formal inquiry into the justice of conquest and its methods.

A sermon condemning Spanish treatment of the Indians, preached by Fray Antonio de Montesinos on Hispaniola in 1511, ignited the first series of debates which culminated in the Laws of Burgos in 1512–13. Spanish intellectuals and officials wrestled with the implications of rule over the Indians and the ensuing laws attempted to define and protect the rights of both Spaniards and Indians in the New World. These laws officially sanctioned the encomienda system, already in practice, through which the Crown gave or "commended" Indians to Spaniards for exaction of labor or tribute. In return, the Spanish encomenderos were obliged to provide religious instruction and to protect the Indians as well as to defend the corresponding area for the king.

Further disputes over the ethical and practical questions of just rule in the New World inspired Pope Paul III to declare in 1537 that the Indians were human beings whose rights must be respected, that they could not be deprived of personal liberty or property, and that they were capable of comprehending the tenets of Christianity. Whether Aristotle's theory that some men are slaves by nature was applicable to the Indians was debated many times—in Burgos in 1512, Salamanca in 1517, and, most dramatically, by Juan Gínes de Sepúlveda and the great defender of the Indians, Fray Bartolomé de las Casas, in Valladolid in 1550–51.

Las Casas, a Dominican friar active in the New World, and others had been trying to convince the king that the Indians suffered greatly under the encomienda system. The New Laws of 1542 abolished it and the enslavement of Indians, and they further protected the rights of the Indians. Although most of the anti-encomienda laws were soon revoked, the legislation illustrates the divided feelings on the subject and the Crown's attempt to institute a humanitarian policy in the New World. When viewed in the context of the period, it is quite remarkable that Spain had antislavery laws on the books, however weak, before the mid-sixteenth century. Although difficult to enforce, the letter of the law and the intent of the Crown were quite enlightened for the time and reflect the brief influence of Renaissance humanism before the Counter-Reformation in Europe.

A major smallpox epidemic among the Indians had greatly aided Cortés in the Conquest of Mexico. Since the native population was highly vulnerable to diseases already minor to Europeans, a series of deadly epidemics—seven major ones by 1600—devastated Mexico. As the population decreased, tributes and workload demanded by Spanish civilians increased, causing maltreatment, more deaths, renewed outcries against the situation, and further confusion over how to strike a balance between use and abuse.

After the Conquest the Spanish rebuilt the city of Mexico over the ruins of Tenochtitlán in a conscious attempt to symbolize their triumph over Aztec military and religious power. Churches were built on the rubble of pyramids, and stone carvings of pagan deities were ceremonially incorporated into the foundations of some Christian buildings. Cortés and his retinue occupied the palaces of Moctezuma on the east and west sides of the great plaza and fortified them with towers and walls in the medieval tradition. From there, he and his soldiers ruled the area much like medieval knights and exacted labor from the Indians much like feudal landowners did from their serfs. Below this overlay of upper-echelon Spaniards, the organization of Indian society retained its general pre-Conquest structure. Indian leaders continued to govern their people and were responsible for collecting taxes and supplying laborers, and Indian communities were theoretically insulated from Spaniards under the system designated as the "Republic of the Indians."

Since the beginning of the Conquest, Cortés had encouraged Charles V to provide for the conversion of the Mexican Indians. In his fourth letter he wrote, "Your Holy Majesty should send to these parts many religious persons . . . who would be most zealous in the conversion of these people, and that they should build houses and monasteries in the provinces."[2] Cortés also suggested that Charles V entrust the conversion of the Mexicans to the mendicant orders, particularly the Franciscans and Dominicans, rather than to secular priests, and the emperor complied. The first three Franciscans arrived in 1523. All three were Flemish and one, Pedro de Gante (Ghent), was a relative of Charles V. They were followed by twelve more Franciscans in 1524, in conscious emulation of the Twelve Apostles. As part of the religious reform sweeping Spain during the time of Cardinal Francisco Ximénez de Cisneros, the Franciscans had recently

rededicated themselves to a simple life of Christian spirituality and service. The Franciscans were followed by the Dominicans in 1526 and the Augustinians in 1533. Millennialism was a popular philosophy among both clerics and laymen at the time. Based on the Apocalypse of St. John, millennial philosophy theorized that the thousand-year rule of Christ on earth would be possible only after all peoples had been exposed to Christianity. The friars saw themselves as part of the second great wave of evangelization in preparation for the Second Coming.

Sixteenth-century open chapel, Teposcolula, Oaxaca

They began by baptizing Indians by the thousands, replacing pagan deities with Christian images and assuming the positions of religious leadership vacated by the native priests. Small temporary chapels were rapidly constructed and the open chapel, one of the architectural solutions unique to the New World, was invented. This structure, an open-sided chancel or chapel, was built to house the altar, the Host, and the celebrating priests while the congregation stood in the churchyard that functioned as an outdoor nave. In some cases, especially in the Yucatán, the open chapel was eventually incorporated into the church structure; in others, as at San José de los Naturales and Cholula, the open nave was roofed but not walled; in still others, the open chapel and atrium continued to function alongside the completed church. This building type evolved in response to several conditions: the Mexican Indians were accustomed to outdoor religious services; an immense number of Indian converts had to be accommodated in the early period; and large churches could not be constructed rapidly.

Reflecting the early period of humanist idealism, the seminary of the Holy Cross, attached to the church of Santiago Tlatelolco, was founded in 1536 to train Indians for the priesthood. In a backlash of conservatism, however, the ecclesiastical council of 1555 prohibited the ordination of Indians. Eventually the different orders also banned mestizo and criollo priests. A few distinguished exceptions to these rules paved the way for Indians and others to enter the priesthood sporadically in the seventeenth century. One notable exception was Diego de Valadés, the first mestizo friar, who became a Franciscan under the tutelage of Fray Pedro de Gante. Valadés was the first Mexican to publish a book in Europe—his *Retórica cristiana* (1579) is a history of the evangelization of New Spain.

In the late 1520s, in an attempt to divert the government of New Spain away from the conquistadors, the Crown established a judicial body known as an audiencia, which initially functioned as the king's representative body. The First Audiencia was founded in 1528 and, unfortunately, constituted one of the most corrupt and cruel governments in the history of colonial Mexico, persecuting Spaniards and Indians alike. In contrast, the Second Audiencia (1530–35) tried desperately to undo the damage of its predecessor and, by the time the first viceroy arrived in 1535, had established a stable political climate in Mexico.

During the 1530s three men came to power who were to have a major impact on the history of Mexico: Bishop Fray Juan de Zumárraga (1527–48), Viceroy Antonio de Mendoza (1535–50), and Judge Vasco de Quiroga (1531–65). These learned men were guided by the humanist theories of the European Renaissance, particularly those of Erasmus of Rotterdam,

Bishop Fray Juan de Zumárraga's copy of the Frobenius edition of Thomas More's *Utopia*. Perry-Castaneda Library, The University of Texas at Austin

Map of Cholula, 1581, from the *Relación geografíca*. Perry–Castaneda Library, The University of Texas at Austin

Thomas More, and Leon Battista Alberti. They shared the vision of implementing the ideals of Renaissance philosophy in the New World. Together or individually they founded towns, schools for Indians, hospitals, a printing press, and the university; they curbed the power of the conquistadors and encomenderos; they commissioned works of art and influenced town planning and architecture.

Zumárraga, a Franciscan, was appointed as the first bishop of Mexico and protector of the Indians in 1527 and was soon embroiled in a bitter dispute with the corrupt judges of the First Audiencia. A proponent of Erasmian thought, Zumárraga published two treatises that advocated the application of humanist-Christian ideas in Mexico: *Doctrina breve*, a manual for missionaries, and *Doctrina cristiana*, a catechism for Christianized Indians. Zumárraga also owned a personal copy of Thomas More's *Utopia*.

His friend and colleague Vasco de Quiroga had arrived in New Spain as one of the judges with the Second Audiencia and later became bishop of Michoacán (1538). Quiroga actually attempted to create communities in Michoacán based on the principles of More's *Utopia* including communally owned property, communally organized projects, democratic government, specialized craft production, free trade, and liberal education. In a sense, the New World provided a place for enlightened Europeans to implement the advanced social ideas that were inapplicable among the entrenched governments and towns of the Old World. What was considered utopian in Europe became a reality in the New World, if only for a brief time.

Mendoza, the first viceroy of Mexico, came from a prominent family that has been credited with introducing aspects of the Italian Renaissance to Spain. Mendoza brought a personal library of more than two hundred books with him to Mexico including a copy of *De re aedificatoria* (On Architecture) by the great Italian Renaissance scholar and theorist Leon Battista Alberti.[3] Mendoza's heavily annotated copy of this treatise has survived and provides an insight into the mind of this learned official.

European cities were already constructed in the haphazard and fortified manner of the Middle Ages, but the New World provided a clean slate for building unfortified cities based on a grid plan. The Aztec city of Tenochtitlan was laid out on a general grid with a large central plaza and main streets at right angles, but streets within the larger grid were apparently narrow and irregular. As a result, it was not difficult to overlay the Renaissance city plan. "Ordered" city plans had been advocated by the Spanish Crown for towns in the New World as early as 1516. Cortés's city planner, Alonso García Bravo, had begun the process shortly after the Conquest. Mendoza, however, has been credited with actually realizing the ideal city plan of the Renaissance in Mexico by widening and regulating streets, orienting them for optimum ventilation and sunlight, and by enlarging the plaza to a rectangle twice as long as wide, all following Alberti's formulas. The unfortified town with its monumental plaza and wide straight streets became a source of amazement to European visitors, and was reproduced all over Latin America.

Mendoza worked closely with the Franciscan and Augustinian friars

to develop a so-called moderate plan for the religious establishments of Mexico, probably also based on the Renaissance formulas of Alberti. Although no written record of this plan has survived, its format is obvious in the uniformity of the sixteenth-century mission structures.[4] They generally include a single-nave church structure, a one- or two-story convent around a patio on one side, and a large walled churchyard or atrium in front. Some atriums include small structures in the four corners, called *posas*, whose function is still unclear but that may have been used as chapels for processional altars. The churches usually dominate one side of the rectangular plaza of the surrounding village. Aside from seaports, the only fortified aspect to most New World towns became the mission churches which had defendable walls and doors, and symbolized the idea that the Christian religion provided the ultimate protection.

These large monastic establishments were built as great outposts of Christianity all over Mexico and represented the Christian Renaissance ideal of a utopian society. Within these complexes the Indians were educated and Christianized. Some establishments remained "moderate," according to Mendoza's instructions, while others, especially those of the Augustinians, were more elaborate. Given that it was under the direction of only several hundred friars at the most and an occasional master craftsman, and using untrained Indian labor, the sheer volume of construction during the sixteenth century is overwhelming. By 1540 there were approximately fifty establishments, and twenty years later there were almost one hundred. Their construction often precipitated conflicts between the priests and Spanish civilians over Indian labor. Whether the Indians participated in these projects through genuine desire, persuasion, or coercion is unclear, but probably all three were operative.

Since there were few trained architects in Mexico, the designs for churches were based on the friars' memories of European buildings combined with models taken from book illustrations. As a result, the architecture is a mixture of Gothic, Renaissance, or Mudejar (Moorish-Christian) styles often executed with a slight pre-Hispanic flavor. For example, church entrances might be decorated with Renaissance porticoes distorted vertically to Gothic proportions or with Mudejar door frames surrounding Classical columns; Gothic rose windows and medieval crenels grace churches with severe Renaissance facades. By midcentury a handful of architects was present in Mexico; they produced a few integrated designs, some of which were copied several times over with varying degrees of elaboration, but their influence was minimal.

The conquistadores had described with wonder the feathered capes and headdresses, turquoise and jade masks, gold and silver objects, painted walls, and great sculptures of Aztec gods. In 1519, before the Conquest was even completed, Cortés sent the first of several shipments of gifts to King Charles. These treasures of the New World were exhibited in Spain and Brussels where they impressed the German artist Albrecht Dürer. In 1520 he wrote: "I have also seen the objects they have brought to the King from the new golden land: a sun of solid gold that measures a full fathom; also a moon of pure silver, equal in size; also two halls filled with curious armaments . . . an endless number of strange objects. . . . In all my life I

Mudejar-style portal, Church of Santiago, Angahuan, Michoacán. Photo: G. Aldana

Mural, Augustinian convent, Ixmiquilpan, Hidalgo

have never seen anything that has so delighted my heart as did these objects; for there I saw strange works of art and have been left amazed by the subtle inventiveness of the men of faroff lands."[5]

The king's treasures stimulated an interest in collecting New World art among the aristocracy and royalty of Europe. Many of the crafts of pre-Conquest Mexico were continued in the sixteenth century, but native iconography was replaced by Christian subject matter for European patrons in both Europe and Mexico.

The continuation of Indian crafts was particularly encouraged in the early post-Conquest period by Fray Pedro de Gante at San José de los Naturales, the Franciscan convent school for Indians in Mexico City, and by Bishop Vasco de Quiroga in Michoacán. In the mid-sixteenth century, pre-Hispanic crafts, especially manuscript painting, were both encouraged and documented by Fray Bernardino de Sahagún at the Franciscan convent school of Santiago Tlatelolco in the northern section of Mexico City. The pre-Conquest art of manuscript painting, with some influence from European painting styles, was used to document native traditions, New World products, and tribute accounts. The pre-Hispanic technique of feather mosaic was applied to priests' vestments and religious pictures, and the native craft of making lightweight sculptures from a paste of corn pith was used for images of Christ and the saints. Walls of churches and convents were covered with mural paintings frequently executed by Indian artists under the supervision of friars with European book engravings as models.

Indian craftsmen were quick to learn European artistic traditions. In some cases they were trained by friars or Spanish master craftsmen; in others they learned by relying on their own ingenuity. Fray Toribio de Benavente, known as Motolinía, described the facility with which Indian artisans copied the work of European masters.

> In the mechanical arts the Indians have made great progress, both in those which they cultivated previously and in those which they learned from the Spaniards. After the arrival of the Flemish and Italian models and paintings which the Spaniards brought, excellent artists developed among the Indians. . . . All they need to be good silversmiths are the tools, and these they do not have. Instead, they place one stone upon another and in this way fashion a smooth cup and a plate. But in melting a piece of silver and in shaping it from the mold, they surpass the silversmiths of Spain in that they fashion a bird which moves its tongue, its head and its wings. . . . They make everything necessary for a saddle seat. . . . The truth is that they did not know how to make the saddletree. So, when a saddler placed one at the door of his house, an Indian waited until the saddler went in to eat; whereupon he stole the saddletree in order to make one like it. The next day, at the same hour, while the saddler was eating, the Indian went and put the saddletree back in its place. Six or seven days later he passed through the streets selling saddletrees.[6]

The degree to which Indian craftsmen retained their own techniques and artistic sensibilities has long been a matter of debate.[7] Indian art in the service of Christianity is referred to as *tequitqui*, a Nahuatl word meaning "one who pays tribute." In the art of the sixteenth century one often detects motifs that appear to have an Indian flavor. Sometimes these are elements

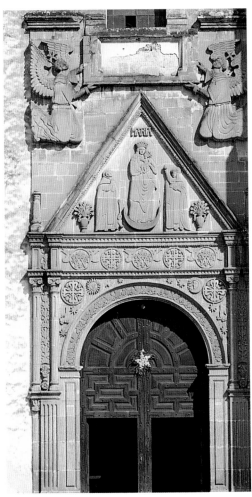

Tequitqui-style portal, Dominican convent, Tepotzlán, Morelos. Photo: G. Aldana

that could have a double meaning, both Christian and Indian; sometimes they employ a pre-Hispanic formula, such as a series of dots for numbers; and, less tangible but more prevalent, they sometimes exhibit stylistic conventions and techniques that had been used in pre-Conquest times. Survival of Indian artistic sensibility in sixteenth-century art is hard to define and harder to prove. Indian style may appear often in areas in which the two traditions, Indian and Spanish, overlap and reinforce each other, making differentiation between the two difficult.

The fervor of the early missionizing period began to die out in Mexico shortly after midcentury. The humanist ideas of the Renaissance, especially those of Erasmus, became confused with Protestantism and were condemned by the Council of Trent. Spain retreated into the Counter-Reformation and the conservatism of the reign of Philip II. The enthusiasm for creating the Christian-humanist utopia in the New World was dampened. The series of European-introduced plagues, maltreatment by Spaniards, and ongoing rebellions in outlying provinces had decimated the Indian population of Mexico. Struggles with Spanish civilians and officials over control and protection of the Indians caused the mendicant orders to fall into political disfavor and they began to be replaced in their missionary posts by secular priests. For the most part, by the 1570s the great wave of evangelization, and the artistic traditions that accompanied it, had subsided.

NOTES

1. Bernal Díaz del Castillo, *Historia verdadera de la conquista de la Nueva España*, 7th ed., with an introduction and notes by Joaquín Ramírez Cabañas (Mexico, 1977), vol. 2, p. 366.
2. Hernán Cortés, *Letters from Mexico*, translated and edited by A. R. Padgen, with an introduction by J. H. Elliott (New Haven and London, 1986) p. 332.
3. Guillermo Tovar de Teresa, *La ciudad de México y la utopia en el siglo XVI* (Mexico, 1987).
4. The following discussion on sixteenth-century church architecture is based on George Kubler, *Mexican Architecture of the Sixteenth Century*, vol. 2 (New Haven, 1948).
5. As quoted by Ferdinand Anders, "Las artes menores/minor arts," *Artes de México* 17, no. 137 (1970) p. 46.
6. Motolinía [Fray Toribio de Benavente], *Motolinía's History of the Indians of New Spain*, translated and annotated by Francis Borgia Steck (Washington, D.C., 1951), pp. 299–300.
7. The most extensive published survey of this question is in Constantino Reyes-Valerio, *Arte indocristiano: escultura del siglo XVI* (Mexico, 1978). See also Linda Bantel and Marcus B. Burke, *Spain and New Spain: Mexican Colonial Arts in Their European Context*, exh. cat., Art Museum of South Texas (Corpus Christi, Texas, 1979) p. 56, n. 43; Manuel González Galván, "Influencia, por selección, de América en su arte colonial," *Anales del Instituto de Investigaciones Estéticas* 13, no. 50 (1982) pp. 43–54; Constantino Reyes-Valerio, "El arte indocristiano o tequitqui" in *Historia del arte mexicano*, 2d ed., vol. 5, *Arte colonial, I* (Mexico, 1986), pp. 706–25, and Elisa Vargas Lugo, "Sobre el concepto tequitqui," in *Historia del arte mexicano*, 2d ed., vol. 5, *Arte colonial, I* (Mexico, 1986), pp. 710–11.

115 ◀ Atrial Cross

◀ Before 1556
◀ Stone; height 345 cm. (135 in.)
◀ SEDUE, Capilla de los Indios, Basílica de
◀ Guadalupe, Mexico City

Crosses such as this one often stood in the atria or forecourts of sixteenth-century mission churches. The present example is made of one piece of stone, except for the scroll bearing the inscription "INRI." Unlike most crosses of this type, the crosspiece and the upright are oval in section. Among the images carved in vigorous relief on the front are the "Arms of Christ," the weapons with which Christ defeated the devil and death, specifically the Cross and the Instruments of the Passion.

Below the Holy Face is the Crown of Thorns, hung as a pectoral falling in equal proportions on both front and back of the sculpture. Surrounding it is a stole that wraps around both arms of the crosspiece; this liturgical garment is a symbol of the immortality that was lost through the sin of Adam and Eve and was recovered by the Redemption. At each end of the crosspiece and on the upright the Holy Nails perforate the cross, which as the Tree of Life gushes drops of blood. The ends of the crosspiece are carved as large pearls, surrounded by corollas with small petals. The same motif is repeated at the top of the upright, where the elaborate scroll with the Latin inscription "INRI" (Ieusus Nazarenus Rex Iudaeorum) ordered by Pilate stands. Around it are cherubs and bursting pomegranates, symbols of the unity of the Church.

The Arms of Christ are arranged along the upright. From the bottom up they are: the column of the Flagellation, with the cock of St. Peter's denial sitting on it, flanked by the sun and the moon—symbols of the Old and New Testaments—and Christ's tunic and the ladder; above these are the bottom nail of the Crucifixion and the gush of Christ's blood, near the chalice with the Eucharistic wafer; beside these are the lance and the reed, the pincers, the pole, and the sponge, St. Peter's sword, the ear of Malchus, and the hammer. This synthesis of the Passion is indicative of the importance of Christocentrism in the evangelization of New Spain.

The images incorporated in the iconography of the Passion that appear on this cross probably did not originate in New Spain, even though this type of solution is most frequently found there, predominantly in the courtyards of sixteenth-century convent churches established by the Franciscan missionaries. It was once believed that this type of cross and imagery were a local innovation, but a few years ago an earlier cross in metal with details of the Passion was discovered in Ravenna, Italy; more recently, small Passion crosses in wood with the same series of images, dating from the sixteenth century, have been found. We do not know, however, if they are European or from New Spain. They may have been used by the missionaries in their personal meditations on the Passion. In any case, we do know from *The Mass of St. Gregory* (cat. no. 119) that by 1539 this type of iconography was established in New Spain.

This cross now stands at Tepeyac, the site of the apparition of the Virgin of Guadalupe, where in pre-Hispanic times a ceremonial center was dedicated to the worship of the goddess Tonantzin, "Our Mother" (and where, according to Torquemada, the Franciscans had decided to build a church dedicated to "the most Holy Virgin who is our Lady and our Mother"[1]). About 1556 the archbishop Montúfar established a hermitage at Tepeyac when the cult of the image of Our Lady of Guadalupe began to spread; this cross was probably erected there at that time. It was recently moved to the roofless nave of the chapel built by the Bachelor Lazo de la Vega between 1640 and 1650; eighteenth-century paintings show it in front of the Colegiata de Guadalupe built by Pedro de Arrieta in 1695–1709.

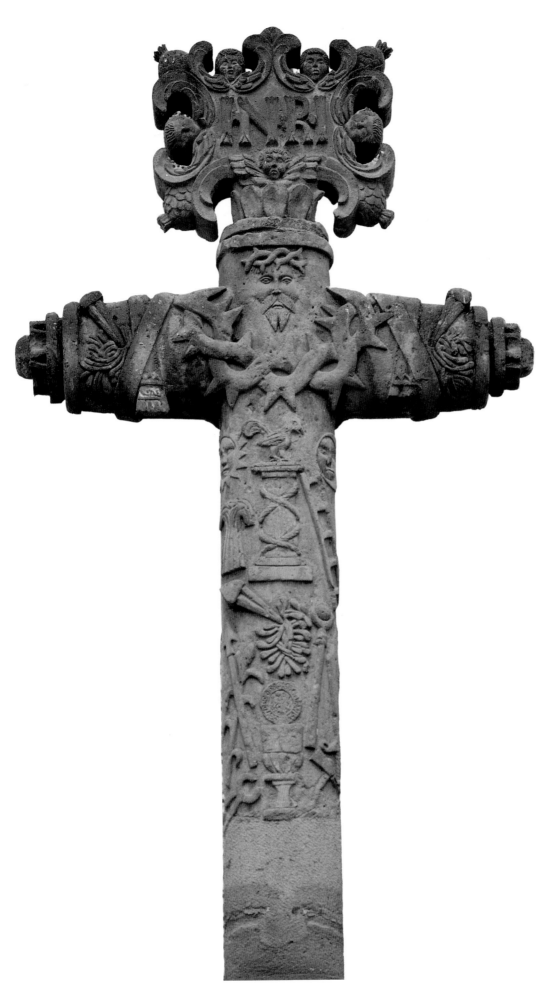

Except for its size and lack of pedestal, this cross is strikingly similar in shape and decoration to the one from the nearby convent at Atzacoalco. The latter dates from the middle of the sixteenth century, the period of Franciscan administration of the school of mechanical arts at San José de los Naturales de San Francisco, and it is conceivable that its sculptor was an artisan at that center. Because both crosses present the same program and technique, it is possible they were made by the same sculptor. A cross in the atrium of the Franciscan convent at Huichapan is larger but has exactly the same features as those at Tepeyac and Atzacoalco.

Motolinía observed that in New Spain "the sign of the cross is more venerated . . . than in any other place in Christendom, and nowhere are there so many crosses or such large ones; in the courtyards of the churches they are very grand, and every Sunday the people adorn them with many roses and flowers and palm branches."[2]

Religious chroniclers note that children who were being taught Christian doctrine often gathered around a convent's atrial cross on Sundays. Perhaps their teachers made didactic use of the Arms of Christ represented on them to illustrate passages concerning the Passion.

EIEG

1. Fray Juan de Torquemada, *Monarquía Indiana*, with an introduction by Miguel León Portilla (Mexico, 1975) vol. 2, pp. 245–46.
2. Motolinía [Fray Toribio de Benavente], *Memoriales, o libros de las cosas de la Nueva España y de los naturales de ella*, edited by Edmundo O'Gorman (Mexico, 1971) p. 167.

REFERENCE
Elizabeth Wilder Weismann. *Mexico in Sculpture, 1521–1821.* Cambridge, Mass., 1950, no. 2, pp. 8–10, pp. 189–90.

116 ‹ Baptismal Font

Mexican, second half 16th century
Stone; height 109 cm. (43¼ in.), diameter 105.4 cm. (41½ in.)
CNCA–INAH, ex-Convento Franciscano, Tecali
NOT IN EXHIBITION

The baptismal fonts and holy-water basins of sixteenth-century New Spain constitute a rich collection of enormous iconographic variety, whether they are made of glazed clay, of stone faced with painted plaster (the technique used in painted murals), or, as in most cases, of stone carved with grotesques, inscriptions, medallions of various sorts, and figurative scenes. The cylindrical basin of this stone font from the church of St. James the Apostle in Tecali rises from a convex corolla carved with more than twenty double petals in the form of a daisy, or *margarita* (in Latin also the word for pearl). Both meanings are symbolically associated with the apocalyptic description of the Gates of Heaven or the New Jerusalem: "Et duodecim portae, duodecim margaritae sunt, per singulas, et singulae portae amant ex singulis margaritis" (And the twelve gates were twelve pearls [margaritae], each of the gates made of a single pearl [margaritis]). (Revelation 21 : 21). Thus the phytomorphic motif seems to bestow on this baptismal font the power of the Gates of Heaven as well as that of the Tree and the Fountain of Life.

Above the corolla in a frieze framed by beaded moldings are six medallions, five containing either the monogram of Christ or the Virgin Mary and one representing the shield of the Five Wounds of Christ. The central monogram (XHS) corresponds to the name of Jesus Christ (devotion to the Holy Name was popularized during the Middle Ages by the Franciscan St. Bernardine of Siena). This iconography had been common since the beginning of proselytiz-

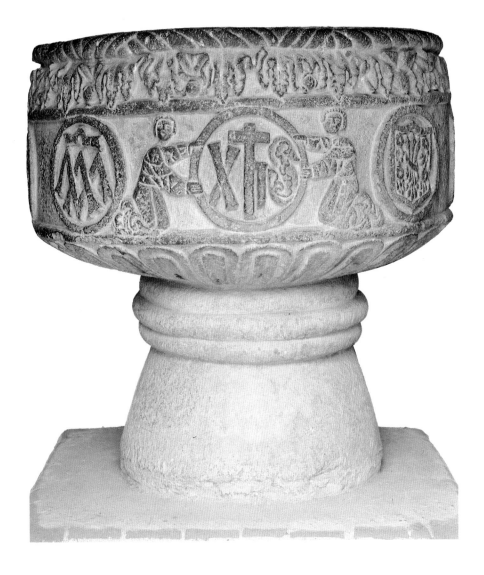

ing efforts in New Spain; along with the Exaltation of the Holy Cross, it was one of the first motifs to appear in the religious art of that period. The monogram is supported by two kneeling figures of heraldic bearing. They wear loose, undulating, ankle-length robes or tunics, like those worn by angels depicted in the reliefs and painted murals in a number of sixteenth-century convents, such as those of the *posas*, or atrium chapels, at Huejotzingo and Calpan, or on the fonts of Zinacatepec and Acatzingo. The figures from the present font, however, are not angelic since they have neither wings nor crowns. Given the millennial and apocalyptic character of Franciscan thought during this period in New Spain, they probably represent catechumens waiting to receive the first sacrament, baptism. The schematic, linear character of the two figures indicates they were inspired by a European woodcut, and this piece is thus an example of the *tequitqui* style of sixteenth-century Mexico. The shield of the Five Wounds to the right of the central monogram refers either to the Franciscan order or to a devotion related to the Five Wounds and the Precious Blood that flows from the Fountain of Life, the baptismal font.

A frieze with a thistle motif, another Christian symbol, appears on the upper part of the basin, and the knotted cord of the Franciscan order forms the upper font's border. The base, robust and rustic, is a truncated cone capped by three moldings.

In Mexico the friars discovered that a number of the Christian sacraments had corresponding rites in pre-Hispanic religion; the Franciscans, imbued as they were with scriptural typology, utilized these for their own syncretistic purposes, as prefigurings of the arrival of a new faith that would be the foundation for spiritual conquest. One such instance involved the spring in the convent orchard of Tlaxcala, which in the pre-Hispanic era was known as *Chalchiuatl* (jade, or precious water) and "was revered as an idol, such that newborn babies were brought to be bathed in its waters as if in baptism, although they weren't named, because they held that babies so washed were purified, and cleansed of all misfortune or evil spirits or any other disasters."[1]

Because the missionaries at first had no fonts in which to baptize the Indians, the Franciscans agreed that certain ritual objects of the Aztecs could be used to represent the triumph of the faith. In this manner Fray Pedro de Gante, forced to improvise a chapel in Texcoco for the arrival of Fray Martín de Valencia and his retinue in 1524, adorned it with objects and tapestries from the treasury of Netzahualcóyotl. After the first Mass had been celebrated there, Fray Martín baptized the chief Ixtlilxochitl and his whole family.[2] Notable examples of specific objects so adapted include a large pre-Hispanic stone carving of a plumed serpent whose base was hollowed out by the friars to create a bowl for use as a baptismal font (now in the Museo Nacional del Virreinato, Tepotzotlán) and a basin for holy water supported by a *cuauhxicalli*, a pre-Hispanic vessel for sacrificial human hearts, that remains in the church of Calixtlahuaca (see also cat. no. 117).

Administering the sacrament to the new converts brought a series of problems to the missionaries during the evangelical period in New Spain. First to be baptized were chiefs and leaders, which generally insured the allegiance of entire towns, transforming them into allies and subjects and requiring them to defend the faith, pay tribute, and provide labor for the construction of the civic and religious establishments. The hegemony of the Hapsburg monarchy rested on effective indoctrination; through baptism, Hernán Cortés was assured the alliances that the Conquest demanded.

The baptism of children and the indoctrination of adults followed, initially undertaken in groups. Some early missionaries baptized as many as forty thousand people in a single day. After a few years, however, some of the clergy began to feel that this was improper; they even wondered if Indians were fully rational human beings. The question was considered by the Royal Audiencia and then by the Royal Council of the Indies. In 1537 Paul III issued a bull in defense of these new Christians, in which he recognized as legitimate the baptisms that had been carried out by the first evangelists. The papal bull reached New Spain in 1538, and in 1539 Bishop Zumárraga convoked the ecclesiastic council to confirm it. Aside from the syncretic pieces recycled from earlier pre-Hispanic objects, the vast majority of fonts stem from the period after 1539.

Detailed descriptions of the administration of the sacrament to the Indians are preserved in texts of the time as well as in visual images, particularly in the murals in the entry of the Augustinian convent in Metztitlán and in the Franciscan chapel of San Francisco Mazapa and in the allegorical engraving concerning the functions of the Franciscan communities in Fray Diego de Valadés's *Retórica cristiana* of 1546. All these date from about the same time as this baptismal font.

EIEG

1. *Relación geográfica de Tlaxcala*, edited by René Acuña. Instituto de Investigaciones Antropológicas, UNAM (Mexico, 1984) pp. 54–55.
2. Alva Ixtlilxochitl [Fernando de Alva], *Obras históricas*, edited by Edmundo O'Gorman. Instituto de Investigaciones Históricas, UNAM (Mexico, 1975) vol. 1, p. 490.

REFERENCE
Constantino Reyes-Valerio. *Arte indocristiano: escultura del siglo XVI en México*. Instituto Nacional de Antropología e Historia. Mexico, 1978, p. 215, pl. 105

117 ◀ Column Base with Earth Monster Relief

Mexico City, recarved about 1525–37
Stone; height 61 cm. (24 in.)
CNCA–INAH, Museo Nacional de Antropología, Mexico City 11–3369, 10–46639

This piece, which shows the god Tlaltecuhtli, lord of the earth and the devourer of the dead, is especially important because it was reused after the Conquest as a column base. There are several examples of sculptures of this same god utilized as column bases in Christian houses and convents. It is logical that the image of Tlaltecuhtli should have been used in this way, since in Aztec practice the god was usually not visible, being placed face down against the floor or the earth. For that very reason the native worker chose this type of sculpture for a column base: the friar was happy that the relief was on the bottom, while the Indian felt that he had succeeded in preserving the worship of the god. This practice was a tangible expression of the mixture of cultures, or *mestizaje*, brought by the Conquest: an ancient pre-Hispanic god transformed by the hand of the Indian himself into a component of European-style architecture.

EMM

The period of destruction of Indian monuments by the Spanish, which began in 1525, was still not complete in 1537. In that year the emperor Charles V, in response to a complaint from the Mexican episcopate, advised that remaining temples be demolished "discreetly" and the stones reused for constructing churches.[1]

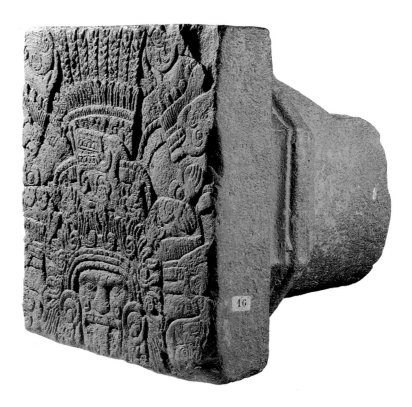

The building from which this fragment derives has not been identified. The octagonal form of the column base itself may be a Mudejar mannerism, to be noted also on the very much larger column fragments that have been excavated from the site of the Mexico City Cathedral. The latter, recarved from the serpents of the pre-Conquest *coatepantli*, or serpent wall, probably formed part of the primitive three-aisled cathedral, begun in 1526 and finished by 1532.[2]

JH

1. Robert Ricard, *The Spiritual Conquest of Mexico: An Essay on the Apostolate and the Evangelizing Methods of the Mendicant Orders in New Spain, 1523–1572*, translated by Lesley Byrd Simpson (Berkeley, Los Angeles, and London, 1966) pp. 38, 328, n. 88.
2. George Kubler, *Mexican Architecture of the Sixteenth Century* (New Haven, 1948), vol. 1, pp. 163–64, vol. 2., pp. 294–99 and passim, for summary of question. See also Elizabeth Wilder Weismann, *Mexico in Sculpture: 1521–1821* (Cambridge, Mass., 1950), p. 192.

118 ◄ Attributed to Sancho García de Larraval

Spanish, active in Mexico 1537–39

Gremial of Archbishop Juan de Zumárraga, about 1539

Embroidered velvet with gold, silver, and silk threads; 113 x 101 cm. (44½ x 39¾ in.)
CNCA–INAH, Museo Nacional del Virreinato, Tepotzotlán 10–12571
EXHIBITED IN NEW YORK ONLY

A gremial is a lap cloth placed across the knees of a bishop seated at Mass or other services. The present example is not only the oldest and most venerable work from what was once the treasure of the Mexico City Cathedral but is also the only piece preserved from the years immediately following the Conquest. It belonged to the Cathedral's first bishop and archbishop, Fray Juan de Zumárraga (1528–48). It is embroidered with gold, silver, and red silk threads on blue European velvet, with white silk appliqués. A border of decorative lettering runs around the edge; small Greek crosses at the corners subdivide the text, which reads, "ARMA MUNDI REDEM+ TORIS REGIS REGUM+UNIVERSI CREATORIS+IHVXPI SALVATORIS +" (The arms of the Redeemer of the World, King of Kings, Creator of the Universe, Jesus Christ the Savior). The center is occupied by a panoply composed of the Arms of Christ—the weapons with which Christ defeated death and the devil, specifically the Cross and the Instruments of the Passion—standing against a blue background. In the panoply are the Cross with its nails and the Crown of Thorns, rising from the empty sarcophagus. On either side are the pole with the sponge dipped in vinegar and the lance; the hammer and the pincers; the tunic; the column; the cock of St. Peter's denial; the scourge and the reed of mockery; the effigy of Judas with the rope around its neck; and the bag with the pieces of silver. A delicate circle of foliate motifs and slit ribbons surrounds the panoply. From the panoply's four sides emerge looped Franciscan cords tied with knots, representing the order's vows. In religious heraldry these loops stand for the sweet yoke of doctrine. Above the central panoply there is an inscription on a ribbon, in the form of a heraldic motto: "SIGNIA REDEMPTIONIS." Shields with the Five Wounds, which can represent either the Precious Blood or the Franciscan coat of arms, occupy the corners. These shields are encircled by small decorative borders.

The gremial has been mounted behind glass in a simple frame, with an inscription at the bottom giving a brief biography of Zumárraga, a Franciscan who in Spain had held posts as definitor, guardian, and provincial and who came to New Spain in 1528 when Emperor Charles V appointed him protector of the Indians and Caroline bishop of New Spain. As a result of his conflict with the First Audiencia, he was recalled to Spain in 1532, but he returned, invested as bishop, in 1534.

On his return from Spain Zumárraga brought with him a master embroiderer to teach that craft, unknown in pre-Hispanic Mexico, to the Indians. This artisan, hired at a salary of forty thousand *maravedíes* per year, was Sancho García de Larraval, Zumárraga's nephew. The new teacher suddenly returned home in 1539, not only owing the bishop money but also carrying off without permission a great many sacerdotal vestments. Fortunately, Sancho García, quite possibly the maker of this gremial, did not include it in the booty he carried back to Spain.

The design for the cloth must have been suggested by the bishop himself. The central panoply is directly patterned on European engravings of the Arms of Christ: the cult of the Passion, so profoundly imbued with the image of Christ, embraced heraldic themes. Panoplies like that on this gremial have been preserved in murals as well as in reliefs in the Augustinian convents at Acolman, Actopan, and Itzmiquilpan. The representations of the Five Wounds are similar to those in both Augustinian and Dominican art.

EIEG

REFERENCES
Manuel Toussaint. *La Catedral de México y el Sagrario Metropolitano: su historia, su tesoro, su arte*. Mexico, 1948, pp. 235, 260 (ill.). **Manuel Toussaint**. *Colonial Art in Mexico*. Translated and edited by Elizabeth Wilder Weismann. Austin and London, 1967, pp. 70–71, fig. 62.

119 ◀ *The Mass of St. Gregory*

◀ Convent school of San José de los Naturales,
◀ Mexico City, 1539
◀ Feather mosaic on wood, with added carved and
◀ painted elements; 68 x 56 cm. (26¼ x 22 in.)
◀ Musée des Jacobins, Auch (France)

The making of feather pictures (*amantecayotl*) reached the highest levels of technical and artistic refinement in the pre-Hispanic world, where it was prized above all other art forms. It was practiced not only by students but also by nobles in the palace workshops attached to aviaries. The varieties of tribute from subject peoples that were most valued by the Mexican empire were colorful feathers in their natural state and feathers worked into mosaics for warrior and priestly robes, as well as the *amantecas* (feather artists) themselves to train artisans in the capital. Here iridescent feathers in orange, green, red, and blue illuminate a picture previously drawn by a *tlacuilo* (painter); they are complemented by small superposed carvings and touches of paint. An inevitable characteristic of feather mosaics is the play of light on the glittering areas so that the rest seems by comparison rather dark and dull.

After the Conquest missionaries founded schools of mechanical arts in connection with the convents, where these native techniques were preserved; at San José de los Naturales, for example, there were workshops dedicated exclusively to the making of feather mosaics. There the *amantecas*, following designs from European prints, turned out religious pictures, altar decorations, grotesques in gold and feathers, and containers for the Eucharist. They were all "worthy of being presented to Princes and Kings and Popes."[1] *The Mass of St. Gregory* is, in fact, dedicated to such an august person, Paul III, but apparently it never reached him.

The scene represents one of the legends of St. Gregory the Great, the sixth-century pope and one of the four Latin Doctors of the Church. When one of his assistants doubted the presence of Christ's body in the Host, the pope prayed for a sign and received a vision of the crucified Christ and the instruments of the Passion on the altar. Kneeling before the altar, the saint and two deacons see Christ rising from the sarcophagus. The elaborate designs on the deacons' dalmatics and on the altar frontal show the *amanteca*'s interpretation of European textile motifs. A syncretic detail may be seen in the thirteen disks within the cross on the chasuble: in the pre-Hispanic world these disks represented *chalchihuite*, a precious stone associated with water; St. Gregory himself interpreted them as symbols of the Old and New Testaments. The number thirteen, symbolizing Christ and his apostles, is repeated in the pattern on the linen corporal on the altar. The symmetry of the overall design is emphasized by the paired arrangement of the instruments of the Passion on each side of the Cross.

The dedicatory Latin epigraph in the border surrounding the scene reads: "PAVLO III PONTIFICI MAXIMA/EN MAGNA INDIARV[M] VRBE MEXICO/ CO[M]POSITA D[OMI]NO DIDACO GVBERNA/TORE CVRA FR[ATR]IS PETRI A GANTE MINORITAE AD 1539." Defects in the Latin impede a definitive translation, but it nonetheless provides information that gives this work special importance in the history of Mexican art. It indicates that the work was made for Pope Paul III, "in the great city of the Indies, Mexico, during the governorship of Don Diego, under the supervision of the Minorite Pedro de Gante [Peter of Ghent], in 1539." The date of the mosaic is the earliest ever recorded on a work of art in New Spain and the name of Fray Pedro de Gante clearly identifies the work with his school at San José de los Naturales. Many of the artists working in the school were of high social rank in the Republic of the Indians, and it is possible that the *amanteca* who created this work of art was actually Don Diego de Alvarado Huanitzin, *tlatoani*, or governor, of Tenochtitlan, officially installed in office by the viceroy Don Antonio de Mendoza in 1538. He would thus be the first identifiable feather mosaicist. His lineage was beyond reproach. He was the grandson of the emperor Axayacatl, the son of Tezozomoc Aconahuacatl and a princess of Ecatepec, and the nephew and son-in-law of Moctezuma II, who had appointed him ruler of Tenochtitlan in 1520. He was also a brother-in-law of Cuauhtémoc and was one of the hostages Hernán Cortés took with him on the expedition to Honduras. His conversion to Christianity must have begun during that long journey, under the tutelage of the two Flemish friars who came to New Spain with Fray Pedro de Gante. He is not known to have been an *amanteca* at Fray Pedro de Gante's school at San José de los Naturales, but he could conceivably have learned the art before the arrival of the Spaniards—possibly in the palace workshops where those of his class often studied. In any case the appearance of his name in this inscription is a sign of the *tlatoani*'s prestige in the early years of the viceroyalty.

The question of why *The Mass of St. Gregory* was dedicated to Paul III in 1539 requires a complex answer. The actual Mass of St. Gregory, one of the rituals in which the relics associated with the Passion were venerated, evolved over several centuries; it attained its greatest popularity in the fifteenth and sixteenth centuries, when a number of popes extended indulgences to those who participated in it. Its popularity spread to New Spain, where the Eucharistic nature of its theme must have been quite effective in teaching new Christians the concept of Holy Communion. The Franciscans were especially

devoted to it; in addition to the present example, the legend is represented on a number of feather miters, and there are surviving murals depicting it in the Franciscan convents at Tepeapulco and Cholula. (St. Gregory's Mass fell out of favor about 1628, when the Holy Commission of Rites prohibited it.)

The dedication of this particular work to Paul III could be an indication of the deep gratitude felt toward the pontiff by the Indians under the care of the Franciscans. In the early years of evangelism in New Spain some clergy thought the Indians were unfit to receive the sacraments—they were considered incapable of reason—and believed it was unlawful to administer such rites to them. The question was considered by the Royal Audiencia and then by the Royal Council of the Indies. Finally, in 1537 Paul III issued a bull proclaiming the rationality of the Indians and the right of the mendicant orders to administer the sacraments to them. This decision was announced in New Spain in 1538 and in 1539, perhaps prompting the new Christians to show their appreciation.

The Mass of St. Gregory, however, never reached its destination, most likely because of piracy in the Caribbean and along the coast of Spain during the late 1530s. In 1987 the painting unexpectedly appeared on the art market and found its way to the Musée des Jacobins in Auch. Its fine state of preservation indicates that between 1539 and 1987 it received very good, albeit anonymous, care.

EIEG / MMRR

1. Gerónimo de Mendieta, *Historia eclesiástica indiana* (about 1574–1596) (Mexico, 1945) vol. 1, p. 56.

REFERENCES
Musée des Jacobins d'Auch. *Trésors américains: Collections du Musée des Jacobins d'Auch*, edited by Pascal Monge. Boulogne-Billancourt, 1988, pl. 16. **Sonia Pérez Carrillo**. "Aproximación a la iconografía de la misa de San Gregorio en América." *Cuadernos de arte colonial* no. 4 (1988), pp. 93–94, fig. 1, pp. 105–6, n. 14; for further references see p. 104, n. 1.

120 ◀ Bishop's Miter

◀ Mexico, 16th century
◀ Feather mosaic; 82.5 x 27.5 cm. (32½ x 10⅞ in.)
◀ San Lorenzo, El Escorial, Spain

Objects covered with feathers, including shields, cloaks, warrior uniforms, and headdresses, were highly prized during pre-Hispanic times in Mexico. Apparently there were two techniques used in featherwork, and these were described and illustrated at length in Fray Bernardino de Sahagún's *Historia general de las cosas de Nueva España* compiled in the second half of the sixteenth century in Mexico. Feather clothing, headgear, and fans were made by sewing or tying overlapped feathers with maguey thread onto a net fabric or cane framework. To make feather-mosaic shields and pictures, patterns were traced onto fig bast or maguey leaf paper reinforced with carded cotton and glue with trimmed and glue-hardened feathers being glued to this as a bed or base. (The feathers were cut with copper or obsidian blades against a hardwood board and were applied with a bone blade.) On top of this were added precious feathers that had been trimmed to the desired lengths and shapes. Very fine lines were created by overlapping the layers so closely that some colors almost disappeared, and the contrast between iridescent and mat feathers was utilized. Feathers used were those of the quetzal, hummingbird, parrot, heron, spoonbill, troupial, and blue cotinga.

Various feather artifacts were among the first gifts sent to Charles V by Cortés during the Conquest of Mexico, and feather objects from Mexico became popular collector's items among European royalty and nobility during

the sixteenth century. After the Conquest, the craft of featherwork was used in the service of Christianity under the direction of friars at convent schools, particularly at San José de los Naturales attached to the main Franciscan house in Mexico City. Apparently sketches or designs of Christian images were provided by Spaniards and then the featherwork applied by Indian artists.

The bishop's miter seen here was deposited in the Escorial by Philip II in 1576, and it has identical iconography to two others—one in the Palazzo Pitti in Florence, and the other in the Musée Historique des Tissus in Lyon.[1] In the central composition on both sides of the miter, branches from the Tree of Life form the superimposed and entwined letters IHS and MA representing the monograms of Christ and the Virgin Mary. On both sides, the central vertical bar, representing both the I and the middle stroke of the M, serves also as the cross of the Crucifixion. The elaborate composition, with the cross partially formed from the intertwined monograms, corresponds in most details to a French miniature in the Louvre dating from about 1500.[2]

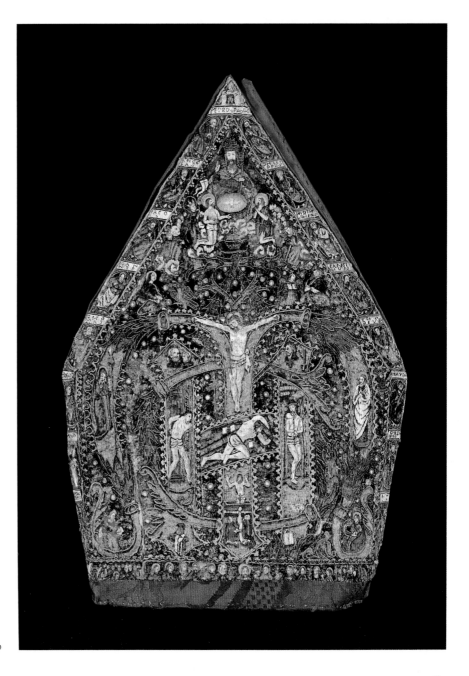

Front of cat. no. 120

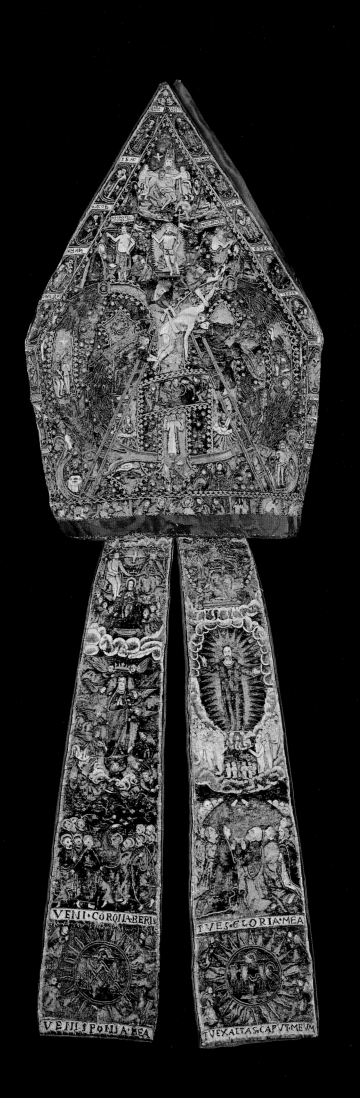

On the front side, the Crucifixion is represented with the Virgin Mary and Mary Magdalen flanking the cross and occupying the outside bars of the letter M. Underneath the figure of Christ on the Cross appear three scenes from the Passion, including Christ at the Column, the Ecce Homo, and the Road to Calvary. These occupy the vertical and horizontal bars of the letter H. Various Instruments of the Passion are interspersed throughout. The four Evangelists with their symbols appear in the corners. Beneath is the Mass of St. Gregory, the only nonbiblical scene on the miter, in which Christ appeared on the altar as the Body and Blood of the Mass. This was frequently represented in New Spain during the period of conversion because of its graphic illustration of the concept of the Eucharist (see cat. no. 119).

The Last Supper, flanked by Christ Washing the Feet of the Disciples and the Seizure in the Garden, appears in a horizontal band at the bottom of the miter. In the top section, God the Father is enthroned with Christ and John the Baptist at his feet. They are flanked by the Virgin as Queen of Heaven and the Apostles. Around the outside borders of the front are full-figure representations of the Fathers of the Church and the Apostles with identifying labels above each one.

On the back, the letters of the monogram serve as a framework for the Descent from the Cross. The ladders of the Descent also form the diagonal members of the letter A and the figures at the base of the cross are seen in the horizontal bar of the letter H. Beneath is the Transfiguration. The Baptism of Christ and the Tree of Jesse are represented in the outside bars of the letter M. The Supper at Emmaus and the Incredulity of Thomas appear in the lower corners.

The border across the bottom of the reverse side includes the Lamentation, the Entombment, and Christ in Limbo. Above the monogram composition can be seen the Resurrection flanked by scenes labeled "Regina Coeli" and "Noli me tangere." The Mercy Seat is depicted at the top of this side with God the Father holding the Crucified Christ in his lap and John the Baptist and the Virgin at his feet. The outside borders include full-figure images of Old Testament kings and prophets identified by name. On both sides, the composition is interspersed with blue circles with white centers probably representing stars in the Precolumbian artistic fashion.

The infulae of the miter represent the Assumption of the Virgin and her Coronation in Heaven on the left and the Ascension of Christ to His Father in Heaven on the right. At the bottom of the left infula appears the MA monogram of Mary and the Latin inscription: "Veni corona beris. Veni sponsa mea." (I come to the true crown. I come to my betrothed.) On the right infula at the bottom is the IHS monogram of Christ with the Latin inscription: "Tu es gloria mea. Tu exaltas caput meum." (You are my glory. You lift up my head. Psalms 3:4).

DP

1. Other feather miters exist in the Cathedral of Toledo, Spain, the Cathedral of Milan, Italy, the Ethnological Museum, Vienna, and the Hispanic Society of America, New York (formerly in a private collection in Hohentwiel, Germany). See Detlef Heikamp, *Mexico and the Medici* (Florence, 1972) pp. 16–18.
2. Heikamp 1972, pp. 17; 69, pl. 19; Sonia Pérez Carrillo, "Aproximación a la iconografía de la misa de San Gregorio en América," *Cuadernos de arte colonial* no. 4 (1988) p. 99, fig. 5.

REFERENCES
Genaro Estrada. *El arte mexicano en España*. Enciclopedia Ilustrada Mexicana no. 5. Mexico, 1937, pp. 34–35, figs. 29–31. **Francisco de la Maza**. "La mitra mexicana de plumas de 'El Escorial'." *Artes de México* 17, no. 137 (1970), pp. 70–76. **Manuel Toussaint**. *Pintura Colonial en México*. 2d ed., edited by Xavier Moyssén. Mexico, 1982, figs. 19–20.

Back of cat. no. 120

121 ◄ Crucified Christ

Mexican, 1550–1600
Polychromed cornstalk paste; height of figure
200 cm. (78¾ in.), of cross 270 cm. (106¼ in.)
SEDUE, Templo de San Francisco, Tlaxcala

This oversize Christ is the finest known cornstalk-paste sculpture. In this technique, a characteristically Mexican one, a paste made from the heart of the cornstalk and certain orchids, bound with *tazingue*, a natural glue, was used to cover an armature of bundled cornstalks or husks. (During the colonial period lengths of rolled paper were sometimes used to provide a hollow framework; occasionally the underlying form was made from the spongy wood of the *tzompantlí* tree.) After the figure was modeled, it was covered with cloth and painted. Images made in this way were extraordinarily light, making them suitable for processions; they weighed so little that an oversize figure could easily be carried by a child.

Of pre-Hispanic origin, the cornstalk technique was at one time used in Michoacán for making idols. Don Vasco de Quiroga, the first bishop and great promoter of "mechanical" arts in the region during the sixteenth century, persuaded the Indian sculptors to turn their talents to making Christian images. Soon thereafter Spaniards, like Matías de la Cerda and his mestizo son Luis, also came to excel in the medium. By the mid-sixteenth century this technique was being used in Mexico City at the school of San José de los Naturales under the direction of Fray Pedro de Gante. In the *Anales de Juan Bautista* an Indian historian of the San Juan district states that toward the end of 1564 a cornstalk sculpture of St. John the Evangelist had been completed.

Hollow crucifixes gained popularity not only in New Spain but in the mother country as well, where they were highly prized. In the present figure, the

Facing page: cat. no. 121 (before restoration)

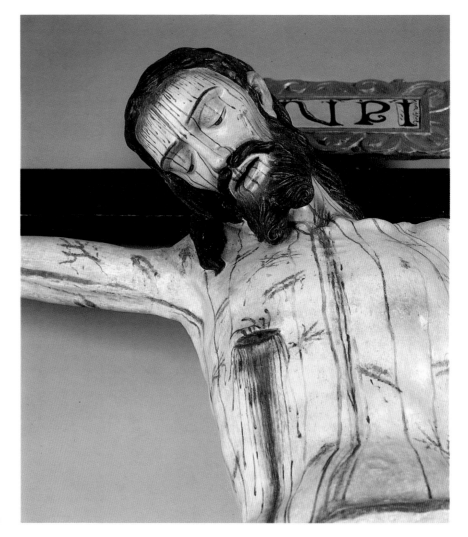

Right: detail of cat. no. 121 (after restoration)

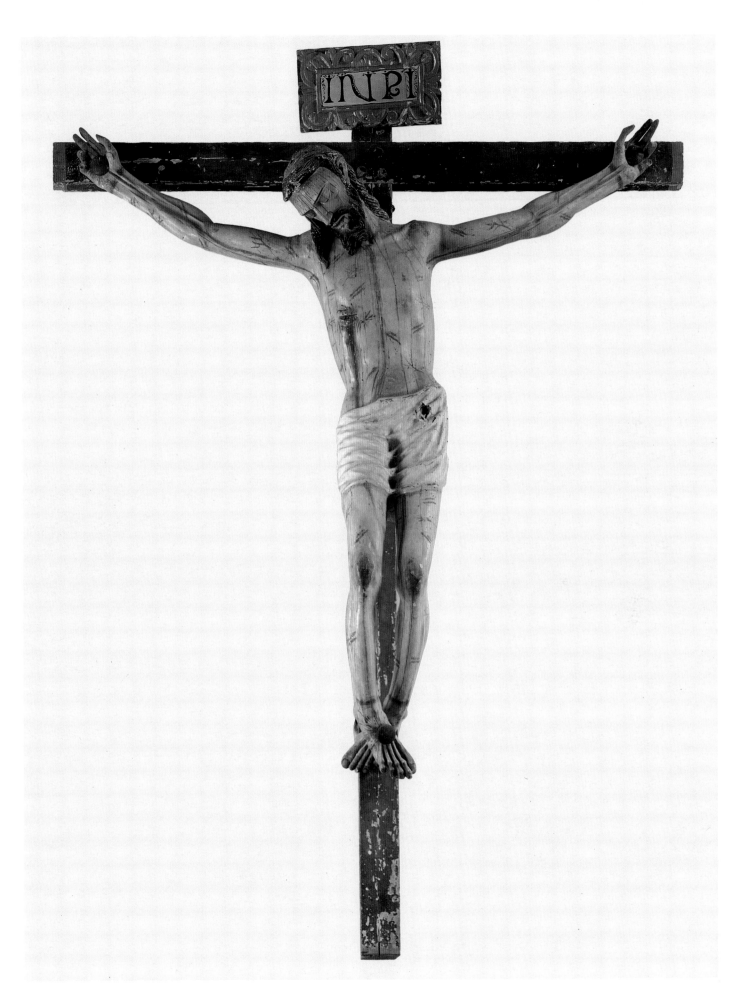

elongated limbs, angularity of the face, and treatment of the half-open eyes are archaistic elements reminiscent of Gothic art. Unlike many colonial figures of Christ, the torso is long and smoothly modeled; the outline of the sternum and the anatomically correct handling of the limbs may perhaps point to a Spanish or Creole sculptor rather than an Indian. The technique continued to be used throughout the viceregal period, and Fray Matías de Escobar, an eighteenth-century chronicler, who recounted the miracles associated with such figures, explained: "God so rejoices to see that material [corn] consecrated, since it once belonged to Satan, that he works wonders to show his pleasure and the happiness he feels."

EIEG

REFERENCE
José Moreno Villa. *La escultura colonial mexicana*. Mexico, 1942, pp. 31–32, fig. 28.

122 ꒡ Frieze Fragment

Puebla, about 1570
Tempera; height 70 cm. (27⅝ in.)
CNCA–INAH, Museo Regional de Puebla, Puebla
10–281100

This mural is of grotesque design, polychrome on black background, bordered top and bottom by four horizontal bands in black, white, and red ocher. It is made up of units consisting of fantastic rampant lions, in ocher, holding twisted shields upon which are triangular inverted escutcheons bearing figures of the saints. The lower parts of the lions' bodies take the shape of sea snails, linked by ribbons to grotesque masks, also leonine, which are crowned with hearts and floral motifs. In the surrounding spaces are small birds with outstretched wings; two of these show indigenous influence, for the *tlacuilo* (painter) has depicted them with the little scroll that represents singing in pre-Hispanic art.

This composition, with its chimerical animals, ornamental and heraldic elements, and real creatures, is typical of the so-called *a lo romano* paintings, or grotesques, of this period. Most painting of this type in New Spain appeared in connection with religious programs. This example, like the one in the Casa del Deán in Puebla, can be considered exceptional in that it was found in a private home; almost all such buildings from the sixteenth century have disappeared or suffered irreparable damage.

Drawing of cat. no. 122 (before restoration)

The saints pictured on the escutcheons can be identified as Peter and Luke, for they are accompanied by their respective symbols: the keys and the ox. It is reasonable, then, to suppose that this grotesque decorated what must have been a domestic chapel or private oratory. In a profoundly religious society with well-established habits of everyday worship, such chapels were common in Creole and Spanish households in the urban centers, as well as in Indian villages where they were encouraged by the Church.

These paintings in tempera or calcimine—the fresco technique was not used—were made by tracing from patterns that could also be used for other types of decoration, such as floral mosaics and sculpture in relief. In the Franciscan church at Tepeji del Río, for example, a single grotesque design is repeated in the same scale both on the walls of the nave and on the font. In the case of the present example, however, no patterns or duplicates have been found. The painters of these murals—Indians, for the most part—worked as traveling teams directed by a *tlacuilotecuhtli* (senior painter) or by a Spanish master. They were trained in the convent schools of mechanical arts and were from the earliest times skilled in copying from engravings which were brought in considerable quantities from Europe. These were usually loose prints or frontispieces of books sent directly to the convent libraries or to urban book-sellers: "After the Christians came, and the Indians saw the examples and pictures brought by the Spaniards from Flanders and Italy, many great paint-ers appeared . . . there is no altarpiece or image, however exquisite, that they cannot reproduce or counterfeit, especially the painters of the city of Mexico, for it is there that can be found everything good that is brought from Castile."[1]

The result was a type of painting that was principally linear, whether mo-nochromatic or in color, and adhered faithfully to the character of the origi-nal. This Italianate fashion owed its wide diffusion to the ascendancy of the graphic arts in the Netherlands. It attained tremendous popularity in New Spain in the sixteenth century, especially in the mural painting that was one of its most vigorous expressions.

EIEG

1. Motolinía [Fray Toribio de Benavente], *Memoriales, o libros de las cosas de la Nueva España y de los naturales de ella*, edited by Edmundo O'Gorman (Mexico, 1971) p. 240.

Painted Manuscripts

ELIZABETH HILL BOONE

In the century following the Spanish invasion of Mexico—when Aztec administrative and cultural systems were radically altered by the demographic collapse and the introduction of European ideas and institutions —the native tradition of manuscript painting flourished as did no other art form. Although Aztec painted books had early been the focus of destruction by zealous conquistadores and mendicant friars from Europe, this trend reversed around the middle of the sixteenth century when Aztecs and Europeans alike realized the utility of the manuscript tradition.

Aztec elites needed to accommodate the new viceregal order, but they still wanted to guard the ideas and institutions of their past and to protect and bolster their present rights and positions. They had maps and property plans painted to document what land holdings and financial interests they retained or claimed, and they commissioned historical documents to record a distinguished past they wanted to continue under the new viceregal and Christian order.

The Spaniards, for their part, recognized the desirability of understanding the Aztec systems in order to reap the full economic, political, and spiritual benefits of their new land. Secular authorities of the viceregal government, who judged pictorial codices admissible as evidence in court cases, sponsored the painting of maps, tax and tribute assessments, and registers of properties and salaries to improve their knowledge and control of the territory. Once the friars saw that their ignorance of the old religious customs hindered their missionary efforts, they began to seek out existing Aztec books and to create their own records of Aztec religion so that they might more effectively combat its continued practice.

The sixteenth-century manuscript painters catered to these new needs, and increasingly they learned and incorporated European pictorial conventions and modes of representation into their work. The flat, even-hued, and static Precolumbian painting style still served well for rendering iconographic detail, but gradually the European contour line, linear perspective, modeling in light and dark, and illusionistic naturalism came to replace the features of the Aztec style. The pre-Conquest screen-fold books of bark paper and animal hide were eschewed in favor of bound books of European paper.

Particularly prized in the sixteenth and later centuries by those mendicant friars and European and Mexican intellectuals who were historically curious were the pictorial codices that described the customs, beliefs, and traditions of the Aztec past. The earliest of these manuscripts, and those considered the most authentic or accurate, were the ones that had a significant pictorial content—that is, where the paintings by native artists presented the fundamental information. Glosses and texts in Nahuatl (the Aztec language) or Spanish then identified the images or explained the paintings to a textually literate audience. While some of these manuscripts were great cultural encyclopedias compiled as a singu-

lar endeavor, others were small, perhaps fragmentary, and well focused, being little more than a few gatherings of painted and glossed folios that pertained to a subject—a history of the Aztec migration, for example, or an account of the monthly ceremonies. Often the friars and historians would gather several small manuscripts together to form a larger compendium of topically related parts. The two pictorial codices represented in this exhibition—the Codex Telleriano-Remensis and the Codex Ixtlilxochitl—are both this kind of manuscript. They are composite documents whose parts were brought together to give a broad picture of Aztec culture.

123 ‹ Codex Telleriano-Remensis

Mexican, 16th century
European paper (50 leaves); 32 x 22 cm.
(12⅝ x 8⅝ in.)
Bibliothèque Nationale, Paris Ms. Mex. 385
EXHIBITED IN NEW YORK ONLY

The Codex Telleriano-Remensis is one of the few Mesoamerican pictorial manuscripts extant, and it ranks among the finest. Compiled in central Mexico in the mid-sixteenth century, a generation after the Spanish Conquest of Mexico in 1521, it is a hybrid document displaying both indigenous and European features. Its images, painted by native artists, preserve the pre-Hispanic stylistic and iconographic traditions that were current in the Basin of Mexico about the time of European contact. In contrast to pre-Conquest manuscripts, however, it bears informative Spanish glosses added by several annotators to explain the esoteric figures and symbolic images to the viewer. Rather than the folded strip of native bark paper commonly used for central Mexican manuscripts, it is composed of individual sheets of imported paper and bound as a European-style codex.

Since no indisputedly pre-Hispanic Aztec pictorial manuscripts have survived, colonial copies of them, like the Codex Telleriano-Remensis, are especially valuable documents. Not only do they provide a reminder of the achievement of a lost Aztec art form, but they help document the persistence of native traditions in the face of persuasive acculturating forces and the resulting emergence of a new Indo-Hispanic form of cultural expression.

Comments in the codex and the partially cognate Codex Vaticanus A (3738), another colonial manuscript now in the Vatican Library, indicate that they were compiled by a Dominican lay brother called Pedro de los Ríos. Although nothing is said about why they were created, the number of other colonial manuscripts that are also compilations of different types of pre-Hispanic manuscripts suggests that they were assembled to supply a broad range of information about the newly encountered cultures of New Spain.

Like most other extant ancient Mexican manuscripts, little is known about the early history of the Codex Telleriano-Remensis. When and how it reached Europe is unknown. The manuscript was first documented in France in 1700, when it appeared among a list of manuscripts donated to the king's library, forerunner of the present Bibliothèque Nationale of Paris, by the industrious bibliophile and archbishop of Reims, Charles-Maurice Le Tellier. There it

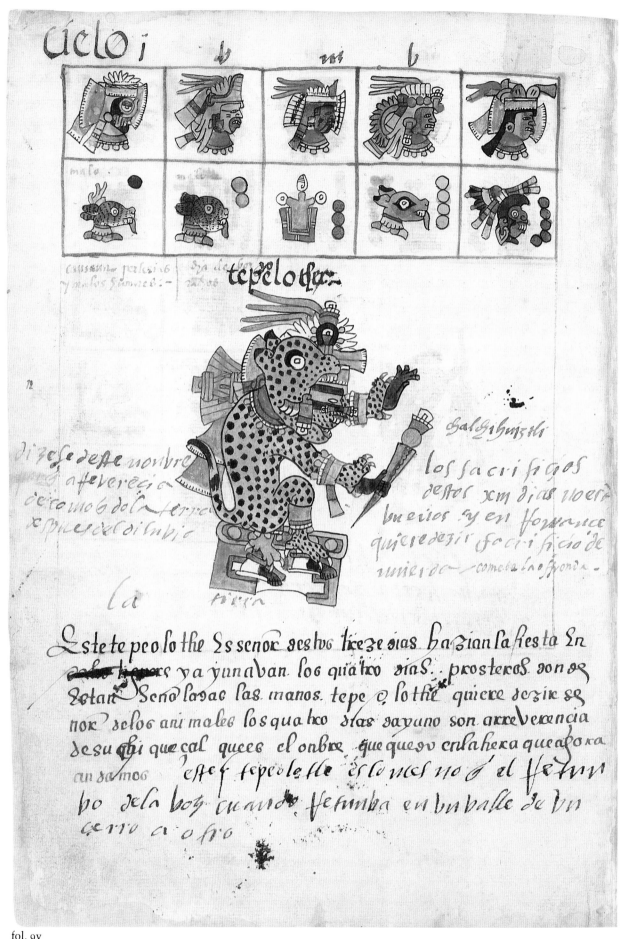

ciclo i

tepelottec

chalchihuiztli

dizese deste nombre
... afeuerecia
o como 6 dola terre
... puesdeldiluuio

los sacrifiçios
destos xm dias noer
buenos sy en formançe
quiere dezir sacrifiçio de
... mierda ... comolanoffonda

la tierra

Este tepeolothe es senor destos treze dias hazian la fiesta En
... yayunauan los quatro dias .prosteros sonoe
...tan Senolauae las manos tepe q lothe quiere dezir se
nor delos animales los quatro dias ayuno son arreuerencia
desu chiquezal quees el onbre que ... enla hera que agora
...damos Estes tepolette ... no ... el ...
... dela boz cuando fetunba en ... baffe de ...
cerro a ... oho

fol. 9v

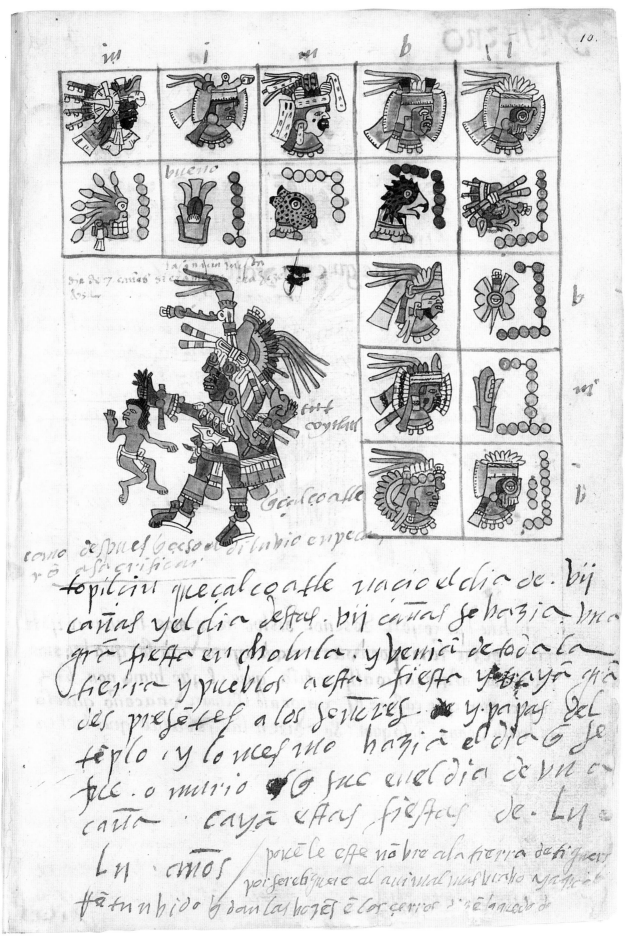

fol. 10r

remained relatively unnoticed until its rediscovery in the early nineteenth century by the great German naturalist Alexander von Humboldt. In his *Vues des cordillères* . . . (1810) Humboldt christened his find Codex Telleriano-Remensis after its first known owner. He also described it, reproduced several of its images, and noted its resemblance to the Codex Vaticanus A.

Now missing at least fourteen of its original leaves, the present manuscript contains fifty folios painted on both sides. Its three major sections reflect pre-Hispanic ritual, calendric, divinatory, and historical traditions that were recorded in pictorial form. The first (fols. 1–7) presents the eighteen major rituals of the solar year. The image of the deity primarily propitiated (or deity impersonator) connotes each ceremony. The second section (fols. 8–24) is a divinatory almanac, or *tonalamatl*. Each of its twenty thirteen-day periods (*trecenas* in Spanish) appears as a two-page spread. The main deity patron dominates the left folio, while a co-patron or minor figure occupies the right. The third historical section (fols. 25–49) is itself subdivided into three parts. A migration account that depicts the wanderings and arrival of migrants in the Basin of Mexico between 1197 (i.e., 1198) and 1274 inaugurates the historical record. An annal focuses on the exploits of the Aztecs, detailing events such as battles, tribute, and accessions of rulers, as well as phenomena such as eclipses, earthquakes, and famines from 1385 to 1518. A chronicle of post-Conquest events continues native history to 1548, with year signs alone extending to 1555 and glosses to 1562.

Folios 9v and 10r feature the third *trecena* of the *tonalamatl*. Glosses identify the main patron (left) as Tepeyollotl (Heart of the Hill) and the co-patron (right) as Quetzalcoatl (Quetzal Feather-Serpent). The image of Tepeyollotl, an aspect of the protean deity Tezcatlipoca (Smoking Mirror) is one of the most spectacular examples of a deity in the guise of his animal alter ego. Although the jaguar aspect predominates, the human hands, feet, and head of the anthropomorphic deity, the latter displaying his typical yellow facial striping, are also visible. The decorative green fans, streamers, and triangular knotted element also relate Tepeyollotl to several fertility deities, although the green color connects him with earth and vegetation rather than the water symbolized by their blue ornaments. In his hand he holds a pointed maguey spine, an implement used for ritual bloodletting, which may allude here to divinatory rituals. Tepeyollotl is an obscure deity about whom little information has survived. Among sixteenth-century sources only the related Codex Telleriano-Remensis/Codex Vaticanus A *tonalamatl* sections specifically identify and describe him.

Spanning both pages are paired boxes with emblems of the days of the period combined with nine repeating deities ("Night Lords"), who along with the patron and co-patron influenced the fate of the days. A small, fine hand specifies the fortunes of several of them. Glosses by two other hands state that Tepeyollotl's feast was celebrated on the day 8 "tigers" (i.e., jaguars), conjecture that his name meant lord of the animals, and associate him with the earth and a resounding echo. Other remarks describe the feast of Quetzalcoatl, who holds a male figure aloft by a forelock in a conventional gesture of capture or, possibly here, human offering.

Folios 27v and 28r present a segment of the migration story. Although Aztec migration accounts are highly variable, this version is one of the most anoma-

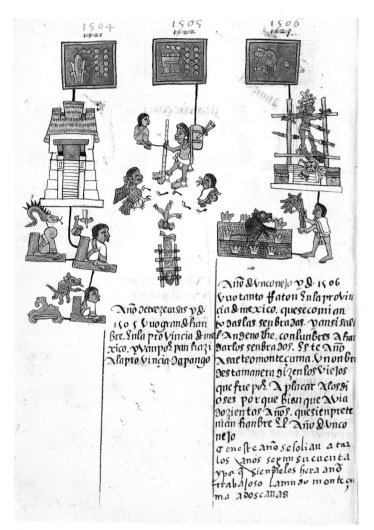

fol. 41v

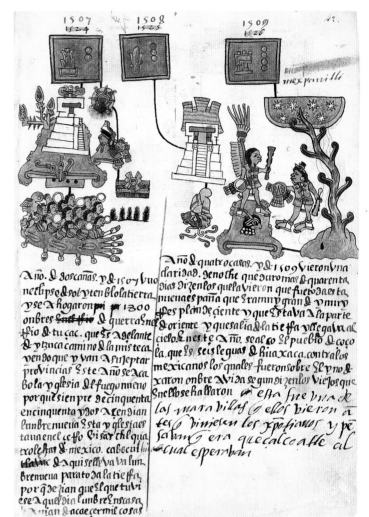

fol. 42r

lous, with several locations appearing only in this source. Within the manu-
script this section is also aberrant. It is largely unannotated, and its awkwardly
sketched figures, drawn by a less traditional artist than the *tonalamatl* and
annals, are somewhat Europeanized. The criss-crossing footprints suggest the
wanderings of the group, while the green hill-like place signs, such as Coatepetl
(Snake Hill) at the top of folio 27v, depict various stops on the journey. Other
images show the rustic, pelt-clad migrants with bows and arrows attacking
better-garbed warriors, who despite their more sophisticated obsidian-studded
clubs appear to be on the losing end of the encounters. The years of the
timeline below, 1245 to 1264, are indicated by the four repeating native year
signs (House, Rabbit, Reed, Stone Knife). The symbol connected to the second
year, 1246 or 1 Rabbit, signifies the New Fire ceremony that inaugurated a
new fifty-two-year cycle, a period analogous to a century in our system.

Folios 41v–42r show six years, 1504 to 1509, in the reign of Moctezuma II,
who was elected ruler of México-Tenochtitlán in 1502. The dynastic chroni-
cle with its numerous images and often lengthy descriptive annotations is
among the manuscript's most informative sections. Scenes on these two fo-
lios represent the death and accession of rulers in 1504, famine in 1505, and a
plague of rats and an arrow sacrifice in 1506. The illustration for 1507 shows a

large hill sign surmounted by a temple, representing the site of the final New Fire ceremony of the Aztec era. Scenes below and to the right portray episodes from Moctezuma's southern campaign in Oaxaca: the drowning of a band of warriors in the River Tozac in 1507 and the subjection of Zozollan (Zollan?; Zoltepec?) in 1509, shown by a victorious Aztec warrior atop its place sign. The Codex Telleriano-Remensis is notable for its numerous depictions of celestial phenomena. Events for 1507 include a solar eclipse, indicated by a circular solar design with a missing wedge, and an earthquake, represented by the X-shaped *ollin* (movement) symbol on the horizontally layered plot of land. According to one annotator, the smoking column and patch of starry sky refer to a mysterious light that appeared in the eastern sky in 1509, which another hand identifies as an omen that heralded the arrival of the Spaniards.

EQK

REFERENCES

Alexander von Humboldt. *Vues des cordillères et monuments des peuples indigènes de l'Amérique.* Paris, 1810. **Codex Telleriano-Remensis. Manuscrit mexicain du cabinet de Charles-Maurice Le Tellier, archevêque de Reims, à la Bibliothèque Nationale** *(ms. mexicain no. 385).* Introduction, transcription, and notes by Ernest-Théodore Hamy. Bibliothèque Nationale, Paris, 1899. **J. Eric S. Thompson**. ''The Prototype of the Mexican Codices Telleriano-Remensis and Vaticanus A.'' *Notes on Middle American Archaeology and Ethnology* 1, no. 6 (1941), pp. 24–26. **Donald Robertson.** *Mexican Manuscript Painting of the Early Colonial Period: The Metropolitan School.* New Haven, 1959. **Antigüedades de México basadas en la recopilación de Lord Kingsborough,** edited by José Corona Nuñez. Vol. 1. Secretaría de Hacienda y Crédito Publico. Mexico, 1964–67. **John B. Glass, in collaboration with Donald Robertson.** ''A Census of Native Middle American Pictorial Manuscripts. In *Handbook of Middle American Indians,* vol. 14, *Guide to Ethnohistorical Sources,* edited by Howard F. Cline, part 3, pp. 81–242. Austin, 1975. **Eloise Quiñones Keber**. ''The Illustrations and Texts of the Tonalamatl of the Codex Telleriano-Remensis.'' Ph.D. diss., Columbia University, 1984. **Eloise Quiñones Keber**. ''Art as History: The Illustrated Chronicle of the Codex Telleriano-Remensis as a Historical Source.'' In *The Native Sources and the History of the Valley of Mexico,* edited by Jacqueline de Durand-Forest, pp. 95–116. British Archaeological Reports International Series, 204. Oxford, 1984. **Eloise Quiñones Keber**. ''The Codex Telleriano-Remensis and Codex Vaticanus A: Thompson's Prototype Reconsidered.'' *Mexicon* (Berlin) 9, no. 1 (1987), pp. 8–16.

124 ◀ Codex Ixtlilxochitl

◀ Mexican, 16th century
◀ European paper, polychrome and metal leaf,
◀ 31 x 21 cm. (12¼ x 8¼ in.)
◀ Bibliothèque Nationale, Paris 65–71
◀ EXHIBITED IN NEW YORK ONLY

The Codex Ixtlilxochitl is a pictorial document whose nature and features reflect the milieu of New Spain in the early colonial period—it is more European than Aztec in conception, style, and technology, but it is topically focused in the Aztec past. The manuscript itself is a composite of three distinct and unrelated documents from the late sixteenth and early seventeenth centuries that were gathered and bound together before the middle of the eighteenth century and have remained together until recently when the pages were disbound.[1]

The first section (fols. 94–104), dating about 1600, is a partial copy of an early cultural encyclopedia that was created between 1529 and 1553 at the behest of a mendicant friar to picture and catalogue Aztec ritual life. The lost original, known today as the prototype of the Magliabechiano Group, contained over sixty paintings of feasts, deities, calendrical cycles, and customs executed by an Aztec-trained artist; almost all were annotated with explanatory glosses and texts in Spanish and Nahuatl. The Codex Ixtlilxochitl preserves the paintings and written descriptions of the cycle of eighteen monthly feasts (fol. 97r), two versions of the deity Quetzalcoatl, and two mortuary rituals.[2]

The third section (fols. 113–22) is an unillustrated discussion of the Aztec calendar, very similar to the Spanish text of the first nineteen chapters in

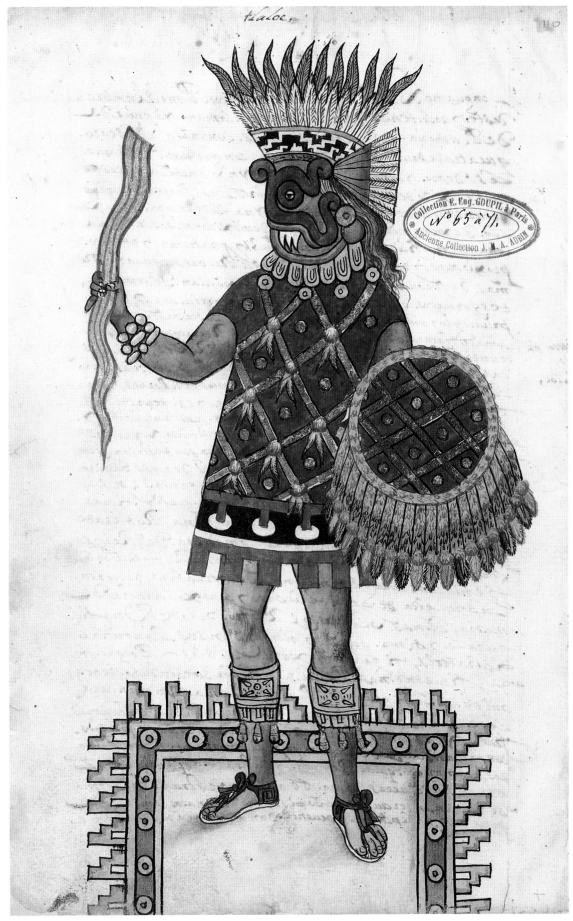

Tlaloc,

fol. 110v

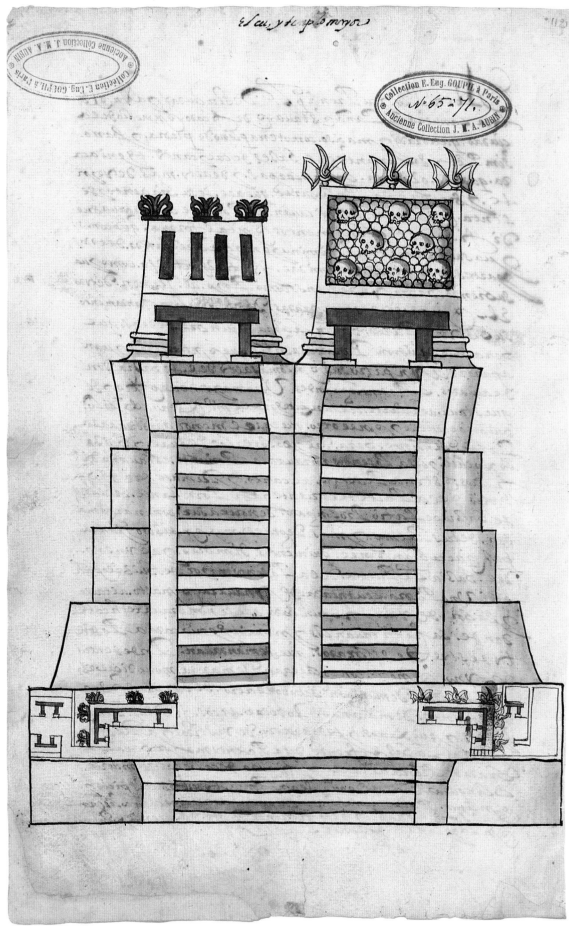

fol. 112v

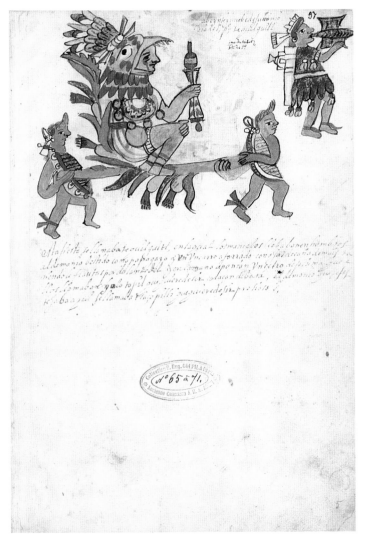

fol. 97r

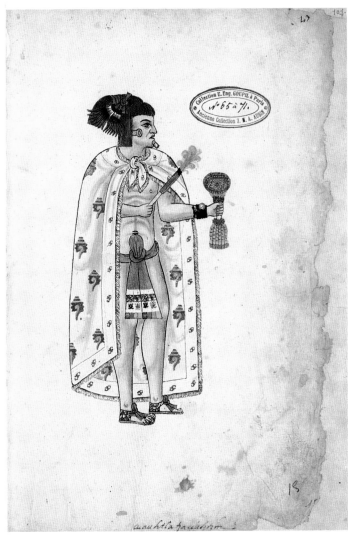

fol. 107r

book 2 of Bernardino de Sahagún's *Historia general*.[3] Thus like the first section, it is founded in the intellectual world of the mendicants.

The second section (fols. 105–12) is more closely connected to the Spanish imperial administration, although it also treats Aztec customs and religion. It is an illustrated fragment of *La relación de Texcoco*, written by Juan Bautista Pomar in answer to the *relación geográfica* questionnaire of 1577. Designed to elicit fundamental information about communities in Spain's overseas empire on the order of Philip II, this questionnaire asked fifty broad questions to be answered by local town officials in the polities in New Spain. In 1582 Pomar, a mestizo descendant of the Aztec rulers of Texcoco, responded for his city with an extensive document that included a major discussion of Aztec deities as well as comments on many other aspects of Precolumbian and early colonial Aztec culture. The Ixtlilxochitl fragment contains six of the illustrations meant to accompany the *relación*. There are four full-length portraits of the Precolumbian rulers of Texcoco, which consciously present the elegance and refinement of Aztec nobility through sumptuous costuming (fol. 107r). More important, however, are the painting of the water god Tlaloc and the representation of the Templo Mayor in Texcoco. The Tlaloc painting is the

most elaborate deity representation to have survived from the early colonial period, and the Templo Mayor painting is the finest early rendering of Aztec religious architecture; both have fragments of Pomar's text on their other sides.

The standing Tlaloc is an extraordinary figure, a blend of Precolumbian and European manners of pictorial representation (fol. 110v). His body exists in three dimensions, modeled and positioned at a slight angle to the viewer to suggest added depth in the picture plane; the hands, feet, hair, bracelet, and sandals are delicately and naturalistically rendered. The other forms, in contrast, remain caught in the Aztec style. Tlaloc's *xicolli* (ritual tunic) and his shield, necklace, face mask, and headdress are all flat, crisp of outline, and static in presentation. While individual feathers in the headdress, tunic, and shield seem to have life, the hem of the tunic and the serpentine face mask of the god stop all sense of movement. The iconographically meaningful features of Tlaloc are presented in the Aztec fashion but are overlaid on a stylistically European figure. The figure stands in space on an architectural platform, but this platform is flatly represented according to the Aztec convention as a band containing concentric circles, bordered by a row of stepped ramparts. There is an unsuccessful attempt to impart volume and depth to the platform through blood-red shadings. This telling juxtaposition of Aztec and European pictorial conventions demonstrates the basic incompatibility of the two visual systems.

Iconographically, the figure is fully Aztec. Tlaloc's face is formed by his diagnostic serpentine mask, in which broad lines define his goggle-eyes, curved brow, scrolled nose, and fanged jaw. In place of a chin, his jade necklace begins directly beneath the jaw. The god's usual dark blue tunic, like the shield, is in this depiction dotted and netted with strips of silver foil, which still glimmer under their tarnish. Gold leaf enlivens and makes more precious his gold earspool, undulating lightning staff, and leg ornaments. The red-and-black "eye" border at the hem of his tunic is often found on garments worn by gods and nobility, and the touches of gold and silver leaf add sumptuous embellishment.

Because it is such an early and unacculturated architectural rendering, the painting of Texcoco's principal temple (fol. 112v) has often been used to illustrate the Templo Mayor in the Aztec capital city of Tenochtitlan as well as in Texcoco. The Templo is built in the typical Aztec form, shared by the major temples in the two neighboring cities. A high, stepped pyramidal platform is fronted by two broad stairways, each bordered by wide balustrades. At the summit rise twin temples, the left dedicated to Tlaloc and the right to Huitzilopochtli, the principal Aztec god. Tlaloc's temple is crested with blue merlons associated with the water god, while the superstructure of Huitzilopochtli's shrine is adorned with human skulls and crested with great stylized shells. The whole rests on another, lower and broader, platform which also supports a forecourt and auxiliary buildings associated with the two deities.

The volumes, lines, and voids of the architectural complex are described using the same combination of Aztec and European styles apparent in the portrait of Tlaloc. The basic iconography of the merlons and skulls is Aztec, and the twin temple is an Aztec form. Aztec too is the convention for a building, which features a doorway defined by a red post-and-lintel unit rising from a slightly wider block. But the artist was not content to use only the Aztec style. He added pinkish shadows to the walls, balustrades, and platform

sides, and he painted every other step pink, perhaps with the idea of differentiating the risers from the steps. He also added shading to the shell merlons of Huitzilopochtli's temple. He rendered the skull decorations in a particularly European way, turning them to a three-quarter view, dropping away the lower jaws, shading them, and drafting their features with European naturalism—they have become European skulls on an Aztec building.

The Codex Ixtlilxochitl is associated with Fernando de Alva Ixtlilxochitl (about 1568–1648), an early seventeenth-century historian and descendant of the rulers of Texcoco, because the third section (the Sahagunite calendar) is said to be in his hand. He may even have gathered the three parts of the codex together, for certainly the Pomar *Relación de Texcoco* fragment is a manuscript he might have owned. It is equally possible, however, that the codex was assembled somewhat later by Carlos Sigüenza y Góngora (1645–1700), a Mexican savant and one-time Jesuit priest, who owned all three parts of the codex, bound together in a volume with other material, as part of his rich library of manuscripts on pre- and post-Conquest Aztec culture. Sigüenza y Góngora, a close friend of the Alva Ixtlilxochitl family, acquired all of Fernando de Alva's papers, probably from Fernando's son Juan de Alva Ixtlilxochitl.[4] After Sigüenza y Góngora's death, the codex passed through the hands of the Italian Jesuit and bibliophile Lorenzo Boturini (1702–1755) when he was in Mexico; it was later owned by the Mexican antiquarian Juan Eugenio de Santelizes; the French historian Joseph Marius Alexis Aubin (1802–1891), who took it to Paris; and the Parisian collector E. Eugène Goupil (1831–1895). After Goupil's death, it was transferred with the rest of his collection to the Bibliothèque Nationale of Paris, where it bears the catalogue number (65–71) it was assigned when Goupil owned it. The folios still retain the page numbers (94–122) they were given when the manuscript was bound and paginated with other manuscripts in Sigüenza y Góngora's library.

EHB

1. Elizabeth H. Boone, *The Codex Magliabechiano and the Lost Prototype of the Magliabechiano Group* (Berkeley, Los Angeles, and London, 1983), pp. 101, 107–12; see also John B. Glass in collaboration with Donald Robertson, "A Census of Native Middle American Pictorial Manuscripts," in *Handbook of Middle American Indians*, vol. 14, *Guide to Ethnohistorical Sources*, edited by Howard F. Cline (Austin, 1975), pp. 147–48.
2. For the Magliabechiano group see Boone, *The Codex Magliabechiano*, pp. 3–6, 139–64.
3. Bernardino de Sahagún, *Historia general de las cosas de Nueva España*, edited by Angel María Garibay Kintana (Mexico, 1975), vol. 1; Boone, *Codex Magliabechiano*, p. 101.
4. For the provenance of the codex see Boone, *Codex Magliabechiano*, pp. 107–12, and Jacqueline de Durand-Forest, "Commentaire," in *Codex Ixtlilxochitl, Bibliothèque Nationale, Paris (Ms. Mex. 65–71)*, edited by Ferdinand Anders (Graz, 1976), pp. 9–11. The assumption may be true that Fernando de Alva owned all three parts of the codex and that Sigüenza y Góngora acquired these from Fernando's son Juan, although there is no actual evidence that Fernando or Juan de Alva owned the first or second part of the codex. Sigüenza y Góngora also obtained manuscripts for his library when he rescued them from a fire in the Palacio Virreinal of Mexico during the Corn Riot of 1692.

Mexican Architecture and Sculpture in Renaissance Modes

JOHANNA HECHT

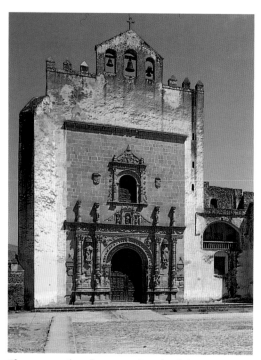

Plateresque facade, 1560, church of the Augustinian convent, Acolman, Mexico. Photo: Michel Zabé

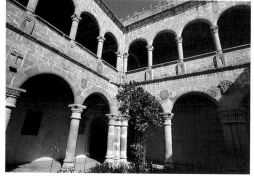

Patio colonnade, Augustinian convent, Acolman

The high Utopian moment in New Spain was brief, its death knell extended. The first archbishop, Fray Juan de Zumárraga, humanist and reader of Erasmus and More, died in 1548 and was succeeded by the anti-native Montúfar. The first viceroy, Antonio de Mendoza, student of Alberti and proponent of ideal civic planning, died in 1552. The last of this remarkable triumvirate, Vasco de Quiroga, devoted to the foundation of utopian social communities, died in 1565. In Spain the enlightened Holy Roman Emperor Charles V, who had lent his support to many idealistic projects, abdicated in 1556, to be succeeded by his dour and reclusive son Philip II. Finally, the Holy Office, or Inquisition, was established in Mexico in 1571. Although the mass of Indians was not subject to its direct supervision, the Inquisition's influence in Mexico was baleful and pervasive and undoubtedly contributed to the decline of the utopian dream.

By the end of the century the schools set up by the Franciscans for the spiritual, intellectual, and vocational instruction of the Indians, as well as the perpetuation of pre-Hispanic arts and crafts, had foundered amid contention between the pro- and anti-nativist factions among the clergy. The mendicants themselves had been supplanted by the secular clergy, who allied themselves with the interests of the increasingly more numerous Spanish settlers. At the same time the Indian population, devastated by diseases to which it had no resistance, tumbled to a small fraction of its former size. As the labor pool decreased so did the production of the silver mines, and the number of Indians available to work on such luxuries as art dwindled. The resultant crisis is seen by some as a reason for the change in the character of Mexican art toward the close of the century.[1]

The architecture from this early period of evangelization, embodied in the great rural convents with their soaring ribbed vaults and arcaded cloisters, was "incorrect" and often haphazard but nonetheless grandiose, free, and personal, combining elements of Northern and Isabelline Gothic, Mudejar, and Classical style.[2] These components had been brought from Spain by craftsmen and patrons (both clerical and civil) equipped with their own widely varied recollections of up-to-date style. Their baggage also included printed treatises and other books that in the manner of the time were decorated with quasi-architectural ornament. Like so many of the imported styles that would subsequently arrive in Mexico, these were subject to personal interpretations that ranged from faithful emulations to the most fanciful and free elaborations.

While the eclectic admixture of Gothic and Moorish continued to survive, various versions of Renaissance style gradually and increasingly came to influence ongoing building campaigns. By midcentury more integrated developments could be found, not only in metropolitan centers

Architectural ornament, Diego de Sagredo, *Medidas del Romano necessarias a los oficiales que quieren sequir las formaciones de las bases, colunas, capiteles, y otros piecas de los edificios antiguos* (Toledo, 1526)

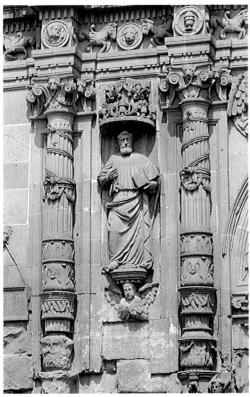

Facade sculpture: St. Paul, 1560, Augustinian convent, Alcoman

but in some of the missions. Yet the introduction of this aesthetic was not as clear-cut as one might have expected, for the hand that set out to draw on the "clean slate," as some have inaccurately described post-Conquest Mexico, was a fairly shaky one.

At the time of the Conquest, Spain itself had only recently begun to absorb the lessons of Classical antiquity transmitted from Italy. Eager to follow the Italian revival of "good architecture," Spanish designers nonetheless initially produced a Renaissance style very different from that predominating in Rome and Florence.[3] Called "a lo romano" by its proponents, the Spanish style was in fact heavily influenced not only by local Iberian precedents but also by the Lombard and Genoese craftsmen who introduced to early Renaissance Spain the fanciful ornamental style known as grotesque. Subsequently termed Plateresque, or silversmith-like, this style has been described as "adjectival" or "loose-fitting"[4] in allusion to its lack of integration with the underlying structure. Although Spanish architects would gradually come to a deeper understanding of the principles of Renaissance design, for the first half of the sixteenth century building ornament especially displayed an affinity for flat relief and repetitive fields of pattern traceable to the Mudejar style.

This version of the Renaissance struck the most sympathetic chord in New Spain. Ornamentation and the organization of surface, not form or space, are the essential elements of the splendid and distinctive building style that evolved in colonial Mexico, a style less of architecture than of facade design. Although briefly suppressed as purer Renaissance styles came into vogue, this decorative tendency reemerged in other formulations and became the triumphant modality of viceregal building.

In New Spain the main propagators of the Plateresque were the Augustinians. The last of the three mendicant orders to arrive in Mexico (1533), they were by all accounts the most unstintingly lavish in the construction of their numerous conventual establishments. Although less sumptuous than comparable projects in sixteenth-century Spain, these elaborate efforts at what some contemporaries critically called unseemly splendor required justification. The usual excuse for this indulgence relied on the Indians' alleged regard for display. Even in the *Códice franciscano* the defense is offered that "it was necessary to ornament and make a show of the churches in order to elevate the Indians' souls and to move them towards things of God, because their very nature, which is remiss and forgetful of inner things, needs to be helped by the outward aspect."[5]

The Augustinian convent of Acolman in the state of Mexico near Teotihuacán is a prime example of pure Plateresque style. Its facade, completed in 1560, was clearly the conception of a European designer. Yet even within this single facade the actual carving of the figures varies from place to place in the degree of fidelity to the presumably European prototypes. This is not a case of European graphic designs being redrawn in stone by native carvers, thus producing the synthesis called *tequitqui*. Rather it raises the question of the extent to which the small number of European sculptors and designers who came to Mexico were able to transmit an understanding of their subtle three-dimensional formal style to the very large number of indigenous carvers who were drafted on to such

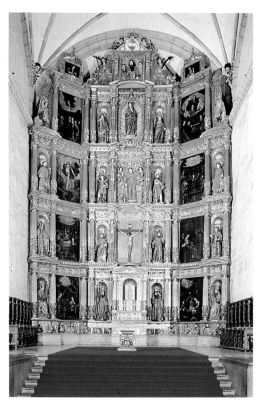

Renaissance-style retablo, 1605, Franciscan convent, Xochimilco, Mexico City

projects. Structures derived from Acolman's example, such as Augustinian convents in the more distant areas of Cuitzeo or Yuriria, also show variation and degrees of improvisation in both carving and conception. But it is uncertain whether this is attributable to a non-European hand on the chisel or to a more old-fashioned European hand at the helm.[6]

The Plateresque continued to flourish even after the introduction of the stripped-down classical Renaissance style known as Purism ("*stilo desornamentado*"), embodied in Philip II's Escorial (built 1563–82). Developed predominantly in Spain, that ostensibly simple style might seem at first glance to have been easier to transmit than the Plateresque, with its profusion of subtly carved ornament, but Purism appears to have been limited in its transatlantic appeal. Its essence was one of proportion and relationship among parts, whereas what continued to travel best to Mexico in this era dominated by comparatively untrained builders were isolated motifs.

Another, less ponderous version of late-Renaissance building style (frequently characterized as Mannerist, for want of a better name) appears in the first cathedrals of New Spain.[7] Early missionary activities had produced a disproportionate number of grandiose structures in distant rural, and subsequently depopulated, areas of the country; in the last three decades of the sixteenth century, as evangelization and settlement gave way to the stable, cultivated life of the Spanish centers, work began on the great cathedrals in major urban areas. These early cathedrals in Mérida (completed 1598) and Guadalajara (1571–1618) both incorporate in their facades the Renaissance ideals of unity and comprehensibility. Still, only a narrow elite subscribed to these ideals, and as a building style, Mannerism, like Purism, remained confined to a small number of structures.

The sequence of Plateresque and late-Renaissance styles that marked building facades also flourished in ecclesiastical interiors, most notably in the elaborate carved and gilded wood structure that in Spanish is called a retablo. Sometimes inaccurately translated as altar screen, the retablo, meaning literally "behind the altar," was a multitiered, multibayed structure whose compartments housed paintings and/or sculpture. This structure retained its central importance in Spain and its empire long after it had disappeared from Protestant Europe. In Mexico the style of the carved elements between the compartments shifted with changing times, but for almost two hundred years the reticular organization of the retablo remained constant. Its modular form would eventually disintegrate, but until it shattered during the last brilliant flowering of the Mexican Baroque in the eighteenth century, this regular repetitive formula continued to dominate ecclesiastical interiors.

The reiterative aspect of Mexican colonial art is first noticeable in the mural paintings that had decorated interiors in the early missionary period. With designs derived from European woodcuts and engravings, such works were produced in far greater numbers in Mexico than they ever had been in Spain. Often executed by native painters (who as workers in the ecclesiastical precincts were exempt from guild restrictions), these sequential illustrations of various religious themes and bands of Renaissance frieze ornament adorned the long expanses of cloisters, stairways, refectories,

Friezelike mural, Augustinian convent, Tlayacapan, Morelos

and other sequestered areas of the great mission churches. They also spread into the more public courtyard porticoes and open chapels and populated the high walls of naves with portraits of church luminaries.

The didactic function of these murals, many of which were painted by untrained friars or Indians, was subsequently assumed by the more purely Spanish retablos. Although a small number of such structures had been imported from Spain, the proliferation of altars in Mexico had awaited the arrival of carvers versed in the aesthetic of Renaissance Europe. The earliest extant retablo, that of about 1570–75 now in Cuauhtinchán, with its striated baluster columns, is unabashedly Plateresque. The high altar of Huejotzingo (1584–86) shows more consistent awareness of Italian Renaissance ideals, while that of Xochimilco (1605) is a pure and elegant manifestation of late-Renaissance/Mannerist design.

Retablo work dominated the activities of two guilds. The painters' guild (which also included gilders) was founded in 1557 and that of the carpenters (which subsumed the trades of wood-carvers and implicitly wood sculptors, joiners, and violin makers) was founded in 1568. The relative importance of the painters and the sculptors in the construction of retablos varied; as time went on sculpture in the round assumed greater significance. At first painters seem to have directed carvers and may also have provided models for reliefs; Andrés de la Concha, for example, has been proposed as the author of both the sculptures and paintings in the retablo of Coixtlahuaca.[8]

The subject matter and iconography of these retablos were restricted by the fact that they came into being during the Counter-Reformation, the great sixteenth-century reform movement through which the Catholic Church mobilized itself in response to the challenge of the Protestant Reformation. Among the specific reforms this movement generated were a number promoting communication of the tenets of the faith to the common people; in the directives promulgated in 1563 after the Council of Trent, art was seen to be one of the major vehicles for disseminating ecclesiastical doctrine and encouraging devotion among the uneducated. Theologians drew up guidelines for artists encouraging clarity, simplicity, and emotional directness; these instructions exerted a profound effect on art all over the Catholic world, but nowhere were they as determining a factor as in Mexico.[9]

As a result, devotional reliefs such as simple images of the Virgin, the Crucifixion, and the stigmatization of St. Francis of Assisi flourished in Mexico, especially as the images of the central retablo bays. However, most of the carvings on retablos were fully three-dimensional representations of Sts. Peter and Paul, the Fathers of the Church, or other saints, particularly the founders of the major orders and, later on, the recently canonized moderns, Ignatius of Loyola and Francis Xavier. In compliance with Counter-Reformation practice, these persons were portrayed as direct participants in the daily life of the believers.

The realism encouraged by the Counter-Reformation led to the perpetuation of certain traditional Spanish techniques. Although the plastic qualities of Mexican sculpture were rarely as corporeal as Spanish wood carving, the artists of New Spain did follow Spanish custom in more superficial

ways. Like the wood sculpture of the Peninsula, Mexican carving was endowed with an uncanny semblance of life through the application of paint, a final touch reserved in theory to the members of the painters' guild. Flesh was represented through the special multilayer painting technique called *encarnación* (incarnation = making flesh). The painters represented cloth through a different technique known as "estofado," which involved gilding the wood carving, covering it with a layer of colored paint, and scratching through the final surface to create elaborately striated gilt patterns. This lavish treatment gave luster to cultivated and popular wood carvings alike and would remain traditional in Mexico years after it ceased to predominate in Spain.

Stylistically the restraint and classicizing impulse inherent in Mexican retablo sculpture is visible almost from the start. Only in some of the earliest Mexican colonial carvings does the expressionist quality of Spanish Renaissance sculpture reveal itself and then usually in only the most subdued form.

The main sculptural influence arrived in the later sixteenth century when a calmer, more classical mood had established itself in Spain. This so-called romanizing style of sculpture, seen in the work of Pablo de Rojas (active 1581–1607) and Juan Bautista Vásquez the Younger (active 1578–90), found a receptive audience in the culture of New Spain and developed into one of the most persistent traits of Mexican sculpture. Within the Mexican version, minor variations are evident. The retablo niche figures of Huejotzingo, for example, are more stolid than those of Xochimilco, which show greater verve and movement. But even at Xochimilco it is interesting to note how the more adventurous sculptures, those of John the Baptist and the Archangel Michael, which already reflect the early seventeenth-century Spanish proto-Baroque of Juan Martínez Montañés, are hemmed in by the pillarlike figures of the Church Fathers.

An exception to the romanizing tendency of this period—one that heralds the other main trend in Mexican colonial carving—is the extraordinary relief of Santiago Mataindios in Tlatelolco. Said to date to the first decade of the seventeenth century, it has been attributed to an Indian carver on the basis of Torquemada's oft-cited reference to native sculptors: "in this town of Santiago, among other able craftsmen, there is an Indian, a native of the town, named Miguel Mauricio, who is a very superior sculptor, and his work is much more highly esteemed than that of some Spanish sculptors."[10] With its angular draperies, clumps of spiral cloud formations, and stereotyped faces on the crowds of subordinate figures, the Tlatelolco relief, like the Assumption of the Virgin of the same period in Mílpa Alta, is particularly evocative of Riojeno relief carving of the seventeenth century. In both these reliefs the contrast between the agitation of the carving and the impassivity of the faces themselves is striking. This carving style persisted in sculpture of both stone and wood well into the eighteenth century.

Unfortunately very little Mexican wood carving in the round has been identified from the first half of the seventeenth century, the golden age that saw the initial flowering of the Spanish Baroque. Certainly few later Mexican sculptures show any evidence of the intense naturalistic expres-

sivity introduced by the Peninsulars Juan Martínez Montañés and Gregorio Fernández. However, the continuation of Mannerist conventions into the eighteenth century makes Mexican sculpture particularly hard to date on the basis of European progressions of style. In fact, such "atemporality"[11] has been cited as one of the main characteristics of Mexican colonial art as a whole. Still, it is hoped that in time a chronological development specific to Mexico may be deduced, but none has yet been approximated. Complicating this already difficult task, in Mexico, even more strictly than in Counter-Reformation Spain, sculptures were intended as signifiers and icons, their "functional" qualities supreme. The sculptor remained anonymous, and his inventiveness was not of paramount importance.

Painted and gilded Mexican wood carvings eventually achieved an abstract ornamental quality and by the eighteenth century became joined visually to the glitter of the retablo's sumptuous decorative framework. This development may be attributed to a cultural instinct for form or even to a "traditional" conception of art, a conception that did not distinguish between the artist and the craftsman. The fact remains that the Mexican carver continued to design figures within a didactic and increasingly ornamental context. An understanding of this context is essential to any investigation of the nature of Mexican colonial sculptural style.

NOTES

1. See George Kubler, *Mexican Architecture of the Sixteenth Century*, 2 vols (New Haven, 1948), for a discussion of sixteenth century decline and further references. More recently, Jorge Alberto Manrique, "El manierismo en Nueva España: letras y artes," *Anales del Instituto de Investigaciones Estéticas* 13, no. 45 (1976), pp. 107–116.

2. See Diego Angulo Iñiguez, *Historia del arte hispanoamericano*, vol. 1 (Barcelona and Buenos Aires, 1945), still the most comprehensive survey of this material.

3. Earl Rosenthal, "The Image of Roman Architecture in Renaissance Spain," *Gazette des Beaux-Arts* 6th ser., 52 (1958), pp. 329–46.

4. George Kubler and Martin Soria, *Art and Architecture in Spain and Portugal and Their American Dominions, 1500 to 1800* (Baltimore, 1959) p. 2.

5. *Códice franciscano* (1569–1571), introduction by Joaquín García Icazbalceta (Mexico, 1941) p. 52; for extended discussion of this issue, see John McAndrew, *The Open-air Churches of Sixteenth-Century Mexico: Atrios, Posas, Open Chapels and other Studies* (Cambridge, Mass., 1965) pp. 174–78.

6. Elizabeth Wilder Weismann, *Mexico in Sculpture, 1521–1821* (Cambridge, Mass., 1950) pp. 36–42, for discussion of this question. For a more recent survey, see Manuel González Galván, "Influencia, por selección, de América en su arte colonial," *Anales del Instituto de Investigaciones Estéticas* 13, no. 50 (1982) pp. 43–54. See further references cited by José Guadalupe Victoria, *Pintura y sociedad en Nueva España, sigol XVI*, Instituto de Investigaciones Estéticas: Estudios y fuentes del arte en México, 56 (Mexico, 1986) p. 53, n. 16.

7. Jorge Alberto Manrique, "Las catedrales," in *Historia del arte mexicano*, 2d ed., vol. 6, *Arte Colonial, II*, (Mexico, 1986) pp. 760–85, also Angulo Iñiquez, *Historia del arte hispanoamericano*, vol. 1, pp. 397–458.

8. Guillermo Tovar de Teresa, *Renacimiento en Mexico: artístas y retablos* (Mexico, 1982) p. 347, n. 120.

9. Elisa Vargas Lugo, "La expresión pictórica religiosa y la sociedad colonial," *Anales del Instituto de Investigaciones Estéticas* 13, no. 50 (1982) pp. 61–65.

10. Fray Juan de Torquemada, *Monarquía Indiana* (Seville, 1615), edited by Miguel León-Portilla, Instituto de Investigaciones Históricas (Mexico, 1977) vol. 5, p. 314 (Book XVII, Ch. 1).

11. Jorge Alberto Manrique, "La estampa como fuente del arte en la Nueva España," *Anales del Instituto de Investigaciones Estéticas* 13, no. 50 (1982) pp. 56–57.

Mexican Painting of the Renaissance and Counter-Reformation

MARCUS BURKE

By 1557 immigrant painters had founded a guild in Mexico City *y sus tierras*.[1] Its ordinances were surprisingly free of racial bias but extremely precise in establishing European control over artistic practices in the capital.[2] Indian artists were allowed to sell or subcontract works only if they had been examined in the (European) techniques of the guild. Furthermore, by the late 1570s, after major epidemics drastically reduced the Indian population, the European, Creole (of European origin but born in the New World), and mestizo (mixed race) communities had grown large enough to compete demographically. At the same time, the enforced Hispanicization of the indigenous ruling classes,[3] the reduction of many Indians to serfdom under the encomienda and subsequent hacienda and mining labor systems, and the legal quarantine of tribal areas (originally intended to protect the Indians from exploitation or attacks by mestizos), had begun to remove or radically circumscribe patronage for indigenous art forms.[4]

The arrival in 1571 of the Jesuits, with their more accommodating evangelical policies, came too late to reverse this trend, especially since in matters of religious art the Jesuits, like all Counter-Reformation Catholics, had to obey the dictates of the Council of Trent enforcing orthodoxy in cult objects. As a result, works of art produced for patrons of any means in New Spain—and this applied to provincial areas as well as metropolitan centers—tended to follow European cultural leads. Monumental painting in particular may be considered after about 1580 to have become a largely European phenomenon, with the sequence of Mexican colonial styles following those of the Old World: Mannerism, Counter-Reformation/ Prosaic Reform, seventeenth-century Tenebrism, Baroque, Rococo.

Although the history of art in Mexico from 1580 to the later seventeenth century may be thought of as an extension of Spanish culture, two aspects of early seventeenth-century Mexican painting illustrate the complex relationship colonial artists had with Spain: on the one hand there was a tendency to maintain Mannerist design elements long after the style ceased to be viable in Europe, while on the other hand the Mexicans shared the Spanish enthusiasm for Counter-Reformation values.

The Mannerist affinity has an obvious origin, since many of the early leaders of the Mexican school, including Simon Pereyns (to Mexico 1566; died 1589), Andrés de la Concha (to Mexico 1567; died after 1612), and Baltasar de Echave Orio (to Mexico about 1580; died after 1620), all worked in a basically Mannerist style derived from Italian and Flemish models (cat. nos. 127–29). Indeed, well into the 1640s Mexican artists such as the Lagartos and the usually reform-minded Alonso López de Herrera were able to paint Mannerist compositions (cat. nos. 133–36), and the style was revived repeatedly, as in the work of Correa and Villalpando at the end of the century (cat. nos. 143–45). In contrast, Mannerism has a restricted history in Spanish art.

The reason for this difference lies in the Flemish (Pereyns), Basque

(Echave Orio), or provincial origins of many of the founders of the Mexican school and in the fact that they began arriving in Mexico at a time when Mannerism was still the international standard. Patronage issues may also have intervened; it is possible that some artists, among them Alonso Vázquez and López de Herrera, may have come to Mexico because their personal styles were not rewarded by Spanish patrons.

However, in the matter of Counter-Reformation culture, Mexican colonial painting shows itself to be completely in tune with the latest European and Spanish values. After the Council of Trent (1545–63), as has been noted, a newly invigorated Catholic Church confronted the Protestant challenge in Europe; the subsequent period, about 1570–1650, is called the Counter-Reformation, and its art is often described as Tridentine, after Tridentum, the Latin name for Trent.[5] It was in this period that new orders of the Church, including the Jesuits, were founded, the Inquisition greatly expanded, and the institutions of the Church reformed and turned to evangelistic purposes. In its final decrees the Council of Trent stressed the importance of holy images and required the Church to reject any profane, lascivious, unclear, or confusing works of religious art. This position, while ultimately leading to Baroque art and other styles of the seventeenth century, first encouraged artists to reform the more radical, hyper-idealized manifestations of the then-dominant "modern" style, Mannerism, and return to the more realistic mode of depiction in High Renaissance art.[6] The resulting Prosaic Reform style produced quietly intense, intimate devotional pictures stressing orthodox instruction, examples of piety, clear narrative, and emotional identification between subject and viewer. In Italy as well as elsewhere in Europe, this style softened the excesses of Mannerism and prepared the way for the seventeenth-century styles of Caravaggio, the Carracci, Rubens, and their contemporaries.

As might be expected, Spain, the most powerful and most enthusiastically orthodox Catholic country—the homeland of such typically Counter-Reformation saints as Ignatius of Loyola—immediately embraced the new style. Initially at El Escorial under Philip II in the 1580s and then in the schools of Madrid and Seville under the artists Vicente Carducho and Francisco Pacheco, among others, Tridentine imagery and the Prosaic Reform dominated artistic production. Thus the compositions of Pereyns, Concha, and Echave Orio, although indisputably Mannerist in style, are far quieter, far less subject to confusing distortions than the central Italian works of the 1550s and 1560s that had so disturbed the reforming bishops at Trent, who in any case had made no pronouncement on style as such but rather on the necessity that art embrace moral purity, doctrinal or narrative clarity, and the encouragement of Catholic devotion. The Mexican painters, like their Spanish colleagues Juan de Juanes and El Greco, carefully kept their imagery within Tridentine bounds and stressed the affective piety demanded by the Church—which was of particular relevance in a society whose moral raison d'être lay partly in proselytizing an indigenous population. In the next generation Mexican artists embraced the Reform style, and in many cases the works of an artist such as Luis Juárez offer parallels with the compositions of such Italian Counter-Reformation artists as Giovanni Battista Crespi (called Il Cerano; 1575–1633).

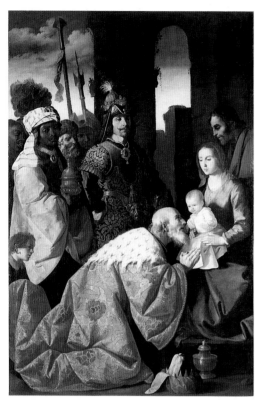

Francisco de Zurbarán. *Adoration of the Magi.*
Oil on canvas. Musée de Peinture et de Sculpture,
Grenoble

On the way to an identity, however, Mexican painting passed through
several stages. The mid-seventeenth century saw the school aligning it-
self with Sevillian painting, especially with the style of Francisco de Zur-
barán, who relied increasingly on New World sales to keep himself and
his workshop employed. In effect, he converted Seville's monopoly on
New World trade into a personal dominance of stylistic influences cross-
ing the ocean. His influence lasted into the 1700s, as is seen in Juan
Rodríguez Juárez's *St. John of God* (Pinacoteca Virreinal de San Diego,
Mexico City).

The first artist to bring seventeenth-century naturalism to Mexico was
the Seville-born Sebastián López de Arteaga (1610–about 1652), who im-
migrated to Mexico sometime around 1640 (cat. no. 137). Arteaga's con-
temporary, José Juárez, son of Luis Juárez, further developed the Tenebrist
manner. José Juárez's works place him in the closest possible relationship
with Zurbarán (cat. no. 142). Zurbarán's influence may also be seen in the
paintings of the third member of the Echave family, Baltasar de Echave
Rioja, presumed to be Juárez's pupil but also more responsive to the Ba-
roque design elements in such artistic sources as prints after Rubens.

One other factor should be considered. Beginning with Baltasar de Echave
Orio (about 1548–after 1620; in Mexico from about 1580), a "dynasty"
passed traditions father-to-son or master-to-pupil for one hundred fifty
years: Baltasar de Echave Ibía (1583–1640); Luis Juárez, a pupil of Echave
Orio (active 1590–1637); José Juárez, son of Luis (1617–1661); Baltasar de
Echave Rioja, son of Echave Ibía and follower of José Juárez (1632–1682);
Antonio Rodríguez, son-in-law of José Juárez (active about 1655–80); Nicolás
and Juan Rodríguez Juárez (1667–1734 and 1675–1728); José de Ibarra,
Juan or Nicolás Rodríguez Juárez's pupil (1688–1756); and Miguel Cabrera
(1695–1768). The importance of this continuity in maintaining European
values while developing a Mexican school within the European tradition
should not be underestimated.

MB

NOTES

1. This essay and those which follow owe much to the works of Diego Angulo Iñiguez, Jacques
 Lafaye, Octavio Paz, Manuel Toussaint (1965), Linda Bantel, and Guillermo Tovar de Teresa, all
 cited in the Further Reading. I also wish to thank Johanna Hecht for her extraordinary contribu-
 tions as a collaborator.
2. Ordinances of 1557 and 1686 published in Manuel Toussaint, *Pintura colonial en México*,
 2d ed., edited by Xavier Moyssén (Mexico, 1982) pp. 220–26; cf. *idem, Colonial Art in Mexico*,
 translated and edited by Elizabeth Wilder Weismann (Austin and London, 1967) p. 132.
3. The official Inquisition was established in Mexico in 1571, but was forbidden to investigate
 Indians. The *caciques*, however, were treated as Spaniards and had long been subject of inquisi-
 torial activity by the bishops, beginning in the 1520s. See Charles Gibson, *The Aztecs under
 Spanish Rule: History of the Indians of the Valley of Mexico, 1519–1810* (Palo Alto, Calif., 1964)
 p. 192 and passim; see also R.E. Greenleaf, *The Mexican Inquisition of the Sixteenth Century*
 (Albuquerque, 1969).
4. On the difficult problem of secularization, see Gibson, *The Aztecs Under Spanish Rule*,
 pp. 98–115. On the indigenous contributions to colonial art, see Donna Pierce, "The Mission:
 Evangelical Utopianism in the New World, 1523–1600," in this volume.
5. See Emile Mâle, *L'Art religieux après le Concile de Trente* (Paris, 1932), passim. For the source of
 Counter-Reformation imagery, see *Canons and Decrees of the Council of Trent*, original text
 with English translation by Rev. H.J. Schroeder, O.P. (St. Louis and London, 1941), pp. 216–17,
 484–85. For further bibliography on this subject, see Marcus B. Burke, "Mexican Colonial
 Painting in Its European Context," in Linda Bantel and Marcus B. Burke, *Spain and New Spain:
 Mexican Colonial Arts in Their European Context*, exh. cat., Art Museum of South Texas
 (Corpus Christi, Texas, 1979) pp. 54–55, n. 12–24.
6. Walter Friedlaender, *Mannerism and Anti-Mannerism in Italian Painting* (New York, 1965);
 Donald Posner, *Annibale Carracci: A Study in the Reform of Italian Painting Around 1590*,
 2 vols (London and New York, 1971).

125 ◀ *St. Peter* and *St. Paul*

◀ Acolman, second half of 16th century
◀ Polychromed and gilded wood; height (each)
◀ 150 cm. (59 in.)
◀ CNCA–INAH, Museo Nacional del Virreinato,
◀ Tepotzotlán 10–7129/7130

These reliefs are heirs to a long European tradition that paired images of Peter and Paul as guardians of the faith. They are among the earliest Mexican carvings in a developed European manner to have survived; especially note-worthy are their surfaces in which the estofado appears to be unretouched.

The sculptor subtly contrasts the personalities of the two founders of the Church. Peter is tense and agitated, barely grasping his giant keys whose jagged shape juts out over one shoulder, breaking the otherwise enclosed contour of the figure; his angular draperies are pressed to his thigh with the same hand that clutches at his book. Paul is calm and stable, from his up-turned gaze to his vertical stafflike sword, his book securely tucked under his arm. His draperies also fall smoothly, and the tasseled hem of one layer suggests ecclesiastical garb. Despite the flatness of the relief and the near-columnar verticality of their poses, the carver has used subtle gradations of depth and artful but simple disposition of drapery to suggest the underlying forms of limbs as well as a gentle contrapposto.

Their style evokes the subtle Berruguete influence encountered in the mid-century school of Palencia or the manner of Diego de Siloe's followers in

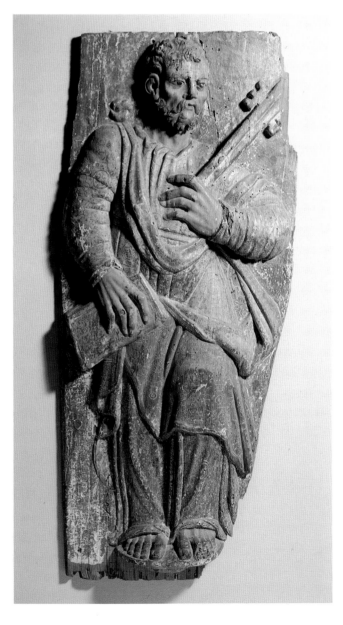

Granada. Certain idiosyncrasies—among them the squat canon and the large splayed hands with their digital lines extending to the wrists and central fingers adjoining—specifically recall the work of Francisco Giralte. The archaizing tendency toward regularly spaced drapery folds falling parallel to the figure or the crossing of arms at right angles and the avoidance of any Berruguetean instability are particularly reminiscent of this sculptor's work.

These two reliefs were undoubtedly once part of a sixteenth-century altar. They closely resemble two clearly Renaissance predella panels of the Twelve Apostles now incorporated into a fragmentary Baroque altar framework. This altar, formerly installed in the nave of the Augustinian mission church in Acolman, is now in the regional museum of Querétaro. It was first published by Romero de Terreros in 1921 at which time it also included two sixteenth-century paintings. One of them, an Annunciation, bears two dates. The first, 1561, he suggested as the year when the picture was first painted and when the altar in which it was installed was constructed; the second, 1713, he hypothesized, was the year when the paintings (and presumably the predella panels) were restored and incorporated into the Baroque altar framework.[1]

The reliefs of Peter and Paul were also found at Acolman, temporarily installed in the upper cloister where Romero de Terreros later identified them as fragments of a sixteenth-century altar. Thus it is tempting to conclude that these reliefs were originally part of the same altar as the predella panels, that they were carved in 1561 as part of the original retablo, and that they remained there until 1713. They may have been placed in storage at that time which would account for the more advanced state of deterioration.

Stylistically the Acolman wood reliefs bear little relationship to the Peter and Paul carved on the church's renowned facade, itself completed in 1560. Echoes of this facade abound in the numerous Augustinian missions north of the capital; related versions of the two enormous niche figures that flank the Acolman main portal also appear in Yuriria and Metztitlán. But no such echoes appear inside the Acolman church itself. Still, the impassive, underlying geometry that marks the figures in the niches and roundels of its facade, although far more severe and unmodulated in the stone carving, is also a feature of the wood reliefs and is a characteristic that will persist in Mexican sculpture throughout the viceregal period.

JH

1. M. Romero de Terreros, "La iglesia y monasterio de S. Agustín Acolman," in *Arte colonial*, 3d ser. (Mexico, 1921) p. 15. Photographs of the altar and these paintings (plus three others apparently from the original altar) in situ were published by Alfonso Toro, "Iglesia y convento de Acolman (siglo XVI)," in *La Cantiga de las Piedras* (Mexico, 1942) p. 21. Also in P. Calders, *Acolman*, Mexico, 1945, figs. 27, 28, 29–31, giving 1562 and 1714 as dates on the painting.

REFERENCES
P. Calders. *Acolman, un convento agustino del siglo XVI*. Mexico, 1945. **Manuel Romero de Terreros.** *El arte en México durante el Virreinato: resumen histórico*. Mexico, 1951, p. 31, pls. 51, 52. **Guillermo Tovar de Teresa.** *Pintura y escultura del Renacimiento en México*. Mexico, 1979.

◀ *St. Christopher and the Christ Child*

Mexican, 16th–17th century
Gilded and polychromed wood; height 240 cm.
(94½ in.)
SEDUE, Catedral de Cuernavaca, Cuernavaca

Depictions of the legendary St. Christopher derive from his story as given in Jacobus de Voragine's *Golden Legend*. According to this widely read medieval source, Christopher was a giant in search of someone stronger than himself whom he might serve. He converted to Christianity and, as a work of charity, devoted himself to carrying wayfarers across a river. One day a little child asked to be taken across, and Christopher took him on his shoulder. Halfway across the stream, he staggered under the child's astonishing weight, but he struggled to the other side and only then reproached the child for placing him in peril. "Marvel not!" the child replied, "for thou hast borne upon thy back the world and him who created it."

For the sculptor especially, this charming story offered unique opportunities for drama and expressivity, opportunities that sprang from the basic prob-

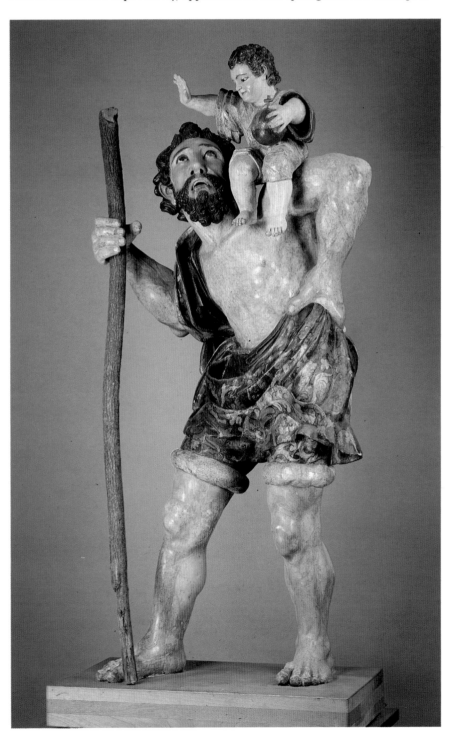

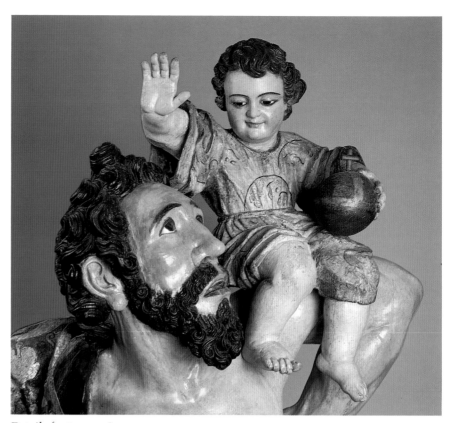

Detail of cat. no. 126

lem of showing a large man in action. Christopher's athletic legend enabled the sculptor to show much more of his body than was generally considered decorous in post-Tridentine Church art. It was, after all, only natural that in crossing a river a person would bare his legs, and so rolled breeches and a hiked-up cloak are a traditional feature of his representation. The custom developed of presenting Christopher outside the confining scale of the retablo niches where most Mexican figural sculptures were designed to fit.

Most frequently, the saint was painted, either directly on the walls of church naves or on gigantic canvases. Although as a practical matter, oversize sculptures were somewhat more difficult to achieve, a number of very large ones were also carved in wood and a few even in stone. This carved wood example, now housed in a niche in the cloister of the former Franciscan monastery (now the cathedral), is presumed to have been made for the nave of the sixteenth-century building, an establishment associated with Cortés and his family.

Although well over normal life-size, this Christopher is not as large as some. The saint's hugeness and his mythic strength are depicted as much through his muscularity and somewhat squat proportions as by his actual size. The sculpture is one of the few in Mexico to show evidence of mid-sixteenth-century Spanish Mannerism, the style that preceded the classicizing mode that would eventually predominate in the sculpture of New Spain. Its monumentality and Herculean proportions, its plastic volume and pliant drapery, all recall the "proto-Baroque" of the great Juan de Juni. Such looseness in handling sculptural form would not appear again in Mexico before the late eighteenth century.

JH

127 ▸ Simon Pereyns
Flemish, about 1530–1589; to Mexico 1566

St. Christopher with the Christ Child, 1588
Oil on wood panel; 200 x 155 cm. (78¾ x 61 in.)
Signed and dated: [illegible] en Pe/rines F / año
1588
SEDUE, Catedral Metropolitana, Mexico City

A Fleming by birth, Simon Pereyns was apparently trained at Antwerp by the first generation of northern Mannerists. Going initially to Portugal and then to the Spanish court at Madrid, he traveled to Mexico in 1566 in the entourage of the new viceroy, Gastón de Peralta, marqués de Falcés. After Peralta was forced to return to Spain in 1568, Pereyns was accused before the Inquisition, for which he painted a devotional image of the Virgin as a penance. His most famous painting, which may or may not be identified with the work made for the Inquisition, was the *Virgin of Pardon* formerly in the Mexico City Cathedral but unfortunately destroyed by fire in 1967. Pereyns's prolific career is amply documented and included collaborations with Francisco de Zumaya and Andrés de la Concha (cat. no. 128), whose style often emulates Pereyns's own Mannerist approach.

According to the *Golden Legend* of Jacobus de Voragine, St. Christopher (the name means "Christ-bearer") was a Canaanite giant, a soldier, who sought to enter the service of the strongest king on earth. He tested the secular realms and even the devil, whom he found to be afraid of Christ. Reasoning that Christ must be the most powerful ruler of all, he sought instruction in the Christian religion and was subsequently advised by a hermit to take up

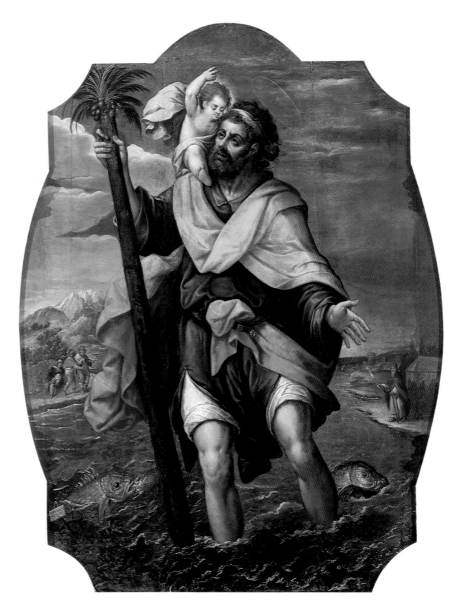

residence by a dangerous river to help those who wished to cross. Fashioning a great staff to aid his efforts, Christopher carried out this mission until one night a child asked to be carried. In spite of his great strength Christopher found the going difficult and the child heavy, as though the whole weight of the world were on his shoulders. Nevertheless he eventually reached the shore, where the child revealed himself as Christ and promised that as a sign Christopher's staff would bloom if planted in the earth. This done, the staff turned into a fruit-laden palm.

Although the legend of St. Christopher had already come under widespread criticism within the Church during the Renaissance, the enormous popularity of the saint made the continuation of his cult a necessity. As the patron of travelers and therefore of pilgrims, St. Christopher had a particular following in Spain, where enormous images of the saint with the Christ Child on his shoulder were painted, as in the Toledo Cathedral. St. Christopher was also popular in Franciscan devotions, and his presence in the Mexico City Cathedral may reflect the importance of the Franciscans in New Spain.

In 1588 the head of the cathedral school, Don Sancho Sánchez de Muñón, donated to the Cathedral an altar dedicated to St. Christopher with an altarpiece —the present work—painted by Pereyns. It should be noted that although several scholars read the date of the picture as "1585" instead of "1588," documentary evidence suggests that 1588 was indeed the year the piece was made. Later, during the renovations of the eighteenth century, the panel was reinstalled in a new altar ensemble dedicated to St. Joseph, now in the Chapel of the Immaculate Conception.

Pereyns has followed the traditional iconography of the saint, depicting Christopher in midstream, his staff budding into a fruit palm, with the Christ Child gesturing in the act of revealing himself. On the shore in the left background a group of pilgrims awaits the saint's assistance; on the right a monk or hermit appears—possibly the hermit who first instructed Christopher in the faith. Only the rather whimsical fish may be thought of as idiosyncratic, although the exaggerated pose of the Christ Child, the flattening of the repoussoir figure of Christopher against the picture plane, the separation of foreground and far background, and the abstract patterns of Christopher's ocher cloak against his blue jacket call attention to Pereyns's Mannerist training.

MB

REFERENCES
Agustín Velázquez Chavez. *Tres siglos de pintura colonial mexicana.* Mexico 1939, pp. 179–80, fig. 23. **Diego Angulo Iñiguez.** *Historia del arte hispanoamericano.* Barcelona and Buenos Aires, 1950, vol. 2, pp. 381, 374, fig. 345. **Manuel Toussaint.** *Colonial Art in Mexico.* Translated and edited by Elizabeth Wilder Weismann. Austin and London, 1967, p. 134. **Friederike Werner.** "Christophorus." In *Lexicon der christlichen Ikonographie,* edited by Engelbert Kirschbaum et al. Vol. 5, edited by Wolfgang Braunfels. Rome and Freiburg, 1973, cols., 496–508. **Enrique Marco Dorta.** *Arte en América y Filipinas.* Ars Hispaniae: Historia Universal del Arte Hispánico, vol. 21. Madrid, 1973, p. 113, fig. 174 (reads date as "1585"). **Manuel Toussaint.** *Pintura colonial in Mexico.* 2d ed., edited by Xavier Moyssén. Mexico, 1982. p. 60, figs. 83, 84. **Guillermo Tovar de Teresa.** *Renacimiento en México: artistas y retablos.* Mexico, 1982, pp. 128–33 (ill.). **Nelly Sigaut.** "Capilla de la Purísima Concepción." In *Catedral de México. Patrimonio artístico y cultural.* Mexico, 1986, pp. 257–58, ill. p. 265. **José Guadelupe Victoria.** "Un pintor flamenco en Nueva España: Simón Pereyns." *Anales del Instituto de Investigaciones Estéticas* 14, no. 55 (1986), pp. 69–83, see esp. pp. 78–80, figs. 2, 3.

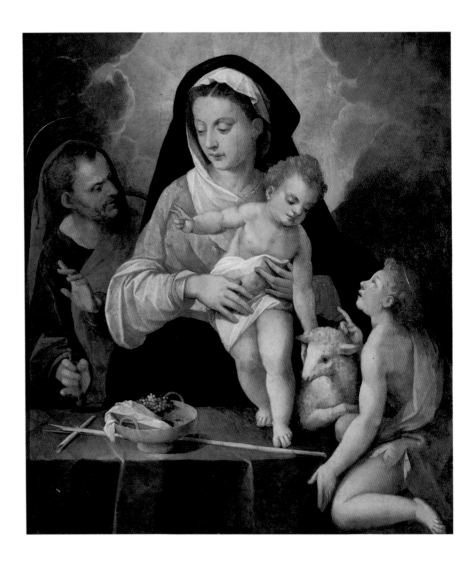

128 ◄ **Andrés de la Concha**
◄ Spanish; to Mexico about 1567–d. after 1612
◄
◄ *The Holy Family with the Young St. John*
◄ *the Baptist,* 1570–1600
◄ Oil on wood; 132 x 118 cm. (52 x 46½ in.)
◄ CNCA–INBA Pinacoteca Virreinal de San Diego,
◄ Mexico City

Andrés de la Concha was born in Seville, where he may have trained under the Hispano-Netherlandish painter Pedro de Campaña (Pieter Kempeneer). He left Seville for the Indies in 1567. A prolific artist, Concha is thought to have been active until at least 1612. Recent scholarship has debated whether documents referring to an Andrés de la Concha active as an architect as well as a painter from 1599 onward indicate the existence of two artists of this name. Documentary evidence, however, tends to favor a single master.

The Holy Family with the Young St. John the Baptist is among a group of works formerly assigned to the putative Master of St. Cecilia, named after the subject of another panel at the Pinacoteca Virreinal de San Diego. The identity of this master was disputed until only recently; Toussaint, for example, hesitantly attributed both works at the Pinacoteca to Simon Pereyns. Scholars have shown, however, that the Master of St. Cecilia may be identified, on both stylistic and circumstantial documentary grounds, with Concha. Certainly the *Holy Family* is well within the stylistic boundaries established by the numerous works documented or securely attributed to Concha, although his close relationship and collaboration with Pereyns leaves open the future refinement of both artists' oeuvres.

Concha's depiction of the Holy Family reveals both his Mannerist training and his awareness of new theological and artistic currents. Images of the Holy Family, especially when restricted to three persons (Mary, Christ, and Joseph),

were particularly important in Counter-Reformation iconography, implying a Trinitarian reference. In this context Concha's inclusion of the young St. John the Baptist maintains the pre-Tridentine tradition, as does his placement of St. Joseph at the margin of the composition. Furthermore, the disjointed spatial composition, exaggerated poses, and porcelainlike figures embody Mannerist stylistic values, probably deriving ultimately from Michelangelo. Concha's rendering of St. Joseph, however, would appear to affirm Counter-Reformation devotional values. His Joseph, if not yet the powerfully masculine protector of Christ found in the works of Baroque artists such as Bartolomé Murillo, is at least no longer the doddering old man of Medieval and Renaissance art.

MB

REFERENCES

Agustín Velázquez Chávez. *Tres siglos de pintura colonial mexicana.* Mexico, 1939. p. 260, fig. 37 (as Master of St. Cecilia). **Diego Angulo Iñiguez.** *Historia del arte hispanoamericano.* Barcelona and Buenos Aires, 1950, vol. 2, p. 377, fig. 347, pp. 384–86 (as Master of St. Cecilia). **George Kubler and Martín Soria.** *Art and Architecture in Spain and Portugal and Their American Dominions: 1500–1800.* Baltimore, 1959, pp. 306, 392, n. 24. **Enrique Marco Dorta.** *Arte en América y Filipinas.* Ars Hispaniae: Historia Universal del Arte Hispánico, vol. 21. Madrid, 1973, pp. 113–14, fig. 176 (as Andrés de la Concha, identified with the Master of St. Cecilia). **Manuel Toussaint.** *Pintura colonial en México.* 2d ed., edited by Xavier Moyssén. Mexico, 1982, pp. 61 (as Simón Pereyns), fig. 86, pp. 67–70, 251, n. 20 (X. Moyssén). **Guillermo Tovar de Teresa.** *Renacimiento en México: artistas y retablos.* Mexico, 1982, pp. 121–23, 124 (ill.). **Martha Fernández.** "El matrimonio de Andrés de Concha." *Anales del Instituto de Investigaciones Estéticas* 13, no. 52 (1983), pp. 85–99 (suggesting the existence of an Andrés de Concha the Younger). **Guillermo Tovar de Teresa.** "Nuevas informaciones sobre Andrés de la Concha." *Excelsior* (Sunday supplement), March 27, 1988, pp. 2ff. **Virginia Armella de Aspe and Mercedes Meade de Angulo.** *Tesoros de la Pinacoteca Virreinal.* Mexico, 1989, pp. 24–25, 48–51, ill.

129 ◀ Baltasar de Echave Orio

Spanish, about 1558–about 1620; to Mexico 1580

Christ After the Flagellation Adored by the Penitent St. Peter

Oil on wood; 190 x 154 cm. (74¾ x 60⅝ in.)
Signed and dated: B de Echave F/Año 1618
SEDUE, Catedral Metropolitana, Mexico City

Baltasar de Echave Orio, founder of the leading dynasty of Mexican colonial painters, was born in the Basque country of Spain about 1558. He came to Mexico in 1580 and allied himself with his countryman, the altar-gilder Francisco de Zumaya, whose daughter Isabel (also said to be an artist) Echave Orio married in 1582. By 1600 Echave Orio had become the foremost artist in Mexico. He was also an intellectual of many achievements, including a treatise on the antiquity of the Basque language that he published in 1607. He is thought to have died about 1620.

According to Luke (22:34), Jesus, before his betrayal, warned the apostle Peter that "the cock will not crow this day," until even Peter would deny association with him. Indeed, after Jesus' arrest, Peter was confronted and accused of being one of his followers; Peter denied the accusation three times, then "immediately, while he was still speaking, the cock crowed.... And the Lord turned and looked at Peter. And Peter remembered the word of the Lord.... And he went out and wept bitterly" (22:54–62). Occurring in all four Gospels, this description of Peter, the chief apostle and founder of the Roman Church, weeping in remorse has always had enormous power within the Christian tradition. This was particularly true of Roman Catholic art during the Counter-Reformation period, when, in the face of Protestant criticism, the Church seized upon the image of St. Peter in Tears as a means of affirming the sacrament of Penance. If the first pope, the apostle to whom Christ had given the "keys to the kingdom of heaven" (Matthew 16:19), were to do penance, how much more necessary was the sacrament for ordinary mortals.

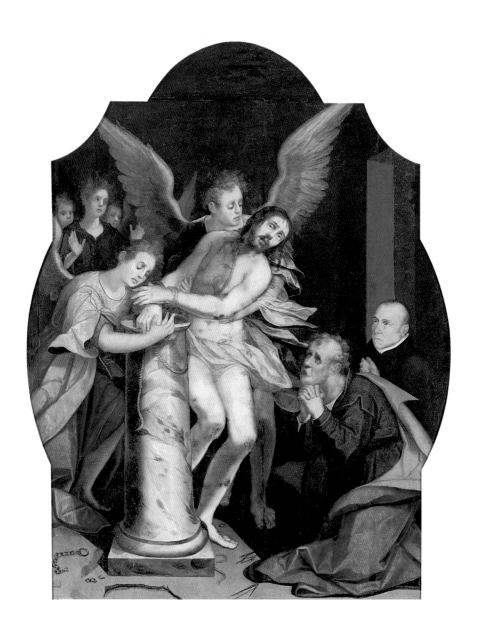

Although many contemporary images of St. Peter in Tears show him alone (Guido Reni's and El Greco's versions of the theme, for example), Spanish artists such as Juan del Castillo also depicted the saint kneeling before Jesus, who has just been scourged. In addition to the Eucharistic reference afforded by the broken body of Christ, such a formulation allows the viewer to make his or her own devotion to the Man of Sorrows. It is this tradition that Echave Orio follows, adding at the right the portrait of a donor, who was identified in an inventory of 1632 as a priest of the Cathedral (*racionero*) named Torres.

Like Pereyns's *St. Christopher* (cat. no. 127), Echave Orio's panel was originally part of a separate altar but was incorporated into its present location during renovations in the eighteenth century. It has been suggested that the work was originally painted for the Cathedral's Chapel of St. Peter, completed in 1615. (It should be noted that the date inscribed on the painting, "1618," was formerly read as "1598.") Perhaps the *racionero* Torres commissioned an altar in that chapel with the present subject as the central theme. Some question also remains about the authorship of the work. Although the panel's condition and inaccessibility have made precise analysis difficult, both the composition and the treatment seem uneven. Since the work is dated at the

very end of Echave Orio's career, it is possible that his son, Baltasar de Echave Ibía, intervened in its creation.

MB

REFERENCES

Agustín Velázquez Chávez. *Tres Siglos de Pintura Colonial Mexicana.* Mexico, 1939. p. 220 (as 1598). **George Kubler and Martín Soria.** *Art and Architecture in Spain and Portugal and Their American Dominions: 1500–1800.* Baltimore, 1959, pp. 307–8. **Manuel Toussaint.** *La Catedral de México y el Sagrario Metropolitano: su historia, su tesoro, su arte.* Mexico, 1948, p. 143, figs. 60, 60A. **Manuel Toussaint.** *Colonial Art in Mexico.* Translated and edited by Elizabeth Wilder Weismann. Austin and London, 1967, p. 143. **Manuel Toussaint.** *Pintura colonial en México.* 2d ed., edited by Xavier Moyssén. Mexico, 1982, pp. 92–94, fig. 126 (as 1598). **Guillermo Tovar de Teresa.** *Renacimiento en México: artistas y retablos.* Mexico, 1982, p. 155. **Nelly Sigaut.** "Capilla de la Purisima Concepción." In *Catedral de México: patrimonio artístico y cultural.* Mexico, 1986, pp. 258–61, ill. p. 266.

130 ◀ Alonso Vázquez

Spanish, about 1565–d. after 1607; to Mexico 1603

The Virgin of the Immaculate Conception, 1605–1607

Oil on canvas; 211 x 155 cm. (83 x 61 in.)
Inscribed: ARVCIEN / TIBUS PRÆPARATIS / ADESCAM [device] ET ALAQVE/IS OPERANTIV/M MENDATI/VM [illegible] devoçion del P. Alon/o / Carvajal [partially illegible] Capp^llan de este Hosp^l
Patronato del Hospital de Jesús, Mexico City

Alonso Vázquez is thought to have been born in Ronda, near Seville in Andalusia, about 1565. He is documented as a painter at Seville from 1582 until mid-1603, when he moved to Mexico in the entourage of the marqués de Montesclaros. He was still active in 1607.

As J. M. Serrera has shown, *The Virgin of the Immaculate Conception* at the Hospital de Jesús compares in detail with devotional works by Vázquez completed before he left Seville and may be identified with the main altarpiece for the chapel of the Hospital of the Immaculate Conception, predecessor of the Hospital de Jesús, for which Vázquez sought payment in February 1607. As such, it not only represents a highly important benchmark against which to judge other works attributed to Vázquez but also serves as a bridge from the world of Spanish art around 1600 to the developing Mexican school.

The painting may have been commissioned, as one of its inscriptions indicates, by Alonso Carvajal, a hospital chaplain, although it is possible that the inscription commemorates the work's reinstallation in the mid-seventeenth century.

The doctrine of the Immaculate Conception states that the Virgin Mary was conceived by her parents without taint of original sin. This belief, widely held among Catholics from the fifteenth century onward, was nevertheless not declared dogma until 1869. In Spain, where Immaculist devotion was particularly strong, sixteenth- and seventeenth-century images of the Virgin of the Immaculate Conception were ubiquitous, representing both an expression of popular piety and a form of religious propaganda urging universal adoption of the doctrine by the Church.

By the 1400s an image of the Immaculate Virgin taken from a variety of biblical and liturgical sources had begun to be the norm. The primary source was the Book of Revelation (chapter 12), in which a pregnant woman appears "clothed with the sun, with the moon under her feet, and upon her head a crown of twelve stars." Menaced by a dragon (the devil), she gives birth to a male child who is taken into heaven and is subsequently given wings with which to escape the dragon's wrath. Associated with this narrative were a group of metaphors from the Song of Solomon. Litanies of the Virgin had consolidated the iconography, including both words and visual images, by about 1500, although it was not until 1576, after the Council of Trent, that the first approved Marian litanies were issued. In the illustrations accompanying such litanies, a youthful Mary was placed amid the numerous symbols of her immaculate status, such as those found in Vázquez's picture, among them,

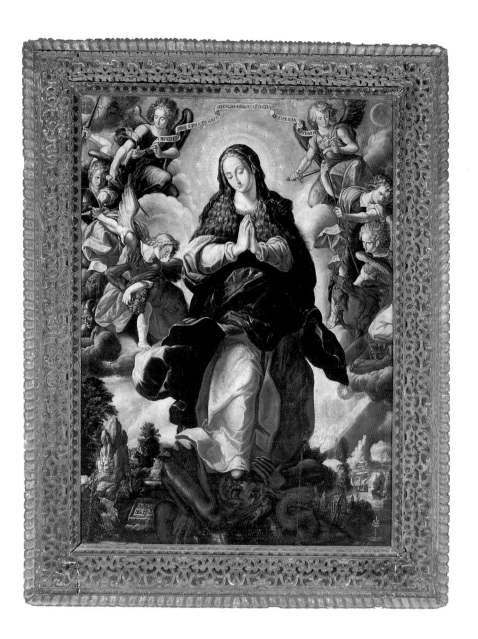

from the Song of Solomon, a "rose of Sharon . . . the lily among thorns" (2:1–2; found in the painting at lower right); "the tower of David" (4:4; lower right); "a locked garden" (4:12; the *hortus conclusus* lower left); "a fountain sealed . . . a well of living waters" (4:12, 15; lower right); "fair as the moon, clear as the sun" (6:10; upper right and left); stately as "a palm tree" (7:7; lower right); and, from the Psalms and medieval liturgies, "star of the sea" and "safe haven" (lower right). By the 1620s, however, artists such as the Sevillian painter and art theorist Francisco Pacheco—along with younger Spanish and Italian artists such as Velázquez, Ribera, and Reni—began to develop a more streamlined iconography placing much less emphasis on the numerous attributes.

Although Vázquez is thought to have shared a commission with Pacheco just before coming to Mexico, his complicated presentation of the subject lies closer to the Mannerist formulations of a Vasari than to subsequent Baroque renderings. Indeed, the aggressively old-fashioned quality of the work may explain why Vázquez chose to immigrate to Mexico rather than stay in Seville, where his *retardataire* style may have been received with less enthusiasm.

MB

REFERENCES
Angelo de Santi. *Les litanies de la Sainte Vierge: étude historique et critique.* Translated by A. Boudinhon. Paris, 1900. **Manuel Toussaint.** *Pintura colonial en México.* 2d ed., edited by Xavier Moyssén. Mexico, 1982, pp. 73–79. **Eduardo Báez Macías.** *El edificio del Hospital de Jesús.* Mexico, 1982, pp. 31–49, 122–23, figs. 15–27. **Suzanne Stratton.** "The Immaculate Conception in Spanish Renaissance and Baroque Art." Ph.D. diss., New York University, 1983. **Juan Miguel Serrera.** "Alonso Vázquez en México." Unpublished ms.

131 ◀ Baltasar de Echave Ibía

Mexican, about 1583–d. after 1641 (1660?)

Sts. Anthony Abbot and Paul the Hermit

Oil on copper; 37 x 51 cm. (14⅝ x 20⅛ in.)
CNCA–INBA, Pinacoteca Virreinal de San Diego, Mexico City

Baltasar de Echave Ibía, son of Baltasar de Echave Orio, grandson of Francisco Ibía de Zumaya, and father of Baltasar de Echave Rioja, was born in Mexico City about 1583 and died there after 1641, perhaps as late as 1660. With his contemporaries Luis Juárez and Fray Alonso López de Herrera, Echave Ibía helped reform the Mannerist tendencies of his father's generation into the more prosaic manner of the early Counter-Reformation. Although he was capable of exquisitely subtle color harmonies and intimate yet monumental presentations of devotional and biblical subjects, his style tends toward a certain dryness.

The hagiographies of Anthony Abbot, the highly popular monastic saint and prototype of Christian steadfastness in the face of temptation, and Paul the Hermit are intertwined. Having heard that a certain Paul was the first to renounce the world and become a hermit monk, Anthony sought to find him. Along the way he encountered such creatures as a centaur and even the devil, but he eventually located the remote cave where the hermit lived. Representations of the two men conversing while receiving bread from a raven, with scenes from St. Anthony's search for St. Paul in the background, are quite common in Spain, where they were used to decorate hermitage churches, as in the famous example by Diego Velázquez, now in the Museo del Prado, Madrid, painted in the 1630s for a chapel on the grounds of the Buen Retiro.

The present painting by Echave Ibía follows the traditional format but also demonstrates the extent to which the Netherlandish influence in Mexican colonial painting continued after the deaths of Pereyns and Maarten de Vos.

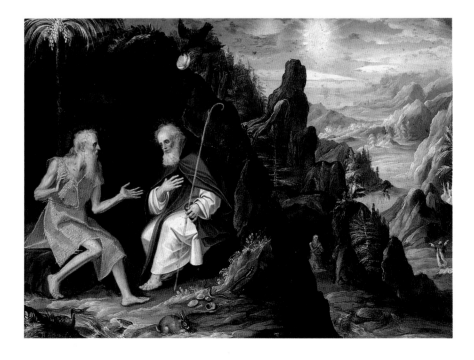

The large Flemish community in Seville, heavily involved in the New World trade, along with the dominant position of the Antwerp printing houses in the export of books to the viceroyalties, served to keep the art of the Catholic Netherlands flowing into Mexico. What is more, late sixteenth- and early seventeenth-century Flemish landscapes could be found almost everywhere in Spain. Documents of seventeenth-century private art collections in Spain often record these pictures in large numbers, and the works of artists such as Joost de Momper the Younger and Joachim Patinir were also frequently engraved.

Echave's wildly romantic landscape clearly derives from these or other similar Netherlandish sources, an influence that seems to have entered his work after he completed his *Baptism of Christ* in 1628 (Parish Church, Xochimilco). A date in the 1630s therefore seems reasonable for this and for several other works in the Netherlandish manner.

<div style="text-align: right">MB</div>

REFERENCES
Agustín Velázquez Chávez. *Tres siglos de pintura colonial mexicana*. Mexico, 1939, p. 224, fig. 56. **Gibson Danes**. "Baltasar de Exhave Ibía: Some Critical Notes on the Stylistic Character of His Art. *Anales del Instituto de Investigaciones Estéticas* 3, no. 9 (1942), pp. 22–26, fig. 8. **Marita Martínez del Río de Redo and Teresa Castelló de Iturbide**. "Art in the Viceregal Period." In *Treasures of Mexico from the Mexican National Museums*, exh. cat. edited by Olga Hammer and Jeanne D'Andrea. Washington D.C., New York, and Los Angeles, 1978, ill. 106, p. 34, no. 106, pp. 120. **Marcus B. Burke**. "Mexican Colonial Painting in Its European Context." In Linda Bantel and Marcus B. Burke, *Spain and New Spain: Mexican Colonial Arts in Their European Context*, exh. cat., Art Museum of South Texas, Corpus Christi, Texas, 1979, pp. 21–25. **Manuel Toussaint**. *Pintura colonial en México*. 2d ed., edited by Xavier Moyssén. Mexico, 1982, pp. 96–97, fig. 131.

132 ◀ Attributed to Luis Juárez

Mexican?, about 1585–d. after 1636

The Archangel Michael (Conquering Satan)

Oil on wood; 172 x 153 cm. (67¾ x 60¼ in.)
CNCA–INBA, Pinacoteca Virreinal de San Diego, Mexico City

Luis Juárez was born, probably in Mexico, about 1585 and died after 1636. Most of his paintings were dated between 1610 and 1630. His works, with those of Echave Ibía and López de Herrera, represent the Counter-Reformation "prosaic" style in Mexico, in which ecstatic holy figures were often portrayed in an intimate, direct way. Juárez left an important artistic legacy, among which should be counted the contributions of his son, the painter José Juárez.

The archangel Michael, commander of the heavenly armies, plays an important role both in Judeo-Christian religious literature and in Christian art. As the principal opponent of Satan, Michael has been the object of intense Catholic piety. Furthermore, in chapter 12 of the Book of Revelation Michael is associated with the Apocalyptic Woman—understood to be the Virgin Mary. Because Marian devotions, and especially the doctrine of the Immaculate Conception, derive much of their imagery from the description of the Apocalyptic Woman, Michael was also linked to the strong Marian current in the Catholic faith. The popularity of the archangels in Latin America has also been attributed by some scholars to syncretistic relationships with Precolumbian messenger deities, but a more likely explanation may lie in the fact that the initial European colonization of the New World coincided with the development of a new European cult of the seven archangels, a devotion greatly augmented in the Counter-Reformation era.

Medieval images of Michael, often used to crown altarpieces in Spain, showed a contemporary knight triumphing over the satanic dragon. By the mid-Renaissance, however, Michael's armor had taken on a more classical Greco-Roman design. Most post-Renaissance images of Michael show some

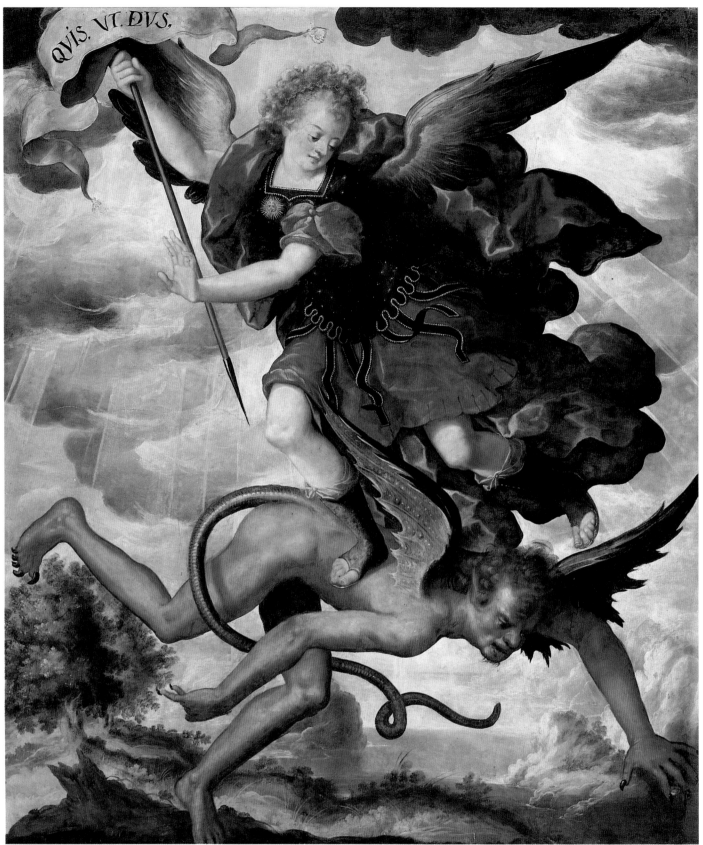

132

awareness of Raphael's dynamic treatment of the subject, which was widely distributed in copies and prints and which probably influenced the works of such Flemish Mannerists as Maarten de Vos, whose work was well known in Mexico. Other sources for imagery could be found in the works of the Italian- and Flemish-influenced artists in Seville, among them Alonso Vázquez, who came to Mexico in 1603.

Indeed, some scholars have attributed this panel to Vázquez. Although a comparison of the rather naturalistic figure of Satan with Vázquez's known Sevillian works might suggest this, the arguments of other experts who ascribe the work to Luis Juárez seem more compelling. The idealistic rendering of the archangel closely follows the soft delineation of other idealized figures in Luis Juárez's oeuvre, such as the *San Ildefonso* now in the Museo Nacional, Mexico City. The contrast between the treatment of the archangel and the more vigorous rendering of his foe is, however, quite marked, and argues for Vázquez's strong influence on his younger Mexican colleague. Assuming this influence to be at its height between Vázquez's arrival in 1603 and his death in 1607, yet allowing time for Luis Juárez's own development, one can assign a date of about 1605–15 to the work.

The Pinacoteca Virreinal possesses a second panel, *The Guardian Angel*, similarly ascribed to Juárez. Since the dimensions, medium, and style of that work are identical to those of *The Archangel Michael*, it is tempting to speculate that they were once part of the same commission.

MB

REFERENCES
Agustín Velázquez Chávez. *Tres siglos de pintura colonial mexicana.* Mexico, 1939, p. 267 (as Alonso Vázquez). **Diego Angulo Iñiguez.** *Historia del arte hispanoamericano.* Barcelona and Buenos Aires, 1950, vol. 2, fig. 360, pp. 396, 398–99 (as probably Luis Juárez). **George Kubler and Martín Soria.** *Art and Architecture in Spain and Portugal and Their American Dominions: 1500–1800.* Baltimore, 1959, pp. 307–8, pl. 167a (as Alonso Vázquez). **Manuel Toussaint.** *Colonial Art in Mexico.* Translated and edited by Elizabeth Wilder Weismann. Austin and London, 1967, p. 139, fig. 134 (as Alonso Vázquez). **Manuel Toussaint.** *Pintura colonial en México.* 2d ed., edited by Xavier Moyssén. Mexico, 1982, p. 283, fig. 105 (as Alonso Vázquez, citing earlier attributions to Luis Juárez and Baltasar de Echave Orio). **Rogelio Ruiz Gomar.** *El pintor Luis Juárez: su vida y su obra.* Instituto de Investigaciones Estéticas, Monografías de arte 15. Mexico, 1987, pp. 172–77, fig. 18 (as Luis Juárez). **Virginia Armella de Aspe and Mercedes Meade de Angulo.** *Tesoros de la Pinacoteca Virreinal.* Mexico, 1989, p. 28, ill. p. 70.

133 ⟨ **Luis Lagarto**

Spanish, 1556–d. after 1619; to Mexico about 1586

The Annunciation

Gouache on vellum; height 30.5 cm. (12 in.)
Signed and dated (upper right): Lvis / Lagar/to./ .F./1610
CNCA–INBA, Pinacoteca Virreinal de San Diego, Mexico City

Manuscript illumination in late sixteenth- and seventeenth-century Mexico was dominated by the atelier of Luis Lagarto of Puebla and his sons, Andrés Lagarto (1589–1666/67) and Luis de la Vega Lagarto (Luis Lagarto the Younger, 1586–after 1631), who were active in both Puebla and Mexico City. Choir books, bibles, prayer books, patents of nobility and appointment to the Holy Office, reliquary images, and miniatures were all produced in exquisite detail and at an extraordinarily high level of quality by the Lagarto family over at least seven decades. In many cases the objects produced by the Lagartos played a significant role in shaping the aesthetic dimensions of ecclesiastical Mexico. The present example, however, shows Lagarto's skill at creating an independent work of art.

In Luke (1:26–38) the archangel Gabriel is sent to confront the Virgin Mary, recently betrothed to Joseph of Nazareth, with the news that she is to miraculously conceive and bear the Messiah, Jesus Christ. Upon entering her cham-

133

ber, the angel greets Mary with the words, "Hail, O favored one," or, as stated in the Latin Bible, "Ave gratia plena" (Hail, thou full of Grace), which is inscribed in Lagarto's image on the banderole on the angel's wand. Mary, after initially rejecting her proposed role, finally accepts with the words, "Behold, I am the handmaid of the Lord," which is suggested in the miniature by her pose. The inscription on the Virgin's book, "Ecce virgo concipiet et pariet filium, et vocabitur [nomen eius Emmanuel]" (Behold, a virgin shall conceive and give birth to a son and call [his name Emmanuel]), is taken from the prophecy of Isaiah (7:14) believed to foretell the birth of Christ.

Lagarto has combined an elegant presentation of the archangel Gabriel and the Virgin Mary with an almost playful view into heaven, whence God the Father dispatches the dove of the Holy Spirit to effect the divine conception of Christ. The composition may be derived, as Tovar de Teresa has suggested, from a print by Pellegrino Tibaldi or others from the Carracci circle, but Lagarto has not followed his model slavishly. Rather, he has varied the poses, as in the increased twist to the angel's body and the rotation of the Virgin's body to face the messenger. The angel to the upper left is probably derived from a print after Raphael.

Adding immeasurably to the dignity of the composition, and without which the Mannerist elements in the rendering of the figures might dissolve the narrative effect, is the Palladian loggia in which Lagarto has set the scene. The impact and three-dimensionality of the image is further augmented by the black background, against which the lightly modeled figures achieve a much greater plasticity than would otherwise be the case.

Lagarto reused the bottom register of the composition in a subsequent image of the same theme, signed and dated 1611, now in the Denver Art Museum. In this later composition the dark ground serves to denote an interior space set in contrast with a garden view to the right.

MB

REFERENCES
Guillermo Tovar de Teresa. *Renacimiento en México: artistas y retablos*. Mexico, 1982, ill, p. 189. **Guillermo Tovar de Teresa**. *Un rescate de la fantasía: el arte de los Lagarto, iluminadores novohispanos de los siglos XVI y XVII*. Mexico and Madrid, 1988, pp. 131–33, ill. p. 130. **Virginia Armella de Aspe and Mercedes Meade de Angulo**. *Tesoros de la Pinacoteca Virreinal*. Mexico, 1989, pp. 63, 65 (ill.).

134 ◀ Luis Lagarto
Spanish, 1556–d. after 1619; to Mexico about 1586

Choir Book: Majuscule "Q" with St. Mary Magdalene
Gouache on vellum, embossed leather case, and silver garniture; leaf 78 x 59 cm. (30¾ x 23¼ in.)
SEDUE, Catedral de Puebla, Puebla

By the sixteenth century book illumination had ceased to be the dominant art form it had been in the Middle Ages, but it continued to play an important role in daily cultural life, especially in the Church. The liturgical and musical reforms of the Counter-Reformation gave illuminators an opportunity to produce large-scale graduals, or choir books, well into the seventeenth century, as in the present example from the Choir of the Puebla Cathedral. Although the cantors and other singers were expected to know the liturgy and music by heart, the choir book served as a teaching device, an aide-mémoire, a safeguard against unauthorized variations, and a visual adornment to the service, during which the congregation depended heavily on the choir to communicate the text of the Mass. Indeed, there exists an extensive literature documenting the importance of music in the spiritual life of colonial Mexico and the enthusiasm with which native Mexicans took up this aspect of Catholic piety; the Mexican cathedral chapters, facing a (probably unreasonable) fear of heterodoxy induced by the use of native instruments, would have had both positive and negative motives in emphasizing the musical texts and other accoutrements of choral liturgy. Furthermore, from the late sixteenth century, the cathedral choir took on, in both Spain and Mexico, a liturgical life of its

own, paralleling that of a monastery and therefore emphasizing such typically monastic objects as illuminated texts.

In 1597 the Puebla cathedral chapter authorized new regulations for the choir, including the requirement that all choir books be readable from a central choir book stand, citing the precedent of the Cathedral of Seville. In May 1600 the chapter commissioned Luis Lagarto to complete the illumination for the new choir books, specifying the size and amount of gold to be used in the initial letters for each page; the work took eleven years to complete.

In the illustrated initial Lagarto has let his sense of fantasy run free, depicting exquisite Renaissance grotesqueries as well as remnants of the medieval bestiary, including horned monsters that serve as finial decorations at upper and lower left and paired griffins that hold bat-winged cherubs, possibly intended to represent some sort of apprentice demons, at top and bottom. The figural passages and treatment in general recall Renaissance Italian illuminations, whereas the rectangular gold field and carefully depicted flowers ultimately derive from Flemish manuscript decoration.

St. Mary Magdalene was one of a number of women named Mary who appear in the Gospels associated with Christ. Medieval and Renaissance hagiography combined several of these women, including Mary of Magdala, who was the first to meet the risen Christ (John 20:1–8) and Mary of Bethany, the sister of Martha and Lazarus of Bethany (Luke 10:39–42; John 11:1–45), into one figure. Because Mary of Bethany anoints Christ's feet in John (12:1–8), she was further identified with the unknown woman "sinner" who anoints Christ's feet at the house of the Pharisee (Luke 7:36–50). Thus arose the belief that Mary Magdalene led a life of sin and luxury before converting to Christ's teachings and repenting of her worldly ways. Images of the Magdalene were common in the seventeenth century, as the Roman Church emphasized the sacrament of Penance in the face of Protestant opposition. The Magdalene appears twice in Lagarto's composition: at the bottom, depicted in penance, meditating on the vanity of earthly life, and at the right, in a more symbolic representation in the guise of a statue in a niche, holding the jar of ointment with which she would anoint Christ's feet.

MB

REFERENCES
Marga Anstett-Janssen. "Maria Magdelena." In *Lexicon der christlichen Ikonographie*, edited by Engelbert Kirschbaum et al. Vol. 7, edited by Wolfgang Braunfels. Rome and Freiburg, 1974, cols. 516–542. **Francisco Pérez de Salazar.** *Historia de la pintura en Puebla.* Mexico, 1964, p. 184. **Guillermo Tovar de Teresa.** *Un rescate de la fantasía: el arte de los Lagarto, iluminadores novohispanos de los siglos XVI y XVII.* Mexico and Madrid, 1988, pp. 79–84, ill. p. 96.

135 ◀ **Attributed to Andrés or Luis de la Vega Lagarto**

Mexican; Andrés: 1589–1666/67; Luis: 1586–d. after 1631

Escudo: *The Virgin, Christ Child, and Saints*

Watercolor on vellum in tortoiseshell frame; diameter 15 cm. (5⅞ in.)
Philadelphia Museum of Art, Robert H. Lamborn Collection 03.900

One of the most interesting aspects of life in the colonial convents was the *escudos,* or devotional badges, that senior Jeronymite and Conceptionist nuns wore around their necks. Typically depicting the Madonna, favorite saints, or a *sacra conversazione,* the *escudos* served both to distinguish the habit of each order and to subordinate the physiognomy of the wearer to a theological concept, in the same way that nuns' names were often hagiographical rather than personal. The practice of wearing *escudos* was established by the early seventeenth century, as the present example attests; by the eighteenth century depictions of nuns wearing *escudos* were common. Extant examples

include the well-known picture in the Museo del Virreinato, Tepotzotlán, documenting the habits of the principal Mexico City convents about 1700–50, and the various portraits of Sor Juana Inés de la Cruz, who apparently wore an *escudo* with an image of the Annunciation (see cat. no. 151).

The present *escudo* was unattributed until 1988, when it was brought to the attention of Tovar de Teresa, who was studying the oeuvre of Luis Lagarto and his sons. The border of the piece is painted on blue over a gold ground with cherubim and *sgraffito* linear decorations. This border also appears on at least two other *escudos*[1] associated with Luis Lagarto's sons, Andrés Lagarto and Luis de la Vega Lagarto the Younger. Tovar de Teresa favors the former as the author on the basis of an *Immaculate Conception* of 1622 now in the Museo Nacional de Historia, Mexico City, while Xavier Moyssén suggests that it was Luis the Younger who was their creator.[2] In fact, the Philadelphia *escudo* exhibits affinities with the documented works of both brothers; until a larger oeuvre can be secured for each, it is difficult to assign the work more precisely. Furthermore, it is possible that the two may have collaborated within a family atelier. On the other hand, there is general agreement on the date; the plastic three-dimensionality of the forms suggests the mid-seventeenth century, after the influence of the early Baroque had been established in Mexico. Depending on the attribution, this would yield a date as early as 1630 for Luis the Younger or about 1640–50 for Andrés.

MB

1. Illustration in Guillermo Tovar de Teresa, *Un rescate de la fantasía: el arte de los Lagarto, iluminadores novohispanos de los siglos XVI y XVII* (Mexico and Madrid, 1988) p. 176.
2. See Tovar de Teresa, *Un rescate de la fantasia*, p. 177.

REFERENCES
Linda Bantel and Marcus B. Burke. *Spain and New Spain: Mexican Colonial Arts in Their European Context*. Exh. cat., Art Museum of South Texas, Corpus Christi, Texas, 1979, no. 37, p. 114.
Guillermo Tovar de Teresa. *Un rescate de la fantasía: el arte de los Lagarto, iluminadores novohispanos de los siglos XVI y XVII*. Mexico and Madrid, 1988, pp. 159–77, 218, n. 16.

136 ◀ Fray Alonso López de Herrera

Spanish, about 1580–d. after 1648; to Mexico before 1609

St. Thomas Aquinas (obverse) and *St. Francis of Assisi Receiving the Stigmata* (reverse)

Oil on copper; 36.5 x 28.5 cm. (14⅜ x 11¼ in.)
Signed and dated (obverse): fr Al° de/Herre[ra]/1639
Acquisition Fund, Meadows Museum, Southern Methodist University, Dallas, Texas 88.08a,b

Fray Alonso López de Herrera was born in Valladolid, Spain, about 1580–85. Little is known about his training (his father may have been an artist), but his work shows close ties with late Mannerist and early seventeenth-century Flemish painting as well as a direct relationship to the school of Seville (1590–1620). He came to Mexico sometime before 1609, possibly in the entourage of the Dominican priest and archbishop Fray García Guerra, whose portrait López de Herrera completed in that year. López de Herrera was himself enrolled in the Dominican order in Mexico, as the title "Fray" before his name indicates.

Copper panels were often used as supports in Spanish colonial painting, but it is extremely rare to find such a panel with images on both sides. Although we cannot be sure that these two images were painted at the same time, the copper must have been prepared with that possibility in mind because the hammer marks typically found on the reverse of copper panels would have to be burnished before priming was applied to either side. This suggests that the

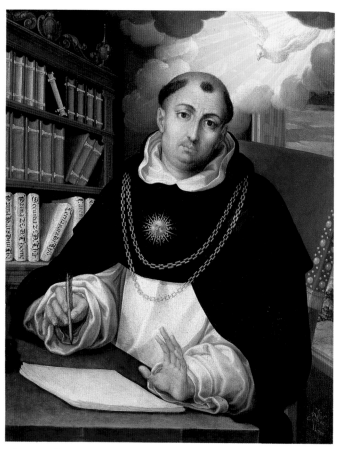

Obverse of cat. no. 136

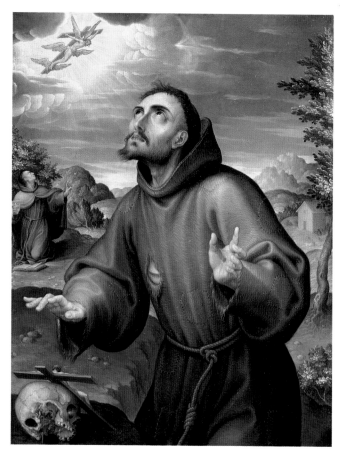

Reverse of cat. no. 136

panel was intended to decorate a door for a tabernacle, reliquary cabinet, portable altar, communion window, or similar opening.

Francis of Assisi (about 1181–1226), founder of the Order of Friars Minor, or Franciscans, was canonized in 1228 following a highly popular ministry emphasizing simple piety, brotherly love, and communal poverty. Thomas Aquinas (about 1225–1274) was canonized in 1323. Educated by the Benedictines at Monte Cassino, he attended the University of Naples and took a master's degree in 1256 at Paris, where he was active as a teacher and theologian. López de Herrera has chosen to contrast the contemplative, scholarly, intellectual aspects of St. Thomas's life with the active, humble, pietistic qualities of St. Francis's ministry. The theologian is accordingly depicted at close range in an interior, among the volumes of his writings, while a dove, symbolic of divine inspiration, bursts onto the scene amid celestial glory. St. Francis, on the other hand, is shown full-length, kneeling in a landscape, caught up in the vision that left him marked with the stigmata.

St. Francis was not only one of the principal objects of Catholic veneration throughout the world but was also a strong example of the virtues and spiritual power of the monastic life, which was under attack by Protestant theology and therefore subject to affirmation in Counter-Reformation art. Furthermore, St. Francis was of particular importance for Mexico, much of which had been converted to Christianity by Franciscan priests. St. Thomas Aquinas, whose summations of medieval Catholic thought and piety were an important source for Tridentine theology, was equally important in terms of Catholic devotion, above all for the Dominicans, whose order he joined in

1244. As the appointed guardians of orthodoxy, Dominican priests looked to Aquinas as a central role model, and the image created by López de Herrera —possibly on the basis of a European print—was often repeated in Mexican colonial devotional paintings.

The *St. Thomas Aquinas* here shows all the characteristics of early Counter-Reformation art: direct contact with the subject, muted colors, clear and relatively simple composition, and strong spiritual presence. The *St. Francis*, however, displays a much greater element of Mannerist design, as can be seen in the pearly light, the elongated body of the saint, the tendency of the background to shoot back away from the foreground figure, and the complicated twist in the pose of Francis's companion, Brother Leo.

MB

REFERENCE
Marcus B. Burke. "Across the Atlantic: Mannerist Art in Colonial Mexico." *Latin American Art* 1, no. 1 (1989), pp. 38–40, ills.

137 ◀ **Sebastián López de Arteaga**
Spanish, 1610–d. 1652; to Mexico about 1635–40

The Incredulity of St. Thomas
Oil on canvas; 223 x 155 cm. (87¾ x 61 in.)
Signed: S. de Arteaga / notario del S.to off. / inventor, pinx' [illegible]
Inscribed: Hizose de los bienes / De el Cap.n fran.co de Aguirre
CNCA–INBA, Pinacoteca Virreinal de San Diego, Mexico City

Sebastián López de Arteaga was born in Seville in 1610, the son of a silver-smith. Trained in Seville, he came to Mexico about 1640, or possibly as early as 1635, bringing an already developed tenebrist manner based on the sharp contrast of light and dark and an aggressive, fluid brushwork. Although the influence of Francisco de Zurbarán (1598–1664) on his work is evident in general, Arteaga's manner is quite distinct, being related more in its details to the gritty realism of artists such as Juan del Castillo and Francisco Herrera the Elder. Along with José Juárez—and the works sent to Mexico by Zurbarán —Arteaga is responsible for bringing Mexican colonial art up to date with European seventeenth-century styles. Like many other Spanish and Spanish colonial artists, including Arteaga's father and the early seventeenth-century Sevillian painter and theorist Francisco Pacheco, Arteaga was an agent of the Holy Office, or Inquisition; he was appointed to the apparently honorary office of notary in 1643. The exact date of his death is uncertain; he made his testament in June of 1652 and is thought to have died soon thereafter.

According to John (20 : 24–29), the apostle Thomas, not having been present at one of the first appearances of the resurrected Christ, doubted the event, declaring, "Unless I see in his hands the print of the nails, and place my finger in the mark of the nails, and place my hand in his side, I will not believe." Eight days later Christ again appeared to the apostles, offering his wounds to Thomas's inspection. At this, Thomas believed. Late sixteenth- and seventeenth-century artists frequently depicted this event in dramatic form, showing Christ seizing Thomas's hand and thrusting it into the wound on his side.

Here Arteaga seems to have drawn from the origin of seventeenth-century Tenebrism, the art of Michelangelo Merisi da Caravaggio, whose version of the theme may have served as a prototype. In effect, the present canvas documents the establishment of tenebrism in the Mexican school. Caravaggio's version of *The Incredulity of St. Thomas* is a half-length, close-up rendering that forces the viewer into Thomas's situation. Arteaga's composition, in spite of displaying a rather classical, full-length Christ, in fact follows the Caravaggesque formula, condensing almost all the significant forms into the

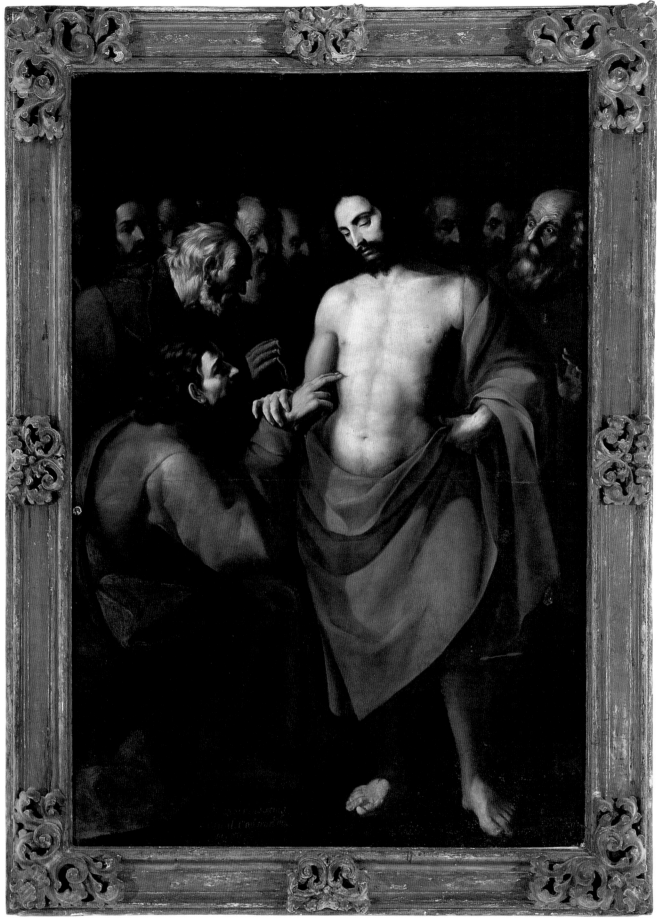

137

upper half of the painting. Several candidates for the specific compositional source have also been suggested, including a print by Maarten de Vos, a Roman painting of 1612 by C. Vermiglia, and a painting at Segovia by Alonso Sánchez Coello with full-length figures and similar poses.

The Incredulity of St. Thomas is signed "Sebastian de Arteaga, notary of the Holy Office, made it" and inscribed "Made from the possessions of the Captain Francisco de Aguirre." Although there is no other evidence to support the hypothesis, it has been suggested that the work was commissioned by Captain Aguirre as part of a penance imposed by the Inquisition. Be this as it may, Arteaga's signature as a notary dates the work to 1643, the date usually given, or after. The terminus ante quem should probably be set at 1650, when a technicality forced Arteaga to refrain from using his notarial title.

MB

REFERENCES
Manuel Romero de Terreros. *Historia sintética del arte colonial de México (1521–1821)*. Mexico, 1922, pp. 58–59, ill. **Agustín Velázquez Chávez**. *Tres siglos de pintura colonial mexicana*. Mexico, 1939, pp. 203–5, fig. 30. **Diego Angulo Iñiguez**. *Historia del arte hispanoamericano*. Barcelona and Buenos Aires, 1950, vol. 2, p. 404, fig. 368. **Manuel Romero de Terreros**. *El arte en México durante el Virreinato: resumen histórico*. Mexico, 1951, pp. 55–56. **George Kubler and Martín Soria**. *Art and Architecture in Spain and Portugal and Their American Dominions: 1500–1800*. Baltimore, 1959, p. 309. **Manuel Toussaint**. *Colonial Art in Mexico*. Translated and edited by Elizabeth Wilder Weismann. Austin and London, 1967, pp. 146–50, fig. 141. **Marcus B. Burke**. "Mexican Colonial Painting in its European Context." In Linda Bantel and Marcus B. Burke, *Spain and New Spain: Mexican Colonial Arts in Their European Context*. Exh. cat., Art Museum of South Texas, Corpus Christi, Texas, 1979, pp. 26–27, figs. 10, 11. **Guillermo Tovar de Teresa**. *México barroco*. Mexico, 1981, p. 297, pl. p. 292. **Manuel Toussaint**. *Pintura colonial en México*. 2d ed., edited by Xavier Moyssén. Mexico, 1982, pp. 146–50, fig. 141, color pl. x (facing p. 148).

138 ◄ **José Juárez**

Mexican, 1617–1661

The Adoration of the Magi

Oil on canvas; 207 x 165 cm. (81½ x 65 in.)
Signed and dated (on cup): Joseph Xuarez
Ynbentor / año de 1655
CNCA–INBA, Pinacoteca Virreinal de San Diego,
Mexico City

139 ◄ **Baltasar de Echave Rioja**

Mexican, 1632–1682

The Adoration of the Magi

Oil on canvas; 153.8 x 197.5 cm. (60½ x 77¾ in.)
Signed and dated: Baltasar De echave.f.ᵗ / año 1659
Davenport Museum of Art, Davenport, Iowa 25.84
EXHIBITED IN NEW YORK AND SAN ANTONIO ONLY

José Juárez was born in Mexico in 1617, the son of the painter Luis Juárez, who is thought to have been José's teacher. Active from the early 1640s, he is presumed to have gone to Seville sometime at the start of his career, since his close dependence on the works of Francisco de Zurbarán (1598–1664) cannot be explained by reference to the works Zurbarán sent to Mexico or by the mediation of Sebastián López de Arteaga (1610–before 1656), who came to Mexico from Seville about 1640 but whose style is quite different from that of his Sevillian colleague. Indeed, it is difficult to imagine how José Juárez could have painted such works as *Sts. Justus and Pastor* or *The Adoration of the Magi* without a direct knowledge of Zurbarán's monumental canvases of the 1630s (*The Apotheosis of St. Thomas Aquinas*, Museo de Bellas Artes, Seville; *The Adoration of the Magi*, Musée de Peinture et de Sculpture, Grenoble).

Baltasar de Echave Rioja was born in Mexico in 1632, the son of Baltasar de Echave Ibía and the grandson of Baltasar de Echave Orio. It may be assumed that Echave Rioja would have initially trained with his father, but if Echave Ibía died in the early 1640s, it would have been necessary for Echave Rioja to move to another master. Recent scholarship citing the central influence of José Juárez's Zurbaránesque manner in Echave Rioja's formation, has considered him a follower and probable pupil of Juárez. Echave Rioja in turn passed on his more Baroque vision to Cristóbal de Villalpando.

The Adoration of the Magi is one of the earliest themes in Christian art and has remained, both in the fine arts and in popular culture, a highly important image for the faith. At once deriving from the biblical narrative (Matthew

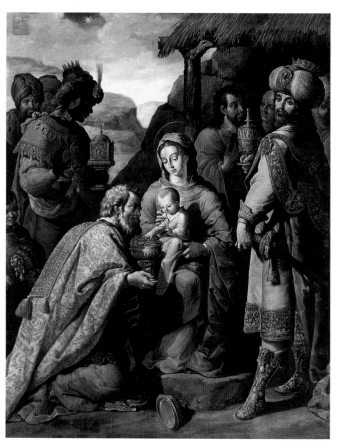

Juárez, *Adoration* (cat. no. 138)

2:1–12) and celebrating the theological concept of the Epiphany (the revelation of Christ's divinity to the nations), images of the Magi adoring the Christ Child were also understood in terms of the subjection of the temporal powers to the authority of the Church. In the Bible three wise men from the East came to King Herod, seeking a child "who has been born king of the Jews. For we have seen his star in the East, and have come to worship him." Traveling to Bethlehem in Judaea, they encountered the Christ Child with his mother, Mary, and "fell down and worshiped him. Then, opening their treasures, they offered him gifts, gold and frankincense and myrrh."

In early Christian, Byzantine, and early medieval art the three wise men are most often depicted as Persians wearing Phrygian caps, hence the term "magi," members of the ancient Persian priestly order. By the year 1000, however, western European representations had begun to depict the three as kings, which became the standard thereafter, with Oriental attributes added according to the artist's knowledge. By the Renaissance the standard representation included three kings of varying races—perhaps representing the continents Africa, Asia, and Europe—and ages. With Turkish power threatening both the Mediterranean area and Eastern Europe, the Magi were often given the exotic garb of Turkish rulers, whose subjection to Christ was fervently sought. Concurrently, for theological reasons, the Feast of the Epiphany on January 6 had come to be considered one of the primary celebrations of the Church year, and nowhere more than in Spain and Latin America, where the day was often marked by parades and fiestas. Indeed, the modern secular celebration of the Christmas season still falls on Epiphany in predominantly Catholic countries, with the Three Kings filling the role assigned to Santa Claus in the United States.

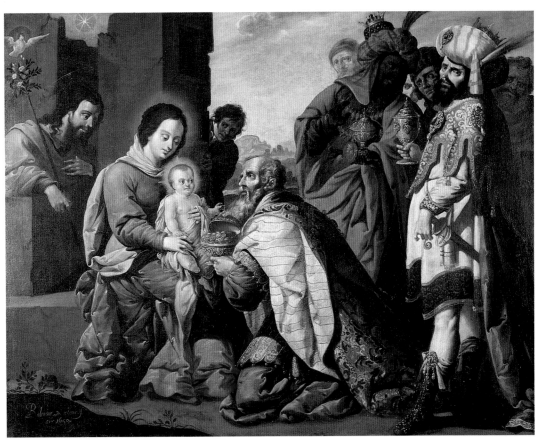

Echave Rioja, *Adoration* (cat. no. 139)

José Juárez's composition maintains the traditional Spanish form of this image, especially as found in the works of Sevillian painters such as Diego Velázquez and Francisco de Zurbarán, who may have been following the lead of the Castilian Vicente Carducho. It has also been suggested that the central group of the Holy Family ultimately derives from Raphael. Here the physiognomic types, particularly the Christ Child with his Spanish "skirts," or infant's costume, and blond widow's peak; the deployment of stage properties such as the domed brass containers held by the Magi; and the alternating use of chiaroscuro and silhouetting against the sky all reveal the strong influence of Zurbarán. At the same time, the slight twist of the upper torso of the kneeling Magus and the way his brocade cloak is thrown back over his shoulder suggest that Juárez was also making use of engravings or copies after *The Adoration of the Magi* (Louvre, Paris) by Peter Paul Rubens, whose *Holy Family with St. John and St. Elizabeth* (Metropolitan Museum, New York) was copied by Juárez in another painting. The presence of engraved images after Rubens should not be surprising, since Flemish publishers had a dominant position in devotional print and book sales in New Spain.

Echave Rioja's monumental canvas, one of the few outstanding examples of Mexican colonial painting outside of Mexico, is of interest not only for its relationship to the composition by José Juárez but also for the ways in which it differs, since these tell us a great deal about the development of the Baroque style in Mexico. Echave has reversed the central figure group of his teacher's composition, maintaining the turbaned Magus at the right whose elbow, thrust illusionistically through the picture plane, leads the viewer's eye into the scene. The way the black Magus inclines his head toward his colleague, as well as the cascade of heads and shoulders from Joseph to the Christ Child, are

clear derivations from Rubens's Paris version of the Adoration, which was engraved by Schelte à Bolswert and which continued to influence Mexican painters in the next century, among them Cabrera. The brushwork is freer and more painterly than in Juárez, due perhaps equally to Echave's study of Luis Juárez or of his own grandfather Baltasar de Echave Orio, as well as of any European canvases recently arrived in Mexico. It is important to bear in mind that although later seventeenth-century Mexican painters sought—through prints, imported paintings, patrons' descriptions, and possible study trips back to Seville—to keep abreast of the latest developments in European art, they were also elaborating a national style on the basis of their own Creole traditions. José Juárez may even have been taking note of his follower's innovations; his second version of the same theme, generally considered to be later in date, seems to follow Echave Rioja's lead in developing the Baroque elements found in Rubens's prints.

Both Juárez and Echave Rioja have accepted Tridentine theology in representing St. Joseph as a mature but still vigorous man, as opposed to the doddering, semicomic elderly figure of medieval and early Renaissance art. As patron of the Roman Catholic Church and protector of the young Christ, not to mention as a model for Christian parents, St. Joseph was an important element in Counter-Reformation piety. The flowering staff and dove that appear in Echave Rioja's composition allude to the miracle by which St. Joseph was chosen to be the Virgin Mary's husband. According to the apocryphal legends of Mary's life, St. Joseph's rod burst into flower and was visited by a heavenly dove when brought to the temple along with those of Mary's other suitors. The dove and flowering rod are often seen in Mexican images of the Marriage of the Virgin to Joseph. The star in Echave Rioja's version is, of course, that which led the Magi to Bethlehem.

MB

REFERENCES

Cat. no. 138: Agustín Velázquez Chávez. *Tres siglos de pintura colonial mexicana.* Mexico, 1939. p. 233, fig. 63. **Justino Fernández.** "Rubens y José Juárez." *Anales del Instituto de Investigaciones Estéticas* 3, no. 10 (1943), pp. 51–57. **Irving Leonard.** *Books of the Brave.* Cambridge, Mass., 1949, pp. 205–6. **Diego Angulo Iñiguez.** *Historia del arte hispanoamericano.* Barcelona and Buenos Aires, 1950, vol. 2, pp. 408–9, fig. 371 (date given erroneously as 1665). **Manuel Toussaint.** *Colonial Art in Mexico.* Translated and edited by Elizabeth Wilder Weismann. Austin and London, 1967, p. 227. **Enrique Marco Dorta.** *Arte en América y Filipinas.* Ars Hispaniae: Historia Universal del Arte Hispánico, vol. 21. Madrid, 1973, p. 341, fig. 552 (following Angulo in citing source of Holy Family grouping in Raphael). **Manuel Toussaint.** *Pintura colonial en México.* 2d ed., edited by Xavier Moyssén. Mexico, 1982, pp. 104–6, fig. 156, color pl. XIV (facing p. 128). **Virginia Armella de Aspe and Mercedes Meade de Angulo.** *Tesoros de la Pinacoteca Virreinal.* Mexico, 1989. pp. 31–32, ill. p. 89.

Cat no. 139: Manuel Toussaint. "Mexican Colonial Paintings in Davenport." *Gazette des Beaux-Arts,* 6th ser., 24 (1943), pp. 167–74. **Diego Angulo Iñiguez.** *Historia del arte hispanoamericano.* Barcelona and Buenos Aires, 1950, vol. 2, pp. 414–16, fig. 377 (citing influence of Rubens). **George Kubler and Martín Soria.** *Art and Architecture in Spain and Portugal and Their American Dominions: 1500– 1800.* Baltimore, 1959, pp. 310, 393, n. 42. **Enrique Marco Dorta.** *Arte en América y Filipinas.* Ars Hispaniae: Historia Universal del Arte Hispánico, vol. 21. Madrid, 1973, pp. 342, 344, fig. 556. **Marcus B. Burke.** "Mexican Colonial Painting in its European Context." In Linda Bantel and Marcus B. Burke, *Spain and New Spain: Mexican Colonial Arts in Their European Context.* Exh. cat., Art Museum of South Texas, Corpus Christi, Texas, 1979, pp. 33–35 (citing print sources). **Linda Bantel.** "Adoration of the Magi." In Linda Bantel and Marcus B. Burke, *Spain and New Spain: Mexican Colonial Arts in Their European Context.* Exh. cat., Art Museum of South Texas, Corpus Christi, Texas, 1979, no. 90, pp. 89–90, color pl. facing p. 96. **José Rogelio Ruiz Gomar.** "Rubens en la pintura novohispana de mediados del siglo XVII." *Anales del Instituto de Investigaciones Estéticas* 13, no. 50 (1982), pp. 87–101, pls. 1–8. **Manuel Toussaint.** *Pintura colonial en México.* 2d ed., edited by Xavier Moyssén. Mexico, 1982, pp. 108, 258, n. 20 (X. Moyssén).

Emergence of a National Style (1650–1715)

Creole Identity and the Transmutation of European Forms

JOHANNA HECHT

Facade sculpture: the Ship of the Church, Mexico City Cathedral. Photo: Michel Zabé

In the course of the seventeenth century the growing class of criollos (Spaniards born in New Spain) began to formulate a distinct identity.[1] Spanish but at the same time not, these descendants of the conquistadores found themselves in an anomalous position, a consequence of the Crown's attempt to regulate the activities of this burgeoning society.

The viceroyalty of New Spain was technically never a colony but rather a discrete part of the Crown of Castile. Nonetheless, from the earliest days of settlement Peninsular authorities, fearful of mutiny and sporadically mindful of their responsibility to the indigenous peoples of the Americas, had found it necessary to keep a rein on the Spanish who lived there. Ultimately the Crown struck a delicate balance between freedom and restraint that permitted the colonists to exploit, within specified limits, the labor of the Indians and the resources of the land on which Spain was increasingly dependent. One humiliating term of this informal compromise, however, was to bar criollos from all high civil offices.

The exclusion scarcely affected their economic well-being, yet criollos quite naturally were stung by the indignity and the second-class citizenship it implied, most especially since they perceived themselves to be playing a unique and critical role in the affairs and destiny of their homeland. Not only were American silver mines the source of the empire's lifeblood, but Mexico was the nexus of Spain's trade with the East Indies, the search for whose treasures had led to the discovery of America. Sor Juana Inés de la Cruz (cat. no. 151), the great Mexican poet of the colonial era, spoke of feelings undoubtedly shared by all cultivated criollos in the following verses, in which she fuses resentment with an indomitable belief in Mexico's divine election:

> Señora, I was born
> in America, land of plenty,
> Gold is my compatriot,
> and the precious metals my comrades.
>
> Here's a land where sustenance
> is almost freely given,
> to no other land on earth
> is Mother Earth so generous.
>
> From the common curse of man
> its sons appear to be born free,
> For here their daily bread
> costs but little sweat of labor.

Woodcut portrait of San Felipe de las Casas; title page of Jacinto de la Serna's *Sermon predicado...* (Mexico, 1652). Photo: The New York Public Library

Title page of Miguel Sanchez, *Imagen de la Virgen Maria madre de Dios de Guadalupe, milagrosamenta aparecida en la ciudad de Mexico* (Mexico, 1648). Collection Centro de Estudios de Mexico Condumex, Mexico City.

Europe knows this best of all
for these many years, insatiable,
She has bled the abundant veins
of America's rich mines.[2]

Like other artists and literati of her time, Sor Juana was accustomed to expressing herself in the rich Baroque language and imagery then current in Spain. Yet while the Mexican elite shared the same refined intellectual milieu as their Peninsular cousins, their culture began to take on a distinctive air, and a number of non-European elements started to infiltrate their literature and visual arts. As it developed, the nascent criollo identity coalesced around certain central cultural and historical events that by the mid-seventeenth century had achieved almost mythic status.

The figure of Felipe de las Casas (1575–1598), the Mexican-born Franciscan whose martyrdom in Japan ultimately led to his canonization as San Felipe de Jesús (see cat. no. 140), was one of the earliest focuses of national consciousness. His cult was instituted shortly after his beatification in 1627 and celebrated in years following with the construction of altars, paintings, and devotional and processional sculptures, including one of pure silver marking the silversmiths' adoption of the saint as one of the patrons of their guild. His martyrdom was honored not only in songs and poems but also in a series of sermons in which his glory was seen to reflect equally on the Franciscan order and the Mexican nation.

Perhaps the most significant cultural milestone of the era was the book devoted to the Virgin of Guadalupe published in 1648 by Miguel Sanchez. This marked the adoption by criollo culture of an event originally the focus of Indian veneration: the appearance of the Virgin to the Indian convert Juan Diego on a site associated with the worship of the Aztec goddess Tonantzin. The appropriation of this cult first by native Americans and its reassimilation in a new form by Creoles is viewed by many to be the supreme symbol of Mexican transculturation. The criollos' pride in what they conceived to have been their role in the rescue and redemption of the supposedly sin-steeped pagan world of pre-Conquest America was expressed by the Mexican scholar Carlos Sigüenza y Góngora, a connoisseur of pre-Hispanic culture, in his *Primavera Indiana* of 1668:

I am Mary, of omnipotent God
The humble Mother, Virgin sovereign,
A Torch whose eternal light
is the splendid North Star of Mankind's hope:
Let a perfumed altar in a holy temple
be installed for me in Mexico, once Pluto's
profane dwelling, whose horrors
my foot dispels in a storm of flowers.[3]

At the time of the Conquest the conquistadores recorded for posterity the wonder they felt upon first viewing Tenochtitlán; this vision lingered in the consciousness of their descendants and was transformed into a glorification of the lost Amerindian past, which, along with the mythic saga of the Conquest, found its way into the criollo legend. Although a few artists and intellectuals may have been truly interested in archaeological accuracy, Aztec history for the most part was resurrected as the Amer-

ican equivalent of Europe's classical past, and a distinct attempt was made to endow it with a similar luster. The most renowned example of this is Sigüenza y Góngora's *Teatro de virtudes políticas*, an elaborate explication of the triumphal arch he conceived for the arrival in 1680 of the new viceroy, the marqués de la Laguna. In place of the traditional allegorical figures of Greco-Latin derivation, the poet substituted images of the Aztec emperors—Acamapichtli, Huitzilíhuitl, Chimalpopoca, Itzcóatl, Moctezuma Ilhuicamina, Tizoc, Moctezuma Xocoyotzin, Cuitláhuac, and Cuauhtémoc—as exemplars of the political virtues.

The developing criollo sentiment, however, did not affect all the arts equally. In literature and painting and in certain self-consciously Mexican media it inspired new subject matter, metaphor, and allegory. Integral to late seventeenth-century depictions of the Conquest in shell inlay, for example, were fantastical re-creations of the magical realm the criollos' ancestors had destroyed; these often included depictions of Moctezuma's palace featuring ancestor portraits of the very rulers that appeared in Sigüenza y Góngora's arch. The more conventional figurative arts of painting and sculpture were distinguished stylistically by a conservative adherence to Mannerist traits. But in the essentially nonfigurative field of architecture—the richest and most creative aspect of colonial visual arts—different issues come into play.

The course of development within viceregal architectural design is marked by a continuing incorporation of European ornament into the Mexican builder's repertory. Of the various options available, however, only a select number were embraced with enthusiasm, and these few were enlarged, extended, and applied in ways distinct from their Peninsular antecedents. Derived from the Old World, these motifs were converted in Mexico into something new, and in the course of the seventeenth century, they began to take on a distinctive and coherent air marked by freedom, variety, and a striking lack of orthodoxy.

As in the previous century the new formulas pertained almost entirely not to space but to the organization and ornamentation of the building's surface. The basic structure of the building itself continued to be confined to rigid cubic volumes. And indeed, with only minor exceptions, Mexican colonial structures never admitted the curves or complexities of the European Baroque plan, a tendency some would see as an outgrowth not only of the rectilinear town plan of New Spain but also of the urban conventions of the pre-Hispanic era.

Ignoring Baroque elaborations of space, Mexican designers reasserted with new vigor the predilection for decoration of the building plane expressed in the constructions of the previous century. The underlying framework of this decoration was more up-to-date, reflecting the influence of Purist and late-Renaissance designs, but as before the motifs were adopted sporadically. Almost all efforts were focused around entranceways, setting them off from the otherwise plain facades, a practice not unknown in Spain but never as dominant there as in Mexico.

The basic designs for these portals were derived from classical Peninsular models dating to the beginning of the seventeenth century. Of particular note are "pyramidal" configurations in which an arched doorway is

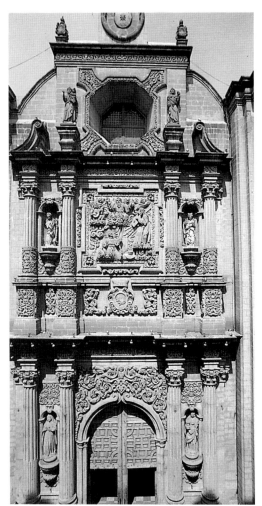

Facade of the church of La Profesa, Mexico City, designed by Pedro Arrieta

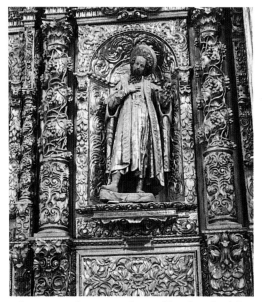

Solomonic columns on the retablo, church of the Franciscan convent, Tlalmenalco, Mexico

flanked on either side by paired columns and surmounted by a narrower second story comprising a pedimented window, niche, or relief carving, itself flanked by single columns or pilasters. This graceful formula soon gave way to a new configuration. In it the portal was endowed with a sense of bulk and solidity, emphasized by a consolidation of the decoration into blocklike forms and a dense rectangular massing of the individual members. The premier exponent of this style was Pedro Arrieta, designer of the Basilica of Guadalupe (1695–1709) and, probably, the Jesuit church of La Profesa (1714–20). Although underlying forms remained relatively Classical, many designers began to abandon the standard vocabulary of Greek or Roman antiquity and to overlay columns and entablatures with pattern and texture.

This ornament, most of which had appeared previously both in Spain and Mexico, included much that was Mudejar, medieval, or Isabelline in origin; motifs such as canopial, zigzag, mixtilinear, and lobed arches as well as unusually striated, filigreed, and otherwise decorated columns proliferated. Ornament could be applied to a cylindrical shaft or to a spiral or Solomonic one. Sometimes more than one pattern was applied to a single column, or spiral and cylindrical forms were juxtaposed, a revival of the old Plateresque "tritostyle" division of the column that continued to prevail in Mexico with more consistency than it had in most of Spain.

The salient decorative motif of this era was the Solomonic column, whose spiral shape was said to have originated in King Solomon's temple in Jerusalem. The form, which lingered through the Middle Ages until its seventeenth-century revival by Bernini, took on new life as the great formal sign of the Baroque and the Church Triumphant. The Solomonic column is believed to have been introduced in Mexico in a design attributed to the great Andalusian sculptor Juan Martínez Montañés, commissioned in 1646 by Archbishop Juan de Palafox y Mendoza for the Altar of the Kings in the Puebla Cathedral. Although the pure and unadorned version of spiral column that appears in this altar never gained much favor in Mexico, an infinitude of elaborations soon sprang up throughout the country. New retablos were commissioned, which included the newly fashionable columns, and old retablos were revamped, retaining their original structures as well as sculptures and paintings while their Classical columns were replaced with Solomonic examples.

In Mexico as elsewhere, the Solomonic column, entwined with grapevines representing the Blood of Christ, was intended to signify the triumph of the Eucharist. In the hands of the designer and craftsman, however, the symbolic value of the grapevine was subordinated to its decorative value, a feature more important to Mexicans than the pulsating shape of the column that it soon subdued or engulfed. In fact by the time the Solomonic column made its first appearance outside, in 1684–85 in the convent of Santa Teresa, its characteristic shape was already essentially cylindrical. There the scarcely recognizable vegetation burrows in channels so narrow and shallow that the helicoid shape is all but lost. Other variations—chains, acanthus scrolls, and scampering putti, as well as a host of nameless inventions—soon entered the designer's vocabulary and were applied to columns both inside and out. The totally perforated filigree or pierced

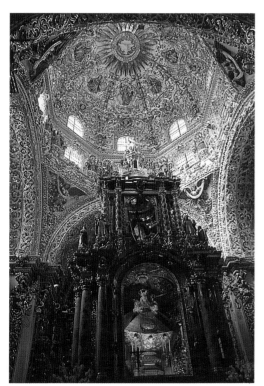

The Rosary Chapel, dedicated in 1690, Church of Santo Domingo, Puebla. Photo: G. Aldana

versions, so frequently encountered in Peninsular regions such as Andalusia and Rioja, became especially popular in eighteenth-century interiors, as did the double helix, a type that also tends to obscure the undulating spiral form. But however ornamental, the retablo column rarely abandoned its role as a framing element for the niche itself. With few exceptions the retablo of this era in Mexico resists the Baroque transformations of late seventeenth-century Spain and adheres to the reticular compartmentalization of the Renaissance model.

The decorative web was extended beyond the individual retablo through a cheek-by-jowl massing of altars and in certain areas through the use of *yesería*. The latter style of modeled-relief ornament, a type of gesso or plasterwork, co-opted from Spain by seventeenth-century Mexican designers, was used in the regions of Puebla and Oaxaca to cover the interior walls and ceilings of churches. The sources for the early designs, which were composed of strapwork and other Mannerist elements, as seen, for example, in the principal nave of Santo Domingo in Puebla (1632), appear to have been books or drawings, many of Netherlandish as well as Spanish origin. Although with time the forms of Mexican *yesería* became less artificial and more organic, they remained subordinate to the native tendency toward abstract decoration and never succumbed to the modulated naturalistic lushness of the Andalusian version. Rarely purely ornamental, these *yeserías* and the related *argamasas* included some of the most inventive figurative subject matter as well. The masterpiece of this technique is the gloriously embroidered interior of the Rosary Chapel (dedicated 1690) also in Santo Domingo.

Retablo sculpture was more orthodox. Subordinate to the overall design of the altar, wood sculpture was subject as well to the conventions of the guild and to accepted formulas for depicting the community of saints and spiritual beings who populate the retablo. Compact and serene, except when established iconography called for expansive gestures, in the late seventeenth century they still continue the contained mood of the Counter-Reformation. Human forms are simplified and abstract. Drapery, while sometimes more buoyant than in the sixteenth and early seventeenth centuries, takes on an angular patterning; it shows little of the suavity of contemporary Andalusian carving and points rather to the early Montañesino style or to the archaizing late Mannerism that prevailed in the Spanish north. This tendency may suggest the influence of Basque and Riojan sculptors in Mexico. It may also reflect the formative influence of imported woodcuts on Mexican colonial carving and the early codification of the angular style derived from these sources.[4]

The fact that figural sculpture was often carved by the same artists who carved the retablo structure may also account for its abstract decorative tendencies. Toward the end of this era, carved wood figures begin to show marginal decorative flourishes in their garments, which echo the increasing movement of the retablo-carving style itself and which in the eighteenth century increasingly help to integrate sculptures ornamentally into the retablo. The faces of these figures, however, even when expressing emotion, remain formulaic and conventional.

The stone figural sculptures carved for church facades, themselves in

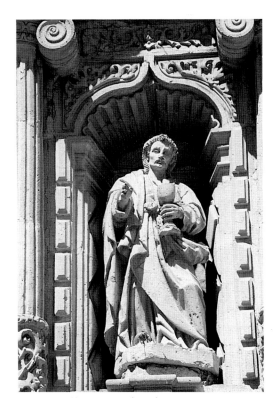

Facade sculpture: St. John, about 1684,
Santuario de Nuestra Señora de La Soledad,
Oaxaca

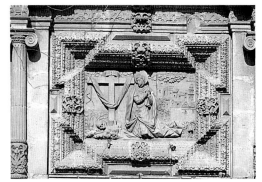

Facade sculpture, about 1684. Santuario de
Nuestra Señora de la Soledad, Oaxaca

effect retablos, are in some cases not only far less conventionalized than the wooden retablo carvings but also more inclined to reflect the stylistic qualities of the Baroque. The facade sculptures of the Mexico City Cathedral (1697) and the Church of the Soledad in Oaxaca (about 1684) are cases in point, both showing a fully Baroque form as well as individual artistic personalities. Similarly, a comparison of the identically composed didactic stone reliefs on the facades of the Augustinian churches at Mexico City and Oaxaca—derived, like so many of these reliefs, from print sources [5] —demonstrates the great originality of carving style possible within such narrow parameters. The best of these facade sculptures, which often also display something of the provincial, lingering Gothic air of carving from Aragon and Rioja, illustrate how effectively the stone carvers of this period were able to manipulate these broadly geometric forms that projected so effectively under the glaring sun.

The explanation for the persistence of so many conservative elements in Mexican figurative art is to be sought not simply in the insecurity and hermetic nature of criollo society but in the particularly syncretic nature of Mexican Catholicism. From the earliest moments of Spanish rule religion was the country's great common denominator, a condition some attribute to predisposing similarities between pre-Hispanic and Hispanic culture. In both societies art was a function of religion and as inextricable from life under the new system as under the old; both religions were marked by a fondness for images, pomp, and ritual.

Although most of the sculptors whose names are known appear to have been Spanish in origin, the vast quantity of images required for the celebration of the Catholic cult were not produced by Spaniards alone. It is clear from documents that some mestizos and Indians were engaged in the production of official art, and the repeated caveats and regulations in guild ordinances limiting the activities of Indian artists indicate that they were producing significant quantities of unofficial religious art as well.

To the celebration of the new religion the indigenous Mexicans brought a view of art in which the didactic, ritual, and decorative functions were supreme. Subject matter, iconography, and rite may have been imposed from above; nonetheless, an attitude that lent itself to the ritualized portrayal of deities was surely supported by the native and mestizo population who were both the primary audience as well as the executors of so many works of art created in New Spain. It is this attitude, inevitably adopted by criollos and ultimately absorbed into mainstream metropolitan art, that lies at the heart of the Mexican colonial style.

NOTES

1. Bernardo Balbuena's *Grandeza mexicana* of 1604 is conventionally cited as the first sign of this rising consciousness. Jorge Alberto Manrique, however, would date it even earlier; see his "Reflexiones sobre el manierismo en México," *Anales del Instituto de Investigaciones Estéticas* 10, no. 40 (1971) pp. 21–42. Also Jacques Lafaye, *Quetzalcóatl and Guadalupe: The Formation of Mexican National Consciousness, 1531–1813*, translated by Benjamin Keen (Chicago and London, 1976); Octavio Paz, *Sor Juana or, the Traps of Faith*, translated by Margaret Sayers Peden (Cambridge, Mass., 1988), and most recently, Anthony Pagden, *Spanish Imperialism and the Political Imagination: Studies in European and Spanish-American Social and Political Theory, 1513–1830* (New Haven and London, 1990).
2. Lafaye, *Quetzalcóatl and Guadalupe*, p. 71.
3. Lafaye, *Quetzalcóatl and Guadalupe*, p. 63.
4. Martha Fernández, *Arquitectura y gobierno virreinal: los maestros mayores de la ciudad de México, siglo XVII*, (Mexico, 1985) p. 267; Martha Fernández, "El nacimiento de la arquitectura

barroca novohispana: una interpretación," *Anales del Instituto de Investigaciones Estéticas* 14, no. 56 (1986) pp. 17–28.

5. Jorge Alberto Manrique, "La estampa como fuente del arte en la Nueva España," *Anales del Instituto de Investigaciones Estéticas* 13, no. 50 (1982) pp. 55–60.

A Mexican Artistic Consciousness

MARCUS BURKE

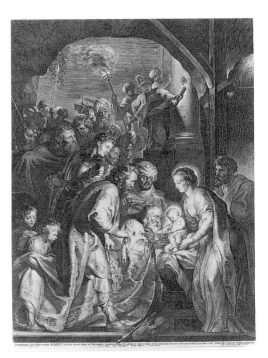

Lucas Vorsterman. *Adoration of the Magi*; engraving after Rubens. The Metropolitan Museum of Art, The Elisha Whittelsey Collection, The Elisha Whittelsey Fund, 1949

Early seventeenth-century Mexican painting was predominantly religious in character; what few secular commissions have survived are portraits of viceroys, bishops, or donors. By the last third of the century, however, this situation had changed dramatically. Not only were large ephemeral works —such as the painted arches erected in celebration of the triumphal entry of each new viceroy—created for public spectacles, but artists began to turn to Mexican history as well as to European history and religion for subjects suitable for expression on a monumental scale. The *Portrait of Moctezuma* in Florence, painted possibly as early as the 1650s but certainly before 1699, and two enormous canvases of about 1653 depicting early events in the history of the cult of the Virgin of Guadalupe (now in the Basilica Museum) document the increased interest in local subjects and cultural values. All three works appear to have used information on indigenous costumes gleaned from sixteenth-century codices and represent what has been described as the awakening of a Creole, or Euro-Mexican, as distinct from Spanish, consciousness.[1]

A related phenomenon may be seen in the art of the two painters most closely associated with the High Baroque style in Mexico, Cristóbal de Villalpando (1649?–1714) and Juan Correa the Elder (cat. nos. 143–45) although this comparison requires some explanation. To look at subject matter alone, the impression given by both painters would be largely Eurocentric, as for example in the decorative screen (*biombo*) attributed to Correa (cat. no. 194), one side of which shows *The Encounter of Cortés and Moctezuma*, the other *The Four Continents*. In both works the archaeological interest of the Guadalupe paintings has been exchanged, in one instance for the typical European image of indigenous Americans, derived as much from prints of Roman emperors as from actual experience, and in the other for the symbol of Europe, the Spanish king Charles II and his queen. Indeed, motifs from contemporary Sevillian painting abound in Villalpando's oeuvre, including a complete copy of Murillo's *Santiago Madonna* used by Villalpando to represent charity in his *Church Militant* for the sacristy of the Mexico City Cathedral. In style too Villalpando relies heavily on later Sevillian painting, notably the works of Juan de Valdés Leal, to whom Villalpando has often been compared.

Nevertheless, both Villalpando's and especially Correa's compositions reveal idiosyncrasies that can only be thought of as identifying marks of a Mexican (as opposed to Spanish) school within the European tradition. Painterly freedoms; distortions of anatomy; preferences for certain formulas, particularly in the rendering of angels; and an occasional touch of naive primitivism set Correa's works apart from those of almost any European contemporary. Even in the works of José Juárez (1617–1661) there had been a tendency for Mannerist stylistic elements, allowable under the

Tridentine Church as long as decency and clarity were maintained, to appear in otherwise thoroughly seventeenth-century compositions, a phenomenon Correa developed into a full-blown revival. This may be explained in part by the continued dependence on Mannerist prints as compositional sources long after their creation and by the lingering Mannerist elements in Zurbarán's oeuvre. But José Juárez and Correa certainly used prints after Rubens as well as earlier sources, and the works that came to the New World from Zurbarán and his shop only occasionally reveal the Seville master's reliance on previous stylistic formulas. Rather, as is most obvious in José Juárez's quotations from earlier Mexican compositions, a local tradition must be invoked to explain the Mexican variance from the European norm.

Indeed, the identification of a Mexican school may be thought of as an exercise in normative aesthetics. By the 1680s, when Villalpando and Correa began to work, European-style painters had enjoyed over a century of guild history, comprising seven artistic generations of father-son or master-pupil relationships. In the way that the Carracci emulated Raphael, Correggio, and Titian, whom they considered the "founders" of the grand tradition of Italian painting, Mexican artists could look back on the works of Pereyns, Concha, and Echave Orio as the foundation stones of the local school. Furthermore, certain localized aspects of style, originating in the compositions of the sixteenth-century artists, began to take on new life, so that how a patron might expect an angel to be represented, for example, would be determined by how they had been depicted by previous local artists. Augmented by the work of the seventeenth-century masters, who often varied their Sevillian models by quoting motifs from earlier Mexican compositions, this nascent Mexican artistic tradition was accessible in scores of altarpieces in or around Mexico City and Puebla, where both artists and patrons could develop a sense of common Creole values by reference to a body of publicly visible art.

From this point of view, Correa and Villalpando were the perfect artists to receive the large-scale patronage of the metropolitan churches. Their styles were sufficiently up-to-date, sufficiently exuberant (that is, Baroque), and sufficiently laced with references to European art to please their cultivated patrons, primarily private citizens, clerics with personal fortunes, or religious corporations. At the same time they exuded a *Mexican* feeling analogous to Sigüenza y Góngora's use of Precolumbian gods and heroes to decorate the triumphal arch of 1680. The patronage Correa and Villalpando enjoyed, in particular from the Jesuit establishments and cathedral chapters, represents exactly the intellectual ambient in which the birth of the new Creole consciousness occurred.

If we look at the poetry of writers such as Sor Juana Inés de la Cruz (cat. no. 151), who in fact provided the decorative program for the renowned *Allegorical Nepture*, one of the arches set up for the marqués de la Laguna in 1680, we see the parallels continue. The Mannerist elements preserved in the large allegorical Baroque pictures (what the nineteenth-century French would call "machines") that Correa and Villalpando created for the cathedrals are analogous to the gongorismo and use of references taken from Renaissance mythography that lace Sor Juana's works, while her

naturalism, psychological penetration, sense of scale, and awareness of the power of the all-embracing artistic ensemble—as in the *Allegorical Neptune*—are fully Baroque.

NOTES

1. Jacques Lafaye, *Quetzalcóatl and Guadalupe: The Formation of Mexican National Consciousness, 1531–1813*, translated by Benjamin Keen (Chicago and London, 1976), pp. 7–76. Cf. the observations of Octavio Paz, *Sor Juana or, the Traps of Faith*, translated by Margaret Sayers Peden (Cambridge, Mass., 1988). The Creole consciousness may be said to have developed relatively early in the seventeenth century, as argued by Guillermo Tovar de Teresa, *Un rescate de la fantasía: el arte de los Lagarto, iluminadores novohispanos de los siglos XVI y XVII* (Mexico and Madrid, 1988).
2. Among many discussions of the prevalence of Mannerism in Mexican art, see Diego Angulo Iñiguez, *Historia del Arte Hispanoamericano* (Barcelona and Buenos Aires, 1950) vol. 2, pp. 393ff.; George Kubler and Martín Soria, *Art and Architecture in Spain and Portugal and Their American Dominions: 1500–1800* (Baltimore, 1959), pp. 303ff.; Jorge Alberto Manrique, "Reflexiones sobre el manierismo en México," *Anales del Instituto de Investigaciones Estéticas* 10, no. 40 (1971) pp. 21–42; idem, "Manierismo en Nueva España: Letras y Artes," *Anales del Instituto de Investigaciones Estéticas* 13, no. 45 (1976) pp. 107–16; Marcus B. Burke, "Mexican Colonial Painting in Its European Context," in Linda Bantel and Marcus B. Burke, *Spain and New Spain: Mexican Colonial Arts in Their European Context*, exh. cat., Art Museum of South Texas (Corpus Christi, Texas, 1979) pp. 20–21, 28–36, and notes; and John F. Moffit, "El Sagrario Metropolitano, Wendel Dietterlin, and the Estípite: Observations on Mannerism and Neo-Plateresque Architectural Style in 18th-Century Mexican Ecclesiastical Facades," *Boletín del Seminario de Estudios de Arte y Arqueología* [University of Valladolid] 50 (1984) pp. 325–48, citing references to architectural studies.

140 ◀ *San Felipe de Jesús*

Mexico City, 17th century
Gilded and polychromed wood; height 135 cm. (53⅛ in.)
SEDUE, Catedral Metropolitana, Mexico City

The Franciscan Felipe de Jesús, executed in Nagasaki in 1597, was one of the Twenty-six Martyrs of Japan. He was the sole member of the group to have been born in Mexico and is a source of great pride to his country. Although he was not canonized until 1862, his cult is believed to have been celebrated privately by Franciscans even before his beatification in 1627. For members of that order, whose involvement in the conversion of central Mexico was ebbing, martyrdom in the cause of the faith was a supreme ideal, but it was ultimately his identity as a *criollo mexicano* that lent most fervor to the celebration of his cult.

Born in 1572, Felipe de las Casas abandoned his first attempt to join the Franciscan order as a youth and embarked for the Philippines, nominally ruled by Spain but in effect a dependency of Mexico. All Spanish contact with the Orient was maintained through Mexico via the flourishing Manila-Acapulco galleon trade established in 1565, and it was in this trade that the young Mexican expected to make his way. Once in the Philippines, however, Felipe experienced a renewal of his vocation and entered the discalced reformed branch of the Franciscan order known as the Dieguinos. His life from then on was so exemplary that he was recalled home, but the galleon on which he took passage was wrecked and landed in Japan. His arrival coincided with the inception of severe persecution of foreign missionaries, and the young Franciscan met his death along with twenty-five others. Bound to a cross on a pyre, he breathed his last when three lances pierced his body.

In this work the martyr's suffering is conveyed with great restraint and an elegant economy of means. The sculptor portrays his exaltation at the point of death in the pallid mask of his face and the balletic gestures of his hands and legs, all of which gain in expressive power in contrast to the stark geome-

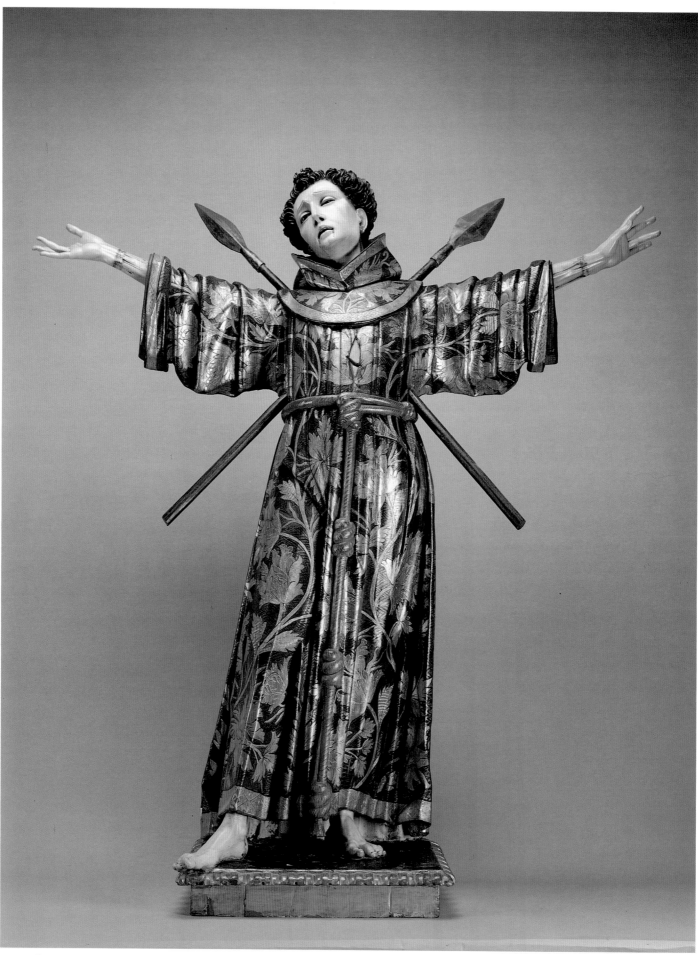

Front of cat. no. 140

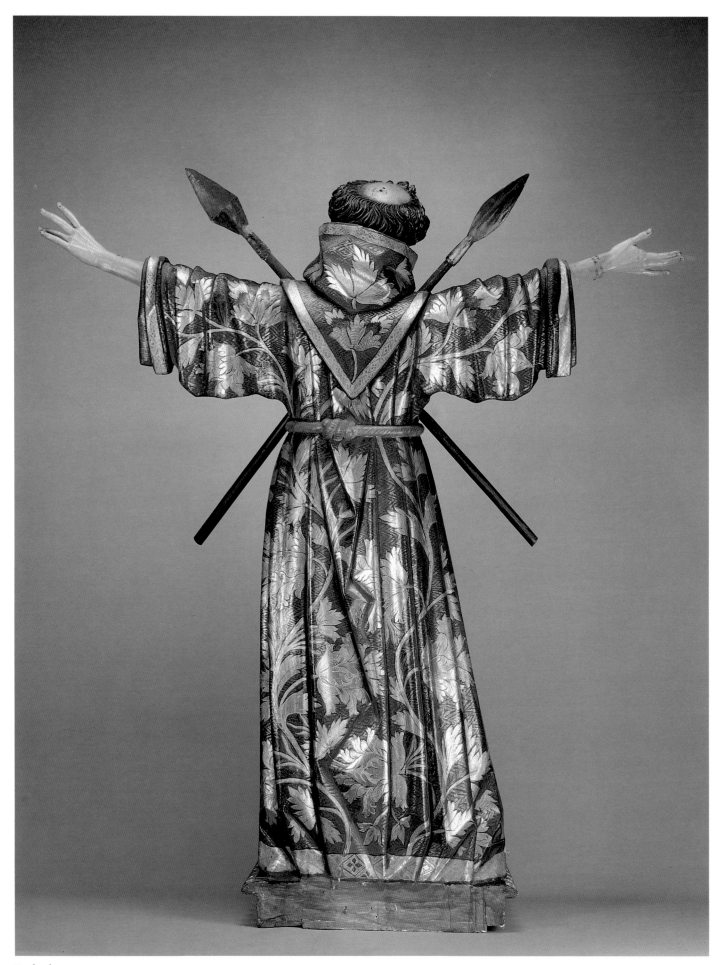

Back of cat. no. 140

Detail of cat. no. 140

try of the form. The pose echoes the agony of Christ, with the stiff drapery of Felipe's habit itself suggesting the missing cross; only ghostly bracelets of blood remain to remind the viewer of the bonds which once attached the young friar to it. The abstract geometry of the design is emphasized by the symmetrical crossing of the two lances which seen from the back line up precisely with the point of his cowl; a chaste parting of his habit reveals the wound of the third spear in his chest. The four-square representation was codified in the earliest depictions of the Martyrs of Nagasaki, including an engraving by Raphaël Sadeler II.[1]

The sculpture stands in bold contrast to its later Rococo surroundings in the cathedral, both in the angular simplicity of its form and the severity of its brown habit (although the latter is embellished with gilt patterning no mendicant Franciscan would ever have known). The actual date of its creation is uncertain. Curiel dates it to the late seventeenth century, but Medina, writing in 1683, describes the sculpture then in the saint's chapel and asserts that it had been blessed by Don Francisco Manso, archbishop of Mexico City at the time of Felipe's beatification. In any case, it is a classic example of the preservation of a devotional figure from an earlier age for reasons of cult rather than economy.

A far cry from sculptural style that evolved in Spain during the seventeenth century, this figure exemplifies the brilliant use of the alternate conventions codified in Mexico after the introduction of European models. It is not the realism of the Andalusian Baroque that underlies the beardless youth's mask of tragedy; rather it is an impulse toward abstraction. But both in the face and in the powerful geometry of the drapery, the anonymous sculptor provides an object lesson in the emotional impact to be yielded through the skillful manipulation of pure form, colored, as so often in Mexico, by an element of graceful and elegant theatricality.

JH

1. *Hollstein's Dutch and Flemish Etchings, Engravings and Woodcuts, ca. 1450–1700*, edited by K.G. Boon (Amsterdam, 1980) vol. 22, p. 217, 40.

REFERENCES
Fray Balthassar de Medina. *Vida, martyrio y beatificacion del invicto proto-martyr de el Japon San Felipe de Jesus, patron de Mexico su patria...* [1st ed., Mexico, 1683], Madrid, 1751, ch. XVIII, p. 142. **Gustavo Curiel.** "Capilla de San Felipe de Jesús." In *Catedral de México. Patrimonio artístico y cultural.* Mexico, 1986, pp. 80–103.

141 ◀ Salvador de Ocampo and Workshop

◀ Choir Stalls

◀ Former Church of San Agustín, 1701–1702
◀ Walnut; 381 x 581.7 cm. (150¼ x 229 in.)
◀ Hall of the "Generalito," Escuela Nacional
◀ Preparatoria, Dirección General del Patrimonio–
◀ Universidad Nacional Autónoma de México,
◀ Mexico City

This section consists of eight stalls: four with high backs and a canopy for the friars and two low-backed stalls for novices and lay brothers on either side. These were part of a monumental group forming the three walls of the upper choir of the convent church. They are richly carved in high and low relief with biblical scenes on the three panels that are part of each of the high backs of the friars' stalls. Each panel is framed by an elaborate border of shields, scrolls, scallop shells, and apples. On the lower novices' seats, the back panels bear foliated designs similar to those on the base running beneath the entire row of stalls. The misericords are deeply carved in a variety of grotesque shapes, and the supports for the arms and the seats carry monstrous faces, profusely foliated; these repeat the motifs on the pilasters, with their caryatids in cuirasses and *atlantes* with naked torsos. Four scallop shells are carved

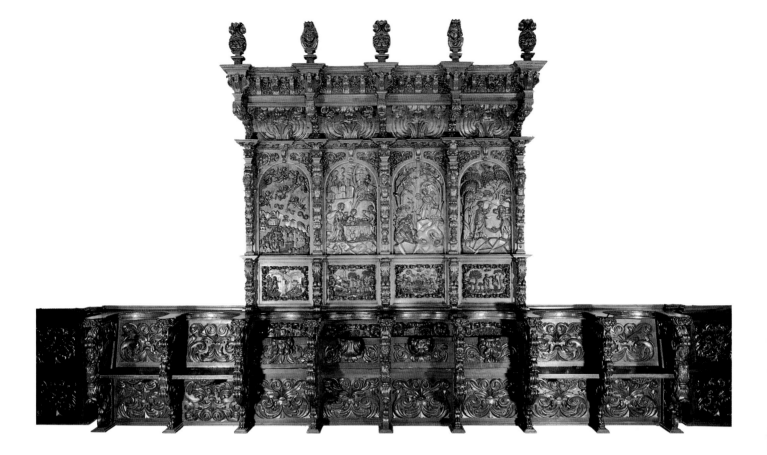

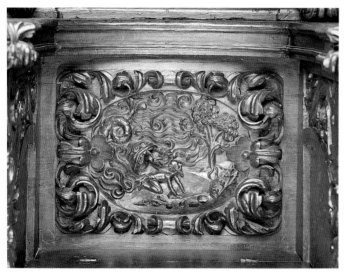

Detail of cat. no. 141

Detail of cat. no. 141

on the cornice of the canopy, and on its ends the caryatid and mask motifs are repeated.

From the time the Augustinian order reached New Spain in 1533, it dedicated a considerable amount of its income to the decoration and enrichment of its churches and convents. In this it was following, among other things, the sentiment expressed in Psalms 26:8: "O Lord, I love the habitation of thy house, and the place where thy glory dwells." In spite of the severe criticism endured by the order from the secular clergy from the time of Archbishop Montúfar's action following the Council of Trent, later, during the splendor of the Baroque movement, the Augustinians were responsible for the creation of one of the most important and sumptuous choir-stall installations in the New World.

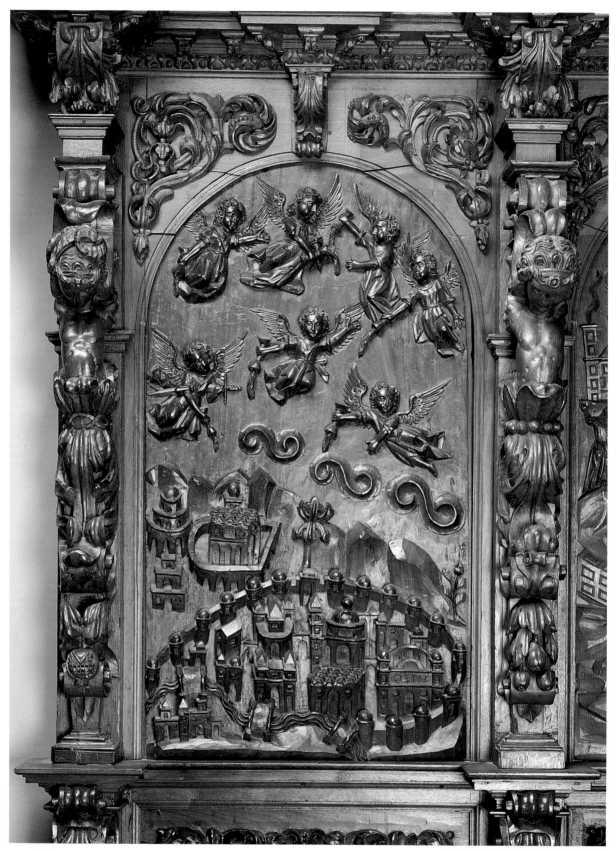

Detail of cat. no. 141

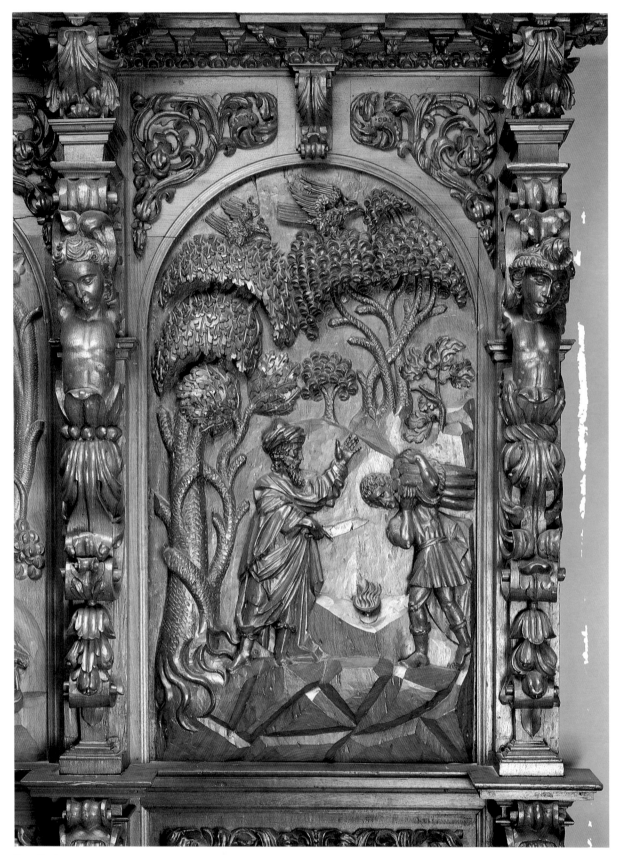

Detail of cat. no. 141

The order's first church in the capital of New Spain was erected between 1541 and 1587, following a model suggested by Charles V and inspired by the church of the Hieronymites in Salamanca. It burned in 1676. At the dedication of the second church in 1692, it was time to plan a new choir. In 1701 the Augustinians signed a contract with Salvador de Ocampo, the Indian master *ensamblador* (joiner) who in 1698 had completed the Solomonic altar for the church of the convent of Metztitlán. This convent belonged to the same religious order—a fact that may have determined the choice. It is certain that Ocampo was the son and certainly the apprentice as well of Tomás Xuárez, who had entered the competition for the contract to build the choir for the Mexico City Cathedral in 1695; however, the contract was awarded to the woodcarver Juan de Rojas because Xuárez did not present his plans on time. Perhaps the general idea contained in these rejected plans for the Cathedral finally took shape when the artist created the choir for the Church of San Agustín.

Native Indian artisans played a larger part in the fine arts of New Spain than is generally believed. According to the Regulations for the Trades of Carpenters, Woodcarvers, Joiners, and Musical Instrument Makers of 1568, Indians were not excluded from these professions if they could pass the examinations. Since woodcarvers were held to be "embellishers of the Divine Doctrine," the injunction of the Council of Trent concerning "decency" in religious art required that the candidate be skillful in portraying the human figure—clothed and nude—in making carvings and foliage *a lo romano*, as well as in drawing. The regulations of 1589, however, exempted Indians from these requirements. Salvador de Ocampo's case is interesting: in spite of his origin, he took the examination and passed in 1698, although the 1589 exemption remained in force until 1703. Xochimilco, with its excellent woodcarvers and joiners, had by this time its own trade guilds and examiners. Since the contract for these choir stalls called for their completion within a year, and slight differences in workmanship are apparent in the panels and other details, it is obvious that several other craftsmen worked on the project under the master's direction.

According to the contract, the series of biblical scenes for the three groups of panels in the choir was not designed by Ocampo; as is usual in the history of sacred art, the plan was supplied by the contracting party—in this case, the provincial of the Augustinian order. Four of these panels are based on prints that illustrated a seventeenth-century French biblical commentary; others derive from a Spanish Bible engraved by Juan de Jáuregui. All of the surviving panels show the strong influence of northern Mannerism, so prevalent in prints since the sixteenth century. The selection of subjects reflects the Augustinians' preoccupation with biblical studies from the beginning of the sixteenth century. Thus most of the scenes chosen for the program of Christian salvation to be executed by the "embellishers of the Divine Doctrine" were derived from Genesis and the Apocalypse. Of the incidents illustrated in the upper registers of the four stalls, one is from the Apocalypse and three are from Genesis. Angels pour out "the seven bowls of the wrath of God" (Rev. 16:1); Lot and his two daughters take refuge in the hills (Gen. 19:30); Hagar abandons her child under a shrub (Gen. 21:15); and Abraham takes his son to be sacrificed (Gen. 22:6). The middle register takes its themes from 1 and 2 Samuel: Dagon, the god of the Philistines, is killed in his temple by the hand of the Lord (1 Sam. 5:4); the lords of the Philistines accompany the ark to

Beth-shemesh (1 Sam. 6 : 12); David offers burnt offerings after having set the ark in the tabernacle (2 Sam. 6:17); Samuel pours oil on David's head, anointing him king of Israel (1 Sam. 16). The lower row illustrates scenes from Daniel, 1 and 2 Kings, and Jonah: Daniel destroys the dragon of the Babylonians (Dan. 7 : 22–26); Elijah is fed by the ravens (1 Kings 17 : 6); a priest deported to Samaria preaches in Bethel (2 Kings 17:28); and the Lord orders the fish to vomit out Jonah (Jonah 2:10). Such emphasis on the Old Testament is uncommon in New Spain.

When the property of the Church was secularized in 1861, the choir stalls were removed from San Agustín and stored in a warehouse; in 1885 eighteen panels were placed on temporary loan in the Museo Nacional. In 1895 they were ceded to the Escuela Nacional Preparatoria and were finally moved to the Hall of the "Generalito" in 1933. During these moves several panels disappeared, and when the group was transferred for the last time, the original sequence was lost. Thus it is impossible to know if there was any thematic order in the original disposition of the panels.

Not many choir stalls have survived in Mexico. Among them are those in the Mexico City Cathedral, the old Franciscan church in Xochimilco, the Church of San Francisco in Puebla, the Church of San Francisco in Querétaro, and the old Church of San Fernando—these last transferred to the Collegiate Church of Guadalupe. There are, however, many colonial paintings of monastery church choirs that provide faithful depictions of their furniture.

EIEG

REFERENCES
Rafael García Granados. *Sillería del coro de la antigua iglesia de San Agustín.* Mexico, 1941. **Heinrich Berlin.** "Salvador de Ocampo, a Mexican sculptor." *The Americas* 4, no. 4 (1948), pp. 415–28. **Diego Angulo Iñiguez.** *Historia del Arte Hispanoamericano.* Barcelona and Buenos Aires, 1950, vol. 2, pp. 278–89. **George Kubler and Martín Soria.** *Art and Architecture in Spain and Portugal and Their American Dominions: 1500–1800.* Baltimore, 1959, p. 168. **Jorge Alberto Manrique.** "Artificio del arte: estudio de algunos relieves barrocos mexicanos." *Anales del Instituto de Investigaciones Estéticas* 8, no. 31, (1962), pp. 19–36. **Magdalena Vences.** "Coro." In *Catedral de México. Patrimonio artístico y cultural.* Mexico, 1986, p. 471. **Manuel Romero de Terreros.** *La iglesia y convento de San Agustín.* 2d ed. Mexico, 1985, pp. 20–23, 40–44.

142 ◀ Manuel de Velasco

Mexican, active late 17th century

Two Archangels, 1685

Gilded and polychromed wood; height 184 and 178 cm. (72½ and 70 in.)

SEDUE, Catedral Metropolitana, Mexico City

The cult of angels flourished in the New World both in North and South America where cities, chapels, and altarpieces were dedicated to these heavenly creatures. Mexican artists followed the recommendations of Francisco Pacheco, the Spanish theorist of painting, that some angels be clad in costumes suggesting Roman armor. Thus they are often depicted with buskinned legs, short skirts, and cuirasses, befitting the militant role they increasingly assumed in post-Tridentine iconography. Such militant angels, as well as more peaceable ones, figured prominently in the Sacristy of the Mexico City Cathedral, the room from which this pair derive. Its decorative program, carried out between 1685 and 1691, is one of the most grandiose achievements of Baroque triumphalism.

The sacristy, on the simplest level, is the room in which the clergy prepared themselves for the celebration of the Mass. But in late seventeenth-century Mexico the iconographical program for the decoration of such spaces assumed complex political and doctrinal significance. These vast enclosures in the cathedrals of Puebla and Mexico City were converted into arenas for the display of giant allegorical canvases which proclaimed the triumph not only

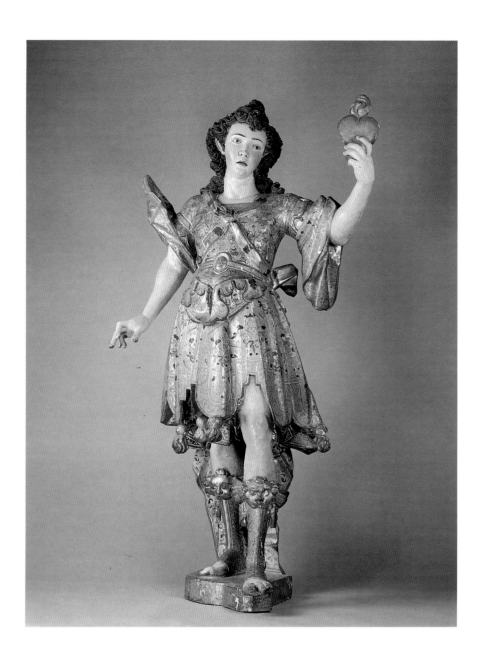

of the Universal Catholic Church[1] but also of the episcopal hierarchy in its
long-standing struggle with the regular orders.[2]

The first stage of the project was the commission to Cristóbal de Villalpando
for the immense painting *The Church Militant and the Church Triumphant*
to cover the north wall of the room. Of the remaining five giant canvases,
Villalpando (cat. nos. 143 and 144) would paint three, and Juan Correa, the other
master of the High Baroque (cat. no. 145), would paint two. As an integral part
of the program, four carved archangels were to stand high in the corners of the
large room, as if to herald the central message of the complex doctrine that
was elaborated in the canvases. They form a transition between the exuberant
iridescent angels on the painted surface and the real world in front of it and
are a vivid example of the Baroque theatricality in Mexico at that moment.

For these two angels and for the carved and gilded frame (which itself includes
ten full-scale polychromed cherubs) that surrounds Villalpando's painting,
Velasco received 1,420 pesos (of this, 720 was for the gilding and the gold leaf
itself which Velasco had to purchase). It is interesting to compare this sum
accorded to the now-obscure carver with the 400 pesos paid for the work of

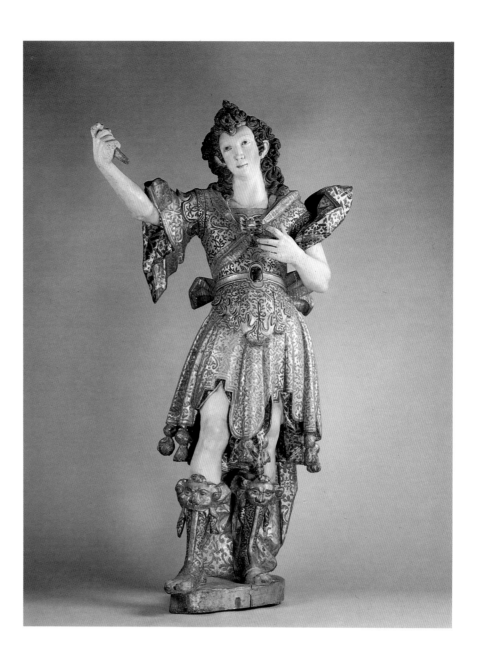

Villalpando, the most important painter of the age (see cat. nos. 143 and 144).

Very little is known about Manuel de Velasco. He appears to have belonged to a family workshop that included members of both the painters' and carvers' guilds; he himself is sometimes recorded as a master joiner and sometimes as a master gilder and estofador. In this commission he was paid for both carving and gilding.

Carvers of figures like this were members of a woodworkers' guild, concerned primarily with the production of quasi-architectural structures; this orientation may explain the persistently angular and hieratic quality in much of their work. In the present figures, for example, the angels' flamboyant sleeves are worked in a highly ornamental but eccentric manner, an attempt perhaps to devise a Baroque sculptural language that would emulate the exuberance of Villalpando's drapery style.

The angels' soft features, elongated and overly articulated necks, and exaggerated Mannerist coiffures also show the painter's influence, but the hanging lambrequin-like skirts are closer in spirit to the style of the older generation. The angels represent a moment of transition. Six years later Velasco would

carve the two south-wall angels in a very different style, the movement entirely focused in their fluttering skirts, evidence of a new formula that would be codified in the next century.

JH

1. This subject and many others here discussed are most thoroughly explored in Gerlero, 1986, pp. 376–409.
2. Nelly Sigaut, "El conflicto clero regular-secular y la iconografía triunfalista," in *Iconología y Sociedad Arte Colonial Hispanoamericano*, XLIV *Congreso Internacional de Americanistas*. Mexico, 1987, pp. 109–23.
3. Gerlero 1986; Francisco de la Maza, *El pintor Cristóbal de Villalpando*, Mexico, 1964, pp. 66.

REFERENCE
Elena I. Estrada de Gerlero. "Sacristia," *Catedral de México. Patrimonio artistico y cultural.* Mexico, 1986, p. 379, ill. p. 403.

143 ◀ Cristóbal de Villalpando

Mexican, about 1645–1714

St. John the Evangelist and Mother María de Jesús de Agreda

Oil on canvas; 190 x 113 cm. (74¾ x 50½ in.)
CNCA–INAH, Museo Regional de Guadalupe, Zacatecas

Cristóbal de Villalpando was one of the most important painters of the Mexican Baroque period. He and Juan Correa (cat. no. 145 and 194) are considered the most representative artists of that rich and magnificent era at the beginning of the eighteenth century.

Without totally discarding the *efectista* handling of luminous contrasts that had been adopted by the painters of the previous generation, Villalpando created images of dazzling brilliance, rich color, and tremendous dynamism; his work has been seen as a reflection of the vigorous art of Rubens, but it is to a greater degree an echo of the fiery and daring manner of the Sevillian Juan de Valdés Leal.

Villalpando was born in Mexico City, and in 1669 he married María de Mendoza, by whom he had at least eight children. It has been suggested that he was trained by either José Juárez or Antonio Rodríguez, both well-known painters, or perhaps by his father-in-law, Diego de Mendoza of Puebla. It is certain, however, that his painting is stylistically akin to that of Baltasar de Echave Rioja, especially in its great freedom of line, expressive brushwork, and rendering of figures (see cat. no. 139). There were other bonds between the two painters: Echave Rioja was the godfather of two of Villalpando's children.

Villalpando died after nearly forty years of activity, leaving one of the most abundant, sensual, imaginative, and vital bodies of work produced in New Spain—but also one of the most unequal in quality, perhaps owing to that very fecundity. It has been said that from one piece of work to the next he could descend from the heights of genius to the level of a clumsy artisan.[1]

Villalpando scorned the rules of realism and the use of carefully worked detail to produce very personal paintings marked by great depth of expression. The present painting and cat. no. 144 display his greatest virtues: the power and elegance of his figures, with their expressive faces, hands, and postures; the grace of his archangels and cherubim; the treatment of the deep folds in draperies; the lively colors; the skillful compositions; and the freedom of the brushwork. At the same time we can see his most obvious weaknesses: careless drawing and faulty anatomy.

In the present canvas Villalpando has brought together two visionaries: St. John the Evangelist and Mother María de Jesús de Agreda, the Spanish *concepcionista* nun who wrote in the mid-seventeenth century. Here the artist has shown the apostle as a man of advanced age, unlike the figure in his other picture of the same subject in the sacristy of the Mexico City Cathedral.

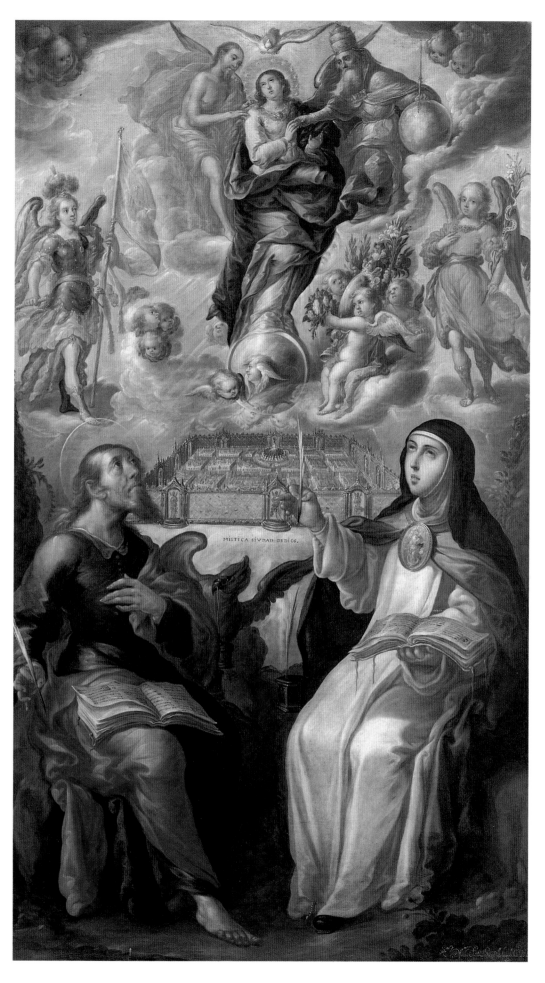

MISTICA SIVDAD DE DIOS.

Since both St. John and Mother Agreda have given us descriptions of ideal cities—in the Apocalypse and *The Mystical City of God*, respectively—the artist has painted a vision of the Heavenly Jerusalem in the background. It is the traditional walled city with twelve gates, three on each side, each guarded by an angel.

Above appears the Virgin of the Apocalypse at the moment of her Assumption, being received by the Trinity. The Father has taken her by the hand, and the Son touches her shoulder—familiar, gracious gestures that remind us of Juan Correa's painting in which the archangel Michael touches the wings of the Virgin of the Apocalypse (Museo Nacional del Virreinato, Mexico City). As his model for the Virgin and the group of cherubs at her feet, Villalpando has taken a *Purísima* by Diego de Borgraf (1685); the latter, in turn, had copied an earlier painting by Francisco Rizi (both in Puebla Cathedral).

RRG

1. Francisco de la Maza, *El pintor Cristóbal de Villalpando*, Memorias del Instituto Nacional de Antropología e Historia no. 9 (Mexico, 1964) p. 243.

REFERENCES
Francisco de la Maza. "Pintura barroca mexicana (Cristóbal de Villalpando)." *Archivo español de arte* 36, no. 141 (1963), p. 31. **Francisco de la Maza**. *El pintor Cristóbal de Villalpando*. Memorias del Instituto Nacional de Antropología e Historia no. 9. Mexico, 1964, pp. 205, 208, ill. (as *La mística Jerusalén*).

144 ◀ Cristóbal de Villalpando

Mexican, about 1645–1714

The Tree of Life

Oil on canvas, 187 x 109 cm. (73⅝ x 48⅞ in.)
CNCA–INAH, Museo Regional de Guadalupe, Zacatecas

This splendid and complex canvas is a lesson in theology as well as in Baroque plasticity. Adam and Eve are seen in adoration of the symbol of Christian Redemption. The cross, totally covered with grapes, bears a crown of thorns at the top and roses on its arms, signifying redemption as the fruit of suffering.

Adam and Eve appear dressed in skins, just as Correa pictured them in his *Expulsion from Paradise* (cat. no. 145), undoubtedly to conform with the restrictive and moralistic atmosphere of New Spain. Vine shoots spring from their breasts to embrace small figures of the Virgin and the crucified Jesus —the second Eve and the second Adam. Below are the occasions for Redemption: "sin," in the conventional symbol of a blue sphere (the world); a serpent with the head of a woman, almost a child, the ears of a pig, and the wings of a dragon (the devil); and a woman decked with jewels, with what is meant to be a provocative expression (the flesh). Along with sin we see its immediate consequence: death, in the form of a skeleton embracing and overpowering the world, joined by a chain to the devil and the flesh.

Beneath the arms of the cross the archangels Michael, Gabriel, and Raphael act as intermediaries between God and man. The inclusion of the "bearers of Christ," St. Christopher and St. Hyacinth of Poland, in the upper corners reinforces the symbolic content of the picture: only by the grace of Redemption can the children of Eve atone for their sins, escape the clutches of the devil, and triumph over death. But putting faith in salvation is not enough; believers must also carry Jesus with them as a guide in all their actions.

RRG

REFERENCES
Francisco de la Maza. "Pintura barroca mexicana (Cristóbal de Villalpando)." *Archivo español de arte* 36, no. 141 (1963), p. 36. **Francisco de la Maza**. *El pintor Cristóbal de Villalpando*. Memorias del Instituto Nacional de Antropología e Historia no. 9. Mexico, 1964, pp. 206–7.

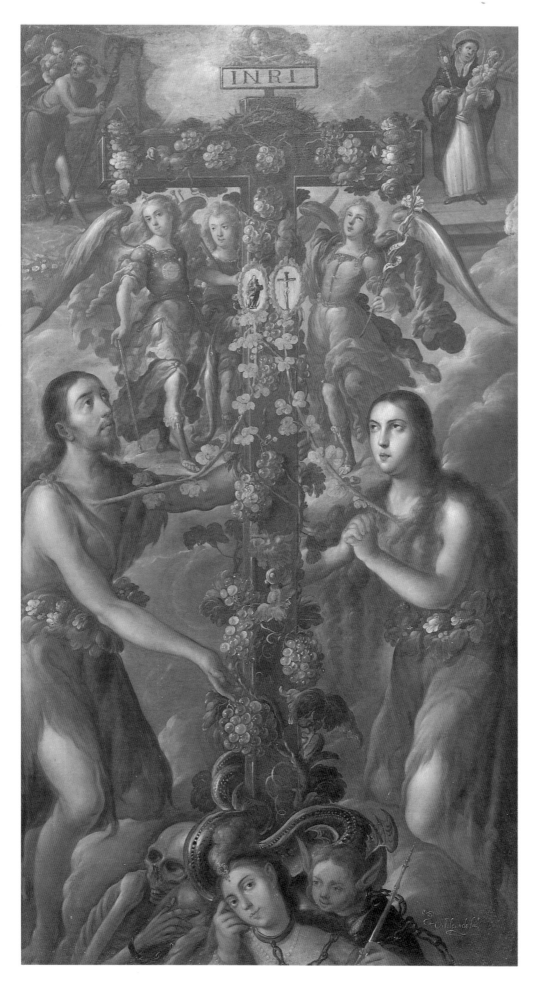

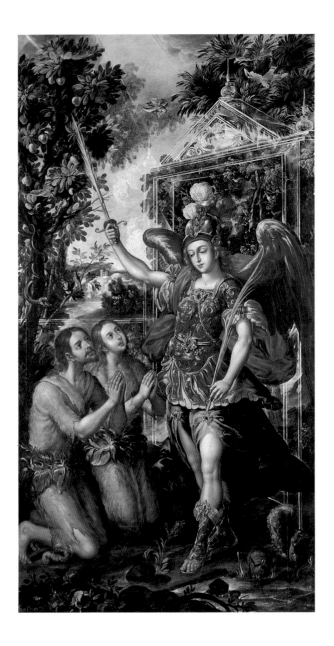

145 ◀ **Juan Correa**
◀ Mexican, b. 1645–50, d. 1716
◀
◀
◀ *The Expulsion from Paradise*
◀ Oil on canvas; 230 x 125 cm. (90½ x 49¼ in.)
◀ Signed lower left: Juan Correa
◀ CNCA–INAH, Museo Nacional del Virreinato,
◀ Tepotzotlán 10–6812

Juan Correa was the son of a prominent mulatto doctor from Cádiz and
a *morena libre* (free black woman) from Mexico City. His first signed work
dates from 1666, and it is likely that he was born between 1645 and 1650.
About 1659 Correa may have studied with Antonio Rodríguez (1635–about
1686). In the present painting Rodríguez's influence seems evident in the
figures' proportions and their idealized faces.

Correa had a long, productive, and prosperous life. Professionally he was
highly esteemed in the society of New Spain, and he achieved a great artistic
triumph: he made more paintings for the Mexico City Cathedral than any
other painter. His workshop was one of the most prolific in viceregal Mexico.
Uncounted paintings left his studio during the seventeenth and eighteenth
centuries for all of New Spain, as well as for Guatemala, Spain, and Rome.

This picture depicts the moment when God drove Adam and Eve from the
Garden of Eden after they had eaten the forbidden fruit from the tree of
the knowledge of good and evil. This episode is depicted in several sixteenth-
century mural paintings, but among paintings on canvas from New Spain
known to date, this representation is unique. The principal figure is the

elegant Archangel Michael, with the crystalline gates of paradise behind him. Genesis 3 : 24, from which the composition derives, relates that "at the east of the garden of Eden [the Lord God] placed the cherubim, and a flaming sword which turned every way, to guard the way to the tree of life." The replacement of the cherubim by the Archangel Michael is based on the religious tradition that since ancient times had held Michael to be the most noble of the angels and the defender of the Church. Among other texts, the apocryphal Gospels of the Resurrection, which provided much inspiration to popular devotion, called him "the guardian of paradise."

The archangel's attire, inspired by Roman military costume, accords with his role as *princeps militiae coelestis* (captain of the heavenly host). The sun and moon on his cuirass are symbols of the Old and New Testaments. In his right hand he holds a flaming sword reminiscent of the lightning bolt, the awesome weapon of the Lord; in his left is a palm branch, symbol of triumph over evil and death.

Adam and Eve kneel before the archangel. According to Scripture, before driving Adam and Eve from Eden, "the Lord God made for [them] garments of skins, and clothed them" (Gen. 3:22). Correa's representation of the dress is curious: over the animal skin garments he places the fig leaf aprons with which Adam and Eve had earlier covered themselves when they first became conscious of their nakedness (Gen. 3:7).

The tree at the left bears the forbidden fruit, and the serpent, symbol of evil, coils around its trunk. Other trees, lush and filled with small birds, evoke the paradisiacal garden. At the bottom a squirrel and a rabbit drink together without fear from a stream; in the distance can be seen the source of the Rivers of Paradise. Thus the scene refers not only to humankind's Fall but also to the divine promise of redemption.

This work is among Correa's finest from the period 1670–80. After 1680 Correa moved toward greater dynamism, and with Cristóbal de Villalpando, he became a notable exponent of the "Luminous" Baroque in New Spain. During this second phase of his career, he and his workshop produced paintings marked by looser drawing and very rich color. The decorative character of the works was accentuated, and there was greater emphasis on overall effect and less attention to detail (see also cat. no. 194).

EVL

REFERENCES
Manuel Toussaint. *Colonial Art in Mexico.* Translated and edited by Elizabeth Wilder Weismann. Austin and London, 1967, pp. 236–238. **Manuel Toussaint**. *Pintura Colonial en México.* 2d ed., edited by Xavier Moyssén. Mexico, 1982, p. 142, fig. 238. **Elisa Vargas Lugo and José Guadalupe Victoria**. *Juan Correa: su vida y su obra.* Mexico, 1985, vol. 2, *Catálogo,* part 1, p. 20. **Elisa Vargas Lugo and Gustavo Curiel**. *Juan Correa: su vida y su obra.* Vol. 3, *Cuerpo de Documentos.* In press. **Elisa Vargas Lugo and José Guadalupe Victoria**. *Juan Correa: su vida y su obra.* Vol. 4, *Repertorio Pictórico.* In press.

146 ◀ Lower Portion of a Retablo

Mexico City, about 1690
Gilt and painted wood, oil on panel, oil on canvas; height, 3.2 m. (9 ft. 11 in.), length 4.2 m. (13 ft. 2 in.)
Jorge Alberto Borbolla Villamil and Angela Malo de Borbolla Collection, Cuernavaca

This retablo was originally in the chapel of the Jesuit hacienda of Santa Lucia near Mexico City, which became the property of Pedro Romero de Terreros, Count of Regla, in 1776. When the ex-hacienda passed to the Mexican Air Force in the 1950s, the retablo was taken to the chapel of the Fundición in Zimapán, Hidalgo, and thence to its present location. The retablo is on the whole well preserved; only a few fragments of the original structure and of the predella sculptures have been lost. The single major change from what must have been the original is at the center of the second level. As it was first

conceived, the retablo most probably had an image of the Crucifixion in place of the painting of St. Lucy now there.

The importance of retablos in Mexican colonial art cannot be overstated. They engaged the talents of the best architects, sculptors, and painters as well as of many artisans, working in collaboration, and they implied considerable cost. Being eminently public art, they represent basic ideological and stylistic trends. This particular retablo, although of relatively small dimensions, is a good example of the late Solomonic phase of the Baroque in Mexico City, before the shift to the use of the *estípite* (column or pilaster tapering toward its base). Painting, sculpture, and architecture exist in a balanced combination, which permits the easy perception of each major element in isolation. Nevertheless, all the surfaces are richly decorated with foliage, grapevines, and abstract curvilinear designs, and there is a marked emphasis on the central image whose niche rises above the cornice. Some of the details of the structure, such as the filigree arch above the Virgin, recall the work of the sculptor Manuel de Velasco (cat. no. 142) in the Sacristy of the Cathedral of Mexico City of around 1690. The paintings confirm this date. They are of good and, in many details, of fine quality in the brushwork and facial expressions, and in a style which is close to that of Juan Correa (cat. no. 145), although the angels surrounding the whole are reminiscent of Cristóbal de Villalpando (cat. nos. 143 and 144). Both these painters were working in the Cathedral at the same time as Manuel de Velasco.

Of great interest is the iconography of this retablo. The complete and coherent program is dedicated to Our Lady of Sorrows, whose image is in the central niche, a typical example of the *imagen vestida*, a figure made to be dressed. Only the bust and arms, and in this case the silver sword, are solid; the rest of the body is an armature to support clothing which could be changed to suit the occasion and to display the gifts of gowns, jewelry, and objects offered to the image. In the full retablo a heart pierced by seven swords, symbolizing the Seven Sorrows of the Virgin, is at the top, just below the figure of God the Father. The twenty angels, painted on wood panels, which surround the whole, carry symbols of the Passion of Christ, while each of the

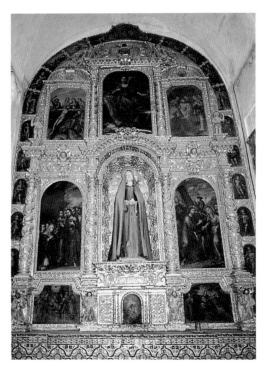

View of entire retablo

Detail of cat. no. 146

Detail of cat. no. 146

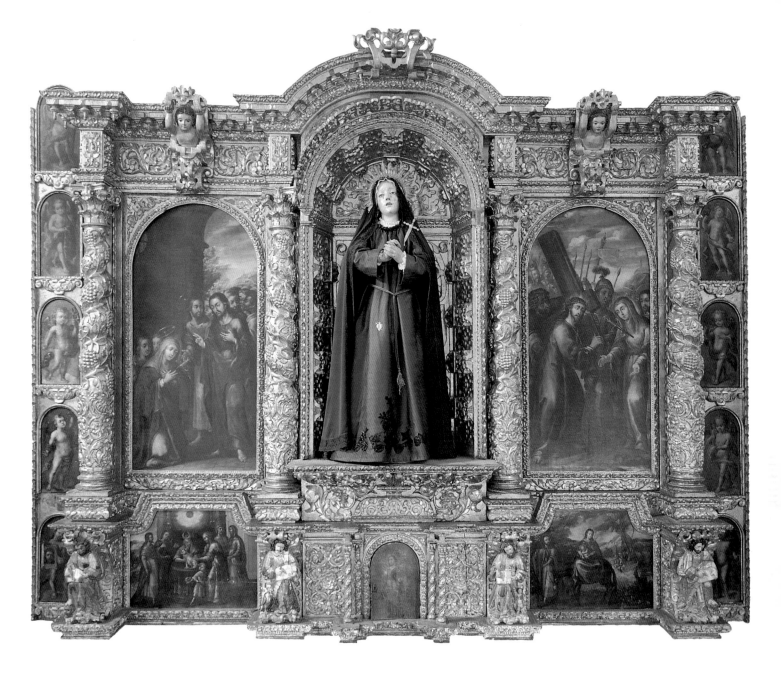

six paintings of the retablo illustrates a sorrowful episode of Christ's life: the Circumcision, the Flight into Egypt (here with the interesting detail in the background of the Holy Family concealed inside a tree trunk, as troops file by), Christ bidding farewell to his mother on beginning his public life, the meeting between Mary and Jesus on the way to Calvary, Christ being nailed to the Cross, and the Deposition. The Crucifixion at the center top would have completed the Seven Sorrows. In each painting Mary's heart is pierced by a sword.

Although the Sorrows of the Virgin are usually seven, they are not always the same, nor with the same details. Noteworthy in this case is the care with which the apostle St. John, the figure in green and red, is identified, especially in the scene of the farewell, an episode which is rarely represented. Significant too is the importance given to St. Joseph whose image, also with swords piercing his heart, is on the tabernacle door. The attention to the apostle builds on the figures of the Evangelists, one of whom is St. John himself, who support the entire retablo structure. Each one is identified not only by his symbol but also by the writing in gold in his book, which is preserved fully only in the case of John ("secundum Juanem").

The cult of the Virgin of Sorrows, as well as the place given to both Joseph and John, can be related to the particular interests of the Jesuit order which commissioned the retablo and are frequent themes in paintings of Juan Correa and his circle. It is known that the Jesuits were zealous in propagating devotion to the Virgin of Sorrows. Father José Vidal, whose writings about the Virgin of Sorrows have come down to us, commissioned a retablo with this theme, to replace an existing retablo of the Immaculate Conception, from Juan Correa, Tomás Juárez, and Alonso de Jerez in 1678 for the Jesuit church of San Pedro and San Pablo in Mexico City. The Santa Lucia retablo also replaced an older retablo which had a central image in sculpture of St. Lucy, according to a colonial inventory. St. Joseph enjoyed a very important cult in New Spain and had been declared patron of the Church there as early as 1555, and Charles II named him patron of the Spanish colonies in 1679. The cult of sorrows and joys associated with the Virgin was extended to St. Joseph and even to St. John. The attention to John can further be related to the sense of apostolic and priestly vocation which was typical of the Jesuit order.

CB

REFERENCES
Archivo General de la Nación. *Temporalidades*, vol. 20, exp. 3. **Manuel Romero de Terreros**. *Antiguas Haciendas de México*. Mexico, 1956. **Elena Estrada de Gerlero**. "Sacristía." In *Catedral de México. Patrimonio artístico y cultural*. Mexico, 1986, pp. 377–409. **Jaime Genaro Cuadriello**. "San José en tierra de gentiles: ministro de Egipto y virrey de las Indias." *Memoria* (México, Museo Nacional de Arte) 1 (1989), pp. 4–33. **Clara Bargellini**. *La arquitectura de la plata: iglesias monumentales del centro-norte de México, 1640-1750*. In press. **Gustavo Curiel**. "Las pinturas de Nuestra Señora de los Dolores y Nuestra Señora de la Piedad en la obra de Juan Correa." In Elisa Vargas Lugo et al., *Juan Correa: su vida y su obra*, vol. 1. In Press.

147 ◀ *St. Francis with Three Spheres*

Puebla or Tlaxcala, about 1700
Gilded and polychromed wood; height 110 cm.
(43¼ in.)
SEDUE, Templo de San Francisco, Tlaxcala

This figure of St. Francis of Assisi supporting the spheres of the three Franciscan orders once also held an image of the Virgin, now lost. The figure is customarily housed in the main altar of the Chapel of the Third Order (lay men and women who have dedicated themselves to following major tenets of the principal order's rule but without necessarily taking vows or retreating from the world). The Franciscan arms and images of the three orders are painted on the spheres. The first is of the friars minor, the second of the female regulars or Poor Clares, and the third of the tertiaries, among whom were numbered many of the most distinguished personalities of the Spanish world. A monarch holding instruments of the Passion appears in the foreground of this last sphere. Several of the lay sisters, who wear habits (unlike the lay brothers who wear sober secular garb), are crowned as well. The regent has not been identified; he is perhaps meant to be Philip III (1578–1621) whose entire court assumed the habit of the order.

This regal image on the third sphere may allude to Tlaxcala's status as *leal ciudad* (faithful city), a title granted by the Spanish Crown in 1535 in recognition of the critical assistance the city had provided to the Spanish in the course of the Conquest. A center of great importance in pre-Hispanic times, Tlaxcala had long resisted the domination of the Aztecs and saw the advent of the Spanish as an opportunity for deliverance from the Triple Alliance's yoke. Tlaxcaltecans fought at the side of the Spanish on their march toward Tenochtitlan and gave them refuge while they regrouped after the debacle of the *noche triste*. As described by the English Dominican Thomas Gage, writing in 1648, the inhabitants of this independent city "clave most faithfully to

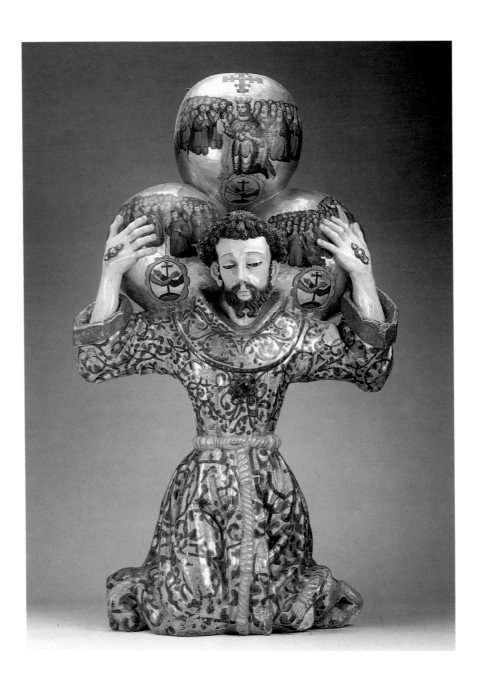

Cortés, and were the chief instruments for the subduing of Mexico, and therefore to this day are freed from tribute by the kings of Spain."[1]

The early conversion of the Tlaxcaltecans became part of the legend of Christian Mexico, and Tlaxcaltecan families were instrumental in the colonization of the northern, less civilized reaches of New Spain throughout the viceregency. The Franciscan foundation in Tlaxcala was one of the oldest in Mexico and was the episcopal seat of the region until 1550 when the bishopric was removed to Puebla. The construction of the present establishment, largely by Tlaxcaltecan natives, dates mainly to the years 1537–40 and is vividly described by Motolinía, who alludes to frescoes of "emperors, kings, and knights" on the walls of the patio chapel.[2]

Later additions to the church, including the construction of the renowned *artesonado* ceiling and the Chapel of the Third Order, have been dated to the seventeenth century. The altar from which the present sculpture derives and for which it was probably carved is the main altar of that chapel. It is a classic example of the so-called Solomonic style that was introduced to Mexico in

Puebla about 1649 and is still well represented in the region and particularly in this church. The altar itself has been dated to about 1700.

The altar's highly embellished surface texture with twisting, hollowed-out, double-helicoid columns, undercut and minutely detailed, stands in strong contrast to the comparatively simple hieratic form of the sculptures in its niches. This figure, representing the titular saint of church and chapel alike, was clearly never meant to be seen except in a niche, which is now covered with glass. Its impact derives from the configuration of its head and raised arms; all the emphasis is on the upper portion: the primitive but powerful hands, the arms like gnarled branches, and the sorrowing empathy of the starkly faceted face. Bold geometry that had by now become convention is here adapted to stress the expressiveness of the simple symmetrical form. In this case the exaggerated width of the face with its broad eyelids and splayed ears reinforces the horizontality of the supporting arms. Only selected details are worked with any care: the meticulously patterned hair and beard that frame the saint's features and the bejeweled stigmata that convert his mystical wounds to treasures.

The lower portion of the figure is rudimentary, even allowing for the kneeling pose, conveying little sense of the reality of the human form. The ends of the robe form a kind of scrolling support, echoed by the taillike end of the Franciscan cord, demonstrating the persistence of formulas found in the earliest Christian art in Mexico. The same convention obtained in the so-called *tequitqui* reliefs, adapted from graphic models. It continues here in three-dimensional sculpture as it does in contemporary book illustrations.

In the mid-eighteenth century St. Francis with the Three Spheres appears in an even more starkly geometric incarnation on the facade of the neighboring Santuario of Our Lady of Ocotlán. There the rigid figure composes a supporting structure for a gracefully swaying Purísima, encircled by a swirl of Baroque drapery. One concludes that the simplicity of form embodied in sculptures like these is clearly a product of both convention and intention.

JH

1. *Thomas Gage's Travels in the New World.* Edited and with an introduction by J. Eric S. Thompson. Norman, Okla., 1958, p. 48.
2. Motolinía [Fray Toribio de Benavente], *Memoriales, o libros de las cosas de la Nueva España y de los naturales de ella*, edited by Edmundo O'Gorman (Mexico, 1971) p. 156.

REFERENCES
Diego Angulo Iñiguez. *Historia del arte hispanoamericano.* Barcelona and Buenos Aires, 1950, vol. 2, pp. 866ff. **Joseph Armstrong Baird, Jr.** *The Churches of Mexico, 1530–1810.* Berkeley, Calif., 1962, p. 121, pl. 115. **Antonio Bonet Correa.** "Retablos del siglo XVII en Puebla." *Archivo español de arte* 36, no. 143 (1963), pp. 233–52. **Marco Díaz.** "Retablos salomónicos en Puebla." *Anales del Instituto de Investigaciones Estéticas* 13, no. 50 (1982), pp. 103–10.

148 ◀ Processional Figure: St. James the Moor-Killer(?)

Mexican, 17th–18th century
Polychromed and gilded wood with horsehair, leather, and wrought iron; height 180 cm. (70⅞ in.)
Museo Franz Mayer, Mexico City 18–057 00486
BEA–004

The legend of St. James the Major (Santiago) was dear to the hearts of the Spanish, most of whom believed that he had converted Spain to Christianity in the first century and that his body had been translated to Santiago da Compostela. This legend was extended by a subsequent one that alleged his miraculous appearance at the side of Catholic troops in their war to reconquer Spain from the Moors. So it was in the guise of a warrior, Santiago Matamoros (Moor-Killer), that countless parishes throughout the Peninsula made Santiago their patron saint. And because they saw their fight to conquer and convert the Indians of the New World as yet another Spanish crusade to win

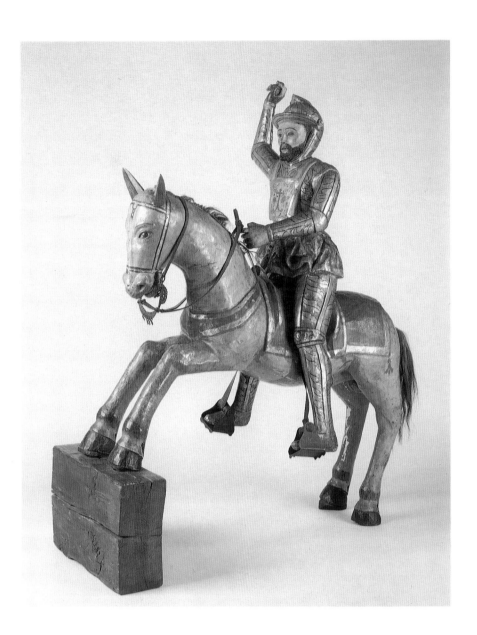

infidel populations to Christianity, the conquistadores brought the cult of St. James to Mexico.[1]

True to his legend, the saint, it was widely affirmed, appeared on the side of the Spaniards during the battles of the Conquest. One consequence of this transferred myth was that the new converts adopted the cult of the bellicose saint who symbolized their defeat. They were convinced that this "god" of the Spanish invaders was a potent deity, the very symbol of the mounted warriors who had swept over Mexico, bringing cavalry warfare (and the horse itself) to the Americas. In venerating James, the Mexican converts sought to appropriate his power for themselves, and he was enthusiastically incorporated into the hagiography of the New World.

Still relevant is Antonio Cortés's view of the Indian devotion to St. James in the church of Atlatongo: "The apostle Santiago represents for the Indian the powerful paladin of Christianity who achieves all through his heroic strength. . . . Even in those towns where the indigenous element is scarcely diluted, it seems that the indigene preserves from former times a highly entrenched devotion for this warrior saint. . . . This concept is formed in them by the constant narratives which told of a corporal apparition in the form of a war-

rior which aided the christian against the gentiles, including besides Cortés and Oñate even the converted indians themselves, e.g., the cacique don Nicolas de San Luis in the conquest of Querétaro."[2]

Most Spanish colonial images of Santiago continue the Peninsular convention of showing him as the vanquisher of the Moors, trampling turbaned Muslims. Yet in many New World parishes, even those with indigenous congregations, he is depicted and venerated as Santiago Mataindios (Indian-Killer), which suggests the Indian pride in their own roles as warriors of Christ. In the years following the Conquest, the converted indigenous population fought in the continuing struggle against the untamed Chichimecas to the north of the Valley of Mexico. A cornstalk-paste Santiago Mataindios, a remarkable seventeenth-century processional figure, is in the Church of Santa María Chiconautla, Estado de México. The block under this horse's hooves is painted with images of three Indians, their heads surmounted with Nahuatl glyphs, flanking the arms of Mexico—the eagle and the serpent on the nopal cactus—and above them all, the Holy Spirit.

Santiago appears on Mexican retablos and facades less frequently than in Spain. (An exception is the seventeenth-century relief salvaged from the destroyed high altar of Santiago Tlatelolco, the church attached to the first college for Indians in the New World.) The most striking manifestations of the cult in Mexico are those associated with popular festivals: processions and dances such as the *moros y cristianos*, in which Santiago is transformed from terrifying divinity to benign ally.

The present Santiago was undoubtedly made to be carried through the streets of its town on days of religious celebration. Such processions have long been features of popular piety in Peninsular Spain, but pre-Hispanic Mexico had its own versions, a convenient parallel with Catholic practice. The Church shrewdly encouraged such parallels, using them to rechannel the devotional energies of its converts into new, but not unfamiliar paths.[3]

The feast of St. James is celebrated with elaborate processions even in pueblos with other nominal patrons. Indeed, in many Indian parishes, Santiago is considered superior to any other saint and his fiestas are the most sumptuous. On nonfestival days as well, he and his steed are surrounded by floral tributes and votive candles; they are often dressed in velvet and satin garments that are offered by parishioners.

The Spanish technique of estofado, in which the painted surface is patterned with punch marks and scratched through to reveal a gold undercoat, continued in Mexico long after it had fallen out of fashion in the Peninsula. This opulent technique was often applied to sculptures whose form, however exuberant and lively, appears naive by contemporary European standards. The surface of this figure is characteristic of the Mexican eighteenth century in that the estofado is augmented with overpainted designs including the somewhat misunderstood Cross of St. James that adorns the horseman's chest. This tension between lavish surface and minimal complexity of underlying form is one of the hallmarks of later viceregal sculpture.

Although official standards of taste may have changed with the end of the colonial era, processional figures of Santiago continued to play a prominent role in Mexican pueblos long after the last viceroy left Mexico. St. James was believed to have come to the aid of Mexicans in their wars of independence and in their battles against foreign invaders well into the nineteenth century. His cult remains strong to this day.

JH

1. Rafael Heliodoro Valle, *Santiago en América* (Mexico, 1946) pp. 10–12, 89ff. for full bibliography.
2. Antonio Cortés, "Artes menores del valle de Teotihuacan en la época colonial," in *La población del valle de Teotihuacan* (Mexico, 1921) pp. 669ff.
3. Robert Ricard, *The Spiritual Conquest of Mexico: An Essay on the Apostolate and the Evangelizing Methods of the Mendicant Orders in New Spain, 1523–1572*, translated by Lesley Byrd Simpson (Berkeley, Los Angeles and London, 1966) p. 181.

149 *Virgin of Guadalupe*

Mexican, late 17th century
Oil, gilding, and mother-of-pearl on wood;
height 190 cm. (74¾ in.)
Museo Franz Mayer, Mexico City 11–062/
10603 AEA–006
EXHIBITED IN NEW YORK ONLY

The dark-skinned Virgin of Guadalupe is Mexico's most revered symbol, with profound religious as well as sociopolitical implications. According to legend, the Virgin appeared to the Indian convert Juan Diego in 1531 on the hill of Tepeyac, a shrine sacred to the mother goddess Tonantzin in pre-Hispanic times. Mary instructed him to tell Archbishop Zumárraga to build a church in her honor on that very site. Juan Diego obeyed her but the archbishop doubted his word. To establish his credibility, the Virgin made flowers miraculously appear on the hill and ordered Juan Diego to bring them to the archbishop in his cloak. But when Juan Diego opened his cloak before Zumárraga, the flowers spilled out revealing on the cloth the image of the Virgin herself. The miracle of this apparition of the Mother of God to a native on American soil gave rise to the most important cult in Mexican Catholicism. At the heart of this cult is the textile image of the Virgin, now housed in the Basilica of Guadalupe in Mexico City and venerated by the faithful as the original cloak of Juan Diego.

Countless other images of the Guadalupana in diverse media, such as this one from the seventeenth century, adhere faithfully to the canonical image. It derives from the description of the Apocalyptic Woman in Revelation (12 : 1): "And there appeared a great wonder in heaven; a woman clothed with the sun, and the moon under her feet, and upon her head a crown of twelve stars." Specific iconographical features rarely vary. The Virgin always stands on a crescent moon and is encircled by a corona of sunrays, which is in turn surrounded by a scalloped oval of clouds. Other constant elements are the brocade pattern on the Virgin's robe, the specific configuration of stars on her cloak, the lappets of her belt, her tubular cuffs, and the little winged cherub in his buttoned shirt, who supports the Virgin on his head while holding the edge of her cloak with his right hand and the hem of her robe with his left.

Because this central image was codified so early, dating of specific versions is difficult. It is true that later renditions frequently reveal their dates in such embellishments as garlands, clouds of cherubs, and especially in the inset ovals showing the main events in the story of Juan Diego (the so-called Four Apparitions). Yet the multitude of Guadalupanas that proliferated after Pope Benedict XIV's recognition of the belief in 1754 (when he confirmed her as patroness of New Spain and instituted a Mass and Office to be celebrated on December 12) scarcely differ in their portrayal of the Virgin from the earliest known replica, the painting of 1606 attributed to Baltasar Echave Orío.

Depictions of the Guadalupana in inlaid mother-of-pearl, a technique that flourished in the later seventeenth and early eighteenth centuries, are numerous. Like the other subjects portrayed in this medium, they utilize the shell inlay for garments, architectural details, and other inanimate areas of the composition while the faces and limbs in particular are finely delineated in oil paint.

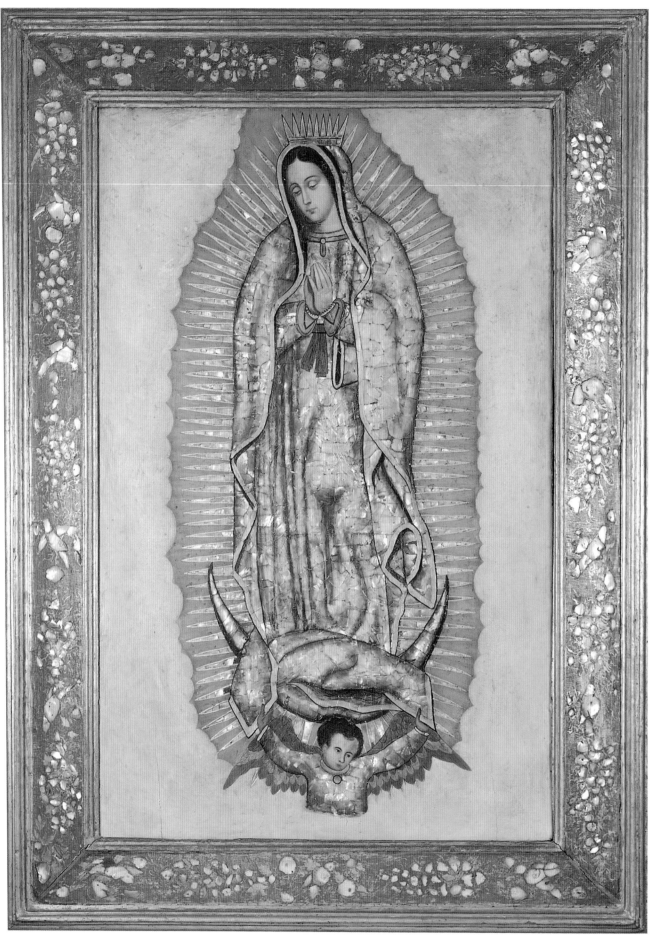

149

Quantities of such images, clearly produced for export, found their way to Spain, prompting some to question their Mexican origin. But they are obviously a quintessentially Mexican subject in a quintessentially Mexican medium. Export models of the Guadalupana were usually far smaller and, while often quite fine, have not the magisterial quality of the present version. This is a particularly austere example that, in its monochrome tonality (except for the angel's wings which incorporate the colors of the Mexican flag), stands apart from the numerous more highly colored versions; it may have been made for one of the innumerable altars throughout Mexico dedicated to the Guadalupe cult.

The origins of this cult are not completely clear. The first mention of the apparitions, as well as the date of 1531, does not appear until 1648, more than a century later, when the cult began to be adopted by the Creole elite. But by 1555, when the basilica was founded in Tepeyac by Archbishop Montúfar, Zumárraga's successor, there was already a considerable devotion. In 1556 the Franciscan Bustamente denounced the cult "to which they have given the title of Guadalupe"; his sermon indicates that the cult was then perceived to have specific associations with Indian worship and had become a point of contention between regular and secular clergy. Soon after the arrival of the Jesuits in 1571, however, this order began enthusiastically to promote its devotion. In any case, the appeal of the Mexican Guadalupana spread quickly from Indians to Creoles and the cult was soon identified with *criollismo* and pride in the new motherland. This apparition to an Indian on native soil signified not only an honor done to Mexico but the salvation of the New World.

Popular fervor carried the Virgin's image to every corner of the country. Her sanctuary became the goal of numberless pilgrimages and her patronage was invoked by those who sought to govern Mexico from the sixteenth-century viceroys to the troops of the Independence movement who marched beneath a banner emblazoned with her likeness. She survived the transition to Independence, the disestablishment of the Church, and the Revolution. To this day her veneration is undiminished and she continues as a symbol of the Mexican nation.

JH

REFERENCES
Album conmemorativo de las apariciones de Nuestra Señora de Guadalupe. Mexico, 1981, pp. 138–39, fig. 49. **Marta Dujovne.** *Las pinturas con incrustaciones de nácar.* Mexico, 1984, p. 58. **Centro Cultural de Arte Contemporáneo.** *Imagenes guadalupanas: cuatro siglos,* exh. cat. Mexico, 1987–88, p. 81, fig. 53.

150 ◀ **Miguel Gonzáles**
Mexican, 1664–d. after 1698

Allegories of the Apostles' Creed:
a. St. Peter; b. St. Jude Thaddeus

Oil and mother-of-pearl laid down on gesso over linen(?) and wood; original frames constructed in same technique; unframed 62 x 82 cm. (24⅜ x 32¼ in.), framed 85 x 105.5 cm. (33½ x 41½ in.)
a. Inscribed in cartouche: San Pedro/Creo en DIOS/ PADRE/todopoderoso/Criador del cielo/y de la tierra; signed: Miguel Gonzales
b. Inscribed in cartouche: Sn/Judas tadeo/ la Resureccion/De la Carne
Collection Banco Nacional de México, Mexico City

These works are two of a series, which originally comprised twelve panels, illustrating the Apostles' Creed; they are believed to have come from the Church of Santa Isabel Tola, near the Villa de Guadalupe. These panels follow the tradition that attributed various articles of faith to the individual followers of Christ. The phrase attributed to St. Peter, "I believe in God the Father the Almighty, Creator of Heaven and earth," is embodied in the first in the series. It depicts the Creator dancing in the air with a flock of birds while a diverse school of sea creatures recedes into the distance of the ocean and a variety of fauna covers the earth. In the background, behind an elephant and a unicorn God reappears for the creation of Eve from the rib of the sleeping Adam.

The other panel shown here is the eleventh and corresponds to the line attributed to St. Jude Thaddeus: the "resurrection of the flesh." Among those

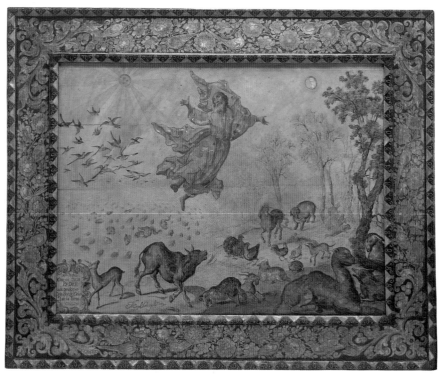

150a

present here, although comparatively small and toward the background, are Christ, Mary, and John the Baptist; the Four Evangelists with their symbols are larger, while trumpeting angels, the most prominent of all, signal the moment.

The inlaying of mother-of-pearl in lacquer was introduced to Mexico from the Far East via the Philippines, where it had been used to decorate furniture that was exported to (and emulated in) Mexico as well as Peru. But in New Spain Mexican artists also adapted the technique to produce images in the European style, combining it with pre-Hispanic lacquer methods and oil painting. Although the Mexican origin of this genre was once questioned (in part because so many examples had so quickly reached Spain), evidence recently discovered by Guillermo Tovar de Teresa[1] substantiates their New World birth and their specific role in the export trade. Miguel Gonzáles, who signed four of the series, was one of the most accomplished of the artists working in this essentially Mexican genre.

The Mexican character of these *enconchados* also emerges again and again in their subject matter. Certain recurrent themes display evidence of the growing Creole national consciousness: among the most frequently depicted are the Virgin of Guadalupe and episodes of the Conquest based on the narrative of Bernal Díaz del Castillo. These imaginative reconstructions of the triumph of Cortés all dwell with greater or lesser degrees of archaeological fantasy on the grandeur of the Aztec empire and express the Creoles' wish to appropriate this noble ancestry for themselves.

The artists who worked in this medium may very well have drawn upon specific graphic models for inspiration. One set of the complete Apostles' Creed was engraved by Daniel Hopfer (about 1470–1536) and others followed. The image of God the Father also closely relates to Salvador de Ocampo's portrayal of the Creation, itself almost certainly modeled on a print. However, while the Resurrection of the Dead, with the figures of the dead rising from

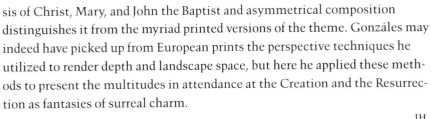

150b

their slitlike graves, recalls numerous widely circulated images, its deemphasis of Christ, Mary, and John the Baptist and asymmetrical composition distinguishes it from the myriad printed versions of the theme. Gonzáles may indeed have picked up from European prints the perspective techniques he utilized to render depth and landscape space, but here he applied these methods to present the multitudes in attendance at the Creation and the Resurrection as fantasies of surreal charm.

JH

1. Guillermo Tovar de Teresa, "Documentos sobre 'enconchados' y la familia mexicana de los Gonzáles [sic]," *Cuadernos de arte colonial* no. 1 (1986), pp. 97–103. Tovar's documents give evidence of Miguel Gonzáles's nationality and date of birth and show that the family workshop contracted lacquer and inlay for a factor, suggesting that they constituted a sort of Mexican export ware.

REFERENCES
Manuel Toussaint. "Las pinturas con incrustaciones de concha nácar en Nueva España." *Anales del Instituto de Investigaciones Estéticas* 5, no. 20 (1952), pp. 14–20. **Marta Dujovne.** *Las pinturas con incrustaciones de nácar.* Instituto de Investigaciones Estéticas, Monografías de arte 8. Mexico, 1984, pp. 28–50. **María Concepción García Sáiz.** "Bedeutung und Entwicklung der 'Perlmutt–bilder' in der mexicanischen Malerei im 17. Jahrhundert." In *Gold und Macht: Spanien in der Neuen Welt,* exh. cat., Künstlerhaus, Vienna, 1987, pp. 167–173.

151 〉 Attributed to Juan de Miranda

Mexican, active about 1680–d. after 1714

Sor Juana Inés de la Cruz

Oil on canvas; height 187 cm. (73⅝ in.)
Inscribed: Miranda fecit
Dirección General del Patrimonio–Universidad
Nacional Autónoma de México, Mexico City

Juan de Miranda was one of five painters bearing this family name in the late seventeenth and eighteenth centuries. He is known to have worked at the viceregal court by 1694 and served as an appraiser of paintings at several points between 1697 and 1711. Little more is known of his biography. Two other painters, both named José de Miranda, were active in the period 1692–1767. Toussaint assumes them to be father and son, but their relationship to Juan de Miranda is not known.

Sor Juana Inés de la Cruz was born Juana Inés Ramírez de Asbaje in the village of San Miguel Nepantla on December 2, 1648, the illegitimate daughter of Isabel Ramírez and one Pedro Manuel de Asbaje, whom Sor Juana de-

scribed as a Basque. She was raised in her mother's family in Nepantla and Panoayán and educated in part by her maternal grandfather, Pedro Ramírez, who had assembled a modest library. After her grandfather's death in 1656, Juana moved to Mexico City to live with an aunt. Something of a child prodigy, she developed into a bright, attractive adolescent and in 1664 was taken into the household of the new vicereine of Mexico, the marquesa de Mancera. Under the vicereine's protection, Juana gained entrance into the best intellectual circles of the capital and became celebrated for her wide learning, keen intelligence, musical skills, and vivid personality. Disinclined to marriage and aware of her precarious social situation, she decided, like many other young Creole women of her era, to become a nun. Initially choosing the strict Carmelite order, she changed her mind and, after a brief return to the viceregal palace, entered the Jeronymite Convent of Santa Paula, her dowry having been provided by a pious aristocrat. Juana took her vows as Sor Juana Inés de la Cruz in 1669.

One of the most remarkable aspects of Mexican society in the late seventeenth and eighteenth centuries was the development of what can only be called a feminist culture in many urban orders of nuns. In contrast to the relatively uniform austerity of Spanish institutions, Mexican convents offered a wide variety of experiences to women seeking an alternative to the traditional roles of wife and mother, as well as to those with a more traditional religious calling. In the most liberal establishments, privileged nuns lived a life of comfort, complete with servants, at the head of semi-independent households lodged in extensive suites of rooms—almost like modern duplex apartments—separated from the areas held in common. Young women (in addition to those preparing to join the order) would come to live in convent boarding schools or even in the apartments of the senior nuns, who would in turn supervise their moral, spiritual, and intellectual training, offering an education otherwise denied in a male-dominated society. A number of the women, such as Sor Juana Inés and Madre María Ana Agueda de San Ignacio (1695–1756), also became literary figures, maintaining personal libraries and publishing influential works. Needless to say, this unusual situation often shocked the more conservative bishops and other clergy sent to Mexico from Spain, who attempted to limit what they saw as the excesses of Mexican convent life and reestablish the more restrictive norms of the Spanish cloisters. The efficacy with which the Mexican nuns resisted such pressures is but one aspect of an intriguing chapter in women's history.

During the first twenty years after her profession Sor Juana participated in the liturgical, educational, theatrical, and musical activities of the convent; maintained a separate household, including at least one slave, within the convent enclosure; and protected and educated her two younger half-sisters as well as three nieces who subsequently took vows in the order. She was twice elected bursar (bookkeeper and business agent) of the convent; hosted regular intellectual and cultural gatherings in her quarters; and wrote the many poems, theatrical pieces, allegorical programs, and popular divertissements that have earned her an important place in Spanish letters. Of her literary works the most famous is the *First Dream*, a long religious poem of about 1685–90 showing the influence of Góngora, Calderón, and Jesuit theology. She was particularly close to Doña María Luisa Manrique de Lara, condesa de Paredes, vicereine from 1680 to 1688; it was Doña María who on her return to Spain arranged for the first publication of Sor Juana's works.[1]

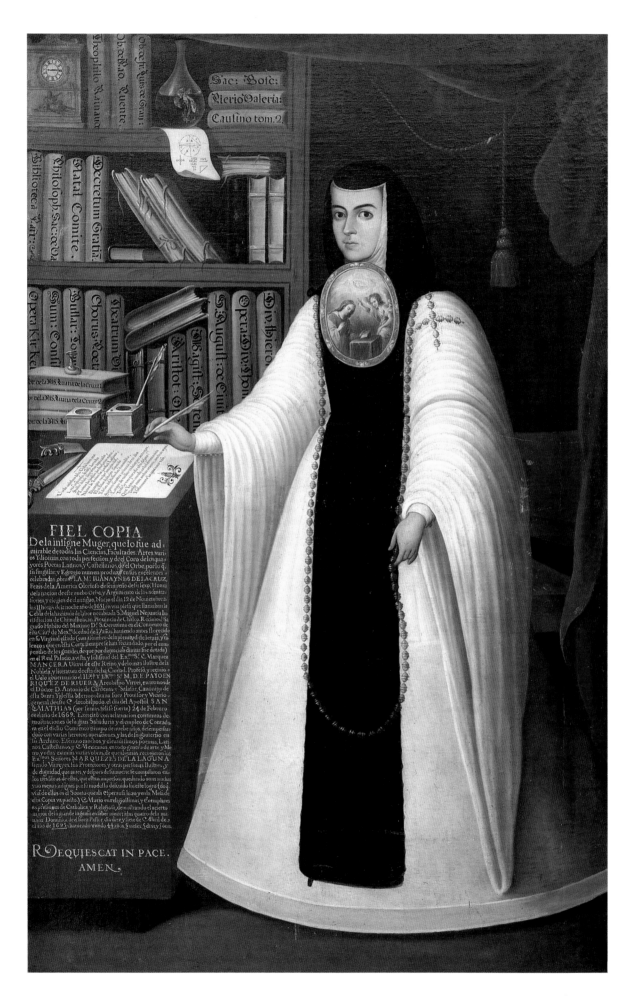

FIEL COPIA

De la insigne Muger, que lo fue admirable de todas las Ciencias, Facultades, Artes, varios Ydiomas, con toda perfeccion, y del Coro de los mayores Poetas Latinos, y Castellanos, de el Orbe, por lo q. su singular, y Egregio numen produxo en sus excelentes, celebradas obras. LA M. IUANA YNES DE LA CRUZ, Fenis de la America. Glorioso desempeño de su sexo, Honra de la nacion deste nuebo Orbe, y Argumento de las admiraciones, y elogios de el antiguo. Nacio el dia 12 de Noviembre à las 11 horas de la noche año de 1651 en una piesa que llamaban la Celda de la hazienda de labor nombrada S. Miguel Nepantla Iurisdiccion de Chimalhuacan, Provincia de Chalco. Recivio el Sagrado Habito del Maximo D. S. Geronimo en el Convento de esta Ciu.d de Mex.co de edad de 17 años, haviendo antes florecido en su Virginal estado (con asombro de su plenitud de letras, y talentos, que en esta Corte siempre se han secundado, por el compendio de los grandes, de que por dignacion divina fue dotada) en el R.al Palacio, à vista, y solicitud del Ex.mo S.or Marquez MANCERA Virrei de este Reino, y de los mas ilustre de la Nobleza, y literatura deesta dicha Ciudad. Profeso, y recivio à el Uelo gouernando el Ill.mo y Ex.mo S.or M. D. F. PAYO ENRIQUEZ DE RIUERA Arçobispo Virrei, en manos de el Doctor D. Antonio de Cardenas y Salazar, Canonigo de esta Santa Yglesia Metropolitana Iuez Provisor, y Vicario general deste S. Arçobispado, el dia del Apostol SAN MATHIAS (por sumas felis suerte) 24 de Febrero de el año de 1669. Ezercitò con aclamacion continua de admiraciones de la gran Sabiduria, y el empleo de Contadora en el dicho Convento tiempo de nuebe años, desempeñandolo con varias heroicas operaciones, y las de su gouierno en su Archivo. Escriuio muchos, y clarissimos poemas, Latinos, Castellanos y Mexicanos, en todo genero de arte, y Metro, y otras eximias varias obras, de que algunas recoxieron los Ex.mos Señores MARQUEZES DE LA LAGUNA siendo Virreyes, sus Protectores, y otras personas Ilustres, y de dignidad, que antes, y despues de su muerte se compilaron en los tres libros de ellas, que estan impresos, quedando otras muchas y no menos insignes por el modelo del cuidado sin el le logrò (de q. virtud de ellas es el Soneto que ala obisperatù hizo y en la Mesa de esta Copia va puesto.) O Murio en religiosissimas, y exemplares expresiones de Catholica, y Religiosa, demostrando el acierto mayor de su grande ingenio en saber morir à las quatro de la mañana Dominica del buen Pastor dia diez y siete de C.Abril de el año de 1695; haviendo viuido 44 años, 5 meses, 5 dias, y 5 oras.

R EQUIESCAT IN PACE.
AMEN.

In 1690 Sor Juana became embroiled in an ecclesiastical dispute between the bishop of Puebla, Manuel Fernández de Santa Cruz, and the archbishop of Mexico City, Francisco de Aguiar y Seijas. To the Spanish male hierarchy of the Church, Sor Juana's literary career seemed at best highly suspect. Subjected to intense theological and pastoral criticism, including pressure from her confessor and mentor, the Jesuit Antonio Núñez de Miranda, Sor Juana at first defended her rights as a Christian female intellectual (*Reply to Sor Filotea*, 1691), but eventually yielded, laying aside her literary and intellectual pursuits and giving up her library and other possessions to be sold in 1694. She died in April 1695 while attending the sick during an epidemic in her convent.

Miranda has depicted Sor Juana standing at a writing desk in her library, dressed in the habit of the Jeronymite nuns of Mexico City. The *escudo* (a framed vellum painting), which she wears around her neck, is found as part of nuns' liturgical attire in several Mexican orders; examples are known from the early seventeenth century (see cat. no. 135). Next to the sheet on which she writes are three volumes of her own works; the labels on the spines of the books identify volumes to which Sor Juana refers, or upon which she relies for information, in her written works. Among the authors represented are the mythographers Natale Conte, Vicenzo Cartari, Baltasar de Vitoria, and Pierio Valeriano; the Church Fathers Sts. Augustine, Jerome, and Thomas Aquinas; the Jesuit theologians Athanasius Kircher and Luis de la Puente; and the philosopher Aristotle. The word *copía* in the inscription should be read as "portrait," not "copy."[2]

Upon her decision to enter the order permanently—that is, after the completion of her novitiate—a young nun was often portrayed in her new habit as a memento for her family, who might have only the most restricted access to her in the future, especially if the order involved was closely cloistered or otherwise very conservative in its rule. Typically, but by no means universally, the nun would be shown crowned with flowers and holding the candles and other accoutrements of the ceremony of her profession; these portraits became known as *monjas coronadas*, or "crowned nuns" (see cat. no. 153). (To judge from posthumous portraits of the later eighteenth and early nineteenth century, these floral crowns appear to have been preserved and reused at the time of the nun's death and interment.) In other cases, however, convent portraits are content to show the young nun in a straightforward manner, engaged in her calling as a bride of Christ. As a group these portraits have a remarkable beauty and a certain poignancy; among them are several of the finest examples of Mexican portraiture in any format. Miranda's portrait of Sor Juana, however, is of another type altogether, reminiscent more of the portraits of male prelates and literary figures than of the *monjas coronadas*.

The sitter's own attitude toward her painted likeness is recorded in a sonnet, in which Sor Juana exposes the vanity of earthly representations:

> This that you gaze on, colorful deceit,
> that so immodestly displays art's favors,
> with its fallacious arguments of colors
> is to the senses cunning counterfeit;
> this on which kindness practiced to delete
> from cruel years accumulated horrors,
> constraining time to mitigate its rigors,
> and thus oblivion and age defeat,
> is but an artifice, a sop to vanity,

is but a flower by the breezes bowed,
is but a ploy to counter destiny,
 is but a foolish labor, ill-employed,
is but a fancy, and, as all may see,
is but cadaver, ashes, shadow, void.[3]

According to González Obregón, the Miranda portrait was first recorded in the collection of the Jeronymite nuns of Mexico City in 1894, at which time it was said to have borne a second inscription recording its presentation to the bursar's office of the Jeronymite convent in the year 1713 by Sor María Gertrudis de San Eustaquio, Sor Juana's "spiritual daughter." By 1940 the work had passed into a Mexican private collection, whence it came to the university, the alleged second inscription having unfortunately been lost. The provenance of the work, as well as the extant inscription, argues for a direct descent from the painter if not from the sitter herself.

There is no reason to doubt that the present portrait represents, or at least copies, an image taken from life. However, a different image of Sor Juana, a bust-length oval in the Philadelphia Museum of Art, bears an inscription declaring it a copy after "another made by herself." Although one can neither confirm nor refute the Philadelphia assertion, it has been taken to imply that all images of Sor Juana derive from a putative self-portrait. There is no basis to this assumption, especially since the differing treatment of details such as the sleeves of the habit indicates that there was more than one image of the nun in circulation during her lifetime.

In fact, at least five other early portraits of Sor Juana are known: the engraving by Lucas de Valdés published to accompany the 1692 Seville edition of Sor Juana's works;[4] a related bust portrait in the Convent of Santa Paula and San Gerónimo, Seville;[5] the half-length portrait in the Philadelphia Museum of Art;[6] the full-length seated posthumous portrait now at Chapultepec, made by Miguel Cabrera in 1750, the head and shoulders of which have much in common with the Philadelphia work; and a half-length portrait of dubious resemblance by Clemente Puche after Joseph Caldevilla, engraved for the frontispiece of Diego Calleja's biography of 1700.[7] If we add the Miranda portrait and remove the Puche-Caldevilla engraving from consideration, these works yield at least three formulations contemporary to the sitter. As Paz points out, the Valdés engraving must have been taken from a portrait of about 1680–88 brought back to Spain by the condesa de Paredes; he also dates the Miranda portrait to those years, in which Sor Juana, through her patroness, would most easily have been in contact with the painter. We thus have two versions documentable to Sor Juana's circle (the Valdés/Seville and Miranda portraits) and a third formulation represented by the Philadelphia and Cabrera versions, which seem to have used a common source, the alleged self-portrait.

Finally, a word of caution should be expressed about the attribution of the present work. It is inscribed "Miranda fecit," and this has traditionally been taken to refer to the painter Juan de Miranda, whose career and connections at the viceregal court in the period 1694–1714 make him the likeliest candidate for authorship of the work, especially if the now-lost inscription indicating a terminus ante quem of 1713 is taken into account.[8] However, if one accepts Paz's argument that the work should be dated to 1680–88, at least six years before our first notice of Juan de Miranda, one must also accept the possibility that another artist, such as the elder José de Miranda, is the "Miranda" indicated on the inscription.

MB

1. Sor Juana Inés de la Cruz, editions of 1689, 1691, 1701, etc., modern editions of 1873, 1929 (edited by M. Toussaint), and the critical edition of *Obras completas*, vol. 1, *Lírica personal*, vol. 2, *Villancicos y letras sacras*, vol. 3, *Autos y loas*, edited by Alfonso Méndez Plancarte, and vol. 4, *Comedias, sainetes y prosa*, edited by Alberto G. Salceda (Mexico, 1951–1957). English translations of selected poems by Margaret Sayers Peden, *Sor Juana Inés de la Cruz: Poems* (Binghamton, N.Y., 1985), and by Alan S. Trueblood, *A Sor Juana Anthology*, with a foreword by Octavio Paz (Cambridge, Mass., and London, 1988).
2. Octavio Paz, *Sor Juana or, the Traps of Faith*, translated by Margaret Sayers Peden (Cambridge, Mass., 1988), p. 236.
3. Margaret Sayers Peden, trans., *Sor Juana Inés de la Cruz: Poems* (Binghamton, N.Y., 1985), p. 51.
4. Paz, *Sor Juana*, p. 238.
5. Elsa Berisso. *Estampas de la vida de Sor Juana Inés de la Cruz*, (Mexico, 1970), n.p.
6. Linda Bantel, "Copy after a Self-Portrait by Sister Juana Inés de la Cruz (1651–1695)," in Linda Bantel and Marcus B. Burke, *Spain and New Spain: Mexican Colonial Arts in Their European Context*, exh. cat., Art Museum of South Texas (Corpus Christi, Texas, 1979), no. 36, pp. 112–14.
7. Francisco de la Maza, ed., *Sor Juana Inés de la Cruz ante la historia (Biografías antiguas. La 'Fama' de 1700. Noticias de 1667 a 1892)*. Revised by Elías Trabulse (Mexico, 1980) pp. 137–39, fig. 5.
8. Francisco de la Maza, "Primer retrato de sor Juana," *Historia Mexicana* 2, no. 1 (1952), pp. 1–22.

REFERENCES

Luis González Obregón. *México Viejo, 1521–1821*. Mexico, 1900, pp. 257–72. **Josefina Muriel de la Torre**. *Conventos de monjas en la Nueva España*. Mexico, 1946. **Francisco de la Maza**. "Un retrato de Sor Juana." **Boletín del Instituto de Antropología e Historia** 25 (September 1966), p. 29, color pl. facing p. 30. **Josefina Muriel de la Torre**. *Cultura femenina novohispana*. Serie de historia novohispana 30. Mexico, 1982. **Manuel Toussaint**. *Pintura colonial en México*. 2d ed., edited by Xavier Moyssén. Mexico, 1982, pp. 144–45, 263, n. 18 (X. Moyssén). **Electa Arenal and Stacey Schlau**. *Untold Sisters: Hispanic Nuns in Their Own Works*. Translations by Amanda Powell. Albuquerque, New Mexico, 1989, pp. 341–43.

Eighteenth-Century Mexico: Tradition and Transformation (1715–1785)

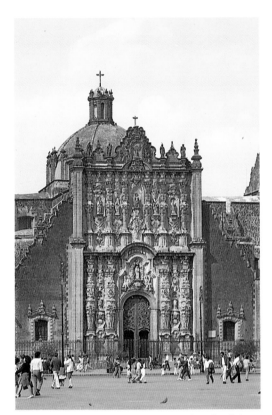

Estípites and niche pilasters, 1749, facade of the Sagrario Metropolitano, Mexico City. Photo: G. Aldana

Pl. 11 from Wendel Dietterlin's *Architectura*, showing the inverted pyramid form of *estípites*

The Liberation of Viceregal Architecture and Design

JOHANNA HECHT

The dawn of the eighteenth century was marked by the collapse of the Hapsburg monarchy in the Iberian Peninsula and the accession of a branch of the French Bourbon dynasty to the throne of Spain.[1] The social, economic, and artistic repercussions of this political event would eventually sound throughout the empire. Among the most notable of the artistic changes in New Spain to follow the dynastic shift was the construction of the Altar of the Kings in the apse of the Mexico City Cathedral (1718–37). This event signaled the start of a new era in Mexican colonial architecture that many consider the most brilliant flowering of the Andalusian retablo style.

The Altar of the Kings represented an iconographical type that followed a particularly American tradition, with precedents in Puebla and South America but not Spain.[2] It was, however, the work of a Peninsular, Gerónimo Balbás, who arrived from Madrid in 1718. In the Mexican chapel Balbás emulated his earlier architectural design for the high altar of the Sagrario of the Seville Cathedral (1702–1705) in which he had emphasized a neo-Mannerist form of support known in Spanish as the *estípite*. This element, also known in France as a *gaine* or *terme*, had had a distinguished life in seventeenth-century northern Europe, where it served as a support for sculpture and as a popular leg form in furniture of the era. The particular version employed by Balbás, with its chunky, blocklike interruptions of the shaft, had been widely disseminated in the mid-seventeenth century in the engravings of the German designer Wendel Dietterlin.[3]

When Balbás arrived in Mexico, the *estípite* was not unknown; it had appeared in Spanish editions of Serlio and had been carved on the altar of Xochimilco in 1605. Nonetheless, the introduction of the *estípite* as a dominant architectural element met with serious resistance from Mexican designers, especially when attempts were made to use it in an exterior format.[4] It was not until 1749 that another Peninsular, Lorenzo Rodríguez, succeeded in introducing the *estípite* to a facade, on the Sagrario Metropolitano adjoining the Mexico City Cathedral.

The *estípite* did more than replace the Solomonic spiral as the sign of advanced taste. Although it was no more difficult to carve than the most elaborate Solomonic columns, Balbás's design innovations, which included the presentation of the *estípite* as a colossal order and the elimination of the traditional niche for paintings and sculptures, introduced a new complexity that had nothing to do with difficulty of carving. It involved the more fundamental restructuring of the retablo itself, the essential design

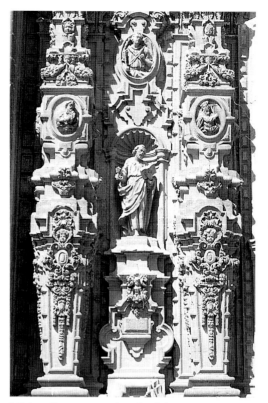

Niche pilaster, 1749, facade of the Sagrario
Metropolitano, Mexico City

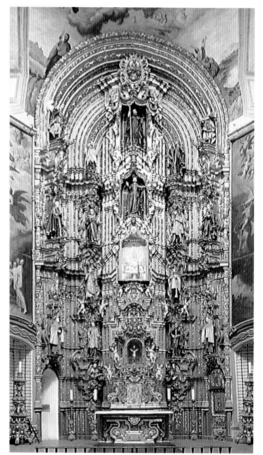

Anastilo-style retablo, Church of La Ensenanza,
Mexico City

of which had for one hundred fifty years followed the modular compartmentalization of the Spanish Renaissance prototype. After Balbás the reticular web of the Mexican retablo was abandoned.

Once the Mexican *retablista*'s initial resistance was overcome, the *estípite* and all that went with it were embraced with an enthusiasm it would never know in Spain. Despite the motif's immediate origins in northern Europe and France, its architectural application was viewed as an assertion of Spanish national style in the face of Bourbon classicism. It may not be farfetched to interpret the *estípite*'s unrivaled success in Mexico as an assertion of *criollo* nationalism. Mexico could now see itself as assuming the mantle of Spanish legitimacy and could justifiably assert that it was more Spanish than Spain itself.

The Mexican version of the *estípite* style was developed by Rodríguez; by Balbás's adopted son Isidoro Vicente, who worked at Taxco; by Higinio de Chavez, who with the painter Miguel Cabrera was responsible for the interior of Tepotzotlán; and by Ildefonso Iniesta Bejarano, credited with the exterior of Tepotzotlán. It was disseminated in the north by Felipe Ureña and his followers, who gave it a particularly distinctive character that varied significantly from Balbás's freestanding pillars and deep apsidal form. In their hands the *estípite*'s already limited architectural vigor dissolves.

This disintegration of structural function was effected in a variety of ways: by the scooping out of niches for sculpture in the columns themselves; by the dizzying duplication of profiles; and by the enlargement and enrichment of the interstitial form called the ornamental niche-pilaster. Popular in eighteenth-century Andalusia, the ornamental niche-pilaster was a vertical decorative element that had come to serve as an infill between and subordinate to the architectonic pilasters. Its expansion finally led to the demise of even those vestigial notions of Classical architecture embodied in its parent style.[5] This development became a new phase altogether, the atectonic style called *anastilo*. In this next stage of the Mexican retablo, all pretense of structural integrity was suppressed in favor of this planar, often sinuous wall decoration. Glorified and finally independent, it achieved its Mexican—and some would claim universal— apotheosis in the Bajío region around Querétaro, the mineral-rich area that would eventually become known as the cradle of Independence.

The Querétaro style is essentially Rococo. Although Bourbon classicism had been rejected in the early part of the eighteenth century, versions of the fashionable Louis XV style, "legitimized" by such non-French interpreters as Thomas Chippendale, were eagerly accepted by the Mexican elite. New styles in furniture and clothing appeared, especially after the loosening of trade restrictions in 1765. A passion for planar textile ornament, always evident in wood sculpture, expanded to painted portraits (see cat. no. 196), pottery (see cat. no. 228), and the retablo as well. The altars, decorated with carved drapery, which were introduced with the *estípite*, were augmented with a conglomeration of contrasting flat textures and painted floral patterns imitating cloth.

Less and less a framework for paintings and sculpture, more and more an end in itself, the retablo and the retablo facade took on the form of a

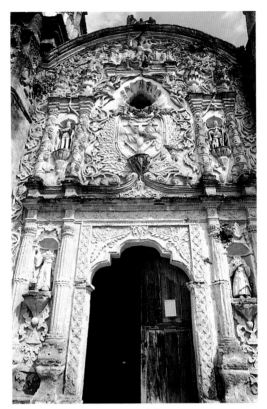

Argamasa facade, church of the Franciscan convent, Conca, Queretaro. Photo: G. Aldana

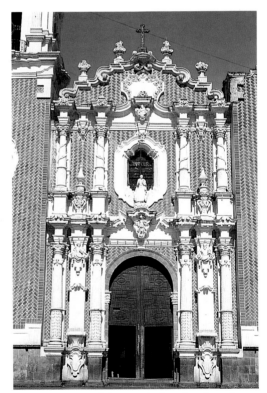

Neostilo facade of the parish church, Tlaxcala

riotous framework. In effect it served as one of the few arenas in which free and flexible artistic development, independent of theological concern, could occur. This inventiveness is exhibited most strikingly, perhaps, in rural churches or in urban centers of the far north, such as Durango, Chihuahua, and Zacatecas. Especially on the exteriors of these buildings local craftsmen achieved new levels of variety and originality. Pulling motifs from an anachronistic grab bag, combining wildly unorthodox versions of Solomonic, Doric, and *estípite* columns with a broad range of other design elements, these often anonymous artists produced some of the glories of Mexican colonial art.

Such rural facades were usually executed in whatever building medium was preferred locally; as a result they provide a catalogue of distinctive regional chromatic variations as well as popular versions of metropolitan and local motifs. Some of the freest of these eclectic designs were created in the stuccolike technique of *argamasa*, whose aesthetic derived from the *yeserías* developed in seventeenth-century Puebla. Carpeting the facades of rural parish churches, *argamasa* flourished throughout the eighteenth century, not only in the Puebla region but also in the Sierra Gorda northeast of Mexico City.[6] Both *yeserías* and *argamasas* provided a good surface for the application of color, a taste Pueblan architects further satisfied through the lavish use of glazed ceramic tiles on building exteriors, where they covered not only domes and cupolas but entire elaborately modeled facades as well.

The formal version of this eclecticism corresponds to a peculiarly Mexican version of the Enlightenment's interest in classification, although more as an inventory of motifs than as the pseudo-taxonomy displayed in the paintings of the *castas* (see cat. nos. 197 and 198), and it appears not only in rural hamlets but also in such lavish high-style buildings as the spectacular Santa Prisca in Taxco. The distinctively Mexican Classical Revival style called *neostilo*, which involved a return of interest in the orthodox use of the column, also displays the same sort of disordered mélange, combining classical orders with Solomonic columns and various mixtilinear motifs. It is exemplified in the architecture of Francisco Antonio Guerrero y Torres.

The *neostilo* style may be seen as an indication that Mexico was mentally prepared for the arrival of the somewhat more conventional "rococo" Neoclassicism brought to her shores by the Spaniards Jerónimo Antonio Gil, Rafael Jimeno y Planes, and Manuel Tolsá (see cat. nos. 238 and 239). The Academy of San Carlos, which Gil established in 1781, is often viewed as an imposition from beyond the sea, but in fact it was widely accepted by many Mexicans; José Luis Rodríguez Alconedo, a martyr of the Independence movement, displayed the very same Neoclassical taste in both his medal of Charles IV (see cat. no. 237) and his own self-portrait.

The critique by Francisco Eduardo Tresguerras, the Mexican avatar of Neoclassical style, of the "bad taste"[7] of his country's architectural excess was part of an international reaction, not confined to Mexico, Spain, or any other individual country. Neoclassicism was the style of the new United States and England, of Louis XVI and Napoleon, and it spread in Mexico like a contagion, wiping out much of its most distinctive heri-

tage. One may perhaps interpret the adoption of Neoclassicism as a sign of Mexico's maturity and its desire to take a place among modern nations. Yet in its rejection of its own past one may wonder whether Mexico was not denying much that was at the heart of a true national style.

NOTES

1. This essay owes much to the unpublished work of Juana Gutiérrez Haces.
2. Rogelio Ruíz Gomar, "Capilla de los Reyes," in *Catedral de México: patrimonio artístico y cultural* (Mexico, 1986) pp. 16–43.
3. Joseph A. Baird, "Eighteenth Century Retables of the Bajío, Mexico: The Querétaro Style," *Art Bulletin* 35, no. 3 (1953) pp. 195–216.
4. Ibid., p. 196, fig. 1.
5. Joseph A. Baird, "The Ornamental Niche-Pilaster in the Hispanic World," *Journal of the Society of Architectural Historians* 15, no. 1 (1956) pp. 5–11.
6. Efraín Castro Morales, "Arquitectura de los siglos XVII y XVIII en la región de Puebla, Tlaxcala y Veracruz," in *Historia del arte mexicano*, 2d ed., vol. 6, *Arte colonial, II* (Mexico, 1982) pp. 860–79.
7. In *Varias piezas divertidas . . .*, as cited in Baird, "Eighteenth Century Retables," p. 208.

Painting: The Eighteenth-Century Mexican School

MARCUS BURKE

While Juan Correa the Elder and Cristóbal de Villalpando were developing their versions of a Mexican national style in the late seventeenth century, other artists were pursuing a course more in keeping with their European contemporaries, albeit in a manner now recognizable as a separate national school. By the last third of the seventeenth century, painters throughout Europe had developed what may be called the International Late Baroque, a combination of the classicizing and Baroque styles that earlier had tended to compete with one another. Works from this period typically rely on an underlying geometric design, which is then animated by the play of dynamic brushwork, light, and color. The proto-Rococo elements in this style, as handled in Spain by Murillo and in Italy by Giordano, are matched by classicizing possibilities, as developed (again) by Murillo and in Italy by Maratta and his followers. In Mexico this style is represented in a somewhat naive way by the prolific mestizo priest-painter Nicolás Rodríguez Juárez and on a more sophisticated level by his brother Juan Rodríguez Juárez and their pupil José de Ibarra.[1] The style is clearly European in inspiration, but it nevertheless manifests subtle distinctions typical of the Mexican school, among them a quiet sense of arrested motion, a certain naïveté, distinctive local pigments, distortions of physiognomy, occasional traces of Mannerism, and a sweet yet psychologically observant idealism. It was this style that guided the works of Miguel Cabrera and his followers at midcentury and, increasingly idealized by the next generation, paved the way for the establishment of the Neoclassical style under the Academy of San Carlos. Within this artistic trajectory, however, there was a tendency, even in the oeuvre of a single artist such as Cabrera (cat. nos. 196 and 197), for the Baroque elements to predominate in large allegorical paintings and decorative cycles, while the classicizing aspects were more often emphasized in small devotional works and easel paintings for the altar ensembles that were such a remarkable feature of eighteenth-century Mexican churches.

The financial prosperity of Mexico in the eighteenth century—a phenomenon driven primarily by the dominant financial position that Mexico's silver, now extracted by more cost-effective processes, gave it in the mercantilist economy of the Spanish empire—led to an explosion in church and convent construction. New edifices, extensive additions, and programs of reconstruction or repair were undertaken on an unprecedented scale, creating opportunities for Mexican architects and altar makers to experiment in wildly original ways (see above). The resulting style has often been called Ultra-Baroque or simply the *estípite* style, after its best-known element.

As has been explained, the arrival of this style in the new century coincided with a radical change in the function of monumental religious paintings. Mexican seventeenth-century altarpieces had continued the tradition of Renaissance altar ensembles, which were centered around painted or sculpted images; even in the case of multistoried Baroque altar ensembles, with their pulsating Solomonic columns, the architecture remained a frame for the relatively large paintings or life-size polychrome statues of saints. Furthermore, the few large allegorical decorative commissions completed at the end of the seventeenth century, including those undertaken by Correa and Villalpando, were often located in the sacristies of buildings, such as the cathedrals of Mexico City and Puebla; the open geometric forms and expansive wall surfaces of these great rooms functioned as supports for what were still essentially independent two-dimensional ensembles.

In the early eighteenth century, however, the situation was completely transformed. Monumental allegorical pictures composed a significant portion of artists' efforts for both religious and secular patron groups, the latter responding to French as well as Spanish and Mexican precedents. In contrast, large painted altarpieces began to fade from the artistic scene. The new *estípite* altar ensembles of eighteenth-century church interiors, to the extent that they incorporated paintings at all, seemed to call for a new kind of picture.[2] Perhaps because of this new function, the works of Ibarra, Cabrera, Francisco Antonio Vallejo, José de Alcíbar, and other eighteenth-century masters, for all their Baroque (or Rococo) energy, almost always retained a classical underlying design, as if the artists were emphasizing the idealizing aspects of their compositions in order to make them islands of narrative or devotional calm amid the stormy seas of niche-pilasters and gold leaf.

Three additional aspects of eighteenth-century Mexican painting deserve mention at this point: the influence of the Sevillian painter Bartolomé Esteban Murillo (1617–1682); the role at midcentury of the Mexican mestizo painter Miguel Cabrera (1695–1768); and the increasing importance of secular subjects, especially portraiture. Although it is unclear whether authentic works by Murillo were exported to Mexico, numerous copies, works by followers, and appropriations of Murillo's compositions by Mexican artists all indicate that the idealization, painterly colorism, and occasional saccharine presentation of subjects by artists from the era of Juan Rodríguez Juárez and Ibarra to that of the Academy of San Carlos may be traced in part to the Sevillian master, whose influence was rapidly

becoming international.[3] Cabrera was certainly aware of Murillo's work, since he occasionally borrowed motifs and even entire compositions.[4] After Ibarra's death in 1756, the Cabrera atelier dominated artistic production, although the great expansion of eighteenth-century building left plenty of commissions for other painters.

Cabrera's portraits, fully au courant with the latest fashions of Madrid and Paris (for comparison, see the works of international Rococo portraitist Jacopo Amigoni), depict a society very much enjoying the tremendous wealth generated in New Spain. Indeed, no matter who the artist, the sumptuous costumes of the marquesas and vicereines of late eighteenth-century Mexico—not to mention the fascinating, hybrid costumes of the genre pictures—leap off the canvas, overwhelming the personalities of the sitters in an affirmation of secular luxury. In certain cases, however, the absence of these distractions allows us to feel more in touch with the personalities of some of the sitters, as with those young women shown professing their vows in the nuns' portraits (including the *monjas coronadas*).

Cabrera practiced another genre of the era: the representation of racial mixtures called *castas* (see cat. nos. 197 and 198). These carefully rendered catalogues of contemporary popular fashions and occupations may also reflect something of the Spanish Enlightenment interest in the classification of the natural world. Here, as in many other eighteenth-century genre types, including scenes gracing such objects of decorative art as screens, Mexican colonial society comes alive in all its wonderful variety.

Cabrera, himself of mixed race, was, like numerous other painters of the time, devoted to such typically Mexican subjects as the image of the Virgin of Guadalupe. On April 30, 1751, he and Ibarra, along with Patricio Morlete Ruíz and Manuel Osorio, were invited to inspect and confirm the miraculous nature of the original image of the Virgin of Guadalupe at the Basilica located at the foot of the hill of Tepeyac, north of Mexico City, site of the original apparitions of the Virgin to Juan Diego in 1531 (see cat. no. 149). On April 15, 1752, Cabrera returned to the Basilica with his followers, José de Alcíbar and José Ventura Amáez, to paint three direct copies of the image, one of which was taken to Rome by the Jesuit Juan Francisco López and presented to Pope Benedict XIV. In 1754 Benedict XIV confirmed the Virgin of Guadalupe as patroness of New Spain and instituted a mass and office to be celebrated on December 12, the date of the second apparition of the Virgin and the creation of the image.[5] In 1756 Cabrera published a pamphlet entitled *Maravilla americana*, which included his pious reactions and those of other artists inspecting the image at midcentury.

The Jesuits had become involved with the cult of the Virgin of Guadalupe in 1572, soon after their establishment in Mexico, when a manuscript of one of the original witnesses of the events of 1531, was brought to the Jesuit library at Tepotzotlán.[6] By the eighteenth century the Jesuits' connection with the cult was so strong, some scholars argue, that the expulsion of the order from the Spanish dominions in 1767 may have been understood as an attack by the Crown on the Mexican national identity—and therefore may have fed Mexican desires for independence.[7] Other scholars suggest that the Jesuit expulsion greatly increased the worldwide

dispersal of the cult, as the image was carried to various parts of the world by the displaced Jesuits.[8] In any event, the inspection of the image by Ibarra, Cabrera, and their contemporaries brings together a number of significant aspects of Mexican eighteenth-century culture: the national cult; the still-vigorous Tridentine model of the pious artist; an Enlightenment appeal to science (here harnessed to the needs of the faith); the role of the Jesuits in colonial society; and the Roman Catholic Church's recognition of the increasing importance of Latin-American Christendom.

NOTES

1. I am indebted to Guillermo Tovar de Teresa for sharing unpublished documentation of Ibarra's relationship with Juan Rodríguez Juárez; see also Virginia Armella de Aspe and Mercedes Meade de Angulo, *Tesoros de la Pinacoteca Virreinal* (Mexico, 1989).

2. The explosion of demand in retablo building between 1680 and 1720 has been documented with regard to guild practices by Guillermo Tovar de Teresa, "Consideraciones sobre retablos, gremios y artíces de la Nueva España en los siglos XVII y XVIII," *Historia Mexicana* 34, no. 1. (1984) pp. 5–40. Tovar notes the tendency of artists to be contractors for whole altar ensembles, in the context of a breakdown of guild-enforced divisions among artistic specialties. This may also have contributed to the new categories of painting in the eighteenth century.

3. Xavier Moyssén, "Murillo en México: la Virgen de Bélen," *Boletín del Instituto de Antropología e Historia* no. 28 (1967) p. 11. Cf. Ellis Waterhouse, "Murillo and Eighteenth-Century Painting Outside Spain," in *Bartolomé Esteban Murillo, 1617–1682*, exh. cat., Royal Academy of Arts, (London, 1982) pp. 70–71.

4. St. Anselm, Mexico City: Pinacoteca Virreinal, following Murillo's St. Isidore and St. Leander (Cathedral Seville,); see Moyssén, "Murillo in Mexico," pp. 11–18, and Marcus B. Burke, "Mexican Colonial Painting in Its European Context," in Linda Bantel and Marcus B. Burke, *Spain and New Spain: Mexican Colonial Arts in Their European Context*, exh. cat., Art Museum of South Texas (Corpus Christi, Texas, 1979) p. 57, n. 69.

5. For an English language summary of the history of the Mexican cult of Guadalupe, see Angel M. Garibay Kintana in *The New Catholic Encyclopedia* (New York, 1967) vol. 6, pp. 821–22.

6. J. García Icazbalceta, *Investigación histórica y documental sobre la aparición de la Virgen de Guadalupe* (Mexico, 1952).

7. Jacques Lafaye, *Quetzalcóatl and Guadalupe: The Formation of Mexican National Consciousness, 1531–1813*, translated by Benjamin Keen (Chicago and London, 1976), pp. 99–136. Lafaye's arguments have by no means been universally accepted by scholars.

8. Garibay Kintana 1967, p. 822.

Decorative Arts and Furniture

DONNA PIERCE

As in Spain, the decorative arts in colonial Mexico followed the trends set by the fine arts in Europe. Decorative motifs were borrowed from the fine arts and applied to the surfaces of furniture, ceramics, metalwork, textiles, and other objects. The tendency to cover surfaces with patterns exhibiting little hierarchy of form was a noticeable trait in the decorative and fine arts of Spain. Space was often filled with a complex pattern using motifs that were either geometric, as in Mudejar or Moorish-inspired art, or Classical, as in Spanish Plateresque art. In the latter, Classical motifs were borrowed from Italian Renaissance art then used in an overall pattern, undifferentiated in size and emphasis.

Surface patterning was also a characteristic of the indigenous art of Mexico and can be seen, for example, in Aztec sculpture, Mixtec manuscripts, and Zapotec ceramics.[1] The representation of native images and iconography was suppressed by the Spanish after the Conquest of Mexico. The need for laborers to create the art and architecture of the early colonial period, however, made it necessary to employ Indians who were only minimally trained in European artistic traditions. The proclivity toward

overall patterning in the art of both cultures provided a common denominator. Since this artistic tradition was nonsymbolic, it was acceptable to the Spanish administrators. Stylistic compatibility in this area may account for the constant resurgence of decorative patterning in Mexican art throughout the colonial period and, in many cases, to the present.

During the colonial era new styles were introduced to Mexico from Europe and, after 1565, from the Orient through the Manila Galleon trade. With these influences the decorative vocabulary changed, but the tendency to fill empty space with a variety of forms using a minimum of accent permeated all styles of Mexican art. Within this artistic amalgam motifs from different styles were often combined. In the sixteenth century Gothic, Renaissance, and Moorish elements, with an occasional indigenous touch, were frequently intermixed. During the Baroque period in Mexico, surfaces were often covered with an exuberant jungle of geometric and floral motifs. Rococo decoration was inspired by a revival of Mannerist elements, including scallops, ovals, and strapwork. When Neoclassicism invaded Mexican art in the late eighteenth century, Classical motifs were frequently multiplied and broken up in ways that would have shocked European purists. In Mexico works of art were not necessarily limited to a single stylistic vocabulary; many combined at least two of these in an elaborate pattern filling the surface of the object. Although intermittently subdued by the introduction of new styles from Europe, the Mexican impulse toward decorative exuberance usually reemerged rather quickly.

The Moorish technique of inlaid designs in wood, bone, shell, and ivory was adopted in Mexico in the sixteenth century. The Hispano-Moresque tradition of covering surfaces with patterns of uniform size and shape was used in Mexico on furniture and boxes into the nineteenth century. These intricate patterns, often lacking a central focal point, created a carpetlike effect over the surfaces of many pieces of Mexican furniture. In the seventeenth and eighteenth centuries European and Oriental styles influenced Mexican furniture, but these were rapidly transformed. The proportions were altered, the curves exaggerated, and the decorative motifs multiplied, giving the furniture a decidedly Mexican character. Lacquer, based on pre-Hispanic and Oriental techniques, was used to decorate the surfaces of furniture, boxes, dishes, and other utilitarian wares. Areas of blank space used in Oriental compositions were often filled with floral patterns.

Although the production of fired pottery was a widespread art in Mexico prior to the Conquest, the technique of glazeware ceramics was introduced from Spain to Mexico in the second half of the sixteenth century. The city of Puebla had an active industry by the end of the century. Although originally inspired by Moorish and Spanish ceramic traditions, Oriental porcelain soon had a profound impact on the ceramic industry of Mexico. The majolica ware produced in Puebla frequently copied the motifs used on Oriental ceramics. The restrained compositional balance between space and form evident on Oriental pieces was soon lost. In its place a more condensed use of space and a standardization in the size and emphasis of forms reflected a stylistic compromise between Hispano-Moresque and Oriental ceramic traditions.

On Mexican silverwork Classical motifs were used in a busy and varied manner during the Plateresque period. In the late sixteenth and early seventeenth centuries the austere Spanish Herreran style influenced silver production but was soon replaced by the lavish Baroque style, characterized by elaborate relief patterns over the surfaces.

The tendency to fill all available space with complex images often reasserted itself in the twentieth century and can be seen in the powerful work of the Mexican muralists as well as in the lush and colorful folk art of the countryside. The syncretism between the Hispano-Moresque inclination toward overall patterning and the indigenous traditions of Mexico, along with some Oriental influence, has produced an artistic concept that is distinctly Mexican.

NOTES
1. For a detailed discussion of the horror vacui in both pre-Hispanic and early colonial art, see Donald Robertson, *Mexican Manuscript Painting of the Early Colonial Period: The Metropolitan School* (New Haven, 1959).

Church and Convent

152 Miguel Cabrera
Mexican, 1695–1768

Madonna and Child with Sts. Francis Borja and John Francis Regis

Oil on canvas; framed, 365 x 295 cm. (143¼ x 116 in.), unframed, 305 x 235 cm. (120⅛ x 92½ in.)
Signed and dated: Mich¹. Cabrera pinx.ᵗ Anni Dñi. 1765
SEDUE, Templo de la Compañía de Jesús, Guanajuato

Miguel Cabrera, a mestizo, was born in 1695. Abandoned at birth, he was raised by a godfather in Oaxaca, where he learned the rudiments of painting; he came to Mexico City in 1719. His style is closely allied with that of José de Ibarra (1688–1756), although Cabrera usually softens the Baroque values in Ibarra's works toward either a Rococo formulation in the large-scale works or a proto-Classical idealism in smaller compositions. Cabrera served as court painter to Archbishop Rubio y Salinas (1749–56) and led the group of Mexican painters who examined the image of the Virgin of Guadalupe in 1751 (see his book, *Maravilla americana*, 1756). In 1753 Cabrera, Ibarra, and other painters tried without success to found an academy in the capital.

Between Ibarra's death in 1756 and Cabrera's own demise in 1768, the Cabrera shop dominated artistic production in Mexico City. Of all the problems of connoisseurship found in Mexican colonial art, the separation of Cabrera from his followers, copyists, imitators, and forgers remains the most intractable and has seriously compromised his reputation.

This large devotional composition is one of a pair or group of pictures that the Society of Jesus (Jesuits) apparently commissioned for their new church at Guanajuato, dedicated November 8, 1765, only seventeenth months before the order was expelled from the Spanish empire on June 25, 1767. The other extant canvas represents Christ with St. Ignatius of Loyola, the founder of the Jesuits, and St. Francis Xavier, the great missionary saint of the order. In the exhibited composition, the Madonna and Christ Child are adored by St. Francis Borja, easily identified by the attribute of a crowned skull held by the putto at bottom center, and St. John Francis Regis, recognizable by his physiognomy and red beard as well as by the attributes of a crucifix and lilies.

Francis Borja, eldest son of the duque de Gandía, was born near Valencia in Spain in 1510. An important member of the court of the Spanish king and Holy Roman Emperor Charles V, Borja was appointed viceroy of Catalonia in 1539; he became duque de Gandía upon his father's death in 1542. Long accustomed to religious devotion, Borja arranged, following his wife's death in

1546, to enter the Society of Jesus, at first secretly. After putting his temporal affairs in order and securing his abdication from the duchy of Gandía, he was ordained priest in 1551 and named Jesuit commissary general for Spain and Portugal in 1554. In 1565 he became the third father general of the order. He was canonized in 1671.

John Francis Regis was born in southern France in 1597. He entered the Jesuit novitiate in 1616 and was ordained, after an extensive education, in 1630. He worked as a teacher and home missionary in the Huguenot-controlled areas of France, ministering to Catholics over a wide area. He died in 1640 and was canonized in 1737.

The choice of St. Francis Borja for a devotional picture in a Mexican Jesuit establishment may be explained by the fact that it was under his generalcy that the Jesuits first began their mission and educational activities in Mexico. Mission work was also the calling of St. John Francis Regis, who seems to have become a prototype for the dedicated Jesuit itinerant priest. His iconography was established in the Hispanic world by a series of six canvases painted for the Jesuit novitiate in Madrid (now the Universidad Autónoma) by Michel-Ange Houasse. Whether St. John's presence in the Guanajuato work refers to Jesuit missions on the northern frontier or to Jesuit work in local parishes is not clear. Perhaps the two extant pictures were part of a larger series that also included images of the scholastic saints Aloysius Gonzaga and Stanislaus Kotska, the other two Jesuits who had been canonized by 1765.

The twelve stars around the Madonna's head are a reference to her Immaculate Conception. The way in which she holds the Christ Child with her veil probably refers to the humeral veil with which the priest holds the monstrance or Eucharistic wafer during certain Catholic rituals. This detail, and the way in which the Christ Child is displayed in both of the Guanajuato canvases, suggests that they may have been intended as altarpieces. Unfortunately contemporary sources are ambiguous about the decoration of the Jesuit complex in Guanajuato, which in any case was dispersed soon after completion, so that the original function of the pictures remains unknown.

Cabrera, faced with the difficult problem of organizing a large composition around two figures dressed in black, has chosen to condense the significant parts of the composition into a triangular region formed by the saints' faces —highlighted to jump into relief above the black cassocks—and that of the Madonna, with the dynamic pose of the Christ Child opposing and enlivening this basic geometry. The colors of the Madonna's clothing and the animated sky further enhance the sense of motion and drama. As in the other extant canvas, where the influence of the Flemish painter Peter Paul Rubens is evident, Cabrera here displays his assimilation of seventeenth-century art, particularly the devotional works of his Sevillian predecessor Bartolomé Murillo.

MB

REFERENCES

[Nicolás Noroña?]. *Rasgo breve de la grandeza Guanajuateña . . . Dedicación del sumptuoso templo de la Sagrada Compañía de Jesús . . .* Guanajuato, 1767. See also the edition of Luis González Obregón, "Introduction," p. xviii. **Abelardo Carrillo y Gariel.** *El pintor Miguel Cabrera.* Mexico, 1966. **Salvador Díaz-Berrio and Victor Manuel Villegas.** *El templo de la Compañía de Jesús en Guanajuato.* Guanajuato, 1969, passim (architectural history and restoration of the church). **Enrique Marco Dorta.** *Arte en América y Filipinas.* Ars Hispaniae: Historia Universal del Arte Hispánico, vol. 21. Madrid, 1973, p. 349. **Theodor Kurrus.** "Franz Régis (Johannes Franz)." In *Lexicon der christlichen Ikonographie,* edited by Engelbert Kirschbaum et al. Vol. 6, edited by Wolfgang Braunfels. Rome and Freiburg, 1974, cols. 321–22. **Santiago Sebastián.** "El pintor Miguel Cabrera y la influencia de Rubens." *Anales del Instituto de Investigaciones Estéticas* no. 43 (1974), pp. 71–73, figs. 1, 2 (Guanajuato work not cited). **J. N. Tylenda.** *Jesuits Saints and Martyrs.* Chicago, 1984, pp. 485–89.

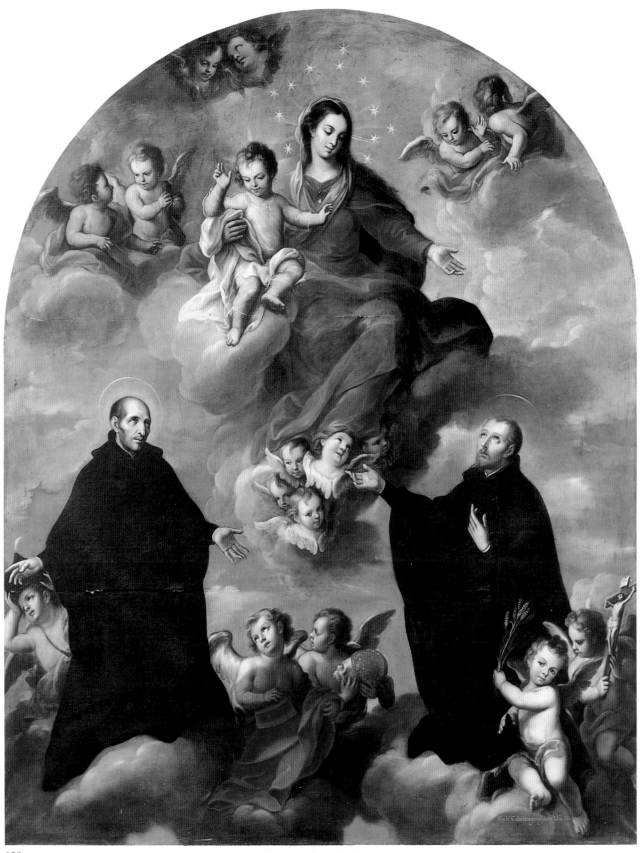

152

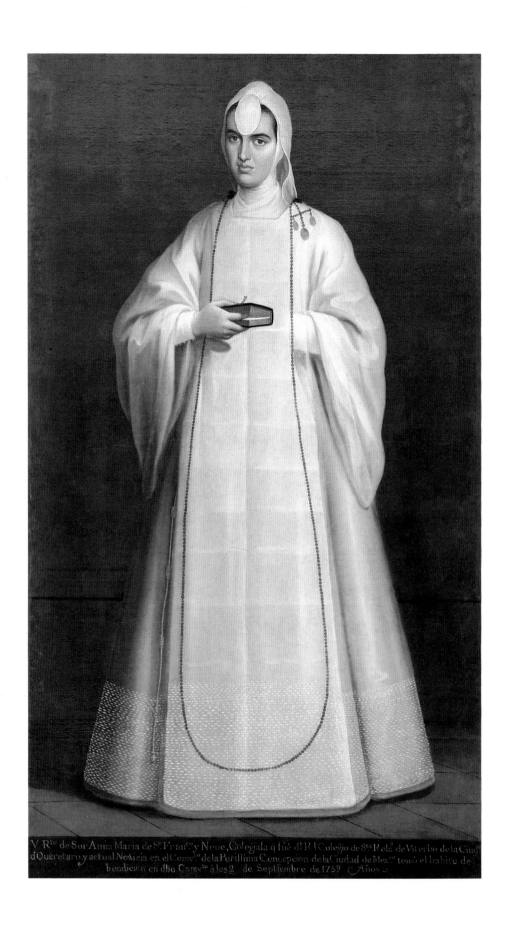

V.Rto de Sor Anna Maria de Sn Franco y Neue, Colegiala q fué dl R l Colegio de Sta Rosa de Viterbo de la Ciud
d Querétaro, y actual Novicia en el Convto de la Puríssima Concepción de la Ciudad de Mexco tomó el habito de
bendicion en dho Convto á los 2 . de Septiembre de 1759 C Años

153 ◀ *Sor Ana María de San Francisco y Neve*

Mexico City, 1750–68
Oil on canvas; 180 x 120 cm. (70⅞ x 47¼ in.)
Church of Santa Rosa de Viterbo, Querétaro

One of the most highly prized works of art of the viceregal period in New Spain is this portrait of a lovely young Creole woman, who was a novice at the convent of Santa Rosa de Viterbo in Querétaro before taking her vows at the La Concepción convent in Mexico City.

In spite of the economy of color and the sober simplicity of the composition —the figure standing against a dark background in her white habit appears in an undefined space and fills almost the entire canvas—the effect is masterly. The novice's fresh, intelligent expression; the plastic definition of her face, her hand, her heavy, full robes, the rosary hanging on the scapular, and the prayer book; and, especially, the warmth and life in her glance—all are extraordinarily pleasing. Since she does not wear a black veil, she has not yet taken her final vows; thus it is likely that the portrait was ordered by her family before she took that all-important step which would remove her from their circle forever. This granddaughter, sister, niece, or goddaughter who had decided to devote her life to God, or who had been saved, against her will, from the dangers and vanities of the world by being confined behind the walls of a convent, would be remembered always by her portrait in the family parlor. In that society, so religiously oriented, her status as a nun would have been a source of pride and deep satisfaction.

Although some have attributed this portrait to José de Páez and others to Cabrera, the painter remains unknown. One thing is certain, however: its high quality indicates that its creator was among the most accomplished artists working in the viceregal capital during the mid-eighteenth century.

RRG

REFERENCE
Rogelio Ruíz Gomar. "La pintura barroco en la ciudad de Querétaro," in *Querétaro: Ciudad barroco* (Mexico, 1988), p. 220, ill. p. 194–95.

154 ◀ **José de Alcíbar (Alzíbar)**

Mexican, active 1751–1803

Sor María Ignacia de la Sangre de Cristo,
about 1777
Oil on canvas; 180 x 109.2 cm. (70⅞ x 43 in.)
CNCA–INAH, Museo Nacional de Historia,
Mexico City

During the colonial period in New Spain, a woman had only two options: marriage or the convent. Most girls whose parents were unable to provide them with the extravagant dowries expected at the time entered one of the innumerable nunneries, some of which were not very strict in their regulations. In a nun's lifetime there were four occasions that might call for the services of a painter: her profession (taking of vows); her appointment as mother superior; her founding of a new order; and her death. It is the first of these that has left us the most attractive works of art.

When a young woman took vows, thus becoming the bride of Christ, she was richly attired. Although this ceremony had always been celebrated with great splendor, it was not until the eighteenth century that the "portraits of the crowned nuns" appeared. These paintings derived their name from the magnificent crown of flowers worn in the sitter's hair. The portraits, like the celebration, were paid for by the nun's relatives; they were the final testimony to her status in society and her last act of vanity before assuming the simple religious habit. The ostentation of her attire for this ceremony can be understood only in the context of a society centered around the court, where etiquette, luxury, theatrical surroundings, and exquisite refinement were part of the social ritual. In the eighteenth century the convent came to be a replica of the royal circle.

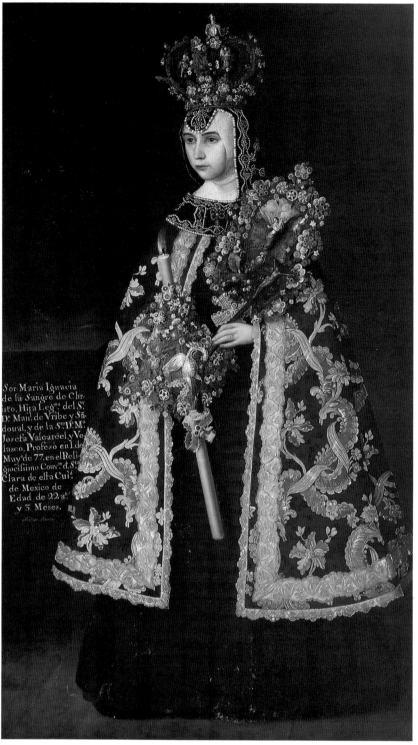

Sor Maria Ignacia
de la Sangre de Chri-
sto, Hija Legma del Sr.
Dr. Manl. de Vribe y Sã-
doual, y de la Sra DMa.
Josefa Valcarcel y Ve-
lasco, Profesó en 1 de
Mayo de 77. en el Reli-
giocissimo Convto. d. Sta
Clara de esta Ciud.
de Mexico de
Edad de 22 as.
y 3 Meses.

154

Perhaps the loveliest example of a "crowned nun" is this portrait of Sor
Ignacia de la Sangre de Cristo, a member of the order of the Poor Clares. The
inscription indicates that she entered the convent on May 1, 1777, at the age of
twenty-two years and three months. It also names her parents—an indication
of their pride at having a nun in the family. The picture functions as a kind of
official document, attesting to a significant event.

The girl's sumptuous robes consist of the novice's habit overlaid with a rich
blue cape—perhaps of velvet—embroidered with silver; her coif is trimmed

with pearls and gold beads. Further elegant touches are added by the beeswax candle, the palm branch, and the crown, called an "imperial." The crucifix on the crown, flanked by angels, is answered by another in her hand. These objects are decorated with wax flowers, glass beads, jewels, and ribbons. The palm branch bears a small painting at its center, depicting the Virgin of the Book of Revelation; it is based on a painting by Rubens. On the candle there is a pelican tearing open its breast, an image representing the self-sacrifice and the blood of Christ as elements of the Redemption. It may also be an allusion to the name chosen for the young woman to begin her life in the cloister (*Sangre de Cristo*=Blood of Christ).

The dark background emphasizes the opulence of Sister Ignacia's robes, the whiteness of her sensitive, childlike face, and the delicate hand with its nuptial ring.

The painter of this charming portrait was José de Alcíbar, a native of Texcoco. In 1753 he joined José de Ibarra in setting up a painting school and was later assistant director of the Academy of San Carlos, Mexico City.

JGH

REFERENCES
Manuel Toussaint. *Colonial Art in Mexico*. Translated and edited by Elizabeth Wilder Weismann. Austin and London, 1967, pp. 339, fig. 314. **Manuel Toussaint**. *Pintura colonial en México*. Edited by Xavier Moyssén. Mexico, 1982, pp. 169–70, fig. 324.

155 ◀ *St. Joseph with the Christ Child*

Puebla(?), 18th century
Marble; height 33 cm. (13 in.)
Museo Franz Mayer, Mexico City 18–003/0057
BEA–0190

There are no known close parallels to this small but imposing object, with its squat proportions (the head and figure nearly as deep as they are wide) and naturalistic faces. With his delicate beard, centrally parted flowing locks, and European face, St. Joseph indeed looks more like Christ, while the disproportionately large Infant has the slightly Oriental features of an indigenous baby. The pose is also unconventional in not showing St. Joseph in his usual guise as loving father or educator. In the solemn, four-square presentation of the Child's body, one senses not mere archaism but rather a most expressive prefiguration of Christ's sacrifice.

The devotion to St. Joseph in his own right rather than as a passive observer at the Nativity was a religious theme that manifested itself in Spain in the wake of the Council of Trent. His cult proliferated in Mexico even earlier than it did in Spain, and he appears frequently both as central image in his own altar or as subsidiary figure in others.

In Mexico the devotion was fostered by the mendicant friars, who themselves shared this veneration and made significant efforts to inculcate it in their indigenous charges. He was held up as the model of the three virtues to which the Franciscans themselves were particularly committed: chastity, poverty, and obedience. Fray Pedro de Gante dedicated the chapel and school of San José de los Naturales (about 1526) to St. Joseph, undoubtedly holding him up as a role model for those additional virtues he embodied as artisan and family man.

The many open chapels subsequently built for the Indians were so frequently dedicated to St. Joseph that "San José" became their familiar name and Indians

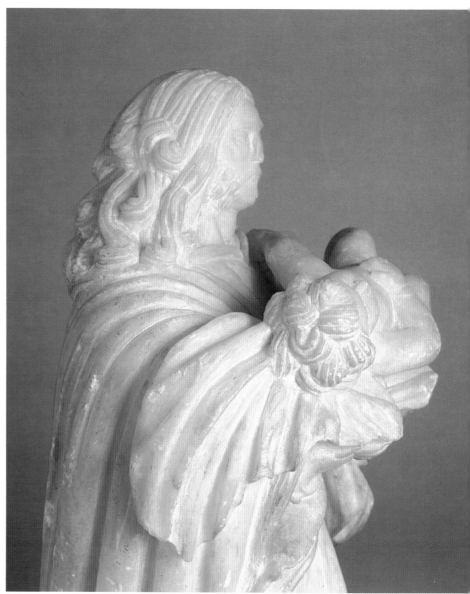

Detail of cat. no. 155

were more typically christened José than were Spanish.[1] Numerous churches and altars were dedicated to him as well, and on June 29, 1555, the province of New Spain adopted this saint as its patron.

Small stone sculptures such as this are not very common. Those in stone intended for a facade tend to be life-size. However, the local Pueblan alabaster known as *tecali* was, indeed, occasionally used for small-scale devotional images, although most are even more "popular" in feeling than is this carving. Still, this St. Joseph appears to be carved from a true marble and shows none of the softness or soapy surface associated with *tecali* carvings. It is possible that this figure originally stood in the niche of a doorway of a Carmelite convent. It is known that St. Teresa de Ávila had a special devotion for the saint she called "our father" and that Carmelite foundations in Spain, almost all dedicated to him, usually featured his image in one of their entrances.

JH

1. Gerónimo de Mendieta, *Historia eclesiástica indiana* (about 1574–1596) (Mexico, 1945), vol. 3, p. 88, as cited by John McAndrew, *The Open-air Churches of Sixteenth-Century Mexico: Atrios, Posas, Open Chapels and Other Studies* (Cambridge, Mass., 1969), p. 393, see also pp. 393–97 for a full discussion of this cult.

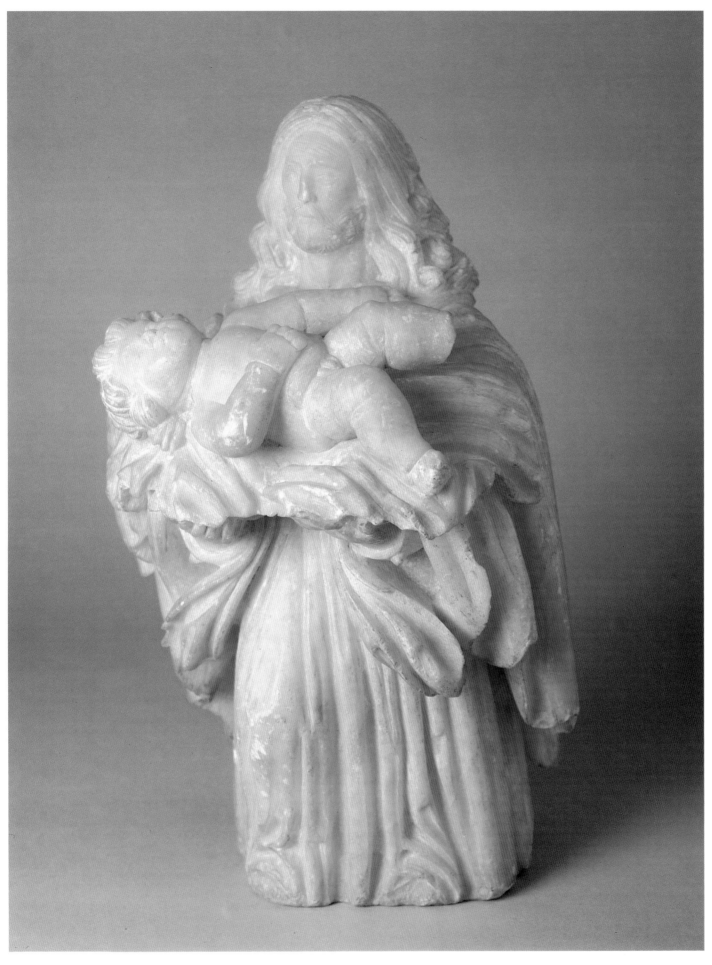

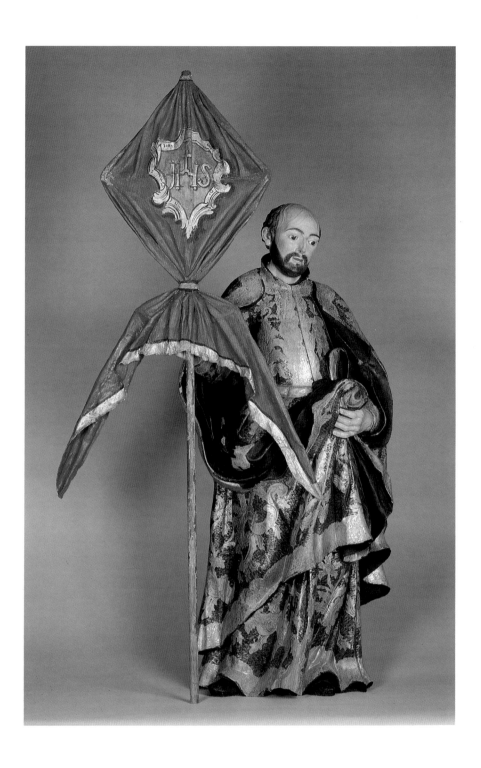

156 ◀ *St. Ignatius of Loyola,* 1776–78

Polychromed wood; height 200 cm. (78¾ in.)
SEDUE, Templo de San Cayetano de La Valenciana,
Guanajuato

This statue of the founder of the Society of Jesus, brandishing the order's banner and gazing down with the directness of a living being, comes from one of three great retablos from the Church of La Valenciana. Begun in 1765, the spectacular edifice was built with funds donated by Don Antonio Obregón y Alcocer five years after he discovered the great vein of silver that became the mine of La Valenciana, in the heights overlooking the city of Guanajuato. The silver-rich region in which Guanajuato lies, called the Bajío, is doubly distinguished: as home to some of the most spectacular eighteenth-century Mexican architecture and as the "cradle of Independence." Both achievements were fostered in part by the vast riches generated by the silver mines and by the pride they engendered in their hugely wealthy Mexican proprietors.

The altar of the left transept, devoted to St. Joseph and the Virgin of Guadalupe, was dedicated in 1778, more than a decade after the expulsion of the Jesuit order from the Spanish empire. It nonetheless includes the figure of the order's founder in a place of great prominence. This is entirely in keeping with the profound attachment to the Jesuits felt on every level of Mexican society, but most especially in the Bajío, where riots erupted at the time of the expulsion. The Jesuits, among other contributions to the spiritual life of the country, distinguished themselves through their promotion of the cult of the Virgin of Guadalupe; some have seen their expulsion as one of the actions of the Bourbon kings that created great disaffection in their New World possessions and helped set the stage for Independence.

The depiction of Ignatius of Loyola, who died in 1556 and was canonized in 1625, was a firmly established convention based on the many contemporary portraits attesting to his appearance. Still, the expression on this figure's face seems particularly benign; it may perhaps be a sign of the instant nostalgia felt at the loss of the Jesuits, perceived by many Mexicans as their special protectors against the regalist power wielded by the episcopal hierarchy.

As usual in the matter of Mexican retablos it is difficult to identify the authors of the figural sculptures. Guillermo Tovar de Teresa cites documents connecting the Valenciana altars to the Queretaran Manuel Cárdenas and his workshop. Curiously, Ignacio's drapery follows a more truly Baroque convention than do the other sculptures on the altar. This is often the case with Counter-Reformation saints whose images first reached Mexico in a late seventeenth-century form but the true explanation may lie elsewhere.

JH

1. Jacques Lafaye, *Quetzalcóatl and Guadalupe: The Formation of Mexican National Consciousness, 1531–1831*, translated by Benjamin Keen (Chicago and London, 1976), pp. 99–136. See also Anthony Padgen, *Spanish Imperialism and the Colonial Imagination: Studies in European and Spanish-American Social and Political Theory, 1513–1830* (New Haven and London, 1990), p. 98.

REFERENCE
Antonio Cortés. *La Valenciana*. Mexico, 1933.

157 ◀ *St. Peter(?) Seated in an Armchair*

◀ Mexican, 18th century
◀ Gilded and polychromed wood; height 125 cm.
◀ (49¼ in.)
◀ CNCA–INAH, Museo Regional de Oaxaca, Oaxaca

St. Peter, if it is indeed he, is represented at the moment during the Last Supper when Christ announces that one of his disciples will betray him. As is conventional, the saint is shown expressing great astonishment.

Such seated figures in chairs are a particularly charming feature of Mexican colonial sculpture. The chairs on which they are seated often replicate real ones of the period. Among the earliest are the three sixteenth-century stone carvings representing the Three Persons of the Trinity, now in the cloister at San Miguel Zinacantepec. With their blocklike lower portions they bring to mind the traditional seated ruler figures of pre-Hispanic convention.

More common later on are representations of the Trinity showing God the Father seated alone with the body of Christ on his lap or St. Anne with the Virgin and Child. Such figures would have been displayed as central devotional images. The present carving, however, seems more likely to have been a subordinate part of a retablo. It recalls the Maundy Thursday series of twelve seated apostles in Santa Rosa de Viterbo in Querétaro or the "tableaux vivants"

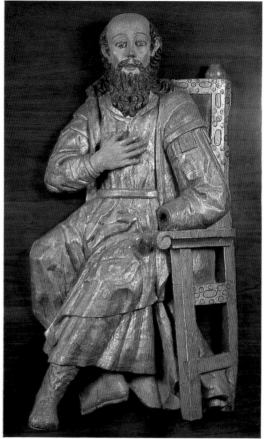

157

in the altars of San Agustín, Salamanca. These ensembles relate more to the Spanish tradition of processional *pasos* than to the theatricality of the Italian Baroque.

Such figures, although rarely sophisticated in their formal sculptural qualities, often have an emotional directness and immediacy that compensate for their lack of conventional stylistic achievement. And, as in so many figures of the time, the lavish estofado of its elaborate medieval garments stands in sharp contrast to the fairly simple popular quality of the carving beneath.

JH

158 ◀ Christ with a Rope Around His Neck

Mexican, 18th century
Polychromed wood, hair, and rope; height 85 cm. (33½ in.)
CNCA–INAH, Museo del ex-Convento Franciscano, Huejotzingo 10–204447

This bloody kneeling figure with crown of thorns and a rope around his neck is one of many such Mexican sculptures depicting scenes from the Passion of Christ. Similar devotional images, often far gorier than this example, were common in Spain, and converted Mexicans wholeheartedly embraced the genre. The oppressed Indians may have identified with Christ's suffering, and the idea of his sacrifice may also have rung a sympathetic note for the sixteenth-century converts, given the Aztec rites of the recent past.

This figure may have served as a devotional image housed in an altar, or it may have been a processional figure. The tradition of processions in observance of the Christian calendar was introduced by the Spanish, but processions, albeit in observance of a different rite, had been a part of daily life for pre-Hispanic Mexicans—a fact the early missionaries understandably exploited.

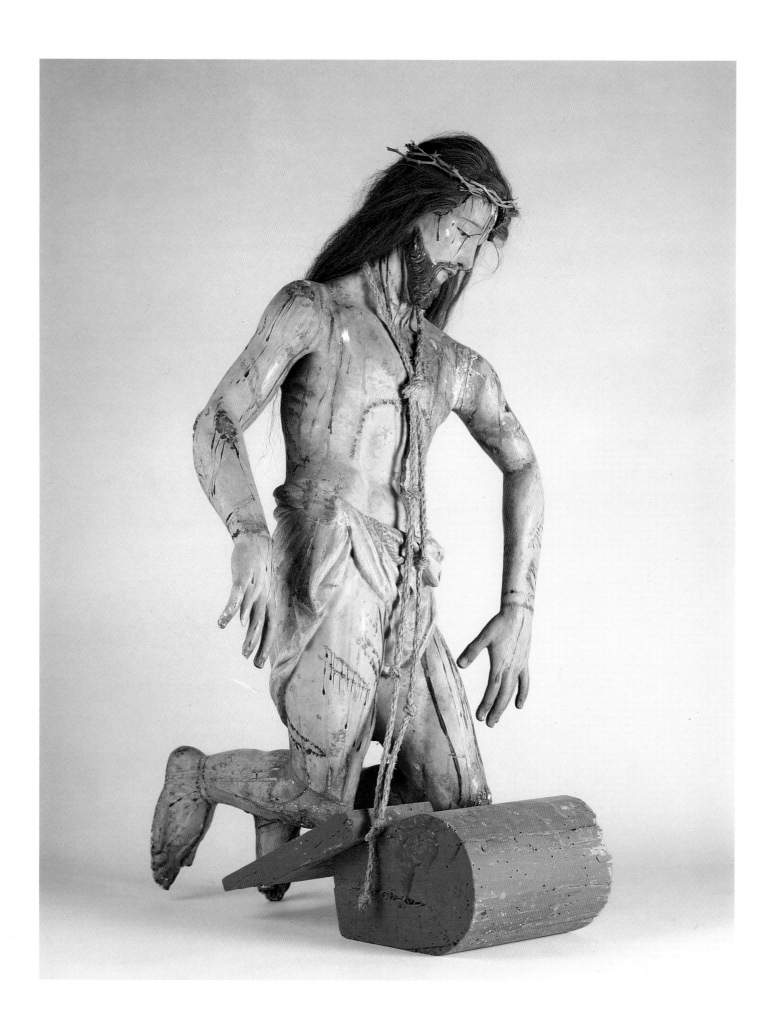

Detail of cat. no. 158

Lenten processions in sixteenth-century Mexico were described by Grijalva: "The confraternities of penance, and the processions of Lent, are admired by all who see them. They are so orderly and silent that they look like a painting... so many devotional images, so many tender *pasos* [images carried by participants], so many candles, so many banners."[1] Some of the images cited are, for example, the Man of Sorrows, the Agony in the Garden, and the Crowning with Thorns.

Even the simplest churches built elaborate retablos in which to display their cherished figures when not in use. A number of them now remain in these places of honor all year; during Holy Week they are covered in special mourning regalia. Even during the remainder of the year, it is rare to see one displayed without some garment bestowed by the devout. The present figure has a carved loincloth that, in normal observance, would have been hidden by an actual swath of cloth donated by the faithful, as was its wig of human hair.

The accoutrements, as well as the naturalistically rendered gore and wounds, add a different level of realism to the softly lifelike form of the sculpture itself. These elements, in addition to the slight Baroque twist, the gentle poignancy of Christ's gesture, and his sweet features, mark it as the work of an eighteenth-century sculptor. It is more accomplished in conventional artistic terms than many other contemporary examples of the genre.

JH

1. Fray Juan de Grijalva, *Crónica de la Orden de N.P.S. Agustín en las provincias de la Nueva España. En cuatro edades desde el año de 1533 hasta el de 1592.* (1st ed., 1624) (Mexico, 1985), pp. 161–62.

159 ⦃ Pulpit

⦃ Probably Querétaro, about 1760
⦃ Wood, gilt bronze, bone, silver, polychrome;
⦃ height 275 cm. (108¼ in.)
⦃ Inscribed: R. Benito
⦃ SEDUE, Santa Rosa de Viterbo, Querétaro

The convent church of Santa Rosa, dedicated in 1752, contains one of the relatively few almost complete eighteenth-century ensembles of New Spain. The pulpit, part of this decoration, does, however, differ from it. Whereas curvilinear and foliate forms cover the retablos, the pulpit is a concentration of rectilinear patterns; and, although it can be said that the human images in the retablos of Santa Rosa play a secondary role to the structural and decorative elements, it is striking that the pulpit, with the exception of the carved image of Santa Rosa that crowns the canopy, has almost no figures at all. Equally noteworthy is the contrast within the pulpit itself between the curvilinear stair with its lyrical bird design, like a swath of opulent cloth flowing to the floor, and the strict, minute geometry of the rest of the piece. Even in color the parts are distinct. Only the repetition of motifs and the extraordinary surface richness in both the curvilinear and the rectilinear parts unify the whole and, in turn, integrate it to the rest of the decoration in the church.

The two design traditions exemplified in the Santa Rosa pulpit are the geometric, which is usually said to derive from Islamic art, and the Oriental. Both are basic in the history of Mexican colonial art. The first exists in carpentry work from the sixteenth century onward. The Querétaro pulpit exemplifies the complexity that geometric work could achieve, along with the richness of inlay. In this case, the main part of the pulpit is covered with a lozenge pattern of inlaid wood and tortoiseshell laid over brass tubing, while the canopy is made in a different technique. Its soffit shows an interlaced star pattern in wood inlay and is signed inside "R. Benito." Oriental influences, by

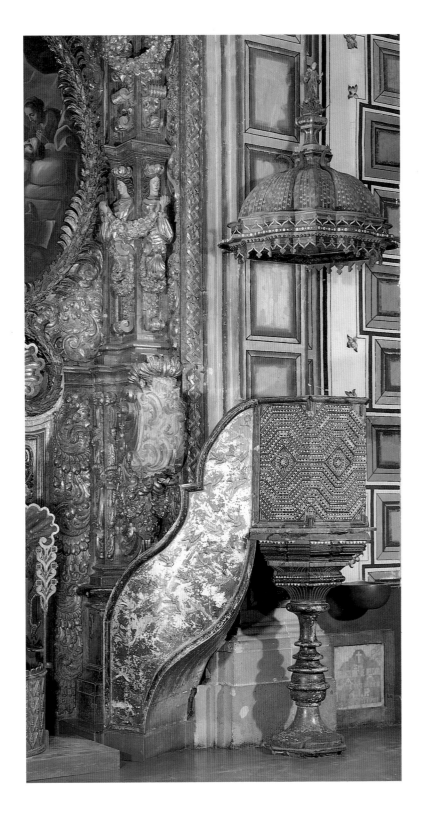

way of the trade route from the Philippines to Spain which passed through New Spain, became frequent in Mexican art from the seventeenth century onward and are very often seen in the eighteenth century. The birds of the stairway of the pulpit are an example of a Chinese motif which became common in Mexico as well.

Another pulpit with similar formal characteristics exists in the Church of San Agustín in Salamanca, not far from Querétaro. Since there are retablos of related styles in both Querétaro and Salamanca, it is possible to suggest that this type of pulpit was executed by artisans of the region, probably in Querétaro

itself, which was the more important city. The stair of the Salamanca pulpit terminates in a scroll which curves upward from the floor; the Santa Rosa pulpit stair may have had the same feature.

CB

REFERENCES
Jorge Loyzaga. "Taracea en México." In Carmen Aguilera et al., *El mueble mexicano: historia, evolución e influencias*. Mexico, 1985, pp. 71–93. **Joseph A. Baird**. *Los retablos del siglo XVIII en el sur de España, Portugal y México*. Mexico, 1987.

160 ⫸ Table

Puebla, about 1760
Carved, gilded, and painted wood; diameter 199 cm. (78⅜ in.)
Inscribed: A Dᵒvᴺ DE ARAGON Y DE SVESPOSA D ANTONIA PAULINA MONFORT AMARTELA DOS ESCLAVOS DE LA SS SE OCOTLAN A QUIEN LA DONAN ESTA Y SON VO DE LA CIUDAD DE LOS ANGELES AN DE 1761 (Donation of JPR de Aragon and his wife Antonia Paulina de Monfort Amartela, both slaves of the Holy Lady of Ocotlán, to whom they present this table, and they are residents of the city of Puebla de los Angeles in the year 1761)
SEDUE, Santuario de Nuestra Señora de Ocotlán, Tlaxcala

This table comes from the Santuario of Our Lady of Ocotlán, an important example of Mexican Baroque architecture. According to the legend, the Virgin of Ocotlán appeared to an Indian named Juan Diego about 1541; she gave him some miraculous water for curing natives afflicted by the plague and at the same time gave him directions for finding a burning forest. Accompanied by the Franciscans, Juan Diego found in an *ocote* tree that was burning more fiercely than the rest an image of the Virgin carved from a single piece of wood from that same tree. The story of the miracle was published in 1750 by the priest Don Manuel Loayzaga, chaplain of the shrine for the next thirty years. Father Loayzaga and the Indian sculptor Francisco Miguel Tlayoltehuanitzin appear to have contributed greatly to the construction and decoration of the shrine.

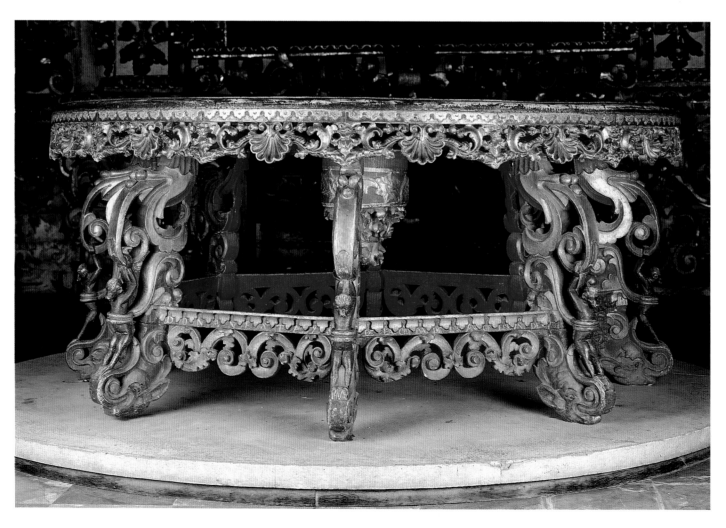

The table is not part of the furnishings of the sacristy itself, but of the *camarino*, the small and exquisite *yesería* octagonal chamber behind the high altar, in which the cult image of the Virgin housed in the altar is dressed. It has eight carved wooden legs and stretchers and a carved wooden border on the top. The carving on the legs shows pre-Hispanic or idolatrous elements, evidence that signs of the religious syncretism of the sixteenth century were still to be seen in the middle of the eighteenth. The feet are in the shape of *tlacuaches*. This animal, the Mexican opossum, is considered to be the incarnation of gluttony because it always keeps its snout to the ground. It may also represent the union or bond between the earth and the animal world. The name derives from the Nahuatl *tla*, or things; *cua*, to eat; and *tzin*, a diminutive. Above the opossums are black monkeys, imprisoned by metal rings. This creature is a symbol of happiness. Its name in Nahuatl is *usumantli*, from *usu*, an onomatopoeic particle, and *matli*, monkey.

The previous attribution of this piece of furniture to Francisco Miguel is an error, as can be seen from the inscription found on the stretcher joining the legs. There we are told that the table was a donation and that it was made in the city of Puebla de los Angeles. The term "slaves" implies that the donors were fervent votaries of the Virgin of Ocotlán.

JOL

REFERENCE
Angel Santamaría. "Santuario y Basílica de nuestra Señora de Ocotlán, Tlaxcala." *Monografías de arte sacro* 15 (January 1987), p. 16.

Sacristy

161 **Sebastián Ramírez**

Mexican, active late 17th century

Crucifix, 1692

Ivory, wood, and shell inlay; 95 x 43 cm. (37⅜ x 16⅞ in.)

SEDUE, Catedral Metropolitana, Mexico City

The head of this strong-featured Christ is dominated by a loosely woven Crown of Thorns. One rigid-looking curl frames the right side of the face and falls to the shoulder. A dark brown mustache and thick beard emphasize the mouth and chin, which rests on the chest. The taut, outstretched arms are attached to the cross palms up, hands slack with two fingers curled. The deep wound in the side is plainly visible against the soft musculature and lightly bruised ribs of the elongated torso. Held in place by a cord, the loincloth falls in gentle folds, exposing the right hip; the legs are bent at the knees and well shaped.

Polychromy is used here as a complementary element to give a realistic touch to the cruel sacrifice. In stark contrast to the figure's mute serenity, blood gushes from the deep wounds in the face, hands, knees, feet, and side. Capturing the tradition of the Spanish Baroque, this bleeding Christ is a good example of the tendency toward exaggerated realism so characteristic of seventeenth-century Mexican Christ figures.

The crucifix is enhanced by its rich ebony cross and the elaborate base on which it rests. Carved to resemble a tree trunk without its branches, the cross has been inlaid with a not unusual floral pattern of stems, leaves, and flowers arranged in a spiral along the crossbar and up its length. The base is composed of a sphere elaborately inlaid with many small horizontal rhombuses to form

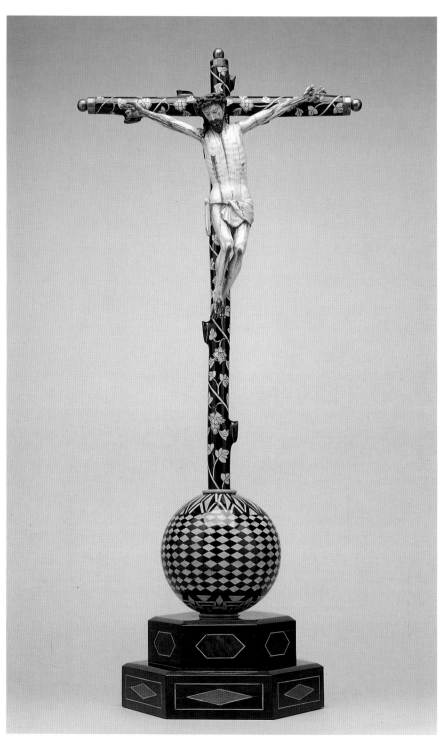

161

a large central band and with other geometric shapes to form two decorative segments, one at each pole. This sphere rests in turn on two hexagonal platforms elegantly inlaid with wood hexagons and rhombuses.

BP

REFERENCES

Xavier Moyssén. *México: angustia de sus Cristos.* Instituto de Antropología e Historia. Mexico, 1967, pp. XV–XVII. **Manuel Romero de Terreros y Vinent.** *Las artes industriales en la Nueva España.* 2d ed., edited by Maria T. Cervantes de Conde and Carlota Romero de Terreros de Prévoisin. Mexico, 1982, pp. 170, 173, pl. 138. **Elena I. Estrada de Gerlero.** "Sacristía." In *Catedral de México: patrimonio artístico y cultural.* Mexico, 1986, p. 429, fig. upper left corner [as anonymous]. **Beatríz Sánchez Navarro de Pintado.** *Marfiles cristianos del oriente en México.* Mexico, 1986, p. 119, pl. 101.

162 ◆ Set of Vestments with Musical Angels

Dominican Convent of St. Rose of Lima, Puebla,
about 1750
Embroidered silk
a. dalmatic, length 116 cm. (45⅜ in.)
b. chasuble, length 115 cm. (45⅜ in.)
c. cope, length 138 cm. (54⅜ in.)
d. chalice cover, 58 x 58 cm. (22⅞ x 22⅞ in.)
e. burse, 48 x 25 cm. (18⅞ x 9⅞ in.)
CNCA–INAH, Museo Nacional del Virreinato,
Tepotzotlán 10–241454/5/12

Among the many articles of apparel presented to Cortés by Moctezuma, some were made of cotton and others of feathers. Although it is known that there was some silk in the Tenochtitlan market, there is no evidence that the Indians used it for clothing. After the Conquest the Spaniards brought sheep, pedal looms, and new dyes. Wool was spun as thread, as were silver and gold. The cultivation of silk was introduced by Fray Juan Zumárraga, Mexico's first bishop, and by the mid-sixteenth century the silk industry was flourishing. A section of the Mexico City market was called the Alcaiceria (the place where silk cloth is made), after the Alcaiceria in Valencia. But after the establishment of trade with Asia, large quantities of very cheap silk cloth, raw silk, embroidered shawls, and scarves began to reach New Spain from the East; consequently within a few years the short-lived native industry disappeared completely.

The art of embroidery developed at a steady pace in the years following the Conquest. Indians received instruction in needlework at Fray Pedro de Gante's school at San José de los Naturales (see cat. no. 118), and they were accepted into the embroiderers' guild. There was close relationship between this guild and Zumárraga; priestly vestments and religious ornaments were the most important embroidered objects commissioned in New Spain.

As the embroiderers' guild grew stronger and gained more members, nuns emerged as an independent group of embroiderers. For their chapels they made ornaments as well as capes for the images of the Virgin and the Infant Jesus; they also accepted commissions from relatives or benefactors, either for religious items or for clothing to be worn at Court.

This set of vestments is an extraordinary example of Rococo design. With the exception of the altar frontal (in the Museo Bello, Puebla), the complete set is at Tepotzotlan. Sets of vestments and altar ornaments that include a dalmatic (a vestment worn by the auxiliary ministers during a Mass or solemn ceremony), were used during special celebrations; for this reason they are the most richly decorated. The present dalmatic demonstrates rare perfection of design and execution. The materials used include gold thread and sequins and silk of various colors.

The embroidery produced by nuns was executed with a technique different from that of the guild embroiderers. In convents such as that of the Dominican order of St. Rose of Lima in Puebla, where the present set was made, the base fabric was covered completely by a variety of stitches; among them is *petatillo* (laid and couched work in a basketweave pattern) in gold or silver which produced a surface resembling lamé. The design itself, often outlined in silver and filled in with slack colored silks in short stitches, was executed over it. The thread used for the flowers and angels' garments is coarser than that employed in the angels' skin and instruments.

This suite of ecclesiastical garments testifies to the mixture of cultural elements that existed in New Spain during the eighteenth century. The Rococo was much evident in Europe in architecture, plasterwork, furniture, and metalwork; its influence can be seen here as well, especially in the use of asymmetry and rocaille elements. Certain Asiatic elements, such as the peonies and the belts of the angels' tunics, are also apparent. The irrepressible movement of the design and the joy of the subject and the coloring reflects the spirit of luxury and Baroque splendor characteristic of New Spain.

The vestments are embroidered with a Crown of Thorns, from which sprouts

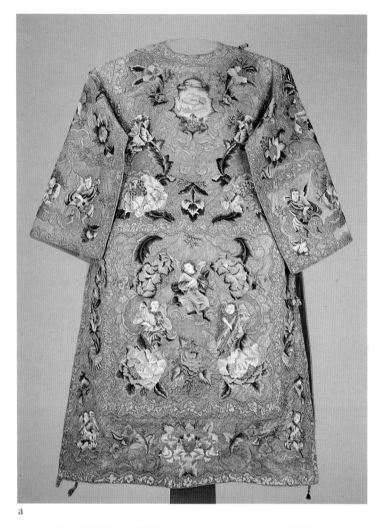

a

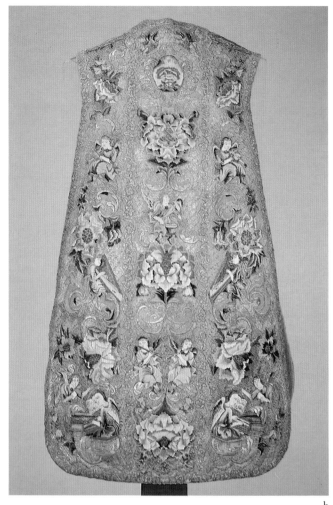

b

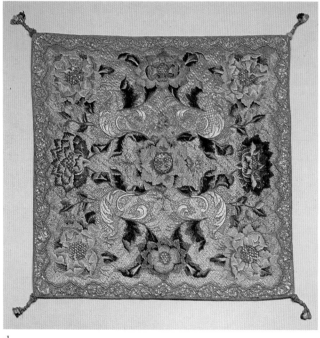

d

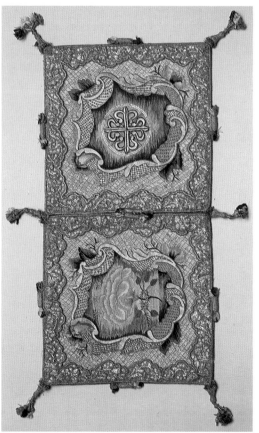

e

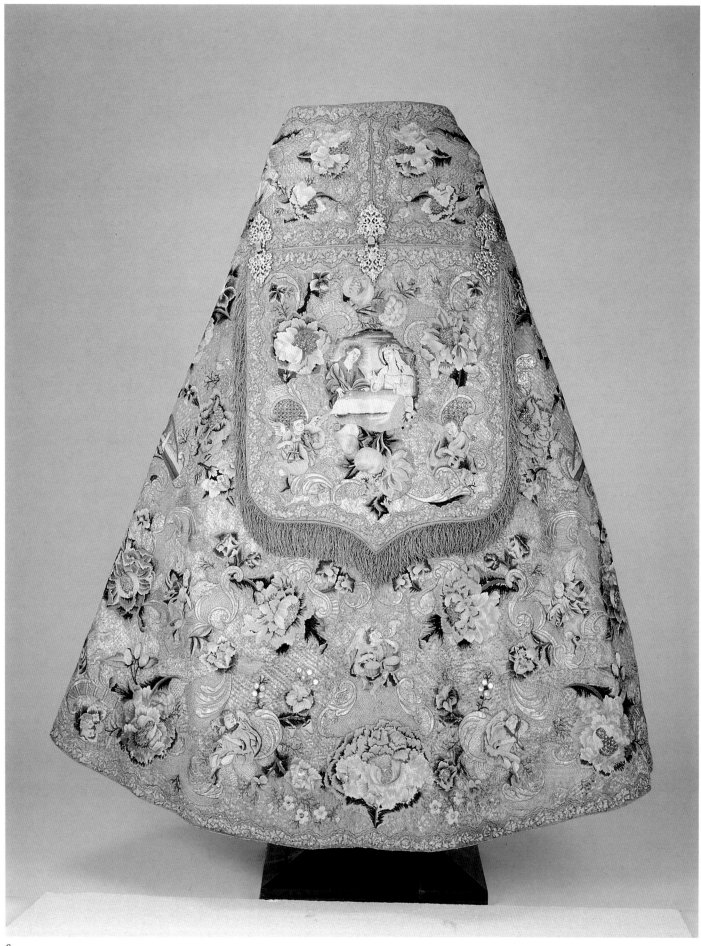

c

a rose surrounded by three stars; this is the coat of arms of the female convents of the Dominican Order, dedicated to St. Rose of Lima, the first woman of the New World to be declared a saint.

VAA

REFERENCES
Manuel Toussaint. *Colonial Art in Mexico.* Translated and edited by Elizabeth Wilder Weismann. Austin and London, 1967, pp. 372–73, figs. 338–40. **Armida Alonso Lutteroth.** "El dibujo y la trama." In *Tepotzotlán: la vida y la obra en la Nueva España*, Museo Nacional del Virreinato. Mexico, 1988, pp. 171 (ill.), 172–73.

163 ◀ Set of Vestments

Mexican, about 1770
Embroidered silk
a. chasuble, length (extended) 238 cm. (93¾ in.)
b. burse, 49 x 24 cm. (19¼ x 9⁷⁄₁₆ in.)
c. chalice cover, 63.5 x 63.5 cm. (25 x 25 in.)
CNCA–INAH, Museo Nacional del Virreinato,
Tepotzotlán 10–12256

This set of elaborately embroidered vestments—a chasuble, a burse, and a chalice cover—was probably made in a convent; the burse and the chalice cover may come from the Dominican convent of St. Rose of Lima in Puebla. All three pieces share a Baroque design with Neoclassical elements.

The chasuble, sometimes known as the "chasuble of the cornucopias" after one of its distinctive motifs, is completely covered with embroidery in three materials: gold, silver, and silk. The ground is filled with gold needlework. The galloons, which define the edge of the garment and divide it into three longitudinal sections, are also in gold, as are the centers of the flowers. Silver is used for the cornucopias that give the garment its name, for the large vase that forms the central motif, and for the chalices containing peonies and pomegranates. The needlework for the cornucopias is raised in relief over filling, with stitching so fine it looks more like silverwork than embroidery.

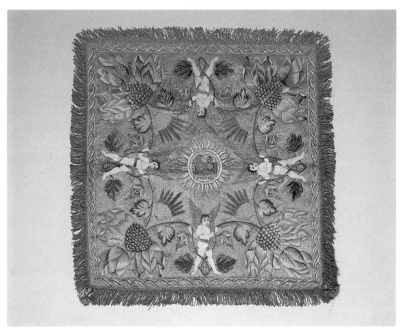

c

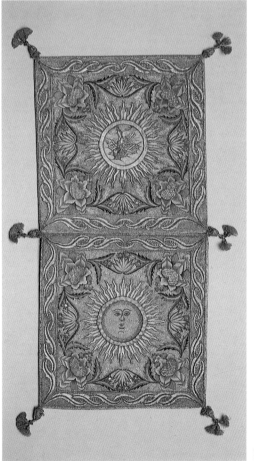

b

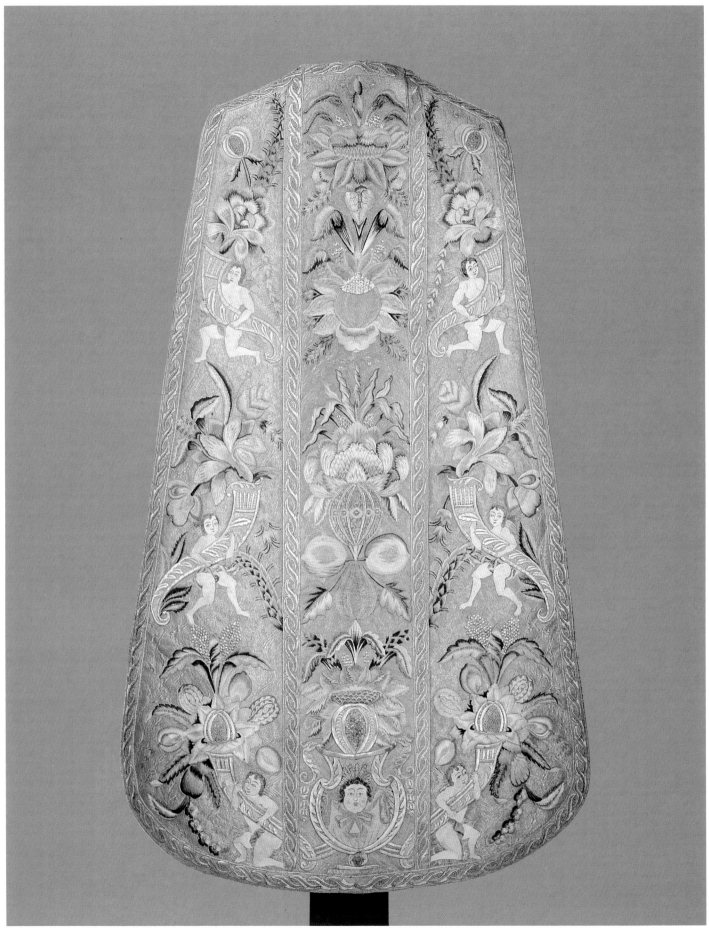

a

Silk is used for the bodies of the cherubs; for the peonies, which are an Asian motif often found in embroidered works from that region; and for the pomegranates, a symbol of Spain.

The second piece in the set, a square pocket called a burse used to carry the communion cloth, may have been designed by a different person, although it includes elements common to the other two.

The edges of both squares are finished with an identical galloon embroidered in gold thread, and the ground is covered with gold needlework. Each of the four corners contain peonies worked in silk. In the center of the front square the face of the sun is surrounded by flamboyant rays, stitched in gold and silk. Silver sequins are scattered throughout the embroidery. The corners terminate in small tassels covered with thread of red silk and gold.

The author of the chalice veil may be distinguished from the author of the chasuble in that she was perhaps more expert in design than in execution. The ground of the chalice veil, like that of the other two pieces in the set, is covered with embroidery in gold thread and has for a border a gold Neoclassical galloon. The central image is the Paschal lamb posed over the Book of the Seven Seals within a circle, the stylized rays around it embroidered in raised gold thread. The lamb's wool is worked in silver thread. The composition, somewhat different from that of the chasuble, includes the Eucharistic symbols of grapes and ears of grain. The remainder of the embroidery is executed in silk and includes cherubs, flowers, fig leaves, and peonies. Concave silver sequins form the stamens of the flowers.

VAA

REFERENCES
Armida Alonso Lutteroth. "El dibujo y la trama." In *Tepotzotlán: la vida y la obra en la Nueva España*, Museo Nacional del Virreinato. Mexico, 1988, pp. 173, 175 (ills.), 174.

164 ◀ Chasuble

◀ Mexican, about 1795
◀ Embroidered Chinese silk; length (extended)
◀ 233 cm. (91¾ in.)
◀ CNCA–INAH, Museo Nacional del Virreinato,
◀ Tepotzotlán 10–12253

The needlework on this purple chasuble incorporates thread, three sizes of sequins, and thin strips, all of silver. The purely Neoclassical design includes a central medallion with the figure of the Paschal lamb over the Book of the Seven Seals, a large sheaf of wheat, ribbons, small flowers, garlands, crowns, and an abundant display of galloon. The use of strips of silver as the spikes of wheat grains is very original. The purple fabric as well as the iconography indicate the chasuble was intended for services during Lent.

VAA

Detail of cat. no. 164

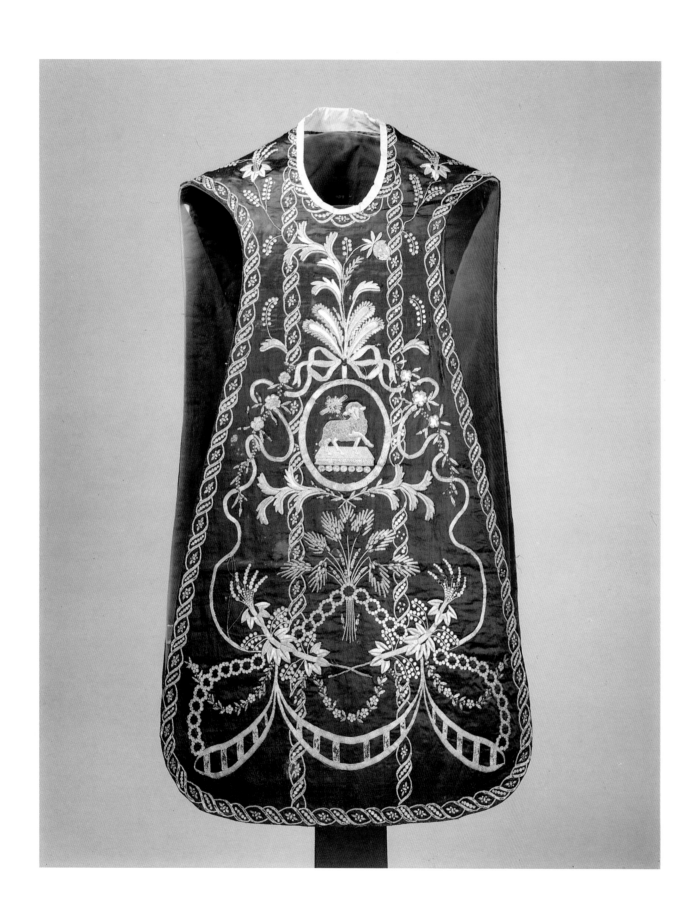

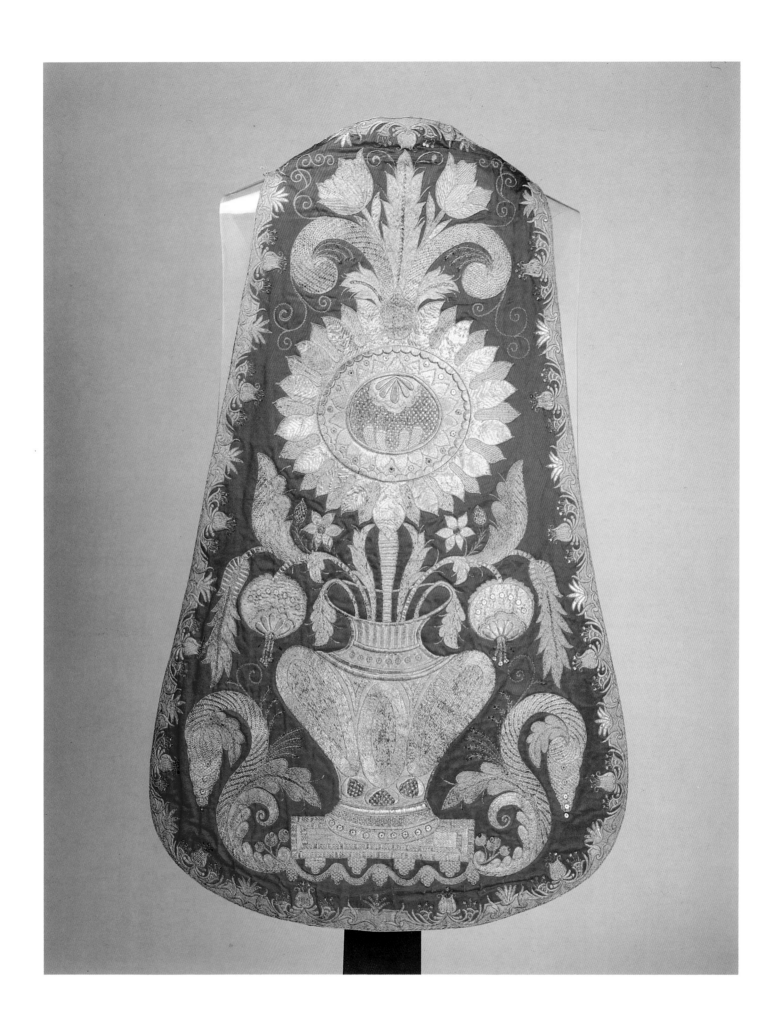

165 ◀ Chasuble

◀ Probably Chinese, mid-18th century
◀ Embroidered silk; length (extended) 228 cm.
◀ (89¾ in.)
◀ CNCA–INAH, Museo Nacional del Virreinato,
◀ Tepotzotlán 10–12360

The design of this red silk chasuble is distinctive. Probably made in China, the garment's decoration and embroidery are completely Asian, without a single element of Catholic iconography. The central motif is a great vase filled with lush foliage and some unusual plant motifs. The lining is a yellow silk damask, also produced in China.

This is a spectacular piece of embroidery, but it is somewhat disconcerting as a liturgical vestment. Red and yellow were the colors of the Spanish flag at that time. It may possibly have been made by a Chinese or Filipino embroiderer recently converted to Christianity whose work continued to employ traditional Asian motifs. VAA

166 ◀ Prelate's Boots

◀ Mexican, 1775–1800
◀ Embroidered satin; height 39 cm. (15 ⅜ in.)
◀ CNCA–INAH, Museo Nacional del Virreinato,
◀ Tepotzotlán 10–12334

Pairs of satin boots, also called buskins, were worn exclusively by bishops during confirmations or ceremonies of the utmost solemnity. When the prelate died he was dressed in cope, miter, gloves, and buskins.

These buskins are made of white silk. The entire surface is embroidered in gold, with some areas also stitched in silk. The figures in silk include cut branches, flowers, and the interiors of the two circular medallions. VAA

REFERENCES
Armida Alonso Lutteroth. "El dibujo y la trama." In *Tepotzotlán: la vida y la obra en la Nueva España*, Museo Nacional del Virreinato. Mexico, 1988, p. 174. **Teresa Castelló Yturbide**. "El traje religioso." In Virginia Armella de Aspe, Teresa Castelló Yturbide and Ignacio Borja Martínez, *La historia de México a través de la indumentaria*. Mexico, 1988, p. 138.

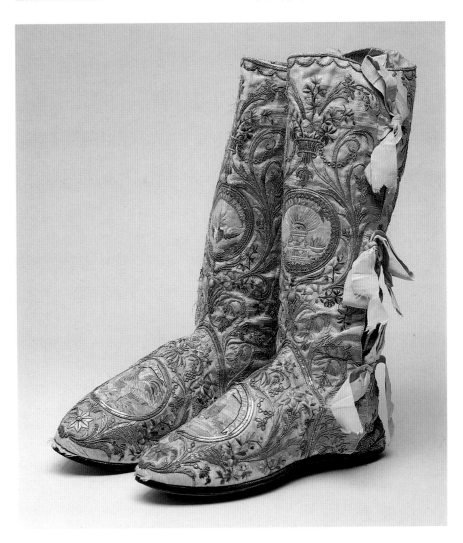

Church Silver

167 ⊰ Martín de Mendiola

Mexican, active mid-sixteenth century

Processional Cross

Mexico City, 1557
White silver; height 83 cm. (32⅝ in.)
Marks: between two pillars, a male head in left
profile with framed crown above and Ḿ below;
lacustrine tower; CONSV/EGRA; −ĒĎLA
Museo Franz Mayer, Mexico City D539
1365/GBC005

The Mexican origin of this cross is confirmed by its complete series of marks stamped in different places. Through these marks, we can identify the provenance, the artist, and even the date of its creation. Three marks pertaining to the assayer Miguel de Consuegra are grouped together: that of the city of Mexico (a variant with the male head turned to his left and the three-pointed vegetal crown inscribed within a pointed framing device); a lacustrine tower (tax stamp?); and his own mark with his surname written on two lines: "CONSV/ EGRA." A fourth mark, which represents the maker ("−ĒĎLA"), is identified with the silversmith Martín de Mendiola.

The date and style are consistent with developments in New Spain, where adherence to traditional formulas was common. It is worth noting in this

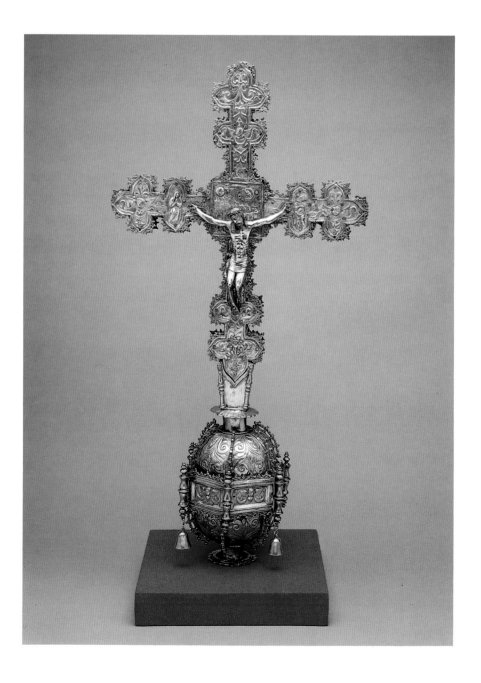

sense that the gothicizing design of the cross must relate to silver workshops in Burgos, while the structure of the knop recalls more closely works from western Andalusia. The decorative vocabulary of the surface ornament, on the other hand, is Renaissance.

Winged angel heads occupy the outer medallions of the lateral arms while the medallions in the shaft contain floral motifs. An image of the crucified Christ sculpted in Renaissance style is seen on the front face; behind this figure is a view of Jerusalem. On the reverse St. Catherine of Alexandria is flanked by the two instruments of her martyrdom (a sword and a spiked wheel); at her feet lies the body of Emperor Maxentius. The knop is decorated with abstract vegetal motifs and small cherub heads as well as small hanging bells.

The present work is important both for its age and for its markings, which document the early date of activity in the silver workshops in the capital.

<div style="text-align: right">CEM</div>

REFERENCE
Cristina Esteras Martín. "Platería virreinal novohispana: Siglos XVI–XIX." In *El arte de la platería mexicana: 500 años*, exh. cat., Centro Cultural de Arte Contemporáneo. Edited by Lucía García-Noriega y Nieto. Mexico, 1989, pp. 124–25, no. 2.

168 ◀ Domingo de Orona

Mexican, 1551–85

Chalice

Mexico City, 1566–72
Silver gilt; height 27.5 (10¾ in.)
Marks: between two pillars, a male head in right profile with crown above and Ḿ below; lacustrine tower; OÑA/TE; ORONA
Victoria and Albert Museum, London M.65-1959

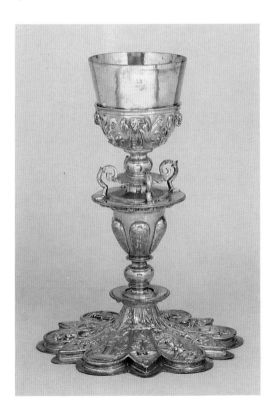

Although it lacks a clearly Mexican style, the origin of this chalice seems to be confirmed by a very complete system of marks stamped on the inner edge of the base. The three that belong to the assayer appear grouped together, and even though the impressions are not completely clear, they are still easy to read although they have been misinterpreted in the past. The assayer's mark separates his family name into two lines: OÑA/TE. The Mexico City mark is incomplete—the crown does not appear because of a defect in imprinting. The third mark consists of a lacustrine tower or castle. These are the same variants that Oñate would use on other occasions.

The name ORONA refers to the silversmith Domingo de Orona, the artisan who crafted the piece. This chalice is the only known surviving example of his work.

The interior of the base is inscribed: "December 8 of the year 1675." This date does not correspond to the style of the work, which is evidently of the 1570s. But in this case the period when the assayer Oñate was active fixes the date between approximately 1566 and 1572, a period that coincides with the activity of Domingo de Orona.

This chalice is of interest for its excellent technical execution and varied ornamentation. Its adornments are taken from a Renaissance repertoire, and the skillfully worked repoussé motifs display a sense of volume. The base shows various emblems of the Passion, the IHS, floral urns, bucrania, and heads of winged angels.

The work's structure seems weakened by the overdevelopment of the knop. This disequilibrium may indicate that this chalice was used as a support for a monstrance.

<div style="text-align: right">CEM</div>

REFERENCES
Charles Oman. *The Golden Age of Hispanic Silver: 1400–1665*. London, 1968, p. 39, fig. 196.
Cristina Esteras Martín. "Platería virreinal novohispana: Siglos XVI–XIX." In *El arte de la platería mexicana: 500 años*, exh. cat., Centro Cultural de Arte Contemporáneo. Edited by Lucía García-Noriega y Nieto. Mexico, 1989, pp. 144–45, no. 12.

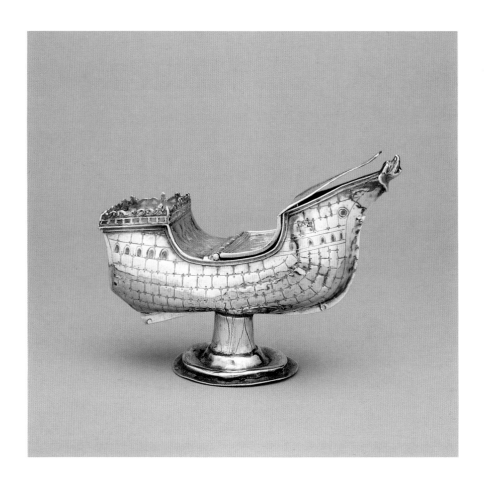

169 ◄ Gabriel de Villasana

Mexican, active second half of 16th century

Incense Boat

Mexico City, 1566–72
White silver; height 14 cm. (5½ in.)
Marks: male head in right profile in the crown
above; lacustrine tower; OÑA/TE;—/SANA
Collection Isaac Backal, Mexico City

Based on a Gothic prototype, this vessel, used for storing incense, is in the form of a ship. The hull imitates a ship's wood joints and includes the line of portholes; the keel is pronounced. The hinged lid opens from the forward half of the bridge toward the bow. The bowsprit takes the form of an animal head. The poop deck has a cast gallery with fleurs-de-lis.

The piece contains a full set of legal marks on the area of the hull close to the bow. The three corresponding to the office of the assayer appear on the left side. This position was occupied by Oñate, whose surname appears in two lines. It is accompanied by the hallmark of Mexico City (incomplete) and a lacustrine tower. The significance of this last mark is still in doubt. At least in 1530 and 1543 it was the seal of the capital of New Spain, but during this period it may have been a sign to indicate payment of royal tax (quinto).

A fourth mark appears on the opposite side from these three marks: the maker's mark "VILL/SANA" (the first line is almost gone), which we interpret as the personal mark of the silversmith Gabriel de Villasana.

The work is unique although not for its design or its technical quality. It is notable for its fully complete markings that show how these regulations were already being followed in the sixteenth century, and for the identification of its artist, especially since this is the only known work with Gabriel de Villasana as the artist and not as the assayer, which is the usual case.

CEM

REFERENCE
Cristina Esteras Martín. "Platería virreinal novohispana: Siglos XVI–XIX." In *El arte de la platería mexicana: 500 años*, exh. cat., Centro Cultural de Arte Contemporáneo. Edited by Lucía García-Noriega y Nieto. Mexico, 1989, pp. 138–39, no. 9.

170 ◄ Chalice

◄ Mexico City, 1575–78
◄ Silver gilt, rock crystal, boxwood, and feathers;
◄ height 33 cm. (13 in.)
◄ Marks: between two pillars, a male head in right
◄ profile with crown above and ℳ below; kneeling
◄ angel
◄ Los Angeles County Museum of Art, Gift of
◄ William Randolph Hearst 48.24.20

The foot of this chalice is adorned with beautifully chased scenes representing the Arrest of Christ, the Last Supper, Christ Carrying the Cross, and the Descent from the Cross. The spoon-shaped spaces contain boxwood reliefs set against feather grounds. They represent scenes of Christ in the Garden of Gethsemane, the Flagellation, St. Veronica, and the Entombment. The figurative decoration is completed by the four Doctors of the Latin Church (Sts. Ambrose, Jerome, Augustine, and Gregory the Great) and the Tetramorph. Four circular cartouches show the emblems of the Passion held by cherubs. The knop is an elaborate octagonal temple with niches containing carved boxwood reliefs of the Twelve Apostles which stand out from a ground of colored feathers. Ionic columns with crystal shafts occupy the angles, and veiled female heads decorate the surface of the cupola. The calyx is decorated with the Four Evangelists between Mannerist *atlantes*.

The entire ornamentation is embossed and chased, and the ground is very finely crosshatched, thus contrasting with and setting off the decorative motifs. Hidden below the pedestal of the stem is the engraved head of a warrior or conquistador, which may be a portrait of the donor (a rare element).

Detail of cat. no. 170

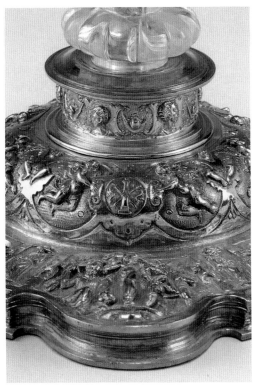

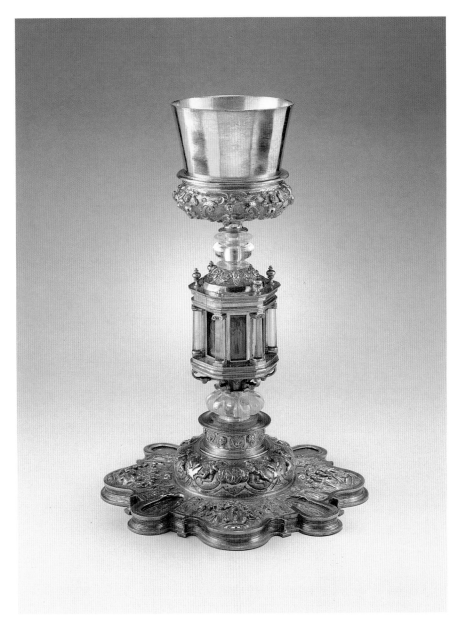

This piece has the marks of Mexico City in various places; some impressions are clearer than others. The mark used here includes the two pillars of Hercules capped by a three-pointed vegetal crown; between the pillars is a male head in right profile, immediately above the initial M̃ (first and last letters of the name of Mexico). The stamp is quadrangular, and the top forms a pointed arch. Near the edge of the chalice is another mark, a vertical rectangle, containing a kneeling angel with large swept-back wings. The identification and meaning of this mark is unknown, but it could correspond to the assayer or the artist.

The design of the piece is based on a Renaissance model, although the ornamental vocabulary includes Mannerist motifs.

This piece is so exceptional that it can be regarded as the most beautiful example of Mexican silverwork of the sixteenth century. This evaluation is based on the fine structural design and the high quality of the silverwork, in which the sculptural beauty and composition of the figurative elements are remarkable. The combination of silver with other very different materials (rock crystal and boxwood) gives the work a rich originality. A most notable feature is its use of colored feathers. The feathers—used in the pre-Hispanic tradition—create chromatic effects (see cat. nos. 119 and 120). Although the piece is European in design, it substitutes this peculiarly indigenous medium of color for the traditional colored enamels.

<div style="text-align: right">CEM</div>

REFERENCES
Charles Oman. *The Golden Age of Hispanic Silver: 1400–1665*. London, 1968, p. 57, figs. 277, 278.
Cristina Esteras Martín. "Platería virreinal novohispana: Siglos XVI–XIX." In *El arte de la platería mexicana: 500 años*, exh. cat., Centro Cultural de Arte Contemporáneo. Edited by Lucía García-Noriega y Nieto. Mexico, 1989, pp. 152–55, no. 15.

171 ◀ Chalice-Monstrance

Mexico City, 1575–78
Silver gilt; height 71 cm. (28 in.)
Mark: between two pillars, a male head in right
profile with crown above and M̃ below
Private collection, Mexico City

This piece consists of a chalice with a monstrance that fits into its bowl. The Host was displayed inside the lower piece of the monstrance, while the upper piece houses a statue of the Savior. The foot of the chalice is decorated with relief busts of the Virgin and of Sts. John the Baptist, Peter, and Paul in the larger fields, alternating with winged cherub heads in the smaller oblong ones.

Although the work is anonymous, it does have hallmarks stamped in various places (the clearest is on the inside edge of the base). This mark, which coincides with that of the chalice in the Los Angeles County Museum of Art (cat. no. 170), confirms the Mexican origin and a date about 1575–78.

This type of chalice-monstrance was found among the various religious orders in New Spain (especially the Franciscans) from 1550 to the early 1600s. Its popularity must be attributed to its double function, which resulted in a reduction of cost.

At this time, the conceptual and formal links between New Spain and the Peninsular silver workshops were still strong; so it is no surprise to find Castilian influence in this work, whose creator can be related to the workshops of Zamora.

<div style="text-align: right">CEM</div>

REFERENCE
Christina Esteras Martín. "Platería virreinal novohispana: Siglos XVI–XIX." In *El arte de la platería mexicana: 500 años*, exh. cat., Centro Cultural de Arte Contemporáneo. Edited by Lucía García-Noriega y Nieto. Mexico, 1989, pp. 82; 146–49, no. 13.

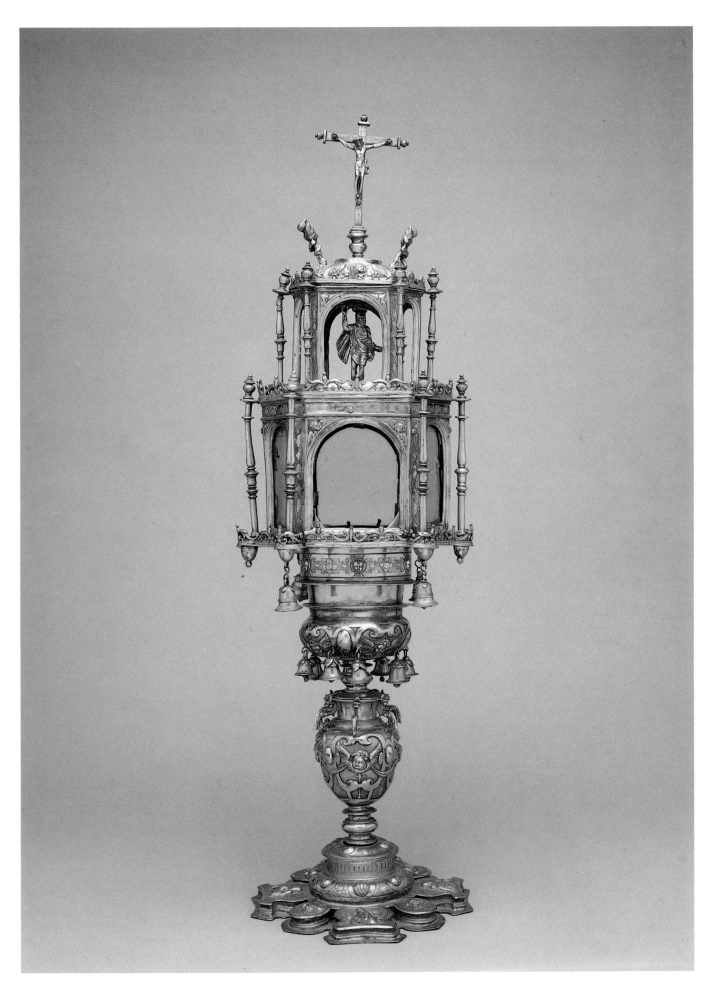

172 ⟨ Cross Reliquary

Mexico City, 1575–78
Silver gilt, rock crystal, blue stones,
and wax seal;
height 41 cm. (16⅛ in.)
Mark: Ṁ between two pillars
Private collection

This reliquary cross is fastened into an impressive rock crystal skull. The oblong foot rests directly on the edge of the base which represents Calvary, combining the irregularities of the terrain with small trees and skulls and crossbones. Four female heads on scallop shells among raised volutes give movement to the bottom portion. On the upper portion is an arrangement of other small figures that are recognizable as Sts. Peter, Mark, and Francis. The presence of St. Francis of Assisi seems to confirm ownership of the piece by the Franciscan Order.

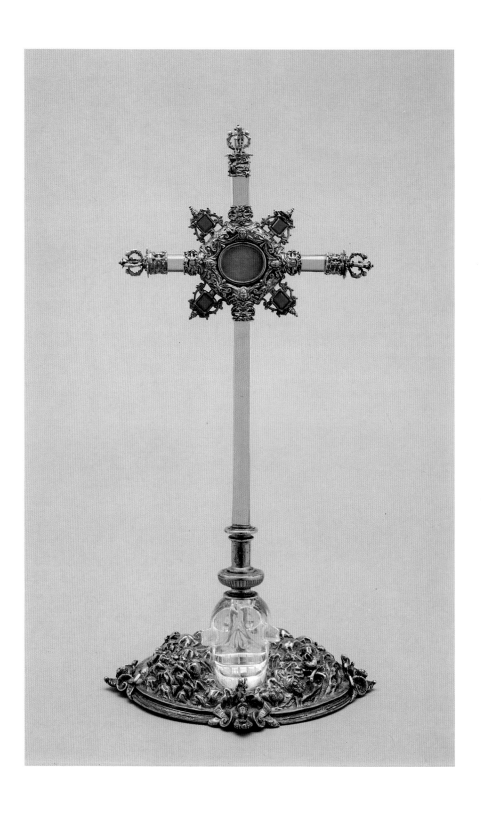

The mark of Mexico City stamped inside the base indicates that the work originated in the capital. Although the impression is defective, the M̊ between two pillars is clearly visible.

This is a work of extraordinary beauty, remarkable for its rich symbolic content. Mannerist forms and elements from Europe are fused with the crystal death's head. The skull, with enormous ocular cavities, very prominent cheekbones, and squared jawbones with complete dentation, has been thought to be Aztec, but more recent opinion inclines to a colonial origin, dating it to the late sixteenth century. In any case, the skull demonstrates the ease with which aesthetic forms from pre-Cortésian cultures were incorporated into religious pieces intended for Catholic worship in the new viceregal society.

Similarly, in this cross reliquary, we can appreciate the impact of the indigenous sensibility not only in the marked dramatic quality of death (the insistence on skulls and crossbones) but in the singular decoration of Calvary: it is disordered, lacks scale, and displays an extremely irregular and almost unreal topography. In short, there is juxtaposition and exaggeration in the ornamentation.

This magnificent work must be considered as a paradigmatic example of "Indochristian" art, which displays the aesthetic fusion of indigenous and Spanish (Christian) cultures.

CEM

REFERENCES
Elizabeth Kennedy Easby and John F. Scott. *Before Cortés: Sculpture of Middle America*, exh. cat., The Metropolitan Museum of Art. New York, 1970, no. 306. **Cristina Esteras Martín**. "Platería virreinal novohispana: Siglos XVI–XIX." In *El arte de la platería mexicana: 500 años*, exh. cat., Centro Cultural de Arte Contemporáneo. Edited by Lucía García-Noriega y Nieto. Mexico, 1989, pp. 83; 156–59, no. 16.

173 ◀ Reliquary of Sts. Peter and Paul

Mexico City, 1579–80
Silver gilt and emeralds; height 47 cm. (18½ in.)
Mark: between two pillars, a male head in right profile with crown above and M below
CNCA–INAH, Museo Nacional del Virreinato, Tepotzotlán 10–241352
EXHIBITED IN NEW YORK ONLY

This pyramidal shaped reliquary was made in Mexico City, according to the hallmark that appears stamped in several places. This mark consists of the traditional coat of arms of the Mexican stamp: male head in right profile over M between columns covered by a crown. However, in this variant the o, which during earlier periods appeared between the head and the M, is omitted.

The piece was given to the Jesuit Colegio Máximo de San Pedro y San Pablo by Don Alonso de Villaseca, the famous Mexican miner whose wealth earned him the epithet "Creso" (Croesus). He commissioned the reliquary for the sumptuous celebrations organized in 1578 by the Jesuits to receive relics sent by Pope Gregory XIII. The commission must have been made between February 1579 and November 1580, when the donor died.

After the expulsion of the Jesuits in 1767, the reliquary became part of the Museo Eclesiástico of the Mexico City Cathedral and was transferred to the Museo Nacional del Virreinato during the present century.

This is an exceptional work of the Late Renaissance that shows the extraordinary creativity and very high caliber of Mexican silversmiths in the sixteenth century. The Mannerist ornamental repertory includes fruits and foliage, geometric forms, and rollwork, interspersed with figurative elements

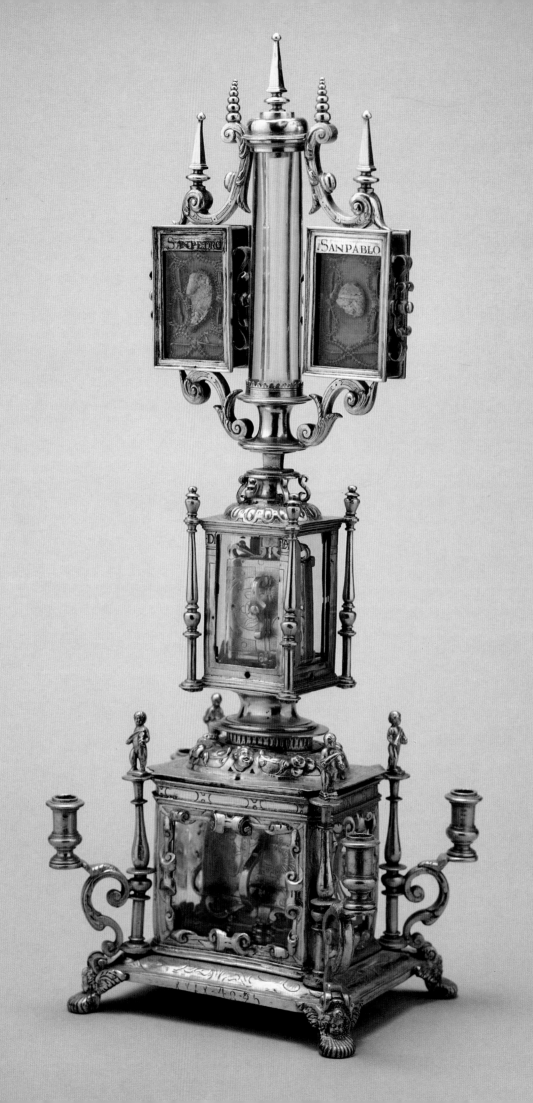

174

such as cast figures of children and embossed heads of putti. Its anonymous creator must have been one of the finest in the viceregal capital, perhaps the prestigious Juan de Torres who was commissioned by Archbishop Moya y Contreras to create important works for the Cathedral.

CEM

REFERENCES
Artemio de Valle-Arizpe. *Notas de platería*. Mexico, 1941, fig. 29. **Manuel Toussaint**. *La catedral de México y el sagrario metropolitano. Su historia, su tesoro, su arte*. Mexico, 1948, fig. 88. **Manuel Romero de Terreros y Vinent**. *Las artes industriales en la Nueva España*. 2d ed., revised and annotated by Maria Teresa Cervantes de Conde and Carlota Romero de Terreros de Prévoisin. Mexico, 1982, fig. 28. **Cristina Esteras Martín**. "Platería virreinal novohispana: Siglos XVI–XIX." In *El arte de la platería mexicana: 500 años*, exh. cat., Centro Cultural de Arte Contemporáneo. Edited by Lucía García-Noriega y Nieto. Mexico, 1989, pp. 162–63, no. 18.

174 ⟨ Crosier

Mexico City (?), about 1650
Tortoiseshell and silver gilt; height 155 cm. (61 in.)
CNCA–INAH, Museo Nacional del Virreinato,
Tepotzotlán 10–240722/OR/02–0201

An exquisite and rare work of great artistic and technical quality, this crosier is in an excellent state of preservation despite the fragility of tortoiseshell. Since it does not display any of the prescribed markings for silverwork, it is impossible to determine the artistic center where it was produced, much less the name of its creator. Mexico City must be considered as a possibility. It should probably be dated about 1650; although the knop still shows clearly. Mannerist traits, the decoration of the crook itself already displays the more naturalistic qualities of Baroque ornament. The crosier may correspond to that listed in the 1649 Cathedral inventory as having come from the treasury of Bishop Feliciano de la Vega (some scholars believed that it may have belonged to the venerated image of St. Peter in the Cathedral).

CEM

REFERENCES
Artemio de Valle-Arizpe. *Notas de platería*. Mexico, 1941, fig. 73. **Manuel Toussaint**. *La catedral de México y el sagrario metropolitano. Su historia, su tesoro, su arte*. Mexico, 1948, p. 234. **Manuel Romero de Terreros y Vinent**. *Las artes industriales en la Nueva España*. 2d ed., revised and annotated by María Teresa Cervantes de Conde and Carlota Romero de Terreros de Prévoisin. Mexico, 1982, p. 24, fig. 3. **Cristina Esteras Martín**. "Platería virreinal novohispana: Siglos XVI–XIX." In *El arte de la platería mexicana: 500 años*, exh. cat., Centro Cultural de Arte Contemporáneo. Edited by Lucía García-Noriega y Nieto. Mexico, 1989, pp. 87, 200–201, no. 37.

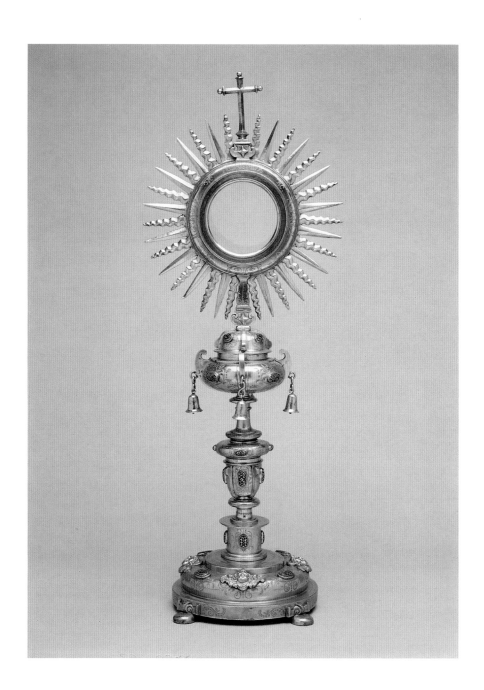

175 ◀ **Monstrance**

◀ Mexico City (?), 1650–75
◀ Silver gilt and enamel; height 65 cm. (25 ⅝ in.)
◀ CNCA–INAH, Museo Nacional del Virreinato,
◀ Tepotzotlán PROC

The lack of marks does not permit a definitive statement as to the place of origin, although the structural type and adornment are characteristic of the silversmith shops of Mexico City. The plastic treatment of the angels' heads is fully Baroque, while the details of the hair (abundant curls, pompadour, and a lock on the forehead) show a typically Mexican formula. The use of stippling to delineate ornamental motifs taken from nature fixes the monstrance's date to between 1650 and 1675.

CEM

REFERENCE
Cristina Esteras Martín. "Platería virreinal novohispana: Siglos XVI–XIX." In *El arte de la platería mexicana: 500 años*, exh. cat., Centro Cultural de Arte Contemporáneo. Edited by Lucía García-Noriega y Nieto. Mexico, 1989, pp. 202–3, no. 38

176 ⟨ Processional Cross

Mexico City, about 1655
White silver; height 86 cm. (33⅞ in.)
Marks: between two pillars, a male head in right
profile with crown above and ℳ below; ENA
Museo Franz Mayer, Mexico City D538/01346

Hallmarks corresponding to Mexico City appear on various parts of the arms and the lower stem of this cross. The particular mark coincides with those found on the monstrances from Fuente del Maestre (Badajoz) and Busturia (Vizcaya, Spain), the paxes of Santoyo (Palencia), and a chalice in the Museo Franz Mayer (Mexico City), all pieces datable between 1660 and 1670. A second signature mark appears in an indistinct impression on the stem and shows the surname ENA. It can now be identified, with some reservation, as the mark of Francisco Ena, who may have been the assayer of the piece. If present knowledge is correct in fixing the activity of this silversmith between 1649 and 1662, then this cross can be dated between these years; I am inclined, however, to date it about 1655.

This is a fine Baroque work of excellent artistic quality. The front face displays a separately cast Mannerist corpus. Behind it, in the central medallion of the crossing, Jerusalem is represented as a cityscape. Small winged cherub heads and groups of flowers occupy the arms. The iconography and decoration is identical on the reverse, with the exception of the medallion at the crossing that shows the Virgin of the Immaculate Conception. The knop

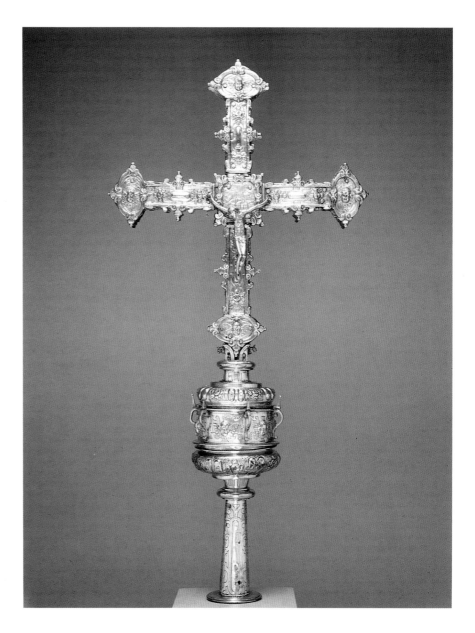

includes winged cherub heads in high relief. The surfaces of the hemispheres are covered with flowers and pairs of bosses. The lower stem, in the shape of a truncated cone, is adorned with abstract geometric motifs and elongated repoussé bosses. Its design is based on a model disseminated in the viceregal capital at least since 1630, the year in which I date a closely analogous processional cross in the Museo Nacional del Virreinato, Tepotzotlán. The type had a long life and was repeated into the eighteenth century.

CEM

177 ◀ Hanging Lamp

Mexico, about 1675–1700
White silver; height 80 cm. (31½ in.)
Mark: between two pillars, a male head in left profile with crown (barely visible) above and IV below
Museo Franz Mayer, Mexico City A–095/06835/
GLA–18

This exceptional piece was created by a silversmith skilled in drawing and composition. It is striking for the beauty and fineness of its engraved ornamentation, in which Mannerist decorative motifs are woven into a dense network of fine lines without losing their clarity. The piece has stylistic traits typical of Baroque works from New Spain in the second half of the seventeenth century, and the sinuous profile of the basin brings to mind the last quarter of that century. The basin hangs from four chains, and the small oil lamp is suspended from four other chains. All the links that form these chains are identical; the chains are attached to lions' heads.

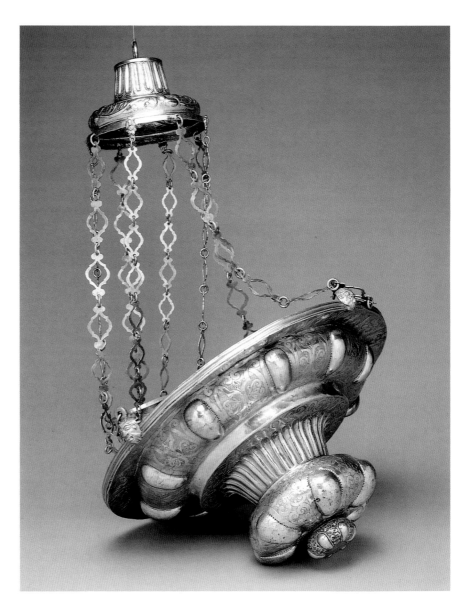

This piece is stamped with an incomplete town mark, the initials IV corresponding to the name of an as yet unidentified city in which the piece was made.

<div align="right">CEM</div>

REFERENCE
Cristina Esteras Martín. "Platería virreinal novohispana: Siglos XVI–XIX." In *El arte de la platería mexicana: 500 años*, exh. cat., Centro Cultural de Arte Contemporáneo. Edited by Lucía García-Noriega y Nieto. Mexico, 1989, pp. 220–21, no. 47.

178 ◀ Monstrance

◀ Oaxaca(?), 1694
◀ Silver gilt with enamel; height 70 cm. (27⅝ in.)
◀ Museo Franz Mayer, Mexico City
◀ F249/02577/GCI–0024

An engraved inscription circles the smooth border of the base of this monstrance: "HIZOSE SIENDO MAYORDO. EL CAPN. FRANCO. PRIETO GALLARDO Y CURA EL BR. DE LA ROCHA Y CAZERES. AÑO 1694 PCDAI FECIT" (Made when Captain Franco Prieto Gallardo was mayor and Brother de la Rocha y Cazeres was priest; PCDAI made it in the year 1694).

The piece, which has no visible markings, is dated 1694 in the inscription, and although the artist's name is included in an anagram (PCDAI), this maker has not been identified.

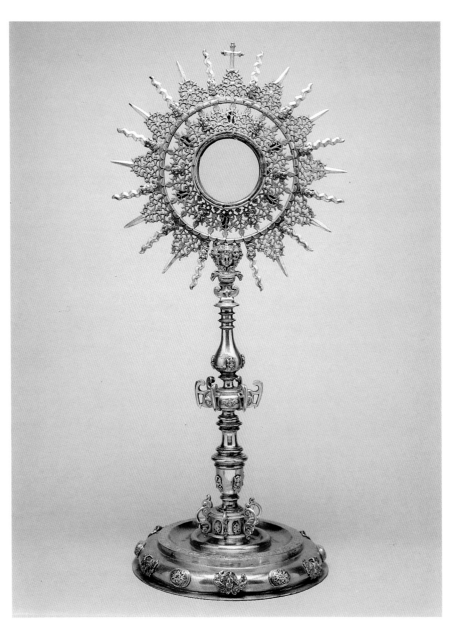

The design of this work is unusual—especially in regard to the gloria—although it does include elements common in monstrances of 1650–1700. For instance, the elaborately developed stem and the brackets that decorate its sections correspond to this period. The artist was a silversmith of broad imagination who succeeded in creating a slender and elegant work by swelling the shaft above the central knop. It is an exquisite and original work of seventeenth-century Baroque style, still impregnated with the kind of Mannerist language that delights in playing with unstable structures by narrowing the stem to make it appear more fragile in relation to the size of the sun—without, however, losing its sense of proportion. As a whole, and in view of its features, the piece appears to have been made in a regional center with a distinct personality, and its type suggests Oaxaca.

CEM

REFERENCE
Cristina Esteras Martín. "Platería virreinal novohispana: Siglos XVI–XIX." In *El arte de la platería mexicana: 500 años*, exh. cat., Centro Cultural de Arte Contemporáneo. Edited by Lucía García-Noriega y Nieto. Mexico, 1989, pp. 224–25, no. 49.

179 ◀ Candlesticks

◀ Mexico, about 1700
◀ White silver; height 38 cm. (15 in.)
◀ Marks: anagram (illegible) within oval
◀ Museo Franz Mayer, Mexico City F–257/F–258/
◀ 0257201/02573–03/GCI–069

In the frieze along the bottom of the base, an engraved inscription reads: "SIRVO ANVESTRA. Sa. DEL ROSARIO DE LA COFRADIA DEL PVEBLO" (I serve Our Lady of the Rosary of the Confraternity of the People). The only other marking is indistinct but seems to contain interlaced letters within an oval. Therefore the assayer and maker or workshop cannot be determined. The stylistic traits of the candlesticks, however, conform to models from silver workshops

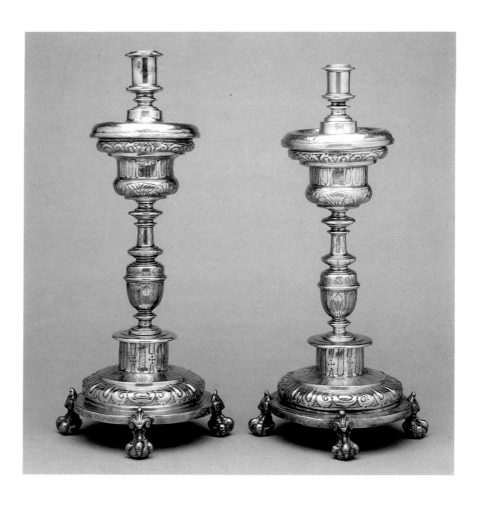

across New Spain, from Veracruz to Guanajuato, Mexico City, and other places in the viceroyalty. This standardization makes exact classification of the pieces difficult.

These candlesticks retain the structure of seventeenth-century pieces with a strong element of Mannerist language in the decoration, but the curved lines of the bowl and the motifs drawn from nature classify them as Baroque. They are thus transitional works from the late seventeenth or early eighteenth century.

CEM

180 ◀ **Processional Cross**

◀ Mexico, about 1700
◀ White silver, partially gilt; height 55 cm. (21⅝ in.)
◀ Museo Franz Mayer, Mexico City 3–301/06230
◀ GCV–0072

The absence of legal markings on this cross does not prevent a secure identification of Mexican origin, given that its structure, decoration, and iconography repeat a model that became standard in the capital of New Spain from the 1630s until the 1750s.

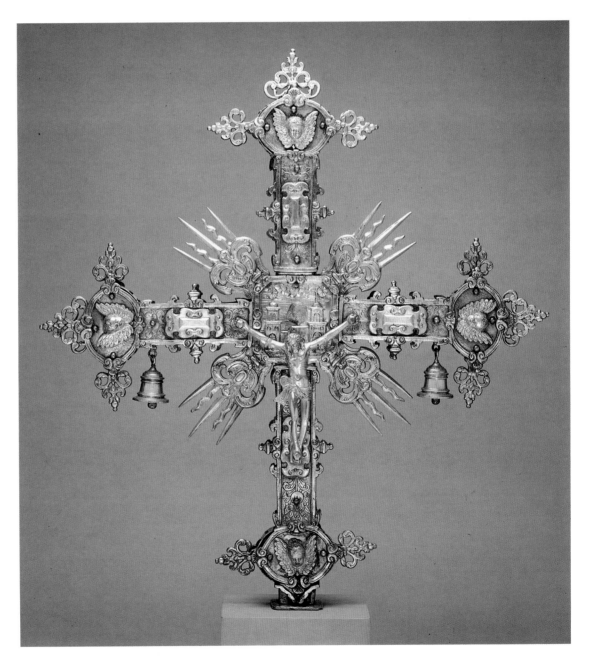

Lightly embossed leaves and flowers and applied cartouches and cherub heads decorate the cross. Large, rayed *potencias* emerge from the angles between the arms, and florid finials grace the ends of the cross. The corpus on the face hangs from three nails and wears a short loincloth. Behind its head, on the central medallion, Jerusalem is represented by a cityscape with orientalizing architecture. A cartouche with foliate decoration is engraved on the reverse, with a crude applied figure of the apostle St. James.

The long survival of Mannerist ornamentation (cartouches, mirrors, knobs, and finials) in New Spanish silver workshops does not prevent us from describing this work as Baroque. The use of more naturalistic forms (in the *potencias*, for example), the pronounced color contrast between gold and silver, and the rich ornamentation—that serves as decoration as well as to break the profile—determine its classification within this style.

A precise dating of the work is a more complex task since the knop and stem, the elements most susceptible to change and modernization, have been lost. This leaves only the cross, for which I propose a date of about 1700.

CEM

REFERENCES
Manuel Toussaint. *Colonial Art in Mexico.* Translated and edited by Elizabeth Wilder Weismann. Austin and London, 1967, p. 259, fig. 235. **Cristina Esteras Martín.** "Platería virreinal novohispana: Siglos XVI–XIX." In *El arte de la platería mexicana: 500 años,* exh. cat., Centro Cultural de Arte Contemporáneo. Edited by Lucía García-Noriega y Nieto. Mexico, 1989, pp. 228–29, no. 51.

181 ◀ Chalice

Puebla, about 1725
Silver gilt; height 23.5 cm. (9¼ in.)
CNCA–INAH, Museo Nacional del Virreinato,
Tepotzotlán 10–12055

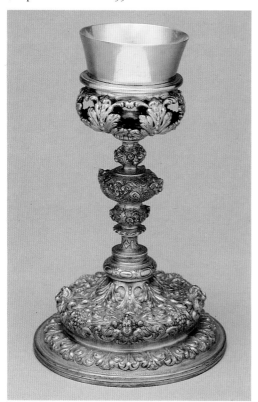

This chalice, which has no marks, repeats a model that originated in the workshops of Puebla de los Angeles. Examples with analogous structure and decoration can be found in the chalices of Icod de los Vinos, Tenerife, and Cordobilla de Lácara, Badajoz. This *poblano* type is enriched in the present chalice with a calyx of greater originality, transformed into an openwork corolla that contrasts with the more compact solutions of the standard examples.

Like all of the *poblano* works of the first half of the eighteenth century, this chalice is characterized by the loosening of the profile throughout with smooth curves and an exuberant and dense naturalistic decoration of leaves and bunches of grapes. As for its date, the bulbous resolution of the neck of the stem and the presence of ornamental motifs rooted in Mannerism—such as winged cherubs, curved-sided rhombuses, and engraved oval bosses—points to a date about 1725.

Made of silver gilt, this example is one of the masterpieces of *poblano* Baroque. It was originally the property of the Cathedral of Mexico City.

CEM

REFERENCES
Artemio de Valle-Arizpe. *Notas de platería.* Mexico, 1941, fig. 45. **Manuel Toussaint.** *La catedral de México y el sagrario metropolitano. Su historia, su tesoro, su arte.* Mexico, 1948, color pl. between pp. 324–25. **Cristina Esteras Martín.** "Platería virreinal novohispana: Siglos XVI–XIX." In *El arte de la platería mexicana: 500 años,* exh. cat., Centro Cultural de Arte Contemporáneo. Edited by Lucía García-Noriega y Nieto. Mexico, 1989, p. 99, pl. 113.

182 ◀ Monstrance

Pachuca(?) or Puebla(?), about 1745
Silver gilt; height 68 cm. (26¾ in.)
Marks: between two pillars, a male head in right
profile with crown above and P below
CNCA–INAH, Museo Nacional del Virreinato,
Tepotzotlán 10–12174

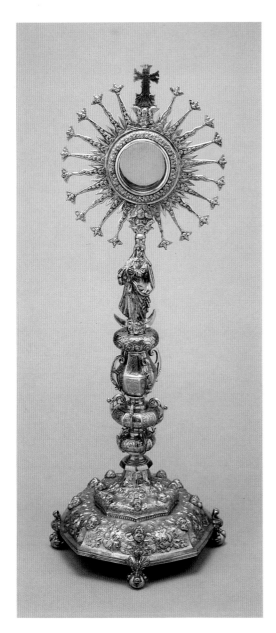

A comparison between this piece and other monstrances from Puebla, like those of Salvatierra de los Barros, Cordobilla de Lácara, or the Santuario de Ocotlán, seems to indicate a common origin. The type is based fully on the traditional model for monstrances created in the silver workshops of Puebla de los Angeles, especially in regard to the design of the gloria, the sense of juxtaposition of the elements of the stem, and the ornamental treatment of the foot. Yet unlike the other pieces, the work has a mark on the small stem that connects the gloria to the statue: it consists of a male head in left profile over a P inside a pair of pillars crested with a crown; the outline of the stamp is quadrangular.

This hallmark suggests identifying it with the city of Puebla, as the initial P could allude to the name of the city. Yet Puebla never had an assayer's office, and the pieces made there had to be stamped in the viceregal capital. The mark could perhaps indicate that the monstrance was made in another silverworking center, despite its evident *poblano* style, or that it was made in Puebla but later stamped somewhere else.

It has been reported that the piece came from the state of Hidalgo when it entered the treasury of the Cathedral of Mexico City. It is possible that the stamp could be that of Pachuca (the capital of Hidalgo), one of the most important silver-mining areas in the viceroyalty, where there was indeed an office of the Cajas Reales. If the monstrance was made in Puebla and marked in Pachuca or if it was created and stamped in Pachuca, this may indicate an artistic relationship between the neighboring states of Hidalgo and Puebla. More information is needed, however, to confirm this hypothesis. If the stamp does in fact represent the city of Pachuca, the attributions of similar pieces, which have been assigned origins as distant as San Luis Potosí, will have to be rethought.

Stylistic traits place this piece at about 1725–50, although the octagonal design—in the base as well as the stem—suggests a date close to 1745 as, at least in the silver workshops in Puebla, the taste for polygonal forms solidified at midcentury.

The upper zone of the base is decorated with bunches of fruit and angel heads, four of them with scallop shells over their heads. Floral motifs occupy the lower base zone, along with the cherubs repeated from the upper. The very long stem, composed of three urn elements with different designs plus the crown in the shape of a bull, has at the top a sculpted figure of the Virgin of the Immaculate Conception. Resting on her head is the gloria, formed by straight and undulating rays that terminate in winged cherub heads. The cross at the apex is a modern addition.

From an artistic point of view the quality of the piece is very high. Outstanding among its features are the rich plastic qualities of the adornments of the base that convert the piece into a fully Baroque work. Especially striking is the pronounced sensation of instability resulting from the four angles of the base that hang unsupported—an optical instability as the piece is perfectly balanced on the four supports provided by the claw-and-ball feet.

CEM

REFERENCES
Artemio de Valle-Arizpe. *Notas de platería.* Mexico, 1941, figs. 18, 19. **Manuel Toussaint.** *La catedral de México y el sagrario metropolitano. Su historia, su tesoro, su arte.* Mexico, 1948, p. 231, fig. 60B.

◀ Mexico, about 1750
◀ White silver, partially gilt; 97 x 249 cm.
◀ (38⅛ x 98 in.)
◀ SEDUE, Catedral de Saltillo

This frontal is composed of thick sheets of repoussé and engraved silver, mounted on a wooden frame; its structure imitates the linen frontals that normally decorate the altar during liturgical celebrations. On the body of the frontal, among fleshy, undulating stems, leaves, and flowers, three Mannerist cartouches frame reliefs of Christ on the Cross (center), the Virgin (to his right), and St. John (to his left); these medallions, representing the traditional, devotional Crucifixion, were gold-plated for heightened color contrast.

This piece lacks identifying marks, and since the archive of the Cathedral contains no sources that could be used for classification, this must be made on the basis of stylistic analysis. Its rampant naturalist decoration, repoussé technique, and treatment of volume and curve suggest a work of the High Baroque. This same Baroque sensibility is found in the distribution of motifs which, far from being grouped in reticulate and compartmentalized compositions typical of the seventeenth and the first quarter of the eighteenth century, find distinct liberty of movement; a horror vacui may be evident, but the treatment in relief of the ornamentation allows a perfect equilibrium between the background and the decorative idiom. The work, therefore, can be dated about 1750, the same period in which the Cathedral chapel was completed (1745). This frontal, now located on a transept altar, was originally executed for the altar of Santo Cristo, situated in the chapel, which since 1762 has been dedicated to the veneration of the famous carving of the Crucifixion. Moreover, the frontal belongs stylistically to the time when the chapel was built and the sacred image placed there, and its iconographic program (the theme of Calvary) corresponds to that of the sculpture.

An unresolved problem is assigning a definite origin to the frontal. The artistic dependence of Saltillo on San Luis Potosí, another very important center for silverwork, suggests its origin in the silversmiths' shops of that city, although this hypothesis cannot be proved until analogous examples are found. Zacatecas is another possibility because of its relative proximity, and a certain parallel can be seen with works created in Puebla de los Angeles and with the ornamental idiom employed in the 1744 sacrarium of the parish church of San Pedro in Huelva, Spain.

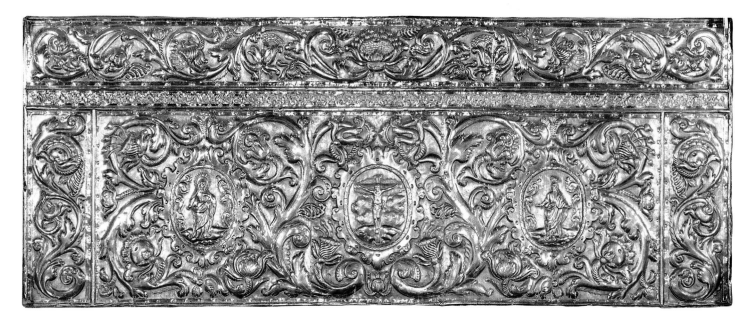

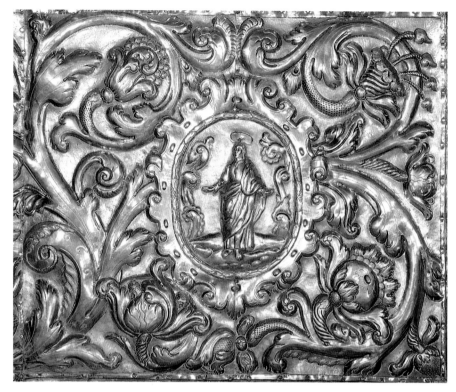

Details of cat. no. 183 (above and below)

Regardless of whether the frontal was created in San Luis Potosí, Zacatecas, Puebla, or in any other of the important silverworking centers of New Spain, this is a piece of exceptional beauty and quality, undoubtedly the best of all the known High Baroque frontals. A particularly significant characteristic of its Mexican origin is the curious treatment of the curly, puffy clouds that cover the background of the medallion depicting the Crucifixion; this is a solution directly connected to work executed in China and the Philippines.

CEM

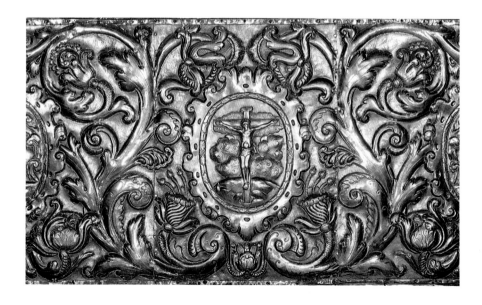

184 ⟨ Chalice

⟨ Mexico City, 1760–70
⟨ Silver gilt; height 26 cm. (10¼ in.)
⟨ Marks: crowned M; GŌSA/LE–; flying eagle
⟨ SEDUE, Museo de la Basílica de Guadalupe,
⟨ Mexico City

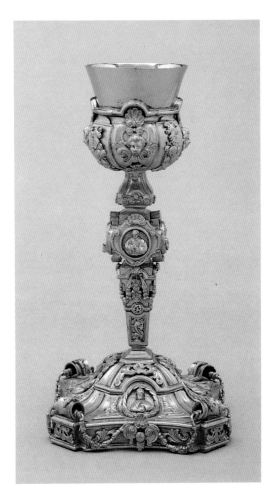

This chalice is adorned with busts of the Doctors of the Latin Church (Sts. Ambrose, Jerome, Augustine, and Gregory the Great). The stem is a handsome, richly ornamented *estípite*: on its base the motifs are drawn from nature (garlands, flowers, and leaves), while on the central cube they are figurative (circular moldings with the four Evangelists). The entire work is cast, and a graver was employed for its finishing.

The base bears three marks: that of Mexico City (an M with a three-pointed crown), that of the treasury (a flying eagle), and the personal mark of the assayer Diego González de la Cueva (GŌSA/LE–; the final consonant is missing). It also displays the sign of the "burin stroke" as proof that the silver was analyzed to determine its quality. Only the maker's mark is missing—at least, it does not appear in a visible spot.

An engraved inscription inside the foot reads: "VICENTE GUTIERREZ PALACIOS. PUEBLA, 12 OCTUBRE 1895." This date refers to one of the chalice's last owners or donors. Because of its style and markings, the piece should be dated in the 1760s, for although the *estípite* had been used as a support by Don Gerónimo Balbás at an earlier date, here the formal design and the decorative idiom—especially the *pinjantes* (angels beneath scallop shells) and the circular moldings—show the clear influence of the later architects Lorenzo Rodríguez and Iniesta Bejarano. The interrelationship of silverwork and architecture is demonstrated in this work and finds its closest parallel in the portal of the Sagrario Metropolitano attached to the Cathedral of Mexico City.

Despite the undoubted success and diffusion of the *estípite* support during the mid-eighteenth century, few examples of metalwork survive in which this support appears.

The anonymous author of this singular piece might very well have belonged to the important group of Andalusian silversmiths (from the area of Seville and Cadiz) working in Mexico City at midcentury, the most outstanding of whom include Juan de Ecija, Francisco de Peña Roja, Juan Pardo de Figueroa, and Manuel Benítez de Aranda.

CEM

REFERENCES
Artemio de Valle-Arizpe. *Notas de Platería.* Mexico, 1941, figs. 43. **Cristina Esteras Martín.** "Platería virreinal novohispana: Siglos XVI–XIX." In *El arte de la platería mexicana: 500 años*, exh. cat., Centro Cultural de Arte Contemporáneo. Edited by Lucía García-Noriega y Nieto. Mexico, 1989, pp. 105–6, 292–93, no. 83.

185 ⟨ Tabernacle Door (Discoverer)

⟨ Mexico, 1770–80
⟨ White silver, partially gilt; height 73.5 cm. (29 in.)
⟨ Collection Isaac Backal, Mexico City

The central motif of this double-leafed door is a sunburst monstrance placed below a canopy and an imperial crown. Two angels draw back the curtains while two others kneel praying next to the monstrance. Symmetrical embossed Rococo motifs appear over the surface. The double-leafed format and large dimensions of the piece and the fact that its principal motif is a monstrance indicate that it is a tabernacle door which, when opened at the high altar, would have exposed a monstrance holding the Holy Eucharist.

Although the piece lacks any markings that might reveal its provenance, its Rococo style offers us a date: about 1770–80. During this decade the Rococo

was at its height in Mexico City; it then spread gradually to silver workshops throughout the viceroyalty.

Indigenous influences are seen in the features of the angels, and the ornamental motifs are disproportionate in scale. These elements lead one to think that the piece was created in a secondary regional workshop by an artist more preoccupied with ornamental effects than with the norms of composition. It is interesting because few works of this kind survive and because the monstrance represented in the relief may correspond to an actual model or at least indicate a type produced by that workshop. The decoration of the base is unusual for its clearly eucharistic symbolism: bunches of grapes and vine leaves.

CEM

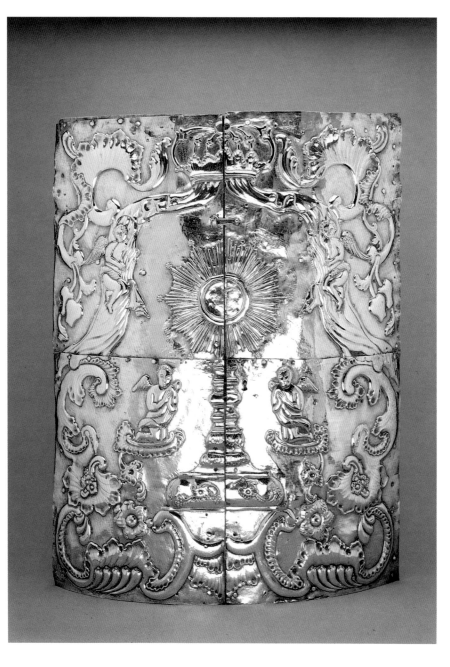

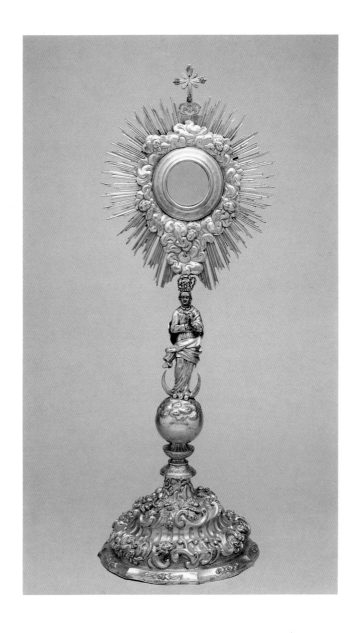

186 ◀ Monstrance

◀ Mexico City, about 1780
◀ Silver gilt, pearls, and diamonds; height 80 cm.
◀ (31½ in.)
◀ Museo Franz Mayer, Mexico City 6–66 05590
◀ GCY–34

Although the piece is unmarked, this monstrance is so like those made in the silversmith shops of Mexico City that it can unhesitatingly be attributed to the viceregal capital. Its adornment is Rococo in style. The stem is composed of a sculpture of the Virgin supported by the sphere of the world; a string of pearls and diamonds on the crown heightens her beauty. (The Virgin was a popular element in Rococo iconography.)

This monstrance is notable for its excellent workmanship and especially for its elegant formal design. The chromatism is remarkable in its ornamental motifs (angels and clouds) and in the Virgin's skin.

CEM

REFERENCE
Cristina Esteras Martín. "Platería virreinal novohispana: Siglos XVI–XIX." In *El arte de la platería mexicana: 500 años*, exh. cat., Centro Cultural de Arte Contemporáneo. Edited by Lucía García-Noriega y Nieto. Mexico, 1989, pp. 306–7, no. 90.

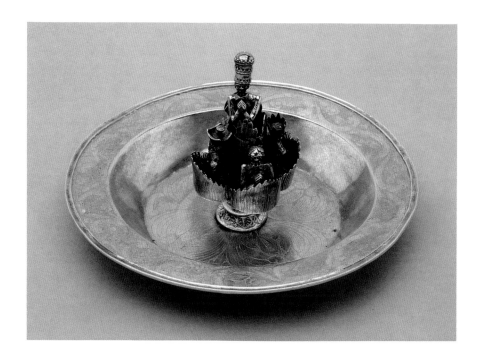

187 ◀ Alms Plate

◀ Puebla(?), 1783
◀ Silver; diameter 21 cm. (8¼ in.)
◀ Collection Isaac Backal, Mexico City

The underside of this alms plate is inscribed: "LO ISO D. QUIRINO HERNANDES, EL AÑO DE 83 POR DISPOSISION DEL SR. CURA D. ANASTASIO SIMON" (D. Quirino Hernandes made this, the year of 83, by order of the Rev. Father D. Anastasio Simón). This dates the piece 1783 and may reveal the name of the craftsman, Quirino Hernández, although such an inscription could refer to the donor or even to the majordomo of the Confraternity of Souls.

Since the piece lacks the marks that could serve as orientation and its style, at present, is not defined, it seems risky to assign the piece to a specific artistic center, although the fact that it was obtained in Puebla leads me to think that it was made in the silversmith shops of this city or region.

Many of the numerous alms plates manufactured in New Spain are dedicated to the souls in Purgatory (this type is rare in South America). In this example, a sculptural group in the center alludes to souls in the flames of Purgatory: a bishop, a priest, a king, and a man appear on the first level, and from their midst a pope emerges. This alms plate is remarkable for this daring iconography which shows monarchs and the highest members of the Church hierarchy together with other suffering souls.

CEM

REFERENCE
Cristina Esteras Martín. "Platería virreinal novohispana: Siglos XVI–XIX." In *El arte de la platería mexicana: 500 años*, exh. cat., Centro Cultural de Arte Contemporáneo. Edited by Lucía García-Noriega y Nieto. Mexico, 1989, pp. 328–29, no. 100.

188 ◀ José de Isunza(?)

◀ Mexican, active late 18th century

◀ Lamp

◀ Puebla, about 1785
◀ Silver gilt; height 207 cm. (81½ in.)
◀ SEDUE, Santuario de Nuestra Señora de Ocotlán, Tlaxcala

This very large votive lamp, one of a pair hanging over the high altar of the Santuario, is executed in hammered silver. It has no inscriptions giving the donation or commission, as is usual with this sort of work; it also lacks markings. The faceted structural design and the rocaille decoration are strongly Rococo. For this reason, an attribution to the silversmith Antonio Fernández appears incorrect[1]—this master was active between 1730 and 1760, and his works are informed by the Baroque spirit of the first half of the century. A

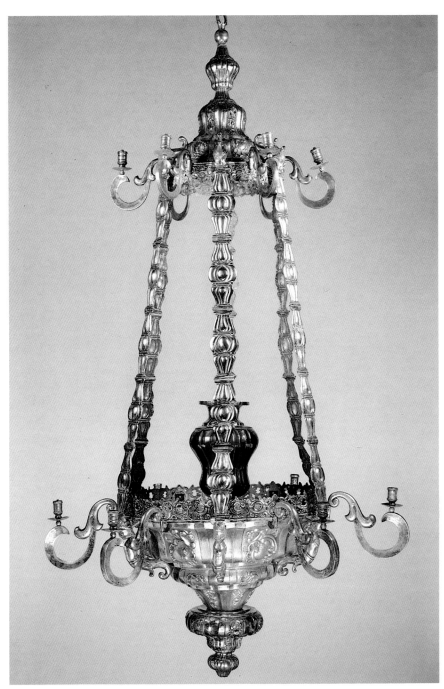

188

more likely candidate is José de Isunza, the prominent *poblano* silversmith
who undertook several commissions for the Ocotlán sanctuary in 1788.

The piece has an unmistakable *poblano* style. The fantastic brackets in
the form of Mannerist *atlantes* are characteristic of silversmiths in Puebla
who produced them throughout the eighteenth century. This lamp is a wor-
thy representative of Puebla de los Angeles, the second most important center
of silver production in the viceroyalty.

CEM

1. Angel Santamaría, "Santuario y Basílica de nuestra Señora de Ocotlán, Tlaxcala," *Monografías
de arte sacro* no. 15 (January, 1987), p. 14.

REFERENCES
Fray Carlos Céspedes Aznar. "La plata labrada del Santuario de Nuestra Señora de Ocotlán."
Ocotlán (Tlaxcala) no. 16 (1941). **Cristina Esteras Martín.** "Platería virreinal novohispana: Siglos
XVI–XIX." In *El arte de la platería mexicana: 500 años*, exh. cat., Centro Cultural de Arte Con-
temporáneo. Edited by Lucía García-Noriega y Nieto, Mexico, 1989, p. 100, pl. 114.

189 ◀ **Manuel Barrientos Lomerín**

Mexican, active late 18th century

Candlesticks

Mexico City, 1790
White silver; height 64 cm. (25 ¼ in.)
Marks: crowned M; eagle on a nopal cactus; FRDA;
BARRI/ENTOS
Museo Franz Mayer, Mexico City FO11/024111/2
3GC1–049

These two candlesticks are part of a set of the six required for the liturgy. All six are preserved, but their corresponding altar cross is missing. One of the candlesticks has an engraved inscription on the foot that reads: "SE YSIERON ESTOS BLANDON, EL AÑO DE 1790 SIENDO CURA EL SEN, DN. JOSE BARRIENTS LOMERIN, Y MAYORDOMO DN. MARCELO ROJAS" (These candlesticks were made in 1790 while D. José Barrients Lomerin was priest and D. Marcelo Rojas was majordomo). All of them, however, are marked with the legal stamps required for Mexican silver and with the assay groove (*burilada*) left by the assayer's burin when the metal was scratched to verify its quality.

The clarity of the four stamps permits precise analysis and makes possible an exact classification of the pieces. They were marked by the chief assayer Antonio Forcada y la Plaza, who on this occasion used his personal mark "FRDA" to accompany the other two marks within his competence: that of Mexico City (crowned M) and a tax stamp (eagle on a nopal cactus). The maker's mark reads "BARRI/ENTOS," a mark as yet unidentified but which I

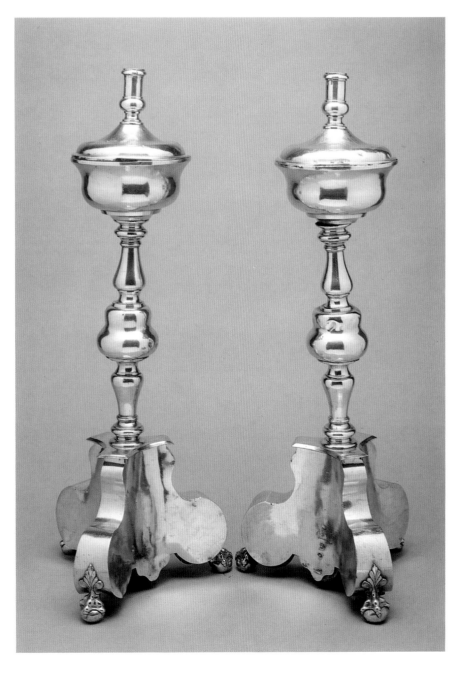

attribute here to Manuel Barrientos Lomerín, a silversmith examined as a master on January 8, 1779.

The date of the candlesticks is established by the engraved inscription which states expressly: "SE YSIERON . . . EN EL AÑO DE 1790." Until now, Antonio Forcada's known activity as assayer had been restricted to the years 1791–1818, but these candlesticks show that he already occupied that position by 1790.

The inscription also states the name of the priest who commissioned the candlesticks: José Barrientos Lomerín. His surname suggests that he may have been a close relative (perhaps a brother) of the maker, which may have dictated his choice of silversmith for the job.

The works are based on Baroque models, notable in the sinuous structure of the bases and its typical triangular scheme. However, the absence of ornament and the favoring of burnished surfaces and elegant profiles announce the approach of Neoclassical tendencies. This is not surprising; Manuel Barrientos was a master formed by the Rococo, but his artistic evolution, like that of most Mexican silversmiths of the era, must have moved gradually toward classicizing design.

These works were created during the artist's maturity (eleven years after he was named master), and they are notable for their strong technique and their singular markings. They are at present the only known works by Manuel Barrientos Lomerín.

CEM

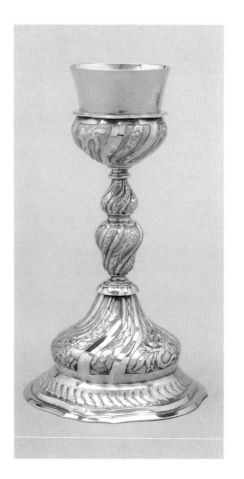

190 ⟨ José María Rodallega

Mexican, 1772–1812

Chalice

Mexico City, about 1795
Silver; height 24.5 cm. (9⅝ in.)
Marks: crowned M; flying eagle; FCDA; RGA.
Private collection, Mexico City

This chalice was assayed by Antonio Forcada y la Plaza, who stamped it not only with his personal mark (FCDA) but also with those of Mexico City (M under an imperial crown) and of the treasury tax (flying eagle inside an octagonal outline). The silversmith was the eminent master José María Rodallega, who marked the piece with one of his personal stamps (RGA.), consisting of his abbreviated family name.

Stylistically the work is a transitional one, showing both Rococo and Neoclassical elements. The structural design, including the spiral movement of the piece, is Rococo, while the decorative program is adopted from Neoclassical models.

CEM

REFERENCE
Cristina Esteras Martín. "Platería virreinal novohispana: Siglos XVI–XIX." In *El arte de la platería mexicana: 500 años*, exh. cat., Centro Cultural de Arte Contemporáneo. Edited by Lucía García-Noriega y Nieto. Mexico, 1989, pp. 346–47, no. 109.

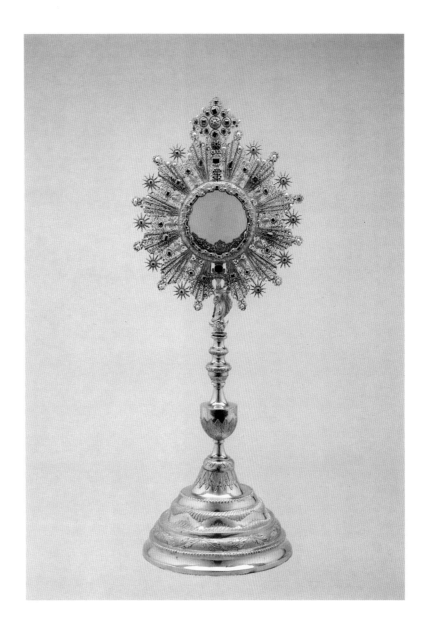

191 ◀ Monstrance

Oaxaca, about 1800
Gold, silver gilt, pearls, and precious stones; height
71 cm. (28 in.)
CNCA–INAH, Museo Nacional del Virreinato,
Tepotzotlán 10–12987/OR/01–0036

The formal and decorative characteristics of this unmarked monstrance point to the end of the eighteenth century, when a Neoclassical direction was imposed on the silversmith shops of New Spain with the founding in 1785 of the Academy of San Carlos in Mexico City. At the top of the monstrance is a sculpture of the Virgin Mary who bears on her head the weight of the sun. The presence of a sculpture as the support of the sun—despite the fact that in this case the sculpture is small and does not occupy the entire stem—underscores the popularity of such compositions in the post-Baroque period.

The most singular and successful part of the piece is the sun, a gold filigree typical of the goldsmith shops of Oaxaca. This provenance is confirmed by the fact that the monstrance belonged to the Temple of the Princes in Oaxaca.

CEM

REFERENCES
Artemio de Valle-Arizpe. *Notas de platería*. Mexico, 1941, figs. 22, 23. **Manuel Toussaint**. *La catedral de México y el sagrario metropolitano. Su historia, su tesoro, su arte*. Mexico, 1948, p. 231. **Cristina Esteras Martín**. "Platería virreinal novohispana: Siglos XVI–XIX." In *El arte de la platería mexicana: 500 años*, exh. cat., Centro Cultural de Arte Contemporáneo. Edited by Lucía García-Noriega y Nieto. Mexico, 1989, pp. 340–41, no. 106.

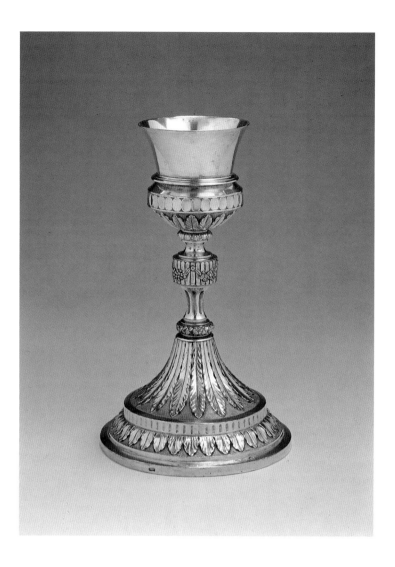

192 ◄ **Alejandro Antonio de Cañas**

Mexican, b. 1755–d. after 1804

Chalice

Mexico City, 1791–1818
Silver gilt; height 23 cm. (9⅛ in.)
Marks: CAÑAS; FOR/CADA; eagle; crown
Collections of the International Folk Art
Foundation of the Museum of International Folk
Art, Museum of New Mexico, Santa Fe FA.71.22–1a

The regularity of form and sense of proportion characteristic of the Neo-classical style are apparent in this chalice. Repetitive leaf forms decorate the base and the bottom of the cup. Bands of smooth oval medallions and bars grace the cup and the stem, with draped garlands over those on the stem. Restrained surfaces and balanced ornament have replaced the exuberance of the Late Baroque or Rococo in Mexico.

The chalice bears the maker's mark of the master silversmith Alejandro Antonio de Cañas who was born in Mexico in 1755. He passed the master silversmith examination in 1786 and served as guild inspector in 1794 and 1804. A chalice and cruet set by Cañas was mentioned in an 1815 update of the inventory of plate in the Mexico City Cathedral.

Although Cañas was active from 1786, this chalice must date after 1791 since it bears the marks of assayer Antonio Forcada y la Plaza who was in office from 1791 to 1818. The mark "FOR/CADA" and the eagle and crown were all used by Forcada, and the flying eagle is thought to have been used by him in the later years of his tenure as assayer.

DP

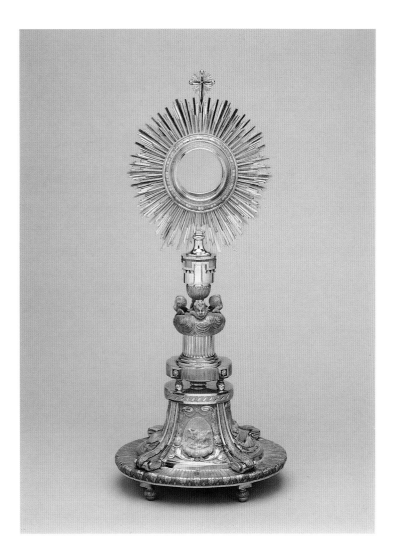

193 ◀ Monstrance

Mexico, 1800–1835
Silver gilt; height 54 cm. (21¼ in.)
Collection Isaac Backal, Mexico City

This sun-type monstrance of cast and chased silver is remarkable for its high quality of design and technical perfection. The flat base is decorated with a radial leaf pattern; four attached ribs, terminating in scrolls, divide the pedestal into sections that display oval medallions. These medallions show: the pelican feeding its young, the mystic lamb, the Tablets of the Law, and the Ark of the Covenant. The stem has four sections: a pedestal on four small feet, a fluted cylinder (recalling a column shaft), a cloud with four cherub heads, and finally an ovoid section decorated with geometric motifs. The container for the Host is circular with moldings, and the sunburst gloria has a double ring of rays. The monstrance is crowned by a cross.

 This piece, which lacks legal marks to verify its origins, presents the unmistakable style of the capital and the Neoclassical spirit dictated by the Academy of San Carlos. This type, characterized by an oblong structure and a combination of iconographic themes relating to the Eucharist (the pelican and the lamb) and the Old Testament (the Tablets of the Law and the Ark of the Covenant), was produced by silver workshops throughout Mexico City; examples are common in both silver and bronze.

CEM

Secular Art

194 ◀ Attributed to Juan Correa

Mexican, b. about 1645–50, d. 1716

Folding Screen (*Biombo*): *The Encounter of Cortés and Moctezuma* (obverse); *The Four Continents* (reverse)

Oil on canvas; 2.5 x 6 m. (8 ft. 2 in. x 19 ft. 8 in.)
Collection Banco Nacional de México,
Mexico City

A considerable number of screens such as this one have survived from the seventeenth and eighteenth centuries; they were the most important type of furniture produced during the viceregal period. The first *biombos* (from the Japanese *byo*, protection, and *bu*, wind—that is, protection from the wind) were brought to New Spain in 1614 by Rokuemon Hasekura, the Japanese ambassador. They proved to be both decorative and utilitarian and were soon widely copied.

The Encounter of Cortés and Moctezuma (obverse of cat. no. 194)

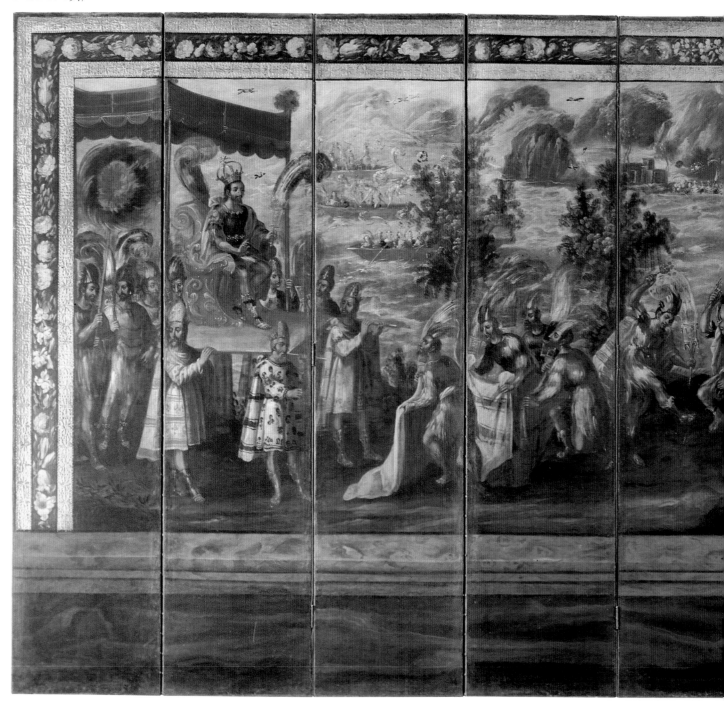

Obverse: Historical painting was a genre seldom practiced in New Spain. As a result, this *biombo* depicting the first encounter between the Spanish conqueror and the Aztec Emperor Moctezuma Xocoyotzin is one of the rare pictorial records that survive of that most significant moment (curiously, with only a few exceptions, all are on *biombos*). The chronicler Bernal Díaz del Castillo, an eyewitness, described the historic scene: "As we came near to

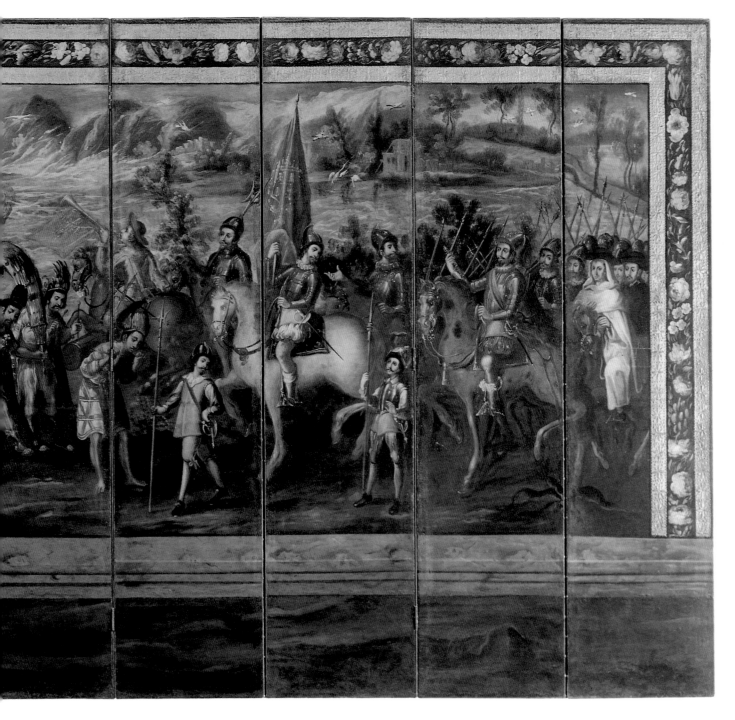

Mexico . . . the great Moctezuma descended from his litter, and these other great *caciques* supported him beneath a marvellously rich canopy of green feathers decorated with gold work, silver, pearls, and *chalchihuites* (jade) which hung from a sort of border."[1]

At the left Moctezuma is seated on a golden throne with Baroque elements, a style repeated throughout the rendering. The throne, along with the canopy about it, is appropriate to the European idea of a triumphal entrance and is similar to others painted by Juan Correa. The throne's frame is capped with a grand volute embellished with acanthus leaves, and a fan of feathers is attached to the back. The Aztec is dressed like a Roman emperor with a paludamentum (royal purple cloak) knotted at his right shoulder and draped

The Four Continents (reverse of cat. no. 194)

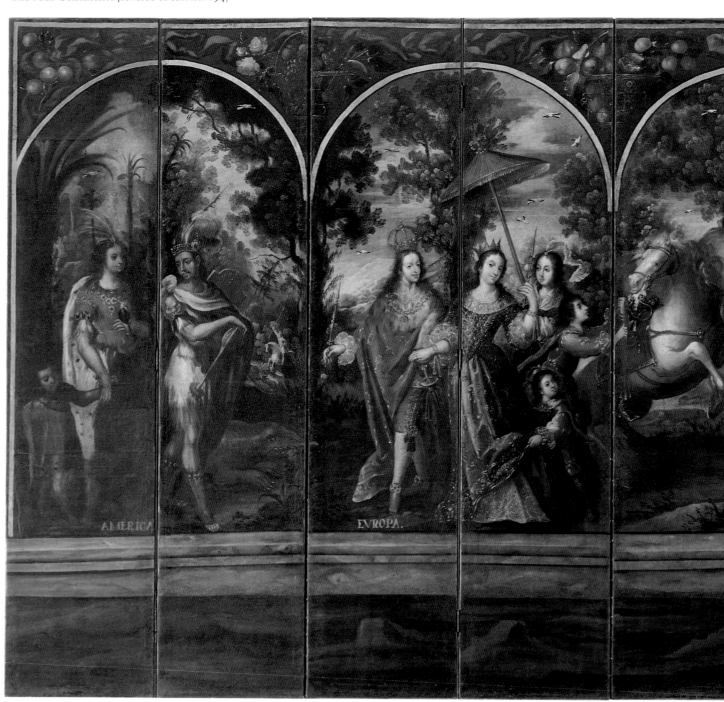

over his left arm. Moctezuma wears greaves on his muscular legs, and the delicacy of his feet suggests that he rarely trod on the ground. In his left hand he holds the large flywhisk or fan made of quetzal feathers mentioned by the chroniclers. He wears an imperial crown surmounted by a dove. On his shoulders there are lion-shaped brooches that accentuate the Roman character of his attire. The throne rests on the shoulders of his chieftains: each wears a *copilli* (headdress), a sign of rank, and their tunics are adorned with military emblems alluding to their victories. Some of the chieftains wear false beards (usually made of *ixtle*, a kind of fiber) to indicate their exalted status, as was customary in representations of native lords in the post-Cortesian codices.

The third and fourth leaves represent "the many lords that went before

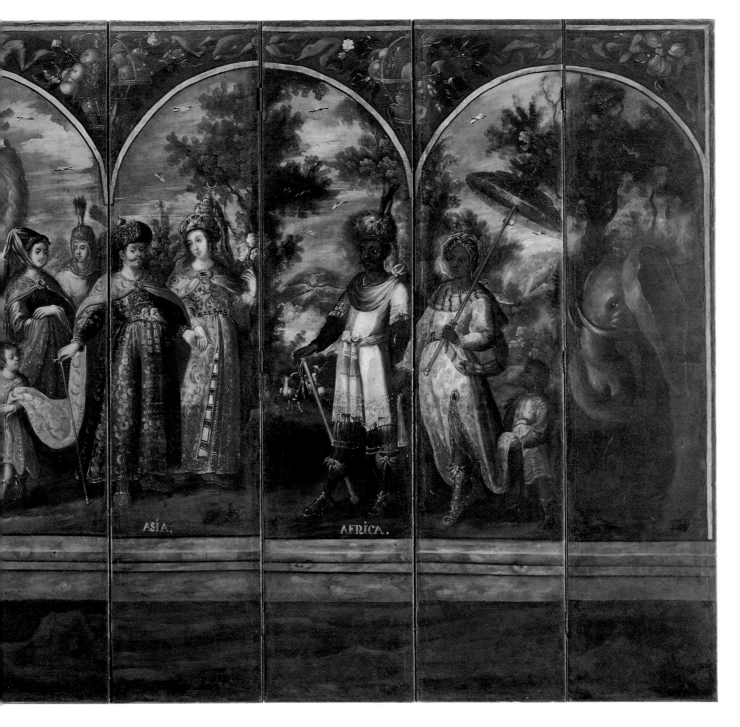

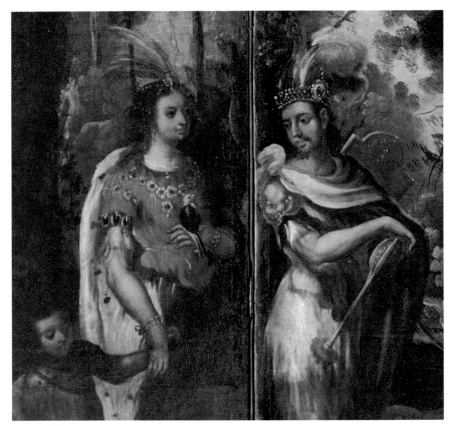

Detail of cat. no. 194

the great Moctezuma, sweeping the ground where he would be stepping and spreading blankets so that he would not come in contact with the ground."[2] Farther ahead the imperial retinue is composed of dancers who carry *sonajas* (tambourinelike instruments) and pre-Hispanic wooden drums called *teponaxtli*.

In the seventh leaf Cortés's entourage is headed by a trumpeter on horseback who announces the arrival of the conquerors; he is followed by a halberdier. The attire of both is in keeping with the fashion that arose after the Spanish wars with Flanders, whose influence predominated when this side of the *biombo* was painted.

Next comes an ensign astride a white horse carrying the standard of Castile. He is dressed in the classic armor of the conquistadores: breastplate, articulated metal armguards, breeches with puffs (*bullones*), leather half-boots, and crested helmet. At his side is a small pikeman carrying a half-pike, a popular weapon in the century following the Conquest.

In the ninth leaf Cortés is mounted on his horse, El Arriero, and carries a royal scepter in his right hand. The artist appears to have wanted to indicate that Cortés and Moctezuma were confronting each other as equals. It is possible that a likeness of Cortés was intended, as Juan Correa was a rather good portraitist. There may also be an attempt to portray the Aztec emperor—his sweet expression was often mentioned by chroniclers of that period. The Mercedarian friar Bartolomé de Olmedo brings up the rear of Cortés's entourage.

In the background is seen the great flotilla of canoes filled with people who, according to the chroniclers, came to witness the event. The setting has several recognizable elements. The ominous rain clouds rising over the mountains, the agitated waters; the trees bending in the wind, and the abandoned buildings seem to symbolize the end of Moctezuma's empire.

The *biombo* is finished with a floral border that resembles those of Flemish tapestries. The importance of the theme and the skill of its handling seem to confirm that the *biombo* had a use similar to that of tapestry in the palaces of Baroque Mexico.

<div align="right">MMRR</div>

Reverse: The splendor of the Baroque is seen in the opulence of these allegorical representations of the Four Continents (America, Europe, Asia, and Africa). The composition is directly based on a series of four French engravings by F. de Witt, which were, in turn, possibly inspired by lost paintings by Charles Lebrun (1619–1690).[3] One of the few major differences between the engravings and the screen is found in the Europe group—the monarchs represented are not Louis XIV and his consort, but the Spanish king Charles II and his first wife, Marie-Louise d'Orléans. The portraits are fairly true-to-life, and Charles's wife is further identified by the fleurs-de-lis on her gown. Their marriage took place in 1683, and she died in 1689. The screen was probably painted about the time of the wedding, since such events were the occasion for the most extravagant religious and civil festivals from the court to the dominions. Royal portraits were sent by the court to every large community in the viceroyalty, and one of these provided the painter with a likeness of Charles and his queen. None of these portraits have survived, but several have been documented. Geographical allegories were popular with the Spanish Hapsburgs, who had long exhibited a desire for world dominance; Charles II himself commissioned works of this sort from Claudio Coello, Luca Giordano, and Antonio Palomino.

In the scene representing America, the man wears a cuirass, epaulets decorated with masks, and jeweled greaves. His short skirt of multicolored feathers is more Amazonian than Mesoamerican. Asia is represented by a sumptuous group of Ottomans; the African figures appear to be from the northern part of that continent.

Except for the palm tree beside the American woman, the flora is not specifically related to the continent depicted. The fauna, however, obeys long-established traditions: the alligator and the parrot from America, the camel from Asia, and the elephant from Africa are as prescribed by Cesare Ripa in his *Iconologia* (1593).

At the top of the screen are festoons and baskets of flowers and fruit. These elements reflect the popularity of still lifes in the Flemish and Italian style, brought from Spain during the seventeenth century.

Aside from the geographical allegories, many other themes of obscure significance to the uninitiated were quite popular in compositions designed for *biombos*, such as the Five Senses, the Four Seasons, the Liberal Arts, Apollo and the Muses, proverbs, and historical events. Spanish influence is strikingly evident in both the principal and secondary theme of this geographical allegory.

<div align="right">EIEG</div>

1. Bernal Díaz del Castillo, *Historia verdadera de la conquista de la Nueva España* [1632] (México, 1955), vol. 1, p. 263. English translation from Bernal Díaz del Castillo, *The Conquest of New Spain*, trans. J. M. Cohen (Middlesex, England, 1963) p. 217.
2. Díaz del Castillo, *Conquest*, p. 263.
3. The engravings have been recently identified by Huguette Zavala.

REFERENCE
Elisa Vargas Lugo and José Guadalupe Victoria. *Juan Correa: su vida y su obra*. Vol. 2, *Catálogo*. Mexico, 1985, part 2, pp. 400–3.

195 ◄ Juan Rodríguez Juárez

Mexican, 1676–1728 (1732?)

The Duke of Linares, Viceroy of Mexico

Oil on canvas; 208 x 128 cm. (81⅞ x 50⅜ in.)
Signed (lower right): Ioannes Rodriguez Xuarez, fecit
Inscribed: D.ⁿ Fernando de Lôn-/castre Norona, y
Silba [illegible] / Duque de Linares, Marques / de
Valdefuentes, Porta Alegre, y Gobea: / Comendador
Maior de la orden de Santiago [illegible] / en
Portugal, Gentilhombre / de la Camara de su
Magestad Theniente General de sus / Exercitos.
Gobernador / General de Sus Reales Armas / en el
Reyno de Napoles / electo Virrey del Reyno de
Sardeña. vicario General de la Toscana; electo Vir /
rey del Peru, Virrey, y Cappⁿ / Genˡ de esta nueba
Espa // [in a different hand] murio en 3 de Junio, y
se entero el / dia 6 d[el] d[icho] en la peaña de este
Al- / tar, año d[e] 1717
CNCA–INBA, Pinacoteca Virreinal de San Diego,
Mexico City

Juan Rodríguez Juárez was born in Mexico City in 1676, the son of the painter Antonio Rodríguez and the grandson of José Juárez; his older brother, the priest Nicolás Rodríguez Juárez, was also a painter. Juan Rodríguez Juárez's career offers a bridge from seventeenth-century tenebrism and the influence of Zurbarán to the late Baroque and Rococo styles in Mexico. Less idiosyncratic than Villalpando or Correa, Juan Rodríguez Juárez kept in touch with European developments, and it was his version of a Mexican national style that in the hands of his pupil José de Ibarra (1688–1756) and Ibarra's contemporary Miguel Cabrera would dominate the eighteenth century.

Fernando de Loncastre Norona y Silva, duke of Linares, viceroy of Mexico from 1710 to 1716, was the second to serve the new Bourbon dynasty that had come to the Spanish throne in the person of Philip, duke of Anjou (Philip V) in 1700. Along with his predecessor, the duke of Albuquerque (viceroy 1701–10), Linares played a key role in maintaining the loyalty of the Spanish empire to Philip in the face of English, Dutch, and Austrian attacks during the War of the Spanish Succession (1701–14). Despite natural disasters, financial troubles, and at least one mutiny, Linares, a veteran of Spanish military and political intervention in Italy, was able to govern effectively. He is remembered for his generosity and just rule. It was during his viceroyalty that the first public library was opened under royal patronage in Mexico City. Furthermore, with the participation of the British in the Veracruz slave trade after 1714, Mexico began to receive many more international influences than it had previously.

Rodríguez Juárez has depicted Linares dressed in the French manner of the Bourbon court at Madrid, wearing a blue velvet coat, shoes with fashionable red heels, and a gold pendant with the red cross of the Spanish Order of Santiago. Apparently taken from life (the inscription noting the viceroy's death is a later addition), the picture represents an extraordinary fusion of the sober Spanish portrait tradition of the Golden Age with the emerging French Rococo, in effect establishing the international Rococo style in Mexican portraiture. At first glance the Linares portrait would seem to derive from the parallel synthesis that the French artist Jean Ranc created at Madrid in the 1720s in his *Charles III as a Prince* (Museo del Prado, Madrid), but Rodríguez Juárez's work is dated almost a decade earlier. How Rodríguez Juárez accomplished his feat at such a remove from his European sources is a mystery. The Spanish portrait tradition, especially as developed by Zurbarán, was abundantly present in the Mexican school itself, but Rodríguez Juárez would presumably have had only the odd French print and the advice of his patron to guide him in understanding the new Bourbon styles. In any event, Mexican portraiture from this point forward remains fully aware of contemporary fashions coming from the Old World.

A posthumous portrait of Linares apparently based on the Rodríguez Juárez canvas was signed and dated by Francisco Martínez in 1725 (current location unknown).[1]

MB

1. Illustrated in Agustín Velázquez Chávez, *Tres siglos de pintura colonial mexicana* (Mexico, 1939), fig. 132.

REFERENCES
Manuel Rivera Cambas and Leonardo Pasquel. *Los gobernantes de México*. Veracruz and Mexico City, 1962, vol. 2, pp. 205–37. **Francisco Pérez Salazar**. *Historia de la pintura en Puebla*. 3d ed., edited by Elisa Vargas Lugo. Estudios y fuentes del arte en México, 13. Mexico, 1963, pp. 202-3. **Manuel Toussaint**. *Colonial Art in Mexico*. Translated and edited by Elizabeth Wilder Weismann. Austin and London, 1967, pp. 244–45, fig. 230. **Enrique Marco Dorta**. *Arte en América y Filipinas*.

D.ⁿ Fernando de Lan
castre Noroña y Silva
Duque de Linares, Marques
de Valdefuentes, Porta Hey
grey Gobea Comendador ma
ior de la orden de Santiago
en Portugal, Gentl hombre
de la Camara de su Mag[?]
tad Theniente General de su
Exercitos, Gobernador
General de sus Reales Arm
en el Reyno de Napole
electo Virey del Reyn
de Sardeña, Vicario Gener
[...]a Toscana, electo [...]
rey del Peru, Virrey y Cap[?]
Gen[?] de esta nueba E[?]
[...]mo en 5 de L[...]aio y se [...] del
dia 6 febrero en [...] mo d[?]
tar año D.[?]

Ars Hispaniae: Historia Universal del Arte Hispánico, vol. 21. Madrid, 1973, pp. 348–49. **Marcus B. Burke**. "Mexican Colonial Painting in its European Context." In Linda Bantel and Marcus B. Burke, *Spain and New Spain: Mexican Colonial Arts in Their European Context*. Exh. cat., Art Museum of South Texas, Corpus Christi, Texas, 1979, pp. 42–43. **Guillermo Tovar de Teresa**. *México barroco*. Mexico, 1981, p. 311. **Manuel Toussaint**. *Pintura colonial en México*. 2d ed., edited by Xavier Moyssén. Mexico, 1982, pp. 148–49, fig. 275, color pl. XIX. **Virginia Armella de Aspe and Mercedes Meade de Angulo**. *Tesoros de la Pinacoteca Virreinal*. Mexico, 1989, p. 33, ill., p. 122.

196 ◀ Miguel Cabrera

Mexican, 1695–1768

Don Juan Xavier Gutiérrez Altamirano Velasco

Oil on canvas; 207.3 x 136 cm. (81⅝ x 53½ in.)
Brooklyn Museum, New York, Dick S. Ramsay Fund 52.166.1
EXHIBITED IN NEW YORK ONLY

Although technically Creole (born in Mexico of European descent) or Indian in origin, many upper-class Mexican colonial families so completely identified themselves with Spanish society as to be indistinguishable from the Iberian-born nobility sent to govern New Spain. Such is the case with the sitter in this presumably posthumous image, an archetypal example of viceregal court portraiture.

Juan Xavier Joaquín Gutiérrez Altamirano Velasco y Castilla Albornos, López Legaspi Ortiz de Ōraa Gorraez Beaumont, y Navarra—to give his full name—was born in 1711, the descendant of a conquistador, two Mexican viceroys, and the man who established Spanish dominion over the Philippines, Miguel López de Legaspi. Don Juan bore noble titles attached to lands in Spain (Salinas de Río Pizuerga) and Mexico (Santiago Calimaya) and received a pension from the Spanish crown by virtue of his hereditary title of *adelantado perpetuo* (governor-in-perpetuity) of the Philippines. He lived a relatively brief life, dying in 1752 at the age of forty-one.

Cabrera has depicted Don Juan dressed in the powdered wig, long coat, waistcoat, knee breeches, and three-cornered hat typical of mid-century Europe. The elaborate embroidery on his costume, possibly of Oriental origin or made in Mexico in imitation of Oriental cloth, is more characteristic of Mexican colonial men's garments than of European ones. As in many contemporary European portraits, however, the costume, along with the large coat of arms in the upper left corner, overwhelms the sitter's personality. To a very great extent, the clothes make the man.

The combination of a stiff pose and a strong emphasis on clothing and other accoutrements of class are typical of Cabrera's formal portraits, which often lack the telling psychological penetration of his intimate portraits and genre scenes (see cat. no. 197). In Don Juan's case, Cabrera may not have had the opportunity to work from life; the elaborate inscription recording the sitter's death seems to have been part of the original composition. Similarly, he is shown grasping a watch, a standard symbol in seventeenth-century *vanitas* allegories of the transitory nature of human existence, further indicating that the portrait was made after the sitter's death.

MB

REFERENCE
Linda Bantel. "Portrait of Don Juan Xavier Joachím Gutiérrez Altamirano Velasco." In Linda Bantel and Marcus B. Burke, *Spain and New Spain: Mexican Colonial Arts in Their European Context*. Exh. cat., Art Museum of South Texas, Corpus Christi, Texas, 1979, no. 33, pp. 108–10.

El Sr. Dn. JUAN XA
VIER JOACHIN Gu-
tierrez Altamirano Velas-
co, y Castilla Albornos, Lo-
pez Legaspy Ortiz de Oraa
Gorraez Beaumont, y Nava-
rra, Luna de Arellano, Cõde
de Santiago Calimaya, Mar-
ques de Salinas del Rio Pi-
zuerga, Sr. delas Casas ð Cas-
tilla, y Soza, y delas Villas de
Verninches, y Azequilla de Ro-
mancos, y de Azuquequa ð Na-
res, Cavallero del Sacro Romano
Imperio, por mrð. del Sr. Emperador Car-
los quinto Adelãtado perpetuo ðlas Islas
Philipinas, Contador ð S. Magð. y del Rl.
y Appco. Tribl. dela Sta. Cruzada; murio
el dia 17 de Junio de 1752, de Edad
de 41 añs. y 2 mesẽs.

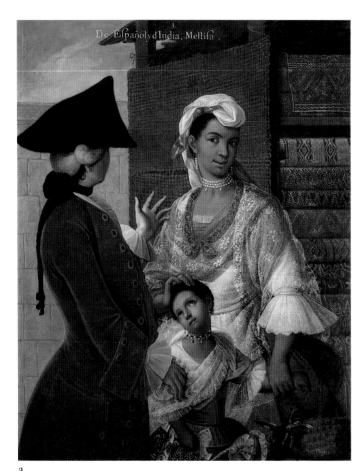

a

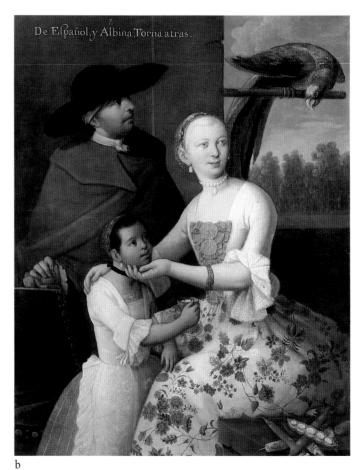

b

197 ◀ **Miguel Cabrera**

Mexican, 1695–1768

Depictions of Racial Mixtures, 1763

Three paintings; oil on canvas; 132 x 101 cm.
(52 x 39¾ in.)
Inscribed: (a) "1 De español y d India, Mestisa"
(1 Spanish father and Indian mother, Mestisa); (b)
"7 De Español y Albina, Torna atras" (7 Spanish
father and Octoroon mother, Throwback); and (c)
"8 De Español y Torna atras, tente en el ayre" (8
Spanish father and Throwback mother, undecided)
Private collection

These three paintings are part of a group originally consisting of sixteen canvases, two of which, nos. 1 and 16, are signed and dated by the mestizo painter Miguel Cabrera. At present the canvases are divided between the Museo de América, Madrid, and a private Mexican collection, although the locations of three of them are unknown.

The series is dedicated to the theme of *mestizaje,* or the mixing of the races, and is known by the generic name of *castas* (breeds), a clear allusion to the representation of the individuals who formed American society in the eighteenth century, when the ethnic mix of whites, blacks, and Indians had created a complicated social structure.

This genre, first produced in America only after 1720, was popular through the early 1800s, undergoing expected stylistic changes in the general composition but maintaining the essence of the earliest works. The notion of classifying people through a hypothetical genealogy, as well as the emphasis of the most typical characteristics of the dress and occupation of each group, corresponds to the intense interest in descriptive classification that developed during this hundred-year period in the wake of the Enlightenment in Europe.

Each canvas depicts a family group composed of father, mother, and one or more children, each representing one of the *castas* produced by progressive *mestizaje.* There are occasional groups of fruit or other New World products, which further accentuate the exoticism and variety of American nature.

The creator of the present canvases, Miguel Cabrera, was the most popular Mexican painter of the eighteenth century; he was responsible for a large

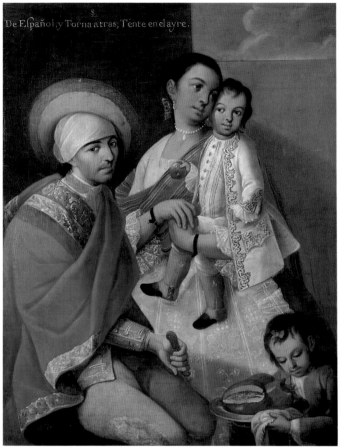

De Eſpañol, y Torna atras; Tente en el ayre.

c

number of religious compositions and important portraits of most of the eminent people of the period. This series is the only one he is known to have dedicated to the portrayal of *castas*. In it he employs a combination of artistic devices that are of great interest because they are used so rarely in the rest of his painting—for example, some of the most daring foreshortening in all his work appears in the first painting in the series, where one can see the Spaniard in profile with his face turned toward his companion, the Indian woman, who attracts the eye of the spectator and becomes the central figure in the scene.

In these three canvases, as well as in the others of the group, Cabrera skillfully differentiates the various fabrics worn by the figures. This is seen in the first painting with the placement of the figures before a stall or shop; the cloth is heaped on shelves and displays a wide repertoire of designs.

Most of the models used by the artist in these scenes escape the types that he ordinarily repeats in his religious painting; they acquire greater variety and personality, a necessity for works in which the representation of outstanding ethnic characteristics is fundamental.

MGS

REFERENCES
Isidoro Moreno. *Los cuadros del mestizaje americano. Estudio antropológico del mestizaje.* Madrid, 1973. **María Concepción García Sáiz.** "Pinturas 'costumbristas' del mexicano Miguel Cabrera." *Goya* no. 142 (1978), pp. 186–93. **Efraín Castro Morales.** "Los cuadros de castas de la Nueva España." *Jahrbuch für Geschichte von Staat, Wirtschaft und Gesellschaft Lateinamerikas* 20 (1983), pp. 671–88. **María Concepción García Sáiz.** "La imagen del mestizaje." In *El mestizaje americano.* Museo de America. Madrid, 1985, pp. 45–55. **María Concepción García Sáiz.** *Las castas mexicanas: un género pictórico americano/The Castes: A Genre of Mexican Painting.* English translation by Julia Escobar. Mexico, 1989.

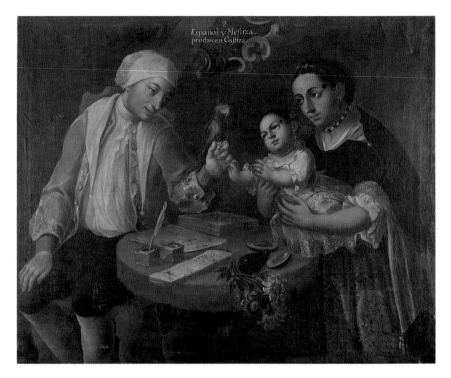

198 ◄ José Joaquín Magón

Mexican, late 18th century

Depiction of Racial Mixtures

Oil on canvas; 115 x 141 cm. (45¼ x 55½ in.)
Inscribed: "2 Español y Mestiza producen Castiza."
(2 Spanish father and Mestiza mother produce a
Quadroon daughter)
Oil on canvas; 116 x 94 cm (45⅝ x 37 in.)
Museo Nacional de Etnología, Madrid

This painting is the second of a series of sixteen signed by the Pueblan painter José Joaquín Magón under the general epigraph that appears in the first of the canvases: "Calidades que de la mezcla de Españoles, Negros e Yndias proceden en la América y son como se siguen por los números." (Qualities which appear in America as a result of the mixture of Spaniards, Blacks, and Indians, which follow and are numbered). In all the canvases the compositional scheme repeats the formula typical of paintings of *castas* (breeds), which consists of the three figures necessary for the representation of *mestizaje*.

Here the family group is located inside an undefinable room with a neutral background. It is placed around a circular table where the father sits, interrupting his writing to attract the attention of the little girl—an affectionate attitude repeated in most of the canvases, which allows the painter to portray communicative looks and gestures among the protagonists.

In this group as well as in another by the same artist, the painter penetrates the atmosphere of daily life through a wide range of attitudes, clothing, and details that make up the domestic and professional effects of the subjects, with their broad-featured faces and fleshy bodies, who dress in accordance with their occupations.

In addition, references to native American fruits and animals are realized through decorative details, apparently out of context, and by small still lifes perfectly integrated into the scene taken as a whole.

In most series dedicated to this theme by other painters who were contemporaries of Magón, the final canvas is reserved for the representation of Gentile or savage Indians—that is, Indians who have not been Christianized. Magón, however, rejects this possibility, and dedicates all his canvases to *castas*.

MCGS

REFERENCES
Isidoro Moreno. *Los cuadros del mestizaje americano. Estudio antropológico del mestizaje.* Madrid, 1973. **María Concepción García Sáiz.** "Pinturas 'costumbristas' del mexicano Miguel Cabrera." *Goya* no. 142 (1978), pp. 186–93. **Efraín Castro Morales.** "Los cuadros de castas de la Nueva España." *Jahrbuch für Geschichte von Staat, Wirtschaft und Gesellschaft Lateinamerikas* 20 (1983), pp. 671–88. **María Concepción García Sáiz.** "La imagen del mestizaje." In *El mestizaje americano.* Museo de América, Madrid, 1985, pp. 45–55. **María Concepción García Sáiz.** *Las castas mexicanas: un género pictórico americano/The Castes: A Genre of Mexican Painting.* English translation by Julia Escobar. Mexico, 1989.

199 ◀ Antonio Pérez de Aguilar

Mexican, active 1749–1769

The Painter's Cupboard, 1769

Oil on canvas; 125 x 98 cm. (49¼ x 38⅝ in.)
CNCA–INBA, Pinacoteca Virreinal de San Diego,
Mexico City

Very few examples of still-life painting have survived from the colonial period. There is evidence of them, however, in inventories of the time, listed as "kitchen canvases" or "dining-room pictures," and dishes of fruit, vases of flowers; complete table groupings seen in other types of paintings testify to artists' proficiency in the technique. *The Painter's Cupboard* is therefore especially interesting. Although previously attributed to the eighteenth-century artist Patricio Morlete Ruíz, it was, in fact, painted by Antonio Pérez de Aguilar, as documented by the signature on the back. We know little else about Pérez de Aguilar except that in 1749 he painted *The Venerable Palafox*, a portrait now in the parish church at Real del Monte, near Pachuca, in Hidalgo.

This still life must have been greatly admired in its day, for it was presented to the gallery of the Academy of San Carlos in Mexico City shortly after its opening in 1785 by the distinguished Don Fernando Mangino, one of the Academy's founders. The title of the work derives from the presence on the top shelf of a palette, some brushes, and a carved image of the Infant Christ from a Nativity that was probably used as a model by the artist himself. Next to them are some books and musical instruments. The two lower shelves hold plates, bottles, pitchers, loaves of bread, and containers for food and tidbits, such as the round wooden boxes in which *cajeta*, a caramel-butterscotch

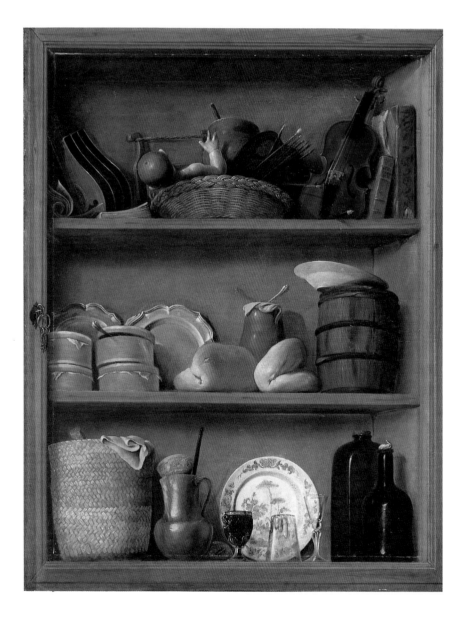

confection, is sold. Perhaps this hierarchical arrangement symbolizes food for both body and spirit.

The informality of these simple objects suggests that they were drawn from actual models. Yet perhaps more important is the fact that the artist here has rejected the paradigm of the Baroque still life, with its contrived composition, to achieve an austerity compatible with the ideas of the Enlightenment. The portrayal of ordinary objects in the dignity of their everyday existence; the silent presence of the common man, who has absentmindedly left the spoon in his cup and neglected to set his plate properly on top of the barrel; and the absence of affected musings about *vanitas*, ephemerality, and death typical of the Baroque—all strike the homely note of the new era. The picture recovers the original sense of this genre, first seen in the Renaissance paintings of small cabinets by Italian and Flemish artists.

<div align="right">JGH</div>

REFERENCES
Manuel Romero de Terreros. "Bodegones y floreros en la pintura mexicana: siglos XVIII y XIX." *Anales del Instituto de Investigaciones Estéticas* 4, no. 14 (1946), pp. 56–57, fig. 4. **Manuel Toussaint**. *Colonial Art in Mexico*. Translated and edited by Elizabeth Wilder Weismann. Austin and London, 1967, pp. 339–40, fig. 315. **Manuel Toussaint**. *Pintura colonial en México*. Edited by Xavier Moyssén. Mexico, 1982, p. 178, fig. 338.

200 ⟨ St. Lucy

Mexican, about 1700–50
Polychromed and gilded wood; height 72 cm.
(28⅜ in.)
Museo Franz Mayer, Mexico City 18–395 00491/1
BEA–0009

St. Lucy, a historical figure, was a virgin martyr of Syracuse, Italy, who perished about A.D. 304 during the persecutions of Diocletian. According to the *Golden Legend* of Jacobus de Voragine, after miraculously surviving a series of torments, she succumbed to the thrust of a dagger through her throat. In subsequent elaborations of her legend she is conflated with another martyr of the same name believed to have put out her own eyes. One of these later versions states that Lucy, angry at her pagan lover's praise for her eyes, plucked them out and sent them to him; another states that she blinded herself to save herself from temptation. In any case, it is likely that this saint's association with eyes (and their diseases) was inspired by her name (Lucia signifies "light"). She frequently displays a pair of eyes on a plate or chalice or at the end of a stalk.

This small carving shows Lucy directing the instrument of her martyrdom toward her eyes, her blood coursing daintily down her cheek. The sculptor has dramatized those embellishments of her legend that are usually presented as symbolic attributes, converting her usually composed persona into an image of suffering that stands in sharp contrast to her elegant toilette. Like even the most austere saints in viceregal art, she shimmers in her estofado finery. Her ruffled sleeves and ribboned coiffure, however, lend an additional note of contemporary fashion to this sculpture, reminiscent of the painted depictions of female martyrs (attributed to Juan de Herrera, 1698) in the altar of *Las reliquias* in the Mexico City Cathedral.

This figure of St. Lucy, whose cult is comparatively uncommon in Mexico, is one of a pair of female martyrs (the other unidentified) in the collection of the Museo Franz Mayer. Both appear to be the work of the sculptor of the small archangel in the Museo Regional, Querétaro, whose Mannerist coiffure has been exaggerated into a similarly stylish confection. It is possible that all three figures were intended for the altar of a small domestic chapel, but the intricate work lavished on their backs would have been wasted unless they were displayed as freestanding objects of devotion or in front of mirrors.

<div align="right">JH</div>

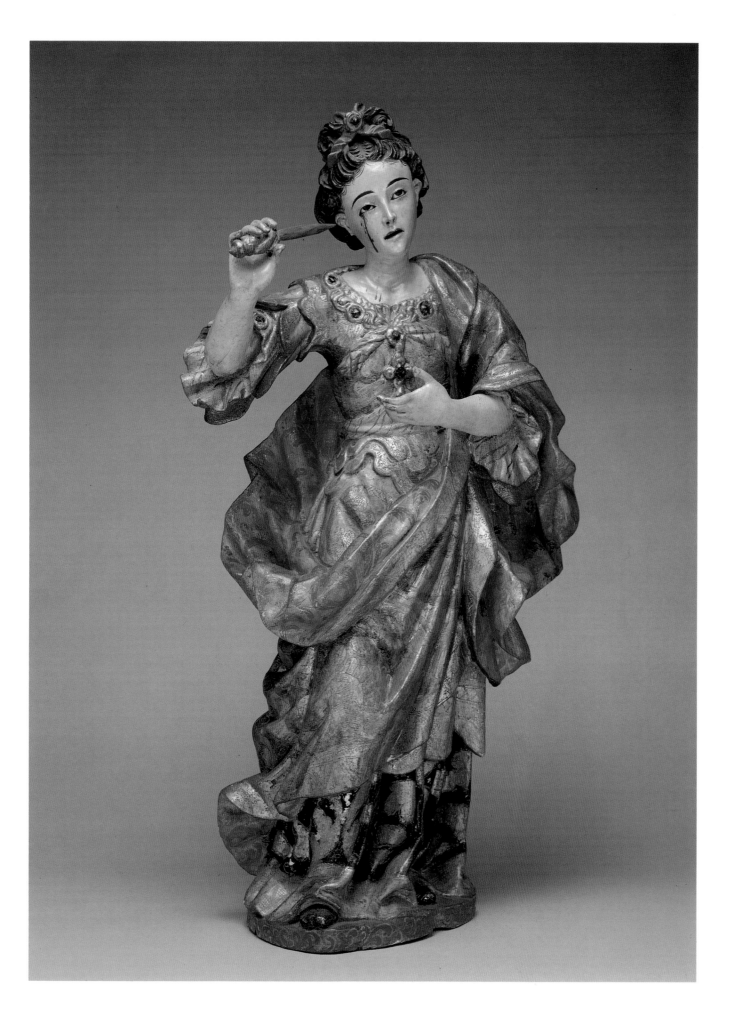

201 ⬧ Casket (*Arqueta*)

⬧ Puebla, early 17th century
⬧ *Tecali* (alabaster) with partially gilt wrought iron;
⬧ 19 x 12 x 12 cm. (7½ x 4¾ x 4¾ in.)
⬧ Museo Franz Mayer, Mexico City H–267 07123
⬧ 9BK–0049

The word *tecali* comes from the Aztec words *tetl*, stone, and *calli*, house. Tecali is the Aztec name of a town in the state of Puebla where large deposits of alabaster exist. This native alabaster, tinted in bright colors as well as in milky white, is used as a substitute for marble or jewels in making various types of decoration. This extremely fragile stone was highly valued in pre-Hispanic times and was also used instead of glass in some churches in colonial times.

Ideal for storing relics or jewels, *arquetas* with rounded covers were favored during the Baroque period (there was a return to flat lids in the eighteenth century). Most of the *arquetas* from this time are shaped like small trunks. The trim is usually of gilt iron. In this instance the gold has all but disappeared.

MMRR

202 ⬧ Octagonal Sewing Box

⬧ Puebla, 17th–18th century
⬧ Tortoiseshell over cedar; inlaid with mother-of-
⬧ pearl; 20 x 48 x 48 cm. (7⅞ x 18⅞ x 18⅞ in.)
⬧ Museo Franz Mayer, Mexico City C–115 05232
⬧ GCD–0031

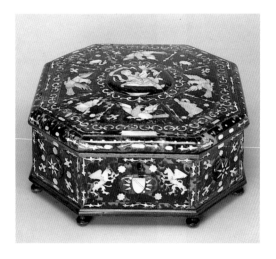

In Spain the use of tortoiseshell as a decorative facing of wood began in the sixteenth century in imitation of fifteenth-century Italian work. In the Far East this technique was equally popular. Since New Spain received tortoise-shell objects from the Philippines as well as from Spain, it was exposed to both traditions—the European and the Oriental.

Mother-of-pearl as well as bone was polished and often beveled and then inlaid in tortoiseshell. This box is decorated with a variety of inlaid mother-of-pearl figures. Lions from the royal coat of arms, a frequently used decorative motif, adorn one side of the box. The fleur-de-lis, an attribute of St. Francis of Assisi, is also used. This and the Franciscan escutcheon on the interior suggest that the sewing box belonged to a member of that religious order. Both men and women in religious orders were skilled embroiderers.

The decoration also includes flamingos—birds that nest in lakes of the Yucatán peninsula. However, both the flamingos and the elephants, strangely interpreted here, evoke an Oriental influence. The cockatoos and parrots that grace the box are found on both continents. The unicorn, a popular symbol of chastity in the Middle Ages, is also present in the design, as well as some Asiatic figures. In the center is a reclining figure with a phylactery bearing no inscription. As with much of the other decoration, the symbolism is difficult to interpret.

MMRR

REFERENCE
Marita Martínez del Río de Redo. "El Galeón de Manila." *Boletín bimestral del museo Franz Meyer*, no. 11 (January–February, 1986), p. 4.

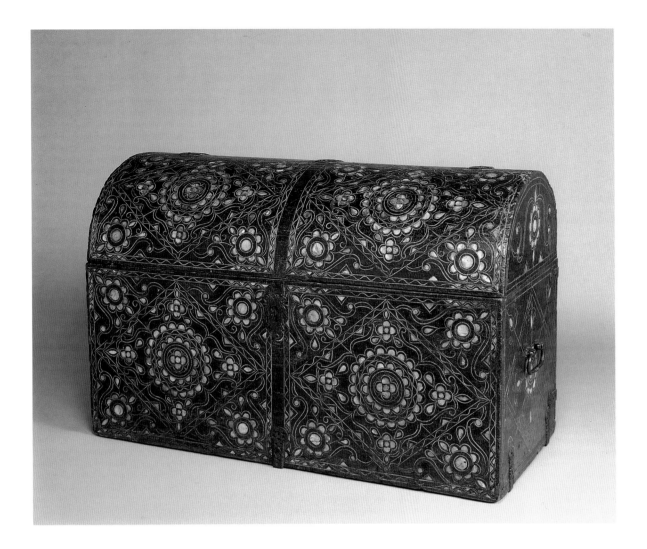

203 ◀ Chest

◀ Durango, 17th century
◀ Mesquite and mother-of-pearl; 64 x 102 x 50 cm.
◀ (25¼ x 40⅛ x 19¾ in.)
◀ Museo Franz Mayer, Mexico City A–001 04900
◀ CAC–0014

The austerity of this chest evokes the northern Mexican landscape, and the design resembles the *ojos de Dios* (eyes of God) or *tzikuri* of the Cora and Huichol Indians.

The basic structure of mesquite wood is coated with dark green paint of vegetable origin, over which mother-of-pearl has been inlaid. Mother-of-pearl was imported from the Orient in the Manila Galleon, which occasionally docked at Mazatlán to unload rich merchandise bound for the silver and gold mining centers of northern Mexico.

The mother-of-pearl was polished and cut to form a design of flowers and rosettes. It was then inlaid on the wood, which had been covered with painted cloth and burnished to imitate lacquer by indigenous processes. Inlaid threads of a light wood run through the mother-of-pearl and simulate the popular *taracea de fideo* (see cat. no. 210). The shell on the curved portion has been especially well polished to follow the curvature. The design on the sides is simpler. The hinges, handles, and the keyhole plate in the form of the double-headed eagle of the House of Austria (Hapsburg) are made of wrought iron from the Cerro del Mercado, a rich iron deposit discovered in 1552 by Ginés Vázquez de Mercado.

MMRR

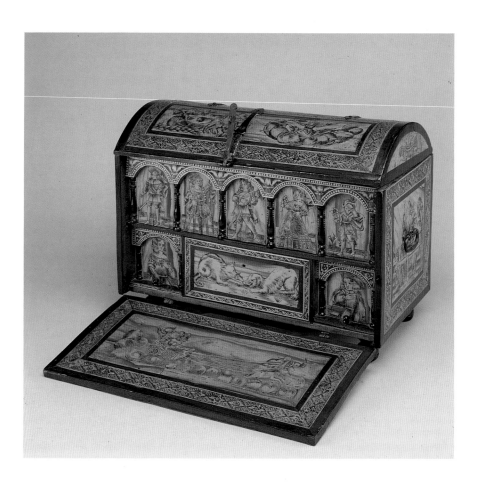

◀ **Writing Desk (*Bufetillo*)**

Oaxaca, 17th century
Wood decorated with *zulaque*; 39 x 53 x 29 cm.
(15⅜ x 20⅞ x 11⅜ in.)
Museo Franz Mayer, Mexico City 7–014 06785

This type of desk, with a front panel that opens to form a writing surface and a rounded lid, was based on German models that were in turn copies of Spanish prototypes. These German desks, made in Augsburg and Nuremberg, became so popular that in Spain Philip III prohibited their importation in 1603. Such desks were copied not only in New Spain but also in the East Indies.

In Mexico these small "German-style" writing chests were made mainly in Oaxaca. They retain the basic structure of the drop panel and the small drawers, some hidden. Decoration was often based on engravings, possibly by the Dutch artist Philip Galle, but executed in a distinctly local style. In Europe the designs were usually incised in the wood using a hot iron; in New Spain the patterns were often filled in with *zulaque*, a bitumenlike paste of burnt lime, oil, and a black vegetable dye extracted from the *palo tinte*, a tree that abounds in the region. Inlay was occasionally used but never to produce the views of cities and ruins so popular in Germany.

In contrast to the Spanish *varqueño*, or traveling desk, the German-style desk had decoration on all its exterior and interior surfaces. The present example shows ladies and gentlemen dressed in German fashion in various courtly poses under a small arcade with superimposed ebony columns. On the center drawer a dog fights with a cat. King Herod appears on the lid's underside; on the upper side Phaëthon is seen. On the sides are ladies with birds and figures with arrows. The scenes are framed with an elegant Greek key fret.

MMRR

205 ◀ Chest

Michoacán, 18th century
Wood; 61 x 98 x 46 cm. (24 x 38⅝ x 18⅛ in.)
Museo Franz Mayer, Mexico City B–054 04958
CAC–0023

This chest is decorated with beveled carving of flowers and leaves in a star form characteristic of Islamic ornamentation. The borders on the ends of the chest were inspired by the galloons woven with silver and gold thread that were popular in the seventeenth century. The shape and proportions of the chest are reminiscent of chests from Manila; Michoacán was one of the stops for merchandise coming from Asia.

Until well into the seventeenth century household furnishings in Spain and New Spain were portable. Handles on the sides lasted, at least as decorative vestiges, until the eighteenth century. At that time chests, trunks, and bridal chests were replaced by clothes cabinets and wardrobes.

There were a large number of forests in Michoacán, and Tarascan craftsmen excelled at working with cedar, oak, and pine. Even though this chest is of popular origin, its maker would have had to comply with the Ordinances of the Guild of Carvers, Joiners, Gilders, and Violin Makers promulgated in Seville in 1527 and ratified in New Spain in 1585. Most of the popular furniture made by joiners and carvers in Michoacán was of pine; it did not have its basic structure hidden by veneers, but it was often covered with lacquer.

MMRR

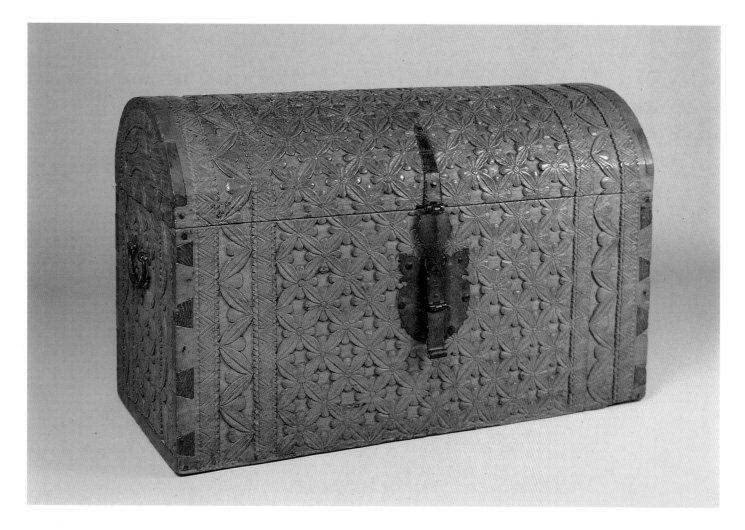

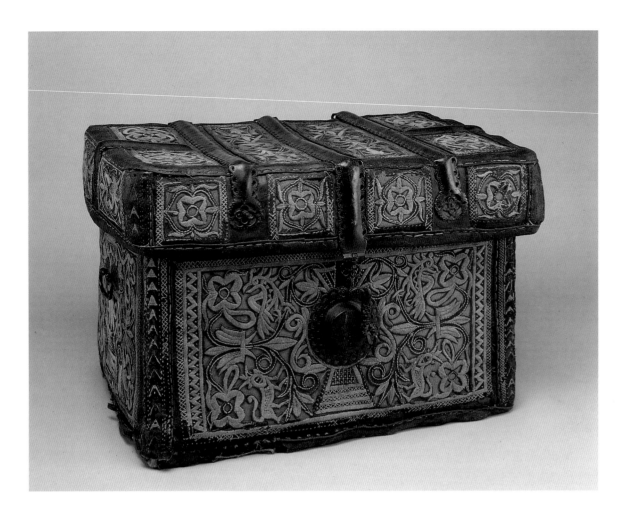

206 ◀ **Woven Trunk (*Petaca*)**

◀ Mexican Highlands, late 17th century
◀ Woven cane, leather, agave fiber; 44 x 73 x 52 cm.
◀ (17⅜ x 28¾ x 20½ in.)
◀ Museo Franz Mayer, Mexico City 7–063 06785
◀ GBK–0015

The *petaca* (from the Aztec *petlacalli* meaning "a trunk made from woven cane") retains many of its pre-Hispanic elements, both in its basic structure and in its stitched decoration of agave or *maguey* fiber thread. The highland variety of agave was widely used in the pre-Conquest period; its fiber was used to weave cloth, and its spines served as needles. Even today the fiber or thread of the agave leaf is used to embroider the saddles of Mexican *charros*. The embroidery, usually employing the *pepenado* stitch, is done on leather and is known by the name *piteado*.

The present trunk has a core of *petate* (woven cane), just as it would have had in pre-Hispanic times, and is covered with leather. The *pepenado* embroidery in white and dark green has been sewn onto leather cutouts appliquéd to red cloth. The design on the top and sides shows birds with stylized plumage and jaguars surrounded by flowers and foliage. This fine embroidery contrasts dramatically with the rough sewing that attaches the leather to the frame. Stout wrought-iron hardware with stylized floral motifs lends a solidity to the trunk, which comes from a region where leather is still embroidered with agave fiber.

Among the gifts that Moctezuma sent to Cortés with his emissary Tentitl was a *petaca* that symbolized the expression "I open my heart."

MMRR

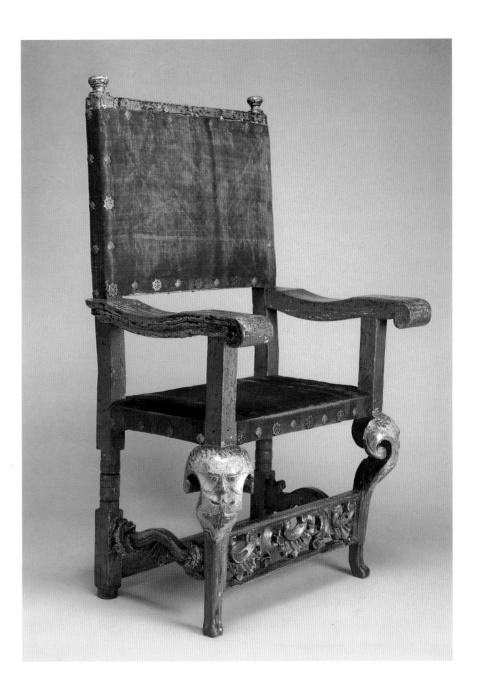

207 ◄ Armchair (*Frailero*)

◄ Mexico, about 1740
◄ Carved and lacquered wood, velvet; 119 x 77 x
◄ 53 cm. (46⅞ x 30¼ x 20⅞ in.)
◄ Museo Franz Mayer, Mexico City 3–33

In the eighteenth century the *frailero* (friar's chair, perhaps alluding to its longtime ecclesiastical use) underwent a remarkable change from the stiffness it had maintained since Renaissance times. The legs were curved into a graceful cabriole, frequently ending in a claw-and-ball foot. The arms, ending in volutes, now lost their rigidity, and the stretchers became more opulent and assertive. Comfort became a major consideration, and seats and backs were now covered in velvet and damask.

This *frailero* shows a sharp contrast between the chair's rigid upper part, which is only slightly tempered by the gentle curve of the arms, and the Baroque character of the lower portion, with its ample gilded stretcher carved in rocailles. On the knees are two enigmatic and grotesque masks which may have been inspired by masks on Baroque architecture. The masks are lacquered, as are the rest of the legs and arms.

MMRR

REFERENCE
Marita Martínez del Río de Redo. "El mueble civil." In Carmen Aguilera et al., *El mueble mexicano: historia, evolución e influencias.* Mexico, 1985, p. 64, no. 79.

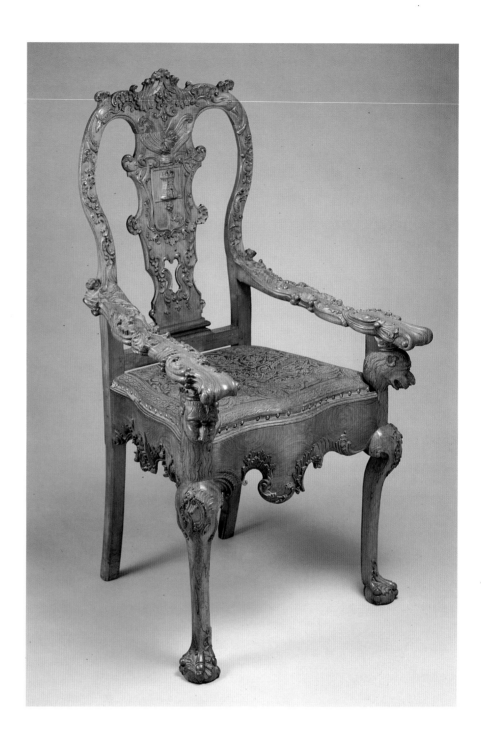

208 ◀ Armchair

Mexico, second half of 18th century
Carved walnut, leather; 116 x 65 x 50 cm.
(45⅝ x 25⅝ x 19⅝ in.)
CNCA–INAH, Museo Nacional del Virreinato,
Tepotzotlán, Mexico 10–54250

When French and English influences began to be felt in Mexico, furniture took on graceful sweeping lines and the maximum degree of art was coaxed from the wood. The work of the English furniture maker Thomas Chippendale was particularly important in Mexico. Designs from his catalogue *The Gentleman and Cabinet Maker's Director*, published in 1754, as well as the pieces of English furniture that were brought to New Spain, were copied in an elegant but distinctly local manner.

Eighteenth-century armchairs, chairs, and settees reflect this new current, and furniture in general took on an increased importance in the house in New Spain. The large pillows set upon low platforms in the drawing room were discarded. (They had been used by ladies, who followed the Moorish custom of receiving visitors, sewing, embroidering, and sometimes even eating while reclining on pillows.)

A large number of eighteenth-century Mexican chairs have survived. The proportions, lines, carving, and variety of design attest to the skill of the anonymous cabinetmakers. The present armchair is a good example of the horror vacui typical of the Baroque and Late Baroque. The back has carved floral and leaf motifs, and the arms end in elaborate volutes supported by zoomorphic heads. On the back splat is a coat of arms. The cut-out stretcher shows Rococo asymmetry. The knees have raised designs typical of the Mexican Chippendale style, and the cabriole legs are lightly curved, ending in feline claws.

MMRR

209 ⁂ Settee

Mexico, second half of 18th century
Mahogany; 103 x 196 x 80 cm.
(40½ x 77⅛ x 31½ in.)
CNCA–INAH, Museo Nacional del Virreinato,
Tepotzotlán

Derived from the bench, the settee is a comfortable piece of furniture used in drawing rooms since the second half of the eighteenth century. Almost always placed before a *biombo* (folding screen), settees were, next to *biombos*, the most important furniture in the room where visitors were received. Like much of the furniture of this era, settees are almost always made of mahogany, the most fashionable wood. Imported from Cuba and Honduras, mahogany was also often used as a veneer.

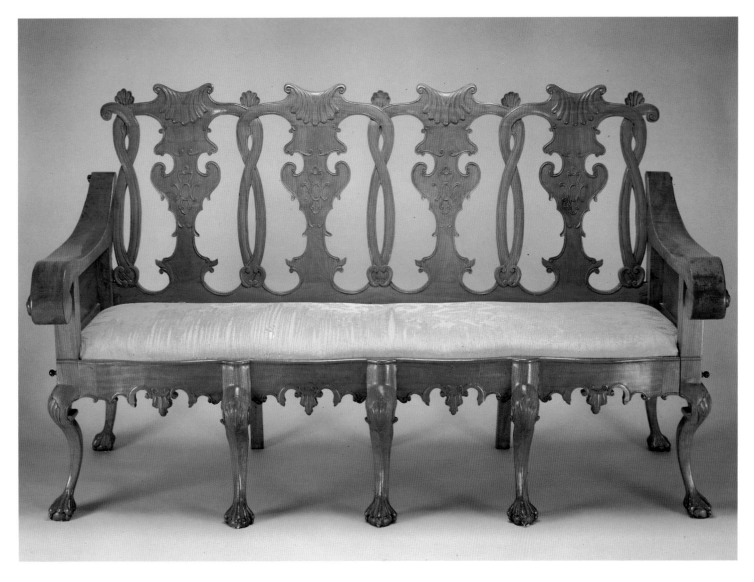

England exported a considerable quantity of furniture to Spain and New Spain during the eighteenth century. The anonymous Mexican furniture makers soon tired of slavishly copying these examples—the copies were so fine that it is difficult to tell them from the original—and gave free rein to their own originality. Since Mexican craftsmen were inspired by the work of Thomas Chippendale, his name is used to identify the style that evolved. This settee is an excellent example of so-called Mexican Chippendale. In fact, however, most Mexican settees are based on the earlier Queen Anne style, which was later enhanced by an exaggerated back or splat, derived from the fiddle splat, that was cut out or perforated. The front seat rail or stretcher in this piece is cut out to echo the splat and is edged with a molding. The cabriole legs end in the claw-and-ball motif that first came into fashion in China and here represents the claw of a dragon holding a pearl.

Settees are usually low, which permitted ladies of the time an easy transition from their custom of sitting on large pillows that showed off their voluminous skirts. The rail on the back of this example is adorned with shells, which were common in the Baroque style, and has depressions to accommodate the wig of the sitter, just as the *peluquera* (wig chair) used by barbers did.

MMRR

210 ◀ Armoire (*Armario*)

Puebla, second half of 18th century
Wood inlaid with wood and bone; 225 x 124 x 41 cm. (88⅝ x 48⅞ x 16⅛ in.)
Museo Franz Mayer, Mexico City B–039 05155
CAD–0012

Originally used for storing weapons (*armas*), *armarios* are usually tall and rather shallow. Later they were used for holy vessels in sacristies and medications in pharmacies. Finally, in the eighteenth century, the *armario* became a standard domestic furnishing.

The doors of this piece are faced with inlay (*taracea*, from the Arabic *tarsi*, encrustation). This technique, widely used during the Renaissance, consists of piecing together small bits of wood veneer in natural or dyed colors, mother-of-pearl, and other materials. Engraved bone (also an Arab element) was often used for inlay in place of the more expensive ivory. In this example the inlay of light and dark cedar with bone creates bands of rhombuses and half-rhombuses. Among these bands winds a fine thread of inlaid wood called *taracea de fideo*, forming a design similar to calligraphic flourishes popular at the time.

The top of the *armario*, which is decorated with inlaid pomegranate flowers, has curved lines that form an ogee arch and is edged with molding. This type of rippled and curled molding was first used by the German cabinetmaker Hans Schwarhard (d. 1621), who may have been inspired by an Oriental prototype. In this *armario* the cabinetmaker has exaggerated the arch and lowered the sides until they almost interfere with the doors.

MMRR

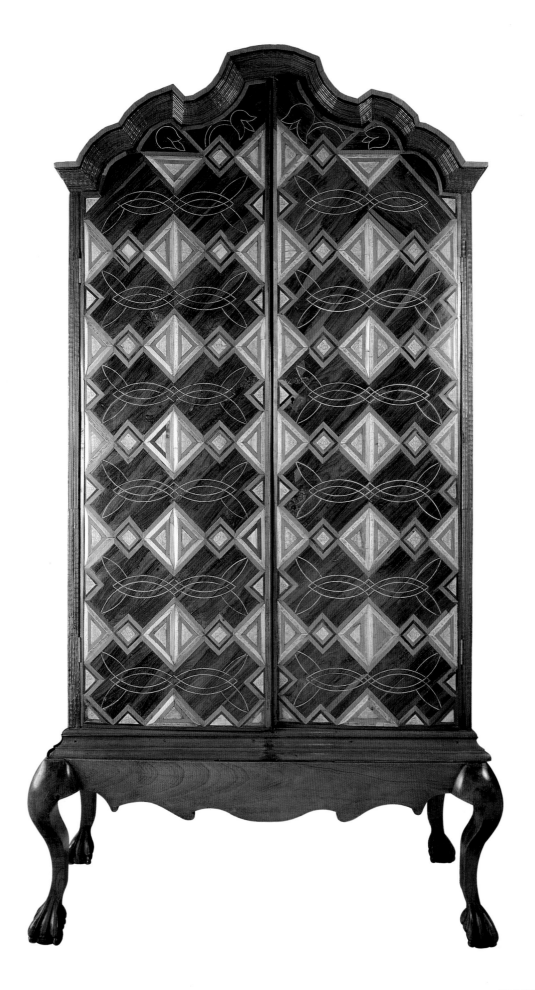

◀ **Wardrobe (*Ropero*)**

Michoacán, about 1780
Decorated lacquer and wood; 196 × 128 × 62 cm.
(77⅛ × 50⅜ × 24⅜ in.)
Museo Franz Mayer, Mexico City D–059 01341
CAD–005
EXHIBITED IN NEW YORK ONLY

In contrast to the *armario* (from *arma*, weapon), where weapons were kept, the *ropero* (from *ropa*, clothing) was, as its name indicates, intended for the storage of clothing. Since the end of the seventeenth century, the popularity of its use for this purpose caused chests and trunks to fall into disuse in the following century. This *ropero* is constructed of panels that clearly recall Castilian (classical Spanish) furniture. This type of home furnishing has remained in the Mexican tradition and is still produced throughout the country. The panel is also used in the construction of doors and window shutters.

The panels of this wardrobe are separated by rails and stiles in a harmonious composition that is repeated in the upper and lower segments of the piece. Smaller panels are set at an angle in the center of the front. The design is repeated on the sides.

The wardrobe is covered with *maque fingido* (imitation lacquer) in dark green, with flowers and foliage on the rails and stiles and gold leaf on the beveled edges. Most of the panels display the chinoiserie in fashion in the eighteenth century both in Europe and in Mexico. There are mandarins, women with parasols, churches that look like pagodas, and pagodas that look like churches—all done in gold with touches of crimson.

The interior of the wardrobe seems to indicate that this piece was used in a store selling fabrics, ribbons, and stockings. The crimson-lacquered panels have scenes—some courtly, some picaresque—and inscriptions alluding to them. There are figures offering merchandise and peddlers with boxes full of ribbons and lace. In one curious scene a demon seems to be tempting a woman to buy.

MMRR

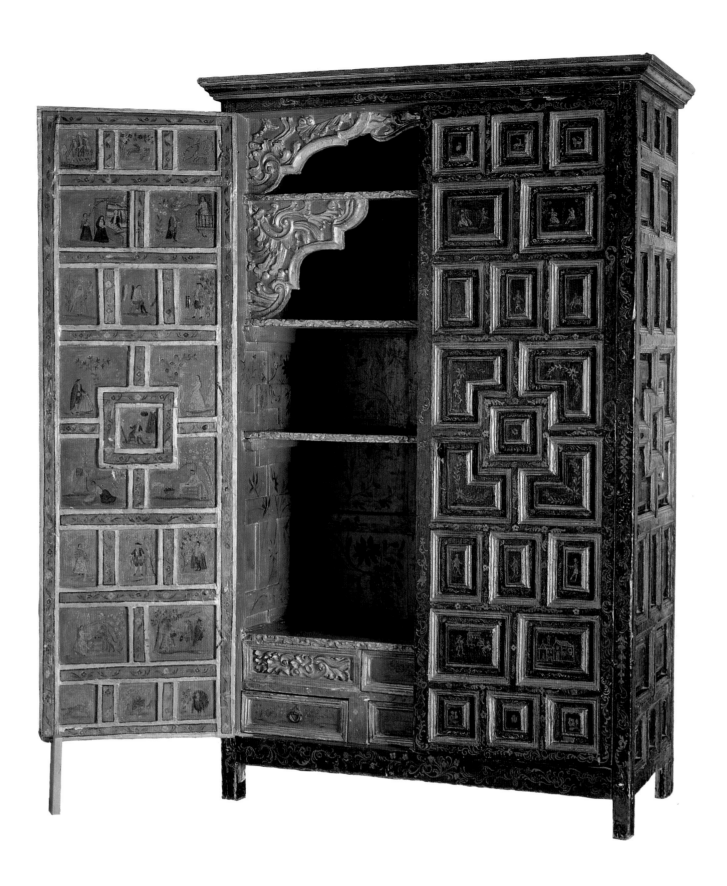

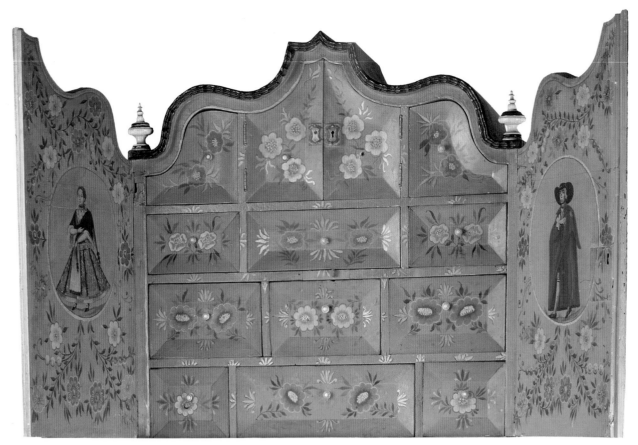

Detail of cat. no. 212

212 ⫸ Secretary

Puebla, late 18th century
Painted and lacquered wood inlaid with wood,
engraved bone; 172 x 76 x 43 cm. (67¾ x 29⅞ x
16⅞ in.)
Private collection, Mexico City
EXHIBITED IN NEW YORK ONLY

The inlaid decoration of this secretary is predominantly Mudejar with con-
trasting woods and engraved bone set in geometric designs featuring rhom-
buses, squares, and rectangles. It is done in the classic style exemplified by
the paneled work of Diego López de Arena of Seville (*Breve compendio de la
carpinteria de lo blanco y tratado de alarifes*, Seville, 1610). An ebony mold-
ing finishes the edges and surrounds the keyholes and part of the inlay. The
top is adorned with fans fashioned from a variety of woods. The interior of
this secretary is coated with *maque fingido* (lacquer imitation) of bright
orange, with flowers and multicolored foliage. On each door is a medallion
with a figure, one male and one female. The woman is dressed in the style of
the era, with a skirt of Chinese damask, a black woolen cape, and a shawl.
The man wears the classic Spanish cape over his left shoulder.

The Puebla craftsmen were enriched by pre-Hispanic traditions and by
emigration from both Europe and the Orient during the colonial period.
They excelled as cabinetmakers and were especially talented in inlay work.
These skills survive to the present day.

MMRR

REFERENCE
Jorge Loyzaga. "Taracea en México." In Carmen Aguilera et al., *El mueble mexicano: Historia,
evolución e influencias.* Mexico, 1985, p. 88, no. 17.

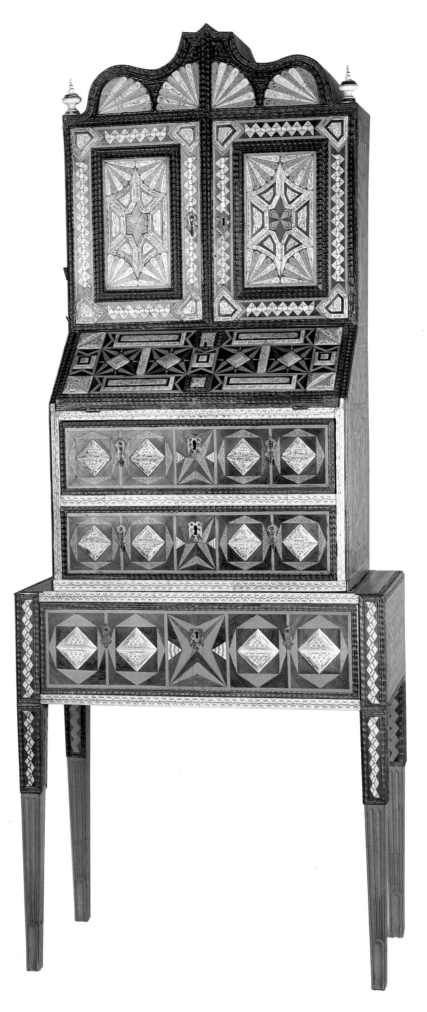

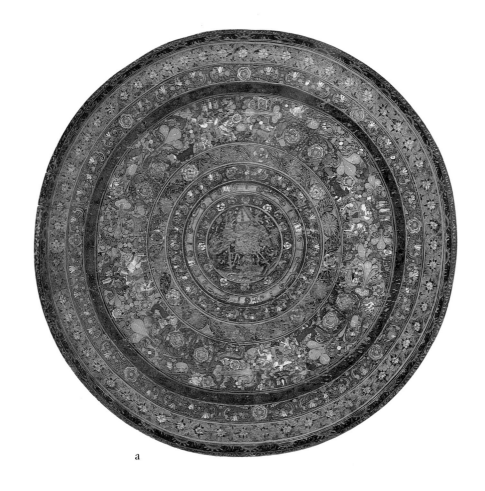

a

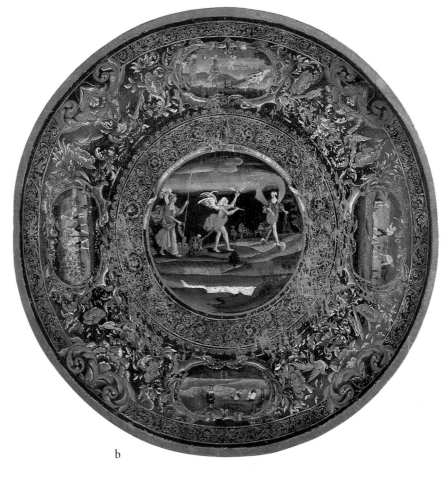

b

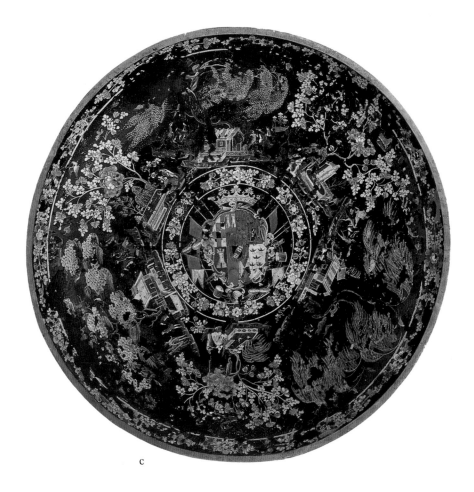

c

213 ⫷ Three Trays

Museo de América, Madrid

a. Uruapan, Michoacán, 17th century
Wood and inlaid lacquer; diam. 125 cm. (49¼ in.)

b. Pátzcuaro, Michoacán, 18th century
Lacquered and painted wood; diam. 107 cm.
(42⅛ in.)

c. Pátzcuaro, Michoacán, 18th century
Lacquered and painted wood; diam. 107 cm.
(42⅛ in.)

In Mexico the term *laca* (lacquer) or *maque mexicano* (Mexican lacquer) is given to the technique used to decorate objects of wood or thick bark, using several coats of a varnish made of animal fat, *aja* (a kind of cochineal), vegetable oil, *chia*, and natural earths. The final finish of the objects depended on the location of the workshops.

In the area of Uruapan, a common method was the *embutido* [inlay] technique, which had pre-Hispanic precedents in gourd decoration. The procedure consists of covering the object with a mixture made of animal fat, vegetable oil, and mineral earth, over which is superimposed the colored powder. This operation is repeated as many times as necessary until a thick coating with a smooth surface is achieved. Then a sharp instrument is used to engrave the outlines of the chosen motifs. The lacquer in these lines is removed, leaving the wood exposed, and the space is filled with the color desired.

This decorative technique is characterized by flat colors and figures with highly defined contours, similar to, but finer than, those achieved with the *rayado* technique.

Craftsmen from the region of Pátzcuaro applied their pigments with a brush. Their decorative programs were marked by didactic, strongly religious content. The scenes were often based on Classical models, available through prints brought from Europe, and chosen by individuals who understood their significance; thus it can be supposed that the majority of these pieces were created for specific commissions.

a. This tray is decorated with a design of concentric bands surrounding a central medallion depicting a double-headed eagle and a bishop's miter and

crosier. On both sides are symmetrical arrangements of animal figures. The bands display geometric and plant designs and human faces in profile, simply drawn. On the fourth band—the widest—are four horsemen with lances, dressed in seventeenth-century style: shirts with full sleeves, lace collars, and wide-brimmed hats with feathers. Between these figures are pictures of deer, suggesting a hunting theme. The design is filled out with large floral groups, birds, and pre-Hispanic motifs.

The back of the tray has birds and flowers painted on a black background in patterns that seem unrelated to those on the front.

b. On the central medallion of this tray is a scene taken from a European engraving, in which Time, pulling a plow guided by Virtue, is preceded by Fortune, who is sowing. The medallion is surrounded by a decorative band with plant motifs, repeated with slight variations in another band along the tray's outer edge. Between them are four smaller medallions with farming scenes and four elaborate floral compositions.

The scene in the center is accompanied by the Latin legend "Semina Fortunae geminat cum Tempore Virtus" (Virtue doubles the products of Fortune with the passage of Time). The text undoubtedly alludes to the need for constancy in good works. The farming scenes in the peripheral medallions emphasize this concept of constancy, for they show the different seasons of the year with their special tasks.

c. On the glossy black background of this tray (which exhibits the lacquer technique of Pátzcuaro) is the central motif of the coat of arms of a marquis, surrounded by a floral band that is repeated along the border of the tray. Under the shield the maker has signed his name: "Mal. dla Zerda Pazqo" (Manuel de la Cerda, Pátzcuaro). The remaining space is filled with six different scenes. These portray both American natives and Europeans, standing in front of Oriental-style buildings. There are weeping willows and peonies, in a style of decoration found in the eighteenth century, when such idealized pictures of exotic worlds and Oriental subjects were common in European and Mexican markets.

Manuel de la Cerda—who was the only eighteenth-century maker of Mexican lacquerware to sign any of his work and whose activities are documented in the eighteenth century—applied his colors with a brush over a base composed of the traditional mixture of animal fat, vegetable oil, and mineral-rich earth. On occasion gold was added to the natural pigments, producing brilliant colors against the black background. The activities of this artisan, who was identified as an "Indian nobleman," included the manufacture of a dozen similar trays for the wife of Viceroy Marquis de Cruillas, as well as small articles of furniture, such as chests and boxes. His work was in great demand, as can be seen by the number of pieces by less gifted artisans who copied his designs and techniques.

MCGS

REFERENCES
María Josefa Martínez del Río de Redo and Maria Teresa Castelló Iturbide. "Una batea del siglo XVIII." *Boletín del Instituto Nacional de Antropología e Historia* no. 33 (1968), pp. 35–38. **Maria Teresa Castelló Iturbide**. *El arte del maque en México*. Mexico, 1980. **D. Rípodas Ardanaz**. "Influencias librescas en las artes aplicadas novohispanas: motivos ornamentales de bateas y búcaros." In *Tres estudios novohispanos*. Buenos Aires, 1983. **María Concepción García Sáiz and Sonia Pérez Carrillo**. "Las *Metamorfosis* de Ovidio y los talleres de la laca en la Nueva España." *Cuadernos de arte colonial* no. 1 (1986), pp. 5–45. **Künstlerhaus**. *Gold und Macht: Spanien in der Neuen Welt*. Exh. cat., Vienna, 1987, no. 4.104, pp. 382–83.

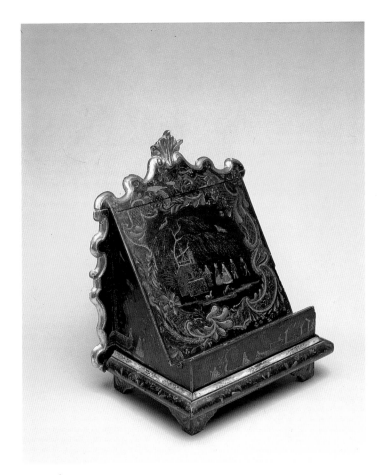

Front of cat. no. 214

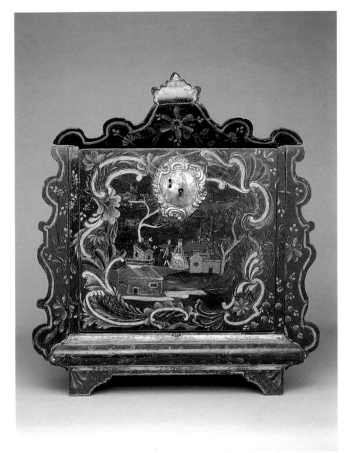

Back of cat. no. 214

214 ◀ Book Stand

◀ Pátzcuaro, Michoacán, about 1760
◀ Lacquered wood, silver mount; 50 x 30 x 24 cm.
◀ (19¼ x 11⅞ x 9½ in.)
◀ Private collection, Mexico City
◀ EXHIBITED IN NEW YORK ONLY

This book stand was made for domestic use. Its sides and back have numerous small drawers and secret compartments lined with Chinese paper, and it has a hidden writing board that slides out.

The stand is coated with lacquer or *maque* (from the Japanese *maki-e*) in the classical style of Pátzcuaro, Michoacán. Craftsmen in this town specialized, as they do today, in applied gold under lacquer. They copied some decorative elements of Chinese and Japanese lacquers but handled them in their own distinctive way.

The piece is decorated with chivalrous, bucolic, and pastoral scenes peopled by a multitude of figures from all social classes mingling in towns with strange houses and fountains. The golden weeping willows, which are of Japanese origin, recall the work of the Cerda family, famous lacquerers of Pátzcuaro, who were active in the seventeenth and eighteenth centuries (cat. no. 213). The birds in the trees are also of Oriental inspiration.

The stand is lacquered in black except for the writing board, which is cobalt blue. The volutes are polychromed, as is the rest of the decoration. The edges and finial shell are beveled and lacquered in gold.

MMRR

REFERENCE
Teresa Castelló Iturbide. "Maque o Laca." *Artes de México* 19, no. 153 (1972), p. 65.

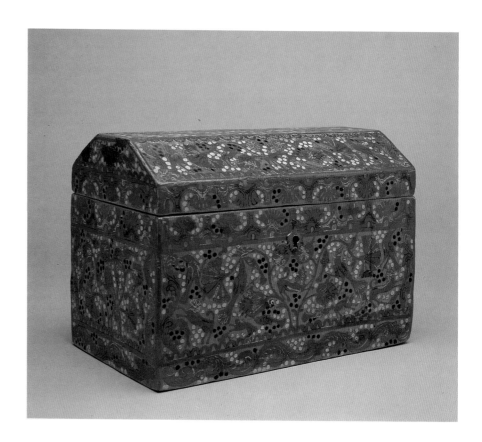

215 ◀ *Arqueta* (Casket)

◀ Olinalá, Guerrero, 18th century
◀ Lacquered wood; 32 x 22 x 19 cm. (12⅛ x 8⅝ x
◀ 7½ cm.)
◀ Museo Franz Mayer, Mexico City C–52 05209
◀ CAC–0028

The lacquerware from Olinalá, Guerrero, now one of the most important centers for lacquer production in Mexico, has special characteristics that distinguish it from the other lacquers that are still made in the traditional way but elaborated in distinct fashions.

Tolto (*toctol*), a white stone, *tecostle* (*tecostil*), a brown stone, and one other stone, *tesicatle* (*tezicaltetl*), are used in the preparation of the lacquer. They are applied to the fragrant wood of the *linaloe* (*bursera aloexyloa*). The design is incised using the thorn of the *huisache* (acacia) in an elaborate and tedious process repeated in multiple layers.

Natural colors like cochineal (*coccus cacti*) for purple, an entwining plant (*cuscuta embellata*) for yellow, and burned oak bark for black are still employed, though artificial pigments are coming into use.

This *arqueta* has a cover shaped like a single gable roof of a house, which may be symbolic since *arquetas* were often given as wedding presents. It is decorated with stylized wildflowers, clusters of grapes, and foliage in tones of crimson, yellow, and black and enriched with white stitching motifs called *canica*.

MMRR

REFERENCE
Teresa Castelló Iturbide. "Maque o Laca." *Artes de México* 19, no. 153 (1972), p. 65.

Ceramics

DONNA PIERCE

> In thee Spain and China meet,
> Italy is linked with Japan,
> and now, finally, a world united
> in order and agreement.
>
> Bernardo de Balbuena, *La grandeza mexicana*[1]

The ceramics produced in colonial Mexico reflect the diverse cultural heritage of that era through motifs inherited from the Orient, the Italian Renaissance, the Moors, Spain, and the New World. In some cases the influence is direct, with obvious borrowing from imported models; in other cases it is indirect, filtered through Spanish ceramics. The copying, however, is never slavish and is always imbued with a spirited intricacy, particularly during the seventeenth and eighteenth centuries, when we see the uninhibited excesses of the Mexican Baroque style. Borrowed elements from various sources are combined at will in Mexican ceramics, and a sense of freedom and whimsy are often apparent in the compositions.

The term *majolica* is generally used for all types of tin-enameled, soft-paste earthenware of Mediterranean, Spanish, or Mexican origin. The addition of tin oxide to lead glaze, which creates majolica's opaque surface, was developed in the eastern Mediterranean area in ancient times and was in use in Spain by the early thirteenth century. Similar ware is referred to as faience in France or as delftware in northern Europe. In Spain and Mexico majolica is often called Talavera ware after the Spanish ceramics center located in the town of Talavera de la Reina.

Majolica with bold geometric and scrollwork patterns executed in plain paint or metallic-luster overglazes developed in eastern and southern Spain during centuries of Moorish domination. After the reconquest of Spain in 1492, production of this Hispano-Moresque ware began to decline. At the same time influence from Italian Renaissance ceramics reached Spain and flourished in the majolica of Talavera de la Reina.

When the Spanish conquered Mexico in the early sixteenth century, they found a thriving pottery industry already in existence. The techniques of wheel-thrown ceramics and glazing, however, were unknown to the Mexican Indians. The beginnings of the majolica industry in Mexico remain obscure, but most scholars agree that the craft was well established in Puebla, and probably also in Mexico City, by the end of the sixteenth century. By 1653 a pottery guild had been established in Puebla. Archaeological excavations indicate that Italian ceramics (from Montelupo, Liguria, and Faenza) as well as Spanish ceramics of both Hispano-Moresque and Italianate styles (from Talavera and Seville) were exported to Mexico during the sixteenth century and inspired Mexican ceramicists.[2] The artistic impetus from Italy and Spain gave way in the late sixteenth century to influence from Chinese blue-and-white porcelain.

Chinese wares were introduced to Europe in quantity first by the Portuguese in the sixteenth century and later by the Dutch from the early seventeenth century on. In the late sixteenth century the Spanish opened trade with China via the Philippines and Mexico. From 1565 to 1815 galleons of the king of Spain laden with trade goods from the Orient arrived annually at the port of Acapulco in western Mexico. The cargo was disembarked and transported by mule train either to Mexico City or through Puebla to Veracruz on the east coast, where it was loaded onto ships for the trip to Spain.

Imports of Chinese porcelain began to influence ceramic production in both Europe and Mexico. During the Ming dynasty (1368–1644) in China blue-and-white porcelain was produced in great quantity both for internal use and for export. Because trade between China and Europe was established during the late Ming dynasty, this style had a major impact on the production of ceramics in Europe and Mexico. One example of a late-Ming jar made for the Mexican market during the reign of Wan-li (1572–1620) combines such Chinese elements as phoenixes, elephants, and lotus petals with the Hapsburg double-headed eagle of the kings of Spain.[3]

The initial peak of the China trade (1570–1620) coincided with Mexico's first silver boom.[4] During this phase a late-Ming export ware, referred to as *kraakporselein* or carrack ware (a term applied by the Dutch to the porcelain found on Portuguese carracks captured in 1602 and 1604), was imported to Mexico in quantity. Transitional ware produced in China during the turbulent change from the Ming to the Ch'ing dynasties entered Mexico in the mid-seventeenth century in lesser amounts. After the transitional period, a renaissance in Chinese porcelain production during the reign of K'ang-hsi (1661–1722) coincided with a revival of the silver economy in Mexico and imports again increased. The blue-and-white porcelain produced during this reign revived many classic Ming motifs. Beginning in the late sixteenth century Chinese polychrome ware was also imported to Mexico.

Mexico may have enjoyed a greater influx of, and consequently influence from, Oriental porcelain ware than did Spain.[5] Many Oriental objects remained in Mexico. Archaeological evidence indicates that blue-and-white Chinese porcelain was prevalent throughout Mexico, appearing even in the northernmost provinces, now Arizona and New Mexico.[6] As early as 1582 the Englishman Henry Hawks wrote of the China trade, "They have brought from [the Islands of China] gold, and much cinnamon, and dishes of earth, and cups of the same, so fine that every man that may have a piece of them, will give the weight of silver for it."[7] By the seventeenth century Chinese porcelain in Mexican homes and convents is frequently mentioned in inventories of the period and by foreign travelers to Mexico.

Pieces of Chinese porcelain served as inspiration for Mexican and European majolica craftsmen. Orientalized ceramics imported from Spain probably reinforced the trend in Mexican ceramics. As a result of Spain's monopoly on trade with its American colonies, it is unlikely that orientalized ceramics from Holland or other European sources would have exercised a major impact on Mexican ceramic designs.

The ceramic ware of Mexico was locally appreciated at the time, as seen in various quotes from the colonial period. Speaking of Puebla in the late seventeenth century, Fray Agustin de Vetancurt chauvinistically claimed that "the glazed pottery is finer than that of Talavera, and can compete with that of China in its fineness."[8] As late as 1745 Fray Juan Villa Sánchez wrote, "The pottery, of which great quantities are made in Puebla, [is] so fine and beautiful that it equals or excels that of Talavera, ... the ambition of the Puebla potters being to emulate and equal the beauty of the wares of China. There is a great demand for this product, especially for the most ordinary qualities which are most in demand throughout the Kingdom."[9]

NOTES

1. Bernardo de Balbuena, *La Grandeza Mexicana* [1604], ed. F. Monterde, Biblioteca del Estudiante Universitario 23 (Mexico, 1954) p. 72. trans. Donna Pierce.

2. Florence C. Lister and Robert H. Lister, *Sixteenth Century Maiolica Pottery in the Valley of Mexico*, Anthropological Papers of the University of Arizona 39 (Tucson, 1982), pp. 45–79; John M. Goggin, *Spanish Majolica in the New World: Types of the Sixteenth to Eighteenth Centuries*, Yale University Publications in Anthropology no. 72 (New Haven, 1968) pp. 212–14.

3. Jean McClure Mudge, *Chinese Export Porcelain in North America* (New York, 1986) p. 47, fig. 49.

4. The following discussion is based on Mudge 1986, pp. 63–84. See also P. J. Bakewell, *Silver Mining and Society in Colonial Mexico: Zacatecas, 1546–1700* (Cambridge, 1971).

5. Lister and Lister, 1982, pp. 78–79; Mudge 1986, pp. 47–50.

6. Florence C. Lister and Robert H. Lister, "Non-Indian Ceramics from the Mexico City Subway," *El Palacio* 81, no. 2 (1975) pp. 25–48; Gonzalo López Cervantes, "Porcelana oriental en la Nueva España," *Anales del Instituto de Antropología e Historia*, época 6ta, 1, no. 55 (1976–1977) pp. 65–82; For New Mexico and Arizona, see Ross Gordon Montgomery, Watson Smith, and John Otis Brew, *Franciscan Awatovi: The Excavation and Conjectural Reconstruction of a 17th-Century Spanish Mission Establishment at a Hopi Indian Town in Northeastern Arizona*, Papers of the Peabody Museum of American Archaeology and Ethnology, vol. 36 (Cambridge, Mass, 1949), and Cordelia Thomas Snow, "A Brief History of the Palace of the Governors and a Preliminary Report on the 1974 Excavation," *El Palacio* 80, no. 3 (1974) pp. 6–21.

7. In Richard Hakluyt, *The Principal Navigations, Voyages, Traffiques and Discoveries of the English Nation* [1589], (London and New York, 1907), vol. 6, p. 291.

8. Fray Agustin de Vetancurt, *Teatro Mexicano: Descripción breve de los sucessos exemplares de la Nueva-España en el nuevo mundo occidental de Las Indias* [1698], Colección Chimalistac 9 (Madrid, 1960), vol. 2, *De los sucesos militares de las armas. Tratado de la ciudad de México. Tratado de la ciudad de Puebla*, p. 305.

9. Fray Juan Villa Sánchez, *Puebla sagrada y profana, informe dado a su ilustre Ayuntamiento el año de 1746* (Puebla, 1746), as quoted in Edwin Atlee Barber, *The Maiolica of Mexico*, Art Handbook of the Pennsylvania Museum and School of Industrial Art (Philadelphia, 1908) p. 17.

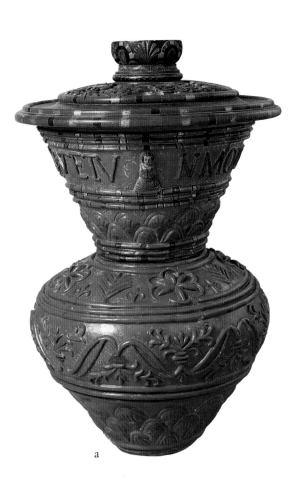

a

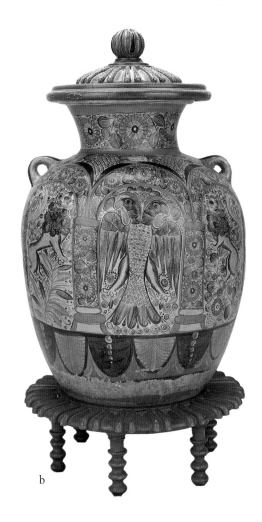

b

216 ◄ Two Jars

◄ Guadalajara, Jalisco, 17th century

◄ a. Modeled ceramic, polychrome over red slip,
◄ burnished; height 86.5 cm. (34 in.), greatest
◄ diameter 63 cm. (24¾ in.)
◄ Inscribed: INMORTAL D. JUAN PEREZ DE GUZMAN
◄ CANTETU
◄ Museo de América, Madrid

◄ b. Modeled ceramic, polychrome over ocher slip,
◄ burnished; height 82 cm. (32¼ in.), greatest
◄ diameter 58.5 cm. (23 in.)
◄ Museo de América, Madrid

These jars are from Guadalajara, whose potteries turned out a tremendous number of similar pieces for export to Europe, where they were very popular. The potteries in Puebla de los Angeles, which made ceramic ware known as "Talavera de Puebla," must have suffered a good deal from the competition. Although their products were similar in some ways, there were marked technical differences. The Guadalajara potters used a reddish clay covered with a red slip and burnished, which was given a single firing; those in Puebla worked with a very refined clay and applied a glaze containing tin, lead, sand, salt, and water between the first and second firings. As a result, the pieces from Guadalajara have a porous surface that allows the clay to breathe, while the Puebla ware has a white, shiny, glazed surface that is impermeable. The Guadalajara potters seem to have employed a fragrant clay, for according to some accounts of the time, their jars were used to perfume and humidify the air.

As for decoration, the Guadalajara jars show a wide variation in technique, mixing painted and modeled surfaces, lozenge work, and in some cases inlays. The colors are white, ocher, and blue against a cream or ocher background. Plant and animal motifs, such as the double-headed eagles and rampant lions seen in jar (a) here, were popular; exotic Oriental birds were also common. The Puebla wares show a wider range of color, thanks to the use of metallic oxides: cobalt blue, yellow, and green enliven both religious and profane subjects.

Pieces from both sources display a wide diversity of shapes, resulting from many different influences. The jars from Guadalajara preserved some of the technical and formal aspects of pre-Hispanic cultures—slip painting and gourd shapes—while Puebla has added to its wealth of forms the glazed tile used in civil and religious architecture, both as interior decoration and as facing for domes and facades.

MCGS

REFERENCES
Detlef Heikamp. *Mexico and the Medici.* With contributions by Ferdinand Anders. Florence, 1972, p. 25. **Thomas H. Carlton and Roberta Reiff Katz.** "Tonalá Bruñida Ware: Past and Present." *Archaeology* 32, no. 1 (1979), pp. 45–53. **María Angeles Albert.** "Arqueología y arte colonial." *Cuadernos de Arte Colonial* no. 3 (1987), pp. 79–92. **María Concepción García Sáiz and José Luis Barrio Moya.** "Presencia de cerámica colonial mexicana en España." *Anales del Instituto de Investigaciones Estéticas* 16, no. 58 (1987), pp. 103–10. **Sylvaine Hänsel.** "Andenken aus der Neuen Welt: Kolonialmexikanische Keramik im Herzog Anton Ulrich-Museum in Braunschweig." *Weltkunst* 59, no. 15 (1989), pp. 2163–67.

217 ◀ Basin (*Lebrillo*)

Puebla, 1600–1650
Earthenware, tin glaze, black in-glaze paint; diameter of rim 43 cm. (16⅞ in.); diameter of base 26 cm. (10¼ in.); depth 12 cm. (4¾ in.)
Private collection, Mexico City
EXHIBITED IN NEW YORK ONLY

Only a few examples of Mexican majolica decorated exclusively with black designs on an off-white ground have survived. All date from the seventeenth century. In Mexican ceramics the paste varies from white to brick in color. The paste of this basin is a reddish color covered by a cream-colored enamel. The black manganese paint has fired to a dark brown color in places and has not taken well to the surface, leaving small bubble impressions in the design. Three scars from stacking the basin on supports during firing can be seen on the bottom surface. The flat-bottomed, vertical-walled, wide-mouthed basin, or *lebrillo*, has a long history in Spanish ceramics, dating at least to the thirteenth century, and was probably introduced by the Moors in the eighth or ninth century. Whereas in Spain the decoration was applied over a previously

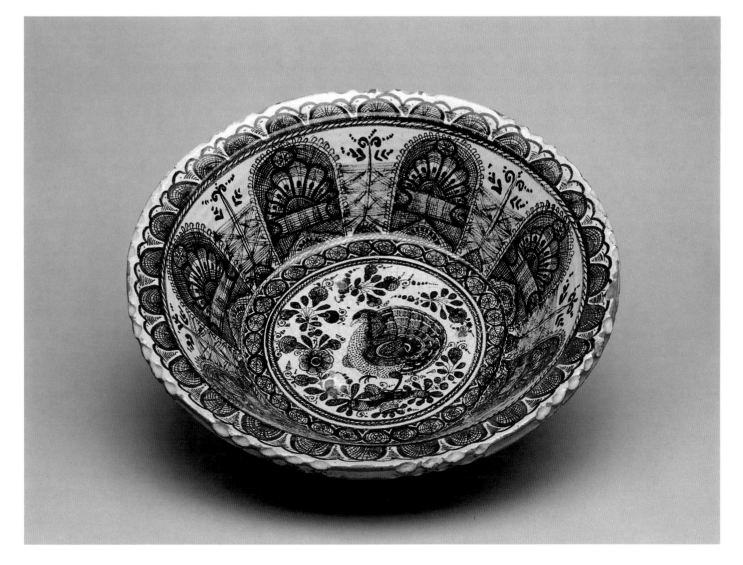

fired glaze and then refired, in Mexico the designs were painted on a glazed, but unfired, surface and then fired.

A style adapting lace patterns fashionable in clothing to pottery designs evolved in Spain at the end of the sixteenth century. The delicacy of lace was evoked by ceramicists through the use of very fine black lines with small dots placed at the intersections to imitate the knots in true lacework. In Spanish ceramics the scalloped lace patterns usually surround a central image with an Italian Renaissance theme such as a sun, cherub, or allegorical figure.

Although the lacework in the Mexican piece is similar to Spanish prototypes, the central image of a turkey—a bird unknown prior to the discovery of America—illustrates the Mexican artisan's independence from Old World traditions. Unlike Spanish examples, the spaces between the lace scallops and those surrounding the turkey are filled in with geometric designs and floral sprays in a manner characteristic of Mexican workmanship. The Renaissance imagery and restrained lace patterns of Spanish pieces have been replaced by indigenous iconography and an even more complex patterning.

DP

REFERENCES
Enrique A. Cervantes. *Loza blanca y azulejo de Puebla.* Mexico, 1939, vol. 1, pp. 104–105. **John M. Goggin.** *Spanish Majolica in the New World: Types of the Sixteenth to Eighteenth Centuries.* Yale University Publications in Anthropology, no. 72. New Haven, 1968, pl. 13a. **Florence C. Lister and Robert H. Lister.** *Andalusian Ceramics in Spain and New Spain: A Cultural Register from the Third Century B.C. to 1700.* Tucson, 1987, p. 239, fig. 136a. **José Luis Pérez de Salazar.** "La Colección Pérez de Salazar." *Artes de Mexico,* n.s., no. 3 (1989), p. 74.

218 ◄ **Basin (*Lebrillo*)**

Puebla, mid-17th century
Earthenware, tin glaze, cobalt and black in-glaze paint; diameter 53 cm. (20¾ in.)
The Metropolitan Museum of Art, Gift of Mrs. Robert W. De Forest, 1912 12.3.1

In the seventeenth century Mexican artisans fused the lace patterns from Spanish Renaissance pottery with abstract scrollwork designs from Hispano-Moresque ceramics, creating a style known as Puebla polychrome. The lace patterns were separated into sections and delineated by wide blue dividing lines. The tendency to use strong outlines to define forms was also characteristic of pre-Hispanic painting in Mexico.

In this example the lace patterns on the base radiate from a four-petaled central motif. On the walls of the basin vertical lines separate the patterns at intervals; although vertical divisions on the walls of plates and bowls are a distinguishing characteristic of Chinese carrack ware, they are also present in Hispano-Moresque ceramics. The bold design covers every area of surface space, exemplifying the horror vacui common in both Hispano-Moresque and Mexican art.

The inscription around the rim of the basin translates "I am for the washing of the purificators and nothing else," indicating use in a religious context. Many pieces of Talavera ware were commissioned for convents or churches and bear appropriate inscriptions. Remnants of Puebla polychrome pottery have been found in archaeological excavations in New Mexico and Florida in the United States, indicating exportation to the missions and settlements operating in those areas in the seventeenth century.

DP

REFERENCES
Enrique A. Cervantes. *Loza blanca y azulejo de Puebla.* Mexico, 1939, vol. 1, pp. 102–103. **John M. Goggin.** *Spanish Majolica in the New World: Types of the Sixteenth to Eighteenth Centuries.* Yale University Publications in Anthropology, no. 72. New Haven, 1968, pl. 13f. **Florence C. Lister and Robert H. Lister.** *Andalusian Ceramics in Spain and New Spain: A Cultural Register from the Third Century B.C. to 1700.* Tucson, 1987, p. 240, fig. 137.

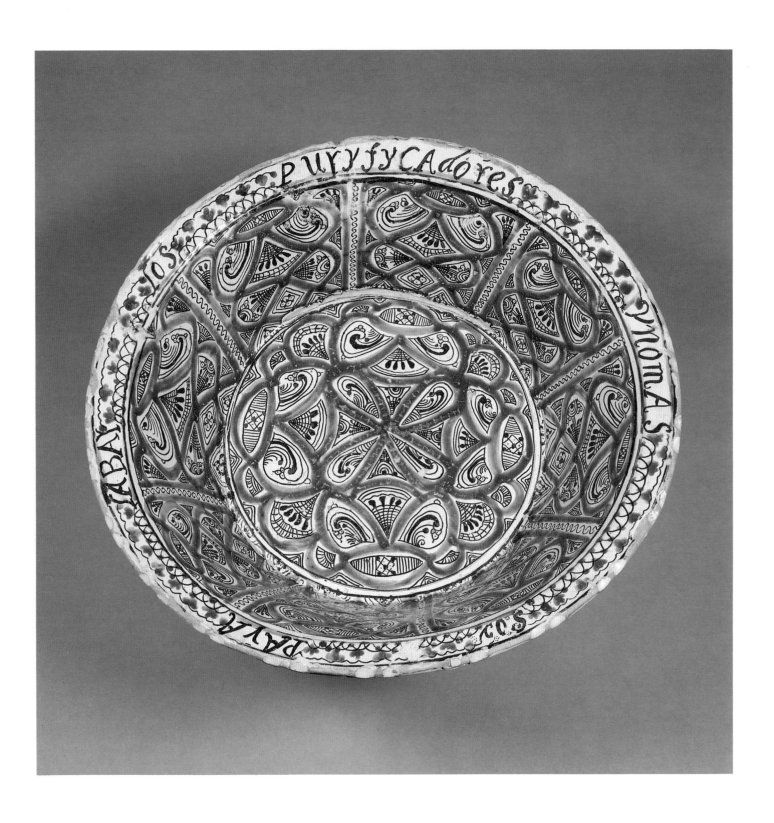

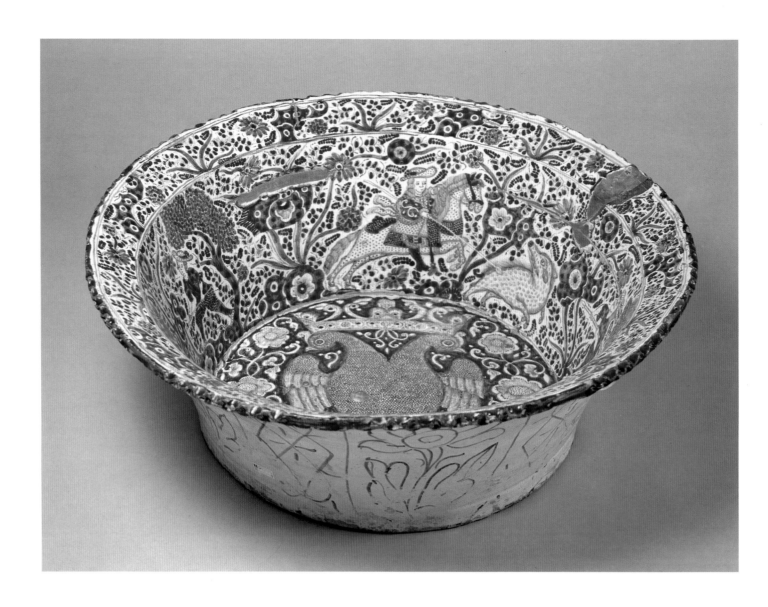

219 ◀ Basin (*Lebrillo*)

◀ Puebla, 1650–1700
◀ Earthenware, tin glaze, cobalt in-glaze paint; height
◀ 31 cm. (12 in.); diameter 86 cm. (34 in.)
◀ Museo Franz Mayer, Mexico City 8–488 00359
◀ GLB–008
◀ EXHIBITED IN NEW YORK ONLY

Dating from the second half of the seventeenth century, this basin is one of the largest pieces of Talavera ware in existence and once belonged to the convent of the Holy Trinity of Conceptionist nuns in Puebla. White- or cream-paste pottery decorated in underglaze blue designs over white enamel was the most common type of pottery during the seventeenth and eighteenth centuries in Mexico. The basin is decorated in both light and dark shades of blue. This style, sometimes incorporating thin black outlines, is considered transitional between the earlier Puebla polychrome and the later classic Puebla blue-on-white ceramics. It may reflect influence from Chinese ceramics of the Chia-ching reign (1521–66) of the Ming dynasty (1368–1644), which also featured designs in two shades of blue with occasional black outlines.

The blue color used on pottery is a form of cobalt oxide. It has been used as a pigment in the Middle East since the Neolithic period but was not applied to ceramics until the ninth century A.D. The formula for its application to ceramics was improved by the Chinese and is evident in the blue-and-white porcelain of the late Yüan dynasty (1279–1368). In Mexican ceramics the cobalt oxide is often concentrated into a thick, dark pigment and applied with

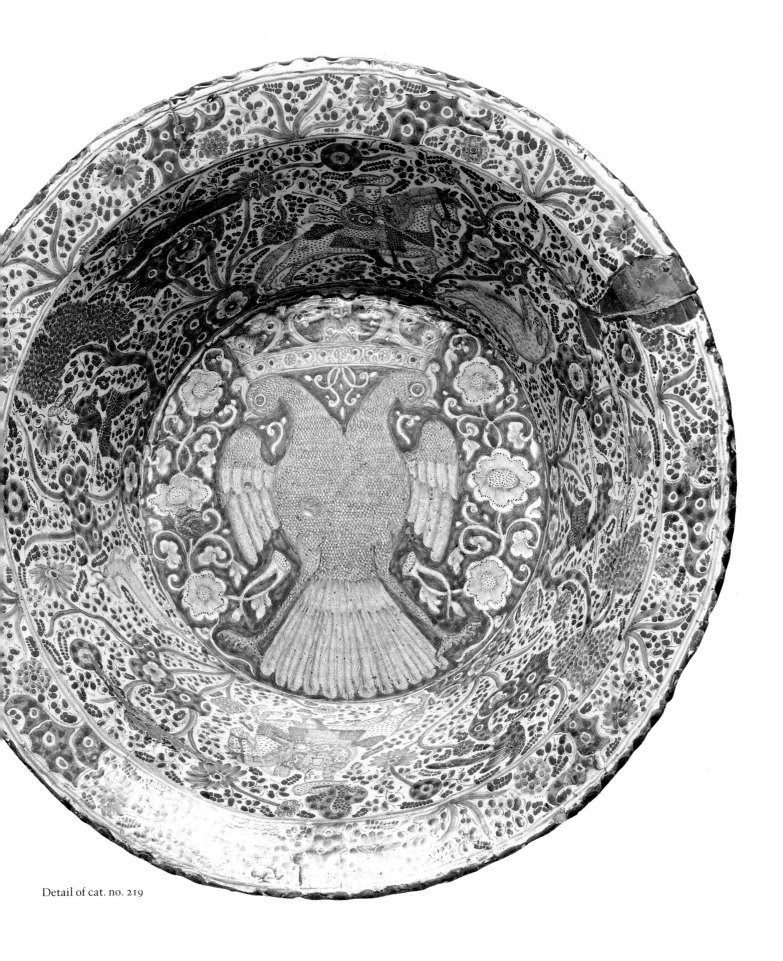

Detail of cat. no. 219

heavy brushstrokes, creating a raised blue pattern over the white ground. Recessed or sunken areas appear in the decoration when the pigment fuses into the glaze during the single firing employed in Mexico. The resulting rippled-surface effect is a distinctive characteristic of Mexican majolica.

The bottom of this basin shows a double-headed eagle, the emblem of the Hapsburg kings of Spain. The feathers on the eagle are made up of small U-shapes on the body and parallel lines on the wings and tail. This repetitive compartmentalization is reminiscent of both Hispano-Moresque and Pre-columbian artistic conventions.

Pastoral scenes were a popular form of decoration on European ceramics of the period. The two hunting scenes depicted on the walls of this Mexican basin reflect that influence. In both scenes a mounted rider pursues his prey with the aid of another person, probably a groom, on foot and armed with a lance. In one scene the rider aims at a stag with a flintlock pistol; in the other, the rider is preparing to lance a wild boar. Both horses are outfitted with rump covers, breastplates, and wide saddle skirts. Both riders are dressed in the tall boots, wide-cuffed waistcoats, and wide-brimmed hats of the second half of the seventeenth century.

The human figures and animals here are covered with small dots or circles. Filling the outlines of living forms with random dotting is a Muslim concept dating back to the ninth century A.D. and was adopted by Spanish, Mexican, and Chinese ceramicists. The illogical scale and crowded space are typical of Mexican pottery decoration. Floral and abstract motifs are spread throughout the scenes, leaving little exposed space, and the trees flanking the figures on foot are dwarfed by giant daisies.

DP

REFERENCE
Alejandra Peón Soler and Leonor Cortina Ortega. *Talavera de Puebla.* Mexico, 1973, pl. 1.

220 ◀ **Vase**

◀ Puebla, mid-17th century
◀ Earthenware, tin glaze, cobalt in-glaze paint;
◀ height 47 cm. (18½ in.)
◀ Philadelphia Museum of Art, Given by Mrs. John
◀ Harrison 07.295T

Inverted pear-shaped vases with narrow necks and serpentine handles became popular in Mexico from the mid-seventeenth century throughout the colonial period. The form is related to Spanish olive jars as well as to Oriental kuan, or storage jars, that date to the fourteenth century.

This example is one of an identical pair. The other is in the collection of the Hispanic Society of America, New York, and bears a maker's mark of "he" in the lower section. This mark has been associated with Damian Hernández, a master ceramicist from Puebla who in 1653 was guild inspector. Hernández was born in Spain but immigrated to Puebla at an early age and learned his trade there under several master potters, including Alejandro Pesaro in 1601 and Antonio de Vega y Cordova in 1607.

The vases are decorated in light and dark shades of blue. On two sides a woman with a parasol appears riding in an elaborate chariot pulled by two horses and driven by a man standing in front. Elsewhere men and women are depicted in various pastoral scenes. The images, particularly the chariot, reflect

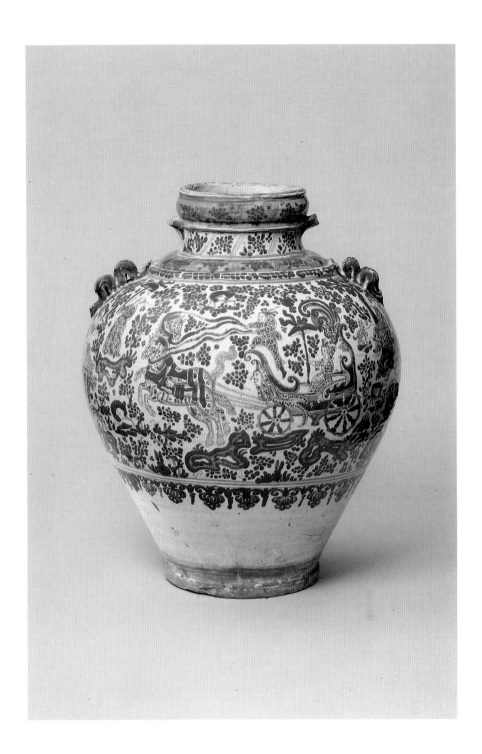

influence from Italian ceramic designs. The humans and animals are filled
with dots in the Muslim tradition for indicating living figures (see also cat.
nos. 219 and 221). Oversize floral sprays are common in Spanish Talavera
ware, but random use of them to fill all empty space in the composition is an
exaggeration characteristic of Mexican ceramics.

DP

REFERENCES
Edwin Atlee Barber. *The Maiolica of Mexico.* Art Handbook of the Pennsylvania Museum and
School of Industrial Art. Philadelphia, 1908, p. 64, fig. 20. **Enrique A. Cervantes.** *Loza blanca y
azulejo de Puebla.* Mexico, 1939, vol. 1, pp. 112–13.

221 ◀ Vase

Puebla, late 17th century
Earthenware, tin glaze, cobalt in-glaze paint;
height 42 cm. (16½ in.)
Private collection, Mexico City
EXHIBITED IN NEW YORK ONLY

Storage jars with locking iron lids are popularly referred to as *chocolateros*, or chocolate jars, in Mexico as a result of their former use to safeguard delicacies such as chocolate, vanilla, and spices. The body of this jar is divided into four cartouches by vertical bands with large bows. Division of the field by vertical bands is a compositional device frequently seen on carrack porcelain. Large scallops surrounding half-flowers form the lower sections of the cartouches and the tops are rimmed with a debased cloud-collar pattern inherited from Chinese ceramics (see cat. no. 224).

Within each cartouche is a large animal surrounded by vegetation, birds, and fantasy architecture. The bodies of the animals are filled with dots in the Muslim tradition for indicating living forms (see cat. nos. 219–220). Dots and clusters of dots are also used to decorate the framing elements and to fill all blank space in the composition. Dot clusters are common on ceramics from Spain, but the unrestrained use of dots to cover nearly all surfaces is an invention of the Mexican artist.

DP

REFERENCES
Alejandra Peón Soler and Leonor Cortina Ortega. *Talavera de Puebla.* Mexico, 1973, pl. 5. **Efraín Castro Morales.** "Puebla y la Talavera a través de los siglos." *Artes de México*, n.s., no. 3 (1989), p. 36.

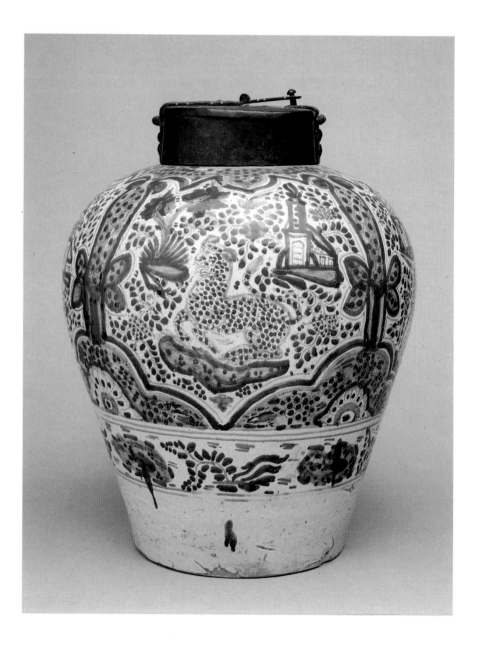

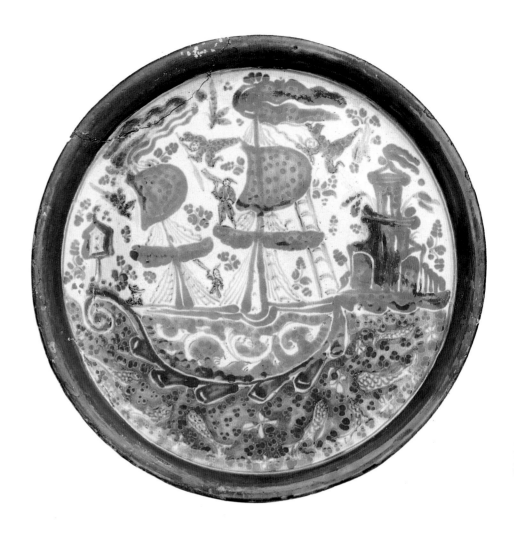

222 ❧ Plate

Puebla, 17th century
Earthenware, tin glaze, cobalt in-glaze paint;
diameter 32 cm. (12⅝ in.)
Private collection, Mexico City
EXHIBITED IN NEW YORK ONLY

The reverse of this plate bears the maker's mark of "he," which has been associated with the potter Damian Hernández (see cat. no. 220). In the center of the plate a large ship, possibly the artist's image of a Chinese junk or a Spanish galleon, heads toward a three-tiered building on land. Ships often decorate plates and bowls from Spain, and this composition may represent the arrival of the Manila Galleon in the port of Acapulco for the great annual trade fair.

Four Orientals, sporting characteristic queues, cavort on the ship. Two swing from ropes attached to the tops of the masts; one sounds a horn from the boom of the lower sail; and a fourth seems to stand on the deck waving either an instrument or a flag. The entire composition is animated with sails billowing, banners flying, waves trailing, and sea creatures swimming in the surrounding water. Birds, along with flowers and dot clusters, fill the sky. The decoration of the plate demonstrates the distinct and whimsical version of chinoiserie developed by Mexican craftsmen.

DP

REFERENCE
Enrique A. Cervantes. *Loza blanca y azulejo de Puebla.* Mexico, 1939, vol. 1, pp. 118–19.

◀ Vase

◀ Puebla, mid–late 17th century
◀ Earthenware, tin glaze, cobalt in-glaze paint;
◀ height 33 cm. (13 in.)
◀ Museo Franz Mayer, Mexico City D–002 01355
◀ GJC–0013

The form of many ceramic vessels in both Europe and Mexico was influenced by Oriental shapes. The double-gourd outline of this vase is related to similar vessels from the Ming dynasty (1368–1644) and earlier in China. In Mexico the shape is less pronounced than in Chinese examples and may reflect influence from the ceramics of pre-Hispanic Mexico.

The motifs on the shoulder of this vessel are stylized versions of the Chinese cloud-collar pattern (see also cat. no. 224). The garden scenes with trees and birds on the shoulder and around the middle of the vase are related to similar vignettes on Oriental porcelain, but here the realistic scale and perspective of Oriental gardens has been disregarded—flowers and birds tower over buildings in a fantasy landscape.

The unidentified potter's mark "Gco" is visible on the undecorated lower section of the vase. The guild ordinances of 1653 decreed that such marks were mandatory for fine wares, but the regulation seems not to have been followed with any consistency. The chevron-and-flower motif on the basal band is a holdover from the lace patterns on Puebla polychrome ceramics (see cat. nos. 217 and 218).

DP

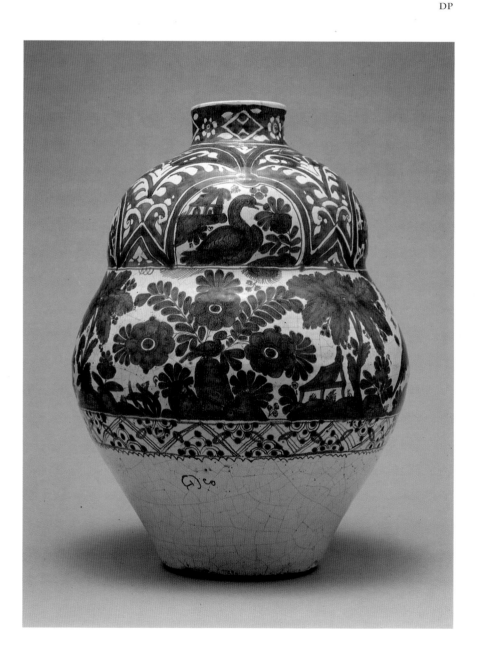

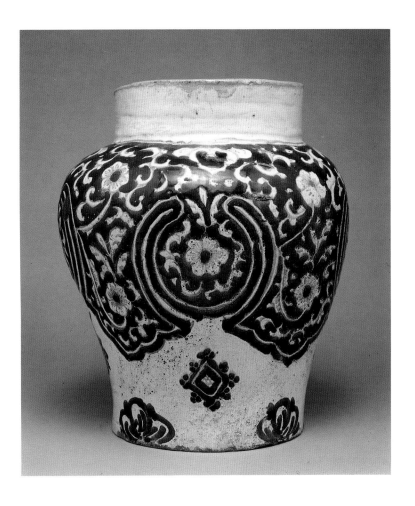

224 ◀ Vase

Puebla, late 17th century–early 18th century
Earthenware, tin glaze, cobalt in-glaze paint;
height 43 cm. (16⅞ in.)
Museo Franz Mayer, Mexico City 14–086 07842
GJC–0075

This vase provides an example of Mexican adaptation of Oriental forms and illustrates how those forms were altered to suit Mexican artistic sensibilities. Here the Mexican artist has borrowed the cloud-collar pattern frequently used on the shoulders of Chinese vases since the fourteenth century. The cloud-collar patterns have been exaggerated and expanded from the Chinese model until they cover most of the surface of the vase. The delicate balance between blank space and form employed by Chinese artists has been replaced by the Mexican tendency to emphasize overall repetitive patterns.

In this Mexican vase the lotus-flower medallion that often appears in the circular space between the clouds in Chinese vases from the Ming dynasty (1368–1644) has been overtaken by the cloud contours, and the lotus has been rendered in such an abstract manner that it is almost unrecognizable as a flower. The border motifs that appear around the base of Ming vessels have been abbreviated and occur only at intervals. The neck of the vase is straight and undecorated and probably had either a ceramic or iron lid.

DP

The cloud-collar device (also known as a lambrequin pattern, *ruyi* lappets, or ogival panels) that commands the entire upper portion of this jar was commonly used as a subordinate motif in Chinese blue-and-white porcelain from the fourteenth century onward. During the seventeenth and eighteenth centuries it was occasionally promoted to a principal design containing reserved floral sprays. This can be seen in some Chinese porcelains that are known to have been exported to the West, or were made for the West, at that time.

SV

REFERENCE
Leonor Cortina. "Polvos azules de Oriente." *Artes de México*, n.s., no. 3 (1989), p. 61.

225 ⟨ Vase

Puebla, early 18th century
Earthenware, tin glaze, cobalt in-glaze paint;
height 50 cm. (19½ in.)
Museo Franz Mayer, Mexico City F—017 0362
GTH—0039

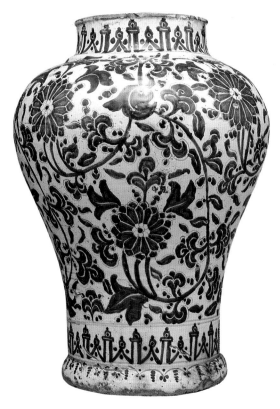

This vase from Puebla exhibits strong Oriental influence and may have been copied directly from an imported Chinese vessel, probably a vase from the K'ang-hsi reign (1661–1722) of the Ch'ing dynasty (1644–1912). During K'ang-hsi's reign the blue-and-white ceramics of the Ming dynasty (1368–1644) were continued alongside polychromed porcelain. Large scrolls of chrysanthemum, peony, or lotus blossoms were common decorative motifs during the period and have been adapted here by the Mexican craftsman.

DP

The bold overall floral scroll on this vase is closely related to a highly stylized lotus scroll that frequently dominates Chinese blue-and-white porcelain of the K'ang-hsi period. These scrolls are characterized by their large flowers; heavy, undulating stems; and the special way in which the flowers and foliage are edged in white. The shape of this vase can also be compared with that of late seventeenth–early eighteenth-century Chinese porcelain.

SV

REFERENCES
Enrique A. Cervantes. *Loza blanca y azulejo de Puebla.* Mexico, 1939, vol. 1, pp. 112–13. **Diego Angulo Iñiguez.** *La ceramica de Puebla (Méjico).* Madrid, 1946, pl. 5. **Leonor Cortina.** "Polvos azules de Oriente." *Artes de México,* n.s., no. 3 (1989), p. 63.

226 ⟨ Vase

Puebla, about 1750
Earthenware, tin glaze, cobalt in-glaze paint;
height 42 cm. (16½ in.)
Private collection, Mexico City

Scenes common on vases from China were appropriated by Mexican craftsmen. Some of the most popular compositions included garden scenes, standing cranes, flying phoenixes, Chinese figures, chrysanthemums, and lotus blossoms. In Mexico these motifs were repeated and stylized to the point of convention. The schematic rendering of these themes often distorted the motifs to a form of shorthand. Some forms became unrecognizable and eventually were converted into a distinct motif. The crane on this vase has been borrowed from Ming-dynasty (1368–1644) vessels, but the bush usually found underneath has been converted here into a Mexican nopal cactus.

A diaper pattern on the shoulders and rims of vessels was a standard compositional device in Ming-dynasty ceramics of the late sixteenth and early seventeenth centuries and was frequently copied in Mexico. A pattern of rocks and waves often with an undulating dragon around the base of vessels originated in the fourteenth century in China and can be seen on this Mexican vase where the dragon has been converted to a snake; the entire configuration of bird on nopal cactus with the snake may reflect the pre-Hispanic emblem that has continued in use through the present day. Vertical bars dividing the field into cartouches around the body of the vase became stock patterns in Chinese export porcelain in the seventeenth century and were frequently used by Mexican artists as well.

DP

There can be little doubt that this vase was copied from a late Ming-dynasty blue-and-white porcelain. At least eight comparable Chinese vases can be

documented as having been exported to the West, one of them at Burghley House, before 1690. These Ming vases are approximately the same shape and size, and they all share with the Mexican example a distinctive disposition of motifs based on a wide ornamental band flanked by a narrower frieze above and below. The shoulder cartouches contain flowers or fruits on a diaper ground and alternate with bands ending in confronting *ruyi* heads. On the sides four large, lobed panels, which are directly under the *ruyi* bands on the shoulder, contain a variety of floral motifs. Alternating with the principal panels, and placed below the cartouches on the shoulder, are *ruyi*-edged bands studded with *ruyi* heads or florets.

Cranes, which are a Taoist symbol of longevity, appear frequently on several types of late Ming-dynasty blue-and-white wares that were exported to the West. They may be seen singly, in pairs, or matched with other creatures such as deer. Although the overall decorative format of this vase is very close to Chinese prototypes, the treatment of the crane-in-landscape motif is somewhat different. Generally, when they are flying, Chinese cranes' wings are outstretched; on the ground, their wings are tucked close to the body. By contrast, the crane here spreads its wings while it is on the ground. Chinese cranes are occasionally perched on the branch of a pine tree (another auspicious Taoist symbol); the Mexican artisan has shown his bird on a cactus plant.

SV

REFERENCE
Leonor Cortina. "Polvos azules de Oriente." *Artes de México*, n.s., no. 3 (1989), pp. 59–60.

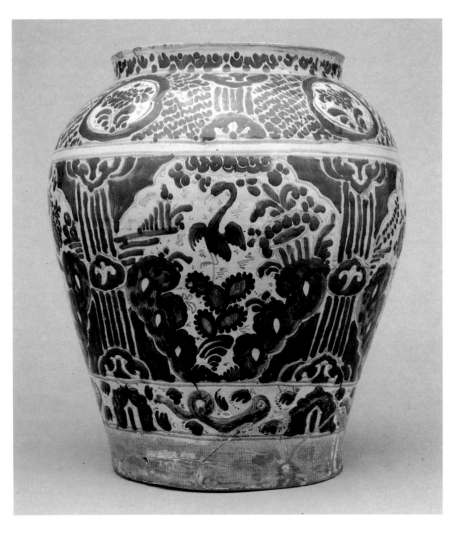

227 ◀ Pair of Vases

Puebla, 1700–1750
Earthenware, tin glaze, cobalt in-glaze paint;
height 62 cm. (24⅜ in.); diameter 39 cm. (15⅜ in.)
a) Museo Franz Mayer, Mexico City 3–036 06153
GJC–0040
b) Art Institute of Chicago, Gift of Mrs. Eva H.
Lewis 1923.1443

This pair of large vases is decorated with alternating floral arabesques and latticework bands arranged in curving vertical patterns. These are intersected by vertical vine patterns that also appear around the neck. The vine motif is common on Mexican majolica ware, particularly around the necks and rims of vessels, and is probably derived from the classic Chinese scroll that became a standard motif in the same location on Ming-dynasty (1368–1644) ceramics. The Mexican version consists of a continuous undulating vine with thick leaves, and sometimes flowers, interspersed in the waves of the vine. The delicacy and spacing of motifs on this vase are reminiscent of brocade patterns on eighteenth-century textiles.

The separate polychromed bases present a Mexican variation on the lotus-petal panels often found as borders on Chinese vessels as early as the four-

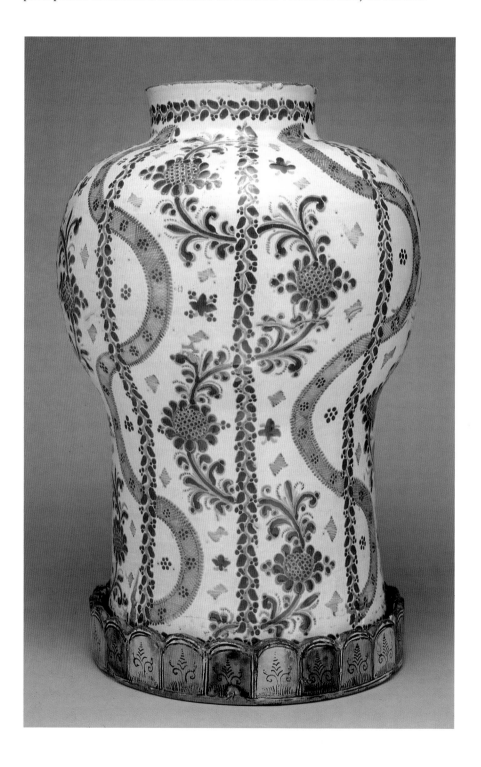

Detail of cat. no. 227b

teenth century. The lotus-petal border can be found throughout Buddhist art and was one of the most enduring decorative elements in Chinese ceramics. Each panel of the border, which often frames other decorative motifs, depicts a single lotus petal with the tip turned down. Although this element is seen on earlier ceramics, such as the blue-and-white porcelain of the Yüan dynasty (1279–1368), Ming-period artists used it extensively, and it was often copied in later periods as well.

<div style="text-align: right;">DP</div>

REFERENCES
Alejandra Peón Soler and Leonor Cortina Ortega. *Talavera de Puebla*. Mexico, 1973, pl. 19. **Leonor Cortina**. "Polvos azules de Oriente." *Artes de México*, n.s., no. 3 (1989), p. 67.

228 ◀ Jar

Puebla, 1732
Earthenware, tin glaze, cobalt in-glaze paint;
height 26 cm. (10 1.4 in.)
Museo Franz Mayer, Mexico City

Talavera ware was often specifically commissioned for both utilitarian and ceremonial purposes. Standard forms of pottery were made with blank cartouches to be filled in later with emblems of religious orders or coats of arms of particular families (see cat. no. 232). This jar bears the emblem of the Mercedarian religious order consisting of a Maltese cross over the vertical bars of the province of Aragon.

Many vessels were labeled with inscriptions specifying their particular function or ownership. The lettering around the neck of this jar states, "For the Reverend Father Joan de Zalazar, Year of 1732." Similar inscriptions were used to indicate functions in the infirmary, pharmacy, kitchen, or sacristy of convents and churches. Tall, narrow pharmacy jars, known as *albarelos* or *canillas*, frequently bear the names of various medicinal herbs and potions.

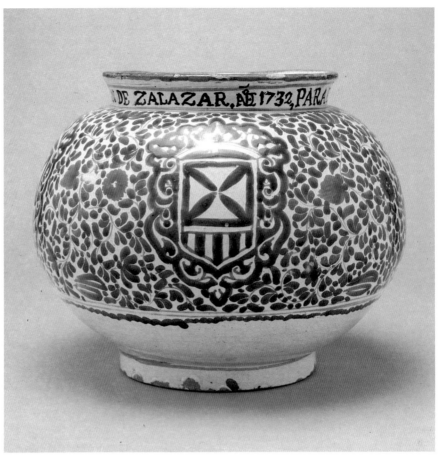

228

This jar provides a standard example of average Mexican majolica production. The luminous and varied quality of the light and dark blue used by Chinese artists during the sixteenth and seventeenth centuries was frequently disregarded by Mexican craftsmen in favor of heavily saturated color. Here the thickly applied blue paint often sinks into the glaze, creating a rippling effect as light reflects off the surface (see cat. no. 219). As a whole, the decorative elements on this jar are densely compacted and exhibit little hierarchy of form. Motifs are barely recognizable and have become subservient to the overall pattern.

DP

REFERENCES
Enrique A. Cervantes. *Loza blanca y azulejo de Puebla*. Mexico, 1939, vol. 1, pp. 174–75. **Alejandra Peón Soler and Leonor Cortina Ortega**. *Talavera de Puebla*. Mexico, 1973, pl. 8.

229 ◀ **Vase with Lid**

◀ Puebla, 18th century
◀ Earthenware, tin glaze, cobalt in-glaze paint, iron
◀ hardware; height 26.7 cm. (10½ in.)
◀ Philadelphia Museum of Art. Purchased, Temple
◀ Fund 08.647

Flying phoenixes were standard decorative elements on porcelain during the Ming dynasty (1368–1644) in China. Borrowed by Mexican artisans, the Chinese phoenix flying over a landscape became one of the most conventional formats for Mexican majolica vases in the eighteenth century. Here the heavy brushwork and thick blue pigment creates an abbreviated form of bird that is reminiscent of the highly prized quetzal bird of southern Mexico.

The cloud collars on the shoulders of the vase as well as the rocks and vegetation in the landscape have been stylized almost beyond recognition. The scalloped rocks beneath the phoenix are probably based on a pattern in Oriental ceramics referred to as "rock of ages."

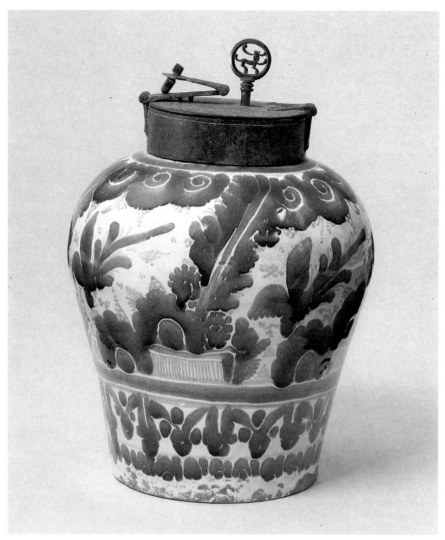

229

Lids and bases were common throughout the colonial period in Mexico. Iron lids were often fitted with locks and were used to protect delicacies such as chocolate, sugar, and vanilla.

Broken or twisted forms were characteristic of the Mexican version of Rococo decoration in the eighteenth century. The twisting curve of the vertical bands on this vase reflects Mexican Rococo taste and is similar to designs on silver objects produced in Mexico in the eighteenth century.

DP

REFERENCE
Edwin Atlee Barber. *The Maiolica of Mexico*. Art Handbook of the Pennsylvania Museum and School of Industrial Art. Philadelphia, 1908, p. 57, fig. 14.

230 ◄ Vase with Lid

Puebla, mid–late 18th century
Earthenware, tin glaze, polychromed in-glaze
paint, bronze hardware; height 32 cm. (12⅝ in.)
Private collection, Mexico City
EXHIBITED IN NEW YORK ONLY

Although blue-and-white porcelain continued to be made during the early Ch'ing dynasty (1644–1912) in China, polychromed styles also were produced in quantity and had a major impact on European ceramics. Exclusively blue-and-white pottery gave way to examples with pastel grounds decorated with multicolored figures. Green, rose, cream, yellow, and light blue became popular base colors. This vase, called Aranama polychrome ware by archaeologists, demonstrates the change in palette. The colors used are green, orange, white,

and black on a yellow ground with a traditional blue-on-white band around the base.

This vase was probably inspired by the chinoiserie ceramics popular in Europe at the time. Nonetheless it still includes a debased cloud-collar pattern from Ming-dynasty (1368–1644) ceramics on the shoulders, now polychromed and more elaborate. The whimsical Oriental figures are reminiscent of European chinoiserie, but the scattering of abstract and floral motifs throughout the composition reflects Mexican decorative tastes.

DP

REFERENCES
Enrique A. Cervantes. *Loza blanca y azulejo de Puebla*. Mexico, 1939, vol. 1, pp. 258–59. **José Luis Pérez de Salazar**. "La Colección Pérez de Salazar." *Artes de México*, n.s., no. 3 (1989), p. 72.

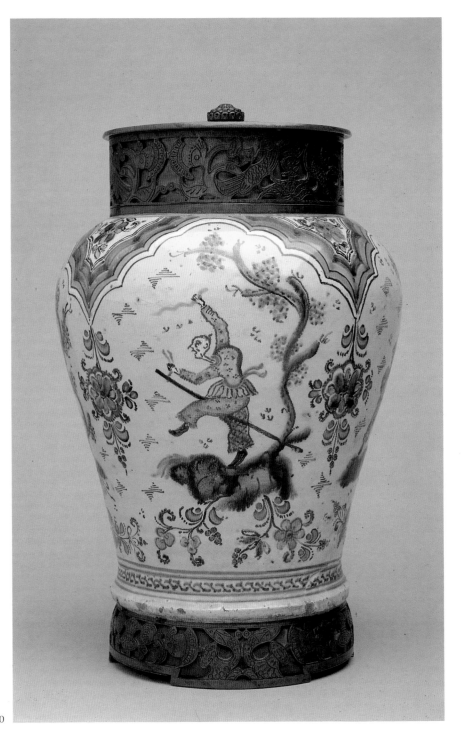

230

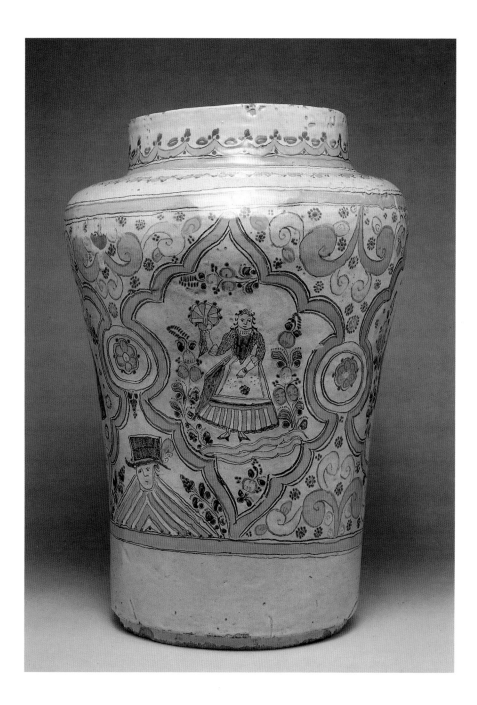

231 **Vase**

Puebla, early 19th century
Earthenware, tin glaze, in-glaze paints; height
68 cm. (26¾ in.)
Museo Franz Mayer, Mexico City 12–029 08303
GJC–0083

Although polychromed majolica had been produced in Spain since the early thirteenth century and in Mexico since the late sixteenth century, it had been overshadowed by the immense popularity of blue-on-white ceramics. In the eighteenth century a revival of polychromed ceramics occurred in both the East and the West. The most popular ground color for ceramics in Mexico beginning in the late eighteenth century was a pale blue popularly known as *azul punche* because of its similarity in color to a pastry made in Puebla. Called Tumacacori polychrome by archaeologists, vessels with this base color were usually decorated in yellow, orange, green, black, and white.

The lobed cartouches used on Chinese Ming-dynasty (1368–1644) ceramics had been a popular convention for framing decorative scenes on vessels in Europe and Mexico since the seventeenth century. In the late eighteenth century the pastoral scenes inherited from Italian and Spanish ceramic wares took on a decidedly independent flavor and became instead scenes from the

folk life of Mexico. Here male and female figures dressed in contemporary clothing decorate the sides of the vase. The man wears a top hat and cape fashionable at the time. The woman's clothing reflects the current interest in folk dress.

DP

REFERENCE
Alejandra Peón Soler and Leonor Cortina Ortega. *Talavera de Puebla*. Mexico, 1973, pl. 22.

232 ◀ Vase

Puebla, early 19th century
Earthenware, tin glaze, in-glaze paints; height
39.4 cm. (15 ½ in.)
Museo Franz Mayer, Mexico City 11–137 07962
GMA–0034

Neoclassicism was introduced to Mexico in the late eighteenth century, and its influence was soon visible in ceramic production. As polychromed ceramics began to eclipse blue-and-white pottery, Neoclassical motifs and color schemes appeared in majolica ware. Neoclassical swags and garlands in either mauve or orange with yellow, green, and black on a cream ground became popular.

On this vase the classic Mexican vine motif in blue is the only remnant from earlier ceramic designs (see cat. no. 228). The Mexican tendency to fill all available space has been slightly restrained in this Neoclassical piece, but it remains much busier than its European counterparts.

Two pendant garlands frame the letters "M.I.M.E.," probably representing the initials of the owner. As in earlier periods, vessels were often specially commissioned by families and were sometimes made with blank cartouches to be filled in upon purchase with the names or initials of the owners (see cat. no. 228).

DP

233 ◀ *Mancerina* (Combination Saucer and Cup Holder)

Chinese, about 1770
Hard-paste porcelain; diameter 24 cm (9½ in.)
CNCA–INAH, Museo Nacional del Virreinato,
Tepotzotlán
10–54470

The overall form corresponds to a model produced in faience at Alcora, Spain, between 1727 and 1749, while the boldly scalloped edge recalls the profile of a shell-form basin current in export porcelain about 1760. For a later version in silver, see cat. no. 234.

The model is not common in export porcelain. The border patterns, the light linear character of the decoration, and its pale mauve color all point to a date of about 1770.

CLC

234 ◀ *Mancerina* (Combination Saucer and Cup Holder)

Mexico, about 1790
Silver; Diameter 22 cm. (8⅝ in.)
Marks: two pillars with crown above; –ORTA
Collection Isaac Backal, Mexico City

The poor impressions of the two marks prevent definite readings. Only the crown and the pillars are visible in the town mark, leaving as a blur the head and the initials that would have indicated the city in which the piece was made. Without this information any interpretation of the inscription "–ORTA" (the first letter could be a C) would be risky: it could indicate either the name of the assayer or that of the artist, especially if the piece was made outside of Mexico City.

Use of this type of domestic utensil spread throughout the viceroyalty of New Spain (and other areas of Spain and its American colonies) with the custom of drinking chocolate. For this reason such pieces are abundant. They were made in other materials besides silver, including Spanish and local Pueblan earthenware, and Chinese export porcelain (see cat. no. 233), and enamel. Although not documented, popular tradition claims that Viceroy Mancera was responsible for the invention of this object: hence the name *mancerina*.

The present example is one of the most outstanding *mancerinas* known. It repeats both the form and decoration of models produced in pottery in Alcora, Spain, and in polychrome enameled copper in China during the final quarter of the eighteenth century. These latter works, along with other service pieces, became the domestic objects most favored by the high society of New Spain.

CEM

REFERENCE
Cristina Esteras Martín. "Platería virreinal novohispana: Siglos XVI–XIX." In *El arte de la platería mexicana: 500 años*, exh. cat., Centro Cultural de Arte Contemporáneo. Edited by Lucía García-Noriega y Nieto. Mexico, 1989, pp. 320–21, no. 97.

233

234

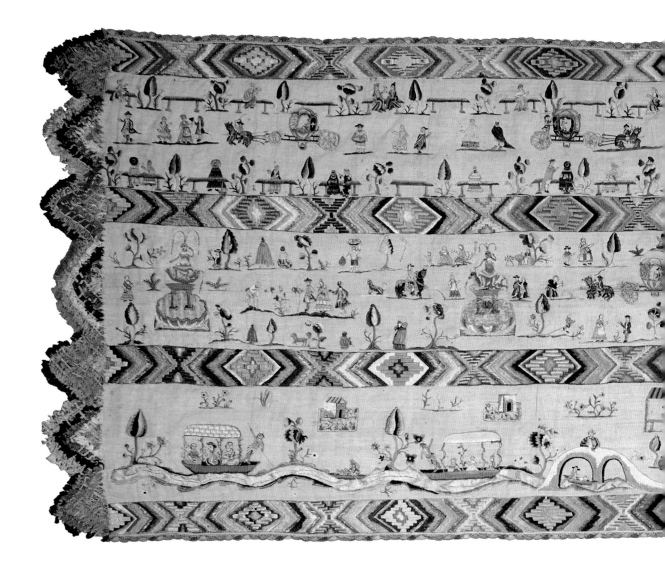

235 ◀ Shawl (*Rebozo*)

◀ Santa María del Río, about 1790
◀ Silk fabric and silk, gold, and silver thread; 72.4 x
◀ 221 cm. (28½ x 87 in.)
◀ Collection at Parham Park, West Sussex, England

The *rebozo*, or shawl, is the most important garment in the Mexican woman's wardrobe. In pictorial documents from the first half of the sixteenth century, women of the pre-Hispanic era are shown wrapped in a long strip of cotton. In the early seventeenth century the Dominican monk Thomas Gage remarked on the way in which Mexican women tossed the shawl's end over their left shoulder; through the centuries the Mexican woman has continued to repeat this gesture.

On its annual voyage to Acapulco the Manila Galleon brought, in addition to spices, porcelain, and furniture, great quantities of silk. Among the textiles were long cloths from India, very similar to those worn by women from the province of Gujarat. The Mexican shawl shows the influence not only of these imports but also of pre-Hispanic fashions. An example of the latter is the fringe, similar to weavings done with bird feathers, which was braided onto the shawl, as can be seen here.

The present *rebozo* is woven with polychrome silk, gold, and silver thread. The three different bands depict favorite recreational areas in eighteenth-century

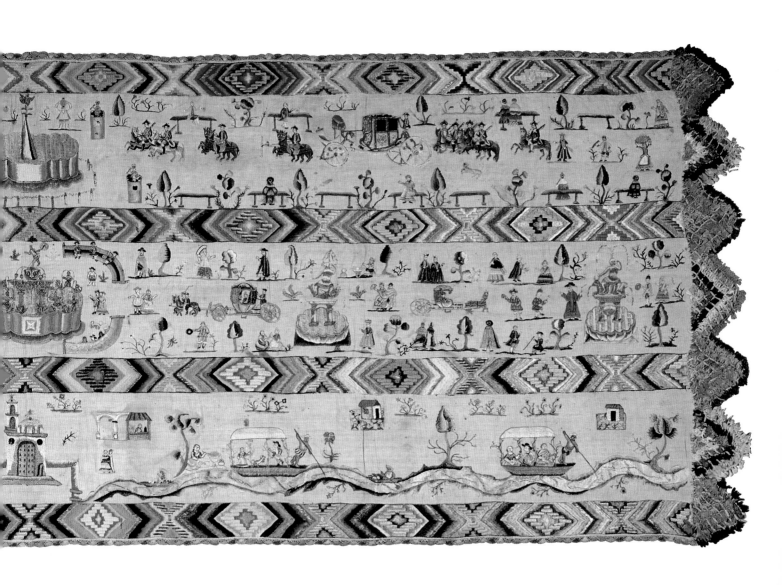

Mexico City. These sites—the Zócalo, or main plaza; the centrally located park of La Alameda; and the floating islands of Xochimilco—still remain popular with the city's inhabitants.

<div align="right">MMRR</div>

REFERENCE
María Josefa Martínez del Río de Redo. "Artes menores: artes industriales." In *Historia del arte mexicano*, vol. 8, *Arte colonial IV*, 2d ed. Mexico, 1986, pp. 1186–88.

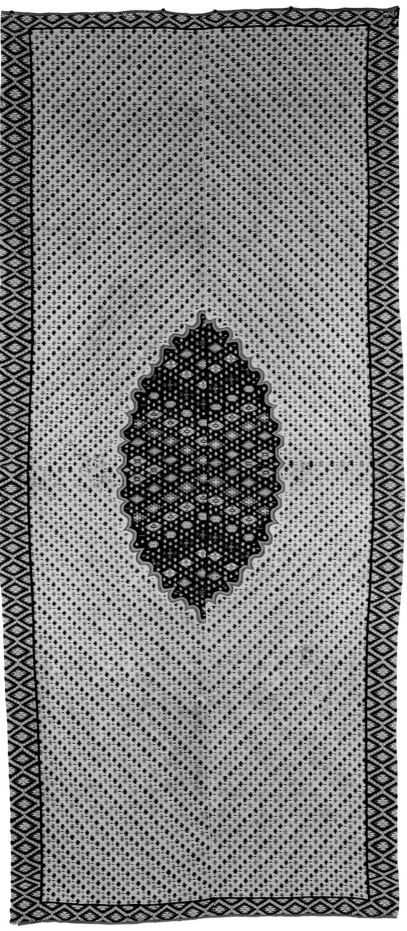

a

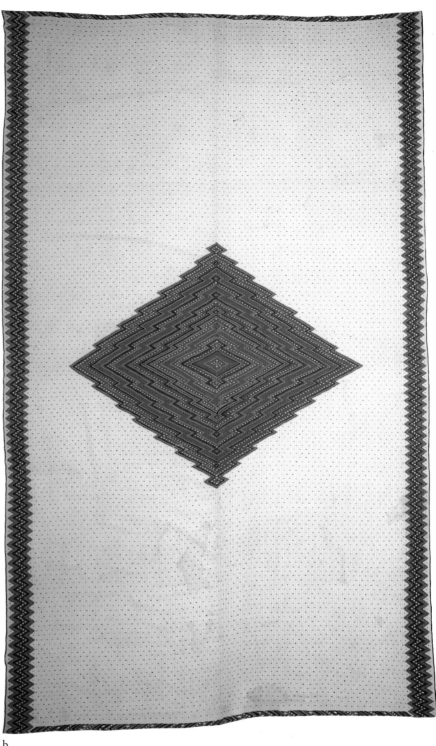

b

236 ◀ Two Serapes

◀ a. Possibly Tialpujahua, Michoacán, late 18th
◀ century
◀ Wool; length 226 cm. (89 in.)
◀ Museo Franz Mayer, Mexico City C–014 04078
◀ FSA–007
◀ b. Saltillo, Coahuila, first half of 19th century
◀ Wool; length 236 cm. (92⅞ in.)
◀ Museo Franz Mayer, Mexico City D–590 04073
◀ FSA–002

The serape is the most characteristic garment used by Mexicans for protection against the cold. Its pre-Hispanic origin is very old. It was originally woven exclusively from *ixtli*, or maguey fiber. About 1420, when the Aztecs and Mexicas conquered settlements where cotton was grown, this new fiber was used in making cloth. The *tilmas*, as these early coverings were called, were made indiscriminately in both cotton and wool and in various sizes, colors, and decorative techniques depending on the status of the prospective owner within the stratified society of ancient Mexico.

With the Spaniards came sheep, pedal looms, and new dyes that enriched the serapes. Their principal designs—sawtooth patterns and large central diamonds—came from Spain and from the Arabs who had conquered her. Rugs and *mantas* (blankets or cloaks) were woven in various cities in Andalusia, principally Cordoba and Almería, following the distant tradition that originated in Asia Minor. Spanish peasants still wear *mantas* for protection from the cold.

Two currents, the native and the Spanish, united in New Spain to produce the very Mexican serape, woven principally by Tlaxcalteca Indians. This group allied with the Spaniards even before the fall of Tenochtitlan and later joined them in colonizing the entire north of the country, where sheep raising became a major enterprise. Important centers of serape production developed in San Miguel el Grande, San Luis Potosí, New Mexico, Arizona, and Texas. The best examples, however, were woven in Saltillo, where about the mid-nineteenth century up to thirteen colors were employed in weaving, all from natural dyes plus gold and silver metal.

a. The neck opening at the center of this serape, a slot for the head to pass through, is placed within a decorative motif called a *bocamanga*, a Baroque contour formed of angles and curves accented with two lines of color. The space within this border contains motifs of small spools, typical of the Tlaxcalteca Indians; diamonds; and hexagons, a Moorish influence. The rest of the serape is white, with designs in two tones of blue arranged symmetrically along diagonals. The dyes are indigo and *zacatlaxcalle*, a yellow color from the zacatlascal plant.

b. This is a fine, thick, and very soft wool textile. The warp is cotton. The large central diamond, which almost reaches the edge of the cloth, has nineteen colored stripes in black and different tones of red obtained from cochineal and huisache. The saw-toothed edge derives from Precolumbian tradition, as do the "eyes" scattered all over. The colors of the zigzag border match those of the *bocamanga* around the neck opening.

VAA

The Academy, Neoclassicism, and Independence

MARCUS BURKE

The final chapter of Mexican colonial art—the establishment of the Academy of San Carlos in Mexico City and the development of Neoclassicism—is in many ways the most interesting from the point of view of social history. Although Seville had founded an academy of fine arts on Italian models in 1660, it was not until 1752, long after the establishment of the centralized Bourbon dynasty, that the Real Academia de Bellas Artes de San Fernando was founded in Madrid. The utility of artists as industrial designers (for example, Goya's long tenure at the Madrid tapestry factory), allied with Bourbon mercantilist economic theories, rendered the academic idea eminently exportable to Spain's colonies in the New World. Indeed, Ibarra, Cabrera, and their contemporaries sought to set up an academy in Mexico in the 1750s, but the idea withered after Ibarra's death in 1756; it was finally revived with the arrival in 1778 of Jerónimo Antonio Gil as supervisor of art standards and metallurgical techniques at the Mexico City mint.

The fine arts were not the only disciplines to enjoy royal patronage at this time. Given Creole interest in Mexican antiquity, it is not surprising that the Mexican colonial government under the Spanish Bourbons, the same dynasty that excavated Pompeii and Herculaneum, also supported the archaeological excavations of Precolumbian monuments. In addition, the centralization of artistic endeavors in an academy made it easier to effect large-scale projects, such as the redesign of the Plaza Mayor (Zócalo) in Mexico City, in which an equestrian statue of Charles IV, cast by the Valencian Manuel Tolsá, was set in a plaza designed by the architect González Velázquez and commemorated in a print by José Joaquín Fabregat after Jimeno y Planes (see cat. nos. 238 and 239).

The transition from the colonial period to the early years of Mexican independence is gradual in the visual arts. In the first place, the Academy was itself part of the intellectual ferment leading to the struggle for Independence. Moreover, because the Academy continued to function after Independence, artists working in both the Neoclassical and Romantic manners, as well as in the subsequent nineteenth-century academic styles, found a continuity of training and patronage. The teachers and especially the students at the academy at the end of the colonial era—not only the younger Neoclassical artists such as Francisco Eduardo Tresguerras and Pedro Patiño Ixtolinque but also Tolsá, who originally supported the Spanish, and Jimeno y Planes—simply became the first generation of artists under the new regime. In fact, one of the greatest of the late colonial artists, José Luis Rodríguez Alconedo (see cat. no. 237), died a hero's death in the struggle for Independence. Even church patronage did not cease or change radically.

What did change was secular subject matter and the relative importance of middle-class and peripheral patronage as opposed to the "official"

patronage of the ruling elite in Mexico City, which in any case eventually became bourgeois. Furthermore, there was from at least 1800 onward an increasing isolation of Mexican visual culture from its European, and particularly its Spanish, roots. For example, relatively few artists, and none of genius, came to Mexico from Spain after the generation of Gil, Tolsá, and Jimeno y Planes, while cultural relationships with other countries, such as England, France, and the United States, developed slowly. Given the Romantic interest in folk art, the already established archaeological investigations of Precolumbian cultures, the interest of many mestizos in their indigenous origins, and the increasing political importance of provincial areas, the significance of native or local traditions also expanded, as it would continue to do throughout the nineteenth century. Interestingly, these values easily find their analogies in the cultures of other countries: Germany, England, Scandinavia, or the United States. As elsewhere in the Western world, the transition from late eighteenth to nineteenth century in Mexico was more a temporal and class phenomenon than a matter of "Spanish colonial" becoming something "Mexican." That change had already transpired in the Creole awakening of the seventeenth century and the cultural development of the Mexican Enlightenment.

237 ◀ José Luis Rodríguez Alconedo
Mexican, 1762–1815

Plaque Depicting Charles IV
Mexico, 1794
White silver; 30 x 25 cm. (11¾ x 9⅞ in.)
CNCA–INAH, Museo Nacional de Historia,
Mexico City

This allegorical representation of the effigy of the Spanish king Charles IV (1748–1819) is fashioned of embossed and chased silver. The monarch appears within an oval medallion, dressed as a Roman emperor. At his left is the lion of Spain, protecting with its sword the two worlds—the Old and the New—symbolized by two spheres. At the right are martial attributes: a cannon with flags and drums. The medallion terminates with a blaze of rays framing the eye of Divine Providence, and it is adorned with oak branches and acorns.

Although the piece is silver, it has no marks; but its signature saves it from anonymity. An inscription reads: "José Luis Rodríguez Alconedo, natural de la ciudad de los Angeles, a 1º de Junio de 1794, a 32 anos de edad" (José Luis Rodríguez Alconedo, born in Ciudad de los Angeles [Puebla, made this] June 1, 1794 at the age of 32). Rodríguez Alconedo was one of the most prestigious silversmiths in Mexico at the end of the eighteenth century. He was also a painter and engraver, especially distinguished for his use of the chisel. Alconedo was a patriot and revolutionary, who allied himself with the forces of the Independence movement and was finally executed by Royalists in 1815.

One of the most outstanding works of Mexican Neoclassicism, this piece shows the artist's exquisite technical mastery as a sculptor and portraitist. It is also one of only two surviving works by the master Alconedo.

CEM

REFERENCES
Francisco de la Maza. "José Luis Rodríguez Alconedo." *Anales del Instituto de Investigaciones Estéticas* 2, no. 6 (1940), fig. 3. **Manuel Toussaint**. *Colonial Art in Mexico*. Translated and edited by Elizabeth Wilder Weismann. Austin and London, 1967, p. 451, fig. 392. **Cristina Esteras Martín**. "Platería virreinal novohispana: Siglos XVI–XIX." In *El arte de la platería mexicana: 500 años*, exh. cat., Centro Cultural de Arte Contemporáneo. Edited by Lucía García-Noriega y Nieto. Mexico, 1989, pp. 114; 334–35, no. 103.

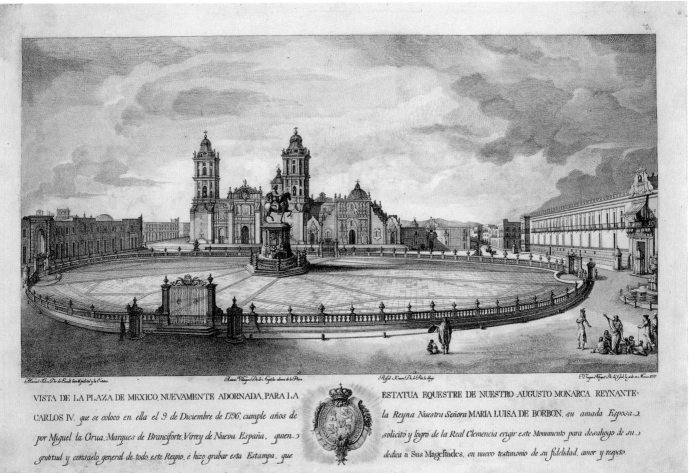

VISTA DE LA PLAZA DE MEXICO, NUEVAMENTE ADORNADA, PARA LA

CARLOS IV. *que se coloco en ella el 9 de Diciembre de 1796, cumple años de*

por Miguel la Grua, Marques de Branciforte,Virrey de Nueva España, quien

gratitud y consuelo general de todo este Reyno, é hizo grabar esta Estampa, que

ESTATUA EQUESTRE DE NUESTRO AUGUSTO MONARCA REYNANTE

la Reyna Nuestra Señora MARIA LUISA DE BORBON, su amada Esposa,

solicitó y logró de la Real Clemencia erigir este Monumento para desahogo de su

dedica a Sus Magestades, en nuevo testimonio de su fidelidad, amor y respeto.

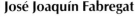

238 ◀ **José Joaquín Fabregat**

b. 1748, Torreblanca, Castellón–d. 1807, Mexico

View of the Plaza Mayor of Mexico City,
1797

After a drawing by Rafael Jimeno y Planes
b. about 1757, Valencia–d. 1825, Mexico; to
Mexico, 1794
Engraving; 34 x 66 cm. (13 ⅛ x 26 in.)
Nettie Lee Benson Latin American Collection,
The University of Texas at Austin

This print was issued to celebrate the completion in 1796 of the renovation of the Plaza Mayor of Mexico City, the principal public open space of New Spain. It shows the equestrian statue of Charles IV, popularly known as the *caballito* (little horse); a temporary version of this figure had been set up by December 9, 1796, the birthday of Queen María Luisa, and the permanent bronze was finished in 1803. The monument stands inside an elliptical enclosure in front of the Cathedral and Sagrario, with the Palace of the Viceroys on the left and the Parián (market) on the right. The inscriptions state that Manuel Tolsá, director of sculpture at the Academy of San Carlos, made the pedestal and the statue; Antonio Velázquez, director of architecture, adorned the plaza; Rafael Jimeno, director of painting, drew it; and José Joaquín Fabregat, director of engraving, executed the print in 1797. Fabregat had engraved views before coming to Mexico, and his technique is that of his Spanish academic contemporaries. The viceroy Miguel de la Grua, marquis of Branciforte, had been behind the entire renovation project and commissioned the print.

All these artists were members of the Spanish faculty of the Academy of San Carlos, which was formally established in 1785 and which was one of the Bourbon administrative reforms aimed at modernizing the colony. All except Velázquez were from Valencia. The print displays their ability in urban planning, architecture, sculpture, drawing, and engraving and documents the consolidation of the institution. Since the new plaza replaced an earlier arrangement

that had been carried out by guild artists, the print also affirms the authority of the Academy in artistic matters. Indeed, the sober taste of the academicians is evident in the underplaying of the elaborate Sagrario facade, while the ample uncluttered space shows Neoclassical inclinations.

The project that is celebrated in the print was a major propaganda event not only for the Academy of San Carlos but also for the Spanish monarchy and its colonial supporters. The king on horseback is in antique garb on a pedestal at the center of an elliptical pavement with markings, in obvious imitation of the statue of Marcus Aurelius and its placement on the Capitoline in Rome. Indeed, the engraving distorts the view of the plaza so as to emphasize the resemblance. It makes it appear that the statue is at the center of the area in front of the Cathedral, which was not the case. What was intended was an affirmation of the monarchy at a time when independence was already in the air. The renovation of the plaza, however, also amounted to a glorification of Mexico City, associating it with Rome, "caput mundi," and suggesting that it could be the capital of the Spanish empire. It is therefore not surprising that the project received the support of the criollos of New Spain.

CB

REFERENCES
Justino Fernández. "El grabado en lámina en la Academia de San Carlos de México durante el siglo XIX." *Universidad de La Habana* 16 (1938), pp. 69–111. **Manuel Toussaint.** *Pintura colonial en México.* 2d ed., edited by Xavier Moyssén. Mexico, 1982. **Clara Bargellini.** "La lealtad americana: el significado de la estatua ecuestre de Carlos IV." In *Iconología y Sociedad: Arte Colonial Hispanoamericano* (XLIV Congreso Internacional de Americanistas). Mexico, 1987, pp. 207–20. **Juan Carrete Parrondo.** "Joaquín José Fabregat, Director de grabado de la Real Academia de San Carlos de México." In *Tolsá, Gimeno, Fabregat: trayectoria artística en España,* exh. cat., Generalitat Valenciana, Valencia, 1989, pp. 173–203.

239 ◄ Rafael Jimeno y Planes

Spanish, b. about 1757, Valencia–d. 1825;
to Mexico, 1794

The Sculptor Manuel Tolsá

Oil on canvas; 102 x 82 cm. (40⅛ x 32¼ in.)
CNCA–INBA, Pinacoteca Virreinal de San Diego,
Mexico City

Rafael Jimeno (or Ximeno) y Planes was born in Valencia about 1757 and trained at the Academy of San Carlos there as well as at the Fine Arts Academy of San Fernando in Madrid from 1774. He returned to Valencia in 1777 and made a trip to Rome from 1783 to 1786. In Madrid Jimeno came under the influence of the Bohemian Neoclassicist Anton Rafael Mengs (1728–1779), chief painter to King Charles III, and of Mengs's principal Spanish disciple, Francisco Bayeu (1734–1795). Appointed to the directorship of painting at the Mexican Academy of San Carlos in July 1793, Jimeno arrived in Mexico City in May 1794. In 1798 he succeeded Gerónimo Antonio Gil (1731–1798) as general director of the Academy. He died in 1825.

The Real Academia de San Carlos en Nueva España had its origins in an informal school of engraving and medal design founded by Gil at the Royal Mint in Mexico City after his appointment there as chief engraver in 1778. Gil, whose forceful personality Jimeno later captured in a splendid portrait (also Pinacoteca Virreinal), proposed in 1781 that the school be expanded into an academy of fine arts. Classes began under viceregal patronage in November of that year with Gil as general director; the royal charter was not received for several years, however, so the Academy "opened" officially on November 4, 1785. (The Academy, like its sister institution in Valencia, was named after the patron saint of King Charles III, whose policies brought, to the extent possible, the Enlightenment to Spain and Latin America.) Because of the idealizing tendencies of the eighteenth-century Mexican school, Gil was able to appoint

local artists such as José de Alcíbar and Carlos Clemente López to faculty positions, but he also sought reinforcements from Spain. A series of émigré Spanish professors, coming especially from Valencia, eventually brought a purer European Neoclassicism. Although the Mexican Academy, like those of Madrid and Valencia, was an expression of the typically Bourbon mercantilist desire to centralize cultural, educational, and economic institutions, it also played an important role in the propagation of the Enlightenment in Mexico and in the development of an already nascent sense of Mexican national identity. In this it may be considered one of the forces preparing the way for independence.

Manuel Tolsá was born at Enguerra near Valencia in Spain in 1757. Trained as a sculptor at the academy in Valencia, he was appointed director of sculpture at the Mexican Academy in September 1790, arriving in July 1791 along with a large library and a collection of plaster casts after the antique that would later impress Humboldt (and, indeed, which remain in service today). He died in Mexico in 1816. Tolsá's influence on the visual arts in Mexico was enormous. An architect as well as a sculptor, he was responsible for the completion of the Mexico City Cathedral, for the College of Mines building, for the high altar and tabernacle of Puebla Cathedral, and for other commissions that set the standards of design in Mexico for decades (see cat. no. 241).

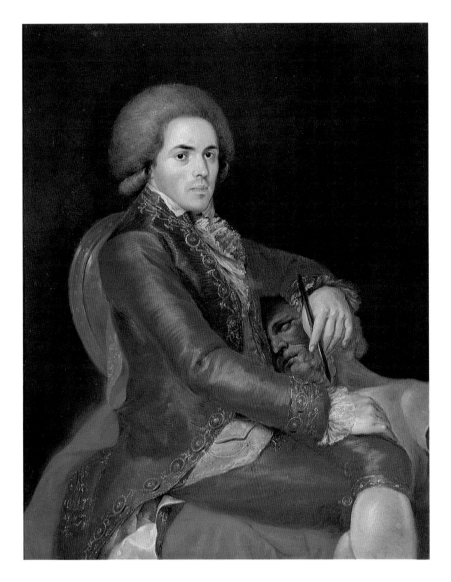

Jimeno has portrayed Tolsá dressed as a gentleman, seated profile right, his proper right hand laid on a crossed leg. His left hand, casually draped over a Classical bust (the so-called "Seneca"?), holds a modeling stylus, the symbol of his profession. The pose, which allows Jimeno to present the sitter in an intimate, seemingly candid way while creating an angular geometric composition in the Neoclassical manner, derives from a long line of precedents stretching back to the sixteenth century (G. B. Moroni, so-called *Schoolmaster of Titian*, National Gallery, Washington) and including Francisco Goya's *Sebastián Martínez* of 1792 (Metropolitan Museum of Art), which Jimeno may have seen in Cádiz on his way to Mexico. The Tolsá portrait almost certainly reflects a second prototype, Velázquez's *Juan Martínez Montañés* (Museo del Prado, Madrid), who is also shown holding a stylus as he sculpts a likeness of Philip IV. Although Jimeno's canvas is not dated, we may assign it to the years immediately after his arrival at the Academy in 1794. By 1796 Tolsá had completed the model for the equestrian monument to Charles IV, the centerpiece for the redesigned Plaza of Mexico City, which was depicted in a panoramic view by Jimeno and engraved by Fabregat in 1797 (see cat. no. 238). If Tolsá had already created his model before he sat for Jimeno's portrait, it is unlikely that a reference to it would be omitted.

MB

REFERENCES
Agustín Velázquez Chávez. *Tres siglos de pintura colonial Mexicana*. Mexico, 1939. p. 313, fig. 126. **Justino Fernández**. "Tiepolo, Mengs, and Don Rafael Ximeno y Planes." *Gazette des Beaux-Arts*, 6th ser., 23 (1943), pp. 345–62. **Jean Charlot**. *Mexican Art and the Academy of San Carlos: 1785–1915*. Austin, 1962, passim. **Manuel Toussaint**. *Colonial Art in Mexico*. Translated and edited by Elizabeth Wilder Weismann. Austin and London, 1967, pp. 401–4, 410–14, 430–36, 441–44, fig. 381. **Enrique Marco Dorta**. *Arte en América y Filipinas*. Ars Hispaniae: Historia Universal del Arte Hispánico, vol. 21. Madrid, 1973, p. 390, fig. 630, p. 392. **Marcus B. Burke**. "Mexican Colonial Painting in Its European Context." In Linda Bantel and Marcus B. Burke, *Spain and New Spain: Mexican Colonial Arts in Their European Context*. Exh. cat., Art Museum of South Texas, Corpus Christi, Texas, 1979, pp. 46–48, and notes. **Manuel Toussaint**. *Pintura colonial en México*. 2d ed., edited by Xavier Moyssén. Mexico, 1982, pp. 200–7, color pl. XXII. **Virginia Armella de Aspe and Mercedes Meade de Angulo**. *Tesoros de la Pinacoteca Virreinal*. Mexico, 1989, p. 38–40, ill., p. 180.

240 ◀ **Ignacio María Barreda**

Mexican, end of 18th century

Doña Juana María Romero, 1794

Oil on canvas; 142 x 116 cm. (55⅞ x 45⅝ in.)
CNCA–INAH, Museo Nacional de Historia,
Mexico City

Little is known about the painter of this picture. Ignacio María Barreda lived at the end of the eighteenth century and may be the only artist of New Spain whose entire known work was in portraiture, an unusual circumstance considering that until that time religious painting had been the dominant genre and perhaps the only kind of work by which a painter could hope to survive. This portrait by Barreda is evidence of the changing taste of a growing Mexican middle class who began to demand simple pictures of ordinary people rather than portrayals of religious figures or stiff official likenesses of members of the political or church hierarchies.

Barreda's painting of Doña Juana María Romero reflects the new artistic climate ushered in by the Enlightenment, as seen here in the bold, almost challenging pose of the subject and her filmy clothing; in the eighteenth-century fashions such as the beauty spot, an artificial mole of velvet or tortoiseshell glued to the temple, and the purely decorative watches; and in the masses of flowers worn on the breast or in the hair, bespeaking the gospel of Nature. The setting of this Baroque portrait in a lady's private apartment, with its dressing table, jewels, and even a small pair of scissors gives it yet another fresh and intimate touch.

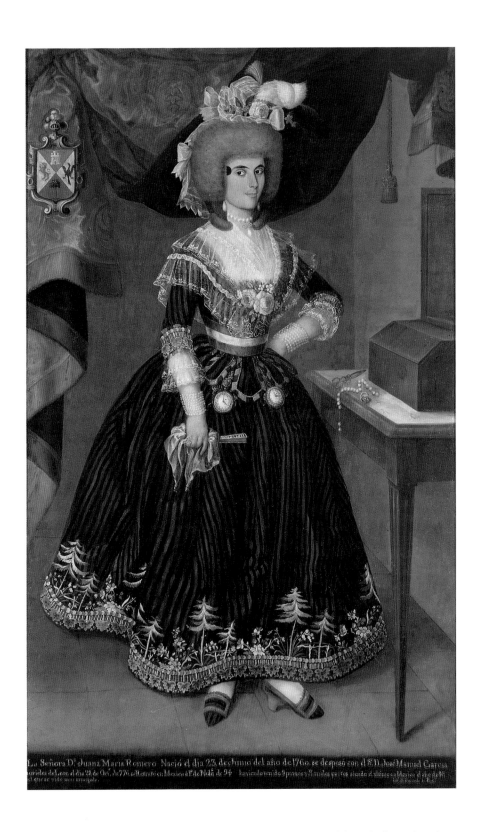

La Señora Dña Juana Maria Romero. Nació el dia 23 deçhimo del año de 1760. se desposó con el Sr D. José Manuel Garcia urioles del leon el dia 28 de Oct. de 776 se Retrató en Mexico à 1º de Novbr. de 94 haviendo tenido 9 partos y 3 malos partos siendo el ultimo en Mexico el año de 95 el que se vido muy apretada.

Despite such accomplished elements as the delicacy of detail, the soft colors, and the boldness of the pose, the composition of the painting is awkward. This carelessness may perhaps be explained by the artist's eagerness to please a clientele who would notice only painterly virtuosity and many allusions to the high social station of the subject.

JGH

REFERENCES
Manuel Toussaint. *Colonial Art in Mexico*. Translated and edited by Elizabeth Wilder Weismann. (Austin and London, 1967) pp. 340, 395; color pl. facing p. 388. **Manuel Toussaint**. *Pintura colonial en México*. Edited by Xavier Moyssén. Mexico, 1982, p. 172, fig. 327.

241 José María Vásquez

Mexican, born about 1765, active 1790–1822

Doña María Luisa Gonzaga, 1806

Oil on canvas; 104 x 81 cm. (41 x 31⅞ in.)
CNCA–INBA, Pinacoteca Virreinal de San Diego,
Mexico City

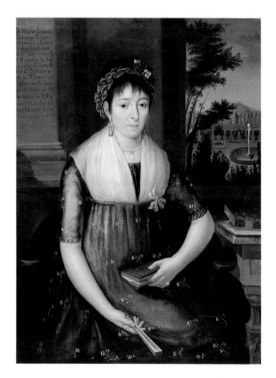

José María Vásquez was one of the most talented pupils of Don Rafael Jimeno y Planes, dean of painting at the Academy of San Carlos in Mexico City. Vásquez was active from 1790 until 1822, the year in which he signed a portrait of Agustín de Iturbide, who shortly thereafter became the first emperor of Mexico.

Vásquez belonged not only to the first generation of Mexican painters to be trained in an academy but also to the first generation of Mexican Neoclassicists. This background, combined with his experiences throughout the War of Independence, made Vásquez typical of the artists working during the period of transition from colonial to independent Mexico. In the years that followed, these artists faced real difficulties because of the reaction against everything Spanish, a reaction that extended to both the Academy of San Carlos and its graduates. This portrait of Doña María Luisa Gonzaga survives as one of the few examples of Neoclassical portraiture by a Mexican artist.

The subject's gown and coiffure are eloquent witnesses of the French influence, especially the Napoleonic, in the New Spain of the late eighteenth and early nineteenth century. Neoclassical portraits in general are characterized by a relaxed and easy pose; Vásquez's teacher Jimeno has given us an example of this in his painting of Manuel Tolsá (cat. no. 239). Although Vásquez is no match for his master in this respect, he has succeeded in giving this woman's face a gentle expression of considerable psychological depth, a quality almost always missing in the work of professional portraitists in New Spain.

Most portrait painters of the time relied upon heavy curtains for their backdrops; Vásquez, however, here chose a severe architectural setting, with a balcony overlooking a garden. He is surprisingly skillful in the delicacy of his drawing, in his use of soft flesh tones, in the masterfully rendered textural qualities, and in his loving treatment of details.

JGH

REFERENCES
Manuel Toussaint, *Colonial Art in Mexico*, translated and edited by Elizabeth Wilder Weismann (Austin and London, 1967) p. 444, fig. 388. **Manuel Toussaint**. *Pintura colonial en México*. Edited by Xavier Moyssén. Mexico, 1982, p. 217, pl. XXIII. **Cristina Esteras Martín**. "Una pintura inédita del mexicano José María Vázquez en Madrid: aportaciones al estudio de su obra." *Archivo español de arte* 53, no. 231 (1985), pp. 296–301.

242 Manuel Tolsá

b. 1757 Enguara, Valencia–d. 1816 Mexico City

Model for the Baldachin of the Cathedral of Puebla

Mexico City and Puebla, 1798
Wood; 104 x 104 x 170 cm. (41 x 41 x 67 in.)
SEDUE, Catedral de Puebla, Puebla

Manuel Tolsá, director of sculpture at the Academy of San Carlos, was given the commission for the baldachin of the Cathedral of Puebla in 1797. Meant to replace a Baroque structure of 1647, this baldachin had to be worthy of the "most correct" cathedral of New Spain and, of course, to be executed not in wood but in durable materials. Tolsá and the silversmith Antonio Caamaño went to Puebla toward the end of 1798 to make a scale model which was to assist those who would work on the baldachin in situ (the metal and stucco elements were fashioned in Tolsá's shop in Mexico City). The baldachin was not completed until 1818, two years after the sculptor's death, by José Manzo (1789–1860).

The Puebla baldachin was Tolsá's first major commission for an ecclesiastical interior in the New World. It presented him with a traditional problem of altarpiece design, which he resolved in a traditional way by combining sculpture and architecture. The vocabulary, however, contrasts sharply with the

complex forms of previous Mexican altarpieces. The baldachin has thus been taken to exemplify a new force in Mexican art, usually defined as Neoclassicism and attributed to the influence of the Academy of San Carlos. Although there can be no doubt about the importance of the Academy and, in particular, about the impact of Tolsá's artistic projects, it is important to note that Mexican artists had begun to return to more classical forms well before the establishment of the Academy. It should also be remarked that the quality of Tolsá's Neoclassical spirit owes a great deal to his reliance on Renaissance and Baroque Rome for inspiration—in the baldachin, for example, the interaction of sculpture and architecture, the drama of convex curves contrasted with openings, and the eruption of gilded rays ultimately recall Roman Baroque models. Finally, the subtle color harmonies of the baldachin, as well as the sweetness of gesture and expression of the figures, suggest Rococo taste and remind us that Spanish academic classicism was partly formed by artists like Anton Mengs and had many ties to French academicism.

The baldachin had to fulfill the function of the high altar of the cathedral, which is dedicated to the Virgin, and it also had to serve as a memorial for the

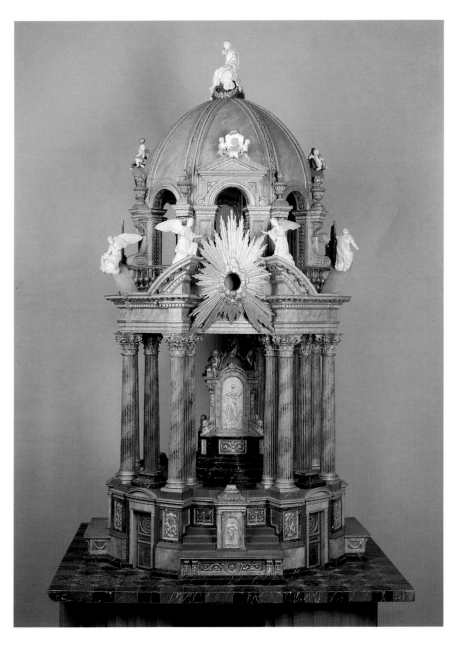

bishops buried in the crypt beneath it. Thus, its iconography develops three principal themes. At the four altars around its first level, the emphasis is on Christ and the Eucharist. The theme of ecclesiastical authority is expressed by the four Doctors of the Church, who are seen on the pedestals between the columns at the second level in the finished version. The four Evangelists of the tabernacle reliefs continue this theme, which culminates with St. Peter at the crown of the dome. The Immaculate Conception appears on the tabernacle, and the angels with symbols of the Virgin extend the Marian theme, which, in the completed baldachin, culminates in the monogram of Mary at the center of the gilded rays.

CB

REFERENCES

Angel J. García Zambrano. "Manuel Tolsá y el baldaquino de la catedral de Puebla." Thesis, Universidad de los Andes, Venezuela, 1976. **Angel J. García Zambrano.** "The Work of José Manzo at Puebla Cathedral, Mexico, 1850–1860." Ph.D. diss., University of New Mexico, Albuquerque, 1980. **Clara Bargellini and Elizabeth Fuentes.** *Guía que permite captar lo bello: yesos y dibujos de la Academia de San Carlos. 1778–1916.* Mexico, 1989. **Joaquín Berchez.** "Manuel Tolsá en la arquitectura española de su tiempo." In *Tolsá, Gimeno, Fabregat: trayectoria artística en España,* exh. cat., Generalitat Valenciana, Valencia, 1989, pp. 13–80.

Nineteenth-Century Art

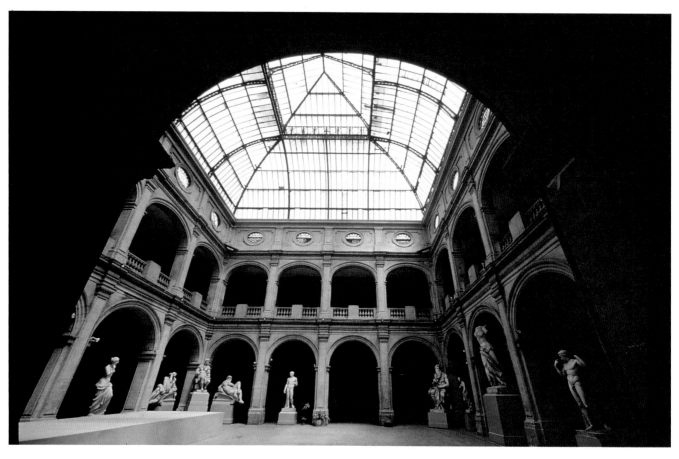

The Nineteenth Century

FAUSTO RAMÍREZ

Nineteenth-century Mexican art actually begins in 1781, the year of the founding of the Academy of San Carlos, and extends to 1911, or perhaps 1914, with the close of the first Modernist cycle. This period is distinguished by four successive stages, with the inevitable overlapping present in all processes of artistic change.

Classical Ruptures and Continuations (1785–1835)

In 1813 José Joaquín Fernández de Lizardi, "El Pensador Mexicano" (1776–1827), a liberal journalist and novelist, published his *Diálogo entre un francés y un italiano sobre la América Septentrional*. Discussing the famous Retablo de los Reyes in the Cathedral in Mexico City, one of his characters remarked: "It is just an assemblage of wood gilded in the old-fashioned way, quite unseemly."

Such a condemnation of a masterwork of the Mexican Baroque indicates the degree to which the Neoclassical ideal of purity of design had permeated the aesthetic judgments of the intellectuals of New Spain on the eve of their independence. What is even more revealing is that this assimilation of Neoclassical taste did not occur spontaneously among the enlightened criollos who, with the founding of the Academy of San Carlos (1781–85) thirty years earlier, had witnessed the introduction of modern style into colonial art.

Despite affinities between the rationalism and functionalism of Neoclassical design and the equally rational and practical spirit that animated well-informed thinkers, some intellectuals (Antonio Alzate is perhaps the best-known example) expressed misgivings about the quality of the works produced in conformity with the new aesthetic. Undoubtedly there was resentment of the authority granted to the Academy teachers recruited in Spain and of their efforts to uproot the Baroque style in order to make of that institution, sponsored by the enlightened despotism of the Bourbons, a true "ministry of taste."

Not all artistic genres were affected equally by the controls of the Academy board. The arts most influenced were those most involved with public life: architecture, especially major projects; sculpture, monumental works as well as academic exercises; numismatics; the design of altars and ecclesiastical ornamentation; and official portraiture and decorative painting.

Other genres and artistic endeavors, although eventually modified by Neoclassicism, showed a relative resistance to the new style. In private portraits, for example, the tradition of including coats of arms and inscriptions persisted, giving these works an archaic flavor.

Neoclassical sculptural tradition was brilliantly inaugurated in Mexico by Manuel Tolsá (1757–1816) with his equestrian statue of Charles IV. This monument, meant for the center of the Plaza Mayor in Mexico City,

The Academy of San Carlos, founded in 1781. The Academy's facade, which dates from 1863–64, was designed by Javier Cavallari. Photos: CNCA

Pedro Patiño Ixtolinque. *King Wamba, Upon Renouncing the Crown, Is Threatened by One of His Electors*, 1817. Relief in white clay. Museo Nacional de Arte, Mexico City. Photo: Museo Nacional de Arte, Mexico City

was intended as an expression of the power of the Spanish Crown over the "four parts of the world." The viceroy, Marqués de Branciforte, must have considered this affirmation necessary in the 1790s, when revolutionary political and social ideas from France began to stir enlightened thinkers in the colonies.

The compositional clarity and balance, calm monumentality, and Classical references of Tolsá's equestrian statue are found, almost a quarter of a century later, in a work by Tolsá's best student, Pedro Patiño Ixtolinque (1774–1835), who later became the director of the Academy. One of his best works is the relief he submitted to San Carlos in 1817 to earn the degree of Académico de Mérito: *El rey Wamba rehusa la corona y es amenazado por uno de sus electores* (King Wamba, upon Renouncing the Crown, Is Threatened by One of His Electors). A group of figures dressed in togas and mantles is harmoniously arranged against a severe architectural background, playing out an episode taken from Juan de Mariana's *History of Spain*. The remote figure of Wamba, a Visigoth king, had gained relevancy during the recent sessions of the Cortes of Cádiz, which had drawn up the Constitution of 1812. In the election of Wamba, Spanish solons had found a historical precedent for the idea, then being debated, that a ruler's sovereignty is determined by consensus of the electors, not by divine right.

Ixtolinque chose this subject in 1817, when the martial ardor that had sparked the War of Independence had flagged and other means were being sought to achieve greater freedom for the Spanish colonies. Thus an academic exercise was shrewdly used to allude metaphorically to the great problems of the moment.

During the first Republican era, the best-known heir to the Neoclassical tradition was José María Labastida (died 1849?). He was one of the few Mexican artists of the first half of the nineteenth century who traveled to Europe to complete his training, and his major works were created during his years in Paris and Rome (1825–35). It is thus unsurprising that his sculptures—for example the allegorical *La constitución de 1824* and the figures of gladiators—show marked similarities to Neoclassical works by European sculptors, most notably Antonio Canova.

These few examples of Neoclassical sculpture demonstrate a radical formal and iconographic break with colonial Baroque traditions; they also show a dramatic abandonment of old materials—polychrome gilded wood was to be replaced by bronze, plaster, and marble. Many years passed, however, before Neoclassical canons were widely accepted. At times a royal order was needed to impose a new aesthetic such as the 1788 decree prohibiting the construction of wood retablos, which argued that they were a fire hazard and which favored stone and mortar altars that conformed to the Academy's directives. Thus the exuberance of the Baroque retablo was abandoned in favor of restrained Neoclassicism.

Ecclesiastical metalwork went through a similar change in form. This Neoclassicism in gold and silver has been called the "Tolsá style"—erroneously, because even before the Valencian master came to the Academy in 1791, student projects showed evidence of the new taste. In fact, Neoclassical models were probably first imported by Jerónimo

Antonio Gil (1731–1798), another master at the Academy. He certainly developed a new style in numismatics, and his commemorative medals inspired other artists for many years after his death. Throughout the period of independence, José Gordillo and other engravers continued to quote Gil's profiles and emblems when they designed medallions celebrating the ephemeral empire of Iturbide.

The iconography conceived to celebrate Agustín I in medals, portraits, and allegorical paintings draws on both Enlightenment and Napoleonic imagery. This amalgam is seen in José Ignacio Paz's allegorical painting of 1822 that commemorates the coronation of Agustín I; it is also evident in numerous images, painted by now-forgotten artists, of the emperor and his wife, Doña Ana Huarte de Iturbide: full-length portraits in which the pair is robed in sumptuous purple and ermine-trimmed mantles and standing amid Empire-style tables and chairs. Not unlike the Napoleonic icons painted by Ingres, these works present images of timeless power. They show little technical assurance, however; they might be the work of a guildsman rather than an Academy graduate. Neoclassical canons were taking hold, even in nonacademic circles, but were mingling with the old pictorial traditions.

The major academic teacher of painting was the Valencian Rafael Jimeno y Planes (1759–1825), who arrived in Mexico in 1793. His portraits of two of his San Carlos colleagues, Gil and Tolsá, are superb and capture both their "official" image and the texture of their personalities. None of his disciples succeeded in equaling Jimeno's convincing and expressive plasticity. José María Vásquez (born about 1765), who had studied at the Academy from its inception, approached him in his images of the noble ladies and children of New Spain; but the necessity of including legends recording the subjects' status—a tradition demanded of the local portraitist—together with a relative uncertainty in placing figures in pictorial space, gives his paintings a provincial air.

José María Labastida. *Roman Gladiator*, about 1834. Marble. Museo Nacional de Arte, Mexico City. Photo: Museo Nacional de Arte, Mexico City

Jimeno was also without peer in history painting, a genre that was supreme in the academic hierarchy. Outstanding among these paintings, both for iconographic interest and compositional skill, are two murals of 1813: *El milagro del pocito* (The Miracle of the Well), a work on the Guadalupe theme painted on a ceiling of the Palacio de Minería, and *La sublevación de los indios del Cardonal* (The Revolt of the Indians of Cardonal), of which only a maquette with preparatory study remains (the apse of the chapel of the Church of Santa Teresa was destroyed in an earthquake). The Jimeno murals show few Neoclassical elements; more closely related to the Baroque or the Rococo, they are typical of the artistic eclecticism of Spanish America during the Enlightenment.

And if this eclecticism is present in the work of an international painter like Jimeno, it is not strange to find such qualities in the work of artists who never left Mexico, often not even the limits of the region in which they were born. Thus the paintings of an artist as versatile as the architect and sculptor Francisco Eduardo Tresguerras (1759–1833) vary according to the models he had at hand, whether the prints of the Klauber brothers or Matías Arteaga y Álfaro, or the paintings of viceregal artists. In the local style, Tresguerras painted several murals of considerable interest

(the best are to be found in the Chapel of the del Carmen Church in Celaya, his masterpiece of public art). Perhaps the most interesting painting by Tresguerras is the portrait of his wife, María Guadalupe Ramírez (1787), whom he painted standing in the middle of a bedchamber, as if surprised in the act of opening a screen or a shutter. Here he achieves an impression of spontaneity matched by a sense of frozen movement.

A similar effect is often seen in the portraits executed a half century later by José María Estrada, a painter from the state of Jalisco, who was active between 1830 and 1860. The disciple of a student of Jimeno, Estrada knew the techniques for an academic portrait but adapted them to his own technical abilities and tastes and to the tastes of his provincial clientele. Thence the peculiar amalgam of grace and severity, of modernity and archaism, that makes his work so attractive and so representative of Mexican provincial painting during the first half of the nineteenth century.

Romantic Currents (1826–1870)

Of the several currents that compose Romanticism, two were most enthusiastically taken up in Mexico. The first was the depiction of local reality, as manifested in landscapes, customs, and types (especially popular types), with the intent of highlighting the specific and the unusual as opposed to the universal and timeless stressed by Neoclassicism. The second was the search for inspiration in the history and styles of the past, particularly when they paralleled the great events of contemporary life.

Most of the European artists who traveled through Mexico in the post-Independence period aspired to the former, recording all that excited their sense of the unusual and picturesque or their scientific curiosity. Many and diverse were the origins, formations, and interests of these traveler-artists. Outstanding works were painted by the Englishman Daniel Thomas Egerton (about 1800–1842), the Frenchman Jean-Baptiste-Louis Gros (1793–1870), and, especially, the German Johann Moritz Rugendas (1802–1858), all of whom visited Mexico during the 1830s. Distinguished for their lithographs are the Italian Claudio Linati (1790–1832), who in 1826 introduced this new, typically Romantic technique of engraving; the German Karl Nebel (1805–1855; also known as Carlos Nebel), who arrived in the late 1820s; and the Englishman Frederick Catherwood (1799–1854), who came in the late 1830s.

These artists depicted the different regions through which they traveled in innumerable views of cities and their inhabitants, all captured in their rich variety. They brought to Mexico the tradition of the plein air landscape; they painted and drew volcanoes, caves, and flamboyant geological formations; they evoked the grandeur of ancient monuments and the vivid color of the local plants and flowers; they depicted the heroes of the Independence and recorded contemporary historical events.

Their presence in Mexico had major artistic repercussions; the lithographers, in particular, stimulated an exploration of local iconography. The prints that issued from the lithographic workshops established in Mexico

in the 1830s and 1840s, whether foreign (especially French) or indigenous, reveal borrowings from the albums of touring artists.

Toward midcentury the first notable Mexican lithographs were seen in collections such as *México y sus alrededores* (Mexico City and Its Environs; 1855–56)—the work of various artists, among them, Casimiro Castro (1826–1889)—and *Los mexicanos pintados por si mismos* (Mexicans Painted by Their Own Hand; 1854–55), based on European prototypes. The latter benefited from the skill of Hesiquio Iriarte (1820–1897), one of the best commercial engravers of the period. (In 1847, along with Plácido Blanco and Joaquín de Heredia, he had signed the delightful sociocritical illustrations that enrich *El gallo pitagórico* [The Pythagorean Rooster].)

In the woodblock (which never enjoyed the widespread acceptance in Mexico it had in other nations), the Yucatecan Gabriel Vicente "Picheta" Gahona (d. 1899) was outstanding. His major work appeared in *Don Bulle Bulle* (1847), a short-lived satirical newspaper. His vignettes are malicious darts aimed at political and social follies.

Mexican commercial engravers and lithographers constantly used Spanish and French models (Grandville, Gavarni, Daumier), which they adapted to their own ends. A comparable practice was followed by Agustín Arrieta (1802–1874), the most interesting regionalist painter of the midcentury (cat. nos. 252–254). He studied at the Academia de Bellas Artes in Puebla, where he became familiar with the best of Baroque realism (Caravaggio, Velázquez, Teniers), a style for which provincial collectors had a predilection.

Regional subjects and *bodegones*, views of towns and buildings—"minor" genres in the academic hierarchy—as well as the inevitable portrait had the greatest interest for the patrons and collectors who supported the Puebla Academy. Thus Arrieta and José María Fernández, a painter of city scenes, flourished in Puebla. In Arrieta's *costumbrista* (local color) works there are quotations from the Baroque masters and, most importantly, vestiges of the emblematic and moralizing tone characteristic of Baroque genre paintings. These elements are intermingled with a sense of color, spatial arrangement, and iconography that expresses a popular sensibility.

These works dedicated to daily realities are in marked contrast to the works painted by the members of the Academy of San Carlos at midcentury. The Catalan painter Pelegrín Clavé (1810–1880) then held sway at the Academy (cat. no. 243). In 1846 he and the sculptor Manuel Vilar (1812–1869), his compatriot and friend, had come to revitalize art studies, which had been in decline in Mexico City for almost thirty years. The copious production of Clavé's students makes clear the aesthetic preferences of their master and the ideological bias of the conservatives then controlling the Academy. Clavé had studied in Barcelona and Rome, absorbing the principles of Nazarene aesthetics. His fondness for biblical subjects and taste for classical principles of composition, his precise outlines and soft and harmonious palette were warmly received by the governing board of the Academy, which was composed of leading members of the Mexican conservative party. For them religion was a bulwark against the secularism and modernism of the liberals.

During the unsettled years of the 1850s when civil strife between

José María Fernández. *The Cathedral of Puebla,* 1831. Oil on canvas. Private collection. Photo: Museo Nacional de Arte, Mexico City

Manuel Vilar. *The Tlaxcalan General Tlahuicole Doing Battle on the Gladiator's Stone of Sacrifice*, 1851. Plaster. Museo Nacional de Arte, Mexico City. Photo: Museo Nacional de Arte, Mexico City

liberals and conservatives was most heated, Clavé's young followers turned out painting after painting on biblical themes, taken from both the Old and New Testaments. Many of these works—grave depictions of familial discord, or war between enemy peoples, or even of cosmic catastrophe—reflected the difficult political times.

Sculpture was less influenced by the intense unrest. Maintaining their commemorative role, sculptors strived to celebrate national heroes. Vilar conceived several monumental projects to honor Mexican Independence (all centered on Agustín de Iturbide) and Christopher Columbus. He also honored those Indians whom he believed historically significant—Moctezuma II, Cortés's interpreter la Malinche, and, especially, Tlahuicole, a valiant Tlaxcalan warrior who died in ritual sacrifice. The last was the subject of a fierce larger-than-life work, much indebted to Hellenistic sculpture. Unfortunately, much of Vilar's work remained in plaster because he could not find patrons to underwrite the final bronze or marble versions. His students too, in order to earn a livelihood, devoted themselves to the inevitable portrait busts—but even for these demand was not great. The prospects for monumental sculptors would not improve until the last quarter of the century.

At midcentury courses in landscape painting were introduced by the Academy of San Carlos. This innovative venture was entrusted to Eugenio Landesio (1810–1879), a talented Italian who came to Mexico in 1855. He had studied in Rome with the Hungarian Karoly Markó, and in his Mexican works he applied the compositional principles of Classic landscape painting (à la Poussin and Claude Lorrain) to the local environment with felicitous results that can best be classified as Classic-Romantic. His views of urban and rural structures (especially of agricultural or mining haciendas), rising up in vast panoramas enlivened by picturesque regional figures, won him devoted clients and disciples (cat. no. 268).

Landesio was a methodical and dedicated master. One of the landscape genres cultivated by his students, among them the talented Luis Coto and José María Velasco (cat. nos. 269–72), was the historical landscape, depicting events from the pre-Hispanic past; many of these paintings date from the Second Empire (1864–67), reflecting Maximilian's interest in such subjects. Landscape artists were the forerunners of the figure painters who would begin to move toward the examination of the Mexican past only with the definitive triumph of the liberal Republican party in 1867.

Toward Realism (1870–1900)

The restructuring of the Academy of San Carlos that Clavé and Vilar effected at midcentury influenced more than the curriculum; it included the organization of periodic exhibitions (which favored the emergence of art criticism and the formation of a more-or-less attentive public); a program of acquisitions for a gallery of modern Mexican art; and the establishment of fellowships for study both in Mexico and abroad. These fellowships provided training for a select group of young artists who on their return from Europe (which essentially meant Rome) would assume the positions vacated by the death or retirement of members of the Acad-

emy faculty. For example, in 1869 José Salomé Pina (1830–1909) succeeded Clavé in the figure-painting class and was assisted by another former fellowship student, Santiago Rebull. Study in Europe, however, was not necessary for success. Landesio was replaced in 1875 by José María Velasco, who had not studied in Europe; Vilar was replaced in 1861 by Felipe Sojo, and Sojo, in turn, by Miguel Noreña in 1869, neither of whom traveled as students in the Old World. It must be emphasized that these substitutions were more than a simple change of personnel; the new leaders were in the forefront of a definite trend toward Realism—a tempered Realism, of course, in line with that promoted by the European academies.

The change in taste was encouraged by the adoption of Positivism as the reigning ideology of triumphant liberalism. The liberal program had as its goal the secularization of Mexican life; thus, the prevailing biblical iconography faded, replaced by episodes from secular history, whether European or national. The change was neither immediate nor easy, but by the mid-1870s Realism had become the dominant style.

Evidence of this change can be seen in 1875, when Santiago Rebull (1829–1902) exhibited his *La muerte de Marat* (closer in iconography to the version of Paul Baudry than that of Jacques-Louis David). The canvas, small in format but exquisitely painted (in the manner of the *tableautins* of Meissonier or Fortuny), impressed the critics with its *verismo*; the violence of the subject was paralleled by the free brushwork and rich impasto. (The Neo-Baroque was another element of the eclecticism evident in Mexican art during the last quarter of the century.)

In the same year, 1875, Rodrigo Gutiérrez (1848–1903), a promising student of Rebull and Pina, painted *La deliberación del senado de Tlaxcala después de la embajada de Cortés* (Deliberation of the Tlaxcala Senate Following a Message from Cortés), a carefully worked painting in which Indians are depicted with relative fidelity. The canvas is marked by astute symbolism: the youthful Xicotenlcatl, the central figure of the episode, is presented as an emblem of national resistance to foreign intervention. Felipe Sánchez Solís (cat. nos. 245 and 246) commissioned the work; he, along with Benito Juárez, opposed French intervention, and he may have suggested this symbolism to the artist.

The number of works on pre-Hispanic themes continued to grow, reaching its apogee in the 1880s and 1890s, when this genre of painting was expressly chosen to represent Mexico in international art competitions. (This was true, for example, of Leandro Izaguirre's *El tormento de Cuauhtémoc* [The Torture of Cuauhtémoc] and Joaquín Ramírez's *Rendición de Cuauhtémoc a Cortés* [The Surrender of Cuauhtémoc to Cortés], both painted to be exhibited at the 1893 World's Columbian Exposition in Chicago.)

Another genre of painting that came to be regarded as quintessentially Mexican was the landscape—in particular, the paintings of José María Velasco (1840–1912; cat. nos. 269–72). This artist moved between the Classic-Romantic tradition he had learned from Landesio and his growing propensity for observing nature with a scientific eye and transferring it directly to the canvas without compositional embellishment. For almost three decades Velasco's abundant output revealed a resultant dichotomy:

Joaquín Ramírez. *The Babylonian Captivity*, 1858. Oil on canvas. Museo Nacional de Arte, Mexico City. Photo: Museo Nacional de Arte, Mexico City

Miguel Noreña. *Fray Bartolomé de las Casas Converting an Aztec Family*, 1865. Plaster relief. Museo Nacional de Arte, Mexico City. Photo: Museo Nacional de Arte, Mexico City

some paintings retain a predisposition for the classic, although skillfully adapted to the local landscape and spiced with regional or symbolic episodes; others are unusually free compositions in which the sole protagonist is nature (rocks, clouds, sky, sparse vegetation) presented with *verismo* exactitude. In the 1890s (after several months in Paris for the International Exposition of 1889, where a large group of his landscapes formed the nucleus of the Mexican exhibition), Velasco achieved a synthesis of these two tendencies in a series of variations on the Valley of Mexico, one of his favorite themes. During the last decade of his life Velasco took ever greater liberties with the motif of the Valley, which had so often inspired him, and began to compose variations tinged with nostalgia—a nostalgia justified not only by the artist's advanced years but also by the irreversible transformation of the central plateau after the massive engineering project for draining the lakes was concluded in 1920.

Costumbrista paintings, although created by artists trained in the Academy, never had a significance comparable either in quantity or quality to history paintings and landscapes. There was no genuine official·interest in acquiring these paintings for the Academy's holdings, and the commission and sale of genre canvases was largely a matter of private patronage. A prime example is *La despedida del joven indio* (The Farewell), a work with obvious autobiographical nuances that Felipe Sánchez Solís commissioned Felipe S. Gutiérrez (1824–1904) to paint (cat. no. 246).

The spirit of *verismo* also brought changes to portraiture. Even in the provinces painters finally abandoned the emblem or informational legend (which destroyed spatial illusion) and concentrated on depicting the subject's appearance and character. This development cannot be explained solely by the broader diffusion of academic style; a particularly significant factor was the increasing familiarity with the literal likenesses produced by photography. The most important provincial portraitist of this Realist phase was Hermenegildo Bustos (1832–1907), a rural jack-of-all-trades who, despite describing himself as an "amateur," had an extraordinary visual and psychological insight (cat. nos. 255–59).

The last two decades of the nineteenth century were marked by political stability and economic prosperity. In this environment monumental sculpture projects, so long delayed, began to be realized; Mexico shared the mania for sculpture peculiar to fin de siècle Western culture.

Miguel Noreña (1843–1894) and his disciples, Gabriel Guerra (1847–1893) and Jesús F. Contreras (1866–1902), created models for commemorative bronzes that were cast and erected throughout the capital city and the provinces. Monuments dedicated to heroes of Independence and Reform, to illustrious military and civil figures, and to educators and poets sprang up everywhere.

Indigenous themes also inspired sculptures: the most important and best executed was Noreña's *Monumento a Cuauhtémoc*, unveiled in 1887 on the Paseo de la Reforma in Mexico City. This work inaugurated a vast program of commemorative figures along the length of that broad avenue, an endeavor in which the Positivists' progressive and didactic concept of history found its equivalent in the arts. The style of this body of sculptures ranged from Neo-Baroque vigor to sober civic Realism.

At the other extreme from this solemn treatment of history was the political caricature, in which daily events were the subject of scathing irony and the most trivial actions and defects of politicians came under a mordant, totally desanctifying scrutiny. The cartoons appeared in newspapers such as *La Orquesta* (1861–77); the lithographic virtuosity of Constantino Escalante (1836–1868) and of Santiago Hernández (1833–1908) was brilliantly displayed in this long-lived and prestigious publication. Later the confrontations of irreconcilable Liberal factions gave rise to the rich lithographic commentary of *El Ahuizote* (1874–76); and finally the courageous opposition to the regime of Porfirio Díaz had such organs of expression as *El Hijo del Ahuizote* (1885–1903) and *El Comillo Público* (1903–6), which showcased the daring works of Daniel Cabrera (1858–1914) and Jesús Martínez Carréon (1860–1906).

The early prints of José Guadalupe Posada (1852–1913) fall within this urban cultural tradition (the political voice of these newspapers was habitually directed to the educated classes, not to the illiterate masses of the population). The Posada caricatures published in *El Jicote* (1871) in Aguascalientes are closely related to the stylistic tradition of Escalante and Hernández. Later, toward the end of the 1880s, his work for publications in the capital, such as *La Patria Ilustrada* and *Revista de México*, reveals a very careful and refined linear style, based on that made popular by José María Villasana (1848–1904), one of the supreme figures of political and popular graphics in the last third of the century.

Posada was already a skilled engraver with great inventive resources. But he was still to discover the lode that was to earn him lasting fame —that popular and fantastic vein he developed when working for Antonio Vanegas Arroyo, a publisher of broadsheets and pamphlets meant for a popular audience. These mature images overflow the boundaries of Realism, and thus his later career is discussed below.

The Advent of Modernismo (1890–1911)

If Positivism provided a conceptual substratum for *verismo*, this philosophy's crisis and decline underlies the genesis of *modernismo*. The term *modernismo* is used in Spanish-American cultural history to designate the innovative literary and artistic manifestations that unfolded from 1890 to 1911. *Modernismo* shared important characteristics—a taste for universality and innovation—with what the Anglo-Saxon world calls Modernism, but it was driven by different social and cultural imperatives, and its chronology is somewhat different.

The advance of scientific knowledge, together with the decline of traditional faith, caused the growing spiritual malaise that nurtured Modernist expression. Dissatisfaction with bourgeois values and the search for a new justification for art in a world dominated by materialism and pragmatism are also found at the base of fin de siècle art. Mexican artists experienced a sharpened consciousness of art for art's sake, a desire for a maximum refinement of modes of expression, and a will to master the newest artistic languages, to be totally au courant, and to measure their creations against the best in world art. Spanish-American artistic expres-

Julio Ruelas. *Méduse*, 1906–1907. Etching on paper. Collection Instituto Nacional de Bellas Artes, Mexico City. Photo: Museo Nacional de Arte, Mexico City

Roberto Montenegro. *Le Paon blanc*, 1908. Ink drawing on paper. Collection Instituto Nacional de Bellas Artes, Mexico City. Photo: Museo Nacional de Arte, Mexico City

sion was made more flexible by a deliberately eclectic open-door aesthetic. The *modernistas* appropriated elements from Symbolism, Impressionism, Naturalism, Art Nouveau, and Oriental art. They were sympathetic to the European decadents, sharing their devotion to the cult of pure beauty. They shared the subjectivism, radical introspection, and skepticism of fin de siècle Western thought; they had little faith in industrial progress and sought to replace the gods that they believed had died.

Young Mexican artists no longer went to Rome to complete their studies; now they preferred the modernism of Paris, Munich, Karlsruhe, and Barcelona. The former Academy of San Carlos (which since 1867 had come to be known as the Escuela Nacional de Bellas Artes) supported their explorations, awarding fellowships for study in these new hubs of modern art; if the young artists did not obtain a fellowship, they could often find a Mexican Maecenas.

Traditional critics repudiated their ideas, but a group of young, generally well informed writers and aesthetes emerged. They founded literary reviews (the most famous and representative was the vanguardist *Revista Moderna*, published from 1898 to 1911) that facilitated closer bonds among artists, poets, and musicians.

Sculpture showed the earliest signs of change, with Jesús F. Contreras (1866–1902) and his very personal works (*El beato Calasanz*, 1895; *Malgré tout*, 1898). Immediately after this modernist standard-bearer came a generation of young sculptors—Agustín Ocampo, Arnulfo Domínguez Bello, Fidencio Nava, Enrique Guerra—who traveled to Paris and absorbed the work of Rodin. The French sculptor had influenced Contreras and would have a prolonged vogue in Mexico that would last well into the 1920s.

With the contrast of light and shadow and irregular contours, the semi-finished surfaces of the works produced during those years sought to create a pictorial impression. In general, the works were consciously erotic female nudes; their titles—*Désespoir*, *Malgré tout*, *Fleur fanée*, *Volupté*, *Après l'orgie*—speak of these victims' passion and ennui. Mythology, the Bible, and the lives of the saints often inspired the iconography of these pieces, but their manner was entirely personal and independent of academic standards.

This same freedom with traditional themes also characterized the works of Julio Ruelas (1870–1907). If any artist deserves to represent the *modernismo* style in Mexico, it is Ruelas. He was the major illustrator for the *Revista Moderna*, and thus it can be said that he guided the era's artistic sensibilities. He also created a relatively small number of remarkably original paintings (cat. no. 274) and, in Paris toward the end of his life, an extraordinary series of etchings.

In all of his work, Ruelas revealed a tormented inner world, imbued with a decadent eros and the constant presence of death. He studied in Karlsruhe in the early 1890s, where he was deeply impressed by the German Symbolists (Böcklin, Klinger); he was equally influenced by the disenchanted and cynical eroticism of Félicien Rops. With Ruelas, such typically fin de siècle motifs as the femme fatale and grotesque and macabre fantasy were assimilated into Mexican art. He treated line and chiar-

oscuro with unprecedented freedom, transforming them into subtle instruments of his personal imaginative repertoire (cat. no. 274). His example was of capital importance to twentieth-century Mexican artists.

Outstanding among Ruelas's followers was Roberto Montenegro (1886–1968). But unlike his master, he was not drawn to the heavy eroticism of German Symbolists; he was seduced, instead, by the drawings of Aubrey Beardsley and the compositional subtleties of Japanese art. Montenegro's fragile visual world focuses on the ephemeral beauty of sumptuous beings and objects threatened by death. Montenegro is at heart a moralizing aesthete, unlike Alberto Fuster (1879–1922), who is a nostalgic aesthete. For Fuster the artist is the repository and dispenser of beauty. His kingdom, however, belongs to the past, to an ancient Classical paradise lost forever and recoverable only through the visual memory of the artist—a memory profoundly influenced, in Fuster's case, by Lawrence Alma-Tadema and Puvis de Chavannes. During his youth Fuster spent long periods in Paris, Florence, and Rome; he returned to Mexico at the beginning of the century, where he found a society resistant to his exquisite vision of the past. After vain attempts to clothe his nostalgia in the garb of Tlacotalpan, the land of his birth, he committed suicide in 1922.

The Munich-educated Germán Gedovius (1867–1937) explored the allegorical potential of Symbolism. A connoisseur both of the techniques of the masters (particularly of the Baroque) and of the freedom of color and impasto introduced by the new painting, Gedovius had a considerable influence on young students in the Escuela Nacional de Bellas Artes at the beginning of the century. He has, however, been somewhat overshadowed by his contemporary Dr. Atl (1875–1964). A landscape painter, Atl strived to achieve a synthetic monumentality, cosmic in tone and quite different from the effect achieved by Velasco (cat. no. 284). Atl's involvement in sociopolitical concerns led him to play a role as agitator and prophet, but these activities are beyond the scope of this essay.

It is clear that during the first decade of the twentieth century the Escuela Nacional de Bellas Artes attracted the most advanced artists of the moment, among them Ruelas, Gedovius, and Atl. In the Escuela's frequent exhibitions the works of its fellowship students studying in Mexico and abroad were displayed, thereby disseminating innovative ideas. And the Escuela endeavored to renovate its curriculum. In sum, it attempted to transform itself, not always successfully, but in a way that contrasts with the resistance to change usually found in an academic institution. The profound aesthetic changes that would flower in the second decade of the twentieth century would break with the academic standards in place in 1910. But it must be underscored that the sources of these changes were in part in the former Academy of San Carlos.

In the same years in which *modernismo* stormed the Academy and installed itself as the reigning artistic discourse, Posada was laboring in a workshop only a short distance away (cat. nos. 276–282). This engraver would come to be recognized as one of the mythic precursors of the Escuela Mexicana de Pintura. Beginning at the turn of the century, the enormous body of work Posada produced at the behest of the publisher Vanegas

Alberto Fuster. *Triptych Dedicated to Justo Sierra*. Oil on cardboard. Museo Nacional de Arte, Mexico City. Photo: Museo Nacional de Arte, Mexico City

Arroyo—influenced by the popular audience to which it was directed (and, in the formal sphere, by the suggestions of Manuel Manilla, an engraver who previously had worked for Vanegas)—breaks both in theme and style with anything he had done before.

The relation of "events," real or invented, the "street gazettes," the *corridos* (songs narrating the lives of popular heroes), the children's tales, the series of *calaveras* (skeletons)—all create an iconography in which the visible and invisible blend and coexist, a world ruled by passion and imagination, with a strong element of traditional morality expressed in terrifying secular allegories that stressed the supernatural. Space and proportion are handled according to a perspective and scale that have more to do with moral values than with Realist criteria. Forms are amplified, altered, or deformed in a quest for greater expressivity.

Thus, moving in tangential artistic spheres, but autonomously, Ruelas and Posada produced a similar interpretation of the world in which they lived, an apocalyptic and devastating interpretation opposed to the rational, orderly, and progressive image the political Positivism of Porfirio Díaz and his cohorts had struggled to establish.

Academic Painting

243 ◀ Pelegrín Clavé

b. 1810 Barcelona–d. 1880 Barcelona

Don José Bernardo Couto, 1849

Oil on canvas; 116 x 94 cm (45⅝ x 37 in.)
Collection Agustín Acosta Lagunes, Mexico City

Both the Spanish painter Pelegrín Clavé and his Mexican sitter, José Bernardo Couto, were influential in the reorganization of the Academy of San Carlos: Couto as promoter and Clavé as founder of a school of painting. Clavé also distinguished himself as a portraitist, painting a large number of men and women of the upper classes. This portrait of Couto, which captures the sitter's character with notable originality, illustrates Clavé's talents in the genre.

Although Clavé is sometimes placed among the Catalan Nazarenes, it is more appropriate to include him in the Madrid circle of Federico de Madrazo.

XM

REFERENCES
Salvador Moreno. *El pintor Pelegrín Clavé*. Mexico, 1966, p. 82, no. 180, pl. 1. **Justino Fernández**. *El arte del siglo XIX en México*. Mexico, 1967, pp. 56–61, color pl. 5.

244 ◀ Juan Cordero

b. 1822 Teziutlán, Puebla–d. 1884 Mexico City

Doña Dolores Tosta de Santa Anna, 1855

Oil on canvas; 220 x 150 cm. (86⅝ x 59 in.)
CNCA–INBA, Museo Nacional de Arte, Mexico City

Cordero studied in the Academy of St. Luke in Rome, where he absorbed Neoclassical ideals and a Romantic manner. When he returned to Mexico, he produced a considerable body of work, including portraits, religious paintings, and murals.

The depiction of the young wife of General Antonio López de Santa Anna is an example of his finest work as a portrait painter. Doña Dolores stands in a room in the Palacio Nacional where the Spanish spirit has yielded to French tastes. The past persists, however, in the Cathedral, glimpsed through a balcony window.

XM

REFERENCES
Justino Fernández. *El arte del siglo XIX en México*. Mexico, 1967, p. 69, color pl. 3. **Elisa García Barragán**. *El pintor Juan Cordero: los dias y las obras*. Mexico, 1984.

243

244

245 ◄ Felipe S. Gutiérrez
b. 1824 Texcoco–d. 1904 Mexico City

Señora Sánchez Solís

Oil on canvas; 216 x 146 cm. (85 x 57½ in.)
Gobierno del Estado de México, Secretaría de
Educación, Cultura y Bien Estar Social, Instituto
Mexiquense de Cultura, Museo de Bellas Artes de
Toluca, Toluca

Gutiérrez was a prominent academic painter, who is also known for his travel writings and art criticism. As a painter, he concentrated on female nudes, portraits, and biblical scenes. This portrait depicts the wife of Felipe Sánchez Solís, a leading member of the nineteenth-century intellectual bourgeoisie. The careful definition of the subject's social status is perhaps the salient quality of this painting, which marks Gutiérrez as a master of Mexican portraiture.

XM

REFERENCES
José Manuel Caballero-Barnard. "Felipe S. Gutiérrez, pintor de academia: Tezcoco, 1824–1904." *Artes de México* 20, no. 171 (1973). **Fausto Ramírez**. *La plástica del siglo de la Independencia.* Mexico, 1985, p. 93.

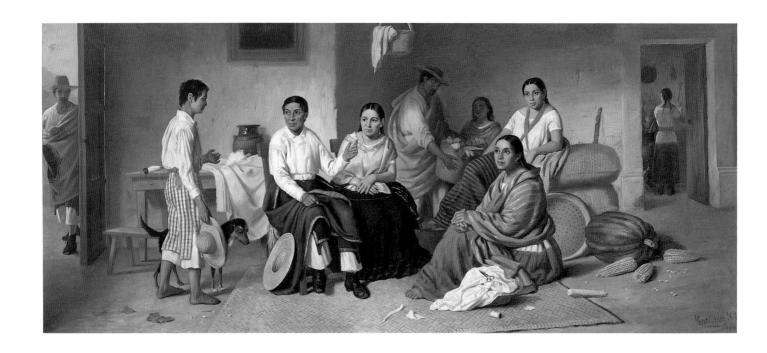

246 ◄ **Felipe S. Gutiérrez**
◄ b. 1824 Texcoco–d. 1904 Mexico City
◄
◄ *The Farewell*
◄
◄ Oil on canvas; 82 x 192 cm. (32¼ x 75⅝ in.)
◄ Private collection, Mexico City

Gutiérrez worked in a variety of genres, thereby escaping the rigidity of academic art; his personal aesthetic permitted him to find genre themes attractive and to explore them in canvases like this one. Among its many qualities, this work is outstanding for the accurate, naturalistic representation of the interior of a humble peasant home in the lake district of Zumpango.

The title, *The Farewell*, relates to the life of the attorney, Felipe Sánchez Solís, who commissioned Gutiérrez to paint the canvas (see cat. no. 245). The young Indian taking leave of his family is Sánchez Solís himself, who in time would become an eminent figure in liberal politics.

XM

REFERENCE
José Manuel Caballero-Barnard. "Felipe S. Gutiérrez, pintor de academia: Tezcoco, 1824–1904". *Artes de México* 20, no. 171 (1973).

247 José Obregón

b. 1832 Mexico City–d. 1902 Mexico City

The Discovery of Pulque, 1869
Oil on canvas; 189 x 230 cm. (74⅜ x 90½ in.)
CNCA–INBA, Museo Nacional de Arte, Mexico City

One of the standard classes at the Academy of San Carlos was history painting, with a strong emphasis on the Mexican past. Events from the pre-Hispanic period were favored, with the intention of rescuing the ancient indigenous world from undeserved oblivion.

The present painting shows the extraction of pulque, an intoxicating drink, from the maguey cactus. It is closer to the classical tradition than to Mexican reality. Thus the king and his throne resemble antique prototypes, and the delicate young Indian woman recalls a Roman vestal virgin. The architecture is completely the artist's invention.

XM

REFERENCE
Justino Fernández. *El arte del siglo XIX en México*. Mexico, 1967, p. 63, fig. 58.

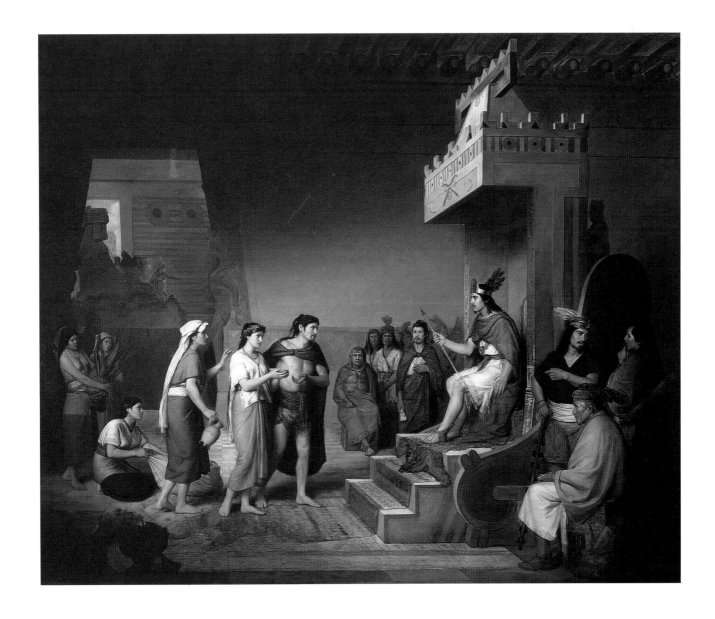

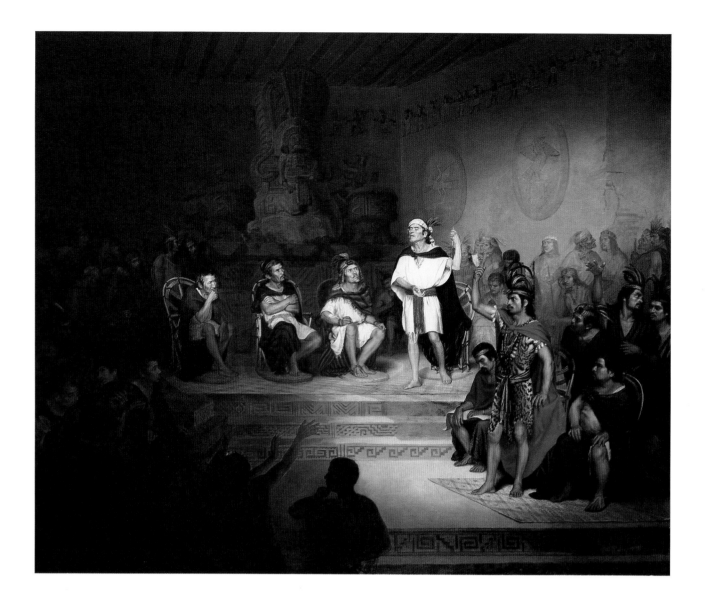

248 ◀ **Rodrigo Gutiérrez**

◀ b. 1848 San Luis Potosí–d. 1909 Zacatecas

◀ ***The Senate of Tlaxcala,*** 1875

◀ Oil on canvas; 191 x 232 cm. (75¼ x 91⅜ in.)
◀ CNCA–INBA, Museo Nacional de Arte, Mexico City

The governing body of the Tlaxcala Indians reminded the conquistadores of the Roman senate. This fancy was widely accepted, and Gutiérrez depicts this "senate" in the present picture. In a large hall embellished with Precolumbian sculptures, four mature Tlaxcalteca "senators" debate before their people. The declamatory posture of one recalls that of a Roman orator; the youth standing slightly below him also resembles an antique sculpture.

XM

REFERENCE
Justino Fernández. *El arte del siglo XIX en México.* Mexico, 1967, p. 64, fig. 59.

Regional Painting

249 ◀ **José María Estrada**

◀ Mexican, active 1830–1860

◀ ***Don Miguel Arochi y Baeza***

◀ Oil on canvas; 79.8 x 51.5 cm. (31¼ x 20¼ in.)
◀ CNCA–INBA, Museo Nacional de Arte, Mexico City

Some nineteenth-century painters worked in provincial towns, independent of the Academy of Fine Arts. They specialized in still lifes and religious paintings, but they also devoted a major part of their efforts to portraits and left behind a gallery of representative types from the provincial society of the time. Estrada, who was active in Guadalajara, Jalisco, between 1830 and 1860, painted men, women, and children with a notable simplicity of composition.

This portrait of Miguel Arochi y Baeza shows the realistic style that distinguishes Estrada's work; here he emphasizes his subject's youth and the elegance of his clothing. A requisite of this genre is the inscription recording biographical information about the subject.

XM

REFERENCES
Paul Westheim. "José María Estrada y sus contemporáneos." *México en el arte* no. 3 (September, 1948). **Justino Fernández**. *El arte del siglo XIX en México*. Mexico, 1967, p. 107, fig. 173.

250 ❮ José María Estrada

Mexican, active 1830–1860

Girl in a Red Dress

Oil on canvas; 42 x 31.3 cm. (16½ x 12⅜ in.)
CNCA–INBA, Museo Nacional de Arte, Mexico City

Estrada used a standardized format with little modification. The person who was posing filled the entire space of the canvas. Estrada's compositions are unimaginative and unresourceful: his backgrounds are always neutral in color, and there is a marked preference for the frontal pose—nothing distracts the eye from the subject of the portrait.

The first priority of provincial artists was fidelity. Their clients wanted a physical realism that would suggest their character and their age; they also demanded extreme care and accuracy in the reproduction of the opulent jewels and clothing they wore. This portrait is a most convincing example of the delicacy Estrada was capable of achieving in portraiture and, at the same time, of his sensitivity to the demands and pretensions of his clientele.

XM

REFERENCES
Paul Westheim. "José María Estrada y sus contemporáneos." *México en el arte* no. 3 (September, 1948). **Justino Fernández**. *El arte del siglo XIX en México*. Mexico, 1967, pp. 106–108.

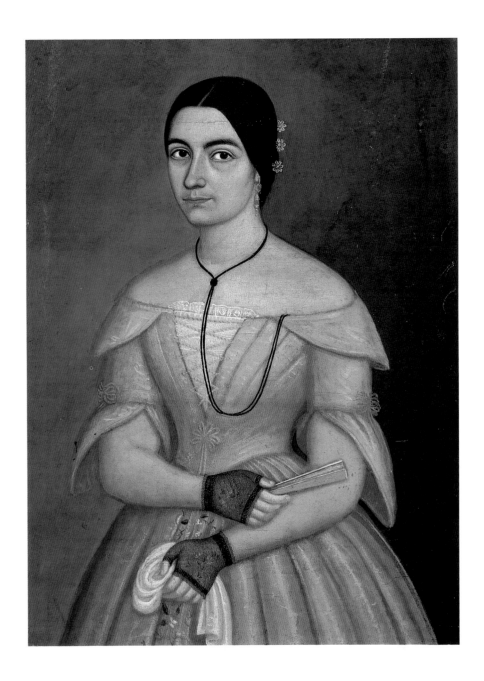

251 ◀ **José María Estrada**

Mexican, active 1830–1860

Don Francisco Torres (The Dead Poet),
1846

Oil on canvas; 42 x 31 cm. (16½ x 12¼ in.)
CNCA–INBA, Museo Nacional de Arte, Mexico City

It was common in viceregal Mexico to portray a nun after her death. This tradition was continued by artists such as Estrada, who painted this portrait in homage to the memory of a young poet. The young man's haughty expression was captured before it was erased in death. The vivid tones of his flower crown soften the portrait's solemnity.

XM

REFERENCES
Paul Westheim. "José María Estrada y sus contemporáneos." *México en el arte* no. 3 (September, 1948). **Justino Fernández**. *El arte del siglo XIX en México*. Mexico, 1967, p. 108, fig. 171. **Xavier Moyssén**. "La pintura en la provincia, durante la primera mitad del siglo XIX." In *Historia del arte mexicano*, vol. 9, *Arte del siglo XIX, I*. 2d ed. Mexico, 1982, pp. 1355–357, fig. p. 1359. **Fausto Ramírez**. *La plástica del siglo de la Independencia*. Mexico, 1985, p. 43.

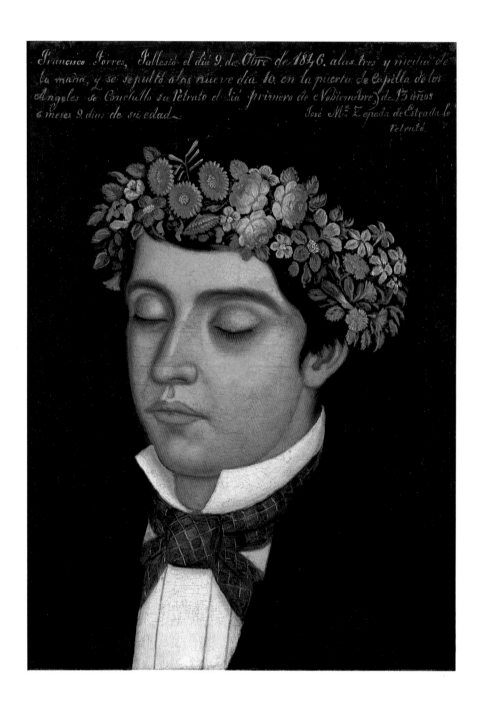

252 ◄ Agustín Arrieta
b. 1802 Santa Ana Chautempan, Puebla–d. 1874
Tlaxcala

Dining Room with Parrot, Candlestick, Flowers, and Watermelon
Oil on canvas; 69 x 124 cm. (27⅛ x 48⅞ in.)
Private collection, Mexico City

One of the supreme exponents of nineteenth-century provincial painting in Mexico is Agustín Arrieta, who lived and worked in Puebla. His religious themes should not be overlooked, but he excelled most as a painter of regional color and creator of still lifes (*bodegones*). He did not always sign his work and even less frequently recorded a date.

Arrieta arranged the various components of his still lifes on a covered table, governed by the objectivity of a naturalist. These still-life paintings are unmistakably Mexican, easily identified by the flowers and fruit they portray, the rustic pottery vessels, the typical sweets and breads, and animals (living or dead). Arrieta's favorite bird was the parrot.

XM

REFERENCE
Francisco Cabrera. *Agustín Arrieta, pintor costumbrista*. Mexico, 1963.

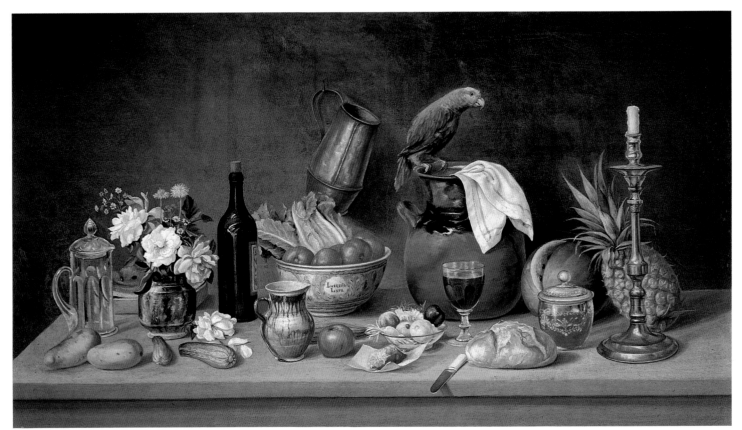

252

253 ◄ Agustín Arrieta
b. 1802 Santa Ana Chautempan, Puebla–d. 1874
Tlaxcala

The Man from the Coast
Oil on canvas; 91 x 71 cm. (35⅞ x 28 in.)
Private collection, Mexico City

A youth from the coast of Veracruz served as Arrieta's model for this interesting work, which is allied to his regional paintings. The subject has a merry expression and is wearing loose, brightly colored clothing that makes his figure stand out against the dark background. The basket of fruit in his hands serves to capture the attention of the viewer. The contents of the basket are typical of the objects Arrieta liked to reproduce in his still lifes. The fruits are varied in color and form: Indian figs, a melon, a pineapple, and two mammees, one of which is cut open to show the color of its delicious flesh. The variety of the fruit suggests the tropical nature of the country.

XM

REFERENCE
Francisco Cabrera. *Agustín Arrieta, pintor costumbrista*. Mexico, 1963.

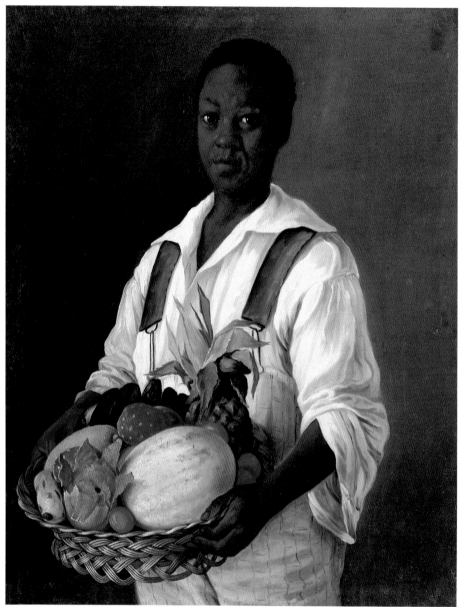

253

254 ◀ **Agustín Arrieta**
b. 1802 Santa Ana Chautempan, Puebla–d. 1874
Tlaxcala

◀ *El Chinaco y la China*
Oil on canvas; 114 x 89 cm. (44⅞ x 35 in.)
Private collection, Mexico City

The *chinaco* and *china* (Indian man and woman) occupy an important position in Arrieta's paintings. This canvas is among the most ambitious he attempted of the human figure. The scene illustrates the woman's submission to the man who sits behind her, one hand on her shoulder and the other holding a captive bird. Sitting cross-legged on the ground, the woman wears a colorful folk costume appropriate to her status, as does her companion. The painter has spread before them a few comestibles, such as enchiladas and fruit, in addition to the always-present glass of pulque. Here Arrieta gives the same attention to realistic detail that is evident in his still lifes.

XM

REFERENCES
Francisco Cabrera. *Agustín Arrieta, pintor costumbrista*. Mexico, 1963. **Justino Fernández**. *El arte del siglo XIX en Mexico*. Mexico, 1967, pp. 113–14. **Xavier Moyssén**. "La pintura en la provincia, durante la primera mitad del siglo XIX." In *Historia del arte mexicano*, vol. 9, *Arte del siglo XIX, I*. 2d ed. Mexico, 1982, pp. 1363–66.

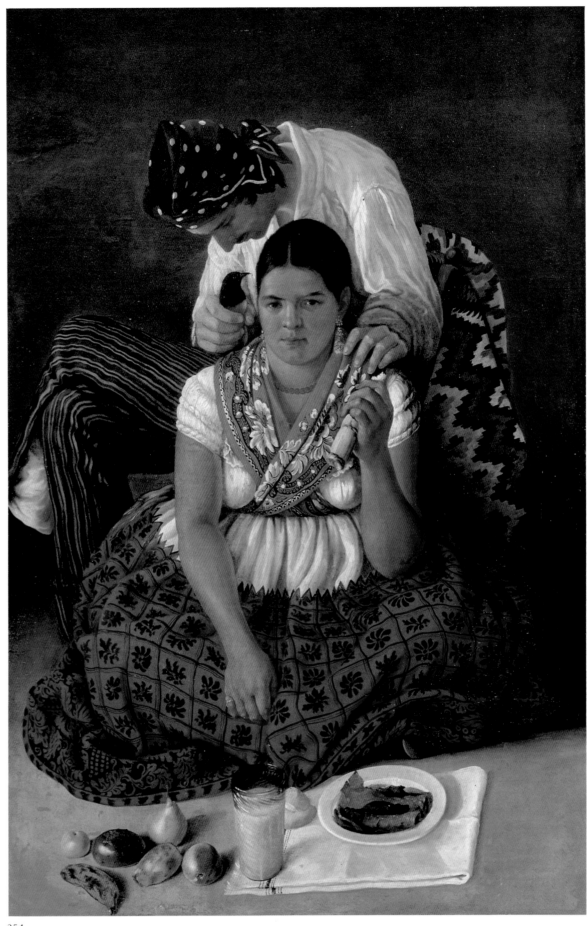

254

255 ◀ Hermenegildo Bustos

b. 1832 Purísima del Rincón, Guanajuato–d. 1907
Purísima del Rincón, Guanajuato

Doña Leocadia López de González, 1854

Oil on metal; 37 x 26 cm. (14⅝ x 10¼ in.)
CNCA–INBA, Gobierno del Estado de Guanajuato,
Museo Regional de Guanajuato, Alhóndiga de
Granaditas, Guanajuato

An inscription on the reverse of this portrait reads: "Painted by Hermenegildo Bustos, an amateur." This provincial master was, however, more than a mere amateur. In fact, Bustos's talent and sensibility make this work one of the most outstanding portraits of nineteenth-century Mexican art.

Leocadia López de González was painted in her ripe maturity. Nothing escaped the painter's attention: the woman's large eyes, her straight nose, and the sensual lips that suggest the trace of a coquettish smile. The flowers in her hair lend light to her face.

XM

REFERENCES
Walter Pach. "A Newly Found American Painter." *Art in America* 31, no. 1 (1943), pp. 32–43.
Pascual Aceves Barajas. *Hermenegildo Bustos: su vida y su obra*. Guanajuato, Mexico, 1956.
Raquel Tibol. *Hermenegildo Bustos: Pintor de Puebla*. Guanajuato, 1981.

256 ◀ Hermenegildo Bustos

b. 1832 Purísima del Rincón, Guanajuato–d. 1907
Purísima del Rincón, Guanajuato

Jesús Muñoz at Eight Years, 1867

Oil on canvas; 40.5 x 28.5 cm. (16 x 11¼ in.)
CNCA–INAH, Gobierno del Estado de Guanajuato,
Museo Regional de Guanajuato, Alhóndiga de
Granaditas, Guanajuato

Bustos worked in isolation and without benefit of academic training. His paintings are now regarded as expressions of popular art which reached a level comparable to that of the academy. In fact, his art is at times more interesting than that by masters who enjoyed greater prestige.

The present portrait, imbued with freshness and innocence, is a fine example of the artist's strengths. Bustos downplayed the awkwardness of the boy's hands and large jacket, successfully investing his sitter with delicacy, distinction, and elegance.

XM

REFERENCES
Walter Pach. "A Newly Found American Painter." *Art in America* 31, no. 1 (1943), pp. 32–43.
Pascual Aceves Barajas. *Hermenegildo Bustos: su vida y su obra*. Guanajuato, Mexico, 1956.
Justino Fernández. *El arte del siglo XIX en México*. Mexico, 1967, pp. 109–10, fig. 182.

256

257 ◀ Hermenegildo Bustos

b. 1832 Purísima del Rincón, Guanajuato–d. 1907
Purísima del Rincón, Guanajuato

Don Juan Muñoz and Doña Juliana Gutiérrez, 1868

Oil on canvas; 53.5 x 72 cm. (21 x 28⅜ in.)
CNCA–INBA, Gobierno del Estado de Guanajuato,
Museo Regional de Guanajuato, Alhóndiga de
Granaditas, Guanajuato

Bustos worked in a variety of genres, but the portrait occupied him more than any other. He was self-taught and had his own concept of painting; although he practiced his art over many years, he always considered himself an "amateur." He tended to prefer single sitters but on occasion painted a group or a couple, as in the present portrait of Juan Muñoz and his wife, Juliana Gutiérrez, who were prominent members of the burgeoning provincial bourgeoisie.

XM

REFERENCES
Walter Pach. "A Newly Found American Painter." *Art in America* 31 no. 1 (1943), pp. 32–43.
Pascual Aceves Barajas. *Hermenegildo Bustos: su vida y su obra*. Guanajuato, Mexico, 1956.
Raquel Tibol. *Hermenegildo Bustos: Pintor de Puebla*. Guanajuato, 1981.

257

58 ◀ Hermenegildo Bustos

b. 1832 Purísima del Rincón, Guanajuato–d. 1907
Purísima del Rincón, Guanajuato

Still Life with Pineapple, 1877

Oil on canvas; 41 x 33.5 cm. (16⅛ x 13⅛ in.)
CNCA–Instituto Nacional de Bellas Artes,
Mexico City

Bustos's lack of formal training is evident in the rigid formalism of his portraits and religious works and in the unsophisticated compositions of the two still lifes he is known to have painted. The present canvas is divided simply into two sections: in the upper half are three rows of fruit; in the lower half the pineapple is placed on a diagonal. Other fruits, following the horizontal lines of the upper part of the canvas, fill the space to the left of the pineapple. The painstakingly descriptive quality of this painting brings to mind the hyperrealist works on the same subject by his contemporary Luis García Guerrero, who, like Bustos, was a native of Guanajuato.

XM

REFERENCES
Walter Pach. "A Newly Found American Painter." *Art in America* 31, no. 1 (1943), pp. 32–43.
Pascual Aceves Barajas. *Hermenegildo Bustos: su vida y su obra.* Guanajuato, Mexico, 1956.
Raquel Tibol. *Historia general del arte mexicano: época moderna y contemporáneo.* Mexico and Buenos Aires, 1964, pp. 79–80, 83, fig. 61. **Justino Fernández**. *El arte del siglo XIX en México.* Mexico, 1967, pp. 109–10, fig. 183. **Fausto Ramírez**. *La plástica del siglo de la Independencia.* Mexico, 1985, p. 94.

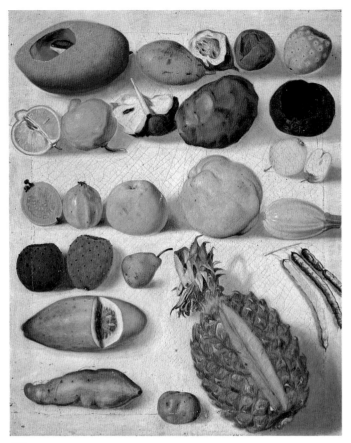

258

259 ◀ Hermenegildo Bustos

b. 1832 Purísima del Rincón, Guanajuato–d. 1907
Purísima del Rincón, Guanajuato

Self-portrait, 1891

Oil on metal; 34 x 24 cm. (13⅛ x 9½ in.)
CNCA–Instituto Nacional de Bellas Artes,
Mexico City

Bustos had no reticence about his origins. On the reverse of this painting he wrote: "[I am an] Indian from the village of Purísima del Rincón . . . and I painted myself to see if I could. . . ." This declaration shares the sincerity and lack of vanity so evident in his works.

The portraits Bustos painted are marked by a rigorous realism. He presented his subjects exactly as he saw them, with no flattery. When he painted his own portrait, he worked in the same severe spirit. A grave, angular face; a stern, penetrating gaze; broad brow; a firm mouth half-hidden beneath a thick mustache—these are the essential features of this man in funereal garb who seems anything but the unique artist he was.

XM

REFERENCES
Walter Pach. "A Newly Found American Painter." *Art in America* 31 no. 1 (1943), pp. 32–43.
Pascual Aceves Barajas. *Hermenegildo Bustos: su vida y su obra*. Guanajuato, Mexico, 1956.
Justino Fernández. *El arte del siglo XIX en México*. Mexico, 1967, p. 110, color pl. 16.

260 ◀ G. Morales

Mexican, active 1870s

El Señor Amo (The Master)

Oil on canvas; 61.3 x 79.7 cm. (24⅛ x 31⅛ in.)
Collection Felipe and Andrés Siegel, Mexico City;
courtesy Denver Art Museum

Although paintings depicting *charros* (elegantly clad horsemen) and their occupations were very popular in the nineteenth century, most of the artists who created them have not been identified. Occasionally a painter signed his work, but, as with the present canvas, we know nothing more than his name. Several of Morales's pictures depicting country life, *charros*, and their activities, date from the 1870s; some are signed "G. Morales," and it is generally supposed that his first name was Gelasio or Guadalupe.

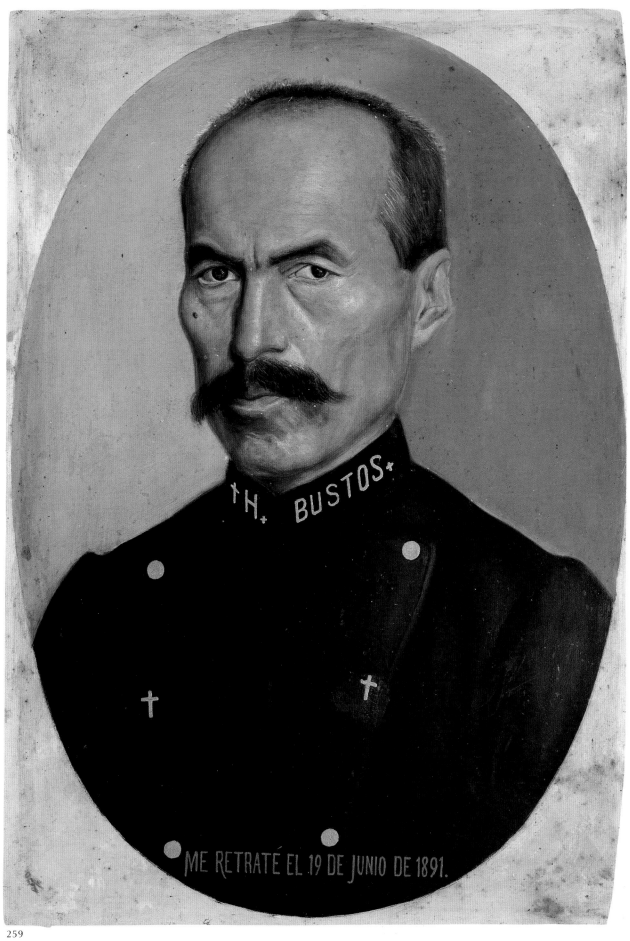

†H.✝ BUSTOS✝

✝

✝

ME RETRATÉ EL 19 DE JUNIO DE 1891.

259

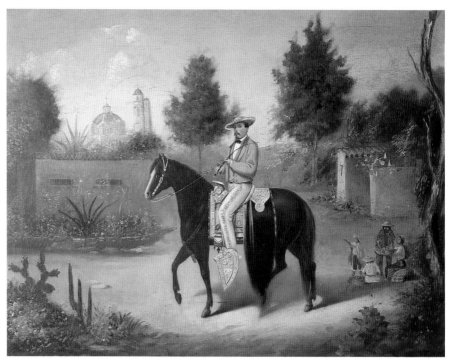

260

In this portrait of El Señor Amo (The Master) Morales has laid special emphasis on the contrast between the rich landowner and the humble country people, between the luxurious life of the *hacendado* and the abject poverty of the peasant. The subject of this painting seems to stand proudly before us, framed by evidence of his affluence.

XM

REFERENCE
Ceferino Palencia. "Los charros pintados por Ernesto Icaza: G. Morales y otros artistas." *Artes de México*, no. 26 (1959).

261 ◀ **Mexican, 19th century**

◀ *La Condesa de Canal*
◀ Oil on canvas; 60.6 x 50.5 cm. (23⅞ x 20 in.)
◀ Philadelphia Museum of Art, Gift of Mrs. René
◀ d'Harnoncourt 69–273–1

During the nineteenth century a large number of works by now-anonymous Mexican artists were painted. It is impossible to identify the creators of these still lifes, landscapes, regional scenes, and portraits, many of which are worthy of attention.

The composition of the present portrait suggests that the painter must have been familiar with academic works. It is also possible he was inspired by a daguerreotype. Of note is his realistic depiction of the countess, dressed in somber but sumptuous attire; she liked to smoke, and the painter did not overlook that detail.

XM

REFERENCE
Xavier Moyssén. "Pintura popular y costumbrista del siglo XIX." *Artes de México*, no. 61 (1965).

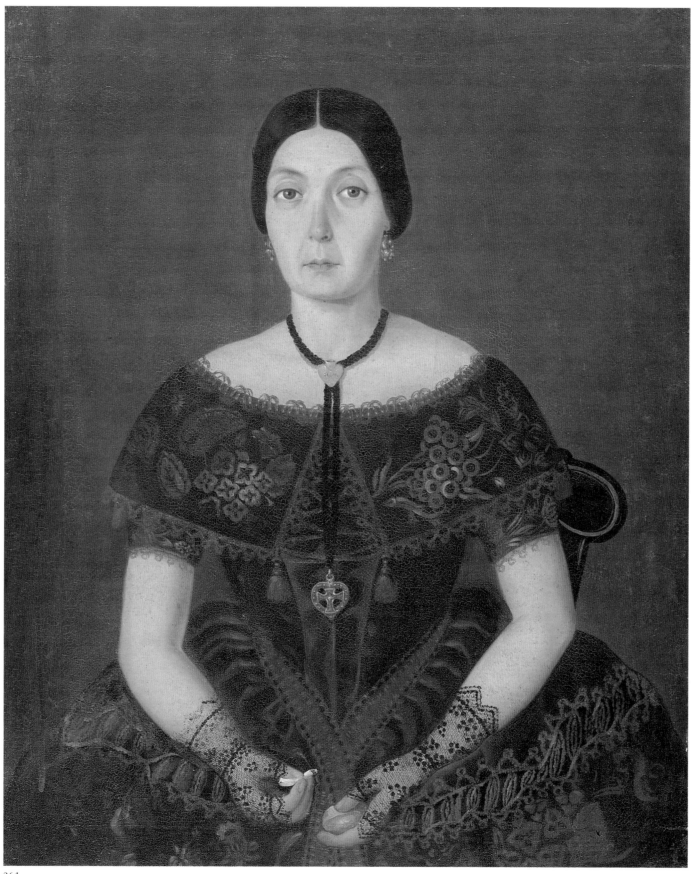

261

Ex-votos

Ex-votos, offerings that express gratitude, were public announcements of a miraculous cure or intervention brought about through devotion to a specific religious figure. They were made in a variety of mediums, although painted ex-votos were perhaps the most common. This genre of painting was practiced in Europe as well as in America; the earliest Mexican ex-votos date from the eighteenth century. The dimensions and compositions of the ex-votos varied according to the wishes of the person who commissioned the work; few names of the painters of these devotional images are known.

Ex-votos represent the natural and the supernatural—the earthly world of the believer and the spiritual world which is the source of the miraculous intervention. For example, in the ex-voto dedicated to "Señor Santiago" (St. James the Greater) the delicately painted image of the apostle is visible in the heavens (cat. no. 263). Of similar size and quality to this work, though some thirty years later, is the ex-voto dedicated to the "Señor de la Columna" (Christ bound to the pillar) by Belem Puente, whose health was restored through devotion to the scourged Christ (cat. no. 265). Puente and his family dedicated this work to their intercessor as a token of their "eternal gratitude."

Great ingenuity is seen in the compositions of ex-votos. Numerous details are included to offer proof of the marvelous event. This careful documentation is evident in the ex-voto dedicated to the "Señor de la Buena Muerte" (Lord of the Good Death; that is, Merciful God) by Cirilo Ramírez, a gunpowder manufacturer, whose three sons were burned in a fire in their home (cat. no. 264). The same artist who painted the Ramírez ex-voto may have executed the work portraying Epifania Landros, who offers thanks to the "Señor de la Columna" for healing her daughter (cat. no. 262).

XM

REFERENCES
Jean Charlot. "Mexican Ex-votos." *Magazine of Art* 42, no. 4 (1949), pp. 139–42. Reprinted in *An Artist on Art: Collected Essays of Jean Charlot*, vol. 2: *Mexican Art*. Honolulu, 1972. Roberto Montenegro. *Retablos de México: Mexican Votive Paintings*. Mexico, 1950. Justino Fernández. *El arte del siglo XIX en Mexico*. Mexico, 1967, pp. 111–12.

262 ◀ *An Infant Healed After a Fall,* 1869

Oil on metal; 22 x 28 cm. (8⅝ x 7⅛ in.)
Collection Luis Felipe del Valle Prieto, Mexico City

263 ◀ *A Man Revived After Being Struck by Lightning,* 1882

Oil on metal; 18 x 13 cm. (7⅛ x 5⅛ in.)
Collection Luis Felipe del Valle Prieto, Mexico City

264 ◀ *Three Children Healed After Being Burned,* 1902

Oil on metal; 22 x 18 cm. (8⅝ x 7⅛ in.)
Collection Luis Felipe del Valle Prieto, Mexico City

265 ◀ *A Man Recovered from Serious Illness,* 1904

Oil on metal; 18 x 13 cm. (7⅛ x 5⅛ in.)
Collection Luis Felipe del Valle Prieto, Mexico City

262

En el dia 9 de Junio del año de 1869, acontecio á Dª. Epifenia Landeros, la desgracia, de haversele caido de la cama su hijita Manuelita Rojas, de un año de edad, y se le rompio las narisitas, y hayandose sumamente angustiada, aclamo al Sõr. de la Columna qᵉ se venera en esta Villa, y se la encomendó: y en pocos dias la vio enteramente Sana por maravilla de su Majestad, á quien dedicó el precente retablo.

263

En la Hacᵈᵃ de Santiago, en un tiempo de 1882, Don Alejandro Perez y otᵃ persona resishendo un oraruzal, le cayo una sentella y abento á los dos, y quedando muerto, que duro como 3 horas en todo este tiempo su tio Jacinto no ceso de encomendarlo Al Sr. Santiago por lo que resuecitⁿ con pequeᵃⁿᵃ cha muscadaᵉⁿ en el pel. Y en prueva de su eterna gratitud, le dedicó éste retablⁿᵒ.

264

Aqui en el Saus de Armenta, el dia 21 de Enero de 1902, acontecio en su casa, á Don Cirilo Ramirez, fabricante de polvora, que desgraciadamente se le quémaron sus tres hijos; uno de 7 años, todo el lado derecho, el de 4 años, poco de la cabesa del lado isquierdo, el de 2 años toda la cara se quemo. Viendolos en tan lamentable cituasion se los encomendo al Smo. Sr. de la Buena muerte que aqui se venera....y al poco tiempo sanaron. Y en testimonio de su eterna gratitud: y para su engrandecimiento de devocion le dedica el presente retablo.

265

En Mexico, en Junio de 1904, el Sr. Don Belem Puente, se enfermó, y se vio mui grave, que los medicos lo desafuciaron, y en esta terrible angustia, lla sin esperanza..su esposa Emilia Gonsalez, y familia, adamaron sin cesar encomendandolo Al Santhsimo Señor de la Columna Quien ólló por su infinita Misericordia sus aflijidas plegarias, quedando en poco tiempo bueno y sáno. Y para testimonio publico de eterna gratitud, le dedicaron el presente.

266 ◀ Mexican, 19th century
◀ *Still Life*
◀ Oil on canvas; 75 x 101 cm. (29½ x 39¼ in.)
◀ Collection Mr. and Mrs. Fenton M. Davison, Flint,
◀ Michigan

A heritage from Spanish Baroque painting are the still lifes (*bodegones*) that were frequently painted by Mexican artists. This still life, may have been painted in Puebla. Were that the case, it would be a forerunner of the work of Agustín Arrieta, a master of the genre. Fruits, sweets, cold meats, cheeses, and breads are scattered among copper, glass, and ceramic tableware, and the artist includes a parrot.

XM

REFERENCE
Leonor Cortina. *Bodegones mexicanos: Siglos XVIII-XIX-XX.* Mexico, 1988.

Landscape Painting

267 ◀ Daniel Thomas Egerton
◀ b. England–d. 1842 Mexico City
◀
◀ *The Valley of Mexico,* 1837
◀ Oil on canvas; 131 x 185 cm. (51⅛ x 72⅞ in.)
◀ Government Art Collection of the United Kingdom,
◀ Great Britain
◀ EXHIBITED IN NEW YORK ONLY

Landscape artists of the nineteenth century were especially attracted by the Valley of Mexico. It was discovered as a pictorial subject by foreign artists who came to Mexico, among them the Englishman Daniel Thomas Egerton, who arrived in Veracruz in 1830. He traveled throughout Mexico, depicting a variety of landscapes. In about 1837 he chose the Valley of Mexico as a subject. He painted it from the southern prospect and included the Iztaccíhuatl

volcano. Two compositions occupied him: the lacustrine landscape with Mexico City in the distance and the everyday life of the inhabitants of Tlalpan. His rendering of these two aspects of the valley was masterly.

XM

REFERENCES
Manuel Romero de Terreros. *Paisajes mexicanos de un pintor inglés*. Mexico, 1942, pp. 15–16.
Martín Kiek. *Egerton en México, 1830–1842*. Mexico, 1976.

268 ◀ Eugenio Landesio
b. 1810 Altessano, Italy–d. 1879 Paris

The Hacienda of Colón, 1857–58
Oil on canvas; 83 x 117 cm. (32⅝ x 6¼ in.)
Montiel Romero Family Collection, Mexico City

Landesio came to Mexico to establish the academic tradition of landscape painting; he succeeded in forming a school of landscape artists, one of whom was José María Velasco (cat. nos. 269–272).

During his stay in Mexico, Landesio painted a large number of canvases, most frequently of haciendas, both those devoted to agriculture and those engaged in mining operations. The landscape is a central motif in his *Hacienda of Colón*, but no less important are the life of the peon, the general atmosphere of the estate, and the peculiarities of its architecture. The golden light of dusk gives a delicate and harmonious glow.

XM

REFERENCES
Manuel G. Revilla. *Eugenio Landesio*. Mexico, 1902. **Manuel Romero de Terreros**. *Paisajistas mexicanos del siglo XIX*. Mexico, 1943, pp. 9–11, 22, pl. 3. **Justino Fernández**. *El arte del siglo XIX en México*. Mexico, 1967, pp. 80–82.

269 ◀ **José María Velasco**
◀ b. 1840 Temascalcingo–d. 1912 Mexico City
◀
◀ ***The Valley of Mexico,*** 1875
◀ Oil on canvas; 157 x 226 cm. (61¾ x 89 in.)
◀ CNCA–INBA, Museo Nacional de Arte, Mexico City

Velasco is the supreme representative of nineteenth-century academic painting in Mexico. He was dedicated to a single theme: the landscape, frequently the Valley of Mexico, of which he was a passionate interpreter. He also showed the present work, one of those that would establish him as the premier painter of the Valley of Mexico, in 1875 at the annual exhibition held by the Academy of San Carlos. This masterpiece demonstrates Velasco's visual grasp of the grandeur of the landscape and all it includes, from the human beings moving about in it, to the lakes and the capital city, to the volcanoes rising above the far horizon—all worked with a flawless exactitude of color and a mastery of perspective.

XM

REFERENCES
Juan de la Encina. *El paisajista José María Velasco, 1840–1912.* Mexico, 1943. **Juan O'Gorman.**
"Velasco: Painter of Time and Space." *Magazine of Art* 36, no. 6 (1943), pp. 203–7. **Justino**
Fernández. *El arte del siglo XIX en México.* Mexico, 1967, pp. 89–90, color pl. 10.

270 ◀ **José María Velasco**
◀ b. 1840 Temascalcingo–d. 1912 Mexico City
◀
◀ ***The Cathedral of Oaxaca,*** 1887
◀ Oil on canvas; 46.3 x 62.3 cm. (24½ x 18¼ in.)
◀ CNCA–INBA, Museo Nacional de Arte, Mexico City

In 1887 Velasco traveled in the state of Oaxaca, making a number of paintings on subjects that captured his fancy. He devoted little attention to buildings, and the present depiction of Oaxaca Cathedral is one of his rare urban landscapes.

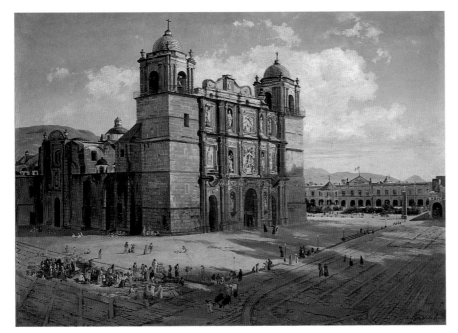

270

The architectural volumes of this colonial building are well defined, and the small market, the human figures, and the group of buildings in the background accentuate its monumentality. Despite this painting's interest, however, it demonstrates that his great mastery of natural landscape far surpassed his skill in creating city scenes.

XM

REFERENCES
Juan de la Encina. *El paisajista José María Velasco, 1840–1912*. Mexico, 1943. **Juan O'Gorman**. "Velasco: Painter of Time and Space." *Magazine of Art* 36, no. 6 (1943), pp. 203–7. **Justino Fernández**. *El arte del siglo XIX en México*. Mexico, 1967, pp. 94–95, fig. 131.

271 ◄ **José María Velasco**
◄ b. 1840 Temascalcingo–d. 1912 Mexico City
◄
◄
◄ ***The Candelabrum of Oaxaca,*** 1887
◄ Oil on canvas; 62 x 46 cm. (24⅜ x 18⅛ in.)
◄ CNCA–INBA, Museo Nacional de Arte, Mexico City

In the semidesert terrain of the Oaxaca mountains rise the startling forms of giant cacti, some of which, because of their shape, are called "candelabra." Velasco saw these plants during his travels in Oaxaca and, being very much the naturalist and scholar, seized the opportunity to paint them. Here the central motif is the candelabrum. Green tonalities emphasize the discrete volume of each of the branches. To establish the vast size of the cactus, Velasco used the time-honored stratagem of including the figure of a man.

XM

REFERENCES
Juan de la Encina. *El paisajista José María Velasco, 1840–1912*. Mexico, 1943. **Juan O'Gorman**. "Velasco: Painter of Time and Space." *Magazine of Art* 36, no. 6 (1943), pp. 203–7. **Justino Fernández**. *El arte del siglo XIX en México*. Mexico, 1967, p. 94, fig. 133.

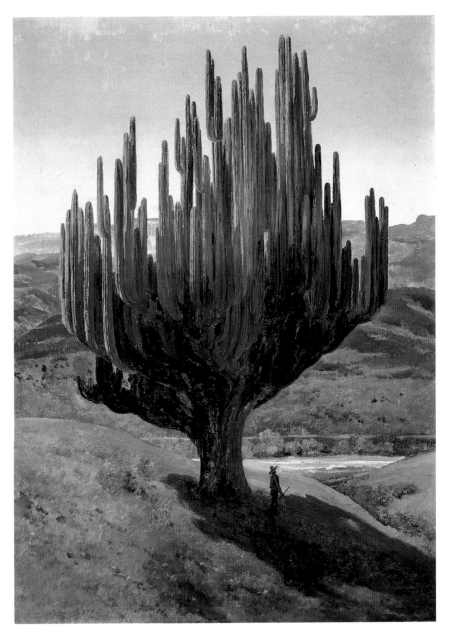

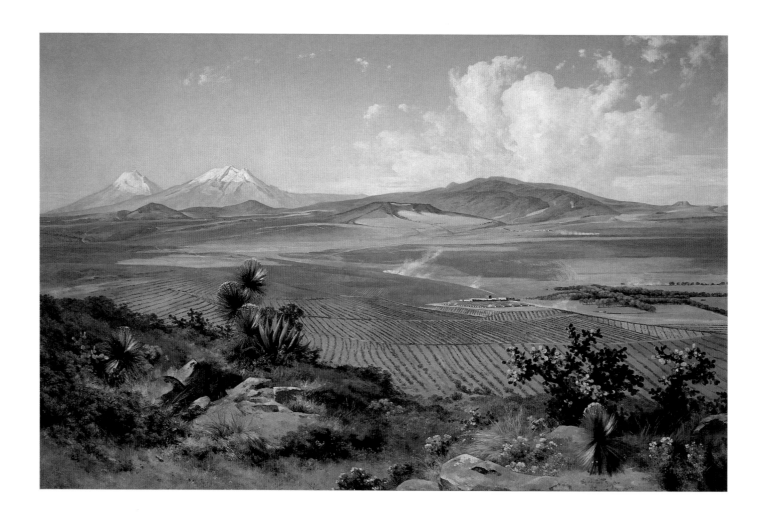

272 ◀ **José María Velasco**
◀ b. 1840 Temascalcingo–d. 1912 Mexico City

◀ *The Hacienda of Chimalpa,* 1893
◀ Oil on canvas; 104 x 159 cm. (41 x 62⅝ in.)
◀ CNCA–INBA, Museo Nacional de Arte, Mexico City
◀ EXHIBITED IN NEW YORK ONLY

Here Velasco abandoned the familiar landscape of the Valley of Mexico to confront the broad panorama that spread below the hacienda, with mountains, including the volcanoes Popocatépetl and Iztaccíhuatl, rising in the background. The grandeur of the countryside and the cold transparency of the air of the high plateau are rendered in an astonishing array of cool tones: the blues, the white of the clouds and snow of the volcanoes, and the cool green of the scrub and cactus in the foreground, which establish a reference for the perspective.

XM

REFERENCES
Juan de la Encina. *El paisajista José María Velasco, 1840–1912*. Mexico, 1943. **Juan O'Gorman**. "Velasco: Painter of Time and Space." *Magazine of Art* 36, no. 6 (1943), pp. 203–7. **Justino Fernández**. *El arte del siglo XIX en México*. Mexico, 1967, p. 97, color pl. 14.

273 ◄ Antonio Becerra Díaz

Mexican, active late 19th century

Los Hacendados de Bocas, 1896

Oil on canvas; 125 x 90 cm. (49¼ x 35⅛ in.)
CNCA–INBA, Casa de la Cultura, San Luis Potosí

Becerra Díaz focused his composition on the figure of a wealthy hacienda owner of Potosí, accompanied by his wife and small daughter. The family group sits contentedly on a spacious *mirador* of their country home. The table indicates that they have enjoyed a delicious meal. The landscape includes the hacienda's chapel, which appears to have a symbolic meaning: the landowner's piety has brought him good fortune and riches. This canvas accurately reflects the well-defined social structure of the artist's era.

XM

REFERENCE
Elisa Vargas Lugo. " 'Los hacendados de Bocas' de Antonio Becerra Díaz." *Anales del Instituto de Investigaciones Estéticas*, 13, no. 45 (1976), pp. 157–63.

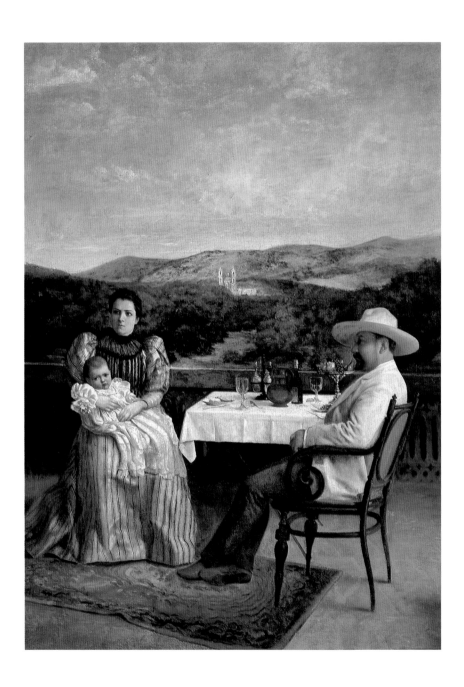

Symbolist Painting

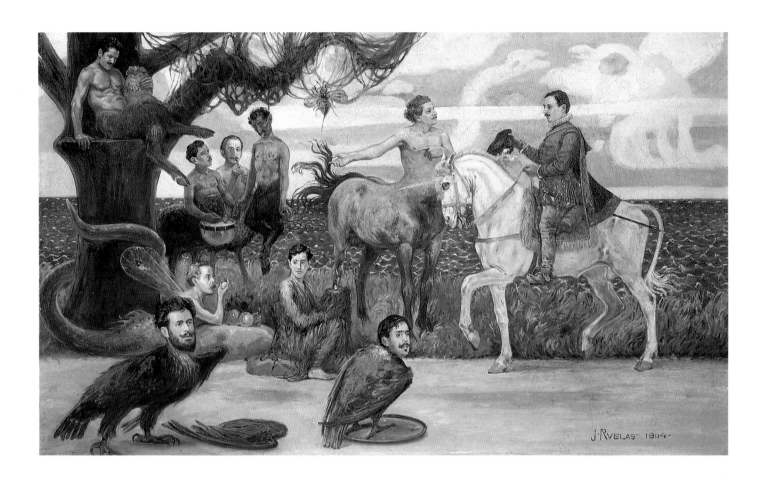

274 ◀ **Julio Ruelas**

b. 1870 Zacatecas–d. 1907 Paris

The Initiation of Don Jesús Luján into the "Revista Moderna," 1904

Oil on canvas; 30 x 50.5 cm. (11¾ x 20 in.)
Private collection, Mexico City

Influenced by French models, the Mexican Symbolist movement had, however, an energetic life of its own. The *Revista Moderna*, the principal Symbolist journal, was founded by the poet Jesús E. Valenzuela, who had earlier met Paul Verlaine in Paris; this publication was extremely influential in disseminating the aesthetic of Latin-American Symbolists.

In the present work, the painter and illustrator Julio Ruelas portrays Don Jesús Luján, the Maecenas of the Symbolist group. As a tribute to his generosity, he was made a member of the board of the *Revista*. Ruelas commemorates this occasion, presenting the poets and artists as mythological beings. Riding a spirited unicorn, Luján is welcomed by the centaur Jesús Ureta; Ruelas portrayed himself in the figure of a hanged satyr.

XM

REFERENCES
Justino Fernández. *El arte del siglo XIX en México*. Mexico, 1967, pp. 146–47, fig. 249. **Teresa del Conde**. *Julio Ruelas*. Instituto de Investigaciones Estéticas: Estudios y Fuentes del Arte en México, 34. Mexico, 1976, pp. 43–46, fig. 24.

Printmaking: Posada and His Contemporaries

DAVID W. KIEHL

For most people, printmaking in Mexico is synonymous with the broadsheet—a printed text accompanied by an illustration or two. The broadsheet is a traditional form of printmaking, and while not uniquely Mexican, it suited Mexican artists and the Mexican people in the nineteenth and twentieth centuries. By the 1880s broadsheets were printed by many different firms, the "penny presses," in Mexico City and other cities and towns throughout the country. The editions were large, the prices low (from one to five centavos, hence the name "penny sheets"). They were sold by the printers, by street vendors, and in the markets. Broadsheets for the Day of the Dead or a sensational murder in the 1890s had later counterparts in the revolutionary sheet *El Machete* during the 1920s and the posters of El Taller de Gráfica Popular, founded in 1937.

Some broadsheets were issued for sale to an avid public for Day of the Dead festivities on November 2 and are known as *calaveras* (skulls). These sheets satirized both the rich and the poor, the powerful and the peasant, the educated and the illiterate. No one was exempt from the barbs of doggerel verse or bold illustration. In *Revumbio de calaveras* (cat. no. 277) even the *papeleros* (broadsheet hawkers) at the special Day of the Dead markets are subject to satirical scrutiny.

And then another sheet (cat. no. 282)—a woman in a flaming cell, her upraised arms beseeching, her hopeful gaze focused on a vision of the Trinity and Mary and Joseph. *La anima sola*, the soul in purgatory asking for mercy and release, is a pictorial prayer, reminding the faithful of their daily obligation to the souls of loved ones. This sheet expresses the piety of the Mexican worker and not that of the gentrified bourgeoisie of the merchant and the educated.

Another sheet (cat. no. 276)—an orator standing in a carriage exhorts a flag-waving crowd of top-hatted men, bonneted women, and a few laborers. This image illustrated the issue of the irregularly published broadsheet *La Gaceta Callejera* that reported on the student-led demonstration of May 13, 1892, against the Porfirio Díaz government. Its next issue had an illustration of mounted soldiers attacking supporters of the demonstration, not the bourgeoisie of the earlier street scene but market women and laborers, and the ensuing riot on May 16, 1892.

And a final sheet (cat. no. 279), another *calaveras* for the Day of the Dead. A top-hatted, bespectacled, black-suited *calavera* stands in the middle of a printing office. Other skeletons set type, work the press, and hawk broadsheets amid a crowd of skulls representing the clergy, the respectable classes, the military, and the peasant. On either side are two additional plates of a skeletal photographer and a skeletal artist at his easel. The accompanying verse commemorates Antonio Vanegas Arroyo, the publisher of these sheets. He was an *editor popular* (people's printer)— a publisher of love verses, of children's games, of exotic adventures, of pious sermons, of the latest scandals, of songbooks, of doggerel ballads for the Day of the Dead, and of reports on political events. The thousands of

sheets printed on Vanegas Arroyo's presses were intended for a broad segment of the Mexican populace, in particular the ordinary citizen—the shopkeeper, the laborer, and the street vendor. His was one of the most prolific of the penny presses in Mexico City, printing a wide range of broadsheets which are among the best examples of the type. Inexpensive colored papers caught the eye, and more importantly, bold, graphic images accompanied the texts. These were essential for Vanegas Arroyo's semiliterate audience—the meaning of the texts was repeated in the images. He, like other penny-press publishers in Mexico City, employed a number of artists of varying abilities. But two are most closely associated with the house—Manuel Manilla (from 1882 until about 1892) and José Guadalupe Posada (from the early 1890s until his death in 1913). Manilla's relief cuts set the tone and style that were intensified and refined by Posada, and the latter's illustrations are most closely associated with Mexico at the end of the nineteenth century and of the Porfiriato.

By 1920 José Guadalupe Posada was forgotten, a name seen only on illustrated broadsheets and paper covers of cheap novellas in the markets. Some of his blocks and plates were still used by the firm of Vanegas Arroyo, then managed by the publisher's sons. Posada was born in Aguascalientes, a town north of Mexico City, in 1852. He apprenticed with a local printer, José Trinidad Pedroza, in 1868 and mastered the art of lithography. When the authorities closed Pedroza's printing shop in 1872, Posada went with him to León, an industrial town closer to Mexico City. He married in 1875. In 1888 Posada moved to Mexico City, where there were greater opportunities for his lithographic skills. By the time he began making illustrations for Vanegas Arroyo, he had mastered engraving in metal, usually zinc; later he learned etching in zinc and newer techniques in response to commercial pressures. He may also have drawn some images on scratchboard which a technician in Vanegas Arroyo's firm would then photographically transfer to plates. Posada had a small workshop on Calle de Santa Inez near the Cathedral and Vanegas Arroyo's printing shop on Calle de Santa Teresa. The Cathedral and its vast square, the Zócalo, were the heart of the capital, swept by tides of political, social, and cultural activities. Posada died a pauper in January 1913.

These are the basic events of Posada's life. Much of the elaboration that later colored discussion of his working techniques and career is an embroidery. For example, Vanegas Arroyo's sons attributed thousands of illustrations to Posada. Not all this work is signed. Could it be the work of other artists employed by their father? In 1929 Anita Brenner presented a romantic portrait of Posada as an artist who championed pure native values over the degenerate foreign values espoused by the bourgeoisie, the upper classes, and the clergy. And autobiographies of the artists of the muralist generation wove personal reminiscences of Posada into the stories of their youth, thereby placing themselves in an almost filial relationship to this rediscovered prophet. Rivera wrote his account in the late 1920s; in the 1940s the older Orozco described his visits to Posada's workshop many years earlier. Both narratives are suspect.

The Posada familiar today is essentially a product of the twentieth century. In the early 1920s Jean Charlot, a young French émigré painter

and printmaker, became intrigued by the graphic strength of the images on old broadsheets and initiated a search that resulted in Posada's rediscovery and a new appreciation of his abilities in delineating his Mexico. Charlot recognized in Posada a Mexican equivalent of the graphic insight and wit of Honoré Daumier, Paul Gavarni, and the French caricaturists of the mid-nineteenth century. In August 1925 Charlot published an article—*"Un precursor del movimiento de arte mexicano"*—that emphasized the elements shared by Posada and the new generation of artists working in murals and in woodcuts. In the years that followed, Posada became an almost mythical personage: the first modern Mexican artist, the touchstone for the "Mexican-ness" of a generation of artists whose murals rank among the artistic monuments of this century. But this characterization can cloud the understanding of his work, drawing attention from the impulses behind the images and the import of Posada's interpretation of the subject or of the printed text. Too often in this century, especially in the 1920s and 1930s, cultural and art historians, collectors, and even artists ascribed symbolic, superficial interpretations to Posada's illustrations. They equated the images with the pottery, boldly patterned weavings, sombreros, and other picturesque accoutrements of Mexican life. José Clemente Orozco, in his letters to Charlot in 1927 and 1928 and in an "Apologia" of 1923 (published posthumously) deplored this folkloric interpretation. Folkloricism vitiated a deeper awareness of the universal values that crossed cultural and national boundaries—values that were essential to Orozco's painting and that he appreciated in the broadsheets of Posada and Manilla.

Who then is José Guadalupe Posada? He is the best known of a group of talented printmakers for the popular press whose boldly expressive images not only document Mexican life in the Porfiriato but also illuminate the universality of human emotions and deeds.

NOTE: Because of the fragility of works on paper, the prints on display in the exhibition may not be the same as those illustrated in the following pages.

REFERENCES
Jean Charlot. "Un precursor del movimiento de arte mexicano: El Grabador Posada." *Revista de Revistas* 16, no. 799 (August 30, 1925), p. 25. **Anita Brenner.** "Posada the Prophet." Chap. 9 in *Idols behind Altars.* New York, 1929. **Fernando Gamboa, Carl O. Schniewind, and Hugh L. Edwards.** *Posada: Printmaker to the Mexican People,* exh. cat., The Art Institute. Chicago, 1944. **Manuel Manilla.** *330 grabados originales.* Mexico, 1971. **Roberto Berdecio and Stanley Appelbaum.** *Posada's Popular Mexican Prints.* New York, 1972. **Jean Charlot.** "Mexican Printmakers: Manilla.", *Forma,* Dec. 1926. Reprinted in *An Artist on Art: Collected Essays of Jean Charlot,* vol. 2, *Mexican Art.* Honolulu, 1972, pp. 157–61. **Jean Charlot.** "José Guadalupe Posada: Printmaker to the Mexican People." *Magazine of Art* 38, no. 1 (1945), pp. 16–21. Reprinted in *An Artist on Art: Collected Essays of Jean Charlot,* vol. 2, *Mexican Art.* Honolulu, 1972, pp. 163–72. **José Clemente Orozco.** *The Artist in New York: Letters to Jean Charlot and Unpublished Writings, 1925–1929.* Translated by Ruth L.C. Simms. Austin and London, 1974. **Ron Ryler,** ed. *Posada's Mexico,* exh. cat., The Library of Congress. Washington, D.C., 1979. **Julian Rothenstein,** ed. *Posada: Messenger of Mortality,* exh. cat., South Bank Centre. London, 1989.

CALAVERA TAPATIA.

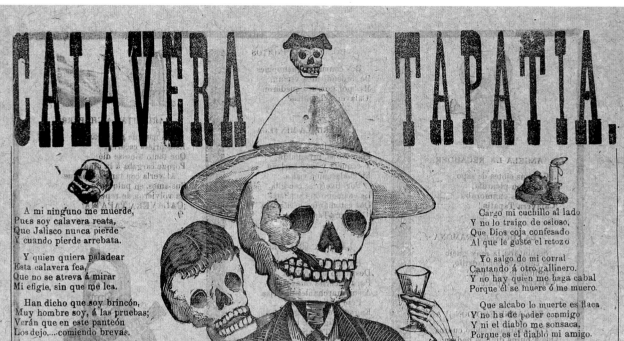

A mi ninguno me muerde,
Pues soy calavera reata,
Que Jalisco nunca pierde
Y cuando pierde arrebata.

Y quien quiera paladear
Esta calavera fea,
Que no se atreva á mirar
Mi efigie, sin que me lea.

Han dicho que soy brincón,
Muy hombre soy, á las pruebas;
Verán que en este panteón
Los dejo.....comiendo brevas.

O si versan de otro modo,
Nos vamos á la Tequila,
Que yo la verso de todo
Con calaveras á pila.

Si por mi terreno fueran
A puños la versarian,
Y buen posole comieran,
Y muertos no se verian.

Porque por Guadalajara
No hay muertos que sean rajones,
Que allí se corta la cara
A los que tienen calzones.

Allí tengo mi morena
Refantasiosa y faceta,
Que ni la muerte la apena,
Tan reata como veleta.

Allí cualquier esqueleto
Está armado de tranchete;
Pero es tan bueno el sujeto
Que con ninguno se mete.

No envidia más que el amor
Y un buen sombrero jarano,
Un buen tequila, un abano,
Y un fierro de lo mejor.

Una baraja de Olea,
Y oro y plata por montón,
Y bebe, y fuma, y chulea
Hasta la muerte en acción.

A nadie provoca, es hombre
De raza la más brava,
Mas quien le burle su nombre
Se va á la difuntería.

Y allí se queja á su suerte,
Pues el tapatío brincón,
Lo despacha con la muerte
A bailar un rigodón.

Mas yo no admito la duda,
Y la calandria que cante,
Si se cree buena y forzuda
Muerte, que luego se plante.

Y que prevenga el cajón
Y sus ceras que prevenga,
Pues lo despacho al panteón
Convenga ó no le convenga.

Y á todo el mundo le digo
Que yo ni muerto me dejo,
Y que el que sea mi enemigo
Pa móle su gallo viejo.

Es pues mi contestación
Ser de maneras sencillas,
Aunque esté ya en el panteón
Exhibiendo mis canillas.

Al que me mira lo azoto
O con mi fierro lo entuerto,
Que á mi no me espanta un roto
Con el petate del muerto.

Al catrin de vecindad
O trovador de velorio,
Lo mando á la eternidad
Sin rezarle un responsorio.

Con la muerte no me asusto
Porque á la muerte chongueo,
Pues que me retoza el gusto
Cuando en parrandas me veo.

Cargo mi cuchillo al lado
Y no lo traigo de osioso,
Que Dios coja confesado
Al que le guste el retozo

Yo salgo de mi corral
Cantando á otro gallinero.
Y no hay quien me haga cabal
Porque él se muere ó me muero.

Que alcabo lo muerte es flaca
Y no ha de poder conmigo
Y ni el diablo me sonsaca,
Porque es el diablo mi amigo.

Hoy hago calaveradas,
Porque aunque se me llegó,
La muerte, patas rajadas,
Quiso entrarme y se rajó.

Yo no nací para prisco,
Ni mi favor acabó,
Calaveras de Jalisco
No cierren que falto yo.

El pais tengo recorrido
Con mi cuchillo filoso,
Y nadie, pues, me ha tosido
Tan bien como yo le toso.

Porque aquel que la intención
Tuvo de toserme de veras,
Rodando está en el panteón
Con muertos y calaveras.

Aquí he matado poblanos
Jorochos y Toluqueños
Tepiqueños y Surianos
De Mérida y Oaxaqueños.

No resiste ni un pellejo
Mi cuchillo nuevecito;
He muerto de puro viejo
Pues fuí en mi vida maldito.

Y á aquél que le guste el *duro*
El tequila y el posole,
Si muere, yo le aseguro
Que en la tumba bebe atole.

Pero que sino es rajado
Y trae como yo sus dientes,
Aquí vive descansado
Y......¡ay reata, no te revientes!

Que aquí no aban los brios
Ni la vida cuesta cara;
Que aquí están los tapatíos
Ygual que en Guadalajara.

Aquí soy hombre de veras
Cuando el sombrero me arrisco,
Y grito á las calaveras:
¡Muchachas, viva Jalisco!

275

275 ◀ Manuel Manilla

Mexican, about 1830–d. 1895

Calavera Tapatia, about 1890

Published by Antonio Vanegas Arroyo, Mexico City
Type-metal engraving and letterpress, printed on
green, thin wove paper; sheet: 40.2 x 30 cm.
(15⅞ x 11⅞ in.)
The Metropolitan Museum of Art, The Elisha
Whittelsey Collection, The Elisha Whittelsey Fund,
1946 46.46.370

Tapatia is a slang word referring to people from Jalisco, the state known for the manufacture of tequila. The term also describes a "tough guy" with his drink (tequila, of course), his cigars (the band says Tapatia), his brunette, and his knife. His attitude is "don't mess with me"; but, as the text elaborates, Death will catch him when he least expects it—bravado is no protection from Death. Manilla's illustrations aptly characterized the *tapatia*, and Vanegas Arroyo frequently reused the image. A later version of the *Calavera tapatia* broadsheet was printed without text—the well-worn image said it all.

DWK

276 ◀ José Guadalupe Posada

Mexican, 1852–1913

***El motin de los estudiantes . . . "Gaceta
Callejera," num. 1, mayo de 1892***
**(The Demonstration of the Students Against
the Reelection of President Porfirio Díaz,
13 May 1892. *Gaceta Callejera*, no. 1,
May 1892)**

Published by Antonio Vanegas Arroyo, Mexico
City
Type-metal engraving and letterpress, printed on
wove paper; sheet: 40.6 x 30.1 cm. (16 x 11⅞ in.)
The Metropolitan Museum of Art, The Elisha
Whittelsey Collection, The Elisha Whittelsey Fund,
1946 46.46.267

The first issue of the broadsheet *Gaceta
Callejera* (Street Journal) described the events
of May 13, 1892, when students protested
the reelection of President Porfirio Díaz. This
was quickly followed with a second number
reporting the ensuing riot as troops attacked
the demonstrators and their supporters. During the next year and a half, Antonio Vanegas
Arroyo published over a dozen numbers of
the *Gaceta* on various political events—
including assassinations, executions, and the
public obsequies for political figures. These
broadsheets demonstrated the publisher's,
and Posada's, discontent with the Porfirio
Díaz government.

DWK

277 ◀ **José Guadalupe Posada**

◀ Mexican, 1852–1913

◀ *Revumbio de calaveras* **(A Noisy Gathering**
◀ **of Calaveras)**
◀ Published by Antonio Vanegas Arroyo, Mexico
◀ City
◀ Type-metal engraving and letterpress, printed on
◀ yellow, thin wove paper; sheet: 39.4 x 29.2 cm.
◀ (15 ½ x 11½ in.)
◀ The Metropolitan Museum of Art, The Elisha
◀ Whittelsey Collection, The Elisha Whittelsey Fund,
◀ 1946 46.46.313

Papeleros hawk broadsheets in a market for the Day of the Dead—each adding to the general din with noisy descriptions of *calaveras* for sale. Booths on either side sell other merchandise for the holiday. These skeletons, oddly jointed and anatomically incorrect, are typical of Posada's work. Vanegas Arroyo reused the plate over the years on broadsheets that were also advertisements for other *calavera* broadsheets available for the Day of the Dead festivities. One such sheet noted that heaps of *calaveras* were available for a modest sum in varieties never before seen in the capital.

DWK

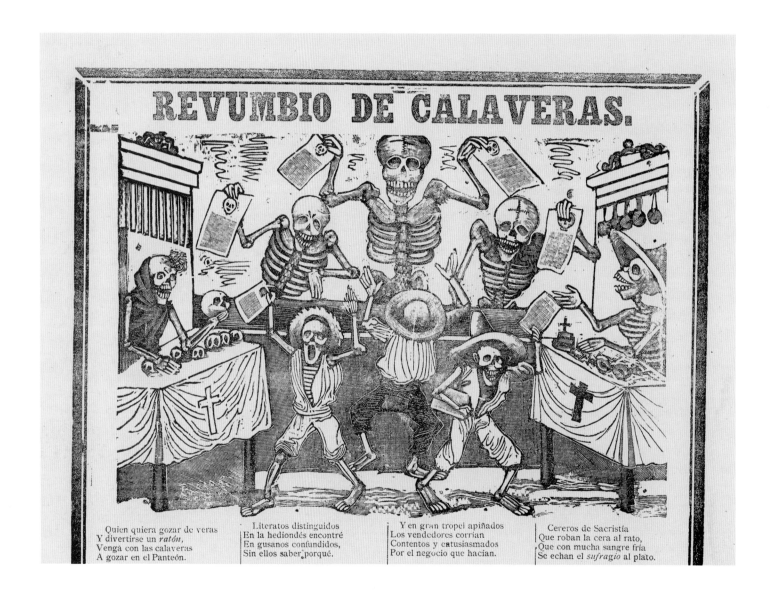

REVUMBIO DE CALAVERAS.

Quien quiera gozar de veras
Y divertirse un *ratón*,
Venga con las calaveras
A gozar en el Panteón.

Literatos distinguidos
En la hediondés encontré
En gusanos confundidos,
Sin ellos saber porqué.

Y en gran tropel apiñados
Los vendedores corrían
Contentos y entusiasmados
Por el negocio que hacían.

Cereros de Sacristía
Que roban la cera al rato,
Que con mucha sangre fría
Se echan el *sufragio* al plato.

278 ◀ **José Guadalupe Posada**

Mexican, 1852–1913

El mosquito americano (**The American Mosquito**), 1903

Published by Antonio Vanegas Arroyo, Mexico City

Type-metal engraving and letterpress, printed on yellow wove paper; sheet: 30.1 x 20 cm. (11⅞ x 7⅞ in.)

The Metropolitan Museum of Art, The Elisha Whittelsey Collection, The Elisha Whittelsey Fund, 1946 46.46.115

El mosquito americano is one of the outstanding political broadsheets published by Vanegas Arroyo. The import of Posada's dramatic illustration of mosquitoes attacking Mexicans of every social strata is clarified by the printed text. Even the type-metal border has mosquitolike elements. These were not ordinary insects but other insectlike pests—the tourists streaming into Mexico through Laredo, Texas, and the many industrial and technical "advisers" imported in by Porfirio Díaz, who brought dollar-corruption with them. Vanegas Arroyo continued to republish this broadsheet during the waning years of the increasingly corrupt Porfiriato.

DWK

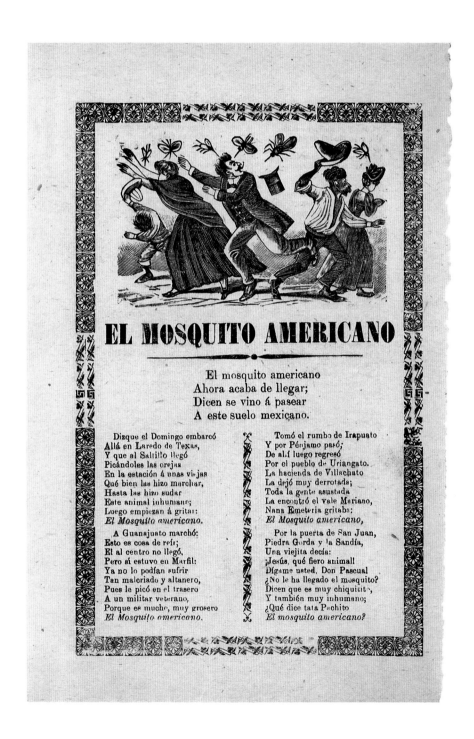

279 ◄ **José Guadalupe Posada**
◄ Mexican, 1852–1913
◄
◄
◄ *Aquí esta la calavera del editor-popular A.*
◄ *Vanegas Arroyo* (Calavera of the People's
◄ Editor, Antonio Vanegas Arroyo), 1907
◄ Published by Antonio Vanegas Arroyo, Mexico City
◄ Zinc etching, type-metal, and letterpress, printed on
◄ thin wove paper; sheet: 40 x 30.8 cm. (15 ¾ x
◄ 12 ⅛ in.)
◄ The Metropolitan Museum of Art, The Elisha
◄ Whittelsey Collection, The Elisha Whittelsey Fund,
◄ 1946 46.46.293

The *calaveras* broadsheets were catholic in subject: everyone—the rich, the poor, the illustrious, and the ordinary—faced a common fate. Even publishers were not exempt; the printed word could not defy death. Posada's image of Antonio Vanegas Arroyo as a *calavera* amidst the skeletal milieu of a printing shop is one of his most striking images. The plate was reused for at least one other broadsheet for the Day of the Dead.

DWK

280 ◀ **José Guadalupe Posada**

Mexican, 1852–1913

Las bravisimas calaveras guatemaltecas de Mora y de Morales **(The Mad Calaveras of the Guatemalans Mora and Morales),** 1907

Published by Antonio Vanegas Arroyo, Mexico City
Zinc etching, type-metal, and letterpress, printed
on blue, thin wove paper; sheet: 40.3 x 29.8 cm.
(15⅞ x 11¾ in.)
The Metropolitan Museum of Art, The Elisha
Whittelsey Collection, The Elisha Whittelsey Fund,
1946 46.46.290

Topicality was an essential feature of the *calaveras* broadsheets published by
Vanegas Arroyo. Bernardo Mora and Florencio Morales, who assassinated the
ex-president of Guatemala, General Manuel Lisandro Barillas, in Mexico City,
were executed by a firing squad in June 1907. Vanegas Arroyo issued a broadsheet
describing the event. For the Day of the Dead that same year, he returned to
the subject of Mora and Morales. His initial commentary noted that these
fierce *calaveras* could turn heads into skull-like marbles; but Vanegas Arroyo
then remarks that these Guatemalans are pawns of fate. In the end death
comes like an assassin to all humans.

DWK

281 ◄ **José Guadalupe Posada**

Mexican, 1852–1913

***Verdadero retrato del señor del santuario de Otatitlan* (The True Portrait of Our Lord of the Sanctuary at Otatitlan),** 1910
(here, as published in 1911)

Published by Antonio Vanegas Arroyo, Mexico City

Zinc etching, type-metal, and letterpress, printed on wove paper; sheet: 40.4 x 30.2 cm. (15⅞ x 11⅞ in.)

The Metropolitan Museum of Art, The Elisha Whittelsey Collection, The Elisha Whittelsey Fund, 1946 46.46.299

The *Señor del santuario de Otatitlan* is one of many religious subjects published by Vanegas Arroyo. Printed below is a reminder that the bishop of Oaxaca has granted a three-hundred-day indulgence for prayers to this image. On the verso is a story more typical of the sensational subjects associated with the firm's broadsheets. The thief and murderer Ricardo Martínez was sentenced to die by firing squad. The bullets never touched him, lodging in the folds of his clothing. The miracle was ascribed to intercessions to this image from Otatitlan. Martinez resolutely denied the miracle and blasphemed the image. Now languishing in hell, he exhorts the reader to fervently honor the Otatitlan image and thereby escape his fate.

DWK

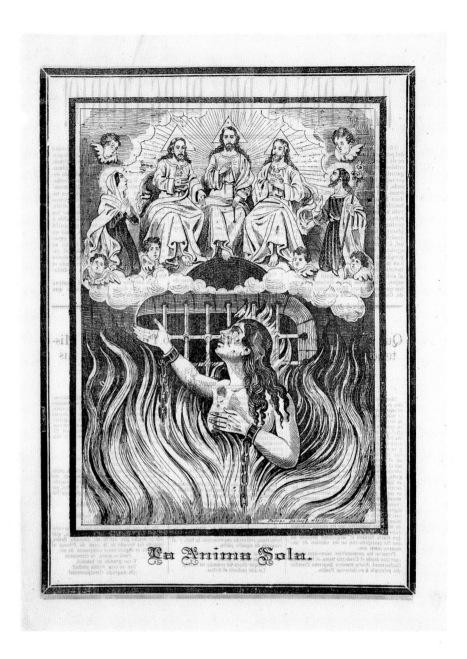

La Anima Sola.

282 ◀ **José Guadalupe Posada**
Mexican, 1852–1913

***La anima sola* (The Soul Alone)**

Published by Antonio Vanegas Arroyo, Mexico
City
Zinc etching and letterpress, printed on wove
paper; sheet: 39.9 x 29.7 cm. (15¾ x 11¾ in.)
The Metropolitan Museum of Art, The Elisha
Whittelsey Collection, The Elisha Whittelsey Fund,
1946 46.46.317

Posada's image of the soul in purgatory was most likely copied from a paint-
ing. Even today the devout can buy holy cards printed with variations of this
image from the many vendors of religious articles outside the churches of
Mexico. On the verso of this broadsheet, Vanegas Arroyo printed exhortations
to the faithful to pray for the souls of loved ones in purgatory.

The representation of the Trinity is noteworthy. In 1745 Pope Benedict XIV
declared depictions of the Trinity as three identical men a heresy; the tradi-
tion persisted, however, among the devout of Mexico and the American South-
west into the early years of this century. The three men are seated on an orb,
each with a triangular halo. Christ has a lamb on his breast, the Holy Spirit
has a dove, and the Father has a sun. The latter attribute was a Mexican
addition to such Trinitarian images.

DWK

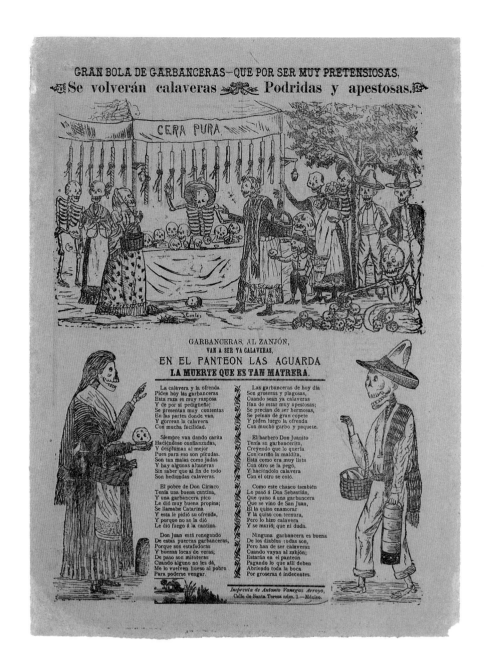

283 ◀ J. Cortéz

Mexican, active about 1900–1910

***Gran bola de garbanceras* (Great Reunion of the Garbanzo Sellers),** about 1908

Published by Antonio Vanegas Arroyo, Mexico City

Zinc etching, type-metal, and letterpress, printed on purple, thin wove paper; sheet: 40 x 29.8 cm. (15 ¾ x 11 ¾ in.)

The Metropolitan Museum of Art, The Elisha Whittelsey Collection, The Elisha Whittelsey Fund, 1946 46.46.374

The *garbanceras* were a favorite target in the publisher's broadsheets for the Day of the Dead. The verses on this sheet state that the women who sold garbanzos, with their pretensions of superiority, were infamously two-faced —all sweetness to one's face and malicious gossips behind one's back. On other broadsheets they are described as notoriously flirtatious. Vanegas Arroyo used the image to remind the buyer that death is attracted to such behavior—even the finest pretensions will stink and rot in death.

Vanegas Arroyo used Cortéz's plate on several broadsheets. It may have appeared for the first time in 1908 as *Calavera comercial*, a broadsheet about the markets set up for the Day of the Dead festivities. It was later reused, probably after 1910, on the broadsheet *Gran verbena de calaveras en el Parque Porfirio Díaz* (The Grand Fiesta of Calaveras in Porfirio Díaz Park). Given its earlier use on *Gran bola de garbanceras*, was Vanegas Arroyo using this image to equate the corruption of the Porfiriato with the behavior of *garbanceras*?

DWK

Twentieth-Century Art

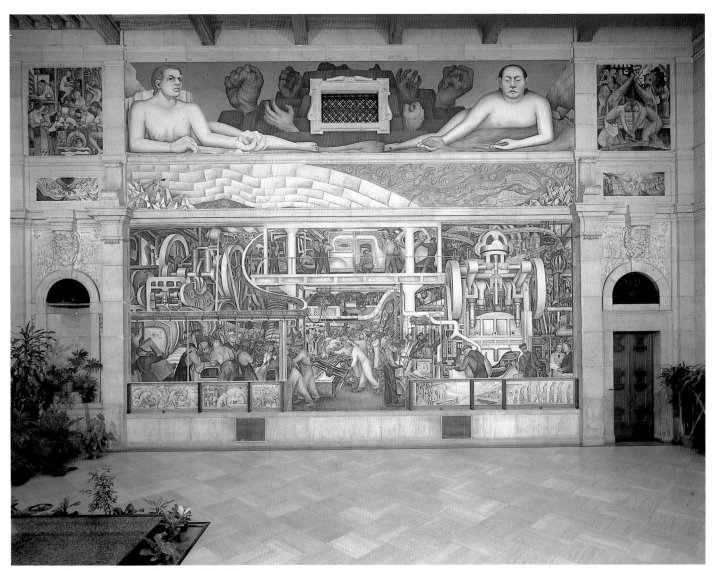

Diego M. Rivera. *Detroit Industry*, south wall,
1932–33. Fresco. The Detroit Institute of Arts,
Founders Society Purchase, Edsel

▼▼▼

Mexican Art of the Twentieth Century

DORE ASHTON

The government of Porfirio Díaz (1830-1915), called the Porfiriato, held power in Mexico from 1876 to 1911. Under his leadership Mexico was brought into the modern age but not without immense social costs and widespread economic abuses. At the turn of the century, the dictatorship had been so long established that young intellectuals could hardly remember a time when his insipid cultural institutions had not dominated Mexican life. Disgusted by the regime's rapacity, the young and spirited restlessly scanned other horizons for succor. They regarded Díaz's policies as intolerable. One of these was his cunning adaptation of French nineteenth-century Positivism. With his team of so-called *científicos*, Díaz rationalized plunder in the name of progress. The reaction on the part of young intellectuals in the last years of the nineteenth century was to become vigorously anti-positivist; the realm of the imagination was substituted for the theories of Auguste Comte, sponsored by the materialists. Dynamic young thinkers had looked during this time to Europe with a sharper eye than their complacent academic colleagues and had seen quite clearly the radical turnings that would sweep the next century. It was a generation that would confront the issue which even today remains central in Latin American cultures: how to maintain a distinct identity while partaking of cosmopolitan intellectual life.

In the visual arts Mexico, like most other former Spanish colonies in the Western Hemisphere, had established an official Academy in which artists were trained to produce paintings worthy of the European academies. These works continued to pour into the villas of wealthy Mexican patrons long after the academies in Europe had been demoted in favor of an independent avant-garde. But the young artists born into the twentieth century were alert, and when the Díaz government sent them off to Europe to acquire the skills taught at the European academies, they turned instead to the real life of the arts which, in the first decade of the century, was transpiring in an access of enthusiasm for radical change.

Even before the convulsion of the Revolution in 1910, there were voices of authority in the arts calling for the revitalization of Mexican culture. Among them were José Vasconcelos and Antonio Caso who together, in 1908, founded the Ateneo de la Juventud (Atheneum of Youth), a cultural center in which the most progressive issues were avidly discussed and the case against the *científicos* made definitive. Shortly after, just weeks before the outbreak of the Revolution, the energetic and eccentric Dr. Atl used his position in the heart of the Academy to organize some of his young friends among the students as the Centro Artístico. In that organization the first project for mural painting was discussed. Among his enthusiasts were José Clemente Orozco and Saturnino Herrán. Dr. Atl, who had wandered the capitals of Europe since 1897, had brought back both the news of vast changes in European painting and a fervent desire to demolish the bastions of reaction in Mexico. He set an example by changing his

own name from Murillo—the despised model of academic imitation for generations in Mexico—to Atl, the Nahuatl word for "water". While his own painting was not inspiring, his views were, as was his ability to find, even during the Díaz regime, influential support for his programs.

When in 1910 the Díaz empire finally collapsed and the cruel wars of the next decade commenced, the young artists were swept into the maelstrom—some as soldiers, some as spectators, some as preparators for the coming revolution in the arts. No account of the arts in Mexico during the first fifty years of the century can negate the significance of the great circumstantial paroxysm of the Revolution. Even those artists who would eventually reject certain of its tenets were compelled by circumstance to respond to the climate of convulsive change.

The biographies of several major Mexican artists suggest that power of circumstance. The three who, among dozens of others, managed to be inscribed in history through their spectacular accomplishments as muralists had very little in common temperamentally, but in each of their lives the fact of the Revolution was to be decisive. The oldest, José Clemente Orozco, had spent his childhood in the old quarter of Mexico City, where he had had the good fortune to watch the great Mexican satirist José Guadalupe Posada at work in his printshop [ed.: for another view of this experience, see p. 540]. Orozco began his own career as a caricaturist and illustrator (though he sporadically attended the Academy to keep his hand in drawing and painting) and was attached as an illustrator to one of the revolutionary armies in 1914–15. The experience was decisive for his development as a muralist; he never forgot the monstrous carnage his bewildered compatriots endured in the violent struggles for power immediately following the downfall of Díaz.

Diego Rivera, three years younger than Orozco, also eventually recognized the extraordinary gifts of the engraver Posada, but unlike Orozco he had followed the traditional course at the Academy and was rewarded, in 1907, with a state scholarship to travel to Europe. Rivera's energy and intelligence quickly brought him into the center of intellectual life in Paris, and there he met artists, poets, and revolutionaries from every corner of the world. Rivera's sojourn in Europe, which lasted until the post-Revolutionary turmoil subsided in Mexico in 1922, provided him not only with an extraordinary vocabulary of vanguard approaches to painting, but also with a great breadth of knowledge of the various political philosophies that were stirring spirited responses among his friends in the international community. Absent from Mexico, he was nonetheless eager for news, and shared with other Latin Americans sheltering in Paris a burgeoning excitement over future possibilities.

David Alfaro Siqueiros, fifteen years younger than Rivera, also attended the Academy as a child and was on hand for the excitement brought by Dr. Atl, whose message of *Mexicanidad* suited his incendiary temperament. Already at the age of thirteen, Siqueiros was serving one of his many jail sentences for political agitation. Released, he immediately recommenced his organizing activities. When war broke out, he became in succession a soldier and an officer, and in 1917 organized his fellow artists in the guerrilla army into the Congreso de Artistas Soldados in Guadala-

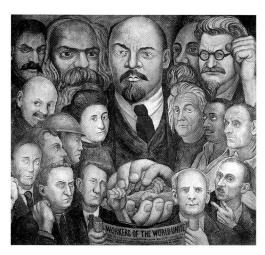

Diego M. Rivera. *Proletarian Unity*, 1931. Fresco.
Collection of Paul Willen and Deborah Meier,
courtesy of Mary-Anne Martin/Fine Art, New York

jara. Despite his exuberant machismo and his contempt for bourgeois interests, Siqueiros eventually took himself to Europe, and it was there, in 1920, that he found common ground with the far more sophisticated Rivera, and sent out the first of many calls for the concerted artistic action that would become the mural movement.

Too often it is forgotten that the Mexican Revolution preceded the Russian Revolution, and that when the Russian Revolution began, the Mexican intelligentsia watched closely. There were obvious parallels: both nations had large peasant populations, great poverty, and disastrous economies. When in 1920 General Alvaro Obregón finally managed to extricate Mexico from its devastating civil war, he turned to José Vasconcelos, an immensely learned intellectual, whose immediate task was to find the means to make the nation literate. Vasconcelos instituted a vast program of education for the rural population, and with his eye on the Soviet Union he considered how he could enlist artists. The model was provided by the extraordinary Soviet minister of culture Anatol Lunacharsky, whose program in those first electrifying years after the Revolution had embraced all the arts in an imaginative and far-reaching enterprise. In Mexico the ground was fertile for such change, since from the days of Dr. Atl's activities at the Academy, Mexican artists had been pondering the possibility of a mural art that could reach the masses. Vasconcelos, who envisioned an integrated nation in which the division between Creoles, Indians, and mestizos would finally be dissolved, lost no time in offering the walls of the Secretaría de Educación Pública and the Escuela Nacional Preparatoria to Rivera, Orozco, Siqueiros, and about a dozen other artists whom Siqueiros would soon organize into the Sindicato de Obreros Técnicos, Pintores y Escultores de México (Syndicate of Technical Workers, Painters, and Sculptors of Mexico). The manifesto, published in 1922, stressed the importance of recognizing that "even the smallest manifestations of the material or spiritual vitality of our race spring from our native midst." Indeed, it was this very intention to create an art identifiably Mexican —something they believed had not existed since the great cultures before Columbus—that could have brought together artists of such markedly different temperaments and formations as Rivera, Orozco, and Siqueiros. One of the declarations in this much-reproduced manifesto would eventually set the tone for all Mexican artists and be vastly influential in other countries as well, both in the Western hemisphere and in Europe. This was the declaration: "We repudiate so-called easel painting and all such art which springs from ultra-intellectual circles, for it is essentially aristocratic." In the context of this repudiation, walls became irresistible. There were very few artists who were not eager to participate in the mural movement, particularly during the first years. The denunciation of easel painting did not, of course, prevent even the muralists from retreating to their private studios now and then, but it did effectively reduce formal experimentation and drive obdurate easel painters out of the limelight.

Even those painters whose primary contribution was to be in easel painting were recognized largely because they upheld one or another of the ideals promulgated during the post-Revolutionary years: the rejection of the old *costumbrista* approach to genre painting; the inclusion of prole-

tarian life in their subject matter; respect for the non-Spanish traditions and rejection of European models. An artist such as Francisco Goitia, who had found success in Europe before the Revolution, turned to the depiction of ordinary life in his own ravished country. Saturnino Herrán, a schoolmate of Rivera's, called attention to the non-Christian pantheon in his work and exerted a certain influence as a teacher. And there were scores of others who stuck to the easel, but few who would rise to the level of recognition won by the muralists.

To contest their hegemony in the new order was not easy, as Rufino Tamayo would discover. Tamayo, who succeeded in gaining international recognition through frequent sorties to the United States, was a contemporary of Siqueiros and had been a student at the Academy. When the strongly renewed interest in Mexican history led to extensive anthropological research (Vasconcelos himself had led an expedition to the state of Yucatán of a group of artists that included Rivera, and Tamayo's friend Roberto Montenegro), Tamayo, at the age of twenty-three, found himself the head of a department at the Museo Nacional de Antropología. His interest in works of ancient cultures began to inform his painting, as did a sometimes naïve appreciation of Picasso. Tamayo's resistance to the increasingly ideological attitudes of the three major muralists won him a position of leadership among other dissidents, and opened what is today a still-flourishing debate on the nature of *Mexicanidad*. For Tamayo, the problem of identity could be confronted only after an artist had contemplated both the sophisticated arts of the ancient world and the culture of the modern world. In later years Tamayo would teach in North America, effectively countering the immense influence of the so-called Big Three.

That influence, however, must not be underestimated. There were any number of reasons that the world took notice of the Mexican mural renaissance. The first, and the most difficult to describe, were the murals themselves. By the time Rivera had almost finished his enormous task in the two courtyards—he worked from 1923 to 1928 on a project for the Secretaría de Educación Pública—countless visitors had come from both the United States and Europe to marvel at his accomplishment, his sheer audacity. Orozco's work at the Escuela Nacional Preparatoria was equally admired, and the two muralists were extensively discussed in the international press. Soon Siqueiros, whose experimental approach came to fruition toward 1930, was also luring countless visitors, often young artists from the United States. The initial visual impact was the major reason for the widespread response to the mural movement.

Word spread quickly to foreign artistic centers abroad. In the postwar period of the 1920s, a sense of inertia pervaded intellectual circles; artists had sensed a slackening of the impetus of radicalism that had flourished in the arts before the First World War. The new classicism in France and Italy seemed to many young artists regressive. The Mexicans, having studied the great murals of the Italian Renaissance, and having recently discovered the murals of their own ancient past, seemed to have found a means of using public spaces in the grand manner without having to sacrifice certain painterly principles of the modern movement. In addition, they had banished the troubling problem of the artist's role in society

by working at their tasks for working men's wages. This idealism held immense appeal for many young artists who had rebelled against the belief in art-for-art's-sake and who, in that dangerous period between the world wars, sensed uneasily that they too would be called upon in the resistance against fascism born almost immediately after the First World War.

The heroes of the Mexican movement were quick to seize opportunities to advance their views, especially in the cities of the United States that had once had such immense influence in the Díaz regime. By 1927, Orozco was in the United States, where for the next four years he would paint important murals—at Pomona College in California, at The New School for Social Research in New York, and at Dartmouth College in New Hampshire—and have, within months of his arrival, two solo exhibitions in New York of drawings and easel paintings. Rivera arrived in 1930, and he too spent four years completing murals—first in California at the California School of Fine Arts, then in Detroit at the Institute of Arts, and finally in New York, where his murals for Rockefeller Center caused one of the biggest scandals a work of art had ever succeeded in provoking in the United States. To the horror of the local art community, they were finally destroyed. Siqueiros arrived in California in 1932 to paint his public wall in the Mexican quarter of Los Angeles, where young American artists watched rapt, among them the nineteen-year-old Philip Guston. Three years later, Siqueiros installed himself in New York and opened an experimental workshop, which was visited faithfully by the young Jackson Pollock until the day Siqueiros closed up shop in order to go to Spain to fight for the Republic.

Not only were these impressive personalities visible in North American artists' haunts, but their work was exhibited regularly in art galleries and museums and, ironically, collected by some of the most important capitalists in the world. By the time the United States had plunged into the Depression the Mexican muralists were almost folk heroes, and it was thanks to them that the United States then undertook one of the most extraordinary programs of support for the arts ever conceived. A school friend of Franklin Delano Roosevelt's, the painter Francis Biddle, wrote him a personal letter proposing that the government rescue its starving artists by creating projects on which artists could work—as did the Mexican muralists—at workers' wages, to promote the vision of Roosevelt's New Deal. This friendly note was passed along to Roosevelt's colleagues, and within months the incomparable program was under way. In the mural division of the WPA, such artists as Arshile Gorky, Stuart Davis, and eventually Philip Guston created works that would become landmarks in American art history, while in the easel division, Willem de Kooning, Pollock, and scores of others later credited with creating a new American art developed their unorthodox points of view.

Meanwhile, in Mexico, a slightly younger generation was welcoming colleagues from the United States, sometimes even arranging to give them walls in public buildings. In the public market in Mexico City several artists from the United States were given walls, among them the sculptor Isamu Noguchi, who, as a friend of Miguel Covarrubias's (who had gone to New York on a scholarship in 1923 and quickly established himself as a

caricaturist for *Vanity Fair* and *The New Yorker*) and of Orozco's (of whom he had made a portrait head in 1932), managed to find his way quickly into the center of Mexican artistic life.

By the mid-1930s that life was seething with activity and also with increasing controversy. A younger generation was seeking to get out from under the shadow of the Big Three and to distance itself from ongoing political wrangling—but with little success. The few artists who did not participate in the mural movement, such as Rivera's friend Antonio M. Ruíz, a much-admired miniaturist with a gently satirical approach to painting, were admired by the inner circle but did not have much impact on aesthetic developments. But as the 1930s drew to a close, there were a few fresh winds. The continual visits to Mexico by foreign artists and intellectuals had begun to elicit interest among younger artists in the new movements in Europe. In 1938 the dean of the Surrealist movement, André Breton, visited Mexico and predictably implanted the seed of a luxuriant Surrealist influence. Breton's insistence on a revolutionary political awareness suited the generally revolutionary approach that lingered with even the mildest of Mexico's painters. As Europe lurched toward disaster, Mexicans, who had been especially sensitive to the Spanish Civil War, were engaged once again in seething political arguments. One of the most compelling issues was that of artistic freedom, which the Russian Communist leader Leon Trotsky, who had taken refuge in Mexico, addressed in 1938 in a manifesto written with Breton (though signed not by Trotsky but by Rivera). Rivera's wife was the artist Frida Kahlo, whose natural proclivity for Surrealist fantasy found favor with Breton (though Kahlo's sources were Mexican folk art rather than Parisian Surrealism). She was an intimate friend of Trotsky's and no doubt helped to bring the old revolutionary to his final, more liberal aesthetic position.

It would be the Surrealist position, filled with contradictions but also providing numerous paths away from tradition, that opened Mexican art to approaches that were removed from the heroic mural movement. The tragedies in Europe brought to Mexico City poets and painters who had long been active in the Surrealist purlieus. Yet the fundamental drive of the Mexican artists who participated in post-Revolutionary artistic life remained constant: Mexican artists still yearned both to establish their Mexican identity through their work and to join the great modern Western tradition. "A Latin American," Octavio Paz remarked in 1972, "is a being who has lived in the suburbs of the West, in the outskirts of history." Poets, he said, were simultaneously cosmopolitan and nativist. "Every Latin American work is a prolongation and a transgression of the Western tradition."[1] Painters, too, felt the need to assimilate and to transgress, and it was through that tension, today still active, that Mexican art in the twentieth century evolved.

1. Interview with Rita Guibert in *Review: A Publication of the Center for Inter-American Relations*, fall 1972, p. 6.

Dr. Atl (Gerardo Murillo Cornadó)
Mexican, 1875–1964

Luminous Morning, Valley of Mexico, 1942
Atlcolor on plywood; 150 x 300 cm. (59 x 118⅛ in.)
Private collection, Mexico. Courtesy of CDS
Gallery, New York

Among the fourteen twentieth-century artists represented in this exhibition, Dr. Atl is the oldest by several years. A versatile intellectual, his interests ranged from painting and writing to politics, as well as to the study of volcanoes and colonial architecture. Although his given name was Gerardo Murillo Cornadó, he changed it in 1911 to "Atl," which in Nahuatl, the language spoken by the Aztecs, means "water"—the source of life.

Born in Guadalajara, Mexico, in 1875, Atl became a spiritual leader for many young artists in Mexico, many of whom he taught at the Escuela Nacional Preparatoria in Mexico City in the early 1900s. Among his students were José Clemente Orozco and Diego Rivera, two of Mexico's great muralists from the 1920s to the 1940s. Atl conveyed to his students his own enthusiasm for Italian fresco painting, which he had studied during his early years in Europe, from 1897 to 1903.

While in Italy in 1901, Atl painted his first murals (which no longer exist) for a private villa in Rome. When he returned to Mexico, he conceived the idea of inviting Mexican artists to decorate the walls of public buildings with murals. This plan was never realized, but in 1921 he was asked by José Vasconcelos, the minister of education, to paint murals (now destroyed) for an annex of the Escuela Nacional Preparatoria. Atl's monumental figures in the murals reflected the strong influence of Michelangelo, specifically the figures from the Sistine Chapel.

As a result of the success of this project, Vasconcelos initiated a state-run program for mural painting in 1922. Over the next two years artists such as David Alfaro Siqueiros, Rivera, and Fernando Leal were invited to make murals for government buildings that illustrated events from Mexican history, particularly the Mexican Revolution. To consolidate their objectives these artists formed a union in 1922, for which the twenty-six-year-old Siqueiros wrote the manifesto. It read in part: "We repudiate so-called easel-painting. . . . Art must no longer be the expression of individual satisfaction, which it is today, but should aim to become a fighting, educative art for all."[1] Perhaps more by his encouragement of their efforts than by his own achievements in mural painting, Atl influenced the direction of such muralists as Orozco, Rivera, and Siqueiros.

Atl's own contribution to Mexican art was in the area of landscape painting, which he said represented "the highest experiences of the human spirit."[2] Like the muralists, he worked on a large, sometimes monumental scale, but his paintings had none of the social and political commentary implicit in their imagery. Instead, his work follows in the tradition of the classical nineteenth-century Mexican landscape painter José María Velasco (1840–1912), who produced on a smaller scale similarly luminous panoramas of plains and mountains.

For Atl, landscape painting was an expression of his interest in volcanoes. From 1907 to 1941, he painted numerous panoramic landscapes depicting the sites around Popocatépetl and Iztaccíhuatl, the two largest volcanoes in Mexico. His observations of these geological phenomena formed the basis of his book *Volcanes de México* (Volcanoes of Mexico), published in 1939. In 1942, the year he painted *Luminous Morning, Valley of Mexico*, Atl built a house near the volcano Parícutin, 200 miles due west of Mexico City. This flat-topped volcano, painted blue, can be seen in the background of the picture at the far left. To the right extends the jagged silhouette of the Sierra Madre.

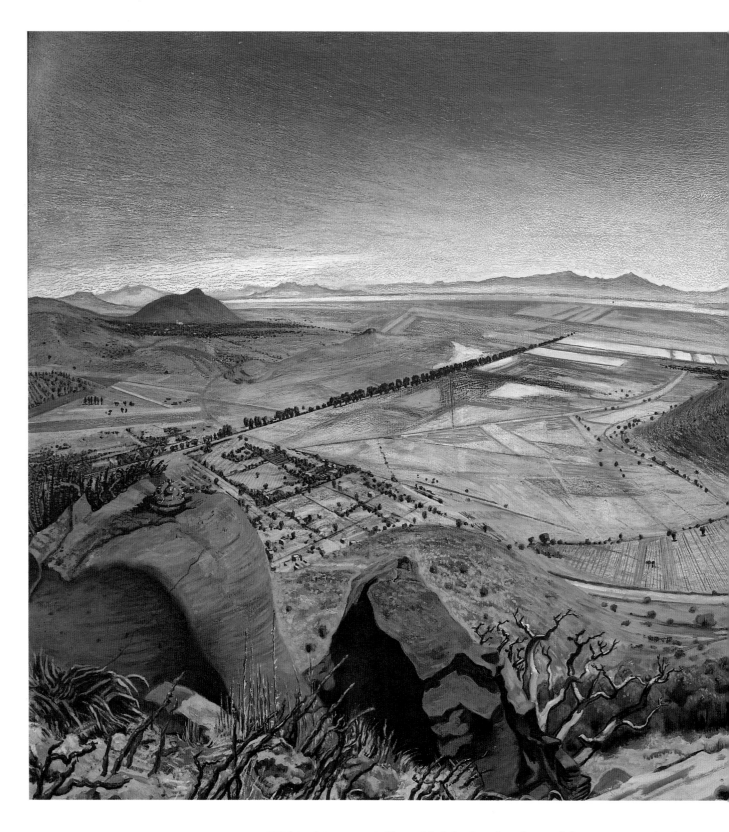

Within this range, Atl has added the familiar shape of the snow-capped volcano Popocatépetl, some 250 miles east of Parícutin. In the picture it can be seen just behind the large brown outcropping of rock, to the right of center.

From the great height of this perspective, we can see the curvature of the earth's surface at the horizon. Although many of Atl's later paintings were first sketched from the aerial perspective of a helicopter or small plane, this particular scene seems to include a close view of rocks and growth in the immediate foreground, which suggests that the artist was situated on the side

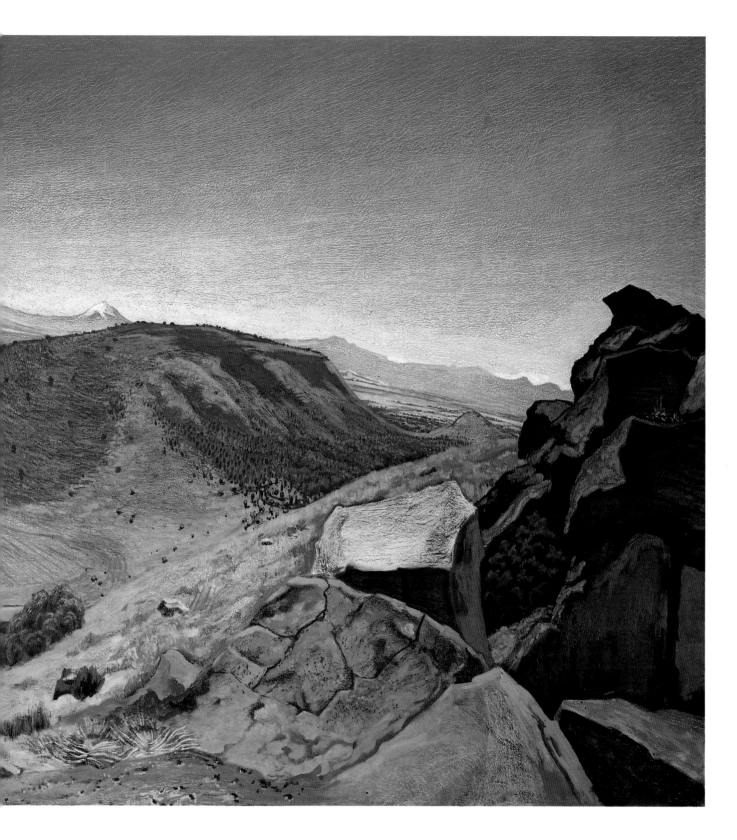

of a mountain. Many related scenes of Parícutin appear in Atl's oeuvre—both paintings and drawings—and explicitly record the devastating eruption that began in 1943 and lasted three years. Atl's book ¡*Cómo nace y crece un volcán! El Parícutin* (The Birth and Growth of a Volcano: Parícutin), published in 1950, documents the history of the volcano.

This picture, however, presents a serene vista, of craggy mountains and flat valley illuminated by the diffuse light of early morning. The bright blue sky extends across the upper register of the nearly ten-foot-long panel, clearly

revealing the drawing method that Atl used. The technique and medium were elaborate and of his own invention. First he produced small drawing sticks made of resin, wax, ground, and melted pigments, which he called "atlcolors" (similar to oil pastels). These colors were used on a dry, textured surface, previously prepared with successive layers of zinc and glue, watercolor wash, and a wax- and resin-based varnish. Applied with a graphic stroke that exposed the textural undersurface, the atlcolors could presumably either be rubbed smooth or left streaky. The formula for this technique unfortunately died with its inventor. Atl was eighty-nine years old when he died in 1964, having outlived most of his generation of Mexican artists. In size and subject *Luminous Morning, Valley of Mexico,* one of Atl's largest compositions, seems to be a grand summation of his previous work. It is perhaps his masterpiece.

In 1942, Diego Rivera wrote the following tribute to the artist: "Dr. Atl is one of the most curious characters born in modern times in this American continent—he has the most colorful history among all of the painters; it is impossible to write this essay without using many volumes."[3]

LMM

1. David Alfaro Siqueiros, "A Declaration of Social, Political and Aesthetic Principles," in *Art and Revolution,* translated by Sylvia Calles (London, 1975) p. 25.
2. Excerpt from "El Paisaje (un ensayo)" by Dr. Atl, 1933, quoted in *Dr. Atl: Pinturas y dibujos.* (Mexico, 1974) p. 12.
3. Quoted in Arturo Casado Navarro, *Gerardo Murillo: el Dr. Atl.* Instituto de Investigaciones Estéticas, Monografías de arte, no. 12 (Mexico, 1984) p. 13.

REFERENCE
Museo Nacional de Arte, Mexico City. *Dr. Atl, 1875–1964: conciencia y paisaje,* exh. cat., Instituto Nacional de Bellas Artes, Mexico, 1985, pl. 16.

285 ◀ **Francisco Goitia**
Mexican, 1882–1960

Landscape of Zacatecas I, about 1914
Oil on canvas; 58 x 96 cm. (22⅞ x 37¾ in.)
CNCA–INBA, Museo Nacional de Arte, Mexico City

In 1912, when the thirty-year-old Francisco Goitia returned to his native state of Zacatecas in north central Mexico after eight years of study and travel in Europe (mainly in Spain and Italy), he found Mexico torn by revolution. Zapata was agitating in the South, and Pancho Villa was fighting his way toward Mexico City from the North. Goitia, who had wanted to be a soldier before he decided to study art at Mexico City's Academy of San Carlos in 1898, joined Villa's revolutionary army as staff artist for the highly cultivated General Felipe Angeles. His job was to give a pictorial account of the Revolution. From this point onward, Goitia, who has been called the most Mexican of Mexican painters, focused on the beauty and pathos of the life and land of Mexico.

In his decision to paint specifically Mexican subject matter, Goitia is seen as a precursor of modern Mexican art. Like Diego Rivera and David Alfaro Siqueiros, who were in Europe a decade later, he had intimations even during his apprentice years abroad that his mission was to create a Mexican art. In Barcelona, where he exhibited with great success in 1907, he was told that his landscape studies looked as if he were a native son. "So I began to think that I would be doing my best work only if I returned to my native country, for in that way I could express all that I was."[1]

As staff artist for General Angeles, Goitia witnessed many battles, includ-
ing the Battle of Zacatecas, in 1914, at which Villa captured the state's capital
city. From the evidence of his paintings and drawings, he was both fascinated
and horrified by the brutality of war. In later years he said, "I went every-
where with the army, observing. I did not carry weapons, because I knew that
the mission of killing was not mine."[2]

Goitia's inspiration came from such events as the murder of General Lazaro
Gómez, who had held off enemy troops almost single-handedly until he ran
out of ammunition and was shot in the back after being taken prisoner. The
general's body was carried by donkey to a tree called the Sad Tree. There he
was beheaded and hung up by the wrists; his head was replaced by the head of
the steer upon which he had been feasting before the enemy attacked. As
Goitia later recalled, "In a few days his clothes fell from him, and caught on
his feet. That was a real phantom. Enormously long, with the head of the
steer, nude, bled. . . . There is my picture."[3]

A few days later, Goitia exhumed several enemy corpses and hung them on
the Sad Tree to serve as models. "Then I had to go to Mexico City, and as the
air [in the state of Zacatecas] is very dry the corpses don't rot, so I had a hut
built around the tree and put a caretaker there, and I have it for when I can
return to continue my studies."[4]

Landscape of Zacatecas I, like all of Goitia's paintings, was done from direct observation. Although a romantic and moved by personal fantasy, Goitia had an almost ethical loyalty to observable fact. In this he brings to mind José María Velasco, one of his teachers at the Academy of San Carlos, who painted highly detailed and empirically accurate landscapes. The combination of Goitia's will to exactitude and his need to express emotion gives his paintings their particular tension.

The desert plateau of Zacatecas was a terrain the artist knew well, for he was born at Patillos, a ranch near the old silver mining town of Fresnillo, forty miles northwest of the city of Zacatecas. It was also a land he loved. He recalled that as a boy "I was not happy working at a desk. I preferred to run in the fields, and because of this I was reprimanded. Without my knowing it, Patillos, with its bubbling springs and dense woods, left the treasure of a profound love for nature in my subconscious."[5]

The dusty grays and mustard yellows of *Landscape of Zacatecas I* describe a harsher, more arid land, the perfect setting for this scene of two cadavers hanging from palms with bonelike branches, vultures circling overhead. The hanging men, camouflaged by the trees, seem absorbed into a landscape so bleak it recalls Golgotha. Indeed, the artist may have had Christ's crucifixion in mind, for he called his paintings of the Revolution "martyrdoms" and many of his scenes of everyday Mexican life have a strong biblical feeling.

The painting perhaps portrays the cycle of life, for there is death in the corpses and life in the birds, death in the gibbet-palms' gray branches and life in their green fronds that thrust toward the sky. As always in Goitia's landscapes, the feeling of desolation goes beyond the fact of his painting the wilderness. Goitia's depopulated landscape is the vision of a man who chose, starting in the late 1920s, to live like a hermit, to wear laborer's clothes, and to sleep on a goatskin spread on the floor of an adobe hut.

Perhaps also, the loneliness of Goitia's landscapes reflects the loneliness he experienced as a result of early separations, which remained with him from childhood. The artist was the illegitimate son of a hacienda manager whose forebears came from the Basque country of Spain. He never knew his mother. Little is known about her except that she was extraordinarily beautiful; apparently her son resembled her. Judging from a photograph of the humble adobe house where Goitia was born, she must have been poor. Because Goitia was of mixed Indian and Spanish descent, it can be assumed she was of Indian extraction.

Soon after Goitia was born, he was placed under the care of a wet nurse. He had fond memories of her, as he did of his adoptive mother, Eduarda Velásquez, a devout Catholic who cared for Goitia as if he were her own son. The young Goitia's life was again disrupted when Eduarda Velásquez married an ill-tempered man whom Goitia disliked intensely. Eventually, she had children of her own and the family left the home to which Goitia was deeply attached.

Of his childhood Goitia wrote, "I was born October 4, 1882, and was named Francisco according to the [church] calendar. My mother, whom I never knew, was named Andrea Altamira. A good woman breast-fed me. Another woman, no less good, took care of me. . . . When I was old enough to start learning, I was taken to another ranch on the same hacienda named Charco Blanco. It was my first feeling of separation."[6] It is this searing feeling of being separated that pervades the vast, uninhabitable spaces of Goitia's landscapes.

HH

1. Anita Brenner, *Idols Behind Altars* (New York, 1929) p. 294. Translations from the Spanish by Anita Brenner.
2. Brenner, *Idols Behind Altars*, p. 294.
3. Brenner, *Idols Behind Altars*, p. 297.
4. Brenner, *Idols Behind Altars*, p. 297.
5. Francisco Goitia, "Datos biográficos," in *Goitia*, Instituto Nacional de Bellas Artes (Mexico, 1987) p. 8. Translation from the Spanish by Maria Balderrama.
6. Goitia, "Datos biográficos," p. 7.

REFERENCES
Alfonso de Neuvillate. *Francisco Goitia: precursor de la escuela mexicana.* Mexico, 1964, pp. 31, 47–48. **José Farías Galindo**. "Presencia de Goitia." In Antonio Luna Arroyo, *Francisco Goitia total.* 2d ed. Mexico, 1987, p. 559; ill. p. 689.

286 ◀ **Francisco Goitia**

Mexican, 1882–1960

Landscape of Zacatecas II about 1914

Oil on canvas; 95 x 110 cm. (37⅜ x 43¼ in.)
CNCA–INBA, Gobierno del Estado de Zacatecas,
Museo Francisco Goitia, Zacatecas

When Goitia returned to Mexico from his eight-year sojourn in Europe, he was well versed in the techniques of painting and in the history of art. In Spain he had studied Velázquez, Zurbarán, El Greco, and above all, Goya, whose Disasters of War had had a strong influence on him. Goitia shared Goya's predilection for the macabre, the deathly, and the cruel, but his view of death has a distinctly Mexican fatalism, which is less dramatic and more down-to-earth than Goya's. While in Europe, Goitia also looked at Italian Renaissance art and at nineteenth-century French painters such as Delacroix, Géricault, Daumier, Millet, Courbet, and the Impressionists.

Goitia's art evolved apart from current developments in Mexico. Although he was only four years older than Diego Rivera, who had been his colleague at the Academy of San Carlos, his painting had little or no connection with the Mexican mural renaissance of the 1920s. The muralists admired him and saw him as a precursor, but they did not pay much attention to him because in both his art and in his life he was an outsider.

Goitia's work was multifarious, showing an extraordinary variety of styles and techniques. He felt, as he put it, "repugnance at the idea of making a system out of painting."[1] He once explained why he painted so slowly and why he was not more prolific: "As opposed to production in series, that is to say, the painting that is 'improvised' and reproduced ad infinitum, I offer the

painting that is an event, the painting that is always a discovery, a progression. And it is clear that for the event-painting to emerge, days pass, weeks and months. Sometimes years."[2] Goitia painted when he felt inspired, and it was his feeling about his subject, not some signature style, that determined how his paintings would look.

The brushwork in *Landscape of Zacatecas II* is much looser than in the contemporaneous *Landscape of Zacatecas I* (cat. no. 285). Indeed, the handling closely resembles that in the painting's preparatory charcoal sketch.[3] Compared with the glaring light in *Landscape of Zacatecas I*, the light here is soft and suffused; color is muted. A shimmering haze, which nearly obscures the white sun, creates a sense of foreboding.

The leafless gibbet-tree echoes the dead men's fleshless bones. In the preparatory study the bodies hang straight down; in the painting they are set swinging. Each body parallels the branch from which it hangs, so that they seem to be blown by different winds. An owl perched in the tree and another about to alight add to the scene's ghostly atmosphere. Of the desolation and sorrow that characterize much of his work, Goitia said, "You see, it is natural that circumstances have made my temperament more inclined to the profound. There is a great deal of sadness in this country and I have tried to sum a certain phase of it."[4]

HH

1. Antonio Luna Arroyo, *Francisco Goitia total*, 2d ed. (Mexico, 1987) p. 185. Translations from the Spanish by Hayden Herrera.
2. Luna Arroyo, *Goitia total*, p. 170.
3. Illustrated in Luna Arroyo, *Goitia total*, p. 664.
4. Anita Brenner, *Idols Behind Altars* (New York, 1929) p. 297. Translation from the Spanish by Anita Brenner.

REFERENCES
Alfonso de Neuvillate. *Francisco Goitia: precursor de la escuela mexicana*. Mexico, 1964, pp. 31, 48. **José Farías Galindo**. "Presencia de Goitia." In Antonio Luna Arroyo, *Francisco Goitia total*. 2d ed. Mexico, 1987, p. 559.

287 ◀ **Francisco Goitia**
Mexican, 1882–1960

***The Witch**, 1916*
Oil on canvas; 39 x 33 cm. (15⅜ x 13 in.)
CNCA–INBA, Gobierno del Estado de Zacatecas, Museo Francisco Goitia, Zacatecas

The Witch is another painting from Goitia's revolutionary period, but he finished it years later, when he had a job making studies of ethnographic types for the Dirección de Antropología, whose director was the prominent anthropologist Manuel Gamio. The painting depicts a grotesque female head looming out of the surrounding darkness like an image in a nightmare—thrust so close to us we can almost feel her breath. The reddish flesh and sagging eyelids are half-decomposed. It is believed that Goitia's model was a dead *soldadera*, one of the women who followed alongside their men in the Revolution. Goitia may also have been inspired by the decapitated heads that he saw (and painted) during these years.

The head's skeletal shape and its over-large gaping mouth bring to mind Edvard Munch's *The Scream*. One thinks also of other turn-of-the-century artists such as Ensor, Kubin, and Redon, though Goitia's head is less poetic and more mercilessly carnal.

With her ferret teeth, lolling tongue, and wide-open mouth, the witch looks like a vampire. She seems to embody a primal fear, most specifically the fear of the devouring woman. Although he was attracted to women, Goitia never married. He apparently tried to avoid involvements with them, though he may have contracted syphilis in 1918. It was this illness, many believed,

that made him *loco*, or crazy, but when he was treated for syphilis at the end of his life, his eccentricities remained.

HH

REFERENCES
Alfonso de Neuvillate. *Francisco Goitia: precursor de la escuela mexicana*. Mexico, 1964, pp. 35–36. **Antonio Luna Arroyo**. *Francisco Goitia total*. 2d ed. Mexico, 1987, p. 197.

288 ◀ Francisco Goitia

Mexican, 1882–1960

Pyramid of the Sun, Teotihuacán, 1925
Oil on canvas; 41 x 73 cm. (16⅛ x 28¾ in.)
CNCA–INBA, Gobierno del Estado de Zacatecas, Museo Francisco Goitia, Zacatecas

When Pancho Villa was driven north and crushed by Alvaro Obregón in 1915, General Angeles advised Goitia to leave the army and go to Mexico City. After some initial resistance the painter agreed, but he went first to Zacatecas. As he recalled, "Villa was defeated, and so then I took my way and stayed on a small ranch in my state. Those were times of misery and disease, and I passed through the calvaries of the humble and for this reason I feel a kind of brotherhood between us, in spite of the difference in class, and the mutual respect. I wore the clothes of a mule driver and went about as one, making the same journeys."[1]

After about three years, Goitia arrived in the nation's capital. No one there took any interest in his work, and his situation became increasingly difficult. Finally, in 1918, he was introduced to Manuel Gamio, then director of anthropology at the Dirección de Antropología. At the lowly salary of six pesos a day, Goitia went to work making sketches of Indians in various regions of Mexico as part of Gamio's ethnographic and archaeological research project,

which centered on his study of San Juan Teotihuacán, a town near the great archaeological zone of Teotihuacán, some thirty miles northeast of Mexico City. The assignment perfectly suited Goitia's outlook—his Christian Socialist ethic, his love of the Mexican people, his distaste for urban bourgeois life. "I am closer to the Indians than I am to the whites," he once said, "although biologically I am closer to the Spaniards."[2]

Goitia told Gamio that he would be happy to provide work in exchange for food. The opposite of a careerist, he had interest in neither money nor fame. For most of his adult life he lived in a hut he had built out of adobe bricks; the corrugated tin roof was held down by large stones. His sole support was a tiny government stipend for which, in return, he gave the government most of his work.

Goitia's objective was to paint the soul of Mexico in a way that would continue the long tradition of religious art. "What counts in art," he said, "is not money, but the dedication, love, and disinterestedness that one puts into the work."[3] Once in the 1920s, realizing that Goitia needed money, Gamio told him that an American colleague of his would pay ten thousand pesos if Goitia would paint a portrait of his wife. Goitia replied that he was so caught up in drawing the people of Teotihuacán that he would not be free to do the portrait for another year or two. Naturally the commission fell through.

At Teotihuacán, Goitia painted *Pyramid of the Sun, Teotihuacán*, which was used to illustrate Gamio's books on San Juan Teotihuacán. Goitia's view of the Pyramid of the Sun (see photograph on page 88), the largest structure in a complex of Precolumbian temples, shows the ruin as it was in the 1920s, still partly covered with vegetation.

The painting is done in an Impressionist palette, with myriad small strokes of close-valued color, giving density to the fall of light on the grassy field and scintillation to the foliage of the trees. Goitia's opaque and somewhat repetitive strokes recall provincial versions of Impressionism, such as that of the Italian painter Giovanni Segantini, whose work Goitia knew. Impressionism was just one of the styles that the eclectic Goitia deployed. Sometimes he veered toward the robust realism of Courbet and the Barbizon School, while at other times he favored a sharper focus and a more highly detailed realism, or even expressionism.

The broken strokes of *Pyramid of the Sun* create a vibration that captures the relentless heat of the midday sun in the Valley of Teotihuacán; the clouds on the horizon offer no shade, and one can imagine the sounds of crickets and bees in the burnt grass. Like many of Goitia's landscapes, this one is devoid of human presence. But unlike the early Zacatecas landscapes, it is not a picture of desolation, for here the artist brings into the present the ancient past, in a shimmering moment of light.

HH

1. Anita Brenner, *Idols Behind Altars* (New York, 1929) p. 295. Translation from the Spanish by Anita Brenner.
2. Antonio Luna Arroyo, *Francisco Goitia total*, 2d ed. (Mexico, 1987) p. 213. Translation from the Spanish by Hayden Herrera.
3. Luna Arroyo, *Goitia total*, p. 211.

REFERENCES
Alfonso de Neuvillate. *Francisco Goitia: precursor de la escuela mexicana*. Mexico, 1964, p. 40.
Antonio Luna Arroyo. *Francisco Goitia total*. 2d ed. Mexico, 1987, p. 217.

289 ◀ **Francisco Goitia**

◀ Mexican, 1882–1960

◀ *Tata Jesucristo (Father Jesus)*, 1926–27
◀ Oil on canvas; 85 x 107 cm. (33½ x 42⅛ in.)
◀ CNCA–INBA, Museo Nacional de Arte,
◀ Mexico City

When Goitia finished his ethnological drawings at Teotihuacán about 1925, Manuel Gamio sent him to make studies of the Zapotec Indians in Oaxaca. Before he left, Gamio asked him how much money he would need. Goitia said that he required no more than what the Indians had to live on. "To paint them well," he explained, "I must live with them so that they will have confidence in me. I must be one of them, know their customs, analyze their tastes, eat with them. In a word, be like them."[1] It was this attitude that led to the frequent comparisons between Francisco Goitia and his namesake and idol, St. Francis. When Goitia was teaching at the Academy of San Carlos in Mexico City in 1929, the year Diego Rivera took over the school's directorship, Goitia told his students: "An artist who does not live his own work, who does not realize its content, . . . who does not give life and feeling to the people in his work, does not succeed in becoming an artist."[2]

In Oaxaca, Goitia painted his masterpiece, *Tata Jesucristo*, a painting of a wake that so beautifully captures the sorrows of the Mexican people that it is,

in effect, a Mexican pietà. The canvas depicts two women dressed in white sitting on the earth and mourning over a body that lies in front of them but outside the picture space. The woman on the left hides her grief with her huge brown hands and her long hair. The woman on the right tries to stifle her wail by holding her sleeves against her mouth in a gesture of extraordinary poignancy. To enhance the impact of the image, Goitia placed the mourners close to the picture plane—the bare foot of the woman on the left seems almost to push against the canvas surface. And he made his own and the viewer's vantage point identical with the spot where the dead person lies. Thus we are drawn into the wake not only by empathy, but because we feel the mourners weeping over us.

Also serving to bring the viewer into the scene are two yellow *cempoalxochitl* flowers (marigolds), which are strewn on the ground and cut off by the canvas edge. Between these blossoms (which since pre-Conquest times have been associated with ceremonies to the dead), a half-burned candle indicates that the women have been watching over the dead body for many hours. Tipped in its primitive clay candlestick, it accentuates the unbalanced feeling of grief. The flame casts a yellow glow on the women's white garments but does little to illuminate the room. The space behind and between the figures is filled with a thickened darkness that leaves no escape from despair.

The woman who bends forward, covering her face with her hair and hands, is a pared-down image of suffering that brings to mind the contemporaneous murals of José Clemente Orozco at the Escuela Nacional Preparatoria in Mexico City. Orozco is said to have been influenced by Goitia's painting *El Baile Revolutionario*, 1913, which depicts simplified figures of soldiers and *soldaderas* dancing. Often they are faceless, like Goitia's mourner in *Tata Jesucristo*. Both artists' use of expressive gesture and sparely articulated figures reveals their admiration for Giotto. A quite different source for Goitia's *Tata Jesucristo* is Precolumbian art, which Goitia studied, drew, and loved. With her squared-off shoulders and with the solid mass of her bent knees forming her base, the kneeling figure on the right resembles an Aztec idol. A third possible source for Goitia's mourning women is Käthe Kollwitz's images of suffering working-class women.

Goitia's empathy for his subject came from personal experience. During the Revolution, he recalled, he saw many women weeping over their lost men. Their grief reverberated throughout Mexico, and he heard it again and again.

When he arrived in Oaxaca, he found his way to a mountain town called San Andrés, where he decided to stay because he found a subject he wanted to draw, an Indian girl wearing beautiful clothes and carrying a machete across her shoulder. A hut was built for him and a woman hired to look after his cooking. "At about eleven at night . . . I would always hear the distant weeping of a woman. It was a bitter, sad crying. Every night it was the same, around eleven, and I never knew who wept. But this prepared for me the atmosphere I needed."[3] The town had a small, half-built chapel, where women wearing white huipils would go to pray and to tell of their sorrows to Christ. "From far away," Goitia remembered, "you could hear their cries and pleas. . . . They wailed and supplicated to Christ, calling him 'Tata Jesucristo! Fulfill our needs and pardon our sins.' From this, . . . my painting was born—from this chapel and these people."[4]

At the chapel Goitia met an old woman whom he associated with the cry of the unknown weeping woman. He asked her to pose for him, and she became

the figure on the right. "She looked like a Prehispanic sculpture, a Precolumbian god," he later said. But he had difficulty painting her. "I wanted to portray her crying: I already had my conception of the painting. And imagine the work it took to convince her to cry: she couldn't. I pleaded: cry . . . but she did not cry. . . . I began to paint the rest of the body. . . leaving the face for later. Meanwhile, the month of November arrived. And on the second, the Day of the Dead, we were working as usual, when all of a sudden, perhaps because she remembered her dead ones . . . , she began to cry and could not stop. . . . I began to paint the face. And in something like ten minutes, I finished I did not touch the face again."[5]

During those ten minutes, the woman on the left began to cry as well. Writhing, she pushed her left foot forward, turning it up in a spasm of anguish: "Then I knew I had it!" Goitia recalled. "Those hands and feet gave their grief the genuine form. . . . They weep the tears of our race. . . . All the sorrow of Mexico is there."[6]

Those few moments of final, furious work were typical of Goitia's creative process. He often deliberated about the problems in his paintings for long periods of time, and then suddenly, something in the motif would be altered and he would experience a kind of pictorial epiphany that enabled him to finish the work very quickly. While painting the women's faces, Goitia wrote, he felt almost "unaware of myself. I worked feverishly, almost pathologically, and I did in minutes what I had not done in months. And those minutes are the ones that have saved many of my works."[7]

Goitia spent six months in San Andrés, two researching and drawing for Gamio and four painting *Tata Jesucristo*. When the painting was completed, he recalled, "I felt great happiness, as if a huge weight had been taken off me, and at the same time a general bodily exhaustion. So I decided to rest. And that's what I did. I stopped working for four months."[8]

HH

1. Antonio Luna Arroyo, *Francisco Goitia total*, 2d ed. (Mexico, 1987) p. 213. Translations from the Spanish by Hayden Herrera.
2. Luna Arroyo, *Goitia total*, p. 226.
3. Luna Arroyo, *Goitia total*, p. 461.
4. Luna Arroyo, *Goitia total*, pp. 203, 461.
5. Luna Arroyo, *Goitia total*, pp. 461–62.
6. Anita Brenner, *Idols Behind Altars* (New York, 1929) p. 298. Translations from the Spanish by Anita Brenner.
7. Luna Arroyo, *Goitia total*, p. 204.
8. Luna Arroyo, *Goitia total*, p. 204.

REFERENCES
Anita Brenner. *Idols Behind Altars*. New York, 1929, p. 298. **Alfonso de Neuvillate**. *Francisco Goitia: precursor de la escuela mexicana*. Mexico, 1964, p. 40. **Justino Fernández**. *A Guide to Mexican Art From Its Beginnings to the Present*. Translated by Joshua C. Taylor. Chicago and London, 1969, p. 179. **Antonio Luna Arroyo**. *Francisco Goitia total*. 2d ed. Mexico, 1987, pp. 224, 228–29, 258, 263–64, p. 556. **Ramón Ortíz**. "Será filmado un documental basado en la vida de Goitia." In Antonio Luna Arroyo, *Francisco Goitia total*. 2d ed. Mexico, 1987, p. 553.

290 ◀ Francisco Goitia

Mexican, 1882–1960

Man Seated on a Trash Heap, 1926–27

Oil on canvas; 53 x 57 cm. (20⅞ x 22½ in.)
CNCA–INBA, Museo Nacional de Arte,
Mexico City

The barefoot, white-bearded man holding a staff and sitting on top of a mountain of garbage in *Man Seated on a Trash Heap* looks like an Old Testament prophet. He may also be a spiritual self-portrait, for with his long hair, weathered brown skin, and worker's cloths, he foretells what Goitia would look like years later, when he lived as a hermit in an adobe shack in Xochimilco. More generally, the old man embodies the strength and forbearance of Mexico's

poor—their acceptance of poverty and death with a shrug and a smile and the words "No hay remedio" (Nothing can be done about it).

The canvas comes from the period when Goitia was making a visual study of the people of Mexico for Manuel Gamio. It was painted in Guadalupe, Zacatecas, and it took six months to complete. For five-and-a-half months Goitia worked, slowly and deliberately, with much preparation and thought. Then, after the solution to his painting was suddenly revealed to him, he finished it in fifteen days.

What Goitia wanted to do, he said, was "to take each aspect of my land and of the race, and to make a whole so that it will be understood well."[1] He painted what he called "the ragged side. . . . I like it that a half-nude, skinny child should hang in the office of the Subsecretary, as if saying 'Look, don't get up too high, here I am.' The old man sitting on a garbage heap next to that child was the happiest man I ever saw. He owned not a thing in the world, not even a hat, and he sat there every day and enjoyed the blue sky. You see, a kind of irony goes through my work. I think that old man would do well hanging in the office of an American millionaire."[2]

The blue sky, which Gamio called "the best ever done by Goitia," takes up most of the canvas.[3] It is vibrant and full of promise, especially in contrast to the figure and the trash on the earth below, painted in beiges and browns in a texture as gritty as dirt. As in many of Goitia's paintings, the heavily impastoed paint derives from the artist's many reworkings of the canvas. By contrast, the sky is smooth. The endless expanse of blue is given dimension by barely visible vultures in the distance. Closer to the viewer, a lone black bird approaches, as deathly as the crows that hover over the wheat field in van Gogh's last painting, except that Goitia's picture suggests an acceptance of death, not a fear of or a desire for it.

Indeed, *Man Seated on a Trash Heap* is a kind of morality tale about death. On the ground at the old man's feet are an animal's skull and an ox's curling horn, as well as several red splotches that look like blood.

The half-destroyed buildings, the garbage heap, and the weary old man may also symbolize Mexico—battered by a decade of Revolution and worn down by poverty. The vision of Mexico as a trash heap was shared by Orozco, but Orozco's vision was more bitter (see, for example, his 1924 fresco *Political Junk Heap*, at the Escuela Nacional Preparatoria, or his Guadalajara murals).

Like Goitia, the tramp has rejected the values of bourgeois society and has chosen to live alone. To Goitia, he must have seemed an exemplary Christian. When in 1957 the artist told an interviewer about his decision to live in solitude, he said: "I always felt myself to be Socialist and Communist, but also Christian.... I try to follow in the steps of St. Francis. I believe that my solitude is the culmination of this process.... All my work is religious, going back to early Christian times, to the heroic epoch of Christianity's battle."[4]

HH

1. Anita Brenner, *Idols Behind Altars* (New York, 1929) p. 295. Translations from the Spanish by Anita Brenner.
2. Brenner, *Idols Behind Altars*, p. 296.
3. Antonio Luna Arroyo, *Francisco Goitia total*, 2d ed. (Mexico, 1987) p. 205. Translations from the Spanish by Hayden Herrera.
4. Luna Arroyo, *Goitia total*, pp. 198–99.

REFERENCES
Anita Brenner. *Idols Behind Altars*. New York, 1929, p. 296. **Alfonso de Neuvillate**. *Francisco Goitia: precursor de la escuela mexicana*. Mexico, 1964, pp. 41–42. **Antonio Luna Arroyo**. *Francisco Goitia total*. 2d ed. Mexico, 1987, p. 205.

291 ⟨ **Francisco Goitia**
Mexican, 1882–1960

Santa Mónica, Zacatecas, by Moonlight
about 1946

Oil on canvas; 43 x 106 cm. (16⅞ x 41¾ in.)
CNCA–INBA, Museo Nacional de Arte,
Mexico City

By the end of the 1920s, Goitia had settled in Xochimilco, a southern suburb of Mexico City famous for its floating gardens. In 1929, Diego Rivera, then director of the Academy of San Carlos, hired him to take Orozco's teaching position at the school. For many years he taught drawing in primary school, and to supplement his income he made and sold coffins (one of which he is said to have used as a bed). Later he also supported himself by restoring colonial paintings in the monastery of Guadalupe in Zacatecas.

In the 1940s, Goitia's work finally began to attract attention. It was shown in various group exhibitions organized by the government. In 1946 he had his first one-man show, at the library in Zacatecas; the state of Zacatecas provided additional financial support; and his government stipend was increased. Two years before his death in 1960, Goitia participated in the first Inter-American Biennale of Mexico in Mexico City; his painting *Tata Jesucristo* (cat. no. 289) won the international prize. Despite this recognition, he was known mostly by hearsay and his paintings were generally ignored.

In his last years, Goitia became more engaged in public life. He was named president of the left-wing artists' association Frente de Artes Plásticas. He was passionately involved with plans to improve Xochimilco, collaborating on a project to build a cultural center and making efforts to organize a museum for his paintings.

Goitia probably painted *Santa Mónica, Zacatecas, by Moonlight* while he was preparing for his 1946 show in Zacatecas. The painting has a companion piece, a view of Santa Mónica in daylight (Museo Francisco Goitia, Zacatecas). The idea of depicting the same scene under different light conditions may have derived from Monet, but unlike the paintings of the Impressionist master, the two landscapes are tightly painted, with sharp, precise detail that would have delighted Goitia's teacher José María Velasco.

The paintings depict a group of abandoned silos that resemble ancient tombs set in a walled city. (At one time, Goitia lived in one of these cones.) Both landscapes gave him problems, the nighttime version with the shadows, the daytime version with the clouds; and both, like *Tata Jesucristo*, were saved by what he saw as divine providence. He could not, he said, explain "how my spirit moves my hand, the hand that holds the paintbrush, and the color that stains it with emotion—this emotion that perhaps God puts there."[1]

In painting the nocturnal view of Santa Mónica, Goitia would set out at about midnight and paint until dawn. The landscape he produced is again a hermit's view of the world—silent, without people, outside of time. Recalling de Chirico, it expresses apprehension and mystery. For Goitia, nature was a manifestation of God. His attention to detail, to the rendering of each speck of earth, each tree, was surely an act of worship.

HH

1. Antonio Luna Arroyo, *Francisco Goitia total*, 2d ed. (Mexico, 1987) p. 204. Translation by Hayden Herrera.

REFERENCES
Alfonso de Neuvillate. *Francisco Goitia: precursor de la escuela mexicana*. Mexico, 1964, p. 45.
Antonio Luna Arroyo. *Francisco Goitia total*. 2d ed. Mexico, 1987, pp. 172, 204–5, 268, 269.

292 ◀ **Saturnino Herrán**
◀ Mexican, 1887–1918
◀
◀ *The Plantain Vendor,* 1912
◀ Oil on canvas; 69.5 x 77 cm. (27⅜ x 30⅜ in.)
◀ CNCA–INBA, Instituto Cultural de
◀ Aguascalientes, Museo de Aguascalientes

The Plantain Vendor depicts an old man bent by a heavy, almost menacing burden. Downtrodden and with eyes downcast, he is resigned to his fate. The cool shadows, and the impastos and glazes of the dark, rich colors evoke a mood more dramatic than any previously expressed by Herrán. The old peasant, a load-bearing genre type, is shown in an amorphous but clearly urban Mexico City setting. The painting is a tour de force of coloristic counterpoint and eloquently dramatic lighting. The luminous buildings at the left are clearly defined and in opposition to the right half of the canvas, obscured in deep shadows and fluid strokes that meld into rich ochers, oranges, browns, and

yellows. The dematerialization of form suggests strong affinities with an international Symbolist style. Perhaps the first in a series of paintings in which Herrán chose themes from everyday Mexican life, *The Plantain Vendor* fuses symbol with reality.

Characteristic of Herrán's monumental single-figure studies is the lower portion of the body left vague and ambiguous, lost in colored patterns and sinuous dark brushstrokes. The fierce energy of the strokes announces the new painterly direction of Herrán's work during this period. The strange and unconventional viewpoint derives from Herrán's study of Japonism, filtered through Art Nouveau illustration and the decorative Impressionist Salon paintings of Ignacio Zuloaga and Joaquín Sorolla.

The theme of toil and labor, central to Herrán's pictorial vision, reflects the influence of fin-de-siècle iconography, particularly the work of the English painter and printmaker Frank Brangwyn. Aged figures, a common Symbolist subject alluding to the ages of man and the meaning of life, were treated in several works by the artist (see also *Old Woman Crocheting*, cat. no. 295).

RF

REFERENCE
Fausto Ramírez. "Notas para una nueva lectura de la obra de Saturnino Herrán." In *Saturnino Herrán, 1887–1987*, exh. cat., Museo de Aguascalientes. Instituto Naćional de Bellas Artes, Mexico, 1987, p. 20, no. 19.

293 ◀ Saturnino Herrán

◀ Mexican, 1887–1918

◀ ***Man with a Rooster,*** 1914

◀ Oil on canvas, 108 x 71 cm. (42½ x 28 in.)
◀ CNCA–INBA, Instituto Cultural de Aguascalientes,
◀ Museo de Aguascalientes

The monumental and sinister figure of the *gallero*, or cock fighter, with his weapon in hand, fills the canvas of this harshly realistic portrait. Herrán began to paint genre figures at a time of fervent nationalistic revival, led in the visual arts by the Catalan painter Antonio Fabrés, who was Herrán's teacher at the Academia de Bellas Artes in Mexico City, and by Alfredo Ramos Martínez, director of the Academia in 1913 and again in the 1920s. Ramos Martínez,

who left Mexico in 1929 for the United States, established an innovative
school at which students were encouraged to paint indigenous scenes from
life in classes conducted out-of-doors in the village of Santa Anita, southeast
of Mexico City.

The high, oblique viewpoint and unexpected plunging cropped perspective
of the background are typical of Herrán's work from this period. The menac-
ing figure is placed at a disconcerting counterpoint to the swirling diagonal
pattern of the shadowed, starkly sunlit *palenque*, or fighting ring, behind
him. In the distance his adversary stands, awaiting the confrontation. The
psychological tension is heightened by the asymmetry of the background and
the unsettling perspective.

The identification of the *gallero* with the cock is brought into dramatic
visual relief. The rancher's small beady eyes, staring with arrogant malice, are
identical to those of the cock, and the distinctive coloring of the rooster is
matched by the dark aggressive reds and blacks of his heavy wool serape.

RF

REFERENCE
Fausto Ramírez. "Notas para una nueva lectura de la obra de Saturnino Herrán." In *Saturnino
Herrán, 1887–1987*, exh. cat., Museo de Aguascalientes. Instituto Nacional de Bellas Artes,
Mexico, 1987, p. 22, no. 31.

294 ◀ **Saturnino Herrán**
Mexican, 1887–1918

Woman from Tehuantepec, 1914
Oil on canvas; 150 x 75 cm. (59 x 29½ in.)
CNCA–INBA, Instituto Cultural de Aguascalientes,
Museo de Aguascalientes

Woman from Tehuantepec is Herrán's passionate tribute to his wife, Rosario Arellano, to whom he was wed in 1914, the year he painted this portrait. Dressed in the elaborate costume worn by the women of the Isthmus of Tehuantepec in the south of Mexico and seated on a typical *equipal*, she gazes seductively from the sumptuously flamboyant headdress that billows around her. The composition, with high, oblique viewpoint, off-center figural pose, and sharp croppings for dramatic effect, is a further elaboration of that seen in *Man with a Rooster* (cat. no. 293), painted the same year.

At this time it was unusual, if not unprecedented, for an urban academic artist such as Herrán to depict the distinctive native dress of the Tehuana women for a formal portrait with an elitist artistic circle in mind. The series of portraits he did of indigenous types seems to have been rooted in the provincial genre or *costumbrista* tradition, but were elevated by Herrán to "high art." Here, the European Symbolist theme of the femme fatale is merged with the Mexican experience to create a new nationalistic modernism.

The fierce beauty and languid sensuality of the model is underscored by the opulent coloration and fluid brushstrokes, executed in a bravura manner to produce bold surface pattern and sharp contrasts of light and shadow. The delicacy of the lace embroidery framing the dark face is deftly rendered, and the swirling red and yellow pattern of the headdress lining lends to the image an organic and expressive potency.

RF

REFERENCES
Fausto Ramírez. "Notas para una nueva lectura de la obra de Saturnino Herrán." In *Saturnino Herrán, 1887–1987*, exh. cat., Museo de Aguascalientes. Instituto Nacional de Bellas Artes, Mexico, 1987, p. 23, no. 40. **Felipe Garrido, ed.** *Saturnino Herrán*, with texts by Ramón López Velarde. Mexico, 1988, pp. 31, 135, pl. 131.

295 ◀ **Saturnino Herrán**
Mexican, 1887–1918

Old Woman Crocheting, 1917
Oil on canvas; 70 x 48.5 cm. (27½ x 19⅛ in.)
CNCA–INBA, Instituto Cultural de
Aguascalientes, Museo de Aguascalientes

Herrán's pictures of old men and women, which he painted throughout his short career, are statements about the human condition. In his earlier paintings, such as *The Plantain Vendor*, 1912 (cat. no. 292), the figures appear defeated, exhausted by a life of toil and suffering. In contrast, *Old Woman Crocheting* and other works painted in 1917 have a serenity and spirituality that bespeaks a sense of peace and renewal.

The old woman is presented in three-quarter view. Her gray hair, combed close to her head, is tied in a knot at the back. A dark shawl covers her shoulders, partially concealing her white dress with blue embroidery on the cuffs of the sleeves. Having momentarily stopped crocheting, she holds the hook in her right hand, while in her left hand, beautifully rendered in foreshortened pose, she holds the thread. In the background are the dome and tower of the colonial church of San Jerónimo in Mexico City.

Herrán included references to religious architecture in many of his paintings. In two pictures from a series dating from 1915–16, known as *Las Criollas* (The Creoles), he used colonial architecture. The repeated use of architecture was perhaps inspired by a series of lectures on Mexican architecture given by Federico Mariscal in 1913–14 at the Universidad Popular Mexicana in Mexico City and organized by the Ateneo de la Juventud (Atheneum of Youth). As a member of this group, Herrán in all likelihood attended the lectures and was

aware of their publication in 1915 in the book *La patria y la arquitectura nacional* (The Nation and National Architecture).

The composition of *Old Woman Crocheting*, with a half-figure in the foreground and a view of architecture in the background, is reminiscent of paintings of both the Italian and Northern Renaissance, in which sitters are placed next to a window, a parapet, or a railing through which a landscape or townscape is seen in the distance.

JQ

REFERENCES
Fausto Ramírez. "Notas para una nueva lectura de la obra de Saturnino Herrán." In *Saturnino Herrán, 1887–1987*, exh. cat., Museo de Aguascalientes. Instituto Nacional de Bellas Artes, Mexico, 1987, p. 29, no. 64. **Felipe Garrido, ed.** *Saturnino Herrán*, with texts by Ramón López Velarde. Mexico, 1988, pp. 18, 45, pl. 19.

Saturnino Herrán

Mexican, 1887–1918

Our Gods **mural project,** 1914–18

a. *The Old Gods: The Indians,* 1914
Composition study for the left and finished half
of *Our Gods*
Charcoal and crayon on cardboard; 88 x 30 cm.
(34⅝ x 11⅞ in.)
Adriana Garduño Vda. de García Flores,
Mexico City

b. *The New Gods: The Spaniards,* 1915
Composition study for the right and unexecuted
half of *Our Gods*
Crayon, pastel, watercolor, pencil, and charcoal on
paper; 61 x 177 cm. (24 x 69¾ in.)
CNCA–INBA, Instituto Cultural de Aguascalientes,
Museo de Aguascalientes

c. *The Old Gods: The Offering,* 1917
Study for a portion of the left half of *Our Gods*
Charcoal on paper; 81 x 185 cm. (31⅞ x 72⅞ in.)
CNCA–INBA, Instituto Cultural de Aguascalientes,
Museo de Aguascalientes

d. *The Old Gods: Three Supplicant Indians,* 1917
Study for a portion of the left half of *Our Gods*
Charcoal on paper; 81 x 137 cm. (31⅞ x 54 in.)
CNCA–INBA, Instituto Cultural de Aguascalientes,
Museo de Aguascalientes

e. *Coatlicue Transformed,* 1918
Study for the central figure of *Our Gods*
Crayon and watercolor on paper; 88.5 x 62.5 cm.
(34⅞ x 24⅝ in.)
CNCA–INBA, Instituto Cultural de Aguascalientes,
Museo de Aguascalientes

Efforts to create a nationalistic art were intensified in Mexico following the Spanish-American War of 1898 between Spain and the United States, which strengthened the bonds between Spain and Mexico and led to an increased interest in Spanish art. While they continued to explore their Precolumbian past during the first decade of the century, Mexican artists also began to emulate the Spanish styles of Synthetism, Symbolism, and Expressionism.

Saturnino Herrán was at the center of the cultural and artistic ferment that culminated in the centenary celebrations of Mexican independence in 1910, during which artists and writers explored and discussed their national heritage. He was a member of Ateneo de la Juventud (Atheneum of Youth), founded in October 1909 by a group of young artists and writers who, in their reaction against the positivist philosophy of the Porfiristas, advocates of modern technological advancement, sought inspiration in the ancient Greeks. Beginning in 1906, they published a number of articles in the journal *Savia Moderna,* in which they espoused nature as the basis of Symbolist and Synthetist expression.

The search for a national art led Herrán and other artists to focus on indigenous subjects, but presented within the context of the Spanish-inspired Symbolist manner. A generation earlier a similar movement had evolved during the latter part of the nineteenth century, when Mexican artists used Indian subjects in historical works painted in a Spanish-inspired neoclassical style. Examples of this style, in which the Indian subjects are presented as idealized Greco-Roman figures, are *The Discovery of Pulque* (cat. no. 247), by José Obregón (1832–1902), *The Senate of Tlaxcala* (cat. no. 248), by Rodrigo Gutiérrez (1848–1903), and *The Torture of Cuauhtémoc,* 1892, by Leandro Izaguirre (1867–1941).

Herrán's unrealized mural project *Our Gods,* which he worked on from 1914 to 1918, the year of his death, in similar vein turns to the Indian as the prototype of the indigenous race. Herrán's Indians move in a timeless, idealized past, actors in a mythological world emerging from a confluence of Spanish and Indian cultures to create a new national identity.

Herrán began *Our Gods* in response to a competition held at the Academy of San Carlos for a decorative frieze to be painted for the Teatro Nacional in Mexico City (today the Palacio de Bellas Artes), then under construction. The artist described his subject as an offering by a group of Indians before an Aztec god.

As the conception for the mural was elaborated by Herrán, the overall format evolved into a triptych, with the Aztec earth-mother goddess Coatlicue occupying the central panel and the subjects paying homage to the idol on each side, Indians on the left and Spaniards on the right. Herrán worked out the final segment of the project in 1918, when he superimposed a crucified Christ on Coatlicue to symbolize the coming together of the Indian and Spanish cultures, indigenous pantheism and Spanish Catholicism. The merging of the two races and cultures is thus symbolized by the central motif. The symmetrically balanced composition, with the dominant figure in the center and secondary figures at either side, has its origins in Precolumbian art.

The mural was never completed. What remains is a series of large studies in charcoal and the partially completed left panel.

The first study for *Our Gods,* done by Herrán in 1914, shows a group of Indians in poses of veneration before the Aztec deity Coatlicue, goddess of birth and death. She is known also as the Goddess of the Serpent Skirt and is portrayed with two serpent heads emerging from her neck, which symbolize

a

c

d

the earthbound character of human life. Serpents also replace the hands and feet. Herrán used as his source for the image of Coatlicue the colossal sculpture of the deity in the Museo Nacional de Antropología in Mexico City.

The wavelike pattern created by the three groups of Indians, which begins at the upper left and moves in a downward arc toward the center and then back up toward the deity on the right, is counterbalanced by the outline of a volcano in the distance, the famous Ixtaccíhuatl, or Sleeping Woman, so named because the silhouette resembles the form of a reclining woman.

The compositional study for the right panel, done in 1915, shows three groups of Spaniards—friars, warriors, and townspeople. The group at the extreme right, complementing the Indians in the left frieze, carries a palanquin with the venerated Virgin of the Remedies, a statue that accompanied the expedition of Cortés to New Spain. In the background is the snowcapped volcano Popocatépetl, or Smoking Mountain.

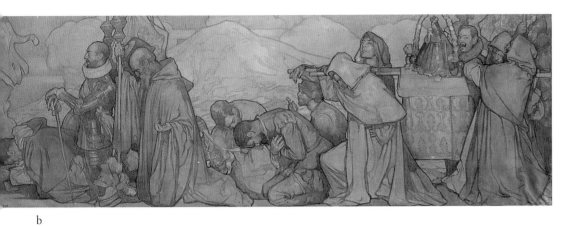

b

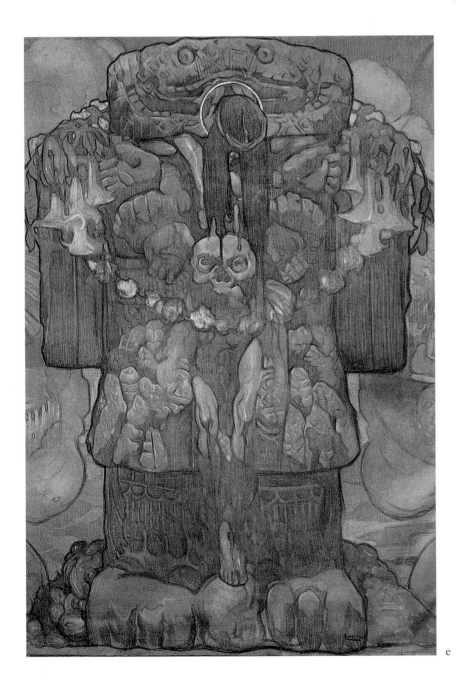

e

The study for Coatlicue transformed contrasts the ferocity of the Aztec goddess with the gentleness of the crucified Christ. Coatlicue, source of life and devourer of all things, is surrounded by flowers and skulls; the hard stone of the idol is contrasted with the soft flesh of the crucified Christ. Together they symbolize Mexico, the mixing of races and the blending of two different worlds, the indigenous with the European.

JQ

REFERENCES
Fausto Ramírez. "Notas para una nueva lectura de la obra de Saturnino Herrán." In *Saturnino Herrán, 1887–1987*, exh. cat., Museo de Aguascalientes. Instituto Nacional de Bellas Artes, Mexico, 1987, pp. 19, 27–28, 39. **Felipe Garrido, ed.** *Saturnino Herrán*, with texts by Ramón López Velarde. Mexico, 1988, pp. 28–29, 109–10, pls. 104–6.

297 ◀ Fernando Leal

Mexican, 1896–1964

Zapatistas at Rest, 1921

Oil on canvas; 150 x 180 cm. (59 x 70 ⅞ in.)
Collection Fernando Leal Audirac, Mexico City

Like many other artists in Mexico during the 1910s and 1920s, Fernando Leal was involved in the open-air painting schools, both as a student and as a teacher. Initiated in Santa Anita in 1913, the program developed in response to student demands for changes in the antiquated curriculum at the Academy of San Carlos in Mexico City (today the Escuela Nacional de Bellas Artes). Unlike the Academy, the many branches of this school promoted open-air painting, popularized by the French Impressionists and the Barbizon School. Students were encouraged to work outdoors directly from nature and from models, in an Impressionist style and palette. The paintings they produced were often romanticized depictions of local Indian peasants set in picturesque landscapes and surrounded by colorful pottery and weavings.

During this time, Emiliano Zapata (about 1879–1919) was leading the fight for agrarian reform. His manifesto, the Plan of Ayala (named for the municipality in which he wrote the document), called for the return of estate land to the peasants. Although Zapata was the most feared of the revolutionary leaders, he was also respected for his single-minded sense of purpose and received widespread support from the Indians in southern Mexico. The men who joined his army were known as Zapatistas, and the women who followed them to attend to their needs were called *soldaderas*. In 1919, after nine years of battle, Zapata was assassinated. His army, demoralized without their leader, soon disbanded. Many of the agrarian reforms that he fought for were, however, adopted by later governments. Zapata's legendary stature did not diminish with his death, and it continued to provide subject matter for the work of the muralists in the decades to follow.

After 1920, with the Revolution over, the open-air painting schools once again received an influx of new students. Among the first to attend at Coyoacán was the twenty-four-year-old Leal. In 1923, Diego Rivera wrote about this school with some disdain: "The young artists cultivated post-impressionism in the agreeable and muted atmosphere of this sympathetic foundation . . . which due to its commodiousness and segregation reminded one insistently of a sanitarium."[1] Elsewhere, however, he suggests the beauty of the site when he mentions "the enchanted pool of Coyoacán."[2] The French artist and writer Jean Charlot, who shared a studio in Coyoacán with Leal, wrote of the arched bay window in their room, which opened out onto "splendid foliage."[3]

It was in 1921 in Coyoacán that Leal painted this large oil on canvas. As the title suggests, *Zapatistas at Rest* depicts soldiers in Zapata's army encamped

in the countryside for a brief respite. The composition is divided down the middle, the two halves united by a harmonica-playing Zapatista. This figure and his two companions at the right are outfitted with accoutrements of both war and leisure. While he plays the harmonica, he keeps his left hand on his rifle; his companion in the upper right wears a belt of bullets and holds a small knife, while his arm rests on a jug of water; and the third man, while captivated by the music, a pink flower dangling from his mouth, remains alert to danger, ready to take up the large knife on the ground. With such divergent symbols Leal represents the dual nature of the Zapatistas, at once fierce soldiers and simple farm workers.

At the left are two Indian peasants, one male and one female. Compositionally they form a single unit, separate from the other three figures. They carry no visible weapons, and are situated between an array of lush fruits in the foreground and a majestic blue mountain in the background. With these attributes, they represent the country and its people—the strength and inspiration of the Zapatista uprising. Uniting these two elements—the peasants and the

Zapatistas—is the harmonica player, on whose sombrero is the emblem of the Virgin of Guadalupe, the patron saint of Mexico, who graces their struggle with her blessings.

Unlike the other work produced in the open-air painting school at this time, Leal here attempts to apply the style taught at the school to a painting with a political theme. While the subject is wholly Mexican, the compositional format, figures, and palette show the influence of the French Post-Impressionist Paul Gauguin, whose work would have been available to Leal in reproduction in books and magazines. This painting was seen as a radical break from the school's accepted formula, and according to Leal's own account it created such a hostile reaction among his fellow students that insults were frequently written on his studio door. Compared, however, to the incendiary imagery of the great muralists who were to follow, Leal's painting seems rather tame—on the surface a gentle genre scene of figures resting in the countryside.

In 1921, the minister of education for the Obregón administration, José Vasconcelos, also a well-known writer and philosopher, paid an unexpected visit to the school and saw Leal's painting on the easel. The artist recalled that Vasconcelos "stopped before the unfinished picture of Zapatistas. At the time I was the first to paint a revolutionary theme, to everybody's disgust and especially to that of Ramos Martínez [the director of the school], who couldn't understand why anyone would paint an Indian with a cartridge belt and pistol when it was more like Millet to paint him holding a folk vase. To the dismay of all present, Vasconcelos stated that I could paint on the walls of the Preparatoria, and invited me to see him at his office at the university the next day."[4] And thus began Leal's participation in the state-run program of mural painting.

LMM

1. Rivera quoted in Jean Charlot, *The Mexican Mural Renaissance 1920–1925* (New Haven and London, 1967) p. 52.
2. Charlot, *Mexican Mural Renaissance*, p. 52.
3. Charlot, *Mexican Mural Renaissance*, p. 181.
4. Charlot, *Mexican Mural Renaissance*, p. 166.

298 ◀ **Fernando Leal**
Mexican, 1896–1964

The Boxer (Tommy Loughran), 1924
Oil on canvas; 55.5 x 40.5 cm. (21 ⅞ x 16 in.)
Collection Fernando Leal Audirac, Mexico City

In 1924, three years after painting *Zapatistas at Rest* (cat. no. 297), Leal produced this engaging portrait of the American boxer Tommy Loughran (1902–1956). In style and color it is very different from *Zapatistas*, and relates much more closely to the teachings of the open-air school. One can immediately recognize the combined influence of such nineteenth-century French painters as Cézanne, Manet, and Toulouse-Lautrec, whose works Leal could have studied in books and magazines. Leal's portrait bears a striking resemblance to a portrait Cézanne did of his son Paul in 1885 (National Gallery of Art, Washington, D.C.). Although the two pictures are oriented differently—like mirror images of each other—both models are posed in three-quarter view and wear a jacket and bowler hat. There are even general similarities between their features—their heavy, square jawlines and the intensity of their gaze. It is not, however, known whether Leal ever saw the portrait by Cézanne or whether he was just following an established tradition of portrait painting.

Tommy Loughran, known as the Phantom of Philly, was born in Philadelphia in 1902. He fought professionally from 1919 to 1937, competing in 227 bouts around the world. He began his career as a light-heavyweight boxer, holding the championship title in this division from 1927 to 1929 before becoming a heavyweight boxer. After his retirement from the ring, he became a sugar broker in New York. In 1956, the year of his death, Loughran was elected to the Boxing Hall of Fame.

Although there is no record of Loughran having fought in Mexico in 1924, the year of this painting, Leal depicts him in front of various billboard signs written in Spanish, which suggests that he was there. Overlapping and cut off, the messages are obscured, but seem to refer to the boxing arena, the score, and the fighter himself: *luneta* (orchestra), *galería* (dress circle), *marcador* (scoreboard), and *boxeo* (boxing). Above Loughran's broad shoulder are the first three letters of his name. The portrait, with the sitter surrounded by the accoutrements of his profession, recalls paintings by Manet, such as *Portrait of Emile Zola*, 1868 (Louvre, Paris), in which a similar device is used.

Leal portrays Loughran as a gentleman, smartly dressed in a brown jacket, light blue shirt, red tie, bowler hat, and daisy boutonniere. His muscular frame is emphasized by the dramatic close-up perspective, which pushes the figure up to the picture plane. Leal has focused attention on the boxer's large hands—the tools of his trade—creating an amusing contrast between the delicate flower and the thick fingers, as the boxer attempts to pin it to his lapel.

LMM

299 ◀ **José Clemente Orozco**
◀ Mexican, 1883–1949
◀
◀ ***Dance in a Brothel***, about 1913
◀ Oil on canvas; 75.6 x 97.8 cm. (29¾ x 38½ in.)
◀ Private collection

José Clemente Orozco's reputation rests on the visual power of the large mural cycles that he painted in Mexico and in the United States from 1923 to 1949. Like many of his colleagues, Orozco painted his first murals at the Escuela Nacional Preparatoria in Mexico City under the national mural program initiated by José Vasconcelos. Throughout his career, however, he also produced over five hundred easel paintings, ten of which are in this exhibition. Although they are much smaller than the architectural scale of his mural compositions (none here measures more than 55 x 45 inches), in subject and style they are closely related to his mural paintings. In some cases, the imagery of the canvases is based directly on specific motifs in the murals, many of which were completed years earlier.

Orozco did not initially set out to be an artist. As a young man he studied both agricultural engineering and architecture. By 1906, however, he had decided to become an artist, and at the age of twenty-three he enrolled at the Academy of San Carlos in Mexico City. There, during his eight years of study, he met the artist Dr. Atl, with whom he later worked, as a caricaturist, at the newspaper *La Vanguardia*.

In 1912, Orozco moved to his first studio in Mexico City, which was located in a poor neighborhood renowned for its brothels. Toward the end of his life, he wrote candidly in his autobiography about this experience and the subjects that inspired him: "I opened a studio in Illescas Street . . . in a neighborhood plagued with luxurious houses of the most magnificent notoriety which sheltered 'embassies' from France, Africa, the Caribbean, and North and Central America. Out in the open air the Barbizonians were painting very pretty landscapes, with the requisite violets for the shadows and Nile green for the skies, but I preferred black and the colors exiled from Impressionist palettes. Instead of red and yellow twilight, I painted the pestilent shadows of closed rooms, and instead of the Indian male, drunken ladies and gentlemen."[1]

These shadowy figures of the night are depicted with considerable pathos —and humor—in Orozco's early painting *Dance in a Brothel*, a summation of the many watercolors and drawings he produced on this theme. Here are all

manner of women on display—fat and thin, blond and brunet, Indian, black, and Caucasian—dancing together in a dimly lit interior. At either side of the composition, cut off by the canvas edge, a man appears dressed in a dark suit. One gropes a prostitute elegantly attired in a flowing pink gown, while the other, head bent and wearing a hat, sits patiently awaiting his turn. Both men are completely anonymous and almost incidental to the main action of the painting. Similarly, we can almost overlook the telling piece of furniture in the far center of the room—the large brown bed.

For Orozco, the true story of this danse macabre is told in the faces and physiques of the women. Their features are grotesquely distorted and illuminated as if in caricature, yet they are given distinctive personalities that make us relate to them as individuals caught up in a desperate and absurd situation. Such specific characterization and appeal to the plight of the individual was eliminated in Orozco's later figure paintings, where people are more usually relegated to an anonymous, faceless mass and the focus of the picture is directed toward societal ills rather than individual concerns.

In May 1916, Orozco participated in a group exhibition at the Escuela Nacional de Bellas Artes, where he showed some of his brothel pictures done in watercolor. The review quoted here describes images that could easily be applied to *Dance in a Brothel*: "Orozco's art is disquieting, spectral, tortured. He is the Marquis de Sade of our painters.... These are nightmarish [images] where human monsters shake in a convulsive dance their rotted flesh, amidst an asphyxiating fog compounded of alcohol fumes, tobacco, and stale pomade, wasted faces dripping doped sweat along the fatty whiteness of cosmetics."[2]

Later that year, in September 1916, Orozco held his first one-man show in Mexico City. He exhibited 106 paintings and drawings on the theme of prostitutes and schoolgirls, plus seventeen political caricatures. Because most of these works were considered indecent, they could not be shown at a gallery and had to be seen instead in a private home. The exhibition was not well received, either by the public or the press, to the bitter disappointment of the artist. Their rejection of his work initiated a fallow period in his art, from 1916 to 1922, when his artistic talent was largely ignored. Orozco wrote to a friend with wry humor, "These people have ceased even to insult me."[3]

In 1917, Orozco decided to leave Mexico and try his luck in the United States. He crossed the border at Laredo, Texas, carrying with him about ninety of the recent brothel pictures. Unfortunately, American authorities also condemned the works as immoral and some seventy of them were destroyed by U.S. Customs agents. *Dance in a Brothel* is perhaps the only surviving painting of this series. This inauspicious beginning marked the tenor of Orozco's first stay in the United States, where he made a living painting street signs and faces on dolls. Disheartened, he returned to Mexico in 1920 and built a studio in Coyoacán. There he earned a meager living making caricatures. It is believed that he produced very little new work until 1923, when he began to paint the murals at the Escuela Nacional Preparatoria.

Several years after he had completed *Dance in a Brothel*, Orozco again revived the theme of prostitution in a fresco that he painted in 1934 at the Palacio de Bellas Artes in Mexico City. In the work *Catharsis*, he used the prostitutes as symbols of social corrosion, painting them with an uncompassionate ferocity not evident in the earlier painting.

In 1940, *Dance in a Brothel* was included in the large exhibition *Twenty Centuries of Mexican Art*, at the Museum of Modern Art in New York.

LMM

1. Orozco quoted in *¡Orozco! 1883–1949*, exh. cat., Museum of Modern Art (Oxford, 1980) p. 6.
2. Raziel Cabildo. "La exposición de la Escuela Nacional de Bellas Artes," *Revista de Revistas*, May 7, 1916. Quoted in Jean Charlot, *The Mexican Mural Renaissance 1920–1925* (New Haven and London, 1967) p. 217.
3. Orozco quoted in José Juan Tablada, "Orozco, the Mexican Goya," *International Studio* 78 (1924) p. 498

REFERENCE
Museum of Modern Art. *Twenty Centuries of Mexican Art*, exh. cat. New York, 1940, p. 154, no. 118.

300 ◀ **José Clemente Orozco**

Mexican, 1883–1949

The White House, about 1925–27

Oil on canvas; 62 x 76 cm. (24⅜ x 29⅞ in.)
CNCA–INBA, Museo de Arte Alvár y Carmen T. de Carrillo Gil, Mexico City

Orozco's first real success as an artist came with his large mural cycle for the Escuela Nacional Preparatoria in Mexico City, which he produced from 1923 to 1926. The murals were on three floors and decorated the northern hallways around a large inner patio. In these compositions Orozco clearly rejects the picturesque folkloric imagery made popular by Diego Rivera and other nationalistic painters. In 1923, Orozco wrote eloquently of his objections to that aesthetic: "We Mexicans are the first ones to blame for having concocted and nurtured the myth of the ridiculous charro and the absurd china as symbols of so-called Mexicanism.... Why pick the most outdated and most ridiculous attributes of a single social class and inflict them on the whole country?"[1] For Orozco, art was to be used in the service of expressing universal rather than national truths: "Painting in its higher form and painting as a minor folk art differ essentially in this: the former has invariable universal traditions from which no one can separate himself... the latter has purely local traditions."[2]

Like the other muralists of the Escuela Nacional Preparatoria project Orozco dealt with the theme of the Mexican Revolution, but his imagery was presented in terms of religious iconography. To reinforce this association, he adopted a style of painting that was influenced by fifteenth- and sixteenth-

century Italian frescoes. His experience during the early part of the Revolution was more as an observer than as an active participant. Although he sided with Venustiano Carranza against Pancho Villa and Emiliano Zapata, and worked as an illustrator for the Carrancist newspaper *La Vanguardia*, he was not deeply involved in the struggle of the Revolution and by the end of the war had left Mexico for the United States.

Nevertheless, the Revolution provided Orozco with a wealth of powerful visual material upon which he could draw in later years. In his autobiography, written in the 1940s, he describes what he had witnessed: "Trains back from the battlefield unloaded their cargoes in the station of Orizaba; the wounded, the tired, exhausted, mutilated soldiers, sweating In the world of politics it was the same, war without quarter, struggle for power and wealth, factions and sub-factions past counting, the thirst for vengeance insatiable. . . . Farce, drama, barbarity. . . a parade of stretchers with the wounded in bloody rags, and all at once the savage pealing of bells and a thunder of rifle fire . . .'La Cucaracha' accompanied by firing."[3] It was what he referred to ironically as the "most diverting of carnivals."[4]

Such images were to become major, recurrent themes in Orozco's work. In *The White House*, we sense the terror and desolation wrought by years of bloody fighting. Three shrouded figures flee from an unseen aggressor, the horror of the moment reflected in their faces.

The two-point perspective used to depict the house creates an unexpected recession into space and a strong vertical anchor to the horizontal thrust created by the fleeing women. It was a device that Orozco regularly employed. The motif of isolated figures outside a square house with a blackened door or window also recurs in his work. A few years after painting *The White House*, Orozco depicted a similar scene in *The Stone House* (cat. no. 304), in which a sense of foreboding replaces the more immediate threat seen here.

The White House was one of six oil paintings that the artist brought with him to New York in 1927, where he remained until 1934. When Alma Reed, the owner of the New York City art gallery Delphic Studios, visited him in his Chelsea studio, she asked to see the canvases that Orozco had stacked against a wall. As he turned them around for her inspection, he remarked, "You will not find them cheerful."[5] Among this group was *The White House* and *The Dead* (cat. no. 302). Eventually, both paintings came into Alma Reed's collection, after which they were bought by Alvár Carrillo Gil, who from 1936 to 1953 formed one of the largest collections of Orozco's work. These holdings eventually formed the core of the present-day collection at the Museo de Arte Alvár y Carmen T. de Carrillo Gil in Mexico City.

LMM

1. Orozco, quoted from an unpublished manuscript of 1923 in Jean Charlot, *The Mexican Mural Renaissance, 1920–1925* (New Haven and London, 1967) p. 66.
2. Orozco, quoted from "Notes on the Early Frescoes at The National Preparatory School" of 1923 in Dawn Ades, *Art in Latin America: The Modern Era, 1820–1980*, exh. cat., The Hayward Gallery (London, 1989) p. 168.
3. Orozco, quoted in "A Comparative Chronology," in *¡Orozco! 1883–1949*, exh. cat., Museum of Modern Art (Oxford, 1980) p. 7.
4. Orozco, quoted in David Elliott, "Orozco: a Beginning," in *¡Orozco! 1883–1949*, p. 16.
5. Orozco, quoted in Alma Reed, *Orozco* (New York, 1956) p. 25.

REFERENCES
Justino Fernández. *Obras de José Clemente Orozco en la colección Carrillo Gil*. Mexico, 1949, vol. I, p. 32, no. 30. **Renato González Mello**. "*Driftwood*, atribución de fecha a un cuadro de J. C. Orozco." Tesis de Licenciatura, Universidad Autónoma de México, 1989, pp. 14–15.

301 ◄ José Clemente Orozco

Mexican, 1883–1949

Combat, about 1925–27

Oil on canvas; 66.7 x 85.7 cm. (26¼ x 33¾ in.)
CNCA–INBA, Museo de Arte Alvár y Carmen T.
de Carrillo Gil, Mexico City

Some five to seven years after the end of the Revolution, Orozco painted *Combat*, one of his most powerful portrayals of the carnage and destruction that left two million people dead.

Against a bright blue background, flat as a wall, a mass of writhing bodies is shown locked together in a bitter struggle of life and death. The faces of the soldiers are dark and mostly concealed and, where visible, completely anonymous. Their bodies are almost indistinguishable from one another as they form a pile of human limbs and torsos. The movement within the picture is insistent and rhythmical. The two central figures, who wear bright white shirts, lunge dramatically to the right, creating a diagonal across the canvas from lower left to upper right. Other figures move in opposition to them, some with daggers raised.

The scene is painted with slashing brushstrokes in somber tones of gray and brown interspersed with shots of red and white. The strong dark and light contrasts make it difficult to focus on the specific, often graphic, details of the scene. The sublimation of narrative detail to formal unity is characteristic of Orozco's work at its most expressive. It is, however, hard to ignore the gruesome sight of the clenched fist thrusting a dagger upward into the white-clothed chest of the central figure. Curiously, though the act seems plausible, there is no blood. This is combat in the abstract, universal sense; the men symbolize the martyrdom and dignity of those who fight for their ideals.

The dramatic image of a pointed blade sticking through a body was repeated by Orozco in his 1934 mural *Catharsis*, at the Palacio de Bellas Artes in Mexico City, and again in his 1936–39 mural *Hidalgo*, at the Palacio de Gobierno de Guadalajara.

For most of his life, Orozco lived modestly, supporting his mother, wife, and three children on a limited income. When he prepared to leave Mexico for the United States in 1927, at the age of forty-four, it was necessary for him to sell this painting in order to pay for his train ticket and to have enough money to survive in New York for three months. Orozco sold *Combat* to Genaro Estrada,

then Mexico's minister of foreign relations. It was later acquired by Alvár Carrillo Gil from an art gallery in Mexico.

<div align="right">LMM</div>

REFERENCE
Justino Fernández. *Obras de José Clemente Orozco en la colección Carrillo Gil*. Mexico, 1949, vol. I, p. 31, no. 29.

302 ◀ **José Clemente Orozco**
Mexican, 1883–1949

The Dead, about 1926–27
Oil on canvas; 54.9 x 60 cm. (21⅝ x 23⅝ in.)
CNCA–INBA, Museo de Arte Alvár y Carmen T.
de Carrillo Gil, Mexico City

In the painting *The Dead* Orozco conveys an overwhelming sense of tragedy with an extreme economy of color and form. The setting is claustrophobic, with little sense of depth. The figures in the composition—a corpse and two rows of mourners—are pushed forward, up against the picture plane. Watching the scene over the shoulders of the silhouetted women, the viewer too becomes one of the mourners.

The immediacy of the composition enhances its emotional impact, as does its dramatic chiaroscuro. Orozco's contrasting of light and dark for expressive purpose may relate to his earlier experience as a caricaturist, when he worked exclusively in black and white. His caricatures from that time were influenced by the engravings of José Guadalupe Posada (1852–1913), whose work Orozco knew as a student and admired. Deep blacks and browns are used in *The Dead* to depict the meager surroundings and the shrouded mourners, whose faces are barely visible beneath their rebozos. Only the corpse, completely wrapped in white cloth, and the flickering candles placed on each corner of the woven *petate* are illuminated in the hermetic setting. In this painting is reflected the sorrow and destruction inflicted upon Mexico's poor by the long years of war; the immediacy of the image makes us forget that it was painted several years after the end of the Revolution.

The composition is closely related to a pen-and-ink and wash drawing that Orozco made, entitled *The Cemetery*, which was one of about fifty such illustrations which he produced between 1926 and 1927 in the series The Horrors of the Revolution, also known as Mexico in Revolution. This particular episode is set outdoors near a large building and is filled with several closed caskets, covered corpses, grieving women, and a lone soldier leaning on his gun. In the background is the scene that Orozco has isolated and enlarged in *The Dead* —that of a draped corpse surrounded front and back by seated women and candles. In the drawing, however, Orozco includes only four women in the back row and one in the front. Based on the close relationship between these two works, we may assign *The Dead* a date of about 1926–27.

The Dead is related thematically to Francisco Goitia's painting *Tata Jesucristo* (cat. no. 289), which also dates from 1926–27 and shows two women in anguished mourning. As in Orozco's painting, their features are mostly obscured by heavy shadow and they sit in a darkened space illuminated by candlelight. It is not known whether either Orozco or Goitia saw the other's work and was perhaps inspired to paint his own version. We do, however, know that the two artists never liked each other personally.

Like *The White House* (cat. no. 300), *The Dead* was one of six paintings that Orozco brought to New York when he moved there in 1927. Alma Reed, an American enthusiast of Mexican art, saw it in Orozco's New York studio and later commented, "Each painting... exerted the mesmeric fascination of the tragic scene, though an element of mysticism dominated the macabre.... The paintings approached death's mystery with the authority of timeless, universal statement."[1]

By 1930, *The Dead* was in Alma Reed's collection and was included in the large *Mexican Arts* exhibition that traveled to eight museums in the United States in 1930 and 1931. The tour began at The Metropolitan Museum of Art in New York in October 1930. Orozco's seven oils and four drawings exceeded the number of works by any other contemporary artist, including Diego Rivera. During the exhibition's four-week showing at the Metropolitan, Orozco made several visits to the museum. One critic wrote of Orozco's "stark, turbulent and Goya-like paintings with their intensity of mood that explains the Mexican artist's success in the United States as a decorator of public buildings."[2]

LMM

1. Alma Reed. *Orozco* (New York, 1956) pp. 25–26.
2. Ralph Flint. "Metropolitan Holds Big Show of Mexican Art," *Art News* 29 (October 18, 1930) p. 5.

REFERENCES
Justino Fernández. *Obras de José Clemente Orozco en la colección Carrillo Gil*. Mexico, 1949, vol. I, p. 32, no. 31. **Renato González Mello**. "*Driftwood*, atribución de fecha a un cuadro de J. C. Orozco." Tesis de Licenciatura, Universidad Autónoma de México, 1989, pp. 13–14.

303 ◀ **José Clemente Orozco**

Mexican, 1883–1949

The Third Avenue Elevated, New York
1928
Oil on canvas mounted on Masonite;
51 x 61 cm. (20⅛ x 24 in.)
Private collection, Mexico City

People always figured prominently in Orozco's work, almost to the exclusion of landscape and surroundings. They were the means through which he expressed his observations and concerns about the plight of mankind. It is therefore odd that his paintings of New York City—produced between 1928 and 1930 in one of the most populated centers in the world —should be so devoid of human life. In nearly all these paintings, Orozco focused his artistic eye on the dreary mechanical facades of the city's buildings, construction sites, bridges,

subways, and elevated trains, even though he is known to have frequented the nightclubs of Harlem, the ethnic neighborhoods of Lower Manhattan, and the crowded beaches at Coney Island. In the few paintings where he did include figures, they are depicted as inactive, anonymous automatons. Such bleak images seem to have been reflections of the artist's own feelings of isolation and loneliness at the time, as he entered a new country without family or friends, and without a command of the language.

Although his autobiography gives no adequate explanation for his trip to New York—he writes simply, "There was little to hold me in Mexico in 1927"[1]—it may be assumed that a major factor was the lack of artistic recognition in his native country. His exhibitions had met with little enthusiasm and had resulted in few sales, and since painting the large mural cycle at the Escuela Nacional Preparatoria in 1923 he had executed only two additional murals; most of the important mural commissions in Mexico were being given to Diego Rivera, whom Orozco openly disliked. Furthermore, Orozco had repainted most of his murals at the Escuela Nacional Preparatoria in 1926 because they had been destroyed by student protesters, and public reaction to his revisions was negative.

By 1927, New York must have seemed like the land of opportunity for this still-struggling forty-four-year-old artist. Orozco arrived in New York for the second time by train, on December 16, 1927. He took up residence for a few months in a small apartment on West Twenty-third Street before moving to Riverside Drive, near Columbia University. He soon became a regular visitor at the home of Alma Reed and Eva Sikelianos, two women interested in and knowledgeable about the arts. With their help, Orozco's work began to be shown in New York, and between 1927 and 1934 his easel paintings, drawings, and prints were included in eight one-man shows and four group shows in the United States. Despite this growing recognition, Orozco still chafed at the common notion that Rivera was the greatest Mexican painter of his day.

He wrote bitterly, "The idea that we are all his disciples is very well entrenched here."[2]

Even more important than the reception accorded Orozco's easel paintings was the fact that during his stay in America he received three mural commissions, which greatly enhanced his reputation both here and in Mexico. The commissions were from Pomona College, Claremont, California (1930), The New School for Social Research, New York City (1930), and Dartmouth College, Hanover, New Hampshire (1932–34). These murals paved the way for his return to Mexico in 1934 as a respected muralist, and in Mexico over the next fifteen years he completed the thirteen mural projects that are considered his greatest legacy.

In his almost seven years in New York, Orozco produced many works on the theme of the Mexican Revolution, which often repeated imagery found in his earlier paintings. Included among this group are three paintings in this exhibition—*The Stone House*, 1929 (cat. no. 304), *Pancho Villa*, 1931 (cat. no. 305), and *Barricade*, 1931 (cat. no. 306). Although the style of these pictures became increasingly expressionistic, their subject matter remained rooted in his pre-1927 Mexican work. In contrast to these images is the series of some fourteen paintings of New York City that Orozco did between 1928 and 1930. Both in subject and in style these pictures mark a decisive break from his Mexican work.

During this brief period of experimentation at the beginning of his New York stay, Orozco painted machinery and urban construction in a manner that recalls Cubism and Fauvism, styles he surely encountered in museums, galleries, and magazines in New York. However, from the disparaging remarks that he made about Picasso's work, it seems more likely that he drew more direct inspiration from the American version of these movements—the Precisionism of Charles Sheeler and Charles Demuth. After visiting the American painting galleries at The Metropolitan Museum of Art, he remarked, "The only true American artists are those who paint machines."[3]

The Third Avenue Elevated, New York is one of Orozco's most complex and abstract compositions of the New York City series. Painted in disturbing tones of ocher, brown, and green, the picture depicts one of the entrances to the elevated train station. Although the Third Avenue El no longer exists, there are still today in the boroughs of New York very similar stations. At either side Orozco painted the staircases, with their peaked roofs, that lead from the street to the central turnstile area. The enclosed building, open platform, and tracks are all suspended above the street by large steel girders. Orozco once commented on their construction to Alma Reed, "How absurd a thing is the Elevated. . . . It is not quite on the ground and it is not quite up in the air. And yet it completely spoils our enjoyment of both."[4]

This *Elevated* is the first of two versions. The second version is a slightly larger, vertical composition that is even flatter and more abstract (Museo de Arte Alvár y Carmen T. de Carrillo Gil, Mexico City). Both paintings were shown in New York in 1929—at the Downtown Gallery in a one-man show that featured Orozco's New York City paintings and drawings, and in a large installation of 113 of his works at The Art Students League of New York, which was arranged by the American muralist Thomas Hart Benton. A year later, Benton and Orozco both worked on separate murals at The New School for Social Research, and it is there that Benton's young student Jackson Pol-

lock is said to have met Orozco. The influence of Orozco's work is very evident in Pollock's early paintings and drawings from the 1930s.

In 1930, at the time of Orozco's show at the Delphic Studios, Lloyd Goodrich wrote, "Orozco's pictures of New York are far from realistic; they are symbolic images, not always complete and sometimes crude, but capturing certain essential qualities of the city in a peculiarly penetrating way."[5]

LMM

1. José Clemente Orozco, *An Autobiography*, translated by Robert C. Stephenson (Austin, 1962) p. 123.
2. Orozco, quoted in Edward Lucie-Smith, *Lives of the Great 20th Century Artists* (New York, 1986) p. 208.
3. Letter to Jean Charlot, in José Clemente Orozco, *The Artist in New York: Letters to Jean Charlot and Unpublished Writings, 1925–1929*, translated by Ruth L. C. Simms (Austin and London, 1974) p. 32.
4. Orozco, quoted in Alma Reed, *Orozco* (New York, 1956) p. 28.
5. Lloyd Goodrich, "In the Galleries: The Delphic Studios," *Arts* 16, no. 6 (1930), p. 423.

304 ◀ José Clemente Orozco

Mexican, 1883–1949

The Stone House, about 1929

Oil on canvas; 43.5 x 60.5 cm. (17⅛ x 23⅞ in.)
Private collection, Mexico City

Although painted in New York, *The Stone House* recalls the composition and subject matter of Orozco's earlier Mexican paintings, such as *The White House*, 1925–27 (cat. no. 300). In both these pictures, a group of figures is seen in an anonymous landscape dominated by a light-colored house with darkened windows and door. However, unlike *The White House*, where the terror expressed by the fleeing figures is enhanced by the energized brushwork, *The Stone House* is pervaded by stillness.

Orozco here exerts a stabilizing hand over the arrangement of figures and setting, forming them into a well-balanced composition that is complemented by a modulated application of paint. The rigid geometry of the structure may reflect Orozco's recent study of the theories of Dynamic Symmetry, put forth by Jay Hambidge.[1] In the painting three young children, whose bright faces look questioning and innocent, are pressed between two darkly ominous figures and their shadows. They seem to be waiting, immobilized. Why they are here and where they are going are not known.

In February 1930, *The Stone House* was included among the twenty-three oils and gouaches that Orozco exhibited at the Delphic Studios in New York City. The same year, Orozco painted similarly styled children in a section of his mural *Home*, at The New School for Social Research, also in New York. The panels at The New School reflect what Orozco later called "the overrigorous and scientific methods of Dynamic Symmetry," which he abandoned after completing that project.[2]

Although strongly rooted in Orozco's Mexican themes, *The Stone House* was created in about 1929, the year of the Great Crash. Orozco's later comments about this devastating event reflect the same gloom and deathly stillness portrayed in the painting: "Factories closed and immense negotiations at a standstill. Panic. Suspended credit. . . . By night in the protection of shadows, whole crowds begged in the streets for a nickel for coffee and there was no doubt, not the slightest, that they needed it. This was the Crash. Disaster."[3]

LMM

1. See Laurence P. Hurlburt, "Notes on Orozco's North American Murals: 1930–34," in *¡Orozco! 1883–1949*, exh. cat., Museum of Modern Art (Oxford, 1980) p. 53.
2. Hurlburt, "Notes on Orozco," p. 53.
3. "A Comparative Chronology," in *¡Orozco! 1883–1949*, p. 8.

305 ◀ José Clemente Orozco

Mexican, 1883–1949

Pancho Villa, 1931

Oil on canvas; 61 x 49.5 cm. (24 x 19½ in.)
CNCA–INBA, Museo de Arte Alvár y Carmen T. de Carrillo Gil, Mexico City

With the passage of time, the legendary exploits of Mexico's two great revolutionary leaders, Pancho Villa (from the North) and Emiliano Zapata (from the South), grew to even greater proportions, and the violence and bloodshed that followed in their wake were interpreted as acts of national heroism and liberation.

In the 1920s and particularly in the 1930s, Villa and Zapata became romanticized heroes in historical discourses, novels, films, and paintings. Frida Kahlo, for example, put Villa's portrait in a place of prominence in her painting *La Adelita, Pancho Villa, and Frida*, 1927 (cat. no. 358), and Orozco painted several pictures of Zapata in 1930. The following year he painted this picture of Pancho Villa, here depicted as a tyrannical leader; previously he had been treated with humor, as in the 1915 caricatures for *La Vanguardia*. It is interesting to speculate whether the 1931 publication of Rafael F. Muñoz's book *Vámonos con Pancho Villa* (Let's Join Up with Pancho Villa)—later made into a movie—played any part in Orozco's decision to paint his own version of the rebel leader the same year.

In this relatively small painting (24 x 19½ inches), Orozco depicts Villa as a ruthless and powerful bandit. His inflated figure dominates the composition with its immense size and stark white clothing. He stands, like the eye of a storm, expressionless in the middle of the maelstrom. At the right is a group of soldiers and all around them evidence of their violent rampage. In the distance a building burns wildly, with blood-red flames shooting from the roof. On the street below a stampede of people run for their lives. Between Villa's open legs is the cadaverous stare of an ashen head and to the left a pair of lifeless feet. Even more disturbing are the two naked and distorted figures, who cower below Villa at the moment of their execution.

Pancho Villa's given name was Doroteo Arango Arámbula; he was born in the state of Durango in 1878. At the age of sixteen he murdered a local man and fled town, assuming the name of Francisco Villa. As an outlaw, he devel-

oped tactics of guerrilla warfare that subsequently served him well as a leader of the Revolution. His men attacked swiftly and unexpectedly, and often at night. He himself was a skilled marksman and horseman, and at the height of his power he commanded a cavalry troop of some ten thousand men.

Pancho Villa's involvement in the Revolution began in 1910, when he joined the peasant uprisings in the North against the government of Porfirio Díaz. Over the next thirteen years he continued to oppose many subsequent governments, often changing allegiances from year to year. Enemies became allies and allies, enemies. In 1915, after the U. S. government officially recognized the presidency of Venustiano Carranza (a former ally but by then an enemy of Villa's), he began to attack towns in the United States that lay along the Mexican border. In retaliation, the United States sent General John ("Black Jack") Pershing and his troops to push Villa back into Mexico. After long years of fighting, Villa was murdered in an ambush on July 20, 1923.

A year after painting *Pancho Villa*, Orozco began work on a large mural commission for Dartmouth College, in Hanover, New Hampshire. The mural, which depicts on an epic scale the development of American civilization, took two years to complete. In one section, called *Hispano-América*, Orozco quotes Villa's pose and clothing from the easel painting, but interestingly, he replaces his head with that of Zapata. This change was perhaps made because by comparison with Villa, Zapata was a more sympathetic character; in the mural he is presented as a martyr about to be killed.

In a passage written a few years earlier, Orozco explained what it meant to be a revolutionary leader: "Every advance that the Hispanic-American peoples have made in the way of civilization, every improvement in their social organization, education of the masses, distribution of wealth or political reform, has been at the cost of the blood of the rebellious people; and the leader, the rebel, has been always sacrificed in the struggle, falling in the battlefield or murdered by the reactionaries."[1]

LMM

1. Orozco, quoted in Alma Reed, *Orozco* (New York, 1956) p. 194.

REFERENCE
Justino Fernández. *Obras de José Clemente Orozco en la colección Carrillo Gil*. Mexico, 1949, vol. 1, p. 35, no. 41.

306 ◄ **José Clemente Orozco**
◄ Mexican, 1883–1949

◄ *Barricade*, 1931
◄ Oil on canvas; 139.7 x 114.3 cm. (55 x 45 in.)
◄ The Museum of Modern Art, New York. Given
◄ Anonymously

By the early 1930s, Orozco's work had gained wider acceptance among American collectors and his sales and commissions had significantly increased. The revenues from these sales were sufficient for him to bring his wife and three children to New York in April 1931. There, they lived in an apartment on West Forty-fourth Street, while Orozco painted in a skylit duplex in the same building. During the months that followed their arrival, until the spring of 1932 when he began the Dartmouth murals in Hanover, New Hampshire, Orozco worked prolifically in oils. His first paintings of this period were done on small canvases.

One of the frequent visitors to his studio was the prominent art collector Stephen C. Clark, who was also a trustee of the Museum of Modern Art, New York. Orozco wrote in a letter of May 1931: "Clark came very early this

morning and he liked very much the paintings I am doing. . . . He told Alma [the art dealer Alma Reed] that I am one of the greatest artists of today. . . . He says that what I need now is to paint large and very important paintings in order to have an exhibition at the Museum of Modern Art. He will buy five or six at the price of $2,500 each for his own collection, which later on will be given to the Museum."[1]

At Clark's suggestion, Orozco began painting large canvases, three of which Clark purchased in 1931 for a total of $7,500: *The Zapatistas*, *The Trench*,[2] and *The Cemetery*. As promised, all three were given anonymously to the Museum of Modern Art, in 1937. To Orozco's annoyance, Alma Reed took half the receipt as her commission. When *The Trench* was included in Reed's 1932 book on Orozco, it was published with a new title, *Barricade*, by which it has been known ever since. This was perhaps done to distinguish it from Orozco's 1926 mural version, also called *The Trench*, which was part of the commission for the Escuela Nacional Preparatoria.

The two versions are closely related in terms of subject but have significant differences in execution. First, they are done in two very distinct media— one fresco, the other oil on canvas. There is also a notable difference in the manner in which Orozco depicted the images. In the mural he worked in a classical and uniformly modeled style, which heightened the realistic, sculptural quality of the figures, drapery, and scaffolding. In the canvas, by contrast, he combined passages of exaggerated realism—the muscles of the men's arms and chests, for example, and the red cloth at the top right—with abstract areas either sketchily brushed in or flatly painted.

In both the fresco and the oil painting, the basic composition remains the same. A bare-chested man, his body taut, is placed diagonally across the center. To the left another man, wearing two bands of bullets across his chest, bends slightly in the same direction, his back to the viewer and his right arm outstretched. This dramatic gesture is also found in Orozco's 1930 mural *Prometheus*, at Pomona College, Claremont, California. The figures as a unit give the impression of the crucified Christ on the cross. In the mural a kneeling soldier grieves below them to the right. In the painting Orozco replaces this figure with three figures, all seen in profile, stacked one upon the other. While the 1926 mural seems to present a scene of death and defeat, the 1931 painting depicts figures still engaged in battle.

For many of his larger paintings and murals, Orozco produced full-size drawings that were squared for transfer. One such study exists for *Barricade*. It reflects the same roughness of expression in its pencil markings as is seen in the brushwork of the final painting.[3]

LMM

1. Letter from Orozco to his wife in Detroit, May 26, 1931, published in José Clemente Orozco, *Cartas a Margarita 1921–1949* (Mexico, 1987) p. 241. Translation from the Spanish by Maria Balderrama.
2. See list of works for 1931, reproduced in Clemente Orozco V., *Orozco, verdad cronológica* (Guadalajara, Mexico, 1983) p. 247. In this list, Orozco refers to this painting as *Trinchera* (*The Trench*).
3. Orozco V., *Orozco, verdad cronológica*, p. 163, where it is identified as a preliminary sketch for the mural at the Escuela Nacional Preparatoria and dated 1926.

REFERENCE
Jacinto Quirarte. "Mexican and Mexican American Artists: 1920–1970." In *The Latin American Spirit: Art and Artists in the United States, 1920–1970*, exh. cat., The Bronx Museum of the Arts. New York, 1988, p. 34.

307 ◀ **José Clemente Orozco**

Mexican, 1883–1949

Self-Portrait, 1940

Oil and gouache on cardboard; 51.4 x 60.3 cm.
(20¼ x 23¾ in.)
The Museum of Modern Art, New York.
Inter-American Fund

As a teenager, Orozco suffered a serious accident while playing with gunpowder. The explosion caused him permanent hearing loss and severe eye damage that required him to wear thick glasses for the rest of his life. It also resulted in the loss of his left hand at the wrist, a disability that he concealed with the sleeve of his jacket. Orozco's reticent and depressive personality has often been seen by art historians and biographers as resulting from this early trauma. Whatever effect it may have had on his psyche, it never inhibited him from expressing himself forcefully in paint.

In this powerful self-portrait, painted with oil and gouache on cardboard, Orozco uses simple, bold shapes and strong color to convey his inner character. He is shown with a stern expression, wearing a casually open light blue-gray shirt, his sallow complexion and shock of dark hair set off against a background of roughly painted rust red. In two other self-portraits, of 1938 and 1937–41, the artist wears a similar shirt, but his head is turned to the left instead of to the right.[1]

This painting is a searing, and distinctly unflattering, portrayal of the fifty-seven-year-old artist. In it Orozco's features, as well as his thick, round glasses and short, black mustache, are summarily defined by heavy black lines. His head and torso loom large in the composition and are slightly distorted by the unusual upward perspective from which the figure is viewed. In Orozco's 1936 frescoes at the Paraninfo de la Universidad de Guadalajara, he had painted, in a similar manner, torsos and heads around the inside of the cupola, using dark outlines and exaggerated angles.

One writer described the present portrait as "electrifying": "The hair is a mess. The furrowed brow, illuminated eyes, aquiline nose, and squared jaw —everything is suggested rather than drawn, and joined together to give the impression of an exact image of the painter; the internal and external image. The face vibrates, not because of the energetic lines or the shocking colors, but because of the illuminated spirit that gives it life."[2] The painting is one of at least six known self-portraits that the artist produced in Mexico from 1935 to 1946. It was painted during the first months of 1940, and in April of the same year it was purchased from the artist for $2,000 by John E. Abbott,

executive vice-president of the Museum of Modern Art, New York, for his own collection.[3]

Two months later Orozco was invited by the Modern to produce a mural in New York for the exhibition *Twenty Centuries of Mexican Art*. The mural took Orozco only ten days to produce at the end of June, and was titled *The Dive Bomber and Tank*. It was painted on six movable panels that could be rearranged in different combinations. The subject of the mural was inspired by the events in Europe that had led to the Second World War, and by the threat of the atomic bomb. Prophetically, Orozco asked in 1940, "Will there be anything else in our world as important as this instrument of annihilation for the next half century?"[4]

In 1942, the Museum of Modern Art bought Orozco's *Self-Portrait* from Abbott for the permanent collection, with money provided by the Inter-American Fund established by Nelson A. Rockefeller. Through this fund the museum also acquired in 1942 some 195 other works by Latin American artists, which were shown there the following year in a large exhibition of Latin American art. The *Self-Portrait* was among the twenty-four works by Orozco included in the installation.

LMM

1. The self-portraits are illustrated in Justino Fernández, *José Clemente Orozco: forma e idea* (Mexico, 1942) pp. 201, 203.
2. Fernandez, *Orozco: forma e idea*, p. 118. Translation from the Spanish by Maria Balderrama.
3. Letter from Orozco to his wife, April 2, 1940, published in José Clemente Orozco, *Cartas a Margarita 1921–1949* (Mexico, 1987) p. 241
4. Orozco quoted in Alma Reed, *Orozco* (New York, 1956) p. 289

REFERENCE
Justino Fernández. *José Clemente Orozco: forma e idea*. Mexico, 1942, p.118.

308 ◀ **José Clemente Orozco**
◀ Mexican, 1883–1949

◀ ***Christ Destroying His Cross**, 1943*
◀ Oil on canvas; 93 x 129.9 cm. (36⅝ x 51⅛ in.)
◀ CNCA–INBA, Museo de Arte Alvár y Carmen T. de
◀ Carrillo Gil, Mexico City

As in so many of Orozco's later works, the image *Christ Destroying His Cross*, which Orozco painted in 1943, first appeared in his murals at the Escuela Nacional Preparatoria some twenty years earlier. The subject is unusual, and does not derive from established Christian iconography; rather, it was invented by Orozco as a metaphor for his own disenchantment with humanity. In 1932–34 he repeated this subject, with major revisions in color and composition, in his murals at Dartmouth College, Hanover, New Hampshire.

In all three versions (the first two done in fresco, the last in oil on canvas), the lone figure of Christ stands holding an axe in his hands. He has just felled his massive cross, which lies diagonally at his feet. In each of the three works —separated from one another by a decade—Orozco was able to sustain the intensity of the theme, changing the style by the purposeful addition of visual imagery for emotional and narrative effect. He also gave the subject new interpretations within the context of historical developments.

In the earliest version, of 1923, entitled *The New Redemption* (now destroyed and known only through photographs), the figure of Christ is large and commanding. His wounds are concealed by a long white robe, and around his powerful head is a halo. Christ has risen with the determination to succeed in the redemption of mankind. He has already chopped down his cross, symbol of hatred and suffering, and is shown putting a torch to it, his steady gaze directed toward an otherworldly vision of floating geometric forms. Dur-

ing the student riots at the Escuela Nacional Preparatoria in 1924, the panel
was completely destroyed, except for the head of Christ. When Orozco re-
painted the mural in 1926, he left Christ's head floating supernaturally above
figures of striking workers.

At Dartmouth College, Orozco expanded the imagery of the scene and
changed its meaning entirely. Here a wounded but ferocious Christ confronts
the ills of society. The figure fills the center of the composition; eyes opened
wide and fist clenched, he is ready to assert his control over a world gone mad.
With axe in hand, he has chopped down not only his own cross but also the
symbols of modern society's religion, culture, and warfare. This Christ is
determined and still hopeful that through his power the world can change for
the better.

Over the years the symbol of the cross and the subtle allusions to religious
themes found their way into Orozco's secular narratives. Then, about 1943,
the artist began to produce a series of pictures that illustrate specific religious
themes, such as the Road to Damascus, the Resurrection of Lazarus, the
Crucifixion, and the Martyrdom of St. Stephen. *Christ Destroying His Cross*
may be considered the culmination of this series, as well as of the Christ
series. The expressionist brushwork and bleak subject matter that Orozco
displayed in all these works of the 1940s find close parallels in contemporane-
ous work being produced in Germany, such as that by Max Beckmann.

Despite the proliferation of ruins and debris in *Christ Destroying His Cross*, the painting maintains a focus on the distraught and emaciated Christ, who cuts down his monumental cross even as flames engulf it. Like an actor at center stage his head is spotlighted by a glowing halo of light. By 1943, the Second World War had taken the lives of millions of men, women, and children. Orozco's painting of Christ issues a desperate warning: If we as a society do not find a way to end war, then even Christ cannot save us. Here, in a fit of rage and despair, Christ destroys the world that he was meant to save. No longer able to act as its savior, he sees no hope for humanity and instead becomes its destroyer. Defeated, he swings his axe at the already fallen cross, while around him the broken pillars of society come crashing down. It is an apocalyptic vision, where even the treasured books and scrolls of mankind's history are consumed by a raging inferno. During the same year, Orozco also worked on a mural cycle that was never completed for the Iglesia del Hospital de Jesús, which he specifically titled *Allegory of the Apocalypse in Relation to Modern Times* (1942–44).

In May 1943, Orozco received a letter from Krister van Kuylen, a Danish collector living in the United States, that mentions a sketch for *Christ Destroying His Cross*.[1] Sometime later, van Kuylen purchased the painting through the Kleeman Gallery in New York for $1,200. It remained in his possession a short while and was sold the following year to Alvár Carrillo Gil for $4,000.

Orozco continued to work on many easel paintings and mural projects in Mexico until 1949, when, on September 7, he suffered a fatal heart attack. His legacy to Mexican art lives on in his work and in the work of those he inspired. It was early in his career, however, that Orozco expressed the central and constant motivation of his art: "My one theme is Humanity; my one tendency is EMOTION TO A MAXIMUM."[2]

LMM

1. See May 23, 1943, letter from Krister van Kuylen to Orozco, published in Clemente Orozco V., *Orozco, verdad cronológica* (Guadalajara, Mexico, 1983) p. 438. There is no reference as to the current whereabouts of this sketch. Note that Krister van Kuylen is also spelled Cristen Van Kuyden in Teresa del Conde, "Sobre la personalidad de Orozco," in Luis Cardoza y Aragón et al., *Orozco: una relectura* (Mexico, 1983) p. 49.
2. Orozco, quoted in Jean Charlot, *The Mexican Mural Renaissance 1920–1925* (New Haven and London, 1967) p. 227.

REFERENCE
Justino Fernández. *Obras de José Clemente Orozco en la colección Carrillo Gil*. Mexico, 1949, vol. 1, pp. 41–42, no. 62.

309 ◄ Diego Rivera

Mexican, 1886–1957

Angelina Beloff, 1909

Oil on canvas; 58 x 45 cm. (22⅞ x 17¾ in.)
Gobierno del Estado de Veracruz, Xalapa

Diego Rivera painted the 1909 portrait of his common-law wife Angelina Beloff to express his warm feelings toward her and to acknowledge his interest in Symbolist art. Rivera used portraiture throughout his career to make personal and artistic, as well as political, statements. Easel portraits and drawings allowed him to commemorate positive experiences and people in his life—hence the numerous portraits of his companions and wives—Angelina Beloff (1911–21), Guadalupe Marín (1922–27), and Frida Kahlo (1929–39 and 1940–54)—and to explore and resolve artistic problems relating to the form and structure and spatial definition of a work of art. Ultimately, Rivera sought to capture the essential character of the sitter in all his easel portraits. To this end, he emphasized the unique physical features and, when appropriate, the

tools that identified the sitter as a sculptor, painter, writer, or some other professional.

Rivera's mural portraits were another matter entirely, for they served political rather than artistic ends. Such concerns were central to the murals he painted in Mexico in the 1920s and in the United States in the 1930s. His stands for or against a particular ideology or point of view were occasionally made with portraits of well-known individuals, such as Emiliano Zapata, with whom Rivera had great sympathy for his position on land reform, one of the rallying cries of the Mexican Revolution of 1910.

The portraits of Angelina Beloff span Rivera's formative years in Europe, beginning with the Symbolist references in the 1909 portrait and continuing with the Cubist portraits of 1916 and the Ingresque drawings of 1917. The Cubist-style oil portraits painted in 1916 are *Portrait of Angelina* (private collection, United States), *Angelina Pregnant*, and *Maternity* (both in the Museo de Arte Alvár y Carmen T. de Carrillo Gil, Mexico City). A pencil drawing, dated December 1917 (Museum of Modern Art, New York), exemplifies the Ingresque portraits that reflect the artist's rejection of Cubism.

The present portrait commemorates the first meeting, in Bruges, between Rivera and Beloff (1879–1969), a Russian printmaker and illustrator of children's books. Rivera had traveled to Bruges from Paris in the summer of 1909 to visit the famous center of Symbolist art and had been introduced to her through María Gutiérrez Blanchard, a Spanish painter he had met earlier in Spain, who was traveling with Beloff in Bruges. Rivera then accompanied the two women to London, where he continued to study the old masters. The portrait was painted soon after his return to Paris, in the winter of that year.

The picture shows Beloff from the waist up, leaning slightly forward. Her face and body are shown in three-quarter view. She wears a high-necked white blouse and a glass-bead necklace. Toying with her necklace, she appears in a pensive mood, lost in thought. In the background, the meandering path of a wide river is echoed by the clouds in the sky. There are references to a city (probably Bruges), with church spires and a bridge spanning the river.

The mood and pose of the lone figure, as well as the setting, are characteristic of Symbolist art, in which the artist's objective was to express the inner reality of the motif or subject represented. The winding river and sky bands in this painting are reminiscent of images painted by the Symbolists of the late nineteenth century. Rivera produced several other Symbolist works prior to this portrait, among them *House on the Bridge*, 1909 (Museo Nacional de Arte, Mexico City), painted during his stay in Bruges, in which nostalgia and ambiguity are conveyed by the early morning or late afternoon light that permeates the scene in which no people are visible.

In June 1911, soon after his second trip to Europe, Rivera asked Beloff to become his common-law wife. They were living in Paris, in Montparnasse, when their son, Dieguito (little Diego), was born in 1916. The child died in 1918, at age one and a half, after which they moved to another apartment near the Champ de Mars. Their relationship ended when Rivera returned to Mexico in 1921. Beloff moved to Mexico in 1932, where she resided until her death in 1969.

JQ

REFERENCES
Bertram D. Wolfe. *The Fabulous Life of Diego Rivera*. New York, 1963, pp. 68–69. **Florence Arquin**. *Diego Rivera: The Shaping of an Artist, 1889–1921*. Norman, Okla., 1971, p. 63, pl. 5. **Ramón Favela**. "Una nueva perspectiva: los años de Francia, España y del cubismo." In *Diego Rivera*, edited by Manuel Reyero. Mexico, 1983, pp. 22, 26; pl. 13. **Laurence P. Hurlburt**. "Diego Rivera (1886–1957): A Chronology of His Art, Life and Times." In *Diego Rivera: A Retrospective*, exh. cat., Detroit Institute of Arts. New York, 1986, p. 33, fig. 26. "Angelina Petrova Belova y Diego María Rivera Barrientos: cronología comparada," in *Angelina Beloff: ilustradora y grabadora*, exh. cat., Museo Estudio Diego Rivera. Mexico, 1988, p. 72.

310 ⟨ **Diego Rivera**

Mexican, 1886–1957

Sailor at Lunch, 1914

Oil on canvas; 114 x 70 cm. (44⅞ x 27½ in.)
CNCA–INBA, Gobierno del Estado de Guanajuato,
Museo Casa Diego Rivera, Guanajuato

Rivera's intellectual curiosity and his capacity to learn both from the art of the past and from contemporary art are seen in the many works he produced in a variety of styles throughout his formative years in Paris. During the fourteen years he spent in Europe he worked in one style after another, from the figurative styles of his first years in Spain to the Symbolist, neo-Impressionist, Cubist, Cézannesque, and Ingresque styles of his later work in Paris. Cubism, however, occupied him for a longer period than any of the others, and from 1913 to 1917 he produced approximately two hundred Cubist paintings. *Sailor at Lunch* corresponds to the painter's Synthetic Cubist phase following his first tentative steps with Analytic Cubism in 1913.

Rivera made two preparatory pencil sketches for *Sailor at Lunch* (both at the Museo Casa Diego Rivera, Guanajuato). In the first version, he concen-

trated almost entirely on the head, which takes up most of the visual surface. The features of the face are placed within a rectangular shape presented at an angle. In the second, he left more room for the shoulder area and included two outlines of the hat, one overlapping the other.

The seated figure in the painting wears the blue-and-white striped T-shirt and the hat of a French sailor—with red pompon and inscribed with the word *patrie*. He has black curly hair, sports a mustache, and holds a glass in his right hand. There are fish on the plate before him. The two-dimensional effect is achieved with the use of a rectilinear grid, by which all the visual elements are arranged and defined. In concert they provide the predominantly horizontal and vertical lines that are parallel to the picture plane.

Rivera explored a number of styles following his return to Paris in June 1911. By the fall of that year, in Catalonia, Spain, he was painting Divisionist landscapes, and in the spring of 1912, in Toledo, he was absorbing the work of El Greco and of the Spanish painter Ignacio Zuloaga. Upon his return to Paris in the fall of 1912, he was influenced by the Dutch painters Piet Mondrian and Conrad Kikkert, whose Cubist works were derived from their study of Cézanne. Having assimilated the teachings of El Greco and, indirectly, of Cézanne, Rivera began to paint Cubist pictures in 1913.

Although he used the Cubist-derived concept of simultaneity (different views of an object or figure in one image) in works dating from 1913, Rivera's interest in volumetric definition was retained from his earlier, predominantly figurative, work. By the end of 1913, he was incorporating the concept of movement, derived from Futurism, in his Cubist works, and using bright colors. Several paintings of the following year, including *Sailor at Lunch*, demonstrate the artist's grasp of Synthetic Cubism, in which the illusion of depth and the volumetric definition of objects are suppressed.

In early 1914, Rivera began to experiment with collage, trompe l'oeil, heavy impasto, and the addition of sand and other materials to his pigment for greater textural effects. These techniques, together with new approaches to composition and the spatial definition of objects, he derived from the work of Juan Gris, whom he met in the spring of 1914. The same year, he was also introduced to Picasso, with whom he discussed Cubism.

JQ

REFERENCES
Bertram D. Wolfe. *The Fabulous Life of Diego Rivera*. New York, 1963, pp. 68–69. **Florence Arquin**. *Diego Rivera: The Shaping of an Artist, 1889–1921*. Norman, Okla., 1971, pp. 50, 73, 76, 81. **Olivier Debroise**. *Diego de Montparnasse*. Mexico, 1979, p. 75, figs. 123–124. **Laurence P. Hurlburt**. "Diego Rivera (1886–1957): A Chronology of His Art, Life and Times." In *Diego Rivera: A Retrospective*, exh. cat., Detroit Institute of Arts. New York, 1986, pp. 37, 42.

311 ◀ Diego Rivera

Mexican, 1886–1957

The Eiffel Tower, 1914

Oil on canvas; 116 x 90 cm. (45⅝ x 35⅜ in.) Private collection, Switzerland. Courtesy of Mary-Anne Martin/Fine Art, New York

From 1911 to 1915, Rivera traveled several times between France and Spain. Often he painted scenes inspired by one locale—Paris or Toledo—even after moving to another. His style, however, remained consistently Cubist after 1913.

Although he had not returned home in several years, Rivera introduced Mexican motifs into his Cubist paintings of 1914 and 1915. Fragments of colorfully woven serapes, sombreros, and references to the Mexican Revolution (rifles and cartridge belts) found their way into his portraits and landscapes. This show of pride in his Mexican heritage may have been inspired by his recent stay in Madrid at the end of 1914, where he was in the company of other Mexican nationals.

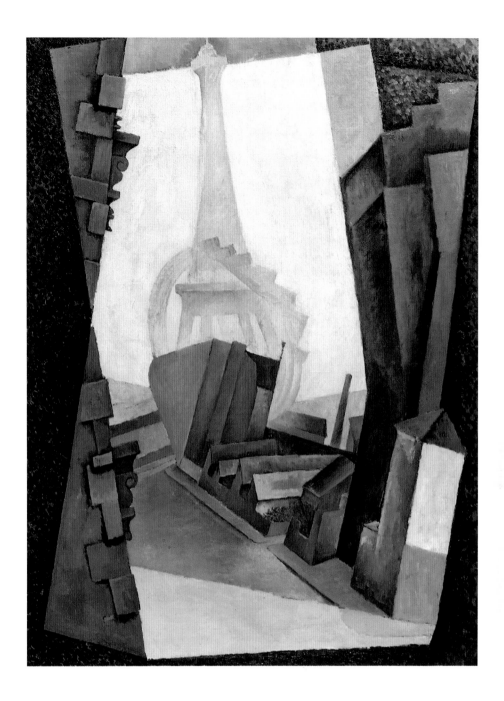

During his years abroad, Rivera had developed particular affection for his
adopted country of France, where he matured as an artist and where he had
many friends within the artistic community of Montparnasse. Swept up in
the spirit of French patriotism at the beginning of the First World War, he even
tried to enlist in the French Army upon his return to Paris in the spring of
1915, only to be turned down because of his enormous size (he was over six
feet tall and weighed three hundred pounds) and flat feet. It is conceivable
that Rivera, disappointed by this rejection, began to think more about his
native country, where a different war was being fought.

Rivera's dual loyalties may be perceived in his painting *The Eiffel Tower*,
executed in Spain in November 1914, before his return to France. *The Eiffel
Tower* appears to have been included in the exhibition "Los Pintores Integros"
(The Integral Painters), held at the Salon 'Arte Moderno' in Madrid in March
1915. The exhibition was organized by Rivera's friend the Dadaist writer Ramón
Gómez de la Serna, whose portrait Rivera painted in 1915 (cat. no. 312). In the

preface to the catalogue, Gómez de la Serna wrote that the painting had "that gloss of the war, hair-raising, and sober without the ostentation of the image [that] is serious and chilling."[1]

The Eiffel Tower is a transitional work, not only in terms of Rivera's Cubist style but also in terms of its Mexican imagery. Rivera here displays a burgeoning interest in flattened planes and decorative patterning, seen in the stippled areas at the left and right edges of the canvas. This technique would become more pronounced in such works as *Table on a Café Terrace* (cat. no. 313), done in Paris just a few months later. Derived from the work of Pablo Picasso, it can also be found in the paintings of Juan Gris, two artists with whom Rivera had become friends in Paris in the early part of 1914.

Unlike the table in *Table on a Café Terrace*, which is totally frontal and flattened, the gray buildings in the foreground of *The Eiffel Tower* retain their sculptural quality as they recede into space. The buildings on either side of the street, however, are more planar, slanting diagonally inward like a theater curtain parted in the middle to reveal center stage. A beam of yellow light focuses on the distinctive shape of the tower, seen in the distance in the Champ de Mars, behind the Great Ferris Wheel built for the Universal Exposition of 1900. Their placement in the painting, in immediate proximity to each other, is a slight distortion of their actual location. Rather than being an exact transcription of what he saw, this painting is more a synthesis of Rivera's feelings and memories about Paris. His earlier portrait of Adolfo Best Maugard, 1913 (Museo Nacional de Arte, Mexico City), includes a more detailed view of the ferris wheel.

Both these Parisian landmarks—the Eiffel Tower and the Great Ferris Wheel—were prominently featured in separate works by Robert Delaunay, an artist Rivera first met in Paris in the fall of 1913 and who was also in Madrid with Rivera in the winter of 1914. The sculptor Jacques Lipchitz remarked that at the time, "the spirit of Montparnasse seemed transported to Madrid."[2]

One further departure from a literal depiction in *The Eiffel Tower* is the tricolor house in the lower right corner. In coloring it ambiguously so that it can be read as either blue, white, and red (the colors of the French flag) or green, white, and red (the colors of the Mexican flag), Rivera was most likely making a symbolic allusion to his own conflicting allegiances.

LMM

1. Ramón Favela, *Diego Rivera: The Cubist Years*, exh. cat., Phoenix Art Museum (Phoenix, 1984) p. 92.
2. Favela, *Rivera*, p. 90

REFERENCES
Bertram D. Wolfe. *Diego Rivera: His Life and Times*. New York, 1939, p. 105, pl. 28. **Ramón Favela**. *Diego Rivera: The Cubist Years*, exh. cat., Phoenix Art Museum. Phoenix, 1984, pp. 91–92.

312 ◀ **Diego Rivera**

Mexican, 1886–1957

Ramón Gómez de la Serna, 1915

Oil on canvas; 109 x 90 cm. (42⅞ x 35⅜ in.)
Plácido Arango Collection, Madrid

Rivera was always interested in portraying his friends in a variety of styles in an effort to capture their essential nature and to explore new formal means of expression. Many of these portraits were painted during the fourteen years he lived and worked in Paris and other European cities. Despite the difficulties of rendering portraits in the Cubist style, where the conventions used in tradi-

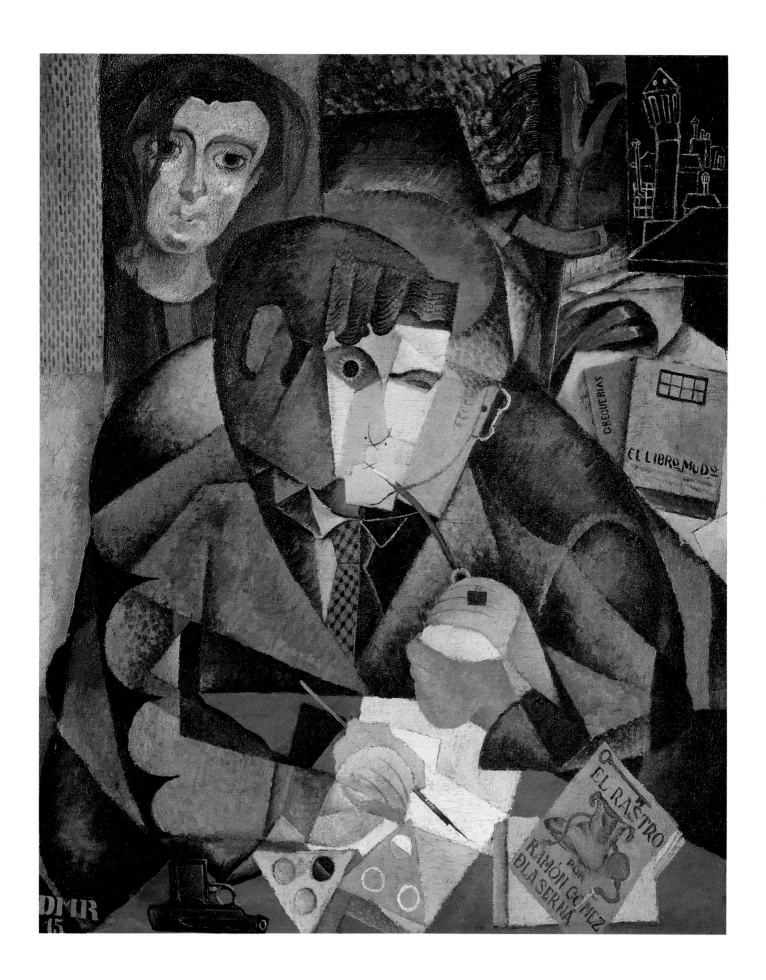

tional portrait painting are suppressed, Rivera was able to capture the character of the sitters by emphasizing their most salient physical features and by including motifs associated with their professions.

Ramón Gómez de la Serna, which exemplifies the Cubist period, shows the Spanish Dadaist writer sitting at a desk, with a pen in his right hand and a pipe in his left. A view of Madrid is visible in the upper right background. The sitter wears a suit and tie and is surrounded by his published books. One of the writer's earliest publications, *El Rastro*, seen in the lower right corner, describes the Madrid flea market that he frequented. Rivera also makes reference, in an inscription in the right background, to the literary genre known as Greguerías, which the writer invented. Another picture with the same theme, entitled *El Rastro* (Fundaçion Dolores Olmedo Patiño, A.C., Mexico City), and painted the same year, includes passages from the book.

Gómez de la Serna greatly admired the present painting and described it as follows:

> When the great Mexican painted my eyes, . . . he did not look at those chestnut eyes of mine whose normal appearance is for "portraitists," . . . he observed them as a technician . . . and he understood the eyes he needed in the portrait. . . . In the round eye is synthesized the moment of luminous impression, and in the long shut eye, the moment of comprehension. . . . Everything is well done in this portrait, even the position of the hand which holds the pipe in smoking, in its three aspects: first that of raising the pipe to the mouth; second, that of having it in the mouth; and third, that of resting the pipe in the hollow of the hand.[1]

In the summer of 1914, Rivera went to Spain with his companion Angelina Beloff and a number of friends, including Jacques Lipchitz and María Gutiérrez Blanchard, on a walking and sketching tour. They camped in Majorca, and there Rivera painted proto-Surrealist landscapes and began to incorporate found objects into his works.

Rivera and Beloff moved with their friends to Madrid in the winter of 1914. There he renewed his friendship with Gómez de la Serna, whom he had met on his first trip to Spain in 1907. Rivera painted this portrait a short time later and included it in an exhibition organized by Gómez de la Serna in early 1915 that introduced Cubism to Madrid. The controversy that ensued resulted in the gallery's being closed by the authorities.

JQ

1. Bertram D. Wolfe, *Diego Rivera: His Life and Times* (New York, 1939) pp. 96–97.

REFERENCES
Ramon Gómez de la Serna. "Riverismo," in *Ismos*, 1931. Reprint, Madrid, 1975, pp. 334–43. **Bertram D. Wolfe**. *Diego Rivera: His Life and Times*. New York, 1939, pp. 94–98. **Gladys March**. *Diego Rivera: My Art, My Life*. New York, 1960, pp. 110–13. **Bertram D. Wolfe**. *The Fabulous Life of Diego Rivera*. New York, 1963, p. 91. **Olivier Debroise**. *Diego de Montparnasse*. Mexico, 1979, pp. 63–68. **Ramón Favela**. *Diego Rivera: The Cubist Years*, exh. cat., Phoenix Art Museum. Phoenix, 1984, pp. 94–98, fig. 24; color pl. p. 95.

313 **Diego Rivera**

Mexican, 1886–1957

Table on a Café Terrace, 1915

Oil on canvas; 60.6 x 49.5 cm. (23⅞ x 19½ in.)
The Metropolitan Museum of Art, New York,
Alfred Stieglitz Collection, 1949 49.70.51

When Rivera returned to Paris from Madrid in the spring of 1915, he began to paint in a more decorative manner, reflecting the influence of the "rococo" Cubist style of Picasso. He also continued to use tromp l'oeil realism (wood grains), inversions of earth and sky, and combinations of interior and exterior spaces, seen in his earlier Cubist works. This style is particularly evident in *Table on a Café Terrace*, a composition that includes a number of objects on a

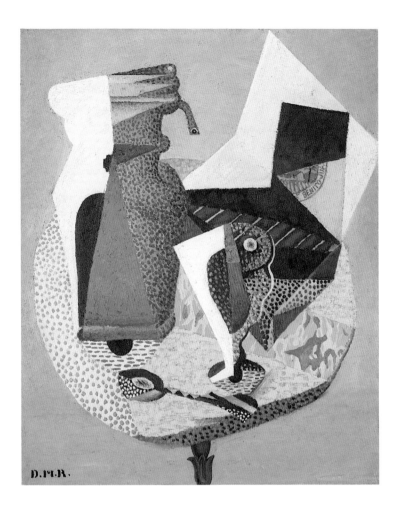

round table—a high-necked container, a spoon, a long-stemmed glass, and a label with a miniature landscape and some lettering.

Unlike Rivera's earlier Cubist works, *Table on a Café Terrace* shows a greater distinction between figure and ground. The table is not anchored to the sides of the picture plane to create a rectilinear grid; rather, it is separate from the background, as are the objects placed on it. The upturned circular tabletop is divided into segments, each of which is painted with a different texture. The juxtaposition of broad, flat areas of color and black and white with the textured areas gives the objects a solidity not seen in earlier, compositionally more complicated works.

The inscription "Benito Jua...," on the label of a Mexican cigar box—a reference to Benito Juárez, a revered figure of the nineteenth century—reflects Rivera's increasing awareness of the events of the Revolution, reports of which he received from Mexican exiles in Madrid and Paris. This awareness went hand in hand with an increased use of Mexican motifs in his paintings and a deepening appreciation of the formal properties of the popular arts of his country. In Paris, the walls of his studio were decorated with *petates* (straw mats) and serapes, reproductions of paintings by El Greco, Russian balalaikas, and photographs of recent Cubist works by Picasso—an indication of his voracious interest in everything that was going on around him, including the neo-Primitivism of the Russian avant-garde in Paris.

Table on a Café Terrace was among the nine paintings exhibited by the artist in New York in October 1916 at Marius de Zayas's Modern Gallery. Also

included were works of Precolumbian art from the collection of de Zayas and his partner Paul Haviland. The exhibition received little notice.

JQ

REFERENCE
Ramón Favela. *Diego Rivera: The Cubist Years*, exh. cat., Phoenix Art Museum. Phoenix, 1984, color pl. p. 102, pp. 104, 111.

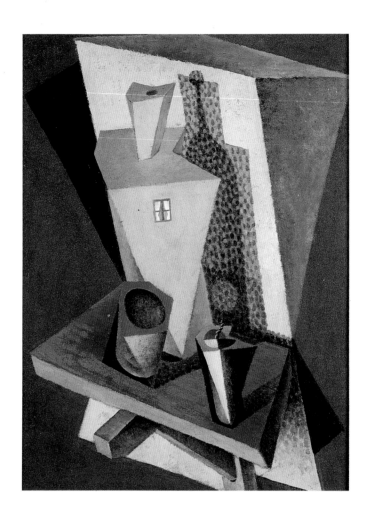

314 ◀ **Diego Rivera**

Mexican, 1886–1957

Still Life with a Green House, 1917

Oil on canvas; 61 x 46 cm. (24 x 18⅛ in.)
Stedelijk Museum, Amsterdam

The decorative elements and Mexican motifs in Rivera's pictures of 1915 gave way to a greater austerity in the classical portraits and still lifes of 1916 and 1917. *Still Life with a Green House* and other works of the same period also reflect Rivera's intense interest in metaphysics and science, subjects that he discussed with a number of artists who shared his enthusiasms, including Gino Severini, André Lhote, Juan Gris, Jean Metzinger, and Jacques Lipchitz. During the latter part of 1916, he emerged as a major figure in the circle of artists who came to be known as the "crystal" or "classical" Cubists as a result of the austere classical style of their works and their highly theoretical and intellectual approach to the image-making process.

Rivera used the group's new theories in a number of still lifes and portraits that he painted in 1916 and 1917 and that reflect his efforts to reduce objects and figures to their basic geometric shapes, colors, and location in space. It was through reflections, shadows, and refractions that the artists hoped to define the fourth dimension. Rivera, claiming to have found the secret of the fourth dimension, in 1917 constructed a device he called *la chose* (the thing),

which he used to demonstrate his achievement, and which the writer André Salmon described thus: "For convenience in demonstration, he had built a curious machine, a sort of articulated plane, of gelatin, like the one of paper which engravers use to make their tracings. His French scientific vocabulary was modest. He called this apparatus *la chose*."[1]

Still Life with Green House belongs to Rivera's last Cubist phase and it differs markedly from *Table on a Café Terrace* (cat. no. 313), painted during his earlier "rococo" Cubist phase. Throughout this period he continued to be influenced by the work of Gris and Picasso.

JQ

1. Bertram D. Wolfe, *Diego Rivera: His Life and Times* (New York, 1939) p. 116.

315 ◀ **Diego Rivera**
Mexican, 1886–1957

The Mathematician, 1919
Oil on canvas; 115.5 x 80.5 cm. (45½ x 31¾ in.)
Fundación Dolores Olmedo Patiño, A.C.,
Mexico City

Like other paintings that show the influence of one artist—such as El Greco or Mondrian—or that bring together in one painting a number of styles—such as Cubism and Futurism—*The Mathematician* represents Rivera's assimilation of the work of Paul Cézanne. In this painting Rivera uses multiple vantage points—faceted surfaces that create a volumetric definition of forms—and a palette limited to browns, yellows, whites, and blacks to emphasize the geometric construction of the composition. The work represents the culmination of Rivera's break with Cubism and his reinvolvement with the work of Cézanne.

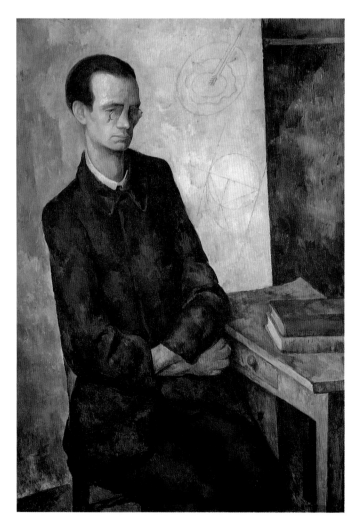

Rivera had abandoned Cubism in the spring of 1917. Among the precipitating factors was his estrangement from his fellow artists following an altercation with the poet and critic Pierre Reverdy, which became known as *l'affaire Rivera*. Reverdy wrote a negative review of Rivera's work in March 1917, which led to a physical confrontation between the two men and the subsequent rejection of Rivera by many of his fellow artists, among them Georges Braque, Juan Gris, Fernand Léger, and Jacques Lipchitz. Shortly thereafter, Rivera began to do Ingresque drawings and paintings, which also reflect the influence of Cézanne. He continued to focus on Ingres and Cézanne in 1918 and 1919, and by 1920 he had added Fauvist-style landscapes to his repertoire.

The lone figure represented in *The Mathematician* is shown seated at a small table on which are placed two books. His arms are crossed, and his left hand is placed inside the right sleeve of his coat. He wears glasses and a buttoned-up brown coat that partially obscures the lapels of his white shirt. The sitter appears lost in thought. On the panel propped up behind him are two sketched-in diagrams.

Rivera worked out the various axes and planes into which the figure was placed in a preparatory construction drawing composed of parallel lines and right angles (Collection Egil Nordahl Rolfsen and Kirsten Revold). A close analysis of the drawing and the painting shows that the artist established every part of the picture with intersecting lines and angles that correspond to several eye levels consistent with Cézanne's approach to painting. For example, the outer edge of the foreshortened tabletop was established by a line drawn from the upper left corner of the picture through the sitter's right eye, thereby relating the table edge to the sitter's line of sight. The complexity of multiple linear connections such as these serves to create a tight and visually cohesive composition.

JQ

REFERENCES
Justino Fernández. *Arte moderno y contemporáneo de México.* Mexico, 1952, p. 312. **Bertram D. Wolfe.** *The Fabulous Life of Diego Rivera.* New York, 1963, pp. 109, 112. **Florence Arquin.** *Diego Rivera: The Shaping of an Artist, 1889–1921.* Norman, Okla., 1971, p. 92, pl. 164. **Ramón Favela.** *Diego Rivera: The Cubist Years,* exh. cat., Phoenix Art Museum. Phoenix, 1984, p. 144. **Laurence P. Hurlburt.** "Diego Rivera (1886–1957): A Chronology of His Art, Life and Times." In *Diego Rivera: A Retrospective,* exh. cat., Detroit Institute of Arts. New York, 1986, p. 50, fig. 69.

316 ◀ **Diego Rivera**
Mexican, 1886–1957

The Balcony, 1921
Oil on canvas; 81 x 65.5 cm. (31⅞ x 25¾ in.)
Collection Samuel Goldwyn, Jr., Beverly Hills

Painted toward the end of 1921, following Rivera's return to Mexico after fourteen years abroad, *The Balcony* reflects the artist's expressed desire to produce a truly Mexican art, as he discussed with David Alfaro Siqueiros the year before in Paris. The results of these discussions led to the writing and publication of Siqueiros's three calls to artists of the Americas. One of these appealed to artists to focus in their work on their native land and to rise above the usual folkloric approaches ("Indianism," "Primitivism," "Americanism") in order to create an art that was in keeping with the land, the geography, the people, and their history.

In November and December 1921, Rivera traveled to the Yucatán with a group of artists (among them Adolfo Best Maugard and Roberto Montenegro) and writers under the auspices of the Mexican government to visit the ancient Mayan and Mayan Toltec ruins at Uxmal and Chichén Itzá. The group was led by José Vasconcelos, the new minister of education, who had commis-

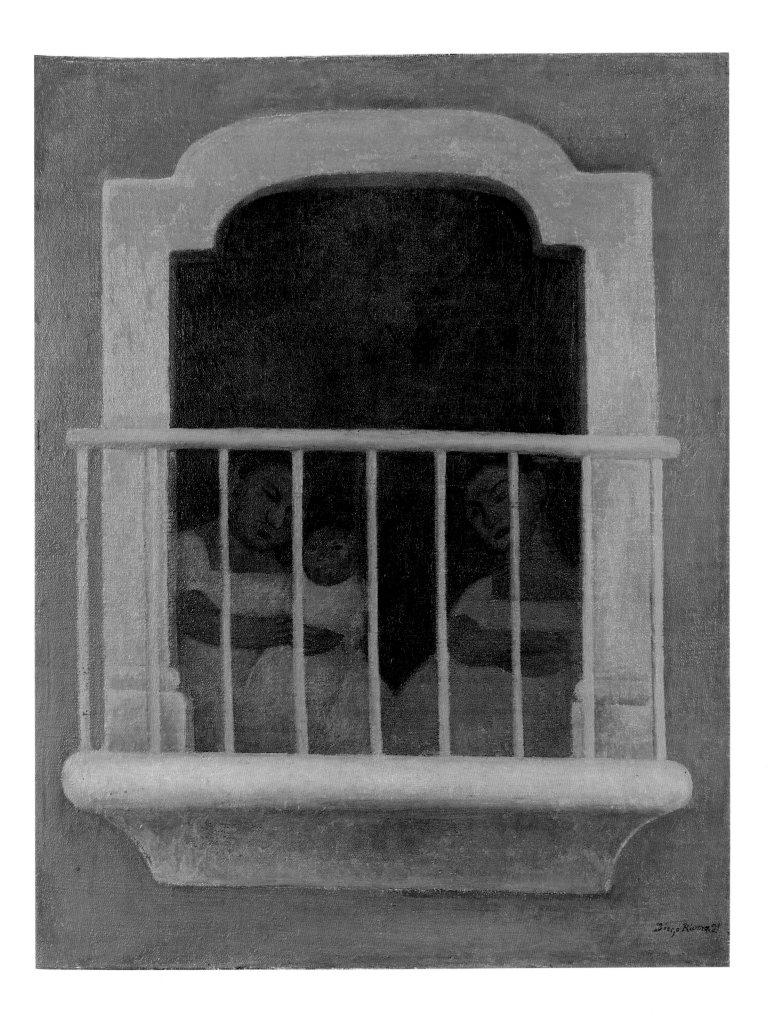

sioned the first government-sponsored mural projects a few months earlier. The purpose of the trip was to acquaint the group with Mexico's ancient past. *The Balcony* was inspired by that trip and represents the beginning of Rivera's focus on his native land, which was to continue throughout his life.

The painting shows two seated women, one holding a child on her lap, looking out through a window with a railing. The figures, framed by the horizontal and vertical bars of the railing, are contained visually within the lower half of the window. The entire ensemble of frame, railing, and figures is centered in a field of a dark red wall. The figures, barely seen in the semidarkness, are secondary to the overriding emphasis on the formal aspects of the painting. This represented a continuation of Rivera's interest in formal problems, but now it was coupled with a renewed interest in his native country.

The Balcony recalls the Italian Renaissance murals that Rivera studied during an extended trip throughout Italy over a period of seventeen months, from early 1920 to mid-1921, shortly before his return to Mexico. Indeed, the impassive figures have a striking resemblance to the figures that look down from their balcony in the fifteenth-century ceiling fresco by Andrea Mantegna in the Camera degli Sposi at the Palazzo Ducale in Mantua. The balcony motif was also used extensively by the Cubists and the Fauves, particularly Matisse, but the vantage point was usually from the inside looking out. The Rivera painting is closer to Goya's *Majas on a Balcony*, 1810–15 (Metropolitan Museum of Art, New York), and Manet's *The Balcony*, 1869 (Louvre, Paris), from which it is clearly derived.

JQ

REFERENCES
Jere Abbott. "Notes on the Style of Diego Rivera." In *Diego Rivera*, exh. cat., The Museum of Modern Art. New York, 1931, p. 39. **Justino Fernández**. *Arte moderno y contemporáneo de México*. Mexico, 1952, p. 318. **Salvador Elizondo**. "Ante el caballete." In *Diego Rivera*, edited by Manuel Reyero. Mexico, 1983, p. 174. **Laurence P. Hurlburt**. "Diego Rivera (1886–1957): A Chronology of His Art, Life and Times." In *Diego Rivera: A Retrospective*, exh. cat., Detroit Institute of Arts. New York, 1986, p. 54, fig. 80.

317 ◄ **Diego Rivera**
◄
◄ Mexican, 1886–1957
◄
◄ *Woman Grinding Maize,* 1924
◄ Encaustic on canvas; 106.7 x 121.9 cm. (42 x 48 in.)
◄ CNCA–INBA, Museo Nacional de Arte, Mexico
◄ City

Woman Grinding Maize reflects Rivera's continuing interest in indigenous subjects following his return to Mexico in July 1921. In November 1921, Rivera had traveled to the Yucatán and in December of the following year to the Isthmus of Tehuantepec. Sketches done on those trips later served as studies both for easel paintings and for murals he painted in the Court of Labor and in the Court of Festivals at the Secretaría de Educación Pública from 1923 to 1928.

In all these projects, Rivera was deeply committed to presenting the indigenous peoples of Mexico with dignity and within the context of their everyday lives. The figure in *Woman Grinding Maize* is shown in profile exerting great pressure in the grinding of the maize on a *metate* (hollowed-out lava grindstone). The woman's body and arms together with the *metate* form a massive truncated pyramid. The middle ground shows a *brasero* (brazier) with a *comal* (large clay disk), on which three tortillas have been placed for baking. The back wall, the lower part painted a muted yet rich violet, echoes the horizontality of the base of the pyramidal shape.

Rivera made two pencil sketches for *Woman Grinding Maize*. One, dated 1924, was probably done as a preparatory drawing for this painting. The other, dated 1920–29, may have been done for an earlier version of the same subject

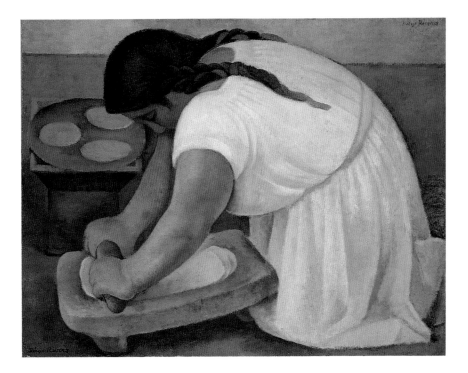

that Rivera painted in 1922 (private collection, New York). The figure in the earlier work is shown in the same pose but with less detail, and the *brasero* and *comal* are not included.

The subject of *Woman Grinding Maize* may be considered in the context of Rivera's focus on people at work, which he explored in the murals of the Court of Labor, where scenes include groups of people weaving, dyeing, harvesting, refining sugar, potting, mining, and working in iron foundries. In these first murals and related easel paintings, Rivera's classical-style pictures of Mexican subjects emerged. The figures, initially relatively flat, would become increasingly modeled and volumetric as Rivera's distinctive style developed. JQ

REFERENCE
Justino Fernández. *Arte moderno y contemporáneo de México.* Mexico, 1952, p. 323.

318 ◀ **Diego Rivera**
◀ Mexican, 1886–1957
◀
◀ *Flower Day,* 1925
◀ Oil on canvas; 147.4 x 120.6 cm. (58 x 47½ in.)
◀ Los Angeles County Museum of Art. Los Angeles
◀ County Fund (25.7.1)

After Rivera completed the murals for the Court of Labor at the Secretaría de Educación Pública in 1923, he began work on the Court of Festivals, in the same building. Earning the equivalent of about two U.S. dollars per day for his mural painting, Rivera supplemented his income selling oils, watercolors, and drawings. The subject matter of these smaller works was often based on the Court of Festivals panels or were used as studies for them.

Flower Day is related in subject and style to the panel *Friday of Sorrows on the Canal at Santa Anita,* in the Court of Festivals, in which the same flower carrier is shown but with his back to the viewer. In the foreground the flower carrier and four kneeling figures face the crowds, while the upper half of the panel shows the festival itself.

The figures in *Flower Day* are defined in simple blocklike forms and arranged symmetrically within a shallow space. The central figure, the subject of the painting, bends slightly forward to allow the viewer to see the load of calla lilies he carries on his back, while two figures kneel Indian-fashion in front of him and others peer out from behind. The painting is hieratic in style,

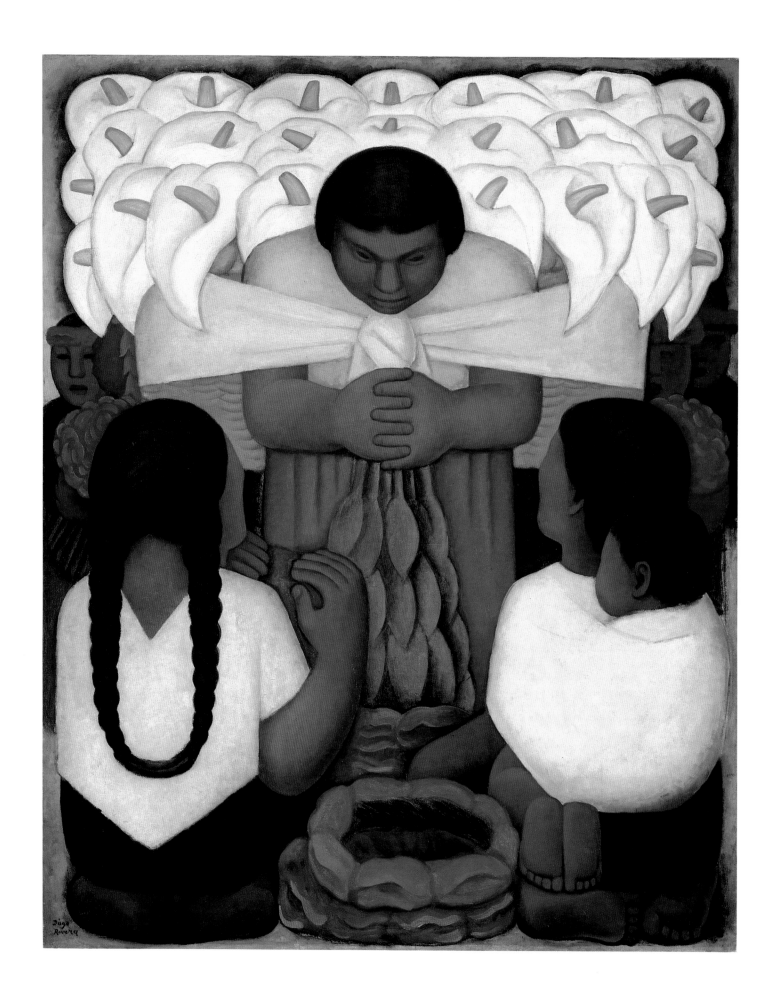

and reminiscent of Maya stelae and other sculptural monuments dating to the Precolumbian period.

Flower Day was included in the Pan-American exhibition at the Los Angeles Museum in 1925, where it was awarded the purchase prize. It has been included in most exhibitions of Mexican art seen in the United States and Europe since the late 1920s and 1930s.

JQ

REFERENCES
Jere Abbott. "Notes on the Style of Diego Rivera." In *Diego Rivera*, exh. cat., The Museum of Modern Art. New York, 1931, p. 39. **Bertram D. Wolfe.** *The Fabulous Life of Diego Rivera.* New York, 1963, p. 280.

319 ◀ **Diego Rivera**
◀ Mexican, 1886–1957
◀
◀ *The Tortilla Maker,* 1925
◀ Oil on canvas; 121.9 x 96.5 cm. (48 x 38 in.)
◀ University of California at San Francisco,
◀ School of Medicine

In the paintings of Diego Rivera, the subject of women and children engaged in performing daily chores occurs repeatedly within the broader theme of the people of Mexico in their everyday lives. It was a subject that allowed the artist to express the deep affection he obviously felt for them, and he would continue to follow this genre even when he was busy painting murals for the Secretaría de Educación Pública (1923–28) and the Universidad Autónoma de Chapingo (1926–27).

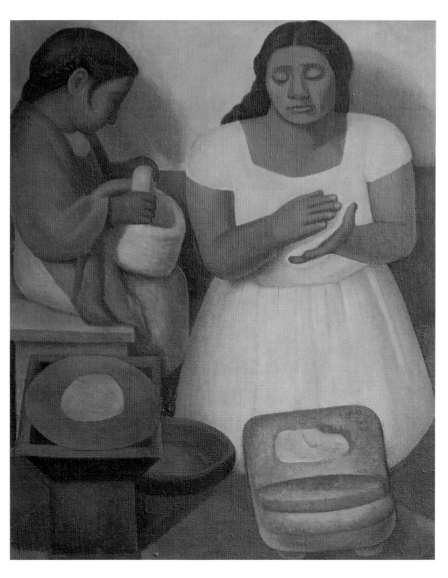

The Tortilla Maker, which is related in subject and style to *Woman Grinding Maize* (cat. no. 317), painted a year earlier, shows a woman in frontal view kneeling behind a *metate* and patting tortillas. A child, shown in profile and seated on a small stool, holds a basket for the tortillas. The background wall is similar to that in *Woman Grinding Maize*. But in contrast to the anonymity of the maize grinder, the woman and child in *The Tortilla Maker* are individualized, their relationship is one of affection and intimacy. (It is perhaps not incidental that a daughter, Lupe, had been born in August 1924 to Rivera and Guadalupe Marín, whom he had married in June 1922.) The simplified human forms, together with the *brasero* and *metate* in the foreground, are treated as a series of geometric shapes to create an essentially abstract painting.

JQ

REFERENCES
Edgar P. Richardson. "Diego Rivera." *Bulletin of the Detroit Institute of Arts* 12, no. 6 (1931), pp. 74–76. **Bertram D. Wolfe.** *Diego Rivera: His Life and Times.* New York, 1939, p. 316. **Los Angeles County Museum of Art.** *Handbook.* Los Angeles, 1977, pp. 147–48. **Salvador Elizondo.** "Ante el caballete." In *Diego Rivera*, edited by Manuel Reyero. Mexico, 1983, p. 174.

320 ◀ **Diego Rivera**

Mexican, 1886–1957

Dance in Tehuantepec, 1928

Oil on canvas; 199 x 162 cm. (78⅜ x 63¾ in.)
Collection of IBM Corporation, Armonk, New York

Rivera visited the Isthmus of Tehuantepec in December 1922. The many sketches he made during that trip appear in numerous drawings, watercolors, and easel paintings from the 1920s, as well as in several panels on the north wall of the Court of Labor, at the Secretaría de Educación Pública. The distinctive costumes worn by the women of Tehuantepec would continue to appear in Rivera's work throughout his career.

Rivera painted *Dance in Tehuantepec*, an exceptionally large work, after having completed the panel *La Zandunga* in the Court of Festivals. The *Zandunga*, a popular folk dance in the region of Tehuantepec, is the subject of both works and one that Rivera would return to repeatedly. In the painting a group of six dancers—three women and three men—are arranged in zigzag fashion on the dance floor. A large coconut tree dominates the middle ground and serves as a kind of protective covering over the dancers. Other people are shown seated in the background in an architectural enclosure with hangings of tissue paper and tinsel along the three walls, just under the roof.

The mural panel in the Court of Festivals shows the same composition, but in a more elaborate setting and with spectators both in the foreground, their backs to the viewer, and in the middle ground, directly behind the dancers.

JQ

REFERENCES
Justino Fernández. *Arte moderno y contemporáneo de México.* Mexico, 1952, p. 323. **Hans F. Secker.** *Diego Rivera.* Dresden, 1957, pp. 103, 105, pl. 80. **Laurence P. Hurlburt.** "Diego Rivera (1886–1957): A Chronology of His Art, Life and Times." In *Diego Rivera: A Retrospective*, exh. cat., Detroit Institute of Arts. New York, 1986, p. 68, fig. 127, p. 70.

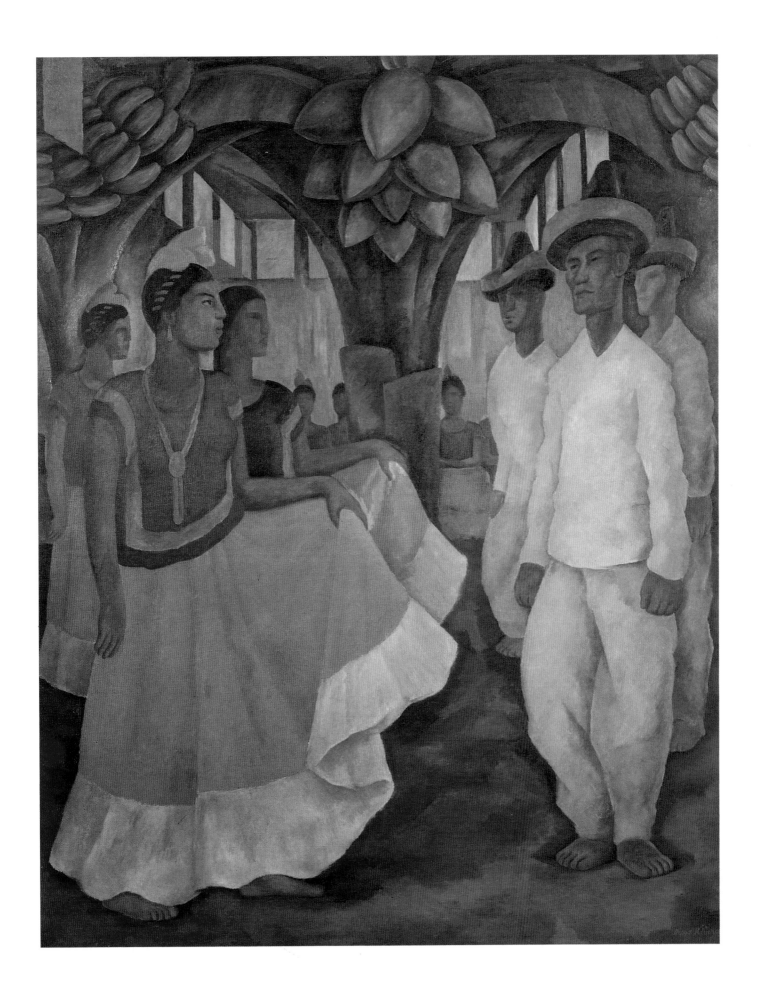

321 ◀ Diego Rivera

Mexican, 1886–1957

May Day, Moscow, 1928

Sketchbook of 45 watercolors
Watercolor and pencil on graph paper, or watercolor
crayon on graph paper; 33 pages: 10.4 x 16.2 cm.
(4⅛ x 6⅜ in.); 12 pages: 16.2 x 10.4 cm. (6⅜ x 4⅛ in.)
The Museum of Modern Art, New York.
Gift of Abby Aldrich Rockefeller

In August 1927, Rivera left Mexico to visit the Soviet Union. He spent nine months there, participating in political meetings, lecturing, and meeting with Soviet artists. In November he signed a contract with the Soviet government to paint murals for the Red Army Club. For this project he made forty-five watercolor sketches, thirty-three in horizontal format and twelve in vertical format. As it turned out, the mural projects were never carried out, although Rivera eventually used some of the sketches for scenes in murals that he painted in Mexico and the United States: the Court of Festivals at the Secretaría de Educación Pública (1928) and the mural at Rockefeller Center in New York, which was destroyed in 1934 and re-created at the Palacio de Bellas Artes in Mexico City the same year.

There is some confusion as to whether Rivera did the watercolor sketches on May Day 1928 or during the tenth anniversary parade of the October Revolution in 1927; Reyero, for example, has suggested that Rivera sketched from the reviewing stand in front of the Kremlin wall during the latter celebrations.[1] But because Rivera arrived in the late summer of 1927 and left in the summer of 1928, the date of the May Day celebrations (if in fact the sketches depict May Day and not the anniversary of the October Revolution) has to be 1928. And indeed, the artist's name and the date 1928 are clearly inscribed on every sketch. It seems highly unlikely that Rivera would have been able to do the sketches from the reviewing stand had he been there, and in addition many of the sketches depict spectators who line the street, as well as marching soldiers, which suggests that Rivera was himself moving about during the day-long parade. A number of watercolors show interior scenes, which further suggests that Rivera did not make all forty-five in one day.

The sketches are quite distinct from most of Rivera's other work in their

remarkable spontaneity of execution. With a few pencil lines, blue-gray washes, and dashes of color, Rivera created a sense of life and movement that is expressive and direct. Details are suppressed to allow an immediate impression of the scenes to emerge—soldiers marching, workers with red banners held aloft, and spectators watching.

One of the sketches was used for the cover of an issue of *Fortune*, and several were reproduced in an article by Emil Ludwig on Joseph Stalin, published in the September 1932 issue of *Cosmopolitan*.

JQ

1. **Manuel Reyero,** "Cronología: Diego Rivera, arte, ciencia y política en el mundo," in *Diego Rivera,* edited by Manuel Reyero (Mexico, 1983) p. 258.

REFERENCES
Frances Flynn Paine. "The Work of Diego Rivera." In *Diego Rivera,* exh. cat., The Museum of Modern Art. New York, 1931, p. 32; pl. 65. **Jorge Juan Crespo de la Serna.** "Pintura de Diego Rivera: el proceso de desarrollo." In *Diego Rivera: 50 años de su labor artística,* exh. cat., Museo Nacional de Artes Plásticas. Mexico, 1951, pp. 61–75. **Manuel Reyero.** "Cronología: Diego Rivera, arte, ciencia y política en el mundo." In *Diego Rivera,* edited by Manuel Reyero. Mexico, 1983, p. 256, pls. 194–197 (as 193–196). **Laurence P. Hurlburt.** "Diego Rivera (1886–1957): A Chronology of His Art, Life and Times." In *Diego Rivera: A Retrospective,* exh. cat., Detroit Institute of Arts. New York, 1986, pp. 66, 69, figs. 130, 31.

322 ◀ **Diego Rivera**

Mexican, 1886–1957

Agrarian Leader Zapata, 1931

Fresco; 238.1 x 188 cm. (7 ft. 9¼ in. x 6 ft. 2 in.)
The Museum of Modern Art, New York.
Abby Aldrich Rockefeller Fund
EXHIBITED IN NEW YORK ONLY

Emiliano Zapata (about 1879–1919), the legendary Mexican revolutionary and leader of the agrarian reform movement, was a favorite subject of Diego Rivera. He first used Zapata as a thematic source as early as 1915, in the Cubist work *Zapatista Landscape—The Guerrilla* (Museo Nacional de Arte, Mexico City). The first portrait, which Rivera painted in 1926–27, appears at the entrance of the chapel of the Universidad Autónoma de Chapingo, where Zapata and another martyr, Otilio Montaño, are depicted as personifications of the seeds from which the fruits of the Revolution will grow. Zapata was next included, as the apotheosis of the Revolution, in the Court of Labor at the Secretaría de Educación Pública (1928). He also appears in the Court of Festivals, as the subject of a ballad dedicated to him and to the Revolution. In the murals at the Palacio Nacional in Mexico City (1929–30, 1935), he is shown with other martyrs of the Revolution, his battle cry, *¡Tierra y Libertad!* (Land and Liberty) blazoned across a large banner.

Rivera based the present work on the mural *Zapata Leading the Agrarian Revolt,* in the Palacio de Cortés (1930–31). The movable fresco panel is one of several large panels Rivera painted in 1931 for his solo exhibition at the Museum of Modern Art in New York. The white-clad Zapata is shown with his white horse and with the fallen enemy sprawled facedown at his feet. Zapata's followers, armed with bows and arrows, machetes, and farm implements, stand behind their leader at a slightly higher ground to the left. Large leaves that echo the horse's mane dominate the composition at the right.

The painting is, in effect, the culmination of Rivera's many representations of the revolutionary leader. The earlier Zapatas were conceived primarily as icons; here, he is portrayed as part of a narrative, a catalyst for revolt.

As in another panel in the Cuernavaca mural cycle, the *Battle of Aztecs and Spaniards,* the white horse in this fresco resembles the horses painted by the fifteenth-century Italian artist Paolo Uccello. Rivera did a number of sketches of the horses in Uccello's *Battle of San Romano* (Uffizi, Florence) during his trip to Italy in 1920–21.

Rivera made a lithograph of this work in 1932.

JQ

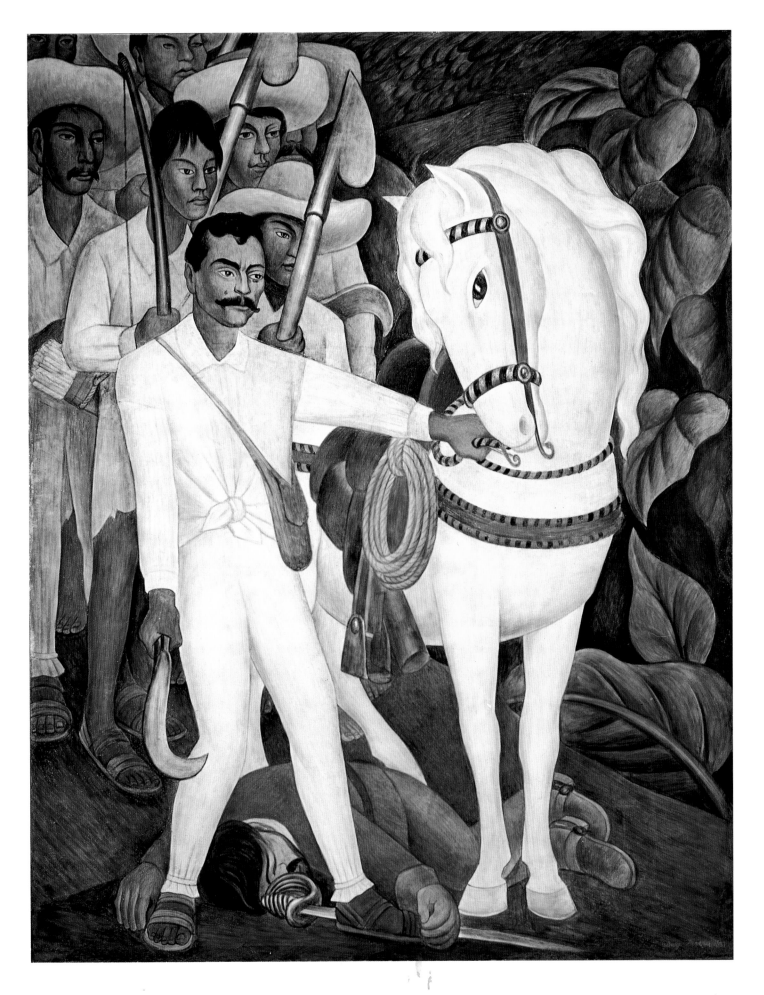

REFERENCES

Justino Fernández. *Arte moderno y contemporáneo de México*. Mexico, 1952, pp. 330–31. **Bertram D. Wolfe**. *The Fabulous Life of Diego Rivera*. New York, 1963, p. 300. **Stanton L. Catlin**. "Mural Census." In *Diego Rivera: A Retrospective*, exh. cat., Detroit Institute of Arts. New York, 1986, pp. 331–32. **Jesús Sotelo Inclán**. "Los zapatas de Rivera." *El Buho*. Supplement to *Excelsior*, October 15, 1989, pp. 1, 6.

323 ◀ Diego Rivera

Mexican, 1886–1957

The Flower Carrier, 1935

Oil and tempera on Masonite; 121.9 x 121.3 cm.
(48 x 47¼ in.)
San Francisco Museum of Modern Art. Albert M.
Bender Collection, Gift of Albert M. Bender
in memory of Caroline Walter
EXHIBITED IN NEW YORK ONLY

In his portrayal of the Mexican people, Rivera painted many compassionate studies of *cargadors* (burden carriers). These include the flower carriers in the mural panel in the Court of Festivals at the Secretaría de Educación Pública and the paintings *Flower Day*, 1925 (cat. no. 318), *The Water Carrier*, 1934 (Collection Moisés Saenz), and *The Garbage Carrier*, 1935 (Earlham College, Richmond). *The Flower Carrier* is probably the best-known example of this theme. It was painted in response to a request from Rivera's patron Albert M. Bender of San Francisco, who gave to the San Francisco Museum of Art five hundred dollars in March 1935 for the purchase of a work by Rivera .

The white-clad figure in *The Flower Carrier* is shown in profile on his knees, preparing to take the large basket of flowers being adjusted by the woman behind him. The flowers in the basket are known in Mexico as *pincel imperial* (literally, royal brush), and are taken to the cemeteries during the Day of the Dead. The man and woman occupy a shallow space defined by the ground and the pointed leaves of a tree behind them. The cylindrical forms of the carrier's arms and legs are echoed by the wide strap used to hold the basket of flowers in place, and the mound of flowers is complemented by the definition of the woman's shoulders.

The source for many of Rivera's paintings of this theme may have been Jean Charlot's mural panel *Burden Carriers*, painted next to Rivera's *La Zandunga* on the north wall of the Court of Festivals.

JQ

REFERENCES

Bertram D. Wolfe. *Diego Rivera: His Life and Times*. New York, 1939, pp. 319–20. **Bertram D. Wolfe**. *The Fabulous Life of Diego Rivera*. New York, 1963, pp. 284–85. **Katherine Church Holland**. "The Flower Carrier." In Diana C. duPont et al., *San Francisco Museum of Modern Art: The Painting and Sculpture Collection*. New York and San Francisco, 1985, pp. 140, 249–50. **Laurence P. Hurlburt**. "Diego Rivera (1886–1957): A Chronology of His Art, Life and Times." In *Diego Rivera: A Retrospective*, exh. cat., Detroit Institute of Arts. New York, 1986, p. 91, fig. 193.

324 ◀ **Diego Rivera**
Mexican, 1886–1957

Lupe Marín, 1938
Oil on canvas; 170.8 x 121 cm. (67¼ x 47⅝ in.)
CNCA–INBA, Museo de Arte Moderno, Mexico City

Lupe Marín was Diego Rivera's wife from 1922 to 1927 and the mother of his two daughters, Lupe and Ruth. They had been divorced for many years when this portrait was painted, and Rivera had been married to the painter Frida Kahlo since 1929. But despite the change in their situation, they remained on friendly terms. Rivera, for example, illustrated *La única*, Marín's novel about their stormy relationship, which was published in 1938.

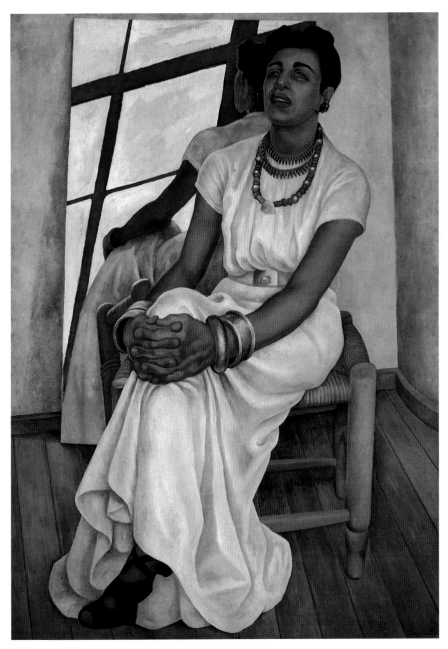

Many years earlier, Marín had been the model for the nude figure in Rivera's first mural in Mexico City, the *Creation* (1922–23), at the Anfiteatro Bolívar, and she appeared as the earth figure in the chapel of the Universidad Autónoma de Chapingo (1926–27). Rivera also painted a number of portraits of Marín during their marriage.

Although Rivera was always intent in his portraits on capturing the essence of the sitter's personality, he also used them to explore formal problems, and at times these aspects seem to dominate. The painting of Lupe Marín is one of these portraits.

Marín is shown seated on a backless Mexican chair in a corner of a room. A mirror is propped up against the wall behind her. She appears to be gazing at the sky, as indicated by her reflected image and part of the window frame in the mirror. The window frame identifies the room as Rivera's studio.

Marín's prominent features—her clear eyes and sensuous mouth—and her long arms and legs are emphasized by the foreshortened pose; the unusually large hands, with interlocked fingers, are the central focus. The diagonal thrust of the composition, established by the body and paralleled by the bars of the window frame reflected in the mirror, is echoed in the chair seat and support bars and the baseboard of the wall. The vertical thrust, formed by the torso and neck, the chair legs, and the meeting of the back and side walls, establishes a countertension, enhancing the spatial complexity of the powerful composition.

Rivera, always drawing on historical precedents, appears in this painting to have made intentional reference to the work of several artists whose work he admired. El Greco is acknowledged in the exaggerated proportions and pose of the figure; the mirrored image recalls works by Velázquez, Ingres, and Manet; and the complex structure of the composition, with its series of intersecting and interlocking planes and axes, brings to mind the work of Cézanne.

JQ

REFERENCES
Bertram D. Wolfe. *Diego Rivera: His Life and Times.* New York, 1939, pp. 197–215. **Justino Fernández.** *Arte moderno y contemporáneo de México.* Mexico, 1952, pp. 342–43. **Hans F. Secker.** *Diego Rivera.* Dresden, 1957, pp. 122–23, pl. 90. **Justino Fernández.** *La pintura moderna mexicana.* Mexico, 1964, p. 69. **Justino Fernández.** *A Guide to Mexican Art: From Its Beginnings to the Present.* Translated by Joshua C. Taylor. Chicago and London, 1969, p. 161. **Rita Eder.** "The Portraits of Diego Rivera." In *Diego Rivera: A Retrospective,* exh. cat., Detroit Institute of Arts. New York, 1986, pp. 197, 199, fig. 343.

325 ◀ **Diego Rivera**

Mexican, 1886–1957

Self-Portrait, 1941

Oil on canvas; 61 x 43 cm. (24 x 16⅞ in.)
Smith College Museum of Art, Northampton,
Massachusetts. Gift of Irene Rich Clifford, 1977

Rivera portrayed himself approximately twenty times in a variety of media—including easel paintings, drawings, murals, and prints—over a period of nearly fifty years beginning in 1906, when he was still a student, until 1951, six years before his death.

All of Rivera's self-portraits were done in a realistic manner, even during the years he was painting in the Cubist style, from 1913 to 1917. Occasionally he portrayed himself full-figure, but in most cases he concentrated on his massive head, which he represented with often brutal honesty. His large, protruding eyes, which earned him the nickname "the frog," were always emphasized.

This *Self-Portrait* was painted by Rivera at the height of his career. The original commission for the portrait came from Sigmund Firestone, a collector from Rochester, New York, who also commissioned a self-portrait by the

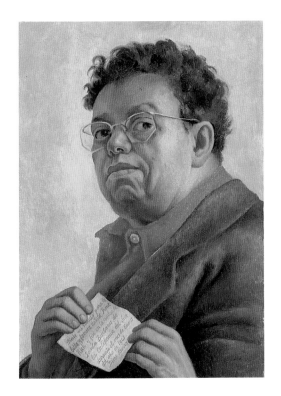

painter Frida Kahlo, Rivera's wife of twelve years. By the time Rivera began work on his self-portrait in January 1941, Kahlo had finished hers, so he used the same size canvas and a similar range of colors in order to complement it.

Rivera actually painted two very closely related self-portraits in January 1941. In 1939, during the San Francisco International Exposition, the film actress Irene Rich had asked Rivera to paint a portrait of her daughter Frances, a sculptor. As arranged, Rivera arrived in Rich's Santa Barbara, California, home in January 1941 to begin work on the portrait. It was agreed that Frances would do a bust of Rivera while he painted her portrait. When he was finished, he asked if he could remain a while longer to begin work on the self-portrait he had agreed to paint for Firestone. Because Frances had not yet completed the bust by the time Rivera had completed the self-portrait for Firestone, Irene Rich bought it, suggesting that Rivera paint another self-portrait for Firestone—which he did.

In both self-portraits Rivera wears rimless glasses, a red shirt, and a brown-gray tweed jacket, and in both he holds a piece of paper that identifies the person for whom the picture was painted. The text in the portrait for Irene Rich reads, in translation: "I painted this portrait for the beautiful and famous artist Irene/Rich, and it was done in the city of/Santa Barbara, Southern California/during the month of January/of/1941/Diego Rivera." The text in the portrait painted for Sigmund Firestone reads: "To my dear friend/Sigmund Firestone/Diego Rivera/January 1941." In the Rich version, the artist is shown in three-quarter view and the piece of paper is held with both hands; in the Firestone version, he appears in frontal view and the piece of paper is held in the right hand.

The use of the inscription derives from the Spanish tradition that was introduced into Mexico during the colonial period, in which portraits and ex-voto paintings include often lengthy inscriptions that relate to the sitter or to the event portrayed. Frida Kahlo used many such inscriptions in her works (see cat. no. 359).

JQ

REFERENCE
Xavier Moyssén. "The Self-Portraits of Diego Rivera." In *Diego Rivera: A Retrospective*, exh. cat., Detroit Institute of Arts. New York, 1986, pp. 188–95, fig. 223.

326 ◀ Diego Rivera

Mexican, 1886–1957

***The Temptations of St. Anthony**, 1947*
Oil on canvas; 90 x 110.5 cm. (35⅜ x 43½ in.)
CNCA–INBA, Museo de Arte Moderno, Mexico City

The annual festival known as the Contest of Radishes and Flower Decorations is held in the city of Oaxaca on December 23. During the celebrations red and white radishes of all sizes and shapes are carved and decorated to form figures and create scenes that are exhibited and awarded prizes by a panel of judges, after which they are sold as souvenirs. Rivera was undoubtedly inspired in this painting by this unusual folk tradition. He may also have been inspired by an event that was reported in art publications in the United States and Europe in 1946 and early 1947: an international competition to select a painting on the theme of the Temptation of St. Anthony to be used in the forthcoming motion picture *The Private Affairs of Bel Ami*. Max Ernst was the eventual recipient of the $3,000 prize, and the entries were exhibited in several cities in the fall of 1946, including New York, at the Knoedler Gallery. Finally, an article on the competition by J. Seznec entitled "Temp-

tations of St. Anthony in Art" appeared in *Magazine of Art* in March 1947—an article that may have caught the attention of Rivera.

The painting shows anthropomorphized radishes that assume preposterous configurations. The figure of St. Anthony appears at the lower right, his tempters to the left. The radish figures have overtly sexual attributes and assume highly provocative poses, while St. Anthony is shown reclining, with his arms upraised in a gesture of rejection. The entire scene is embedded in a finely textured surface that resembles freshly dug soil.

JQ

REFERENCE
Laurence P. Hurlburt. "Diego Rivera (1886–1957): A Chronology of His Art, Life and Times." In *Diego Rivera: A Retrospective*, exh. cat., Detroit Institute of Arts. New York, 1986, pp. 106–7, fig. 233.

327 ◀ **Diego Rivera**
Mexican, 1886–1957

Nocturnal Landscape, 1947
Oil on canvas; 111 x 91 cm. (43¾ x 35⅞ in.)
CNCA–INBA, Museo de Arte Moderno, Mexico City

In March 1947, Diego Rivera began two paintings with fantastic themes, *The Temptations of St. Anthony* (cat. no. 326) and *Nocturnal Landscape*. The same month, he also started work on the mural *Dream of a Sunday Afternoon in the Alameda*, for the newly constructed Hotel del Prado. The mural includes a scene with Rivera himself as a little boy and with his wife, Frida Kahlo, portrayed as his mother. It is perhaps not insignificant that at this time, shortly before he painted *Nocturnal Landscape*, Rivera was seriously ill with bronchial pneumonia and was hospitalized in Mexico City.

The painting shows a large, centrally located tree on whose branches children are seated in a variety of poses, spectators to an unseen event. The rapt expressions of the children and the branches of the tree are accentuated by the luminous yellow light that bathes the scene. A violet-blue donkey peers out of the semidarkness at the foot of the tree.

In the same year, near Tampico, Mexico, the American movie *The Treasure of the Sierra Madre*, directed by John Huston, was being filmed. It has been suggested that *Nocturnal Landscape* shows a group of boys who were watching the filming, the bright yellow branches reflecting the spotlights as the cameras rolled.[1]

JQ

1. *Diego Rivera: catálogo general de obra de caballete*, Instituto Nacional de Bellas Artes (Mexico, 1989) p. 232, no. 1782.

REFERENCE
Laurence P. Hurlburt. "Diego Rivera (1886–1957): A Chronology of His Art, Life and Times." In *Diego Rivera: A Retrospective*, exh. cat., Detroit Institute of Arts. New York, 1986, pp. 106–7, fig. 234.

328 ◀ **David Alfaro Siqueiros**
◀ Mexican, 1896–1974
◀
◀ *Penitentiary*, 1930
◀ Oil on canvas; 81.6 x 52.1 cm. (32⅛ x 20½ in.)
◀ San Francisco Museum of Modern Art. Gift
◀ of Brayton Wilbur
◀ EXHIBITED IN NEW YORK AND SAN FRANCISCO ONLY

David Alfaro Siqueiros was born in Chihuahua, Mexico, in 1896. One of the legendary "Great Ones" of the Mexican mural movement, he was certainly the most active and volatile politically. The first expression of his fiery political passion came while he was an art student at the Academy of San Carlos in Mexico City, when he became involved in a student strike in 1911 and was jailed later for participating in a violent demonstration in which students were protesting the French academic curriculum and promoting the idea of open-air painting. In 1913, during the Mexican Revolution, Siqueiros ran off at the age of sixteen to join the Constitutional Army. Ironically, his involvement with the military gave impetus to his artistic career. By 1919 he had risen to the rank of captain and was sent first to Madrid and then to Paris as the military attaché at the Mexican legation. While in Paris he was able to observe modern art firsthand and to meet members of avant-garde artistic

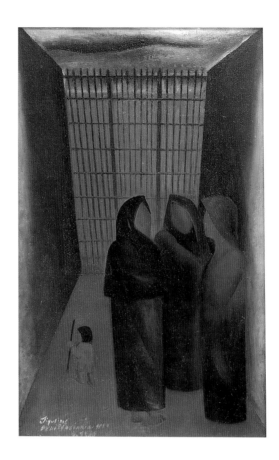

circles. Among them was his countryman Diego Rivera, with whom he began to formulate the revolutionary art-politics that coalesced in the mural school of Mexico in the early 1920s. He returned to Mexico in 1922.

After having been occupied primarily with mural painting during the 1920s, both at the Escuela Nacional Preparatoria in Mexico City and at the university at Guadalajara, Siqueiros from about 1925 to 1930 turned increasingly to political activities. He served as the secretary of the Communist Party of Mexico and of the Workers Confederation of Jalisco state. He was president of both the National Revolutionary Federation of Miners and the Committee of the Pro-Unity Syndicate. And he organized a mineworkers union in Jalisco and was the editor of a Communist newspaper.

This painting was executed in 1930, when Siqueiros was incarcerated in Taxco after having taken part in a May Day parade in Mexico City. It is one of a group of paintings he did that reflect on this experience and that mark his return to easel painting after his earlier involvement with large-scale public works. Two shrouded female figures, their features barely distinguishable, are shown waiting in a small courtyard in a prison complex. A child at the left brandishes a staff. Siqueiros has compressed the space with emphatic orthogonal lines, which constrain the figures so that they too seem to be imprisoned. The simple, blocklike forms in shades of green, orange, and red are typical of the period 1922 to 1932 and attest to the artist's close study of the mural paintings of Giotto and Masaccio, as well as the formal conventions of Cubism and Precolumbian art.

LSS

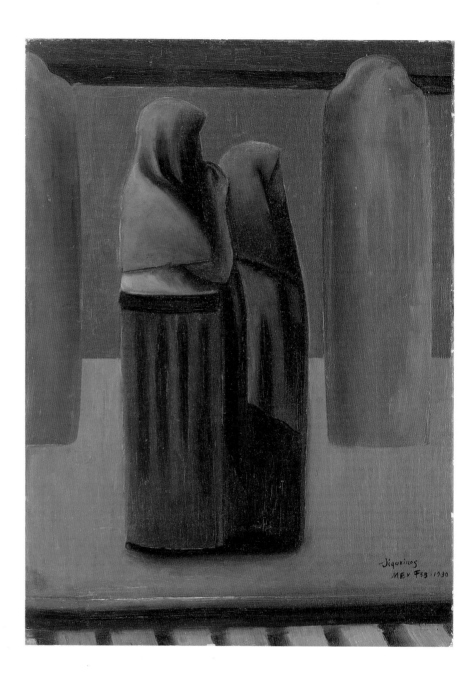

David Alfaro Siqueiros

Mexican, 1896–1974

Two Indian Women, 1930

Oil on canvas; 60 x 44 cm. (28 x 22 in.)
Santa Barbara Museum of Art. Gift, Charles Grayson

The monumentality of the forms in this painting belies its intimate scale. The theme, like that of *Penitentiary* (cat. no. 328), is of women in waiting. Here they look expectantly to the right for a train that will arrive on the tracks seen at the bottom of the composition. Siqueiros has eliminated anecdotal and anatomical detail, reducing both the figures and the particulars of the scene to general impressions. The anonymity of the figures serves the artist's purpose of focusing our attention on them as red and blue columnar structures that define the space.

The sculptural quality of the figures and of the two forms at either side is enhanced by Siqueiros's use of oil paint mixed with copal, a tree resin also used to make incense. Siqueiros was an inveterate experimenter and advocated the use of unconventional materials to rouse artists from confining themselves to academic approaches to painting. In his first murals of the 1920s he used encaustic, which afforded him the richly textural surfaces he preferred. To complement this effect, Siqueiros often introduced a dramatic

perspective. Later he would actually apply sculptural elements to the surfaces of his murals.

For Siqueiros, easel paintings such as *Two Indian Women* were ideologically less important than murals. He wrote in 1922: "We repudiate so-called easel painting and every kind of art favoured by ultra-intellectual circles, because it is aristocratic, and we praise monumental art in all its forms because it is public property."[1] Indeed, he considered his easel paintings preparatory to his murals. More often than not, Siqueiros worked on paintings when he was in prison, or when he had to prepare for an exhibition.

LSS

1. "A Declaration of Social, Political and Aesthetic Principles," in David Alfaro Siqueiros, *Art and Revolution*, translated by Sylvia Calles (London, 1975) p. 25.

330 ◀ **David Alfaro Siqueiros**
◀ Mexican, 1896–1974
◀
◀ *Head of an Indian Woman*, 1931
◀ Oil on canvas; 54.5 x 42 cm. (21½ x 16½ in.)
◀ Private collection, Mexico City

In a manifesto published in *Vida Americana*, the short-lived magazine that Siqueiros wrote and published in Barcelona in 1921, he cited the work of Paul Cézanne as a source of "spiritual renewal," noted the "purifying" aspects of Cubism, and welcomed the "reevaluation of 'classical voices'" in art.[1] All these qualities are to be found in a series of portrait heads that Siqueiros did in the late 1920s and early 1930s. While we have already noted that the modest scale of these works is the result of their having been painted while the artist was in prison in Taxco, a sense of monumentality is achieved by the use of simple sculptural forms that literally fill the picture plane.

In this enigmatic depiction of an anonymous Indian woman seen in profile, our attention is focused on the highlighted edge of the red rebozo that covers her head. This arc of light continues in a series of patterns that progress across her copper-complexioned face, starting at the area of her nostrils. The woman's profile and the details of her physiognomy are done in sharp, dark lines that emphasize the eyes, nose, and mouth. Precolumbian sculpture, as well as an adaptation of the formal elements of European modernism, is evident in the deft, massive handling of the forms. Siqueiros often exhorted his compatriots to look to traditional Mexican art for inspiration: "We must come closer to the work of the ancient settlers of our valleys, the Indian painters and sculptors (Mayas, Aztecs, Incas, etc.); our physical proximity to them will help us to absorb the constructive vigour of their work. . . . We must adopt their synthetic energy, but avoid the lamentable archaeological reconstructions . . . which are leading us into ephemeral stylizations."[2] It was this fostering of an *indigenismo*, or interest in Indian cultures, that formed the cornerstone of the revolutionary movement promulgated by Mexican artists and intellectuals between the two world wars.

LSS

1. "A New Direction for the New Generation of American Painters and Sculptors," in David Alfaro Siqueiros, *Art and Revolution*, translated by Sylvia Calles (London, 1975) p. 21.
2. Siqueiros, "A New Direction for the New Generation," p. 22.

331 ◀ David Alfaro Siqueiros

Mexican, 1896–1974

***Woman with Stone Mortar**, 1931*

Oil and pyroxylin on burlap; 101 x 76 cm.
(39¾ x 29⅞ in.)
Private collection, Mexico City

In this painting, the figure of an Indian woman grinding corn literally fills the space. Siqueiros subordinates realistic detail to the compositional exigencies of the large head—placed so that we do not see the face—which forms a bisected circular form from which the powerful shoulders flow into the strong but strangely truncated arms. The *metate*, a hollowed-out lava grindstone, splays out in a trapezoidal shape from the center of the composition, providing a structural complement to the torso of the woman above. The figure seems to be a predecessor of the powerful female figures seen in Siqueiros's later work, such as the central figure in the mural *New Democracy*, executed in 1944–45 at the Palacio de Bellas Artes in Mexico City. Here, the forms have a metallic quality, enhanced by the blue and green tones and set off by the reddish glow of the background.

The subject of *Woman with Stone Mortar* would seem to comply with the vogue for emulating popular culture, which was prevalent among Mexican artists at the time. But Siqueiros has emphasized the social condition of his subject rather than its ethnic appeal. In 1933, he issued a stern warning about

the dangers inherent in what he termed the "Mexican Curious" tendency for the modern art movement in Mexico: "This type of painting increases in direct proportion to the tourist trade in Mexico...[and] manifests itself as a tendency to paint the typical picture that the tourist wants. Modern art is thus ceasing to be an organically aesthetic expression of geography, social environment and Mexican tradition; instead, it becomes folk art for export.... We should see less of popular art and more of the work of the Indian masters, both of Mexico and the rest of America...because they will teach us to understand the great essential masses, the primary forms...[and] the metaphysical complement inherent to the masterpieces of all the world and all the ages."[1]

<div style="text-align: right">LSS</div>

1. "New Thoughts on the Plastic Arts in Mexico," in David Alfaro Siqueiros, *Art and Revolution*, translated by Sylvia Calles (London, 1975) pp. 31–32.

332 ◀ David Alfaro Siqueiros

Mexican, 1896–1974

Zapata, 1931

Oil on canvas; 135.3 x 105.7 cm. (53¼ x 41⅝ in.) Hirshhorn Museum and Sculpture Garden, Smithsonian Institution, Washington, D.C. Gift of Joseph H. Hirshhorn, 1966

Emiliano Zapata (about 1879–1919) was, along with the nineteenth-century reformer and lawyer Benito Juárez, one of the great legends of Indian ancestry in Mexican history. Zapata came to represent the interests of the poor farmers and workers within the complex machinations of the Mexican Revolution. The primary goal of Zapata and his followers was agrarian reform, outlined in his program the Plan of Ayala (1911), which called for one-third of all large estates to be turned over to Indian villages. In addition, the properties of all landowners who fought against the Revolution were to be confiscated. Eventually betrayed by a member of an allied group within the revolutionary forces, he was assassinated in 1919.

Zapata was a popular subject with the artists of the mural movement. He epitomized the populist aspect of the Revolution, which provided the ideological and philosophical thrust to their work. Diego Rivera portrayed Zapata leading a group of peasants who have struck down a member of the aristocracy and confiscated his horse (cat. no. 322). Siqueiros's interpretation compresses a bust of Zapata within a multicorridored architectural space that resembles the prison courtyards depicted in many other paintings of the early 1930s (see, for example, cat. no. 328). The artist also used this compositional format in his 1930 portrait of Moisés Sáenz, who was an advocate of a comprehensive and universal education in the rural areas of Mexico.

Although in the popular image Zapata appears in a white tunic and trousers and wears a high-crowned sombrero and cartridge belts slung across his chest, Siqueiros has created a more formal portrait. Here, Zapata is dressed in his trademark sombrero and a shirt, vest, and jacket. He is clean-shaven, and his mustache seems to have been waxed into place. The masklike quality of his face points to Siqueiros's interest in Cubism as well as Precolumbian art. Zapata seems to have been carved out of obsidian. The stylization of such features as the eyelids, eyebrows, and mustache contributes to a hieratic impression and brings to mind descriptions of the leader as taciturn but decisive. The painting may be based on a full-length portrait of the revolutionary leader that Siqueiros did as a lithograph a year earlier, in which we see the same man seated on a horse against a mountainous landscape.

Although the genre of portraiture could have been considered either counter-Revolutionary or antimodern, Siqueiros believed that it had an important

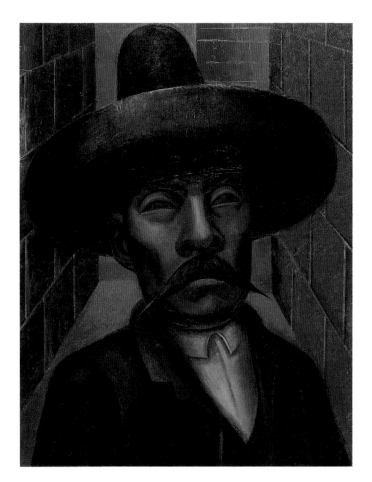

function within the Mexican art movement: "Painting and sculpture require not only a knowledge of art mechanisms but also metaphysical expression; portrait painting emphasizes this, because all the factors required for a complete work of art appear in a portrait."[1]

<div align="right">LSS</div>

1. "New Thoughts on the Plastic Arts in Mexico," in David Alfaro Siqueiros, *Art and Revolution*, translated by Sylvia Calles (London, 1975) p. 35.

REFERENCES
Mario de Micheli. *Siqueiros.* Translated by Ron Strom. New York, 1968, p. 8. **Abram Lerner, ed.** *The Hirshhorn Museum and Sculpture Garden, Smithsonian Institution.* New York, 1974, p. 746. **Jacinto Quirarte.** "Mexican and Mexican American Artists in the United States: 1920–1970." In *The Latin American Spirit: Art and Artists in the United States, 1920–1970*, exh. cat., The Bronx Museum of the Arts. New York, 1988, p. 17.

333 ◀ **David Alfaro Siqueiros**
Mexican, 1896–1974

Echo of a Scream, 1937
Enamel on wood; 121.9 x 91.4 cm. (48 x 36 in.)
The Museum of Modern Art, New York. Gift of
Edward M. M. Warburg

Echo of a Scream is probably Siqueiros's best-known image, particularly in the United States. An abandoned infant sits amid the detritus of industrial civilization. Clad only in a red cloth draped over one shoulder, he wails in unmitigated pain. It is this undying wail that reverberates in our consciousness, with the visual reinforcement that Siqueiros has devised. The head of the orphan is repeated—surrealistically enlarged—so that the original head seems to telescope out of the mouth of the outsize head. The orchestration of sound, movement, and emotion is comparable to that achieved by the Futurist artist Umberto Boccioni in his 1911 painting series *States of Mind*

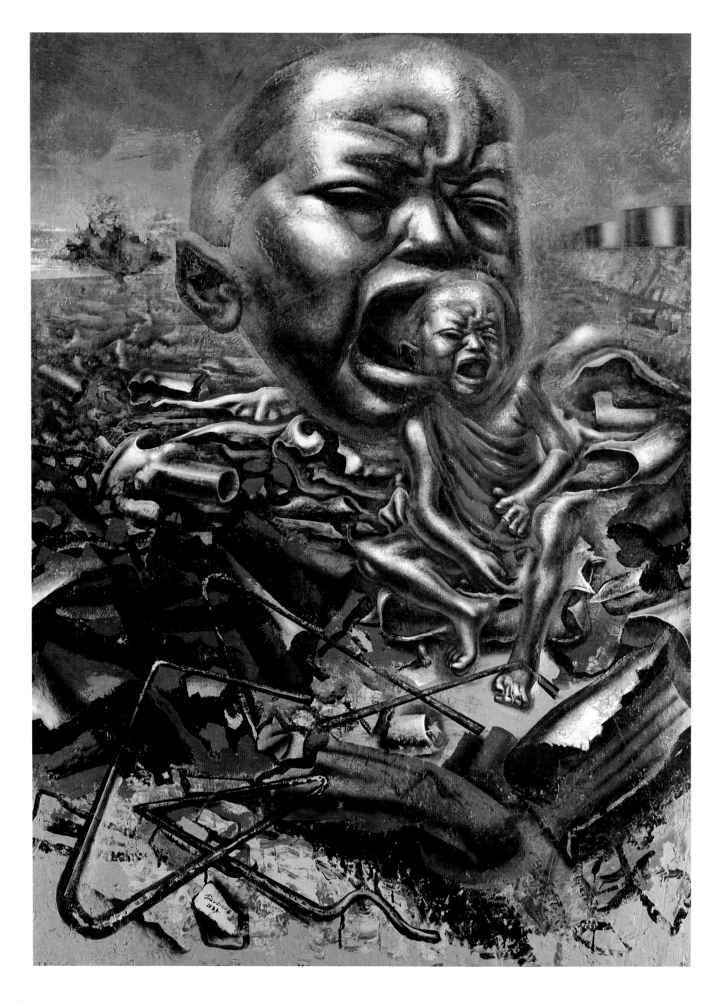

(Museum of Modern Art, New York). The telescoping of an image to simulate sound also recalls Charles Demuth's 1928 visual tone poem *I Saw the Figure 5 in Gold* (Metropolitan Museum of Art, New York), which Siqueiros may well have seen when it was exhibited in New York in 1935 at the Whitney Museum of American Art.

Siqueiros advocated the exploitation of photography both in the analysis of space and form and in the development of new methods of perspective and composition, and the influence of photography is evident here both in the artist's analytical approach to the image and as a possible source for the image itself. Such techniques as the "superimposed pictorial style of polyangular forms—movie forms" (seen here in the head of the infant) Siqueiros considered essential "in the search for a truly modern ideological expression."[1] Stylistically, the painting exemplifies the alternation between carefully modeled forms and textural abstract effects that Siqueiros developed, particularly in the 1940s.

The abandoned child, the universal victim, sits atop a carefully composed landscape of rubble; the triangles formed by wires and the cylinders by scrap plumbing establish an abstract pattern that extends through three-quarters of the composition. At the right are tanks for industrial waste or produce. The ballooning cloud at left, like that seen in Siqueiros's 1936 painting *Explosion in the City* (Museo de Arte Alvár y Carmen T. de Carrillo Gil, Mexico City), seems, in retrospect, a premonition of disasters yet to come.

Echo of a Scream is usually thought to have been done during Siqueiros's sojourn in Spain from 1937 to 1939. It was, however, purchased by Edward M. M. Warburg in New York in 1937, which would suggest that it was done either in Mexico City or New York.

LSS

1. "The Historical Process of Modern Mexican Painting," in David Alfaro Siqueiros, *Art and Revolution*, translated by Sylvia Calles (London, 1975) p. 15.

REFERENCES
Mario de Micheli. *Siqueiros.* Translated by Ron Strom. New York, 1968, p. 12. **Helm MacKinley.** *Modern Mexican Painters: Rivera, Orozco, Siqueiros and Other Artists of the Social Realist School.* 1941. Reprint. New York, 1989, p. 94.

334 ◀ David Alfaro Siqueiros

Mexican, 1896–1974

Ethnography, 1939

Enamel on composition board; 122.2 x 82.2 cm. (48⅛ x 32⅜ in.)
The Museum of Modern Art, New York. Abby Aldrich Rockefeller Fund

At one time entitled *The Mask*, this painting is one of the most stunning evocations created by Siqueiros. The apparition of an Indian peasant reincarnated as an Olmec deity effects a psychological and emotional empowerment of this disenfranchised segment of the Mexican population, one of the enduring artistic and political goals of the Mexican Revolution. The painting was executed upon the artist's return to Mexico in 1939, after he had fought with the Republican forces in the Spanish Civil War. In mid-decade he had been working in New York City, where he established the Experimental Workshop to foster material and technical exploration in painting. We observe in this painting the influence of both experiences, a painterly audacity and a renewal of Siqueiros's political mission as a Mexican artist.

The figure is set against a turbulent sky. In contrast to the more generalized, blocklike handling of form in the work produced earlier in the decade, here Siqueiros has lavished attention on detailing the pleats and folds of the shirt and the luxurious fullness of the sleeves, as well as the assertive architecture of the straw hat. The abstract, textural quality of the landscape areas in the lower background is typical of Siqueiros's paint surfaces at this time.

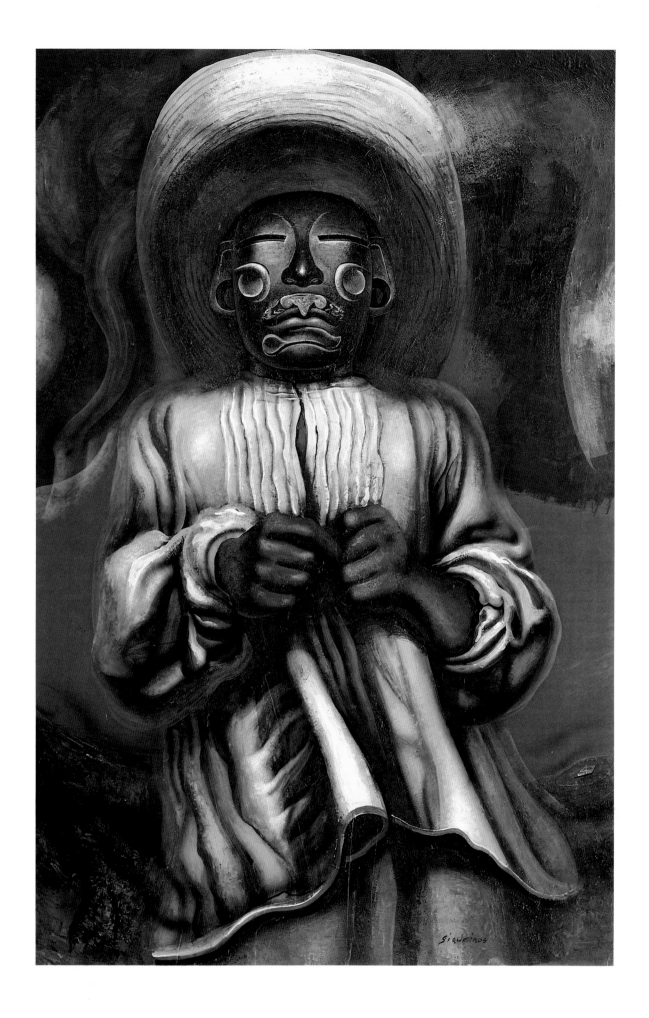

The face of the figure is based on a wood Olmec mask currently in the collection in the American Museum of Natural History in New York, which was purchased by that museum from the Burma Collection in 1949. Found in a cave in the state of Guerrero during the 1930s, the mask was until 1940 in the collection of William Spratling, an American expatriate whom Siqueiros met in the early 1930s when Siqueiros was serving a prison sentence in Taxco. Spratling was instrumental in revitalizing the silver industry in Taxco; he was also a dealer in Precolumbian art, and Siqueiros undoubtedly saw the mask in his collection. Spratling supported Siqueiros financially during his imprisonment and not only acquired paintings from the artist but also provided him with materials to do woodcuts and engravings.

LSS

REFERENCE
Helm MacKinley. *Modern Mexican Paintings: Rivera, Orozco, Siqueiros and Other Artists of the Social Realist School*. 1941. Reprint. New York, 1989, p. 95 (as *The Mask*)

335 ◀ **David Alfaro Siqueiros**
Mexican, 1896–1974

Self-Portrait (El Coronelazo), 1945
Pyroxylin on Masonite; 91 x 121 cm. (35⅞ x 47⅝ in.)
CNCA–INBA, Museo Nacional de Arte, Mexico City

A man who voraciously devoured life and art, Siqueiros here portrays himself dramatically reaching out to grab the world. His intense and determined expression seems literally to will the universe into existence or, more correctly, into submission. This gesture became a trademark of the artist, who throughout his career projected the image of a Marxist polemicist who could wield his influence with the masses.

The figure's huge hand is like an orb of superhuman energy. Even the nails pulsate with a lavalike glow. The strong specificity of the modeling of the head and the extended right shoulder, arm, and hand contrasts with the rich texture that surrounds the figure—a texture achieved through Siqueiros's experimentation with pyroxylin, Duco paint, and other plastic media. Siqueiros employed this organic, metamorphic quality to symbolize the struggle between the forces of the universe and used it to advantage in his mural paintings. The subtitle of this work, *El Coronelazo* (the Great Colonel), is an

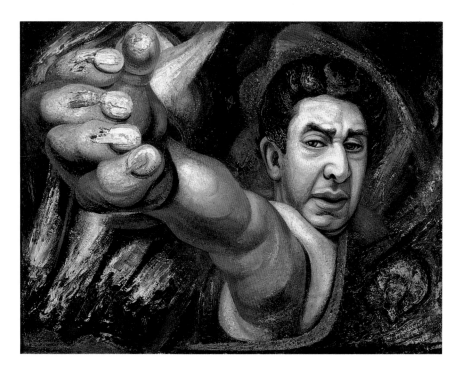

affectionate title given to the artist by his friends upon his return to Mexico, which refers to the rank he attained while fighting with the Republican forces in the Spanish Civil War from 1937 to 1939. This painting is said to be a polemical work, intended by the artist as an expression of confrontation with his political and artistic opponents. It was painted three years after his return to Mexico from Chile in 1942, where he had been in exile following his participation in the 1940 attempted assassination of Leon Trotsky. This event had naturally put him at odds with Diego Rivera and other intellectuals who had supported Trotsky's break with Stalin.

In 1945, Siqueiros was given a commission to execute a mural in the Palacio de Bellas Artes in Mexico City. This was interpreted as a gesture of reconciliation on the part of the Mexican government with the volatile artist, who would nevertheless continue his confrontational relationship with the government and with the fine arts establishment throughout his life.

LSS

REFERENCES
David Alfaro Siqueiros. "New Thoughts on the Plastic Arts in Mexico." In *Art and Revolution*, translated by Sylvia Calles. London, 1975, p. 35. **Antonio Rodríguez.** "Siqueiros teórico e innovador." In Mario de Micheli, *Siqueiros*. Mexico, 1985, pp. 35, 30–31, color pl. **Dorothy Chaplik.** *Latin American Art: An Introduction to Works of the 20th Century*. Jefferson, N.C., 1988, pp. 23–27 [as *The Great Colonel*].

336 ◀ **David Alfaro Siqueiros**

Mexican, 1896–1974

The Devil in the Church, 1947

Enamel on celotex; 214 x 153.7 cm. (84¼ x 60½ in.)
CNCA–INBA, Museo de Arte Moderno, Mexico City

The conception of evil as a composite of various animal and human attributes dates back to ancient Egypt and Persia. The monstrous figure in this composition, tearing through the roof of a church, comprises parts of an eagle, a lion, and a snake, all of which are usually associated with a griffin. The imaginary creature is ambiguous in nature and could represent either Christ or the Antichrist, a dual role befitting the evocation of false prophets, which Siqueiros seems to have chosen as his theme.

Siqueiros leads us into the picture by means of the dramatic architectural perspective focused on a vanishing point at the rear doorway, through which is seen a mysterious, luminous, pulsating form. The barrel-vaulted space, with simple architectural embellishment may well have been inspired by the chapel at the Hospicio Cabañas in Guadalajara, where Orozco executed an elaborate mural program in 1938–39. Circular patterns, like lines of energy, frame the bottom scene, as well as the gallery area, from which a passive elite observes the dramatic events above and below.

In the nave the assembled faithful, dressed in white, stand in rows with arms upraised as they look to the apparition above. The repetition of the pose creates a ripple effect that, like the lines of energy, reveals Siqueiros's interest in Futurism. Between these figures, others—dressed in reds, oranges, and yellows—cower in fear. Siqueiros may here be subverting our usual association of white with the sacred and bright colors with the profane. He achieved a comparable image of a monumental open space in his *Portrait of George Gershwin*, 1936 (private collection), in which the composer is seen from the back of the stage playing the piano before a theater filled to capacity. As he does in *The Devil in the Church*, Siqueiros in that painting conveys the impression of a large number of people through an accumulation of repetitive forms; he creates a tension between fantasy and reality, which precedes that in such compositions as *The Devil in the Church*.

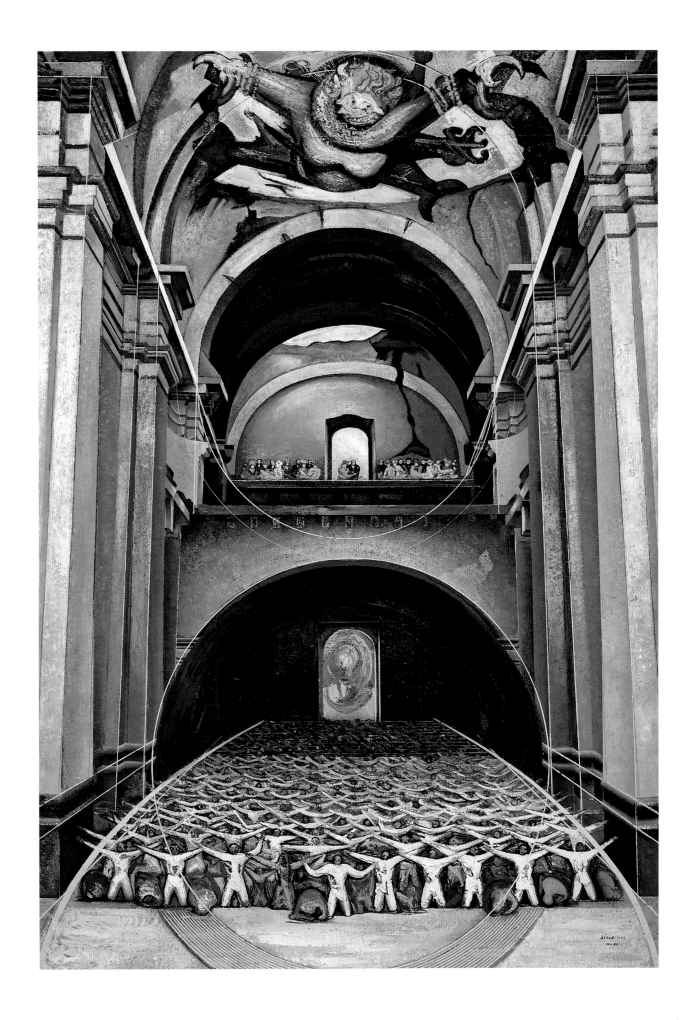

The art historian Renato Gonzales Mello has suggested that Revelation (9 : 7) may be the source for *The Devil in the Church*, particularly the image of the apparition: "Their faces were as the faces of men . . . and they had hair as the hair of women, and their teeth were as the teeth of lions . . . and the sound of their wings was as the sound of chariots . . . and they had tails like unto scorpions, and there were stings in their tails." He also notes that Siqueiros would probably have adapted a biblical theme to a Mexican context and that the artist's lifelong allegiance to Marxism would be a more suitable approach from which to begin to decipher this composition.[1]

LSS

1. Renato Gonzalez Melo in a letter to The Metropolitan Museum of Art, New York, Jan. 21, 1990.

REFERENCES
Antonio Rodríguez. *A History of Mexican Mural Painting.* Translated by Marina Corby. New York and London, 1969, p. 379. **Hans Haufe.** *Funktion und Wandel christlicher Themen in der mexikanischen Malerei des 20. Jahrhunderts.* Berlin, 1978, p. 123, ill. 81

337 ◀ **Miguel Covarrubias**
◀ Mexican, 1904–1957

◀ ***The Bone (Rural Schoolteacher),*** 1937
◀ Oil on canvas; 75.3 x 59.6 cm. (29⅛ x 23½ in.)
◀ CNCA–INBA, Museo Nacional de Arte, Mexico City

Miguel Covarrubias began his career as a caricaturist. Awarded a government scholarship at the age of eighteen in 1923, he went to New York, where he achieved immediate success as an illustrator and cartoonist for *Vanity Fair* (with which he was associated until 1936) and *The New Yorker.* Widely traveled, he went on to redirect his prodigious talents not only in painting but in archaeological and ethnological studies, writing the classic *Island of Bali* (1937) and the monumental *The Eagle, the Jaguar, and the Serpent: Indian Art of the Americas* (1954). He also taught ethnology at the University of

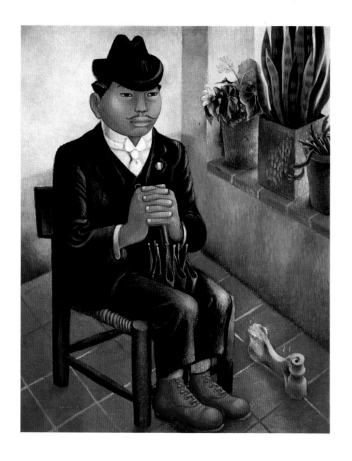

Mexico and was director of the dance department of the Instituto de Bellas Artes in Mexico City.

The Bone, subtitled *Rural Schoolteacher*, probably Covarrubias's most well-known painting, is a satirical portrait of a provincial Mexican bureaucrat, a slavishly law-abiding civil servant, who, in return for politically correct behavior, receives a dog's bone—that is, an easy government job. The portrait of the stolid, vaguely ridiculous-looking minor functionary is based on a figure in the artist's mural of a Sunday outing on one of the lagoons of Xochimilco, *A Sunday in Xochimilco*, done the same year for the bar of the Ritz Hotel in Mexico City. Using keen observation and an economy of means typical of his illustrational style, Covarrubias has created a visual delight enhanced by bright Mexican colors and potted tropical plants that seem to mirror the slightly absurd disposition of the seated figure. In his lapel he wears a tiny pin emblazoned with the tricolor of the Mexican flag, a fitting embellishment for someone who has voted correctly and is thus the recipient of his just reward.

RF

REFERENCES
Museum of Modern Art. *Twenty Centuries of Mexican Art*, exh. cat. New York, 1940, p. 163.
Arturo Casado Navarro. "La crítica pro y contra de la escuela mexicana." In *Historia del Arte Mexicano*, vol. 13, *Arte contemporáneo, I.* 2d ed. Mexico, 1986, p. 1887.

138 ◀ Antonio M. Ruíz

Mexican, 1897–1964

Jesús ("Chucho") Bribiesca, 1923
Oil on canvas; 100 x 70 cm. (39⅜ x 27½ in.)
Private collection, Mexico City

The works of Antonio Ruíz are little known, even in his native Mexico.[1] He did not participate in the muralist movement that dominated Mexican art from 1920 to 1940, and thus his name is often omitted from surveys discussing this period. If drama, pathos, and heroism fill the majority of Mexican paintings and murals, popular scenes drawn from daily life animate Ruíz's small canvases. These naïve, often poignant, images record Mexican society in all its colorful variety with a sharp eye, subtle humor, and fine irony. Ruíz painted slowly, never producing more than three or four small paintings each year. In composition his works are carefully planned, and their sometimes virtuoso use of perspective reveals the artist's knowledge of architecture and stage design.

Ruíz was born September 2, 1897, in Texcoco, a small town twenty-five miles northeast of Mexico City, to a cultured family. His father was a physician, his mother a concert pianist; his grandfather had been a painter. He studied painting and drawing from 1914 to 1916 at the Academy of San Carlos in Mexico City, but after two years changed his course of study to architecture. He worked during the same time as a technical draftsman at the Ministry of Communications and Public Services. In 1921, Ruíz began his lifelong career as a teacher, first as a drawing instructor at elementary schools and then, in 1932, as a professor at the Escuela Superior de Ingeniería y Arquitectura at the state polytechnic in Mexico City, where he founded the first atelier for the construction of technical models. In 1938, he became a professor of scenography and perspective at the Escuela Nacional de Artes Plásticas at the Universidad Nacional Autónoma de México. Finally, in 1942, he founded and was named director of the Escuela de Pintura y Escultura (La Esmeralda), where his friends the artists Frida Kahlo and Diego Rivera, among others, also taught.

This life-size portrait of Jesús ("Chucho") Bribiesca is exceptional in Ruíz's small-scale oeuvre as it is his largest work and thus may have been a com-

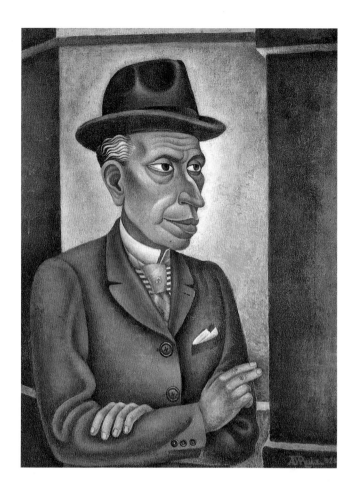

mission. Ruíz chose as format the traditional portrait bust, and adopted the dark tonalities of his teacher Saturnino Herrán. Chucho (the nickname for Jesús), a man in his late sixties and a friend of Ruíz's, had apparently once been a colleague at the Ministry of Communications and Public Services.[2] In later pencil sketches by Ruíz, Chucho's long crooked nose, narrowing eyes, and protruding chin appear just as prominently. Here, however, painstakingly recorded in paint, these features seem exaggerated to the point of caricature, especially for a head that looks disproportionately large on the slight body. Chucho's dark skin reveals his Indian descent. Fastidiously groomed, he sports a hat, starched white collar, tie, and jacket, and looks ready to spend the afternoon at the races or at his favorite café. As always in Ruíz's pictures, finely observed details abound: the wavy salt-and-pepper sideburns, the modishly different stripes of shirt and tie, the tiny horseshoe tiepin, the white handkerchief jauntily tucked into the breast pocket, and the cross-stitching on the jacket buttons.

Ruíz's clinical portrait of Chucho relates this work to that of the contemporaneous German painters of the Neue Sachlichkeit, with whom Ruíz probably shared an admiration for the precisely rendered detail of earlier painting.

A question remains: Did Chucho ever hang this portrait in his house?

SR

1. Ruíz was called "El Corzo" (or "El Corcito") by his friends, and he is often cited in the literature by this name. It seems that he bore a strong physical resemblance to the famous Spanish bullfighter Manuel Corzo, who was also nicknamed "El Corcito" and had lived earlier in the century.
2. Information provided by Ruíz's daughter, Vilma Ruíz de Barrios.

39 ◄ **Antonio M. Ruíz**

◄ Mexican, 1897–1964

◄ *The Lottery Ticket*, 1932

◄ Oil on canvas; 56 x 46 cm. (22 x 18⅛ in.)
◄ Alejandra R. de Yturbe and Mariana Pérez
◄ Amor, Galería de Arte Mexicano, Mexico City

Ruíz's favorite subjects were scenes taken from daily life. The image shown here—a young woman of about sixteen or seventeen selling lottery tickets, her baby hidden beneath the blue-and-yellow-striped rebozo—is even today a prevalent sight in Mexico. The model has the broad features of the Mexican Indian and wears her hair braided in the back, as is customary for unmarried women. She alone is responsible for herself and her baby; her blank stare bespeaks hardship and resignation.

The deep red of the wall indicates that she is in a bar or restaurant, one of many stops on her nightly round. The strange contraption at her left, which resembles a mousetrap, is a light switch. In Mexico these devices are larger than in Europe or in the United States; they are also uncovered, which makes them look life-threatening. With his usual precision—as if for a how-to book—Ruíz records the switch's inner workings: the two top fuses, the black wooden handle in the on position, and the two copper levers that connect the two power lines leading away from the switch. Also meticulously rendered is the lottery ticket in the woman's hand, with the number 12007 appearing on both coupons.

The Mexican lottery has never been accused of corruption. Under the supervision of the Board of Public Welfare, the lottery's annual profits are distributed to orphanages, hospitals, and other charitable institutions. More than

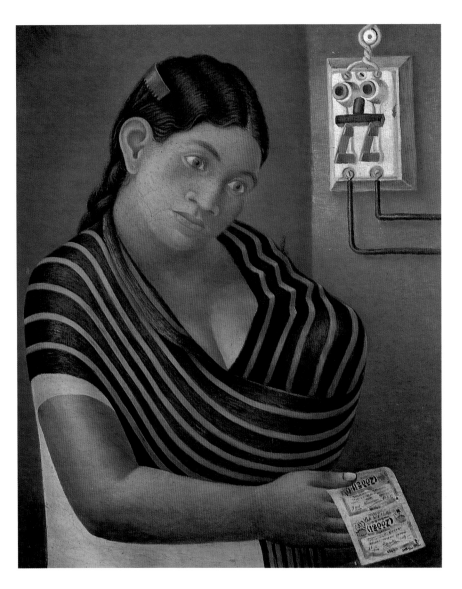

just a game of lucky numbers, it is a highly commendable enterprise. Aspects of this charitable spirit seem to have influenced Ruíz when he idealized this young yet disillusioned woman.

<div style="text-align: right">SR</div>

340 ◀ Antonio M. Ruíz

◀ Mexican, 1897–1964

◀ ***Schoolchildren on Parade**, 1936*
◀ Oil on canvas; 24 x 33.8 cm. (9½ x 13¼ in.)
◀ Secretaría de Hacienda y Crédito Público,
◀ Mexico City

This small picture, measuring just over 9 x 13 inches, seems to contain a cast of thousands. The crowd is celebrating Independence Day, September 16, Mexico's greatest national holiday. On that date in 1810, the priest Miguel Hidalgo y Costilla (1753–1811) first proclaimed Mexican independence. He was subsequently captured and shot by the Spanish, but his uprising marked the beginning of Mexico's struggle for freedom. It is Hidalgo's portrait—with black cassock, high collar, and flowing white hair—that adorns the pink banner at the head of the parade, surrounded by the inscription *Municipalidad Tepetlaoxtoc* (Municipality of Tepetlaoxtoc). It is on the edge of this small town fourteen miles northeast of Texcoco—where Ruíz was born—that the parade is taking place.

Schoolboys from all over the district must have been called upon to march in this formidable parade; all of the same height, they have the appearance,

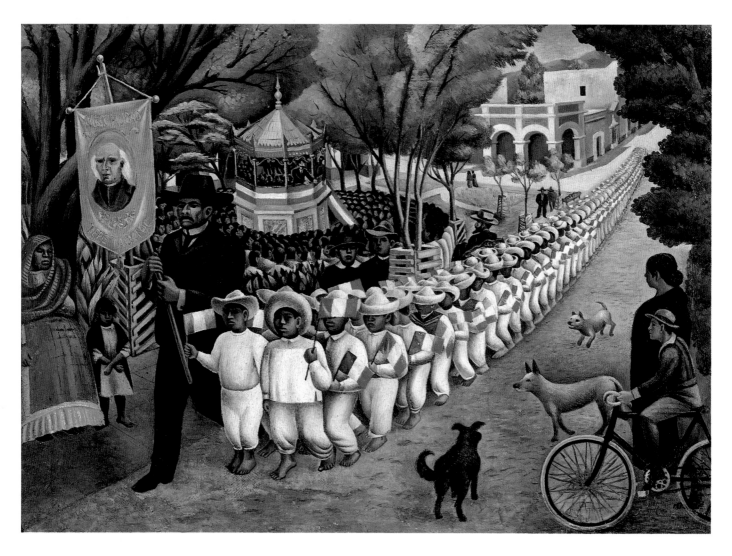

collectively, of a giant centipede. Led by their headmaster in black, the bare-
foot tots—all in white—wear the heavy cotton garments and round straw
hats of the Mexican peasantry. The boys move with the precision of a Swiss
watch—except for those in the front rows—in this curiously long parade
that recedes far into the distance, where the colonial houses of Tepetlaoxtoc
are visible. Green, white, and red national flags flutter gaily in their hands,
the flag held by the boy in the first row momentarily blinding the boy in the
second. Another large crowd—this one is older and some of them are dressed
in white and black shirts—has gathered to listen to the speaker who addresses
them from the gazebo farther back on the left, also decorated with a national
flag. The sea of tiny dark heads, heaves in the shade provided by the large oak
and evergreen trees.

Ruíz placed these separate events only in the left two-thirds of the composi-
tion. His economic and effective use of space is surely related to his experi-
ence as an assistant film set designer at Universal Studios in Hollywood
from 1925 to 1927. At that time, Universal dominated the market of silent
horror films, producing such movies as *The Phantom of the Opera* (1925).
Ruíz was perhaps influenced by the work of the celebrated German film
director Paul Leni (1885–1929), who made films for Universal. Leni had been
a poster and set designer for Max Reinhardt (1873–1943) in Germany and
Austria, and his innovative movie sets would later influence Alfred Hitchcock.
After his stay in Hollywood, Ruíz continued to work in Mexico as a stage and
costume designer for films, the theater, and the ballet.

Ruíz was fond of juxtaposing different social classes in his tiny canvases.
Here, while an Indian woman in a blue dress stands with a barefoot little girl
observing on the left, so on the right a well-to-do boy in European dress sits on
his bicycle, next to a woman who might be his governess. The right side of the
picture remains relatively empty, which affords an impressive view of the
parade, watched excitedly by three hairless xolos dogs.

SR

341 ◀ **Antonio M. Ruíz**
Mexican, 1897–1964

Bicycle Race, Texcoco, 1938
Oil on canvas; 36.8 x 41.9 cm. (14½ x 16½ in.)
Philadelphia Museum of Art. Purchased:
Nebinger Fund

In photographs Ruíz appears as an impeccably dressed gentleman usually
wearing a dark three-piece suit and a tie. And this is precisely how he is
dressed in the rare cameo appearance he makes in this picture of a bicycle race
at Texcoco, his birthplace. Ruíz is the shortest of the four men who stand in a
group on the right—one of them wears a red sweater and holds a bicycle—and
the only one without a hat. His friend Miguel Covarrubias, in turtleneck and,
as customary, with his hands in his pockets, stands to his left. Ruíz collabo-
rated with Covarrubias in 1938 and 1939 in painting six murals, entitled the
Pageant of the Pacific, which were shown in 1939 at the Golden Gate Interna-
tional Exposition in San Francisco.

Ruíz's was apparently an uneventful and ordered life, devoted to painting
and teaching. He lived with his family in a tidy blue house near the shrine of
Guadalupe in Mexico City, working in a tiny attic to the sound of a French
music box. According to his friend Diego Rivera, his entire oeuvre could have
fit into a cabinet.

In this small picture, Ruíz manages to gather together a large group of
people—some eighty-three adults and children, along with a horse, a dog, and
a young goat—while at the same time creating a composition filled with

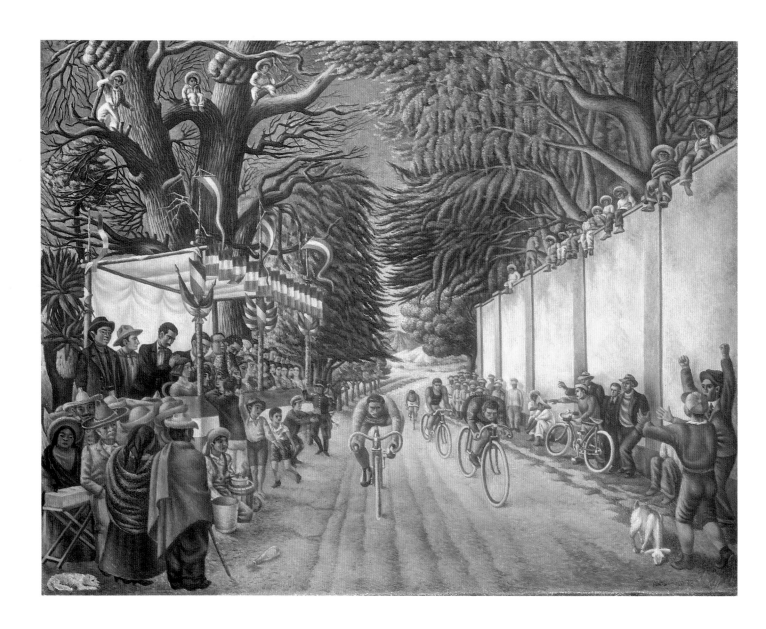

space and light. By delegating most of the small figures to the sides, he clears the center for a view of the sweeping perspective and of the four bicyclists who appear to approach a finish line that must lie just beyond the picture plane. Huge jacaranda trees in various shades of green tower above this spectacle, providing shade.

Such popular events always draw a rich sampling of Mexico's colorful population, which Ruíz lovingly depicts in all its variety. High society is seated —hatless—in the tribune decorated with the national colors reserved for the guests of honor on the left. The women, two of them adorned with mantillas, occupy the front row, their husbands standing directly behind. All around them mingle Mexican Indians, recognizable by their hats and ponchos; street vendors sell pink sweets and ice cream; a military man salutes; children run or sit high up in the trees; other children watch from atop the stone wall on the right; a group of soldiers in khaki-colored uniforms stands in the right background. While the guests of honor and the Indians look on impassively, the young sporty ones cheer.

The Philadelphia Museum of Art acquired this work in 1949. It is one of the only three paintings that Ruíz sold during his lifetime.

<div style="text-align: right">SR</div>

REFERENCE
Jacinto Quirarte. "Mexican and Mexican American Artists in the United States: 1920–1970." In *The Latin American Spirit: Art and Artists in the United States, 1920–1970*, exh. cat., The Bronx Museum of the Arts. New York, 1988, pp. 38–39, no. 20.

342 ◀ **Antonio M. Ruíz**

Mexican, 1897–1964

***The Orator*, 1939**

Oil on canvas; 32 x 26 cm. (12⅝ x 10¼ in.)
Collection Mr. and Mrs. Stanley Marcus, Dallas
EXHIBITED IN NEW YORK ONLY

According to an old Spanish folk custom, when a young woman wants to jilt a suitor, she sends him a *calabaza*, a pumpkin. A stupid person is also called a pumpkin. Ruíz surely alludes to this second meaning in this picture of a little man addressing a group of large pumpkins. The pumpkins, the orator's soapbox—a large plain kitchen chair—and the red floor tiles are of regular size. But why is the speaker such an itsy-bitsy little fellow? With his blue work shirt, baggy pants, and unkempt hair, he might be a General Tom Thumb in proletarian disguise.

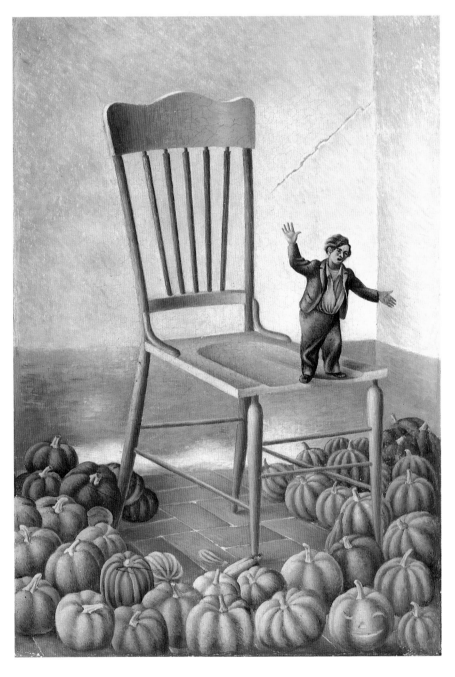

Does Ruíz depict the sensations that a frustrated speaker feels when he faces an unresponsive audience that seems to turn into a crowd of faceless pumpkins while he is reduced to insignificance? Are we being shown the orator from the perspective of the crowd to whom his mindless rumblings render him as silly as a puppet? Or could Ruíz be poking fun at someone in particular? It is impossible to say. Mexico's stormy history probably gave him ample opportunities to witness politicians of all kinds trying to win voters —especially in 1939, the year this picture was painted—as campaigning got under way for the general elections of 1940.

The Orator was one of two paintings by Ruíz that were chosen to be shown at the International Exhibition of Surrealism, held from January to February 1940 at the Galería de Arte Mexicano in Mexico City. This important first exhibition of Surrealism in Mexico was organized by Wolfgang Paalen, Cesar Moro, and André Breton. While the established Mexican artists, among them Diego Rivera, Frida Kahlo, and Manuel Alvarez Bravo, were listed in the catalogue among the international artists—the country of origin was not mentioned —Ruíz's name appeared in a separate section called Painters of Mexico, which included artists whose work Breton had seen during his earlier visit to Mexico in 1938, but whom he did not consider part of the official Surrealist movement.

SR

REFERENCES
Virginia Stewart. *45 Contemporary Mexican Artists: A Twentieth Century Renaissance*. Stanford, Calif., 1951, p. 53. **Ida Rodríguez Prampolini.** *El surrealismo y el arte fantástico de México.* Mexico, 1969, p. 58, pl. 26.

343 ◀ **Antonio M. Ruíz**

Mexican, 1897–1964

The New Rich, 1941
Oil on canvas; 32.1 x 42.2 cm. (12⅝ x 16⅝ in.)
The Museum of Modern Art, New York.
Inter-American Fund

The New Rich referred to in the title can be easily spotted. Mr. New Rich stands in the center of the picture, listening with only one ear to his contractor, who holds a blueprint while his foreman looks on. His stance—the open legs, the hands on the wide girth, the rudely averted face—leaves no doubt about who is the boss and who calls the shots. In contrast with the impeccable dark suit and tie of his contractor, Mr. New Rich wears roomy pants, boots, and a yellow shirt that seems to burst at the seams and is topped by a green kerchief jauntily knotted into a tie. Mrs. New Rich tries out new curtain material with her friend in the top window of their new, garishly painted, modern Spanish colonial house. Ruíz gently mocks their gaudy European getup, all in rose hues: the low-cut dress, the fur-trimmed coat, the heavy makeup, and the friend's dyed blond curls. Of the same simple Mexican Indian stock as the workers around them, Mr. and Mrs. New Rich may have come into money, but not to taste, Ruíz seems to say in his ironic narrative. In comparison with the artist's usual exuberant cast of thousands in his earlier out-of-door scenes (see cats. nos. 340, 341), this small canvas is relatively underpopulated, with only eleven figures and one dog.

The most picturesque scene unfolds on the right, where three masons eat the meal one of their mothers has prepared. Tortillas heat over the fire on the red clay dish; posol soup fills the four cups on the floor; and pulque, a Mexican liquor, waits in the tall demijohn. Two laborers work in the house right through lunchtime.

An imposing new stone bridge with pillars that match those of the facade gives access to the house over a dry gulch of a river. Ruíz echoes the facade's

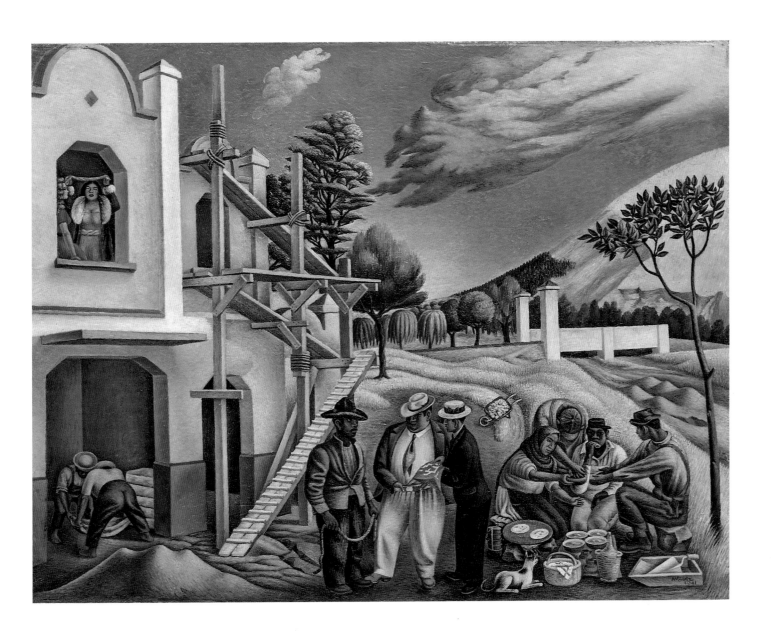

rising silhouette by the hill on the right, which is covered by the softer yellow of burnt grass. Green weeping willows, orange trees, and pines fill the distant valley.

The fine eye of Ruíz records every detail: the nailheads or rope on the boards of the scaffolding; the pieces of pork swimming in the soup; the blue-and-white pattern of the napkin in the straw food basket; the leaves on the little orange tree to the right.

This painting could be titled *Mexican Conversation Piece* because it contains all the elements that make up that popular eighteenth-century English genre: a group of figures—full-length and on a small scale—engaged in every-day occupations and shown against a background of their own houses. If most of the figures here do not own the house depicted, at this moment they are closely linked with it. The Museum of Modern Art, New York, bought this painting in 1943. It is one of the three paintings (see also cat. no. 341) Ruíz sold during his lifetime.

SR

REFERENCE
Alfred H. Barr, Jr. *What is Modern Painting?* Rev. ed., Museum of Modern Art. New York, 1984, p. 15.

344 ◀ **Antonio M. Ruíz**
◀ Mexican, 1897–1964
◀
◀ *The Soprano*, 1949
◀ Oil on wood; 27 x 24.5 cm. (10⅝ x 9⅝ in.)
◀ Secretaría de Hacienda y Crédito Público,
◀ Mexico City

The voluminous soprano and the gently curved black grand piano are perfectly matched, down to their tiny feet!

The Spanish word *gallo* translates as both "rooster" and "false note"; thus, when someone sings a false note, people say "a rooster comes out of his mouth." It is this moment, when a false note, a "rooster," issues forth from a singer's mouth, that Ruíz depicts in this little satire.

This particular image seems best suited to the small ex-voto-like format that Ruíz always chose for his paintings (cat. nos. 338 and 339 are exceptions) because the amazing event depicted here appears just as miraculous as those featured in the small Mexican religious paintings.

The strangeness of the rooster—and he is scrawny to boot—is accentuated by the meticulously realistic petit-bourgeois setting. Judging by the dark windowpanes glimpsed through the transparent white lace curtains, the soprano is giving an evening recital at her house. She is dolled up for the occasion, with earclips, a curly hairdo, and a festive sky-blue dress, whose tight fit and low cut displays her generous proportions: huge arms, enormous breasts, and triple chin. She looks powerful enough to lift the piano off any stage after a recital. These two heavyweights, the soprano and the grand, leave just enough room for some lightweight furniture: a Thonet-style chair and a small high

table, as well as the fake Baroque mirror, which reflects the rooster's amazed head. The curiously "sacred parlor" atmosphere of the salon is emphasized by the brand-new green carpet on the floor and the empty black vase on the table. A black-and-white photograph of a man leans against it—the soprano's sweetheart?

Ruíz's finely observed details heighten the comical aspect of the image: the flesh spilling over the cruelly tight shoes; the tiny black ribbon stuck like a fly on the décolletage; the extended pinky of the left hand clutching the evening's program.

The soprano's opulent proportions foreshadow by some fifteen years the seemingly air-pumped bodies that the Colombian painter Fernando Botero would make his trademark.

SR

345 ◀ Jesús Guerrero Galván
Mexican, 1910–1973

Girl in Pink, 1941
Oil on canvas; 58 x 44 cm. (22⅞ x 17⅜ in.)
Alejandra R. de Yturbe and Mariana Pérez Amor,
Galería de Arte Mexicano, Mexico City

One of the great romantics of the Mexican movement, Jesús Guerrero Galván was inspired as a painter by memories of his childhood in Tonalá, Jalisco. His paintings include guardian angels, miraculous healers, and visitations from tombs, mystical episodes set in remote dream landscapes. Although Galván was active as a muralist in the 1930s, moving to Mexico City and working

on decorative murals in schools and public buildings in the capital, he is known primarily as an easel painter.

Girl in Pink, one of a series of portraits of young girls done in a subtle palette of gray-blues, pinks, and red-ochers, is a departure from Galván's earlier paintings of monumental classicized figures. The massive hands, however, show the influence of Picasso's paintings of the early 1920s, studies of nudes and solitary figures of monumental proportions.

The portrait is compositionally quite simple—a flowing triangle formed of the top of the head down through the arms to the hem of the dress—yet complex in its broad planar distortions that afford a tense, unstable quality, heightened by surprising patches of vibrant color. Also evident is Galván's familiarity with the expressive brushwork of the French moderns and the influence of Siqueiros's "baroque" portraits from the late 1930s of young girls and women, with their dynamic painterly facture and virtuoso treatment of flowing forms.

"It is impossible for me to explain theoretically what it is that incites me to express myself plastically," wrote Galván. "I believe that the expression of feeling can be enjoyed without limit. But that joy is lost when we make it philosophical. I ignore the fact that my paintings are within the tradition of good Mexican painting. My daily impulse is to pursue the truth and not to deceive myself. I love deeply the ground I tread and the air I breathe. I would like to find within my canvases the tenderness and sweetness that others find there. I do not believe it is there, for only I know myself.... I have never believed in surrealism or in collective painting. They give me the chills. I simply love to paint."[1]

RF

1. Virginia Stewart, *45 Contemporary Mexican Artists: A Twentieth-Century Renaissance* (Stanford, Calif., 1951) p. 119.

346 ◀ Julio Castellanos

Mexican, 1905–1947

St. John's Day, 1938

Oil on canvas; 40 x 40.8 cm. (15¾ x 16 in.)
Collection Banco Nacional de México,
Mexico City

Early in his career, Julio Castellanos was employed as a drawing instructor in a public school, where he taught the traditional Mexican Drawing Method developed by Adolfo Best Maugard. A flat, decorative, geometric style that drew primarily on indigenous archetypal and folk sources, the method formed the basis of the primitive aesthetic of several modernist Mexican painters.

By the late 1930s, Castellanos had developed a distinctive classicizing style, metaphysical in its spare, silent settings of isolated, brooding monumental figures. His manner is marked by archaic Maya figures, with ovoid heads and elongated limbs and torsos, that express an eerie, ambiguous sensuality. The development of Castellanos's mannered style is fully expressed in his most important painting, *St. John's Day*.

In Mexico, June 24 is the day of San Juan, or St. John the Baptist. The fiesta of St. John was traditionally celebrated in the villages by ritual bathing—an allusion to the baptism of Christ by St. John—in purifying lakes and rivers and to this day in public baths and swimming pools. In cities, groups of youngsters organize parties, play musical instruments, and decorate the pools with brightly colored flowers. Castellanos's rendition of St. John's Day is based on a photograph, also entitled *St. John's Day*, by the photographer Lola

Alvarez Bravo (born 1907), who took the photograph at the Centro Escolar de Revolution, Mexico City, in 1937.

Castellanos is known to have been fascinated by the photograph, which shows children in bathing suits sunning themselves on stadium benches. Castellanos greatly expanded the composition, pushing the benches back and to the right and adding a modern pool equipped with an elaborate scaffolded diving board, swimmers and reclining nudes, a bathhouse in the distance, and a volcanic background landscape.

Despite the 116 figures crowded onto the small canvas, the picture imparts a complicated play of multiple perspectives and a sense of panoramic complexity, underscored and dramatized by the monumental presence in the foreground of a woman draped in a flowing white gown, her face partially covered. The figures, though in an outdoor setting, appear to be lighted by an artificial source in bright, luminous, contrasting colors, adding to the evocative Symbolist quality that pervades the scene. Castellanos, trained as a set designer, here transforms a fairly typical scene of ordinary people into a theatrical and highly charged vision.

Castellanos sold the painting to the collector Nelson A. Rockefeller, who lent it to the Museum of Modern Art, New York, for several years. It is one of only about thirty paintings by the artist, whose production also includes some one hundred drawings and a few prints.

RF

REFERENCES
Museum of Modern Art. *Twenty Centuries of Mexican Art*, exh. cat. New York, 1940, p. 159.
Olivier Debroise. *Figuras en el trópico: plástica mexicana, 1920–1940.* Barcelona, 1983, pp. 144–47.

347 ◀ **Julio Castellanos**

Mexican, 1905–1947

The Angel Kidnappers, 1943

Oil on canvas; 57.5 x 94.9 cm. (22⅝ x 37⅜ in.)
The Museum of Modern Art, New York.
Inter-American Fund

The Angel Kidnappers belongs to the mature phase of Castellanos's work and is similar in its surreal, poetic quality to two other paintings, *St. John's Day*, 1938 (cat. no. 346), and *Maya Dwelling*, 1945, which depicts a scene that Castellanos witnessed in the state of Yucatán when vast numbers of butterflies swarmed over the countryside. The painting shows a group of Maya women and children sheltered from the heat in the shade of a thatched hut. The older children reach for butterflies in the trees.

The Angel Kidnappers represents a tragic vision of Mexico, in which the more common narrative references to actual events—in this case, the pervasive reality of infant mortality in the daily lives of the poor—are replaced by a poetic evocation of death. The picture shows an impoverished peasant couple asleep in their bed while two monumental angels of death steal their child from its cradle. A stark moonlight illuminates the scene in an ethereal twilight that is at once cold and brilliant.

In the majority of his paintings, Castellanos focused on the subject of women and children. *The Angel Kidnappers*, which speaks of the loss of a child, reflects the widely held belief that in death an infant is transformed into an angel or joined by angels because he is taken in a state of innocence. In Mexico the annual holy days associated with death, All Saints' Day (November 1) and All Souls' Day, or the Day of the Dead (November 2), are celebrated on two different dates to distinguish between the *angelitos*, those who have died in childhood, and those who have died at a later stage of life.

The works Castellanos painted during the last ten years of his life, exemplified by *The Angel Kidnappers*, differ from those he painted earlier in their surface treatment. The later paintings are more highly textured, built up by layer

upon layer of pigment applied with fine brushstrokes. Some of the painted areas are scratched through or scraped away to create a more volumetric effect. The textured surfaces are in sharp contrast to those of the earlier works, in which the surface is also built up with fine brushstrokes but the pigment is more thinly applied, creating a tempera-like effect.

In composition, *The Angel Kidnappers* is comparable to many paintings of the Italian Renaissance. Castellanos used similar conventions in his set designs.

JQ

REFERENCES
Raul Flores Guerrero. *Cinco pintores mexicanos: Frida Kahlo, Guillermo Meza, Juan O'Gorman, Julio Castellanos, Jesús Reyes Ferreira*. Mexico, 1957, p. 113. **Jacinto Quirarte**. "Mexican and Mexican American Artists in the United States: 1920–1970." In *The Latin American Spirit: Art and Artists in the United States, 1920–1970*, exh. cat., The Bronx Museum of the Arts. New York, 1988, pp. 39–40, no. 21.

348 ◀ Rufino Tamayo

Mexican, born 1899

Mandolins and Pineapples, 1930

Oil on canvas; 50.1 x 69.8 cm. (19¾ x 27½ in.)
The Phillips Collection, Washington, D.C.

In the 1930s, Rufino Tamayo was among the group of Mexican artists who rejected the political focus of the painters associated with the mural movement during the previous decade. In their determination to pursue the goals of European modernism Tamayo and his fellow artists, such as María Izquierdo and Carlos Mérida, were frustrated by the fact that so few examples of the new art could be found in Mexico. Consequently, they were forced to seek out reproductions in art publications and to rely on the experiences of such artists as Roberto Montenegro, who had been to Europe. Tamayo, determined to find a more culturally stimulating environment, left for New York in 1926 with his friend Carlos Chávez, the composer. He stayed for two years, returning to Mexico in 1928. He went back to the United States in 1936, where he painted and taught until 1950, returning each summer to Mexico.

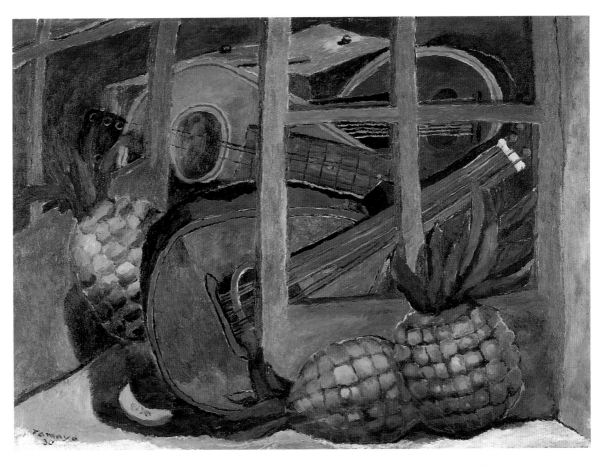

The composition of this still life is typical of the arrangements of fruits, musical instruments, and everyday objects, such as light bulbs, clocks, and cigarettes, that Tamayo executed in the late 1920s and early 1930s. Here pineapples, mandolins, and windowpanes alternate as the composition progresses back into space. At the top edge of this crowded picture, we glimpse a table with a rod and two small spherical forms on top. More than in other compositions of this type, Tamayo is concerned with creating a rhythmic pattern by the repetition of forms, an effect offset by the incongruous crescent of the single banana at the left. This decorative impulse may be an indication of Tamayo's earlier contact with the work of Matisse, as is the manner in which the depiction of reality is made secondary to the overall compositional scheme. The influence of Cézanne may also lurk in the sturdy physicality of the compositional elements and in the cultivated tentativeness also seen in the work of such artists as Stuart Davis and Joaquín Torres-García a decade earlier. Both Davis and Torres-García were interested in everyday objects as subject matter. The connection is especially pertinent since Tamayo met Davis during his first visit to New York in 1926–28. Other compositions by Tamayo of this period feature light bulbs and packages of cigarettes, two Davis motifs of the period 1922–24.

After being orphaned at the age of twelve, Tamayo left his native Oaxaca to live with an aunt and uncle in Mexico City. There he worked with his aunt selling fruit in the market, an experience that undoubtedly influenced his preoccupation as a painter with fruit. Their presence in his paintings has also been seen as an iconographic reference to the five senses (one that the artist commented on); the watermelon, in particular, became a recurring motif. In this picture the mandolin may also be an homage to his friend Chávez, who was an accomplished guitarist, and a symbol of the artist's own lifelong love of music. There is also a reference to the long tradition in European art of stringed instruments as icons of sensual pleasure. The relatively somber palette —muted ochers, olive greens, blues, and browns—was to characterize Tamayo's work throughout the 1930s. Bright colors would return in the 1940s, as exemplified in the brilliant reds and blues of *Woman Spinning Wool* (cat. no. 351).

LSS

REFERENCE
Jacinto Quirarte. "Mexican and Mexican American Artists in the United States: 1920–1970." In *The Latin American Spirit: Art and Artists in the United States, 1920–1970*, exh. cat., The Bronx Museum of the Arts. New York, 1988, pp. 51–52, pl. 34.

349 ◀ **Rufino Tamayo**
Mexican, born 1899

The Muses of Painting, 1932
Oil on canvas; 75 x 100 cm. (29½ x 39⅜ in.)
CNCA–INBA, Museo de Arte Moderno, Mexico City

This painting is the first of several allegorical compositions that Tamayo executed in the 1930s, including *Venus Fotogénica* (Ministry of Finance and Public Credit, Mexico) and *Homage to Zapata* (Collection Herman Weitz, Mexico), both of 1935, and *New York from the Terrace* (private collection, Mexico), done in 1937. *The Muses of Painting* is a curious composition. In a crowded atelier the artist works with his back to the viewer, painting a donkey outfitted with a fancy bridle and blanket. The donkey, not the most elevated subject matter, is nevertheless rendered with the high seriousness accorded to animal portraiture of aristocratic agrarian circles. The image of the artist is similarly humble; he is depicted in a sailor's blouse, as if a mere apprentice or student. His darker, apparently nude, doppelgänger appears to

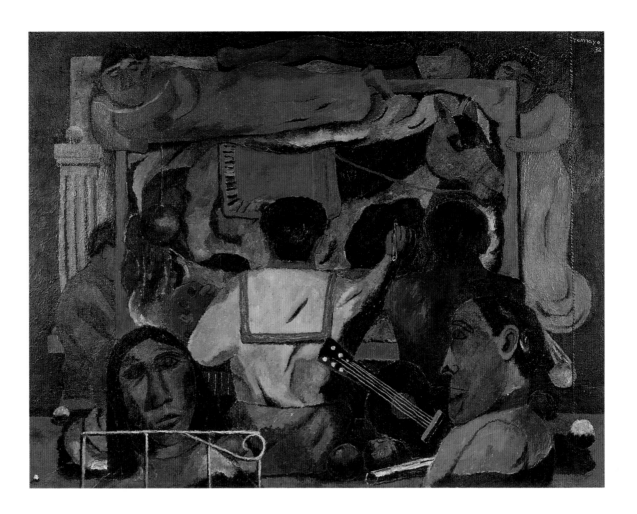

the right, mysteriously passive. A guitar, a recurring motif in Tamayo's work, links the artist compositionally to his double.

Gustave Courbet's 1855 monumental painting *Artist's Studio* (Louvre, Paris) was undoubtedly the inspiration for Tamayo's composition, in which he assembled actual and allegorical figures. In addition, the influence of Giorgio de Chirico may be seen in the classical fragments, such as the column and ball at the left and the fallen fluted rod at the right. Chirico's compressed space defined by planar elements is also felt, as well as his love of enigmatic situations —the hanging rope at the right, which does not quite connect with the unnaturally airborne ball. A female figure looks out at the viewer from the left foreground, while her male companion appears in profile at the right. Another visitor to the studio is partially cut off from view by the painting in progress. The two muses that float atop the picture and hold it in place bring to mind in their blocklike classicism the languid personifications of the four continents in Diego Rivera's mural of the same year, *Detroit: Man and Machine*, at the Detroit Institute of Arts. In addition to Tamayo's adherence to European precedents in this work, he characteristically includes specific references to Mexican culture—the donkey for one, and the internal framing of the scene (formed by the muses and the architectural elements), which recall the wood-and-cardboard frames used at fairs and fiestas, behind which visitors would assemble for souvenir photos.

Art historians have remarked on correspondences in Tamayo's work of this time with the painting of María Izquierdo, Tamayo's student and companion from 1929 to 1933. The question of mutual influence in their work may long

remain a matter for discussion and conjecture, but what is evident is that both artists were close followers of European modernism.

LSS

REFERENCE
Olivier Debroise. "María Izquierdo." In *María Izquierdo*, exh. cat., Centro Cultural/Arte Contemporáneo, A.C. Mexico, 1988, p. 35.

350 ◀ Rufino Tamayo

Mexican, born 1899

Lion and Horse, 1942

Oil on canvas; 91.5 x 116.8 cm. (36 x 46 in.)
Washington University Gallery of Art, St. Louis.
University Purchase, Kende Sale Fund, 1946

"Picasso's use of animal imagery and fractured form to express human anguish and terror in *Guernica* became the catalyst for the crystallization of Tamayo's mature style, which begins with his animal series of the early 1940s."[1] Tamayo was probably able to view *Guernica* in New York in 1939 at the Valentine Gallery, where it was exhibited prior to the opening of a major exhibition of Picasso's work at the Museum of Modern Art in 1940. "In works like *Lion and Horse* (1942) . . . Tamayo amalgamated Cubism with Mexican subject matter and color schemes derived from folk art and Precolumbian ceramics."[2]

The iconography of this composition is mysterious. Neither the lion nor the horse is a Precolumbian subject, although the horse is clearly a quotation of the frenzied animal in *Guernica*. Rita Eder has suggested that it also represents the anguished state of the Mexican people.[3] Within Picasso's oeuvre the horse has a feminine identity—in contrast to the masculinity of the bull—and may also be a reference to the matador, pitted against the bull. In a Latin American context the horse appears as a symbol of Europe, the colonizing force that introduced this animal to the American continent.

The significance of the lion is more problematic. While feline imagery is integral to Precolumbian America, it is the jaguar and the puma that predominate and have specific mythic and iconographic resonances. Most likely,

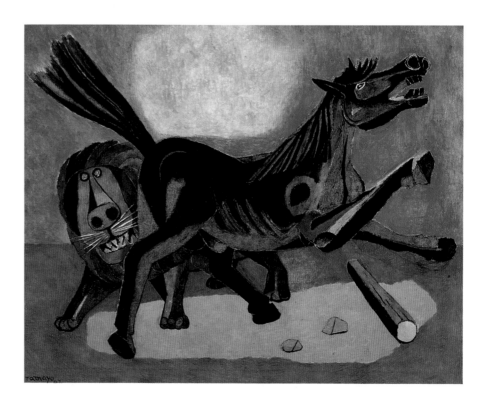

then, the lion is European-derived. In this connection it may symbolize the Evangelists St. Mark or St. Jerome, or it could also signify the temperament of choler and, on a more sinister note, the devil.

Although such programmatic approaches to iconography were anathema to Tamayo, twenty-five years after he executed this painting he conceived a hybridization of a tiger and the devil to represent the negative forces of Western cosmology in the mural he executed for the 1967 World's Fair in Montreal. Interestingly, lions also appear in the 1937 composition *Siren and Lions* (Robert Brady Foundation), by Tamayo's former companion the painter María Izquierdo.

LSS

1. Holliday T. Day and Hollister Sturges, *Art of the Fantastic: Latin America, 1920–1987,* exh. cat., Indianapolis Museum of Art (Indianapolis, 1987) p. 98.
2. Ibid.
3. Rita Eder, "Tamayo en Nueva York," *Rufino Tamayo: 70 años de Creación* (Mexico City; Centro Cultural, 1987) p. 60.

351 ◀ Rufino Tamayo

Mexican, born 1899

Woman Spinning Wool, 1943

Oil on canvas; 106.7 x 83.9 cm. (42 x 33 in.)
Collection Mr. and Mrs. Roy R. Neuberger,
New York
EXHIBITED IN NEW YORK ONLY

The influence of Precolumbian art is particularly evident in this picture of a hieratic figure drawing thread from a ball of cotton or wool. The influence of Picasso was also at its strongest at this time, particularly the "stained glass" stylizations seen in his work of the late 1930s and early 1940s, as in such paintings as *Girl Looking in the Mirror*, 1937 (Museum of Modern Art, New York).

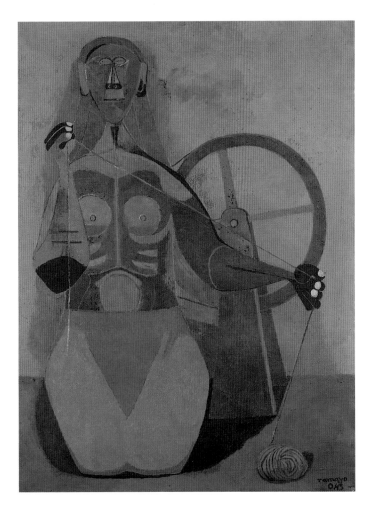

The composition of *Woman Spinning Wool* is structured as a series of circular elements that interact architecturally with horizontal, vertical, and diagonal elements. For this reason the spinning wheel is a formal extension of the figure, repeating the contours of her body and rhythmically connecting the woman to her work.

When he painted this picture, Tamayo had been living in New York for four years. The subject of primitivism, which had been prevalent in the international art world from the beginning of the century, had reemerged in New York art circles in the 1940s. In general, primitivism was discussed in terms of the totemic and mythic content of African and Oceanic art; Tamayo introduced the contribution of Mexican art to this dialogue. Interested in popular Mexican art and Precolumbian art from the beginning of his career, Tamayo had served as head of the Department of Ethnographic Drawing at the Museo Nacional de Antropología in Mexico City from 1921 to 1923. The influence of popular culture accounts for the artist's choice of colors as well as his choice of subject. He wrote: "Colors are a reflection of economic conditions in my country.... They are very cheap.... This kind of blue... is used to whiten clothing... the reds and oranges...[can be found on] ancient pottery."[1]

It is interesting to note that even at this time in Mexico, weavers made offerings to the earth and to the plants and trees from which they made their dyes. They would wear the same colors as the dyes they were making and say prayers in Nahuatl so that their work would be blessed.

LSS

1. Rufino Tamayo, "A Commentary by the Artist," in *Tamayo*, exh. cat., Phoenix Art Museum (Phoenix, Ariz., 1968) p. 2.

352 ◀ **Rufino Tamayo**
◀ Mexican, born 1899
◀ ***Cantinflas***, 1945
◀ Oil on canvas; 99.7 x 79.4 cm. (39¼ x 31¼ in.)
◀ Private collection, New York

Mario Moreno (b. 1911), popularly known as Cantinflas, is one of Mexico's most famous and beloved motion picture stars. Dubbed the Charlie Chaplin of Mexico, he created a comparable *pelado* (tramp) persona, easily recognized by his awkward gait, ill-fitting clothing, and rambling speech. The character, using visual and physical slapstick, serves as a comic catalyst who unmasks the stupidity and hypocrisy of society. Through willful disingenuousness he dismantles social pretensions, offering his audience a sense of vicarious participation that serves to encourage an empathic response to the character. Some of Cantinflas's best-known Mexican films are *The Three Musketeers* (1942), *Romeo and Juliet* (1943), *Grand Hotel* (1944), and *I Am a Fugitive* (1946). He became known to audiences in the United States in the role of Passepartout, David Niven's valet and companion in the 1956 production of *Around the World in 80 Days*.

Tamayo has painted many portraits during his career, some commissioned, and several of his wife, Olga. This painting is distinctive in that we see the subject engaged in his livelihood. Cantinflas stands in front of a schematized building, acting before the camera. He wears his habitual costume of dark, loosely fitting pants, a white T-shirt, and a jaunty felt hat. The costume is completed by what he called his *gabardina*, a thin piece of cloth worn around his neck, that masquerades as a fancier garment. At the left of the composi-

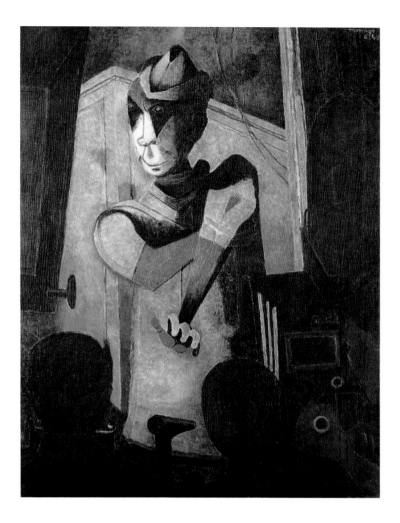

tion is the silhouette of what appears to be a monitor. The backs of the head and shoulders of two figures (one of them undoubtedly the director) can be seen in the foreground, and to the right is the hand of the cameraman. Cantinflas is rendered in the blocklike physique derived from Precolumbian figurines, which characterizes all Tamayo's figures at this time. The masked eyes, reminiscent of stylistic conceits in figures of the so-called Chinesca style of Nayarit (about A.D. 100), are unexpectedly sinister.

LSS

Rufino Tamayo

Mexican, born 1899

The Merry Drinker, 1946

Oil on canvas; 112.8 x 87.1 cm. (44⅜ x 34¼ in.)
Private collection, U.S.A.

"Tamayo's figures love, eat, drink, smoke, listen and gaze in total, narcissistic dedication to the particular sensation. No psychological shadows adumbrate these states of self-gratification; nothing disturbs their clarity and purity."[1] The manic smile on the face of this male figure indicates a well-advanced state of intoxication, as do the several bottles at his feet and his cocky, cross-legged pose. In another similar composition, *A Toast* (present location unknown), also dated 1946, the drinker gestures gaily as he raises the glass to his lips. Here a guitar, like the bottles of wine an attribute of sensuality, can be seen leaning against the wall. But is Tamayo perhaps hinting at something more ominous in this scene of a merry tippler? Because for all his exuberant gesturing and expostulating, the figure seems curiously restrained within the tight, boxlike space. Tamayo reinforces this sense of claustrophobia by cropping off the top of the hat.

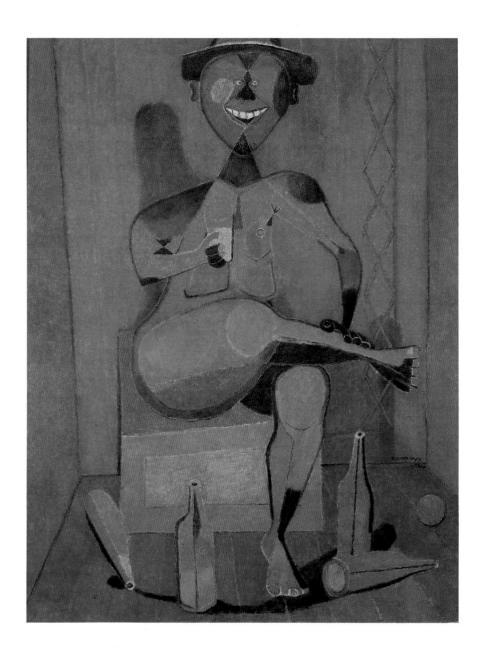

The figure's incongruously nude body—all the more puzzling because of the hat—shows the schematic structure of the torso common to Tamayo's figuration during the 1940s. The body is dominated by the large ovoid forms of the right thigh, negating the sense of the knee's protruding outward and concealing the lower portion of the torso and sexual identity of the figure.

LSS

1. James B. Lynch, Jr., "The Language of Tamayo," in *Tamayo*, exh. cat., Phoenix Art Museum (Phoenix, Ariz., 1968) p. 11.

354 ◀ **Rufino Tamayo**
Mexican, born 1899

***Children Playing with Fire**, 1947*
Oil on canvas; 127 x 172 cm. (50 x 67¼ in.)
Private collection, New York. Courtesy of
Mary-Anne Martin Fine Art, New York
EXHIBITED IN NEW YORK ONLY

Rufino Tamayo has always deemphasized the significance of content in his work, preferring that the spectator focus on the formal aspects of his compositions. During the late 1940s, however, he executed a series of paintings that are clearly responses to the devastations of the Second World War and the advent of the atomic age. Like many of his fellow artists, Tamayo was skeptical of man's ability to deal wisely with the unlimited power at his command:

"We are in a dangerous situation," he observed, "and the danger is that man may be absorbed and destroy what he has created."[1]

While *Children Playing with Fire* has been interpreted as an allegory of the Mexican Revolution, it may more properly relate to a universal message— a metaphor of mankind playing at dangerous games and precipitating world conflagration. Other artists working in New York during the late 1940s also used children at play as a metaphor of society. "Stephen Greene recalls discussing the importance of mysteriousness and ritual in children's play. The ritual in these intrigued [Philip] Guston, who saw it as a reflection of society, its war games and ordinary procedures. They also dig into the recesses of his own childhood memories. These . . . paintings, then, contain many levels: . . . specific social concerns (the poor, slum children, poverty, and class wars) combined with an integral and elemental search for self and universality."[2]

Children Playing with Fire shows a further evolution in Tamayo's figuration. The schematic, hieratic figures of the early 1940s are now active, gesticulating entities. Their anguish, expressed in the more freely described contours, is echoed in the flames that leap up in sweeping crescent patterns.

LSS

1. Quoted in Holliday T. Day and Hollister Sturges, *Art of the Fantastic: Latin America, 1920–1987*, exh. cat., Indianapolis Museum of Art (Indianapolis, 1987) pp. 96, 98.
2. Greta Berman and Jeffrey Wechsler, *Realism and Realities: The Other Side of American Painting, 1940–1960*, exh. cat., Rutgers University Art Gallery (New Brunswick, N.J., 1982) p. 71.

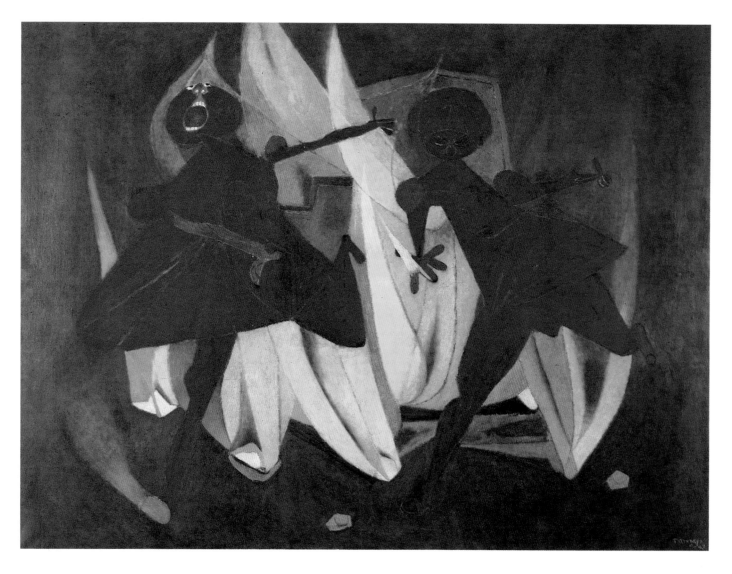

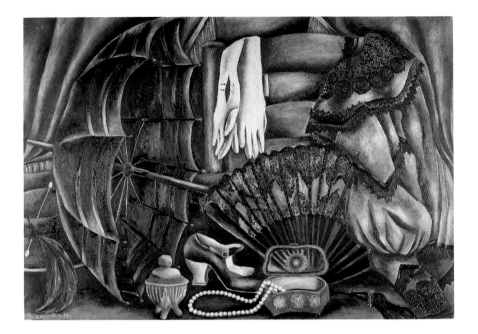

355 ◀ **María Izquierdo**

◀ Mexican, 1902–1955

◀ ***The Jewelry Box,*** 1942

◀ Oil on canvas; 70 x 100 cm. (27½ x 39⅜ in.)
◀ Collection Banco Nacional de México,
◀ Mexico City

Although Frida Kahlo is the one Mexican woman artist of her generation to be accorded widespread praise and recognition, the painter María Izquierdo is once again being considered for her role in the development of twentieth-century Mexican art. The 1988–89 retrospective exhibition of 160 paintings and drawings by Izquierdo at the Centro Cultural/Arte Contemporáneo in Mexico City again demonstrated the originality of her style and the force of her expression.

Like Kahlo, Izquierdo worked with important Mexican artists of her day. As a student in Mexico City she met Diego Rivera and Rufino Tamayo at the Escuela Nacional de Bellas Artes (formerly the Academy of San Carlos) in 1928. Rivera was then the director of the school and Tamayo one of its instructors, to whose studio Izquierdo was assigned. The association of Izquierdo and Tamayo developed into an intimate relationship that lasted four years, from 1929 to 1933. Many of the women in Tamayo's paintings at that time are based on Izquierdo. Although their respective works of this period take the same forms and include similar images—still lifes, portraits, and landscapes with animals—these subjects were already present in their own work by 1927 (one year prior to their meeting). These early paintings suggest that each of them was influenced by the primitivistic style of such artists as Paul Gauguin and Pablo Picasso, but further, they indicate that each was influenced independently. For both Izquierdo and Tamayo, this style of painting was adopted in the service of developing a Mexican art form that was neither politically nor socially polemical. Their artistic collaboration from 1929 to 1933 may therefore be understood more as a meeting of like sensibilities than as one artist's following the other's lead.

Recognition of Izquierdo's talents by her contemporaries came early in her career and preceded by several years her eventual success with the public. Although her first one-woman show, held in 1929 at the Galería de Arte Moderno del Teatro Nacional in Mexico City, was organized by Rivera, who also wrote the introduction to the catalogue, it generated no sales. Other exhibitions followed in Mexico, New York, and Europe in the 1930s, which brought her work to a wider audience. Among those who admired her paintings was the French Surrealist writer Antonin Artaud.

Between 1929 and 1942, the date of this painting, Izquierdo had ten one-woman shows and participated in twenty group shows, including the large survey of Mexican art exhibited at The Metropolitan Museum of Art in 1930. It was not, however, until a new relationship with the Chilean painter and diplomat Rául Uribe Castillo began in 1938 that Izquierdo found a group of patrons. Izquierdo and Uribe were married in 1944; they were divorced in 1953.

The Jewelry Box is a highly personal still life, which shows items from Izquierdo's dressing room. A table and chair—almost obscured by the profusion of overlapping objects—provide the support for the arrangement. Every object is carefully and lovingly placed in the composition to produce the desired effect of well-balanced and symmetrical harmony. In the foreground a covered glass jar and a small, open jewelry box stand like sentinels before a treasure. An umbrella, a hat, and a black lace fan rest behind them. Several of the other items—the lace-trimmed satin blouse, the long white gloves, the strand of pearls, and the ankle-strap shoe—can be found in paintings and photographs of the artist. Although no figure appears, Izquierdo's presence is strongly felt, making this in effect a portrait of the artist.

LMM

356 ◀ María Izquierdo
Mexican, 1902–1955

The Open Cupboard, 1946
Oil on canvas; 62 x 50 cm. (24⅜ x 19¾ in.)
Collection César Montemayor Zambrano, Monterrey

Throughout her career Izquierdo painted still lifes, such as *The Jewelry Box* (cat. no. 355), in which she used everyday objects—clothing, fruit, and folk art—to express personal feelings. The exact meanings of these paintings often elude us, but the repeated appearance of certain images over many years suggests that the objects had assumed a special significance to the artist that transcended their formal qualities.

During the 1940s, Izquierdo used these objects in such traditionally Spanish genres as religious altar paintings intended for the home and in pictures of *alacenas* (open cupboards). In part they refer back to her childhood and to her strict religious upbringing, and in part they demonstrate her desire to paint specifically Mexican subjects. In 1947, Izquierdo wrote her artistic credo: "I try to make my work reflect the true Mexico, which I feel and love. I avoid anecdotal, folkloric, and political themes because they do not have expressive or poetic strength, and I think that in the world of art, a painting is an open window to human imagination." Instead of narrative, she relied on what she called the "shapes and colors of Mexico" to express her nationalistic pride and heritage—her "Mexicanness."[1]

These shapes and colors often took the form of clay or ceramic figurines of people and animals, *papel picados* (paper cutouts), and decorated bowls and pitchers. Izquierdo took pleasure in collecting such objects, displaying them in open cupboards in her home. In her paintings they are often shown with brightly colored fruits and vegetables.

The Open Cupboard is a picture of an *alacena*, a shelved wooden box that displays a collection of keepsakes hung on a wall or placed on a countertop. Izquierdo's image follows a tradition of *alacena* painting that is also seen in Antonio Pérez de Aguilar's 1769 painting from the colonial period of a three-shelved cupboard (cat. no. 199). Izquierdo's painting, however, captures the

distinct vitality of Mexican art in the 1940s and differs greatly from its predecessor in its palette and technique.

The predominant red of the painting is enlivened with patches of blue, green, orange, yellow, and white. Placed symmetrically on the three shelves of the bare wood cupboard are two white horses (a popular image in Izquierdo's paintings), vessels made of glass and ceramic, an abundant array of fresh—and marzipan—fruits and vegetables, pieces of wrapped candy, and a nut roll set on *papel picado*. The objects in this still life are painted in a stylized and naïve manner that corresponds in spirit to popular Mexican folk art.

The *alacenas* and related altarpieces and religious dioramas that Izquierdo painted in the 1940s all deal with the idea of objects confined within a closed space. One may perhaps see in these works a metaphor for Izquierdo's own life in Mexico. As an artist and as a woman, Izquierdo faced the restrictions and expectations imposed by traditional Mexican values. She found acceptance in the artistic community when she was considered an extension of one or the other of her male companions (Tamayo and Uribe). But the image of her as an independent artist met with resistance.

In 1945, one year before she painted *The Open Cupboard*, Izquierdo lost an important commission for a large mural for the Palacio Nacional in Mexico City. The decision to rescind this invitation, eight months after it was issued and before any work had actually begun, was instigated by Diego Rivera and David Alfaro Siqueiros, both of whom felt that she was inexperienced in fresco painting and would be unable to handle such a project. The loss of the commission was devastating to Izquierdo and added to the pain of her deteriorating marriage to Uribe. Obstacles such as these, however, never prevented Izquierdo from painting—and perhaps even heightened the poignancy of her highly personal symbolism.

LMM

1. Izquierdo's "Artistic Creed" of 1947 is reprinted in *María Izquierdo*, edited by Miguel Cervantes, with an introduction by Carlos Monsiváis (Mexico, 1986) p. 145. Translation from the Spanish by Maria Balderrama.

REFERENCE
Olivier Debroise. *Figuras en el trópico: Plástica mexicana, 1920–1940.* Barcelona, 1983, p. 154.

357 ⁞ **María Izquierdo**

⁞ Mexican, 1902–1955

⁞ ***The Little Girl Who Did Not Care,*** 1947
⁞ Oil on canvas; 85.5 x 66 cm. (33 ⅝ x 26 in.)
⁞ Alejandra R. de Yturbe and Mariana Pérez Amor,
⁞ Galería de Arte Mexicano, Mexico City

Izquierdo's memories of childhood often inspired the imagery in her paintings of the 1930s and 1940s. As a young child, left in the care of relatives, she lived a highly confined life in several provincial towns. In 1917 Izquierdo's family arranged for her marriage, at the age of fourteen, to an army colonel, and shortly thereafter she bore three children. Unhappy and unfulfilled in her marriage, she eventually left her husband in 1927 to begin her study of art.

One of the few happy memories that she carried from childhood was the annual appearance of the traveling circus. Its arrival, with brightly colored banners, decorations, games, hot-air balloons, and visitors, transformed the town into a fiesta. The spectacle of these events always remained with her, as they provided a marked contrast to her daily life. It is interesting to note, however, that even in her liveliest renderings of circus performers, a pervasive melancholy seems to lie just beneath the surface.

During the 1930s and 1940s, Izquierdo also painted several portraits of children, whose sullen, unexpressive faces often bear a strong resemblance to

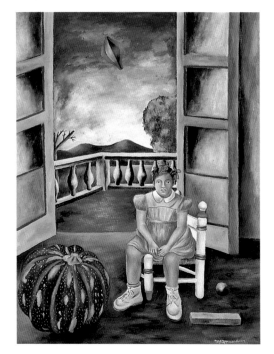

photographs of herself as a child. These paintings are different from the circus pictures of the same period in that where the melancholy of the circus performers is veiled, in the paintings of children the artifice is stripped away. The children are pictured by themselves or posed next to an adult. Although they are physically well cared for, their spirits have been deadened by inactivity and indifference.

Painted in 1947, when the artist was forty-five years old, *The Little Girl Who Did Not Care* recalls the isolation that Izquierdo felt as a child. A young girl, who looks like the artist at about age six, sits alone in an unadorned room, neatly dressed and coiffed as if waiting to go out. Her inertia is reflected in her blank expression and in the placement of her feet, which are firmly planted on the ground. Around her on the floor are three objects, which she ignores: a spinning top, a block, and, quite unexpectedly, an oversize green-and-yellow squash. The appearance of the squash is bizarre, and fraught with suggestive meaning. Its bloated presence seems almost a visual analogy to the girl herself—her lethargy, her unfulfilled potential, or perhaps her anger, sealed in to the bursting point.

Beyond the confines of the room is an empty terrace and forbidding landscape. The arrangement of open glass doors, terrace and balustrade, and outdoor scene is reminiscent of Matisse's paintings of southern France in the late 1910s and 1920s. Izquierdo, however, has appropriated Matisse's compositional format without suggesting the joy of its expression. Here, only the lone hot-air balloon floats free.

For Izquierdo, painting became the means through which she escaped the unhappiness of her childhood and also the method through which she integrated her experience. In 1948, a year after she painted this picture, she suffered the first of three strokes that eventually left her paralyzed on one side. Although she continued to paint with difficulty until she died in 1955, she produced only about twenty additional paintings.

LMM

358 ◄ Frida Kahlo

Mexican, 1907–1954

La Adelita, Pancho Villa, and Frida, about 1927

Oil on canvas; 65 x 45 cm. (25⅝ x 17¾ in.)
Gobierno del Estado de Tlaxcala, Instituto
Tlaxcalteca de Cultura, Tlaxcala

In this early unfinished painting, as in so many of the some two hundred works that Frida Kahlo produced between 1926, when she began painting, and 1954, when she died at the age of forty-seven, Frida stares out from the picture's center with the sloe-eyed, penetrating glance that made her impossible to ignore. Her hair is cropped short, as it was in her first self-portrait from the previous year, and she is dressed "fit to kill" in an off-the-shoulder gown. It is clear that even when she was a young woman, flamboyant or eccentric clothes formed an important part of Kahlo's self-invention.

Painted about a year and a half after a bus crash that left her a partial invalid for life and made her unable to bear children, *La Adelita, Pancho Villa, and Frida* shows the young artist struggling to learn how and what to paint. It is awkward in drawing and stilted in composition—at this early stage, Kahlo's naïve style was not yet a means chosen intentionally to distance the painfulness of her subject matter; rather, it is the primitivism of a fledgling and self-taught artist. As in several other works painted around this time (see, for example, *Los Cachuchas*, location unknown), space is flattened with a rather crude version of Cubism, which allows Kahlo to combine disparate elements in one canvas.

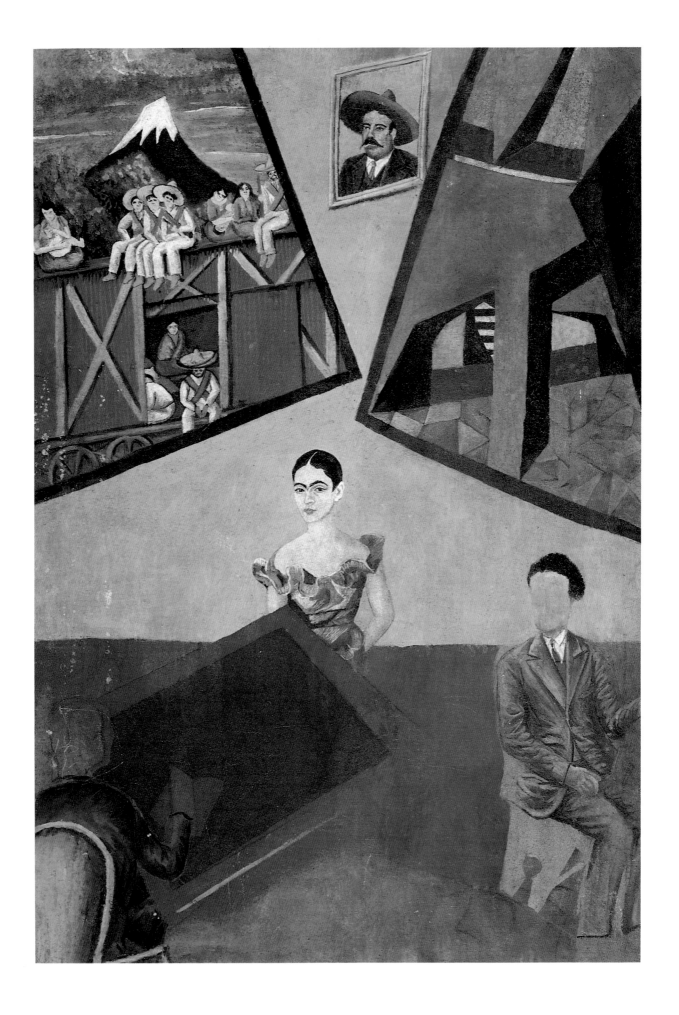

Frida is shown standing (or perhaps sitting—the clumsiness of the drawing makes this unclear) at one corner of a table, which appears to be covered with green felt. At the opposite corner is an unfinished seated male figure, probably one of Frida's band of friends from her years at the Escuela Nacional Preparatoria. (In the drawing for this painting six figures, one of whom appears to be giving a speech, are arranged around the table.) Another faceless man sits, slightly apart, with his back to Frida. Perhaps he is Alejandro Gómez Arias, Kahlo's boyfriend who in 1927, because his parents felt he should get away from the ill and needy Frida, went abroad for the better part of a year.

Although her dress could not be more different from the long skirts and shawls worn by the *Adelitas*, or *soldaderas*, who followed their men to the battlefields of the Mexican Revolution, Frida does look feisty enough to be a revolutionary; indeed, the painting's theme is evidence of the leftist political sympathies that would lead Kahlo to join the Communist Party in 1928. Above Frida hangs a portrait of the revolutionary leader Pancho Villa, on either side of which are framed scenes that look like stage flats. One shows soldiers and *Adelitas* going off to fight the Revolution in a cattle car. The other depicts an architectural structure that may be a bullring. Everything in the painting except for Frida is tilted, drawn in incorrect perspective and askew, giving her portrait added importance by making it the only stable, frontal image. Frida is like the center of a pinwheel; the painting's various motifs are related to one another only through her.

The year after Kahlo painted *La Adelita, Pancho Villa, and Frida*, she took several canvases to show to the muralist Diego Rivera, whom she admired but knew only by sight. She asked him if he thought she should continue painting. "You have talent," he said. Rivera's encouragement was essential to Kahlo; she took his advice and kept on working. A year later they were married.[1]

HH

1. Bambi, "Frida Kahlo es una mitad," *Excelsior* (Mexico City, June 13, 1954) p. 6. Translations from the Spanish by Hayden Herrera.

REFERENCES
Martha Zamora. *Frida: el pincel de la angustia*. Mexico, 1987, pp. 91, 374. **Helga Prignitz-Poda, Salomón Grimberg, and Andrea Kettenmann, eds.** *Frida Kahlo: Das Gesamtwerk*. Frankfurt am Main, 1988, p. 232, no. 3.

359 ◄ Frida Kahlo
Mexican, 1907–1954

Frieda and Diego Rivera, 1931
Oil on canvas; 100 x 78.7 cm. (39⅜ x 31 in.)
San Francisco Museum of Modern Art. Albert M.
Bender Collection. Gift of Albert M. Bender

When the twenty-two-year-old Frida Kahlo married Diego Rivera, her parents said it was "like marriage between an elephant and a dove."[1] Her German Jewish father, who immigrated to Mexico in 1891 and became one of the country's foremost photographers, supported the union. Her mother, a Mexican of mixed Indian and Spanish descent, thought Rivera was too old and too fat. Even worse, he was a Communist and an atheist. But Frida prevailed, and in 1929 she was married in Coyoacán, the suburb of Mexico City where she was born and raised.

Frieda and Diego Rivera is a kind of wedding portrait painted a year and a half after the fact, when the couple was living in San Francisco, where Rivera had mural commissions. More refined and more minutely painted than Kahlo's previous works, the double portrait shows the influence of naïve Mexican portraiture of the nineteenth century, especially that of José María Estrada, whose work both Kahlo and Rivera greatly admired. At this point in Kahlo's

career, primitivism becomes a chosen style rather than the artlessness of an amateur painter. Not only does it serve to distance the viewer from the often anguished subject matter, but it also expresses the artist's passion for the culture of "the people." In addition, it coincides with Kahlo's view of herself as an artist. Although serious about her work, she was always modest, deferring to her husband as the great artist while she posed as a charming amateur. Kahlo's words, inscribed (in Spanish) on a ribbon held in the beak of a dove (a device taken from Mexican popular art), are as delightfully folkloric as the painting itself: "Here you see us, me Frieda Kahlo,[2] with my beloved husband Diego Rivera. I painted these portraits in the beautiful city of San Francisco California for Mr. Albert Bender, and it was in the month of April in the year 1931."

There is a great change since Kahlo painted her first self-portrait in 1926 and since her appearance in *La Adelita, Pancho Villa, and Frida* (cat. no. 358), in about 1927. In the earlier works she is shown wearing formal European clothes. Now she wears a floor-length ruffled skirt, a red rebozo, a necklace of Precolumbian jade beads, and green wool ribbons woven into her braided hair, which is pinned up in native Mexican style. After she met Rivera, Kahlo began to dress in Mexican costume, especially that of the women of Tehuantepec. She did this to please Rivera, to hide her slight limp, and to state her espousal of the ethic of *Mexicanidad*, which she shared with her husband and with many other Mexican artists of the post-Revolution decade. Rivera, on the other hand, wore European clothes, either baggy suits and blue work shirts, as in the wedding portrait, or overalls to show his solidarity with the masses.

The 1931 wedding portrait is one of Kahlo's most cheerful works; only after a miscarriage in Detroit the following year did she begin to make portraits of herself under physical duress as a way of recording, communicating, and exorcising her pain. In 1931 in San Francisco her health was good, and her marriage reasonably happy. Yet Rivera, an inveterate philanderer, may already have begun to stray. During the time Kahlo worked on this painting, he was entranced with the tennis champion Helen Wills, whose nude portrait appears on the ceiling of his mural for the Luncheon Club of the Pacific Stock Exchange in San Francisco.

For all the wedding portrait's optimism, the problems that would eventually nearly destroy the Kahlo-Rivera relationship (they separated and divorced in 1939, and remarried in 1940) are already hinted at here. First there is Diego's enormity and Frida's diminutive stature. He stands solid as a boulder, whereas her dainty feet barely brush the ground. He holds his palette and brushes in his right hand; her right hand holds his. Rivera lived for his art; Frida lived for Diego. And while she cocks her head toward him, he turns slightly away from her. Even at this early date, Kahlo seems to acknowledge that Rivera could not be possessed, and later she would try to make light of his affairs. "Being the wife of Diego is the most marvelous thing in the world," she said. "I let him play at matrimony with other women. Diego is not anybody's husband and never will be, but he is a great comrade."[3] Frida's grasp on Diego's hand seems tenuous at best. Although she had, as this portrait reveals, a fierce strength and a saucy self-possession, she could never stop needing Diego. Their clasped hands she placed at the very center of the painting; the center of her life was the marriage bond.

HH

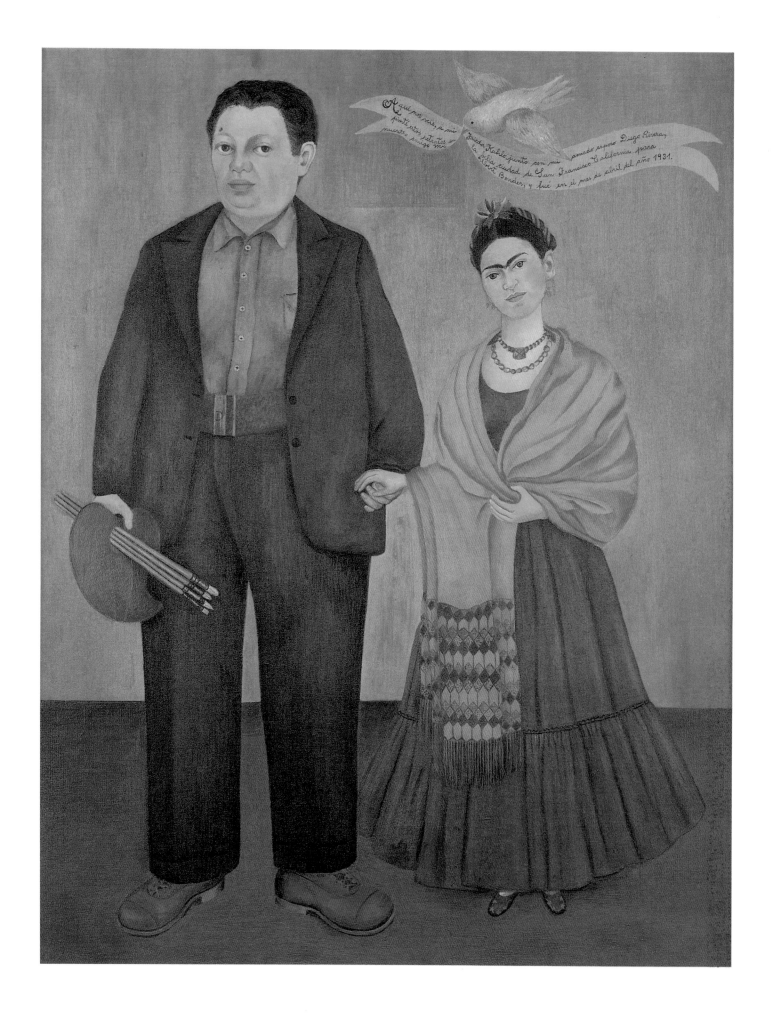

Aquí nos veis, a mi
Frida Kahlo, junto con mi amado esposo Diego Rivera,
pinté estos retratos en la bella ciudad de San Francisco California para
nuestro amigo mr. Albert Bender, y fué en el mes de abril del año 1931.

1. Bambi, "Frida Kahlo es una mitad," *Excelsior* (Mexico City, June 13, 1954) p. 6.
2. About 1932, Kahlo changed the spelling of her name from Frieda to Frida, probably because of the rise of fascism in Germany.
3. Rafael Lozano, Mexico City, dispatch to *Time*, November 10, 1950.

REFERENCES
Hayden Herrera. *Frida: A Biography of Frida Kahlo*. New York, 1983, pp. 123, 124–25, 317, 360–61.
Helga Prignitz-Poda, Salomón Grimberg, and Andrea Kettenmann, eds. *Frida Kahlo: Das Gesamtwerk*. Frankfurt am Main, 1988, p. 236, no. 29.

360 ◀ **Frida Kahlo**
◀
◀ Mexican, 1907–1954
◀
◀
◀ *The Deceased Dimas,* 1937
◀
◀ Oil on Masonite; 48 x 31.5 cm. (18⅞ x 12⅜ in.)
◀ Fundación Dolores Olmedo Patiño, A.C.,
◀ Mexico City

In 1937, when Frida Kahlo painted *The Deceased Dimas*, she and Diego Rivera were living in the San Angel district of Mexico City, having returned to Mexico in 1934 after four years of residence in the United States. Since her return, Kahlo had hardly worked at all. Her misery at Rivera's affair with her younger sister Cristina had crushed her creative drive. There are no known paintings from 1934 and only four from 1935 and 1936. But by 1937 her marriage was strong again. It combined deep affection, respect, and mutual autonomy—the couple even lived in separate houses joined by a bridge.

The year 1937 was extremely productive for Kahlo. Her paintings take on a new psychological depth and a technical mastery. "As you can observe, I have painted," she wrote to a friend the following year. "Which is already something, since I have spent my life up until now loving Diego and being a good-for-nothing with respect to work. Now I continue loving Diego, but what's more I have begun to paint monkeys seriously. Concerns of the sentimental and amorous order . . . have been a few, but without going beyond mere flings."[1]

Kahlo's self-portraits from 1937 show the artist at the height of her health and beauty, sure of her magnetic attractiveness and of her status as an exotic and fascinating woman. This was the year she had a brief love affair with the Russian revolutionary Leon Trotsky, for whom Rivera had secured asylum in Mexico and to whom Kahlo lent her Coyoacán house.

Kahlo's hard work paid off. The following year she made her first major sale of four paintings to the American film star Edward G. Robinson. Her first critical reception came when the Surrealist poet André Breton arrived in Mexico, claimed her as a self-invented Surrealist, and called her art "a ribbon around a bomb."[2] Furthermore, she had an exhibition in New York. According to *Time* magazine's report: "Flutter of the week in Manhattan was caused by the first exhibition of paintings by famed muralist Diego Rivera's German-Mexican wife, Frida Kahlo." Frida's pictures, the reviewer said (and he might well have been thinking of *The Deceased Dimas*), had "the playfully bloody fancy of an unsentimental child."[3]

But for all the playfulness there was, as always, an underlying sorrow. In 1937, Kahlo wrote to her old friend Alejandro Gómez Arias, "I am still sick and will get worse, but I am learning to be alone and this is an advantage and a small triumph."[4]

Much of her unhappiness came from her frustrated desire for motherhood. Soon after she married, Kahlo discovered that "we could not have a child, and I cried inconsolably. But I distracted myself by cooking, dusting the house, sometimes by painting, and every day going to accompany Diego on the scaffold. It gave him great pleasure when I arrived with the midday meal in a basket covered with flowers."[5] In 1930, after three months of pregnancy, Kahlo

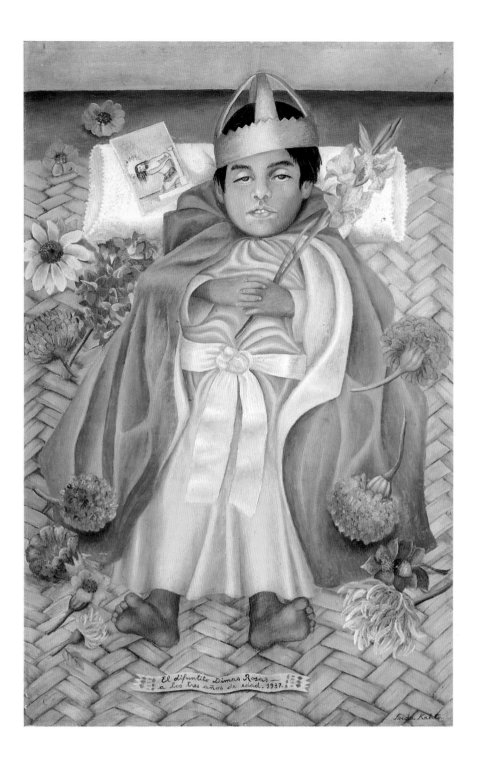

had an abortion because her fetus was in the wrong position. She miscarried in Detroit in 1932. And from the evidence of paintings such as *Me and My Doll*, 1937 (private collection, Mexico City), *My Nurse and I*, 1937 (Fundación Dolores Olmedo Patiño, A. C., Mexico City), *Girl with Death Mask*, 1938 (private collection, Texas), and especially *The Deceased Dimas*, Kahlo probably lost another child in 1937. In 1954, the year she died, she told a friend: "My painting carries with it the message of pain. . . . Painting completed my life. I lost three children. . . . Painting substituted for all of this. I believe that work is the best thing."[6]

In *The Deceased Dimas*, Kahlo projects her sadness about her own lost children into a depiction of a typical lying-in-state of a Mexican child. Dimas,

the son of a Mexican-Indian couple from Ixtapalapa, was one of several siblings who served as models for Rivera. An inscribed ribbon at the bottom of the painting says: "The little dead Dimas Rosas at three years of age, 1937." Dressed like a holy personage and holding the *vara de San José*, or flowering rod, an attribute of St. Joseph, Dimas wears a cardboard crown and a luxurious silk mantle that make his poverty, indicated by his bare feet, all the more poignant. His bed is the humble *petate*, or mat, which serves as the cradle, bed, and coffin of Mexico's poor.

The painting is inspired by the Mexican tradition of postmortem portraiture that dates back to the colonial period. An example of this type of painting hangs above Kahlo's bed in her Coyoacán home (now the Museo Frida Kahlo). Kahlo departs from conventional postmortem portraiture by showing Dimas not from the side, but from an unusual "feet-first" perspective that recalls Andrea Mantegna's *Dead Christ* (Brera, Milan), which Kahlo, well versed in art history, would almost certainly have known. Her purpose in choosing this vantage point is to draw the viewer into the scene, inviting us to participate in the mourning, and without sentimentality forcing us to confront the grim facts of death. Drops of blood dribble from Dimas's nose and mouth; his open eyes are frightening in their glazed lifelessness.

Beside Dimas's head is a postcard image of Christ's flagellation, signaling his family's faith that their child will go to heaven. Kahlo's view of death, by contrast, is relentlessly matter-of-fact and nontranscendent. Her image of Dimas is that of a victim of poverty and ignorance and of Mexico's high child mortality rate in those years. Kahlo felt compassion, but she was also sardonic. As in many of her paintings, there is an irony in her choice of colors: orange, yellow, and bright pink make the death scene strangely chilling. When she included *The Deceased Dimas* in her 1938 show, she titled it, with wry wit, *Dressed Up for Paradise*.

What is the point, she seems to ask, of lavishing such rich garments on a dead child who in life wore rags? Why place a little white pillow with lace trim under a head that can no longer feel the pillow's softness? Why are flowers strewn around a boy who can no longer see or smell? Even as she recognizes the child's family's need to turn Dimas into an icon, she insists that none of this ritual embellishment will carry his soul to heaven. The image of the dead child powerfully exemplifies Kahlo's extraordinary ability to use irony to augment pathos.

HH

1. Frida Kahlo, letter to Ella Wolfe, spring 1937. The letter, in the Bertram D. Wolfe archive, Hoover Institute, Stanford University, is dated Wednesday 13, 1938.
2. André Breton, "Frida Kahlo de Rivera," in *Surrealism and Painting*, translated by Simon Watson Taylor (New York, 1972) p. 144.
3. *Time*, "Bomb Beribboned" (November 14, 1939) p. 29.
4. Raquel Tibol, *Frida Kahlo: crónica, testimonios y aproximaciones* (Mexico, 1977) p. 50.
5. Bambi, "Frida Kahlo es una mitad," *Excelsior* (Mexico City, June 13, 1954) p. 6.
6. Tibol, *Frida Kahlo: crónica*, p. 50.

REFERENCES
Hayden Herrera. *Frida: A Biography of Frida Kahlo.* New York, 1983, pp. 218–99, 221-23, no. XI.
Helga Prignitz-Poda, Salomón Grimberg, and Andrea Kettenmann, eds. *Frida Kahlo: Das Gesamtwerk.* Frankfurt am Main, 1988, pp. 110, 240, no. 48.

Frida Kahlo

Mexican, 1907–1954

Self-Portrait with Monkeys, 1943

Oil on canvas; 81.5 x 63 cm. (32⅛ x 24¾ in.)
Private collection, Mexico City

In a number of her self-portraits, Frida Kahlo is accompanied by spider monkeys or by other pets, such as parrots, cats, or dogs. These animals, in particular the monkeys, were for Kahlo a substitute for children. Her self-portraits with them also suggest another kind of deprivation. Diego Rivera was often absent, and Kahlo expressed her loneliness in such paintings as *Self-Portrait with Monkeys* by showing herself surrounded by animals, which, though they may embrace her, do little to alleviate her solitude. Sometimes her monkeys are bound to her by ribbons twisted both around her neck and theirs. Frida felt so connected to them that in one painting she gave her features a slight simian cast. In *Moses*, 1945 (private collection, Houston), she placed a male and female ape beside Adam and Eve to show their common ancestry. The pets in *Self-Portrait with Monkeys* are the family she was never able to have.

It is possible that the monkeys had for Kahlo other meanings as well. In Christian mythology monkeys were associated with sin, in Aztec culture with lust, the dance, and festivals of love. Kahlo must have been drawn to them for their mischief and animal vitality. No doubt she was attracted also to their freedom of movement, so different from her own confinement. The design embroidered on her white huipil is a sign for movement in the Aztec calendar.

Compared with her self-portrait in *Fulang-Chang and I*, 1937 (Museum of Modern Art, New York), where she first appears with a monkey, in *Self-Portrait with Monkeys*, 1943, Frida looks tense, wary, and solemn. What has intervened is years of illness and the agonizing year she was divorced from Rivera before they remarried in 1940. Suffering has toughened and hardened her features. With ferocious honesty her self-portraits confronted her pain and strengthened her resolve to continue living.

With her full, carnal lips, her slight mustache, and her dark eyes surmounted by connecting eyebrows, Frida's face in *Self-Portrait with Monkeys* is, as in nearly all her self-portraits, all the more arresting for being not exactly beautiful. Her hair, pulled tightly into a headdress of braids, looks painfully stretched. Set high on her long neck, her head is as elegantly exotic as the bird of paradise blossoming just beside it. As always in the self-portraits, her face is a mask; Kahlo preferred to communicate her pain by showing violations to her body.

As in *Self-Portrait with Monkey*, 1940 (private collection, Mexico City), darkness in the interstices of the jungle leaves makes this a nighttime painting and sets a mood of mourning. In both works the wall of leaves cuts off the space directly behind the figure, creating a spatial compression that carries the painting's emotional tension to a claustrophobic pitch. The leaves in *Self-Portrait with Monkeys* are tinted with orange. Their fleshy appearance reflects Kahlo's empathy with all living things. That she saw herself as physically connected to leaves is demonstrated in *Roots* (private collection, Houston), another self-portrait from 1943, in which the childless Frida dreams that her body opens up to give birth to a vine through which her own blood courses.

Although Kahlo deliberately retained a certain hardness in the contours of her figures and a primitivism in her handling of space and volume, *Self-Portrait with Monkeys* reveals the development of a realism of almost miniaturist precision. It is as though knowing her hold on life was tenuous, she needed to re-create herself on canvas as a highly defined and concrete image. As a result, when we look at her self-portrait, we feel that she is looking at us, or—more disconcerting still—that we are looking into the mirror into which she looked

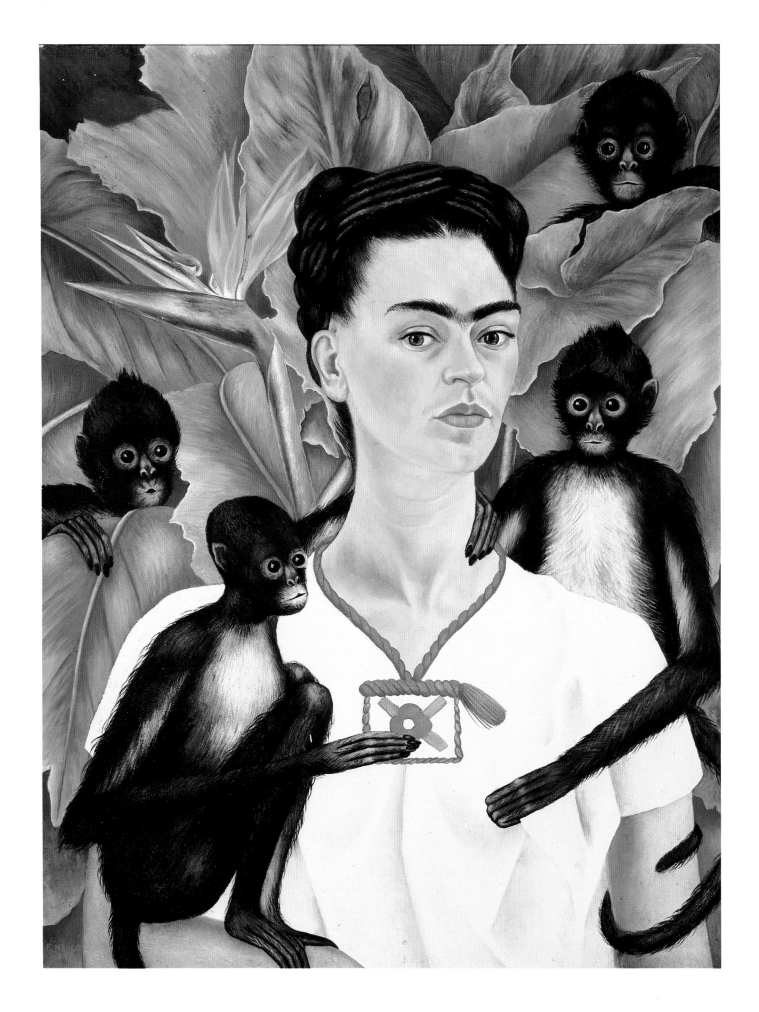

in order to paint herself. Either way, her presence is powerfully alive.

The extreme clarity of Kahlo's style comes also from her drive to make her feelings known in the simplest and most direct fashion. "I paint my own reality," she once said. "The only thing I know is that I paint because I need to, and I paint always whatever passes through my head, without any other consideration."[1]

HH

1. Bertram D. Wolfe, "Rise of Another Rivera," *Vogue* (New York, November 1, 1938) p. 64.

REFERENCE
Helga Prignitz-Poda, Salomón Grimberg, and Andrea Kettenmann, eds. *Frida Kahlo: Das Gesamtwerk.* Frankfurt am Main, 1988, p. 251, no. 87.

362 ◀ Frida Kahlo
Mexican, 1907–1954

Self-Portrait as a Tehuana (Diego on My Mind), 1943
Oil on canvas; 76 x 61 cm. (29⅞ x 24 in.)
Private collection, Mexico City

One of Frida Kahlo's most arresting works, *Self-Portrait as a Tehuana (Diego on My Mind)*, presents the artist wearing the ceremonial headdress of the women of Tehuantepec. Although she sometimes wore other native Mexican costumes, the long skirt and richly ornamented Tehuana blouse was Kahlo's favorite, perhaps because Tehuantepec women are known for their beauty, independence, and strength. After their remarriage in 1940, the Riveras maintained a certain independence from each other, and Kahlo was proud of her autonomy. They lived in her house in Coyoacán, and Diego used the San Angel home for his studio. There were frequent separations and reconciliations. Although Kahlo insisted that Rivera should be free, and she too had affairs, her paintings show that his love affairs continued to hurt her.

Kahlo's diary, written in the last decade of her life, is like a love poem to her husband: "Diego, I am alone," she wrote; and pages later: "My Diego, I am no longer alone. You accompany me. You put me to sleep and you revive me." Some passages make it clear that her love was more than comradely: "Diego: Nothing is comparable to your hands and nothing is equal to the gold-green of your eyes. My body fills itself with you for days and days. You are the mirror of the night. The violent light of lightning. The dampness of the earth. Your armpit is my refuge. My fingertips touch your blood. All my joy is to feel your life shoot forth from your fountain-flower which mine keeps in order to fill all the paths of my nerves which belong to you."[1]

This passion pulses through *Self-Portrait as a Tehuana*. Yet, though she is dressed in the bridelike Tehuana headdress to attract Diego, he remains distant from her, and all her festive finery only makes her loneliness more acute. Like so many of Kahlo's self-portraits, this one is a plea for attention. So obsessive is her desire to possess her husband that she has lodged a miniature portrait of him in her forehead. The device recalls the third eye that Kahlo occasionally placed in the foreheads of people of wisdom and vision (like Rivera or Moses). Not surprisingly, Kahlo never gave herself such an eye. Only Rivera appears in her forehead or, in *Thinking About Death* from the same year (private collection), a skull and crossbones.

In the Tehuana self-portrait, there is something sinister in Frida's need for possession. Surrounded by petals of starched lace, she looks like a carnivorous flower. The network of tentacles that springs from the lace and flowers of the headdress brings to mind also a great female spider that has devoured her mate. Even so, Rivera does not seem possessable. His wide-set eyes look upward and far away. As Kahlo observed, they were "constructed especially for a

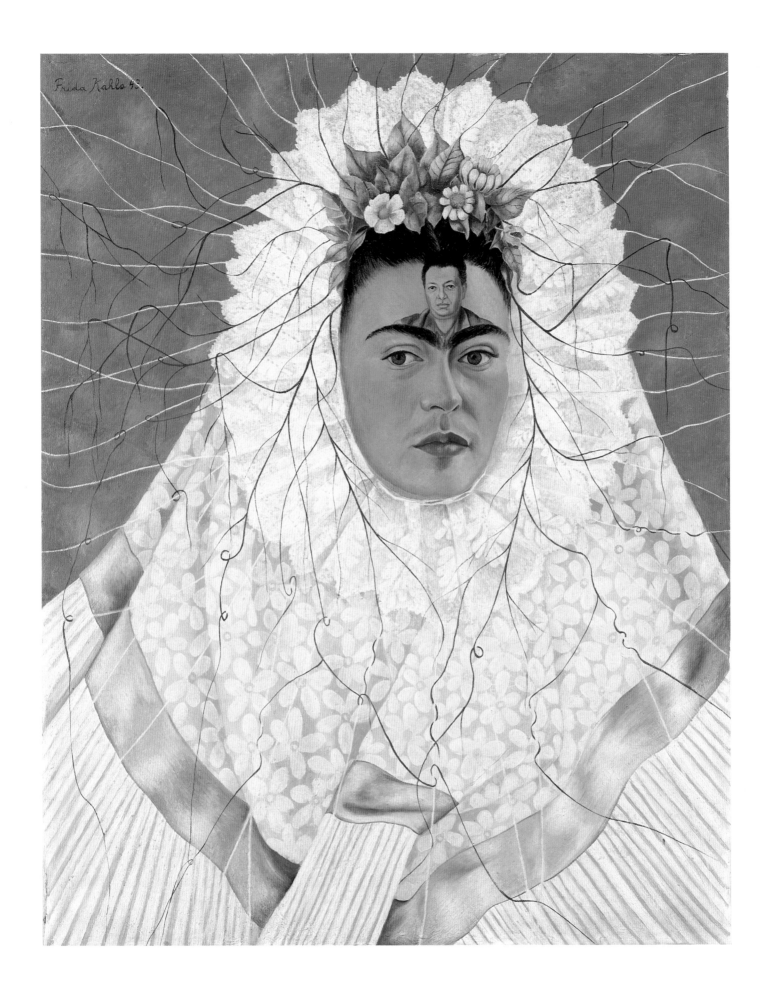

painter of spaces and multitudes."[2] Rivera did not focus on Frida; he scanned the vast and varied universe.

The tentacles that radiate from Frida's headdress to the painting's edge serve, like the wall of jungle leaves in other bust-length self-portraits, to lock her figure into place. These tendrils, which appear as roots or veins in other paintings, express Kahlo's need for connectedness. They are her way of showing that though she was often confined to her home by invalidism and though she was cut off from future generations by childlessness, her vitality extended out into the world. The tendrils also express Kahlo's view (shared by Rivera) of a universe in which every element is linked—plants, animals, rocks, water, air, people.

In this self-portrait from 1943 and in another one in which Frida wears the Tehuana headdress, there is a strange dichotomy between face and body. Her face Kahlo perceives as active. The alert gaze is both that of Frida looking out at the world (specifically conjuring up an image of Diego) and that of Frida the painter, staring at herself in the mirror, consumed with the narcissism of sorrow. Frida's body, by contrast, is as still as an icon. It is the passive object of the artist's regard. To raise herself out of her unhappiness, Kahlo created of herself a mythic being, an idol for herself and others to adore.

Kahlo's need to know herself and to make herself known impels *Self-Portrait as a Tehuana*. "I paint myself," she once said, "because I am so often alone. Because I am the person I know best."[3]

HH

1. Frida Kahlo's diary is on display at the Museo Frida Kahlo in Mexico City.
2. Frida Kahlo, "Retrato de Diego," *México en la cultura*, supplement to *Novedades* (Mexico City, July 17, 1955) p. 5.
3. Antonio Rodríguez, private interview with the author, Mexico City, August 1977, and Antonio Rodríguez, "Una pintora extraordinaria: la vigorosa obra de Frieda Kahlo surge de su propia tragedia con fuerza y personalidad excepcionales." Undated newspaper clipping, Antonio Rodríguez personal archive, Mexico City, n.p.

REFERENCES
Hayden Herrera. *Frida: A Biography of Frida Kahlo*. New York, 1983, pp. 361, 366–67, 372, no. XXI. **Martha Zamora**. *Frida Kahlo: el pincel de la angustia*. Mexico, 1987, p. 328. **Helga Prignitz-Poda, Salomón Grimberg, and Andrea Kettenmann, eds**. *Frida Kahlo: Das Gesamtwerk*. Frankfurt am Main, 1988, p. 252, no. 89.

363 ◀ **Frida Kahlo**

Mexican, 1907–1954

The Bride Who Became Frightened When She Saw Life Opened, 1943

Oil on canvas; 63 x 81.5 cm. (24¾ x 32⅛ in.)
Private collection, Mexico City

The title of the painting *The Bride Who Became Frightened When She Saw Life Opened* is inscribed on the side of a table, the top of which is covered by lush tropical fruit. The bride is the doll that peeps out from behind the watermelon on the left. Purchased by Kahlo in a Paris flea market, the doll was one of many in her collection. Unlike an earlier painting, *Me and My Doll*, 1937 (private collection, Mexico City), in which the doll is a substitute for a baby and alludes to the artist's childlessness, in the present work the doll is part of a tableau that expresses Kahlo's delight in the fullness of life.

The scene enacted is the loss of innocence. The bride opens her virginal blue eyes wide as she discovers sexuality, symbolized by ripe cut-open fruit. It is as though Kahlo imagined the fruit from the doll's point of view—huge, close to her, and invested with magic vitality. A coconut, for example, has a face as alert as that of the owl beside it (presumably the owl stands for the

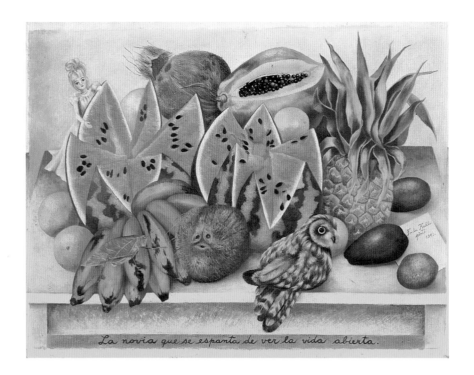

La novia que se espanta de ver la vida abierta.

wisdom of experience) and appears to converse with a grasshopper. The grasshopper walks across a bunch of red bananas that projects over the table's edge and out toward the viewer. Given Kahlo's penchant for painting fruit and flowers that allude to human genitals, one can assume she meant the bananas to be phallic. (The sexual references in a still-life tondo of 1942, now in the Museo Frida Kahlo, Mexico City, so unnerved the wife of Mexico's president that she returned the commissioned work to the painter.) Certainly the wedged papaya and the watermelon, with its fleshy red pulp dotted with seeds, suggest the female genitals.

The still life with the frightened bride also reveals Kahlo's passion for popular art. The dining room in the Coyoacán house was decorated with still lifes painted by anonymous Mexican folk artists, and Kahlo loved and emulated the unconventional disposition of fruits she saw in these paintings. The yellow table on which the fruit is placed is folkloric as well. It is modeled after Kahlo's own yellow kitchen table, which is typical of the cheap painted furniture found in Mexican markets. Even her choice of fruit is emphatically Mexican and, together with the ingenuous style in which the fruit is painted, asserts Frida Kahlo's Mexican identity.

HH

REFERENCE
Helga Prignitz-Poda, Salomón Grimberg, and Andrea Kettenmann, eds. *Frida Kahlo: Das Gesamtwerk.* Frankfurt am Main, 1988, pp. 47, 252, no. 90.

Frida Kahlo

Mexican, 1907–1954

The Little Deer, 1946

Oil on canvas; 22.4 x 30 cm. (8⅞ x 11⅞ in.)
Collection Mrs. Carolyn Farb, Houston

Like the nude Frida pierced by nails in *The Broken Column,* 1944, the Frida transformed into a fawn pierced by arrows in *The Little Deer* is a profane St. Sebastian. Bleeding wounds make her suffering palpable and direct. As usual, her face is impassive, her anguish expressed through the mutilation of her body. Kahlo's sufferings were both physical and emotional. As her health deteriorated over the years, she was subjected to some thirty surgical operations. And the pain of Rivera's womanizing never stopped.

The deer's arrows, like the arrows that pierce Valentine hearts, point to pain in love. Each may record an infidelity by Rivera. In Mexico a cuckolded man is spoken of as having antlers or horns. In *The Little Deer,* the nine points that form Frida's antlers match the nine arrows that penetrate her body. Similarly, *Ruin,* a drawing from 1947 (Museo Frida Kahlo, Mexico City), depicts an amalgam of Frida's and Diego's heads supported by an architectural scaffold whose twenty numbered protrusions refer to Rivera's love affairs.

Kahlo depicted herself as a male deer, perhaps because the expression about having horns usually refers to a cuckolded man. It is also possible that the deer's testicles allude to the male aspect of Kahlo's duality—either her bisexuality or her *machismo.* She might mean to say that she has courage: having "balls" in Spanish, as in English, means having "guts."

At the time that she painted *The Little Deer,* Kahlo needed all the courage she could call upon; she was about to undergo a spinal fusion. After being bedridden for several months in 1946, she flew to New York and entered the Hospital for Special Surgery, where Dr. Philip Wilson performed the operation. Before she left Mexico, she gave this painting to Arcady Boytler and his wife, Lina, as a token of her gratitude for their having recommended this surgeon. The gift was accompanied by a ballad:

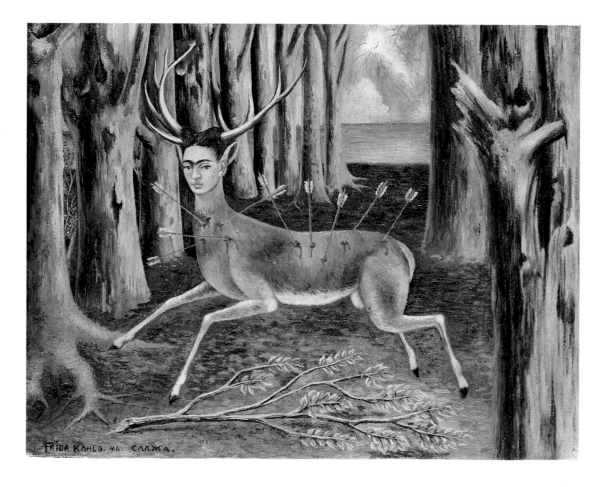

The deer walked alone
very sad, and very wounded,
until in Arcady and Lina
he found warmth and a home.

When the deer returns,
strong, happy, and cured,
the wounds he now has
will have vanished.

Thank you, children of my heart,
Thank you for so much advice,
in the forest of the deer
the sky is brightening.

I leave you my portrait
so that you will have my presence
all the days and nights
that I am away from you.

Sadness portrays herself
in all my paintings.
But that's how my condition is;
I am beyond healing.

But still I carry
joy in my heart,
knowing that Arcady and Lina
love me as I am.

Accept this little picture,
painted with my tenderness,
in exchange for your affection
and your immense sweetness.

Frida[1]

Although the stormy sky at the end of the alley of trees across which the deer runs is, as Kahlo says, "brightening," we know the deer will never shake off its arrows or reach the distant sea. The deer's youthful grace contrasts with the ancient tree trunks, whose broken branches and knots correspond to his wounds. Beneath his spindly legs a slender branch broken from a young tree alludes to his—and Frida's—broken youth and imminent death. It may also refer to the pre-Hispanic custom of placing a dry branch on a grave to help the deceased enter paradise, where the dry, dead branch is transformed into a green, living one.

HH

1. Martha Zamora, *Frida Kahlo: el pincel de la angustia* (Mexico, 1987) p. 346. Translation from the Spanish by Hayden Herrera.

REFERENCES
Ida Rodríguez Prampolini. *El surrealismo y el arte fantástico de México*. Mexico, 1969, p. 61, no. 35. **Hayden Herrera**. *Frida: A Biography of Frida Kahlo*. New York, 1983, pp. 356–58, 410, no. XXXI. **Martha Zamora**. *Frida: el pincel de la angustia*. Mexico, 1987, pp. 12, 73, 97, 123, 346. **Helga Prignitz-Poda, Salomón Grimberg, and Andrea Kettenmann, eds.** *Frida Kahlo: Das Gesamtwerk*. Frankfurt am Main, 1988, pp. 63, 257, no. 113.

365 ┤ **Frida Kahlo**

Mexican, 1907–1954

The Love-Embrace of the Universe, The Earth (Mexico), Diego, Me, and Mr. Xólotl, 1949

Oil on canvas; 70 x 60.5 cm. (27½ x 23⅞ in.)
Private collection, Mexico City

Frida Kahlo's longing for connectedness and for possession of her husband appears to be satisfied in this painting of a fantastic mountain made of interlocked love-embraces. Dressed in a Tehuana costume, Frida holds Diego, who is depicted as a fat, naked baby. The couple is sustained by the Mexican earth, which resembles a Precolumbian idol, and by the universe, another Mexican-looking figure that is only partly concretized out of a cloudy sky. Frida's pet escuincle dog, Mr. Xólotl, is comfortably curled on the universe's right arm.

As in several of Kahlo's paintings, the sky is divided into night and day. The joint presence of the sun and moon stands for a series of dualities—night/day, light/dark, male/female, life/death—that Kahlo saw as underlying all of reality. The juxtaposition of the sun and the moon might also have a Christian

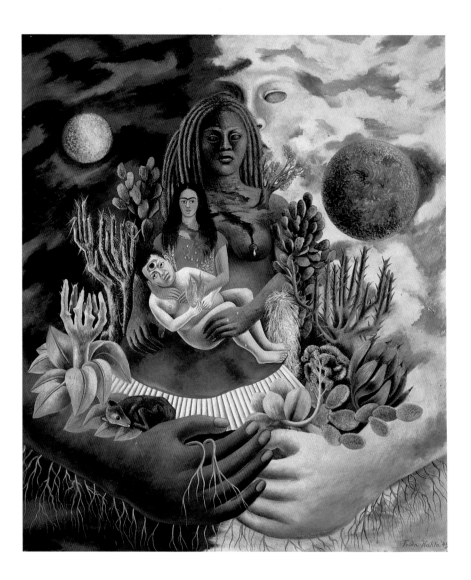

meaning, as they sometimes appear together in Mexican scenes of the Cruci-
fixion, where they refer to the eclipse at the time of Christ's death. Whether
Christian or pagan in reference, these orbs give Kahlo's personal drama a
cosmic dimension.

The painting also suggests some kind of resolution in the Kahlo-Rivera
marriage. As time went on, Kahlo realized that the best way to hold Rivera and
to cope with his often cruel mischief was to become his indulgent mother. She
wrote in her journal, "At every moment he is my child, my child born every
moment, diary, from myself." In her "Portrait of Diego," written the same
year as *The Love-Embrace*, Kahlo confessed, "Women—I among them—always
would want to hold him in their arms like a newborn baby."[1] In this painting
her wish is fulfilled; Frida is the nurturing earth mother, and Rivera is trans-
formed into the little "Dieguito" she was never able to have.

Although Frida looks content in the laps of the earth and of the universe,
The Love-Embrace is a disquieting image. Like *My Nurse and I*, 1937 (Fundación
Dolores Olmedo Patiño, A.C., Mexico City), another self-portrait in which
Kahlo affirms her Mexican roots by showing herself in the arms of a Mexican
idol (actually her Indian wet nurse wearing a Teotihuacán mask), *The Love-
Embrace* speaks of her feeling of disconnectedness. The layered love-embraces
form a mountain that is uprooted and floats in the sky. Its roots are left
dangling like the black tendrils in *Self-Portrait as a Tehuana* (cat. no. 362).

These dangling roots suggest Kahlo's fear of isolation, of being cut off from nurture and love. Also disturbing is the way the half-green, half-brown Mexican earth idol does not really embrace Frida. (In this she resembles the stone-faced, unloving wet nurse in *My Nurse and I*.) Instead, while she holds Diego with one arm, the other arm merely hangs against Frida's skirt. But the principal evidence of Kahlo's continued unhappiness are the tears on her face and the bloody crevasse that cracks open her neck and chest and from which a magical fountain of milk gushes forth. As if in sympathy, the earth idol's breast opens into a chasm and one drop of milk falls, like a tear, from her nipple. Close to this chasm, a green tree holds the promise of regeneration. Perhaps this is the tree from Frida's motto, "Tree of hope, keep firm." (The words are emblazoned on the flag Frida holds in her double self-portrait *Tree of Hope*, 1946, Collection Daniel Filipacchi, Paris.)

As is usual in Kahlo's work, the wounds refer to events in her life. The year she painted *The Love-Embrace*, Rivera almost divorced her a second time, wishing to marry the beautiful film star María Felix, who was also an intimate friend of Kahlo's. But the affair ended, and as Rivera later reflected in his autobiography, "Within a short space of time ... everything was well again. I got over my rejection by María. Frida was happy to have me back, and I was grateful to be married to her still."[2]

Kahlo was indeed happy to keep her husband, and her 1949 essay about him lovingly describes the Diego she painted in *The Love-Embrace*. The third eye in the baby Diego's forehead is, she wrote, the invisible eye of "Oriental wisdom." Rivera's "Buddha-ish mouth" is set in "an ironic and tender smile. ...Diego is an immense baby with an amiable face and a slightly sad glance.... Seeing him nude, you immediately think of a boy frog standing on his hind legs. His skin is greenish white like that of an aquatic animal."[3] The painted image of Diego wittily reverses a favorite Rivera image—that of a voluptuous female nude holding a sexual-looking flower. Frida's baby Diego holds a maguey plant which must stand for what she called his "fountain-flower." Holding the plant like an emblem, he recalls the Christ child holding a cross. *The Love-Embrace* can be seen as a Mexican version of the Assumption of the Virgin, with mother and child reunited in a Precolumbian heaven. The painting is a summing up of everything Kahlo wanted and everything she believed in; in it she is sustained by her Mexican heritage and by a universe united by love, with Diego Rivera at its center.

HH

1. Frida Kahlo, "Retrato de Diego," *Mexico en la cultura*, supplement to *Novedades* (Mexico City, July 17, 1955) p. 5.
2. Diego Rivera with Gladys March, *My Art, My Life: An Autobiography* (New York, 1960) pp. 264–65.
3. Frida Kahlo, "Retrato de Diego," p. 5

REFERENCES
Hayden Herrera. *Frida: A Biography of Frida Kahlo*. New York, 1983, pp. 361, 375, 377–78, no. XXXIII. **Martha Zamora**. *Frida: el pincel de la angustia*. Mexico, 1987, pp. 65, 73, 99, 129, no. 353. **Helga Prignitz-Poda, Salomón Grimberg, and Andrea Kettenmann, eds.** *Frida Kahlo: Das Gesamtwerk*. Frankfurt am Main, 1988, pp. 162, no. 118.

Acknowledgments

During the long months of organization, many individuals and institutions aided in the formation of *Mexico: Splendors of Thirty Centuries*. First thanks for the Precolumbian loans must go to Mexico's Instituto Nacional de Antropología e Historia, the official overseer of the country's ancient heritage. Both directors of INAH—as the venerable organization is universally known—with whom we worked, Enrique Florescano and Roberto García Moll, were men dedicated to the task of safeguarding the Mexican patrimony. The professional, administrative, and legal staffs of INAH were indispensable in moving the project forward, and particular note must be made of Mario Vázquez who, charged with the formidable task of caring for INAH's many museums, was the first, and often again the last, person from whom help had to be sought.

The INAH museums themselves contributed the lion's share of Precolumbian loans, and specific mention must be made of the Museo Nacional de Antropología in Mexico City, without whose participation this section of the exhibition could not have been realized. Precolumbian objects, large and small, have come from the world-famous halls of this great museum, to be exhibited—many for the first time—to a United States public. Sonia Lombardo de Ruíz, Director of the Museo Nacional, was instrumental in furthering our efforts, as were the many members of her staff who were called upon for the myriad tasks that major loans entail. The regional INAH centers and museums also had to cope with the demands for loans, the request for information, photography, conservation, and the requirements of packing and shipping; their efforts were essential. Conservation further was an awesome task, encompassing as it did objects of different media, different size, and widely separated locations. INAH's Dirección de Restauración in Churubusco, under the watchful eye of its director, María Luisa Franco, was responsible for this work.

The cooperation of the governors of the Mexican states in which the archaeological sites in the exhibition are located was much appreciated. Their substantial concern for the great ancient sites that lie within their state boundaries was manifest, and aid was forthcoming from their representatives in Mexico City and/or from the state directors of culture or tourism. Among those who extended special consideration to the exhibition were Dante Delgado Rannauro, Governor of the State of Veracruz, Rubén Pabello Rojas, his Mexico City representative, and Salvador Neme Castillo, Governor of Tabasco, Francisco Peralta Burelo, Director of that state's Instituto de Cultura, and Julío César Javier Quero, Director of its Patrimonio Cultural. We greatly appreciate their help.

Other organizations to be acknowledged are the Universidad Veracruzana and its splendid new Museo de Antropología in Xalapa and the Universidad de las Américas and its well-known Museo Frissell de Arte Zapoteca in Mitla. We extend our appreciation to Salvador Valencia Carmona, Rector

of the Universidad Veracruzana, and to Russel Edwin Kennedy, President of the Universidad de las Américas at the time of our loan negotiations.

One of the great pleasures for me in organizing my section of the exhibition was visiting the Precolumbian sites in the company of archae-ologists who have long known and worked on these ancient places. I am grateful to them—their names appear elsewhere in this publication—for the degree of personal involvement and appreciation they bring to the Precolumbian centers, making visits with them a special and insightful experience.

I am grateful too to numbers of others who have helped in ways too diverse to mention, but special thanks must be extended to a few. To Franz Feuchtwanger, Doris Heyden, Merle Greene Robertson, Heidi King, W. L. Schonfeld, John Paddock, Romulo O'Farrill, Arnulfo Hardy, Rubén Vera Cabrera, and Luis Felipe del Valle Prieto, I extend gratitude. To Agustín Espinosa, whose depth of experience and evenness of temper were invaluable in countless ways, I owe particular recognition. Further, to Debra Nagao, the Metropolitan's Exhibition Assistant in Mexico City, a heartfelt thanks for her unfailing efforts and endless attentions on behalf of the exhibition.

JULIE JONES
Curator, Department of Primitive Art
The Metropolitan Museum of Art

The portion of this exhibition devoted to the art of viceregal Mexico presented a series of special problems and has required contributions on so many different levels that they defy easy summary; the variety of people whose skills have been essential to mounting an exhibition of this nature can only be understood by someone familiar with the remarkable nation whose genius we are celebrating.

Converting my armchair knowledge to something deeper required a total immersion that only the most patient and forbearing of guides and mentors could share with me. First among the cicerones was Arq. Miguel Celorio Blanco. His unstinting contribution of time and knowledge, in-troducing me to the treasures of Puebla, from its Franciscan mission churches to the cathedrals of Palafox and Tolsá, provided bearings, both practical and intellectual, without which I would soon have been lost.

Two North Americans have from the start lent to this exhibition the benefit of their previous experience with Mexican colonial studies—through their contributions to the catalogue and in many other ways. For her profound knowledge of the art and culture of New Spain, which she shared selflessly, as well as her guidance and exemplary tact in our en-counters with modern Mexico, I am most deeply indebted to Dr. Donna Pierce, who carried on under the most trying personal circumstances. In addition, for his scholarship, enthusiasm, and support, as well as the stimulating perspective he brought to bear on all aspects of our enterprise, special thanks are due to Dr. Marcus Burke.

Two other North Americans, Drs. Elizabeth H. Boone and Eloise Quiñones Keber, whose expertise lies primarily outside the field of colonial studies, have enormously enriched the catalogue with their scholarly contributions.

The list of Mexicans who supported our enterprise is far longer. I am most grateful to Mtra. Elena Isabel Estrada de Gerlero and Sra. Maríta Martínez del Rio de Redo for their moral support, their enthusiasm, and their erudite contributions to the catalogue, as well as their insights into Mexican collections, both within and without the walls of museums. Sras. Virginia Armella de Aspe and Beatriz Sánchez Navarro de Pintado have also given generously of their time and advice and made notable contributions to the catalogue.

For their previous learned and perceptive contributions to the field of colonial studies, which have inspired so many students of colonial art, as well as their present contributions to our catalogue, special thanks are due to Dra. Elisa Vargas Lugo and Mtro. Jorge Alberto Manrique. Dra. Clara Bargellini, Mtro. Rogelio Ruíz Gomar, and Mtra. Juana Gutiérrez Haces have not only written extensively for the catalogue but have been extraordinarily generous in their advice, for which I am most thankful.

Much gratitude is also due to the Instituto de Investigaciones Estéticas of the Universidad Nacional Autónoma de México whose research in the field of Mexican colonial studies has been a pillar upon which we have all leaned heavily.

The extraordinary contribution of Guillermo Tovar de Teresa, which falls outside all of the categories listed above, is deserving of special mention. We have all benefited immeasurably from his indefatigable scholarship and his energetic pursuit of the buried records of artistic activity in viceregal Mexico; we count on his continuing efforts to bring light to a field that still remains too much in shadow.

For her scholarly advice and broad perspective on the issues presented by the art of New Spain as well as her contributions to the catalogue I thank Dra. María Concepción García Sáiz. For her guidance in selecting silver and her scholarly discussion of it in the catalogue I am grateful to Dra. Cristina Esteras Martín.

From the time he joined our project, we have benefited from the special skills of Arq. Jaime Ortíz Lajous. His familiarity with the technical, art historical, and political aspects of Mexico's religious heritage has enormously enhanced our ability to bring to the attention of a larger public a number of Mexico's greatest treasures.

The patience, tact, and friendship of Lic. Luís Felipe del Valle Prieto have been mentioned elsewhere. I offer him my special thanks for many valiant efforts on our behalf.

Kären Anderson is also thanked by others for her devoted work in our Mexico City office. Her talents as photographer, diplomat, and guide have been of special value in dealing with the problems we met in assembling the colonial section of this exhibition. Finally, thanks to Natalya Majluf. Without her knowledge, enthusiasm, and initiative this project would never have reached its present state of completion.

An extraordinary aspect of this exhibition is the presence in it of works from Mexico's truest "museums" of viceregal art: its colonial churches.

Without the consent of their numerous guardians—from sacristans to SEDUE officials—it would have been impossible for us to convey even a partial sense of the splendor of the viceregal achievement.

Finally, my heartfelt thanks to the staff and trustees of the Museo Franz Mayer for their patience and for their generosity which has enriched our enterprise beyond measure.

JOHANNA HECHT
Associate Curator, Department of
European Sculpture and Decorative Art
The Metropolitan Museum of Art

Two colleagues, both Mexican and both eminent in the field of nineteenth-century Mexican studies, have given me invaluable advice: Maestro Fausto Ramírez, professor at the Universidad Nacional Autónoma de México (UNAM) and researcher at the Instituto de Investigaciones Estéticas, and Professor Xavier Moyssén, professor in the Philosophy and Letters Department at UNAM and researcher at the Instituto de Investigaciones Estéticas. Making the final selection of nineteenth-century paintings took longer than I anticipated, and I am grateful for their extraordinary patience during this process. I also extend my sincerest thanks for their work as the authors of a general essay and entries for the exhibition catalogue.

I want to extend special thanks to Rochelle Cohen for her dedication and efficiency. Whether overseeing loan requests, photography permissions, or insurance and indemnity queries or dealing expertly with many of the countless elements of an international loan exhibition, she has been steadfast.

JOHN K. MCDONALD
Coordinator
Mexico: Splendors of Thirty Centuries

I extend my warmest thanks to Mr. and Mrs. Emilio Azcárraga for their most generous and unfailing hospitality and for many thoughtful kindnesses. I would also like to thank in particular three friends: Mary-Anne Martin, who has generously contributed her advice to the selection of twentieth-century works; Kay Bearman, Administrator, Department of Twentieth-Century Art, who has collaborated on the selection since its inception; and Maria Balderrama, Research Assistant, Department of Twentieth-Century Art, who has provided much valuable information and documentation.

WILLIAM S. LIEBERMAN
Chairman, Department of
Twentieth-Century Art
The Metropolitan Museum of Art

Further Reading

GENERAL WORKS

Artes de México. A Spanish-language periodical with English summaries. Each issue is devoted to specific artists or genres from all periods of Mexican art.

Jean Charlot. *An Artist on Art: Collected Essays of Jean Charlot.* Vol. 2, *Mexican Art.* Honolulu, 1972.

Diego Angulo Iñiguez, with contributions by Enrique Marco Dorta and Mario J. Buschiazzo. *Historia del arte hispanoamericano.* 3 vols. Barcelona and Buenos Aires, 1945, 1950, and 1956.

Hernan Cortés. *Letters from Mexico.* Translated and edited by Anthony Pagden, with an introduction by J. H. Elliott. New Haven and London, 1986.

Bernal Díaz del Castillo. *Historia verdadera de la conquista de la Nueva España.* 2 vols. Edited by Miguel León-Portilla. Madrid, 1984. English ed. (abridged), *The Discovery and Conquest of Mexico, 1517–1521,* edited by Genaro García, translated with introduction and notes by A. P. Maudslay. New York, 1956.

Fray Diego Durán. *Historia de las Indias de Nueva España e islas de tierra firme.* 2 vols. Edited by Angel María Garibay Kintana. Mexico, 1967. English ed., *Books of the Gods and Rites and the Ancient Calendar* (1st and 2d parts). Norman, Okla., 1971

Justino Fernández. *A Guide to Mexican Art.* Translated by Joshua C. Taylor. Chicago and London, 1969.

Justino Fernández. *Estética del arte mexicano. Coatlique: estética del arte indígena antiguo; El retablo de los reyes: estética del arte de la Nueva España; El hombre: estética del arte moderno y contemporáneo.* Instituto de Investigaciones Estéticas, UNAM. Mexico, 1972.

Jacques Lafaye. *Quetzalcóatl and Guadalupe: The Formation of Mexican Consciousness, 1531–1813.* Translated by Benjamin Keen. Chicago and London, 1976.

Diego de Landa. *Landa's Relación de las cosas de Yucatán.* Translated and edited by Alfred M. Tozzer. Papers of the Peabody Museum of American Archaeology and Ethnology, Harvard University, vol. 18. Cambridge, Mass., 1941.

Jorge Alberto Manrique, gen. ed. *Historia del arte mexicano.* 2d ed. Vols. 1–4, *Arte prehispánico,* edited by Beatriz de la Fuente; vols. 5–8, *Arte colonial,* edited by Elisa Vargas Lugo; vols. 9–11, *Arte del siglo XIX,* edited by Fausto Ramírez; vols. 12–16, *Arte contemporáneo,* edited by Jorge Alberto Manrique. Mexico, 1986.

Mexico City, Centro Cultural/Arte Contemporáneo. *Octavio Paz: los privilegios de la vista.* Exh. cat., with texts by Octavio Paz and essays by Roberto R. Littman, Alberto Ruy Sanchez, Dore Ashton, Damián Bayón, Pierre Schneider, Beatriz de la Fuente, Charles Tomlinson, Claude Esteban, Eliot Weinberger, Severo Sarduy, Guillermo Tovar de Teresa, and Luis Roberto Vera. Mexico, 1990.

Motolinía (Fray Toribio de Benavente). *Motolinía's History of the Indians of New Spain.* Translated and annotated with a bio-bibliographical study of the author by Francis Borgia Steck. Academy of Franciscan History, Washington, D.C., 1951.

Octavio Paz. *México en la obra de Octavio Paz.* Vol. 3, *Los privilegios de la vista: arte de México.* Mexico, 1987.

Fray Bernardino de Sahagún. *The Florentine Codex: A General History of the Things of New Spain, Books 1–12.* Translated by Arthur J. O. Anderson and Charles E. Dibbie. Santa Fe and Salt Lake City, 1950–81.

PRECOLUMBIAN ART

Elizabeth P. Benson, ed. *The Olmec and Their Neighbors: Essays in Memory of Matthew W. Stirling.* Dumbarton Oaks Research Library and Collections, Washington, D.C., 1981.

Elizabeth P. Benson and Gillet G. Griffin, eds. *Maya Iconography.* Princeton, N.J., 1988.

Victoria Reifler Bricker, gen. ed. *Supplement to the Handbook of Middle American Indians.* 4 vols. Austin, 1981–86. *See also* Robert Wauchope.

Michael D. Coe. *Mexico.* 3d ed. London and New York, 1984.

Michael D. Coe and Richard A. Diehl. *In the Land of the Olmec.* Vol. 1, *The Archaeology of San Lorenzo Tenochtitlán;* vol. 2, *The People of the River.* Austin and London, 1980.

Clemency Chase Coggins and Orrin C. Shane III, eds. *Cenote of Sacrifice: Maya Treasures from the Sacred Well at Chichén Itzá.* Exh. cat., Science Museum of Minnesota in cooperation with the Peabody Museum of Archaeology and Ethnology, Harvard University. Austin, 1984.

Merle Greene Robertson. *The Sculpture of Palenque.* Vol. 1, *The Temple of the Inscriptions;* vol. 2, *The Early Buildings of the Palace and the Wall Paintings;* vol. 3, *The Late Buildings of the Palace.* Princeton, N. J., 1983–85.

George Kubler. *The Art and Architecture of Ancient America: The Mexican, Maya and Andean Peoples.* 3d ed. Harmondsworth, England, and New York, 1984.

Eduardo Matos Moctezuma. *The Great Temple of the Aztecs: Treasures of Tenochtitlan.* Translated by Doris Heyden. New York and London, 1988.

Sylvanus G. Morley and George W. Brainerd. *The Ancient Maya.* 4th ed., revised by Robert J. Sharer. Stanford, Calif., 1983.

Esther Pasztory. *Aztec Art.* New York, 1983.

Linda Schele and Mary Ellen Miller. *The Blood of Kings: Dynasty and Ritual in Maya Art.* Exh. cat., Kimbell Art Museum. New York and Fort Worth, 1986.

Robert Wauchope, gen. ed. *Handbook of Middle American Indians.* 16 vols. Austin, 1964–76.

Muriel Porter Weaver. *The Aztecs, Maya and Their Predecessors: Archaeology of Mesoamerica.* 2d ed. New York, 1981.

VICEREGAL ART

María Concepción Amerlinck. *Arte virreinal en el sureste.* Historia del arte mexicano, vol. 8. Madrid, 1987.

María Concepción Amerlinck. *Arte virreinal en México y sus alrededores.* Historia del arte mexicano, vol. 5. Madrid, 1987.

María Concepción Amerlinck. *Arte virreinal entre Querétaro y Zacatecas.* Historia del arte mexicano, vol. 6. Madrid, 1987.

Linda Bantel and Marcus B. Burke. *Spain and New Spain: Mexican Colonial Arts in Their European Context.* Exh. cat., Art Museum of South Texas. Corpus Christi, 1979.

Efraín Castro Morales. *Arte virreinal en el occidente.* Historia del arte mexicano, vol. 9. Madrid, 1987.

George Kubler. *Mexican Architecture of the Sixteenth Century.* 2 vols. New Haven, 1948.

George Kubler and Martín Soria. *Art and Architecture in Spain and Portugal and Their American Dominions, 1500–1800.* Baltimore, 1959.

John McAndrew. *The Open-Air Churches of Sixteenth-Century Mexico: Atrios, Posas, Open Chapels and Other Studies.* Cambridge, Mass., 1965.

Enrique Marco Dorta. *Arte en América y Filipinas.* Ars Hispaniae: Historia universal del arte hispánico, vol. 21. Madrid, 1973.

Octavio Paz. *Sor Juana or, the Traps of Faith.* Translated by Margaret Sayers Peden. Cambridge, Mass., 1988.

Constantino Reyes-Valerio. *Arte indocristiano: escultura del siglo XVI en México.* Instituto Nacional de Antropología e Historia. Mexico, 1978.

Robert Ricard. *The Spiritual Conquest of Mexico: An Essay on the Apostolate and the Evangelizing Methods of the Mendicant Orders in New Spain, 1523–1572.* Translated by Lesley Byrd Simpson. Berkeley, Los Angeles, and London, 1966.

Donald Robertson. *Mexican Manuscript Painting of the Early Colonial Period: The Metropolitan Schools.* New Haven, 1959.

Pedro Rojas. *Historia general del arte mexicano: época colonial.* Mexico and Buenos Aires, 1963.

Manuel Romero de Terreros y Vinent. *Las artes industriales en la Nueva España.* Rev. ed., edited and annotated by María Teresa Cervantes de Conde and Carlota Romero de Terreros de Prévoisin. Mexico, 1982.

Manuel Toussaint. *Colonial Art in Mexico.* Translated and edited by Elizabeth Wilder Weismann. Austin and London, 1967.

Manuel Toussaint. *Pintura Colonial en México.* 2d ed., edited by Xavier Moyssén. Mexico, 1982.

Guillermo Tovar de Teresa. *México barroco.* Mexico, 1981.

Guillermo Tovar de Teresa. *Renacimiento en México: artistas y retablos.* Mexico, 1982. Rev. ed. of *Pintura y escultura del Renacimiento en México.* Instituto Nacional de Antropología e Historia, Mexico, 1979.

José Guadalupe Victoria. *Pintura y sociedad en Nueva España, siglo XVI.* Mexico, 1986.

Elizabeth Wilder Weismann. *Art and Time in Mexico: From the Conquest to the Revolution.* New York, 1985.

Elizabeth Wilder Weismann. *Mexico in Sculpture, 1521–1821.* Cambridge, Mass., 1950.

NINETEENTH-CENTURY ART

Jean Charlot. *Mexican Art and the Academy of San Carlos, 1785–1915.* Austin, 1962.

Justino Fernández. *El arte del siglo XIX en México.* 2d ed. Mexico, 1967.

Elisa García Barragán. "En torno al arte del siglo XIX: 1850–1980." In *Los estudios sobre el arte mexicano: examen y prospectiva (VIII Coloquio de Historia del Arte),* UNAM. Mexico, 1986, pp. 119–53.

Roberto Montenegro. *Retablos de México: Mexican Votive Paintings.* Translated by Irene Nicholson. Mexico, 1950.

Fausto Ramírez. *La plástica del siglo de la Independencia.* Mexico, 1985.

Ida Rodríguez Prampolini. *La crítica de arte en México en el siglo XIX.* 3 vols. Estudios y fuentes del arte en México, vols. 16–18. Instituto de Investigaciones Estéticas, UNAM. Mexico, 1964.

Manuel Romero de Terreros. *Paisajistas mexicanos del siglo XIX.* Instituto de Investigaciones Estéticas, UNAM. Mexico, 1943.

Manuel Romero de Terreros. *Catálogos de las exposiciones de la Antigua Academia de San Carlos de México, 1850–1898.* Mexico, 1963.

Raquel Tibol. *Historia general del arte mexicano: época moderna y contemporánea.* Mexico and Buenos Aires, 1964.

TWENTIETH-CENTURY ART

Dawn Ades, with contributions by Guy Brett, Stanton Loomis Catlin and Rosemary O'Neill. *Art in Latin America: The Modern Era, 1820–1890.* Exh. cat., The Hayward Gallery, and elsewhere. London, 1989.

Jean Charlot. *The Mexican Mural Renaissance, 1920–1925.* New Haven and London, 1967.

Holliday T. Day and Hollister Sturges. *Art of the Fantastic: Latin America, 1920–1987.* Exh. cat., Indianapolis Museum of Art, and elsewhere. Indianapolis, 1987.

Olivier Debroise. *Figuras en el trópico: plástica mexicana, 1920–1940.* Barcelona, 1984.

Frankfurt am Main, Schirn Kunsthalle, and elsewhere. *Images of Mexico: Der Beitrag Mexikos zur Kunst des 20. Jahrhunderts.* Exh. cat., edited by Erica Billeter. Frankfurt am Main, 1987.

Shifra M. Goldman. *Contemporary Mexican Painting in a Time of Change.* Austin and London, 1981.

Laurence P. Hurlburt. *The Mexican Muralists in the United States.* Albuquerque, N. M., 1989.

Helm MacKinley. *Modern Mexican Painters: Rivera, Orozco, Siqueiros and Other Artists of the Social Realist School.* 1941. Reprint. New York, 1989.

Bernard S. Myers. *Mexican Painting in Our Time.* New York, 1956.

New York, The Bronx Museum of the Arts, and elsewhere. *The Latin American Spirit: Art and Artists in the United States, 1920–1970.* Exh. cat., with essays by Luis R. Cancel, Jacinto Quirarte, Marimar Benítez, Nelly Perazzo, Lowery S. Sims, Eva Cockcroft, Félix Angel, and Carla Stellweg. New York, 1988.

Ida Rodríguez Prampolini. *El surrealismo y el arte fantástico de México.* Instituto de Investigaciones Estéticas, UNAM. Mexico, 1969.

Laurence E. Schmeckebier. *Modern Mexican Art.* Minneapolis, 1939.

Virginia Stewart. *Forty-five Contemporary Mexican Artists: A Twentieth-Century Renaissance.* Stanford, Calif., 1951.

Raquel Tibol. *Historia del arte mexicano: época moderna y contemporánea.* Mexico and Buenos Aires, 1964.

Index

Illustrations are indicated by italic page numbers.

Abbott, John E., 603–604
Abstract Expressionism, 36
Academy of San Carlos (Real Academia de San Carlos en Nueva España; now Escuela Nacional de Bellas Artes), Mexico City, 361, 508, 509; authority of, in artistic matters, 490, 499; brilliant beginning of, 29; competition sponsored by, 581; conservative ideology and curriculum of, 490, 503, 553, 584; directives of, concerning retablos, 500; directors of, 371, 490–91, 500, 570, 574, 576, 674; Dr. Atl's visionary programs at, 553–54, 555; exhibitions at, 504, 589; fellowships granted by, 504–505, 508, founding of, 242, 359, 419, 435, 487, 490, 498, 553; history painting taught at, 515; landscape courses introduced at, 504; Neoclassicism and, 29, 242, 360, 419, 421, 490, 491, 495, 499; paintings acquired by, 435, 506; photographs of, 498; restructuring of, 504, 509, 510; student protests at, 584; students at, 31, 33, 490, 494, 501, 504, 553, 554, 556, 562, 563, 564, 576, 588, 637, 651, 674; teaching faculty at, 29, 491, 494, 503, 504, 505, 553, 563, 570, 574, 576, 674; teaching faculty, recruited from Spain, 489, 491, 499, 500–501; teaching faculty, trained in Rome, 504–505
Acatzingo, baptismal font from, 253
Acolman, Augustinian convent at, 257, 281–82; atrial cross from, 22; 22; facade of, 290; 280; facade sculpture from, 281; patio colonnade of, 280; relief sculpture from, 289, 290; cat. no. 125
Acosta, Jorge R., 125
Actopan, Augustinian convent at, 257
agricultural deity, see Tlaloc
Agrinier, Pierre, 83, 84, 85, 86
Aguiar y Seijas, Francisco de (archbishop), 354
Aguilar, Antonio Pérez de, 435; works by: Painter's Cupboard, The, 435–36, 675–76; cat. no. 199; Venerable Palafox, The, 435
Aguirre, Francisco de, 311
Agustín I (emperor of Mexico), 501; see also Iturbide, Agustín de
Ahuizote, El, newspaper, 507
Ahuizotl (Aztec ruler), 221
Alberti, Leon Battista, 241, 247, 280; writing by: On Architecture, 24, 246
Alcíbar, José de (or Alzíbar), 361, 362, 371, 491; work by: Sor María Ignacia de la Sangre de Cristo, 354, 369–71; cat. no. 154
Alconedo, José Luis Rodríguez, 359, 487; work by: Plaque Depicting Charles IV, 488; cat. no. 237
Alcora, Spain, 481
Alexander VI (pope), 243
alfardas, from Palenque, 144
Allegorical Neptune, ceremonial arch, 322, 323
Alma-Tadema, Lawrence, 509
Almería, Spain, 486
alms plate, 415; cat. no. 187
Aloysius Gonzaga (saint), 366
altar frontal, 410–11; cat. no. 183
altarpieces, see retablos
altars: from Chichén Itzá, 195–96; cat. no. 85; from Izapa, 42, 43, 73, 74, 75; 75; cat. no. 15; from La Venta, 52; Maya, 46
Alva Ixtlilxochitl, Fernando de, 279
Alva Ixtlilxochitl, Juan de, 279
Alvarado Huanitzin, Diego de (governor), 259
Alzate, Antonio, 499
Amigoni, Jacopo, 362
Anales de Juan Bautista, 264
anastilo style, 358

Andalusia, Spain, 393, 486
Andalusian retablo style, 357
Angahuan, Church of Santiago, portal of, 247
Angeles, Felipe (general), 562, 563, 568
Anonymous artists, works by: Christ with a Rope Around His Neck, 376, 378; 378; cat. no. 158; Condesa de Canal, La, 528; cat. no. 261; Crucified Christ, 264, 266; 264; cat. no. 121; Portrait of Moctezuma, 321; St. Christopher and the Christ Child, 291–92; 292; cat. no. 126; San Felipe de Jesús, 323, 326; 326; cat. no. 140; St. Francis with Three Spheres, 342–44; cat. no. 147; St. Ignatius of Loyola, 374–75; cat. no. 156; St. James the Moor-Killer(?), 344–47; cat. no. 148; St. Joseph with the Christ Child, 371–72; cat. no. 155; St. Lucy, 436; cat. no. 200; St. Paul, 289–90; cat. no. 125; St. Peter, 289–90; cat. no. 125; St. Peter(?) Seated in an Armchair, 375–76; cat. no. 157; Sor Ana María de San Francisco y Neve, 369; cat. no. 153; Still Life, 532; cat. no. 266; Virgin of Guadalupe, 347, 349; cat. no. 149
Anthony Abbot (saint), 300
Aparicio, 171, 173
Aranama polychrome ware, 477–78
Arango Arámbula, Doroteo, see Villa, Pancho
architectural relief sculpture: from Chichén Itzá, 17, 18, 47–48, 185–86, 188, 193, 194, 195–98, 211; 198; cat. nos. 85–86; from El Tajín, 17, 18, 159, 160–64, 169, 175, 176, 178, 180–81; 17, 164, 178, 181; cat. nos. 68–69, 80; from Palenque, 149–50; cat. nos. 64–65; from Teotihuacán, 100, 101, 103; 44, 102; cat. no. 37
architecture, colonial: Baroque, 24, 25, 26, 27–28, 318, 380, 443; Classical elements of, 318, 358; eighteenth-century, 319, 357–59, 361, 374; Gothic elements of, 23, 247, 280; Isabelline elements of, 318; Mannerist style for cathedrals, 282; Mudejar elements of, 23, 318; Plateresque style, 23, 280, 281, 282, 318; Renaissance-style elements of, 23, 280–81, 282, 317; seventeenth-century, 317–18; sixteenth-century, 23, 24, 237, 240, 245, 246–47, 280–82; Solomonic columns and, 318
architecture, pre-Hispanic, 15; Aztec, 49, 278; at Chichén Itzá, 15, 16, 47, 183, 185, 198; at Copán, 15–16, 17; at El Tajín, 16, 45, 155, 156, 157, 158–59, 161, 172, 178, 180; at Izapa, 72; at La Venta, 41, 52, 53, 59; Maya, 8, 46–47, 139, 142, 185; at Monte Albán, 8, 17, 44–45, 115–16, 117; Olmec, 41; at Palenque, 15, 17, 46–47, 138, 139, 141–42; at Tenochtitlan, 48, 49, 212, 213; at Teotihuacán, 8, 16, 17, 43–44, 45; at Tikal, 15, 17; Zapotec, 44–45
Architectura (Dietterlin), illustration from, 357
Arellano, Rosario, 579; portrait of (Herrán), 579; cat. no. 294
Arellanos Melgarejo, Ramón, 173
argamasa technique, 359
Aristotle, 243, 354
armchair, 444–45; cat. no. 208; frailero type, 443; cat. no. 207
armoire (armario), 446, 448; cat. no. 210
Arochi y Baeza, Miguel, portrait of (Estrada), 516–17; cat. no. 249
Around the World in 80 Days (motion picture), 670
arquetas (caskets), 438, 456; cat. nos. 201, 215
Arrieta, Agustín, 30, 503, 520–21, 532; works by: Chinaco y la China, El, 521; cat. no. 254; Dining Room with Parrot, Candlestick, Flowers, and Watermelon, 520; cat. no. 252; Man from the Coast, The, 520; cat. no. 253
Arrieta, Pedro de, 250, 318; La Profesa, Mexico City, facade of, 318
Arroyo de Anda, Luis Aveleyra, 70

Artaud, Antonin, 674
Arteaga y Álfaro, Matías, 501
Art Nouveau, 28, 508, 576
Asbaje, Redro Manuel de, 351–52
Atheneum of Youth (Ateneo de la Juventud), 553, 579, 581
Atl, Dr. (Gerardo Murillo Cornadó), 509, 553–54, 555, 559, 588; work by: Luminous Morning, Valley of Mexico, 559; cat. no. 284; writings by: Birth and Growth of a Volcano: Parícutin, The, 561; Volcanoes of Mexico, 559
atlantean figures: from Chichén Itzá, 193–94, 211; 194; cat. no. 84; Toltec, 48; from Tula, 202
Atlatluacan, Augustinian convent, open chapel of, 23
Atlatongo, church of, 345
atrial crosses: from Acolman, 22; 22; from Tepeyac, 250, 252; cat. no. 115
Atzacoalco, convent at, 252
Atzompa, see Cerro Atzompa
Aubin, Joseph Marius Alexis, 279
Augustine (saint), 354
Augustinian order: arrival of, in Mexico, 21; convents of, 22, 23, 248, 254, 257, 280, 281–82, 283, 290, 326; 23, 236, 280–81; conversion of Mexican Indians by, 245; decoration of churches and convents by, 327, 330; iconography of the art of, 257, 330; monastic architecture approved by, 246–47; as propagators of Plateresque style, 281
Axayacatl (Aztec emperor), 218, 259
Aztec, 8, 163, 194, 209; architecture, 49, 278; artifacts of, sent to Spain by Cortés, 247–48; calendar, 16; clothing designs of, for the elite, 54, 56; conquest of, 20, 22; deities, 14, 18–19, 22, 162, 173, 175, 212, 214, 215, 228, 229, 232, 255, 316; furniture, 442; literature and poetry, 18; manuscript painting, 268, 269; military defeat, 218; myths, 14, 15, 16–17; regions controlled by, 217, 219; ritual objects of, used by Franciscans, 254; rituals and religious beliefs, 13, 62, 77, 215, 232; sculpture, 49, 363; 40; sculpture, used in colonial architecture, 255; social classes of, 10; symbolism, 223–24, 226, 228, 232; system of writing, 18, 111; Tenochtitlan, as center of empire of, 212; textiles, 485; woodcarving, 222

Bajío region, 358, 374, 375
Balbás, Gerónimo, 357–58, 412
Balbuena, Bernardo de, writing by: Grandeza mexicana, La, 457
ball game rituals, 17–18, 45, 46, 48, 159, 162, 164, 165, 167, 168, 170, 171, 173, 174, 175, 176, 181
ball game sculptures, 17, 159, 163, 164–67, 169–70, 171–76; 165; cat. nos. 70–71, 73–77
Banderilla, Rancho El Paraíso, palmas from, 172–73; cat. no. 75
baptismal fonts, 252, 253, 254; from Tecali, 252–55; cat. no. 116
Barbizon School, 569, 584
Baroque, 24–25, 499, 500, 501, 503, 532; appearance of, as style in Mexico, 241; architecture, 24, 25, 26, 27–28, 318, 380, 443; ceramics, 457; decorative arts, 364; embroidered vestments, 383, 386; expansion of, as movement, in seventeenth and eighteenth centuries, 242; furniture, 438, 443, 445, 446; High, 321, 332, 410, 411; International Late, 360; Late, 445; "Luminous," 339; Neo-, 505, 506; painting, 27, 286, 288, 322, 332, 334, 336, 339, 360, 361, 365, 627, 428, 492; poetry, 25, 27; proto-, 284, 292; retablos, 27, 28; 28; sculpture, 320, 327, 331, 333, 344, 381, 495; silverwork, 365, 401, 402, 403, 404, 406, 407, 408, 409, 410, 411, 418; Solomonic phase of, 340; Ultra-, 361

199, 200, 201, 202, 203, 204, 205, 206, 207, 208, 209, 210; sculpture at, 186; altar, 195–96; cat. no. 85; architectural relief, 17, 18, 47–48, 185–86, 188, 193, 194, 195–98, 211; *198*; cat. nos. 85–86; atlantean figures, 193–94, 211; *194*; cat. no. 84; chacmools, 192–93, 211, 224; cat. no. 83; relief, 188, 191, 195–98, 200, 201, 208; *198*; cat. nos. 85–86; standard-bearer, 188, 189, 191, 193, 211; *191*; cat. no. 82; stone, 188–89, 191–94; cat. nos. 81–84; site plan, *184*; site view, *182*; symbolism of works found at, 47, 163, 188–89, 196, 200, 208–209; Temple of the Big Table, 193; Temple of the Jaguars, 193, 200, 207; Temple of the Little Table, 193; Temple of the Three Lintels, 47; Temple of the Warriors Group, 47, 185, 191, 193; turquoise imported to, 194; Tzompantli, 185, 192; Venus Platform, 188, 189, 193; wood pendant mask from, 204; cat. no. 92

Chicomecoatl (deity), 228

Chihuahua, 359

Chilam Balam (Maya text), 18

Ch'ing dynasty, 458, 472, 477

Chippendale, Thomas, 358, 444, 445, 446; catalogue by: *Gentleman and Cabinet Maker's Director, The*, 444

Chirico, Giorgio de, 33, 575, 667

Cholula, 77, 245; Franciscan convent at, 260; map of, *246*

Chorti Maya, 80

Christopher (saint), 291, 293–94

Churriguera, José Benito de, 27

Churrigueresque style, 27–28

científicos, 553

Cipactli dragon monster (deity), 84, 85

Cisneros, Francisco Ximénez de (cardinal), 244

city planning: sixteenth-century, 24, 246; at Tenochtitlan, 24, 246; at Teotihuacán, 43, 88, 91–92

Claremont, California, *see* Pomona College

Clark, Stephen C., 600, 602

Classical Revival style, 359

Classical style, 280, 318, 358, 359, 363, 364, 365

Classic-Romantic style, 504, 505

Classic Veracruz style, 164, 167, 168, 171, 175

Claude Lorraine (Claude Gellée), 504

Clavé, Pelegrín, 503, 504, 505, 510; work by: *Don José Bernardo Couto*, 510; cat. no. 243

Clemente López, Carlos, 491

Coatepec, *palma* from, 173–74; cat. no. 76

Codex Fejérváry-Mayer, 177

Codex Ixtlilxochitl, 269, 274, 277–79; cat. no. 124

Codex Laud, 177

Codex Telleriano-Remensis, 221, 269, 272–74; cat. no. 123

Codex Vaticanus A, 269, 272

Códice franciscano, 281

Coe, Michael D., 9, 14

Coello, Claudio, 427

Coixtlahuaca, retablo from, 283

Colima, 167

Colombia, 207

colossal heads: from La Venta, 41–42, 52; from San Lorenzo, 41–42, 70; cat. no. 14; from Tres Zapotes, 41–42

Columbus, Christopher, 504

column base, from Mexico City, 254, 255–56; cat. no. 117

Comillo Público, El, newspaper, 507

Comte, Auguste, 31, 553

Concha, Andrés de la, 283, 286, 287, 293, 295, 322; work by: *Holy Family with the Young St. John the Baptist, The*, 295–96; cat. no. 128

Conquistador anonimo (Ramusio), 9

Constable, John, 31

Consuegra, Miguel de, 392

Conte, Natale, 354

Contreras, Jesús F., 506, 508; works by: *Beato Calasanz, El*, 508; *Malgré tout*, 508

Copán, 9, 15–16, 17, 43

Cora Indians, 439

Cordero, Juan, 29, 510; work by: *Doña Dolores Tosta de Santa Anna*, 510; cat. no. 244

Cordoba, Spain, 486

Cordobilla de Lácara, Badajoz, 408, 409

corn deities, 76

corn-pith (cornstalk paste) sculpture, 238, 248, 264, 266, 346; *264*; cat. no. 121

Correa, Juan, the Elder, 336, 342, 360, 424; altarpiece commissions of, 332, 338, 340, 361; artistic style of, 321, 322, 339; artistic success of, 332, 334, 338; Baroque style and, 332, 334, 339; compared to: Rodríguez Juárez, 428; Villalpando, 321, 322, 334, 339, 340; family background of, 338; influenced by Antonio Rodríguez, 338; Mannerism and, 286, 321–22; as portraitist, 426, 427; work attributed to: *Encounter of Cortés and Moctezuma, The; The Four Continents*, 321, 339, 422–27; *426*; cat. no. 194; work by: *Expulsion from Paradise, The*, 336, 338–39, 340; cat. no. 145

Correggio (Antonio Allegri), 322

Cortés, Antonio, 345–46

Cortés, Hernán, 10, 48, 246, 346, 504; Aztec artifacts sent as gifts by, to Charles V, 247, 260; conquest of Mexico by, 21, 244, 350; conversion of Mexican Indians advocated by, 244, 254; expedition to Honduras made by, 259; meeting of, with Moctezuma, 423–26; Moctezuma's gifts to, 383, 442; monastery associated with, 292; portrait and coat of arms of, 20; publication of letters by, 214; Tlaxcala's loyalty to, 343; as writer, 21

Cortés valeroso (Vega), 20

Cosmopolitan magazine, 630

Coto, Luis, 504

Cotzumalhuapan, 17

Council of Trent, 249, 283, 286, 287, 298, 327, 330, 371

Counter-Reformation, 44, 249, 285, 286, 287; iconography of, 283, 296, 308, 314; liturgical and musical reforms of, 305; painting style associated with, 300, 301, 309; sculptural style associated with, 319, 375

Courbet, Gustave, 565, 569; work by: *Artist's Studio*, 667

Courtes, Velérie, 67

Couto, José Bernardo, 510; portrait of (Clavé), 510; cat. no. 243

Covarrubias, Miguel, 557–58, 650, 655; portrait of (Ruíz), 655; cat. no. 341; works by: *Bone, The (Rural Schoolteacher)*, 650–51; cat. no. 337; *Pageant of the Pacific* (with Ruíz), 655; *Sunday in Xochimilco, A*, 651; writings by: *Eagle, the Jaguar, and the Serpent: Indian Art of the Americas, The*, 650; *Island of Bali*, 650

Coyoacán, open-air painting school at, 584

Coyohuacan, 48

Coyolxauhqui (deity), 215, 229

Crespi, Giovanni Battista (called Il Cerano), 287

crosier, 401; cat. no. 174

Cruillas, Marquis de (viceroy), 454

Cruz, Patricia, 108

Cruz del Milagro, 41

Cuauhtémoc (Aztec emperor), 259

Cuauhtitlan, funerary offerings from, 97; cat. no. 32

Cuauhtotolapan, 41

Cubism, 620; Analytic, 608; Kahlo and, 677; Orozco and, 596; Rivera and, 33, 607, 608, 610, 612, 614–15, 616, 617, 618; Siqueiros and, 638, 640, 642; Synthetic, 608, 610; Tamayo and, 668

Cuernavaca, mural cycle from (Rivera), 630

Cuicuilco, 225

Cuitzeo, Augustinian convent at, 282

cups, from Monte Albán, 123

Curiel, Gustavo, 326

Dainzú, 116

Dalí, Salvador, 36

Dartmouth College, Hanover, New Hampshire, mural for (Orozco), 557, 596, 600, 604, 605; *34*

Daumier, Honoré, 503, 541, 565

David, Jacques-Louis, 505

Davis, Stuart, 557, 666

Day of the Dead festival, 539, 544, 546, 547, 550

death and Venus deity, *see* Itzapapolotl

Dehesa, Teodoro, 166, 175, 176

De Kooning, Willem, 557

Delacroix, Eugène, 565

Delaunay, Robert, 612

delftware, 457

Del Río throne, from Palenque, 152; reconstruction drawing of, *152*

Delvaux, Paul, 36

Demuth, Charles, 596; work by: *I Saw the Figure 5 in Gold*, 645

Detroit Institute of Arts, mural for (Rivera), 557, 667; *32, 552*

Diálogo entre un francés y un italiano sobre la América Septentrional (Fernández de Lizardi), 499

Díaz, Porfirio, 30, 33, 507, 510, 539, 543, 545, 550, 553, 554, 557, 600; *see also* Porfiriato

Díaz del Castillo, Bernal, 4–5, 10, 21, 243, 350, 423–24; writing by: *Discovery and Conquest of Mexico*, 5

Diego, Juan, 316, 347, 362, 380

Dieguinos order, 323

Dietterlin, Wendel, 357; writing by: *Architectura*, illustration from, *357*

Dirección de Antropología, 137

Discovery and Conquest of Mexico (Díaz del Castillo), 5

disks, gold, from Chichén Itzá, 198, 206, 208–209; *208*; cat. no. 95

Divisionism, 610

Doctrina breve (Zumárraga), 246; *241*

Doctrina cristiana (Zumárraga), 246

Domínguez Bello, Arnulfo, 508

Dominican order: arrival of, in Mexico, 21; convents of, 249, 383, 386; conversion of Mexican Indians by, 244, 245; doctrines and beliefs of, 308–309; iconography of the art of, 257

Don Bulle Bulle, newspaper, 503

Drucker, Philip, 59, 60, 61, 63, 66

Durán, Diego, 77

Durango, 359

Dürer, Albrecht, 247–48

Dynamic Symmetry, 597, 598

Eagle, the Jaguar, and the Serpent: Indian Art of the Americas, The (Covarrubias), 650

earflares: from Izapa, 77, 78–79; cat. no. 18; from La Venta, 56, 63; cat. no. 8; from Tenochtitlan, 220

ear pendants, from Chiapa de Corzo, 78, 81–82; cat. no. 21

Echave Ibía, Baltasar de, 288, 298, 300, 301, 311; works by: *Baptism of Christ*, 301; *Sts. Anthony Abbot and Paul the Hermit*, 300–301; cat. no. 131

Echave Orio, Baltasar de, 286, 287, 288, 296, 300, 311, 314, 322, 347; work by: *Christ After the Flagellation Adored by the Penitent St. Peter*, 296–98; cat. no. 129

Echave Rioja, Baltasar de, 288, 300, 311, 314, 334; work by: *Adoration of the Magi, The*, 311–14, 334; cat. no. 139

Ecija, Juan de, 412

Eder, Rita, 668

effigy vessel, from Cerro de la Campana, 129; cat. no. 55

Egerton, Daniel Thomas, 502, 532–33; work by: *Valley of Mexico; The*, 532–33; cat. no. 267

Ehecatl (deity), 77, 78, 175; *see also* Quetzalcoatl

El Petén region, 140

El Salvador, 77, 83, 164

El Tajín, 43, 155–60, 171; apogee of, 157, 160, 164, 171, 181; architecture at, 16, 45, 155, 156, 157, 158–59, 161, 172, 178, 180; ball-game rituals at, 17, 18, 159, 162, 164, 165, 167, 168, 170, 171, 173, 174, 175, 176, 181; Building of the Columns, 158, 160, 165, 171, 178, 180, 181; cacao crop controlled by, 162; cranial deformation practiced by, 178; cult of pulque at, 159, 181; East Ridge, 158; importance

produced in, 457; city planning for, 24; Colegio de San Ildefonso, mural for (Rivera), 33; Colegio Máximo de San Pedro y San Pablo, 399; convents at, 239; Dirección de Antropología, 566, 568; Escuela de Pintura y Escultura (La Esmeralda), 651; Escuela Nacional de Artes Plásticas, 651; Escuela Nacional Preparatoria, 559, 605, 679; murals for, 555; (Atl) 559; (Leal) 586; (Orozco) 556, 571, 574, 588, 589, 590, 595, 602, 604–605; (Siqueiros) 638; Escuela Superior de Ingeniería y Arquitectura, 651; Galería de Arte Mexicano, 658; Galería de Arte Moderno del Teatro Nacional, 674; Hospital de Jesús, painting at, 298; cat. no. 130; Hospital of the Immaculate Conception, 298; Hotel del Prado, mural for (Rivera), 636; Iglesia del Hospital de Jesús, mural for (Orozco), 606; Inter-American Biennale of Mexico, 575; La Concepción, convent of, 369; La Ensenanza, Church of, retablo from, 358; La Profesa, 318; facade of (Arrieta), 318; marketplace of, 381, 489; Museo Nacional de Antropología, 556, 670; Palace of the Viceroys, 489; Palacio de Bellas Artes, 581; murals for: (Orozco) 589, 592; (Rivera) 626; (Siqueiros) 641, 648; 35; Palacio de Cortés, mural for (Rivera), 630; Palacio de Minería (Tolsá), 29, 501; 29; Palacio Nacional, 676; murals for (Rivera), 630; Paseo de la Reforma, 506; plan of (1556), 9; Plaza Mayor (Zócalo), 24, 487, 489–90, 492, 499; 25 (engraving of, 489–90; cat. no. 238; view of, 213); recreational areas in, 482–83; Ritz Hotel, mural for (Covarrubias), 651; Rococo style, at its height in, 413; Sagrario Metropolitano, 28, 357, 489, 490 (facade of, 357, 358; portal of, 412); San Agustín, Church of, choir stalls from, 326–27, 330–31; 328–29; cat. no. 141; San Fernando, choir stalls of, 331; San Francisco, convent of, 239, 252 (see also San José de los Naturales); Santa Isabel Tola, 349; San José de los Naturales, 248, 252, 264, 371, 383 (chapel of, 239, 245, 371; feather mosaics from, 258–60, 261; cat. no. 119); Santa María Chiconautla, 346; Santa María Tonantzintla, 27; 27; San Pedro and San Pablo, Jesuit church of, 342; Santa Teresa, convent of, 318, 501; Santiago Tlatelolco, 245, 248, 346; Secretaría de Educación Pública, murals for (Rivera), 555, 556, 623 (Court of Festivals, 620, 621, 624, 626, 630, 632, 633; Court of Labor, 620, 621, 624, 630); silverwork from, 392, 393, 394, 396, 399, 401, 402, 403, 407, 412, 414, 417; cat. nos. 167–76, 184, 186, 189–90, 192; Teatro Nacional, 581 (see also Palacio de Bellas Artes); Universidad Popular Mexicana, 579; University of Mexico, 241, 246; Zócalo, see Plaza Mayor; see also Academy of San Carlos, Mexico City; Xochimilco

Mexico City and Its Environs, lithographic collection, 503

Mexico City Cathedral, 24, 489, 499; altar of Las reliquias in, 436; Altar of the Kings, 357; Chapel of St. Peter, 297; Chapel of the Immaculate Conception, 294; choir, 330; choir stalls, 331; column fragments excavated from, 256; facade sculpture, 320; 315; gremial from, 256–57; cat. no. 118; paintings in, 293, 294, 296, 297, 321, 331, 332, 334, 338, 340, 361; Retablo de los Reyes, 499; Sacristy of, 321, 331–32, 334, 340, 361; Sagrario Metropolitano adjoining, 357, 412; sculpture for, 323, 326, 331, 340; cat. nos. 140, 142; silverwork owned by, 401, 408, 409, 420; Tolsá's work on, 491; views of, 25, 213

Mezcala region, Guerrero, 217
Mezcala style, 105, 219, 220
Michelangelo Buonarroti, 296, 559
Michoacán, 218, 246, 248; cornstalk paste technique used in, 264; furniture made in, 441; cat. no. 205
millennialism, 245
Miller, Mary Ellen, 15
Millet, Jean François, 565, 586
Millon, René, 111, 112, 113, 114
Milpa Alta, sculpture from, 284
Ming dynasty, 458, 464, 470, 471, 472, 473, 474, 475, 476, 478, 479

Miranda, José de (father), 351, 355
Miranda, José de (son), 351
Miranda, Juan de, 351, 355; work attributed to: Sor Juana Inés de la Cruz, 307, 351–52, 354–56; cat. no. 151
mirrors: from Izapa, 78; from La Venta, 59, 62–63, 66; cat. no. 7
Mitla, 8
Mixe dialect, 74
Mixe-Zoquean, 74, 81
Mixtec, 8, 18, 49, 120, 127, 363
Moctezuma II (Moctezuma Xocoyotzin), 20, 244, 259, 273, 274, 383, 423–26, 442, 504
Modernism, 507
modernismo, 507–10
Momper, Joost de, the Younger, 301
Mondrian, Piet, 610, 617
Monet, Claude, 575
monstrances, 402, 405–406, 409, 412, 414, 419, 421; cat. nos. 175, 178, 182, 186, 191, 193
Montañés, Juan Martínez, 284, 285, 318
Montañesino style, 319
Montaño, Otilio, 630
Monte Albán, 43, 44–45, 115–20, 124, 134; architecture at, 8, 17, 44–45, 115–16, 117; Ball Court, 17, 115; 118; burial customs at, 116, 118, 120, 127, 128; ceramics from, 45, 117, 120, 123, 127–28, 131; 128; cat. nos. 48, 54; decline of, 120; geographical characteristics of, 115; Main Plaza, 45, 115; 117; military character of, 9; mural paintings at, 45; North Platform, 115; population of, 115; rituals and ceremonies at, 117, 120; sculpture at, 45; stelae, 45, 127, 132; cat. no. 53; site plan, 119; site view, 116; South Platform, 115, 127; symbolism of works found at, 127; system of writing at, 18; tombs at, 120, 127
Montelupo, Italy, 457
Montenegro, Roberto, 509, 556, 618, 665; work by: Paon blanc, Le, 508
Montesclaros, marqués de, 298
Montesinos, Antonio de (fray), 243
Montreal: World's Fair (Expo '67), mural for (Tamayo), 669
Montúfar (archbishop), 250, 280, 327, 349
monuments, stone: from Izapa, 72, 73, 74–75, 76; from La Venta, 52–53
moon deity, see Xbalanqul
Moorish-Christian style, see Mudejar style
Mora, Bernardo, 547
Morales, Florencio, 547
Morales, G., 526, 528; work by: Señor Amo, El (the Master), 526, 528; cat. no. 260
More, Thomas, 21, 31, 246, 280; writing by: Utopia, 246; 246
Morelos, State of, 54
Morley, Sylvanus G., 196
Moro, Cesar, 658
Moroni, G.B., work by: Schoolmaster of Titian, 492
Moscow: Red Army Club, proposed murals for (Rivera), 626
Motolinía (Fray Toribio de Benavente), 237, 248, 252, 343
Moya y Contreras (archbishop), 401
Moyssén, Xavier, 307
Mudejar style, 23, 247, 256, 280, 281, 318, 363, 450
Munch, Edvard, 35; work by: Scream, The, 566
Muñoz, Jesús, portrait of (Bustos), 524; cat. no. 256
Muñoz, Juan, 524; portrait of (Bustos), 524; cat. no. 257
Muñoz, Rafael F., writing by: Let's Join Up with Pancho Villa, 598
mural paintings, pre-Hispanic: from Chichén Itzá, 186, 188, 200, 201; from El Tajín, 158, 176–78; cat. nos. 78–79; from Monte Albán, 45; from Teotihuacán, 14, 43, 44, 88, 89, 91, 92, 99, 103, 109–14, 177; 14; cat. nos. 44–47
mural paintings, sixteenth-century, 248, 252, 253, 254, 260, 266–67, 282–83; 248, 283; cat. no. 122
mural paintings, twentieth-century (Mexican muralism), 32, 33–35, 553–58; by Orozco, 33, 34, 35,

554, 555, 556, 557, 559, 571, 574, 588, 589, 590, 592, 595, 596, 598, 600,602, 603, 604–605, 606; 34, 37; by Rivera, 33, 34, 554, 555, 556, 557, 559, 595, 607, 620, 621, 623, 624, 626, 630, 632, 633, 634, 636, 667, 679; 32, 552; by Siqueiros, 33, 34, 35, 555, 557, 559, 637, 638, 639, 640, 641, 647, 648; 35
Murillo, Bartolomé Esteban, 296, 360, 361–62, 366; work by: Santiago Madonna, 321
Murillo Cornadó, Gerardo, see Atl, Dr.
Mystical City of God, The (María de Jesús de Agreda), 336

Nahua, 8, 14, 187, 188
Nahuatl language, 94, 215, 248, 268, 274, 346, 381, 554, 559
Napatecuhtlan, hacha from, 169–70; cat. no. 73
Napoleon Bonaparte, 359
Narratio regionum indicarum per hispanos quosdam devastatarum verissima (Casas, B.), 243; 243
Naturalism, 508
Nava, Fidencio, 508
Nazarene aesthetics, 503, 510
Nebaj, 200
Nebel, Karl (or Carlos), 155, 160, 502
necklace, from Izapa, 77, 78; cat. no. 18
Neo-Baroque style, 505, 506
Neoclassicism: Academy of San Carlos and, 29, 242, 360, 419, 421, 490, 491, 495, 499; ceramics and, 480; eighteenth-century, 239, 242, 359–60, 364, 487, 491; embroidered vestments and, 386, 388; nineteenth-century, 29, 499–502, 510; painting and, 492, 494; sculpture and, 495; silverwork and, 418, 419, 420, 421, 488
Neo-Impressionism, 608
Neoplatonism, 24
neostilo, 359
Netzahualcóyotl, 254
Neue Sachlichkeit, 652
New Laws (1542), 244
New School for Social Research, New York City, mural for (Orozco), 557, 596, 598; 37
New York City: Art Students League, 596; Delphic Studios, 591, 597, 598; Downtown Gallery, 596; Experimental Workshop, 645; Kleeman Gallery, 606; Knoedler Gallery, 635; Metropolitan Museum of Art, 594, 596, 675; Modern Gallery, 615–16; Museum of Modern Art, 589, 600, 602, 604, 630, 663, 668; New School for Social Research, mural for (Orozco), 557, 596, 598; 37; Rockefeller Center, mural for (Rivera), 557, 626; Valentine Gallery, 668; Whitney Museum of American Art, 645
New Yorker, The, magazine, 558, 650
niche pilasters, 358, 361; 358
Niven, David, 670
Noguchi, Isamu, 557
Noreña, Miguel, 505, 506; works by: Fray Bartolomé de las Casas Converting an Aztec Family, 506; Monumento a Cuauhtémoc, 506
Núñez de Miranda, Antonio (fray), 354

Oaxaca: Santuario de Nuestra Señora de la Soledad, facade sculpture from, 320; 320; silverwork from, 406, 419; cat. nos. 178, 191; Temple of the Princes, 419; writing desks made in, 440; cat. no. 204; yesería style used in, 319
Oaxaca, State of, 8, 43, 74, 185
Oaxaca, Valley of, 44, 115, 117, 120, 127; ceramic vessels from, 122, 123–24, 125, 129; cat. no. 51; ceramic wall reliefs from, 122–23, 124, 125, 132; cat. nos. 49–50; relief sculpture from, 133–34; cat. no. 58
Obregón, Alvaro (general), 555, 568, 586
Obregón, José, 515; work by: Discovery of Pulque, The, 515, 581; cat. no. 247
Obregón y Alcocer, Antonio, 374
obsidian funerary offerings, from Cuauhtitlan(?), 97; cat. no. 32
Ocampo, Agustín, 508
Ocampo, Salvador de, 330, 350

Photo Credits

Site Photographs Commissioned by the Metropolitan Museum
Enrique Franco Torrijos

Object Photographs Taken by Photographers in Mexico Commissioned by the Metropolitan Museum

Salvador Lutteroth/Juan José Medina/Jesus Sánchez Uribe:
23–24, 243–50, 252, 255–59, 262–66, 268, 270–71, 273–74, 276–98, 300–302, 304–305, 308–10, 315, 317, 324, 326–27, 331, 335, 336–40, 344–46, 349, 356–58, 360–61, 365

Encuadre: Gerardo Suter–Lourdés Almeida:
115–16, 118, 121–22, 125–33, 137–38,

140–67, 169, 171–91, 193–95, 199–212, 214–15, 217, 219, 221–27a, 228, 230–34, 236–37, 239–42

Michel Zabé:
1–18, 21–22, 25–30, 33–40, 42–44a–d, 45, 48, 50–56a–b, 57–58, 61–62, 64–65, 67a, 68–69, 73–76, 78–86, 90–93, 98–108, 112–14, 117, 134

Other Photographs
19, 20: Schecter Lee, New York; 46: Allen Mims; 111: Scala/Art Resource, New York; 197 a, c: Roger Fry; 251, 253, 254, 269, 272: The South Bank Center, Hayward Gallery Touring Exhibitions Arts Council Collection, London; 260: Guillermo Aldana; 266: Joseph A. Zayac, Flint Institute of Arts, Mich.; 284: Courtesy of CDS Gallery, New York; 299, 311, 353: Courtesy of Mary-Anne Martin/Fine Art, New York; 303: Christie's, New York; 319: Ben Blackwell; 330, 363: Jorge Contreras Chacel, Courtesy of the Centro Cultural Arte Contemporáneo, Mexico City; 349: Courtesy Museo Rufino Tamayo, Mexico City; 351, 352, 362: Lynton Gardiner, New York; 354: Sotheby's, New York; 355: Lourdés Almeida and Gerardo Suter, Courtesy of the Centro Cultural Arte Contemporáneo, Mexico City.

All other photographs were provided by the lenders.